*The following is regarded as an extension of the copyright page.*

# CONTENTS

# II ❑ Film and Reality    135

# III ❑ The Film Medium: Image and Sound    283

IV ❏ Film Narrative and the Other Arts   405

xii                                   CONTENTS

# PREFACE

In the thirty years since the first edition of this collection appeared in 1974—let alone the more than one hundred years since the first films were shown—the academic study of film has changed enormously, and the journalistic and popular criticism of film has been deeply affected as well. Yet many of the same issues that preoccupied and stimulated writers from the very beginning of film theory and criticism are still puzzling later generations: Is the filmed world realistic or artificial? Is film a language? Is its world best expressed in silence? in sound? through stories that may be derived from other arts? through stories that can be told only on film?

Many of these questions were first formulated in critical language indebted to the methods and terminology of such humanistic disciplines as literary criticism, art history, and aesthetics. But early on, theorists began to emphasize the obligation to appreciate what was different, even unique, about film in comparison with the other arts: its formal qualities, its common need for enormous capital investment, and its relation to a mass audience.

In the light both of continuing issues and evolving ideas, we might roughly divide the history of film theory into three somewhat overlapping phases. The first, which generally corresponds to the silent period, was formalist. From about 1916 (the year in which the earliest essay in this volume was published) to the mid-1930s, theorists such as Hugo Münsterberg, Rudolf Arnheim, and Sergei Eisenstein attempted to demonstrate that film was indeed an art, not just a direct recording of nature. The coming of synchronized sound then brought on a realist reaction to the formalist argument. Siegfried Kracauer and André Bazin among others argued that film was not an art in contrast to nature but an art *of* nature.

By the 1960s and 1970s, this classical phase of film theory was being challenged by writers responding both to historical conditions (the Viet Nam war, the student

riots in France and America) and to new developments in the academic conception of "knowledge," as defined by literature and the social sciences. Just at the time that film study itself was gaining an academic status separate from the departments of literature and art in which it had often first appeared, these writers questioned the confidence with which classical film theory had used such terms as art, nature, society, reality, illusion, self, performance, work, author, and artist—and in the process claimed to unearth hidden assumptions about race, class, gender, and language itself that could be best addressed through an analysis of film.

Especially beginning in the 1970s an explosion of new interpretive approaches derived from a broad range of disciplines began to have a tremendous influence on humanistic studies generally and—in part because of the relative youth of the field—on film study in particular. One powerful early inspiration came from linguistics. Here, drawing upon the work of C. S. Peirce, Ferdinand de Saussure, Roman Jakobson, Louis Hjelmslev, and Noam Chomsky, film theorists and critics explored the systems of meaning that allow communication of all kinds to exist. A formal consideration of the meaning of individual films, or the special nature of film among the arts, became a less significant question than the place of both in more general systems of communication and meaning.

In this fertile and energetic period—perhaps the richest in new explorations of film since the invention of the medium itself—the most salient avenues of interpretation first followed semiotic and structuralist models, derived from the structural anthropology of Claude Lévi-Strauss as well as the demystified cultural history of Roland Barthes and Michel Foucault, and often augmented with Marxist historical and Freudian psychoanalytic analysis. Somewhat later came the influence of Jacques Lacan's revisionary view of Freud (itself responsive to linguistic issues), the feminist interrogation of the power structures of vision (in which Marx and Freud were often married), and the deconstructive views of Jacques Derrida (where efforts to pierce the surface of the text and discover its "contradictions" often employed Marxist and psychoanalytic tools).

None of these new approaches appeared without controversy or has maintained its relevance without polemic. Each in its own way has contributed to such classical issues of film theory as the relation of film to reality and how film may (or may not) be considered a language. In addition, they have introduced such fresh considerations as the way that films reveal the underlying social attitudes and ideologies of the cultures that produce them, the ways films manipulate audience beliefs, and the ways they raise, exploit, and seek to satisfy audience desires.

In the 1990s and into the twenty-first century, film study still maintains its earliest concerns with discovering the general terms and assumptions required for understanding film. However, since the mid-1980s, we have entered a fourth, more eclectic, period. One significant aspect of this new phase seeks to merge insights owed to history, psychology, and linguistics into larger perspectives suitable for understanding individual films as well as film in general. These approaches sometimes draw upon feminism, neoformalism, cognitive psychology, empiricism, or phenomenology. They may assert the shaping activity of the audience on film meaning (as opposed to the passive audience usually postulated in earlier approaches).

Or they may emphasize the resistance of the performer, especially the star, to the meaning imposed by the film narrative; the ability of the independent filmmaker to construct a personal statement despite the supposedly totalitarian necessities of the medium; the web of financial, political, and artistic decisions that constitute film production; or the challenge of digitization and new forms of media.

Surveys of how earlier editions of *Film Theory and Criticism* were being used in the classroom have indicated that courses are most often structured around an interplay between classical and contemporary answers to basic issues, along with an acute awareness of the new avenues that have been opened by the willingness to venture beyond disciplinary barriers. With this new phase still only beginning to demonstrate its potential, we have maintained the historical perspective of this collection as a broad survey of thinking about film over the past century. In revising, we have therefore retained a good number of "classical" works that have set the agenda of even some of the most advanced recent theory and criticism. We have maintained the space given to major theorists such as André Bazin and Christian Metz, and we continue to enhance our selections from the work of Sergei Eisenstein with a new translation. At the same time we have tried to illustrate the crucial new directions theory has taken over the last thirty years. In the process of opening space for new essays, we have regretted the need to drop old favorites, if only to keep the collection to a manageable size (and price).

Perhaps because so many of these questions about film have turned out to be perennially interwoven, our division of the complexity of theory into seven major topics now more than ever indicates general emphasis rather than exclusive argument. As in past editions, the final section—"Film: Psychology, Ideology, and Technology"—most obviously carries the banners of the new approaches: how film shapes or reflects cultural attitudes, reinforces or rejects the dominant modes of cultural thinking, and stimulates or frustrates the needs and drives of the psyche.

But the impact of new thinking is visible in each section. Every teacher will have his or her own way of organizing these essays into a course, and every reader will discover connections and ramifications that go beyond the confines of a particular section. To help those echoes be heard more clearly, we have continued to include an index of proper names, marking especially those places where individual films are discussed at length.

New essays have been added to many of the seven sections. Section I treats basic issues of "Film Language." Section II expands the argument to include the relation between "Film and Reality." Section III is focused on "The Film Medium: Image and Sound" to register the inclusion of essays that deal with both the visual and the aural components of the medium. Section IV in the past generally emphasized the connections between film and the other arts and, later, the issue of adaptation. Now, it brings those themes together with a unifying focus on the central issue of film narration. A consideration of "The Film Artist" takes up Section V, while issues of "Film Genre" and audience are stressed in Section VI, with a particular focus on the genre of horror, which still attracts so much attention from both critics and theorists (as well as audiences). To register the impact of the many new techniques of visual representation, Section VII has been retitled "Film: Psychology, Ideology, and Technology."

Our deep thanks to all those friends and colleagues whose suggestions and criticism helped us formulate this new edition, in particular Richard Peña and Ed McCann, as well as the teachers of film who took the time to respond in such useful detail to Oxford's queries about their use of the fifth edition. We are also grateful to Arman Satchyan, who prepared the index for the present edition.

*June 2003*

L. B.
M. C.

# Film Theory and Criticism

# 1

# Film Language

Because films embody, communicate, enforce, and suggest meanings, film theorists often suggested that film constitutes a language, a "visual esperanto." They have spoken of film's grammar, its vocabulary, and even of its jargon. The poet Vachel Lindsay spoke of film as a kind of "hieroglyphic" language while the theorist Béla Balász thought of it as a new "form-language." Russian formalists have similarly talked of "semantic signs" and investigated film's relation to "inner speech." In what sense, then, is film a language? Is the claim a suggestive metaphorical one or one that can, as the semioticians think, be subjected to systematic, scientific analysis? And, more generally, by what procedures does film generate meaning?

Those who consider film to be a language often rely on the analogy between the word and the shot. But simply stringing words together does not produce intelligible discourse, and most theorists agree that simply stringing separate photographic shots together will not produce intelligible works of visual art.

The great Soviet filmmakers Sergei M. Eisenstein and Vsevolod Pudovkin asked what more than mere ability to photograph reality was required to transform the new technical resources into a great new art. Their answer was montage, the art of combining pieces of film or shots into larger units—first, the scene, then the sequence, and, finally the complete film. D. W. Griffith, the great American director of *The Birth of a Nation* and *Intolerance*, to whom the Soviet directors acknowledged a great debt, was not important because he took better pictures than anybody else. He was important for having discovered montage, the fluid integration of the camera's total range of shots, from extreme close-up to distant panorama, so as to produce the most coherent narrative sequence, the most systematic meaning, and the most effective rhythmic pattern. In doing so, Griffith had, they thought, contributed to the development of a cinematic language and invented the distinctive art of the film.

Eisenstein, the most brilliant figure in Soviet cinema, began his career as a stage director. The youthful Eisenstein then made four films in five years: *Strike* (1924), *Potemkin* (1925), *October* (1927), and *Old and New* (1928). In the 1930s and 1940s (until his death in 1948) he worked primarily as a theorist and teacher, completing only *Alexander Nevsky* and *Ivan the Terrible, Parts I* and *II*. Eisenstein's conversion from an artist to a theorist is to be explained in part by political realities, for his emphasis on cinematic "form" was uncongenial to his government's official aesthetics of socialist realism. But it is equally true that his conception of montage did not easily accommodate itself to the use of synchronized dialogue and, therefore, to the kind of film which had prevailed by the 1930s.

Eisenstein viewed montage as a kind of collision or conflict, especially between a shot and its successor. He sees each shot as having a kind of potential energy which can display itself in purely visual terms: the direction of its movements, the volume of its shapes, the intensity of its light, and so forth. This potential energy becomes kinetic when the first shot collides with the succeeding one. The two shots can produce a conflict in their emotional content (happy versus sad), in their use of illumination (dark versus light), in their rhythms (slow versus fast), in their objects (large versus small), in their directions of movement (right versus left), in their distances (close-up versus far shot), or in any combination thereof. In his films, this conflict produced the tense, violent rhythms that became an Eisenstein trademark. Conflict was also important to Eisenstein because he took it to be an expression, in the realm of images, of the Marxist dialectical principle. Indeed, Eisenstein maintained that just as the meaning of a sentence arises from the interaction of its individual words, cinematic meaning is the result of the dialectical interplay of shots. His emphasis on the conflict of shots, as distinct from a mere linking of shots, distinguishes his concept from that of his colleague, Pudovkin. Pudovkin's view of montage as a method of building, of adding one thing to another, is not merely of theoretical interest. His theory produced more realistic narratives (*Mother, Storm over Asia*), with their more deliberate, calmer pace.

Eisenstein, like many theorists who emerged in the era of silent films, was uncomfortable with the addition of synchronized dialogue. Because "silent" films had always used asynchronous sound effects and music, Eisenstein believed that the sound film could use these tools with even greater precision and complexity. But he rejected dialogue as being incompatible with the proper use of montage (see Section III). By contrast, André Bazin, while agreeing that dialogue and montage are incompatible, regards synchronized speech as a necessary and proper development. For Bazin, dialogue returns film to the rightful path from which montage and silence diverted it. According to him, the film image ought to reveal reality whole, not cut it into tiny bits. The cinematic method Bazin endorses, which combines composing with the camera and staging an action in front of it, has, like montage, come to be known by a French term, mise-en-scène.

In Bazin's view the montage theorists did not in fact speak for all of the silent film. He discerns in the work of Erich von Stroheim, F. W. Murnau, and Robert Flaherty an alternative, mise-en-scène tradition, which emphasizes not the ordering, but the content of images. The film's effect and meaning are not the product of a juxtaposition of images, but are inherent in the visual images themselves. For Bazin, the mon-

tage theorists' emphasis on the analogy between word and shot is false, and he rejects it along with their reluctance to employ sound as a source of cinematic meaning. Bazin argues that the mise-en-scène tradition within silent film actually looked toward the incorporation of synchronous sound as a fulfillment, not as a violation, of the film's destiny.

Bazin considers German expressionism and Russian symbolism to have been superseded in the 1930s and 1940s by a form of editing more appropriate to the dialogue film. This "analytic" editing, which characteristically manifests itself in the dramatic technique of shot/reverse shot, was an important innovation. Still more important, however, was the development of the depth of field shot by Orson Welles and William Wyler in the early 1940s (anticipated in the 1930s by Jean Renoir), which made even the use of "analytic" montage unnecessary. Entire scenes could now be covered in one take, the camera sometimes remaining motionless. For Bazin, the shot-in-depth, like the use of synchronous sound, constituted a crucial advance toward total cinema and an important stage in the evolution of the language of cinema. It allowed for greater realism and encouraged a more active mental attitude on the part of the viewer, who could now explore more fully the interpretive and moral ambiguity inherent in the film image.

Bazin's composition-in-depth is one kind of long take, but Brian Henderson calls attention to a quite different type developed by Jean-Luc Godard. Godard's long, slow tracking shot avoids depth. Cinema is a two-dimensional art that creates the illusion of a third dimension through its "walk-around" capability. Indeed, both montage and composition-in-depth are techniques that reach for that third dimension, although in different ways: montage through a succession of shots from different angles and at different ranges, composition-in-depth through movements of the camera or of the actors. Bazin's shot can thus be regarded as a long take, in which the camera pauses before a scene rich with interpretive possibilities. In his analysis of the films of Godard, Henderson calls attention to a quite different kind of long take: Godard's slow tracking shot that (perhaps in polemical opposition to the views of Bazin) concertedly avoids and even excludes the impression of depth, to adhere to the single-point perspective of painting.

In Henderson's view, Godard does so for ideological reasons. Composition-in-depth presents an infinitely deep, rich, complex, ambiguous and mysterious bourgeois world. Godard's reversion to one plane demystifies this world and its pretenses. Godard's style of presentation is intimately related to the critical point of view he insists upon. The viewer is presented visually and ideologically with a single flat picture of the bourgeois world not to be unthinkingly accepted as transparent and easy to understand, but to be examined, criticized, and (Godard might conclude) rejected.

Eisenstein and Bazin, for all their differences, were both intrigued by the idea that film was a language, and we might view Godard as adding to the resources of that language. But it is only with the rise of structuralism and semiotics that writers such as Christian Metz and Umberto Eco subjected the topic to more precise analysis. Metz particularly brought this issue to the center of film studies and attempted to put the discussion on a firm scientific basis. He did so by invoking the analysis of language provided by linguists in the semiotic tradition of Ferdinand de Saussure, a tradition that attempted to develop a science of "signs." Saussure distinguished sharply

between signs which constitute a *langue* and those that constitute a *langage*. It is Metz's contention that film does not constitute a *langue* in the strict sense of constituting a language system, but that it nevertheless qualifies as a *langage* in the looser sense of being a signifying practice characterized by recognizable ordering procedures. Cinema lacks the double articulation characteristic of natural language. The phonemes of natural language are basic, distinctive units of sound which do not themselves signify. It is only when they are articulated at the second level by combining them into monemes (morphemes) or words that they signify. By contrast, the basic unit of cinema, the shot, conveys meaning because of the iconic or isomorphic relation it bears to the world it photographs. The shot is motivated, and is unlike the basic units of language which are arbitrary, conventional and unmotivated.

If Metz rejects the assimilation of film language to natural language, he also rejects the common analogy between shot and word. In Metz's view the shot is equivalent not to the word but to the sentence or statement, and it is the organization of shots in the film chain that invites and supports the claim that film constitutes a language. In the beginning film was purely iconic—it signified exclusively by means of the resemblance of its imagery to objects in the visible world. But reality does not tell stories. It is only when shots are organized according to repeatable, recognizable codes that they become discourse and are capable of telling a story. Cinematic language comprises a number of cinematic codes and sub-codes, but the code which Metz analyses in detail (the code which was more or less established by the time of D. W. Griffith) is the *grande syntagmatique* of the image track. This code, a sub-code of the montage code, permits us to account for the procedures by which cinema denotes such narrative phenomena as succession, priority, temporal breaks, and spatial continuity. As he shows in his analysis of what he calls the alternate syntagma (one of the eight he describes) the order in which signifying images occur may or may not be the same as that in which the realities they signify occur. The student of the language of cinema must therefore account for the processes and mechanisms that make it possible for the viewer to interpret them correctly. For Metz film does not simply reveal reality; it describes it in a language whose features we are only beginning to understand.

Despite Metz's critique of the claim that film constitutes a *langue*, many theorists in the tradition of Saussure, Louis Althusser, and Jacques Lacan maintain that all cinematic meaning is essentially linguistic and that the relation between signifier and signified is arbitrary, conventional, and both culturally determined and culturally relative. The meanings of signifiers are determined by their relation to other signifiers rather than by their reference to any extra-linguistic reality. Films are texts to be "read" and reading them requires our initiation into the specific conventions and ideological biases of cinematic discourse. As Stephen Heath argues, "the match of film and world, is a matter of representation, and representation is in turn a matter of discourse. . . . [I]n this sense at least, film is a series of languages, a history of codes."

Against this influential view Stephen Prince argues that cinematic coding is not linguistic but is largely iconic and mimetic, that film images are typically understood because they resemble the realities to which they refer. The capacity to understand these signs has a biological basis (even animals manifest it). Interpreting iconic signs is more a matter of recognizing similarities by transferring real world skills to the cinematic situation than it is a matter of mastering arbitrary, unmotivated, cultural con-

ventions. Indeed, the capacity to understand iconic signs is shared cross-culturally and this ability helps to explain the intelligibility and global popularity of cinema (recall the early description of it as a verbal Esperanto). Pictorial meaning cannot be explained as a kind of linguistic meaning.

Daniel Dayan views film language from a post-structuralist perspective which goes beyond Metz's earlier, structuralist concept. Using a term drawn from the psychoanalytic theories of Lacan, Dayan describes the system of the suture which negotiates the viewer's access to the film. In Dayan's view this system, which relates to classical narrative cinema as verbal language does to literature, is ideologically charged. Bazin prizes the depth-of-field shot, while Henderson analyzes the meaning of Godard's parallel tracking shot. Essential to Dayan's system is his revaluation of the shot/reverse shot sequence. The viewer's pleasurable possession of the image, his seeing of the image in shot one, is disrupted by his discovery of the frame and his sense of being dispossessed of what he is prevented from seeing. In the first step of reading the film he discovers that he is authorized to see only what happens to be in the axis of the glance of another spectator, called by Jean-Pierre Oudart "the absent-one." The second shot, the reverse shot of the first, represents the fictional owner of the glance corresponding to the first shot. The reverse shot "sutures" the hole opened in the spectator's imaginary relationship with the filmic field by the perception of the absent one.

The absent one stands for that which any shot necessarily lacks if it is to attain meaning—another shot. For, within the system of the suture, the meaning of a shot depends on the next shot and the pair constitute a cinematic statement. The meaning of the shot is given retrospectively and only in the memory of the spectator. Thus, the system encroaches on the spectator's freedom by interpreting, indeed, by remodeling his memory. According to this deconstructive analysis, the system imposes an ideology and the spectator loses his access to the present. The system of the suture is not, however, the only cinematographic system, and Dayan describes how Godard has explored an alternative in his later films.

Nick Browne rejects the adequacy of the shot/reverse shot sequence to account for the operation and effects of classic film style and his more complex rhetorical analysis is meant to contribute to the semiotic study of filmic texts. According to him the system of suture establishes the origin of film imagery by reference to the agency of character (the absent-one) but, surprisingly, does not consider the final agency, the authority of the narrator. The traces of the narrator's action may seem to be effaced by the system as the suture theorists suggest but, in Browne's opinion, such an effect can only be the result of a more general rhetoric. He therefore proposes an account in which the structure of the imagery, whatever its apparent forms of presentation, refers jointly to the action of an implied narrator (who defines his position with respect to the tale by his judgments, including his moral judgments) as well as to the imaginative action occasioned by his placing or being placed by the spectator. The point-of-view of the spectator, in turn, and contrary to the views of Jean-Luc Comolli and Jean-Louis Baudry, is not centered at a single point of view or at the center of any simply optical system. The way in which we, as spectators, are implicated in the action is as much a matter of our position with respect to the unfolding of events as it is in their representation from a point in space. In Browne's analysis of Ford's

*Stagecoach* he shows that, although we see the action with Lucy's eyes and are invited by a set of structures to experience the force and character of that view, we are put in a position finally of having to reject it as a view either that is right or that we must assent to. Even though we have been sutured into that point of view, we are not thereby committed to the ideology enforced by the system of the suture.

# VSEVOLOD PUDOVKIN
## *FROM* FILM TECHNIQUE

## [ON EDITING]

## METHODS OF TREATMENT OF THE MATERIAL
### *(Structural Editing)*

A cinematograph film, and consequently also a scenario, is always divided into a great number of separate pieces (more correctly, it is built out of these pieces). The sum of the shooting-script is divided into sequences, each sequence into scenes, and, finally, the scenes themselves are constructed from a whole series of pieces (script-scenes) shot from various angles. An actual scenario, ready for use in shooting, must take into account this basic property of the film. The scenarist must be able to write his material on paper exactly as it will appear upon the screen, thus giving exactly the content of each shot as well as its position in sequence. The construction of a scene from pieces, a sequence from scenes, and reel from sequences, and so forth, is called *editing*. Editing is one of the most significant instruments of effect possessed by the film technician and, therefore, by the scenarist also. Let us now become acquainted with its methods one by one.

### *Editing of the Scene*

Everyone familiar with a film is familiar with the expression "close-up." The alternating representation of the faces of the characters during a dialogue; the representation of hands, or feet, filling the whole screen—all this is familiar to everyone. But in order to know how properly to use the close-up, one must understand its significance, which is as follows: the close-up directs the attention of the spectator to that detail which is, at the moment, important to the course of the action. For instance, three persons are taking part in a scene. Suppose the significance of this scene consist in the *general* course of the action (if, for example, all three are lifting some heavy object),

then they are taken simultaneously in a *general* view, the so-called long-shot. But suppose any one of them change to an independent action having significance in the scenario (for example, separating himself from the others, he draws a revolver cautiously from his pocket), then the camera is directed on him alone. His action is recorded separately.

What is said above applies not only to persons, but also to separate parts of a person, and objects. Let us suppose a man is to be taken apparently listening calmly to the conversation of someone else, but actually restraining his anger with difficulty. The man crushes the cigarette he holds in his hand, a gesture unnoticed by the other. This hand will always be shown on the screen separately, in close-up, otherwise the spectator will not notice it and a characteristic detail will be missed. The view formerly obtained (and is still held by some) that the close-up is an "interruption" of the long-shot. This idea is entirely false. It is no sort of interruption. It represents a proper form of construction.

In order to make clear to oneself the nature of the process of editing a scene, one may draw the following analogy. Imagine yourself observing a scene unfolded in front of you, thus: a man stands near the wall of a house and turns his head to the left; there appears another man slinking cautiously through the gate. The two are fairly widely distant from one another—they stop. The first takes some object and shows it to the other, mocking him. The latter clenches his fists in a rage and throws himself at the former. At this moment a woman looks out of a window on the third floor and calls, "Police!" The antagonists run off in opposite directions. Now, how would this have been observed?

1. The observer looks at the first man. He turns his head.

2. What is he looking at? The observer turns his glance in the same direction and sees the man entering the gate. The latter stops.

3. How does the first react to the appearance on the scene of the second? A new turn by the observer; the first takes out an object and mocks the second.

4. How does the second react? Another turn; he clenches his fists and throws himself on his opponent.

5. The observer draws aside to watch how both opponents roll about fighting.

6. A shout from above. The observer raises his head and sees the woman shouting at the window.

7. The observer lowers his head and sees the result of her warning—the antagonists running off in opposite directions.

The observer happened to be standing near and saw every detail, saw it clearly, but to do so he had to turn his head, first left, then right, then upwards, whithersoever his attention was attracted by the interest of observation and the sequence of the developing scene. Suppose he had been standing farther away from the action, taking in the two persons and the window on the third floor simultaneously, he would have received only a general impression, without being able to look separately at the first, the second, or the woman. Here we have approached closely the basic significance of editing. Its object is the showing of the development of the scene in relief, as it were, by guiding the attention of the spectator now to one, now to the other separate element. The lens of the camera replaces the eye of the observer, and the changes of angle of the camera—directed now on one person, now on another, now on one detail,

now on another—must be subject to the same conditions as those of the eyes of the observer. The film technician, in order to secure the greatest clarity, emphasis, and vividness, shoots the scene in separate pieces and, joining them and showing them, directs the attention of the spectator to the separate elements, compelling him to see as the attentive observer saw. From the above is clear the manner in which editing can even work upon the emotions. Imagine to yourself the excited observer of some rapidly developing scene. His agitated glance is thrown rapidly from one spot to another. If we imitate this glance with the camera we get a series of pictures, rapidly alternating pieces, creating a *stirring scenario editing-construction.* The reverse would be long pieces changing by mixes, conditioning a calm and slow editing-construction (as one may shoot, for example, a herd of cattle wandering along a road, taken from the viewpoint of a pedestrian on the same road).

We have established, by these instances, the basic significance of the constructive editing of scenes. It builds the scenes from separate pieces, of which each concentrates the attention of the spectator only on that element important to the action. The sequence of these pieces must not be uncontrolled, but must correspond to the natural transference of attention of an imaginary observer (who, in the end, is represented by the spectator). In this sequence must be expressed a special logic that will be apparent only if each shot contain an impulse towards transference of the attention to the next. For example (1) A man turns his head and looks; (2) What he looks at is shown.

### Editing of the Sequence

The guidance of the attention of the spectator to different elements of the developing action in succession is, in general, characteristic of the film. It is its basic method. We have seen that the separate scene, and often even the movement of one man, is built up upon the screen from separate pieces. Now, the film is not simply a collection of different scenes. Just as the pieces are built up into scenes endowed, as it were, with a connected action, so the separate scenes are assembled into groups forming whole sequences. The sequence is constructed (edited) from scenes. Let us suppose ourselves faced with the task of constructing the following sequence: two spies are creeping forward to blow up a powder magazine; on the way one of them loses a letter with instructions. Someone else finds the letter and warns the guard, who appears in time to arrest the spies and save the magazine. Here the scenarist has to deal with simultaneity of various actions in several different places. While the spies are crawling towards the magazine, someone else finds the letter and hastens to warn the guard. The spies have nearly reached their objective; the guards are warned and rushing towards the magazine. The spies have completed their preparations; the guard arrives in time. If we pursue the previous analogy between the camera and an observer, we now not only have to turn it from side to side, but also to move it from place to place. The observer (the camera) is now on the road shadowing the spies, now in the guardroom recording the confusion, now back at the magazine showing the spies at work, and so forth. But, in combination of the separate scenes (editing), the former law of sequence succession remains in force. A consecutive sequence will appear upon the screen only if the attention of the spectator be transferred correctly from scene to scene. And this correctness is conditioned as follows: the spectator sees the creeping spies, the loss of the letter,

and finally the person who finds the letter. The person with the letter rushes for help. The spectator is seized with inevitable excitement—Will the man who found the letter be able to forestall the explosion? The scenarist immediately answers by showing the spies nearing the magazine—his answer has the effect of a warning "Time is short." The excitement of the spectator—Will they be in time?—continues; the scenarist shows the guard turning out. Time is very short—the spies are shown beginning their work. Thus, transferring attention now to the rescuers, now to the spies, the scenarist answers with actual impulses to increase of the spectator's interest, and the construction (editing) of the sequence is correctly achieved.

There is a law in psychology that lays it down that if an emotion give birth to a certain movement, by imitation of this movement the corresponding emotion can be called forth. If the scenarist can effect in even rhythm the transference of interest of the intent spectator, if he can so construct the elements of increasing interest that the question, "What is happening at the other place?" arises and at the same moment the spectator is transferred whither he wishes to go, then the editing thus created can really excite the spectator. One must learn to understand that editing is in actual fact a compulsory and deliberate guidance of the thoughts and associations of the spectator. If the editing be merely an uncontrolled combination of the various pieces, the spectator will understand (apprehend) nothing from it; but if it be co-ordinated according to a definitely selected course of events or conceptual line, either agitated or calm, it will either excite or soothe the spectator.

### Editing of the Scenario

The film is divided into reels. The reels are usually equal in length, on an average from 900 to 1,200 feet long. The combination of the reels forms the picture. The usual length of a picture should not be more than from 6,500 to 7,500 feet. This length, as yet, involves no unnecessary exhaustion of the spectator. The film is usually divided into from six to eight reels. It should be noted here, as a practical hint, that the average length of a piece (remember the editing of scenes) is from 6 to 10 feet, and consequently from 100 to 150 pieces go to a reel. By orientating himself on these figures, the scenarist can visualise how much material can be fitted into the scenario. The scenario is composed of a series of sequences. In discussing the construction (editing) of the scenario from sequences, we introduce a new element into the scenarist's work— the element of so-called dramatic continuity of action that was discussed at the beginning of this sketch. The continuity of the separate sequences when joined together depends not merely upon the simple transference of attention from one place to another, but is conditioned by the development of the action forming the foundation of the scenario. It is important, however, to remind the scenarist of the following point: a scenario has always in its development a moment of greatest tension, found nearly always at the end of the film. To prepare the spectator, or, more correctly, preserve him, for this final tension, it is especially important to see that he is not affected by unnecessary exhaustion during the course of the film. A method . . . that the scenarist can employ to this end is the careful distribution of the titles (which always distract the spectator), securing compression of the greater quantity of them into the first reels, and leaving the last one for uninterrupted action.

Thus, first is worked out the action of the scenario, the action is then worked out into sequences, the sequences into scenes, and these constructed by editing from the pieces, each corresponding to a camera angle.

# EDITING AS AN INSTRUMENT OF IMPRESSION
## (Relational Editing)

We have already mentioned, in the section on editing of sequences, that editing is not merely a method of the junction of separate scenes or pieces, but is a method that controls the "psychological guidance" of the spectator. We should now acquaint ourselves with the main special editing methods having as their aim the impression of the spectator.

*Contrast.*—Suppose it be our task to tell of the miserable situation of a starving man; the story will impress the more vividly if associated with mention of the senseless gluttony of a well-to-do man.

On just such a simple contrast relation is based the corresponding editing method. On the screen the impression of this contrast is yet increased, for it is possible not only to relate the starving sequence to the gluttony sequence, but also to relate separate scenes and even separate shots of the scenes to one another, thus, as it were, forcing the spectator to compare the two actions all the time, one strengthening the other. The editing of contrast is one of the most effective, but also one of the commonest and most standardised, of methods, and so care should be taken not to overdo it.

*Parallelism.*—This method resembles contrast, but is considerably wider. Its substance can be explained more clearly by an example. In a scenario as yet unproduced a section occurs as follows: a working man, one of the leaders of a strike, is condemned to death; the execution is fixed for 5 a.m. The sequence is edited thus: a factory-owner, employer of the condemned man, is leaving a restaurant drunk, he looks at his wrist-watch: 4 o'clock. The accused is shown—he is being made ready to be led out. Again the manufacturer, he rings a door-bell to ask the time: 4.30. The prison waggon drives along the street under heavy guard. The maid who opens the door—the wife of the condemned—is subjected to a sudden senseless assault. The drunken factory-owner snores on a bed, his leg with trouser-end upturned, his hand hanging down with wrist-watch visible, the hands of the watch crawl slowly to 5 o'clock. The workman is being hanged. In this instance two thematically unconnected incidents develop in parallel by means of the watch that tells of the approaching execution. The watch on the wrist of the callous brute, as it were connects him with the chief protagonist of the approaching tragic *dénouement*, thus ever present in the consciousness of the spectator. This is undoubtedly an interesting method, capable of considerable development.

*Symbolism.*—In the final scenes of the film *Strike* the shooting down of workmen is punctuated by shots of the slaughter of a bull in a stockyard. The scenarist, as it were, desires to say: just as a butcher fells a bull with the swing of a pole-axe, so, cruelly and in cold blood, were shot down the workers. This method is especially inter-

esting because, by means of editing, it introduces an abstract concept into the consciousness of the spectator without use of a title.

*Simultaneity.*—In American films the final section is constructed from the simultaneous rapid development of two actions, in which the outcome of one depends on the outcome of the other. The end of the present-day section of *Intolerance* . . . is thus constructed. The whole aim of this method is to create in the spectator a maximum tension of excitement by the constant forcing of a question, such as, in this case: Will they be in time?—will they be in time?

The method is a purely emotional one, and nowadays overdone almost to the point of boredom, but it cannot be denied that of all the methods of constructing the end hitherto devised it is the most effective.

*Leit-motif (reiteration of theme).*—Often it is interesting for the scenarist especially to emphasise the basic theme of the scenario. For this purpose exists the method of reiteration. Its nature can easily be demonstrated by an example. In an anti-religious scenario that aimed at exposing the cruelty and hypocrisy of the Church in employ of the Tsarist régime the same shot was several times repeated: a church-bell slowly ringing and, superimposed on it, the title: "The sound of bells sends into the world a message of patience and love." This piece appeared whenever the scenarist desired to emphasise the stupidity of patience, or the hypocrisy of the love thus preached.

The little that has been said above of relational editing naturally by no means exhausts the whole abundance of its methods. It has merely been important to show that constructional editing, a method specifically and peculiarly filmic, is, in the hands of the scenarist, an important instrument of impression. Careful study of its use in pictures, combined with talent, will undoubtedly lead to the discovery of new possibilities and, in conjunction with them, to the creation of new forms.

1926

# SERGEI EISENSTEIN
## *FROM* FILM FORM

## BEYOND THE SHOT [THE CINEMATOGRAPHIC PRINCIPLE AND THE IDEOGRAM]

It is a weird and wonderful feeling to write a booklet about something that does not in fact exist.

There is, for example, no such thing as cinema without cinematography.

Nevertheless the author of the present book has managed to write a book about the *cinema* of a country that has no *cinematography*,

about the cinema of a country that has an infinite multiplicity of cinematic characteristics but which are scattered all over the place—with the sole exception of its cinema.

This article is devoted to the cinematic features of Japanese culture that lie outside Japanese cinema and it lies outside the book in the same way as these features lie outside Japanese cinema.

Cinema is: so many firms, so much working capital, such and such a 'star', so many dramas.

Cinema is, first and foremost, montage.

Japanese cinema is well provided with firms, actors and plots.

And Japanese cinema is quite unaware of montage.

Nevertheless the principle of montage may be considered to be an element of Japanese representational culture.

The script, for their script is primarily representational.

The hieroglyph.

The naturalistic representation of an object through the skilled hands of Ts'ang Chieh in 2650 BC became slightly formalised and, with its 539 fellows, constituted the first 'contingent' of hieroglyphs.

The portrait of an object, scratched with a stylus on a strip of bamboo, still resembled the original in every way.

13

But then, at the end of the third century, the brush was invented.
In the first century after the "happy event" (AD) there was paper
and in the year 220 indian ink.
A complete transformation. A revolution in draughtsmanship. The hieroglyph,
which has in the course of history undergone no fewer than fourteen different styles
of script, has crystallised in its present form.
The means of production (the brush and indian ink) determine the form. The four-
teen reforms have had their effect.

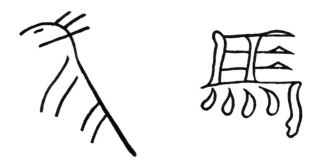

In short, it is already impossible to recognise in the enthusiastically cavorting
hieroglyph *ma* (a horse) the image of the little horse settling pathetically on its hind
legs in the calligraphy of Ts'ang Chieh, the horse that is so well known from ancient
Chinese sculpture.
But to hell with the horse and with the 607 remaining symbols of the *hsiang-cheng*,
the first *representational* category of hieroglyphs.
It is with the second category of hieroglyphs—the *huei-i*, or 'copulative'—that our
real interest begins.
The point is that the copulation—perhaps we had better say the combination—of
two hieroglyphs of the simplest series is regarded not as their sum total but as their
product, i.e. as a value of another dimension, another degree: each taken separately
corresponds to an object but their combination corresponds to a *concept*. The combi-
nation of two 'representable' objects achieves the representation of something that
cannot be graphically represented.
For example: the representation of water and of an eye signifies 'to weep',
the representation of an ear next to a drawing of a door means 'to listen',
a dog and a mouth mean 'to bark'
a mouth and a baby mean to 'scream'
a mouth and a bird mean 'to sing'
a knife and a heart mean 'sorrow', and so on
But—this is montage!!
Yes. It is precisely what we do in cinema, juxtaposing representational shots that
have, as far as possible, the same meaning, that are neutral in terms of their meaning,
in meaningful contexts and series.
It is an essential method and device in any cinematographic exposition. And, in a
condensed and purified form, it is the starting-point for 'intellectual cinema',

a cinema that seeks the maximum laconicism in the visual exposition of abstract concepts.

We hail the method of the (long since) dead Ts'ang Chieh as a pioneering step along this path.

I have mentioned laconicism. Laconicism provides us with a stepping-stone to another point. Japan possesses the most laconic forms of poetry, the *hai-kai* (that appeared at the beginning of the 12th century) and the *tanka*.

They are virtually hieroglyphics transposed into phrases. So much so that half their value is judged by their calligraphic quality. The method by which they are resolved is quite analogous.

This method, which in hieroglyphics provides a means for the laconic imprinting of an abstract concept, gives rise, when transposed into semantic exposition, to a similarly laconic printed imagery.

The method, reduced to a stock combination of images, carves out a dry definition of the concept from the collision between them.

The same method, expanded into a wealth of recognised semantic combinations, becomes a profusion of *figurative* effect.

The formula, the concept, is embellished and developed on the basis of the material, it is transformed into an image, which is the form.

In exactly the same way as the primitive thought form—thinking in images—is displaced at a certain stage and replaced by conceptual thought.

But let us pass on to examples:

The *hai-kai* is a concentrated Impressionist sketch:

> Two splendid spots
> on the stove.
> The cat sits on them.
> 
> (GE-DAI)

> Ancient monastery.
> Cold moon.
> Wolf howling.
> 
> (KIKKO)

> Quiet field.
> Butterfly flying.
> Sleeping.
> 
> (GO-SIN)

The *tanka* is a little longer (by two lines).

> Mountain pheasant
> moving quietly, trailing
> his tail behind.
> Oh, shall I pass
> endless night alone.
> 
> (HITOMASO)

We see these as montage phrases, montage lists.

The simplest juxtaposition of two or three details of a material series produces a perfectly finished representation of another order, the psychological.

Whereas the finely honed edges of the intellectual formulation of the concept produced by the juxtaposition of hieroglyphs are here blurred, the concept blossoms forth immeasurably in *emotional* terms.

In Japanese script you do not know whether it is the inscription of a character or the independent product of graphics.

Born from a cross between the figurative mode and the denotative purpose, the hieroglyphic method has continued its tradition not just in literature but also, as we have indicated, in the *tanka* (not *historically* consistent but consistent *in principle* in the minds of those who have created this method).

Precisely the same method operates in the most perfect examples of Japanese figurative art.

Sharaku was the creator of the finest prints of the 18th century and, in particular, of an immortal gallery of actors' portraits. He was the Japanese Daumier. That same Daumier whom Balzac (himself the Bonaparte of literature) in turn called the 'Michelangelo of caricature'.

Despite all this Sharaku is almost unknown in our country.

The characteristic features of his works have been noted by Julius Kurth. Examining the question of the influence of sculpture on Sharaku, he draws a parallel between

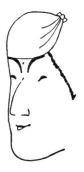 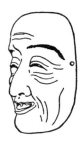

The expression on the mask, also created in Sharaku's day, is the same as that in the portrait of Tomisaburo. The facial expression and the arrangement of masses are very similar to one another even though the mask represents an old man and the print a young woman (Tomisaburo in the role of a woman). The similarity is striking but nevertheless the two have nothing in common. Here we find a characteristic feature of Sharaku's work: whereas the anatomical proportions of the carved wooden mask are almost correct, the proportions of the face in the print are quite simply impossible. The distance between the eyes is so great as to make a mockery of common sense. The nose, in comparison with the eyes at least, is twice as long as a normal nose could possibly be, the chin is on the whole out of all proportion to the mouth: the relationships between the eyebrows, the mouth, the details in general are quite unthinkable. We can observe the same thing in all Sharaku's large heads. It is just not possible that the great master was unaware that these proportions were wrong. He quite deliberately repudiated naturalism and, *while each detail taken separately is constructed on the principles of concentrated naturalism, their general compositional juxtaposition is subjugated to a purely semantic purpose. He took as the norm for the proportions the quintessence of psychological expressiveness*. . . .

the portrait of the actor Nakayama Tomisaburo and an antique mask of the semi-religious No theatre, the mask of Rozo, the old bonze.

Is this not the same as the hieroglyph that juxtaposes the independent 'mouth' and the dissociated 'child' for the semantic expression 'scream'?

Just as Sharaku does by stopping time so we too do in time by provoking a monstrous disproportion between the parts of a normally occurring phenomenon, when we suddenly divide it into 'close-up of hands clasped', 'medium shots of battle' and 'big close-ups of staring eyes' and produce a montage division of the phenomenon into the types of shot! We make an eye twice as large as a fully grown man! From the juxtaposition of these monstrous incongruities we reassemble the disintegrated phenomena into a single whole but from our own perspective, in the light of our own orientation towards the phenomenon.

The disproportionate representation of a phenomenon is organically inherent in us from the very beginning. A. R. Luria has shown me a child's drawing of 'lighting a stove'. Everything is depicted in tolerable proportions and with great care: firewood, stove, chimney. But, in the middle of the room space, there is an enormous rectangle crossed with zigzags. What are they? The turn out to be 'matches'. Bearing in mind the crucial importance of these matches for the process depicted, the child gives them the appropriate scale.

The representation of an object in the actual (absolute) proportions proper to it is, of course, merely a tribute to orthodox formal logic, a subordination to the inviolable order of things.

This returns periodically and unfailingly in periods when absolutism is in the ascendancy, replacing the expressiveness of antiquated disproportion with a regular 'ranking table' of officially designated harmony.

Positivist realism is by no means the correct form of perception. It is simply a function of a particular form of social structure, following on from an autocratic state that has propagated a state uniformity of thought.

It is an ideological uniformity that makes its visual appearance in the ranks of uniforms of the Life Guard regiments. . . .

Thus, we have seen how the principle of the hieroglyph—'denotation through representation'—split into two.

Following the line of its purpose (the principle of 'denotation') to the principles of the creation of literary imagery.

Following the line of the methods of achieving this purpose (the principle of 'representation') to the striking methods of expressiveness used by Sharaku.

Just as we say that the two diverging arms of a hyperbola meet at infinity (although no one has ever been such a long way away!), so the principle of hieroglyphics, splitting endlessly into two (in accordance with the dynamic of the signs), unexpectedly joins together again from this dual divergence in yet a fourth sphere—theatre.

Estranged from one another for so long, they are once again—the theatre is still in its cradle—present in *parallel* form, in a curious dualism.

The denotation of the action, the representation of the action, is carried out by the so-called Joruri, a silent puppet on the stage.

This antiquated practice, together with a specific style of movement, passes into the early Kabuki theatre as well. It is preserved to this day, as a partial method, in the classical repertoire.

But let us pass on. This is not the point. The hieroglyphic (montage) method has penetrated the very technique of acting in the most curious ways.

However, before we move on to this, since we have already mentioned the representational aspect, let us dwell on the problem of the shot so that we settle the matter once and for all.

The shot.

A tiny rectangle with some fragment of an event organised within it.

Glued together, these shots form montage. (*Of course*, if this is done in the appropriate rhythm!)

That, roughly, is the teaching of the old school of film-making.

> Screw by screw,
> Brick by brick. . . .

Kuleshov, for instance, even writes with a brick: 'If you have an idea-phrase, a particle of the story, a link in the whole dramaturgical chain, then that idea is expressed and built up from shot-signs, just like bricks. . . .

> Screw by screw,
> Brick by brick . . .

as they used to say.

The shot is an element of montage.

Montage is the assembling of these elements.

This is a most pernicious mode of analysis, in which the understanding of any process as a whole (the link: shot—montage) derives purely from the external indications of the course it takes (one piece glued to another).

You might, for instance, come to the notorious conclusion that trams exist merely to block streets. This is an entirely logical conclusion if you confine yourself to the functions that they performed, for example, in February 1917. But the Moscow municipal authorities see things in a different light.

The worst of the matter is that an approach like this does really, like an insurmountable tram, block the possibilities of formal development. An approach like this condemns us not to dialectical development but to [the process of] mere evolutionary 'perfection', in so far as it does not penetrate to the dialectical essence of the phenomenon.

In the final analysis this kind of evolutionising leads either through its own refinement to decadence or, vice versa, to straightforward weakness caused by a blockage in the blood supply. However odd it may seem, there is an eloquent, nay melodious, witness to both these eventualities simultaneously in Kuleshov's *The Happy Canary*.

The shot is by no means a montage *element*.

The shot is a montage cell. Beyond the dialectical jump in the *single* series: shot—montage.

What then characterises montage and, consequently, its embryo, the shot? Collision. Conflict between two neighbouring fragments. Conflict. Collision.

Before me lies a crumpled yellowing sheet of paper.

On it there is a mysterious note:

'Series—P' and 'Collision—E'.

This is a material trace of the heated battle on the subject of montage between E (myself) and P (Pudovkin) six months ago.

We have already got into a habit: at regular intervals he comes to see me late at night and, behind closed doors, we wrangle over matters of principle.

So it is in this instance. A graduate of the Kuleshov school, he zealously defends the concepts of montage as a *series* of fragments. In a chain. 'Bricks'. Bricks that *expound* an idea serially.

I opposed him with my view of montage as a *collision*, my view that the collision of two factors gives rise to an idea.

In my view a *series* is merely one possible *particular* case.

Remember that physics is aware of an infinite number of combinations arising from the impact (collision) between spheres. Depending on whether they are elastic, non-elastic or a mixture of the two. Among these combinations is one where the collision is reduced to a uniform movement of both in the same direction.

That corresponds to Pudovkin's view.

Not long ago we had another discussion. Now he holds the view that I held then. In the meantime he has of course had the chance to familiarise himself with the set of lectures that I have given at the GTK since then.

So, montage is conflict.

Conflict lies at the basis of every art. (A unique 'figurative' transformation of the dialectic.)

The shot is then a montage cell. Consequently we must also examine it from the point of view of *conflict*.

Conflict within the shot is:

potential montage that, in its growing intensity, breaks through its four-sided cage and pushes its conflict out into montage impulses between the montage fragments;

just as a zigzag of mimicry flows over, making those *same* breaks, into a zigzag of spatial staging,

just as the slogan, 'Russians know no obstacles', breaks out in the many volumes of peripeteia in the novel *War and Peace*.

If we are to compare montage with anything, then we should compare a phalanx of montage fragments—'shots—with the series of explosions of the internal combustion engine, as these fragments multiply into a montage dynamic through "impulses" like those that drive a car or a tractor.

Conflict within the shot. It can take many forms: it can even be part of . . . the story. Then it becomes the 'Golden Series'. A fragment 120 metres long. Neither the analysis nor the questions of film form apply in this instance.

But these are 'cinematographic':

the conflict of graphic directions (lines)

the conflict of shot levels (between one another)

the conflict of volumes

the conflict of masses (of volumes filled with varying intensities of light)
the conflict of spaces, etc.

Conflicts that are waiting only for a single intensifying impulse to break up into antagonistic pairs of fragments. Close-ups and long shots. Fragments travelling graphically in different directions. Fragments resolved in volumes and fragments resolved in planes. Fragments of darkness and light . . . etc.

Lastly, there are such unexpected conflicts as:
the conflict between an object and its spatial nature and the conflict between an event and its temporal nature.

However strange it may seem, these are things that have long been familiar to us. The first is achieved through optical distortion by the lens and the second through animation or *Zeitlupe* [slow motion].

The reduction of all the properties of cinema to a single formula of conflict and of cinematographic indicators to the dialectical series of one *single indicator* is no empty rhetorical pastime.

We are now searching for a single system of methods of cinematographic expression that will cover all its elements.

The reduction of these to a series of general indicators will solve the problem as a whole.

Our experience of the various elements of cinema is quite variable.

Whereas we know a very great deal about montage, we are floundering about, as far as the theory of the shot is concerned, between the Tretyakov Gallery, the Shchukin Museum and geometricisations that set your teeth on edge.

If we regard the shot as a particular molecular instance of montage and shatter the dualism 'shot—montage', then we can apply our experience of montage directly to the problem of the theory of the shot.

The same applies to the theory of lighting. If we think of lighting as the collision between a beam of light and an obstacle, like a stream of water from a fire hose striking an object, or the wind buffeting a figure, this will give us a quite differently conceived use of light from the play of 'haze' or 'spots'.

Thus far only the principle of conflict acts as this kind of denominator:
*the principle of optical counterpoint.*

We should not forget now that we must resolve a counterpoint of a different order, *the conflict between the acoustic and the optical in sound cinema.*

But let us for the moment return to one of the most interesting optical conflicts:
the conflict between the frame of the shot and the object.

The position of the cinema represents the materialisation of the conflict between the organising logic of the director and the inert logic of the phenomenon in collision, producing the dialectic of the camera angle.

In this field we are still sickeningly impressionistic and unprincipled.

Nevertheless there is a clear principle even in this technique.

A mundane rectangle that cuts across the accident of nature's randomness. . . .

Once again we are in Japan! Because one of the methods of teaching drawing used in Japanese schools is so cinematographic.

Our method of teaching drawing is to: take an ordinary sheet of Russian paper with

four corners. In the majority of cases you then squeeze on to it, ignoring the edges (which are greasy with sweat!), a bored caryatid, a conceited Corinthian capital or a plaster Dante (not the magician, the other one—Alighieri, the man who writes comedies).

The Japanese do it the other way round. You have a branch of a cherry tree or a landscape with a sailing boat.

From this whole the pupil cuts out compositional units: a square, a circle, a rectangle.

He creates a shot!

These two schools (theirs and ours) precisely characterise the two basic tendencies that are fighting one another in contemporary cinema!

Our school: the dying method of spatial organisation of the phenomenon in front of the lens:

from the 'staging' of a scene to the erection literally of a Tower of Babel in front of the lens.

The other method, used by the Japanese, is that of 'capturing' with the camera, using it to organise. Cutting out a fragment of reality by means of the lens.

Now, however, at a time when the centre of attention in intellectual cinema is at last beginning to move from the raw material of cinema as it is to 'deductions and conclusions', to 'slogans' based on the raw material, the differences are becoming less important to both schools and they can quietly blend into a synthesis.

Eight or so pages back, the question of theatre slipped from our grasp, like a pair of galoshes on a traum, slipped from our grasp.

Let us go back to the question of the methods of montage in Japanese theatre, particularly in acting.

The first and most striking example, of course, is the purely cinematographic method of 'transitionless acting'. Together with extremely refined mime transitions the Japanese actor also makes use of the direct opposite. At a certain moment in his performance he halts. The 'black men' obligingly conceal him from the audience. So,

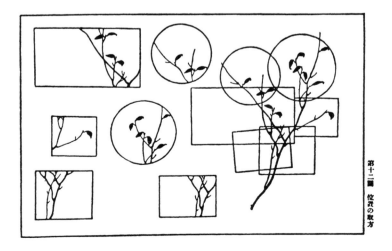

he emerges in new make-up, a new sign: these characterise a new stage (step) in his emotional state.

Thus, for instance, the play *Narukami* is resolved by Sadanji's transition from drunkenness to madness. Through a mechanical cut. And a change in the range (arsenal) of coloured stripes on his face, emphasising those whose duty it is to demonstrate that the intensity is greater than in the first make-up.

This method is organic to film. The forced introduction into film of the European acting tradition of fragments of 'emotional transitions' once more compels cinema to make time. At the same time, the method of 'cut' acting provides the opportunity to devise entirely new methods. If you replace a single changing face by a whole gamut of faces of varying dispositions—typage—the expression is always more intense than that on the surface of the face of a professional actor, which is too receptive and devoid of any organic resistance.

I have utilised the distinction between the polar stages of facial expression in a pointed juxtaposition in our new film about the countryside [*Old and New*]. This results in a more pointed 'play of doubt' around the separator. Will the milk thicken or not? Deception? Money? Here the psychological process of the play of motives—faith and doubt—resolves into the two extreme states of joy (certainty) and gloom (disillusionment). In addition, this is heavily underlined by light (which by no means conforms to real life). This leads to a significant heightening of tension.

Another remarkable feature of the Kabuki theatre is the principle of 'decomposed acting'. Shocho, who played the leading female roles when the Kabuki troupe visited Moscow, portrayed the dying girl in *The Mask Maker* through quite disconnected fragments of acting.

Acting with just the right arm. Acting with one leg. Acting merely with the neck and head. The whole process of the death agony was decomposed into solo performances by each 'party' separately: the legs, the arms, the head. Decomposition into shot levels. And each successive fragment became shorter as the unhappy ending—death—approached.

Freed from primitive naturalism and using this method, the actor wins the audience over completely 'with his rhythm', which makes a scene based on its general composition on the most consistent and detailed naturalism (blood, etc.) not only acceptable but extremely attractive.

Since we are no longer distinguishing in principle between montage and what happens within the shot, we can cite here a third method.

The Japanese actor in his work utilises slow tempo to a degree that is unknown in our theatre. Take the famous hara-kiri scene in *The Forty-Seven Samurai*. That degree of slowing down is unknown on our stage. Whereas in our previous example we observed the decomposition of the links between movements, here we see the decomposition of the process of movement, i.e. *Zeitlupe* [slow motion]. I know of only one case of the consistent application of this method, which is technically acceptable in cinema, on a compositionally meaningful level. (It is usually deployed either for visual effect, as in the 'underwater kingdom' in *The Thief of Bagdad*, or for a dream, as in *Zvenigora*. Even more frequently it is used simply for formal trifles and pointless mischief with the camera, as in Vertov's *The Man with the Movie Camera*.) I have in mind Epstein's *The Fall of the House of Usher*. Judging by press reports, normally

acted states [of mind], shot with a speeded-up camera and played back in slow motion on the screen, produced unusual emotional tension. If you bear in mind that the attraction exerted by the actor's performance on the audience is based on the audience's identification with it, you can easily attribute both examples to one and the same casual explanation. The intensity of our perception increases because the process of identification is easier when the movement is decomposed.

Even instruction is handling a rifle can be drummed into the heads of the densest raw recruit if the instructor uses the method of 'decomposition'.

The most interesting link is of course the one between Japanese theatre and sound film which can and must learn from the Japanese what to it is fundamental: the reduction of visual and aural sensations to a single physiological denominator.

Thus, it has been possible to establish briefly the fact that the most varied branches of Japanese culture are permeated by a purely cinematic element and by its basic nerve—montage.

And it is only cinema that falls into the same trap as the 'left-inclining' Kabuki. Instead of learning how to isolate the principles and techniques of their unique acting from the traditional feudal forms of what they are acting, the progressive theatrical people of Japan rush to borrow the loose formlessness of the acting of our 'intuitivists'. The result is lamentable and saddening. In its cinema Japan also strives to imitate the most appalling examples of the most saleable mediocre American and European commercial trash.

Understand and apply its specific cultural quality to its own cinema—that is what Japan must do!

Japanese comrades, are you really going to leave this to us?

# THE DRAMATURGY OF FILM FORM
# [THE DIALECTICAL APPROACH TO FILM FORM]

According to Marx and Engels the system of the dialectic is only the conscious reproduction of the dialectical course (essence) of the external events of the world.

RAZUMOVSKY, *The Theory of Historical Materialism*, Moscow, 1928

*Thus*:
the projection of the dialectical system of objects into the brain
—*into abstract creation*—
—*into thought*—
produces dialectical modes of thought—dialectical materialism—PHILOSOPHY.
*Similarly*:
the projection of the same system of objects—in concrete creation—in form—produces ART.

The basis of this philosophy is the *dynamic* conception of objects: being as a constant evolution from the interaction between two contradictory opposites.

Synthesis that *evolves* from the opposition between thesis and antithesis.

It is equally of basic importance for the correct conception of art and all art forms.

In the realm of art this dialectical principle of the dynamic is embodied in CON-FLICT as the essential basic principle of the existence of every work of art and every form. FOR ART IS ALWAYS CONFLICT:

1. because of its social mission.
2. because of its nature,
3. because of its methodology.

1. *Because of its social mission, since*: it is the task of art to reveal the contradictions of being. To forge the correct intellectual concept, to form the right view by sitting up contradictions in the observer's mind and through the dynamic clash of opposing passions.

2. *Because of its nature, since*: because of its nature it consists in the conflict between natural being and creative tendentiousness. Between organic inertia and purposeful initiative.

The hypertrophy of purposeful initiative—of the principle of rational logic—leaves art frozen in mathematical technicism. (Landscape becomes topography, a painting of St. Sebastian becomes an anatomical chart.) Hypertrophy of organic naturalness—of organic logic—dissolves art into formlessness. (Malevich becomes Kaulbach, Archipenko a waxworks show.)

Because: the limit of organic form (the passive principle of being) is NATURE. The limit of rational form (the active principle of production) is INDUSTRY *and*: at the intersection of nature and industry stands ART.

1. The logic of organic form versus 2. the logic of rational form produces in collision the dialectic of the art form.

*The interaction between the two produces and determines the dynamic*. (Not just in the sense of space-time, but also in the field of pure thought. I similarly regard the evolution of new concepts and attitudes in the conflict between normal conceptions and particular representations as a dynamic—a dynamisation of the inertia of perception—a dynamisation of the 'traditional view' into a new one.)

*The basis of distance determines the intensity of the tension*: (viz., for instance, in music the concept of intervals. In it there can be cases where the gap is so wide that it can lead to a break, to a disintegration of the homogeneous concept of art. The 'inaudibility' of certain intervals.)

*The spatial form of this dynamic is the expression of the phases in its tension—rhythm*. This applies to every art form and, all the more so, to every form of its expression. Thus human expression is a conflict between conditioned and unconditioned reflex.

(I do not agree on this point with Klages who
1. considers human expression not dynamically as process but statically as result and

2. attributes everything that moves to the field of the 'soul' and, by contrast, only that which restrains to 'reason', in the idealistic concept of 'reason' and 'soul' which here corresponds indirectly with the ideas of conditioned and unconditioned reflex.)

The same is equally true for every field, in so far as it can be understood as art. Thus, for instance, logical thought, viewed as art, also produces the same dynamic

From *Potemkin* (1925). "Representation of a spontaneous action. Woman with pince-nez. Followed immediately—without a transition—by the same woman with shattered pince-nez and bleeding eye. Sensation of a shot hitting the eye" (EISENSTEIN, page 35).

mechanism: 'The intellectual lives of Plato or Dante . . . were largely guided and sus-tained by their delight in the sheer beauty of the *rhythmic relation* between law and instance, species and individual, or cause and effect.'

This also applies in other fields, e.g. in language, where the strength, vitality and dynamism derive from the irregularity of the particular in relation to the rule govern-ing the system as a whole.

In contrast to this we can see the sterility of expression in artificial, totally regu-lated languages like Esperanto. It is from this same principle that the whole charm of poetry derives: its rhythm emerges as conflict between the metric measure adopted and the distribution of sounds that ambushes that measure.

The concept of even a formally static phenomenon as a dynamic function dialecti-cally symbolises the wise words of Goethe that

'Architecture is frozen music.'

We shall employ this concept further. And, just as in homogeneous thought (a monistic attitude), both the whole and the minutest detail must be permeated by a *sin-gle principle*, so, together with the conflict of *social conditionality* and the conflict of *reality*, that same principle of conflict serves as the foundation stone for the *method-ology* of art. As the basic principle of the rhythm that is to be created and of the der-ivation of the art form.

3. *Because of its methodology*: shot and montage are the basic elements of film.

## MONTAGE

Soviet film has stipulated this as the nerve of film.

To determine the essence of montage is to solve the problem of film as such.

The old film-makers, including the theoretically quite outmoded Lev Kuleshov, regarded montage as a means of producing something by describing it, adding indi-vidual shots to one another like building blocks.

Movement within these shots and the resulting length of the pieces were thus to be regarded as rhythm.

A fundamentally false notion! It would mean defining an object exclusively in terms of its external course. Regarding the mechanical process of sticking the pieces together as a principle. We cannot characterise this kind of relationship between lengths as rhythm.

It would give rise to a metre that was as opposed to rhythm as such as the mechan-ical-metric Mesendick system is opposed to the organic-rhythmic Bode school in the case of bodily expression.

According to this definition (which Pudovkin also shares as a theorist) montage is the means of *unrolling* an idea through single shots (the "epic" principle).

*But in my view montage is not an idea composed of successive shots stuck together but an idea that* DERIVES *from the collision between two shots that are independent of one another* (the 'dramatic' principle). ('Epic' and 'dramatic' in relation to the methodology of form and not content or plot!!) As in Japanese hieroglyphics in which two independent ideographic characters ('shots') are juxtaposed and *explode* into a concept.

Sophistry? Not at all! Because we are trying here to derive the whole essence, the stylistic principle and the character of film from its technical (-optical) foundations.

We know that the phenomenon of movement in film resides in the fact that still pictures of a moved body blend into movement when they are shown in quick succession one after the other.

The vulgar description of what happens—as a *blending*—has also led to the vulgar notion of montage mentioned above.

Let us describe the course of the said phenomenon more precisely, just as it really is, and draw our conclusions accordingly.

Is that correct? In pictorial-phraseological terms, yes.

But not in mechanical terms.

For in fact each sequential element is arrayed, not *next* to the one it follows, but on *top* of it. *For*: the idea (sensation) of movement arises in the process of superimposing on the retained impression of the object's first position the object's newly visible second position.

That is how, on the other hand, the phenomenon of spatial depth as the optical superimposition of two planes in stereoscopy arises. The superimposition of two dimensions of the same mass gives rise to a completely new higher dimension.

In this instance, in the case of stereoscopy, the superimposition of two nonidentical two-dimensionalities gives rise to stereoscopic three-dimensionality. In another field: concrete word (denotation) set against concrete word produces abstract concept.

As in Japanese (see above), in which *material* ideogram set against *material* ideogram produces *transcendental result* (concept).

The incongruity in contour between the first picture that has been imprinted on the mind and the subsequently perceived second picture—the conflict between the two—gives birth to the sensation of movement, the idea that movement has taken place.

The degree of incongruity determines the intensity of impression, determines the tension that, in combination with what follows, will become the real element of authentic rhythm.

Here we have, in the temporal sense, what we see emerging spatially on the graphic or painted surface.

What does the dynamic effect of a picture consist of?

The eye follows the direction of an element. It retains a visual impression which then collides with the impression derived from following the direction of a second element. The conflict between these directions creates the dynamic effect in the apprehension of the whole.

I. It may be purely linear: Fernand Léger, Suprematism.

II. It may be 'anecdotal'. The secret of the fabulous mobility of the figures of Daumier and Lautrec consists in the fact that various parts of the bodies of their figures are depicted in spatial situations (positions) that vary temporally. See, for instance, Lautrec's 'Miss Cissy Loftus':

A logical development of position A for the foot leads to the elaboration of a corresponding position A for the body. But from the knee up the body is already repre-

sented in position A + a. The cinematic effect of the still picture is already visible here: from hips to shoulders we already have A + a + a. The figure seems alive and kicking!

III.  Primitive Italian Futurism lies somewhere between I and II: the man with six legs in six positions. (Between I and II because II achieves its effects by retaining natural unity and anatomical cohesion, whereas I achieves this through purely elementary elements, while III, although undermining nature, is not yet pushed as far as abstraction.)

IV.  It can be of ideographic kind. Like the pregnant characterisation of a Sharaku (eighteenth-century Japan). The secret of his extremely clever power of expression lies in the anatomical *spatial disproportion* of the parts. (You might term I above *temporal disproportion.*)

The spatial calculation of the corresponding size of one detail in relation to another and the collision between that and the dimension determined for it by the artist produces the characterisation: the resolution of the representation.

Finally, colour. A colour shade conveys a particular rhythm of vibration to our vision. (This is not perceived visually, but purely physiologically, because colours are distinguished from one another by the frequency of their light vibrations.) The nearest shade has a different frequency of vibration.

The counterpoint (conflict) between the two—the retained and the still emerging—frequency produces the dynamic of our perceptions and of the interplay of colour.

From here we have only to make one step from visual vibration to acoustic vibration and we find ourselves in the field of music. We move from the realm of the spatial-pictorial to the realm of the temporal-pictorial.

Here the same law rules. Because for music counterpoint is not just a form of composition but the basic rationale for the possibility of sound perception and differentiation. One might also say that in all the cases cited here the same *principle of comparison* operates: it makes possible for us discovery and observation in every field. With the moving image (film) we have, as it were, the synthesis of these two counterpoints: the spatial counterpoint of the image and the temporal counterpoint of music. Characterised in film through what we might describe as:

## VISUAL COUNTERPOINT

This concept, when applied to film, allows us to designate various approaches to the problem, to a kind of film grammar. Similarly with a syntax of film expressions in which the visual counterpoint can determine a completely new system of forms of expression. (Experiments in this direction will be illustrated by extracts from my films.) In all this:

The *basic presupposition* is:

*The shot is not a montage element—the shot is a montage cell* (*a molecule*). This formulation explodes the dualistic division in the analysis:

of: title and shot

and: shot and montage.

Instead it is viewed dialectically as three different *phases in the formation of a*

*homogeneous expressive task.* With homogeneous characteristics that determine the homogeneity of their structural laws.

*The relationship between the three: conflict within a thesis* (an abstract idea):

1. is *formulated* in the dialectic of the *title*,
2. is *formed* spatially in the *conflict within* the shot—and
3. *explodes* with the growing intensity of the *conflict montage between the shots*.

Once again this is quite analogous to human psychological expression. This is a conflict of motives. Conceivable, likewise, in three phases:

1. Purely verbal utterance. Without intonation: spoken expression.
2. Gesticulative (mimic-intentional) expression. Projection of conflict on to the entire expressive body-system of man. ("Gesture" and "sound gesture"—intonation).
3. Projection of conflict into the spatial. With the growing intensity (of motives) the zigzag of mimic expression is catapulted into the surrounding space according to the same distorting formula. A zigzag of expression deriving from the spatial disposition of man in space.

Herein lies the basis for a quite new conception of the problems of film form. We cite as examples of conflict:

1. Graphic conflict
2. Conflict between planes
3. Conflict between volumes
4. Spatial conflict
5. Conflict in lighting.
6. Conflict in tempo, etc., etc.

(NB Here they are characterised by their principal feature, by their *dominant*. It is obvious that they occur mainly as complexes, grouped together. That applies to both the shot and to montage.)

For montage transition it is sufficient to imagine any example as being divided into two independent primary pieces

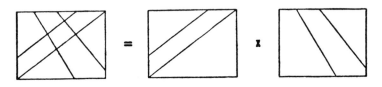

NB The graphic case. It applies also to all other cases. The extent to which the conflict concept extends in the treatment of film form is illustrated by the following further examples:

7. Conflict between matter and shot (achieved by *spatial distortion* using camera angle).

Ten shots from the montage sequence
on the "Odessa Steps" from *Potemkin*
(1925). "The gradual succession
continues in a process of comparing
each new image with its common
designation and *unleashes a process
that, in terms of its form, is identical to
a process of logical deduction*"
(EISENSTEIN, page 40). "The cre-
ation of a sense or meaning not proper
to the images themselves but derived
exclusively from their juxtaposition"
(BAZIN, page 42).

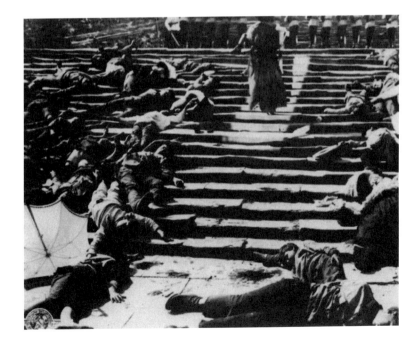

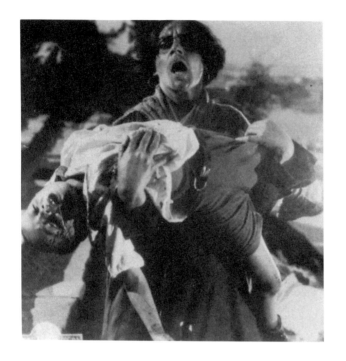

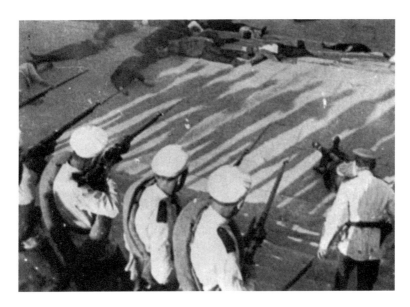

8. Conflict between matter and its spatiality (achieved by *optical distortion* using the lens).
9. Conflict between an event and its temporality (achieved by slowing down and speeding up [*Multiplikator*]) and lastly:
10. Conflict between the entire *optical* complex and a quite different sphere.

That is how the conflict between optical and acoustic experience produces:

<div align="center">

SOUND FILM

which is realisable as

AUDIO-VISUAL COUNTERPOINT.
</div>

The formulation and observation of the phenomenon of film in the form of conflict provides the first opportunity to devise a homogeneous system of *visual dramaturgy* for every special and particular case of the problem of film.

To create a *dramaturgy of visual film form* that is determined in the same way as the existing *dramaturgy of film material* is determined. . . .

The same standpoint—viewed as an outcome for film composition—produces the following stylistic forms and possibilities and this could constitute a

# FILM SYNTAX
# A TENTATIVE FILM SYNTAX.

*We shall list here*:

A series of compositional possibilities that develop dialectically from the thesis that the concept of filmic movement (time lapse) derives from the superimposition of—the counterpoint between—two different stills.

I. *Each moving piece of montage in its own right*. Each photographed piece. The technical determination of the phenomenon of movement. *Not yet composition* (a man running, a gun firing, water splashing).

II. *Artificially produced representation of movement*. The basic optical sign is used for arbitrary composition:

A. *Logical*
Example 1. *Ten Days That Shook the World* (*October*).
Montage: repetition of a machine-gun firing by cross-cutting the relevant details of the firing.
*Combination a*):

Brightly lit machine-gun. Dark one.
Different shot. Double burst:
Graphic burst and light burst.

*Combination b*):

Machine-gun.
Close up of the machine-gunner
Effect almost of double exposure with rattling montage effect.
Length of the pieces—two frames.

Example 2. *Potemkin* (1925)
Representation of a spontaneous action, *Potemkin*. Woman with pince-nez. Followed immediately—without a transition—by the same woman with shattered pince-nez and bleeding eye. Sensation of a shot hitting the eye.

*B. Alogical*
Example 3. *Potemkin*.
This device used for symbolic pictorial expression. *Potemkin*. The marble lion leaps us, surrounded by the thunder of *Potemkin*'s guns firing in protest against the blood-bath on the Odessa Steps.

Cut together from three immobile marble lions at Alupka Castle (Crimea). One sleeping. One waking. One rising. The effect was achieved because the length of the middle piece was correctly calculated. Superimposition on the first piece produced the first jump. Time for the second position to sink in. Superimposition of the third position on the second—the second jump. Finally the lion is standing.

Example 4. *Ten Days*.
The firing in Example 1 is symbolically produced from elements that do not belong to the actual firing. To illustrate General Kornilov's attempted monarchist *putsch* it occurred to me that his militarist *tendency* could be shown in the cutting (montage), but creating the montage material itself out of religious details. Because Kornilov had betrayed his tsarist tendency in the form of a curious "crusade" of Mohammedans (!) (his "Wild Division" from the Caucases) and Christians (all the others) against the . . . Bolsheviks. To this end a Baroque Christ with beams streaming (exploding) from its halo was briefly intercut with a self-contained egg-shaped Uzume mask. The temporal conflict between the self-contained egg shape and the graphic star produced the effect of a simultaneous explosion (a bomb, a shot).

Example 5. *Ten Days*.
A similar combination of a Chinese sacred statue and a madonna with a halo. (NB As we see, this already provides the opportunity for tendentious (ideological) expression.)

Another example of more primitive effect from the same place: in the simple cross-cutting between church towers leaning in opposite directions.

So far the examples have shown *primitive-psychological* cases—using *only* the optical superimposition of movement.

III. The case of emotional combinations not merely of the visible elements of the pieces but principally of the chains of psychological association. *Associational montage (1923–4)*. As a means of sharpening (heightening) a situation emotionally.

In Case I we had the following: two pieces A and B following one another area materially identical. According to the position of the material in the shot they are, however, not identical:

These two combined produced dynamisation in space—the impression of spatial dynamic:

The degree of difference between positions A and B determines the tension of the movement. But let us take a new case:

Shot A and Shot B are, in terms of material, *not identical*. The associations of the two shots are identical: associatively identical. By analogy this *dynamisation of the material* produces, not in the spatial but in the *psychological, i.e. the emotional, field*:

## EMOTIONAL DYNAMISATION.

Example 1. *The Strike* (1923–4).
The shooting down of the workers is cut in such a way that the massacre is intercut with the slaughter of a cow. (Difference in material. But the slaughter is employed as an appropriate association.) This produces a powerful emotional intensification of the scene.

NB In this case the homogeneity of gesture plays a very great role in generally achieving the effect (the homogeneity of the dynamic gesture: movement within the shot—or of the static gesture: the graphic attitude of the shot). Here is an excerpt from the first version of this scene in the montage list (1923):

1. The head of a bull.
2. The butcher's knife strikes a downward blow.
3. Five hundred workers fall down a hill.
4. Fifty men get up. Hands.
5. A soldier's face. He aims.
6. Shots.
7. The bull standing. It twitches and falls.
8. Close-up. Convulsions of the hind legs. A hoof kicks into the blood.
9. Rifles.
10. Semi-close-up. People get up. Wounded.
11. Imploring hands raised towards the camera.

12. Butcher with blood-stained rope approaches the camera.
13. Hands.
14. The butcher approaches, etc.

This principle was subsequently also used by Pudovkin in *The End of St Petersburg* (1927) when he intercut shots of stock exchange and battlefield. And, in *The Mother* (1926), the ice breaking and the workers' demonstration.

This method may decay pathologically if the essential viewpoint—the emotional dynamisation of the material—gets lost. Then it ossifies into lifeless literary symbolism and stylistic mannerism. We may cite the following as an example:

Example 2: *Ten Days.*
The mellifluous peace overtures of the Mensheviks at the Second Congress of the Soviets (during the storming of the Winter Palace) are intercut with harp-playing hands. A purely literary parallelism that does nothing to enliven the material.

Similarly in Otsep's *The Living Corpse*, with the intercutting (in imitation of *Ten Days*) of church cupolas or lyrical landscapes into the speeches of the prosecution and the defence counsels in the court. The same mistake as that above.

On the other hand, the predominance of purely dynamic effects may have a positive result:

Example 3: *Ten Days.*
The pathos of the adherence of the cycle battalion to the Second Congress of the Soviets is dynamised by the fact that, when their delegates enter, abstractly spinning cycle wheels (association with the battalion) were intercut. These resolved the pathetic content of the event as such into a perceptible dynamic. The same principle—the emergence of a concept, of a sensation from the juxtaposition of two disparate events—led on to:

IV. *The emancipation of closed action from its conditioning by time and space.* The first attempts at this were made in the *Ten Days* film.

Example 1. (*Ten Days*)
A trench packed with soldiers seems to be crushed by the weight of an enormous cannonball descending on the whole thing. Thesis brought to expression. In material terms the effect is achieved through the apparently chance intercutting between an independently existing trench and a metal object with a similarly military character. In reality they have absolutely no spatial relationship with one another.

Example 2: *Ten Days.*
Similarly in the scene of Kornilov's *putsch* attempt, which puts an end to Kerensky's Bonapartist plans. In this sequence one of Kornilov's tanks, emerging from the trench, shatters the plaster figure of Napoleon that stands on Kerensky's desk in the palace of Petrograd and has purely symbolic meaning.

This method of making whole sequences in this way is now mainly being

employed by Dovzhenko: *The Arsenal* (1929). Also by Esfir Shub on her Tolstoy film (1928). In addition to this method of dissolving the accepted forms of handling film material I should like to cite another example, which has, however, not been realised in practice.

In 1924–5 I was very concerned with the idea of the filmic representation of real (actual) man. At that time the prevailing trend was that living man could only be shown in film in *long* dramatic scenes. And that cutting (montage) would destroy the idea of real man.

Abram Room established the record in this respect in *The Bay of Death* by using eighty metre-long uncut dramatic scenes. I felt (and feel) that such a concept is utterly unfilmic.

For what really is, in linguistic terms, a precise characterisation of man?

His raven-black hair . . .

The waves in his hair . . .

His flashing, bright blue eyes . . .

His steely muscles . . .

Even when it is not so exaggeratedly phrased, every description, every verbal representation of a man (see above!) becomes an accumulation of waterfalls, lightning conductors, landscapes, birds, etc.

Why then should cinema in its forms follow theatre and painting rather than the methodology of language, which gives rise, through the combination of concrete descriptions and concrete objects, to quite new concepts and ideas? It is much closer to film than, for instance, painting, where form derives from *abstract* elements (line, colour). In film, by contrast, it is precisely the material *concreteness* of the shot as an element that is the most difficult aspect of the process of formation. Why not then lean rather more towards the system of language, where the same mechanism exists in the use of words and word complexes?

Why is it, on the other hand, that montage cannot be avoided even in the orthodox feature film?

The differentiation in montage pieces is determined by the fact that each piece has in itself no reality at all. But each piece is itself in a position to evoke a certain association. The accumulation of associations then achieves the same effect as that provoked in the audience by purely physiological means by a theatrical play that is unfolding in reality.

E.g. Murder on stage has a purely physiological effect. Perceived in a *single* montage sequence it acts like an item of *information*, a title. It only begins to work *emotionally* when it is presented in montage fragments. In montage pieces, each of which provokes a certain association, the sum of which amounts to a composite complex of emotional feeling. In traditional terms:

1. A hand raises a knife.
2. The eyes of the victim open wide.
3. His hands clutch the table.
4. The knife jerks.
5. The eyes close.
6. Blood spurts out.

7. A mouth shrieks.
8. Drops fall on to a shoe . . .

and all that kitsch! In any event each *individual piece* is already almost *abstract* in relation to the *action as a whole*. The more differentiated they are, the more abstract they become, aiming only at provoking a certain association. Now the following thought arises quite logically: could one not achieve the same effect more productively if one did not adhere so slavishly to plot but materialised the notion of *murder* in a free accumulation of associative material? Because the most important thing is to convey the representation of murder, the feeling of murder as such. Plot is only one of the means without which we still do not know how to communicate something to the audience. At any rate an attempt of this sort would produce the most interesting variety of forms. Let someone try it! Since 1923–4, when this thought occurred to me, I have unfortunately not had the time to carry out this experiment. Now I have turned to quite different problems.

But, *revenons à nos moutons*, which will bring us closer to these tasks. Whereas, with 1, 2 and 3 the suspense was calculated to achieve purely physiological effects, from the purely optical to the emotional, we must also mention here the case in which the same conflict tension serves to achieve new concepts, new points of view, in other words, serves purely intellectual ends.

Example 1: *Ten Days*.

Kerensky's rise to (untrammelled) power and dictatorship after July 1917. Comic effect is achieved by *intercutting titles denoting ever higher rank* ('Dictator', 'Generalissimo', 'Minister of the Navy and the Army', etc.) with five or six sequences of the staircase in the Winter Palace with Kerensky ascending the *same* flight each time.

Here the conflict between the kitsch of the ascending staircase and Kerensky treading the same ground produces an intellectual resultant: the satirical degradation of these titles in relation to Kerensky's nonentity.

Here we have a counterpoint between a verbally expressed, conventional idea and a pictorial representation of an individual who is unequal to that idea.

The incongruity between these two produces a purely *intellectual* resolution at the expense of this individual. Intellectual dynamisation.

Example 2: *Ten Days*.

Kornilov's march on Petrograd took place under the slogan "In the Name of God and the Fatherland". Here we have an attempt to use the representation for anti-religious ends. A number of images of the divine were shown in succession. From a magnificant Baroque Christ to an Eskimo idol.

Here a conflict arises between the concept "God" and its symbolisation. Whereas idea and image are completely synonymous in the first Baroque image, they grow further apart with each subsequent image. We retain the description 'God' and show idols that in no way correspond with our own image of this concept. From this we are to draw anti-religious conclusions as to what the divine as such really is.

Similarly, there is here an attempt to draw a purely intellectual conclusion as a resultant of the conflict between a preconception and its *gradual tendentious discrediting by degrees* through pure illustration.

The gradual succession continues in a process of comparing each new image with its common designation and *unleashes a process that, in terms of its form, is identical to a process of logical deduction.* Everything here is already intellectually conceived, not just in terms of the resolution but also of the method of expressing ideas.

The conventional *descriptive* form of the film becomes a kind of reasoning (as a formal possibility).

Whereas the conventional film directs and develops the *emotions*, here we have a hint of the possibility of likewise developing and directing the entire *thought process*.

These two attempts were received in a very hostile fashion by the majority of the critics. Because they were understood in purely political terms, I willingly concede that it is precisely *this form that is best suited to express ideologically critical theses.* But it is a pity that the critics completely overlooked the filmic opportunities that could be derived from it. In both these attempts we find the first, still embryonic attempts to construct a really quite new form of filmic expression.

A purely intellectual film which, freed from traditional limitations, will achieve direct forms for thoughts, systems and concepts without any transitions or paraphrases. And which can therefore become a SYNTHESIS OF ART AND SCIENCE. That will become the really new watchword for our epoch in the field of art. And really justify Lenin's statement that 'of all the arts . . . cinema is the most important.'

One of my next films, which is intended to embody the Marxist world-view, will be devoted to an experiment in this direction.

1929

# ANDRÉ BAZIN
## *FROM* WHAT IS CINEMA?

## THE EVOLUTION OF THE LANGUAGE OF CINEMA

By 1928 the silent film had reached its artistic peak. The despair of its elite as they witnessed the dismantling of this ideal city, while it may not have been justified, is at least understandable. As they followed their chosen aesthetic path it seemed to them that the cinema had developed into an art most perfectly accommodated to the "exquisite embarrassment" of silence and that the realism that sound would bring could only mean a surrender to chaos.

In point of fact, now that sound has given proof that it came not to destroy but to fulfill the Old Testament of the cinema, we may most properly ask if the technical revolution created by the sound track was in any sense an aesthetic revolution. In other words, did the years from 1928 to 1930 actually witness the birth of a new cinema? Certainly, as regards editing, history does not actually show as wide a breach as might be expected between the silent and the sound film. On the contrary there is discernible evidence of a close relationship between certain directors of 1925 and 1935 and especially of the 1940's through the 1950's. Compare for example Erich von Stroheim and Jean Renoir or Orson Welles, or again Carl Theodore Dreyer and Robert Bresson. These more or less clear-cut affinities demonstrate first of all that the gap separating the 1920's and the 1930's can be bridged, and secondly that certain cinematic values actually carry over from the silent to the sound film and, above all, that it is less a matter of setting silence over against sound than of contrasting certain families of styles, certain basically different concepts of cinematographic expression.

Aware as I am that the limitations imposed on this study restrict me to a simplified and to that extent enfeebled presentation of my argument, and holding it to be less an objective statement than a working hypothesis, I will distinguish, in the cinema between 1920 and 1940, between two broad and opposing trends: those directors who put their faith in the image and those who put their faith in reality. By "image" I here

mean, very broadly speaking, everything that the representation on the screen adds to the object there represented. This is a complex inheritance but it can be reduced essentially to two categories: those that relate to the plastics of the image and those that relate to the resources of montage, which after all, is simply the ordering of images in time.

Under the heading "plastics" must be included the style of the sets, of the make-up, and, up to a point, even of the performance, to which we naturally add the lighting and, finally, the framing of the shot which gives us its composition. As regards montage, derived initially as we all know from the masterpieces of Griffith, we have the statement of Malraux in his *Psychologie du cinéma* that it was montage that gave birth to film as an art, setting it apart from mere animated photography, in short, creating a language.

The use of montage can be "invisible" and this was generally the case in the pre-war classics of the American screen. Scenes were broken down just for one purpose, namely, to analyze an episode according to the material or dramatic logic of the scene. It is this logic which conceals the fact of the analysis, the mind of the spectator quite naturally accepting the viewpoints of the director which are justified by the geography of the action or the shifting emphasis of dramatic interest.

But the neutral quality of this "invisible" editing fails to make use of the full potential of montage. On the other hand these potentialities are clearly evident from the three processes generally known as parallel montage, accelerated montage, montage by attraction. In creating parallel montage, Griffith succeeded in conveying a sense of the simultaneity of two actions taking place at a geographical distance by means of alternating shots from each. In *La Roue* Abel Gance created the illusion of the steadily increasing speed of a locomotive without actually using any images of speed (indeed the wheel could have been turning on one spot) simply by a multiplicity of shots of ever-decreasing length.

Finally there is "montage by attraction," the creation of S. M. Eisenstein, and not so easily described as the others, but which may be roughly defined as the reenforcing of the meaning of one image by association with another image not necessarily part of the same episode—for example the fireworks display in *The General Line* following the image of the bull. In this extreme form, montage by attraction was rarely used even by its creator but one may consider as very near to it in principle the more commonly used ellipsis, comparison, or metaphor, examples of which are the throwing of stockings onto a chair at the foot of a bed, or the milk overflowing in H.G. Clouzot's *Quai des orfèvres*. There are of course a variety of possible combinations of these three processes.

Whatever these may be, one can say that they share that trait in common which constitutes the very definition of montage, namely, the creation of a sense or meaning not proper to the images themselves but derived exclusively from their juxtaposition. The well-known experiment of Kuleshov with the shot of Mozhukhin in which a smile was seen to change its significance according to the image that preceded it, sums up perfectly the properties of montage.

Montage as used by Kuleshov, Eisenstein, or Gance did not give us the event; it alluded to it. Undoubtedly they derived at least the greater part of the constituent elements from the reality they were describing but the final significance of the film was

McTeague (Gibson Gowland) confronting Marcus Schouler (Jean Hersholt) in the wastes of Death Valley in *Greed* (1923); Nanook building his igloo in *Nanook of the North* (1922). Von Stroheim and Flaherty were two of "those who put their faith in reality" (BAZIN, page 41).

found to reside in the ordering of these elements much more than in their objective content.

The matter under recital, whatever the realism of the individual image, is born essentially from these relationships—Mozhukhin plus dead child equal pity—that is to say an abstract result, none of the concrete elements of which are to be found in the premises; maidens plus appletrees in bloom equal hope. The combinations are infinite. But the only thing they have in common is the fact that they suggest an idea by means of a metaphor or by an association of ideas. Thus between the scenario properly so-called, the ultimate object of the recital, and the image pure and simple, there is a relay station, a sort of aesthetic "transformer." The meaning is not in the image, it is in the shadow of the image projected by montage onto the field of consciousness of the spectator.

Let us sum up. Through the contents of the image and the resources of montage, the cinema has at its disposal a whole arsenal of means whereby to impose its interpretation of an event on the spectator. By the end of the silent film we can consider this arsenal to have been full. On the one side the Soviet cinema carried to its ultimate consequences the theory and practice of montage while the German school did every kind of violence to the plastics of the image by way of sets and lighting. Other cinemas count too besides the Russian and German, but whether in France or Sweden or the United States, it does not appear that the language of cinema was at a loss for ways of saying what it wanted to say.

If the art of cinema consists in everything that plastics and montage can add to a given reality, the silent film was an art on its own. Sound could only play at best a subordinate and supplementary role: a counterpoint to the visual image. But this possible enhancement—at best only a minor one—is likely not to weigh much in comparison with the additional bargain-rate reality introduced at the same time by sound.

Thus far we have put forward the view that expressionism of montage and image constitute the essence of cinema. And it is precisely on this generally accepted notion that directors from silent days, such as Erich von Stroheim, F.W. Murnau, and Robert Flaherty, have by implication cast a doubt. In their films, montage plays no part, unless it be the negative one of inevitable elimination where reality superabounds. The camera cannot see everything at once but it makes sure not to lose any part of what it chooses to see. What matters to Flaherty, confronted with Nanook hunting the seal, is the relation between Nanook and the animal; the actual length of the waiting period. Montage could suggest the time involved. Flaherty however confines himself to showing the actual waiting period; the length of the hunt is the very substance of the image, its true object. Thus in the film this episode requires one set-up. Will anyone deny that it is thereby much more moving than a montage by attraction?

Murnau is interested not so much in time as in the reality of dramatic space. Montage plays no more of a decisive part in *Nosferatu* than in *Sunrise*. One might be inclined to think that the plastics of his image are impressionistic. But this would be a superficial view. The composition of his image is in no sense pictorial. It adds nothing to the reality, it does not deform it, it forces it to reveal its structural depth, to bring out the preexisting relations which become constitutive of the drama. For example, in *Tabu*, the arrival of a ship from left screen gives an immediate sense of destiny at

work so that Murnau has no need to cheat in any way on the uncompromising realism of a film whose settings are completely natural.

But it is most of all Stroheim who rejects photographic expressionism and the tricks of montage. In his films reality lays itself bare like a suspect confessing under the relentless examination of the commissioner of police. He has one simple rule for direction. Take a close look at the world, keep on doing so, and in the end it will lay bare for you all its cruelty and its ugliness. One could easily imagine as a matter of fact a film by Stroheim composed of a single shot as long-lasting and as close-up as you like. These three directors do not exhaust the possibilities. We would undoubtedly find scattered among the works of others elements of nonexpressionistic cinema in which montage plays no part—even including Griffith. But these examples suffice to reveal, at the very heart of the silent film, a cinematographic art the very opposite of that which has been identified as "*cinéma par excellence*," a language the semantic and syntactical unit of which is in no sense the Shot; in which the image is evaluated not according to what it adds to reality but what it reveals of it. In the latter art the silence of the screen was a drawback, that is to say, it deprived reality of one of its elements. *Greed*, like Dreyer's *Jeanne d'Arc*, is already virtually a talking film. The moment that you cease to maintain that montage and the plastic composition of the image are the very essence of the language of cinema, sound is no longer the aesthetic crevasse dividing two radically different aspects of the seventh art. The cinema that is believed to have died of the soundtrack is in no sense "*the* cinema." The real dividing line is elsewhere. It was operative in the past and continues to be through thirty-five years of the history of the language of the film.

Having challenged the aesthetic unity of the silent film and divided it off into two opposing tendencies, now let us take a look at the history of the last twenty years.

From 1930 to 1940 there seems to have grown up in the world, originating largely in the United States, a common form of cinematic language. It was the triumph in Hollywood, during that time, of five or six major kinds of film that gave it its overwhelming superiority: (1) American comedy (*Mr. Smith Goes to Washington*, 1936); (2) The burlesque film (The Marx Brothers); (3) The dance and vaudeville film (Fred Astaire and Ginger Rogers and the Ziegfield Follies); (4) The crime and gangster film (*Scarface, I Am a Fugitive from a Chain Gang, The Informer*); (5) Psychological and social dramas. (*Back Street, Jezebel*); (6) Horror or fantasy films (*Dr. Jekyll and Mr. Hyde, The Invisible Man, Frankenstein*); (7) The western (*Stagecoach*, 1939). During that time the French cinema undoubtedly ranked next. Its superiority was gradually manifested by way of a trend towards what might be roughly called stark somber realism, or poetic realism, in which four names stand out: Jacques Feyder, Jean Renoir, Marcel Carné, and Julien Duvivier. My intention not being to draw up a list of prizewinners, there is little use in dwelling on the Soviet, British, German, or Italian films for which these years were less significant than the ten that were to follow. In any case, American and French production sufficiently clearly indicate that the sound film, prior to World War II, had reached a well-balanced stage of maturity.

First as to content: Major varieties with clearly defined rules capable of pleasing a worldwide public, as well as a cultured elite, provided it was not inherently hostile to the cinema.

Secondly as to form: well-defined styles of photography and editing perfectly adapted to their subject matter; a complete harmony of image and sound. In seeing again today such films as *Jezebel* by Willian Wyler, *Stagecoach* by John Ford, or *Le Jour se lève* by Marcel Carné, one has the feeling that in them an art has found its perfect balance, its ideal form of expression, and reciprocally one admires them for dramatic and moral themes to which the cinema, while it may not have created them, has given a grandeur, an artistic effectiveness, that they would not otherwise have had. In short, here are all the characteristics of the ripeness of a classical art.

I am quite aware that one can justifiably argue that the originality of the postwar cinema as compared with that of 1938 derives from the growth of certain national schools, in particular the dazzling display of the Italian cinema and of a native English cinema freed from the influence of Hollywood. From this one might conclude that the really important phenomenon of the years 1940–1950 is the introduction of new blood, of hitherto unexplored themes. That is to say, the real revolution took place more on the level of subject matter than of style. Is not neorealism primarily a kind of humanism and only secondarily a style of film-making? Then as to the style itself, is it not essentially a form of self-effacement before reality?

Our intention is certainly not to preach the glory of form over content. Art for art's sake is just as heretical in cinema as elsewhere, probably more so. On the other hand, a new subject matter demands new form, and as good a way as any towards understanding what a film is trying to say to us is to know how it is saying it.

Thus by 1938 or 1939 the talking film, particularly in France and in the United States, had reached a level of classical perfection as a result, on the one hand, of the maturing of different kinds of drama developed in part over the past ten years and in part inherited from the silent film, and, on the other, of the stabilization of technical progress. The 1930's were the years, at once, of sound and of panchromatic film. Undoubtedly studio equipment had continued to improve but only in matters of detail, none of them opening up new, radical possibilities for direction. The only changes in this situation since 1940 have been in photography, thanks to the increased sensitivity of the film stock. Panchromatic stock turned visual values upside down, ultrasensitive emulsions have made a modification in their structure possible. Free to shoot in the studio with a much smaller aperture, the operator could, when necessary, eliminate the soft-focus background once considered essential. Still there are a number of examples of the prior use of deep focus, for example in the work of Jean Renoir. This had always been possible on exteriors, and given a measure of skill, even in the studios. Anyone could do it who really wanted to. So that it is less a question basically of a technical problem, the solution of which has admittedly been made easier, than of a search after a style—a point to which we will come back. In short, with panchromatic stock in common use, with an understanding of the potentials of the microphone, and with the crane as standard studio equipment, one can really say that since 1930 all the technical requirements for the art of cinema have been available.

Since the determining technical factors were practically eliminated, we must look elsewhere for the signs and principles of the evolution of film language, that is to say by challenging the subject matter and as a consequence the styles necessary for its expression.

By 1939 the cinema had arrived at what geographers call the equilibrium-profile of a river. By this is meant that ideal mathematical curve which results from the requisite amount of erosion. Having reached this equilibrium-profile, the river flows effortlessly from its source to its mouth without further deepening of its bed. But if any geological movement occurs which raises the erosion level and modifies the height of the source, the water sets to work again, seeps into the surrounding land, goes deeper, burrowing and digging. Sometimes when it is a chalk bed, a new pattern is dug across the plain, almost invisible but found to be complex and winding, if one follows the flow of the water.

## THE EVOLUTION OF EDITING SINCE THE ADVENT OF SOUND

In 1938 there was an almost universal standard pattern of editing. If, somewhat conventionally, we call the kind of silent films based on the plastics of the image and the artifices of montage, "expressionist" or "symbolistic," we can describe the new form of storytelling "analytic" and "dramatic." Let us suppose, by way of reviewing one of the elements of the experiment of Kuleshov, that we have a table covered with food and a hungry tramp. One can imagine that in 1936 it would have been edited as follows:

(1) Full shot of the actor and the table.
(2) Camera moves forward into a close-up of a face expressing a mixture of amazement and longing.
(3) Series of close-ups of food.
(4) Back to full shot of person who starts slowly towards the camera.
(5) Camera pulls slowly back to a three-quarter shot of the actor seizing a chicken wing.

Whatever variants one could think of for this scene, they would all have certain points in common:

(1) The verisimilitude of space in which the position of the actor is always determined, even when a close-up eliminates the decor.
(2) The purpose and the effects of the cutting are exclusively dramatic or psychological.

In other words, if the scene were played on a stage and seen from a seat in the orchestra, it would have the same meaning, the episode would continue to exist objectively. The changes of point of view provided by the camera would add nothing. They would present the reality a little more forcefully, first by allowing a better view and then by putting the emphasis where it belongs.

It is true that the stage director like the film director has at his disposal a margin within which he is free to vary the interpretation of the action but it is only a margin and allows for no modification of the inner logic of the event. Now, by way of contrast, let us take the montage of the stone lions in *The End of St. Petersburg*. By skillful juxtaposition a group of sculptured lions are made to look like a single lion getting to its feet, a symbol of the aroused masses. This clever device would be

unthinkable in any film after 1932. As late as 1935 Fritz Lang, in *Fury*, followed a series of shots of women dancing the can-can with shots of clucking chickens in a farmyard. This relic of associative montage came as a shock even at the time, and today seems entirely out of keeping with the rest of the film. However decisive the art of Marcel Carné, for example, in our estimate of the respective values of *Quai des Brumes* or of *Le Jour se lève* his editing remains on the level of the reality he is analyzing. There is only one proper way of looking at it. That is why we are witnessing the almost complete disappearance of optical effects such as superimpositions, and even, especially in the United States, of the close-up, the too violent impact of which would make the audience conscious of the cutting. In the typical American comedy the director returns as often as he can to a shot of the characters from the knees up, which is said to be best suited to catch the spontaneous attention of the viewer—the natural point of balance of his mental adjustment.

Actually this use of montage originated with the silent movies. This is more or less the part it plays in Griffith's films, for example in *Broken Blossoms*, because with *Intolerance* he had already introduced that synthetic concept of montage which the Soviet cinema was to carry to its ultimate conclusion and which is to be found again, although less exclusively, at the end of the silent era. It is understandable, as a matter of fact, that the sound image, far less flexible than the visual image, would carry montage in the direction of realism, increasingly eliminating both plastic impressionism and the symbolic relation between images.

Thus around 1938 films were edited, almost without exception, according to the same principle. The story was unfolded in a series of set-ups numbering as a rule about 600. The characteristic procedure was by shot-reverse-shot, that is to say, in a dialogue scene, the camera followed the order of the text, alternating the character shown with each speech.

It was this fashion of editing, so admirably suitable for the best films made between 1930 and 1939, that was challenged by the shot in depth introduced by Orson Welles and William Wyler. *Citizen Kane* can never be too highly praised. Thanks to the depth of field, whole scenes are covered in one take, the camera remaining motionless. Dramatic effects for which we had formerly relied on montage were created out of the movements of the actors within a fixed framework. Of course Welles did not invent the in-depth shot any more than Griffith invented the close-up. All the pioneers used it and for a very good reason. Soft focus only appeared with montage. It was not only a technical must consequent upon the use of images in juxtaposition, it was a logical consequence of montage, its plastic equivalent. If at a given moment in the action the director, as in the scene imagined above, goes to a close-up of a bowl of fruit, it follows naturally that he also isolates it in space through the focusing of the lens. The soft focus of the background confirms therefore the effect of montage, that is to say, while it is of the essence of the storytelling, it is only an accessory of the style of the photography. Jean Renoir had already clearly understood this, as we see from a statement of his made in 1938 just after he had made *La Bête humaine* and *La Grande illusion* and just prior to *La Règle du jeu*: "The more I learn about my trade the more I incline to direction in depth relative to the screen. The better it works, the less I use the kind of set-up that shows two actors facing the camera, like two well-behaved

subjects posing for a still portrait." The truth of the matter is, that if you are looking for the precursor of Orson Welles, it is not Louis Lumière or Zecca, but rather Jean Renoir. In his films, the search after composition in depth is, in effect, a partial replacement of montage by frequent panning shots and entrances. It is based on a respect for the continuity of dramatic space and, of course, of its duration.

To anybody with eyes in his head, it is quite evident that the sequence of shots used by Welles in *The Magnificent Ambersons* is in no sense the purely passive recording of an action shot within the same framing. On the contrary, his refusal to break up the action, to analyze the dramatic field in time, is a positive action the results of which are far superior to anything that could be achieved by the classical "cut."

All you need to do is compare two frames shot in depth, one from 1910, the other from a film by Wyler or Welles, to understand just by looking at the image, even apart from the context of the film, how different their functions are. The framing in the 1910 film is intended, to all intents and purposes, as a substitute for the missing fourth wall of the theatrical stage, or at least in exterior shots, for the best vantage point to view the action, whereas in the second case the setting, the lighting, and the camera angles give an entirely different reading. Between them, director and cameraman have converted the screen into a dramatic checkerboard, planned down to the last detail. The clearest if not the most original examples of this are to be found in *The Little Foxes* where the mise-en-scène takes on the severity of a working drawing. Welles' pictures are more difficult to analyze because of his overfondness for the baroque. Objects and characters are related in such a fashion that it is impossible for the spectator to miss the significance of the scene. To get the same results by way of montage would have necessitated a detailed succession of shots.

What we are saying then is that the sequence of shots "in depth" of the contemporary director does not exclude the use of montage—how could he, without reverting to a primitive babbling?—he makes it an integral part of his "plastic." The storytelling of Welles or Wyler is no less explicit than John Ford's but theirs has the advantage over his that it does not sacrifice the specific effects that can be derived from unity of image in space and time. Whether an episode is analyzed bit by bit or presented in its physical entirety cannot surely remain a matter of indifference, at least in a work with some pretensions to style. It would obviously be absurd to deny that montage had added considerably to the progress of film language, but this has happened at the cost of other values, no less definitely cinematic.

This is why depth of field is not just a stock in trade of the cameraman like the use of a series of filters or of such-and-such style of lighting, it is a capital gain in the field of direction—a dialectical step forward in the history of film language.

Nor is it just a formal step forward. Well used, shooting in depth is not just a more economical, a simpler, and at the same time a more subtle way of getting the most out of a scene. In addition to affecting the structure of film language, it also affects the relationships of the minds of the spectators to the image, and in consequence it influences the interpretation of the spectacle.

It would lie outside the scope of this article to analyze the psychological modalities of these relations, as also their aesthetic consequences, but it might be enough here to note, in general terms:

(1) That depth of focus brings the spectator into a relation with the image closer to that which he enjoys with reality. Therefore it is correct to say that, independently of the contents of the image, its structure is more realistic;

(2) That it implies, consequently, both a more active mental attitude on the part of the spectator and a more positive contribution on his part to the action in progress. While analytical montage only calls for him to follow his guide, to let his attention follow along smoothly with that of the director who will choose what he should see, here he is called upon to exercise at least a minimum of personal choice. It is from his attention and his will that the meaning of the image in part derives.

(3) From the two preceding propositions, which belong to the realm of psychology, there follows a third which may be described as metaphysical. In analyzing reality, montage presupposes of its very nature the unity of meaning of the dramatic event. Some other form of analysis is undoubtedly possible but then it would be another film. In short, montage by its very nature rules out ambiguity of expression. Kuleshov's experiment proves this *per absurdum* in giving on each occasion a precise meaning to the expression on a face, the ambiguity of which alone makes the three successively exclusive expressions possible.

On the other hand, depth of focus reintroduced ambiguity into the structure of the image if not of necessity—Wyler's films are never ambiguous—at least as a possibility. Hence it is no exaggeration to say that *Citizen Kane* is unthinkable shot in any other way but in depth. The uncertainty in which we find ourselves as to the spiritual key or the interpretation we should put on the film is built into the very design of the image.

It is not that Welles denies himself any recourse whatsoever to the expressionistic procedures of montage, but just that their use from time to time in between sequences of shots in depth gives them a new meaning. Formerly montage was the very stuff of cinema, the texture of the scenario. In *Citizen Kane* a series of superimpositions is contrasted with a scene presented in a single take, constituting another and deliberately abstract mode of story-telling. Accelerated montage played tricks with time and space while that of Welles, on the other hand, is not trying to deceive us; it offers us a contrast, condensing time, and hence is the equivalent for example of the French imperfect or the English frequentative tense. Like accelerated montage and montage of attractions these superimpositions, which the talking film had not used for ten years, rediscovered a possible use related to temporal realism in a film without montage.

If we have dwelt at some length on Orson Welles it is because the date of his appearance in the filmic firmament (1941) marks more or less the beginning of a new period and also because his case is the most spectacular and, by virtue of his very excesses, the most significant.

Yet *Citizen Kane* is part of a general movement, of a vast stirring of the geological bed of cinema, confirming that everywhere up to a point there had been a revolution in the language of the screen.

I could show the same to be true, although by different methods, of the Italian cinema. In Roberto Rossellini's *Paisà* and *Allemania Anno Zero* and Vittorio de Sica's *Ladri de Biciclette*, Italian neorealism contrasts with previous forms of film realism in its stripping away of all expressionism and in particular in the total absence of the

The shot-in-depth from *Citizen Kane* (1941). "Thanks to the depth of field, whole scenes are covered in one take, the camera remaining motionless. . . . Director and cameraman have converted the screen into a dramatic checkerboard, planned down to the last detail" (BAZIN, pages 48, 49).

effects of montage. As in the films of Welles and in spite of conflicts of style, neorealism tends to give back to the cinema a sense of the ambiguity of reality. The preoccupation of Rossellini when dealing with the face of the child in *Allemania Anno Zero* is the exact opposite of that of Kuleshov with the close-up of Mozhukhin. Rossellini is concerned to preserve its mystery. We should not be misled by the fact that the evolution of neorealism is not manifest, as in the United States, in any form of revolution in editing. They are both aiming at the same results by different methods. The means used by Rossellini and de Sica are less spectacular but they are no less determined to do away with montage and to transfer to the screen the *continuum* of reality. The dream of Zavattini is just to make a ninety-minute film of the life of a man to whom nothing ever happens. The most "aesthetic" of the neorealists, Luchino Visconti, gives just as clear a picture as Welles of the basic aim of his directorial art in *La Terra Trema*, a film almost entirely composed of one-shot sequences, thus clearly showing his concern to cover the entire action in interminable deep-focus panning shots.

However we cannot pass in review all the films that have shared in this revolution in film language since 1940. Now is the moment to attempt a synthesis of our reflections on the subject.

It seems to us that the decade from 1940 to 1950 marks a decisive step forward in the development of the language of the film. If we have appeared since 1930 to have lost sight of the trend of the silent film as illustrated particularly by Stroheim, F. W. Murnau, Robert Flaherty, and Dreyer, it is for a purpose. It is not that this trend seems to us to have been halted by the talking film. On the contrary, we believe that it represented the richest vein of the so-called silent film and, precisely because it was not aesthetically tied to montage, but was indeed the only tendency that looked to the realism of sound as a natural development. On the other hand it is a fact that the talking film between 1930 and 1940 owes it virtually nothing save for the glorious and retrospectively prophetic exception of Jean Renoir. He alone in his searchings as a director prior to *La Règle du jeu* forced himself to look back beyond the resources provided by montage and so uncovered the secret of a film form that would permit everything to be said without chopping the world up into little fragments, that would reveal the hidden meanings in people and things without disturbing the unity natural to them.

It is not a question of thereby belittling the films of 1930 to 1940, a criticism that would not stand up in the face of the number of masterpieces, it is simply an attempt to establish the notion of a dialectic progress, the highest expression of which was found in the films of the 1940's. Undoubtedly, the talkie sounded the knell of a certain aesthetic of the language of film, but only wherever it had turned its back on its vocation in the service of realism. The sound film nevertheless did preserve the essentials of montage, namely discontinuous description and the dramatic analysis of action. What it turned its back on was metaphor and symbol in exchange for the illusion of objective presentation. The expressionism of montage has virtually disappeared but the relative realism of the kind of cutting that flourished around 1937 implied a congenital limitation which escaped us so long as it was perfectly suited to its subject matter. Thus American comedy reached its peak within the framework of a form of editing in which the realism of the time played no part. Dependent on logic for its effects, like vaudeville and plays on words, entirely conventional in its moral

and sociological content, American comedy had everything to gain, in strict line-by-line progression, from the rhythmic resources of classical editing.

Undoubtedly it is primarily with the Stroheim-Murnau trend—almost totally eclipsed from 1930 to 1940—that the cinema has more or less consciously linked up once more over the last ten years. But it has no intention of limiting itself simply to keeping this trend alive. It draws from it the secret of the regeneration of realism in storytelling and thus of becoming capable once more of bringing together real time, in which things exist, along with the duration of the action, for which classical editing had insidiously substituted mental and abstract time. On the other hand, so far from wiping out once and for all the conquests of montage, this reborn realism gives them a body of reference and a meaning. It is only an increased realism of the image that can support the abstraction of montage. The stylistic repertory of a director such as Hitchcock, for example, ranged from the power inherent in the basic document as such, to superimpositions, to large close-ups. But the close-ups of Hitchcock are not the same as those of C. B. de Mille in *The Cheat* [1915]. They are just one type of figure, among others, of his style. In other words, in the silent days, montage evoked what the director wanted to say; in the editing of 1938, it described it. Today we can say that at last the director writes in film. The image—its plastic composition and the way it is set in time, because it is founded on a much higher degree of realism—has at its disposal more means of manipulating reality and of modifying it from within. The film-maker is no longer the competitor of the painter and the playwright, he is, at last, the equal of the novelist.

1950–55

# BRIAN HENDERSON
# TOWARD A NON-BOURGEOIS CAMERA STYLE

Godard has developed a new camera style in his later period.[1] Its prime element is a long, slow tracking shot that moves purely laterally—usually in one direction only (left to right or right to left), sometimes doubling back (left to right then right to left, right to left then left to right)—over a scene that does not itself move, or strictly speaking, that does not move in any relation to the camera's movement. Examples of this shot are the automobile trilogy or triptych: the backed-up highway of cars in *Weekend*, the wrecked cars piled up in *One Plus One*, and the auto assembly line in *British Sounds*; most of the studio scenes with the Stones in *One Plus One*; several of the guerrilla scenes in *Weekend* ("I salute you, old ocean"); and the shot of the University of Nanterre and environs in *La Chinoise*. Before we consider this shot as part of a stylistic complex and in the various contexts in which it appears, we must consider the shot in itself—its structure and implications as shot.

First we must distinguish Godard's tracking shot from other such shots in the history of cinema. It is not, first of all, forward camera movement, proving the depth of space, as in Murnau. Godard's tracking shot moves neither forward nor backward in space, nor in any diagonal or arc, nor at any angle but 90° to the scene it is shooting. That is, Godard's track lies exactly along the 0°/180° line. The scenes or subjects which these shots address lie also along a 0°/180° line, which, furthermore, is exactly parallel to the camera line. This extreme stylization, wherein a plane or planes of subject are paralleled exactly by the plane of art, is unusual in cinema and gives the shot very much the form of a planimetric painting. A partial exception to the rule is the camera's sinuosity in the traffic jam shot in *Weekend*, its slight

---

[1]This article is part of a longer critical study, "*Weekend* and History," which considers that film in its various historical contexts—cinema and dramatic history, history of the bourgeoisie, human history.

"angling" to left and right as it moves laterally, getting slightly behind or ahead of the scene it is filming, a kind of warp in the shot's even, continuous space-time. The base line of the camera's movement remains exactly straight, however, and exactly parallel to the scene. More fundamental departures from the lateral track are the Action Musicale sequence-shot in *Weekend*, in which the camera remains in the center of the scene and *turns* 360°, and the shot in *One Plus One*, in which the camera *tracks* 360° around the studio in which the Stones are playing. In the first the camera is at the center of a circle, in the second at the periphery, but in both there is the sense of a circular subject rendered flat and linear: these shots look like the lateral tracking shot and fit easily into formats which align them end-to-end with such shots.

The shot, secondly, is not like Ophuls's tracking shots which—though often lateral and hence formally like Godard's—are essentially following shots. Ophuls tracks in order to follow his characters, to give them movement or to attend their movement. His tracks center on, are filled with, derive life and motion from his characters, that is, from individuals. Godard, like Eisenstein, repudiates "the individualist conception of the bourgeois hero" and his tracking shots reflect this. His camera serves no individual and prefers none to another. It never initiates movement to follow a character and if it picks one up as it moves it leaves him behind as haphazardly (the workers and Wiazemsky in the Action Musicale and the shot with Juliet Berto in and out, in *Weekend*). Also—though some may dispute this—Ophuls's tracks are essentially uncritical of their subjects, whereas the essence of Godard's tracking shot is its critical distance from what it surveys. Also, Ophuls frequently uses the composition-in-depth technique of interposing objects in the foreground, between character and camera. Godard never does this.

Thirdly, the shot is not like Fellini's pans and short tracks, though the latter also survey persons fixed in space rather than moving ones, that is, "discover" them in place as the camera moves. There are two chief differences. First, Fellini's camera *affects* his characters, calls them into life or bestows life upon them. Godard's camera does not affect the reality it unfolds and is not affected by it. There is a different camera dialectic in each: Fellini's camera interacts with reality, touches and is touched, causes as well as registers effects; Godard's camera assumes a position over against reality, outside, detached. Secondly, Fellini's tracks are frequently subjective—in the sense that the camera eye is a character's eye. In $8^1/_2$ the reactions of characters to the camera are their reaction to Guido; the pain we feel when we see them is Guido's pain. Because subjective, Fellini's tracks are most often in medium close or close-up range, sometimes with only faces coming into view; Godard's tracks, which are never subjective, are usually in long shot, taking in as much of an event and its context as possible. Also, Fellini introduces depth by arraying characters and objects in multiple planes, some very close to the camera, others at a distance, making for surprise and variety as the camera moves over them. Godard avoids depth: he arranges his characters in a single plane only—none is ever closer to the camera than another. The resulting flatness of Godard's shots, particularly in *Weekend*, is discussed below.

Godard's tracking shot is a species of long take,[2] very often of sequence shot,[3] but it has few or none of the characteristics in terms of which André Bazin discussed and defended the shot and cinematic styles based upon it. In Godard's shot there is continuity of dramatic space and time, the irreducibles of the long take (indeed its very definition); but there is strict avoidance of composition-in-depth, for Bazin the essence of the shot—or that of greatest value in its use. As mentioned, Godard's frames are flat, composed in relation to the plane occupied by his characters. Other planes, where present, are used merely as backdrop to this one. Not only composition-in-depth but the *values* which Bazin found in composition-in-depth are missing in Godard's version of the long take (and in late Godard generally): greater realism, greater participation on the part of the viewer, and a reintroduction of ambiguity into the structure of the film image. It is clear that Godard is no realist; in *La Chinoise* he specifically repudiates the realist aesthetic (of Bazin and others): "Art is not the reflection of a reality; it is the reality of that reflection." Godard's later style does require the active participation of the viewer, but not in Bazin's sense of choosing what to see within a multi-layered image and, presumably, making his own moral connections within it also. Godard presents instead an admittedly synthetic, single-layered construct, which the viewer must examine critically, accept or reject. The viewer is not drawn *into* the image, nor does he make choices within it; he stands outside the image and judges it *as a whole*. It is clear also that Godard of the later films is not interested in ambiguity—through flatness of frame and transparency of action, he seeks to eliminate ambiguity. Thus Godard uses the long take for none of the traditional reasons; in fact he reinvents the long take, and the tracking shot, for his own purposes.

A camera moves slowly, sideways to the scene it is filming. It tracks. But what is the result when its contents are projected on a screen? It is a band or ribbon of reality that slowly unfolds itself. It is a mural or scroll that unrolls before the viewer and rolls up after him. To understand the nature of this visual band we must go beyond the tracking shot itself. We encounter here the aesthetic problem of parts and wholes: Godard's tracking shot is but one element in a remarkably rich and complete stylistic complex or repertoire. It appears not in isolation, but in formal combinations with other kinds of shots, and with sounds. In short, the tracking shot cannot be understood apart from the varying contexts in which it appears—it has a different meaning and formal function in *La Chinoise*, in *Weekend*, in *One Plus One*, and in *British Sounds*, and even at different places within the same film. Moreover, the matter of "context"

---

[2]A single piece of unedited film; of course "long" is relative to "short"—the cut-off would seem to be a shot used for wholly independent effect rather than as part of a montage pattern. None of Eisenstein's early films contains a single long take—such was the theoretical purity of his practice; no Godard film is without several long takes.

[3]A sequence filmed in one take; a one-shot sequence. A sequence is a series of closely related scenes; a scene is a shot or shots that cover a single and continuous dramatic action. We must bear in mind that Godard's "sequences" are not those of conventional narrative cinema, hence the concepts "sequence" and "sequence shot" lose the reasonably clear meaning they had for Bazin. What meanings will take their place, we do not yet know. See André Bazin, "The Evolution of the Language of Cinema" (tr. by Hugh Gray), in *What Is Cinema?* (Berkeley, 1967); also contained in *The New Wave*, ed. by Peter Graham (New York, 1968). [And reprinted here, pp. 41–53.]

is not as simple as it might appear. Each of the latter films is built upon a complex camera/sound conception or donnée, and no two of these are alike. Our principal concern is the formal construction of *Weekend* and the specific role of the tracking shot in that construction; that is, the relation of formal part and whole. We will not understand either aspect of *Weekend*, however, until we see that film's characteristic shot in the alternative contexts of the other late films and understand the formal principles of those works themselves. The use of the tracking shot in the other films clarifies its use in *Weekend* and the formal principles of the other films put into perspective the formal principle of *Weekend* itself.

*La Chinoise* contains some interesting instances of the tracking shot even though the film is in no sense built upon this shot, as both *Weekend* and *One Plus One* are. (In the latter films, the whole is chiefly a relation among tracking shots; in *La Chinoise* the whole is a relation among many kinds of shots, relatively few of which are tracking shots.) There are, first of all, the remarkable shots from the balcony, in which the action within the apartment is carefully orchestrated in relation to the camera's passage, in various mathematical variations, along the apartment's three windows and two walls, and back. There is, secondly, a usage of the shot as a special kind of documentation. As Véronique describes her awakening to social contradictions at Nanterre, the camera tracks slowly (from right to left) across the shabby, overcrowded dwellings of the Algerian workers who live near the university, coming to rest at last on the modern, efficient buildings of the university complex. The workers' shacks are flat and horizontal, the university buildings high and vertical, but the shot is set up so that the camera does not have to move back to take in the tall, commanding structures—it takes in everything within a single perspective. Eisenstein would have cut from a shot of the one to a shot of the other, making the juxtaposition for the viewer, obliterating time and space relations to make a clearcut social relation. Godard observes the time and space relations and lets the viewer make the social relation. His shot establishes the true proportions of extreme contrast and close proximity. He does this by virtue of the long take's continuity of dramatic space and time, which this usage reveals as itself a form of argumentation or demonstration; the shot has its own internal relations, its own logic. This instance of the shot seems Bazinian but, far from fidelity to the real, Godard rips this bit of footage from its grounding in the real and puts it down in the midst of a highly abstract film essay. Goddard impresses the real into his own service—ignoring the form of the real itself, he subjects it firmly to his own formal construct. Besides the tracking shots, *La Chinoise* also includes several static long takes—the two dialogues between Véronique and Guillaume, the assassination scene—as well as montage (or collage) constructions. (It has become a commonplace that modern film-makers fall between Eisenstein and Bazin, that they combine editing techniques and long takes in various, distinctive styles.) The overall formal principle of *La Chinoise* would seem to be collage, which is also the formal principle of *The Married Woman*, portions of *Le Gai Savoir*, and, in certain senses, or *Pravda*.

The difference between montage and collage is a complex question. Film critics generally use the term collage without elucidating its meaning nor even its difference from montage. There is sometimes the suggestion that the pieces of a collage are shorter or more fragmented than those of a montage, but this does not hold up. Mod-

ern film-makers rarely use any shorter than Eisenstein's average shot in *Potemkin*. Moreover, collage as practiced by moderns allows long takes and tracking shots; montage as practiced by Eisenstein did not. It seems clear that the difference between montage and collage is to be found in the divergent ways in which they associate and order images, not in the length or nature of the images themselves. Montage fragments reality in order to reconstitute it in highly organized, synthetic emotional and intellectual patterns. Collage does not do this; it collects or sticks its fragments together in a way that does not entirely overcome their fragmentation. It seeks to recover its fragments *as fragments*. In regard to overall form, it seeks to bring out the internal relations of its pieces, whereas montage imposes a set of relations upon them and indeed collects or creates its pieces to fill out a pre-existent plan. (This point is discussed further in the comparison of the collage principle to the visual organization of *Weekend* and *One Plus One* below.)

In *Weekend* the collage principle all but disappears. Intercut titles—showing the day and the hour, the car speedometer, names of sequences such as "Action Musicale," "Scenes from Provincial Life"—serve as breaks within takes and between scenes, but all within the film's single-image continuum. They do not interact with the pictorial images to form montage patterns, as in *La Chinoise*. Conversely: whereas in *La Chinoise* the tracking shot is incidental, in *Weekend* it is the master shot: the entire film aspires to the condition of this shot. The cuts are merely connective; once outside the Paris apartment, the film might as well be a single, fixed-distance travelling shot along the highway and across the provincial landscape. *Weekend* indeed approximates this ideal form by its remarkable adherence to a single camera range—it is filmed almost entirely in long shot. Thus *Weekend* is the film in which the structure of the tracking shot and the formal principle of the whole very nearly coincide. Not just its characteristic shot but the whole of *Weekend* itself is a continuous visual band that unfolds itself along a linear axis.*

We have found that *Weekend* is the one film among the later works in which the structure of the tracking shot and the formal principle of the whole are nearly identical. Because the shots of *Weekend* deal with a single situation (rather than two or more), they are not juxtaposed (as in *One Plus One*), but merely linked—as though to form one long composite tracking shot. This continuity is emphasized by the near-constant camera range of long shot, which renders the entire film, even static shots, into a single band of reality. In our discussion of the tracking shot as long take we distinguished it from composition-in-depth shots and thereby characterized the tracking shot in terms of a certain kind of flatness. If the overall structure of *Weekend* parallels that of the tracking shot, then the film as a whole must exhibit flatness also. In light of our distinction between parts and wholes, it must also be that flatness of the whole is something different from flatness of the part; and in *Weekend* this is found to be true. Nevertheless—flatness seems an odd category in which to discuss the formal organization of a work, partly because it seems a negative concept, partly

---

*Omitted from this reprinting is a passage that extends the discussion of the tracking shot and of part-whole relations to the films that Godard made after *Weekend*—*One Plus One*, *British Sounds*, *Le Gai Savoir*, *Pravda*, and *Wind From the East*. In these films, more than in *Weekend* and *La Chinoise*, the organization of sound-image relation (at levels of part and whole) is fundamental.—B.H.

because "flatness" has no meaning except in relation to "depth." In fact, however, *Weekend* itself is negative—regarding its subject, the bourgeoisie—in several important respects. And, as we shall see also, the "flatness" of *Weekend* has specific relation to a previous "depth"—composition-in-depth, the principal mode of bourgeois self-presentment in cinema.

If we now propose to discuss the formal organization of *Weekend*, part and whole, in terms of flatness, the effect may well be one of anti-climax and disappointment. If this is so, it is due in large measure to the imprecision that such terms, and especially this term, carry in film analysis. What this means, since the category of flatness comes up inescapably here and elsewhere, is that some theoretical clarification needs to be done. This task cannot be undertaken here but minimal clarification must be done to permit our analysis of *Weekend*. There is no single sense of flatness in cinema but in fact several senses, not only in regard to different films but often in regard to the same film. A single work may be flat in several senses, or now in one sense and now in another; so we must ask not simply which films and scenes are "more flat" than others but in precisely which senses they are flat. An equally great problem area is how critics use the judgment of flatness—the correlations they make between flatness and other matters, particularly those of subject and meaning. Clearly an undifferentiated judgment of flatness cannot be the basis for an adequate interpretation or discussion of subject. A correlation between the "flatness" of *Made in USA* or *Weekend* and Herbert Marcuse's theory of a One Dimensional society is too general—in regard to both elements—to be of much use. Criticism must cut finer than this or it is not helpful. Rather we must ask in each case which of several kinds of flatness has/have been achieved and what is its/their specific relation to the subject of the part and/or whole to which it relates.

Cinema, like painting, is a two-dimensional art which creates the illusion of a third dimension. Painting is limited to its two dimensions; cinema is not. Cinema escapes the limits of two dimensions through its own third dimension, time. It does this by varying its range and perspective, by taking different views of its subject (through montage and/or camera movement). Cinema overcomes two-dimensionality through its "walk-around" capability, which is also a prime feature of ordinary human perception. E. H. Gombrich says: "While (one) turns, in other words, he is aware of a succession of aspects which swing round with him. What we call 'appearance' is always composed of such a succession of aspects, a melody, as it were, which allows us to estimate distance and size; it is obvious that this melody can be imitated by the movie camera but not by the painter with his easel." (*Art and Illusion*, pp. 256–7). Cinema can take several views of a subject, go from one camera angle to a reverse angle or other angle, from long shot to close-up, etc. It can take the measure of a character or object from many sides, in short, in three dimensions. Both montage and composition-in-depth accomplish this walk-around project, both create and explore three dimensions, though in two-dimensional steps or segments, so to speak. It is obvious how montage accomplishes this—through a succession of shots from different angles and at different ranges. It is equally clear that a moving camera can accomplish the same succession of aspects within a single shot. Even in those long takes which do not involve a moving camera, the actors themselves may move with respect to the camera; that is, they walk back-and-forth, or at diagonals, changing in relative

size, etc. In short, the actors *turn themselves* around for us, creating different angles and perspectives on themselves. Instead of the camera's walking around, they walk around in relation to the camera. This also is well beyond the two dimensions of painting, whereby we see only one side of a figure, which must stand for and suggest his entirety.

It is precisely cinema's capacity for depth which Godard excludes in *Weekend*. His moving camera, by adhering rigidly to the single-perspective, one-sided view of painting, eliminates the succession of aspects. The tracking shot's lateral motion *extends* this single perspective rather than alters it, very much as a mural does. The movement of Godard's camera creates not a succession of aspects, but a single aspect upon an unfolding subject matter. Both montage and the usual moving camera multiply aspects or perspectives *in regard to a single subject*. To borrow a term from music, the succession of aspects is a kind of *elaboration*. The subject in question is put through multiple variations (or views), toward some *exhaustion* of its nature, meaning, or appearance. Godard's tracking shot does not elaborate in this sense. Its variations through time open up ever new subject matter; they do not elaborate or take multiple views of the same subject, as both montage and composition-in-depth (nearly) always do. Throughout the duration of a tracking shot, a one-to-one relation is maintained: a single perspective per stretch or segment of subject matter, with never a doubling or curving of perspective on a single subject.

It should be emphasized that this flatness of the single aspect is a formal quality of the whole, not of the part. We cannot judge aspect succession or constancy on the basis of the part alone since the succession of aspects is often a succession *of shots*. It is true that each tracking shot in *Weekend* is flat in this sense of singleness of perspective, but what is done in one shot may be undone, or complemented, by another. This is the method of montage, whereby the angle and range of one shot give way to those of another and another, until a totality of aspects is accumulated. Even with lateral long takes, a subsequent tracking shot may provide a different view of the subject of a previous tracking shot. Thus we do not know until a film is over whether a given subject is elaborated multiply or not. We must look at *all* the shots of a sequence or film before we can say whether they present a succession of aspects on a single subject or, as in *Weekend*, a single aspect on a single, unfolding subject. Thus the flatness of the mural effect is an attribute or quality of the whole.

We have argued that *Weekend* is flat in an overall or structural sense in that it eliminates the succession of aspects, by which cinema approximates the third dimension. This is an absolute flatness—a sequence, a film either varies aspects or it does not. Generally speaking, the frames of *Weekend* are also relatively flat in several painterly respects, and this is always a relative flatness, a question of more or less. The clearest case of this kind of flatness is achieved by posing a character or characters against a short wall or background, as Godard does in *Masculin Feminin, Made in USA*, and other films, and as Skolimowski does in all his films. *Weekend* has certain of these shots, but it also has others with considerable depth—the camera follows its subjects, the bourgeois couple, across a continuous background/landscape that is sometimes flat (thick foliage behind the pair), sometimes deep (the highway backup).

But there are other kinds of flatness. The shallow wall shot achieves flatness simply by eliminating the long shot range, and perhaps also the medium-shot range.

Godard's tracking shot achieves a converse flatness by eliminating the close-up, medium-close, and often medium shot ranges—by arranging his subject(s) and background all within the long shot range. The point may be clarified by a comparison with composition-in-depth, which aims for maximum visual and expressive use of depth, in that both a close-up and a long shot can be included within the same shot. Composition-in-depth achieves its illusion of great depth by arranging its subject through all possible ranges of the deep-focus shot and, of course, by making dramatic relations among these subject ranges. Godard achieves flatness using only a portion of the depth which deep-focus lenses permit—he uses the long-shot range and leaves the shorter ranges "blank," so to speak. Thus, even where there are several planes in a *Weekend* shot—highway, countryside, tree-line, etc.—they are all relatively flattened together, because all lie within the long-shot range. (Moreover, Godard does not achieve this flattening by using telephoto lenses, as Kurosawa did in *Red Beard*.)

Secondly, Godard's planes, even where multiple, are strictly parallel—they do not intersect or interrelate. Consequently the eye is not led back into the depth of the frame nor forward to its surfaces. How we have to "read" a painting or frame is one aspect of its depth; to read the frames of *Weekend*, the eye moves strictly from left to right (sometimes from right to left), never from front to back or back to front. What is true in a compositional sense is also true of the subject of these frames: the film's action. The characters, their movements and activities, never take us into or out of the frame but always from side to side. Neither in a compositional sense nor a narrative sense are we ever required to relate foreground and background in *Weekend*. Strictly speaking, there is no foreground and background, only background, just as in the shallow wall shot there is only foreground. In another sense, foreground and background are here merged into a single plane. Again, composition-in-depth provides a definitive contrast. Like the baroque in painting, composition-in-depth makes a great deal of foreground/background relations, or foreshortening, of huge objects in the foreground, etc. It is not too much to say that foreground/background relation is the axis of composition-in-depth expressivity. As we have seen, it is its moral base also.

Thirdly, the non-intersection of planes in *Weekend* is the result not only of their strict parallelism but also of the fixed, 90° camera angle, which arranges all planes in parallel to the borders of the frame itself. Of these planes, all are inert or non-operative in both a narrative and a compositional sense, except that occupied by the characters. All interest and movement reside in the characters and they occupy (or constitute) always the same plane; they do not move between planes. *Weekend* is single-planed in the sense that the camera and the viewer's eye fix upon only one plane, that occupied by the characters, and follow it out, in one direction only, at infinite length. The frame may contain several planes, but the film as a whole is constructed in relation to only one of these.

*Weekend*'s single-plane construction sets it apart from either school of film aesthetics, montage or composition-in-depth; comparing *Weekend* to them will help us understand the various senses of the film's flatness historically. It is clear that montage editing (and overall film construction) involves or results in a series of planes or planar perspectives. Cutting among close-ups, medium close-ups, medium shots, and long shots, in any order or combination, is obviously an alternation of the planes of a

scene, and the result when assembled a sequence of planes.[4] The scene or event is broken into its component parts or planes, then these are reconstructed in various patterns, in accord with a structural montage principle—rhythmic, emotional, or intellectual. Besides changes of camera range, there are also changes of angle, which can alternate planar perspectives rather than particular planes. Cutting to a different angle on the same scene, however, is also a rearrangement or reordering of the planes bearing upon the action. This ordering or sequence of planes is the very texture of Eisenstein's art. Composition-in-depth is not fundamentally different in principle and overall purpose. Composition-in-depth internalizes the sequence of planes within the shot; its ideal, as Bazin presents it, is the inclusion of all planes bearing upon an action within a single camera set-up. With all the planes of a situation before or available to the camera, the entire action of the scene may be worked out within a single shot. As with montage cinema, dramatic action is advanced by way of the alternation and interaction of planes, but now this is done by camera movement and/or by the movement of actors, themselves planes or parts of planes, through or in relation to the planes of the scene. At the same time the camera must organize these planes in terms of importance, dramatic interest, etc. By composition-in-depth the succession of planes is greatly fluidized, proceeding in a smooth flow rather than in jumps, but the right solution to a given scene becomes more difficult and complex. Implicit in the shot's first image, or accessible to it, must be all the scene's action and the full exploitability of its planes. Shots must be worked out carefully and carefully rehearsed. An example of the way that composition-in-depth orders planes within the frame is given by Bazin—the scene in *The Little Foxes* in which the steel box sought by several characters occupies the extreme foreground of the frame while its seekers are arrayed in multiple planes behind it. A more extreme case is the scene in *Citizen Kane* in which Mrs. Kane learns about her son's inheritance. Shot with a static camera, the shot is very narrow and very deep, virtually a visual corridor. Within the squeezed cabin room we see the mother huge in the foreground, the banker from the East behind her, the window in the wall of the cabin behind them, and in the far distance, young Kane playing with his sled. Not only the composition of the shot but its dramatic action requires the eye to move continually back and forth. It is clear that Godard's treatment of planes in *Weekend* is directly opposed to that of this shot, an extreme in the opposite direction. Godard's visual field has little or no depth and has—or aspires to—infinite length; that is, it exists in a single lateral plane.

Consideration of *Weekend* points up underlying similarities between montage and composition-in-depth and serves to set Godard's film apart from either school of film aesthetics: both montage and composition-in-depth define cinema in terms of a mul-

---

[4]As it happens, this phrase also appears in Stuart Gilbert's translation of André Malraux's *Museum Without Walls* (Garden City, 1967, page 75): "The means of reproduction in the cinema is the moving photograph, but its means of expression is the sequence of planes. (The planes change when the camera is moved; it is their sequence that constitutes cutting.)." A similar mistranslation of the French *plan* (shot) as plane occurs in Gilbert's translations of Malraux's variants of this passage in *The Psychology of Art: I: Museum Without Walls* (New York, 1949–51, page 112) and in *The Voices of Silence* (New York, 1953, page 122), in which Malraux is made to assert that "the average duration of each [plane] is ten seconds." But Malraux was simply expounding the classical view that cutting, the sequence of shots, is the source of expressivity in cinema.

tiplicity of planes and both see the problem of form or technique as the inclusion or relation of planes in a meaningful format. Godard in *Weekend* renounces the multiplicity of planes as a project of cinema and hence rejects both schools.

What are the implications of these shifts from three dimensions to two, from depth to flatness? An ideological interpretation suggests itself—composition-in-depth projects a bourgeois world infinitely deep, rich, complex, ambiguous, mysterious. Godard's flat frames collapse this world into two-dimensional actuality; thus reversion to a cinema of one plane is a demystification, an assault on the bourgeois worldview and self-image.[5] *Weekend*'s bourgeois figures scurry along without mystery toward mundane goals of money and pornographic fulfillment. There is no ambiguity and no moral complexity. That space in which the viewer could lose himself, make distinctions and alliances, comparisons and judgments, has been abrogated—the viewer is presented with a single flat picture of the world that he must examine, criticize, accept or reject. Thus the flatness of *Weekend* must not be analyzed only in itself but in regard to the previous modes of bourgeois self-presentment, particularly of composition-in-depth. The subject of *Weekend* is the historical bourgeoisie, the bourgeoisie in history; the film's flatness must not be seen statistically, as a single moment, but dialectically, as a *flattening*. Given this overall correlation, the specific correlations of the several senses of flatness fall into place. The succession of aspects not only multiplies viewpoints on the bourgeois world so that final judgment and any kind of certainty become impossible, it projects a bourgeois world infinitely inexhaustible and elaborable. Godard's tracking shot format insists on a single perspective and on the sufficiency of a single comprehensive survey for understanding of the transparent, easy-to-understand bourgeois world. Whereas in montage and composition-in-depth, complex form works on simple material, working it up as complex also, in Godard simple form works on simple material. The tracking shot and single-plane construction suggest an infinitely thin, absolutely flat bourgeois substance that cannot be elaborated but only surveyed. Finally, the single camera range represents not only a refusal to participate in bourgeois space, through forward camera movement, intercutting camera ranges, etc., it also has to do with the maintenance of critical perspective. Given that the film's subject is the historical bourgeoisie, Godard keeps his subject before him at all times. He refuses to pick and choose within the bourgeois world or to prefer any part of it to any other—even for a moment—because that involves partial eclipse of the whole. The nature of the bourgeois totality and the project of criticizing it require that it never be lost from view, or broken up into parts and aspects, but always be kept before the viewer as single and whole. Obviously the

---

[5]This transition is more than a formal one. The practitioners and advocates of composition-in-depth genuinely believed in this moral depth and ambiguity. Bazin points out that the conception and interpretation of *Citizen Kane* depend on the composition of the image. It could hardly be otherwise in a great masterpiece. William Wyler's composition-in-depth films, which (as Bazin says) have little or no ambiguity, are not masterpieces. In such a case composition-in-depth becomes merely an imposed format, a style without internal correlates. (Wyler's better films, such as *The Letter*, are not structured around composition-in-depth). Welles, the greatest composition-in-depth director, is also the director who has made the most of the theme of inexhaustible mystery. Not only *Kane* but many or most of Welles's other films center on impenetrable mystery and several, also like *Kane*, proceed through a multiplicity of viewpoints and perspectives which nevertheless fail to yield certainty concerning the underlying questions.

long-shot range is the range of the totality and the tracking shot the instrument of its critical survey. For this reason also Godard does not allow the close-up and medium-close ranges to be filled, for a face or figure huge in the foreground literally obstructs the whole and distracts attention from it in an emotional and intellectual sense also. Flatness in *Weekend*, in its various senses, is in fact the result of a formal totality that refuses to relinquish total perspective on the socio-historical totality that is its subject.

1970

# CHRISTIAN METZ
## *FROM* FILM LANGUAGE

## SOME POINTS IN THE SEMIOTICS OF THE CINEMA

The purpose of this text is to examine some of the problems and difficulties confronting the person who wants to begin undertaking, in the field of "cinematographic language," de Saussure's project of a general semiotics: to study the ordering and functionings of the main signifying units used in the filmic message. Semiotics, as de Saussure conceived it, is still in its childhood, but any work bearing on one of the nonverbal "languages," provided that it assumes a resolutely semiological relevance and does not remain satisfied with vague considerations of "substance," brings its contribution, whether modest or important, to that great enterprise, the general study of significations.

The very term "cinematographic *language*" already poses the whole problem of the semiotics of film. It would require a long justification, and strictly speaking it should be used only after the in depth study of the semiological mechanisms at work in the filmic message had been fairly well advanced. Convenience, however, makes us retain, right from the start, that frozen syntagma—"language"—which has gradually assumed a place in the special vocabulary of film theoreticians and aestheticians. Even from a strictly semiological point of view, one can perhaps at this time give a preliminary justification for the expression "cinematographic language" (not to be confused with "cinematographic *langue*" (language system), which does not seem to me acceptable)—a justification that, in the present state of semiological investigations, can only be very general. I hope to outline it in this essay. . . .

## CINEMA AND NARRATIVITY

A first choice confronts the "film semiologist": Is the corpus to be made up of feature films (*narrative films*) or, on the contrary, of short films, documentaries, technological, pedagogical, or advertising films, etc.? It could be answered that it depends

simply on what one wants to study—that the cinema possesses various "dialects," and that each one of these "dialects" can become the subject of a specific analysis. This is undoubtedly true. Nevertheless, there is a hierarchy of concerns (or, better yet, a methodological urgency) that favors—in the beginning at least—the study of the narrative film. We know that, in the few years immediately before and after the Lumière brothers' invention in 1895, critics, journalists, and the pioneer cinematographers disagreed considerably among themselves as to the *social function* that they attributed to, or predicted for, the new machine: whether it was a means of preservation or of making archives, whether it was an auxiliary technography for research and teaching in sciences like botany or surgery, whether it was a new form of journalism, or an instrument of sentimental devotion, either private or public, which could perpetuate the living image of the dear departed one, and so on. That, over all these possibilities, the cinema could evolve into a machine for telling stories had never been really considered. From the very beginnings of the cinematograph there were various indications and statements that suggested such an evolution, but they had no common measure with the magnitude that the narrative phenomenon was to assume. The merging of the cinema and of narrativity was a great fact, which was by no means predestined—nor was it strictly fortuitous. It was a historical and social fact, a fact of civilization (to use a formula dear to the sociologist Marcel Mauss), a fact that in turn conditioned the later evolution of the film as a semiological reality, somewhat in the same way—indirect and general, though effective—that "external" linguistic events (conquests, colonizations, transformations of language) influence the "internal" functioning of idioms. In the realm of the cinema, all nonnarrative genres—the documentary, the technical film, etc.—have become marginal provinces, border regions so to speak, while the *feature-length film of novelistic fiction*, which is simply called a "film"—the usage is significant—has traced more and more clearly the king's highway of filmic expression.

This purely numerical and social superiority is not the only fact concerned. Added to it is a more "internal" consideration: Nonnarrative films for the most part are distinguished from "real" films by their social purpose and by their content much more than by their "language processes." The basic figures of the semiotics of the cinema—montage, camera movements, scale of the shots, relationships between the image and speech, sequences, and other large syntagmatic units—are on the whole the same in "small" films and in "big" films. It is by no means certain that an independent semiotics of the various nonnarrative genres is possible other than in the form of a series of discontinuous remarks on the points of difference between these films and "ordinary" films. To examine fiction films is to proceed more directly and more rapidly to the heart of the problem.

There is, moreover, an encouraging diachronic consideration. We know, since the observations of Béla Balázs, André Malraux, Edgar Morin, Jean Mitry, and many others, that the cinema was not a specific "language" from its inception. Before becoming the means of expression familiar to us, it was a simple means of mechanical recording, preserving, and reproducing moving visual spectacles—whether of life, of the theater, or even of small *mises-en-scène*, which were specially prepared and which, in the final analysis, remained theatrical—in short, a "means of reproduction," to use André Malraux's term. Now, *it was precisely to the extent that the cinema con-*

*fronted the problems of narration* that, in the course of successive groupings, it came to produce a body of specific signifying procedures. Historians of the cinema generally agree in dating the beginning of the "cinema" as we know it in the period 1910–15. Films like *Enoch Arden*, *Life for the Czar*, *Quo Vadis?*, *Fantômas*, *Cabiria*, *The Golem*, *The Battle of Gettysburg*, and above all *Birth of a Nation* were among the first films, in the acceptation we now give this word when we use it without a determinant: Narration of a certain magnitude based on procedures that are supposed to be specifically cinematographic. It so happens that these procedures were perfected in the wake of the narrative endeavor. The pioneers of "cinematographic language"— Méliès, Porter, Griffith—couldn't care less about "formal" research conducted for its own sake; what is more (except for occasional naïve and confused attempts), they cared little about the symbolic, philosophical or human "message" of their films. Men of denotation rather than of connotation, they wanted above all to tell a story; they were not content unless they could subject the continuous, analogical material of photographic duplication to the *articulations*—however rudimentary—of a narrative discourse. Georges Sadoul has indeed shown how Méliès, in his story-teller's naïveté, was led to invent double exposure, the device of multiple exposures with a mask and a dark backdrop, the dissolve and the fade-in, and the pan shot. Jean Mitry, who has written a very precise synthesis of these problems, examines the first occurrences of a certain number of procedures of filmic language—the close-up, the pan shot, the tracking shot, parallel montage, and interlaced, or alternative, montage—among the film primitives. I will summarize the conclusions he reaches: The principal "inventions" are credited to the Frenchmen Méliès and Promio, to the Englishmen G. A. Smith and J. Williamson, and to the American E. S. Porter; it was Griffith's role to define and to stabilize—we would say, to codify—the *function* of these different procedures in relation to the filmic narrative, and thereby unify them up to a certain point in a coherent "syntax" (note that it would be better to use the term *syntagmatic category*; Jean Mitry himself avoids the word syntax). Between 1911 and 1915, Griffith made a whole series of films having, more or less consciously, the value of experimental probings, and *Birth of a Nation*, released in 1915, appears as the crowning work, the sum and the public demonstration of investigations that, however naïve they may have been, were nonetheless systematic and fundamental. Thus, it was in a single motion that the cinema became narrative and took over some of the attributes of a language.

Today, still, the so-called filmic procedures are in fact filmic-narrative. This, to my mind, justifies the priority of the narrative film in the filmosemiological enterprise— a priority that must not of course become an exclusivity.

## STUDIES OF DENOTATION AND STUDIES OF CONNOTATION IN THE SEMIOTICS OF THE CINEMA

The facts I have just reviewed lead to another consequence. The semiotics of the cinema can be conceived of either as a semiotics of connotation or as a semiotics of denotation. Both directions are interesting, and it is obvious that on the day when the semiological study of film makes some progress and begins to form a body of knowledge, it will have considered connotative and denotative significations together. The

study of connotation brings us closer to the notion of the cinema as an art (the "seventh art"). As I have indicated elsewhere in more detail, the art of film is located on the same semiological "plane" as literary art: The properly aesthetic orderings and constraints—versification, composition, and tropes in the first case; framing, camera movements, and light "effects" in the second—serve as the connoted instance, which is superimposed over the denoted meaning. In literature, the latter appears as the purely linguistic singification, which is linked, in the employed idiom, to the units used by the author. In the cinema, it is represented by the literal (that is, perceptual) meaning of the spectacle reproduced in the image, or of the sounds duplicated by the soundtrack. As for connotation, which plays a major role in all aesthetic languages,* its significate is the literary or cinematographic "style," "genre" (the epic, the western, etc.), "symbol" (philosophical, humanitarian, ideological, and so on), or "poetic atmosphere"—and its signifier is the whole denotated semiological material, whether signified or signifying. In American gangster movies, where, for example, the slick pavement of the waterfront distills an impression of anxiety and hardness (significate of the connotation), the scene represented (dimly lit, deserted wharves, with stacks of crates and overhead cranes, the significate of denotation), and the technique of the shooting, which is dependent on the effects of lighting in order to produce a certain *picture* of the docks (signifier of denotation), converge to form the signifier of connotation. The same scene filmed in a different light would produce a different impression; and so would the same technique used on a different subject (for example, a child's smiling face). Film aestheticians have often remarked that filmic effects must not be "gratuitous," but must remain "subordinate to the plot." This is another way of saying that the significate of connotation can establish itself only when the corresponding signifier brings into play *both* the signifier and the significate of denotation.

The study of the cinema as an art—the study of cinematographic expressiveness—can therefore be conducted according to methods derived from linguistics. For instance, there is no doubt that films are amenable to analyses comparable (*mutatis mutandis*) to those Thomas A. Sebeok has applied to Cheremis songs, or to those Samuel R. Levin has proposed. But there is another task that requires the careful attention of the film semiologist. For also, and even first of all, through its procedures of *denotation*, the cinema is a specific language. The concept of *diegesis* is as important for the film semiologist as the idea of art. The word is derived from the Greek διηγησις, "narration" and was used particularly to designate one of the obligatory parts of judiciary discourse, the recital of facts. The term was introduced into the framework of the cinema by Étienne Souriau. It designates the film's *represented* instance (which Mikel Dufrenne contrasts to the expressed, properly aesthetic, instance)—that is to say, the sum of a film's denotation: the narration itself, but also the fictional space and time dimensions implied in and by the narrative, and consequently the characters, the landscapes, the events, and other narrative elements, in so

---

*Aesthetic language practices a kind of promotion of connotation, but connotation occurs as well in various phenomena of expressiveness proper to ordinary language, like those studied by Charles Bally (*Le Langage et la vie*, Geneva, Payot, 1926).

far as they are considered in their denoted aspect. How does the cinema indicate successivity, precession, temporal breaks, causality, adversative relationships, consequence, spatial proximity, or distance, etc.? These are central questions to the semiotics of the cinema.

One must not indeed forget that, from the semiological point of view, the cinema is very different from still photography whence its technique is derived. In photography, as Roland Barthes has clearly shown, the denoted meaning is secured entirely through the automatic process of photochemical reproduction; denotation is a visual transfer,[1] which is not codified and has no inherent organization. Human intervention, which carries some elements of a proper semiotics, affects only the level of connotation (lighting, camera angle, "photographic effects," and so on). And, in point of fact, there is no specifically photographic procedure for designating the significate "house" in its denotated aspect, unless it is by showing a house. In the cinema, on the other hand, a whole semiotics of denotation is possible and necessary, for a film is composed of *many* photographs (the concept of montage, with its myriad consequences)—photographs that give us mostly only partial views of the diegetic referent. In film a "house" would be shot of a staircase, a shot of one of the walls taken from the outside, a close-up of a window, a brief establishing shot of the building,[2] etc. Thus a kind of filmic *articulation* appears, which has no equivalent in photography: It is the denotation itself that is being constructed, organized, and to a certain extent codified (*codified*, not necessarily *encoded*). Lacking absolute laws, filmic intelligibility nevertheless depends on a certain number of dominant habits: A film put together haphazardly would not be understood.

I return to my initial observations: "Cinematographic language" is first of all the literalness of a plot. Artistic effects, even when they are substantially inseparable from the semic act by which the film tells us its story, nevertheless constitute another level of signification, which from the methodological point of view must come "later."

## PARADIGMATIC AND SYNTAGMATIC CATEGORIES

. . . In the cinema, where the number of images is indefinite. Several times indefinite, one should say. For the "pro-filmic" spectacles[3] are themselves unlimited in

---

[1] I am speaking here as a semiologist and not as a psychologist. Comparative studies of visual perception, both in "real" and in filmic conditions, have indeed isolated all the optical distortions that differentiate between the photograph and the object. But these transformations, which obey the laws of optical physics, of the chemistry of emulsions and of retinal physiology, do not constitute a signifying system.

[2] Even if this over-all view is the only one shown us in the film, it is still the result of a choice. We know that the modern cinema has partially abandoned the practices of visual fragmentation and excessive montage in favor of the continuous shot (cf. the famous "shot-sequence" controversy). This condition modifies to the same extent the semiotics of filmic denotation, but it in no way dismisses it. Simply, cinematographic language, like other languages, has a diachronic side. A single "shot" itself contains several elements (example: switching from one view to another through a camera movement, and without montage).

[3] As defined by Étienne Souriau. The "profilmic" spectacle is whatever is placed in front of the camera, or whatever one places the camera in front of, in order to "shoot" it.

number; the exact nature of lighting can be varied infinitely and by quantities that are nondiscrete; the same applies to the axial distance between the subject and the camera (in variations which are said to be scalar—that is, scale of the shot), to the camera angle, to the properties of the film and the focal length of the lens, and to the exact trajectory of the camera movements (including the stationary shot, which represents zero degree in this case). It suffices to vary one of these elements by a perceptible quantity to obtain *another* image. The shot is therefore not comparable to the word in a lexicon; rather it resembles a complete statement (of one or more sentences), in that it is already the result of an essentially free combination, a "speech" arrangement. . . . The image is almost always assertive—and assertion is one of the great "modalities" of actualization, of the semic act. It appears therefore that the paradigmatic category in film is condemned to remain partial and fragmentary, at least as long as one tries to isolate it on the level of the *image*. This is naturally derived from the fact that *creation* plays a larger role in cinematographic language than it does in the handling of idioms: To "speak" a language is to use it, but to "speak" cinematographic language is to a certain extent to invent it. The speakers of ordinary language consitute a group of users; film-makers are a group of creators. On the other hand, movie *spectators* in turn constitute a group of users. That is why the semiotics of the cinema must frequently consider things from the point of view of spectator rather than of the film-maker. Étienne Souriau's distinction between the filmic point of view and the "*cinéastique*," or filmmaking, point of view is a very useful concept; film semiotics is mainly a *filmic* study. The situation has a rough equivalent in linguistics: Some linguists connect the speaker with the message, while the listener in some way "represents" the code, since he requires it to understand what is being said to him, while the speaker is presumed to know beforehand what he wants to say.

But, more than paradigmatic studies, it is the syntagmatic considerations that are at the center of the problems of filmic denotation. Although each image is a free creation, the arrangement of these images into an intelligible sequence—cutting and montage—brings us to the heart of the semiological dimension of film. It is a rather paradoxical situation: Those proliferating (and not very discrete!) units—the *images*—when it is a matter of composing a film, suddenly accept with reasonably good grace the constraint of a few large syntagmatic structures. While no image ever entirely resembles another image, the great majority of narrative films resemble each other in their principal syntagmatic figures. *Filmic narrativity*—since it has again crossed our path—by becoming stable through convention and repetition over innumerable films, has gradually shaped itself into forms that are more or less fixed, but certainly not immutable. These forms represent a synchronic "state" (that of the present cinema), but if they were to change, it could only be through a complete positive evolution, liable to be challenged—like those that, in spoken languages, produce diachronic transformations in the distribution of aspects and tenses. Applying de Saussure's thought to the cinema, one could say that the large syntagmatic category of the narrative film *can change*, but that no single person can make it change over night. A failure of intellection among the viewers would be the automatic sanctioning of a purely individual innovation, which the system would refuse to confirm. The originality of creative artists consists, here as elsewhere, in tricking the code, or at

least in using it ingeniously, rather than in attacking it directly or in violating it—and still less in ignoring it. . . .

## OTHER PROBLEMS

These very brief remarks provided an example of what the syntagmatic study of filmic denotation could be. There are important differences between the semiotics of the cinema and linguistics itself. Without repeating those mentioned elsewhere, let me recall some of the main points: Film contains nothing corresponding to the purely distinctive units of the second articulation; all of its units—even the simplest, like the dissolve and the wipe—are directly significant (and moreover, as I have already pointed out, they only occur in the actualized state). The commutations and other manipulations by which the semiotics of the cinema proceeds therefore affect the large significatory units. The "laws" of cinematographic language call for *statements* within a narrative, and not monemes within a statement, or still less phonemes within a moneme.

Contrary to what many of the theoreticians of the silent film declared or suggested ("*Ciné langue*," "visual Esperanto," etc.), the cinema is certainly not a language system (*langue*). It can, however, be considered as a *language*, to the extent that it orders signifying elements within ordered arrangements different from those of spoken idioms—and to the extent that these elements are not traced on the perceptual configurations of reality itself (which does not tell stories). Filmic manipulation transforms what might have been a mere visual transfer of reality into discourse. Derived from a kind of signification that is purely analogous and continuous—animated photography, cinematography—the cinema gradually shaped, in the course of its diachronic maturation, some elements of a proper semiotics, which remain scattered and fragmentary within the open field of simple visual duplication.

The "shot"—an already complex unit, which must be studied—remains an indispensable reference for the time being, in somewhat the same way that the "word" was during a period of linguistic research. It might be somewhat adventurous to compare the shot to the *taxeme*, in Louis Hjelmslev's sense, but one can consider that it constitutes the largest *minimum segment* (the expression is borrowed from André Martinet), since at least one shot is required to make a film, or part of a film—in the same way, a linguistic statement must be made up of at least one phoneme. To isolate several shots from a sequence is still, perhaps, to analyze the sequence; to remove several frames from a shot is to destroy the shot. If the shot is not the smallest unit of filmic *signification* (for a single shot may convey several informational elements), it is at least the smallest unit of the filmic chain.

One cannot conclude, however, that every minimum filmic segment is a shot. Besides shots, there are other minimum segments, *optical devices*—various dissolves, wipes, and so on—that can be defined as visual but not photographic elements. Whereas images have the objects of reality as referents, optical procedures, which do not represent anything, have images as referents (those contiguous in the syntagma). The relationship of these procedures to the actual shooting of the film is somewhat like that of morphemes to lexemes; depending on the context, they have two main functions: as "trick" devices (in this instance, they are sorts of semiologi-

cal exponents influencing contiguous images), or as "punctuation." The expression "filmic punctuation," which use has ratified, must not make us forget that optical procedures separate large, complex statements and thus correspond to the articulations of the literary narrative (with its pages and paragraphs, for example), whereas actual punctuation—that is to say, typographical punctuation—separates sentences (period, exclamation mark, question mark, semicolon), and clauses (comma, semicolon, dash), possibly even "verbal bases," with or without characteristics (apostrophe, or dash, between two "words," and so on).

## IN CONCLUSION

The concepts of linguistics can be applied to the semiotics of the cinema only with the greatest caution. On the other hand, the methods of linguistics—commutation, analytical breakdown, strict distinction between the significate and the signifier, between substance and form, between the relevant and the irrelevant, etc.—provide the semiotics of the cinema with a constant and precious aid in establishing units that, though they are still very approximate, are liable over time (and, one hopes, through the work of many scholars) to become progressively refined.

# PROBLEMS OF DENOTATION IN THE FICTION FILM

The film semiologist tends, naturally, to approach his subject with methods derived from linguistics. Consequently wherever the language of cinematography differs from language itself, film semiology encounters its greatest obstacles. Let us begin immediately with the points of *maximum difference*. There are two of them: There is the problem of the *motivation* of signs and that of the *continuity* of meanings. Or, if one prefers, the question of the arbitrariness of signs (in the Saussurian sense) and the question of discrete units.

## CINEMATOGRAPHIC SIGNIFICATION IS ALWAYS MORE OR LESS MOTIVATED, NEVER ARBITRARY

Motivation occurs on two levels: on that of the relationship between the denotative signifiers and significates, and that of the relations between the connotative signifiers and significates.

*Denotation*: The motivation is furnished by analogy—that is to say, by the perceptual similarity between the signifier and of the significate. This is equally true for the sound-track (the sound of a cannon on film resembles a real cannon sound) as for the image track (the image of a dog is like the dog).

We therefore have visual analogy and auditory analogy; for the cinema is derived from photography and from the phonograph, which are both modern technologies of *mechanical duplication*. Of course the duplication is never perfect; between the

object and its image there are many perceptible differences, which film psychologists have studied. But, from the point of view of semiotics, it is not necessary that the signifier and the significate be *identical*. Simple analogy provides sufficient motivation.

For, even when it partially distorts its model, mechanical duplication does not *analyze* into specific units. There is no actual transformation of the object, but a simple partial *distortion*, which is purely perceptual.

*Connotation*: Connotative meanings are motivated, too, in the cinema. But in this case the motivation is not necessarily based on a relationship of perceptual analogy. . . .

We will not insist upon the problems of cinematographic connotation here, for this is a study of denotation. Suffice it to say that cinematographic connotation is always symbolic in nature: The significate motivates the signifier but goes beyond it. The notion of *motivated overtaking* (*depassement motivé*) may be used to define almost all filmic connotations. Similarly, one says that the cross is the symbol of Christianity because, although Christ died on a cross (the motivation), there are many more things in Christianity than there are in a cross (the "overtaking").

The *partial motivation* of filmic connotations does not prevent them from giving rise quite often to codifications or to conventions, which are more or less extended according to the case. Here is a simple example: In a talking film in which the hero has, among other diegetic peculiarities, the habit of whistling the first bars of a certain tune—and provided that this fact has been clearly impressed upon the spectator from the beginning of the film—the mere appearance of the tune on the sound track (in the visual absence of the hero himself) will be sufficient to suggest the totality of the character later in the film after the hero has gone on a long journey or even vanished. It is not without powerful connotations that the character may have been thus designated. In this simplified example we see that the hero has not been "symbolized" by some arbitrary characteristic, but by a feature entirely his own (thus, lack of *total* arbitrariness). Yet in the whole character there was more than just the familiar tune; other features, which belong to him also, could have been chosen to "symbolize" him (and would have involved other connotations). There is, then, some arbitrariness in the relationship between the connotative signifier (the melody) and the connotative significate (the character).

Even the subtlest and most ingenious cinematographic connotations are based then on this simple principle, which we might state as follows: A visual or an auditory theme—or an arrangement of visual and auditory themes—once it has been placed in its correct syntagmatic position within the discourse that constitutes the whole film, takes on a value greater than its own and is increased by the additional meaning it receives. But this addition itself is never entirely "arbitrary," for what the theme symbolizes in this manner is an integral situation or whole process, *a part of which in fact it is*, within the story told by the film (or which the spectator knows to be an actual part of life). In short, the connotative meaning *extends over* the denotative meaning, but without *contradicting* or *ignoring* it. Thus the partial arbitrariness; thus the absence of total arbitrariness. . . . Many of the misunderstandings and arguments about these subjects derive from the fact that no one has yet attempted to draw up a half-way complete list of the different heterogeneous and superimposed codes co-

present in any cultural activity of some importance, and no one has yet tried to clarify the precise organization of their interactions.*

In any event, it seems to me that one can distinguish at least two main types of signifying organization: *cultural* codes and *specialized* codes. The first define the culture of each social group; they are so ubiquitous and well "assimilated" that the viewers generally consider them to be "natural"—basic constituents of mankind itself (although they are clearly *products*, since they vary in space and time). The handling of these codes requires no *special* training—that is to say, no training other than that of living, and having been raised, in a society. On the other hand the codes I have called "specialized" concern more specific and restricted social activities. They appear more explicitly as codes, and they require a special training—to a large or small extent depending on the case (relatively "small" in the cinema)—that is to say, a training even the "native" person, possessing the culture of his group, cannot dispense with. . . .

A Frenchman, born and raised in France, does not need to be specially taught the gestures expressing anger, refusal, resigned acceptance, or the gesture that stands for "Come here!"—but, though he is French, he will need to be specially taught the sign language of the deaf and dumb (in his own language), otherwise he will never know it.

The purely cinematographic signifying figures studied here (montage, camera movements, optical effects, "rhetoric of the screen," interaction of visual and auditory elements, and so on) constitute specialized codes—although relatively "easy" ones, as we will see later—that function above and beyond photographic and phonographic analogy. The iconological, perceptual, and other codes are cultural codes, and they function in good part *within* photographic and phonographic analogy, as Umberto Eco, to whom the hypothesis advanced in these pages owes much, has rightly pointed out.

So far, I have been speaking about denotation (the literal sense of the film). But, among the large body of connoted significations in the cinema (the "symbolic sense" of all varieties), there are a certain number that, outside of the specifically cinematographic codifications, intrude into the film by means of perceptual analogy each time an object or an ordering of objects (visual or auditory) "symbolizes" within the film what it would have symbolized outside of the film—that is to say, within culture (with the chance that it will carry *in addition*, and only in the film, symbolic significations that will then derive from its location within the cinematographic discourse proper). "Objects" (and characters must also be included)—that is to say, the different basic elements of filmic discourse—do not enter the film in a virgin state; they carry with them, before even "cinematographic language" can intervene, a great deal more than their simple literal identity—which does not prevent the spectator belonging to a given culture from deciphering this "increment" at the same time that he identifies the object. . . .

---

*The discussions that have taken place in recent years about the semiotics of the cinema have made it appear more and more clearly that *the cinema as a whole* is a locus where many signifying systems are superimposed and interwoven—and that *cinematographic language* is only one of these systems.

# THE CINEMA AS SUCH HAS NOTHING CORRESPONDING TO THE DOUBLE ARTICULATION OF VERBAL LANGUAGES

Let us note first that the cinema has no *distinctive* units (I mean distinctive units of its own).* It does not have anything corresponding to the phoneme or to the relevant phonic feature on the level of expression, nor, on the level of content, does it have anything equivalent to the seme in Algirdas Julien Greimas's sense, or in Bernard Pottier's sense.

Even with respect to the signifying units, the cinema is initially deprived of discrete elements. It proceeds by whole "blocks of reality," which are actualized with their total meaning in the discourse. These blocks are the "shots." The discrete units identifiable in the filmic discourse on another level—for, as we shall see, there is another level—are not equivalent to the first articulation of spoken languages.

Certainly, it is true that montage is in a sense an analysis, a sort of articulation of the reality shown on the screen. Instead of showing us an entire landscape, a film-maker will show us successively a number of partial views, which are broken down and ordered according to a very precise intention. It is well known that the nature of the cinema is to transform the world into discourse.

But this kind of articulation is not a true articulation in the linguistic sense. Even the most partial and fragmentary "shot" (what film people call the close-up) still presents a complete segment of reality. The close-up is only a shot taken closer than other shots.

It is true that the film *sequence* is a real unit—that is to say, a sort of coherent *syntagma* within which the "shots" react (semantically) to each other. This phenomenon recalls up to a certain point the manner in which words react to each other within a sentence, and that is why the first theoreticians of the cinema often spoke of the shot as a word, and the sequence as a sentence. But these were highly erroneous identifications, and one can easily list five radical differences between the filmic "shot" and the linguistic word:

(1) Shots are infinite in number, contrary to words, but like statements, which can be formulated in a verbal language.

(2) Shots are the creations of the film-maker, unlike words (which pre-exist in lexicons), but similar to statements (which are in principal the invention of the speaker).

(3) The shot presents the receiver with a quantity of undefined information, contrary to the word. From this point of view, the shot is not even equivalent to the

---

*I mean to say that cinematographic language as such lacks distinctive units. For, as a totality, the cinema contains various other signifying systems, each one of which behaves differently in relation to the problem of articulations.

The most obvious example—there are others less apparent—of the superposition of codes within the total cinematographic institution (superpositions that complicate the problem of the articulations in the cinema) is provided by the occurrence of the *verbal element* in talking films: The effect of its intervention is to integrate the doubly articulated significations into the global message of the film, but not into the specific language of the "cinema."

sentence. Rather, it is like the complex statement of undefined length (how is one to describe a film shot completely by means of natural language?).

(4) The shot is an actualized unit, a unit of discourse, an assertion, unlike the word (which is a purely virtual lexical unit), but like the statement, which always refers to reality or a reality (even when it is interrogative or jussive). The image of a house does not signify "house," but "Here is a house"; the image contains a sort of index of actualization, by the mere fact that it occurs in a film.

(5) Only to a small extent does a shot assume its meaning in paradigmatic contrast to the other shots that might have occurred at the same point along the filmic chain (since the other possible shots are infinite in number), whereas a word is always a part of at least one more or less organized semantic field. The important linguistic phenomenon of the clarification of present units by absent units hardly comes into play in the cinema. Semiologically, this confirms what the aestheticians of the cinema have frequently observed: namely, that the cinema is an "art of presence" (the dominance of the image, which "shuts out" everything external to itself).

The filmic "shot" therefore resembles the statement rather than the word. Nevertheless, it would be wrong to say that it is equivalent to the statement. For there are still great differences between the shot and the linguistic statement. Even the most complex statement is reducible, in the final analysis, to discrete elements (words, morphemes, phonemes, relevant features), which are fixed in number and in nature.

To be sure, the filmic shot is also the result of an ordering of several elements (for example, the different visual elements in the image—what is sometimes called the *interior montage*), but these elements are indefinite in number and undefined in nature, like the shot itself. The analysis of a shot consists in progressing from a nondiscrete whole to smaller nondiscrete wholes: One can decompose a shot, but one cannot reduce it.

All that can be affirmed, therefore, is that a shot is less unlike a statement than a word, but it does not necessarily resemble a statement.

## THE LARGE SYNTAGMATIC CATEGORY OF THE IMAGE TRACK

So far, I have examined only the status of "cinematographic grammar," and I have said nothing about its *content*. I have not given the table of the codified orderings of various kinds used in film.

It is not possible here to give this table in its complete form, with all the explanations required by each one of the indicated orderings, and with the *principles of commutation* between them (and consequently to enumerate them).

Let us content ourselves, then, with the almost unpolished "result,"—the table itself in a summarized form—and only that part of it that outlines the large syntagmatic category of the image track (i.e., the codified and signifying orderings on the level of the *large** units of the film, and ignoring the elements of sound and speech).

Naturally this problem constitutes only one of the chapters of "cinematographic syntax."

In order to determine the number and the nature of the main syntagmatic *types* used in current films, one must start from common observation (existence of the "scene," the "sequence," "alternate montage," etc.) as well as on certain "presemiotic" analyses by critics, historians, and theoreticians of the cinema ("tables of montage," various classifications, etc.). This preliminary work must account for several points of importance—that is why it in no way precludes the viewing of numerous films—and it must then be organized into a coherent body—that is to say, into a list of all the main types of image-orderings occurring in films under the various headings into which they are naturally classified.

One thus arrives at a first "tabulation" of the syntagmatic components of films—a chart remaining fairly close to the concrete filmic material, but which, from the point of view of semiological theory, is as yet insufficiently developed. . . .

At present, then, I distinguish eight main types of autonomous segments, that is, "sequences" (but henceforth I will reserve the term sequence for only two of these eight types, numbers 7 and 8).

The autonomous segment is a subdivision of the first order in film; it is therefore a part of a film, and not a part of a part of a film. (If an autonomous section is composed of five successive shots, each one of these shots is a part of a part of the whole film—that is to say, a nonautonomous segment). It is clear nevertheless that the "autonomy" of the autonomous segments themselves is not an *independence*, since each autonomous segment derives its final meaning in relation to the film as a whole, the latter being the *maximum syntagma* of the cinema.

In distinguishing between the "shot" and the "sequence," everyday language clearly indicates that there are two things in the cinema (without prejudice to eventual intermediate levels): On the one hand there is the minimum segment, which is the shot, and on the other hand the autonomous segment. This, as we will see shortly, does not prevent a minimum segment from being occasionally autonomous.

Let us now examine our eight syntagmatic types.

(1) At first relevance allows us to distinguish autonomous segments constituted by a single shot—that is to say, *autonomous shots*—from the seven other varieties of autonomous segment, which all contain several shots. The latter are therefore all *syntagmas* (autonomous segments having more than one minimum segment). In the case of the autonomous shot, on the contrary, a single shot presents an "episode" of the plot. The autonomous shot is therefore the only instance where a single shot constitutes a primary, and not a secondary, subdivision of the film. Similarly, in literature the sentence is a unit smaller than the paragraph, but some paragraphs contain only one sentence (in linguistics the same could be said of the relation between the

---

*That is to say, on a level roughly corresponding to that of the "sequence" in the usual sense of that word. The term "large syntagmatic category" is therefore meant to indicate the difference between this approach and, for example, a shot-by-shot analysis, or an analysis within the shot itself. But one must not forget that an even broader syntagmatic level also exists: groups of sequences, "main parts" of the film, return or repetition of extended motifs, etc.

**General Table of the Large Syntagmatic Category of the Image-Track**

*In italics*: the syntagmatic types that are initially identifiable in films (inductive method), but which are arrived at last in the system (deductive method)—that is to say, the eight main syntagmatic types.

Each of these types is given the number it had in the text.

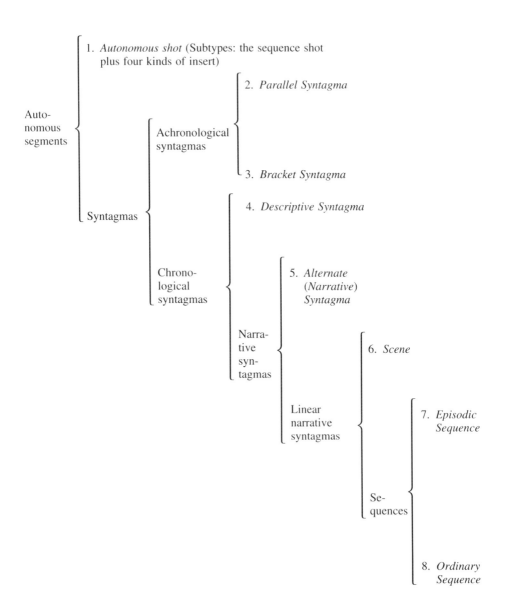

phoneme and the moneme, or between the moneme and the statement: in other words, we are dealing with a phenomenon that is common in semiotics). In short, some of the autonomous segments of a film are syntagmas, and others are not; conversely, some of the shots in a film are autonomous and others are not.

The autonomous shot includes several subtypes: There is, on the one hand, the famous "sequence shot" of the modern cinema (an entire scene treated in a single shot; the shot derives its autonomy from the unity of "action"); on the other hand, there are the various kinds of shot that owe their autonomy to their status as syntagmatic *interpolations* and could be collectively termed *inserts*. If one selects the *cause* of their interpolative nature as a principle of classification, one will notice that up to now there have been only four types of insert in the cinema: the *nondiegetic* insert (i.e., image having a purely comparative function; showing an object which is external to the action of the film); the *subjective* insert (i.e., image conveying not the present instance, but an absent moment experienced by the hero of the film. Examples: images of memory, dream, fear, premonition, etc.); the *displaced diegetic* insert (an image that, while remaining entirely "real," is displaced from its normal filmic position and is purposely intruded into a foreign syntagma. Example: Within a sequence showing the pursuers, a single shot of the pursued is inserted); and, finally, the *explanatory* insert (the enlarged detail, in a magnifying-glass effect. The detail is removed from its empirical space and is presented in the abstract space of a mental operation. Example: close-up of a visiting card or letter).

(2 and 3) Among the syntagmas (autonomous segments composed of several shots), a second criterion allows us to distinguish between *nonchronological* and chronological syntagmas. In the first variety, the temporal relationship between the facts presented in the different images is not defined by the film (i.e., temporary withdrawal of the significate of temporal denotation); in the second kind it is.

I have so far identified two main types of nonchronological syntagma. One of them is well known by film aestheticians and is called "parallel montage sequence" (I prefer to say *parallel syntagma*, to save the word "sequence" for other uses). Definition: montage brings together and interweaves two or more alternating "motifs," but no precise relationship (whether temporal or spatial) is assigned to them—at least on the level of denotation. This kind of montage has a direct symbolic value (scenes of the life of the rich interwoven with scenes of the life of the poor, images of tranquility alternating with images of disturbance, shots of the city and of the country, of the sea and of wheat fields, and so on).

The second type of nonchronological syntagma has not (to my knowledge) been identified before, but it is easily isolated in films. Definition: a series of very brief scenes representing occurrences that the film gives as typical samples of a same order of reality, without in any way chronologically locating them in relation to each other in order to emphasize their presumed kinship within a category of facts that the filmmaker wants to describe in visual terms. None of these little scenes is treated with the full syntagmatic breadth it might have commanded; it is taken as an element in a system of allusions, and therefore it is the series, rather than the individual, that the film takes into account. Thus the series is equivalent to a more ordinary sequence, and so it constitutes an autonomous segment (this is a kind of filmic equivalent to conceptualization). Example: the first erotic images of *Une Femme mariée* (Jean-Luc Godard,

1964) sketch a global picture of "modern love" through variations and partial repetitions; or again, the succeeding shots of destruction, bombings, and grief at the beginning of *Quelque part en Europe* (Geza Radvanyi, 1947) are an exemplary illustration of the idea of the "Disasters of War."

Let us call this construction of images the *bracket syntagma*, since it suggests that, among the occurrences that it groups together, there is the same kind of relationship as that between the words in a typographical bracket. In the bracket syntagma it is frequently the case that different successive evocations are strung together through optical effects (dissolves, wipes, pan shots, and, less commonly, fades). This use, which has a redundant function, provides the sequence with a common thread and confirms the viewer's impression that the sequence must be taken as a whole, and that he must not attempt to link the short partial scenes directly to the rest of the narrative. Example: in *The Scarlet Empress* (Joseph von Sternberg, 1935), the sequence that constructs the terrifying yet fascinating image of Tzarist Russia that the future empress images as a little girl (prisoners tied to giant bell clappers, the executioner with his axe, and so on).

Thus, among the nonchronological syntagmas, it is the presence or absence of a systematic alternating of images in interwoven series that allows us to distinguish between the parallel syntagma and the bracket syntagma (presence equals parallel syntagma; absence equals bracket syntagma). The bracket syntagma directly groups all the images together; the parallel syntagma contains two or more series, each one having several images, and these series alternate on the screen (A B A/B, etc.).

(4) In the *chronological* syntagmas, the temporal relationships between the facts that successive images show us are defined on the level of denotation (i.e., literal temporality of the plot, and not just some symbolic, "profound" time). But these precise relationships are not necessarily those of consecutiveness; they may also be relations of simultaneity.

There is one syntagmatic type in which the relationship between *all* the motifs successively presented on the screen is one of simultaneity: the descriptive syntagma (i.e., various filmic descriptions). It is the only case of consecutiveness on the screen that does not correspond to any diegetic consecutiveness. (Remember that the screen is the location of the signifier, and the diegesis is the location of the significate). Example: the description of a landscape (a tree, followed by a shot of a stream running next the tree, followed by a view of a hill in the distance, etc.). In the descriptive syntagma, the only intelligible relation of coexistence between the objects successively shown by the images is a relation of *spatial* coexistence.

This in no way implies that the descriptive syntagma can only be applied to *motionless* objects or persons. A descriptive syntagma may very well cover an action, provided that it is an action whose only intelligible internal relationship is one of spatial parallelism at any given moment in time—that is to say, an action the viewer cannot mentally string together in time. Example: a flock of sheep being herded (views of the sheep, the shepherd, the sheepdog, etc.). In the cinema as elsewhere, description is a modality of discourse, and not a substantial characteristic of the object of discourse; the same object can either be *described* or *told*, depending on the logic of what is said about it.

(5) All chronological syntagmas other than the descriptive syntagma are *narrative syntagmas*—that is to say, syntagmas in which the temporal relationship between the

objects seen in the images contains elements of consecutiveness and not only of simultaneity. But within the narrative syntagmas there are two divisions: The syntagma may interweave several distinct temporal progressions, or, on the contrary, it may consist of a single succession encompassing all of the images. Thus, the alternate narrative syntagma (or *alternate syntagma*) is distinguished from the various sorts of linear narrative syntagma.

The alternate syntagma is well known by theoreticians of the cinema under the names "alternate montage," "parallel montage," "synchronism," etc., depending on the case. Typical example: shot of the pursuers, followed by a shot of the pursued, and back to a shot of the pursuers. Definition: The montage presents alternately two or more series of events in such a way that within each series the temporal relationships are consecutive, but that, between the series taken as wholes, the temporal relationship is one of simultaneity (which can be expressed by the formula "Alternating of images equals simultaneity of occurrences").

(6) Within the *linear narrative syntagmas* (i.e., a single succession linking together all the acts seen in the images), a new criterion lets us make yet another distinction: Succession may be *continuous* (without break or ellipsis) or discontinuous (jumps). Naturally one must not count as true ellipses—that is to say, as *diegetic breaks*—what might be called simple camera breaks (i.e., temporal continuity is interrupted by a displacing of the camera, or by a cutaway, and is then taken up again at the exact chronological point it had meanwhile reached).

When succession is continuous (i.e., with no diegetic breaks), we have the only kind of syntagma in the cinema that resembles a "scene" in the theater—or a scene in everyday life—that is to say, it represents a spatio-temporal integrality experienced as being without "flaws" (by "flaw" I mean those brusque effects of appearance or disappearance that are the frequent corollaries of the very multiplicity of shots, which film psychologists have studied and which constitute one of the major differences between filmic perception and real perception). This is the *scene properly speaking* (or simply scene). It was the only construction known to the early film-makers; it still exists today, but merely as one type among other types (it is therefore commutable). Example: conversation scenes (the presence on the sound-track of a coherent succession of linguistic statements has the effect of rendering a unitary, "flawless" visual construction more probable—though not obligatory).

Thus, through means that are *already* filmic (separate shots that are later combined), the scene reconstructs a unit *still* experienced as being "concrete": a place, a moment in time, an action, compact and specific. The signifier is fragmentary in the scene—a number of shots, all of them only partial "profiles" (*Abschattungen*)—but the significates is unified and continuous. The profiles are interpreted as being taken from a common mass—for what one calls "viewing a film" is in fact a very complex phenomenon, constantly involving three distinct activities (perception, restructuring of the visual field, and immediate memory), which propel each other on, and, as fast as it comes in, never cease working on the information they furnish to themselves.

(7 and 8) Distinct from, and opposed to, the scene are the various kinds of linear narrative syntagma in which the temporal order of the facts presented is *discontinuous*. They are the *sequences proper*.

Within the sequence proper (i.e., single discontinuous temporal order), one finds two species. The temporal discontinuity may be unorganized and, so to speak, scat-

tered—and the viewer skips the moments that have, to his mind, no direct bearing on the plot: This is the *ordinary sequence*, a syntagmatic type very common in the cinema. On the other hand, the discontinuity may be *organized* and may therefore be the principle of structure and intelligibility in the sequence, in which case we have what I would call the *episodic sequence*. Definition: The sequence strings together a number of very brief scenes, which are usually separated from each other by optical devices (dissolves, etc.) and which succeed each other in chronological order.* None of these allusive little scenes is treated with the syntagmatic thoroughness it might have commanded, for the scenes are taken not as separate instances but only in their totality, which has the status of an ordinary sequence and which therefore constitutes an autonomous segment. In its extreme form (that is, when the successive episodes are separated by a long diegetic duration), this construction is used to condense gradual progressions. In Orson Welles's *Citizen Kane* (1941), the sequence portraying the gradual deterioration of the relationship between the hero and his first wife shows a chronological series of quick allusions to dinners shared by the couple in an atmosphere that is decreasingly affectionate; the scenes, treated in a succession of pan shots, are connected over intervening periods of months. In a less spectacular but structurally identical form, the episodic sequence is used to represent, through a series of regularly distributed (and less "striking") abridgements, various kinds of minor diegetic progression of less extended total duration by systematically isolating some of their succeeding "moments."

The ordinary sequence and the episodic sequence are both sequences in the proper—including the extracinematographic—sense of the word: the concept of a single concatenation plus the concept of discontinuity. However, in the episodic sequence, each one of the images constituting the series appears distinctly as the symbolic summary of one stage in the fairly long evolution condensed by the total sequence. In the ordinary sequence, each one of the units in the narrative simply presents one of the unskipped moments of the action. Consequently, in the first case each image stands for more than itself and is perceived as being taken from a group of other possible images representing a single phase of a progression.

For all that, the ordinary sequence itself already constitutes a more specifically filmic narrative unit, and one that is more removed from the conditions of real perception, than the film scene (and *a fortiori* the theater scene); unlike the scene, the sequence is not the locus of the coincidence—even in principle—of screen time and diegetic time (time of the signifier and time of the significate). The sequence is based on the unity of a more complex action (although it is still single, contrary to what occurs, for example, in the parallel syntagma or in the bracket syntagma), an action that "skips" those portions of itself it intends to leave out and that is therefore apt to unfold in several different locations (unlike the scene). A typical example is the sequence of escape (in which there is an approximate unity of place, but one that is essential rather than literal: that is, the "escape-location," that paradoxical unit, the mobile locus). Thus, one encounters diegetic breaks within the sequence (and not just

---

*That is the major difference between the episodic sequence and the bracket syntagma. Otherwise, as one can readily see, the two types have many characteristics in common.

camera interruptions, as in the scene), but these hiatuses are considered insignificant—at least on the level of denotation—and are to be distinguished from those indicated by the faces or by any other optical device between two autonomous segments. Indeed, the latter are reputed to be over-significant, even in denotation: We are told nothing, yet we are informed that a great deal could be told us (the fade is a segment that shows nothing but is very visible), and the "skipped moments" emphasized in this way are presumed to have influenced the events narrated by the film (unlike diegetic breaks within the sequence) and to be therefore necessary in some way, despite their absence, to the literal intellection of whatever follows. . . .

## RELATIONS BETWEEN THE LARGE SYNTAGMATIC CATEGORY AND THE CONCEPT OF CINEMATOGRAPHIC "MONTAGE"

Each of the eight main syntagmatic types—with the exception of the autonomous shot, where the problem does not occur—may be effected in one of two ways: either by recourse to *montage proper* (as was usually the case in the cinema of the past) or by means of *subtler forms of syntagmatic ordering* (as is often the case in the modern cinema). Combinations that avoid *collage*-juxtaposition (i.e., continuity shooting, long shots, sequence shots, use of the "wide" screen, and so on) are nonetheless *syntagmatic* constructions, examples of montage in the broad sense, as Jean Mitry has clearly shown. It is true that the concept of montage as irresponsible, magical, and all-powerful manipulation has become obsolete. However, montage as the *structuring of intelligible coherence by means of various "conjunctures"* is by no means "outmoded," since film is always *discourse*, and therefore the locus of many different actualized elements.

Example: A filmic description can be made in a single "shot," apart from any kind of montage, simply through camera movements: The intelligible structure ordering the different visual elements is the same as that linking the different *shots* within a classical descriptive syntagma. Montage proper is an *elementary* form of the large syntagmatic category of film, for each "shot" theoretically isolates a single visual element. Thus the *relation between visual elements* coincides with the relation between shots, rendering analysis easier than in the complex (and culturally "modern") forms of the cinematographic syntagmatic category.

Consequence: A deeper analysis of the syntagmatic category in modern films would require revising the status of the autonomous shot—at the very least in its form of "sequence shot"—because, up to a certain point, it may contain image structures that, in the seven other syntagmatic types, continue to exist in a free "undetermined" state. (This is the phenomenon expressed very approximately, in a simple juxtaposition of words, by the term "sequence shot.")

## REMARK ON THE DIACHRONIC EVOLUTION OF CINEMATOGRAPHIC CODES

The large syntagmatic category of the cinema is not immutable; it has a diachronic aspect. It evolves distinctly *faster* than languages do, a circumstance derived from the

fact that art and language are more closely interrelated in film than in the verbal field. The creative film-maker exerts more influence on the diachronic evolution of cine- matographic language than the imaginative writer on the evolution of his idiom, for idiom may exist in the absence of art, whereas the cinema must be an art to become a language with a partial denotative code. Remember, also, that film-makers consti- tute a limited social group (creative group), whereas the users of language are coex- tensive as a group with society itself (user group).

Nevertheless the large syntagmatic category of the cinema ensures a codification that is coherent for every diachronic "state." Too great a deviation from this codifica- tion at any given moment results in the inability to understand—for the mass of the spectators—the film's literal meaning (example: certain "avant-garde" films).

## "NATURAL LOGIC" AND CONVENTIONAL CODIFICATION IN FILMIC ORDERING

Cinematographic "grammar" is codified, but it is not arbitrary. The distinction between the arbitrary and the motivated does not at all coincide, in this case, with that between the "free" and the codified.

The syntagmatic types in which denotation is not *analogous* retain a certain amount of *naturalness* in their relationship of the significate to the signifier. Thus, in the alternate syntagma, denotation is not analogous—since the images alternate while the facts are presumably simultaneous and not alternating—yet, it has been shown[26] that the intelligibility of this kind of montage is based on a spontaneous form of interpolation that the spectator practices quite naturally (i.e., as soon as the rhythm of the alternating becomes sufficiently rapid, the spectator is able to guess that a series of events, A, is continuing to unfold in the diegesis, while only a fragment of the series of events, B, is being shown on the screen).

But this "natural" characteristic is not total, and therefore we can speak only of par- tial codification. Among the possible image structures (a fairly large number of which should exist), only a few are conventionalized; among the more or less natural (or *log- ical*) patterns of intelligibility on which the cinema *could* build its syntagmatic order- ings, only a very few are retained—and they become *effective* patterns of intellection and are almost always grasped by the normal, adult spectator belonging to a society acquainted with the cinema. It is striking that, compared to all the conceivable image orderings, only a very small number is actually used. Just as in semantics there is the arbitrariness of lexicalization, in the cinema one has the arbitrariness of grammati- calization.

This alliance between natural logic and conventional codification has a conse- quence that has been singled out, with varying degrees of clarity, by psychosociolo- gists, educators, filmologists, and the specialists of "popular animation": The prac- tice of the cinema, both in its creating and in its viewing, requires a certain *apprenticeship*, but this apprenticeship is very *slight* compared to the one language demands. On the phylogenetic level, the evolution of cinematographic language took approximately twenty years (from 1895 to 1915 roughly: from Lumière to Griffith)— this is both a long time and a very short time. On the ontogenetic level, it is known

that, before approximately the age of twelve years, a child is not able to grasp the literal meaning of an ordinary modern feature film in its whole continuity, but after that age he is gradually able to do so without having to undergo massive schooling such as the learning of a foreign language (or even a thorough knowledge of the mother tongue) requires. This is also true of adults in societies without cinema (black Africa, etc.): At first contact, they do not immediately understand the complex films of our societies, but later they are able to grasp them quite rapidly. All investigations agree on these points. . . .

## FILM AND DIEGESIS: THE SEMIOTICS OF THE CINEMA AND THE SEMIOTICS OF THE NARRATIVE

The reader will perhaps have observed in the course of this article (and especially in the definition of the different types of autonomous segment) that it is no easy matter to decide whether the large syntagmatic category in film involves the *cinema* or the cinematographic *narrative*. For all the units I have isolated are located *in* the film but in *relation* to the plot. This perpetual see-saw between the screen instance (which signifies) and the diegetic instance (which is signified) must be accepted and even erected into a methodological principle, for it, and only it, renders commutation possible, and thus identification of the units (in this case, the autonomous segments).

One will never be able to analyze film by speaking *directly* about the diegesis (as in some of the film societies, *ciné clubs*, in France and elsewhere, where the discussion is centered around the plot and the human problems it implies), because that is equivalent to examining the significates without taking the signifiers into consideration. On the other hand, isolating the units without considering the diegesis *as a whole* (as in the "montage tables" of some of the theoreticians of the silent cinema) is to study the signifiers without the significates—since the nature of narrative film is to narrate. . . .

The necessity of this see-sawing I have just described is nothing other than the consequence of an underlying cultural and social fact: The cinema, which could have served a variety of uses, in fact is most often used to *tell stories*—to the extent that even supposedly nonnarrative films (short documentary films, educational films, etc.) are governed essentially by the same semiological mechanisms that govern the "feature films."

Had the cinema not become thoroughly narrative, its grammar would undoubtedly be entirely different (and would perhaps not even exist). The reverse of this coin, however, is that a given narrative receives a very different semiological treatment in the cinema than it would in a novel, in classical ballet, in a cartoon, and so on.

There are therefore two distinct enterprises, neither of which can replace the other: On the one hand, there is the semiotics of the narrative film, such as the one I am attempting to develop; on the other hand, there is the structural analysis of actual narrativity—that is to say, of the narrative taken *independently from the vehicles carrying it* (the film, the book, etc.). . . . The *narrated event*, which is a significate in the semiotics of narrative vehicles (and notably of the cinema), becomes a signifier in the semiotics of narrativity.

## CONCLUSION

The concept of a "cinematographic grammar" is very much out of favor today; one has the impression, indeed, that such a thing cannot exist. But that is only because it has not been looked for in the right place. Students have always implicitly referred themselves to the *normative grammar of particular languages* (namely, their maternal languages), but the linguistic and grammatical phenomenon is much vaster than any single language and is concerned with the *great and fundamental figures of the transmission of all information.* Only a general linguistics and a general semiotics (both nonnormative and simply analytical disciplines) can provide the study of cinematographic language with the appropriate methodological "models." It does not suffice merely to observe that there is nothing in the cinema corresponding to the consecutive clause in French, or to the Latin adverb, which are extremely particular linguistic phenomena, are not necessary, and are not universal. The dialogue between the film theoretician and the semiologist can commence only beyond the level of such idiomatic specifications or such restrictive prescriptions. *The fact that must be understood is that films are understood.* Iconic analogy alone cannot account for the intelligibility of the co-occurrences in filmic discourse. That is the function of the large syntagmatic category.

1968

# STEPHEN PRINCE
# THE DISCOURSE OF PICTURES: ICONICITY AND FILM STUDIES

In its analysis of images, film theory since the 1970s has been deeply indebted to structuralist and Saussurean-derived linguistic models. Indeed, it would be difficult to overstate the depth and importance of this relationship. As Robert Stam has noted, "Semiotics in general, and film semiotics in particular, must be seen . . . as local manifestations of a more widespread linguistic turn."[1] To speak, for example, about "reading" a film, as many film analysts now do, irrespective of the critical methodology employed to generate the reading, is to index and emphasize this lineage. Like books, films are regarded as texts for reading by viewers or critics, with the concomitant implication that such reading activates similar processes of semiotic decoding.

But does it? To what extent are linguistic models appropriate for an understanding of how images communicate? Film theory since the 1970s has tended to place great emphasis upon what is regarded as the arbitrary nature of the signifier-signified relationship, that is, upon the purely conventional and symbolic aspect of signs. What this focus has tended to displace is an appreciation of the iconic and mimetic aspect of certain categories of signs, namely pictorial signs, those most relevant to an understanding of the cinema. This stress upon the arbitrary nature of semiotic coding has had enormous consequences for the way film studies as a discipline has tended to frame questions about visual meaning and communication.

Our purpose here is to examine some of these consequences and to see how well they square with the observable evidence about how viewers perceive and compre-

---

My thanks to Carl Plantinga for reading an earlier version of this essay and offering helpful suggestions.

[1] Robert Stam, "Film and Language: From Metz to Bakhtin," in *The Cinematic Text: Methods and Approaches*, ed. R. Barton Palmer (New York: AMS Press, 1989), p. 277.

hend cinematic sequences. We will see that current film theory, tracing its lineage from Saussure, Althusser, and Lacan, has constructed accounts of the ways in which film transmits meaning that are, in certain important respects, counter to the observable skills, abilities, and reactions of real-world viewers. The viewer, as theorized in these accounts, differs substantially from his/her real-world counterpart. We shall emphasize some of these discrepancies in order to suggest a reorientation of theoretical focus. In short, a renewed attention to the iconic, mimetic nature of pictorial signs is warranted, so that our theories might become more sensitive to the unique, constitutive features of pictorial—as opposed to linguistic—modes of communication. (It is important to note that other currents exist in contemporary film theory. Pier Paolo Pasolini and Peter Wollen, for example, have offered analyses of cinematic signs that are inflected rather differently than the Saussurean-inspired accounts that this essay examines.[2] More than 20 years ago, Wollen stressed the importance of paying attention to the iconic aspect of pictorial signs. Borrowing from Charles Peirce's triadic model of the sign, he argued that in cinema, iconic and indexical aspects are more powerful than symbolic, and he pointed out that semiologists have neglected the subject of iconic signs because they are biased in favor of conceptions of signs as arbitrary and symbolic.)

Let me state very clearly at the outset that this suggested reorientation is not intended as a substitute for the very real and necessary work on the role that culture plays in film spectatorship and interpretation. Culture-bound attitudes do indeed inflect the content of film narratives, along with their stylistic visualization, at the point of production and, again, through the inferences viewers draw from those narratives. The position this essay takes is not intended as a replacement either for the critical work of ideological analysis and interpretation, or for inquiries into how viewers' judgements about the nature of a social world depicted in film may be shaped by elements of cinematic structure. But, in the interest of conducting this kind of interpretive work, it is important to have a clear sense of where cultural variables do and do not enter into the production of meaning by the cinematic image. Only when we have a good understanding of those aspects of visual signification where culture plays a less determinative role are we likely to be able to construct a clear portrait of where it does play a role. Thus, this essay certainly does not argue against the role of cultural analysis in film interpretation, but it does attempt to suggest some reasons for caution when employing linguistic categories and models of cultural relativism in film analysis. It is not that there are no cases in which they might profitably be applied, but rather that there are some significant aspects of visual communication to which they probably *should not* be applied.

## THE LINGUISTIC TURN IN CONTEMPORARY FILM STUDIES

To begin, it will help to briefly trace the linguistic influence on contemporary film theory, after which we may question whether it supplies an adequate account of

---

[2]See Pier Paolo Pasolini, *Heretical Empiricism*, ed. Louise K. Barnett, trans. Ben Lawton and Louise K. Barnett (Bloomington: Indiana University Press, 1988) and Peter Wollen, *Signs and Meaning in the Cinema* (Bloomington: Indiana University Press, 1976), especially pp. 116–54.

images or even, in certain crucial respects, of language itself. It is well known that Saussure's account of the sign as having an arbitrary and unmotivated connection between its structural components has been directly taken over by many film theorists. As Philip Rosen has pointed out, "One effect of the argument for the basic conventionality of cinematic images was to open the way for a utilization of the ideal of difference in cinematic signification."[3] Stressing the signifier as a differential construction enabled film theory to emphasize communication as discourse, as a culture-bound activity, relative to and differentially patterned by the unique social worlds of diverse groups of interactants. Signs, whether linguistic or cinematic, were viewed as culturally instantiated: "Sign systems don't produce meaning outside of the social and cultural context from which they have developed."[4]

This concept of the sign enabled theorists to explicate many aspects of cinematic coding, from discrete optical devices like dissolves or wipes to more complex structures such as shot/reverse-shot cutting, subjective images, and other aspects of point-of-view editing. Viewing these devices as symbolic codes permitted theorists to emphasize the construction of cinematic discourse, that is, the deployment in film of an elaborate semiotic system whose address, and effects, could be comprehensible in Althusserian-Lacanian terms as the interpellation of subjects. Using a symbol system like language, in this view, entails being positioned—socially, ideologically—in and by the categories which that system has helped create. Thus film, like language, could be comprehensible as discourse, as the creation of apparent meaning where only true relations of difference prevail (due to the arbitrary nature of the sign and the consequent need for it to receive definition only in relation to what it is not, i.e., to all other signs). As Althusser and Lacan (and the film theory they inspired) emphasized, these deceptively real constellations of apparently fixed meaning could be an excellent site for ideology and for imaginary conceptions of the self to take root. Viewed as discourse, cinema assumed a symbiotic relationship with ideology, becoming an effective vehicle for its transmission. The work of film theory became increasingly focused on deciphering the ideology at work inside the cinema's deceptive and transparent appearance of reality. That appearance of reality was, furthermore, suspect for having ideological effects (e.g., naturalizing that which is historical or cultural, etc.) and for creating ideal and false subject unities.[5] Viewed in these terms, film history is the history of discourse, and the relation between film and the world is a matter of representational convention. As Stephen Heath has written, "That reality, the match of film and world, is a matter of representation, and representation is in turn a matter of discourse. . . . [I]n this sense at least, film is a series of languages, a history of codes."[6]

---

[3]Philip Rosen, ed., *Narrative, Apparatus, Ideology* (New York: Columbia University Press, 1986), p. 3.

[4]"Introduction," in *Explorations in Film Theory: Selected Essays from Cine-Tracts*, ed. Ron Burnett (Bloomington: Indiana University Press, 1991), p. xv.

[5]In the influential analyses of Jean-Louis Baudry, these functions are a consequence of the machinery of camera and projector, irrespective of the content and subjects that are filmed. See "Ideological Effects of the Basic Cinematographic Apparatus" and "The Apparatus: Metapsychological Approaches to the Impression of Reality in the Cinema," in Rosen, ed., *Narrative, Apparatus, Ideology*, pp. 286–318. [see also this edition, pp. 355–65, 206–23.—EDS.]

[6]Stephen Heath, *Questions of Cinema* (New York: Macmillan, 1981), p. 26.

Furthermore, an emphasis upon differential and relational signifiers has entailed a denial, or, at best a suspicion, of reference. If signs are arbitrarily related to what they represent, then meaning is at best provisional, at worst illusory or ideological. Representation which is non-arbitrary tends to be construed by film theory in terms of a relationship of identity between sign and referent, thus generating a dichotomy of arbitrariness/identity. Semiotic representation is either a matter of arbitrary coding or of identity and transparence, with the latter condition being construed negatively in terms of illusion and error. Identity is regarded as a deceptively false universal, as a part of what is sometimes called the ideology of the visual. "Reading encounters the text as a relation of difference not identity."[7] Taken a step further, this view regards empirical knowledge about the world as being thoroughly mediated by signs, as itself discourse. "The empirical . . . is not 'the real' but the product of the discourses of the dominant ideology."[8] Since the "real" embodies the false universals of ideology, the relations among cinematic signifiers tend to be seen as cultural (and therefore symbolic), rather than as iconic or mimetic. The spectator's understanding of the cinema is therefore explained as a matter of cultural conditioning and learning. "The spectator chains together the film's signifiers on a cultural grid of intelligibility—an ensemble of assumptions and presuppositions about the 'real'—into an account that makes the film socially intelligible."[9]

Note the assumptions here. Language imposes a system of relational distinctions upon the world, creating culture from the real. One makes entry into language, or, in Lacanian terms, into the Symbolic order, learning the culturally patterned distinctions and, in the process, being interpellated as a subject. Film is akin to language by virtue of employing relational, differential signifiers. Comprehension of the cinema, then, should likewise be predicated upon cultural conditioning, upon the apprehension of "cultural grids of intelligibility." But, as we will see, the spectator's understanding of cinematic images seems more immediately explicable in terms of mimetic, referential coding rather than via the chains of displaced, arbitrary, and relational meaning in prevailing theories. In other words, this understanding is more a matter of recognition than translation. We will return to this point. Moreover, iconic representation is appropriately understood in terms of degrees of resemblance rather than the all-or-nothing terms of arbitrariness or identicality. A photograph, for example, exhibits a higher degree of iconicity than a line drawing.

Transposed in film theory to units of cinematic structure, the Saussurean view of the sign as an arbitrary and, taken in isolation, meaningless unit has allowed current theory to construct an extended analogy with language. Although no one any longer searches for the filmic equivalent of such linguistic features as the period or the comma, the debt to Saussurean linguistics is apparent in the axioms that the connections between cinematic representation and the world are, in all important respects, a matter of historical or cultural coding and convention, that is, that filmic representa-

---

[7]D. N. Rodowick, *The Difficulty of Difference: Psychoanalysis, Sexual Difference and Film Theory* (New York: Routledge, 1991), p. 138.

[8]Mas'ud Zavarzadeh, *Seeing Films Politically* (Albany: State University of New York Press, 1991), p. x.

[9]Ibid. p. 11.

tion is a matter of symbolic rather than iconic coding and that a viewer, rather than perceiving a film, "reads" it.

## PROBLEMS WITH LINGUISTIC RELATIVITY

We shall explore some discrepancies between these axioms and the observable evidence about how viewers perceive and process cinematic images. First, however, it will be helpful to discuss some reservations regarding the alleged arbitrariness of the linguistic sign and the uses to which film studies has put this concept. As Devitt and Sterelny have recently pointed out, emphasizing the sign as a relational entity, defined through relations of difference, presents a problem for meaning.[10] This emphasis fails to specify how meaning may arise or even how lexical borrowing from other language systems may occur. When speakers borrow terms from another language, they are often doing so in response to a perception that some thing or condition exists that needs a name, although at present it has none or is insufficiently labeled. In such a case, linguistic skills are deployed in response to non- or extra-linguistic perceptions, a condition which models of linguistic determinism have a hard time accounting for. Furthermore, rejecting reference, as Saussurean models do, mystifies language acquisition.

In a Saussurean view, where meaning is defined through relations of difference (e.g., Jonathan Culler's well-known view that understanding the color brown entails grasping the relation between brown and what it is not, i.e., all other colors), it is difficult to see how a child ever learns a language. As Devitt and Sterelny note, "We want to say that a child begins by learning a minimal vocabulary and a few rudimentary syntactic rules. The child continues by extending these rules. On a structuralist picture of language, we cannot say this. Vocabulary does not remain constant across changes in the system. Each time the child changes the system, *everything changes*. Language learning cannot be represented as a cumulative process."[11]

Part of the problem here is that to specify meaning, one at times has to step outside the language system, and poststructural methodologies have been most unwilling to posit the possibility of doing this. In many accounts, one cannot get outside representation at all because it is, by definition, determinative of human thought and experience. It is commonly maintained that "there is no absolute moment without signs, without language, without, in other words, a whole host of mediations between seeing, experience, and knowledge."[12] Stephen Heath has noted that the referents of cinematic images exist only in discourse, as representations already constituted by history and culture. "The represented a discourse produces is grasped, realized, exists as such in the particular discursive process of representation, and it is this that needs first and foremost to be interrogated."[13]

This view—that pictorial representations and, beyond them, patterns of human and social organization are the expressions of discursive relations and positions—is a

---

[10]Michael Devitt and Kim Sterelny, *Language and Reality* (Cambridge, MA: MIT Press, 1987), pp. 215–18.

[11]Ibid, p. 216.

[12]Burnett, *Explorations in Film Theory*, p. xvii.

[13]Heath, *Questions of Cinema*, p. 191.

reformulation of the famous Whorf-Sapir hypothesis which suggested that radically different language systems might organize the world in unique ways for their users. The Whorf-Sapir hypothesis is a statement of extreme linguistic relativity, arguing for the influence of features of linguistic organization upon the perceptual habits of a community. It is a relativistic view because it argues against the possibility of semantic or perceptual universals. As languages vary, so do the realities they construct. The Whorf-Sapir hypothesis has been a very seductive and influential one for film studies. Bill Nichols has noted the relevance of this hypothesis for poststructural film theory. "Post-structuralist work does not regard language or, by extension, film as the neutral means by which we understand ourselves, others, and our world. Rather, it draws on versions of the Whorf-Sapir hypothesis, which describes a world constructed in, by, and through language."[14]

Benjamin Lee Whorf's study of Indian languages led him to emphasize how different languages may segment the world for their community of speakers in divergent ways.[15] There are some data to support a limited view of this hypothesis.[16] Language undoubtedly does modulate our experience of the world. Yet there is little evidence to support the extreme relativity of the Whorfian view (i.e., that language determines both thought and perception) and some clear evidence to counter it.[17] Advocates of linguistic relativity, or discourse relativity, often support their position with reference to color terminology, i.e., to the fact that different cultures have varying numbers of color terms to designate locally important attributes, such as snow for an arctic community. In suggesting that representational images, like other texts, rely upon culturally determined codes. Nichols, for example, has employed this notion of linguistic relativity, writing that "to not know the perceptual codes maintained by a given culture is tantamount to being an illiterate infant wandering through an unintelligible world. (An example would be the utter inability of most members of non-Eskimo cultures to distinguish the dozens of different kinds of snow for which the Eskimo has separate words.)"[18] Analogously, Mas'ud Zavarzadeh has asserted that "we understand colors not because we respond to them directly through our sensory organs, but because the responses of our sensory organs are made meaningful for us by the language. Different languages make sense of this physical continuum in startlingly different and dissimilar ways. . . ."[19]

---

[14]"Introduction," in *Movies and Methods*, vol. 2, ed. Bill Nichols (Berkeley, CA: University of California Press, 1986), p. 16.

[15]The relevant essays explicating this position can be found in *Language, Thought and Reality: Selected Writings of Benjamin Lee Whorf*, ed. John B. Carroll (Cambridge, MA: MIT Press, 1984).

[16]See, for example, John B. Carroll and Joseph B. Casagrande, "The Function of Language Classifications in Behavior," in *Readings in Social Psychology*, ed. Eleanor E. Maccoby, Theodore M. Newcomb, and Eugene L. Hartley (New York: Holt, Rinehart and Winston, 1958), pp. 18–31. It should be noted, however, that the results of this study, while offering some support of the Whorfian view, are nevertheless mixed and somewhat inconsistent.

[17]For a review of evidence bearing on strong and weak versions of Whorfian hypothesis, see Earl Hunt and Franca Agnoli, "The Whorfian Hypothesis: A Cognitive Psychology Perspective," *Psychological Review* 98, no. 3 (1991), pp. 377–89.

[18]Bill Nichols, *Ideology and the Image* (Bloomington: Indiana University Press, 1981), p. 26.

[19]Zavarzadeh, *Seeing Films Politically*, p. 102.

In contrast to the Whorf-Sapir hypothesis, however, a classic crosscultural study of color terminology found respondents plotting the same range of basic colors on a Munsell color chart irrespective of the labels furnished by their culture.[20] Experimental data were obtained from speakers of 20 languages and were supplemented with historical information on 78 additional languages. The researchers found a universal inventory of 11 basic color categories across all languages studied and a fixed evolutionary sequence governing the order in which languages added new basic color categories. Writing that the allegation of arbitrariness in the way languages segment the color spectrum is "a gross overstatement," the researchers concluded that "the referents for the basic color terms of all languages appear to be drawn from a set of eleven universal perceptual categories, and these categories become encoded in the history of a given language in a partially fixed order. There appears to be no evidence to indicate that differences in complexity of basic color lexicons between one language and another reflect perceptual differences between the speakers of those languages."[21] Different languages can make more or fewer distinctions according to environmental or cultural needs but cannot override the biological basis of color perception.

The evidence furnished by Berlin and Kay on color terminology fails to support the extreme linguistic relativity hypothesis that has been so influential for film studies, and suggests instead the importance of retaining a concept of referentiality outside language to which language may respond. This example can be a heuristic one for film theory. Reopening a space for principles of referentiality and iconicity could be a very useful development, enabling our theories to move closer to observable real-world evidence about how viewers understand the cinema. Thus, with respect to pictures, film theory might ask if there is a nonlinguistic, even biological, basis on which visual communication might rest. Investigation of this question may help provide a more secure sense of the methodological limits constraining the equation of cinema with discourse. Julian Hochberg has recently made this point, noting, "only when we know where the line lies that separates . . . lower, mandatory cognitive processes from the higher, elective functions, can we sensibly formulate explanations—linguistic, psychoanalytic, and so on—that rest on cultural determination."[22]

One final point to note about the concepts of linguistic relativity and arbitrariness operative in current film theory is the extent to which accounts of the cinema as discourse, analogized with language, construct the analogy based on limited features rather than seeing language in more comprehensive terms. The linguist Charles Hockett, for example, seeking to distinguish human language from animal systems of communication, formulated a set of 13 design features uniquely characterizing human language.[23] Arbitrariness of the sign was only one of them, and many of the

---

[20]Brent Berlin and Paul Kay, *Basic Color Terms: Their Universality and Evolution* (Berkeley, CA: University of California Press, 1969).

[21]Ibid., pp. 4–5.

[22]Julian Hochberg, "The Perception of Moving Images," *Iris*, no. 9 (Spring, 1989), p. 41.

[23]See Charles F. Hockett, "Logical Considerations in the Study of Animal Communication," in *The View from Language: Selected Essays 1948–1974* (Athens, GA: University of Georgia Press, 1977), pp. 124–62.

others, such as prevarication, displacement, and abstractness, point to clear differences between the communicational capabilities of language and pictures, suggesting that analogies with language may not be the best way of explicating pictorial communication. The design feature of displacement, for example, denotes the capability of the language-system to create messages that refer to a time and space outside of the immediate communicational situation. Pictures, by contrast, lack tense and other aspects of syntax that can be used to establish remote temporal or spatial conditions (the dissolves, wipes, and odd music used to signal flashbacks in Hollywood narratives are a less powerful and flexible means of approximating this ability). Furthermore, as several scholars have pointed out, pictures cannot express negatives.[24] These and other differences between pictorial and linguistic messages point toward distinctly different communicational modalities. Interestingly, Christian Metz also noted some of these fundamental distinctions between linguistic and pictorial modes of communication. He pointed out that cinema lacks the double level of structure in language (i.e., the morphemic and phonemic levels) and is a one-way system of communication, unlike language, where senders and receivers are interchangeable, and he concluded, therefore, that the concept of a language is probably inapplicable to film. Despite these objections, Metz nevertheless went on to explore film structure as *parole*, in terms of a taxonomy of segment types.

If cinematic meaning is to be developed from a theoretical basis originating with a Saussurean conception of the relativity of the sign, film theory sometimes seems a little imprecise about the functional and at times invariant nature of communicational rules. As noted, film theory tends to view cutting patterns, camera positions, even perspectively based images as culturally relative yet syntactically precise conventions. But, with respect to language (and perceptual images), Noam Chomsky points out that "having acquired the system of language, the person can (in principle) choose to use it or not, as he can choose to keep to or disregard his judgements concerning the position of objects in space. He cannot choose to have sentences mean other than what they do, any more than he can choose to have objects distributed in perceptual space otherwise than the way they are."[25] In other words, if the assumptions of the Saussurian view, as applied to pictures, are correct, we should find more crosscultural variation on basic picture recognition tasks than we in fact do. We will explore this point in more detail shortly.

## VISUAL GRAMMAR OR NARRATIVE CONTEXT?

Chomsky's observation raises the issue of grammaticality, which should be central to questions about whether film structure operates like a language. As noted, Metz's presentation is somewhat ambiguous with respect to grammaticality, but this is an issue that cannot easily be avoided for accounts that seek to analogize film and lan-

---

[24]Sol Worth, "Pictures Can't Say Ain't," in *Film/Culture*, ed. Sari Thomas (Metuchen, N.J.: Scarecrow Press, 1982), pp. 97–109, and Edward Branigan, "Here Is a Picture of No Revolver," *Wide Angle* 8, no. 34 (1986), pp. 8–17.

[25]Noam Chomsky, *Reflections on Language* (New York: Pantheon, 1975), p. 71.

guage. Film theory has identified a number of syntactic elements (e.g., point-of-view editing employing perspectively based images, suture) which are thought to operate as codes with discernible effects across a range of individual films, thus constituting a kind of cinematic grammar. But the test of ungrammaticality is not often applied (that is, judgements about the syntactic correctness of given filmic constructions). The most thorough and complete exploration of the application of linguistic principles to problems of film structure is found in the work of John Carroll, who has sought to apply Chomskian transformational-generative grammar to the cinema.[26]

Carroll identifies a series of principles underlying cinema grammar violations of which ostensibly constitute cinematic equivalents of grammatical errors and allegedly give rise to sequences that viewers will judge to be confusing or unfilmic. These are essentially continuity editing rules, such as the injunction that if an actor looks and reacts to anything off-frame, the next shot will be interpreted by viewers as a subjective shot. Carroll describes a sequence from *The Birds* where Hitchcock seems to violate this principle, and he remarks that viewers will find this confusing. It is the scene showing Tippi Hedren waiting outside the schoolhouse while, behind her, the birds gather en masse on the playground jungle gym. Hitchcock cuts between a shot of Hedren looking off-frame and a shot of the gathering flock, as if to imply (by virtue of the cutting pattern) that she must see it.

In a recent and thorough review of the issue of visual literacy in film and television, Messaris points out that, while Carroll is technically correct, the salient point is that the confusion (not shared by all viewers) is only momentary, because the surrounding contextual-narrative information makes it clear that the subsequent shot is not a subjective one.[27] In other words, given the narrative context, it would be implausible to assume the character sees the birds without reacting because their deadly nature has already been established in the story. Messaris points out that one reason why notions of grammaticality are difficult to apply to film is that narrative context often overrules code. "The role of formal conventions in conveying a movie's meaning is generally subordinate to conventional standards of plausibility or probability ('conventional' in the sense that the film-maker must be able to assume them of her/his audience). . . . [T]he viewer's interpretation of edited sequences is largely a matter of cross-referencing possible interpretations against a broader context (i.e., the larger story in the movie itself, together with corresponding situations from real life and other movies), rather than a matter of 'decoding' formal devices (e.g., an off-screen look followed by a cut to a new shot). . . . Interpretation is driven by the narrative context, not the code."[28]

Another example should make this clear, although this instance does not involve an alleged violation of grammar. In *The Searchers*, after Ethan and Marty discover that Lucy has been killed by her Indian abductors and Brad, her lover, is killed while charging into the Indian camp, the searchers ride into a snowy landscape where Marty despairs of ever finding Debbie. Ethan, in reply, makes his famous speech

---

[26]See John M. Carroll, *Toward a Structural Psychology of Cinema* (New York: Mouton, 1980).

[27]Paul Messaris, *Visual Literacy: How Images Make Sense* (Boulder, CO: Westview Press, forthcoming).

[28]Ibid.

about being a critter that just keeps coming. Fade out and fade in on the Jorgensens' ranch as Ethan and Mary ride up. As a symbolic pictorial device that has no clear analogy in real-life visual experience, the fade operates in accord with its conventional usage to bracket and separate sections of the narrative, assisting the viewer's parsing operations. But it is the contextual narrative information that provides the salient cues about the precise nature of the narrative shift. At the Jorgensens', Ethan and Marty inhabit a different landscape. The absence of snow indicates a seasonal shift, and Jorgensen tells Ethan that his letter about Brad's death arrived the previous year. The viewers' extra-filmic knowledge of seasonal patterns and, most importantly, the dialogue between Ethan and Jorgensen establish the precise nature of the time shift in a way that the purely visual code—the fade—cannot. The dominance of narrative context over code explains why it would be equally permissible— though not in a film of the 1950s—to signal the temporal shift with a straight cut. With redundant informational cues available in the narrative, the viewer should be able to follow the flow of events, permitting a degree of interchangeability in the use of codes. Thus, image patterns may not need to be as rigidly sequenced as the concept of a "grammar" might imply, and the ostensive violation of grammatical rules may carry less significance (for the viewer's interpretational abilities) than is sometimes thought, as the violations of the 180-degree rule in contemporary productions should indicate.

## EMPIRICAL EVIDENCE ABOUT IMAGE COMPREHENSION

The foregoing discussion has suggested that the linguistic orientation of film theory may not be the most efficacious for dealing with visual meaning or cinema structure. Currently, the discipline is undergoing some profound shifts as the Saussurean and Lacanian accounts are contested by alternative formulations advocating perceptually or cognitively based approaches. The cognitive turn in contemporary theory has opened a space for renewed appraisal of perceptual evidence that runs counter to notions of film as language and their logical consequence—that viewers must learn to interpret pictorial displays. Reviewing the results of empirical research on the perceptual and cognitive processing of visual images and narratives will help clarify some of the problems inherent in using concepts of arbitrary or relational signifiers to explain principles of cinematic meaning and communication.

Contemporary notions that film is analogous to a language are consistent with the speculations of film theorists dating from virtually the beginning of cinema history. Boris Eichenbaum, for example, noted that "Film language is no less conventional than any other language. . . . Cinema has not only its 'language,' but also its 'jargon,' rather inaccessible to the uninitiated."[29] Béla Balázs suggested that, to be comprehended, the new "form-language" of cinema required of its viewers a new sensibility and understanding, without which novice viewers would be baffled.[30] However, to

---

[29]Boris Eichenbaum, "Cinema Stylistics," in *Russian Formalist Film Theory*, ed. Herbert Eagle (Ann Arbor, MI: University of Michigan Press, 1981), p. 77.

[30]Béla Balázs, *Theory of the Film* (New York: Dover, 1970), p. 34.

posit language-based modes of cinematic communication is to implicitly raise the issue of visual literacy by implying that a period of tutoring would be logically necessary in order to gain interpretive mastery of the cinematic vocabulary (learning, for example, that a subjective shot represents the view of the absent character or that the portions of an event elided by continuity editing nevertheless still occurred within the narrative). The assumption that untutored or inexperienced viewers would encounter difficulties making sense of unfamiliar images finds some apparent confirmation in the existing anecdotal reports of viewers' bewildering first-time encounters with motion and still pictures.[31] However, these difficulties are often due less to an inherent inability of naïve viewers to see the pictorial objects than to a first-time encounter with a novel recording surface (e.g., paper in the case of still pictures) or a culturally unfamiliar depth cue used to render an object in abstract terms (e.g., linear perspective suggesting a straight road in a line drawing). Moreover, even where anthropologists and field workers report difficulties with picture perception, respondents typically are able to integrate figure-ground relations rather quickly, resulting in correct picture perception.[32] Viewers who find picture perception completely impossible under any condition are quite rare and probably anomalous.

Convincing evidence about inherent human abilities to perceive pictures is available from a classic experiment in which the researchers prevented a child (their own) from birth from seeing pictures until the age of 19 months, when it began to actively seek them out.[33] The child learned his vocabulary solely through the use of objects and received no training regarding pictorial meaning or content. He was nevertheless able to recognize, when tested with a series of 21 two-dimensional line drawings and photographs, the series of pictured objects (people and things familiar in his environment). The researchers concluded that the results indicate the existence of innate picture perception abilities and that, if there are allegations of cultures or viewers lacking these, it cannot be a matter of not yet having learned the language of pictures.

Empirical research indicates that one basis for these innate abilities probably lies in the activation by pictures of perceptual skills (object recognition, depth perspective, etc.) developed in real-world experience, skills which are then transferred to pictures. Scholars have commonly emphasized that pictures replicate a series of monocular depth cues used in real-world experience for inferring information about the positioning of objects in physical space (e.g., overlap, texture density gradients, shading, and, in motion pictures, motion parallax).[34] Picture perception, then, seems clearly based on 3D spatial skills transferred to the 2D representation, and one would expect that the more complete the set of cues employed by the picture regarding the spatial layout of the depicted scene, and the more culturally familiar the depicted

---

[31]See the accounts in Balázs, *Theory of the Film*, pp. 34–35, and J. B. Deregowski, "Real Space and Represented Space: Cross-Cultural Perspectives," in *Behavioral and Brain Sciences* 12 (1989), pp. 56–59.

[32]Messaris also makes this point.

[33]Julian Hochberg and Virginia Brooks, "Picture Perception as an Unlearned Ability: A Study of One Child's Performance," *American Journal of Psychology* 74, no. 4 (Dec. 1962), pp. 624–28.

[34]Discussing these cues, David Bordwell points out that cinematic images also routinely distort or alter them (e.g., through the effects of different focal length lenses, etc.). David Bordwell, *Narration in the Fiction Film* (Madison, WI: University of Wisconsin Press, 1985), pp. 107–10.

objects, the greater the ease of recognition. If naïve viewers can perceive still pictures, there is no logical reason for inferring that they would have difficulty doing so with moving pictures, especially since movies will supply the additional real-world depth cue of motion parallax.

But what about the role of culture in visual perception? As we have seen, culture-bound determinations are very important in language-based film theories which rely on arbitrary, relational signifiers. The move to empirical, perceptually based evidence might be unwelcome for linguistically based accounts of pictorial meaning because it can be seen as replacing cultural categories with biological (and therefore ideologically suspect) ones, and because it may suggest that pictorial and linguistic modalities are distinct from each other. With respect to the role of culture in picture perception, some evidence does exist for varying cultural susceptibilities to different visual illusions (the Mueller-Lyer illusion and the Sander parallelogram), perhaps due to variations in the physical environments of different cultures, but these do not seem to impact basic picture perception abilities.[35]

In a recent summary of the existing crosscultural research on picture perception, Deregowski suggests that relationships of culture, perception, and viewing abilities be conceptualized in terms of sets of contiguous and, at times, overlapping skills.[36] Real-world spatial experience may utilize 3D skills that 2D representations do not exploit, such as binocular disparity (using the differences in the images recorded by each eye as a means of inferring information about depth and distance). Many real-world perceptual skills, by contrast, do overlap with visual skills relevant for picture perception, and some may be influenced by varying patterns of cultural organization (e.g., as Segall et al. point out, respondents from plains or dense jungle environments may demonstrate less sensitivity to linear perspective when used as a pictorial depth code). Finally, some pictures employ purely representational codes with no overlap in real-life experience (e.g., wipes in film or streaky lines used to represent speed in comics). Obviously, with this last category one might expect greater interpretational difficulties for naïve viewers, but not inevitably. As our example from *The Searchers* indicated, narrative contextual information may be used to connect separate images or events even when the optical transition employed is a more symbolic one.

What, then, does all of this imply about the need for a period of tutoring implicit in the film-as-language model? Quite simply, such a period should not be necessary for inferring narrative relations in standard movies (i.e., movies that do not create deliberate narrative enigmas, in contrast to movies like *Last Year at Marienbad*). Empirical research with naïve viewers (in most cases young children and, in one unique study, inexperienced adults) offers evidence that the use of specifically cinematic devices (or, as the film-as-language paradigm might term them, symbolic codes), such as montage, camera movement, or subjective shots, do not pose substantial interpretational obstacles for naïve viewers provided developmental requisites are met (i.e., that the viewers have developed sufficient real-world conceptual and cognitive skills that can be applied to the film or television medium). A brief

---

[35]See Marshall H. Segall, Donald T. Campbell, and Melville J. Herskovits, *The Influence of Culture on Visual Perception* (Indianapolis, IN: Bobbs-Merrill, 1966).
[36]Deregowski, "Real Space," pp. 69–72.

review of some of this evidence will help clarify these points and will provide further evidence from which to question the theoretical and methodological efficacy of grounding film theory in conceptions of cinematic relationships involving arbitrary, unmotivated signs.

Young children's comprehension of an array of cinematic techniques was explored in a recent study by Smith, Anderson, and Fisher.[37] In one experiment, they showed three- and five-year-old children brief stop-animation video sequences that employed pans, zooms, and cuts to present a simple story. Another group of children saw the same stories in sequences with no editing or camera movement. When the children were invited to recreate the stories using the dolls and sets seen in the films, no differences in story comprehension were observed between the two groups, indicating that these film techniques seemed to pose few cognitive or interpretational problems for these young viewers. These were viewers who had seen television before. It is, however, the absence of age-related differences in their performance that is striking, especially in light of the hypothesis that these techniques should require medium-specific learning in order to be understood.

Because these sequences were relatively simple in structure (featuring only one pan, zoom, and cut), the researchers ran a second experiment with more complex visual presentations and longer visual narratives. Cinematic manipulations this time consisted of parallel editing to imply simultaneity of action, subjective shots representing a character's literal viewpoint, ellipses achieved through editing that deletion portions of a continuous event or action, and editing to imply a layout of contiguous spaces (e.g., cutting from an establishing shot of two buildings to a shot of a character looking out of a window, then to a reverse-angle interior shot of the character at the window). This time the children were four and seven years old.

As before, they were asked to recreate character perspectives and spatial layouts using the dolls and sets that had appeared in the films. Comparisons across all classes of montage indicated that clear majorities in both age groups made correct inferences of space, ellipsis, and character perspective. Inferences of simultaneity proved difficult for the four-year-olds, but not for the seven-year-olds. Both groups proved especially skilled at reconstructing implied actions omitted in the edited narratives.

This study indicates good comprehension by young children of basic montage techniques, which is what one would expect if interpretation of the visual displays draws on a child's developing real-world visual skills and experience. Emphasizing the status of cinematic images as iconic signs having a clear referential basis and inviting a transfer of real-world visual skills to the pictorial display does not deny the existence of medium-specific skills relevant for making sense of a motion picture, but it does reserve a more modest space for them than would the arbitrary-relational signifier model. Clearly, some film techniques are more symbolic than iconic and may be coded in a more arbitrary fashion. Such techniques would invite the viewer's application of specific, medium-based competencies. For example, the Smith et al study employed parallel editing as one category of montage. Drawing the

---

[37]Robin Smith, Daniel R. Anderson, and Catherine Fischer, "Young Children's Comprehension of Montage," *Child Development* 56 (1985), pp. 962–71.

correct inference from parallel editing is arguably a medium-specific skill, and, as one would expect, the largest age differences in the average percentage of correct responses showed up there. But, rather than needing to become proficient at manipulating an arbitrarily symbolic set of cinematic signifiers, children can generally interpret visual displays involving point-of-view editing by transferring to the display their developing real-world visual skills and experience. Evidence supporting a developmental view of the application of real-world cognitive and perceptual skills to film and television displays involving point-of-view editing is found in Comuntzis-Page's study of the relationship between children's evolving real-world perspective-taking skills and their ability to infer meaning from an edited video sequence.[38] She found that children who successfully demonstrated a knowledge of visual perspectives in actual 3-dimensional situations (e.g., children who knew that observers situated in different places can see different sides of a common object) were better able to understand the changing camera viewpoints of a television presentation. In fact, she found that skill at inferring character relationships in a 3-dimensional layout seemed to be a prerequisite for making the proper analogous inferences from the 2-dimensional video display. Only children who did well at the former task also did well on the latter, and clear age-related differences between perspective takers and nonperspective takers were found, supporting a developmental view.

The research cited thus far has used children to represent a population of relatively unskilled viewers. However, one unique study of motion picture perception and interpretation exists using adult viewers who had little familiarity with any mass media.[39] Working with a seminomadic, nonliterate, pastoral tribe in Kenya, a community whose aesthetic expressions concentrated on personal adornment and performance arts, the researchers showed adult villagers two videotapes of a culturally familiar story. One version was unedited, the other featured 14 cuts with frequent alterations of close-ups, medium shots, long shots, and zooms. No significant differences in ability to recall story information were found between respondents who viewed the edited and unedited versions. Fragmentation of the visual scene through point-of-view editing did not hinder comprehension, nor did it seem to require the use of any medium-specific skills. The researchers concluded that, on the contrary, continuity editing codes that manipulate point of view seem to function as "analogs of perceptual processes."[40]

## LEVELS OF ICONICITY

The evidence reviewed thus far bears on the capability of pictures to furnish cues regarding the spatial layout of a scene or situation that are analogous to sources of information commonly found in real-world visual experience. It also bears mentioning, however, that another level of iconic information typically exists in pictures which

---

[38]Georgette Comuntzis-Page, "Changing Viewpoints in Visual Presentations: A Young Child's Point of View," paper presented at Eastern Communication Association Convention, Baltimore, 1988.

[39]Renee Hobbs, Richard Frost, Arthur Davis, and John Stauffer, "How First-Time Viewers Comprehend Editing Conventions," *Journal of Communication* 38 (1988), pp. 50–60.

[40]Ibid., p. 58.

is central to a consideration of the comprehensibility and emotional effects of the cinema. Photographic images of people necessarily reproduce that information about facial expression and gesture which Ray Birdwhistell has called "kinesics." Birdwhistell and his colleagues studied the systematic patterning of body motion within cultures and designed an elaborate notational system to transcribe and study the distinctively patterned strings of body motion cues (called "kines") that are situationally articulated as a communicative form in everyday life. Birdwhistell explicitly rejected the notion that language was the most important channel of communication, arguing instead for a conception of communication as a multi-model, multi-sensory process which included visual and gestural as well as auditory channels.[41] He demonstrated how body motions are culturally patterned in symbolically significant ways that are understood by members of a given community whose socialization processes have sensitized them to coded kinesic displays. While Birdwhistell emphasized the importance of cultural context in determining the encoding of specific kinesic patterns, other researchers have argued that some gestural expressions—those on the face, for example—may function as biologically based pancultural signals for emotion. While all cultures mandate display rules governing who may display which emotions and when, experimental evidence furnished by Paul Ekman and his colleagues has indicated that certain facial displays seem correlated with basic categories of human emotion and are capable of being recognized crossculturally.[42]

The obvious point to be made from this brief discussion of the work on facial and body motion communication is that the motion picture camera furnishes an excellent means of recording the expressive meanings carried by these channels. Birdwhistell, in fact, employed still photographs and motion picture footage to record and store the data used in his analyses. It should be an assertion of the obvious to point out that a major source of the appeal and power of the movies lies here, in film's ability to capture the subtleties and nuances of socially resonant streams of kinesic expressions, and not just to passively capture them but, via close-ups and other expressive devices, to intensify and emphasize the most salient cues for the viewer's understanding in cognitive and affective terms of the meaning of the scenes depicted on screen. (Recent studies of acting by James Naremore and Roberta Pearson have emphasized the way that different performance traditions code expressive behavior and how film technique may be used to frame and emphasize this coding.[43]) The relational-arbitrary signifier hypothesis has tended to draw attention away from this clear source of iconic meaning in motion pictures, despite

---

[41]See Ray L. Birdwhistell, *Kinesics and Context* (Philadelphia: University of Pennsylvania Press, 1970).

[42]See Paul Ekman and Wallace V. Friesen, "Constants Across Cultures in the Face and Emotion," *Journal of Personality and Social Psychology* 17, no. 2 (1971), pp. 124–29, and Paul Ekman, "Expression and the Nature of Emotion," in *Approaches to Emotion*, ed. Klaus R. Scherer and Paul Ekman (Hillsdale, N.J.: Lawrence Erlbaum Association, 1984), pp. 319–43. The latter volume is especially useful for containing a range of theoretical positions, often competing, on the nature and expression of emotion and the ways it may be culturally coded.

[43]See James Naremore, *Acting in the Cinema* (Berkeley, CA: University of California Press, 1988) and Roberta Pearson, *Eloquent Gestures: The Transformation of Performance Style in the Griffith Biograph Films* (Berkeley, CA: University of California Press, 1992).

its obvious importance in helping to explicate the crosscultural appeal and power of the movies.

## THE DISCOURSE OF PICTURES

What do these studies and avenues of research tell us about cinematic codes and the appropriateness of defining them, as current film theory does, as a series of relational differences among arbitrary signs? The empirical evidence clearly suggests that pictorial identification skills do not develop from an extended period of exposure to signification and consequent learning, as do language skills, and that this is probably due to the fact that most realistic pictures are isomorphic with corresponding real-world visual displays, unlike symbolic signs, which have a more arbitrary relationship to what they represent. Furthermore, via the technologies of motion picture recording, the camera is able to reproduce in clearly recognizable and even intensified form the familiar streams of facial and body motion cues which symbolically encode the meanings of the social situations portrayed on screen. These cues should be readily understood by cinema viewers, just as they are in real-world visual experience. If the distinctions between iconic and symbolic modes that we have been emphasizing are really relevant to differences between pictures and language, then one would expect iconic modes to be processed more readily than symbolic ones, especially by young children, and existing research lends support to this idea.[44]

Thus, it is not clear how the concept of the relational, arbitrary signifier might apply to cinematic images or, for that matter, to any iconic image. Certainly, as Hockett indicated, few communicational signs are completely iconic, since a state of total iconicity would imply that the sign was completely indistinguishable from its referent.[45] Nevertheless, pictorial signs do bear clear structural similarities to their referents, with the attendant consequences for perception and comprehension that we have just reviewed. The linguistic model has proven to be a very powerful paradigm for the analysis of images and larger film structures (e.g., dramatic scenes) in part because that analysis is typically conducted via words. When film scholars analyze images, visual information is translated into verbal description, one modality is substituted for another. But, as Branigan has noted, one must be cautious in speaking about the discourse of pictures: "The analyst must recognize that the very fact of talking about narration requires a re-presentation of it by verbal or other means which may capture only some of its features."[46] The concept of the relational, arbitrary signifier would seem most applicable to pictures here, in the language of analysis which is employed to intellectually manipulate pictorial representations. Furthermore, while empirical evidence indicates that viewers easily and readily make the required inferences necessary to sequence a series of pictures into a coherent narrative, even to the extent of

---

[44]See S. L. Calvert, A. C. Huston, B. A. Watkins, and J. C. Wright, "The Effects of Selective Attention to Television Forms on Children's Comprehension of Content," *Child Development* 53 (1982), pp. 601–10, and D. S. Hayes and D. W. Birnbaum, "Preschoolers' Retention of Televised Events: Is a Picture Worth a Thousand Words?," *Developmental Psychology* 16 (1980), pp. 410–16.

[45]Hockett, "Logical Considerations in the Study of Animal Communication," p. 143.

[46]Branigan, "Here Is a Picture of No Revolver," p. 11.

inferring information about situations not directly pictured,[47] several scholars have argued that these inferences are organized on a conceptual and propositional—but not necessarily a linguistic—basis. Pylyshyn, for example, suggested that "Such concepts and predicates may be perceptually well defined without having any explicit natural language label.

Thus we may have a concept corresponding to the equivalence class of certain sounds or visual patterns without an explicit verbal label for it. Such a view implies that we can have mental concepts or ways of abstracting from our sense data which are beyond the reach of our current stock of words, but for which we could develop a vocabulary if communicating such concepts became important."[48] Linguistic models, in other words, are not requisite for explaining how we respond to and make sense out of pictorial information, nor even for describing how we encode visual information for longterm memory storage such that it can be subsequently reaccessed.[49]

As noted, arbitrary-relational signifier models are most applicable where the discourse being examined is language-based rather than strictly pictorial. In his respect, it follows that theories about ideology and ideological effects are best formulated not with regard to pictures sui generis (e.g., as has been done with perspective-based images) or with such machines for seeing as the camera and projector, but rather as a matter of the content of a given film and its modulation via techniques of cinematic style. As Noël Carroll has remarked, ideological design needs to be examined film by film, on an individual case-by-case basis. Because theories about linguistic structure do not seem to be directly applicable to pictures, they therefore form an insufficient basis for grounding a critique of cinematic discourse or the place of ideology in pictorial images.

Proponents of the application of the Saussurean lineage to cinema studies might reply that the poststructural attention to textuality and discourse as culturally relative constructs provides a framework for investigating ideology and the cultural or political polyvalence of a given text. That the poststructural methodology works in this way is undoubtedly true. But, unfortunately, what tends to be displaced are issues of how cinema is able to communicate crossculturally (i.e., attain global popularity) and the even more basic questions of what makes the cinema intelligible to its viewers. Not all cultures organize libidinal and psychic energy in the same way, and one would not therefore wish to posit Lacanian categories as basic mechanisms explicating the means of cinematic communication. Yet all cultures currently studied do demonstrate clear pictorial and cinematic perception abilities. Moreover, these abilities are shared

---

[47]See Patricia Baggett, "Memory for Explicit and Implicit Information in Picture Stories," *Journal of Verbal Learning and Verbal Behavior* 14 (1975), pp. 538–48.

[48]Zenon W. Pylyshyn, "What the Mind's Eye Tells the Mind's Brain: A Critique of Mental Imagery," *Psychological Bulletin* 80, no. 1 (July 1973), p. 7.

[49]However, with regard to certain categories of pictures—namely, relatively ambiguous ones—some evidence exists to indicate that linguistic cues may influence the recollection of details of pictorial form. See the classic study by L. Carmichael, H. P. Hogan, and A. A. Walter, "An Experimental Study of the Effect of Language on the Reproduction of Visually Perceived Form," *Journal of Experimental Psychology* 15 (1932), pp. 73–86, and the replication by W. C. H. Prentice, "Visual Recognition of Verbally Labelled Figures," *American Journal of Psychology* 67 (1954), pp. 315–20.

with a variety of animals.[50] Picture recognition abilities have been demonstrated across a wide range of nonhuman subjects—primates, birds, fish, reptiles, even insects. These include unlearned, spontaneous responses to still and motion pictures as well as responses that are the result of conditioning. Recognition of objects by non-human subjects has been demonstrated across different classes of pictorial media—black-and-white and color photographs, high-contrast photographs, film and video-tape, even line drawings. Comprehension of filmed events has been elicited, as well as the formation and pickup of object-class concepts from pictures (e.g., as in the ability of pigeons, trained to recognize human figures in slides of various environments, to transfer this ability and the class concept of "human being" to sets of slides they had never seen before).

Positing arbitrary signifiers and unconscious processes of the mind seems to deflect the ability of cinema studies to grapple with some of the most basic questions about cinema, namely, how are viewers crossculturally able to make sense of the medium and what is the necessary biological basis of pictorial communication that makes it so effective for human and nonhuman subjects alike. As Noël Carroll has recently suggested, emphasizing the way that film structure works to secure the cognitive clarity of the experience for the viewer can give us a basis for explaining the attractiveness and appeal, and perhaps even the emotional power, of the medium.[51]

Furthermore, emphasizing the cinematic code as an arbitrary, unmotivated sign places film theory in the uncomfortable position of implying certain consequences for the real-world viewer that are contrary to the observable evidence, namely, that cinematic images should not function in ways that are isomorphic with their real-world counterparts, that viewers should have to learn the symbolic meanings of basic cinematic structure, and that, logically, because discourse is culture-bound, the appeal of the medium should be too. Film theory has dealt with these problems by pointing to the transparency effect of the cinema or to the illusionism of the photo-graphic image based on what are regarded as the culture-bound and symbolic conventions of perspective. But, as this article has suggested, some important gaps and contradictions are found between these formulations, the Saussurean lineage, and the empirical evidence regarding pictorial recognition and visual communication. Unless film theory can reconceptualize the cinema as an iconic, rather than as a purely symbolic, mode of communication, it is difficult to see how these serious theoretical gaps may be closed. We need to recover a recognition of the analogical component of pictorial signs. Rather than dealing with this component in metaphorical terms (e.g., via transparency effects, subject positioning in the discourse of the Imaginary, or illusionism), an appreciation of the isomorphic relations between pictorial signs and their referents, and attention to the *differences* between pictorial and linguistic modes of communication, can help invigorate film theory by reconnecting it to the observable experiences of real viewers.

---

[50]For a review of picture-perception research involving animals, see Patrick A. Cabe, "Picture Perception in Nonhuman Subjects," in *The Perception of Pictures*, vol. 2, ed. Margaret A. Hagen (New York: Academic Press, 1980), pp. 305–43.

[51]Noël Carroll, *Mystifying Movies* (New York: Columbia University Press, 1988).

As noted at the beginning of this essay, the intention here is not to remove cultural considerations from questions about film viewing and interpretation. Culture clearly enters into the inferences viewers draw from cinematic images and narratives where meaning may be constructed in terms of the intellectual horizons provided by class, race, gender, and similar variables. But it has been the contention of this essay that culture plays a less decisive role at the level of comprehension discussed herein. Furthermore, only by knowing where cultural considerations shade off into what may be more properly termed physiological or cognitive capabilities are we likely to be able to apply cultural analyses in fruitful and relevant ways. This approach can help theory explicate the intelligibility and power of the movies in ways that are responsive to, and grounded in, the observable experiences of actual viewers.

# DANIEL DAYAN
# THE TUTOR-CODE OF
# CLASSICAL CINEMA

Semiology deals with film in two ways.* On the one hand it studies the level of fiction, that is, the organization of film content. On the other hand, it studies the problem of "film language," the level of enunciation. Structuralist critics such as Barthes and the *Cahiers du Cinéma* of "*Young Mr. Lincoln*" have shown that the level of fiction is organized into a language of sorts, a mythical organization through which ideology is produced and expressed. Equally important, however, and far less studied, is filmic enunciation, the system that negotiates the viewer's access to the film—the system that "speaks" the fiction. This study argues that this level is itself far from ideology-free. It does not merely convey neutrally the ideology of the fictional level. As we will see, it is built so as to mask the ideological origin and nature of cinematographic statements. Fundamentally, the enunciation system analyzed below—the system of the *suture*—functions as a "tutor-code." It speaks the codes on which the fiction depends. It is the necessary intermediary between them and us. The system of the suture is to classical cinema what verbal language is to literature. Linguistic studies stop when one reaches the level of the sentence. In the same way, the system analyzed below leads only from the shot to the cinematographic statement. Beyond the statement, the level of enunciation stops. The level of fiction begins.

Our inquiry is rooted in the theoretical work of a particular time and place, which must be specified. The political events of May 1968 transformed reflection on cinema in France. After an idealist period dominated by André Bazin, a phenomenologist period influenced by Cohen-Séat and Jean Mitry, and a structuralist period initiated by the writings of Christian Metz, several film critics and theorists adopted a per-

---

*Brian Henderson collaborated in writing this article from a previous text.

spective bringing together semiology and Marxism. This tendency is best represented by three groups, strongly influenced by the literary review *Tel Quel*; the cinemato-graphic collective *Dziga Vertov*, headed by Jean-Pierre Gorin and Jean-Luc Godard: the review *Cinéthique*; the new and profoundly transformed *Cahiers du Cinéma*.

After a relatively short period of hesitation and polemics, *Cahiers* established a sort of common front with *Tel Quel* and *Cinéthique*. Their program, during the period which culminated between 1969 and 1971, was to establish the foundations of a science of cinema. Defined by Althusser, this required an "epistemological break" with previous, ideological discourses on cinema. In the post-1968 view of *Cahiers*, ideological discourses included structuralist systems of an empiricist sort. In seeking to effect such a break within discourse on cinema, *Cahiers* concentrated on authors of the second structuralist generation (Kristeva, Derrida, Schefer) and on those of the first generation who opposed any empiricist interpretation of Lévi-Strauss's work.

The point was to avoid any interpretion of a structure that would make it appear as its own cause, thus liberating it from the determinations of the *subject* and of *history*. As Alain Badiou put it,

> The structuralist activity was defined a few years ago as the construction of a "simu-lacrum of the object," this simulacrum being in itself nothing but intellect added to the object. Recent theoretical work conducted both in the Marxist field and in the psychoan-alytic field shows that such a conception of structure should be completely rejected. Such a conception pretends to find inside of the real, a knowledge of which the real can only be the object. Supposedly, this knowledge is already there, just waiting to be revealed.*

Unable to understand the causes of a structure, what they are and how they function, such a conception considers the structure as a cause in itself. The effect is substituted for the cause; the cause remains unknown or becomes mythical (the "theological" author). The structuralism of *Cahiers* holds, on the other hand, that there is more to the whole than to the sum of its parts. The structure is not only a result to be described, but the trace of a structuring *function*. The critic's task is to locate the invisible agent of this function. The whole of the structure thus becomes the sum of its parts plus the cause of the structure plus the relationship betwen them, through which the structure is linked to the context that produced it. To study a structure is therefore *not* to search for latent meanings, but to look for that which causes or deter-mines the structure.

Given the *Cahiers* project of a search for causes, what means were available to realize it? As Badiou points out, two systems of thought propose a structural concep-tion of causality, Louis Althusser's Marxism and Jacques Lacan's psychoanalysis. Althusser's theses massively influenced the *Cahiers* theoretical production during the period in question. His influence was constantly commented on and made explicit, both within the *Cahiers* texts and by those who commented on them. Less well under-stood is the influence on *Cahiers* of Lacanian psychoanalysis, that *other* system from which a science of cinema could be expected to emerge by means of a critique of empiricist structuralism.

---

*Cited by Jean Narboni in an article on Jancsó, *Cahiers du Cinéma*, no. 219. (April, 1970).

For Lacan, psychoanalysis is a science.

Lacan's first word is to say: in principle, Freud founded a *science*. A new science which was the science of a new object: the unconscious. . . . If psychoanalysis is a science because it is the science of a distinct object, it is also a science with the structure of all sciences: it has a *theory* and a *technique* (method) that makes possible the knowledge and transformation of its object in a specific *practice*. As in every authentically constituted science, the practice is not the absolute of the science but a theoretically subordinate moment; the moment in which the theory, having become method (technique), comes into theoretical contact (knowledge) or practical contact (cure) with its specific object (the unconscious).*

Like Claude Lévi-Strauss, Lacan distinguishes three levels within human reality. The first level is nature, the third is culture. The intermediate is that in which nature is transformed into culture. This particular level gives its structure to human reality—it is the level of the symbolic. The symbolic level, or order, includes both language and other systems which produce signification, but it is fundamentally structured by language.

Lacanian psychoanalysis is a theory of intersubjectivity, in the sense that it addresses the relationship(s) between "self" and "other" independently of the subjects who finally occupy these places. The symbolic order is a net of relationships. Any "self" is definable by its position within this net. From the moment a "self" belongs to culture its fundamental relationships to the "other" are taken in charge by this net. In this way, the laws of the symbolic order give their shape to originally physical drives by assigning the compulsory itineraries through which they can be satisfied. The symbolic order is in turn structured by language. This structuring power of language explains the therapeutic function of speech in psychoanalysis. The psychoanalyst's task is, through the patient's speech, to re-link the patient to the symbolic order, from which he has received his particular mental configuration.

Thus for Lacan, unlike Descartes, the subject is *not* the fundamental basis of cognitive processes. First, it is only one of many psychological functions. Second, it is not an innate function. It appears at a certain time in the development of the child and has to be constituted in a certain way. It can also be altered, stop functioning, and disappear. Being at the very center of what we perceive as our self, this function is invisible and unquestioned. To avoid the encrusted connotations of the term "subjectivity," Lacan calls this function "the imaginary." It must be understood in a literal way—it is the domain of images.

The imaginary can be characterized through the circumstances of its genesis or through the consequences of its disappearance.

The imaginary is constituted through a process which Lacan calls the mirror-phase. It occurs when the infant is six to eighteen months old and occupies a contradictory situation. On the one hand, it does not possess mastery of its body; the various segments of the nervous system are not coordinated yet. The child cannot move or control the whole of its body, but only isolated discrete parts. On the other hand, the child enjoys from its first days a precocious visual maturity. During this stage, the

---

*Louis Althusser, *Lenin and Philosophy* (New York: Monthly Review Press, 1971), pp. 198–199.

child identifies itself with the visual image of the mother or the person playing the part of the mother. Through this identification, the child perceives its own body as a unified whole by analogy with the mother's body. The notion of a unified body is thus fantasy before being a reality. It is an image that the child receives from outside.

Through the imaginary function, the respective parts of the body are united so as to constitute one body, and therefore to constitute somebody: one self. Identity is thus a formal structure which fundamentally depends upon an identification. Identity is one effect, among others, of the structure through which images are formed: the imaginary. Lacan thus operates a radical desacralization of the subject: the "I," the "ego," the "subject" are nothing but images, reflections. The imaginary constitutes the subject through a "speculary" effect common to the constitution of all images. A mirror on a wall organizes the various objects of a room into a unified, finite image. So also the "subject" is no more than a unifying reflection.

The disappearance of the imaginary results in schizophrenia. On the one hand, the schizophrenic loses the notion of his "ego" and, more generally, the very notion of ego, of person. He loses both the notion of his identity and the faculty of identification. On the other hand, he loses the notion of the unity of his body. His fantasies are inhabited by horrible visions of dismantled bodies, as in the paintings of Hieronymus Bosch. Finally, the schizophrenic loses his mastery of language. The instance of schizophrenia illuminates the role of language in the functioning of the imaginary in general. Because this relationship language-imaginary is highly important for our subject, the role of the imaginary in cinema, we will pursue this point in some detail.

The role of the imaginary in the utilization of language points to an entire realm of inadequacy, indeed absence, in traditional accounts of language. Saussure merely repressed or avoided the problem of the role of the subject in language utilization. The subject is eliminated from the whole field of Saussurian linguistics. This elimination commands the famous oppositions between code and message, paradigm and syntagm, language system and speech. In each case, Saussure grants linguistic relevance to one of the terms and denies it to the other. (The syntagm term is not eliminated, but is put under the paradigms of syntagms, i.e., syntax). In this way, Saussure distinguishes a deep level of linguistic structures from a superficial one where these structures empirically manifest themselves. The superficial level belongs to the domain of subjectivity, that is, to psychology. "The language system equals language less speech." Speech, however, represents the utilization of language. The entity which Saussure defines is language less its utilization. In the converse way, traditional psychology ignores language by defining thought as prior to it. Despite this mutual exclusion, however, the world of the subject and the universe of language do meet. The subject speaks, understands what he is told, reads, and so on.

To be complete, the structuralist discourse must explain the relationship language/subject. (Note the relevance of Badiou's critique of empiricist structuralism to Saussure.) Here Lacan's definition of the subject as an imaginary function is useful. Schizophrenic regression shows that language cannot function without a subject. This is not the subject of traditional psychology: what Lacan shows is that language

cannot function outside of the imaginary. The conjunction of the language system and the imaginary produces the effect of reality: the referential dimension of language. What we perceive as "reality" is definable as the intersection of two functions, either of which may be lacking. In that language is a system of differences, the meaning of a statement is produced negatively, that is, by elimination of the other possibilities formally allowed by the system. The domain of the imaginary translates this negative meaning into a positive one. By organizing the statement into a whole, by giving limits to it, the imaginary transforms the statement into an image, a reflection. By conferring its own unity and continuity upon the statement, the subject organizes it into a body, giving it a fantasmatic identity. This identity, which may be called the "being" or the "ego" of the statement, is its meaning, in the same way that "I" am the meaning of my body's unity.

The imaginary function is not limited to the syntagmatic aspect of language utilization. It commands the paradigms also. A famous passage by Borges, quoted by Foucault in *The Order of Things*, illustrates this point. An imaginary Chinese encyclopedia classified animals by this scheme: (a) belonging to the emperor; (b) embalmed; (c) tamed; (d) guinea-pigs; (e) sirens; (f ) fabulous; (g) dogs without a leash; (h) included in the present classification. According to Foucault, such a scheme is "impossible to think" because the sites where things are laid are so different from each other that it becomes impossible to find any surface that would accept all the things mentioned. It is impossible to find a space common to all the animals, a common ground under them. The common place lacking here is that which holds together words and things. The paradigms of language and culture hold together thanks to the perception of a common place, of a "topos" common to its elements. This common place can be defined at the level of history or society as "episteme" or "ideology." This common place is what the schizophrenic lacks.

Thus, in summary, the speculary, unifying, imaginary function constitutes, on the one hand, the proper body of the subject and, on the other, the limits and the common ground without which linguistic syntagms and paradigms would be dissolved in an infinite sea of differences. Without the imaginary and the limit it imposes on any statement, statements would not function as mirrors of the referent.

The imaginary is an essential constituent in the functioning of language. What is its role in the functioning of language? What is its role in *other* semiotic systems? Semiotic systems do not follow the same patterns. Each makes a specific use of the imaginary; that is, each confers a distinctive function upon the subject. We move now from the role of the subject in language use to the role of the subject in classical painting and in classical cinema. Here the writings of Jean-Pierre Oudart, Jean Louis Schefer, and others will serve as a guide in establishing the foundations of our inquiry.*

---

*See Jean-Louis Schefer, *Scénographie d'un tableau* (Paris: Seuil, 1969); and articles by Jean-Pierre Oudart, "La Suture, I and II," *Cahiers du Cinéma*, nos. 211, 212 (April–May, 1969), "Travail, Lecture, Jouissance," *Cahiers du Cinéma*, no. 222 (with S. Daney, July 1970), "Un discours en defaut," *Cahiers du Cinéma*, no. 232 (October 1971).

We meet at the outset a fundamental difference between language and other semiotic systems. A famous Stalinian judgment established the theoretical status of language: language is neither part of science nor part of ideology. It represents some sort of a third power, appearing to function—to some extent—free of historical influences. The functioning of semiotic systems such as painting and cinema, however, clearly manifests a direct dependency upon ideology and history. Cinema and painting are historical products of human activity. If their functioning assigns certain roles to the imaginary, one must consider these roles as resulting from choices (conscious or unconscious) and seek to determine the rationale of such choices. Oudart therefore asks a double question: What is the semiological functioning of the classical painting? Why did the classical painters develop it?

Oudart advances the following answers. (1) Classical figurative painting is a discourse. This discourse is produced according to figurative codes. These codes are directly produced by ideology and are therefore subjected to historical transformations. (2) This discourse defines in advance the role of the subject, and therefore predetermines the reading of the painting. The imaginary (the subject) is used by the painting to mask the presence of the figurative codes. Functioning without being perceived, the codes reinforce the ideology which they embody while the painting produces "an impression of reality" (*effet-de-réel*). This invisible functioning of the figurative codes can be defined as a "naturalization": the impression of reality produced testifies that the figurative codes are "natural" (instead of being ideological products). It imposes as "truth" the vision of the world entertained by a certain class. (3) This exploitation of the imaginary, this utilization of the subject is made possibly by the presence of a system which Oudart calls "representation." This system englobes the painting, the subject, and their relationship upon which it exerts a tight control.

Oudart's position here is largely influenced by Schefer's *Scénographie d'un tableau*. For Schefer, the image of an object must be understood to be the pretext that the painter uses to illustrate the system through which he translates ideology into perceptual schemes. The object represented is a "pretext" for the painting as a "text" to be produced. The object hides the painting's textuality by preventing the viewer from focusing on it. However, the text of the painting is totally offered to view. It is, as it were, hidden *outside* the object. It is here but we do not see it. We see through it to the imaginary object. Ideology is hidden in our very eyes.

How this codification and its hiding process work Oudart explains by analyzing *Las Meninas* by Velasquez.* In this painting, members of the court and the painter himself look out at the spectator. By virtue of a mirror in the back of the room (depicted at the center of the painting), we see what they are looking at: the king and queen, whose portrait Velasquez is painting. Foucault calls this the representation of classical representation, because the spectator—usually invisible—is here inscribed into the painting itself. Thus the painting represents its own functioning, but in a paradoxical, contradictory way. The painter is staring at us, the spectators who pass in front of the canvas; but the mirror reflects only one, unchanging thing, the royal couple. Through

---

*Oudart borrows here from ch. 1 of Michel Foucault's *The Order of Things* (London: Tavistock, 1970).

this contradiction, the system of "representation" points toward its own functioning. In cinematographic terms the mirror represents the reverse shot of the painting. In theatrical terms, the painting represents the stage while the mirror represents its audience. Oudart concludes that the text of the painting must not be reduced to its visible part; it does not stop where the canvas stops. The text of the painting is a system which Oudart defines as a double-stage. On one stage, the show is enacted; on the other, the spectator looks at it. In classical representation, the visible is only the first part of a system which always includes an invisible second part (the "reverse shot").

Historically speaking, the system of classical representation may be placed in the following way. The figurative techniques of the quattrocento constituted a figurative system which permitted a certain type of pictorial utterance. Classical representation produces the same type of utterances but submits them to a characteristic transformation—by presenting them as the embodiment of the glance of a subject. The pictorial discourse is not only a discourse which uses figurative codes. It is that which somebody sees.

Thus, even without the mirror in *Las Meninas*, the other stage would be part of the text of the painting. One would still notice the attention in the eyes of the painting's figures, etc. But even such psychological clues only reinforce a structure which could function without them. Classical representation as a system does not depend upon the subject of the painting. The Romantic landscapes of the nineteenth century submit nature to a remodeling which imposes on them a monocular perspective, transforming the landscape into that which is seen by a given subject. This type of landscape is very different from the Japanese landscape with its multiple perspective. The latter is *not* the visible part of a two-stage system.

While it uses figurative codes and techniques, the distinctive feature of representaiton as a semiological system is that it transforms the painted object into a sign. The object which is figured on the canvas in a certain way is the signifier of the presence of a subject who is looking at it. The paradox of *Las Meninas* proves that the presence of the subject must be signified but empty, defined but left free. Reading the signifers of the presence of the subject, the spectator occupies this place. His own subjectivity fills the empty spot predefined by the painting. Lacan stresses the unifying function of the imaginary, through which the act of reading is made possible. The representational painting is *already unified*. The painting proposes not only itself, but its own reading. The specator's imaginary can only coincide with the painting's built-in subjectivity. The receptive freedom of the spectator is reduced to the minimum—he has to accept or reject the painting as a whole. This has important consequences, ideologically speaking.

When I occupy the place of the subject, the codes which led me to occupy this place become invisible to me. The signifiers of the presence of the subject disappear from my consciousness because they are the signifiers of my presence. What I perceive is their signified: myself. If I want to understand the painting and not just be instrumental in it as a catalyst to its ideological operation, I must avoid the empirical relationship it imposes on me. To understand the ideology which the painting conveys, I must avoid providing my own imaginary as a support for that ideology. I must refuse that identification which the painting so imperiously proposes to me.

Oudart stresses that the initial relationship between a subject and any ideological object is set up by ideology as a trap which prevents any real knowledge concerning the object. This trap is built upon the properties of the imaginary and must be deconstructed through a critique of these properties. On this critique depends the possibility of a real knowledge. Oudart's study of classical painting provides the analyst of cinema with two important tools for such a critique: the concept of a double-stage and the concept of the entrapment of the subject.

We note first that the filmic image considered in isolation, the single frame or the perfectly static shot, is (for purposes of our analysis) equivalent to the classical painting. Its codes, even though "analogic" rather than figurative, are organized by the system of representation: it is an image designed and organized not merely as an object that is seen, but as the glance of a subject. Can there be a cinematography not based upon the system of representation? This is an interesting and important question which cannot be explored here. It would seem that there has not been such a cinematography. Certainly the classical narrative cinema, which is our present concern, is founded upon the representation system. The case for blanket assimilation of cinema to the system of representation is most strongly put by Jean-Louis Baudry, who argues that the perceptual system and ideology of representation are built into the cinematographic apparatus itself. (See "Ideological Effects of the Basic Cinematographic Apparatus," in *Cinéthique* #7–8.) [See Section III of this volume.] Camera lenses organize their visual field according to the laws of perspective, which thereby operate to render it as the perception of a subject. Baudry traces this system to the sixteenth and seventeenth centuries, during which the lens technology which still governs photography was developed.

Of course cinema cannot be reduced to its still frames and the semiotic system of cinema cannot be reduced to the systems of painting or of photography. Indeed, the cinematic succession of images threatens to interrupt or even to expose and to deconstruct the representation system which commands static paintings or photos. For its succession of shots is, by that very system, a succession of views. The viewer's identification with the subjective function proposed by the painting or photograph is broken again and again during the viewing of a film. Thus cinema regularly and systematically raises the question which is exceptional in painting (*Las Meninas*): "Who is watching this?" The point of attack of Oudart's analysis is precisely here— what happens to the spectator-image relation by virtue of the shot-change peculiar to cinema?

The ideological question is hardly less important than the semiological one and, indeed, is indispensable to its solution. From the standpoint of the imaginary and of ideology, the problem is that cinema threatens to expose its own functioning as a semiotic system, as well as that of painting and photography. If cinema consists in a series of shots which have been produced, selected, and ordered in a certain way, then these operations will serve, project, and realize a certain ideological position. The viewer's question, cued by the system of representation itself—"Who is watching this?" and "Who is ordering these images?"—tends, however, to expose this ideological operation and its mechanics. Thus the viewer will be aware (1) of the cine-

matographic system for producing ideology and (2) therefore of specific ideological messages produced by this system. We know that ideology cannot work in this way. It must hide its operations, "naturalizing" its functioning and its messages in some way. Specifically, the cinematographic system for producing ideology must be hidden and the relation of the filmic message to this system must be hidden. As with classical painting, the code must be hidden by the message. The message must appear to be complete in itself, coherent and readable entirely on its own terms. In order to do this, the filmic message must account *within itself* for those elements of the code which it seeks to hide—changes of shot and, above all, what lies behind these changes, the questions "Who is viewing this?" and "Who is ordering these images?" and "For what purpose are they doing so?" In this way, the viewer's attention will be restricted to the message itself and the codes will not be noticed. That system by which the filmic message provides answers to the viewer's questions—imaginary answers—is the object of Oudart's analysis.

Narrative cinema presents itself as a "subjective" cinema. Oudart refers here not to avant-garde experiments with subjective cameras, but to the vast majority of fiction films. These films propose images which are subtly designated and intuitively perceived as corresponding to the point of view of one character or another. The point of view varies. There are also moments when the image does not represent anyone's point of view; but in the classical narrative cinema, these are relatively exceptional. Soon enough, the image is reasserted as somebody's point of view. In this cinema, the image is only "objective" or "impersonal" during the intervals between its acting as the actors' glances. Structurally, this cinema passes constantly from the personal to the impersonal form. Note, however, that when this cinema adopts the personal form, it does so somewhat obliquely, rather like novelistic descriptions which use "he" rather than "I" for descriptions of the central character's experience. According to Oudart, this obliqueness is typical of the narrative cinema: it gives the impression of being subjective while never or almost never being strictly so. When the camera *does* occupy the very place of a protagonist, the normal functioning of the film is impeded. Here Oudart agrees with traditional film grammars. Unlike them, however, Oudart can justify this taboo, by showing that this necessary obliquity of the camera is part of a coherent system. This system is that of the suture. It has the function of transforming a vision or seeing of the film into a reading of it. It introduces the film (irreducible to its frames) into the realm of signification.

Oudart contrasts the seeing and the reading of a film by comparing the experiences associated with each. To *see* the film is *not* to perceive the frame, the camera angle and distance, etc. The space between planes or objects on the screen is perceived as real, hence the viewer may perceive himself (in relation to this space) as fluidity, expansion, elasticity.

When the viewer discovers the frame—the first step in reading the film—the triumph of his former *possession* of the image fades out. The viewer discovers that the camera is hiding things, and therefore distrusts it and the frame itself, which he now understands to be arbitrary. He wonders why the frame is what it is. This radically transforms his mode of participation—the unreal space between characters and/or objects is no longer perceived as pleasurable. It is now the space which separates the camera from the characters. The latter have lost their quality of presence. Space puts

them between parentheses so as to assert its own presence. The spectator discovers that his possession of space was only partial, illusory. He feels dispossessed of what he is prevented from seeing. He discovers that he is only authorized to see what happens to be in the axis of the glance of another spectator, who is ghostly or absent. This ghost, who rules over the frame and robs the spectator of his pleasure, Oudart proposes to call "the absent-one" (*l'absent*).

The description above is not contingent or impressionistic—the experiences outlined are the effects of a system. The system of the absent-one distinguishes cinematography, a system producing meaning, from any impressed strip of film (mere footage). This system depends, like that of classical painting, upon the fundamental opposition between two fields: (1) what I see on the screen, (2) that complementary field which can be defined as the place from which the absent-one is looking. Thus: any filmic field defined by the camera corresponds to *another* field from which an absence emanates.

So far we have remained at the level of the shot. Oudart now considers that common cinematographic utterance which is composed of a shot and a reverse shot. In the first, the missing field imposes itself upon our consciousness under the form of the absent-one who is looking at what we see. In the second shot, the reverse shot of the first, the missing field is abolished by the presence of somebody or something occupying the absent-one's field. The reverse shot represents the fictional owner of the glance corresponding to shot one.

This shot/reverse shot system orders the experience of the viewer in this way. The spectator's pleasure, dependent upon his identification with the visual field, is interrupted when he perceives the frame. From this perception he infers the presence of the absent-one and that other field from which the absent-one is looking. Shot two reveals a character who is presented as the owner of the glance corresponding to shot one. That is, the character in shot two occupies the place of the absent-one corresponding to shot one. This character retrospectively transforms the absence emanating from shot one's other stage into a presence.

What happens in *systemic* terms is this: the absent-one of shot one is an element of the code that is attracted into the message by means of shot two. When shot two replaces shot one, the absent-one is transferred from the level of enunciation to the level of fiction. As a result of this, the code effectively disappears and the ideological effect of the film is thereby secured. The code, which *produces* an imaginary, ideological effect, is hidden by the message. Unable to see the workings of the code, the spectator is at its mercy. His imaginary is sealed into the film; the spectator thus absorbs an ideological effect without being aware of it, as in the very different system of classical painting.

The consequences of this system deserve careful attention. The absent-one's glance is that of a nobody, which becomes (with the reverse shot) the glance of a somebody (a character present on the screen). Being on screen he can no longer compete with the spectator for the screen's possession. The spectator can resume his previous relationship with the film. The reverse shot has "sutured" the hole opened in the spectator's imaginary relationship with the filmic field by his perception of the absent-one. This effect and the system which produces it liberates the imaginary of the spectator, in order to manipulate if for its own ends.

Besides a *liberation of the imaginary*, the system of the suture also commands a *production of meaning*. The spectator's inference of the absent-one and the other field must be described more precisely: it is a *reading*. For the spectator who becomes frame-conscious, the visual field *means* the presence of the absent-one as the owner of the glance that constitutes the image. The filmic field thus simultaneously belongs to representation and to signification. Like the classical painting, on the one hand it represents objects or beings, on the other hand it signifies the presence of a spectator. When the spectator ceases to identify with the image, the image necessarily signifies to him the presence of another spectator. The filmic image presents itself here not as a simple image but as a show, that is, it structurally asserts the presence of an audience. The filmic field is then a signifier; the absent-one is its signified. Since it represents another field from which a fictional character looks at the field corresponding to shot one, the reverse shot is offered to the film audience as being the other field, the field of the absent-one. In this way, shot two establishes itself as the signified of shot one. By substituting for the other field, shot two becomes the meaning of shot one.

Within the system of the suture, the absent-one can therefore be defined as the intersubjective "trick" by means of which the second part of a given representative statement is no longer simply what comes after the first part, but what is *signified* by it. The absent-one makes the different parts of a given statement the signifiers of each other. His stratagem: Break the statement into shots. Occupy the space between shots.

Oudart thus defines the basic statement of classical cinematography as a unit composed of two terms: the filmic field and the field of the absent-one. The sum of these two terms, stages, and fields realizes the meaning of the statement. Robert Bresson once spoke of an exchange between shots. For Oudart such an exchange is impossible—the exchange between shot one and shot two cannot take place directly. Between shot one and shot two the other stage corresponding to shot one is a necessary intermediary. The absent-one represents the exchangability between shots. More precisely, within the system of the suture, the absent-one represents the fact that no shot can constitute by itself a complete statement. The absent-one stands for that which any shot necessarily lacks in order to attain meaning: another shot. This brings us to the dynamics of meaning in the system of the suture.

Within this system, the meaning of a shot depends on the next shot. At the level of the signifier, the absent-one continually destroys the balance of a filmic statement by making it the incomplete part of a whole yet to come. On the contrary, at the level of the signified, the effect of the suture system is a retroactive one. The character presented in shot two does not replace the absent-one corresponding to shot two, but the absent-one corresponding to shot one. The suture is always chronologically posterior to the corresponding shot, that is, when we finally know what the other field was, the filmic field is no longer on the screen. The meaning of a shot is given retrospectively, it does not meet the shot on the screen, but only in the memory of the spectator.

The process of reading the film (perceiving its meaning) is therefore a retroactive one, wherein the present modifies the past. The system of the suture systematically encroaches upon the spectator's freedom by interpreting, indeed by remodeling his memory. The spectator is torn to pieces, pulled in opposite directions. On the one hand, a retroactive process organizes the *signified*. On the other hand, an anticipatory

process organizes the *signifier*. Falling under the control of the cinematographic system, the spectator loses access to the present. When the absent-one points toward it, the signification belongs to the future. When the suture realizes it, the signification belongs to the past. Oudart insists on the brutality, on the tyranny with which this signification imposes itself on the spectator or, as he puts it, "transits through him."

Oudart's analysis of classical cinema is a deconstruction not a destruction of it. To deconstruct a system implies that one inhabits it, studies its functioning very carefully, and locates its basic articulations, both external and internal. Of course there are other cinematographic systems besides that of the suture.* One of many such others is that of Godard's late films such as *Wind from the East*. Within this system, (1) the shot tends to constitute a complete statement, and (2) the absent-one is continuously perceived by the spectator. Since the shot constitutes a whole statement, the reading of the film is no longer suspended. The spectator is not kept waiting for the remaining-part-of-the statement-which-is-yet-to-come. The reading of the shot is contemporary to the shot itself. It is immediate, its temporality is the present.

Thus the absent-one's functional definition does not change. Within the Godardian system as well as within the suture system the absent-one is what ties the shot (filmic level) to the statement (cinematographic level). However, in Godard's case, the two levels are not disjoined. Cinematography does not hide the filmicity of the shot. It stands in a clear relationship to it.

The system of the suture represents exactly the opposite choice. The absent-one is masked, replaced by a character, hence the real origin of the image—the conditions of its production represented by the absent-one—is replaced with a false origin and this false origin is situated inside the fiction. The cinematographic level fools the spectator by connecting him to the fictional level rather than to the filmic level.

But the difference between the two origins of the image is not only that one (filmic) is true and the other (fictional) false. The true origin represents the cause of the image. The false origin suppresses that cause and does not offer anything in exchange. The character whose glance takes possession of the image did not produce it. He is only somebody who sees, a spectator. The image therefore exists independently. It has no cause. It is.

In other terms, it is its own cause. By means of the suture, the film-discourse presents itself as a product without a producer, a discourse without an origin. It speaks. Who speaks? Things speak for themselves and, of course, they tell the truth. Classical cinema establishes itself as the ventriloquist of ideology.

1974

---

*Indeed, shot/reverse shot is itself merely one figure in the system(s) of classical cinema. In this initial moment of enunciation in film, we have chosen it as a privileged example of the way in which the origin of the glance is displaced in order to hide the film's production of meaning.

# NICK BROWNE
# THE SPECTATOR-IN-THE-TEXT: THE RHETORIC OF *STAGECOACH*

The sequence from John Ford's *Stagecoach*, shown in the accompanying stills, raises the problem of accounting for the organization of images in an instance of the "classical" fiction film and of proposing the critical terms appropriate for that account. The formal features of these images—the framing of shots and their sequencing, the repetition of setups, the position of characters, the direction of their glances—can be taken together as a complex structure and understood as a characteristic answer to the rhetorical problem of telling a story, of showing an action to a spectator. Because the significant relations have to do with seeing—both in the ways the characters "see" each other and the way those relations are shown to the spectator—and because their complexity and coherence can be considered as a matter of "point of view," I call the object of this study the "specular text."

Explanations of the imagery of the classical narrative film are offered by technical manuals and various theories of editing. Here, though, I wish to examine the connection between the act of narration and the imagery, specifically in the matter of the framing and the angle of view determined by setups, by characterizing the narrating agency or authority which can be taken to rationalize the presentation of shots. An explanation of this kind necessarily involves clarifying in some detail the notion of the "position of the spectator." Thus we must characterize the spectator's implied position with respect to the action, the way it is structured, and the specific features of the process of "reading" (though not in the sense of interpretation). Doing so entails a description (within the terms of the narrative) of the relation of literal and fictional space that comprehends what seems, ambiguously, like the double origin of the filmic images.

An inquiry into the forms of authority for the imagery and the corresponding strategies which implicate the viewer in the action has few precedents, yet it raises general but basic questions about filmic narration that begin to clarify existing

accounts of the relation of narrative to image. The sequence from *Stagecoach* is interesting as a structure precisely because, in spite of its simplicity (it has no narrative or formal eccentricity), it challenges the traditional premises of critical efforts to account for the operation and effects of "classical" film style.

The traditional rationale for the presentation of imagery is often stated by the camera's relation to the spectator. For instance, a basically dramatic account has it that the shots should show essentially what a spectator would see if the action were played on a stage, and if at each moment he had the best view of the action (thus the changing angles only supply "accents"). Editing would follow the spectator's natural course of attention as it is implied by the action of the *mise-en-scène*. In such a mode the question of agency—that is, who is "staging" and making these events appear in this way—is referred not to the author or narrator but to the action itself, fully embodied in the characters. Everything that happens must be exhibited clearly for the eye of the spectator. On this theory, all the structures of the presentation are directed to a place external to the scene of the action—to the final authority, the ideal spectator. Oudart's account (*Film Quarterly*, Fall 1974) proposes that imagery is paradigmatically referred to the authority of the glance of the "absent one," the offscreen character within the story who in the countershot is depicted within the frame; the spectator "identifies" with the visual field of the "owner" of the glance. The "system of the suture" is an explanation that establishes the origin of the imagery by reference to the agency of character, but, surprisingly, it does not consider (indeed it seems to deny) the final agency, the authority of the narrator. The traces of the action of the narrator may seem to be effaced by this sytem, but such an effect can only be the result of a certain more general rhetoric. Thus I am proposing an account in which the structure of the imagery, whatever its apparent forms of presentation, refers jointly to the action of an implied narrator (who defines his position with respect to the tale by his judgments) and to the imaginative action occasioned by his placing and being placed by the spectator. Neither the traditional nor the more recent theories seem fully adequate to this problematic.

Thus the problem that arises from *Stagecoach* is to explain the functioning of the narrator and the nature and effects of spectator placement; specifically, describing and accounting for in detail a filmic rhetoric in which the agency of the narrator in his relation to the spectator is enacted jointly by the characters and the particular sequence of shots that show them. To describe this rhetoric in a rigorous and illuminating way means clarifying in filmic terms the notions of "narrative authority," "point of view," and "reading," and showing that these concepts are of use precisely because they arise naturally from the effort to account for the concrete structures of the text.

The moment in the story that the sequence depicts is the taking of a meal at the Dry Fork station on the stage's way to Lordsburg. Earlier in the film, the prostitute Dallas (the woman in the dark hat) has been run out of town by the Ladies' Law and Order League and has been put aboard the stagecoach. There she joined, among others, a cavalry officer's wife named Lucy (in the white hat) and Hatfield, her chivalrous but distant escort. Just before the present scene, the Ringo Kid (John Wayne), who has broken out of jail to avenge his brother's murder, has been ordered aboard by the sheriff when discovered by the side of the road. The sequence begins immediately after a

vote among the members of the group to decide whether to go on to Lordsburg and ends shortly before the end of the scene when the group exits the station. For purposes of convenience, I have called shots 4, 8, and 10, which are from the same setup, series A, and shots 3, 7, 9, and 11, series B.

One of the rationales that might be proposed to account for the setups, the spatial fields they show, the sequence of shots, is their relation to the "psychology" of the characters. How, if at all, are the setups linked to the visual attention, as with the glance, or say the interests of a character in the story? In the shot/reverse shot pattern which is sometimes, wrongly I think, taken as an exclusive paradigm of the "classical" style, the presence of the shot on the screen is "explained" or read as the depiction of the glance of the offscreen character, who, a moment later, is shown in the reverse shot. But because only a few shots of this sequence (or of most films) follow this pattern, we shall be pressed to a different formulation. The general question is how the two setups of the two major series of shots—series A from the head of the table and series B from the left side—are to be explained.

Series A is related to the visual attention of the woman at the head of the table, Lucy. The connection between the shots and her view, especially in the modulation of the force and meaning of that view, must, however, be established. These shots from A are readable as the depiction of Lucy's glance only retrospectively, after series B has shown her at the head of the table and after the animation conveyed in the dolly forward has implied its significance. The point remains, however, that the shots of series A are finally clearly authorized by a certain disposition of attention of one of the characters.

In contrast to series A, the series B shots from the left of the table are like the opening and closing shots (1, 12) in not being associated with or justified spatially as the depiction of anyone's glance. Can the placement of these shots be justified either as the "best angle" for the spectator or as the depiction of some other more complex conception of "psychology" of character than an act of attention in a glance? Persons to whom these shots might be attributed as mental disposition, ensemble of attitude, judgment and intention, is this framing significant of? Whose disposition? On what basis would such an attribution be effected? If establishing the interpretation of the framing depended on or was referred to as a character's "state of mind," which in fact changes significantly over the course of the sequence for each of the major characters (Dallas, Ringo, and Lucy), how would it be possible to accommodate those changing feelings to the fixity of setup? The fact of the fixity of setup denies that the explanation for camera placement can as a principle be referred to a psychology of character(s) based on the kind of emotional changes—surprise, repudiation, naiveté, humiliation—that eventuate in the sequence.

As another hypothesis we could say that the particular compositional features of series B are a presentation not of the "mind" of any single character but of a state of affairs within the group, a relationship among the parties. What is the state of affairs within this society that the framing depicts? There are two significant features of the compostion from setup B: the relation of Lucy in the immediate foreground to the group behind her, a group whose responsiveness to events repeats the direction of her own attention, and her relation, spatially, to Dallas and Ringo, who, excluded by the

1

4a DALLAS: Thank you.

2 RINGO: Set down here, ma'am.

4b

3a

4c

3b

5

A sequence from John Ford's *Stagecoach* (1939). "The formal features of these images—the framing of shots and their sequencing, the repetition of setups, the position of characters, the direction of their glances—can be taken as a complex structure and understood as a characteristic answer to the rhetorical problem of telling a story, of showing an action to a spectator" (BROWN, page 118).

6a

8a

6b

8b

7a

9 HATFIELD: May I find you another place, Mrs. Mallory? It's cooler by the window

7b

10

11a LUCY: Thank you.

12a

11b

12b

11c

left edge of the frame, are outside. The permanent and underlying fact about the mise-en-scène which justifies the fixity of camera placement is its status as a social drama of alliance and antagonism between two social roles—Lucy, an insider, a married woman and defender of custom; and Dallas, outsider and prostitute who violates the code of the table. The camera setups and the spatial fields they reveal, the compositional exclusion of the outlaw couple and their isolation in a separate space, with the implied assertion of Lucy's custodial relation to the body of legitimate society, respond to and depict in formal terms the social "positions" of the characters. In the kind of dramatic presentation they effect, the features of the framing are not justified as the depiction of personal psychology considered as changes of feeling; instead, by their emphasis on social positions, or types, they declare a psychology of intractable situations.

The framing of series B from the left of the table does not represent literally or figuratively any single person's view; rather, it might be said, it depicts, by what it excludes and includes, the interplay of social positions within a group. This asymmetry of social position of Lucy over Dallas extends as well to formal and compositional features of the sequence. Though setup B represents both positions, Dallas's negatively, it makes Lucy's position privileged in the formal mechanism of narrative exposition. The fundamental narrative feature of the sequence is a modification and inflection of the logic of shot/countershot. Here it is an alternation of series A and B around, not two characters, but either Lucy's eye or body. That is, in series A Lucy is present as an eye, as the formal beholder of the scene. Alternately, in B, Lucy is shown bodily dominating the foreground, and as the eye to which the views of series A are referred. Formally the narration proceeds by alternatingly shifting Lucy's presence from the level of the depicted action, as body (B), to the level of representation, as the invisible eye (A), making Lucy's presence the central point of spatial orientation and legibility. In shots 5 and 6, the closeup of the exchange of looks between the two women, the formal asymmetry is the difference of their frontality, and the shot of Lucy is from a place that Dallas could not literally occupy. Lucy's frontality (5) marks a dispossession, a displacement, that corresponds to Dallas's social "absence" in the entire sequence—to her exclusion from the frame in B, to her isolation as the object of Lucy's scornful glance in A. By contrast to Lucy's presence everywhere, as body and eye, Dallas's eye is never taken as the source of authority for a shot. Her eye is averted. She is always, in both A and B, the object of another's gaze—a condition that corresponds to the inferiority of her social position, and to her formal invisibility—she cannot authorize a view.

The shots of setup B, which might be called "objective," or perhaps "nobody's" shots, in fact refer to or are a representation of Lucy's social dominance and formal privilege. B shows a field of vision that closely matches Lucy's *conception* of her own place in that social world: its framing corresponds to her alliance with the group and to her intention to exclude the outsiders, to deny their claim to recognition. It is, in other words, not exactly a description of Lucy's subjectivity but an objectification of her social self-conception. Though Lucy is visible in the frame, series B might be said, metaphorically, to embody her point of view.

This explanation seems cogent as far as it goes. But there are some further issues that arise from the passage, in the way it is experienced, that suggests that the fore-

going analysis of the justification of these formal features is incomplete as an account of the grounds for the effects the passage produces and theoretically limited in terms of explaining the strategies of framing and other premises of the narration.

Simply put, the experience of the passage is a feeling of empathy for Dallas's exclusion and humiliation, and a repudiation of Lucy's prejudice as unjust, two feelings brought together by a sense of inevitability of the conflict. There is, in other words, a curious opposition between the empathetic response of a spectator toward Dallas and the underlying premises of the mechanism of the narrative which are so closely related, formally, to Lucy's presence, point of view, and interests. It is this sense of incongruity between feeling and formal structure that occasions the following effort to consider the sequence in terms of the ways it produces its effects, that is, rhetorically.

One question about a formal matter which draws attention to the limitations of a structural account based on a conception of the social order is why the outsiders are seen from a position that is associated with Lucy's place at the table, her gaze. This fact, and the action of the audience within the film, casts doubt on two theories of agency. Our attention as spectators, in the shots of series B, does not follow the visual attention of any depicted characters. These shots might perhaps be read as statements of the "interests" of characters, the nature of their social positions, but that is already a kind of commentary or interpretation that needs explanation. The actions of the men at the bar, the audience within the film, disprove the traditional rationale for editing stated by reference to an ideal spectator: as "placed" spectators we anticipate, not follow, the movements of their attention (2, 3); the object of their attention is sometimes out of the frame we see (3b) and what they see is shown only from a view significantly different from any simply "accented" or "best view," indeed from a place they could not occupy; and sometimes (7b, 8) they have turned away, uninterested, but the screen doesn't go black. In general, an adequate account of the formal choices of the passage must be quite different from an account of the event as if it were staged for the natural attention of a spectator, depicted or real. To ask why the spectator sees in the way he does refers to a set of premises distinguishable from an account based on the attention of either a character or an ideal spectator. It refers to the concrete logic of the placement of the implied spectator and to the theory of presentation that accounts for the shaping of his response. Such an account makes the "position" of the spectator, the way in which he is implicated in the scene, the manner and location of his presence, his point of view, problematical.

It is this notion of the "position of the spectator" that I wish to clarify insofar as that notion illuminates the rhetorical strategies, particularly choice of setup (implying scale and framing) that depicts the action. In contemporary French film theory, particularly in the work of Comolli and Baudry, the notion of the "place" of the spectator is derived from the central position of the eye in perspective and photographic representation. By literally substituting the epistemological subject, the spectator, for the eye, in an argument about filmic representation, the filmic spectator is said to be "theological," and "centered" with respect to filmic images. Thus the theory of the filmic spectator is treated as if subject to the Derridean critique of center, presence, etc. French theory is wrong to enforce this analogy, based on the position of the eye

in photographic perspective, because what is optical and literal in that case corresponds only to the literal place of the spectator in the projection hall, and not at all to his figurative place in the film, nor to his place as subject to the rhetoric of the film, or reader or producer of the sense of the discourse. Outside of a French ideological project which fails to discriminate literal and figurative space, the notion of "place" of the spectator, and of "center," is an altogether problematic notion whose significance and function in critical discussion has yet to be explicated.

The sequence from *Stagecoach* provides the terms in which the notion of the position of the spectator might be clarified, provided we distinguish, without yet expecting full clarification, the different senses of "position." A spectator is (a) seated physically in the space of the projection hall and (b) placed by the camera in a certain fictional position with respect to the depicted action; moreover (c), insofar as we see from what we might take to be the eye of a character, we are invited to occupy the place allied to the place he holds, for example, in the social system; and finally (d), in another figurative sense of place, it is the only way that our response can be accounted for, that we can identify with a character's position in a certain situation.

In terms of the passage at hand, the question is then: how can I describe my "position" as spectator in identifying with the humiliated position of one of the depicted characters, Dallas, when my views of her belong to those of another, fictional character, Lucy, who is in the act of rejecting her? What is the spectator's "position" in identifying with Dallas in the role of the passive character? Dallas in averting her eyes from Lucy's in shot 6 accepts a view of herself in this encounter as "prostitute" and is shamed. However, in identifying with Dallas in the role of outcast, presumably the basis for the evocation of our sympathy and pity, our response as spectator is not one of shame, or anything even analogous. We do not suffer or repeat the humiliation. I understand Dallas's feeling but I am not so identified with her that I reenact it. One of the reasons for this restraint is that though I identify with Dallas's abject position of being seen as an unworthy object by someone whose judgment she accepts, I identify with her as the object of another's action. Indeed, in a remarkable strategy, I am asked to see Dallas through Lucy's eyes. That as spectator I am sharing Lucy's view and, just as important, her manner of viewing, is insisted on most emphatically by the dolly forward (4) and by disclosures effected by shot/countershot, thus placing me in a lively and implicated way in a position fully associated with Lucy's place at the head of the table.

Insofar as I identify with Dallas, it is not by repeating her shame, but by imagining myself in her position (situation). The early scenes of the film have carefully prepared us to believe that this exclusion is an unjust act. When the climactic moment arrives, our identification with Dallas as an object of view is simultaneously established as the ground for repudiating the one whose view we share and are implicated in. Though I share Lucy's literal geographical position of viewing at this moment in the film, I am not committed to her figurative point of view. I can, in other words, repudiate Lucy's view of or judgment on Dallas, without negating it as a view, in a way that Dallas herself, captive of the other's image, cannot. Because our feelings as spectators are not "analogous" to their interests and feelings of the characters, we are not bound to accept their views either of themselves or of others. Our "position" as spectator then is very different from the previous senses of "position"; it is defined neither

in terms of orientation within the constructed geography of the fiction nor in terms of social position of the viewing character. On the contrary, our point of view on the sequence is tied more closely to our attitude of approval or disapproval and is very different from any literal viewing angle or character's point of view.

Identification asks us as spectators to be two places at once, where the camera is and "with" the depicted person—thus its double structure of viewer/viewed. As a powerful emotional process it thus throws into question any account of the position of the spectator as centered at a single point or at the center of any simply optical system. Identification, this passage shows, necessarily has a double structure in the way it implicates the spectator in the position of both the one seeing and the one seen. This sequence, however, does establish a certain kind of "center" in the person of Lucy. Each of the shots is referred alternately to the scene before her eye or the scene of her body, but it is a "center" that functions as a principle of spatial legibility, and is associated with a literal point within the constructed space of the fiction. This center stands, though, as I have suggested, in a very complicated relation to our "position" as spectator. That is, the experience of the passage shows that our identification, in the Freudian sense of an emotional investment, is not with the center, either Lucy or the camera. Rather, if, cautiously, we can describe our figurative relation to a film in geographical terms, of "in," "there," "here," "distance" (and this sequence, as part of its strategy as a fiction, explicitly asks us to by presenting action to us from the literal view of a character), then as spectators, we might be said to formally occupy someone else's place, to be "in" the film, all the while being "outside" it in our seats. We can identify with a character and share her "point of view" even if the logic of the framing and selection of shots of the sequence deny that she has a view or a place within the society that the mise-en-scène depicts. There are significant differences between structures of shots, views, and identification: indeed, this sequence has shown, as a principle, that we do not "identify" with the camera but with the characters, and hence do not feel dispossessed by a change in shots. For a spectator, as distinct perhaps from a character, point of view is not definitively or summarily stated by any single shot or even set of shots from a given spatial location.

The way in which we as spectators are implicated in the action is as much a matter of our position with respect to the unfolding of those events in time as in their representation from a point in space. The effect of the mode of sequencing, the regular opposition of insiders and outsiders, is modulated in ways that shape the attitudes of the spectator/reader toward the action. This durational aspect emphasizes the process of inhabiting a text with its rhythms of involvement and disengagement in the action, and suggests that the spectator's position, his being in time, might appropriately be designated the "reader-in-the-text." His doubly structured position of identification with the features and force of the act of viewing and with the object in the field of vision are the visual terms of the dialectic of spectator placement. The rhetorical effort of shots 2–6 is directed to establishing the connection between shots and a "view," to endowing the position at the head of the table with a particular sense of a personalized glance. Shot 2, like 4, cannot at the moment it appears on the screen be associated with Lucy's glance. The shot/countershot sequencing discloses Lucy's location, and the turn of the head (3b) establishes a spatial relation between A and B; the animation, or gesture, implied by the dolly forward, combined with the emotional

intensity implied by the choice of scale (5, 6) is read in terms of a personalized agency and clarified by what is shown in the visible field, Lucy's stern face (5). It is a rhetoric that unites the unfolding shots and gives meaning to this depicted glance—affront. It creates with the discrete shots (2, 3, 4) the impression of a coherent act of viewing, a mental unity whose meaning must make itself felt by the viewer at the moment of confrontation (5, 6) to effect the sense of repudiation of Lucy's view and the abjectness of Dallas. It takes time—a sequence of shots, in other words—to convey and specify the meaning of an act of viewing.

Reading, as this instance shows, is in part a process of retrospection, situating what could not be "placed" at the moment of its origin and bringing it forward to an interpretation of the meaning of the present moment. As such it has a complex relation to the action and to the spatial location of viewing. But the process of reading also depends on forgetting. After the climactic moment (5, 6) signaling Dallas's averting her eyes, a different temporal strategy is in effect. Lucy has looked away in 7b, and in subsequent shots from the head of the table, our attention is directed not so much to the act of showing, and what it means—unawareness (2), recognition (4), rejection (6)—but rather in 8 and 10 is directed at the action within the frame. The spectator's forgetting of what the dramatic impact depended on just a few moments before (here the personalized force that accompanied the act of showing the shot as a glance) is an effect of placement that depends on an experience of duration which occludes a previous significance and replaces it with another, a process we might call fading.

The modulation of the effects of fading is what, to take another example, is at issue in the interpretation of the shots of both series A and B. I have argued above that the setup and field of B correspond to Lucy's understanding of her place in the social system—to her point of view in the metaphorical sense. This interpretation corresponds to the general impression of the first six shots, taken together, as representing Lucy's manner of seeing. Shot 7 initiates a new line of dramatic action that poses the question of what Lucy will do now, and also begins a process not exactly of rereading, but a search for a new reading of the meaning of the setups. At this moment (7b), Lucy has turned her attention away from Dallas and is now turned toward Hatfield; and Ringo, previously occupied with his table etiquette (2, 4) is looking (8b, 10) intently out of frame right. The initial sense of the setup B is partially replaced by but coexists with another: that the depicted action in the frame is now being viewed by someone looking from outside the frame, namely Ringo, who is waiting expectantly for something to happen. The view from the left of the table is readable, not exactly as Lucy's self-conceptions as before, and not as a depiction of Ringo's glance, but as a representation of his interest in the scene, his point of view (again, in the metaphorical sense). Similarly, shots 8 and 10, showing Dallas and Ringo, no longer seem to characterize Lucy as the one doing the seeing, as in 4 and 6; they have become impersonal. The rigidity and opposition of setups A and B correspond to the rigidity of social position, but our reading of the changing secondary significances of the framing is an effect of fading that is responsive to acts of attention and seeing depicted within the frame.

Our anticipation, our waiting to see what will happen, is provoked and represented on the level of the action by the turning around of the audience-in-the-film (Billy and Doc Boone in 3b, 9). Our own feeling, because of our visual place to the left of the

table, is closer to Ringo's than to theirs. Certainly the distention and delay of the climactic moment by a virtual repetition (9, 11a) of those shots of a hestitating Lucy (unnecessary for simple exposition) produce a sense of our temporal identification with Ringo (8b, 10), necessary for the success of the moment as drama—its uncertainty and resolution. The drama depends for the lesson it demonstrates not on Lucy's self-regard before a general public as previously, but on being watched by the parties to be affected. It is Ringo's increasingly involved presence as an authority for a view, even though he mistakenly thinks he is being ostracized, that makes the absent place left by Lucy's departure so evidently intended as a lesson in manners, so accusingly empty. By these strategies and effects of duration—retrospection, fading, delay, and anticipation—the reading of emphasis on the act of showing or what is shown, the significance of angle and framing, can be modulated. Together these means define features of a rhetoric which, though different from the placement effected by visual structures, also locate and implicate the reader/spectator in the text.

The spectator's place, the locus around which the spatiotemporal structures of presentation are organized, is a construction of the text which is ultimately the product of the narrator's disposition toward the tale. Such structures, which in shaping and presenting the action prompt a manner and indeed a path of reading, convey and are closely allied to the guiding moral commentary of the film. In this sequence the author has effaced himself, as in other instances of indirect discourse, for the sake of the characters and the action. Certainly he is nowhere visible in the same manner as the characters. Rather he is visible only through the materialization of the scene and in certain masked traces of his action. The indirect presence to his audience that the narrator enacts, the particular form of self-effacement, could be described as the masked displacement of his narrative authority as the producer of imagery from himself to the agency of his characters. That is, the film makes it appear as though it were the depicted characters to whom the authority for the presentation of shots can be referred—most evidently in the case of a depiction of a glance, but also, in more complex fashion, in the reading of shots as depictions of a "state of mind." The explanation of the presence of the imagery is referred by the film not to the originating authority who stands invisible, behind the action, but to his masks within the depicted space.

In accord with the narrator's efforts to direct attention away from his own activity, to mask and displace it, the narrator of *Stagecoach* has a visible persona, Lucy, perform a significant formal function in the narration: to constitute and to make legible and continuous the depicted space, by referring shots on the screen alternately to the authority of her eye or the place of her body. The literal place of the spectator in the projection hall, where in a sense all the shots are directed, is a "center" that has a figurative correspondence on the level of the discourse in the "place" that Lucy occupies in the depicted space. But because Lucy performs her integrative function not exactly by her being at a place, the head of the table, but by enacting a kind of central consciousness that corresponds to a social and formal role, a role which for narrative purposes can be exploited by shifting the views representing the manner of her presence, the notion of "center" might be thought of not as a geographical place but as a structure or function. As such, this locus makes it possible for the reader himself to occupy that role and himself to make the depicted space coherent and readable. For

the spectator, the "center" is not just a point either in the projection hall or in the depicted geography, but is the result of the impression produced by the functioning of the narrative and of his being able to fictionally occupy the absent place.

Locating this function, "inscribing" the spectator's place on the level of the depicted action, has the effect of making the story seem to tell itself by reference not to an outside author but to a continuously visible, internal narrative authority. This governing strategy, of seeming to internalize the source of the exposition in characters, and thus of directing the spectator's attention to the depicted action, is supported by other features of the style: shot/countershot, matching of glances, continuity.

Consequently, the place of the spectator in his relation to the narrator is established by, though not limited to, identifications with characters and the views they have of each other. More specifically his "place" is defined through the variable force of identification with the one viewing and the one viewed—as illustrated in the encounter between Lucy and Dallas. Though the spectator may be placed in the "center" by the formal function Lucy performs, he is not committed to her view of things. On the contrary, in the context of the film, that view is instantly regarded as insupportable. Our response to Dallas supports the sense that the spectator's figurative position is not stated by a description of where the camera is in the geography of the scene. On the contrary, though the spectator's position is closely tied to the fortunes and views of characters, our analysis suggests that identification, in the original sense of an emotional bond, need not be with the character whose view he shares, even less with the disembodied camera. Evidently, a spectator is several places at once—with the fictional viewer, with the viewed, and at the same time in a position to evaluate and respond to the claims of each. This fact suggests that like the dreamer, the filmic spectator is a plural subject: in his reading he is and is not himself.

In a film, imagining ourselves in a character's place by identification, in respect to the actual situation, is a different process, indeed a different order of fiction than taking a shot as originating from a certain point within the fictional geography. The relation though between the literal space of the projection hall and the depicted space of the film image is continuously problematic for a definition of the "thatness" of the screen and for an account of the place of the spectator. If a discourse carries a certain impression of reality, it is an effect not exactly of the image but rather of the way the image is placed by the narrative or argument. My relation to an image on the screen is literal because it can be taken as being directed to a physical point, my seat (changing that seat doesn't alter my viewing angle on the action), as though I were the fixed origin of the view. On the other hand, the image can also be taken as originating from a point in a different kind of space, recognizably different in terms of habitability from that of the projection hall: it is from a fictional and changeable place implied by an origin contained in the image. The filmic image thus implies the ambiguity of a double origin—both from my literal place as spectator and from the place where the camera is within the imaginative space.

One structural result of the ambiguous relation of literal and depicted space and of the seemingly contradictory efforts of the text to both place and displace the spectator is the prohibition against the "meeting," though no such act is literally possible, of actor's and spectator's glances, a prohibition that is an integral feature of the sequence as a "specular text." In its effect on the spectator, the prohibition defines the

different spaces he simultaneously inhabits before the screen. By denying his presence in one sense, the prohibition establishes a boundary at the screen that underscores the fact that the spectator can have no actual physical exchange with the depicted world, that he can do nothing relevant to change the course of the action. It places him irretrievably outside the action.

At the same time, the prohibition is the initial premise of a narrative system for the representation of fictional space and the means of introducing the spectator imaginatively into it. The prohibition effects this construction and engagement by creating an obliquity between our angle of viewing and that of the characters which works to make differences of angle and scale readable as representations of different points of view. As such it plays a central part in our process of identification or nonidentification with the camera and depicted characters. It provides the author an ensemble of narrative forms—an imaginary currency consisting of temporary exchange, substitution, and identification—that enables us, fictionally, to take the place of another, to inhabit the text as a reader.

Establishing agency by either the authority of character or of spectator corresponds in its alternative rhetorical forms to the articulation of the ambiguity of the double origin of the image. In a particular text it is the narration that establishes and arbitrates the spectator's placement between these two spaces. *Stagecoach* makes definite efforts to imply that not only is the spectator not there, not present in his seat, but that the film-object originates from an authority within the fictional space. The narration seems to insist that the film is a free-standing entity which a spectator, irrelevant finally to its construction, could only look on from the outside. On the other hand, in the ways that I have described, the film is directed in all its structures of presentation toward the narrator's construction of a commentary on the story and toward placing the spectator at a certain "angle" to it. The film has tried not just to direct the attention but to place the eye of the spectator inside the fictional space, to make his presence integral and constitutive of the structure of views. The explanation the film seems to give of the action of narrative authority is a denial of the existence of a narrator different from character and an affirmation of the dominating role of fictional space. It is a spatial mode not determined by the ontology of the image as such but is in the last instance an effect of the narration.

Masking and displacement of narrative authority are thus integral to establishing the sense of the spectator "in" the text, and the prohibition to establishing the film as an independent fiction, different from dream in being the product of another, that can nevertheless be inhabited. Fascination by identification with character is a way the integrity of fictional space is validated, and because the spectator occupies a fictional role, is a way too that the film can efface the spectator's consciousness of his position. As a production of the spectator's reading, the sense of reality that the film enacts, the "impression of the real," protects the account the text seems to give of the absent narrator.

The cumulative effect of the narrator's strategy of placement of the spectator from moment to moment is his introduction into what might be called the moral order of the text. That is, the presentational structures which shape the action both convey a point of view and define the course of the reading, and are fundamental to the exposition of moral idea—specifically a discussion about the relation of insiders to outsiders. The

effect of the distinction between pure and impure is the point of the sequence, though as a theme it is just a part of the total exposition. The sequence thus assists in the construction of attitudes toward law and custom and to those who live outside their strictures. It introduces the question of the exercise of social and customary (as distinguished from legal) authority. To the extent we identify with Ringo and Dallas—and the film continuously invites us to by providing multiple grounds: the couple's bravery, competence, and sincerity—the conventional order and the morality it enforces is put in doubt. Without offering a full interpretation of the theme of *Stagecoach*, which would I think be connected with the unorthodox nature of their love and the issue of Ringo's revenge and final exemption from the law by the sheriff, I can still characterize the spectator's position at this particular moment in the film.

It amounts to this: that though we see the action from Lucy's eyes and are invited by a set of structures and strategies to experience the force and character of that view, we are put in the position finally of having to reject it as a view that is right or that we could be committed to. The sequence engages us on this point through effecting an identification with a situation in which the outsider is wronged and thus that challenges Lucy's position as the agent of an intolerant authority. We are asked, by the manner in which we must read, by the posture we must adopt, to repudiate Lucy's view, to see behind the moral convention that supports intolerance, to break out of a role that may be confining us. As such, the importance of the sequence in the entire film is the way it allies us emotionally with the interests and fortunes of the outsiders as against social custom, an identification and theme that, modulated in subsequent events, continues to the end of the film. The passage, lifted out of its context, but drawing on dispositions established in prevous sequences, is an illustration of the process of constructing a spectator's attitudes in the film as a whole through the control of point of view. Whether or not the western genre can in general be characterized by a certain mode of identification, as, for example, in the disposition or wish to see the right done, and whether *Stagecoach* has a particularly significant place in the history of the genre by virtue of its treatment of outsiders, is an open question. In any case the reader's position is constituted by a set of views, identifications, and judgments that establish his place in the moral order of the text.

Like the absent narrator who discloses himself and makes his judgments from a position inseparable from the sequence of depicted events that constitute the narrative, the spectator, in following the story, in being subject of and to the spatial and temporal placement and effects of exposition, is in the process of realizing an identity we have called his position. Following the trajectory of identifications that establishes the structure of values of a text, "reading" as a temporal process could be said to continuously reconstruct the place of the narrator and his implied commentary on the scene. In this light, reading, as distinct from interpretation, might be characterized as a guided and prompted performance that (to the extent a text allows it, and I believe *Stagecoach* does) recreates the point of view enacted in a scene. As a correlative of narration, reading could be said to be the process of reenactment by fictionally occupying the place of the narrator.

Certain formal features of the imagery—framing, sequencing, the prohibition, and "invisibility" of the narrator—I have suggested, can be explained as the ensemble of

ways authority implicitly positions the spectator/reader. As a method, this analysis of *Stagecoach* points to a largely unexplored body of critical problems associated with describing and accounting for narrative and rhetorical signifying structures. The "specular text" and the allied critical concepts of "authority," "reading," "point of view," and "position of the spectator," however provisional, might be taken then as a methodological initiative for a semiotic study of filmic texts.

1975

# II

# Film and Reality

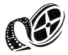

The main tradition of Western aesthetics, deriving fom Aristotle's *Poetics,* adopts the view that art "imitates" nature or, in Hamlet's phrase, holds "the mirror up to nature." Painting, from the early Renaissance to the late nineteenth century, from Giotto to Manet and the Impressionists, pursued this ideal with ever-increasing success. Later the novels of Balzac and Tolstoy provided a more detailed representation of nature and society than anything literature had previously known, and the plays of Ibsen and Chekhov seemed to carry Hamlet's ideal of the theater to its limit. All these achievements were eclipsed, however, by the invention of photography. For the camera, and especially the motion picture camera, was unique in its ability to represent nature. If the ideal of art is to create an illusion of reality, the motion picture made it possible to achieve this ideal in an unprecedented way.

But is the aim of art to imitate nature at all? And if it is, what role remains for the other arts when film achieves it so simply and perfectly? An anti-realist tradition therefore denies that the goal of art is the imitation of nature. Some anti-realists have argued that to create a work of art is not simply to copy the world but to add another, and very special, object to the world. This object may be valuable because it offers an interpretation or idealization of the world, or even because it creates another, wholly autonomous, world. Others in this anti-realist tradition argue that the value of such an object may be that it expresses the feelings and emotions of its creator, or that the artist manages to impose a beautiful or a significant form on the materials with which he works. The artist's feelings may be expressed abstractly, and the resulting form may be purely imaginative. The work of art may not allude to nature at all.

For example, theorists of modern painting have argued that painting should not even attempt to provide a three-dimensional representation of reality but acknowledge, instead, that it is essentially the application of pigments to a two-dimensional surface. This modernist view assumes that painting cannot and should not compete

135

with film in attempting to mirror reality. Painting must renounce that task altogether. Other critics have countered, however, that film cannot reproduce reality either. And, even if it could, it ought not to try. According to this anti-realist view, film, like any other art form, must offer an interpretation of the world or, by the manipulation of the camera, create an alternative world. Just as painting must acknowledge that it is not really a mirror but pigments on canvas, cinema must acknowledge that it is simply projected images on a screen. To claim that these images ought to be images of phys-ical reality—as opposed to any other kinds of images—is pure dogma. Why should these images not liberate the imagination from the tedium of reality, introducing us to the world of abstractions or of dreams instead?

Siegfried Kracauer is a leading exponent of the realist view of cinema. In his book, *Theory of Film,* Kracauer argues that because film literally photographs reality it alone is capable of holding the mirror up to nature. Film actually reproduces the raw material of the physical world within the work of art. This makes it impossible for a film to be a "pure" expression of the artist's formative intentions or an abstract, imag-inative expression of his emotions. Kracauer insists that it is the clear obligation and the special privilege of film (a descendant of still photography) to record and reveal, and thereby redeem, physical reality.

Kracauer's attitude is a response to the common complaint that the abstractions and categorizations of modern science and technology make it impossible for us to appreciate the concrete world in which we live—what John Crowe Ransom called "the world's body." The distinct function of art (especially of poetic imagery) might therefore well be to help us possess the concrete world once more. Kracauer believes that film art actually does this; it "literally redeems this world from its dormant state, its state of virtual nonexistence, by endeavoring to experience it through the camera." For Kracauer film delivers us from technology by technology.

In his earlier work, *From Caligari to Hitler,* a study of the German cinema from 1919 to 1933, Kracauer traces the decline of German political culture as reflected in the history of its cinema. By representing its story as a tale told by a madman, *Cali-gari* reflects the general retreat from the facts of German life as well as the abuse of power and authority characteristic of German political institutions. The total organi-zation of Caligari's landscapes within studio walls, its scenery of the soul, reveal the German cinema turning away from a reality which is haphazard, incalculable, and uncontrollable. In doing so, says Kracauer, German cinema helped prepare the way for Hitler's rise by subtly diverting the audience from a serious appraisal of social realities. This era of German film, usually considered one of the great periods in the history of cinema, is for Kracauer an example of all that cinema must avoid. By ignor-ing the claims of camera reality the German cinema achieved the damnation, not the redemption, of German life.

André Bazin, who also insists on the unique realism of cinema, does so, however, from a markedly different viewpoint. Bazin, a French critic who founded the influ-ential journal *Cahiers du Cinéma* in the late 1940s and whose disciples include Jean-Luc Godard, François Truffaut, and Claude Chabrol, is perhaps the most important theorist for whom the experience of silent film is no longer decisive. In "The Ontol-ogy of the Photographic Image" Bazin argues that photography and cinema are dis-coveries which finally satisfy the obsession with realism (long manifested in our

obsession with realism in painting). The photographic image is a mechanical repro-
duction of reality and we therefore accept as real the object reproduced or *re*-pre-
sented. The cinematic image shares the being of the model, whose reality is trans-
ferred to it. For the first time, an image of the world is formed automatically, without
the creative intervention of man. Alone among the arts, photography derives an
advantage from man's absence. Despite his celebration of the mechanical nature of
photography Bazin points out in "The Myth of Total Cinema" that any account of cin-
ema that relied merely on the technical inventions that made it possible would be
wholly inadequate. These very inventions were born of the converging of various
obsessions, out of a myth of total cinema that preceded and motivated them. The myth
expressed a nonaesthetic, psychological need to recreate the world in its own image,
an image unburdened by the artist's freedom to interpret or by the irreversibility of
time.

Bazin's commitment to the realist aesthetic manifested itself in his admiration for
the realist style of the French director Jean Renoir, the American directors Orson
Welles and William Wyler, and the major works of Italian neorealism. In contrast
both to the chief schools of realism that preceded it and to Soviet cinema, neo-realism
never makes reality the servant of some pre-existing point of view. And in contrast to
expressionism it asks the actor, often the man in the street rather than the professional
actor, to *be* rather than to act or pretend to be; it prefers an open, natural setting to an
expressionistic mise-en-scène that imposes meaning on action; and, above all, it
requires the narrative to respect the actual qualities and duration of the event in pref-
erence to the artificial, abstract, or dramatic duration favored in classic montage.
Bazin's admiration for these characteristics of neorealism manifest an ontological
position rather than a stylistic preference and, in the films of Vittorio de Sica, mani-
fest a love for the creation itself.

Rudolf Arnheim, who has also written extensively on the psychology of percep-
tion, is a leading early exponent of the anti-realist tradition in film theory. For Arn-
heim, if cinema were the mere mechanical reproduction of real life it could not be an
art at all. Arnheim acknowledges the existence of a primitive desire to get material
objects into one's power by creating them afresh, but he believes that this primitive
impulse must be distinguished from the impulse to create art. The "wax museum"
ideal may satisfy our primitive impulse, but it fails to satisfy the true artistic urge—
not simply to copy, but to originate, to interpret, and to mold. The very properties that
keep photography from reproducing reality perfectly must be exploited by the film
artist, for they alone provide the possibilities for a film art. Bazin's myth of "total"
cinema is nothing more than Arnheim's fallacy of the "complete" film. The pursuit of
an ever more complete realism through the use of sound, color, and stereoscopic
vision is simply a prescription for undermining the achievement of film art, which
must respect, even welcome, the inherent limitations of the art.

The consideration of film's relationship to reality has powerfully influenced eval-
uations of fictional, narrative films; however, these considerations are also important
to an alternative film tradition, one called, variously, independent, experimental, or
avant garde cinema. Two of the most important American contributors to that tradi-
tion are Maya Deren and Stan Brakhage. Deren accepted the inherent realism of the
photographic image, beginning with her very first film, *Meshes of the Afternoon,* in

1943. For Deren, as for Kracauer and Bazin, "the photographic image as reality . . . is the building block for the creative use of the medium." But Deren's program for the "creative use" of this photographic reality synthesizes the opposing views of the realist theorists and Rudolf Arnheim: the filmmaker creatively alters photographic reality by distorting the anticipated and familiar spatio-temporal relationships within the sequential flow of images. Deren suggests ways to alter what Arnheim called reality's "space-time continuum"—by using slow motion, reverse motion, and the freeze frame.

However, Deren also depends on our recognizing and understanding the perceptual reality which the photographic image presents and represents. Her films can then creatively exploit the various attributes of the photographic image—its fidelity, reality, and authority—by effectively undermining what we know about these realistic spaces.

Stan Brakhage, who began making his highly personal films just after the Second World War, takes an exactly opposite position. For Brakhage, the supposed reality of the photographic image is itself a conventionalized illusion, imposed by rules of perspective, compositional logic, and lenses grounded to achieve nineteenth-century Western compositional perspective. Brakhage's argument thus looks forward to those of the post-structuralist theorists who similarly attack the ideology of perspective and the cinema apparatus (see especially Section VII of this volume). But its fundamental purpose is to propose that the goal of cinema is the liberation of the eye itself, the creation of an act of seeing previously unimagined and undefined by conventions of representation, an eye as natural and unprejudiced as that of a cat, a bee, or an infant. Brakhage hopes to replace the absolute realism of the motion picture, which he calls "a contemporary mechanical myth," with a new "unrealized, therefore potential, magic." If there is one clear link between Deren and Brakhage it is that, whatever their opposing views, their films and writings represent reflexive, modernist meditations on the act and art of cinema itself.

Jean-Louis Baudry compares the experience of film to that of dream. He attempts, in doing so, to account for the "impression of reality," that "more than real" experience created by film. Baudry observes that many features of the film spectator's situation—features, that is, of the cinematic apparatus—resemble the dream. The spectator's movements are inhibited; he sits in a darkened room and is unable to engage in reality testing. The distinction between perception and representation does not operate. The images he views are projected on a screen (in the dreamer's case the mother's breast, what Bertram Lewin calls the dream screen); the intense images are more-than-real. According to psychoanalytic theory, the dream is endowed with this quality of heightened reality because it occasions a regression to the stage of primitive narcissism. Given the many similarities between the film experience and the dream experience, we can infer that the more-than-real experience of the film spectator is attributable to a similar regression. The desire for this regressive experience explains the history and creation of the cinematic apparatus and can be traced all the way back to its frequently invoked precursor, Plato's myth of the cave. According to Baudry, the prisoner in Plato's cave bears a striking analogy both to the dreamer and to the film spectator.

Noël Carroll challenges every significant feature of Baudry's analogy between the film spectator and the dreamer. In his view, the film spectator does not suffer motor inhibition but can get up and even have a smoke. Unlike dreams, film images are publicly accessible, but reality testing in Baudry's sense is in fact inapplicable to them. The dreamer may be (or may not be) in a darkened room, but this is not, in any case, part of the dream experience. Dreams are not, in fact, typically projected on (white) breasts, and, insofar as one can work with the vague concept of the "more-than-real" this notion applies more typically to dreams than to film. To be sure, some films provide a heightened experience of this sort but, when they do, this should be attributed more to particular features of their internal structure than to the projection situation or the cinematic apparatus itself. Carroll doubts the utility of the dream analogy to the understanding of film since we understand film better than we understand dreams. And he is highly critical of what he regards as a literary and impressionistic approach to questions that require scientific evidence and analytic precision.

Like Bazin, the French philosopher Gilles Deleuze views Welles and neo-realism as marking a fundamental break in the historical development of the film image. In contrast to those who defined neo-realism by its social context, however, Bazin argued that its crucial feature was the exhibition of a new form of reality, which he characterized as dispersive, elliptical, errant, or wavering, with deliberately weak connections between floating events. Instead of representing an already deciphered reality, neo-realism aimed at an always ambiguous reality that resisted deciphering. Deleuze admires the richness of Bazin's conception but believes that the introduction of an "additional reality" is insufficient. For Deleuze the problem arises at the level of the mental and displays itself in terms of thought.

In Deleuze's view pre–Second World War Hollywood films are dominated by the movement-image. Its various forms—the perception-, affection-, and action-image—relate perception, affection, and action. In the post–Second World War period Italian neo-realism loosens this sensory-motor scheme and thereby opens the way to the regime of the time-image, which for Deleuze is more significant than the transition from silents to talkies.

In classical Hollywood cinema, Deleuze argues, situations typically occasion actions that in turn create new situations (the SAS structure). All these elements are governed by the intelligible causal relations that make traditional narrative possible. By contrast, modern cinema emphasizes situations in which the characters no longer know how to react, in spaces we no longer know how to describe. These conditions disrupt the orderly narrative procedures of the commercial Hollywood film and inaugurate a more difficult cinema whose images are no longer linked by rational cuts, whose spaces are empty, fragmentary, and discontinuous, and whose characters are seers rather than doers, visionaries rather than agents. Actions create situations that in turn generate new actions (the ASA structure).

These features enable but do not yet establish the time-image. In the time-image, the subordination of time to movement is reversed, and a direct, rather than an indirect, image of time is revealed on the surface of the screen. The time-image presents a purely optical and sound situation that replaces the faltering sensory-motor system and its control of action. Into the world of continuous space-time where practical

action occurs, the modern cinema brings the emancipated senses into direct relation with thought and time, where the audience may grasp something too powerful, too unjust, or too beautiful, something that outstrips its sensory-motor capacities. To the extent that optical and visual description replaces motor action in this new regime of opsigns and sonsigns, a new principle of indeterminacy governs. We no longer know the difference between subjective and objective, imaginary and real, physical and mental—not because we are confused but because there is no longer a secure place from which to ask the questions.

Coming at these issues from the angle of technological innovation, Stephen Prince suggests that the increasing prominence of digital imaging requires a reconsideration of the classic debate between the realist and the formalist traditions of film theory. The realist theorists including Bazin, Kracauer, and Cavell have assumed that photographic images are what Peirce called indexical signs that are causally or existentially connected to their referents. But, Prince argues, computer-generated images challenge indexically based notions of photographic realism. The perceived reality of computer-generated images is a function of complex algorithms stored in computer memory rather than the result of a mechanically generated resemblance to an external reality. These images have a different ontological status. In the traditional debate the only alternative to the realist position is the "formalist" conception of Arnheim, Vertov, and Eisenstein. This view, which emphasizes the artificiality of the cinema structure, expresses itself in contemporary theories of the apparatus, of psychoanalysis, and of ideology. Theorists of this persuasion view cinematic realism as a discourse coded for transparency. The indexicality of photographic realism is replaced by the "reality-effect" produced by codes and discourses. Today, indexically based notions of cinema realism exist in tension with a semiotic view of cinema as discourse and of realism as one discourse among others. Shall we, then, conclude that digital imaging technologies, non-indexical by nature, are necessarily illusionistic, that they construct a reality-effect which is merely discursive? When faced with digitized images, will we need to discard entirely notions of realism in the cinema?

Prince thinks not. By employing, in place of an indexically based notion of film realism, a correspondence based view, we can avoid this conclusion. An extensive body of evidence indicates the many ways in which film spectatorship builds on correspondences between selected features of the cinematic display and a viewer's real-world visual and social experience. Attributions of realism or its lack will inhere in the ways these correspondences are structured or transformed by the image and the film. Instead of asking whether a film is realistic or formalistic, we should ask about the links between the represented fictionalized reality of a given film and the visual and social coordinates of our own three-dimensional world. This can be done for "realistic" and "fantasy" films alike.

Such a focus need not reinstate indexicality as the ground of realism, on the one hand, or turn everything about cinema back into discourse on the other. Even unreal images can be perceptually real. Perceptual realism designates a relationship between the image or film and the spectator, and it can encompass both unreal images (Spielberg's dinosaurs) and those which are referentially realistic (the documentary). This tension between perceptual realism and referential artifice clearly predates digital

imagery. What is new and revealing about digital imagery is that it increases to an extraordinary degree a filmmaker's control over the informational cues that establish perceptual realism. Unreal images have never seemed so real.

Digital imaging thus exposes the enduring dichotomy in film theory as a false boundary. It is not as if cinema either indexically records the world or stylistically transfigures it. Cinema does both. But digital imaging practices suggest that contemporary film theory's insistence on the constructedness of cinema's discursive practices may be less productive than is commonly thought. The problem here is the implication of discursive equivalence, the idea that all cinematic representations are, in the end, equally artificial, since all are the constructions of form or ideology. Rather some of these representations, while being referentially unreal, are perceptually realistic. We need to develop a precise understanding of how these images work in securing for the viewer a perceptually valid experience which may even invoke, as a kind of memory trace, now historically superseded assumptions about indexical referencing as the basis of the credibility that photographic images seem to possess.

# SIEGFRIED KRACAUER
## *FROM* THEORY OF FILM

## BASIC CONCEPTS

Like the embryo in the womb, photographic film developed from distinctly separate components. Its birth came about from a combination of instantaneous photography, as used by Muybridge and Marey, with the older devices of the magic lantern and the phenakistoscope. Added to this later were the contributions of other nonphotographic elements, such as editing and sound. Nevertheless photography, especially instantaneous photography, has a legitimate claim to top priority among these elements, for it undeniably is and remains the decisive factor in establishing film content. The nature of photography survives in that of film.

Originally, film was expected to bring the evolution of photography to an end— satisfying at last the age-old desire to picture things moving. This desire already accounted for major developments within the photographic medium itself. As far back as 1839, when the first daguerreotypes and talbotypes appeared, admiration mingled with disappointment about their deserted streets and blurred landscapes. And in the 'fifties, long before the innovation of the hand camera, successful attempts were made to photograph subjects in motion. The very impulses which thus led from time exposure to snapshot engendered dreams of a further extension of photography in the same direction—dreams, that is, of film. Abut 1860, Cook and Bonnelli, who had developed a device called a photobioscope, predicted a "complete revolution of photographic art. . . . We will see . . . landscapes," they announced, "in which the trees bow to the whims of the wind, the leaves ripple and glitter in the rays of the sun."

Along with the familiar photographic leitmotif of the leaves, such kindred subjects as undulating waves, moving clouds, and changing facial expressions ranked high in early prophecies. All of them conveyed the longing for an instrument which would capture the slightest incidents of the world about us—scenes that often would involve crowds, whose incalculable movements resemble, somehow, those of waves or leaves. In a memorable statement published before the emergence of instantaneous

143

photography, Sir John Herschel not only predicted the basic features of the film camera but assigned to it a task which it has never since disowned: "the vivid and lifelike reproduction and handing down to the latest posterity of any transaction in real life—a battle, a debate, a public solemnity, a pugilistic conflict." Ducos du Hauron and other forerunners also looked forward to what we have come to label newsreels and documentaries—films devoted to the rendering of real-life events. This insistence on recording went hand in hand with the expectation that motion pictures could acquaint us with normally imperceptible or otherwise induplicable movements—flashlike transformations of matter, the slow growth of plants, etc. All in all, it was taken for granted that film would continue along the lines of photography. . . .

## PROPERTIES OF THE MEDIUM

The properties of film can be divided into basic and technical properties.

The basic properties are identical with the properties of photography. Film, in other words, is uniquely equipped to record and reveal physical reality and, hence, gravitates toward it.

Now there are different visible worlds. Take a stage performance or a painting: they too are real and can be perceived. But the only reality we are concerned with is actually existing physical reality—the transitory world we live in. (Physical reality will also be called "material reality," or "physical existence," or "actuality," or loosely just "nature." Another fitting term might be "camera-reality.") . . . The other visible worlds reach into this world without, however, really forming a part of it. A theatrical play, for instance, suggests a universe of its own which would immediately crumble were it related to its real-life environment.

As a reproductive medium, film is of course justified in reproducing memorable ballets, operas, and the like. Yet even assuming that such reproductions try to do justice to the specific requirements of the screen, they basically amount to little more than "canning," and are of no interest to us here. Preservation of performances which lie outside physical reality proper is at best a sideline of a medium so particularly suited to explore that reality. This is not to deny that reproductions, say, of stage production numbers may be put to good cinematic use in certain feature films and film genres.

Of all the technical properties of film the most general and indispensable is editing. It serves to establish a meaningful continuity of shots and is therefore unthinkable in photography. (Photomontage is a graphic art rather than a specifically photographic genre.) Among the more special cinematic techniques are some which have been taken over from photography—e.g. the close-up, soft-focus pictures, the use of negatives, double or multiple exposure, etc. Others, such as the lap-dissolve, slow and quick motion, the reversal of time, certain "special effects," and so forth, are for obvious reasons exclusively peculiar to film.

These scanty hints will suffice. It is not necessary to elaborate on technical matters which have been dealt with in most previous theoretical writings on film. Unlike these, which invariably devote a great deal of space to editing devices, modes of lighting, various effects of the close-up, etc., the present book concerns itself with cinematic techniques only to the extent to which they bear on the nature of film, as defined

by its basic properties and their various implications. The interest lies not with editing in itself, regardless of the purposes it serves, but with editing as a means of implementing—or defying, which amounts to the same—such potentialities of the medium as are in accordance with its substantive characteristics. In other words, the task is not to survey all possible methods of editing for their own sake; rather, it is to determine the contributions which editing may make to cinematically significant achievements. Problems of film technique will not be neglected; however, they will be discussed only if issues going beyond technical considerations call for their investigation.

This remark on procedures implies what is fairly obvious anyway: that the basic and technical properties differ substantially from each other. As a rule the former take precedence over the latter in the sense that they are responsible for the cinematic quality of a film. Imagine a film which, in keeping with the basic properties, records interesting aspects of physical reality but does so in a technically imperfect manner; perhaps the lighting is awkward or the editing uninspired. Nevertheless such a film is more specifically a film than one which utilizes brilliantly all the cinematic devices and tricks to produce a statement disregarding camera-reality. Yet this should not lead one to underestimate the influence of the technical properties. It will be seen that in certain cases the knowing use of a variety of techniques may endow otherwise non-realistic films with a cinematic flavor.

## THE TWO MAIN TENDENCIES

If film grows out of photography, the realistic and formative tendencies must be operative in it also. Is it by sheer accident that the two tendencies manifested themselves side by side immediately after the rise of the medium? As if to encompass the whole range of cinematic endeavors at the outset, each went the limit in exhausting its own possibilities. Their prototypes were Lumière, a strict realist, and Méliès, who gave free rein to his artistic imagination. The films they made embody, so to speak, thesis and antithesis in a Hegelian sense.

### Lumière and Méliès

Lumiére's films contained a true innovation, as compared with the repertoire of the zootropes or Edison's peep boxes: they pictured everyday life after the manner of photographs. Some of his early pictures, such as *Baby's Breakfast* (*Le Déjeuner de bébé*) or *The Card Players* (*La Partie d'écarté*), testify to the amateur photographer's delight in family idyls and genre scenes. And there was *Teasing the Gardener* (*L'Arroseur arrosé*), which enjoyed immense popularity because it elicited from the flow of everyday life a proper story with a funny climax to boot. A gardener is watering flowers and, as he unsuspectingly proceeds, an impish boy steps on the hose, releasing it at the very moment when his perplexed victim examines the dried-up nozzle. Water squirts out and hits the gardener smack in the face. The denouement is true to style, with the gardener chasing and spanking the boy. This film, the germ cell and archetype of all film comedies to come, represented an imaginative attempt on the part of Lumière to develop photography into a means of story telling. Yet the story was just a real-life incident. And it was precisely its photographic veracity which

made Maxim Gorki undergo a shock-like experience. "You think," he wrote about *Teasing the Gardener*, "the spray is going to hit you too, and instinctively shrink back."

On the whole, Lumière seems to have realized that story telling was none of his business; it involved problems with which he apparently did not care to cope. Whatever story-telling films he, or his company, made—some more comedies in the vein of his first one, tiny historical scenes, etc.—are not characeristic of his production. The bulk of his films recorded the world about us for no other purpsoe than to present it. This is in any case what Mesguich, one of Lumière's "ace" cameramen, felt to be their message. At a time when the talkies were already in full swing he epitomized the work of the master as follows: "As I see it, the Lumière Brothers had established the true domain of the cinema in the right manner. The novel, the theater, suffice for the study of the human heart. The cinema is the dynamism of life, of nature and its manifestations, of the crowd and its eddies. All that asserts itself through movement depends on it. Its lens opens on the world."

Lumière's lens did open on the world in this sense. Take his immortal first reels *Workers Leaving the Lumière Factory* (*Sortie des usines Lumière*), *Arrival of a Train* (*L'Arrivée d'un train*), *La Place des Cordeliers à Lyon*: their themes were public places, with throngs of people moving in diverse directions. The crowded streets captured by the stereographic photographs of the late 'fifties thus reappeared on the primitive screen. It was life at its least controllable and most unconscious moments, a jumble of transient, forever dissolving patterns accessible only to the camera. The much-imitated shot of the railway station, with its emphasis on the confusion of arrival and departure, effectively illustrated the fortuity of these patterns; and their fragmentary character was exemplifed by the clouds of smoke which leisurely drifted upward. Significantly, Lumière used the motif of smoke on several occasions. And he seemd anxious to avoid any personal interference with the given data. Detached records, his shots resembled the imaginary shot of the grandmother which Proust contrasts with the memory image of her.

Contemporaries praised these films for the very qualities which the prophets and forerunners had singled out in their visions of the medium. It is inevitable that, in the comments on Lumière, "the ripple of leaves stirred by the wind" should be referred to enthusiastically. The Paris journalist Henri de Parville, who used the image of the trembling leaves, also identified Lumière's over-all theme as "nature caught in the act." Others pointed to the benefits which science would derive from Lumière's invention. In America his camera-realism defeated Edison's kinetoscope with its staged subjects.

Lumière's hold on the masses was ephemeral. In 1897, not more than two years after he had begun to make films, his popularity subsided. The sensation had worn off; the heyday was over. Lack of interest caused Lumière to reduce his production.

Georges Méliès took over where Lumière left off, renewing and intensifying the medium's waning appeal. This is not to say that he did not occasionally follow the latter's example. In his beginnings he too treated the audience to sightseeing tours; or he dramatized, in the fashion of the period, realistically staged topical events. But his main contribution to the cinema lay in substituting staged illusion for unstaged reality, and contrived plots for everyday incidents.

The two pioneers were aware of the radical differences in their approach. Lumière told Méliès that he considered film nothing more than a "scientific curiosity," thereby implying that his cinematograph could not possibly serve artistic purposes. In 1897, Méliès on his part published a prospectus which took issue with Lumière: "Messrs. Méliès and Reulos specialize mainly in fantastic or artistic scenes, reproductions of theatrical scenes, etc. . . . thus creating a special genre which differs entirely from the customary views supplied by the cinematograph—street scenes or scenes of every-day life."

The Two Tendencies: Lumière's *Workers Leaving the Lumière Factory* (1895) and Méliès's *The Witch* (1900). "Lumière's lens did open on the world . . . Méliès ignored the workings of nature out of the artist's delight in sheer fantasy" (KRACAUER, pages 146, 148).

Méliès's tremendous success would seem to indicate that he catered to demands left unsatisfied by Lumière's photographic realism. Lumière appealed to the sense of observation, the curiosity about "nature caught in the act"; Méliès ignored the workings of nature out of the artist's delight in sheer fantasy. The train in *Arrival of a Train* is the real thing, whereas its counterpart in Méliès's *An Impossible Voyage* (*Voyage à travers l'impossible*) is a toy train as unreal as the scenery through which it is moving. Instead of picturing the random movements of phenomena, Méliès freely interlinked imagined events according to the requirements of his charming fairy-tale plots. Had not media very close to film offered similar gratifications? The artist-photographers preferred what they considered aesthetically attractive compositions to searching explorations of nature. And immediately before the arrival of the motion picture camera, magic lantern performances indulged in the projection of religious themes, Walter Scott novels, and Shakespearean dramas.

Yet even though Méliès did not take advantage of the camera's ability to record and reveal the physical world, he increasingly created his illusions with the aid of techniques peculiar to the medium. Some he found by accident. When taking shots of the Paris Place de l'Opéra, he had to discontinue the shooting because the celluloid strip did not move as it should; the surprising result was a film in which, for no reason at all, a bus abruptly transformed itself into a hearse. True, Lumière also was not disinclined to have a sequence of events unfold in reverse, but Méliès was the first to exploit cinematic devices systematically. Drawing on both photography and the stage, he innovated many techniques which were to play an enormous role in the future—among them the use of masks, multiple exposure, superimposition as a means of summoning ghosts, the lap-dissolve, etc. And through his ingenuity in using these techniques he added a touch of cinema to his playful narratives and magic tricks. Stage traps ceased to be indispensable; sleights-of-hand yielded to incredible metamorphoses which film alone was able to accomplish. Illusion produced in this climate depended on another kind of craftsmanship than the magician's. It was cinematic illusion, and as such went far beyond theatrical make-believe. Méliès's *The Haunted Castle* (*Le Manoir du diable*) "is conceivable only in the cinema and due to the cinema," says Henri Langlois, one of the best connoisseurs of the primitive era.

Notwithstanding his film sense, however, Méliès still remained the theater director he had been. He used photography in a pre-photographic spirit—for the reproduction of a papier-maché universe inspired by stage traditions. In one of his greatest films, *A Trip to the Moon* (*Le Voyage dans la lune*), the moon harbors a grimacing man in the moon and the stars are bull's-eyes studded with the pretty faces of music hall girls. By the same token, his actors bowed to the audience, as if they performed on the stage. Much as his films differed from the theater on a technical plane, they failed to transcend its scope by incorporating genuinely cinematic subjects. This also explains why Méliès, for all his inventiveness, never thought of moving his camera; the stationary camera perpetuated the spectator's relation to the stage. His ideal spectator was the traditional theatergoer, child or adult. There seems to be some truth in the observation that, as people grow older, they instinctively withdraw to the positions from which they set out to struggle and conquer. In his later years Méliès more and more turned from theatrical film to filmed theater, producing *féeries* which recalled the Paris Châtelet pageants.

## The Realistic Tendency

In following the realistic tendency, films go beyond photography in two respects. First, they picture movement itself, not only one or another of its phases. But what kinds of movements do they picture? In the primitive era when the camera was fixed to the ground, it was natural for film makers to concentrate on moving material phenomena; life on the screen was life only if it manifested itself through external, or "objective," motion. As cinematic techniques developed, films increasingly drew on camera mobility and editing devices to deliver their messages. Although their strength still lay in the rendering of movements inaccessible to other media, these movements were no longer necessarily objective. In the technically mature film "subjective" movements—movements, that is, which the spectator is invited to execute—constantly compete with objective ones. The spectator may have to identify himself with a tilting, panning, or traveling camera which insists on bringing motionless as well as moving objects to his attention. Or an appropriate arrangement of shots may rush the audience through vast expanses of time and/or space so as to make it witness, almost simultaneously, events in different periods and places.

Nevertheless the emphasis is now as before on objective movement; the medium seems to be partial to it. As René Clair puts it: "If there is an aesthetics of the cinema . . . it can be summarized in one word: 'movement.' The external movement of the objects perceived by the eye, to which we are today adding the inner movement of the action." The fact that he assigns a dominant role to external movement reflects, on a theoretical plane, a marked feature of his own earlier films—the ballet-like evolutions of their characters.

Second, films may seize upon physical reality with all its manifold movements by means of an intermediary procedure which would seem to be less indispensable in photography—staging. In order to narrate an intrigue, the film maker is often obliged to stage not only the action but the surroundings as well. Now this recourse to staging is most certainly legitimate if the staged world is made to appear as a faithful reproduction of the real one. The important thing is that studio-built settings convey the impression of actuality, so that the spectator feels he is watching events which might have occurred in real life and have been photographed on the spot.

Falling prey to an interesting misconception, Emile Vuillermoz champions, for the sake of "realism," settings which represent reality as seen by a perceptive painter. To his mind they are more real than real-life shots because they impart the essence of what such shots are showing. Yet from the cinematic point of view these allegedly realistic settings are no less stagy than would be, say, a cubist or abstract composition. Instead of staging the given raw material itself, they offer, so to speak, the gist of it. In other words, they suppress the very camera-reality which film aims at incorporating. For this reason, the sensitive moviegoer will feel disturbed by them. (The problems posed by films of fantasy which, as such, show little concern for physical reality will be considered later on.)

Strangely enough, it is entirely possible that a staged real-life event evokes a stronger illusion of reality on the screen than would the original event if it had been captured directly by the camera. The late Ernö Metzner who devised the settings for the studio-made mining disaster in Pabst's *Kameradschaft*—an episode with the ring

of stark authenticity—insisted that candid shots of a real mining disaster would hardly have produced the same convincing effect.

One may ask, on the other hand, whether reality can be staged so accurately that the camera-eye will not detect any difference between the original and the copy. Blaise Cendrars touches on this issue in a neat hypothetical experiment. He imagines two film scenes which are completely identical except for the fact that one has been shot on the Mont Blanc (the highest mountain of Europe) while the other was staged in the studio. His contention is that the former has a quality not found in the latter. There are on the mountain, says he, certain "emanations, luminous or otherwise, which have worked on the film and given it a soul." Presumably large parts of our environment, natural or man-made, resist duplication.

## The Formative Tendency

The film maker's formative faculties are offered opportunities far exceeding those offered the photographer. The reason is that film extends into dimensions which photography does not cover. These differ from each other according to area and composition. With respect to areas, film makers have never confined themselves to exploring only physical reality in front of the camera but, from the outset, persistently tried to penetrate the realms of history and fantasy. Remember Méliès. Even the realistic-minded Lumière yielded to the popular demand for historical scenes. As for composition, the two most general types are the story film and the nonstory film. The latter can be broken down into the experimental film and the film of fact, which on its part comprises, partially or totally, such subgenres as the film on art, the newsreel, and the documentary proper.

It is easy to see that some of these dimensions are more likely than others to prompt the film maker to express his formative aspirations at the expense of the realistic tendency. As for areas, consider that of fantasy: movie directors have at all times rendered dreams or visions with the aid of settings which are anything but realistic. Thus in *Red Shoes* Moira Shearer dances, in a somnambulistic trance, through fantastic worlds avowedly intended to project her conscious mind—agglomerates of landscape-like forms, near-abstract shapes, and luscious color schemes which have all the traits of stage imagery. Disengaged creativity thus drifts away from the basic concerns of the medium. Several dimensions of composition favor the same preferences. Most experimental films are not even designed to focus on physical existence; and practically all films following the lines of a theatrical story evolve narratives whose significance overshadows that of the raw material of nature used for their implementation. For the rest, the film maker's formative endeavors may also impinge on his realistic loyalties in dimensions which, because of their emphasis on physical reality, do not normally invite such encroachments; there are enough documentaries with real-life shots which merely serve to illustrate some self-contained oral commentary.

## Clashes Between the Two Tendencies

Films which combine two or more dimensions are very frequent; for instance, many a movie featuring an everyday-life incident includes a dream sequence or a

documentary passage. Some such combinations may lead to overt clashes between the realistic and formative tendencies. This happens whenever a film maker bent on creating an imaginary universe from freely staged material also feels under an obligation to draw on camera-reality. In his *Hamlet* Laurence Olivier has the cast move about in a studio-built, conspicuously stagy Elsinore, whose labyrinthine architecture seems calculated to reflect Hamlet's unfathomable being. Shut off from our real-life environment, this bizarre structure would spread over the whole of the film were it not for a small, otherwise insignificant scene in which the real ocean outside that dream orbit is shown. But no sooner does the photographed ocean appear than the spectator experiences something like a shock. He cannot help recognizing that this little scene is an outright intrusion; that it abruptly introduces an element incompatible with the rest of the imagery. How he then reacts to it depends upon his sensibilities. Those indifferent to the peculiarities of the medium, and therefore unquestioningly accepting the staged Elsinore, are likely to resent the unexpected emergence of crude nature as a letdown, while those more sensitive to the properties of film will in a flash realize the make-believe character of the castle's mythical splendor. Another case in point is Renato Castellani's *Romeo and Juliet*. This attempt to stage Shakespeare in natural surroundings obviously rests upon the belief that camera-reality and the poetic reality of Shakespeare verse can be made to fuse into each other. Yet the dialogue as well as the intrigue establish a universe so remote from the chance world of real Verona streets and ramparts that all the scenes in which the two disparate worlds are seen merging tend to affect one as an unnatural alliance between conflicting forces.

Actually collisions of this kind are by no means the rule. Rather, there is ample evidence to suggest that the two tendencies which sway the medium may be interrelated in various other ways. Since some of these relationships between realistic and formative efforts can be assumed to be aesthetically more gratifying than the rest, the next step is to try to define them.

## THE CINEMATIC APPROACH

It follows from what has been said . . . that films may claim aesthetic validity if they build from their basic properties; like photographs, that is, they must record and reveal physical reality. . . . One might argue that too exclusive an emphasis on the medium's primary relation to physical reality tends to put film in a strait jacket. This objection finds support in the many existing films which are completely unconcerned about the representation of nature. There is the abstract experimental film. There is an unending succession of "photoplays" or theatrical films which do not picture real-life material for its own sake but use it to build up action after the manner of the stage. And there are the many films of fantasy which neglect the external world in freely composed dreams or visions. The old German expressionist films went far in this direction; one of their champions, the German art critic Herman G. Scheffauer, even eulogizes expressionism on the screen for its remoteness from photographic life.

Why, then, should these genres be called less "cinematic" than films concentrating on physical existence? The answer is of course that it is the latter alone which afford insight and enjoyment otherwise unattainable. True, in view of all the genres which

do not cultivate outer reality and yet are here to stay, this answer sounds somewhat dogmatic. But perhaps it will be found more justifiable in the light of the following two considerations.

First, favorable response to a genre need not depend upon its adequacy to the medium from which it issues. As a matter of fact, many a genre has a hold on the audience because it caters to widespread social and cultural demands; it is and remains popular for reasons which do not involve questions of aesthetic legitimacy. Thus the photoplay has succeeded in perpetuating itself even though most responsible critics are agreed that it goes against the grain of film. Yet the public which feels attracted, for instance, by the screen version of *Death of a Salesman*, likes this version for the very virtues which made the Broadway play a hit and does not in the least care whether or not it has any specifically cinematic merits.

Second, let us for the sake of argument assume that my definition of aesthetic validity is actually one-sided; that it results from a bias for one particular, if important, type of cinematic activities and hence is unlikely to take into account, say, the possibility of hybrid genres or the influence of the medium's nonphotographic components. But this does not necessarily speak against the propriety of that definition. In a strategic interest it is often more advisable to loosen up initial one-sidedness— provided it is well founded—than to start from all too catholic premises and then try to make them specific. The latter alternative runs the risk of blurring differences between the media because it rarely leads far enough away from the generalities postulated at the outset; its danger is that it tends to entail a confusion of the arts. When Eisenstein, the theoretician, began to stress the similarities between the cinema and the traditional art media, identifying film as their ultimate fulfillment, Eisenstein, the artist, increasingly trespassed the boundaries that separate film from elaborate theatrical spectacles: think of his *Alexander Nevsky* and the operatic aspects of his *Ivan the Terrible*.

In strict analogy to the term "photographic approach" the film maker's approach is called "cinematic" if it acknowledges the basic aesthetic principle. It is evident that the cinematic approach materializes in all films which follow the realistic tendency. This implies that even films almost devoid of creative aspirations, such as newsreels, scientific or educational films, artless documentaries, etc., are tenable propositions from an aesthetic point of view—presumably more so than films which for all their artistry pay little attention to the given outer world. But as with photographic reportage, newsreels and the like meet only the minimum requirement.

What is of the essence in film no less than photography is the intervention of the film maker's formative energies in all the dimensions which the medium has come to cover. He may feature his impressions of this or that segment of physical existence in documentary fashion, transfer hallucinations and mental images to the screen, indulge in the rendering of rhythmical patterns, narrate a human-interest story, etc. All these creative efforts are in keeping with the cinematic approach as long as they benefit, in some way or other, the medium's substantive concern with our visible world. As in photography, everything depends on the "right" balance between the realistic tendency and the formative tendency; and the two tendencies are well balanced if the latter does not try to overwhelm the former but eventually follows its lead.

# THE ISSUE OF ART

When calling the cinema an art medium, people usually think of films which resemble the traditional works of art in that they are free creations rather than explorations of nature. These films organize the raw material to which they resort into some self-sufficient composition instead of accepting it as an element in its own right. In other words, their underlying formative impulses are so strong that they defeat the cinematic approach with its concern for camera-reality. Among the film types customarily considered art are, for instance, the above-mentioned German expressionist films of the years after World War I; conceived in a painterly spirit, they seem to implement the formula of Hermann Warm, one of the designers of *The Cabinet of Dr. Caligari* settings, who claimed that "films must be drawings brought to life." Here also belongs many an experimental film; all in all, films of this type are not only intended as autonomous wholes but frequently ignore physical reality or exploit it for purposes alien to photographic veracity. By the same token, there is an inclination to classify as works of art feature films which combine forceful artistic composition with devotion to significant subjects and values. This would apply to a number of adaptations of great stage plays and other literary works.

Yet such a usage of the term "art" in the traditional sense is misleading. It lends support to the belief that artistic qualities must be attributed precisely to films which neglect the medium's recording obligations in an attempt to rival achievements in the fields of the fine arts, the theater, or literature. In consequence, this usage tends to obscure the aesthetic value of films which are really true to the medium. If the term "art" is reserved for productions like *Hamlet* or *Death of a Salesman*, one will find it difficult indeed to appreciate properly the large amount of creativity that goes into many a documentary capturing material phenomena for their own sake. Take Ivens's *Rain* or Flaherty's *Nanook*, documentaries saturated with formative intentions: like any selective photographer, their creators have all the traits of the imaginative reader and curious explorer; and their readings and discoveries result from full absorption in the given material and significant choices. Add to this that some of the crafts needed in the cinematic process—especially editing—represent tasks with which the photographer is not confronted. And they too lay claim to the film maker's creative powers.

This leads straight to a terminological dilemma. Due to its fixed meaning, the concept of art does not, and cannot, cover truly "cinematic" films—films, that is, which incorporate aspects of physical reality with a view to making us experience them. And yet it is they, not the films reminiscent of traditional art works, which are valid aesthetically. If film is an art at all, it certainly should not be confused with the established arts. There may be some justification in loosely applying this fragile concept to such films as *Nanook*, or *Paisan*, or *Potemkin* which are deeply steeped in camera-life. But in defining them as art, it must always be kept in mind that even the most creative film maker is much less independent of nature in the raw than the painter or poet; that his creativity manifests itself in letting nature in and penetrating it.

1960

# SIEGFRIED KRACAUER
# *FROM* FROM CALIGARI TO HITLER

## THE CABINET OF DR. CALIGARI

The Czech Hans Janowitz, one of the two authors of the film *Das Cabinet des Dr. Caligari* (*The Cabinet of Dr. Caligari*), was brought up in Prague—that city where reality fuses with dreams, and dreams turn into visions of horror.* One evening in October 1913 this young poet was strolling through a fair at Hamburg, trying to find a girl whose beauty and manner had attracted him. The tents of the fair covered the Reeperbahn, known to any sailor as one of the world's chief pleasure spots. Nearby, on the Holstenwall, Lederer's gigantic Bismarck monument stood sentinel over the ships in the harbor. In search of the girl, Janowitz followed the fragile trail of a laugh which he thought hers into a dim park bordering the Holstenwall. The laugh, which apparently served to lure a young man, vanished somewhere in the shrubbery. When, a short time later, the young man departed, another shadow, hidden until then in the bushes, suddenly emerged and moved along—as if on the scent of that laugh. Passing this uncanny shadow, Janowitz caught a glimpse of him: he looked like an average bourgeois. Darkness reabsorbed the man, and made further pursuit impossible. The following day big headlines in the local press announced: "Horrible sex crime on the Holstenwall! Young Gertrude . . . murdered." An obscure feeling that Gertrude might have been the girl of the fair impelled Janowitz to attend the victim's funeral. During the ceremony he suddenly had the sensation of discovering the murderer, who had not yet been captured. The man he suspected seemed to recognize him, too. It was the bourgeois—the shadow in the bushes.

---

*The following episode, along with other data appearing in my pages on *Caligari*, is drawn from an interesting manuscript Mr. Hans Janowitz has written about the genesis of this film. I feel greatly indebted to him for having put his material at my disposal. I am thus in a position to base my interpretation of *Caligari* on the true inside story, up to now unknown.

154

Carl Mayer, co-author with Janowitz of *Caligari*, was born in the Austrian provincial capital of Graz, where his father, a wealthy businessman, would have prospered had he not been obsessed by the idea of becoming a "scientific" gambler. In the prime of life he sold his property, went, armed with an infallible "system," to Monte Carlo, and reappeared a few months later in Graz, broke. Under the stress of this catastrophe, the monomaniac father turned the sixteen-year-old Carl and his three younger brothers out into the street and finally committed suicide. A mere boy, Carl Mayer was responsible for the three children. While he toured through Austria, peddling barometers, singing in choirs, and playing extras in peasant theaters, he became increasingly interested in the stage. There was no branch of theatrical production which he did not explore during those years of nomadic life—years full of experiences that were to be of immense use in his future career as a film poet. At the beginning of the war, the adolescent made his living by sketching Hindenburg portraits on postcards in Munich cafés. Later in the war, Janowitz reports, he had to undergo repeated examinations of his mental condition. Mayer seems to have been very embittered against the high-ranking military psychiatrist in charge of his case.

The war was over. Janowitz, who from its outbreak had been an officer in an infantry regiment, returned as a convinced pacifist, animated by hatred of an authority which had sent millions of men to death. He felt that absolute authority was bad in itself. He settled in Berlin, met Carl Mayer there, and soon found out that this eccentric young man, who had never before written a line, shared his revolutionary moods and views. Why not express them on the screen? Intoxicated with Wegener's films, Janowitz believed that this new medium might lend itself to powerful poetic revelations. As youth will, the two friends embarked on endless discussions that hovered around Janowitz' Holstenwall adventure as well as Mayer's mental duel with the psychiatrist. These stories seemed to evoke and supplement each other. After such discussions the pair would stroll through the night, irresistibly attracted by a dazzling and clamorous fair on Kantstrasse. It was a bright jungle, more hell than paradise, but a paradise to those who had exchanged the horror of war for the terror of want. One evening, Mayer dragged his companion to a sideshow by which he had been impressed. Under the title "Man or Machine" it presented a strong man who achieved miracles of strength in an apparent stupor. He acted as if he were hypnotized. The strangest thing was that he accomanied his feats with utterances which affected the spellbound spectators as pregnant forebodings.

Any creative process approaches a moment when only one additional experience is needed to integrate all elements into a whole. The mysterious figure of the strong man supplied such an experience. On the night of this show the friends first visualized the original story of *Caligari*. They wrote the manuscript in the following six weeks. Defining the part each took in the work, Janowitz calls himself "the father who planted the seed, and Mayer the mother who conceived and ripened it." At the end, one small problem arose: the authors were at a loss as to what to christen their main character, a psychiatrist shaped after Mayer's archenemy during the war. A rare volume, *Unknown Letters of Stendhal*, offered the solution. While Janowitz was skimming through this find of his, he happened to notice that Stendhal, just come from the battlefield, met at La Scala in Milan an officer named Caligari. The name clicked with both authors.

Their story is located in a fictitious North German town near the Dutch border, significantly called Holstenwall. One day a fair moves into the town, with merry-go-rounds and sideshows—among the latter that of Dr. Caligari, a weird, bespectacled man advertising the somnambulist Cesare. To procure a license, Caligari goes to the town hall, where he is treated haughtily by an arrogant official. The following morning this official is found murdered in his room, which does not prevent the townspeople from enjoying the fair's pleasures. Along with numerous onlookers, Francis and Alan—two students in love with Jane, a medical man's daughter—enter the tent of Dr. Caligari, and watch Cesare slowly stepping out of an upright, coffinlike box. Caligari tells the thrilled audience that the somnambulist will answer questions about the future. Alan, in an excited state, asks how long he has to live. Cesare opens his mouth; he seems to be dominated by a terrific, hypnotic power emanating from his master. "Until dawn," he answers. At dawn Francis learns that his friend has been stabbed in exactly the same manner as the official. The student, suspicious of Caligari, persuades Jane's father to assist him in an investigation. With a search warrant the two force their way into the showman's wagon, and demand that he end the trance of his medium. However, at this very moment they are called away to the police station to attend the examination of a criminal who has been caught in the act of killing a woman, and who now frantically denies that he is the pursued serial murderer.

Francis continues spying on Caligari, and, after nightfall, secretly peers through a window of the wagon. But while he imagines he sees Cesare lying in his box, Cesare in reality breaks into Jane's bedroom, lifts a dagger to pierce the sleeping girl, gazes at her, puts the dagger away and flees, with the screaming Jane in his arms, over roofs and roads. Chased by her father, he drops the girl, who is then escorted home, whereas the lonely kidnaper dies of exhaustion. As Jane, in flagrant contradiction of what Francis believes to be the truth, insists on having recognized Cesare, Francis approaches Caligari a second time to solve the torturing riddle. The two policemen in his company seize the coffinlike box, and Francis draws out of it—a dummy representing the somnambulist. Profiting by the investigators' carelessness, Caligari himself manages to escape. He seeks shelter in a lunatic asylum. The student follows him, calls on the director of the asylum to inquire about the fugitive, and recoils horror-struck: the director and Caligari are one and the same person.

The following night—the director has fallen asleep—Francis and three members of the medical staff whom he has initiated into the case search the director's office and discover material fully establishing the guilt of this authority in psychiatric matters. Among a pile of books they find an old volume about a showman named Caligari who, in the eighteenth century, traveled through North Italy, hypnotized his medium Cesare into murdering sundry people, and, during Cesare's absence, substituted a wax figure to deceive the police. The main exhibit is the director's clinical records; they are evidence that he desired to verify the account of Caligari's hypnotic faculties, that his desire grew into an obsession, and that, when a somnambulist was entrusted to his care, he could not resist the temptation of repeating with him those terrible games. He had adopted the identity of Caligari. To make him admit his crimes, Francis confronts the director with the corpse of his tool, the somnambulist.

No sooner does the monster realize Cesare is dead than he begins to rave. Trained attendants put him into a straitjacket.

This horror tale in the spirit of E.T.A. Hoffmann was an outspoken revolutionary story. In it, as Janowitz indicates, he and Carl Mayer half-intentionally stigmatized the omnipotence of a state authority manifesting itself in universal conscription and declarations of war. The German war government seemed to the authors the prototype of such voracious authority. Subjects of the Austro-Hungarian monarchy, they were in a better position than most citizens of the Reich to penetrate the fatal tendencies inherent in the German system. The character of Caligari embodies these tendencies; he stands for an unlimited authority that idolizes power as such, and, to satisfy its lust for domination, ruthlessly violates all human rights and values. Functioning as a mere instrument, Cesare is not so much a guilty murderer as Caligari's innocent victim. This is how the authors themselves understood him. According to the pacifist-minded Janowitz, they had created Cesare with the dim design of portraying the common man who, under the pressure of compulsory military service, is drilled to kill and to be killed. The revolutionary meaning of the story reveals itself unmistakably at the end, with the disclosure of the psychiatrist as Caligari: reason overpowers unreasonable power, insane authority is symbolically abolished. Similar ideas were also being expressed on the contemporary stage, but the authors of *Caligari* transferred them to the screen without including any of those eulogies of the authority-freed "New Man" in which many expressionist plays indulged.

A miracle occurred: Erich Pommer, chief executive of Decla-Bioscop, accepted this unusual, if not subversive, script. Was it a miracle? Since in those early postwar days the conviction prevailed that foreign markets could only be conquered by artistic achievements, the German film industry was of course anxious to experiment in the field of aesthetically qualified entertainment.[1] Art assured export, and export meant salvation. An ardent partisan of this doctrine, Pommer had moreover an incomparable flair for cinematic values and popular demands. Regardless of whether he grasped the significance of the strange story Mayer and Janowitz submitted to him, he certainly sensed its timely atmosphere and interesting scenic potentialities. He was a born promoter who handled screen and business affairs with equal facility, and, above all, excelled in stimulating the creative energies of directors and players. In 1923, Ufa was to make him chief of its entire production.[2] His behind-the-scenes activities were to leave their imprint on the pre-Hitler screen.

Pommer assigned Fritz Lang to direct *Caligari*, but in the middle of the preliminary discussions Lang was ordered to finish his serial *The Spiders*; the distributors of this film urged its completion.[3] Lang's successor was Dr. Robert Wiene. Since his father, a once-famous Dresden actor, had become slightly insane toward the end of his life, Wiene was not entirely unprepared to tackle the case of Dr. Caligari. He suggested, in complete harmony with what Lang had planned, an essential change of the

[1]Vincent, *Histoire de l'Art Cinématographique*, p. 140.
[2]*Jahrbuch der Filmindustrie*, 1922/3, pp. 35, 46. For an appraisal of Pommer, see Lejeune, *Cinema*, pp. 125–31.
[3]Information offered by Mr. Lang.

original story—a change against which the two authors violently protested. But no one heeded them.[1]

The original story was an account of real horrors; Wiene's version transforms that account into a chimera concocted and narrated by the mentally deranged Francis. To effect this transformation the body of the original story is put into a framing story which introduces Francis as a madman. The film *Caligari* opens with the first of the two episodes composing the frame. Francis is shown sitting on a bench in the park of the lunatic asylum, listening to the confused babble of a fellow sufferer. Moving slowly, like an apparition, a female inmate of the asylum passes by: it is Jane. Francis says to his companion: "What I have experienced with her is still stranger than what you have encountered. I will tell it to you."[2] Fade-out. Then a view of Holstenwall fades in, and the original story unfolds, ending, as has been seen, with the identification of Caligari. After a new fade-out the second and final episode of the framing story begins. Francis, having finished the narration, follows his companion back to the asylum, where he mingles with a crowd of sad figures—among them Cesare, who absentmindedly caresses a little flower. The director of the asylum, a mild and understanding-looking person, joins the crowd. Lost in the maze of his hallucinations, Francis takes the director for the nightmarish character he himself has created, and accuses this imaginary fiend of being a dangerous madman. He screams, he fights the attendants in a frenzy. The scene is switched over to a sickroom, with the director putting on horn-rimmed spectacles which immediately change his appearance: it seems to be Caligari who examines the exhausted Francis. After this he removes his spectacles and, all mildness, tells his assistants that Francis believes him to be Caligari. Now that he understands the case of his patient, the director concludes, he will be able to heal him. With this cheerful message the audience is dismissed.

Janowitz and Mayer knew why they raged against the framing story: it perverted, if not reversed, their intrinsic intentions. While the original story exposed the madness inherent in authority, Wiene's *Caligari* glorified authority and convicted its antagonist of madness. A revolutionary film was thus turned into a conformist one—following the much-used pattern of declaring some normal but troublesome individual insane and sending him to a lunatic asylum. This change undoubtedly resulted not so much from Wiene's personal predilections as from his instinctive submission to the necessities of the screen; films, at least commercial films, are forced to answer to mass desires. In its changed form *Caligari* was no longer a product expressing, at best, sentiments characteristic of the intelligentsia, but a film supposed equally to be in harmony with what the less educated felt and liked.

If it holds true that during the postwar years most Germans eagerly tended to withdraw from a harsh outer world into the intangible realm of the soul, Wiene's version was certainly more consistent with their attitude than the original story; for, by putting the original into a box, this version faithfully mirrored the general retreat into a shell. In *Caligari* (and several other films of the time) the device of a framing story

---

[1]Extracted from Mr. Janowitz's manuscript. See also Vincent, *Histoire de l'Art Cinématographique*, pp. 140, 143–44.

[2]Film license, issued by Board of Censors, Berlin, 1921 and 1925 (Museum of Modern Art Library, clipping files); *Film Society Programme*, March 14, 1926.

was not only an aesthetic form, but also had symbolic content. Significantly, Wiene avoided mutilating the original story itself. Even though *Caligari* had become a conformist film, it preserved and emphasized this revolutionary story—as a madman's fantasy. Caligari's defeat now belonged among psychological experiences. In this way Wiene's film does suggest that during their retreat into themselves the Germans were stirred to reconsider their traditional belief in authority. Down to the bulk of social democratic workers they refrained from revolutionary action; yet at the same time a psychological revolution seems to have prepared itself in the depths of the collective soul. The film reflects this double aspect of German life by coupling a reality in which Caligari's authority triumphs with a hallucination in which the same authority is overthrown. There could be no better configuration of symbols for that uprising against the authoritarian dispositions which apparently occurred under the cover of a behavior rejecting uprising.

Janowitz suggested that the settings for *Caligari* be designed by the painter and illustrator Alfred Kubin, who, a forerunner of the surrealists, made eerie phantoms invade harmless scenery and visions of torture emerge from the subconscious. Wiene took to the idea of painted canvases, but preferred to Kubin three expressionist artists: Hermann Warm, Walter Röhrig and Walter Reimann. They were affiliated with the Berlin Sturm group, which, through Herwarth Walden's magazine *Sturm*, promoted expressionism in every field of art.[1]

Although expressionist painting and literature had evolved years before the war, they acquired a public only after 1918. In this respect the case of Germany somewhat resembled that of Soviet Russia where, during the short period of war communism, diverse currents of abstract art enjoyed a veritable heyday.[2] To a revolutionized people expressionism seemed to combine the denial of bourgeois traditions with faith in man's power freely to shape society and nature. On account of such virtues it may have cast a spell over many Germans upset by the breakdown of their universe.[3]

"Films must be drawings brought to life": this was Hermann Warm's formula at the time that he and his two fellow designers were constructing the *Caligari* world.[4] In

---

[1] Mr. Janowitz's manuscript; Vincent, *Histoire de l'Art Cinématographique*, p. 144; Rotha, *Film Till Now*, p. 43.

[2] Kurtz, *Expressionismus*, p. 61.

[3] In Berlin, immediately after the war, Karl Heinz Martin staged two little dramas by Ernst Toller and Walter Hasenclever within expressionist settings. Cf. Kurtz, ibid., p. 48; Vincent, *Histoire de l'Art Cinématographique*, pp. 142–43; Schapiro, "Nature of Abstract Art," *Marxist Quarterly*, Jan–March 1937, p. 97.

[4] Quotation from Kurtz, *Expressionismus*, p.66. Warm's views, which implied a verdict on films as photographed reality, harmonized with those of Viking Eggeling, an abstract Swedish painter living in Germany. Having eliminated all objects from his canvases, Eggeling deemed it logical to involve the surviving geometrical compositions in rhythmic movements. He and his painter friend Hans Richter submitted this idea to Ufa, and Ufa, guided as ever by the maxim that art is good business or, at least, good propaganda, enabled the two artists to go ahead with their experiments. The first abstract films appeared in 1921. While Eggeling—he died in 1925—orchestrated spiral lines and comblike figures in a short he called *Diagonal Symphony*, Richter composed his *Rhythm 21* of squares in black, gray and white. One year later, Walter Ruttmann, also a painter, joined in the trend with *Opus I*, which was a dynamic display of spots vaguely recalling X-ray photographs. As the titles reveal, the authors themselves considered their products a sort of optical music. It was a music that, whatever else it tried to impart, marked an utter withdrawal

accordance with his beliefs, the canvases and draperies of *Caligari* abounded in complexes of jagged, sharp-pointed forms strongly reminiscent of gothic patterns. Products of a style which by then had become almost a mannerism, these complexes suggested houses, walls, landscapes. Except for a few slips or concessions—some backgrounds opposed the pictorial convention in too direct a manner, while others all but preserved them—the settings amounted to a perfect transformation of material objects into emotional ornaments. With its oblique chimneys on pell-mell roofs, its windows in the form of arrows or kites and its treelike arabesques that were threats rather than trees, Holstenwall resembled those visions of unheard-of cities which the painter Lyonel Feininger evoked through his edgy, crystalline compositions.[1] In addition, the ornamental system in *Caligari* expanded through space, annuling its conventional aspect by means of painted shadows in disharmony with the lighting effects, and zigzag delineations designed to efface all rules of perspective. Space now dwindled to a flat plane, now augmented its dimensions to become what one writer called a "stereoscopic universe."[2]

Lettering was introduced as an essential element of the settings—appropriately enough, considering the close relationship between lettering and drawing. In one scene the mad psychiatrist's desire to imitate Caligari materializes in jittery characters composing the words "I must become Caligari"—words that loom before his eyes on the road, in the clouds, in the treetops. The incorporation of human beings and their movements into the texture of these surroundings was tremendously difficult. Of all the players only the two protagonists seemed actually to be created by a draftman's imagination. Werner Krauss as Caligari had the appearance of a phantom magician himself weaving the lines and shades through which he paced, and when Conrad Veidt's Cesare prowled along a wall, it was as if the wall had exuded him. The figure of an old dwarf and the crowd's antiquated costumes helped to remove the throng on the fair's tent-street from reality and make it share the bizarre life of abstract forms.

---

from the outer world. This esoteric *avantgarde* movement soon spread over other countries. From about 1924, such advanced French artists as Fernand Léger and René Clair made films which, less abstract than the German ones, showed an affinity for the formal beauty of machine parts, and molded all kinds of objects and motions into surrealistic dreams.—I feel indebted to Mr. Hans Richter for having permitted me to use his unpublished manuscript, "Avantgarde, History and Dates of the Only Independent Artistic Film Movement, 1921–1931." See also *Film Society Programme*, Oct. 16, 1927; Kurtz, *Expressionismus*, pp. 86, 94; Vincent, *Histoire de l'Art Cinématographique*, pp. 159–61; Man Ray, "Answer to a Questionnaire," *Film Art*, no. 7, 1936, p. 9; Kraszna-Krauss, "Exhibition in Stuttgart, June 1929, and Its Effects," *Close Up*, Dec. 1929, pp. 461–62.

[1]Mr. Feininger wrote to me about his relation to *Caligari* on Sept. 13, 1944: "Thank you for your . . . letter of Sept. 8. But if there has been anything I never had a part in nor the slightest knowledge of at the time, it is the film Caligari. I have never even seen the film . . . I never met nor knew the artists you name (Warm, Röhrig and Reimann) who devised the settings. Some time about 1911 I made, for my own edification, a series of drawings which I entitled: 'Die Stadt am Ende der Welt.' Some of these drawings were printed, some were exhibited. Later, after the birth of *Caligari*, I was frequently asked whether I had had a hand in its devising. This is all I can tell you. . . ."

[2]Cited by Carter, *The New Spirit*, p. 250, from H. G. Scheffauer, *The New Spirit in the German Arts*.— For the *Caligari* décor, see also Kurtz, *Expressionismus*, p. 66; Rotha, *Film Till Now*, p. 46; Jahier, "42 Ans de Cinéma," *Le Rôle intellecutal du Cinéma*, pp. 60–61; "The Cabinet of Dr. Caligari," *Exceptional Photoplays*, March 1921, p. 4; Amiguet, *Cinéma! Cinéma!*, p. 50. For the beginnings of Werner Krauss and Conrad Veldt, see Kalbus, *Deutsche Filmkunst*, I, 28, 30, and Veidt, "Mein Leben," *Ufa-Magazin*, Jan. 14–20, 1927.

If Decla had chosen to leave the original story of Mayer and Janowitz as it was, these "drawings brought to life" would have told it perfectly. As expressionist abstractions they were animated by the same revolutionary spirit that impelled the two scriptwriters to accuse authority—the kind of authority revered in Germany—of inhuman excesses. However, Wiene's version disavowed this revolutionary meaning of expressionist staging, or, at least, put it, like the original story itself, in brackets. In the film *Caligari* expressionism seems to be nothing more than the adequate translation of a madman's fantasy into pictorial terms. This was how many contemporary German reviewers understood, and relished, the settings and gestures. One of the critics stated with self-assured ignorance: "The idea of rendering the notions of sick brains . . . through expressionist pictures is not only well conceived but also well realized. Here this style has a right to exist, proves an outcome of solid logic."[1]

In their triumph the philistines overlooked one significant fact: even though *Caligari* stigmatized the oblique chimneys as crazy, it never restored the perpendicular ones as normal. Expressionist ornaments also overrun the film's concluding episode, in which, from the philistines' viewpoint, perpendiculars should have been expected to characterize the revival of conventional reality. In consequence, the *Caligari* style was as far from depicting madness as it was from transmitting revolutionary messages. What function did it really assume?

During the postwar years expressionism was frequently considered a shaping of primitive sensations and experiences. Gerhart Hauptmann's brother Carl—a distinguished writer and poet with expressionist inclinations—adopted this definition, and then asked how the spontaneous manifestations of a profoundly agitated soul might best be formulated. While modern language, he contended, is too perverted to serve this purpose, the film—or the bioscop, as he termed it—offers a unique opportunity to externalize the fermentation of inner life. Of course, he said, the bioscop must feature only those gestures of things and of human beings which are truly soulful. . . .[2]

Carl Hauptmann's views elucidate the expressionist style of *Caligari*. It had the function of characterizing the phenomena on the screen as phenomena of the soul—a function which overshadowed its revolutionary meaning. By making the film an outward projection of psychological events, expressionist staging symbolized—much more strikingly than did the device of a framing story—that general retreat into a shell which occurred in postwar Germany. It is not accidental that, as long as this collective process was effective, odd gestures and settings in a expressionist or similar style marked many a conspicuous film. *Variety*, of 1925, showed the final traces of them. Owing to their stereotyped character, these settings and gestures were like some familiar street sign—"Men at Work," for instance. Only here the lettering was different. The sign read: "Soul at Work."

After a thorough propaganda campaign culminating in the puzzling poster "You must become Caligari," Decla released the film in February 1920 in the Berlin Mar-

---

[1]Review in *8 Uhr Abendblatt*, cited in *Caligari-Heft*, p. 8
[2]Carl Hauptmann, "Film und Theater," *Der Film von Morgen*, p. 20. See also Alten, "Die Kunst in Deutschland," *Ganymed*, 1920, p. 146; Kurtz, *Expressionismus*, p. 14.

morhaus.[1] Among the press reviews—they were unanimous in praising *Caligari* as the first work of art on the screen—that of *Vorwärts*, the leading Social Democratic Party organ, distinguished itself by utter absurdity. It commented upon the film's final scene, in which the director of the asylum promises to heal Francis, with the words: "This film is also morally invulnerable inasmuch as it evokes sympathy for the mentally diseased, and comprehension for the self-sacrificing activity of the psychiatrists and attendants."[2] Instead of recognizing that Francis' attack against an odious authority harmonized with the Party's own antiauthoritarian doctrine, *Vorwärts* preferred to pass off authority itself as a paragon of progressive virtues. It was always the same psychological mechanism: the rationalized middle-class propensities of the Social Democrats interfering with their rational socialist designs. While the Germans were too close to *Caligari* to appraise its symptomatic value, the French realized that this film was more than just an exceptional film. They coined the term "*Caligarisme*" and applied it to a postwar world seemingly all upside down; which, at any rate, proves that they sensed the film's bearing on the structure of society. The New York première of *Caligari*, in April 1921, firmly established its world fame. But apart from giving rise to stray imitations and serving as a yardstick for artistic endeavors, this "most widely discussed film of the time" never seriously influenced the course of the American or French cinema.[3] It stood out lonely, like a monolith.

*Caligari* shows the "Soul at Work." On what adventures does the revolutionized soul embark? The narrative and pictorial elements of the film gravitate toward two opposite poles. One can be labeled "Authority," or, more explicitly, "Tyranny." The theme of tyranny, with which the authors were obsessed, pervades the screen from beginning to end. Swivel chairs of enormous height symbolize the superiority of the city officials turning on them, and, similarly, the gigantic back of the chair in Alan's attic testifies to the invisible presence of powers that have their grip on him. Staircases reinforce the effect of the furniture: numerous steps ascend to police headquarters, and in the lunatic asylum itself no less than three parallel flights of stairs are called upon to mark Dr. Caligari's position at the top of the hierarchy. That the film succeeds in picturing him as a tyrant figure of the stamp of Homunculus and Lubitsch's Henry VIII is substantiated by a most illuminating statement in Joseph Freeman's novel, *Never Call Retreat*. Its hero, a Viennese professor of history, tells of his life in a German concentration camp where, after being tortured, he is thrown into a cell: "Lying alone in that cell, I thought of Dr. Caligari; then, without transition, of the Emperor Valentinian, master of the Roman world, who took great delight in imposing the death sentence for slight or imaginary offenses. This Caesar's favorite expressions were: 'Strike off his head!'—'Burn him alive!'—'Let him be beaten with clubs till he expires!' I thought what a genuine twentieth century ruler the emperor was, and promptly fell asleep."[4] This dreamlike reasoning penetrates Dr. Caligari to the core

---

[1] *Jahrbuch der Filmindustrie*, 1922/3, p. 81.
[2] Quoted from *Caligari-Heft*, p. 23.
[3] Quotation from Jacobs, *American Film*, p. 303; see also pp. 304–5.
[4] Freeman, *Never Call Retreat*, p. 528.

by conceiving him as a counterpart of Valentinian and a premonition of Hitler. Caligari is a very specific premonition in the sense that he uses hypnotic power to force his will upon his tool—a technique foreshadowing, in content and purpose, that manipulation of the soul which Hitler was the first to practice on a gigantic scale. Even though, at the time of *Caligari*, the motif of the masterful hypnotizer was not unknown on the screen—it played a prominent role in the American film *Trilby*, shown in Berlin during the war—nothing in their environment invited the two authors to feature it.[1] They must have been driven by one of those dark impulses which, stemming from the slowly moving foundations of a people's life, sometimes engender true visions.

One should expect the pole opposing that of tyranny to be the pole of freedom; for it was doubtless their love of freedom which made Janowitz and Mayer disclose the nature of tyranny. Now this counterpole is the rallying point of elements pertaining to the fair—the fair with its rows of tents, its confused crowds besieging them, and its diversity of thrilling amusements. Here Francis and Alan happily join the swarm of onlookers; here, on the scene of his triumphs, Dr. Caligari is finally trapped. In their attempts to define the character of a fair, literary sources repeatedly evoke the memory of Babel and Babylon alike. A seventeenth-century pamphlet describes the noise typical of a fair as "such a distracted noise that you would think Babel not comparable to it," and, almost two hundred years later, a young English poet feels enthusiastic about "that Babylon of booths—the Fair."[2] The manner in which such biblical images insert themselves unmistakably characterizes the fair as an enclave of anarchy in the sphere of entertainment. This accounts for its eternal attractiveness. People of all classes and ages enjoy losing themselves in a wilderness of glaring colors and shrill sounds, which is populated with monsters and abounding in bodily sensations—from violent shocks to tastes of incredible sweetness. For adults it is a regression into childhood days, in which games and serious affairs are identical, real and imagined things mingle, and anarchical desires aimlessly test infinite possibilities. By means of this regression the adult escapes a civilization which tends to overgrow and starve out the chaos of instincts—escapes it to restore that chaos upon which civilization nevertheless rests. The fair is not freedom, but anarchy entailing chaos.

Significantly, most fair scenes in *Caligari* open with a small iris-in exhibiting an organ-grinder whose arm constantly rotates, and, behind him, the top of a merry-go-round which never ceases its circular movement.[3] The circle here becomes a symbol of chaos. While freedom resembles a river, chaos resembles a whirlpool. Forgetful of self, one may plunge into chaos; one cannot move on in it. That the two authors selected a fair with its liberties as contrast to the oppressions of Caligari betrays the flaw in their revolutionary aspirations. Much as they longed for freedom, they were apparently incapable of imagining its contours. There is something Bohemian in their conception; it seems the product of naïve idealism rather than true insight. But it

---

[1] Kalbus, *Deutsche Filmkunst*, I, 95.

[2] McKechnie, *Popular Entertainments*, pp. 33, 47.

[3] Rotha, *Film Till Now*, p. 285. For the role of fairs in films, see E. W. and M. M. Robson, *The Film Answers Back*, pp. 196–97—An iris-in is a technical term for opening up the scene from a small circle of light in a dark screen until the whole frame is revealed.

might be said that the fair faithfully reflected the chaotic condition of postwar Germany.

Whether intentionally or not, *Caligari* exposes the soul wavering between tyranny and chaos, and facing a desperate situation: any escape from tyranny seems to throw it into a state of utter confusion. Quite logically, the film spreads an all-pervading atmosphere of horror. Like the Nazi world, that of *Caligari* overflows with sinister portents, acts of terror and outbursts of panic. The equation of horror and hopelessness comes to a climax in the final episode which pretends to re-establish normal life. Except for the ambiguous figure of the director and the shadowy members of his staff, normality realizes itself through the crowd of insane moving in their bizarre surroundings. The normal as a madhouse: frustration could not be pictured more finally. And in this film, as well as in *Homunculus*, is unleashed a strong sadism and an appetite for destruction. The reappearance of these traits on the screen once more testifies to their prominence in the German collective soul.

Technical peculiarities betray peculiarities of meaning. In *Caligari* methods begin to assert themselves which belong among the special properties of German film technique. *Caligari* initiates a long procession of 100 percent studio-made films. Whereas, for instance, the Swedes at that time went to great pains to capture the actual appearance of a snowstorm or a wood, the German directors, at least until 1924, were so infatuated with indoor effects that they built up whole landscapes within the studio walls. They preferred the command of an artificial universe to dependence upon a haphazard outer world. Their withdrawal into the studio was part of the general retreat into a shell. Once the Germans had determined to seek shelter within the soul, they could not well allow the screen to explore that very reality which they abandoned. This explains the conspicuous role of architecture after *Caligari*—a role that has struck many an observer. "It is of the utmost importance," Paul Rotha remarks in a survey of the postwar period, "to grasp the significant part played by the architect in the development of the German cinema."[1] How could it be otherwise? The architect's façades and rooms were not merely backgrounds, but hieroglyphs. They expressed the structure of the soul in terms of space.

*Caligari* also mobilizes light. It is a lighting device which enables the spectators to watch the murder of Alan without seeing it; what they see, on the wall of the student's attic, is the shadow of Cesare stabbing that of Alan. Such devices developed into a specialty of the German studios. Jean Cassou credits the Germans with having invented a "laboratory-made fairy illumination,"[2] and Harry Alan Potamkin considers the handling of the light in the German film its "major contribution to the cinema."[3] This emphasis upon light can be traced to an experiment Max Reinhardt made on the stage shortly before *Caligari*. In his *mise-en-scène* of Sorge's prewar drama *The Beggar* (*Der Bettler*)—one of the earliest and most vigorous manifestations of expressionism—he substituted for normal settings imaginary ones created by means

[1]Rotha, *Film Till Now*, p. 180. Cf. Potamkin, "Kino and Lichtspiel," *Close Up*, Nov. 1929, p. 387.
[2]Cited in Leprohon, "Le Cinéma Allemand," *Le Rouge et le Noir*, July 1928, p. 135.
[3]Potamkin, "The Rise and Fall of the German Film," *Cinema*, April 1980, p. 24.

of lighting effects.[1] Reinhardt doubtless introduced these effects to be true to the drama's style. The analogy to the films of the postwar period is obvious: it was their expressionist nature which impelled many a German director of photography to breed shadows as rampant as weeds and associate ethereal phantoms with strangely lit arabesques or faces. These efforts were designed to bathe all scenery in an unearthly illumination marking it as scenery of the soul. "Light has breathed soul into the expressionist films," Rudolph Kurtz states in his book on the expressionist cinema. Exactly the reverse holds true: in those films the soul was the virtual source of the light. The task of switching on this inner illumination was somewhat facilitated by powerful romantic traditions.

The attempt made in *Caligari* to coordinate settings, players, lighting, and action is symptomatic of the sense of structural organization which, from this film on, manifests itself on the German screen. Rotha coins the term "studio constructivism" to characterize "that curious air of completeness, of finality, that surrounds each product of the German studios."[2] But organizational completeness can be achieved only if the material to be organized does not object to it. (The ability of the Germans to organize themselves owes much to their longing for submission.) Since reality is essentially incalculable and therefore demands to be observed rather than commanded, realism on the screen and total organization exclude each other. Through their "studio constructivism" no less than their lighting the German films revealed that they dealt with unreal events displayed in a sphere basically controllable.[3]

In the course of a visit to Paris about six years after the première of *Caligari*, Janowitz called on Count Etienne de Beaumont in his old city residence, where he lived among Louis Seize furniture and Picassos. The Count voiced his admiration of *Caligari*, terming it "as fascinating and abstruse as the German soul." He continued: "Now the time has come for the German soul to speak, Monsieur. The French soul spoke more than a century ago, in the Revolution, and you have been mute. . . . Now we are waiting for what you have to impart to us, to the world."[4]

The Count did not have long to wait.

<div align="right">1947</div>

---

[1]Kurtz, *Expressionismus*, p. 59.

[2]Rotha, *Film Till Now*, pp. 107–8. Cf. Potamkin, "Kino and Lichtspiel," *Close Up*, Nov. 1929, p. 388, and "The Rise and Fall of the German Film," *Cinema*, April 1930, p. 24.

[3]Film connoisseurs have repeatedly criticized *Caligari* for being a stage imitation. This aspect of the film partly results from its genuinely theatrical action. It is action of a well-constructed dramatic conflict in stationary surroundings—action which does not depend upon screen representaion for significance. Like *Caligari*, all "indoor" films of the postwar period showed affinity for the stage in that they favored inner-life dramas at the expense of conflicts involving outer reality. However, this did not necessarily prevent them from growing into true films. When, in the wake of *Caligari*, film technique steadily progressed, the psychological screen dramas increasingly exhibited an imagery that elaborated the significance of their action. *Caligari's* theatrical affinity was also due to technical backwardness. An immovable camera focused upon the painted décor; no cutting device added a meaning of its own to that of the pictures. One should, of course, not forget the reciprocal influence *Caligari* and kindred films exerted, for their part, on the German stage. Stimulated by the use they made of the iris-in, stage lighting took to singling out a lone player, or some important sector of the scene. Cf. Barry, *Program Notes*, Series III, program 1; Gregor, *Zeitalter des Films*, pp. 134, 144–45; Rotha, *Film Till Now*, p. 275; Vincent, *Histoire de l'Art Cinématographique*, p. 189.

[4]From Janowitz's manuscript.

# ANDRÉ BAZIN
# *FROM* WHAT IS CINEMA?

## THE ONTOLOGY OF THE PHOTOGRAPHIC IMAGE

If the plastic arts were put under psychoanalysis, the practice of embalming the dead might turn out to be a fundamental factor in their creation. The process might reveal that at the origin of painting and sculpture there lies a mummy complex. The religion of ancient Egypt, aimed against death, saw survival as depending on the continued existence of the corporeal body. Thus, by providing a defense against the passage of time it satisfied a basic psychological need in man, for death is but the victory of time. To preserve, artificially, his bodily appearance is to snatch it from the flow of time, to stow it away neatly, so to speak, in the hold of life. It was natural, therefore, to keep up appearances in the face of the reality of death by preserving flesh and bone. The first Egyptian statue, then, was a mummy, tanned and petrified in sodium. But pyramids and labyrinthine corridors offered no certain guarantee against ultimate pillage.

Other forms of insurance were therefore sought. So, near the sarcophagus, alongside the corn that was to feed the dead, the Egyptians placed terra cotta statuettes, as substitute mummies which might replace the bodies if these were destroyed. It is this religious use, then, that lays bare the primordial function of statuary, namely, the preservation of life by a representation of life. Another manifestation of the same kind of thing is the arrow-pierced clay bear to be found in prehistoric caves, a magic identity-substitute for the living animal, that will ensure a successful hunt. The evolution, side by side, of art and civilization has relieved the plastic arts of their magic role. Louis XIV did not have himself embalmed. He was content to survive in his portrait by Le Brun. Civilization cannot, however, entirely cast out the bogy of time. It can only sublimate our concern with it to the level of rational thinking. No one believes any longer in the ontological identity of model and image, but all are agreed that the image helps us to remember the subject and to preserve him from a second spiritual death. Today the making of images no longer shares an anthropocentric, util-

itarian purpose. It is no longer a question of survival after death, but of a larger concept, the creation of an ideal world in the likeness of the real, with its own temporal destiny. "How vain a thing is painting" if underneath our fond admiration for its works we do not discern man's primitive need to have the last word in the argument with death by means of the form that endures. If the history of the plastic arts is less a matter of their aesthetic than of their psychology then it will be seen to be essentially the story of resemblance, or, if you will, of realism.

Seen in this sociological perspective photography and cinema would provide a natural explanation for the great spiritual and technical crisis that overtook modern painting around the middle of the last century. André Malraux has described the cinema as the furthermost evolution to date of plastic realism, the beginnings of which were first manifest at the Renaissance and which found a limited expression in baroque painting.

It is true that painting, the world over, has struck a varied balance between the symbolic and realism. However, in the fifteenth century Western painting began to turn from its age-old concern with spiritual realities expressed in the form proper to it, towards an effort to combine this spiritual expression with as complete an imitation as possible of the outside world.

The decisive moment undoubtedly came with the discovery of the first scientific and already, in a sense, mechanical system of reproduction, namely, perspective: the camera obscura of Da Vinci foreshadowed the camera of Niepce. The artist was now in a position to create the illusion of three-dimensional space within which things appeared to exist as our eyes in reality see them.

Thenceforth painting was torn between two ambitions: one, primarily aesthetic, namely the expression of spiritual reality wherein the symbol transcended its model; the other, purely psychological, namely the duplication of the world outside. The satisfaction of this appetite for illusion merely served to increase it till, bit by bit, it consumed the plastic arts. However, since perspective had only solved the problem of form and not of movement, realism was forced to continue the search for some way of giving dramatic expression to the moment, a kind of psychic fourth dimension that could suggest life in the tortured immobility of baroque art.*

The great artists, of course, have always been able to combine the two tendencies. They have allotted to each its proper place in the hierarchy of things, holding reality at their command and molding it at will into the fabric of their art. Nevertheless, the fact remains that we are faced with two essentially different phenomena and these any objective critic must view separately if he is to understand the evolution of the pictorial. The need for illusion has not ceased to trouble the heart of painting since the sixteenth century. It is a purely mental need, of itself nonaesthetic, the origins of which must be sought in the proclivity of the mind towards magic. However, it is a need the pull of which has been strong enough to have seriously upset the equilibrium of the plastic arts.

---

*It would be interesting from this point of view to study, in the illustrated magazines of 1890–1910, the rivalry between photographic reporting and the use of drawings. The latter, in particular, satisfied the baroque need for the dramatic. A feeling for the photographic document developed only gradually.

The quarrel over realism in art stems from a misunderstanding, from a confusion between the aesthetic and the psychological; between true realism, the need that is to give significant expression to the world both concretely and its essence, and the pseudorealism of a deception aimed at fooling the eye (or for that matter the mind); a pseudorealism content in other words with illusory appearances.* That is why medieval art never passed through this crisis; simultaneously vividly realistic and highly spiritual, it knew nothing of the drama that came to light as a consequence of technical developments. Perspective was the original sin of Western painting.

It was redeemed from sin by Niepce and Lumière. In achieving the aims of baroque art, photography has freed the plastic arts from their obsession with likeness. Painting was forced, as it turned out, to offer us illusion and this illusion was reckoned sufficient unto art. Photography and the cinema on the other hand are discoveries that satisfy, once and for all and in its very essence, our obsession with realism.

No matter how skillful the painter, his work was always in fee to an inescapable subjectivity. The fact that a human hand intervened cast a shadow of doubt over the image. Again, the essential factor in the transition from the baroque to photography is not the perfecting of a physical process (photography will long remain the inferior of painting in the reproduction of color); rather does it lie in a psychological fact, to wit, in completely satisfying our appetite for illusion by a mechanical reproduction in the making of which man plays no part. The solution is not to be found in the result achieved but in the way of achieving it.†

This is why the conflict between style and likeness is a relatively modern phenomenon of which there is no trace before the invention of the sensitized plate. Clearly the fascinating objectivity of Chardin is in no sense that of the photographer. The nineteenth century saw the real beginnings of the crisis of realism of which Picasso is now the mythical central figure and which put to the test at one and the same time the conditions determining the formal existence of the plastic arts and their sociological roots. Freed from the "resemblance complex," the modern painter abandons it to the masses who, henceforth, identify resemblance on the one hand with photography and on the other with the kind of painting which is related to photography.

Originality in photography as distinct from originality in painting lies in the essentially objective character of photography. [Bazin here makes a point of the fact that the lens, the basis of photography, is in French called the "objectif," a nuance that is lost in English.—TR.] For the first time, between the originating object and its reproduction there intervenes only the instrumentality of a nonliving agent. For the first time an image of the world is formed automatically, without the creative intervention of man. The personality of the photographer enters into the proceedings only in his selection of the object to be photographed and by way of the purpose he has in mind. Although the final result may reflect something of his personality, this does not play

---

*Perhaps the Communists, before they attach too much importance to expressionist realism, should stop talking about it in a way more suitable to the eighteenth century, before there were such things as photography or cinema. Maybe it does not really matter if Russian painting is second-rate provided Russia gives us first-rate cinema. Eisenstein is her Tintoretto.

†There is room, nevertheless, for a study of the psychology of the lesser plastic arts, the molding of death masks for example, which likewise involves a certain automatic process. One might consider photography in this sense as a molding, the taking of an impression, by the manipulation of light.

the same role as is played by that of the painter. All the arts are based on the presence of man, only photography derives an advantage from his absence. Photography affects us like a phenomenon in nature, like a flower or a snowflake whose vegetable or earthly origins are an inseparable part of their beauty.

This production by automatic means has radically affected our psychology of the image. The objective nature of photography confers on it a quality of credibility absent from all other picture-making. In spite of any objections our critical spirit may offer, we are forced to accept as real the existence of the object reproduced, actually re-presented, set before us, that is to say, in time and space. Photography enjoys a certain advantage in virtue of this transference of reality from the thing to its reproduction.*

A very faithful drawing may actually tell us more about the model but despite the promptings of our critical intelligence it will never have the irrational power of the photograph to bear away our faith.

Besides, painting is, after all, an inferior way of making likenesses, an *ersatz* of the processes of reproduction. Only a photographic lens can give us the kind of image of the object that is capable of satisfying the deep need man has to substitute for it some-thing more than a mere approximation, a kind of decal or transfer. The photographic image is the object itself, the object freed from the conditions of time and space that govern it. No matter how fuzzy, distorted, or discolored, no matter how lacking in documentary value the image may be, it shares, by virtue of the very process of its becoming, the being of the model of which it is the reproduction; it *is* the model.

Hence the charm of family albums. Those grey or sepia shadows, phantomlike and almost undecipherable, are no longer traditional family portraits but rather the dis-turbing presence of lives halted at a set moment in their duration, freed from their des-tiny; not, however, by the prestige of art but by the power of an impassive mechani-cal process: for photography does not create eternity, as art does, it embalms time, rescuing it simply from its proper corruption.

Viewed in this perspective, the cinema is objectivity in time. The film is no longer content to preserve the object, enshrouded as it were in an instant, as the bodies of insects are preserved intact, out of the distant past, in amber. The film delivers baroque art from its convulsive catalepsy. Now, for the first time, the image of things is likewise the image of their duration, change mummified as it were. Those cate-gories of *resemblance* which determine the species *photographic* image likewise, then, determine the character of its aesthetic as distinct from that of painting.†

The aesthetic qualities of photography are to be sought in its power to lay bare the realities. It is not for me to separate off, in the complex fabric of the objective world, here a reflection on a damp sidewalk, there the gesture of a child. Only the impassive lens, stripping its object of all those ways of seeing it, those piled-up preconceptions, that spiritual dust and grime with which my eyes have covered it, is able to present it

---

*Here one should really examine the psychology of relics and souvenirs which likewise enjoy the advantages of a transfer of reality stemming from the "mummy-complex." Let us merely note in passing that the Holy Shroud of Turin combines the features alike of relic and photograph.

†I use the term *category* here in the sense attached to it by M. Gouhier in his book on the theater in which he distinguishes between the dramatic and the aesthetic categories. Just as dramatic tension has no artistic value, the perfection of a reproduction is not to be identified with beauty. It constitutes rather the prime matter, so to speak, on which the artistic fact is recorded.

in all its virginal purity to my attention and consequently to my love. By the power of photography, the natural image of a world that we neither know nor can know, nature at last does more than imitate art: she imitates the artist.

Photography can even surpass art in creative power. The aesthetic world of the painter is of a different kind from that of the world about him. Its boundaries enclose a substantially and essentially different microcosm. The photograph as such and the object in itself share a common being, after the fashion of a fingerprint. Wherefore, photography actually contributes something to the order of natural creation instead of providing a substitute for it. The surrealists had an inkling of this when they looked to the photographic plate to provide them with their monstrosities and for this reason: the surrealist does not consider his aesthetic purpose and the mechanical effect of the image on our imaginations as things apart. For him, the logical distinction between what is imaginary and what is real tends to disappear. Every image is to be seen as an object and every object as an image. Hence photography ranks high in the order of surrealist creativity because it produces an image that is a reality of nature, namely, an hallucination that is also a fact. The fact that surrealist painting combines tricks of visual deception with meticulous attention to detail substantiates this.

So, photography is clearly the most important event in the history of plastic arts. Simultaneously a liberation and an accomplishment, it has freed Western painting, once and for all, from its obsession with realism and allowed it to recover its aesthetic autonomy. Impressionist realism, offering science as an alibi, is at the opposite extreme from eye-deceiving trickery. Only when form ceases to have any imitative value can it be swallowed up in color. So, when form, in the person of Cézanne, once more regains possession of the canvas there is no longer any question of the illusions of the geometry of perspective. The painting, being confronted in the mechanically produced image with a competitor able to reach out beyond baroque resemblance to the very identity of the model, was compelled into the category of object. Henceforth Pascal's condemnation of painting is itself rendered vain since the photograph allows us on the one hand to admire in reproduction something that our eyes alone could not have taught us to love, and on the other, to admire the painting as a thing in itself whose relation to something in nature has ceased to be the justification for its existence.

On the other hand, of course, cinema is also a language.

1945

# THE MYTH OF TOTAL CINEMA

Paradoxically enough, the impression left on the reader by Georges Sadoul's admirable book on the origins of the cinema is of a reversal, in spite of the author's Marxist views, of the relations between an economic and technical evolution and the imagination of those carrying on the search. The way things happened seems to call for a reversal of the historical order of causality, which goes from the economic infra-

structure to the ideological superstructure, and for us to consider the basic technical discoveries as fortunate accidents but essentially second in importance to the preconceived ideas of the inventors. The cinema is an idealistic phenomenon. The concept men had of it existed so to speak fully armed in their minds, as if in some platonic heaven, and what strikes us most of all is the obstinate resistance of matter to ideas rather than of any help offered by techniques to the imagination of the researchers.

Furthermore, the cinema owes virtually nothing to the scientific spirit. Its begetters are in no sense savants, except for Marey, but it is significant that he was only interested in analyzing movement and not in reconstructing it. Even Edison is basically only a do-it-yourself man of genius, a giant of the *concours Lépine*. Niepce, Muybridge, Leroy, Joly, Demeny, even Louis Lumière himself, are all monomaniacs, men driven by an impulse, do-it-yourself men or at best ingenious industrialists. As for the wonderful, the sublime E. Reynaud, who can deny that his animated drawings are the result of an unremitting pursuit of an *idée fixe*? Any account of the cinema that was drawn merely from the technical inventions that made it possible would be a poor one indeed. On the contrary, an approximate and complicated visualization of an idea invariably precedes the industrial discovery which alone can open the way to its practical use. Thus if it is evident to us today that the cinema even at its most elementary stage needed a transparent, flexible, and resistant base and a dry sensitive emulsion capable of receiving an image instantly—everything else being a matter of setting in order a mechanism far less complicated than an eighteenth-century clock—it is clear that all the definitive stages of the invention of the cinema had been reached before the requisite conditions had been fulfilled. In 1877 and 1880, Muybridge, thanks to the imaginative generosity of a horse-lover, managed to construct a large complex device which enabled him to make from the image of a galloping horse the first series of cinematographic pictures. However to get this result he had to be satisfied with wet collodion on a glass plate, that is to say, with just one of the three necessary elements—namely instantaneity, dry emulsion, flexible base. After the discovery of gelatino-bromide of silver but before the appearance on the market of the first celluloid reels, Marey had made a genuine camera which used glass plates. Even after the appearance of celluloid strips Lumière tried to use paper film.

Once more let us consider here only the final and complete form of the photographic cinema. The synthesis of simple movements studied scientifically by Plateau had no need to wait upon the industrial and economic developments of the nineteenth century. As Sadoul correctly points out, nothing had stood in the way, from antiquity, of the manufacture of a phenakistoscope or a zoötrope. It is true that here the labors of that genuine savant Plateau were at the origin of the many inventions that made the popular use of his discovery possible. But while, with the photographic cinema, we have cause for some astonishment that the discovery somehow precedes the technical conditions necessary to its existence, we must here explain, on the other hand, how it was that the invention took so long to emerge, since all the prerequisites had been assembled and the persistence of the image on the retina had been known for a long time. It might be of some use to point out that although the two were not necessarily connected scientifically, the efforts of Plateau are pretty well contemporary with those of Nicéphore Niepce, as if the attention of researchers had waited to

concern itself with synthesizing movement until chemistry quite independently of optics had become concerned, on its part, with the automatic fixing of the image.

I emphasize the fact that this historical coincidence can apparently in no way be explained on grounds of scientific, economic, or industrial evolution. The photographic cinema could just as well have grafted itself onto a phenakistoscope foreseen as long ago as the sixteenth century. The delay in the invention of the latter is as disturbing a phenomenon as the existence of the precursors of the former.

But if we examine their work more closely, the direction of their research is manifest in the instruments themselves, and, even more undeniably, in their writings and commentaries we see that these precursors were indeed more like prophets. Hurrying past the various stopping places, the very first of which materially speaking should have halted them, it was at the very height and summit that most of them were aiming. In their imaginations they saw the cinema as a total and complete representation of reality; they saw in a trice the reconstruction of a perfect illusion of the the outside world in sound, color, and relief.

As for the latter, the film historian P. Potoniée has even felt justified in maintaining that it was not the discovery of photography but of stereoscopy, which came onto the market just slightly before the first attempts at animated photography in 1851, that opened the eyes of the researchers. Seeing people immobile in space, the photographers realized that what they needed was movement if their photographs were to become a picture of life and a faithful copy of nature. In any case, there was not a single inventor who did not try to combine sound and relief with animation of the image—whether it be Edison with his kinetoscope made to be attached to a phonograph, or Demenay and his talking portraits, or even Nadar who shortly before producing the first photographic interview, on Chevreul, had written, "My dream is to see the photograph register the bodily movements and the facial expressions of a speaker while the phonograph is recording his speech" (February, 1887). If color had not yet appeared it was because the first experiments with the three-color process were slower in coming. But E. Reynaud had been painting his little figurines for some time and the first films of Méliès are colored by stencilling. There are numberless writings, all of them more or less wildly enthusiastic, in which inventors conjure up nothing less than a total cinema that is to provide that complete illusion of life which is still a long way away. Many are familiar with that passage from *L'Éve Future* in which Villiers de l'Isle-Adam, two years before Edison had begun his researches on animated photography, puts into the inventor's mouth the following description of a fantastic achievement: ". . . the vision, its transparent flesh miraculously photographed in color and wearing a spangled costume, danced a kind of popular Mexican dance. Her movements had the flow of life itself, thanks to the process of successive photography which can retain six minutes of movement on microscopic glass, which is subsequently reflected by means of a powerful lampascope. Suddenly was heard a flat and unnatural voice, dullounding and harsh. The dancer was singing the *alza* and the *olé* that went with her *fandango*."

The guiding myth, then, inspiring the invention of cinema, is the accomplishment of that which dominated in a more or less vague fashion all the techniques of the mechanical reproduction of reality in the nineteenth century, from photography to the phonograph, namely an integral realism, a recreation of the world in its own image,

an image unburdened by the freedom of interpretation of the artist or the irreversibilty of time. If cinema in its cradle lacked all the attributes of the cinema to come, it was with reluctance and because its fairy guardians were unable to provide them however much they would have liked to.

If the origins of an art reveal something of its nature, then one may legitimately consider the silent and the sound film as stages of a technical development that little by little made a reality out of the original "myth." It is understandable from this point of view that it would be absurd to take the silent film as a state of primal perfection which has gradually been forsaken by the realism of sound and color. The primacy of the image is both historically and technically accidental. The nostalgia that some still feel for the silent screen does not go far enough back into the childhood of the seventh art. The real primitives of the cinema, existing only in the imaginations of a few men of the nineteenth century, are in complete imitation of nature. Every new development added to the cinema must, paradoxically, take it nearer and nearer to its origins. In short, cinema has not yet been invented!

It would be a reversal then of the concrete order of causality, at least psychologically, to place the scientific discoveries or the industrial techniques that have loomed so large in its development at the source of the cinema's invention. Those who had the least confidence in the future of the cinema were precisely the two industrialists Edison and Lumière. Edison was satisfied with just his kinetoscope and if Lumière judiciously refused to sell his patent to Méliès it was undoubtedly because he hoped to make a large profit out of it for himself, but only as a plaything of which the public would soon tire. As for the real savants such as Marey, they were only of indirect assistance to the cinema. They had a specific purpose in mind and were satisfied when they had accomplished it. The fanatics, the madmen, the disinterested pioneers, capable, as was Berard Palissy, of burning their furniture for a few seconds of shaky images, are neither industrialists nor savants, just men obsessed by their own imaginings. The cinema was born from the converging of these various obsessions, that is to say, out of a myth, the myth of total cinema. This likewise adequately explains the delay of Plateau in applying the optical principle of the persistence of the image on the retina, as also the continuous progress of the syntheses of movement as compared with the state of photographic techniques. The fact is that each alike was dominated by the imagination of the century. Undoubtedly there are other examples in the history of techniques and inventions of the convergence of research, but one must distinguish between those which come as a result precisely of scientific evolution and industrial or military requirements and those which quite clearly precede them. Thus, the myth of Icarus had to wait on the internal combustion engine before descending from the platonic heavens. But it had dwelt in the soul of everyman since he first thought about birds. To some extent one could say the same thing about the myth of cinema, but its forerunners prior to the nineteenth century have only a remote connection with the myth which we share today and which has prompted the appearance of the mechanical arts that characterize today's world.

1946

# DE SICA: METTEUR-EN-SCÈNE

. . . It is by way of its poetry that the realism of De Sica takes on its meaning, for in art, at the source of all realism, there is an aesthetic paradox that must be resolved. The faithful reproduction of reality is not art. We are repeatedly told that it consists in selection and interpretation. That is why up to now the "realist" trends in cinema, as in other arts, consisted simply in introducing a greater measure of reality into the work: but this additional measure of reality was still only an effective way of serving an abstract purpose, whether dramatic, moral, or ideological. In France, "naturalism" goes hand in hand with the multiplication of novels and plays *à thèse*. The originality of Italian neorealism as compared with the chief schools of realism that preceded it and with the Soviet cinema, lies in never making reality the servant of some *à priori* point of view. Even the Dziga-Vertov theory of the "Kino-eye" only employed the crude reality of everyday events so as to give it a place on the dialectic spectrum of montage. From another point of view, theater (even realist theater) used reality in the service of dramatic and spectacular structure. Whether in the service of the interests of an ideological thesis, of a moral idea, or of a dramatic action, realism subordinates what it borrows from reality to its transcendent needs. Neorealism knows only immanence. It is from appearance only, the simple appearance of beings and of the world, that it knows how to deduce the ideas that it unearths. It is a phenomenology.

In the realm of means of expression, neorealism runs counter to the traditional categories of spectacle—above all, as regards acting. According to the classic understanding of this function, inherited from the theater, the actor expresses something: a feeling, a passion, a desire, an idea. From his attitude and his miming the spectator can read his face like an open book. In this perspective, it is agreed implicitly between spectator and actor that the same psychological causes produce the same physical effect and that one can without any ambiguity pass backward and forward from one to the other. This is, strictly speaking, what is called acting.

The structures of the *mise-en-scène* flow from it: decor, lighting, the angle and framing of the shots, will be more or less expressionistic in their relation to the behavior of the actor. They contribute their part to confirm the meaning of the action. Finally, the breaking up of the scenes into shots and their assemblage is the equivalent of an expressionism in time, a reconstruction of the event according to an artificial and abstract duration: dramatic duration. There is not a single one of these commonly accepted assumptions of the film spectacle that is not challenged by neorealism.

First, the performance: it calls upon the actor to *be* before expressing himself. This requirement does not necessarily imply doing away with the professional actor but it normally tends to substitute the man in the street, chosen uniquely for his general comportment, his ignorance of theatrical technique being less a positively required condition than a guarantee against the expressionism of traditional acting. For De Sica, Bruno was a silhouette, a face, a way of walking.

Second, the setting and the photography: the natural setting is to the artificial set what the amateur actor is to the professional. It has, however, the effect of at least partly limiting the opportunity for plastic compositions available with artificial studio lighting.

But it is perhaps especially the structure of the narrative which is most radically turned upside down. It must now respect the actual duration of the event. The cuts that logic demands can only be, at best, descriptive. The assemblage of the film must never add anything to the existing reality. If it is part of the meaning of the film as with Rossellini, it is because the empty gaps, the white spaces, the parts of the event that we are not given, are themselves of a concrete nature: stones which are missing from the building. It is the same in life: we do not know everything that happens to others. Ellipsis in classic montage is an effect of style. In Rossellini's films it is a lacuna in reality, or rather in the knowledge we have of it, which is by its nature limited.

Thus, neorealism is more an ontological position than an aesthetic one. That is why the employment of its technical attributes, like a recipe, do not necessarily produce it, as the rapid decline of American neorealism proves. In Italy itself not all films without actors, based on a news item, and filmed in real exteriors, are better than the traditional melodramas and spectacles. On the contrary, a film like *Cronaca di un Amore* by Michelangelo Antonioni can be described as neorealist (in spite of the professional actors, of the detective-storylike arbitrariness of the plot, of expensive settings, and the baroque dress of the heroine) because the director has not relied on an expressionism outside the characters; he builds all his effects on their way of life, their way of crying, of walking, of laughing. They are caught in the maze of the plot like laboratory rats being sent through a labyrinth.

The diversity of styles among the best Italian directors might be advanced as a counter argument and I know how much they dislike the word neorealist. Zavattini is the only one who shamelessly admits to the title. The majority protest against the existence of a new Italian school of realism that would include them all. But that is a reflex reaction of the creator to the critic. The director as artist is more aware of his differences than his resemblances. The word neorealist was thrown like a fishing net over the postwar Italian cinema and each director on his own is doing his best to break the toils in which, it is claimed, he has been caught. However, in spite of this normal reaction, which has the added advantage of forcing us to review a perhaps too easy critical classification, I think there are good reasons for staying with it, even against the views of those most concerned.

Certainly the succinct definition I have just given of neorealism might appear on the surface to be given the lie by the work of Lattuada with its calculated, subtly architectural vision, or by the baroque exuberance, the romantic eloquence of De Santis, or by the refined theatrical sense of Visconti, who makes compositions of the most down-to-earth reality as if they were scenes from an opera or a classical tragedy. These terms are summary and debatable, but can serve for other possible epithets which consequently would confirm the existence of formal differences, of oppositions in style. These three directors are as different from one another as each is from De Sica, yet their common origin is evident if one takes a more general view and especially if one stops comparing them with one another and instead looks at the American, French, and Soviet cinema.

Neorealism does not necessarily exist in a pure state and one can conceive of it being combined with other aesthetic tendencies. Biologists distinguish, in genetics, characteristics derived from different parents, so-called dominant factors. It is the

same with neorealism. The exacerbated theatricality of Malaparte's *Cristo Proibito* may owe a lot to German expressionism, but the film is nonetheless neorealist, radically different from the realist expressionism of a Fritz Lang.

But I seem to have strayed a long way from De Sica. This was simply that I might be better able to situate him in contemporary Italian production. The difficulty of taking a critical stand about the director of *Miracolo a Milano* might indeed be precisely the real indication of his style. Does not our inability to analyze its formal characteristics derive from the fact that it represents the purest form of neorealism, from the fact that *Ladri di Biciclette* is the ideal center around which gravitate, each in his own orbit, the works of the other great directors? It could be this very purity which makes it impossible to define, for it has as its paradoxical intention not to produce a spectacle which appears real, but rather to turn reality into a spectacle: a man is walking along the street and the onlooker is amazed at the beauty of the man walking.

Until further information is available, until the realization of Zavattini's dream of filming eighty minutes in the life of a man without a cut, *Ladri di Biciclette* is without a doubt the ultimate expression of neorealism.

Though this *mise-en-scène* aims at negating itself, at being transparent to the reality it reveals, it would be naïve to conclude that it does not exist. Few films have been more carefully put together, more pondered over, more meticulously elaborated, but all this labor by De Sica tends to give the illusion of chance, to result in giving dramatic necessity the character of something contingent. Better still, he has succeeded in making dramatic contingency the very stuff of drama. Nothing happens in *Ladri di Biciclette* that might just as well not have happened. The worker could have chanced upon his bicycle in the middle of the film, the lights in the auditorium would have gone up and De Sica would have apologized for having disturbed us, but after all, we would be happy for the worker's sake. The marvelous aesthetic paradox of this film is that it has the relentless quality of tragedy while nothing happens in it except by chance. But it is precisely from the dialectical synthesis of contrary values, namely artistic order and the amorphous disorder of reality, that it derives its originality. There is not one image that is not charged with meaning, that does not drive home into the mind the sharp end of an unforgettable moral truth, and not one that to this end is false to the ontological ambiguity of reality. Not one gesture, not one incident, not a single object in the film is given a prior significance derived from the ideology of the director.

If they are set in order with an undeniable clarity on the spectrum of social tragedy, it is after the manner of the particles of iron filings on the spectrum of a magnet—that is to say, individually; but the result of this art in which nothing is necessary, where nothing has lost the fortuitous character of chance, is in effect to be doubly convincing and conclusive. For, after all, it is not surprising that the novelist, the playwright, or the filmmaker should make it possible for us to hit on this or that idea, since they put them there beforehand, and have seeded their work with them. Put salt into water, let the water evaporate in the fire of reflection, and you will get back the salt. But if you find salt in water drawn directly from a stream, it is because the water is salty by nature. The workman, Bruno, might have found his bike just as he might have won the lottery—even poor people win lotteries. But this potential capacity only serves to

bring out more forcefully the terrible powerlessness of the poor fellow. If he found his bike, then the enormous extent of his good luck would be an even greater condemnation of society, since it would make a priceless miracle, an exorbitant favor, out of the return to a human order, to a natural state of happiness, since it would signify his good fortune at not still being poor.

It is clear to what an extent this neorealism differs from the formal concept which consists of decking out a formal story with touches of reality. As for the technique, properly so called, *Ladri di Biciclette*, like a lot of other films, was shot in the street with nonprofessional actors but its true merit lies elsewhere: in not betraying the essence of things, in allowing them first of all to exist for their own sakes, freely; it is in loving them in their singular individuality. "My little sister reality," says De Sica, and she circles about him like the birds around Saint Francis. Others put her in a cage or teach her to talk, but De Sica talks with her and it is the true language of reality that we hear, the word that cannot be denied, that only love can utter.

To explain De Sica, we must go back to the source of his art, namely to his tenderness, his love. The quality shared in common by *Miracolo a Milano* and *Ladri di Biciclette*, in spite of differences more apparent than real, is De Sica's inexhaustible affection for his characters. It is significant then in *Miracolo a Milano*, that none of the bad people, even the proud or treacherous ones, are antipathetic. The junkyard Judas who sells his companion's hovels to the vulgar Mobbi does not stir the least anger in the onlookers. Rather he amuses us in the tawdry costume of the "villain" of melodrama, which he wears awkwardly and clumsily: he is a good traitor. In the same way the new poor, who in their decline still retain the proud ways of their former fine neighborhoods, are simply a special variety of that human fauna and are not therefore excluded from the vagabond community—even if they charge people a lira a sunset. And a man must love the sunset with all his heart to come up with the idea of making people pay for the sight of it, and to suffer this market of dupes.

Besides, none of the principal characters in *Ladri di Biciclette* is unsympathetic. Not even the thief. When Bruno finally manages to get his hands on him, the public would be morally disposed to lynch him, as the crowd could have done earlier to Bruno. But the spark of genius in this film is to force us to swallow his hatred the moment it is born and to renounce judgment, just as Bruno will refuse to bring charges.

The only unsympathetic characters in *Miracolo a Milano* are Mobbi and his acolytes, but basically they do not exist. They are only conventional symbols. The moment De Sica shows them to us at slightly closer quarters, we almost feel a tender curiosity stirring inside us. "Poor rich people," we are tempted to say, "how deceived they are." There are many ways of loving, even including the way of the inquisitor. The ethics and politics of love are threatened by the worst heresies. From this point of view, hate is often more tender, but the affection De Sica feels for his creatures is no threat to them, there is nothing threatening or abusive about it. It is courtly and discreet gentleness, a liberal generosity, and it demands nothing in return. There is no admixture of pity in it even for the poorest or the most wretched, because pity does violence to the dignity of the man who is its object. It is a burden on his conscience.

The tenderness of De Sica is of a special kind and for this reason does not easily lend itself to any moral, religious, or political generalization. The ambiguities of

*Miracolo a Milano* and *Ladri di Biciclette* have been used by the Christian Democrats and by the Communists. So much the better: a true parable should have something for everyone. I do not think De Sica and Zavattini were trying to argue anybody out of anything. I would not dream of saying that the kindness of De Sica is of greater value than the third theological virtue* or than class consciousness, but I see in the modesty of his position a definite artistic advantage. It is a guarantee of its authenticity while, at the same time, assuring it a universal quality. This penchant for love is less a moral question than one of personal and ethnic temperament. As for its authenticity, this can be explained in terms of a naturally happy disposition developed in a Neapolitan atmosphere. But these psychological roots reach down to deeper layers than the consciousness cultivated by partisan ideologies. Paradoxically and in virtue of their unique quality, of their inimitable flavor, since they have not been classified in the categories of either morals or politics, they escape the latter's censure, and the Neapolitan charm of De Sica becomes, thanks to the cinema, the most sweeping message of love that our times have heard since Chaplin.

To anyone who doubted the importance of this, it is enough to point out how quick partisan critics were to lay claim to it. What party indeed could afford to leave love to the other? In our day there is no longer a place for unattached love but since each party can with equal plausibility lay claim to being the proprietor of it, it means that much authentic and naïve love scales the walls and penetrates the stronghold of ideologies and social theory.

Let us be thankful to Zavattini and De Sica for the ambiguity of their position— and let us take care not to see it as just intellectual astuteness in the land of Don Camillo, a completely negative concern to give pledges on all sides in return for an all-around censorship clearance. On the contrary it is a positive striving after poetry, the stratagem of a person in love, expressing himself in the metaphors of his time, while at the same time making sure to choose such of them as will open the hearts of everyone. The reason why there have been so many attempts to give a political exegesis to *Miracolo a Milano* is that Zavattini's social allegories are not the final examples of this symbolism, these symbols themselves being simply the allegory of love. Psychoanalysts explain to us that our dreams are the very opposite of a free flow of images. When these express some fundamental desire, it is in order perforce to cross the threshold of the superego, hiding behind the mark of a twofold symbolism, one general, the other individual. But this censorship is not something negative. Without it, without the resistance it offers to the imagination, dreams would not exist.

There is only one way to think of *Miracolo a Milano*, namely as a reflection, on the level of a film dream, and through the medium of the social symbolism of contemporary Italy, of the warm heart of Vittorio De Sica. This would explain what seems bizarre and inorganic in this strange film: otherwise it is hard to understand the gaps in its dramatic continuity and its indifference to all narrative logic.

In passing, we might note how much the cinema owes to a love for living creatures. There is no way of completely understanding the art of Flaherty, Renoir, Vigo, and

---

*The first two theological virtues, according to 1st Corinthians, are faith and hope. The third is ’αγάπη (agape), translated in the King James Bible as "charity" and in the Revised Version as "love," in Bazin's French "amour."—Eds.

In Vittorio de Sica's *The Bicycle Thief* (1948) Father (Lamberto Maggiorani) and son (Enzo Staiola) search for the father's stolen bicycle, without which he will lose his job. ". . . *Ladri di Biciclette*, like a lot of other films, was shot in the street with nonprofessional actors but its true merit lies elsewhere: in not betraying the essence of things, in allowing them first of all to exist for their own sakes, freely; it is in loving them in their singular individuality" (BAZIN, page 177).

especially Chaplin unless we try to discover beforehand what particular kind of tenderness, of sensual or sentimental affection, they reflect. In my opinion, the cinema more than any other art is particularly bound up with love. The novelist in his relations to his characters needs intelligence more than love; understanding is his form of loving. If the art of a Chaplin were transposed into literature, it would tend to lapse into sentimentality; that is why a man like André Suarès, a man of letters *par excellence*, and evidently impervious to the poetry of the cinema, can talk about the "ignoble heart" of Chaplin when this heart brings to the cinema the nobility of myth. Every art and every stage in the evolution of each art has its specific scale of values. The tender, amused sensuality of Renoir, the more heartrending tenderness of Vigo, achieve on the screen a tone and an accent which no other medium of expression could give them. Between such feelings and the cinema there exists a mysterious affinity which is sometimes denied even to the greatest of men. No one better than De Sica can lay claim to being the successor to Chaplin. We have already remarked how as an actor he has a quality of presence, a light which subtly transforms both the scenario and the other actors to such an extent that no one can pretend to play opposite De Sica as he would opposite someone else. We in France have not hitherto known the brilliant actor who appeared in Camerini's films. He had to become famous as a director before he was noticed by the public. By then he no longer had the physique of a young leading man, but his charm survived, the more remarkable for being the less easy to explain. Even when appearing as just a simple actor in the films of other directors, De Sica was already himself a director since his presence modified the film and influenced its style. Chaplin concentrates on himself and within himself the radiation of his tenderness, which means that cruelty is not always excluded from his world; on the contrary, it has a necessary and dialectic relationship to love, as is evident from *Monsieur Verdoux*. Charlie is goodness itself, projected onto the world. He is ready to love everything, but the world does not always respond. On the other hand, De Sica the director infuses into his actors the power to love that he himself possesses as an actor. Chaplin also chooses his cast carefully but always with an eye to himself and to putting his character in a better light. We find in De Sica the humanity of Chaplin, but shared with the world at large. De Sica possesses the gift of being able to convey an intense sense of the human presence, a disarming grace of expression and of gesture which, in their unique way, are an irresistible testimony to man. Ricci (*Ladri di Biciclette*), Toto (*Miracolo a Milano*), and *Umberto D*, although greatly differing in physique from Chaplin and De Sica, make us think of them.

It would be a mistake to believe that the love De Sica bears for man, and forces us to bear witness to, is a form of optimism. If no one is really bad, if face to face with each individual human being we are forced to drop our accusation, as was Ricci when he caught up with the thief, we are obliged to say that the evil which undeniably does exist in the world is elsewhere than in the heart of man, that it is somewhere in the order of things. One could say it is in society and be partly right. In one way *Ladri di Biciclette*, *Miracolo a Milano*, and *Umberto D* are indictments of a revolutionary nature. If there were no unemployment it would not be a tragedy to lose one's bicycle. However, this political explanation does not cover the whole drama. De Sica protests the comparison that has been made between *Ladri di Biciclette* and the works

of Kafka on the grounds that his hero's alienation is social and not metaphysical. True enough, but Kafka's myths are no less valid if one accepts them as allegories of social alienation, and one does not have to believe in a cruel God to feel the guilt of which Joseph K. is culpable. On the contrary, the drama lies in this: God does not exist, the last office in the castle is empty. Perhaps we have here the particular tragedy of today's world, the raising of a self-deifying social reality to a transcendental state.

The troubles of Bruno and Umberto D have their immediate and evident causes but we also observe that there is an insoluable residue comprised of the psychological and material complexities of our social relationships, which neither the high quality of an institution nor the good will of our neighbors can dispose of. The nature of the latter is positive and social, but its action proceeds always from a necessity that is at once absurd and imperative. This is, in my opinion, what makes this film so great and so rich. It renders a twofold justice: one by way of an irrefutable description of the wretched condition of the proletariat, another by way of the implicit and constant appeal of a human need that any society whatsoever must respect. It condemns a world in which the poor are obliged to steal from one another to survive (the police protect the rich only too well) but this imposed condemnation is not enough, because it is not only a given historical institution that is in question or a particular economic setup, but the congenital indifference of our social organization, as such, to the for-tuitousness of individual happiness. Otherwise Sweden could be the earthly paradise, where bikes are left along the sidewalk both day and night. De Sica loves mankind, his brothers, too much not to want to remove every conceivable cause of their unhap-piness, but he also reminds us that every man's happiness is a miracle of love whether in Milan or anywhere else. A society which does not take every opportunity to smother happiness is already better than one which sows hate, but the most perfect still would not create love, for love remains a private matter between man and man. In what country in the world would they keep rabbit hutches in an oil field? In what other would the loss of an administrative document not be as agonizing as the theft of a bicycle? It is part of the realm of politics to think up and promote the objective conditions necessary for human happiness, but it is not part of its essential function to respect its subjective conditions. In the universe of De Sica, there lies a latent pes-simism, an unavoidable pessimism we can never be grateful enough to him for, because in it resides the appeal of the potential of man, the witness to his final and irrefutable humanity.

I have used the word love. I should rather have said poetry. These two words are synonymous or at least complementary. Poetry is but the active and creative form of love, its projection into the world. Although spoiled and laid waste by social upheaval, the childhood of the shoeshine boy has retained the power to transform his wretchedness in a dream. In France, in the primary schools, the children are taught to say "Who steals an egg, steals a bull." De Sica's formula is "Who steal an egg is dreaming of a horse." Toto's miraculous gift which was handed on to him by his adopted grandmother is to have retained from childhood an inexhaustible capacity for defense by way of poetry; the piece of business I find most significant in *Miracolo a Milano* is that of Emma Grammatica rushing toward the spilled milk. It does not mat-ter who else scolds Toto for his lack of initiative and wipes up the milk with a cloth, so long as the quick gesture of the old woman has as its purpose to turn the little catas-

trophe into a marvelous game, a stream in the middle of a landscape of the same pro-
portion. And so on to the multiplication tables, another profound terror of one's child-
hood, which, thanks to the little old woman, turns into a dream. City dweller Toto
names the streets and the squares "four times four is sixteen" or "nine times nine is
eighty-one," for these cold mathematical symbols are more beautiful in his eyes than
the names of the characters of mythology. Here again we think of Charlie; he also
owes to his childhood spirit his remarkable power of transforming the world to a bet-
ter purpose. When reality resists him and he cannot materially change it—he switches
its meaning. Take for example, the dance of the rolls, in *The Gold Rush*, or the shoes
in the soup pot, with this proviso that, always on the defensive, Charlie reserves his
power of metamorphosis for his own advantage, or, at most, for the benefit of the
woman he loves. Toto on the other hand goes out to others. He does not give a
moment's thought to any benefit the dove can bring him, his joy lies in his being able
to spread joy. When he can no longer do anything for his neighbor he takes it on him-
self to assume various shapes, now limping for the lame man, making himself small
for the dwarf, blind for the one-eyed man. The dove is just an arbitrarily added pos-
sibility, to give poetry a material form, because most people need something to assist
their imaginations. But Toto does not know what to do with himself unless it is for
someone else's benefit.

Zavattini told me once: "I am like a painter standing before a field, who asks him-
self which blade of grass he should begin with." De Sica is the ideal director for a dec-
laration of faith such as this. There is also the art of the playwright who divides the
moments of life into episodes which, in respect of the moments lived, are what the
blades of grass are to the field. To paint every blade of grass one must be the Douanier
Rousseau. In the world of cinema one must have the love of a De Sica for creation
itself.

1953

# RUDOLF ARNHEIM
## *FROM* FILM AS ART

## THE COMPLETE FILM

The technical development of the motion picture will soon carry the mechanical imitation of nature to an extreme. The addition of sound was the first obvious step in this direction. The introduction of sound film must be considered as the imposition of a technical novelty that did not lie on the path the best film artists were pursuing. They were engaged in working out an explicit and pure style of silent film, using its restrictions to transform the peep show into an art. The introduction of sound film smashed many of the forms that the film artists were using in favor of the inartistic demand for the greatest possible "naturalness" (in the most superficial sense of the word). By sheer good luck, sound film is not only destructive but also offers artistic potentialities of its own. Owing to this accident alone the majority of art-lovers still do not realize the pitfalls in the road pursued by the movie producers. They do not see that the film is on its way to the victory of wax museum ideals over creative art.

The development of the silent film was arrested possibly forever when it had hardly begun to produce good results; but it has left us with a few splendidly mature films. In the future, no doubt, "progress" will be faster. We shall have color films and stereoscopic films, and the artistic potentialities of the sound film will be crushed at an even earlier stage of their development.

What will the color film have to offer when it reaches technical perfection? We know what we shall lose artistically by abandoning the black-and-white film. Will color ever allow us to achieve a similar compositional precision, a similar independence of "reality"?

The masterpieces of painting prove that color provides wider possibilities than black-and-white and at the same time permits of a very exact and genuine style. But can painting and color photography be compared? Whereas the painter has a perfectly free hand with color and form in presenting nature, photography is obliged to record mechanically the light values of physical reality. In achromatic photography the

183

reduction of everything to the gray scale resulted in an art medium that was suffi-
ciently independent and divergent from nature. There is not much likelihood of any
such transposition of reality into a qualitatively different range of colors in color film.
To be sure, one can eliminate individual colors—one may, for example, cut out all
blues, or, vice versa, one may cut out everything except the blues. Probably it is pos-
sible also to change one or more color tones qualitatively—for example, give all reds
a cast of orange or make all the yellows greenish—or let colors change places with
one another—turn all blues to red and all reds to blue—but all this would be, so to
speak, only transposition of reality, mechanical shifts, whose usefulness as a forma-
tive medium may be doubted. Hence there remains only the possibility of controlling
the color by clever choice of what is to be photographed. All kinds of fine procedures
are conceivable, especially in the montage of colored pictures, but it must not be over-
looked that in this way the subjective formative virtues of the camera, which are so
distinctive a characteristic of film, will be more and more restricted, and the artistic
part of the work will be more and more focused upon what is set up and enacted
*before* the camera. The camera is thereby increasingly related to the position of a
mere mechanical recording machine.

Above all, it is hardly realistic to speculate on the artistic possibilities of the color
film without keeping in mind that at the same time we are likely to be presented with
the three-dimensional film and the wide screen. Efforts in these directions are in
progress. The illusion of reality will thereby have been increased to such a degree that
the spectator will not be able to appreciate certain artistic color effects even if they
should be feasible technically. It is quite conceivable that by a careful choice and
arrangement of objects it might be possible to use the color on the projection surface
artistically and harmoniously. But if the film image becomes stereoscopic there is no
longer a plane surface within the confines of the screen, and therefore there can be no
composition of that surface; what remains will be effects that are also possible on the
stage. The increased size of the screen will render any two-dimensional or three-
dimensional composition less compelling; and formative devices such as montage
and changing camera angles will become unusable if the illusion of reality is so enor-
mously strengthened. Obviously, montage will seem an intolerable accumulation of
heterogeneous settings if the illusion of reality is very strong. Obviously also a
change in the position of the camera will now be felt as an actual displacement within
the space of the picture. The camera will have to become an immobile recording
machine, every cut in the film strip will be mutilation. Scenes will have to be taken in
their entire length and with a stationary camera, and they will have to be shown as
they are. The artistic potentialities of this form of film will be exactly those of the
stage. Film will no longer be able in any sense to be considered as a separate art. It
will be thrown back to before its first beginnings—for it was with a fixed camera and
an uncut strip that film started. The only difference will be that instead of having all
before it film will have nothing to look forward to.

This curious development signifies to some extent the climax of that striving after
likeness to nature which has hitherto permeated the whole history of the visual arts.
Among the strivings that make human beings create faithful images is the primitive
desire to get material objects into one's power by creating them afresh. Imitation also
permits people to cope with significant experiences; it provides release, and makes

for a kind of reciprocity between the self and the world. At the same time a repro-
duction that is true to nature provides the thrill that by the hand of man an image has
been created which is astoundingly like some natural object. Nevertheless, various
countertendencies—some of them purely perceptual—have prevented mechanically
faithful imitation from being achieved hundreds of years ago. Apart from rare excep-
tions, only our modern age has succeeded in approaching this dangerous goal. In
practice, there has always been the artistic urge not simply to copy but to originate,
to interpret, to mold. We may, however, say that aesthetic theory has rarely sanctioned
such activities. Even for artists like Leonardo da Vinci the demand for being as true
to nature as possible was a matter of course when he talked theory, and Plato's attack
on artists, in which he charged them with achieving nothing but reproductions of
physical objects, is far from the general attitude.

To this very day some artists cherish this doctrine, and the general public does so
to an even greater extent. In painting and sculpture it is only in recent decades that
works have been appearing which show that their creators have broken with this prin-
ciple intellectually and not merely practically. If a man considers that the artist should
imitate nature, he may possibly paint like Van Gogh, but certainly not like Paul Klee.
We know that the very powerful and widespread rejection of modern art is almost
entirely supported by the argument that it is not true to nature. The development of
film shows clearly how all-powerful this ideal still is.

Photography and its offspring, film, are art media so near to nature that the general
public looks upon them as superior to such old-fashioned and imperfect imitative
techniques as drawing and painting. Since on economic grounds film is much more
dependent on the general public than any other form of art, the "artistic" preferences
of the public sweep everything before them. Some work of good quality can be smug-
gled in but it does not compensate for the more fundamental defeats of film art. The
complete film is the fulfillment of the age-old striving for the complete illusion. The
attempt to make the two-dimensional picture as nearly as possible like its old model
succeeds; original and copy become practically indistinguishable. Thereby all form-
ative potentialities which were based on the differences between model and copy are
eliminated and only what is inherent in the original in the way of significant form
remains to art.

H. Baer in a remarkable little essay in the *Kunstblatt* has pointed out that color film
represents the accomplishment of tendencies which have long been present in graphic
art.

"Graphic art (he says)—of which photography is one branch—has always striven
after color. The oldest woodcuts, the blockbooks, were finished off by being hand-
painted. Later, a second, colored, plate was added to the black-and-white—as in
Dürer's portrait of 'Ulrich Varnbühler.' A magnificent picture of a knight in armor in
black, silver, and gold, exists by Burgmair. In the eighteenth century multicolored
etchings were produced. In the nineteenth the lithographs of Daumier and Gavarni
are colored in mass production. . . . Color invaded the graphic arts as an increased
attraction for the eye. Uncivilized man is not as a rule satisfied with black-and-white.
Children, peasants and primitive peoples demand the highest degree of bright color-
ing. It is the primitives of the great cities who congregate before the film screen.
Therefore film calls in the aid of bright colors. It is a fresh stimulus."

In itself, the perfection of the "complete" film need not be a catastrophe—if silent film, sound film, and colored sound film were allowed to exist alongside it. There is no objection to the "complete" film as an alternative to the stage—it might help to take into remote places fine performances of good works, as also of operas, musical comedies, ballets, the dance. Moreover, by its very existence it would probably have an excellent influence on the other—the real—film forms, by forcing them to advance along their own lines. Silent film, for example, would no longer provide dialogue in its titles, because then the absence of the spoken word would be felt as artificial and disturbing. In sound film, too, any vague intermediate form between it and the stage would be avoided. Just as the stage will feel itself obliged by the very existence of film to emphasize its own characteristic—the predominance of dramatic speech—so the "complete" film could relegate the true film forms to their own sphere.

The fact is, however, that whereas aesthetically these categories of film could and should exist along with mechanically complete reproduction, they are inferior to it in the capacity to imitate nature. Therefore the "complete" film is certain to be considered an advance upon the preceding film forms, and will supplant them all.

1933

# MAYA DEREN

# CINEMATOGRAPHY: THE CREATIVE USE OF REALITY

The motion-picture camera is perhaps the most paradoxical of all machines, in that it can be at once independently active and infinitely passive. Kodak's early slogan, "You push the button, it does the rest," was not an exaggerated advertising claim, and, connected to any simple trigger device, a camera can even take pictures all by itself. At the same time, while a comparable development and refinement of other mechanisms has usually resulted in an increased specialization, the advances in the scope and sensitivity of lenses and emulsions have made the camera capable of infinite receptivity and indiscriminate fidelity. To this must be added the fact that the medium deals, or can deal, in terms of the most elemental actuality. In sum, it can produce maximum results for virtually minimal effort: it requires of its operator only a modicum of aptitude and energy; of its subject matter, only that it exist; and of its audience, only that they can see. On this elementary level it functions ideally as a mass medium for communicating equally elementary ideas.

The photographic medium is, as a matter of fact, so amorphous that it is not merely unobtrusive but virtually transparent, and so becomes, more than any other medium, susceptible of servitude to any and all the others. The enormous value of such servitude suffices to justify the medium and to be generally accepted as its function. This has been a major obstacle to the definition and development of motion pictures as a creative fine-art form—capable of creative action in its own terms—for its own character is as a latent image which can become manifest only if no other image is imposed upon it to obscure it.

Those concerned with the emergence of this latent form must therefore assume a partially protective role, one which recalls the advice of an art instructor who said, "If you have trouble drawing the vase, try drawing the space around the vase." Indeed, for the time being, the definition of the creative form of film involves as careful attention to what it is not as to what it is.

187

# ANIMATED PAINTINGS

In recent years, perceptible first on the experimental fringes of the film world and now in general evidence at the commercial art theaters, there has been an accelerated development of what might be called the "graphic arts school of animated film." Such films, which combine abstract backgrounds with recognizable but not realistic figures, are designed and painted by trained and talented graphic artists who make use of a sophisticated, fluent knowledge of the rich resources of plastic media, including even collage. A major factor in the emergence of this school has been the enormous technical and laboratory advance in color film and color processing, so that it is now possible for these artists to approach the two-dimensional, rectangular screen with all the graphic freedom they bring to a canvas.

The similarity between screen and canvas had long ago been recognized by artists such as Hans Richter, Oskar Fischinger, and others, who were attracted not by its graphic possibilities (so limited at that time) but rather by the excitements of the film medium, particularly the exploitation of its time dimension—rhythm, spatial depth created by a diminishing square, the three-dimensional illusion created by the revolutions of a spiral figure, etc. They put their graphic skills at the service of the film medium, as a means of extending film expression.*

The new graphic-arts school does not so much advance those early efforts as reverse them, for here the artists make use of the film medium as an extension of the plastic media. This is particularly clear when one analyzes the principle of movement employed, for it is usually no more than a sequential articulation—a kind of spelling out in time—of the dynamic ordinarily implicit in the design of an individual composition. The most appropriate term to describe such works, which are often interesting and witty, and which certainly have their place among visual arts, is "animated paintings."

This entry of painting into the film medium presents certain parallels with the introduction of sound. The silent film had attracted to it persons who had talent for and were inspired by the exploration and development of a new and unique form of visual expression. The addition of sound opened the doors for the verbalists and dramatists. Armed with the authority, power, laws, techniques, skills, and crafts which the venerable literary arts had accumulated over centuries, the writers hardly even paused to recognize the small resistance of the "indigenous" film-maker, who had had barely a decade in which to explore and evolve the creative potential of his medium.

The rapid success of the "animated painting" is similarly due to the fact that it comes armed with all the plastic traditions and techniques which are its impressive heritage. And just as the sound film interrupted the development of film form on the commercial level by providing a more finished substitute, so the "animated painting" is already being accepted as a form of film art in the few areas (the distribution of 16

---

*It is significant that Hans Richter, a pioneer in such a use of film, soon abandoned this approach. All his later films, along with the films of Léger, Man Ray, Dali, and the painters who participated in Richter's later films (Ernst, Duchamp, etc.) indicate a profound appreciation of the distinction between the plastic and the photographic image and make enthusiastic and creative use of photographic reality.

mm. film shorts of film series and societies) where experiments in film form can still find an audience.

The motion-picture medium has an extraordinary range of expression. It has in common with the plastic arts the fact that it is a visual composition projected on a two dimensional surface; with dance, that it can deal in the arrangement of movement; with theater, that it can create a dramatic intensity of events; with music, that it can compose in the rhythms and phrases of time and can be attended by song and instrument; with poetry, that it can juxtapose images; with literature generally, that it can encompass in its sound track the abstractions available only to language.

This very profusion of potentialities seems to create confusion in the minds of most film-makers, a confusion which is diminished by eliminating a major portion of those potentialities in favor of one or two, upon which the film is subsequently structured. An artist, however, should not seek security in a tidy mastery over the simplifications of deliberate poverty; he should, instead, have the creative courage to face the danger of being overwhelmed by fecundity in the effort to resolve it into simplicity and economy.

While the "animated painting" film has limited itself to a small area of film potential, it has gained acceptance on the basis of the fact that it *does* use an art form—the graphic art form—and that it does seem to meet the general condition of film: it makes its statement as an image in movement. This opens the entire question of whether a photograph is of the same order of image as all others. If not, is there a correspondingly different approach to it in a creative context? Although the photographic process is the basic building block of the motion-picture medium, it is a tribute to its self-effacement as a servant that virtually no consideration has been given to its own character and the creative implications thereof.

## THE CLOSED CIRCUIT OF THE PHOTOGRAPHIC PROCESS

The term "image" (originally based on "imitation") means in its first sense the visual likeness of a real object or person, and in the very act of specifying resemblance it distinguishes and establishes the entire category of visual experience which is *not* a real object or person. In this specifically negative sense—in the sense that the photograph of a horse is not the horse itself—a photograph is an image.

But the term "image" also has positive implications: it presumes a mental activity, whether in its most passive form (the "mental images" of perception and memory) or, as in the arts, the creative action of the imagination realized by the art instrument. Here reality is first filtered by the selectivity of individual interests and modified by prejudicial perception to become experience; as such it is combined with similar, contrasting or modifying experiences, both forgotten and remembered, to become assimilated into a conceptual image; this in turn is subject to the manipulations of the art instrument; and what finally emerges is a plastic image which is a reality in its own right. A painting is not, fundamentally, a likeness or image of a horse; it is a likeness of a mental concept which may resemble a horse or which may, as in abstract painting, bear no visible relation to any real object.

Photography, however, is a process by which an object creates its own image by the action of its light or light-sensitive material. It thus presents a closed circuit

precisely at the point where, in the traditional art forms, the creative process takes place as reality passes through the artist. This exclusion of the artist at that point is responsible both for the absolute fidelity of the photographic process and for the widespread conviction that a photographic medium cannot be, itself, a creative form. From these observations it is but a step to the conclusion that its use as a visual printing press or as an extension of another creative form represents a full realization of the potential of the medium. It is precisely in this manner that the photographic process is used in "animated paintings."

But in so far as the camera is applied to objects which are already accomplished images, is this really a more creative use of the instrument than when, in scientific films, its fidelity is applied to reality in conjunction with the revelatory functions of telescopic or microscopic lenses and a comparable use of the motor?

Just as the magnification of a lens trained upon matter shows us a mountainous, craggy landscape in an apparently smooth surface, so slow-motion can reveal the actual structure of movements or changes which either cannot be slowed down in actuality or whose nature would be changed by a change in tempo of performance. Applied to the flight of a bird, for example, slow-motion reveals the hitherto unseen sequence of the many separate strains and small movements of which it is compounded.

By a telescopic use of the motor, I mean the telescoping of time achieved by triggering a camera to take pictures of a vine at ten-minute intervals. When projected at regular speed, the film reveals the actual integrity, almost the intelligence, of the movement of the vine as it grows and turns with the sun. Such telescoped-time photography has been applied to chemical changes and to physical metamorphoses whose tempo is so slow as to be virtually imperceptible.

Although the motion-picture camera here functions as an instrument of discovery rather than of creativity, it does yield a kind of image which, unlike the images of "animated paintings" (animation itself is a use of the telescoped-time principle), is unique to the motion-picture medium. It may therefore be regarded as an even more valid basic element in a creative film form based on the singular properties of the medium.

## REALITY AND RECOGNITION

The application of the photographic process to reality results in an image which is unique in several respects. For one thing, since a specific reality is the prior condition of the existence of a photograph, the photograph not only testifies to the existence of that reality (just as drawing testifies to the existence of an artist) but is, to all intents and purposes, its equivalent. This equivalence is not at all a matter of fidelity but is of a different order altogether. If realism is the term of a graphic image which precisely simulates some real object, then a photograph must be differentiated from it as *a form of reality itself*.

This distinction plays an extremely important role in the address of these respective images. The intent of the plastic arts is to make meaning manifest. In creating an image for the express purpose of communicating, the artist primarily undertakes to create the most effective aspect possible out of the total resources of his medium.

Photography, however, deals in a living reality which is structured primarily to endure, and whose configurations are designed to serve that purpose, not to communicate its meaning; they may even serve to conceal that purpose as a protective measure. In a photograph, then, we begin by recognizing a reality, and our attendant knowledges and attitudes are brought into play; only then does the aspect become meaningful in reference to it. The abstract shadow shape in a night scene is not understood at all until revealed and identified as a person; the bright red shape on a pale ground which might, in an abstract, graphic context, communicate a sense of gaiety, conveys something altogether different when recognized as a wound. As we watch a film, the continuous act of recognition in which we are involved is like a strip of memory unrolling beneath the images of the film itself, to form the invisible underlayer of an implicit double exposure.

The process by which we understand an abstract, graphic image is almost directly opposite, then, to that by which we understand a photograph. In the first case, the aspect leads us to meaning; in the second case the understanding which results from recognition is the key to our evaluation of the aspect.

## PHOTOGRAPHIC AUTHORITY AND THE "CONTROLLED ACCIDENT"

As a reality, the photographic image confronts us with the innocent arrogance of an objective fact, one which exists as an independent presence, indifferent to our response. We may in turn view it with an indifference and detachment we do not have toward the man-made images of other arts, which invite and require our perception and demand our response in order to consummate the communication they initiate and which is their *raison d'être*. At the same time precisely because we are aware that our personal detachment does not in any way diminish the verity of the photographic image, it exercises an authority comparable in weight only to the authority of reality itself.

It is upon this authority that the entire school of the social documentary film is based. Although expert in the selection of the most effective reality and in the use of camera placement and angle to accentuate the pertinent and effective features of it, the documentarists operate on a principle of minimal intervention, in the interests of bringing the authority of reality to the support of the moral purpose of the film.

Obviously, the interest of a documentary film corresponds closely to the interest inherent in its subject matter. Such films enjoyed a period of particular preeminence during the war. This popularity served to make fiction-film producers more keenly aware of the effectiveness and authority of reality, an awareness which gave rise to the "neo-realist" style of film and contributed to the still growing trend toward location filming.

In the theater, the physical presence of the performers provides a sense of reality which induces us to accept the symbols of geography, the intermissions which represent the passage of time, and the other conventions which are part of the form. Films cannot include this physical presence of the performers. They can, however, replace the artifice of theater by the actuality of landscape, distances, and place; the interruptions of intermissions can be transposed into transitions which sustain and even

intensify the momentum of dramatic development; while events and episodes which, within the context of theatrical artifice, might not have been convincing in their logic or aspect can be clothed in the verity which emanates from the reality of the surrounding landscape, the sun, the streets and buildings.

In certain respects, the very absence in motion pictures of the physical presence of the performer, which is so important to the theater, can even contribute to our sense of reality. We can, for example, believe in the existence of a monster if we are not asked to believe that it is present in the room with us. The intimacy imposed upon us by the physical reality of other art works presents us with alternative choices: either to identify with or to deny the experience they propose, or to withdraw altogether to a detached awareness of that reality as merely a metaphor. But the film image—whose intangible reality consists of lights and shadows beamed through the air and caught on the surface of a silver screen—comes to us as the reflection of another world. At that distance we can accept the reality of the most monumental and extreme of images, and from that perspective we can perceive and comprehend them in their full dimension.

The authority of reality is available even to the most artificial constructs if photography is understood as an art of the "controlled accident." By "controlled accident" I mean the maintenance of a delicate balance between what is there spontaneously and naturally as evidence of the independent life of actuality, and the persons and activities which are deliberately introduced into the scene. A painter, relying primarily upon aspect as the means of communicating his intent, would take enormous care in the arrangement of every detail of, for example, a beach scene. The cinematographer, on the other hand, having selected a beach which, in general, has the desired aspect—whether grim or happy, deserted or crowded—must on the contrary refrain from over-controlling the aspect if he is to retain the authority of reality. The filming of such a scene should be planned and framed so as to create a context of limits within which anything that occurs is compatible with the intent of the scene.

The invented event which is then introduced, though itself an artifice, borrows reality from the reality of the scene—from the natural blowing of the hair, the irregularity of the waves, the very texture of the stones and sand—in short, from all the uncontrolled, spontaneous elements which are the property of actuality itself. Only in photography—by the delicate manipulation which I call controlled accident—can natural phenomena be incorporated into our own creativity, to yield an image where the reality of a tree confers its truth upon the events we cause to transpire beneath it.

## ABSTRACTIONS AND ARCHETYPES

Inasmuch as the other art forms are not constituted of reality itself, they create metaphors for reality. But photography, being itself the reality or the equivalent thereof, can use its own reality as a metaphor for ideas and abstractions. In painting, the image is an abstraction of the aspect; in photography, the abstraction of an idea produces the archetypal image.

This concept is not new to motion pictures, but its development was interrupted by the intrusions of theatrical traditions into the film medium. The early history of film

is studded with archetypal figures: Theda Bara, Mary Pickford, Marlene Dietrich, Greta Garbo, Charles Chaplin, Buster Keaton, etc. These appeared as personages, not as people or personalities, and the films which were structured around them were like monumental myths which celebrated cosmic truths.

The invasion of the motion-picture medium by modern playwrights and actors introduced the concept of realism, which is at the root of theatrical metaphor and which, in the a priori reality of photography, is an absurd redundancy which has served merely to deprive the motion-picture medium of its creative dimension. It is significant that, despite every effort of pretentious producers, directors and film critics who seek to raise their professional status by adopting the methods, attitudes, and criteria of the established and respected art of theater, the major figures—both the most popular stars and the most creative directors (such as Orson Welles)—continue to operate in the earlier archetypal tradition. It was even possible, as Marlon Brando demonstrated, to transcend realism and to become an archetypal realist, but it would appear that his early intuition has been subsequently crushed under the pressures of the repertory complex, another carry-over from theater, where it functioned as the means by which a single company could offer a remunerative variety of plays to an audience while providing consistent employment for its members. There is no justification whatsoever for insisting on a repertory variety of roles for actors involved in the totally different circumstances of motion pictures.

## PHOTOGRAPHY'S UNIQUE IMAGES

In all that I have said so far, the fidelity, reality, and authority of the photographic image serve primarily to modify and to support. Actually, however, the sequence in which we perceive photography—an initial identification followed by an interpretation of the aspect according to that identification (rather than in primarily aspectual terms)—becomes irreversible and confers meaning upon aspect in a manner unique to the photographic medium.

I have previously referred to slow-motion as a time microscope, but it has its expressive uses as well as its revelatory ones. Depending upon the subject and the context, it can be a statement of either ideal ease or nagging frustration, a kind of intimate and loving meditation on a movement or a solemnity which adds ritual weight to an action; or it can bring into reality that dramatic image of anguished helplessness, otherwise experienced only in the nightmares of childhood, when our legs refused to move while the terror which pursues us comes ever closer.

Yet, slow-motion is not simply slowness of speed. It is, in fact, something which exists in our minds, not on the screen, and can be created only in conjunction with the identifiable reality of the photographic image. When we see a man in the attitudes of running and identify the activity as a run, one of the knowledges which is part of that identification is the pulse normal to that activity. It is because we are aware of the known pulse of the identified action while we watch it occur at a slower rate of speed that we experience the double-exposure of time which we know as slow-motion. It cannot occur in an abstract film, where a triangle, for instance, may go fast or slow, but, having no necessary pulse, cannot go in slow-motion.

Another unique image which the camera can yield is reverse motion. When used meaningfully, it does not convey so much a sense of a backward movement spatially, but rather an undoing of time. One of the most memorable uses of this occurs in Cocteau's *Blood of a Poet*, where the peasant is executed by a volley of fire which also shatters the crucifix hanging on the wall behind him. This scene is followed by a reverse motion of the action—the dead peasant rising from the ground and the crucifix reassembling on the wall; then again the volley of fire, the peasant falling, the crucifix shattering; and again the filmic resurrection. Reverse motion also, for obvious reasons, does not exist in abstract films.

The photographic negative image is still another striking case in point. This is not a direct white-on-black statement but is understood as an inversion of values. When applied to a recognizable person or scene, it conveys a sense of a critically qualitative change, as in its use for the landscape on the other side of death in Cocteau's *Orpheus*.

Both such extreme images and the more familiar kind which I referred to earlier make use of the motion-picture medium as a form in which the meaning of the image originates in our recognition of a known reality and derives its authority from the direct relationship between reality and image in the photographic process. While the process permits some intrusion by the artist as a modifier of that image, the limits of its tolerance can be defined as that point at which the original reality becomes unrecognizable or is irrelevant (as when a red reflection in a pond is used for its shape and color only and without contextual concern for the water or the pond).

In such cases the camera itself has been conceived of as the artist, with distorting lenses, multiple superpositions, etc. used to simulate the creative action of the eye, the memory, etc. Such well-intentioned efforts to use the medium creatively, by forcibly inserting the creative act in the position it traditionally occupies in the visual arts, accomplish, instead, the destruction of the photographic image as reality. This image, with its unique ability to engage us simultaneously on several levels—by the objective authority of reality, by the knowledges and values which we attach to that reality, by the direct address of its aspect, and by a manipulated relationship between these—is the building block for the creative use of the medium.

## THE PLACEMENT OF THE CREATIVE ACT AND
## TIME-SPACE MANIPULATIONS

Where does the film-maker then undertake his major creative action if, in the interests of preserving these qualities of the image, he restricts himself to the control of accident in the pre-photographic stage and accepts almost complete exclusion from the photographic process as well?

Once we abandon the concept of the image as the end product and consummation of the creative process (which it is in both the visual arts and the theater), we can take a larger view of the total medium and can see that the motion-picture instrument actually consists of two parts, which flank the artist on either side. The images with which the camera provides him are like fragments of a permanent, incorruptible memory; their individual reality is in no way dependent upon their sequence in actuality, and they can be assembled to compose any of several statements. In film, the image can and should be only the beginning, the basic material of the creative action.

All invention and creation consist primarily of a new relationship between known parts. The images of film deal in realities which, as I pointed out earlier, are structured to fulfill their various functions, not to communicate a specific meaning. Therefore they have several attributes simultaneously, as when a table may be, at once, old, red, and high. Seeing it as a separate entity, an antique dealer would appraise its age, an artist its color, and a child its inaccessible height. But in a film such a shot might be followed by one in which the table falls apart, and thus a particular aspect of its age would constitute its meaning and function in the sequence, with all other attributes becoming irrelevant. The editing of a film creates the sequential relationship which gives particular or new meaning to the images *according to their function*; it establishes a context, a form which transfigures them without distorting their aspect, diminishing their reality and authority, or impoverishing that variety of potential functions which is the characteristic dimension of reality.

Whether the images are related in terms of common or contrasting qualities, in the causal logic of events which is narrative, or in the logic of ideas and emotions which is the poetic mode, the structure of a film is sequential. The creative action in film, then, takes place in its time dimension; and for this reason the motion picture, though composed of spatial images, is primarily *a time form*.

A major portion of the creative action consists of a manipulation of time and space. By this I do not mean only such established filmic techniques as flashback, condensation of time, parallel action etc. These affect not the action itself but the method of revealing it. In a flashback there is no implication that the usual chronological integrity of the action itself is in any way affected by the process, however disrupted, of memory. Parallel action, as when we see alternately the hero who rushes to the rescue and the heroine whose situation becomes increasingly critical, is an omnipresence on the part of the camera as a witness of action, not as a creator of it.

The kind of manipulation of time and space to which I refer becomes itself part of the organic structure of a film. There is, for example, the extension of space by time and of time by space. The length of a stairway can be enormously extended if three different shots of the person ascending it (filmed from different angles so that it is not apparent that the identical area is being covered each time) are so edited together that the action is continuous and results in an image of enduring labor toward some elevated goal. A leap in the air can be extended by the same technique, but in this case, since the film action is sustained far beyond the normal duration of the real action itself, the effect is one of tension as we wait for the figure to return, finally, to earth.

Time may be extended by the reprinting of a single frame, which has the effect of freezing the figure in mid-action; here the frozen frame becomes a moment of suspended animation which, according to its contextual position, may convey either the sense of critical hesitation (as in the turning back of Lot's wife) or may constitute a comment on stillness and movement as the opposition of life and death. The reprinting of scenes of a casual situation involving several persons may be used either in a prophetic context, as a *déjà-vu*; or, again, precise reiteration, by intercutting reprints, of those spontaneous movements, expressions, and exchanges, can change the quality of the scene from one of informality to that of a stylization akin to dance; in so

doing it confers dance upon non-dancers, by shifting emphasis from the purpose of the movement to the movement itself, and an informal social encounter then assumes the solemnity and dimension of ritual.

Similarly, it is possible to confer the movement of the camera upon the figures in the scene, for the large movement of a figure in a film is conveyed by the changing relationship between that figure and the frame of the screen. If, as I have done in my recent film *The Very Eye of Night*, one eliminates the horizon line and any background which would reveal the movement of the total field, then the eye accepts the frame as stable and ascribes all movement to the figure within it. The hand-held camera, moving and revolving over the white figures on a totally black ground, produces images in which their movement is as gravity-free and as three-dimensional as that of birds in air or fish in water. In the absence of any absolute orientation, the push and pull of their interrelationships becomes the major dialogue.

By manipulation of time and space, I mean also the creation of a relationship between separate times, places, and persons. A swing-pan—whereby a shot of one person is terminated by a rapid swing away and a shot of another person or place begins with a rapid swing of the camera, the two shots being subsequently joined in the blurred area of both swings—brings into dramatic proximity people, places, and actions which in actuality might be widely separated. One can film different people at different times and even in different places performing approximately the same gesture or movement, and, by a judicious joining of the shots in such a manner as to preserve the continuity of the movement, the action itself becomes the dominant dynamic which unifies all separateness.

Separate and distant places not only can be related but can be made continuous by a continuity of identity and of movement, as when a person begins a gesture in one setting, this shot being immediately followed by the hand entering another setting altogether to complete the gesture there. I have used this technique to make a dancer step from woods to apartment in a single stride, and similarly to transport him from location to location so that the world itself became his stage. In my *At Land*, it has been the technique by which the dynamic of the *Odyssey* is reversed and the protagonist, instead of undertaking the long voyage of search for adventure, finds instead that the universe itself has usurped the dynamic action which was once the prerogative of human will, and confronts her with a volatile and relentless metamorphosis in which her personal identity is the sole constancy.

These are but several indications of the variety of creative timespace relationships which can be accomplished by a meaningful manipulation of the sequence of film images. It is an order of creative action available only to the motion-picture medium because it is a photographic medium. The ideas of condensation and of extension, of separateness and continuity, in which it deals, exploit to the fullest degree the various attributes of the photographic image: its fidelity (which establishes the identity of the person who serves as a transcendent unifying force between all separate times and places), its reality (the basis of the recognition which activates our knowledges and values and without which the geography of location and dislocation could not exist), and its authority (which transcends the impersonality and intangibility of the image and endows it with independent and objective consequence).

## THE TWENTIETH-CENTURY ART FORM

I initiated this discussion by referring to the effort to determine what creative film form is not, as a means by which we can arrive eventually at a determination of what it is. I recommend this as the only valid point of departure for all custodians of classifications, to the keepers of catalogues, and in particular to the harassed librarians, who, in their effort to force film into one or another of the performing or the plastic arts, are engaged in an endless Procrustean operation.

A radio is not a louder voice, an airplane is not a faster car, and the motion picture (an invention of the same period of history) should not be thought of as a faster painting or a more real play.

All of these forms are qualitatively different from those which preceded them. They must not be understood as unrelated developments, bound merely by coincidence, but as diverse aspects of a new way of thought and a new way of life—one in which an appreciation of time, movement, energy, and dynamics is more immediately meaningful than the familiar concept of matter as a static solid anchored to a stable cosmos. It is a change reflected in every field of human endeavor, for example, architecture, in which the notion of mass-upon-mass structure has given way to the lean strength of steel and the dynamics of cantilever balances.

It is almost as if the new age, fearful that whatever was there already would not be adequate, had undertaken to arrive completely equipped, even to the motion-picture medium, which, structured expressly to deal in movement and time-space relationships, would be the most propitious and appropriate art form for expressing, in terms of its own paradoxically intangible reality, the moral and metaphysical concepts of the citizen of this new age.

This is not to say that cinema should or could replace the other art forms, any more than flight is a substitute for the pleasures of walking or for the leisurely panorama of landscapes seen from a car or train window. Only when new things serve the same purpose better do they replace old things. Art, however, deals in ideas; time does not deny them, but may merely make them irrelevant. The truths of the Egyptians are no less true for failing to answer questions which they never raised. Culture is cumulative, and to it each age should make its proper contribution.

How can we justify the fact that it is the art instrument, among all that fraternity of twentieth-century inventions, which is still the least explored and exploited; and that it is the artist—of whom, traditionally, the culture expects the most prophetic and visionary statements—who is the most laggard in recognizing that the formal and philosophical concepts of his age are implicit in the actual structure of his instrument and the techniques of his medium?

If cinema is to take its place beside the others as a full-fledged art form, it must cease merely to record realities that owe nothing of their actual existence to the film instrument. Instead, it must create a total experience so much out of the very nature of the instrument as to be inseparable from its means. It must relinquish the narrative disciplines it has borrowed from literature and its timid imitation of the causal logic of narrative plots, a form which flowered as a celebration of the earthbound, step-by-step concept of time, space and relationship which was part of the primitive materi-

alism of the nineteenth century. Instead, it must develop the vocabulary of filmic images and evolve the syntax of filmic techniques which relate those. It must determine the disciplines inherent in the medium, discover its own structural modes, explore the new realms and dimensions accessible to it and so enrich our culture artistically as science has done in its own province.

1960

# STAN BRAKHAGE
## *FROM* METAPHORS ON VISION

Imagine an eye unruled by man-made laws of perspective, an eye unprejudiced by compositional logic, an eye which does not respond to the name of everything but which must know each object encountered in life through an adventure of perception. How many colors are there in a field of grass to the crawling baby unaware of "Green?" How many rainbows can light create for the untutored eye? How aware of variations in heat waves can that eye be? Imagine a world alive with incomprehensible objects and shimmering with an endless variety of movement and innumerable gradations of color. Imagine a world before the "beginning was the word."

To see is to retain—to behold. Elimination of all fear is in sight—which must be aimed for. Once vision may have been given—that which seems inherent in the infant's eye, an eye which reflects the loss of innocence more eloquently than any other human feature, an eye which soon learns to classify sights, an eye which mirrors the movement of the individual toward death by its increasing inability to see.

But one can never go back, not even in imagination. After the loss of innocence, only the ultimate of knowledge can balance the wobbling pivot. Yet I suggest that there is a pursuit of knowledge foreign to language and founded upon visual communication, demanding a development of the optical mind, and dependent upon perception in the original and deepest sense of the word.

Suppose the Vision of the saint and the artist to be an increased ability to see—vision. Allow so-called hallucination to enter the realm of perception, allowing that mankind always finds derogatory terminology for that which doesn't appear to be readily usable, accept dream visions, day-dreams or night-dreams, as you would so-called real scenes, even allowing that the abstractions which move so dynamically when closed eyelids are pressed are actually perceived. Become aware of the fact that you are not only influenced by the visual phenomenon which you are focused upon and attempt to sound the depths of all visual influence. There is no need for the mind's

eye to be deadened after infancy, yet in these times the development of visual understanding is almost universally forsaken.

This is an age which has no symbol for death other than the skull and bones of one stage of decomposition . . . and it is an age which lives in fear of total annihilation. It is a time haunted by sexual sterility yet almost universally incapable of perceiving the phallic nature of every destructive manifestation of itself. It is an age which artificially seeks to project itself materialistically into abstract space and to fulfill itself mechanically because it has blinded itself to almost all external reality within eyesight and to the organic awareness of even the physical movement properties of its own perceptibility. The earliest cave paintings discovered demonstrate that primitive man had a greater understanding than we do that the object of fear must be objectified. The entire history of erotic magic is one of possession of fear thru the beholding of it. The ultimate searching visualization has been directed toward God out of the deepest possible human understanding that there can be no ultimate love where there is fear. Yet in this contemporary time how many of us even struggle to deeply perceive our own children?

The artist has carried the tradition of vision and visualization down through the ages. In the present time a very few have continued the process of visual perception in its deepest sense and transformed their inspirations into cinematic experiences. They create a new language made possible by the moving picture image. They create where fear before them has created the greatest necessity. They are essentially preoccupied by and deal imagistically with—birth, sex, death, and the search for God.

## CAMERA EYE

Oh transparent hallucination, superimposition of image on image, mirage of movement, heroine of a thousand and one nights (Scheherazade must surely be the muse of this art), you obstruct the light, muddie the pure white beaded screen (it perspires) with your shuffling patterns. Only the spectators (the unbelievers who attend the carpeted temples where coffee and paintings are served) think your spirit is in the illuminated occasion (mistaking your sweaty, flaring, rectangular body for more than it is). The devout, who break popcorn together in your humblest double-feature services, know that you are still being born, search for your spirit in their dreams, and dare only dream when in contact with your electrical reflection. Unknowingly, as innocent, they await the priests of this new religion, those who can stir cinematic entrails divinely. They await the prophets who can cast (with the precision of Confucian sticks) the characters of this new order across filmic mud. Being innocent, they do not consciously know that this church too is corrupt; but they react with counter hallucinations, believing in the stars, and cast themselves among these Los Angelic orders. Of themselves, they will never recognize what they are awaiting. Their footsteps, the dumb drum which destroys cinema. They are having the dream piped into their homes, the destruction of the romance thru marriage, etc.

So the money vendors have been at it again. To the catacombs then, or rather plant this seed deeper in the undergrounds beyond false nourishing of sewage waters. Let it draw nourishment from hidden uprising springs channeled by gods. Let there be no cavernous congregation but only the network of individual channels, that narrowed

vision which splits beams beyond rainbow and into the unknown dimensions. (To those who think this is waxing poetic, squint, give the visual objects at hand their freedom, and allow the distant to come to you; and when mountains are moving, you will find no fat in this prose). Forget ideology, for film unborn as it has no language and speaks like an aborigine—monotonous rhetoric. Abandon aesthetics—the moving picture image without religious foundations, let alone the cathedral, the art form, starts its search for God with only the danger of accepting an architectural inheritance from the categorized "seven," other arts its sins, and closing its circle, stylistic circle, therefore zero. Negate technique, for film, like America, has not been discovered yet, and mechanization, in the deepest possible sense of the word, traps both beyond measuring even chances—chances are these twined searches may someday orbit about the same central negation. Let film be. It is something . . . becoming. (The above being for creator and spectator alike in searching, an ideal of anarchic religion where all are priests both giving and receiving, or rather witch doctors, or better witches, or . . . O, for the unnamable).

And here, somewhere, we have an eye (I'll speak for myself ) capable of any imagining (the only reality). And there (right there) we have the camera eye (the limitation, the original liar); yet lyre sings to the mind so immediately (the exalted selectivity one wants to forget that its strings can so easily make puppetry of human motivation (for form as finality) dependent upon attunation, what it's turned to (ultimately death) or turned from (birth) or the way to get out of it (transformation). I'm not just speaking of that bird on fire (not thinking of circles) or of Spengler (spirals neither) or of any known progression (nor straight lines) logical formation (charted levels) or ideological formation (mapped for scenic points of interest); but I am speaking for possibilities (myself), infinite possibilites (preferring chaos).

And here, somewhere, we have an eye capable of any imagining. And then we have the camera eye, its lenses ground to achieve 19th century Western compositional perspective (as best exemplified by the 19th century architectural conglomeration of details of the "classic" ruin) in bending the light and limiting the frame of the image just so, its standard camera and projector speed for recording movement geared to the feeling of the ideal slow Viennese waltz, and even its tripod head, being the neck it swings on, balled with bearings to permit it that Les Sylphides motion (ideal to the contemplative romantic) and virtually restricted to horizontal and vertical movements (pillars and horizon lines) a diagonal requiring a major adjustment, its lenses coated or provided with filters, its light meters balanced, and its color film manufactured, to produce that picture post card effect (salon painting) exemplifed by those oh so blue skies and peachy skins.

By deliberately spitting on the lens or wrecking its focal intention, one can achieve the early stages of impressionism. One can make this prima donna heavy in performance of image movement by speeding up the motor, or one can break up movement, in a way that approaches a more direct inspiration of contemporary human eye perceptibility of movement, by slowing the motion while recording the image. One may hand hold the camera and inherit worlds of space. One may over or underexpose the film. One may use the filters of the world, fog, downpours, unbalanced lights, neons with neurotic color temperatures, glass which was never designed for a camera, or even glass which was but which can be used against specifications, or one may photograph an hour

after sunrise or an hour before sunset, those marvelous taboo hours when the film labs will guarantee nothing, or one may go into the night with a specified daylight film or vice versa. One may become the supreme trickster, with hatfuls of all the rabbits listed above breeding madly. One may, out of incredible courage, become Méliès, that marvelous man who gave even the "art of the film" its beginning in magic. Yet Méliès was not witch, witch doctor, priest, or even sorcerer. He was a 19th-century stage magician. His films *are* rabbits.

What about the hat? the camera? or if you will, the stage, the page, the ink, the hieroglyphic itself, the pigment shaping that original drawing, the musical and/or all other instruments for copula-and-then-procreation? Kurt Sachs talks sex (which fits the hat neatly) in originating musical instruments, and Freud's revitalization of symbol charges all contemporary content in art. Yet possession thru visualization speaks for fear-of-death as motivating force—the tomb art of the Egyptian, etc. And then there's "In the beginning," "Once upon a time," or the very concept of a work of art being a "Creation." Religious motivation only reaches us thru the anthropologist these days—viz., Frazer on a golden bough. And so it goes—ring around the rosary, beating about the bush, describing. One thread runs clean thru the entire fabric of expression—the trick-and-effect. And between those two words, somewhere, magic . . . the brush of angel wings, even rabbits leaping heavenwards and, given some direction, language corresponding. Dante looks upon the face of God and Rilke is heard among the angelic orders. Still the Night Watch was tricked by Rembrandt and Pollack was out to produce an effect. The original word was a trick, and so were all the rules of the game that followed in its wake. Whether the instrument be musical or otherwise, it's still a hat with more rabbits yet inside the head wearing it—i.e., thought's a trick, etc. Even The Brains for whom thought's the world, and the word and visi-or-audibility of it, eventually end with a ferris wheel of a solar system in the middle of the amusement park of the universe. They know it without experiencing it, screw it lovelessly, find "trick" or "effect" derogatory terminology, too close for comfort, are utterly unable to comprehend "magic." We are either experiencing (copulating) or conceiving (procreating) or very rarely both are balancing in that moment of living, loving, and creating, giving and receiving, which is so close to the imagined divine as to be more unmentionable than "magic."

In the event you didn't know, "magic" is realmed in "the imaginable," the moment of it being when that which is imagined dies, is penetrated by mind and known rather than believed in. Thus "reality" extends its picketing fence and each is encouraged to sharpen his wits. The artist is one who leaps that fence at night, scatters his seeds among the cabbages, hybrid seeds inspired by both the garden and wits-end forest where only fools and madmen wander, seeds needing several generations to be . . . finally proven edible. Until then they remain invisible, to those with both feet on the ground, yet prominent enough to be tripped over. Yes, those unsightly bulges between those oh so even rows will find their flowering moment . . . and then be farmed. Are you really thrilled at the sight of a critic tentatively munching artichokes? Wouldn't you rather throw overalls in the eventual collegic chowder? Realize the garden as you will—the growing is mostly underground. Whatever daily care you may give it—all is planted only by moonlight. However you remember it—everything in it originates elsewhere. As for the unquotable magic— it's as indescribable as the unbound woods it comes from.

(A foot-on-the-ground-note: The sketches of T. E. Lawrence's "realist" artist companion were scratches to Lawrence's Arab friends. Flaherty's motion picture projection of NANOOK OF THE NORTH was only a play of lights and silhouettes to the Aleutian Islander Nanook himself. The schizophrenic does see symmetrically, does believe in the reality of Rorschach, yet he will not yield to the suggestion that a pinpoint light in a darkened room will move, being the only one capable of perceiving its stasis correctly. Question any child as to his drawing and he will defend the "reality" of what you claim "scribbles." Answer any child's question and he will shun whatever quest he'd been beginning.)

Light, lens concentrated, either burns negative films to a chemical crisp which, when lab washed, exhibits the blackened pattern of its ruin or, reversal film, scratches the emulsion to eventually bleed it white. Light, again lens concentrated, pierces white and casts its shadow patterned self to reflect upon the spectator. When light strikes a color emulsion, multiple chemical layers restrict its various wave lengths, restrain its bruises to eventually produce a phenomenon unknown to dogs. Don't think of creatures of uncolored vision as restricted, but wonder, rather, and marvel at the known internal mirrors of the cat which catch each spark of light in the darkness and reflect it to an intensification. Speculate as to insect vision, such as the bee's sense of scent thru ultraviolet perceptiblity. To search for human visual realities, man must, as in all other homo motivation, transcend the original physical restrictions and inherit worlds of eyes. The very narrow contemporary moving visual reality is exhausted. The belief in the sacredness of any man-achievement sets concrete about it, statues becoming statutes, needing both explosives, and earthquakes for disruption. As to the permanency of the present or any established reality, consider in this light and thru most individual eyes that without either illumination or photographic lens, any ideal animal might claw the black off a strip of film or walk ink-footed across transparent celluloid and produce an effect for projection identical to a photographed image. As to color, the earliest color films were entirely hand painted a frame at a time. The "absolute realism" of the motion picture image is a human invention.

What reflects from the screen is shadow play. Look, there's no real rabbit. Those ears are index fingers and the nose a knuckle interfering with the light. If the eye were more perceptive it would see the sleight of 24 individual pictures and an equal number of utter blacknesses every second of the show. What incredible films might ultimately be made for such an eye. But the machine has already been fashioned to outwit even that perceptibility, a projector which flashes advertisement at subliminal speed to up the sale of popcorn. Oh, slow-eyed spectator, this machine is grinding you out of existence. Its electrical storms are manufactured by pure white frames interrupting the flow of the photographed images, its real tensions are a dynamic interplay of two-dimensional shapes and lines, the horizon line and background shapes battering the form of the horseback rider as the camera moves with it, the curves of the tunnel exploding away from the pursued, camera following, and tunnel perspective converging on the pursuer, camera preceding, the dream of the close-up kiss being due to the linear purity of facial features after cluttersome background, the entire film's soothing syrup being the depressant of imagistic repetition, a feeling akin to counting sheep to sleep. Believe in it blindly, and it will fool you—mind wise, instead of sequins on cheesecloth or max-manu-factured make-up, you'll see stars. Believe in it

eye-wise, and the very comet of its overhead throw from projector to screen will intrigue you so deeply that its fingering play will move integrally with what's reflected, a comet-tail integrity which would lead back finally to the film's creator. I am meaning, simply, that the rhythms of change in the beam of illumination which now goes entirely over the heads of the audience would, in the work of art, contain in itself some quality of a spiritual experience. As is, and at best, that hand spreading its touch toward the screen taps a neurotic chaos comparable to the doodles it produces for reflection. The "absolute realism" of the motion picture image is a 20th-century, essentially Western, illusion.

Nowhere in its mechanical process does the camera hold either mirror or candle to nature. Consider its history. Being machine, it has always been manufacturer of the medium, mass-producer of stilled abstract images, its virtue—related variance, the result—movement. Essentially, it remains fabricator of a visual language, no less a linguist than the typewriter. Yet in the beginning, each of an audience thought him-self the camera, attending a play or, toward the end of the purely camera career, being run over by the unedited filmic image of a locomotive which had once rushed straight at the lens, screaming when a revolver seemed fired straight out of the screen, motion of picture being the original magic of the medium. Méliès is credited with the first splice. Since then, the strip of celluloid has increasingly revealed itself suited to trans-formations beyond those conditioned by the camera. Originally Méliès' trickery was dependent upon starting and stopping the photographic mechanism and between-times creating, adding objects to its field of vision, transformations, substituting one object for another, and disapperances, removing the objectionable. Once the celluloid could be cut, the editing of filmic images began its development toward Eisenstein-ian montage, the principle of 1 plus 2 making 3 in moving imagery as anywhere else. Meantime labs came into the picture, playing with the illumination of original film, balancing color temperature, juggling double imagery in superimposition, adding all the acrobatic grammar of the film inspired by D. W. Griffith's dance; fades to mark the montage sentenced motion picture paragraph, dissolves to indicate lapse of time between interrelated subject matter, variations in the framing for the epic horizontal composition, origin of Cinemascope, and vertical picture delineating character, or the circle exclamating a pictorial detail, etc. The camera itself taken off the pedestal, began to move, threading its way, in and around its source of material for the even-tual intricately patterned fabric of the edited film. Yet editing is still in its 1, 2, 3 infancy, and the labs are essentially still just developing film, no less trapped by the standards they're bearing than the camera by its original mechanical determination. No very great effort has ever been made to interrelate these two or three processes, and already another is appearing possible, the projector as creative instrument with the film show a kind of performance, celluloid or tape merely source of material to the projectioning interpreter, this expression finding its origins in the color, or the scent, or even the musical organ, its most recent manifestations—the increased pro-gramming potential of the IBM and other electronic machines now capable of invent-ing imagery from scratch. Considering then the camera eye as almost obsolete, it can at last be viewed objectively and, perhaps, viewpointed with subjective depth as never before. Its life is truly all before it. The future fabricating machine in performance will invent images as patterned after cliché vision as those of the camera, and its

results will suffer a similar claim to "realism," IBM being no more God nor even a "Thinking machine" than the camera eye all-seeing or capable of creative selectivity, both essentially restricted to "yes-no," "stop-go," "on-off," and instrumentally dedicated to communication of the simplest sort. Yet increased human intervention and control renders any process more capable of a balance between sub-and-objective expression, and between those two concepts, somewhere, soul . . . The second stage of transformation of image editing revealed the magic of the movement. Even though each in the audience then proceeded to believe himself part of the screen reflection, taking two-dimension visual characters as his being within the drama, he could not become every celluloid sight running thru the projector, therefore allowance of another viewpoint, and no attempt to make him believe his eye to be where the camera eye once was has ever since proven successful—excepting the novelty of three-dimension, audiences jumping when rocks seemed to avalanche out of the screen and into the theatre. Most still imagine, however, the camera a recording mechanism, a lunatic mirroring, now full of sound and fury presenting its half of a symmetrical pattern, a kaleidoscope with the original pieces of glass missing and their movement removed in time. And the instrument is still capable of winning Stanford's bet about horse-hooves never all leaving the ground in galloping, though Stanford significantly enough used a number of still cameras with strings across the track and thus inaugurated the flip-pic of the penny arcade, Hollywood still racing after the horse. Only when the fans move on to another track can the course be cleared for this eye to interpret the very ground, perhaps to discover its non-solidity, to create a contemporary Pegasus, without wings, to fly with its hooves, beyond any imagining, to become gallop, a creation. It can then inherit the freedom to agree or disagree with 2000 years of Western equine painting and attain some comparable aesthetic stature. As is, the "absolute realism" of the motion picture image is a contemporary mechanical myth. Consider this prodigy for its virtually untapped talents, viewpoints it possesses more readily recognizable as visually non-human yet within the realm of the humanly imaginable. I am speaking of its speed for receptivity which can slow the fastest motion for detailed study, or its ability to create a continuity for time compression, increasing the slowest motion to a comprehensibility. I am praising its cyclopean penetration of haze, its infra-red visual ability in darkness, its just-developed 360 degree view, its prismatic revelation of rainbows, its zooming potential for exploding space and its telephotic compression of same to flatten perspective, its micro- and macroscopic revelations. I am marvelling at its Schlaeran self capable of representing heat waves and the most invisible air pressures, and appraising its other still camera developments which may grow into motion, its rendering visible the illumination of bodily heat, its transformation of ultraviolets to human cognizance, its penetrating X-ray. I am dreaming of the mystery camera capable of graphically representing the form of an object after it's been removed from the photographic scene, etc. The "absolute realism" of the motion picture is unrealized, therefore potential, magic.

1963

# JEAN-LOUIS BAUDRY
# THE APPARATUS: METAPSYCHOLOGICAL APPROACHES TO THE IMPRESSION OF REALITY IN CINEMA

One constantly returns to the scene of the cave: real effect or impression of reality. Copy, simulacrum, and even simulacrum of simulacrum. Impression of the real, more-than-the-real? From Plato to Freud, the perspective is reversed; the procedure is inverted—so it seems. The former comes out of the cave, examines what is intelligible, contemplates its source, and, when he goes back, it is to denounce to the prisoners the apparatus which oppresses them, and to persuade them to leave, to get out of that dim space. The latter (on the contrary—no, for it is not a matter of simple opposition, or of a simplifying symmetry) is more interested in making them go back there precisely where they are; where they didn't know how to find themselves, for they thought themselves outside, and it is true they had been contemplating the good, the true, and the beautiful for a long time. But at what price and as a result of what ignorance; failure to recognize or repress, compromise, defense, sublimation? Like Plato, he urges them to consider the apparatus to overcome their resistances, to look a little more closely at what is coming into focus on the screen, the other scene. The other scene? What brings the two together and separates them? For both, as in the theater, a left side, a right side, the master's lodge, the valet's orchestra. But the first scene would seem to be the second's other scene. It is a question of truth in the final analysis, or else: "the failure to recognize has moved to the other side." Both distinguish between two scenes, or two places, opposing or confronting one another, one dominating the other. These aren't the same places; they don't respond point by point, although, in many respects, we who come after Freud would not be unjustified in superimposing more or less grossly the solar scene where the philosopher is at first dazzled, blinded by the good, on the scene of the conscious and its well-meaning exploits—we who, as a result of this very discovery of the unconscious, or of the other scene, could be induced to interpret the move, the exit, ascension, an initial blinding of the philosopher in a totally different manner. "Suppose one of them were

set free and forced suddenly to stand up, turn his head, and walk with eyes lifted to
the light; all these movements would be painful, and he would be too dazzled to make
out the objects. . . . And if he were forced to look at the firelight itself, would not his
eyes ache, so that he would try to escape and turn back to the things which he could
see distinctly?" But the philosopher's cave could certainly not be superimposed onto
that other scene, the scene of the unconscious! That remains to be seen. For we are
dealing here with an apparatus, with a metaphorical relationship between places or a
relationship between metaphorical places, with a topography, the knowledge of
which defines for both philosopher and analyst the degree of relationship to truth or
to description, or to illusion, and the need for an ethical point of view.

So you see, we return to the real or, for the experiencing subject (I could say, for
the subject who is felt or who is acted), the impression of reality. And one could
naively wonder why, some two and half thousand years later, it is by means of an opti-
cal metaphor—of an optical construct which signals term for term the cinemato-
graphic apparatus—that the philosopher exposes man's condition and the distance
that separates him from "true reality"; and why it is again precisely by means of an
optical metaphor that Freud, at the beginning and at the end of his writings, tries to
account for the arrangement of the physical apparatus, for the functioning of the
Unconscious and for the rapport/rupture Conscious-Unconscious. Chapter 7 of the
*Traumdeutung*:

> What is presented to us in these words is the idea of a *psychical locality*. I shall entirely
> disregard the fact that the mental apparatus with which we are concerned is also known
> to us in the form of an anatomical preparation, and I shall carefully avoid the temptation
> to determine psychical locality in an anatomical fashion. I shall remain upon psycholog-
> ical ground, and I propose simply to follow the suggestion that we should picture the
> instrument which carries out our mental functions as resembling a compound microscope
> or a photographic apparatus, or something of the kind. On that basis, psychical locality
> will correspond to a point inside the apparatus at which one of the preliminary stages of
> an image comes into being. In the microscope and telescope, as we know, these occur in
> part at ideal points, regions in which no tangible component to the apparatus is situated.
> I see no necessity to apologize for the imperfections of this or of any similar imagery.*

However imperfect this comparison may be, Freud takes it up again forty years
later at the very beginning of the *Abriss*: "We admit that psychical life is the function
of an apparatus to which we attribute a spatial extension which is made up of several
parts. We imagine it like a kind of telescope, or microscope or some similar device."
Freud doesn't mention cinema. But this is because cinema is already too technologi-
cally determined an apparatus for describing the psychical apparatus as a whole. In
1913, however, Lou Andréas Salomé remarked: "Why is it that cinema has been of
no use to us [analysts]? To the numerous arguments that could be advanced to save
face for this Cinderella of the artistic conception of art, several psychological con-
siderations should be added. First, that the cinematographic technique is the only one
that makes possible a succession of images rapid enough to roughly correspond to our
faculty for producing mental images. Furthermore," she concludes "this provides
food for reflection about the impact film could have in the future for our psychical

*Sigmund Freud, *The Interpretation of Dreams* (New York: Avon, 1965), pp. 574–75.

make-up." Clearly Salomé seems to envision a very enigmatic track, unless we have misunderstood her. Does she mean that film may bear some sort of likeness to the psychical apparatus, that, for this reason, it could be of interest to those who, because of its direct relation to their practice, are immediately affected by a theorization of psychical operation linked to the discovery of the Unconscious? And is it not the apparatus, the cinematographic process itself rather than the content of images—that is, the film—which is under scrutiny here? She only points out that there might be correspondences between cinematographic technique and our ability to produce mental images. But there are many aspects of film technique, many different connections, from the recording of the images to their reproduction—an entire process which we have named elsewhere the *basic cinematographic apparatus*. And certainly such a technical construct—if only as examples and metaphor—should have interested Freud, since the major purpose of metapsychological research is to comprehend and to theoretically construct devices capable of recording traces, memory traces, and of restoring them in the form of representation. He admits: the concept of the "magic writing pad" (which he substitutes for the optical metaphor to which he later returns) is missing something: the possibility of restoring inscribed traces by using specific memory mechanisms which are exclusively constituted by living matter but which a certain number of technical inventions of the time already mimic: the phonograph and cinema, precisely. The advantage of the magic writing pad is that since the external surface doesn't retain any trace of the inscriptions, it is best suited to illustrate the system Perception-Conscious; in addition, the waxy substance inside preserves, superimposed and to some extent associated, the different traces which have inscribed themselves throughout time, preserves them from what could be called historical accidents. Obviously, nothing prevents the same thing from applying to the material of the record or to the film stock of the film if not that such reproduction would be confusing and indecipherable to us: the inscription follows other tracks, which are organized according to other principles than those of inanimate matter.

Yet, there is something there which should capture our attention: the double place of the subject (constituted on the one hand by the system perception = Conscious characterized by the transcience, successiveness, and mobility of perceptions and representations; on the other by Unconscious system traces/inscriptions characterized by permanence) finds itself once more within an idealist perspective considerably displaced with respect to the unconscious in Plato. But as we have learned from Marx, there is often a truth hidden from or in idealism, a truth which belongs to materialism, but which materialism can only discover after many detours and delays—a hidden or disguised truth. In Plato, something haunts the subject; something belabors him and determines his condition (could it be the pressure of the "Ideas"?) As for Freud, the subject which Plato describes, the prisoner in the cave, is deceived (this whole theme of the mistaken subject which runs through the history of philosophy!); he is the prey of illusions, and, as for Freud, these illusions are but distortions and symptoms (gradations, the idealist would say—and admit this changes everything) of what is happening somewhere else. Even though Ideas take the place of the Unconscious for him, Plato confronts a problem equivalent to that which at first preoccupies Freud in his metapsychological research and which, precisely, the cave myth is presumed to resolve: the transfer, the access from one place to another, along with the

ensuing distortions. Plato's prisoner is the victim of an illusion of reality, that is, of precisely what is known as a hallucination, if one is awake, as a dream, if asleep; he is the prey of an impression, of *an impression of reality*. As I have said, Plato's *topos* does not and could not possibly correspond exactly to Freud's and surely, although it may be interesting to show what displacement occurs from one *topos* to the other (the location of reality for Plato obviously doesn't correspond to what is real for Freud), it is still more important to determine what is at work on the idealist philosopher's discourse unknown to him, the truth which proclaims, very different yet contained within the one he consciously articulates.

As a matter of fact, isn't it curious that Plato, in order to explain the transfer, the access from one place to another and to demonstrate, reveal, and make understood what sort of illusion underlies our direct contact with the real, would imagine or resort to an apparatus that doesn't merely evoke, but quite precisely describes in its mode of operation the cinematographic apparatus* and the spectator's place in relation to it.

It is worth rereading the description of the cave from this perspective.

First, the space: "a kind of cavernous underground chamber with an entrance open to the light" but too small to light it up. As Plato points out farther on: "a dim space." He emphasizes the effect of the surrounding darkness on the philosopher after his sojourn in the outside world. To his companions he will at first appear blind, his eyesight ruined; and his clumsiness will make them laugh. They will not be able to have confidence in him. In the cave, the prisoner-spectators are seated, still, prisoners because immobilized: unable to move—constraint or paralysis? It is true that they are chained, but, freed, they would still refuse to leave the place where they are; and so obstinately would they resist that they might put to death anyone trying to lead them out. In other words, this first constraint, against their will, this deprivation of movement which was imposed on them initially, this motor inhibition which affected so much their future dispositions, conditions them to the point that they prefer to stay where they are and to perpetuate this immobility rather than leave. Initial constraint which seems in this way to turn itself into a kind of spite or at least to inscribe the compulsion to repeat, the return to a former condition. There are things like that in Plato? It is not unnecessary to insist on this point as we reread the Platonic myth from the special perspective of the cinematographic apparatus. Forced immobility is undoubtedly a valuable argument for the demonstration/description that Plato makes of the human condition: the coincidence of religious and idealist conceptions; but the initial immobility was not invented by Plato; it can also refer to the forced immobility of the child who is without motor resources at birth, and to the forced immobility of the sleeper who we know repeats the postnatal state and even interuterine existence; but this is

*In a general way, we distinguish the *basic cinematographic apparatus* [*l'appareil de base*], which concerns the ensemble of the equipment and operations necessary to the production of a film and its projection, from the apparatus [*le dispositif*] discussed in this article, which solely concerns projection and which includes the subject to whom the projection is addressed. Thus the *basic cinematographic apparatus* involves the film stock, the camera, developing, montage considered in its technical aspects, etc., as well as the apparatus [*dispositif*] of projection. The basic cinematographic apparatus is a long way from being the camera by itself, to which some have wanted to say I limit it (one wonders what bad arguments this can serve).

also the immobility that the visitor to the dim space rediscovers, leaning back into his chair. It might even be added that the spectators' immobility is characteristic of the filmic apparatus as a whole. The prisoner's shackles correspond to an actual reality in the individual's evolution, and Plato even draws the conclusion that it could have an influence on his future behavior, and would be a determining factor in the prisoner's resistance to breaking away from the state of illusion. "He might be required once more to deliver his opinion on those shadows, in competition with the prisoners who had never been released. . . . If they could lay hands on the man who was trying to set them free and lead them up, they would kill him." Does he mean that immobility constitutes a necessary if not sufficient condition for the prisoner's credulity, that it constitutes one of the causes of the state of confusion into which they have been thrown and which makes them take images and shadows for the real? I don't want to stretch Plato's argument too far, even if I am trying to make his myth mean more than it actually says. But note: "In this underground chamber they have been *from childhood*, chained by the leg and also by the neck, so that they cannot move and can see only what is in front of them, because the chains will not let them turn their heads" [my emphasis]. Thus it is their motor paralysis, their inability to move about that, making the reality test impractical for them, reinforces their error and makes them inclined to take for real that which takes its place, perhaps its figuration or its projection onto the wall/screen of the cavern in front of them and from which they cannot detach their eyes and turn away. They are bound, shackled to the screen, tied and related—relation, extension between it and them due to their inability to move in relation to it, the last sight before falling asleep.

Plato says nothing about the quality of the images: is two-dimensional space suited to the representation of depth produced by the images of objects? Admittedly, they are flat shadows, but their movements, crossings over, superimpositions, and displacements allow us perhaps to assume that they are moving along different planes. However, Plato calls the projector to mind. He doesn't feel a need for making use of natural light; but it is also important to him to preserve and protect that light from an impure usage: idealism makes the technician. Plato is satisfied with a fire burning behind them "at some distance higher up." As a necessary precaution, let us examine Plato's accuracy in assembling his apparatus. He is well aware that, placed otherwise, the fire would transmit the reflections of the prisoners themselves most prominently onto the screen. The "operators," the "machinists" are similarly kept out of the prisoners' sight, hidden by "a parapet, like the screen at a puppet-show, which hides the performers while they show their puppets over the top." For, undoubtedly, by associating themselves with the objects that they are moving back and forth before the fire, they would project a heterogeneous image capable of canceling the reality effect they want to produce: they would awake the prisoner's suspicions; they would awake the prisoners.

Here is the strangest thing about the whole apparatus. Instead of projecting images of natural/real objects, of living people, etc. onto the wall/screen of the cave as it would seem only natural to do for simple shadow plays, Plato feels the need, by creating a kind of conversion in the reference to reality, to show the prisoners not direct images and shadows of reality but, even at this point, a simulacrum of it. One might easily recognize the idealist's prudence, the calculated progress of the philosopher

who prefers pushing the real back another notch and multiplying the steps leading to it, lest excessive haste lead his listener again to trust his senses too much. In any case, for this reason (or for another), he is led to place and to suppose between the projector, the fire, and the screen something which is itself a mere prop of reality, which is merely its image, its copy, its simulacrum: "figures of men and animals in wood or stone or other materials" suggestive of studio objects of papier mâché decor, were it not for the more striking impression created by their passing in front of the fire like a film.

All that is missing is the sound, in effect much more difficult to reproduce. Not only this: more difficult to copy, to employ like an image in the visible world; as if hearing, as opposed to sight, resisted being caught up in simulacra. Real voices, then, they would emanate from the bearers, the machinists, and the marionette players (a step is skipped in the reference to reality) but nevertheless, given over to the apparatus, integrated with it since it requires a total effect for fear of exposing the illusion. But voice that does not allow representation as do artificial objects—stone and wooden animals, and statues—will still give itself over to the apparatus thanks to its reverberation. "And suppose their prison had an echo from the wall facing them?" "When one of the people crossing behind them spoke, they could only suppose that the sound came from the shadow passing before their eyes." If a link is missing in the chain that connects us back to reality, the apparatus corrects this, by taking over the voice's echo, by integrating into itself these excessively real voices. And it is true that in cinema—as in the case of all talking machines—one does not hear an image of the sounds but the sounds themselves. Even if the procedures for recording the sounds and playing them back deforms them, they are reproduced and not copied. Only their source of emission may partake of illusion; their reality cannot. Hence, no doubt one of the basic reasons for the privileged status of voice in idealist philosophy and in religion: voice does not lend itself to games of illusion, or confusion, between the real and its figurativity (because voice cannot be represented figuratively) to which sight seems particularly liable. Music and singing differ qualitatively from painting in their relation to reality.

As we have seen, Plato constructs an apparatus very much like sound cinema. But, precisely because he has to resort to sound, he anticipates an ambiguity which was to be characteristic of cinema. This ambiguity has to do with the impression of reality: with the means used to create it, and with the confusion and lack of awareness surrounding its origin, from which result the inventions which mark the history of cinema. Plato effectively helps us to recognize this ambiguity. For, on the one hand, he is careful to emphasize the artificial aspect of reproduced reality. It is the apparatus that creates the illusion, and not the degree of fidelity with the Real: here *the prisoners have been chained since childhood*, and it will therefore not be the reproduction of this or that specific aspect of that reality, which they do not know, which will lead them to attribute a greater degree of reality to the illusion to which they are subject (and we have seen that Plato was already careful to insert artifice, and that already what was projected was deception). On the other hand, by introducing voice, by reconstructing a talking machine, by complementing the projection with sound, by illustrating, as it were, the need to affect as many sense faculties as possible, at any rate the two most important, he certainly seems to comply with a necessity to dupli-

cate reality in the most exact manner and to make his artifice as good a likeness as can be made. Plato's myth evidently functions as a metaphor for an analogy on which he himself insists before dealing with the myth: namely, that what can be known through the senses is in the same relationship to that which can be known through the intellect as projection in the cave is to experience (that is, to ordinary reality). Besides that, isn't it remarkable that Plato should have been forced to resort to such a procedure and that, in his attempt to explain the position, the locus of that which can be known through the intellect, he was led to take off, so to speak, toward "illusion"; he was led to construct an apparatus which will make it possible, that it is capable of producing a special effect through the impression of reality it communicates to the spectator.

Here I must add something which may be of importance: in the scene taking place inside the cave, voices, words, "[these echoes which] they could only suppose that the sound came from the shadow passing before their eyes," do not have a discursive or conceptual role; they do not communicate a message; they belong to ordinary reality which is as immediate to the prisoners as are images; they cannot be separated from the latter; they are characterized according to the same mode of existence and in effect treated in the same way as words in a dream "fragments of discourse *really* spoken or heard, *detached from their context*" (my emphasis), and functioning like other kinds of dream representation.

But there is another way to state the problem. What desire was aroused, more than two thousand years before the actual invention of cinema, what urge in need of fulfillment would be satisifed by *a montage, rationalized into an idealist perspective precisely in order to show that it rests primarily on an impression of reality?* The impression of reality is central to Plato's demonstration. That his entire argument is developed in order to prove that this impression is deceptive abundantly demonstrates its existence. As we have already noted, something haunts Plato's text: the prisoners' fascination (how better to convey the condition that keeps them chained up, those fetters that prevent them from moving their heads and necks), their reluctance to leave, and even their willingness to resort to violence. But isn't it principally the need to construct another scene apart from the world, underground, in short to construct it as if it existed, or as if this construction also satisfied a desire to objectify a similar scene—an apparatus capable precisely of fabricating an impression of reality. This would appear to satisfy and replace the nostalgia for a lost impression which can be seen as running through the idealist movement and eating away at it from inside, and setting it in motion. That the real in Plato's text is at an equal distance from or in a homologous relationship to the "intelligibly real"—the world of Ideas—and "reality-subject"—"the impression of reality" produced by the apparatus in the cave should moreover be sufficient to make us aware of the real meaning of the world of Ideas and of the field of desire on which it has been built (a world which, as we know, "exists outside of time," and which, after numerous encounters, the conscious subject can rediscover in himself).

Cave, grotto, "sort of cavernous chamber underground," people have not failed to see in it a representation of the maternal womb, of the matrix into which we are supposed to wish to return. Granted, but only the place is taken into account by this interpretation and not the apparatus as a whole; and if this apparatus really produces

images, it first of all produces an effect of specific subjects—to the extent that a subject is intrinsically part of the apparatus; once the cinema has been technically perfected, it produces this same effect defined by the words "impression of reality" (words that may be confusing but which nevertheless need to be clarified). This impression of reality appears as if—just as if—it were known to Plato. At the very least, it seems that Plato ingeniously attempts and succeeds in fixing up a machine capable of reproducing "something" that he must have known, and that has less to do with its capacity for repeating the real (and this is where the Idealist is of great help to us by sufficiently emphasizing the artifice he employs to make his machine work) than with reproduction and repetition of a particular condition, and the representation of a particular place on which this condition depends.

Of course, from the analytic perspective we have chosen, by asking cinema about the wish it expresses, we are aware of having distorted the allegory of the cave by making it reveal, from a considerable historic distance, the approximate construct of the cinematographic apparatus. In other words, a same apparatus was responsible for the invention of the cinema and was already present in Plato. The text of the cave may well express a desire inherent to a participatory effect deliberately produced, sought for, and expressed by cinema (and the philosopher is first of all a spokesman of desire before becoming its great "channeler," which shows why it is far from useless to bring an analytic ear to bear on him despite or because of his rationalizations, even though he would deny it as tolerable suspicion, even and especially though he complains, rightly from his point of view, of our having distorted his text). We can thus propose that the allegory of the cave is the text of a signifier of desire which haunts the invention of cinema and the history of its invention.

You see why historians of cinema, in order to unearth its first ancestor, never leave off dredging a prehistory which is becoming increasingly cluttered. From the magic lantern to the praxinoscope and the optical theater up to the *camera obscura*, as the booty piles up, the excavations grow: new objects and all kinds of inventions—one can feel the disarray increasing. But if cinema was really the answer to a desire inherent in our psychical structure, how can we date its first beginnings? Would it be too risky to propose that painting, like theater, for lack of suitable technological and economic conditions, were dry runs in the approximation not only of the world of representation but of what might result from a certain aspect of its functioning and which only the cinema is in a position to implement? These attempts have obviously produced their own specificity and their own history, but their existence has at its origin a psychical source equivalent to the one which stimulated the invention of cinema.

It is very possible that there was never any first invention of cinema. Before being the outcome of technical considerations and of a certain state of society's development (necessary to its realization and to its completion), it was primarily the target of a desire which, moreover, its immediate success as well as the interest which its ancestors had aroused has demonstrated clearly enough. A desire, to be sure, a form of lost satisfaction which its apparatus would be aimed at rediscovering in one way or another (even to the point of simulation) and to which the impression of reality would seem to be the key.

I would now like to look more closely at what the impression of reality and the desire objectified in its entails by surveying certain analytical texts.

And since I have already mentioned the cave, "a kind of cavernous underground chamber," as Plato says, I went back to the *Interpretation of Dreams* and discovered a remark of Freud's that could guide our search. This remark is to be found in the passage dedicated to examples of dream work. Freud examines the kinds of figuration that occur during analysis. After having shown how the treatment gets itself represented, Freud comes to the unconscious, "If the unconscious, insofar as it belongs to waking thought, needs to be represented in dreams, it is represented in them in underground places." Freud adds the following which, because of the above, is very interesting: "Outside of analytic treatment, these representations would have symbolized the woman's body or the womb." If the world of Ideas offers numerous concepts which correspond to those which Freud discovered in the Unconscious (the permanence of traces, the ignorance of time), that is, if the philosophical edifice can be envisaged as a rationalization of the Unconscious's thrust, of its suspected but rejected existence, then we can ask whether it is not the Unconscious or certain of its mechanisms that are figured, that represent themselves in the apparatus of the cave. In any case, paraphrasing Fechner, we could propose that the scene of the cave (and of cinema) is perhaps quite different from that of the activity of representation in a state of wakefulness. In order to learn a little more about that other scene, it might be useful to linger a while before the dream scene.

A parallel between dream and cinema had often been noticed: common sense perceived it right away. The cinematographic projection is reminiscent of dream, would appear to be a kind of dream, really a dream,* a parallelism often noticed by the dreamer when, about to describe his dream, he is compelled to say "It was like in a movie . . ." At this point, it seems useful to follow Freud closely in his metapsychological analysis of dream. Once the role and function of dream as a protector of sleep and as fulfillment of a wish has been recognized as well as its nature and the elaboration of which it is the result, and after the material, the translation of the manifest content into dream thoughts, has been studied, one must still determine the conditions of dream formation, the reasons that give dream a specific qualitative nature in the whole of the psychical life, the specific "dream effect" that it determines. This is the subject of chapter 7 of *The Interpretations of Dreams* and the *Supplement to the Theory of Dreams* fifteen years later. In the latter text, Freud at first seems concerned with understanding why dream manifests itself to the dreamer's consciousness in the form of what might be called the "specific mode of dream," a feature of reality which should more properly belong to the perception of the external world. What are the determining factors of a necessarily metapsychological order, that is, involving the construction and operation of the psychical apparatus, which makes it possible for

---

*A close relationship which has led filmmakers to believe that cinema was the instrument finally suited for the representation of dreams. The failure of their attempt still remains to be understood. Is it not that the representation of dreams in cinema would not function like the representation of dreams in dreams, precisely destroying the impression of reality in the same way as the thought that one is dreaming intervenes in dream as a defense mechanism against the "mashing" desire of dream. The displacement of dream in the projection results unavoidably in sending the spectator back to his consciousness; it imposes a distance which denounces the artifice (and is there anything more ridiculous than those soft focus clouds, supposedly dreamlike representations) and it destroys completely the *impression of reality* which precisely also defines dream.

dream to pass itself off for reality to the dreamer. Freud begins with sleep: dream is the psychical activity of the dreamer. Sleep, he tells us, "from a somatic viewpoint is *a revivescence of one's stay in the body of the mother, certain conditions of which it recreates: the rest position, warmth, and isolation which protects him from excitement*" [emphasis added]. This makes possible a first form of regression: *temporal regression*, which follows two paths—regression of the libido back to a previous period of hallucinatory satisfaction of desire; and regression in the development of the self back to a primitive narcissism which results in what has been defined as the totally egotistical nature of dream: "*the person who plays the main part in dream scenes is always the dreamer himself.*" Sleep favors the appearance of another form of regression which is extremely important for the manifestation of the dream effect: by deactivating equally the Cs, Pcs, and Ucs systems, that is, by allowing an easier communication between them, sleep leaves open the regressive path which the cathetic representations will follow as far as perception. *Topical regression* and *temporal regression* combine to reach the edge of dream.

I do not want to insist excessively on Freud's analysis. We need only note that the dream wish is formed from daytime residues in the Proconscious system which are reinforced by drives emanating from the Unconscious. Topical regression first allows the transformation of the dream thoughts into images. It is through the intermediary of regression that word representations belonging to the Preconscious system are translated into thing representations which dominate the Unconscious system.* "Thoughts are transposed into images—mostly visual ones—thus the representations of words are reduced to representations of objects corresponding to them as if, throughout the whole system, considerations of representability overwhelmed the whole process." So much so that a dream wish can be turned into a dream fantasy. Once again, it is regression which gives dream its definitive shape. "The completion of the dream process is also marked by the fact that the content of thought, transformed by regression and reshaped into a fantasy of desire, comes into consciousness as a sensory perception and then undergoes the secondary elaboration which affects any perceptual content. We are saying that the dream wish is hallucinated and finds, in the guise of hallucination a belief in the reality of its fulfillment." Dream is "an hallucinatory psychosis of desire"—that is, a state in which mental perceptions are taken for perceptions of reality. Moreover, Freud hypothesized that the satisfaction resulting from hallucination is a kind of satisfaction which we knew at the beginning of our psychical life when perception and representation could not be differentiated, when the different systems were confused, that is, when the system of Consciousness-Perception had not differentiated itself. The object of desire (the object of need), if it happens to be lacking, can at this point be hallucinated. It is precisely the repeated failure offered by this form of satisfaction which results in the differentiation between perception and representation through the creation of the reality test. A perception which can be eliminated by an action is recognized as exterior. The reality test is

---

*In *The Ego and the Id*, Freud adds comments which allow him to assert that "visual thought is closer to the unconscious processes than verbal thought, and older than the latter, from the phylogenetic as well as from the ontogenetic standpoints. Verbal representations all belong to the Pcs, while the unconscious only relies on visual ones."

dependent on "motoricity." Once "motoricity" has been interrupted, as during sleep, the reality test can no longer function. The suspension of "motoricity," its being set apart, would indeed favor regression. But it is also because sleep determines a withdrawal of cathexis in the Cs, Ucs, and Pcs systems that the fantasies of the dream wish follow the original path which differentiate them from fantasies produced during the waking state.* Like daytime fantasies, they could have become conscious without nevertheless being taken for real or completed; but, having taken the path of regression, not only are they capable of taking over consciousness but, because of the subject's inability to rely upon the reality test, they are marked by the very character of perception and appear as reality. The processes of dream formation succeed well in presenting dream as real.

The transformations accomplished by sleep in the psychical apparatus: withdrawal of cathexis, instability of the different systems, return to narcissism, loss of motoricity (because of the impossibility of applying the reality test), contribute to produce features which are specific to dream: its capacity for figuration, translation of thought into images, reality extended to representations. One might even add that we are dealing with a *more-than-real* in order to differentiate it from the impression of the real which reality produces in the normal waking situation: the more-than-real translating the cohesion of the subject with his perceived representations, the submersion of the subject in his representations, the near impossibility for him to escape their influence and which is dissimilar if not incompatible with the impression resulting from any direct relation to reality. There appears to be an ambiguity in the words poorly expressing the difference between the relationship of the subject to his representations experienced as perceived and his relation to reality.

Dream, Freud also tells us, is a projection, and, in the context in which he uses the word, projection evokes at once the analytic use of the defense mechanism which consists in referring and attributing to the exterior representations and affects which the subject refuses to acknowledge as his own, and it also evokes a distinctly cinematographic use since it involves images which, once projected, come back to the subject as a reality perceived from the outside.

That dream is a projection reminiscent of the cimematographic apparatus is indeed what seems to come out of Lewin's discovery of the *dream screen*, the hypothesis for which was suggested to him by his patients' enigmatic dreams. One young woman's dream, for example: "I had my dream all ready for you, but while I was lying here looking at it, it began to move in circles far from me, wrapped up on itself, again and again, like two acrobats." This dream shows that the screen, which can appear by itself, like a white surface, is not exclusively a representation, a content—in which case it would not be necessary to privilege it among other elements of the dream content; but, rather, it would present itself in all dreams as the indispensable support for

---

*This is why it is not by paying attention to the content of images that one is able to account for the impression of reality but by questioning the apparatus. The differentiation between fantasies and dream is due to the transformation of the psychical apparatus during the transition from the state of being awake to sleep. Sleep will make necessary the work of figuration the economy of which can be created by daytime fantasies; in addition, daytime fantasies do not accompany the belief in reality of the fulfillment which characterizes dream. This is why in attempting to understand the cinema effect—the impression of reality—we have to go through the intermediary of dream and not daytime fantasies.

the projection of images. It would seem to pertain to the dream apparatus. "The dream screen is a surface on which a dream seems to be projected. It is the 'blank background' (empty basic surface) which is present in dream although it is not necessarily seen; the manifest content of dream ordinarily perceived takes place over it, or in front of it." "Theoretically it can be part of the latent content or of the manifest content, but the distinction is academic. The dream screen is not often noticed by analysts, and, in the practice of dream interpretation, the analyst does not need to deal with it." It is cinema which suggested the term to Lewin because, in the same way as its analog in the cinematographic apparatus, the dream screen is either ignored by the dreamer (the dreaming spectator) or unrelated to the interest resulting from the images and the action.* Lewin adds nevertheless (and this remark reminds us of a modern use of the screen in cinema) that in some circumstances, the screen does play a part of its own and becomes discernible. According to Lewin's hypothesis, the dream screen is the dream's hallucinatory representation of the mother's breast on which the child used to fall asleep after nursing. In this way, it expresses a state of complete satisfaction while repeating the original condition of the oral phase in which the body did not have limits of its own, but was extended undifferentiated from the breast. Thus, the dream screen would correspond to the desire to sleep: archetype and prototype of any dream. Lewin adds another hypothesis: the dream itself, the visual representations which are projected upon it, would correspond to the desire to be awake. "A visual dream repeats the child's early impression of being awake. His eyes are open and he sees. For him, to see is to be awake." Actually, Lewin insists on Freud's explanation of the predominance of visual elements in dream: that latent thoughts in a dream are to a large extent shaped by unconscious mnemic traces which can only exist as a visual representation—the repetition of a formal element from the child's earliest experience. It is evident that the dream screen is a residue from the most archaic mnemic traces. But, additionally, and this is at least as important, one might assume that it provides an opening for understanding the dreamer's "primal scene" which establishes itself during the oral phase. The hallucinatory factor, the lack of distinction between representation and perception—representation taken as perception which makes for our belief in the reality of dream—would correspond to the lack of distinction between active and passive, between acting and suffering experience, undifferentiation between the limits of the body (body/breast), between eating and being eaten, etc., characteristics of the oral phase and borne out by the envelopment of the subject by the screen. For the same reasons, we would find ourselves in a position to understand the specific mode in which the dreamer identifies with his dream, a mode which is anterior to the mirror stage, to the formation of the self, and therefore founded on a permeability, a fusion of the interior with the exterior.

On the other hand, if the dream itself, in its visual content, is likely to represent the desire to stay awake, the combination dream screen/projected images would manifest a conflict between contradictory motions, a state in effect of undistinction between a hallucinatory wish, sign of satisfaction, and desire for perception, of contact with the

---

*Bertram Lewin, "Sleep, the Mouth and the Dream Screen," *Psychoanalytic Quarterly* (1946), 15:419–43, "Inferences from the Dream Screen," *International Journal of Psychoanalysis* (1948). 29:224–431.

real. It is therefore conceivable that something of a desire in dream unifying percep-
tion and representation—whether representation passes itself for perception, in
which case we would be closer to hallucination, or whether perception passes itself
for perceived representation, that is, acquires as perception the mode of existence
which is proper to hallucination—takes on the character of specific reality which
reality does not impart, but which hallucination provokes: *a more-than-real* that
dream precisely, considered as apparatus and as the repetition of a particular state
which defines the oral phase, would, on its own, be able to bring to it. Dream alone?

Lewin's hypothesis, which complements and extends Freud's ideas on the forma-
tion of dream in relation to the feeling of reality which is linked to it, presents, in my
opinion, the advantage of offering a kind of formation stage, of dream constitution,
which might be construed as operative in the cinema effect. Impression of reality and
that which we have defined as the desire of cinema, as cinema in its general appara-
tus would recall, would mime a form of archaic satisfaction experienced by the sub-
ject by reproducing the scene of it.

Of course, there is no question of identifying mental image, filmic image, mental
representation, and cinematographic representation. The fact that the same terms are
used, however, does reveal the very workings of desire in cinema, that is, at the same
time the desire to rediscover archaic forms of desire which in fact structure any form
of desire, and the desire to stage for the subject, to put in the form of representation,
what might recall its own operation.

In any case, this deviation through the "metapsychological fiction" of dream could
enlighten us about the effect specific to cinema, "the impression of reality," which, as
is well known, is different from the usual impression which we receive from reality,
but which has precisely this characteristic of being more than real which we have
detected in dream.

Actually, cinema is a simulation apparatus. This much was immediately recog-
nized, but, from the positivist viewpoint of scientific rationality which was predomi-
nant at the time of its invention, the interest was directed toward the simulation of
reality inherent to the moving image with the unexpected effects which could be
derived from it, without finding it necessary to examine the fact that the cinemato-
graphic apparatus was initially directed toward the subject and that *simulation could
be applied to states or subject effects before being directed toward the reproduction
of the real.* It is nevertheless curious that in spite of the development of analytic the-
ory, the problem should have remained unsolved or barely considered since that
period. Almost exclusively, it is the technique and content of film which have retained
attention: characteristics of the image, depth of field, offscreen space, shot, single-
shot sequence, montage, etc.; the key to the impression of reality has been sought in
the structuring of image and movement, in complete ignorance of the fact that the
impression of reality is dependent first of all on a subject effect and that it might be
necessary to examine the position of the subject facing the image in order to deter-
mine the raison d'être for the cinema effect. Instead of considering cinema as an ideo-
logically neutral apparatus, as it has been rather stupidly called, the impact of which
would be entirely determined by the content of the film (a consideration which leaves
unsolved the whole question of its persuasive power and of the reason for which it

revealed itself to be an instrument particularly well suited to exert ideological influence), in order to explain the cinema effect, it is necessary to consider it from the viewpoint of the apparatus that it constitutes, apparatus which in its totality includes the subject. And first of all, the subject of the unconscious. The difficulties met by the theoreticians of cinema in their attempt to account for the impression of reality are proportionate to the persisting resistance to really recognizing the unconscious. Although nominally accepted, its existence has nevertheless been left out of the theoretical research. If psychoanalysis has finally permeated the content of certain films, as a complement to the classic psychology of character's action and as a new type of narrative spring, it has remained practically absent from the problematics raised by the relation of the projection to the subject. The problem is nevertheless to determine the extent to which the cinematographic apparatus plays an important part in this subject which Lacan after Freud defines as an apparatus,* and the way in which the structuring of the unconscious, the modalities of the subject's development throughout the different strata deposited by the various phases of drives, the differentiation between the Cs, Pcs, and Ucs systems and their relations, the distinction between primary and secondary processes, make it possible to isolate the effect which is specific to cinema.

Consequently, I will only propose several hypotheses.

First of all, that taking into account the darkness of the movie theater, the relative passivity of the situation, the forced immobility of the cine-subject, and the effects which result from the projection of images, moving images, the cinematographic apparatus brings about a state of artificial regression. It artificially leads back to an anterior phase of his development—a phase which is barely hidden, as dream and certain pathological forms of our mental life have shown. It is the desire, unrecognized as such by the subject, to return to this phase, an early state of development with its own forms of satisfaction which may play a determining role in his desire for cinema and the pleasure he finds in it. Return toward a relative narcissism, and even more toward a mode of relating to reality which could be defined as enveloping and in which the separation between one's own body and the exterior world is not well defined. Following this line of reasoning, one may then be able to understand the reasons for the intensity of the subject's attachment to the images and the process of identification created by cinema. A return to a primitive narcissism by the regression of the libido, Freud tells us, noting that the dreamer occupies the entire field of the dream scene; the absence of delimitation of the body; the transfusion of the interior out into the exterior, added Lewin (other works, notably Melanie Klein's could also be mentioned); without excluding other processes of identification which derive from the specular regime of the ego, from its constitution as "Imaginary." These do not, however, strictly pertain to the cinema effect, although the screen, the focalization produced by the basic apparatus, as I indicated in my earlier paper,* could effectively produce mirror effects and cause specular phenomena to intervene directly in the viewing experience. In any case, the usual forms of identification, already supported

---

*"The subject is an apparatus. This apparatus is lacunary, and it is within this lacuna that the subject sets up the function of an object as lost object." Jacques Lacan, *Les Quatres Concepts fondamenteux de la psychanalyse* (Paris: Le Seuil, 1973).

by the apparatus, would be reinforced by a more archaic mode of identification, which has to do with the lack of differentiation between the subject and his environment, a dream scene model which we find in the baby/breast-screen relationship.

In order to understand the particular status of cinema, it is necessary to underline the partial elimination of the reality test. Undoubtedly, the means of cinematographic projection would keep the reality test intact when compared to dreams and hallucination. The subject has always the choice to close his eyes, to withdraw from the spectacle, or to leave, but no more than in dream does he have means to act in any way upon the object of his perception, change his viewpoint as he would like. There is no doubt that in dealing with images, and the unfolding of images, the rhythm of vision and movement are imposed on him in the same way as images in dream and hallucination. His relative motor inhibition which brings him closer to the state of the dreamer, in the same way as the particular status of the reality he perceives (a reality made up of images) would seem to favor the simulation of the regressive state, and would play a determining role in the subject effect of the impression of reality, this more-than-real of the impression of reality, which as we have seen is characteristic not of the relation of the subject to reality, but precisely of dreams and hallucinations.

One must therefore start to analyze the impression of reality by differentiating between perception and representation. The cinematographic apparatus is unique in that *it offers the subject perceptions "of a reality" whose status seems similar to that of representations experienced as perception.* It should also be noted in this connection that if the confusion between representation and perception is characteristic of the primary process which is governed by the pleasure principle, and which is the basic condition for the satisfaction produced by hallucination, the cinematographic apparatus appears to succeed in suspending the secondary process and anything having to do with the principle of reality without eliminating it completely. This would then lead us to propose the following paradoxical formula: the more-than-real, that is, the specific characteristic (whatever is specific) of what is meant by the expression "impression of reality," consists in keeping apart (toning down, so that they remain present but as background) the secondary process and the reality principle. Perception of the image passing for perception: one might assume that it is precisely here that one might find the key to the impression of reality, that which would at once approximate and differentiate the cinematographic effect and the dream. Return effect, repetition of a phase of the subject's development during which representation and perception were not yet differentiated, and the desire to return to that state along with the kind of satisfaction associated to it, undoubtedly an archetype for all that which seeks to connect with the multiple paths of the subject's desire. It is indeed desire as such, that is, desire of desire, the nostalgia for a state in which desire has been satisfied through the transfer of a perception to a formation resembling hallucination, which seems to be activated by the cinematographic apparatus. According to Freud: "To desire initially must have been a hallucinatory cathexis of the memory of

---

*Jean-Louis Baudry, "Cinéma: Effets idéologiques produits par l'appareil de base," *Cinéthique* (1970) nos. 7–8, pp. 1–8. Published in an English translation by Alan Williams in *Film Quarterly* (Winter 1974–75), 28(2):39–47. [See this edition, pp. 355–65.]

satisfaction."* Survival and insistence of bygone periods, an irrepressible backward movement. Freud never ceased to remind us that in its formal constitution, dream was a vestige of the subject's phylogenetic past, and the expression of a wish to have again the very form of existence associated with this experience. "Dream which fulfills its wish by the short-cut of regression does nothing but conserve a type of primary operation of the psychical apparatus which had been eliminated because of its inefficiency." It is also the same survival and the same wish which are at work in some hallucinatory psychoses. Cinema, like dream, would seem to correspond to a temporary form of regression, but whereas dream, according to Freud, is merely a "normal hallucinatory psychosis," cinema offers an artificial psychosis without offering the dreamer the possibility of exercising any kind of immediate control. What I am really saying is that for such a regression to be possible, it is necessary for anterior phases to survive, but that it be cathected by a wish, as is proven by the existence of dream. This wish is remarkably precise, and consists in obtaining, from reality a position, a condition in which what is perceived would no longer be distinguished from representations. It can be assumed that it is this wish which prepares the long history of cinema: the wish to construct a simulation machine capable of offering the subject perceptions which are really representations mistaken for perceptions. Cinema offers a simulation of regressive movement which is characteristic of dream—the transformation of thoughts by means of figuration. The withdrawal of cathexis of all the systems Cs, Pcs, Ucs during sleep causes the representations cathected by dream during the dream work to determine a sensory activity; the operation of dream can be crudely represented by a diagram.

The simulation apparatus therefore consists in transforming a perception into a quasi-hallucination endowed with a reality effect which cannot be compared to that which results from ordinary perception. The cinematographic apparatus reproduces the psychical apparatus during sleep: separation from the outside world, inhibition of motoricity; in sleep, these conditions causing an overcathexis of representation can penetrate the system of perception as sensory stimuli; in cinema, the images perceived (very likely reinforced by the setup of the psychical apparatus) will be overcathected and thus acquire a status which will be the same as that of the sensory images of dream.

One cannot hesitate to insist on the *artificial* character of the cine-subject. It is precisely this artificiality which differentiates it from dream or hallucinations. There is, between cinema and these psychical states, the same distance as between a real object and its simulacrum, with this additional factor that dream and hallucination are

---

*It may seem peculiar that desire which constituted the cine-effect is rooted in the oral structure of the subject. The conditions of projection do evoke the dialectics internal/external, swallowing/swallowed, eating/being eaten, which is characteristic of what is being structured during the oral phase. But, in the case of the cinematographic situation, the visual orifice has replaced the buccal orifice: the absorption of images is at the same time the absorption of the subject in the image, prepared, predigested by his very entering the dark theater. The relationship visual orifice/buccal orifice acts at the same time as analogy and differentiation, but also points to the relation of consecution between oral satisfaction, sleep, white screen of the dream on which dream images will be projected, beginning of the dream. On the importance of sight during the oral phase, see Spitz's remarks in *The Yes and the No*. In the same order of ideas, it may be useful to reintroduce Melanie Klein's hypothesis on the oral phase, her extremely complex dialectics between the inside and the outside which refer to reciprocal forms of development.

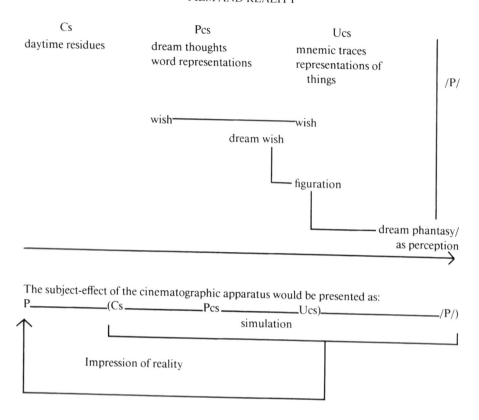

The subject-effect of the cinematographic apparatus would be presented as:

already states of simulation (something passing itself off for something else, representation for perception). One might even argue that it is this embedded structure which makes it so difficult to deal with the subject effect. While, in dreams and hallucinations, representations appear in the guise of perceived reality, a real perception takes place in cinema, if not an ordinary perception of reality. It would appear that it is this slight displacement which has misled the theoreticians of cinema, when analyzing the impression of reality. In dream and hallucination, representations are taken as reality in the absence of perception; in cinema, images are taken for reality but require the mediation of perception. This is why, on the one hand, for the realists, cinema is thought of as a duplicate of reality—and on the other cinema is taken as an equivalent of dream—but the comparison stops there, leaving unresolved the problem raised by the impression of reality. It is evident that cinema is not dream: but it reproduces an impression of reality, it unlocks, releases a cinema effect which is comparable to the impression of reality caused by dream. The entire cinematographic apparatus is activated in order to provoke this simulation: it is indeed a simulation of a condition of the subject, a position of the subject, a subject and not reality.

   Desire for a real that would have the status of hallucination or of a representation taken for a perception—one might wonder whether cinema is not doubled by another

wish, complementary to the one that is at work in the subject and which we have presumed to be at work in Plato's cave apparatus.

For, if dream really opens onto another scene by way of a regressive track, one might suppose that the existence of an unconscious where the subject's early mode of functioning, defined by the primary process, persists, the unconscious, constantly denied, rejected, excluded, never ceases requiring of the subject and proposing to him, by multiple detours (even if only through artistic practice), representations of his own scene. In other words, without his always suspecting it, the subject is induced to produce machines which would not only complement or supplement the workings of the secondary process but which could represent his own overall functioning to him: he is led to produce mechanisms mimicking, simulating the apparatus which is no other than himself. The presence of the unconscious also makes itself felt through the pressure it exerts in seeking to get itself represented by a subject who is still unaware of the fact that he is representing to himself the very scene of the unconscious where he is.

1975

# NOËL CARROLL
## *FROM* MYSTIFYING MOVIES

## JEAN-LOUIS BAUDRY AND "THE APPARATUS"

A major reason, given by contemporary film theorists, for their shift from a semiological framework of study to a psychoanalytic one, is that the semiological model is too narrow. It concerns itself with the structure of the cinematic sign but does not, according to many contemporary film theorists, pay sufficient attention to the effects of cinema upon the spectator. The semiological model, at least in the ways it was employed in the late sixties and early seventies, was felt to be myopically object-oriented. In order to remedy this putative shortcoming, film theorists resorted to psychoanalysis.

Jean-Louis Baudry's essay "The Apparatus" was a seminal essay in the turn to psychoanalysis. In this essay, he attempts to account for the impression of reality that cinema is said to impart to spectators. He intends to use psychoanalysis, that is, to analyze what he takes to be a paramount effect of cinema on audiences. However, though the phrase "impression of reality" recurs frequently in "The Apparatus," one must be careful in that which one identifies as the phenomenon with which Baudry is concerned. For Baudry does not contend that the impression of reality caused by cinema is equivalent to our everyday encounters with the world; cinema is not a replication of our ordinary impressions of reality. Rather, cinema is said to deliver an impression of reality that is more-than-real. That is, less paradoxically stated, Baudry wishes to deploy psychoanalysis to explain cinema's intense effect on spectators; he wants to analyze the peculiarly charged relationship we have with the screen when we attend movies.

Moreover, Baudry does not search for this effect by scrutinizing the content of the images or the stories of particular films or even of particular kinds of films. Instead he sees this effect as the product of what he calls "the apparatus," a network which includes the screen, the spectator, and the projector. That is, Baudry seeks the origin

of the impression-of-reality effect in the projection situation itself, irrespective of what is being screened.

Baudry's basic procedure for discovering the origin of the impression-of-reality effect is to draw a series of analogies between dreams and the projection context, or, as he prefers to call the latter, the apparatus. He is motivated in this by a belief that dreams like film engender an impression of reality that is highly charged, that is, an impression of what Baudry thinks of as the more-than-real effect. Thus, Baudry hopes to extrapolate the psychoanalytic explanation of the charged impression of reality in dreams into an explanation of the impression of reality in cinema.

Though Baudry does not set out his case in a logically rigorous fashion, his analysis implicitly takes the form of an inductive argument by logical analogy. For example, he notes that the film viewer and the dreamer share the property of having their movements inhibited, that both inhabit darkened rooms, and that both film and dream impart an impression of reality. Dream, in turn, is said to have this consequence insofar as it induces regression to an earlier psychosexual stage, that of primitive narcissism where the self is supposedly not differentiated from the other nor is perception differentiated from representation. On the basis of the similar conditions and effects, respectively, of film and dream, Baudry infers that the impression of reality in film is brought about by a regressive mechanism similar to that operative in dream.

Though arguments by analogy are not absolutely conclusive—they are, after all, inductive rather than deductive—and though they are often abused, they are a respectable form of reasoning. We use them all the time. For example, if you have a 1964 Saab and I have a 1964 Saab, and both cars are the same model, both engines are in exactly the same condition and state of repair, both carry the same weight, use the same fuel, and have been serviced in the same way by the same mechanic, and my Saab can go 55 mph, then we infer that (probably) your car can go 55 mph. Stated formally, this type of argument takes the following pattern: If we have items A and B, and they are similar in a number of relevant respects, say in terms of properties $p1$ through $px$-1, and item B also has property px, then we infer that (probably) A has $px$. That is,

1. Item A has properties $p1 \ldots px$-1 (e.g., A is a 1964 Saab).
2. Item B has properties $p1 \ldots px$-1.
3. Item B also has property $px$ (e.g., B can go 55 mph).
4. Therefore, (probably) Item A also has property $px$.

Premises 1 and 2 set out the analogy; if more items are being analogized more premises will be added here. Once the analogy is set out, these premises can be combined with premise 3, which states a property known to be possessed by B (but not observed to be a property of A), in order to license the probable conclusion stated in 4. Obviously such arguments gain strength when the number of items and/or the number of relevant properties cited are multiplied. Inversely, the argument loses force as either data base for the analogy is diminished. This can be done by:

A. showing that the analogies cited fail (for example, your car is really a 1921 Ford, not a 1964 Saab).

B. demonstrating that the analogies cited are irrelevant to what is at issue (for example, that both cars are green).
C. noting relevant disanalogies between items A, B . . . in order to challenge the purported similarity of the cases under comparison (for example, that your Saab has no wheels).

With this sketch of the logic of Baudry's approach, we can go on to fill in the details and evaluate the persuasiveness of his account of the psychic mechanism that he believes causes cinema's characteristic impression of reality.

As we have already noted, Baudry holds that the conditions of reception of film and dream are analogous; both involve a darkened room and the inhibition of movement. The film viewer sits in his seat; the dreamer lies abed. Inhibited motoricity is also a feature of the infantile state to which the dreamer is said to regress. Connected to this inhibition of motoricity is another feature: the lack of the means to test reality. Baudry writes:

> In order to understand the particular status of cinema, it is necessary to underline the partial elimination of the reality test. Undoubtedly, the means of cinematographic projection would keep the reality test intact when compared to dreams and hallucination. The subject always has the choice to close his eyes, to withdraw from the spectacle or to leave but no more than dreams does he have means to act in any way upon the object of his perception, change his viewpoint as he would like. . . . His relative motor inhibition which brings him closer to the state of the dreamer, in the same way as the particular status of the reality he perceives (a reality made up of images) would seem to favor the simulation of the regressive state, and would play a determining role in the subject effect of the impression of reality, this more-than-real impression of reality, which as we have seen is characteristic not of the relation of the subject to reality, but precisely of dreams and hallucinations.*

Here, Baudry notes that there is only a partial analogy in regard to reality testing between film and dream. But he thinks this similarity is important because along with inhibited motoricity, and perhaps because of it, the lack of reality testing reproduces the conditions of the infantile state of primitive narcissism that explains the impression-of-reality effect that the cinematic apparatus is said to induce. Also, in this passage, Baudry alludes to two other analogies between film and dreams: both traffic in the medium of images and both deliver a more-than-real impression of reality.

So far five analogies between film and dream have been noted: inhibited motoricity in the subject; lack of reality testing; darkened rooms; the medium of images; the more-than-real impression of reality. Are there other analogies?

For Baudry, following the psychoanalyst Bertram Lewin, dreams, like the cinematic apparatus, have screens. That is, Baudry argues that dreams are projections onto dream screens in a way that is analogous to film projection. Baudry writes:

> That dream is a projection reminiscent of the cinematographic apparatus is indeed what seems to come out of Lewin's discovery of the *dream screen*, the hypothesis for which was suggested to him by his patients' enigmatic dreams. One young woman's dream, for

---

*Jean-Louis Baudry, "The Apparatus: Metapsychological Approaches to the Impression of Reality in the Cinema" [see this edition, p. 220.]

example: "I had my dream all ready for you, but while I was lying here looking at it, it began to move in circles far from me, wrapped up on itself, again and again like two acrobats." This dream shows that the screen, which can appear by itself, like a white surface, is not exclusively a representation, a content—in which case it would not be necessary to privilege it among other elements of the dream content; but, rather, it would present itself in all dreams as the indispensable support for the projection of images. It would seem to pertain to the dream apparatus. "The dream screen is a surface on which a dream seems to be projected. It is the 'blank background' (empty basic surface) which is present in the dream although it is not necessarily seen; the manifest content of dream ordinarily perceived takes place over it, or in front of it."[1]

Baudry also points out that people often describe their dreams as being like movies.

The dream screen/film screen, dream apparatus/film apparatus analogy is particularly crucial for Baudry. For Lewin has a psychoanalytic account of the dream screen that is pertinent to the effect dreams have upon us. And Baudry intends to extend that account to cinema.

> According to Lewin's hypothesis, the dream screen is the dream's hallucinatory representation of the mother's breast on which the child used to fall asleep after nursing. In this way, it expresses a state of complete satisfaction while repeating the original condition of the oral phase in which the body did not have limits of its own, but was extended undifferentiated from the breast.[2]

Thus, via the dream screen, the dreamer regresses to and relives a stage in our psychosexual development marked by primitive narcissism, a stage where self and environment are said to merge and where perception and representation are believed to be undifferentiated. Moreover, this regression satisfies a desire, a desire to return to that sense of undifferentiated wholeness. It is this desire in turn which gives the dream imagery its special charge and which accounts for the intensity with which we regard it.

Insofar as the cinematic apparatus mirrors relevant aspects of the dream apparatus—inhibited motoricity, lack of reality testing, visual imagery, the more-than-real impression of reality, projection, and a screen support—Baudry feels warranted in adopting Lewin's hypothesis about the causation of dream and the dream effect as an explanation of our animating desire for and our experience of the cinematic apparatus. That is, a regressive mechanism seeking to revive the experience of primitive narcissism in what draws us to movies while satisfaction of that desire is what renders that experience more-than-real. So, by postulating the return to primitive narcissism as the operative agency in film spectators, Baudry thinks he has isolated the cause of the cinematic effect while also, in the process, supplying an account of why the movie experience is desirable to us. . . . From Baudry's perspective, the answer seems to be to relive that stage of primitive narcissism where all-is-one, including a conflation of perception and representation. Indeed, for Baudry, the cinematic apparatus incarnates a wish for a simulation machine "capable of offering the subject perceptions which are really representations mistaken for perceptions,"[3] thereby recalling the dream

---

[1]Baudry, pp. 216–17.
[2]Ibid.
[3]Baudry, p. 217.

state which itself derives from a regression to an archaic state where perception and representation are not differentiated.

Summarizing Baudry's case so far, his argument looks like this:

1. The dream apparatus has the following features: inhibition of movement; lack of reality testing; an imagistic medium; a dark room; projection; a screen; a more-than-real impression of reality; a tendency to efface the distinction between perception and representation.
2. The cinematic apparatus has exactly the same features noted in premise 1.
3. A significant animating force behind the dream apparatus is the desire for and regression to primitive narcissism which enactment causes the charged experience of dreams.
4. Therefore it is probable that a significant animating force behind the cinematic apparatus is the desire for and regression to primitive narcissism which enactment causes the charged experience of cinema.

Baudry, of course, does not hold that films are mistaken for dreams. He rather construes them as simulations of dreams. For this reason he might want to say that the regression encountered in cinema is less intense than that of dreams. Nevertheless, he would appear to hold that to whatever degree the more-than-real impression of reality of film approximates the analogous effect of dreams, it is a function of the process of some measure of regression to the all-is-one state of primitive oral narcissism.

Because of the emphasis Baudry places on the cinematic apparatus as a simulation of unconscious phenomena, specifically of the hallucinatory aura of dreams, one might offer a slightly different interpretation of Baudry's argument than the one just presented. That is, one might take Baudry to be saying that since film replicates the most significant conditions of dreaming—for example, motor inhibition, lack of reality testing, and so on—it triggers the same effect—regression to primitive narcissism. On this interpretation of Baudry's strategy, the argument rides on the principle: same conditons, same effects. However, whether one chooses this interpretation or the interpretation of the analysis as an inductive argument by analogy is logically indifferent for the purposes of evaluating Baudry's central claims. For in either case Baudry's central assertions stand or fall on the basis of the adequacy of the correlations he draws between cinema and dreams.

Baudry concludes his essay by asserting that the unconscious has an instinctual desire to manifest itself to consciousness. This suggests that cinema is one means for fulfilling this instinctual desire. For in simulating dream, cinema satisfies the desire of the unconscious for acknowledgment. This somewhat resembles a claim that Metz makes to the effect that by combining elements of night dream and daydream film causes pleasure by externalizing what is usually experienced as internal. But this claim of Baudry's can only be accepted if cinema is a suitable simulation of dreams, that is, if the analogies Baudry draws between film and dream are fitting and if they are not outweighed by significant disanalogies.

However, before turning to an assessment of Baudry's central thesis, it is important to take notice of an elaborate complication in the text which has not been remarked upon so far. Baudry not only analogizes film and dream but he also compares both with the description of the circumstances of the prisoners in Plato's myth

of the cave.[1] Those prisoners are chained in a darkened vault. Behind and above them, fires burn. As passersby walk between the prisoners and the flames, the strollers' ambulating shadows are cast upon the wall of the cave. The prisoners see these moving shadows and take them for reality. Through this allegory, Plato sets forth his disparaging estimation of the ordinary person's "knowledge" of the world. It is based on illusion; it is nought but shadowy deception.

Baudry calls attention to the ways in which Plato's cave resembles the cinematic apparatus. The cave is analogous to the apparatus in obvious respects: the motoricity of the prisoners is inhibited as is their capacity to test reality. The cave, like the movie theater, is a dim space. The shadows in Plato's cave might be thought of as projections and the wall of the cave is a screen of sorts. Moreover, the projecting device is above and behind the prisoners and is, so to speak, hidden from them. The imagery in both Plato's cave and the cinema is a matter of shadows or reflections caused by passing something before a light. And in both cases, one can designate the play of "two scenes": first, the scene in the world that gives rise to the "shadows" and second, the scene comprised of the shadows themselves. These analogies lead Baudry to conclude that Plato's myth of the cave "doesn't merely evoke, but quite precisely describes in its mode of operation the cinematographic apparatus and the spectator's place in relation to it."[2]

Now the question immediately arises as to what logical purpose the analogies between Plato's cave and the cinematic apparatus serve in the context of Baudry's overall analysis of film in terms of regression to primitive narcissism. For these added cave analogies do not function logically to enhance Baudry's argument concerning film and dream. The conclusion of that argument is that regression is the motor of the cinematic apparatus just as it is the motor of the dream apparatus. For the analogies with Plato's cave to film and dream to bolster this conclusion—namely, that regression to primitive narcissism is the motor of the cinematic apparatus—we would have to have reason to claim antecedent knowledge to the effect that Plato's myth was generated by the type of regressive mechanism that the argument wants to attribute to the cinematic apparatus. But we do not have such knowledge. Whether Plato's myth of the cave derives from a regressive desire remains to be proved to the same degree that the cinematic apparatus' origin in such a desire does. That is, the psychoanalytic cause of Plato's myth is not known prior to Baudry's argument and in that sense is logically in the same boat as whatever the animating force behind the cinematic apparatus turns out to be. Thus, adding the analogies of Plato's cave, since the cause of that myth cannot be supplied as a premise of the argument (but, at best, as a corollary conclusion), does not strengthen the argument by analogy between the cinematic apparatus and the dream apparatus. So the question remains as to the point of Baudry's ornate rendition of Plato's myth.

Baudry, of course, has no wish to endorse Plato's epistemological position which he, Baudry, misidentifies as idealism, a label more apt for a post-Cartesian such as Berkeley (that is, Plato does not believe that all that exists is mental and, indeed, the mental/physical distinction relevant to the formation of an idealist philosophy does

[1]Plato, *Republic* 7.514.
[2]Baudry, "The Apparatus," p. 209.

not appear to have been historically available to Plato). Rather, Baudry tears the myth
of the cave out of the context in which it functions as an allegory, and he treats it as
a fantasy ripe for psychoanalysis. Among other things, Baudry claims that it is a
proto-cinematic wish, that is, a deep-seated wish for something very much like cin-
ema before the invention of cinema. Baudry sees evidence for similar proto-
cinematic wishes throughout history: the camera obscura, the magic lantern, the
praxinoscope. What Baudry seems to conclude from the existence of a proto-
cinema stretching from Plato's cave to the praxinoscope is that it supplies evidence
for a transhistorical, psychical, or instinctual source of desire behind the invention of
the cinematic apparatus and its prefigurations.[1] And, of course, if the compelling
force behind cinema is instinctual, that may supply prima facie grounds for approach-
ing it psychoanalytically. Thus, I take it that the point of Baudry's use of Plato's cave
in "The Apparatus" is not to enhance the central argument about the causal relevance
of regression to film, but rather to mount a coordinated but independent argument to
persuade us that the recent invention of cinema is really a manifestation of a long-
standing, transhistorical, or instinctual desire of the sort that psychoanalysis is fitted
to examine. That is, the discussion of Plato's cave is meant to convince us of the
appropriateness of psychoanalyzing cinema and it is not, properly speaking, part of
the argument by analogy that concludes with the assertion of regression as key to the
cinematic apparatus.

Of course, in speaking this way I am offering an interpretation of Baudry's essay,
one guided by the logical requirements of the type of argument Baudry appears to
advance. I admit that at points Baudry himself writes as though the analysis of the
allegory of the cave were an essential part of the film/dream argument. Not only does
this fly in the face of the logical point made earlier, but it also promotes many extrav-
agant and confusing, free-associative leaps as Baudry attempts to forge connections
simultaneously between Plato's cave, film, and dream. For example, Plato's cave cor-
relates with the darkened room of the movie theater. What connection does this have
with dreams? Baudry says that the dreamwork often represents the unconscious by
means of underground places.[2] Now even if this has some connection with Plato's
cave, what is its relevance to the cinematic apparatus? Films are not characteristically
viewed in caves or underground places. The effects of such whimsical flights of fancy
can be minimized if we restrict our attention to the central argument that analogizes
film and dream which, anyway, is the logical fulcrum of Baudry's case. Thus, a sense
of interpretive charity leads me to regard the film/dream argument and the analysis of
Plato's cave as making separate though coordinated points.

Undoubtedly, Baudry's essay also attempts to show that the "apparatus" of Plato's
cave has the same regressive mechanism behind it as does the dream "apparatus."
And Baudry's way of showing this is ostensibly an argument by analogy like that
concerning the cinematic apparatus. But this is, logically, a parallel argument to the
film/dream argument, one that neither supports nor derives support from the specula-
tions on film and dream. That is, the cave/dream argument concluding with regres-
sion as the motor behind Plato's myth is an induction to be pursued independently of

---

[1] Baudry, p. 213.
[2] Ibid., p. 214.

the film/dream argument. Indeed, Baudry's discussion of Plato is only relevant to film theorists—as opposed to historians of philosophy—insofar as the myth of the cave can be demonstrated to be proto-cinematic. Thus, I will restrict comment upon Baudry's cave/dream analogies to those points that are relevant to establishing the existence of a proto-cinematic wish.

Baudry's "The Apparatus," then, contains at least two major arguments for film theorists: that the apparatus of cinema importantly involves regression to primitive narcissism and that the archaic wish underlying cinema is atavistic, reaching as far back in history as Plato's myth of the cave. Of these two arguments the former seems to me of greater moment because, if it is true, it is what gives the claim about a proto-cinematic wish precise substance, and also because it would supply an interesting and substantial insight even if the claims about proto-cinematic wishes were false, that is, if the invention of cinema responded to a historically recent wish rather than to an ancient longing of the human race.

The argument that the cinematic apparatus involves regression to a period of primitive narcissism where self is not differentiated from the environment is an inductive argument by analogy and, therefore, its conclusions are only probable. This is not problematic for most of what we value as knowledge is at best probable. The degree of warrantability in such an argument, however, depends on the strength of the analogies cited in the premises and on the presumption that there are not significant disanalogies, in this case between film and dream, which would neutralize or outweigh the persuasiveness of the analogies advanced. Thus, to assess Baudry's thesis we must consider whether his analogies are apt and compelling, and whether or not there are profound disanalogies between film and dream which render Baudry's analogies fledgling.

The two analogies that Baudry repeatedly stresses involve the inhibition of movement and the absence of reality testing, features purportedly shared by the cinematic apparatus and dream. Supposing that these are features of dreams, are they also features of film viewing? The dreamer is asleep; insofar as he is not a somnambulist, his literal movement is restricted to tossing and turning. Of course, his movement capacities as a character in his own dream can be quite expansive. But insofar as he is asleep, the movement of his physical body is involuntary. But what of the cinema viewer?

Conventionally we sit in our seats, moving our heads, arms, and so on within a small perimeter of activity. But is our movement inhibited in a way that is significantly analogous to the inertness of sleep? First of all, a key reason for speaking of motor inhibition, both in terms of sleep and in terms of the infantile state of primitive narcissism, is that in those cases the lack of mobility, for different reasons, is involuntary. However, no matter how sedentary our film viewing is, we are not involuntary prisoners in our seats.

Of course, Baudry speaks of this lack of motoricity not only in respect to film viewing and dreaming, but also with reference to Plato's prisoners whose constraint is involuntary. So the dream state and that of the prisoners correlate along the dimension of involuntary motor inhibition. And movie viewers are supposed to resemble the prisoners. But from this one cannot surmise that it is correct to claim corresponding motor inhibition for movie spectators since movie spectators resemble the prisoners only in

such respects as being viewers of reflection and not in terms of involuntariness. Unlike Plato's prisoners, the film viewer can move her head voluntarily, attending to this part of the screen and then the next. What she sees comes under her control, unlike the dreamer or the prisoner, in large measure because of her capacity to move her head and her eyes. And, the film viewer, as Baudry admits, can leave the theater, change her seat, or go into the lobby for a smoke.

Though Baudry does not make this move, a proponent of the inhibition analogy might claim that when a film spectator adopts the convention of sitting before the movie screen, she adopts the pretense of having her motor capacities inhibited. But there is no evidence that such a game of make-believe is occurring. A more likely description of what the spectator does when adopting the convention of taking a seat is that she opts for the easiest method of attending to the film. Literally, her motoricity is not inhibited, nor does she feel it or pretend it to be. If we are willing to describe film viewing as involving motor inhibition, we should be equally willing to describe witnessing baseball games and listening to political speeches as involving motor inhibition. And to the extent that such descriptions of baseball and speeches is inaccurate, so is a description of movie viewing as movement inhibited inaccurate. Moreover, even if there is a sense in which we might say that movement in all these cases is "inhibited," it is certainly not a matter of motor inhibition, but a voluntary inhibition promoted by respect for conventional decorum.

Of course, the point that sitting at movies is a social convention is central. Movies can be watched *with no loss of effect* while standing; people frequently walk to the rear of the theater and watch, stand in the aisles while they grab a smoke or relax their bottoms. Nor are such standing filmgoers necessarily stationary; if one watches the film while pacing across a side aisle, the impression the film imparts need not be lost. Baudry connects the putative impression of reality imparted by film to inhibited motoricity. Given this, one would predict that that impression would not occur if the spectator watched while also moving voluntarily. If there is such a phenomenon as the impression of reality, then it should be an empirical matter to establish whether it disappears when the spectator is in movement. In my own case, I have found that I can back out of a movie theater while watching the screen or return to my seat from the beverage bar with no discernible difference in the impressions I derive from the screen than when I am seated. I know I'm walking in one case and sitting in the other, but these are proprioceptive impressions and not screen impressions.

Perhaps Baudry would admit that the film viewer's movement is not literally inhibited, but would attempt to save his analogy by saying that the film viewer *feels* inhibited. Phenomenologically, I have never had such an experience. But even if others do have such experiences, this will not help the analogy that Baudry wishes to draw. Why? Well, if we shift to a phenomenological register, then the dreamer often *feels* in motion when dreaming, for instance, when one dreams one is falling or being pursued by a three-headed ogre. That is, the dreamer often feels in motion when he is not, whereas the film viewer does not ordinarily take himself to be literally in motion when he is not.* Of course, Baudry may say that the inhibited movement which is attributed to

---

*"Ordinarily" here is meant to acknowledge that there are certain tricks which, as in Cinerama, can induce the impression of, say, plummeting. But these are extraordinary moments of cinema, and not the sort of evidence to be adduced in an account of the customary effects of film.

the movie spectator is really metaphorical. But why should a correlation between his metaphorical description of the film viewer and the literal motor inhibition of the sleeper count as anything more than an entertaining but fanciful piece of equivocation?

Baudry's second key analogy between the cinematic apparatus and dream hinges on the claim that both involve an absence of reality testing. Of course, in one sense, the film viewer is fully capable of indulging in reality testing. He can go up to the screen and touch it; he can shift his view of the screen, noting that the contours around the objects do not alter, and, thereby, he can surmise that the projected array is two dimensional. Also, things like coke bottles and cabbages can be and have been thrown at movies, a dramatic measure for revealing the nature of the screen. Baudry is aware of this; when he speaks of an absence of reality testing in film viewing, his reference is not to an incapacity the viewer has in relation to objects, such as screens, in the actual world; rather Baudry has in mind that the viewer lacks the ability to test reality within the world of the film. That is, the movie viewer cannot enter the visual array onscreen in order to ascertain whether the buildings in *Siegfried* are concrete or merely cardboard.

Baudry also connects lack of reality testing with the inhibition of movement. Plato's prisoners, and the preambulatory infants at the stage of primitive narcissism cannot test reality at a distance because they are immobile. But the same correlation between motor inhibition and absence of reality testing cannot, as Baudry suggests, be extrapolated to film viewing and dreaming. For if there is an absence of reality testing in both these cases, then that is a function of the fact that, *loosely speaking*, there is no reality to be tested *in* the world of the film and the world of the dream (where "reality" is understood as the foil of "representation"). So if the correlation based on absence of reality due to inhibited movement is key to aligning film and dream with the infantile state of primitive narcissism, the analogy is inaccurate.

We may also wish to know whether it is really appropriate to hold that the film viewer has no means for testing reality inside the world of the film. Certainly it is true that we cannot walk into the world of *Casablanca* in order to determine whether the characters are really drinking whiskey. But at the same time, I think that it pays to recall a really overwhelming disanalogy between film viewing and dreaming. Namely, films are publicly accessible; they can be viewed by more than one person. Moreover, they can be repeated; we can see the same film again and again, and we can fall back on all sorts of evidence—production and distribution records, the testimony of other viewers and of the filmmakers, the existence of similar prints, and so on—to warrant the claim that the film we just saw, say *Captain Blood*, is the same film we saw in the past. This is a radical disanalogy with dreaming. Neither the analyst nor anyone but the dreamer has access to the dream. And no one, including the dreamer, can be sure that his report of a dream is accurate; there is no interpersonal validation available. Even with a "recurring" dream, we have little reason to be confident that the dreamer experienced exactly the same dream from night to night. What does this epistemic disanalogy have to do with reality testing? Simply that with films there is a way in which we can "test reality," that is, corroborate our experience of a movie. We can ask someone else if she saw what we saw. Nor is this something we do only after a film is over. During *Lifeforce* I leaned over to my neighbor and asked "Did I really just see a vampire-nun?" to which she replied "I saw her too."

There are, in short, means to test the veracity of our experience of films. We cannot plunge into the image, but we can corroborate what we see there, which is the sort of reality testing that is appropriate to visual fictions (as opposed to what might be called ordinary visual "realities"). Moreover, if we are worried about testing the fidelity of documentaries to their subjects, that is also possible. My point here is simply that it seems to me inappropriate to describe the film viewer as lacking the means for testing reality. And if I am right in this matter, this short-circuits Baudry's second key analogy between film and dream. However, if I am wrong and the analogy is acceptable, the considerations I have just raised present another problem for Baudry. For even if in some sense his analogy works, I have also pointed to a major disanalogy between film and dream: namely, that film experiences are open to interpersonal verification. This appears to me to be important enough to outweigh analogies between film and quasi-solipsistic phenomena, since it establishes that film viewing has an objective dimension and is not purely subjective.

Films are a visual medium and so are dreams. Is this a significant analogy between the external and internal phenomena under comparison? Not really. For memories are also often visual. Why not analogize film to memories as certain film realists might propose? Here, it might be argued that dream is the appropriate analog—that we know to eliminate memory as a viable candidate—because of the earlier analogies that correlate film with dream rather than memory. But as I hope I have shown, those earlier analogies are not so sturdy, nor, I might add, is the film theorist under any imperative to identify *any* mental correlate for film.

However, there is also an important disanalogy between film imagery and dream imagery which indicates that the two are not congruent. The single film image is ordinarily complete, by which I mean that, typically, it is visually articulated throughout. Dream images, on the other hand, tend to be incomplete, foregrounds without backgrounds or figures in a void. This can be simulated in film as can the "noise" of the dreamwork; note Brakhage's films. However, the ordinary film image does not "look like" the ordinary dream image. That is, even if film and dream are imagistic, they are radically dissimilar imagistic media. They are too unlike to be treated as cognate phenomena. . . . Metz notices further, crucial dissimilarities between film and dream,* which added to the disanalogies I adduce render Baudry's argument even more unlikely.

Baudry's analogy between film and dream in respect of darkened rooms is also problematic. One can, of course, fall asleep mid-day on the beach. And movies can be viewed in well-lit circumstances. I expect that Baudry is probably right in asserting that most of the time we dream and view films in the dark. But there is still something strange about this correlation. The film viewer is not only objectively in a darkened room; she is experientially aware of being in a darkened room. But even if the dreamer is objectively in a darkened room, she is unaware of it. Indeed, she may believe that she is on a blistering, sun-baked desert. That is, though there is a possible objective analogy between the film viewer and the dreamer, their experiences are disanalogous. Now if a film is supposed to simulate dreams or trigger the same kind of response or mechanism in the subject, wouldn't it seem more likely that what the

*In Christian Metz, "The Fiction Film and its Spectator," *New Literary History* (Fall 1976).

viewer experiences be key to the dream analogy rather than the objective, physical conditions of reception? That is, the dreamer does not have the same experiential awareness of a darkened room that the film viewer does. So why would the film viewer's awareness of a darkened room remind one of dreaming or simulate dreaming for the unconscious? In this case, Baudry seems to overvalue the significance of correlations between the objective, physical conditions of film viewing and dreaming while forgetting the crucial, phenomenological disanalogies between the film experience and dream experience. We saw that there was a similar problem with his treatment of inhibited motoricity, where he ignored the fact that objectively, physically leaden sleepers often feel in vigorous motion.

Another analogy that Baudry proposes between film and dream is that both impart what he refers to as a more-than-real impression of reality. Part of the problem with evaluating this claim is the vagueness of the notion of a more-than-real impression of reality. That is, even if film and dream impart such broadly describable impressions, are their respective impressions the same in analytically revealing respects? Both quartz and lemurs can be described as matter but they are matter of such different sorts that the observation does not tell us much that is useful. Are the respective more-than-real impressions proffered by film and dream very alike or very unalike?

Answering this question is difficult since Baudry tells us next to nothing about the phenomena to which he wants us to refer. However, if the impressions he has in mind are a matter of imagery charged with affect, we can remark that dream imagery is, if not just more vividly charged, it is at least more invariantly charged than movie imagery. The reason for this, which Metz notes,* is that the affect that attaches to dream imagery originates in the dreamer and her personal associations whereas the affect derivable from film imagery comes from an external source—such as the imaginations of screenwriters and directors—which may or may not correspond to the film viewer's emotive life. Thus, if the more-than-real impression of reality of films and dreams is identified with a constant correlation of imagery and affect, then the film apparatus and dream are very different. Moreover, if the more-than-real impression of reality is not a matter of a constant coincidence of affect and imagery, what is it? Merely occasionally exciting imagery? But isn't that enough to correlate a televised chess game to dreams?

But there is another way to probe the problems with Baudry's use of the notion of the more-than-real impression of reality. In dream, this impression appears to refer to imagery charged with affect. In film, we are told that this impression is one that diverges from our ordinary encounters with mundane life. And, admittedly, the events we witness on film are most often more exciting, more expressively characterized, and more emotionally arresting than those of quotidian existence. However, it is important to note that films of this sort, though common, are also very special. They are, in the majority of cases, fiction films or they are films otherwise designed explicitly to promote intense affective responses. A film like *Greed*, or *Sunrise*, or *Potemkin*, or *The Passion of Joan of Arc*, may leave an impression that is, as they say, "larger than life." But this sort of impression is not a function of simply throwing an image on the screen. It is the internal structure of these films that accounts for their

---

*Ibid.

effect, not the fact that they are projected. Not all films bestow comparable affective results. Home movies, or bank surveillance footage, especially of persons unknown to us, may appear affectless, flat, and lackadaisical. That is, many films are projected, but few are chosen. Now this is an important point against Baudry. For he claims that the more-than-real impression of which he writes is a consequence of the cinematic apparatus, a claim tantamount to predicting that whatever is projected onscreen will be swathed in affect. But this is downright false; just recall Warhol's *Empire*.

Another major analogy between film and dream that Baudry produces asserts that both have screens, or projection supports. It seems reasonable, barring the complications of TV, to agree that films are *normally* projected onto screens. But frankly the claim seems shaky in regard to dreams. The evidence appears to be that some of Lewin's patients reported dream screens in their nightly reveries. I have no reason to question their reports. However, does this amount to evidence that something like a dream screen is an essential or normal element in all dreams? Perhaps Lewin's patients had personal associations with movie screens and this accounts for the appearance of screens in *their* dreams. Why suppose that a screen element is a characteristic feature of all dreams? Were there visions of screens in dreams before there were screened entertainments? Were there visions of screens in cultures without screened entertainments? And, furthermore, what general criteria are there for establishing that phenomena, like the appearance of a screen in a dream, are organic ingredients of dreaming rather than the associative imagery of given dreams? Until these questions can be satisfactorily answered the dream screen/film screen correspondence—and with it the dream/film apparatus analogy—appear extremely dubious. Of course, as I have already admitted, dream imagery is often incomplete; but where the dream "picture" is unarticulated it is not necessarily the case that the dreamer apprehends a screen, white, silver, or otherwise. There is rather just a void.

So far Baudry's argument by analogy has been attacked by showing that his analogies are hardly compelling and by remarking upon salient disanalogies between film and dream. The accumulated force of these objections shows that Baudry's argument by analogy is without substantial warrant. I think the previously cited disanalogies are enough to swamp his case. But also the premises that set out the analogies between film and dream are virtually without support.[1] Thus, Baudry's argument fails to go through.[2]

Of course, questions, as well, might be raised not only about Baudry's analogies but also about the crucial premise that asserts that the underlying mechanism in dream is regression to primitive, oral narcissism. This is a psychoanalytic claim, not a film theoretical one, and, as such, we should probably not pursue this issue in depth here. Yet, it pays to remember that the Lewin-Baudry hypothesis about regression is extremely controversial.

---

[1] A film/dream analogy of Baudry's that I have not touched upon is the assertion that, in film and dream, representation is taken as perception. I reject the notion that film spectators mistake cinematic representations as perceptions and, therefore, reject the basis of this analogy.

[2] Moreover, if Baudry's analogies between film and dream are groundless, then it is hard to see how film could simulate dream, nor is it easy to see how film could trigger the same sort of regression that dreams do.

The regression hypothesis appears to ride upon the postulation of a dream screen which, in turn, can be associated with a mother's breast. The evidence for a dream screen as an organic, essential, or merely characteristic element of dreaming has already been challenged. Insofar as the dream screen serves as a linchpin for the inference of regression, and insofar as the dream screen phenomenon is not generic, then there is no evidence for a generic regressive mechanism, of the specificity Baudry claims, in dreaming.

Also one must at least question the purported screen/breast association. What is its basis? And how extensive is it? Maybe some white people envision breasts as white and then go on to associate the latter with white screens. But not everyone is white. And I even wonder if many whites associate breasts and screens. Certainly it is not an intuitively straightforward association like that between guns and penises. For example, screens are flat; and lactating breasts are not. A screen is, ideally, uniform in color and texture; but a breast has a nipple. Nor will the association work if it is put forward by saying that breasts are, for the infant in the state of oral regression, targets of projections as are screens. For according to the theory of primitive narcissism, the mother's breasts are part of an undifferentiated, all-is-one experience, and, therefore, could not have been recognized way back then by the primitive narcissist, and, thus, cannot be recalled now to be targets of projection. For primitive narcissism admits no distinctions between targets of projections, projections, and projectionists.

I do not deny that there may be some people who associate screens and breasts, thereby at least suggesting the hypothesis of oral regression in those cases. After all, it is probably psychologically possible to associate anything with anything else. But even if some people associate breasts and screens, that does not provide enough evidence to claim a general pattern of association between breasts and screens such as might support a theory about all dreaming. And if oral regression is not the general causal force energizing the dream, then it cannot be extrapolated by analogy as the causal force behind the cinema apparatus.

Baudry's central argument in "The Apparatus" is beset by problems at every turn. Do his subsidiary arguments fare any better? By analogical reasoning, he links Plato's myth of the cave with dreaming, and also with filmgoing, inferring that all three can be explicated by reference to regression. Plato's cave, furthermore, is identified as proto-cinematic, indicating to Baudry, that the instinctual desire that propels filmgoing is ancient.

The analogies between Plato's prisoners and dreamers are rather weak, often in ways reminiscent of the problems with Baudry's film/dream analogies. Both prisoners and dreamers are said to be immobile, in a darkened place, bombarded with visual imagery, and unable to test reality. Contra Baudry, we must note again, with reference to darkened places, that people can sleep and dream in broad daylight, while the "world of the dream" need not be dark. And, as was pointed out earlier, the dreamer as a character in a dream need not be immobile, while the sleeper, unlike Plato's prisoners, is unaware of being immobile. Also, what Plato's prisoners see differs radically from the dreamer's imagery—that is, Plato's prisoners see uniformly black figures whose only features are shadowy contours rather than internally articulated figures with eyes and moustaches. And, of course, Plato's prisoners are awake while dreamers are not, which reminds us that Plato's prisoners do literally see something—even

if they misinterpret it—and this indicates that they can objectively correct each other about the look of the shadows before them, a type of reality testing not available to the dreamer. One could go on at length discounting Baudry's dream analysis of Plato, but this appears to be more of an issue for historians of philosophy, if it is an issue for anyone, than for film theorists. So let the preceding, hurried refutation of Baudry's version of Plato's cave suffice.

Baudry also claims that Plato's myth of the cave is a prefiguration of cinema. Needless to say this ignores the philosophical purposes Plato designed the myth to serve. But Baudry believes that the myth evinces a myth deeper than Plato was aware of. Baudry holds that Plato's cave is proto-cinematic, which leads him to claim that cinema answers a desire of ancient, instinctual origins. Many, more historically minded, film theorists might wish to question the existence of transhistorical, transcultural desires of the sort Baudry postulates. Nor is the existence of such a transcultural desire absolutely integral to the project of psychoanalyzing the cinematic apparatus. For cinema might be the answer to culturally specific desires of the nineteenth and twentieth centuries.

Baudry's analogies between the cinematic apparatus and Plato's cave are underwhelming. Both, purportedly, involve projection from behind the spectator. But films are often rear-projected and early Japanese cinemas positioned their audiences at right angles to the projection apparatus (not to mention the possibility of projecting films via large video screens). Are either of these practices uncinematic or do audiences at, for example, rear-projected movies have different film experiences than those at cinemas with projectors behind the audience. Baudry speaks of the projection in the cave and in cinema as hidden. But film projection is not always hidden. One can set up a projector in one's living room or in a classroom or boardroom, for all to see, and still have a typical film experience. We have already noted the film viewer is not necessarily immobile. Plato's prisoners are shackled at the neck; even the seated film viewer can move her head. Furthermore, the images of film are immensely different than Plato's shadows. The prisoners see solid black blotches on the wall while film viewers see internally articulated pictures. How, for example, could Plato's prisoner see the eyes of one of the people who cast the shadows on their wall? And isn't this disanalogy far more striking than the analogies that Baudry defends?

Plato's prisoners cannot enter the world of the shadows for purposes of reality testing and neither can viewers of *Casablanca* belly up to Rick's bar for a fast Scotch. But, on the other hand, film viewers can touch the screen, and what is more important, they are aware that there is a screen, and that they are watching a movie. Thus, their status, epistemologically, is exactly opposite that of Plato's prisoners. Also, I think we would agree that one could see a film that portrayed the world accurately whereas Plato's shadow representations are putatively always deceptive. There are surely some surface resemblances between Plato's prisoners and film viewers—they both see projections. But this is hardly sufficient for supporting the claim that both film and the myth of the cave address the same psychic need and mobilize the same psychic mechanism.

Baudry believes that Plato's cave is part of the prehistory of cinema. Apart from the inductive weakness of the analogies he draws, there is also something strained in

Baudry's use of the notion of the prehistory of cinema. Is every instance and/or report of shadow projection, prior to 1895, to be considered part of the prehistory of cinema? What criteria determine that which we are to count as legitimately and four-squaredly part of the prehistory of cinema? The camera obscura, Marey's repeating camera, the praxinoscope, and Muybridge's battery of cameras are clear-cut examples of what people include in the prehistory of cinema. And it is easy to see that what these devices have in common is that they can figure in causal accounts of the invention of cinema. But there is no historical argument in sight to show that Plato's myth of the cave literally played a role in the invention of cinema. Thus, even if Baudry's analogies were more convincing, it is not clear that it would be appropriate to consider Plato's cave as part of the prehistory of cinema.

The central argument, as well as the subsidiary ones, in "The Apparatus" appear, upon scrutiny, to be utterly groundless. Undoubtedly, some readers may complain that my methods of examining Baudry's hypotheses are not suitable and perhaps even boorish. For, in my account, Baudry is making a series of literal, logical, scientific claims about a causal process. Thus, Baudry's conclusions are assessed with the rigor one would apply to any scientific hypothesis. However, many contemporary film theorists might object that Baudry is doing something more "interesting" or "important" than pedestrian science.

Personally, I find it difficult to see why a claim about the isolation of a causal mechanism (in this case, regression as a motor force behind cinema) should not be treated as a scientific hypothesis. And so treated, Baudry's arguments by analogy are woefully inept; he fails to consider significant disanalogies, while the analogies he presents are loose and superficial. But many contemporary film theorists, especially those with backgrounds in literature, may counter that that which I call "loose" and "superficial" is really graceful, imaginative, and ingenious. They admire Baudry, as they admire Barthes, for his supposed expertise in belles lettres. But however seductive to some literary sensibilities "The Apparatus" may be, contemporary belles lettres does not afford the means to defend causal claims about the processes underlying cinema. Film theorists with backgrounds in literature may bewail this fact; but it is unavoidable. Moreover, as we shall see, the confusion of belles lettres, on the one hand, with scientific and philosophical reasoning, on the other, is one of the most egregious problems in contemporary film theory. Indeed, the extremely detailed, literal-minded, and argumentive style of this chapter . . . is mandated by my conviction that contemporary film theorists, with their penchant for belletristic expression, including slippery analogies and metaphors, must be shown that they are using the wrong tools for the tasks at hand.

1988

# GILLES DELEUZE
## *FROM* CINEMA 1 and CINEMA 2

### PREFACE TO THE ENGLISH EDITION

Over several centuries, from the Greeks to Kant, a revolution took place in philosophy: the subordination of time to movement was reversed, time ceases to be the measurement of normal movement, it increasingly appears for itself and creates paradoxical movements. Time is out of joint: Hamlet's words signify that time is no longer subordinated to movement, but rather movement to time. It could be said that, in its own sphere, cinema has repeated the same experience, the same reversal, in more fast-moving circumstances. The movement-image of the so-called classical cinema gave way, in the post-war period, to a direct time-image. Such a general idea must of course be qualified, corrected, adapted to concrete examples.

Why is the Second World War taken as a break? The fact is that, in Europe, the post-war period has greatly increased the situations which we no longer know how to react to, in spaces which we no longer know how to describe. These were 'any spaces whatever', deserted but inhabited, disused warehouses, waste ground, cities in the course of demolition or reconstruction. And in these any-spaces-whatever a new race of characters was stirring, kind of mutant: they saw rather than acted, they were seers. Hence Rossellini's great trilogy, *Europe 51, Stromboli, Germany Year 0:* a child in the destroyed city, a foreign woman on the island, a bourgeoise woman who starts to 'see' what is around her. Situations could be extremes, or, on the contrary, those of everyday banality, or both at once: what tends to collapse, or at least to lose its position, is the sensory-motor schema which constituted the action-image of the old cinema. And thanks to this loosening of the sensory-motor linkage, it is time, 'a little time in the pure state', which rises up to the surface of the screen. Time ceases to be derived from the movement, it appears in itself and itself gives rise to *false movements*. Hence the importance of *false continuity* in modern cinema: the images are no longer linked by rational cuts and continuity, but are relinked by means of false continuity and irrational cuts. Even the body is no longer exactly what moves; subject of

240

movement or the instrument of action, it becomes rather the developer [*révélateur*] of time, it shows time through its tirednesses and waitings (Antonioni).

It is not quite right to say that the cinematographic image is in the present. What is in the present is what the image 'represents', but not the image itself, which, in cinema as in painting, is never to be confused with what it represents. The image itself is the system of the relationships between its elements, that is, a set of relationships of time from which the variable present only flows. It is in this sense, I think, that Tarkovsky challenges the distinction between montage and shot when he defines cinema by the 'pressure of time' in the shot. What is specific to the image, as soon as it is creative, is to make perceptible, to make visible, relationships of time which cannot be seen in the represented object and do not allow themselves to be reduced to the present. Take, for example, a depth of field in Welles, a tracking shot in Visconti: we are plunged into time rather than crossing space. Sandra's car, at the beginning of Visconti's film, is already moving in time, and Welles's characters occupy a giant-sized place in time rather than changing place in space.

This is to say that the time-image has nothing to do with a flashback, or even with a recollection. Recollection is only a former present, whilst the characters who have lost their memories in modern cinema literally sink back into the past, or emerge from it, to make visible what is concealed even from recollection. Flashback is only a signpost and, when it is used by great authors, it is there only to show much more complex temporal structures (for example, in Mankiewicz, 'forking' time: recapturing the moment when time could have taken a different course . . .). In any case, what we call temporal structure, or direct time-image, clearly goes beyond the purely empirical succession of time—past-present-future. It is, for example, a coexistence of distinct durations, or of levels of duration; a single event can belong to several levels: the sheets of past coexist in a non-chronological order. We see this in Welles with his powerful intuition of the earth, then in Resnais with his characters who return from the land of the dead.

There are yet more temporal structures: the whole aim of this book is to release those that the cinematographic image has been able to grasp and reveal, and which can echo the teachings of science, what the other arts uncover for us, or what philosophy makes understandable for us, each in their respective ways. It is foolish to talk about the death of the cinema because cinema is still at the beginning of its investigations: making visible these relationships of time which can only appear in a creation of the image. It is not cinema which needs television—whose image remains so regrettably in the present unless it is enriched by the art of cinema. The relations and disjunctions between visual and sound, between what is seen and what is said, revitalize the problem and endow cinema with new powers for capturing time in the image (in quite different ways, Pierre Perrault, Straub, Syberberg . . . ). Yes, if cinema does not die a violent death, it retains the power of a beginning. Conversely, we must look in pre-war cinema, and even in silent cinema, for the workings of a very pure time-image which has always been breaking through, holding back or encompassing the movement-image: an Ozu still life as unchanging form of time?

I would like to thank Robert Galeta and Hugh Tomlinson for the care which they have put into translating this adventure of movement and time.

July 1988

# THE ORIGIN OF THE CRISIS: ITALIAN NEO-REALISM AND THE FRENCH NEW WAVE

But can a crisis of the action-image be presented as something new? Was this not the constant state of the cinema? The purest action films have always had value in episodes outside the action, or in idle periods between actions, through a whole set of extra-actions and infra-actions which cannot be cut out in montage without disfiguring the film (hence the formidable power of producers). At all times too, the cinema's potentialities, its vocation for changes of location, have caused directors to wish to limit or even to suppress the unity of action, to undo the action, the drama, the plot or the story and to carry further an ambition with which literature was already permeated. On the one hand, the SAS structure found itself called into question: there was no globalising situation which was able to concentrate itself in a decisive action, but action or plot were only to be a component in a dispersive set, in an open totality. Jean Mitry is right in this sense to show that Delluc, scriptwriter of Germaine Dulac's *La Fête espagnole,* already wanted to plunge the drama into a 'multiplicity of facts', none of which would be principal or secondary, so that it could only be reconstituted following a broken line lifted from among all the points and all the lines of the whole of the festival. On the other hand, the structure ASA was subjected to an analogous critique. In the same way as there was no previous history, there was no preformed action whose consequences on a situation could be foreseen, and the cinema could not transcribe events which had already happened, but necessarily devoted itelf to reaching the event in the course of happening, sometimes by cutting across an 'actuality', sometimes by provoking or producing it. Comolli has shown this very well: however far the work of preparation in many directors goes, the cinema cannot avoid the 'detour through the direct'. There is always a moment when the cinema meets the unforeseeable or the improvisation, the irreducibility of a present living under the present of narration, and the camera cannot even begin its work without engendering its own improvisations, both as obstacles and as indispensable means. These two themes, the open totality and the event in the course of happening, are part of the profound Bergsonianism of the cinema in general.

Nevertheless, the crisis which has shaken the action-image has depended on many factors which only had their full effect after the war, some of which were social, economic, political, moral and others more internal to art, to literature and to the cinema in particular. We might mention, in no particular order, the war and its consequences, the unsteadiness of the 'American Dream' in all its aspects, the new consciousness of minorities, the rise and inflation of images both in the external world and in people's minds, the influence on the cinema of the new modes of narrative with which literature had experimented, the crisis of Hollywood and its old genres. . . . Certainly, people continue to make SAS and ASA films: the greatest commercial successes always take that route, but the soul of the cinema no longer does. The soul of the cinema demands increasing thought, even if thought begins by undoing the system of actions, perceptions and affections on which the cinema had fed up to that point. We hardly believe any longer that a global situation can give rise to an action which is capable of modifying it—no more than we believe that an action can force a situation to dis-

close itself, even partially. The most 'healthy' illusions fall. The first things to be com-promised everywhere are the linkages of situation–action, action–reaction, excitation–response, in short, the sensory-motor links which produced the action-image. Realism, despite all its violence—or rather with all its violence which remains sensory-motor—is oblivious to this new state of things where the synsigns disperse and the indices become confused. We need new signs. A new kind of image is born that one can attempt to identify in the post-war American cinema, outside Hollywood.

In the first place, the image no longer refers to a situation which is globalising or synthetic, but rather to one which is dispersive. The characters are multiple, with weak interferences and become principal or revert to being secondary. It is nevertheless not a series of sketches, a succession of short stories, since they are all caught in the same reality which disperse them. Robert Altman explores this direction in *A Wedding* and particularly in *Nashville,* with the multiple sound-tracks and the anamorphic screen which allows several simultaneous stagings. The city and the crowd lose the collective and unanimist character which they have in King Vidor; the city at the same time ceases to be the city above, the upright city, with skyscrapers and low-angle shots, in order to become the recumbent city, the city as horizontal or at human height, where each gets on with his own business, on his own account.

In the second place, the line or the fibre of the universe which prolonged events into one another, or brought about the connection of portions of space, has broken. The small form ASA is therefore no less compromised than the large form SAS. Ellipsis ceases to be a mode of the tale [*récit*], a way in which one goes from an action to a partially disclosed situation: it belongs to the situation itself, and reality is lacunary as much as dispersive. Linkages, connections, or liaisons are deliberately weak. Chance becomes the sole guiding thread, as in Altman's *Quintet.* Sometimes the event delays and is lost in idle periods, sometimes it is there too quickly, but it does not belong to the one to whom it happens (even death . . . ). And there are close relationships between these aspects of the event: the dispersive, the direct in the course of happening and the non-belonging. Cassavetes plays on these three aspects in *The Killing of a Chinese Bookie* and in *Too Late Blues.* We could call them white events, events which never truly concern the person who provokes or is subject to them, even when they strike him in his flesh: events whose bearer, a man internally dead, as Lumet says, is in a hurry to extricate himself. In Scorsese's *Taxi Driver,* the driver wavers between killing himself and committing a political murder and, replacing these projects by the final slaughter, is astonished by it himself, as if the carrying out concerned him no more than did the preceding whims. The actuality of the action-image, the virtuality of the affection-image can interchange, all the more easily for having fallen into the same indifference.

In the third place, the sensory-motor action or situation has been replaced by the stroll, the voyage and the continual return journey. The voyage has found in America the formal and material conditions of a renewal. It takes place through internal or external necessity, through the need for flight. But now it loses the initiatory aspect that it had in the German journey (even in Wenders' films) and that it kept, despite everything, in the beat journey (Dennis Hopper and Peter Fonda's *Easy Rider*). It has become urban voyage, and has become detached from the active and affective struc-

ture which supported it, directed it, gave it even vague directions. How could there be a nerve fibre or a sensory-motor structure between the driver of *Taxi Driver* and what he sees on the pavement in his driving mirror? And, in Lumet, everything happens in continual trips and in return journeys, at ground level, in aimless movements where characters behave like windscreen wipers (*Dog Day Afternoon, Serpico*). This is in fact the clearest aspect of the modern voyage. It happens in any-space-whatever—marshalling yard, disused warehouse, the undifferentiated fabric of the city—in opposition to action which most often unfolded in the qualified space-time of the old realism. As Cassavetes says, it is a question of undoing space, as well as the story, the plot or the action.[1]

In the fourth place, we ask ourselves what maintains a set [*ensemble*] in this world without totality or linkage. The answer is simple: what forms the set are *clichés,* and nothing else. Nothing but clichés, clichés everywhere. . . . The problem had already been raised by Dos Passos, and the new techniques that he began in the novel, before the cinema had ever dreamed of them: dispersive and lacunary reality, the swarming of characters with weak interferences, their capacity to become principal and revert to being secondary, events which descend on the characters and which do not belong to those who undergo or provoke them. Now, what consolidates all this, are the current clichés of an epoch or a moment, sound and visual slogans, which Dos Passos calls, with names borrowed from the cinema, 'actualities' and 'eye of the camera' (actualities are news interwoven with political or social events, interest items, interviews and light-hearted songs and the eye of the camera is the internal monologue of any third whatever, who is not an identified character). They are these floating images, these anonymous clichés, which circulate in the external world, but which also penetrate each one of us and constitute his internal world, so that everyone possesses only psychic clichés by which he thinks and feels, is thought and is felt, being himself a cliché among the others in the world which surrounds him.[2] Physical, optical and auditory clichés and psychic clichés mutually feed on each other. In order for people to be able to bear themselves and the world, misery has to reach the inside of consciousnesses and the inside has to be like the outside. It is this romantic and pessimist vision that we discover in Altman or Lumet. In *Nashville* the city locations are redoubled by the images to which they give rise—photos, recordings, television—and it is in an old song that the characters are finally brought together. This power of the sound cliché, a little song, is asserted in Altman's *A Perfect Couple:* the voyage/ballad[3] takes on its second sense here, the sung and danced poem. In Lumet's *Bye Bye Braveman,* which tells the story of the stroll through the city of four Jewish intellectuals going to the burial of a friend, one of the four wanders among the tombs reading to the dead the recent news from the newspapers. In *Taxi Driver* Scorsese makes

---

[1]On all these points, we refer particularly to the journal *Cinématographe:* on Altman, no. 45, March 1979 (Maraval's article) and no. 54, January 1980 (Fieschi, Carassonne); on Lumet, no. 74, January 1982 (Rinieri, Cebe, Rieschi); on Cassavetes, no. 38, May 1978 (Lara) and no. 77, April 1982 (Sylvie Trosa, Prades); on Scorsese, no. 45, March 1979 (Cuel).

[2]Claude-Edmonde Maguy has analysed all these points in Dos Passos, *L'Âge du roman américain,* pp. 125–37. Dos Passos' novels have influenced Italian neo-realism; conversely he himself was subject to a certain influence of Vertov's 'cine-eye'.

[3]'Bal(l)ade': an untranslatable pun on the words '*ballade*' (ballad) and '*balade*' (voyage).

a catalogue of all the psychic clichés which bustle about in the driver's head, but at the same time of the optical and sound clichés of the neon-city that he sees filing past along the streets: he himself, after his slaughter, will be the national hero of a day, attaining the state of cliché, without the event being his for all that. Finally, it is no longer even possible to distinguish what is physical and psychic in the universal cliché of *King of Comedy,* sucking the interchangeable characters into a single void.

The idea of one single misery, internal and external, in the world and in consciousness, had already been had by English Romanticism in its blackest form, notably in Blake or Coleridge. People would not accept the intolerable if the same 'reasons' which it imposed on them from the outside were not insinuating themselves in them in order to make them adhere, from the inside. According to Blake there was a whole *organisation of misery,* from which the American revolution could perhaps save us.[4] But we can see how America, on the contrary, raised the romantic question again, by giving it a still more radical, still more urgent, still more technical form: the reign of clichés internally as well as externally. How can one not believe in a powerful concerted organisation, a great and powerful plot, which has found the way to make clichés circulate, from outside to inside, from inside to outside? The criminal conspiracy, as organisation of Power, was to take on a new aspect in the modern world, that the cinema would endeavour to follow and to show. It is no longer the case, as in the *film noir* of American realism, of an organisation which related to a distinctive milieu, to assignable actions by which the criminals would be distinguishable (although very successful films of this kind, like *The Godfather,* are still made). There is no longer even a magic centre, from which hypnotic actions could start spreading everywhere as in Lang's first two Mabuse films. We do, it is true, see that Lang evolves in this respect: *The Testament of Dr Mabuse* no longer passes through a production of secret actions, but rather through a monopoly of reproduction. Occult power is confused with its effects, its supports, its media, its radios, its televisions, its microphones: it now only operates through the 'mechanical reproduction of images and of sounds'.[5] And this is the fifth characteristic of the new image, this is the one which inspired post-war American cinema. In Lumet, the conspiracy is the system of reception, surveillance and transmission of *The Anderson Tapes; Network,* also, doubles the city with all the transmissions and reception that it ceaselessly produces, whilst *The Prince of the City* records the whole city on magnetic tape. And Altman's *Nashville* fully grasps this operation which doubles the city with all the clichés that it produces, and divides in two the clichés themselves, internally and externally, whether optical or sound clichés and psychic clichés.

These are the five apparent characteristics of the new image: *the dispersive situation, the deliberately weak links, the voyage form, the consciousness of clichés, the condemnation of the plot.* It is the crisis of both the action-image and the American Dream. Everywhere there is a re-examination of the sensory-motor schema; and the Actors Studio becomes the object of severe criticism, at the same time as it undergoes an evolution and internal splits. But how can the cinema attack the dark organisation of clichés, when it participates in their fabrication and propagation, as much as mag-

---

[4]On the importance of this theme in English Romanticism, cf. Paul Rozenberg, *Le Romantisme anglais.*
[5]Cf. Pascal Kane, 'Mabuse et le pouvoir', *Cahiers du cinéma,* no. 309, March 1980.

azines or television? Perhaps the special conditions under which it produces and reproduces clichés allow certain directors to attain a critical reflection which they would not have at their disposal elsewhere. It is the organisation of the cinema which means that, however great the controls which bear upon him, the creator has at his disposal at least a certain time to 'commit' the irreversible. He has the chance to extract an Image from all the clichés and to set it up against them. On the condition, however, of there being an aesthetic and political project capable of constituting a positive enterprise. Now, it is here that the American cinema finds its limits. All the aesthetic or even political qualities that it can have remain narrowly critical and in this way even less 'dangerous' than if they were being made use of in a project of positive creation. Then, either the critique swerves abruptly and attacks only a misuse of apparatuses and institutions, in striving to save the remains of the American Dream, as in Lumet; or it extends itself, but becomes empty and starts to grate, as in Altman, content to parody the cliché instead of giving birth to a new image. As Lawrence said about painting: the rage against clichés does not lead to much if it is content only to parody them; maltreated, mutilated, destroyed, a cliché is not slow to be reborn from its ashes.[6] In fact, what gave the American cinema its advantage, the fact of being born without a previous tradition to suffocate it, now rebounded against it. For the cinema of the action-image had itself engendered a tradition from which it could now only, in the majority of cases, extricate itself negatively. The great genres of this cinema, the psycho-social film, the *film noir*, the Western, the American comedy, collapse and yet maintain their empty frame. For great creators the path of emigration was thus reversed, for reasons which were not just related to McCarthyism. In fact, Europe had more freedom in this respect; and it is first of all in Italy that the great crisis of the action-image took place. The timing is something like: around 1948, Italy; about 1958 France; about 1968, Germany.

## TOWARDS A BEYOND OF THE MOVEMENT-IMAGE

Why Italy first, before France and Germany? It is perhaps for an essential reason, but one which is external to the cinema. Under the impetus of de Gaulle, France had, at the end of the war, the historical and political ambition to belong fully to the circle of victors. The Resistance, therefore, even when underground, needed to appear as the detachment of a regular, perfectly organised army and the life of the French, even when full of conflict and ambiguities, needed to appear as a contribution to victory. These conditions were not favourable to a renewal of the cinematographic image, which found itself kept within the framework of a traditional action-image, at the service of a properly French 'dream'. The result of this was that the cinema in France was only able to break with its tradition rather belatedly and by a reflexive or intellectual detour which was that of the New Wave. The situation in Italy was completely different. It could certainly not claim the rank of victor; but, in contrast to Germany, on the one hand it had at its disposal a cinematographic institution which had escaped fascism relatively successfully, on the other hand it could point to a resistance and a popular life underlying oppression, although one without illusion. To grasp these, all

---

[6] D. H. Lawrence, *Eros et les chiens,* Bourgois, p. 253–7.

that was necessary was a new type of tale [*récit*] capable of including the elliptical and the unorganised, as if the cinema had to begin again from zero, questioning afresh all the accepted facts of the American tradition. The Italians were therefore able to have an intuitive consciousness of the new image in the course of being born. This explains nothing of the genius of Rossellini's first films. But it does at least explain the reaction of certain American critics who saw in them the inordinate pretension of a defeated country, an odious form of blackmail, a way of making the conquerors ashamed.[7] And above all, it is this very special situation of Italy which made possible the enterprise of neo-realism.

It was Italian neo-realism which forged the five preceding characteristics. In the situation at the end of the war, Rossellini discovered a dispersive and lacunary reality—already in *Rome, Open City,* but above all in *Païsa*—a series of fragmentary, chopped up encounters, which call into question the SAS form of the action-image. It is the post-war economic crisis, on the other hand, which inspires De Sica, and leads him to shatter the ASA form: there is no longer a vector or line of the universe which extends and links up the events of *The Bicycle Thief;* the rain can always interrupt or deflect the search fortuitously, the voyage of the man and of the child. The Italian rain becomes the sign of idle periods and of possible interruption. And again the theft of the bicycle, or even the insignificant events of *Umberto D,* have a vital importance for the protagonists. However, Fellini's *I Vitelloni* testifies not only to the insignificance of events, but also to the uncertainty of the links between them and of their non-belonging to those who experience them in this new form of the voyage. In the city which is being demolished or rebuilt, neo-realism makes any-space-whatevers proliferate—urban cancer, undifferentiated fabrics, pieces of wasteground—which are opposed to the determined spaces of the old realism.[8] And what rises to the horizon, what is outlined on this world, what will be imposed in a third moment, is not even raw reality, but its understudy, the reign of clichés, both internally and externally, in people's heads and hearts as much as in the whole of space. Did not *Païsa* already propose all the possible clichés of the encounters between America and Italy? And in *Strangers* Rossellini catalogues the clichés of pure Italianness, as seen by a bourgeois woman out walking; volcano, museum statues, Christian sanctuary. . . . In *General della Rovere* he drew out the cliché of the manufacture of a hero. In a very special way, it is Fellini who put his first films under the sign of the manufacture, the detection and the proliferation of external and internal clichés: the photo-novel of *The White Sheikh,* the photo-inquest of *Un'Agenzia matrimoniale,* the nightclubs, music halls and circuses, and all the jingles which console or despair. Should we add the great conspiracy which organised this misery, and for which Italy had a ready-made name, the Mafia? Francesco Rosi set up the faceless portrait of the bandit *Salvatore Giuliano,* by cutting up history according to the prefabricated roles

---

[7]Cf. R. S. Warshow's violent text reproduced in *Le Néo-réalisme italien, Etudes cinématographiques,* pp. 140–2. There will always be a grudge, coming from a part of America, against Italian neo-realism, which 'dared' to instigate another conception of the cinema. The Ingrid Bergman scandal also had this aspect: having become the adoptive daughter of America, she did not simply abandon her family for Rossellini, she abandoned the cinema of the conquerors.

[8]Cf. the two issues of *Cinématographe* on neo-realism, 42 and 43, December 1978 and January 1979, notably the articles by Sylvie Trosa and Michel Devillers.

which were imposed on it by a power which cannot be pinned down, which is only known by its effects.

Neo-realism already had a high technical conception of the difficulties that it would encounter and of the means that it invented; it had a no less sure intuitive consciousness of the new image in the course of being born. It is rather by way of an intellectual and reflexive consciousness that the French New Wave was able to take up this mutation on its own account. It is here that the voyage-form is freed from the spatio-temporal co-ordinates which were left over from the old Social Realism and begins to have value for itself or as the expression of a new society, of a new pure present: the return journey from Paris to the provinces and from the provinces to Paris in Chabrol (*Le beau Serge* and *Les Cousins*); wanderings which have become analytic instruments of an analysis of the soul, in Rohmer (the series of *Moral Tales*) and in Truffaut (the trilogy of *L'Amour à vingt ans*, *Baisers volés* and *Domicile conjugal*); Rivette's investigation-outing [*promenade-enquête*] (*Paris nous appartient*); the flight-outing [*promenade-fuite*] of Truffaut (*Tirez sur le pianiste*) and particularly of Godard (*A bout de souffle*, *Pierrot le fou*). In these we see the birth of a race of charming, moving characters who are hardly concerned by the events which happen to them—even treason, even death—and experience and act out obscure events which are as poorly linked as the portion of the any-space-whatever which they traverse. Rivette's film title is echoed by Péguy's song-formula, 'Paris belongs to no one.' And, in Rivette's *L'Amour fou*, forms of behaviour are replaced by the postures of the asylum, by explosive acts, which shatter the actions of characters as well as the connexions of the play which they are rehearsing. In this new kind of image the sensory-motor links tend to disappear, a whole sensory-motor continuity which forms the essential nature of the action-image vanishes. It is not only the famous scene in *Pierrot le fou*, 'I dunno what to do', where the voyage/ballad imperceptibly becomes the sung and danced poem; but it is also a whole upsurge of sensory-motor disturbances, which are hardly indicated when necessary, movements which make false [*font faux*], 'slight warping of perspectives, slowing down of time, alteration of gestures' (Godard's *Les Carabiniers*, *Tirez sur le pianiste*, or *Paris nous appartient*).[9] Making-false [*faire-faux*] becomes the sign of a new realism, in opposition to the making-true of the old. Clumsy fights, badly aimed punches or shots, a whole out-of-phase of action and speech replace the too perfect duels of American Realism. Eustache makes a character in *La Maman et la putain* say, 'The more you appear false like that, the farther you go, the false is the beyond.'

Under this power of the false all images become clichés, sometimes because their clumsiness is shown, sometimes because their apparent perfection is attacked. The gauche gestures of the *Carabiniers* have as a correlate the series of postcards that they bring back of the war. The external, optical and sound clichés have as their correlate internal or psychic clichés. It is perhaps in the perspectives of the new German cinema that this element finds its fullest development: Daniel Schmid invents a slowness which makes possible the dividing in two of characters, as if they were to one side of

---

[9]Ollier, *Souvenirs écran*, p. 58. It is Alain Robbe-Grillet who insists on the importance of the detail which 'makes' false, seeing here a sign of reality as opposed to verism; see his *Pour un nouveau Roman*, p. 140.

what they say and do, and chose from among the external clichés the one that they will embody from the inside, in a perpetual interchangeability of inside and outside (already in *La Paloma* but above all in *Schatten der Engel* where 'the Jew could be the fascist, the prostitute could be the pimp . . .', in a game of cards which makes each player himself a card, but a card played by another).[10] If things are like this, how is it possible not to believe in a world-wide, diffuse conspiracy, an enterprise of generalised enslavement which extends to every location of the any-space-whatever, spreading death everywhere? In Godard, *Le petit Soldat, Pierrot le fou, Made in USA, Weekend,* with their maquis of resistance to the end illustrate in different ways a plot from which escape is impossible. And Rivette, from *Paris nous appartient* to *Pont du Nord,* via *La Religieuse,* ceaselessly invokes the world-wide conspiracy which distributes roles and situations in a kind of malevolent game of snakes and ladders.

But, if everything is clichés and a plot to exchange and propagate them, the only result seems to be a cinema of parody or contempt for which Chabrol and Altman are sometimes criticised. What do the neo-realists mean, on the contrary, when they speak of the respect and the love which is necessary for the birth of the new image? Far from being satisfied with a negative or parodic critical consciousness, the cinema is engaged in its highest reflection, and has constantly deepened and developed it. We will find in Godard formulas which express the problem: if images have become clichés, internally as well as externally, how can an Image be extracted from all these clichés, 'just an image', an autonomous mental image? An image *must* emerge from the set of clichés. . . . With what politics and what consequences? What is an image which would not be a cliché? Where does the cliché end and the image begin? But, if the question has no immediate answer, it is precisely because the set of preceding characteristics do not constitute the new mental image which is being sought. The five characteristics form an envelope (including physical and psychic clichés), they are a necessary external condition, but do not constitute the image although they make it possible. And here one can assess the similarities to and the differences from Hitchcock. The New Wave could be called with good reason Hitchcocko-Marxian, rather than 'Hitchcocko-Hawksian'. Like Hitchcock it wanted to reach mental images and figures of thought (thirdness). But, whilst Hitchcock saw there a kind of complement which ought to have extended and realised the traditional 'perception-action-affection' system, it discovered there on the contrary a requirement which was enough to smash the whole system, to cut perception off from its motor extension, action, from the thread which joined it to a situation, affection from adherence or belonging to characters. The new image would therefore not be a bringing to completion of the cinema, but a mutation of it. It was necessary, on the contrary, to want what Hitchcock had constantly refused. The mental image had not to be content with weaving a set of relations, but had to form a new substance. It had to become truly thought and thinking, even if it had to become 'difficult' in order to do this. *There*

---

[10]Cf. *Dossier Daniel Schmid,* pp. 78–86 (notably what Schmid calls 'papier mâché clichés'). But Schmid is perfectly conscious of the danger of leaving to the cinema only a parodic function (p. 78): therefore clichés only proliferate in order for something to come out of them. In *Schatten der Engel,* two characters emerge from the clichés which assail them from the outside and inside, the Jew and the prostitute, because they knew how to keep the feeling of 'fear'.

*were two conditions.* On the one hand, it would require and presuppose a putting into crisis of the action-image, the perception-image and the affection-image, even if this entailed the discovery of 'clichés' everywhere. But, on the other hand, this crisis would be worthless by itself, it would only be the negative condition of the upsurge of the new thinking image, even if it was necessary to look for it beyond movement.

1983

# BEYOND THE MOVEMENT-IMAGE

1

Against those who defined Italian neo-realism by its social content, Bazin put forward the fundamental requirement of formal aesthetic criteria. According to him, it was a matter of a new form of reality, said to be dispersive, elliptical, errant or wavering, working in blocs, with deliberately weak connections and floating events. The real was no longer represented or reproduced but 'aimed at'. Instead of representing an already deciphered real, neo-realism aimed at an always ambiguous, to be deciphered, real; this is why the sequence shot tended to replace the montage of representations. Neo-realism therefore invented a new type of image, which Bazin suggested calling 'fact-image'.[1] This thesis of Bazin's was infinitely richer than the one that he was challenging, and showed that neo-realism did not limit itself to the content of its earliest examples. But what the two theses had in common was the posing of the problem at the level of reality: neo-realism produced a formal or material 'additional reality'. However, we are not sure that the problem arises at the level of the real, whether in relation to form or content. Is it not rather at the level of the 'mental', in terms of thought? If all the movement-images, perceptions, actions and affects underwent such an upheaval, was this not first of all because a new element burst on to the scene which was to prevent perception being extended into action in order to put it in contact with thought, and, gradually, was to subordinate the image to the demands of new signs which would take it beyond movement?

When Zavattini defines neo-realism as an art of encounter—fragmentary, ephemeral, piecemeal, missed encounters—what does he mean? It is true of encounters in Rossellini's *Paisa,* or De Sica's *Bicycle Thief.* And in *Umberto D,* De Sica constructs the famous sequence quoted as an example by Bazin: the young maid going into the kitchen in the morning, making a series of mechanical, weary gestures, cleaning a bit, driving the ants away from a water fountain, picking up the coffee grinder, stretching out her foot to close the door with her toe. And her eyes meet her pregnant woman's belly, and it is as though all the misery in the world were going to be born. This is how, in an ordinary or everyday situation, in the course of a series of gestures, which are insignificant but all the more obedient to simple sensory-motor schemata, what has

---

[1]Bazin, *What Is Cinema?,* trans. Hugh Gray, Berkeley: University of California Press, 1971, Vol. II, p. 37 (and the whole of the chapters on neo-realism). It is Amédée Ayfre who takes up and develops Bazin's thesis to give it a pronounced phenomenological expression: 'Du premier au second néo-réalisme', *Le néo-réalisme italien, Etudes cinématographiques.*

suddenly been brought about is a *pure optical situation* to which the little maid has no response or reaction. The eyes, the belly, that is what an encounter is . . . Of course, encounters can take very different forms, even achieving the exceptional, but they follow the same formula. Take, for example, Rossellini's great quartet, which, far from marking an abandonment of neo-realism, on the contrary, perfects it. *Germany Year 0* presents a child who visits a foreign country (this is why the film was criticized for not maintaining the social mooring which was held to be a condition of neo-realism), and who dies from what he sees. *Stromboli* presents a foreign woman whose revelation of the island will be all the more profound because she cannot react in a way that softens or compensates for the violence of what she sees, the intensity and the enormity of the tunny-fishing ('It was awful . . .'), the panic-inducing power of the eruption ('I am finished, I am afraid, what mystery, what beauty, my God . . .'). *Europe 51* shows a bourgeoise woman who, following the death of her child, crosses various spaces and experiences the tenement, the slum and the factory ('I thought I was seeing convicts'). Her glances relinquish the practical function of a mistress of a house who arranges things and beings, and pass through every state of an internal vision, affliction, compassion, love, happiness, acceptance, extending to the psychiatric hospital where she is locked up at the end of a new trial of Joan of Arc: she sees, she has learnt to see. *The Lonely Woman* [*Viaggio in Italia*] follows a female tourist struck to the core by the simple unfolding of images or visual clichés in which she discovers something unbearable, beyond the limit of what she can personally bear.[2] This is a cinema of the see-er and no longer of the agent [*de voyant, non plus d'actant*].

What defines neo-realism is this build-up of purely optical situations (and sound ones, although there was no synchronized sound at the start of neo-realism), which are fundamentally distinct from the sensory-motor situations of the action-image in the old realism. It is perhaps as important as the conquering of a purely optical space in painting, with impressionism. It may be objected that the viewer has always found himself in front of 'descriptions', in front of optical and sound-images, and nothing more. But this is not the point. For the characters themselves reacted to situations; even when one of them found himself reduced to helplessness, bound and gagged, as a result of the ups and downs of the action. What the viewer perceived therefore was a sensory-motor image in which he took a greater or lesser part by identification with the characters. Hitchcock had begun the inversion of this point of view by including the viewer in the film. But it is now that the identification is actually inverted: the character has become a kind of viewer. He shifts, runs and becomes animated in vain, the situation he is in outstrips his motor capacities on all sides, and makes him see and hear what is no longer subject to the rules of a response or an action. He records rather than reacts. He is prey to a vision, pursued by it or pursuing it, rather than engaged in an action. Visconti's *Obsession* rightly stands as the forerunner of neo-realism; and what first strikes the viewer is the way in which the black-clad heroine is possessed by an almost hallucinatory sensuality. She is closer to a visionary, a sleepwalker, than to a seductress or a lover (similarly, later, the Countess in *Senso*).

---

[2]On these films, cf. Jean-Claude Bonnet, 'Rossellini ou le parti pris des choses', *Cinématographe*, no. 43, janvier 1979. This review devoted two special numbers to neo-realism, 42 and 43, with the very apt title 'Le regard néo-réaliste'.

In Volume 1 the crisis of the action-image was defined by a number of character-
istics: the form of the trip/ballad,[3] the multiplication of clichés, the events that hardly
concern those they happen to, in short the slackening of the sensory-motor connec-
tions. All these characteristics were important but only in the sense of preliminary
conditions. They made possible, but did not yet constitute, the new image. What con-
stitutes this is the purely optical and sound situation which takes the place of the fal-
tering sensory-motor situations. The role of the child in neo-realism has been pointed
out, notably in De Sica (and later in France with Truffaut); this is because, in the adult
world, the child is affected by a certain motor helplessness, but one which makes him
all the more capable of seeing and hearing. Similarly, if everyday banality is so
important, it is because, being subject to sensory-motor schemata which are auto-
matic and pre-established, it is all the more liable, on the least disturbance of equi-
librium between stimulus and response (as in the scene with the little maid in
*Umberto D*), suddenly to free itself from the laws of this schema and reveal itself in
a visual and sound nakedness, crudeness and brutality which make it unbearable, giv-
ing it the pace of a dream or a nightmare. There is, therefore, a necessary passage
from the crisis of image-action to the pure optical-sound image. Sometimes it is an
evolution from one aspect to the other: beginning with trip/ballad films [*films de
bal(l)ade*] with the sensory-motor connections slackened, and then reaching purely
optical and sound situations. Sometimes the two coexist in the same film like two lev-
els, the first of which serves merely as a melodic line for the second.

It is in this sense that Visconti, Antonioni and Fellini are definitely part of neo-
realism, in spite of all their differences. *Obsession,* the forerunner, is not merely one
of the versions of a famous American thriller, or the transposition of this novel to the
plain of the Po.[4] In Visconti's film, we witness a very subtle change, the beginnings
of a mutation of the general notion of situation. In the old realism or on the model of
the action-image, objects and settings already had a reality of their own, but it was a
functional reality, strictly determined by the demands of the situation, even if these
demands were as much poetic as dramatic (for instance, the emotional value of
objects in Kazan). The situation was, then, directly extended into action and passion.
After *Obsession,* however, something appears that continues to develop in Visconti:
objects and settings [*milieux*] take on an autonomous, material reality which gives
them an importance in themselves. It is therefore essential that not only the viewer
but the protagonists invest the settings and the objects with their gaze, that they see
and hear the things and the people, in order for action or passion to be born, erupting
in a pre-existing daily life. Hence the arrival of the hero of *Obsession,* who takes a
kind of visual possession of the inn, or, in *Rocco and his Brothers,* the arrival of the
family who, with all their eyes and ears, try to take in the huge station and the
unknown city: this will be a constant theme in Visconti's work, this 'inventory' of a

---

[3]Translators' note: Deleuze uses the word 'bal(l)ade', an untranslatable pun on the words *ballade* (bal-
lad) and *balade* (trip or voyage).

[4]James Cain's novel, *The Postman Always Rings Twice,* has given rise to four pieces of work in the cin-
ema: Pierre Chenil (*Le dernier tournant,* 1939), Visconti (1942), Garnett (1946) and Rafelson (1981). The
first is part of French poetic realism, and the latter two, of American action-image realism. Jacques Fieschi
does a very interesting comparative analysis of the four films: *Cinématographe,* no. 70, septembre 1981,
pp. 8–9 (the reader is also referred to his article on *Obsession,* no. 42).

setting—its objects, furniture, tools, etc. So the situation is not extended directly into action: it is no longer sensory-motor, as in realism, but primarily optical and of sound, invested by the senses, before action takes shape in it, and uses or confronts its elements. Everything remains real in this neo-realism (whether it is film set or exteriors) but, between the reality of the setting and that of the action, it is no longer a motor extension which is established, but rather a dreamlike connection through the intermediary of the liberated sense organs.[5] It is as if the action floats in the situation, rather than bringing it to a conclusion or strengthening it. This is the source of Visconti's visionary aestheticism. And *The Earth Trembles* confirms these new parameters in a singular way. Of course the fishermen's situation, the struggle they are engaged in, and the birth of a class consciousness are revealed in this first episode, the only one that Visconti completed. But this embryonic 'communist consciousness' here depends less on a struggle with nature and between men than on a grand vision of man and nature, of their perceptible and sensual unity, from which the 'rich' are excluded and which constitutes the hope of the revolution, beyond the setbacks of the floating action: a Marxist romanticism.[6]

In Antonioni, from his first great work, *Story of a Love Affair,* the police investigation, instead of proceeding by flashback, transforms the actions into optical and sound descriptions, whilst the tale itself is transformed into actions which are dislocated in time (the episode where the maid talks while repeating her tired gestures, or the famous scene with the lifts).[7] And Antonioni's art will continue to evolve in two directions: an astonishing development of the idle periods of everyday banality; then, starting with *The Eclipse,* a treatment of limit-situations which pushes them to the point of dehumanized landscapes, of emptied spaces that might be seen as having absorbed characters and actions, retaining only a geophysical description, an abstract inventory of them. As for Fellini, from his earliest films, it is not simply the spectacle which tends to overflow the real, it is the everyday which continually organizes itself into a travelling spectacle, and the sensory-motor linkages which give way to a succession of *varieties* subject to their own laws of passage. Barthélemy Amengual produces a formula which is true for the first half of this work: 'The real becomes spectacle or spectacular, and fascinates for being the real thing . . . The everyday is identified with the spectacular . . . Fellini achieves the deliberate confusion of the real and the spectacle' by denying the heterogeneity of the two worlds, by effacing not only distance, but the distinction between the spectator and the spectacle.[8]

The optical and sound situations of neo-realism contrast with the strong sensory-motor situations of traditional realism. The space of a sensory-motor situation is a setting which is already specified and presupposes an action which discloses it, or prompts a reaction which adapts to or modifies it. But a purely optical or sound situ-

---

[5]These themes are analysed in *Visconti, Etudes cinématographiques,* especially the articles by Bernard Dort and René Duloquin (cf. Duloquin, on the subject of *Rocco and his Brothers,* p. 86: 'From the monumental staircase of Milan to the indistinct countryside, the characters float in a set whose boundaries they cannot reach. They are real, and so is the set, but their relation is not and approaches that of a dream.').

[6]On this 'communism' in *The Earth Trembles,* cf. Yves Guillaume, *Visconti,* Editions Universitaires, p. 17 f.

[7]Cf. the commentary by Noël Burch, *Praxis du cinéma,* Gallimard, pp. 112–18.

[8]Barthélemy Amengual, 'Du spectacle au spectaculaire', *Fellini I, Etudes cinématographiques.*

ation becomes established in what we might call 'any-space-whatever', whether dis-
connected, or emptied (we find the passage from one to the other in *The Eclipse,*
where the disconnected bits of space lived by the heroine—stock exchange, Africa,
air terminal—are reunited at the end in an empty space which blends into the white
surface). In neo-realism, the sensory-motor connections are now valid only by virtue
of the upsets that affect, loosen, unbalance, or uncouple them: the crisis of the action-
image. No longer being induced by an action, any more than it is extended into one,
the optical and sound situation is, therefore, neither an index nor a synsign. There is
a new breed of signs, *opsigns* and *sonsigns.* And clearly these new signs refer to very
varied images—sometimes everyday banality, sometimes exceptional or limit-
circumstances—but, above all, subjective images, memories of childhood, sound and
visual dreams or fantasies, where the character does not act without seeing himself
acting, complicit viewer of the role he himself is playing, in the style of Fellini.
Sometimes, as in Antonioni, they are objective images, in the manner of a *report,*
even if this is a report of an accident, defined by a geometrical frame which now
allows only the existence of relations of measurement and distance between its ele-
ments, persons and objects, this time transforming the action into displacement of fig-
ures in space (for instance, the search for the vanished woman in *The Adventure*).[9] It
is in this sense that the critical objectivism of Antonioni may be contrasted with the
knowing subjectivism of Fellini. There would be, then, two kinds of opsigns, reports
[*constats*] and 'instats',[10] the former giving a vision with depth, at a distance, tend-
ing towards abstraction, the other a close, flat-on vision inducing involvement. This
opposition corresponds in some respects to the alternative as defined by Worringer:
abstraction or *Einfühlung.* Antonioni's aesthetic visions are inseparable from an
objective critique (we are sick with Eros, because Eros is himself objectively sick:
what has love become that a man or a woman should emerge from it so disabled, piti-
ful and suffering, and act and react as badly at the beginning as at the end, in a cor-
rupt society?), whilst Fellini's visions are inseparable from an 'empathy', a subjec-
tive sympathy (embrace even that decadence which means that one loves only in
dreams or in recollection, sympathize with those kinds of love, be an accomplice of
decadence, and even provoke it, in order to save something, perhaps, as far as is pos-
sible . . .).[11] On both sides these are higher, more important, problems than common-
places about solitude and incommunicability.

   The distinctions, on one hand between the banal and the extreme, and on the other
between the subjective and the objective, have some value, but only relatively. They
are valid for an image or a sequence, but not for the whole. They are still valid in rela-

---

[9]Pierre Leprohon has emphasized this notion of report in Antonioni: *Antonioni,* Seghers.

[10]Translators' note: 'Instats' is a neologism coined by Deleuze.

[11]Fellini has frequently claimed this sympathy for decadence (for instance, 'it is not a trial by a judge,
it is a trial conducted by an accomplice,' quoted by Amengual, op. cit., p. 9). In contrast, in relation to the
world, and the feelings and characters which appear in it, Antonioni retains a critical objectivity in which
there has been discerned an almost Marxist inspiration: cf. the analysis by Gérard Gozlan, *Positif,* no. 35,
juillet 1960. Gozlan points to Antonioni's fine text: how is it that men rid themselves with ease of their sci-
entific and technical concepts when they turn out to be lacking or unsuitable, whilst they remain attached
to 'moral' beliefs and feelings which no longer bring anything but their unhappiness, even when they
invent an even more harmful immoralism? (Antonioni's words are reprinted in Leprohon, op. cit., pp.
104–6).

tion to the action-image, which they bring into question, but already they are no longer wholly valid in relation to the new image that is coming into being. They mark poles between which there is continual passage. In fact, the most banal or everyday situations release accumulated 'dead forces' equal to the life force of a limit-situation (thus, in De Sica's *Umberto D*, the sequence where the old man examines himself and thinks he has fever). In addition, the idle periods in Antonioni do not merely show the banalities of daily life, they reap the consequences or the effect of a remarkable event which is reported only through itself without being explained (the break-up of a couple, the sudden disappearance of a woman . . . ). The method of report in Antonioni always has this function of bringing idle periods and empty spaces together: drawing all the consequences from a decisive past experience, once it is done and everything has been said. 'When everything has been said, when the main scene seems over, there is what comes afterwards . . .'[12]

As for the distinction between subjective and objective, it also tends to lose its importance, to the extent that the optical situation or visual description replaces the motor action. We run in fact into a principle of indeterminability, of indiscernibility: we no longer know what is imaginary or real, physical or mental, in the situation, not because they are confused, but because we do not have to know and there is no longer even a place from which to ask. It is as if the real and the imaginary were running after each other, as if each was being reflected in the other, around a point of indiscernibility. We will return to this point, but, already, when Robbe-Grillet provides his great theory of descriptions, he begins by defining a traditional 'realist' description: it is that which presupposes the independence of its object, and hence proposes a discernibility of the real and the imaginary (they can become confused, but none the less by right they remain distinct). Neo-realist description in the *nouveau roman* is completely different: since it *replaces* its own object, on the one hand it erases or *destroys* its reality which passes into the imaginary, but on the other hand it powerfully brings out all the reality which the imaginary or the mental *create* through speech and vision.[13] The imaginary and the real became indiscernible. Robbe-Grillet will become more and more conscious of this in his reflection on the *nouveau roman* and the cinema: the most objectivist determinants do not prevent their realizing a 'total subjectivity'. This is what was embryonic from the start of Italian neo-realism, and what makes Labarthe remark that *Last Year in Marienbad* is the last of the great neo-realist films.[14]

We can already see in Fellini that a particular image is clearly subjective, mental, a recollection or fantasy—but it is not organized into a spectacle without becoming objective, without going behind the scenes, into 'the reality of the spectacle, of those who make it, who live from it, who are absorbed in it': the mental world of a character is so filled up by other proliferating characters that it becomes inter-mental, and through flattening of perspectives ends 'in a neutral, impersonal vision . . . all our

---

[12]Antonioni, *Cinéma 58,* septembre 1958. And Leprohon's formulation, op. cit., p. 76: 'The story can only be read in filigree, through images which are consequences and no longer act.'

[13]Robbe-Grillet, 'Temps et description', *Pour un nouveau roman,* Editions de Minuit, p. 127 (English translation: *Snapshots, or Towards a New Novel,* trans. Barbara Wright, London: Calder & Boyars, 1965). We shall have frequent recourse to the theory of description in this text of Robbe-Grillet's.

[14]André Labarthe, *Cahiers du cinéma,* no. 123, septembre 1961.

world' (hence the importance of the telepath in 8½).[15] Conversely, in Antonioni, it is as if the most objective images are not formed without becoming mental, and going into a strange, invisible subjectivity. It is not merely that the method of report has to be applied to feelings as they exist in a society, and to draw from them such consequences as are internally developed in characters: Eros sick is a story of feelings which go from the objective to the subjective, and are internalized in everyone. In this respect, Antonioni is much closer to Nietzsche than to Marx; he is the only contemporary author to have taken up the Nietzschean project of a real critique of morality, and this thanks to a 'symptomatologist' method. But, from yet another point of view, it is noticeable that Antonioni's objective images, which impersonally follow a becoming, that is, a development of consequences in a story [récit], none the less are subject to rapid breaks, interpolations and 'infinitesimal injections of a-temporality': for example, the lift scene in *Story of a Love Affair*. We are returned once more to the first form of the any-space-whatever: disconnected space. The connection of the parts of space is not given, because it can come about only from the subjective point of view of a character who is, nevertheless, absent, or has even disappeared, not simply out of frame, but passed into the void. In *The Outcry,* Irma is not only the obsessive, subjective thought of the hero who runs away to forget, but the imaginary gaze under which this flight takes place and connects its own segments: a gaze which becomes real again at the moment of death. And above all in *The Adventure,* the vanished woman causes an indeterminable gaze to weigh on the couple—which gives them the continual feeling of being spied on, and which explains the lack of co-ordination of their objective movements, when they flee whilst pretending to look for her. Again in *Identification of a Woman,* the whole quest or investigation takes place under the presumed gaze of the departed woman, concerning whom we will not know, in the marvellous images at the end, whether or not she has seen the hero curled up in the lift cage. The imaginary gaze makes the real something imaginary, at the same time as it in turn becomes real and gives us back some reality. It is like a circuit which exchanges, corrects, selects and sends us off again. From *The Eclipse* onwards, the any-space-whatever had achieved a second form: empty or deserted space. What happened is that, from one result to the next, the characters were objectively emptied: they are suffering less from the absence of another than from their absence from themselves (for example, *The Passenger*). Hence, this space refers back again to the lost gaze of the being who is absent from the world as much as from himself, and, as Ollier says in a phrase which is true for the whole of Antonioni's work, replaces 'traditional drama with a kind of *optical drama* lived by the character'.[16]

In short, pure optical and sound situations can have two poles—objective and subjective, real and imaginary, physical and mental. But they give rise to opsigns and

[15]Amengual, op. cit., p. 22.

[16]Claude Ollier, *Souvenirs écran,* Cahiers du cinéma, Gallimard, p. 86. It is Ollier who analyses the breaks and injections in Antonioni's images, and the role of the imaginary gaze which gives parts of space continuity. The excellent analyses by Marie-Claire Ropars-Wuilleumier may also be referred to: she shows how Antonioni does not simply move from a disconnected space to an empty one, but, simultaneously, from a person who is suffering from the absence of another to a person who is suffering still more deeply from an absence in himself and in the world ('L'espace et le temps dans l'univers d'Antonioni', *Antonioni, Etudes cinématographiques,* pp. 22, 27–8, reprinted in *L'Ecran de la mémoire,* Seuil.

sonsigns, which bring the poles into continual contact, and which, in one direction or the other, guarantee passages and conversions, tending towards a point of indiscernibility (and not of confusion). Such a system of exchange between the imaginary and the real appears fully in Visconti's *White Nights*.[17]

The French new wave cannot be defined unless we try to see how it has retraced the path of Italian neo-realism for its own purposes—even if it meant going in other directions as well. In fact, the new wave, on a first approximation, takes up the previous route again: from a loosening of the sensory-motor link (the stroll or wandering, the ballad, the events which concern no one, etc.), to the rise of optical and sound situations. Here again, a cinema of seeing replaces action. If Tati belongs to the new wave, it is because, after two ballad-films, he fully isolates what was taking shape in these—a burlesque whose impetus comes from purely optical and, in particular, sound, situations. Godard begins with some extraordinary ballads, from *Breathless* to *Pierrot le fou,* and tends to draw out of them a whole world of opsigns and sonsigns which already constitute the new image (in *Pierrot le fou,* the passage from the sensory-motor loosening, 'I dunno what to do', to the pure poem sung and danced, 'the line of your hips'). And these images, touching or terrible, take on an ever greater autonomy after *Made in USA;* which may be summed up as follows: 'A witness providing us with a series of reports with neither conclusion nor logical connection . . . without really effective reactions.'[18] Claude Ollier says that, with *Made in USA,* the violently hallucinatory character of Godard's work is affirmed for itself, in an art of description which is always being renewed and always replacing its object.[19] This descriptive objectivism is just as critical and even didactic, sustaining a series of films, from *Two or Three Things I Know about Her,* to *Slow Motion,* where reflection is not simply focused on the content of the image but on its form, its means and functions, its falsifications and creativities, on the relations within it between the sound dimension and the optical. Godard has little patience with or sympathy for fantasies: *Slow Motion* will show us the decomposition of a sexual fantasy into its separate, objective elements, visual, and then of sound. But this objectivism never loses its aesthetic force. Initially serving a politics of the image, the aesthetic force is powerfully brought out for its own sake in *Passion:* the free build-up of pictorial and musical images as *tableaux vivants,* whilst at the other end the sensory-motor linkages are beset by inhibitions (the stuttering of the female worker and the boss's cough). *Passion,* in this sense, brings to its greatest intensity what was already taking shape in *Le Mépris,* when we witnessed the sensory-motor failure of the couple in the traditional drama, at the same time as the optical representation of the drama of Ulysses and the gaze of the gods, with Fritz Lang as the intercessor, was soaring upwards. Throughout all these films, there is a creative evolution which is that of a visionary Godard.

For Rivette, *Le pont du Nord* has exactly the same perfection of provisional summary as *Passion* for Godard. It is the ballad of two strange women strollers to whom a grand vision of the stone lions of Paris will present pure optical and sound situa-

---

[17]Cf. the analyses by Michel Esteve, 'Les nuits blanches ou le jeu du réel et de l'irréel', *Visconti, Etudes cinématographiques.*

[18]Sadoul, *Chroniques du cinéma français,* I, Paris: UGE, p. 370.

[19]Ollier, op. cit., pp. 23–4 (on the space in *Made in USA*).

tions, in a kind of malicious snakes and ladders where they replay the hallucinatory drama of Don Quixote. But, from the same starting-point, Rivette and Godard seem to mark out the two contrasting sides. This is because, with Rivette, the break in the sensory-motor situations—to the benefit of optical and sound situations—is connected to a knowing subjectivism, an empathy, which most frequently works through fantasies, memories, or pseudo-memories, and finds in them a unique gaiety and lightness (*Celine and Julie Go Boating* is certainly one of the greatest French comic films, along with the work of Tati). Whilst Godard drew inspiration from the strip cartoon at its most cruel and cutting, Rivette clothes his unchanging theme of an international conspiracy in an atmosphere of fable and children's games. Already in *Paris Belongs to Us,* the stroll culminates in a twilight fantasy where the cityscape has no reality or connections other than those given by our dream. And *Celine and Julie Go Boating,* after the stroll-pursuit of the girl with a double, has us witness the pure spectacle of her fantasy, a young girl whose life is threatened in a family novel. The double, or rather the woman double [*la double*], is herself present with the aid of magic sweets; then, thanks to the alchemical potion, she introduces herself into the spectacle which no longer has viewers, but only behind the scenes, and finally saves the child from her appointed fate as a little boat takes her off into the distance: there is no more cheerful a fairy-tale. *Twilight* does not even have to get us into the spectacle; the heroines of the spectacle, the solar woman and the lunar woman, who have already passed into the real, under the sign of the magic stone track down, make disappear or kill the surviving characters who would still be capable of being witnesses.

Rivette could be said to be the most French of the new wave authors. But 'French' here has nothing to do with what has been called the French quality. It is rather in the sense of the pre-war French school, when it discovers, following the painter Delaunay, that there is no struggle between light and darkness (expressionism), but an alternation and duel of the sun and the moon, which are both light, one constituting a circular, continuous movement of complementary colours, the other a faster and uneven movement of jarring, iridescent colours, the two together making up and projecting an eternal mirage on to the earth.[20] This is the case with *Twilight*. This is the case with *Merry-go-round,* where the description made of light and colours constantly begins again in order to obliterate its objects. Rivette takes this to the highest level in his art of light. All his heroines are daughters of fire, all his work is under this sign. In the end, if he is the most French of film-makers, it is in the sense that Gérard de Nerval could be called the supreme French poet, could even be called the 'Good Gerard', singer of the Ile de France, just like Rivette, singer of Paris and its rustic streets. When Proust asks himself what there is behind all these names that were applied to Nerval, he

---

[20]In Volume I we saw this special sense of light in the French pre-war school, particularly in Grémillon, but Rivette carries it to a higher level, picking up Delaunay's most elevated conceptions: 'In contrast to the cubists, Delaunay does not look for the secrets of renewal in the presentation of objects, or more precisely of light at the level of objects. He holds that light creates forms by itself, independently of its reflections on matter . . . If light destroys objective forms, what it brings with it is its order and movement . . . It is then that Delaunay discovers that the movements which enliven light are different depending on whether the sun or the moon is more prominent . . . With the two fundamental spectacles of light in movement he associates the image of the universe, in the form of the earthly globe presented as the locus of eternal mirages' (Pierre Francastel, *Du cubisme à l'art abstrait, Robert Delaunay,* Bibliothèque de l'Ecole pratique des hautes études, pp. 19–29).

replies that in fact it is some of the greatest poetry that there has been in the world, and madness itself or the mirage to which Nerval succumbed. For, if Nerval needs to see, and to walk in the Valois, he needs this like some reality which has to 'verify' his hallucinatory vision, to the point where we no longer have any idea what is present or past, mental or physical. He needs the Ile de France as the real that his speech and his vision create, as the objective in his pure subjectivity: a 'dream lightning', a 'bluish and purple atmosphere', solar and lunar.[21] The same goes for Rivette and his need of Paris. Here again, we have to conclude that the difference between the objective and the subjective has only a provisional, relative value, from the point of view of the optical-sound image. The most subjective, the knowing subjectivism of Rivette, is utterly objective, because it creates the real through the force of visual description. And conversely what is most objective, Godard's critical objectivism, was already completely subjective, because in place of the real object it put visual description, and made it go 'inside' the person or object (*Two or Three Things I Know about Her*).[22] On both sides, description tends towards a point of indiscernibility of the real and the imaginary.

A final question: why does the collapse of traditional sensory-motor situations, in the form these had in the old realism or in the action-image, allow only pure optical and sound situations, opsigns and sonsigns, to emerge? It will be noted that Robbe-Grillet, at least at the beginning of his reflections, was even harsher: he renounced not merely the tactile, but even sounds and colours as inept for the report, too tied to emotions and reactions, and he kept only visual descriptions which operated through lines, surfaces and sizes.[23] The cinema was one of the causes of his evolution, because it made him discover the descriptive power of colour and sounds, as these replace, obliterate and re-create the object itself. But, even more, it is the tactile which can constitute a pure sensory image, on condition that the hand relinquishes its prehensile and motor functions to content itself with a pure touching. In Herzog, we witness an extraordinary effort to present to the view specifically tactile images which characterize the situation of 'defenceless' beings, and unite with the grand visions of those suffering from hallucinations.[24] But it is Bresson, in a quite different way, who makes touch an object of view in itself. Bresson's visual space is fragmented and disconnected, but its parts have, step by step, a manual continuity. The hand, then, takes on a role in the image which goes infinitely beyond the sensory-motor demands of the action, which takes the place of the face itself for the purpose of affects, and which, in the area of perception, becomes the mode of construction of a space which is

[21]Proust, *Against Sainte-Beuve* 'Gérard de Nerval'. Proust ends his analysis by noting that a mediocre dreamer is not going to see again the places that he has caught in his dream, since it is only a dream, whilst a true dreamer goes there all the more because it is a dream.

[22]Godard already said in relation to *Vivre sa vie* that 'the external side of things' must allow 'the feeling of inside' to be given: 'How do we do the inside? Well, precisely by staying prudently outside', like the painter. And Godard presents *Two or Three Things . . .* as adding a 'subjective description' to the 'objective description' to give a 'feeling of a whole' (*Jean-Luc Godard par Jean-Luc Godard*, Belfond, pp. 394–5.

[23]Robbe-Grillet, op. cit., p. 66.

[24]Emmanuel Carrère has clearly demonstrated this 'attempt to approach tactile sensations' (*Werner Herzog*, Edilig, p. 25): not only in *Land of Silence and Darkness*, which puts before us some deaf and blind people, but in *Kaspar Hauser* which has grand dream-visions coexisting with little tactile gestures (for instance, the pressure of the thumb and fingers when Kaspar forces himself to think).

adequate to the decisions of the spirit. Thus, in *Pickpocket,* it is the hands of the three accomplices which connect the parts of space in the Gare de Lyon, not exactly through their seizing an object, but through brushing it, arresting it in its movement, giving it another direction, passing it on and making it circulate in this space. The hand doubles its prehensile function (of object) by a connective function (of space); but, from that moment, it is the whole eye which doubles its optical function by a specifically 'grabbing' [*haptique*] one, if we follow Riegl's formula for indicating a touching which is specific to the gaze. In Bresson, opsigns and sonsigns cannot be separated from genuine tactisigns which perhaps regulate their relations (this is the originality of Bresson's any-space-whatevers).

<div align="center">2</div>

Although he was subject, from the outset, to the influence of certain American authors, Ozu built up in a Japanese context a body of work which was the first to develop pure optical and sound situations (even so he came quite late to the talkie, in 1936). The Europeans did not imitate him, but came back to him later via their own methods. He none the less remains the inventor of opsigns and sonsigns. The work borrows a trip/ballad [*bal(l)ade*] form, train journey, taxi ride, bus trip, a journey by bicycle or on foot: the grandparents' return journey from the provinces to Tokyo, the girl's last holiday with her mother, an old man's jaunt . . . But the object is everyday banality taken as family life in the Japanese house. Camera movements take place less and less frequently: tracking shots are slow, low 'blocs of movement'; the always low camera is usually fixed, frontal or at an unchanging angle: dissolves are abandoned in favour of the simple *cut.*[25] What might appear to be a return to 'primitive cinema' is just as much the elaboration of an astonishingly temperate modern style: the montage-cut, which will dominate modern cinema, is a purely optical passage or punctuation between images, working directly, sacrificing all synthetic effects. The sound is also affected, since the montage-cut may culminate in the 'one shot, one line' procedure borrowed from American cinema. But there, for instance, in Lubitsch, it was a matter of an action-image functioning as an index, whereas Ozu modifies the meaning of the procedure, which now shows the absence of plot: the action-image disappears in favour of the purely visual image of what a character *is,* and the sound image of what he *says,* completely banal nature and conservation constituting the essentials of the script (this is why the only things that count are the choice of actors according to their physical and moral appearance, and the establishment of any dialogue whatever, apparently without a precise subject-matter.[26]

---

[25]Donald Richie, *Ozu,* Editions Lettre du Blanc: 'When he was about to get down to the script-writing, confident of his list of themes, he rarely wondered what the story was going to be. He asked himself instead which people were to occupy his film . . . A name was assigned to each character along with an arsenal of general characteristics appropriate to his family situation, father, daughter, aunt, but few recognizable traits. This character would grow, or rather the dialogue that gave him life would grow . . . beyond all reference to the plot or story . . . Although the opening scenes are always full of dialogue, the dialogue seems to turn on no particular subject . . . The character was thus constructed and modelled almost exclusively by virtue of the conversations he had' (pp. 15–26). And, on the 'one shot, one line' principle, cf. pp. 143–5.

[26]Paul Schrader, *Transcendental Style in Film: Ozu, Bresson, Dreyer* (extracts in *Cahiers du cinéma,* no. 286, mars 1978).

It is clear that this method immediately presents idle periods, and leads to their increase in the course of the film. Of course, as the film proceeds, it might be thought that the idle periods are no longer important simply for themselves but recoup the effect of something important: the shot or the line would, on this view, be extended by a quite long silence or emptiness. But it is definitely not the case, with Ozu, that we get the remarkable *and* the ordinary, limit-situations *and* banal ones, the former having an effect on, or purposely insinuating themselves into, the latter. We cannot follow Paul Schrader when he contrasts, like two phases, 'the everyday' on one hand, and, on the other, 'the moment of decision', 'the disparity', which introduce an inexplicable break or emotion into daily banality.[27] This distinction would seem strictly more valid for neo-realism. In Ozu, everything is ordinary or banal, even death and the dead who are the object of a natural forgetting. The famous scenes of sudden tears (that of the father in *An Autumn Afternoon* who starts to weep silently after his daughter's wedding, that of the daughter in *Late Spring* who half smiles as she looks at her sleeping father, then finds herself on the verge of tears, that of the daughter in *Dernier caprice* who makes a sharp comment about her dead father, then bursts into tears) do not mark out a strong period which might be contrasted with the weak periods in the flow of life, and there is no reason to suggest the emergence of a repressed emotion as 'decisive action'.

The philosopher Leibniz (who was not unaware of the existence of the Chinese philosophers) showed that the world is made up of series which are composed and which converge in a very regular way, according to ordinary laws. However, the series and sequences are apparent to us only in small sections, and in a disrupted or mixed-up order, so that we believe in breaks, disparities and discrepancies as in things that are out of the ordinary. Maurice Leblanc wrote a very good serial which comes close to a Zen kind of wisdom: the hero, Balthazar, 'professor of everyday philosophy', teaches that there is nothing remarkable or exceptional in life, that the oddest adventures are easily explained, and that everything is made up of ordinary things.[28] It is just that we have to admit that, because the linkages of the terms in the series are naturally weak, they are constantly upset and do not appear in order. An ordinary term goes out of sequence, and emerges in the middle of another sequence of ordinary things in relation to which it takes on the appearance of a strong moment, a remarkable or complex point. It is men who upset the regularity of series, the continuity of the universe. There is a time for life, a time for death, a time for the mother, a time for the daughter, but men mix them up, make them appear in disorder, set them up in conflicts. This is Ozu's thinking: life is simple, and man never stops complicating it by 'disturbing still water' (as in the three companions in *Late Autumn*). And if, after the war, Ozu's work does not at all fall into the decline that has sometimes been suggested, it is because the postwar period helps confirm this thinking, but by renewing it, by reinforcing and going beyond the theme of conflicting generations: American ordinariness helps break down what is ordinary about Japan, a clash of two everyday realities which is even expressed in colour, when Coca-Cola red or plastic yellow violently interrupt the series of

---

[27]Maurice Leblanc, *La vie extravagante de Balthazar,* Le Livre de Poche.
[28]On colour in Ozu, see the remarks of Renaud Bezombes, *Cinématographe,* no. 41, novembre 1978, p. 47, and no. 52, novembre 1979, p. 58.

washed-out, unemphatic tones of Japanese life.[29] And, as the character says in *The Flavour of Green Tea over Rice:* what if the opposite had occurred, if saki, samisen and geisha wigs had suddenly been introduced into the everyday banality of Americans . . . ? On this point it seems to us that nature does not, as Schrader believes, intervene in a decisive moment or in a clear break with everyday man. The splendour of nature, of a snow-covered mountain, tells us one thing only: everything is ordinary and regular, everything is everyday! Nature is happy to renew what man has broken, she restores what man sees shattered. And, when a character emerges for a moment from a family conflict or a wake to contemplate the snow-covered mountain, it is as if he were seeking to restore to order the series upset in his house but reinstated by an unchanging, regular nature, as in an equation that provides us with the reason for apparent breaks, 'for the turns and returns, the highs and the lows', as Leibniz puts it.

Daily life allows only weak sensory-motor connections to survive, and replaces the action-image by pure optical and sound images, opsigns and sonsigns. In Ozu, there is no universal line which connects moments of decision, and links the dead to the living, as in Mizoguchi; nor is there any breathing space or encompasser to contain a profound question, as in Kurosawa. Ozu's spaces are raised to the state of any-space-whatevers, whether by disconnection, or vacuity (here again Ozu may be considered one of the first inventors). The false continuity of gaze, of direction and even of the position of objects are constant and systematic. One case of camera movement gives a good example of disconnection: in *Early Summer,* the heroine goes forward on tiptoe to surprise someone in a restaurant, the camera drawing back in order to keep her in the centre of the frame; then the camera goes forward to a corridor, but this corridor is no longer in the restaurant, it is in the house of the heroine who has already returned home. As for the empty spaces, without characters or movement, they are interiors emptied of their occupants, deserted exteriors or landscapes in nature. In Ozu they take on an autonomy which they do not immediately possess even in neo-realism, which accords them an apparent value which is relative (in relation to a story) or consequential (once the action is done with). They reach the absolute, as instances of pure contemplation, and immediately bring about the identity of the mental and the physical, the real and the imaginary, the subject and the object, the world and the I. They correspond in part to what Schrader calls 'cases of stasis', Noël Burch 'pillow-shots', Richie 'still lifes'. The question is to know whether there is not all the same a distinction to be made at the centre of this category itself.[30]

Between an empty space or landscape and a still life properly so called there are certainly many similarities, shared functions and imperceptible transitions. But it is not the same thing; a still life cannot be confused with a landscape. An empty space owes its importance above all to the absence of a possible content, whilst the still life is defined by the presence and composition of objects which are wrapped up in themselves or become their own container: as in the long shot of the vase almost at the end

---

[29]Reference should be made to Noël Burch's fine analysis of the 'pillow shot' and its functions: suspension of human presence, passage to the inanimate, but also reverse passage, pivot, emblem, contribution to the flatness of the image, pictorial composition (*Pour un observateur lointain,* Cahiers du cinéma Gallimard, pp. 175–86). We simply wonder if there is not room to distinguish two different things in these 'pillow shots'. Similarly for what Richie calls 'still lifes', pp. 164–70.

[30]Dôgen, *Shôbogenzo,* Editions de la Différence.

of *Late Spring*. Such objects are not necessarily surrounded by a void, but may allow characters to live and speak in a certain soft focus, like the still life with vase and fruit in *The Woman of Tokyo,* or the one with fruit and golf-clubs in *What Did the Lady Forget?* It is like Cézanne, the landscapes—empty or with gaps—do not have the same principles of composition as the full still lifes. There comes a point when one hesitates between the two, so completely can their functions overlap each other and so subtle are the transitions that can be made: for instance, in Ozu, the marvellous composition with the bottle and the lighthouse, at the beginning of *A Story of Floating Weeds.* The distinction is none the less that of the empty and the full, which brings into play all the nuances or relations in Chinese and Japanese thought, as two aspects of contemplation. If empty spaces, interiors or exteriors, constitute purely optical (and sound) situations, still lifes are the reverse, the correlate.

The vase in *Late Spring* is interposed between the daughter's half smile and the beginning of her tears. There is becoming, change, passage. But the form of what changes does not itself change, does not pass on. This is time, time itself, 'a little time in its pure state': a direct time-image, which gives what changes the unchanging form in which the change is produced. The night that changes into day, or the reverse, recalls a still life on which light falls, either fading or getting stronger (*That Night's Wife, Passing Fancy*). The still life is time, for everything that changes is in time, but time does not itself change, it could itself change only in another time, indefinitely. At the point where the cinematographic image most directly confronts the photo, it also becomes most radically distinct from it. Ozu's still lifes endure, have a duration, over ten seconds of the vase: this duration of the vase is precisely the representation of that which endures, through the succession of changing states. A bicycle may also endure; that is, represent the unchanging form of that which moves, so long as it is at rest, motionless, stood against the wall (*A Story of Floating Weeds*). The bicycle, the vase and the still lifes are the pure and direct images of time. Each is time, on each occasion, under various conditions of that which changes in time. Time is the full, that is, the unalterable form filled by change. Time is 'the visual reserve of events in their appropriateness'.[31] Antonioni spoke of 'the horizon of events', but noted that in the West the word has a double meaning, man's banal horizon and an inaccessible and always receding cosmological horizon. Hence the division of western cinema into European humanism and American science fiction.[32] He suggested that it is not the same for the Japanese, who are hardly interested in science fiction: one and the same horizon links the cosmic to the everyday, the durable to the changing, one single and identical time as the unchanging form of that which changes. It is in this way that nature or stasis was defined, according to Schrader, as the form that links the everyday in 'something unified and permanent'. There is no need at all to call on a transcendence. In everyday banality, the action-image and even the movement-image tend to disappear in favour of pure optical situations, but these reveal connections of a new type, which are no longer sensory-motor and which bring the emancipated

[31]Cf. Antonioni, 'The horizon of events' (*Cahiers du cinéma*, no. 290, juillet 1978, p. 11) which insists on European dualism. And, in a later interview, he returns briefly to this theme, pointing out that the Japanese raise the problem differently (no. 342, décembre 1982).

[32]Paul Rozenberg sees in this the essence of English romanticism: *Le romantisme anglais,* Larousse.

senses into direct relation with time and thought. This is the very special extension of the opsign: to make time and thought perceptible, to make them visible and of sound.

## 3

A purely optical and sound situation does not extend into action, any more than it is induced by an action. It makes us grasp, it is supposed to make us grasp, something intolerable and unbearable. Not a brutality as nervous aggression, an exaggerated violence that can always be extracted from the sensory-motor relations in the action-image. Nor is it a matter of scenes of terror, although there are sometimes corpses and blood. It is a matter of something too powerful, or too unjust, but sometimes also too beautiful, and which henceforth outstrips our sensory-motor capacities. *Stromboli*: a beauty which is too great for us, like too strong a pain. It can be a limit-situation, the eruption of the volcano, but also the most banal, a plain factory, a wasteland. In Godard's *Les carabiniers* the girl militant recites a few revolutionary slogans, so many clichés; but she is so beautiful, of a beauty which is unbearable for her torturers who have to cover up her face with a handkerchief. And this handkerchief, lifted again by breath and whisper ('Brothers, brothers, brothers . . .'), itself becomes unbearable for us the viewers. In any event something has become too strong in the image. Romanticism had already set out this aim for itself: grasping the intolerable or the unbearable, the empire of poverty, and thereby becoming visionary, to produce a means of knowledge and action out of pure vision.[33]

Nevertheless, are there not equal amounts of fantasy and dreaming in what we claim to see as there are of objective apprehending? Moreover, do we not have a subjective sympathy for the unbearable, an empathy which permeates what we see? But this means that the unbearable itself is inseparable from a revelation or an illumination, as from a third eye. Fellini has strong sympathies with decadence, only in so far as he prolongs it, extends its range, 'to the intolerable', and reveals beneath the movements, faces and gestures a subterranean or extra-terrestrial world, 'the tracking shot becoming a means of peeling away, proof of the unreality of movement', and the cinema becoming, no longer an undertaking of recognition [*reconnaisance*], but of knowledge [*connaisance*], 'a science of visual impressions, forcing us to forget our own logic and retinal habits'.[34] Ozu himself is not the guardian of traditional or reactionary values, he is the greatest critic of daily life. He picks out the intolerable from the insignificant itself, provided that he can extend the force of a contemplation that is full of sympathy or pity across daily life. The important thing is always that the character or the viewer, and the two together, become visionaries. The purely optical and sound situation gives rise to a seeing function, at once fantasy and report, criticism and compassion, whilst sensory-motor situations, no matter how violent, are directed to a pragmatic visual function which 'tolerates' or 'puts up with' practically anything, from the moment it becomes involved in a system of actions and reactions.

---

[33]J. M. G. Le Clezio, 'The extra-terrestrial', in 'Fellini', *L'Arc*, no. 45, p. 28.

[34]On Marxist criticism on the evolution of neo-realism and its characters, cf. *Le néo-réalisme, Etudes cinématographiques,* p. 102. And on Marxist criticism in Japan, especially against Ozu, cf. Noël Burch, op. cit., p. 283. It must be emphasized that in France the new wave, in its visionary aspect, was deeply understood by Sadoul.

In Japan and Europe, Marxist critics have attacked these films and their characters for being too passive and negative, in turn bourgeois, neurotic or marginal, and for having replaced modifying action with a 'confused' vision. And it is true that, in cinema, characters of the trip/ballad are unconcerned, even by what happens to them: whether in the style of Rossellini, the foreign woman who discovers the island, the bourgeoise woman who discovers the factory; or in the style of Godard, the Pierrot-le-fou generation. But it is precisely the weakness of the motor-linkages, the weak connections, that are capable of releasing huge forces of disintegration. These are the characters with a strange vibrance in Rossellini, strangely well-informed in Godard and Rivette. In the west as in Japan, they are in the grip of a mutation, they are themselves mutants. On the subject of *Two or Three Things . . .* , Godard says that *to describe* is to observe mutations.[35] Mutation of Europe after the war, mutation of an Americanized Japan, mutation of France in '68: it is not the cinema that turns away from politics, it becomes completely political, but in another way. One of the two women strollers in Rivette's *Pont du Nord* has all the characteristics of an unforeseeable mutant: she has at first the capacity of detecting the Maxes, the members of the organization for enslaving the world, before going through a metamorphosis inside a cocoon, then being drafted into their ranks. Similarly with the ambiguity of the *Petit soldat*. A new type of character for a new cinema. It is because what happens to them does not belong to them and only half concerns them, because they know how to extract from the event the part that cannot be reduced to what happens: that part of inexhaustible possibility that constitutes the unbearable, the intolerable, the visionary's part. A new type of actor was needed: not simply the non-professional actors that neo-realism had revived at the beginning, but what might be called professional non-actors, or, better, 'actor-mediums', capable of seeing and showing rather than acting, and either remaining dumb or undertaking some never-ending conversation, rather than of replying or following a dialogue (such as, in France, Bulle Ogier or Jean-Pierre Léaud).[36]

Neither everyday nor limit-situations are marked by anything rare or extraordinary. It is just a volcanic island of poor fishermen. It is just a factory, a school . . . We mix with all that, even death, even accidents, in our normal life or on holidays. We see, and we more or less experience, a powerful organization of poverty and oppression. And we are precisely not without sensory-motor schemata for recognizing such things, for putting up with and approving of them and for behaving ourselves subsequently, taking into account our situation, our capabilities and our tastes. We have schemata for turning away when it is too unpleasant, for prompting resignation when it is terrible and for assimilating when it is too beautiful. It should be pointed out here that even metaphors are sensory-motor evasions, and furnish us with something to say when we no longer know what do to: they are specific schemata of an affective nature. Now this is what a cliché is. A cliché is a sensory-motor image of the thing. As Bergson says, we do not perceive the thing or the image in its entirety, we always perceive less of it, we perceive only what we are interested in perceiving, or rather

---

[35]Cf. *Jean-Luc Godard par Jean-Luc Godard*, p. 392.
[36]Marc Chevrie analyses Jean-Pierre Léaud's playing as 'medium' in terms close to Blanchot's (*Cahiers du cinéma*, no. 351, septembre 1983, pp. 31–3).

what it is in our interest to perceive, by virtue of our economic interests, ideological beliefs and psychological demands. We therefore normally perceive only clichés. But, if our sensory-motor schemata jam or break, then a different type of image can appear: a pure optical-sound image, the whole image without metaphor, brings out the thing in itself, literally, in its excess of horror or beauty, in its radical or unjustifiable character, because it no longer has to be 'justified', for better or for worse . . . The factory creature gets up, and we can no longer say 'Well, people have to work . . .' *I thought I was seeing convicts:* the factory is a prison, school is a prison, literally, not metaphorically. You do not have the image of a prison following one of a school: that would simply be pointing out a resemblance, a confused relation between two clear images. On the contrary, it is necessary to discover the separate elements and relations that elude us at the heart of an unclear image: to show *how and in what sense* school is a prison, housing estates are examples of prostitution, bankers killers, photographs tricks—literally, without metaphor.[37] This is the method of Godard's *Comment ça va:* not being content to enquire if 'things are OK' or if 'things are not OK' between two photos, but 'how are things' [*comment ça va*] for each one and for the two together. This was the problem with which Volume 1 ended: tearing a real image from clichés.

On the one hand, the image constantly sinks to the state of cliché: because it is introduced into sensory-motor linkages, because it itself organizes or induces these linkages, because we never perceive everything that is in the image, because it is made for that purpose (so that we do not perceive everything, so that the cliché hides the image from us . . . ). Civilization of the image? In fact, it is a civilization of the cliché where all the powers have an interest in hiding images from us, not necessarily in hiding the same thing from us, but in hiding something in the image. On the other hand, at the same time, the image constantly attempts to break through the cliché, to get out of the cliché. There is no knowing how far a real image may lead: the importance of becoming visionary or seer. A change of conscience or of heart is not enough (although there is some of this, as in the heroine's heart in *Europe 51,* but, if there were nothing more, everything would quickly return to the state of cliché, other clichés would simply have been added on). Sometimes it is necessary to restore the lost parts, to rediscover everything that cannot be seen in the image, everything that has been removed to make it 'interesting'. But sometimes, on the contrary, it is necessary to make holes, to introduce voids and white spaces, to rarify the image, by suppressing many things that have been added to make us believe that we were seeing everything. It is necessary to make a division or make emptiness in order to find the whole again.

What is difficult is to know in what respect an optical and sound image is not itself a cliché, at best a photo. We are not thinking simply of the way in which these images provide more cliché as soon as they are repeated by authors who use them as formulas. But is it not the case that the creators themselves sometimes have the idea that the

---

[37]Criticism of metaphor is equally present in the new wave, with Godard, and in the new novel with Robbe-Grillet (*Pour un nouveau roman*). It is true that, more recently, Godard has taken inspiration from a metaphorical form, for instance, in the case of *Passion:* 'The knights are metaphors for the bosses' (*Le Monde,* 27 mai 1982), but, as we shall see, this form draws on a genetic and chronological analysis of the image, much more than on a synthesis or comparison of images.

new image has to stand up against the cliché on its own ground, make a higher bid than the postcard, add to it and parody it, as a better way of getting over the problem (Robbe-Grillet, Daniel Schmid)? The creators invent obsessive framings, empty or disconnected spaces, even still lifes: in a certain sense they stop movement and rediscover the power of the fixed shot, but is this not to resuscitate the cliché that they aim to challenge? Enough, for victory, to parody the cliché, not to make holes in it and empty it. It is not enough to disturb the sensory-motor connections. It is necessary to *combine* the optical-sound image with the enormous forces that are not those of a simply intellectual consciousness, nor of the social one, but of a profound, vital intuition.[38]

Pure optical and sound images, the fixed shot and the montage-cut, do define and imply a beyond of movement. But they do not strictly stop it, neither in the characters nor even in the camera. They mean that movement should not be perceived in a sensory-motor image, but grasped and thought in another type of image. The movement-image has not disappeared, but now exists only as the first dimension of an image that never stops growing in dimensions. We are not talking about dimensions of space, since the image may be flat, without depth, and through this very fact assumes all the more dimensions or powers which go beyond space. Three of these growing powers can be briefly summarized. First, while the movement-image and its sensory-motor signs were in a relationship only with an indirect image *of* time (dependent on montage), the pure optical and sound image, its opsigns and sonsigns, are directly connected to a time-image which has subordinated movement. It is this reversal which means that time is no longer the measure of movement but movement is the perspective of time: it constitutes a whole cinema of time, with a new conception and new forms of montage (Welles, Resnais). In the second place, at the same time as the eye takes up a clairvoyant function, the sound as well as visual elements of the image enter into internal relations which means that the whole image has to be 'read', no less than seen, readable as well as visible. For the eye of the seer as of the soothsayer, it is the 'literalness' of the perceptible world which constitutes it like a book. Here again all reference of the image of description to an object assumed to be independent does not disappear, but is now subordinated to the internal elements and relations which tend to replace the object and to delete it where it does appear, continually displacing it. Godard's formula, 'it isn't blood, it's some red', stops being only pictural and takes on a sense specific to the cinema. The cinema is going to become an analytic of the image, implying a new conception of cutting, a whole 'pedagogy' which will operate in different ways; for instance, in Ozu's work, in Rossellini's late period, in Godard's middle period, or in the Straubs. Finally, the fixity of the camera does not represent the only alternative to movement. Even when it is mobile, the camera is no longer content sometimes to follow the characters' movement, sometimes itself to undertake movements of which they are merely the object, but in every case it subordinates description of a space to the functions of thought.

---

[38]D. H. Lawrence wrote an important piece in support of the image and against clichés in relation to Cézanne. He shows how parody is not a solution; and neither is the pure optical image, with its voids and disconnections. According to him, it is in the still lifes that Cézanne wins his battle against clichés, rather than in the portraits and landscapes ('Introduction to these paintings', *Eros et le chiens,* Bourgois, pp. 253–64). We have seen how the same remarks applied to Ozu.

This is not the simple distinction between the subjective and the objective, the real and the imaginary, it is on the contrary their indiscernibility which will endow the camera with a rich array of functions, and entail a new conception of the frame and reframings. Hitchcock's premonition will come true: a camera-consciousness which would no longer be defined by the movements it is able to follow or make, but by the mental connections it is able to enter into. And it becomes questioning, responding, objecting, provoking, theorematizing, hypothesizing, experimenting, in accordance with the open list of logical conjunctions ('or', 'therefore', 'if', 'because', 'actually', 'although . . .'), or in accordance with the functions of thought in a *cinéma-vérité*, which, as Rouch says, means rather truth of cinema [*vérité du cinéma*].

This is the triple reversal which defines a beyond of movement. The image had to free itself from sensory-motor links; it had to stop being action-image in order to become a pure optical, sound (and tactile) image. But the latter was not enough: it had to enter into relations with yet other forces, so that it could itself escape from a world of clichés. It had to open up to powerful and direct revelations, those of the time-image, of the readable image and the thinking image. It is in this way that opsigns and sonsigns refer back to 'chronosigns', 'lectosigns' and 'noosigns'.[39]

Antonioni, considering the evolution of neo-realism in relation to *Outcry*, said that he was tending to do without a bicycle—De Sica's bicycle, naturally. Bicycle-less neo-realism replaces the last quest involving movement (the trip) with a specific weight of time operating inside characters and excavating them from within (the chronicle).[40] Antonioni's art is like the intertwining of consequences, of temporal sequences and effects which flow from events out-of-field. Already in *Story of a Love Affair* the investigation has the result, of itself, of provoking the outcome of a first love affair, and the effect of making two oaths of murder ring out in the future and in the past. It is a whole world of chronosigns, which would be enough to cast doubt on the false evidence according to which the cinematographic image is necessarily in the present. If we are sick with Eros, Antonioni said, it is because Eros is himself sick; and he is sick not just because he is old and worn out in his content, but because he is caught in the pure form of a time which is torn between an already determined past and a dead-end future. For Antonioni, there is no other sickness than the chronic. Chronos is sickness itself. This is why chronosigns are inseparable from lectosigns, which force us to read so many symptoms in the image, that is, to treat the optical and sound image like something that is also readable. Not only the optical and the sound, but the present and the past, and the here and the elsewhere, constitute internal elements and relations which must be deciphered, and can be understood only in a progression analogous to that of a reading: from *Story of a Love Affair*, indeterminate spaces are given a scale only later on, in which Burch calls a 'continuity grasped

---

[39]'Lectosign' refers to the Greek *lekton* or Latin *dictum*, which indicates what is expressed in a proposition independent of the relationship of this to its object. Similarly for the image when it is captured intrinsically, independent of its relationship with a supposedly external object.

[40]Text of Antonioni's quoted by Leprohon, op. cit., p. 103: 'Now that we have today eliminated the problem of the bicycle (I am using a metaphor, try to understand beyond my words), it is important to see what there is in the spirit and heart of this man whose bicycle has been stolen, how he has adapted, what has stayed with him out of all his past experiences of the war, the post-war and everything that has happened in our country.' (And the text on Eros sick, pp. 104–6.)

through discrepancy' [*raccord à appréhension décalée*], closer to a reading than to a perception.[41] And later, Antonioni the colourist would be able to treat variations of colours as symptoms, and monochrome as the chronic sign which wins a world, thanks to a whole play of deliberate modifications. But *Story of a Love Affair* already exhibits a 'camera autonomy' when it stops following the movement of the characters or directing its own movement at them, to carry out constant reframings as functions of thought, noosigns expressing the logical conjunctions of sequel, consequence, or even intention.

1985

---

[41]Noël Burch is one of the first critics to have shown that the cinematographic image ought to be read no less than seen and heard; and this in connection with Ozu (*Pour un observateur lointain,* p. 175). But already in *Praxis du cinéma* Burch showed how *Story of a Love Affair* inaugurated a new relation between story and action, and gave the camera an 'autonomy', rather like that of a reading pp. 112–18; and on the 'continuity grasped through discrepancy', p. 47).

# STEPHEN PRINCE
# TRUE LIES: PERCEPTUAL REALISM, DIGITAL IMAGES, AND FILM THEORY

Digital imaging technologies are rapidly transforming nearly all phases of contemporary film production. Film-makers today storyboard, shoot, and edit their films in conjunction with the computer manipulation of images. For the general public, the most visible application of these technologies lies in the new wave of computer-generated and -enhanced special effects that are producing images—the watery creature in *The Abyss* (1989) or the shimmering, shape-shifting *Terminator 2* (1991)—unlike any seen previously.

The rapid nature of these changes is creating problems for film theory. Because the digital manipulation of images is so novel and the creative possibilities it offers are so unprecedented, its effects on cinematic representation and the viewer's response are poorly understood. Film theory has not yet come to terms with these issues. What are the implications of computer-generated imagery for representation in cinema, particularly for concepts of photographically based realism? How might theory adapt to an era of digital imaging?

Initial applications of special-effects digital imaging in feature films began more than a decade ago in productions like *Tron* (1982), *Star Trek II: The Wrath of Khan* (1982), and *The Last Starfighter* (1984). The higher-profile successes of *Terminator 2, Jurassic Park* (1993), and *Forrest Gump* (1994), however, dramatically demonstrated the creative and remunerative possibilities of computer-generated imagery (CGI).

Currently, two broad categories of digital imaging exist. Digital-image processing covers applications like removing unwanted elements from the frame—hiding the wires supporting the stunt performers in *Cliffhanger* (1994), or erasing the Harrier jet

Thanks to Carl Plantinga and Mark J. P. Wolf for their helpful suggestions on an early version of this paper.

from shots in *True Lies* (1994) where it accidentally appears. CGI proper refers to building models and animating them in the computer. Don Shay, editor of *Cinefex,* a journal that tracks and discusses special-effects work in cinema, emphasizes these distinctions between the categories.[1]

As a consequence of digital imaging, *Forrest Gump* viewers saw photographic images of actor Gary Sinise, playing Gump's amputee friend and fellow Vietnam veteran, being lifted by a nurse from a hospital bed and carried, legless, through three-dimensional space. The film viewer is startled to realize that the representation does not depend on such old-fashioned methods as tucking or tieing the actor's limbs behind his body and concealing this with a loose-fitting costume. Instead, Sinise's legs had been digitally erased from the shot by computer.

Elsewhere in the same film, viewers saw photographic images of President Kennedy speaking to actor Tom Hanks, with dialogue scripted by the film's writers. In the most widely publicized applications of CGI, viewers of Steven Spielberg's *Jurassic Park* watched photographic images of moving, breathing, and chomping dinosaurs, images which have no basis in any photographable reality but which nevertheless seemed realistic. In what follows, I will be assuming that viewers routinely make assessments about the perceived realism of a film's images or characters, even when these are obviously fictionalized or otherwise impossible. Spielberg's dinosaurs made such a huge impact on viewers in part because they seemed far more life-like than the miniature models and stop-motion animation of previous generations of film.

The obvious paradox here—creating credible photographic images of things which cannot be photographed—and the computer-imaging capabilities which lie behind it challenge some of the traditional assumptions about realism and the cinema which are embodied in film theory. This essay first explores the challenge posed by CGI to photographically based notions of cinematic realism. Next, it examines some of the problems and challenges of creating computer imagery in motion pictures by drawing on interviews with computer-imaging artists. Finally, it develops an alternate model, based on perceptual and social correspondences, of how the cinema communicates and is intelligible to viewers. This model may produce a better integration of the tensions between realism and formalism in film theory. As we will see, theory has construed realism solely as a matter of reference rather than as a matter of perception as well. It has neglected what I will term in this essay "perceptual realism." This neglect has prevented theory from understanding some of the fundamental ways in which cinema works and is judged credible by viewers.

Assumptions about realism in the cinema are frequently tied to concepts of indexicality prevailing between the photographic image and its referent. These, in turn, constitute part of the bifurcation between realism and formalism in film theory. In order to understand how theories about the nature of cinematic images may change in the era of digital-imaging practices, this bifurcation and these notions of an indexically based film realism need to be examined.

This approach to film realism—and it is, perhaps, the most basic theoretical understanding of film realism—is rooted in the view that photographic images, unlike paintings or line drawings, are indexical signs: they are causally or existentially connected

---

[1]Telephone interview with the author, October 19, 1994.

to their referents. Charles S. Peirce, who devised the triadic model of indexical, iconic, and symbolic signs, noted that "Photographs, especially instantaneous photographs, are very instructive, because we know that in certain respects they are exactly like the objects they represent . . . they . . . correspond point by point to nature. In that respect then, they belong to the second class of signs, those by physical connection."[2]

In his analysis of photography, Roland Barthes noted that photographs, unlike every other type of image, can never be divorced from their referents. Photograph and referent "are glued together."[3] For Barthes, photographs are causally connected to their referents. The former testifies to the presence of the latter. "I call 'photographic referent' not the *optionally* real thing to which an image or sign refers but the *necessarily* real thing which has been placed before the lens without which there would be no photograph."[4] For Barthes, "Every photograph is a certificate of presence."[5]

Because cinema is a photographic medium, theorists of cinema developed concepts of realism in connection with the indexical status of the photographic sign. Most famously, André Bazin based his realist aesthetic on what he regarded as the "objective" nature of photography, which bears the mechanical trace of its referents. In a well-known passage, he wrote, "The photographic image is the object itself, the object freed from the conditions of time and space which govern it. No matter how fuzzy, distorted, or discolored, no matter how lacking in documentary value the image may be, it shares, by virtue of the very process of its becoming, the being of the model of which it is the reproduction; it *is* the model."[6]

Other important theorists of film realism emphasized the essential attribute cinema shares with photography of being a recording medium. Siegfried Kracauer noted that his theory of cinema, which he subtitled "the redemption of physical reality," "rests upon the assumption that film is essentially an extension of photography and therefore shares with that medium a marked affinity for the visible world around us. Films come into their own when they record and reveal physical reality."[7] Like Bazin, Stanley Cavell emphasized that cinema is the screening or projection of reality because of the way that photography, whether still or in motion, mechanically (that is, automatically) reproduces the world before the lens.[8]

For reasons that are alternately obvious and subtle, digital imaging in its dual modes of image processing and CGI challenges indexically based notions of photographic realism. As Bill Nichols has noted, a digitally designed or created image can be subject to infinite manipulation.[9] Its reality is a function of complex algorithms stored in computer memory rather than a necessary mechanical resemblance to a ref-

    [2]Quoted in Peter Wollen. *Signs and Meaning in the Cinema* (Bloomington, IN: Indiana University Press, 1976), pp. 123–24.
    [3]Roland Barthes, *Camera Lucida: Reflections on Photography,* trans. Richard Howard (New York: Hill and Wang, 1981), p. 5.
    [4]Ibid., p. 76.
    [5]Ibid., p. 87.
    [6]André Bazin, *What Is Cinema?* vol. 1, ed. and trans. Hugh Gray (Berkeley, CA: University of California Press, 1967), p. 14.
    [7]Siegfried Kracauer, *Theory of Film: The Redemption of Physical Reality* (New York: Oxford University Press, 1960), p. ix.
    [8]Stanley Cavell, *The World Viewed* (Cambridge, MA: Harvard University Press, 1979), pp. 16–23.
    [9]Bill Nichols, *Representing Reality: Issues and Concepts in Documentary* (Bloomington, IN: Indiana University Press, 1991), note 2, p. 268.

erent. In cases like the slithery underwater creature in James Cameron's *The Abyss,* which began as a wireframe model in the computer, no profilmic referent existed to ground the indexicality of its image. Nevertheless, digital imaging can anchor pictured objects, like this watery creature, in apparent photographic reality by employing realistic lighting (shadows, highlights, reflections) and surface texture detail (the creature's rippling responses to the touch of one of the film's live actors). At the same time, digital imaging can bend, twist, stretch, and contort physical objects in cartoonlike ways that mock indexicalized referentiality. In an Exxon ad, an automobile morphs into a tiger, and in a spot for Listerine, the CGI bottle of mouthwash jiggles, expands, and contracts in an excited display of enthusiasm for its new formula.[10]

In these obvious ways, digital imaging operates according to a different ontology than do indexical photographs. But in less obvious ways, as well, digital imaging can depart from photographically coded realism. Objects can be co-present in computer space but not in the physical 3D space which photography records. When computer-animated objects move around in a simulated space, they can intersect one another. This is one reason why computer animators start with wireframe models which they can rotate and see through in order to determine whether the model is intersecting other points in the simulated space. Computer-simulated environments, therefore, have to be programmed to deal with the issues of collision detection and collision response.[11]

The animators who created the herd of gallimimus that chases actor Sam Neill and two children in *Jurassic Park* were careful to animate the twenty-four gallis so they would look like they might collide and were reacting to that possibility.[12] First, they had to ensure that no gallis actually did pass into and through one another, and then they had to simulate the collision responses in the creatures' behaviors as if they were corporeal beings subject to Newtonian space.

In other subtle ways, digital imaging can fail to perform Kracauer's redemption of physical reality. Lights simulated in the computer don't need sources, and shadows can be painted in irrespective of the position of existing lights. Lighting, which in photography is responsible for creating the exposure and the resulting image, is, for computer images, strictly a matter of painting, of changing the brightness and coloration of individual pixels. As a result, lighting in computer imagery need not obey the rather fixed and rigid physical conditions which must prevail in order for photographs to be created.

One of the more spectacular digital images in *True Lies* is a long shot of a chateau nestled beside a lake and surrounded by the Swiss Alps. The image is a digital composite, blending a mansion from Newport, Rhode Island, water shot in Nevada, and a digital matte painting of the Alps.[13] The compositing was done by Digital Domain, a state-of-the-art effects house created by the film's director, James Cameron. The

---

[10]The design and creation of these ads are profiled in detail in Christopher W. Baker, *How Did They Do It? Computer Illusion in Film and TV* (Indianapolis, IN: Alpha Books, 1994).

[11]See Ming C. Lin and Dinesh Manocha, "Interference Detection Between Curved Objects for Computer Animation," in *Models and Techniques in Computer Animation,* ed. Nadia Magnenat Thalmann and Daniel Thalmann (New York: Springer-Verlag, 1993), pp. 43–57.

[12]Ron Magid, "ILM's Digital Dinosaurs Tear Up Effects Jungle," *American Cinematographer,* vol. 74, no. 12 (December 1993), p. 56.

[13]Stephen Pizello, *"True Lies* Tests Cinema's Limits," *American Cinematographer,* vol. 75, no. 9 (September 1994), p. 44.

shot is visually stunning—crisply resolved, richly saturated with color, and brightly illuminated across Alps, lake, and chateau.

Kevin Mack, a digital effects supervisor at Digital Domain who worked on *True Lies* as well as *Interview with the Vampire,* points out that the image is unnaturally luminant.[14] Too much light is distributed across the shot. If a photographer exposed for the lights in the chateau, the Alps would film too dark, and, conversely, if one exposed for the Alps in, say, bright moonlight, the lights in the chateau would burn out. The chateau and the Alps could not be lit so they'd both expose as brightly as they do in the image. Mack points out that the painted light effects in the shot are a digital manipulation so subtle that most viewers probably do not notice the trickery.

Like lighting, the rendering of motion can be accomplished by computer painting. President Kennedy speaking to Tom Hanks in *Forrest Gump* resulted from two-dimensional painting, made to look like 3D, according to Pat Byrne, Technical Director at Post Effects, a Chicago effects house that specializes in digital imaging.[15] The archival footage of Kennedy, once digitized, was repainted with the proper phonetic mouth movements to match the scripted dialogue and with highlights on his face to simulate the corresponding jaw and muscle changes. Morphs were used to smooth out the different painted configurations of mouth and face.[16]

When animating motion via computer, special adjustments must be made precisely because of the differences between photographically captured reality and the synthetic realities engineered with CGI. Credible computer animation requires the addition of motion blur to simulate the look of a photographic image. The ping-pong ball swatted around by Forrest Gump and his Chinese opponents was animated on the computer from a digitally scanned photographic model of a ping-pong ball and was subsequently composited into the live-action footage of the game (the game itself was shot without any ball). The CGI ball seemed credible because, among other reasons, the animators were careful to add motion blur, which a real, rapidly moving object passing in front of a camera will possess (as seen by the camera which freezes the action as a series of still frames), but which a key-framed computer animated object does not.

In these ways, both macro and micro, digital imaging possesses a flexibility that frees it from the indexicality of photography's relationship with its referent.[17] Does this mean, then, that digital-imaging capabilities ought not be grouped under the rubric of a realist film theory? If not, what are the alternatives? What kind of realism, if any, do these images possess?

In traditional film theory, only one alternative is available: the perspective formulated in opposition to the positions staked out by realists like Kracauer, Bazin, and Cavell. This position, which might be termed the formalist outlook, stresses cinema's capacity for reorganizing, and even countering and falsifying, physical reality. Early exponents of such a position include Rudolf Arnheim, Dziga Vertov, and Sergei Eisenstein. In his discussion of classical film theory, Noël Carroll has pointed out this

---

[14]Telephone interview with the author, October 25, 1994.

[15]Telephone interview with the author, October 25, 1994.

[16]Ron Magid, "ILM Breaks New Digital Ground for *Gump*," *American Cinematographer,* vol. 75, no. 10 (October 1994), p. 52.

[17]I do not wish to imply that photography was ever a mere mechanical recording of the visual world. During shooting, printing, and developing, photographers found ways of creating their own special effects. Despite this, theorists have insisted upon the medium's fundamental indexicality.

bifurcation between the camps of realism and formalism and linked it to an essentializing tendency within theory, a predilection of theorists to focus on either the cinema's capability to photographically copy physical reality or to stylistically transcend that reality.[18]

This tension in classical theory between stressing the ways film either records or reorganizes profilmic reality continues in contemporary theory, with the classical formalist emphasis upon the artificiality of cinema structure being absorbed into theories of the apparatus, of psychoanalysis, or of ideology as applied to the cinema. In these cases, cinematic realism is seen as an *effect* produced by the apparatus or by spectators positioned within the Lacanian Imaginary. Cinematic realism is viewed as a discourse *coded* for transparency such that the indexicality of photographic realism is replaced by a view of the "reality-effect" produced by codes and discourse. Jean-Louis Baudry suggests that "Between 'objective reality' and the camera, site of inscription, and between the inscription and the projection are situated certain operations, a *work* which has as its result a finished product."[19] Writing about the principles of realism, Colin McCabe stresses that film is "constituted by a set of discourses which . . . produce a certain reality."[20]

Summarizing these views, Dudley Andrew explains, "The discovery that resemblance is coded and therefore learned was a tremendous and hard-won victory for semiotics over those upholding a notion of naive perception in cinema."[21] Where classical film theory was organized by a dichotomy between realism and formalism, contemporary theory has preserved the dichotomy even while recasting one set of its terms. Today, indexically based notions of cinema realism exist in tension with a semiotic view of the cinema as discourse and of realism as one discourse among others.

In some of the ways just discussed, digital imaging is inconsistent with indexically based notions of film realism. Given the tensions in contemporary film theory, should we then conclude that digital-imaging technologies are necessarily illusionistic, that they construct a reality-effect which is merely discursive? They do, in fact, permit film artists to create synthetic realities that can look just like photographic realities. As Pat Byrne noted, "The line between real and not-real will become more and more blurred."[22] How should we understand digital imaging in theory? How should we build theory around it? When faced with digitized images, will we need to discard entirely notions of realism in the cinema?

The tensions within film theory can be surmounted by avoiding an essentializing conception of the cinema stressing unique, fundamental properties[23] and by employing, in place of indexically based notions of film realism, a correspondence-based

[18]Noël Carroll, *Philosophical Problems of Classical Film Theory* (Princeton, N.J.: Princeton University Press, 1988).

[19]Jean-Louis Baudry, "Ideological Effects of the Basic Cinematographic Apparatus," in *Narrative, Apparatus, Ideology,* ed. Philip Rosen (New York: Columbia University Press, 1986), p. 287.

[20]Colin McCabe, "Theory and Film: Principles of Realism and Pleasure," in *Narrative, Apparatus, Ideology,* p. 182.

[21]Dudley Andrew, *Concepts in Film Theory* (New York: Oxford University Press, 1984), p. 25.

[22]Telephone interview with the author, October 25, 1994.

[23]Noël Carroll has urged film theory in this direction by recommending smaller scale, piece-meal theorizing about selected aspects of cinema rather than cinema in toto and on a grand scale. See *Philosophical Problems of Classical Film Theory,* p. 255, and Carroll, *Mystifying Movies: Fads and Fallacies in Contemporary Film Theory* (New York: Columbia University Press, 1988), pp. 230–34.

model of cinematic representation. Such a model will enable us to talk and think about both photographic images and computer-generated images and about the ways that cinema can create images that seem alternately real and unreal. To develop this approach, it will be necessary to indicate, first, what is meant by a correspondence-based model and, then, how digital imaging fits within it.

An extensive body of evidence indicates the many ways in which film spectatorship builds on correspondences between selected features of the cinematic display and a viewer's real-world visual and social experience.[24] These include iconic and non-iconic visual and social cues which are structured into cinematic images in ways that facilitate comprehension and invite interpretation and evaluation by viewers based on the salience of represented cues or patterned deviations from them. At a visual level, these cues include the ways that photographic images and edited sequences are isomorphic with their corresponding real-world displays (e.g., through replication of edge and contour information and of monocular distance codes; in the case of moving pictures, replication of motion parallax; and in the case of continuity editing, the creation of a screen geometry with coherent coordinates through the projective geometry of successive camera positions). Under such conditions, empirical evidence indicates that naive viewers readily recognize experientially familiar pictured objects and can comprehend filmed sequences, and that continuity editing enhances such comprehension.[25]

At the level of social experience, the evidence indicates that viewers draw from a common stock of moral constructs and interpersonal cues and percepts when evaluating both people in real life and represented characters in the media. Socially derived assumptions about motive, intent, and proper role-based behavior are employed when responding to real and media-based personalities and behavior.[26] As communication scholars Elizabeth Perse and Rebecca Rubin have pointed out, "'people' constitutes

[24]For a fuller discussion of this literature, see my essays "The Discourse of Pictures: Iconicity and Film Studies," *Film Quarterly*, vol. 47, no. 1 (Fall 1993), pp. 16–28 and "Psychoanalytic Film Theory and the Problem of the Missing Spectator," in *Post-Theory: Reconstructing Film Studies*, ed. David Bordwell and Noël Carroll (Madison WI: University of Wisconsin Press, 1996).

[25]See Uta Frith and Jocelyn E. Robson, "Perceiving the Language of Films," *Perception*, vol. 4 (1975), pp. 97–103; Renee Hobbs, Richard Frost, Arthur Davis, and John Stauffer, "How First-Time Viewers Comprehend Editing Conventions," *Journal of Communication*, no. 38 (1988), pp. 50–60; Julian Hochberg and Virginia Brooks, "Picture Perception as an Unlearned Ability: A Study of One Child's Performance," *American Journal of Psychology*, vol. 74, no. 4 (December 1962), pp. 624–28; Robert N. Kraft, "Rules and Strategies of Visual Narratives," *Perceptual and Motor Skills* no. 64 (1987), pp. 3–14; Robert N. Kraft, Phillip Cantor, and Charles Gottdiener, "The Coherence of Visual Narratives," *Communication Research*, vol. 18, no. 5 (October 1991), pp. 601–16; Robin Smith, Daniel R. Anderson, and Catherine Fischer, "Young Children's Comprehension of Montage," *Child Development* no. 56 (1985), pp. 962–71.

[26]See Austin S. Babrow, Barbara J. O'Keefe, David L. Swanson, Renee A. Myers, and Mary A. Murphy, "Person Perception and Children's Impression of Television and Real Peers," *Communication Research*, vol. 15, no. 6 (December 1988), pp. 680–98; Thomas J. Berndt and Emily G. Berndt, "Children's Use of Motives and Intentionality in Person Perception and Moral Judgement," *Child Development* no. 46 (1975), pp. 904–12; Aimee Dorr, "How Children Make Sense of Television," in *Reader in Public Opinion and Mass Communication*, ed. Morris Janowitz and Paul M. Hirsch (New York: Free Press, 1981), pp. 363–85; Cynthia Hoffner and Joanne Cantor, "Developmental Differences in Response to a Television Character's Appearance and Behavior," *Developmental Psychology*, vol. 21, no. 6 (1985), pp. 1065–74; Paul Messaris and Larry Gross, "Interpretations of a Photographic Narrative by Viewers in Four Age Groups," *Studies in the Anthropology of Visual Communication* no. 4 (1977), pp. 99–111.

a construct domain that may be sufficiently permeable to include both interpersonal and [media] contexts."[27]

Recognizing that cinematic representation operates significantly, though not exclusively, in terms of structured correspondences between the audiovisual display and a viewer's extra-filmic visual and social experience enables us to ask about the range of cues or correspondences within the image or film, how they are structured, and the ways a given film patterns its represented fictionalized reality around these cues. What kind of transformations does a given film carry out upon the correspondences it employs with viewers' visual and social experience? Attributions of realism, or the lack thereof, by viewers will inhere in the ways these correspondences are structured into and/or transformed by the image and film. Instead of asking whether a film is realistic or formalistic, we can ask about the kinds of linkages that connect the represented fictionalized reality of a given film to the visual and social coordinates of our own three-dimensional world, and this can be done for both "realist" and "fantasy" films alike. Such a focus need not reinstate indexicality as the ground of realism, since it can emphasize falsified correspondences and transformation of cues. Nor need such a focus turn everything about the cinema back into discourse, into an arbitrarily coded reorganization of experience. As we will see, even unreal images can be perceptually realistic. Unreal images are those which are referentially fictional. The Terminator is a represented fictional character that lacks reference to any category of being existing outside the fiction. Spielberg's dinosaurs obviously refer to creatures that once existed, but as *moving photographic images* they are referentially fictional. No dinosaurs now live which could be filmed doing things the fictionalized creatures do in *Jurassic Park*. By contrast, referentially realistic images bear indexical and iconic homologies with their referents. They resemble the referent, which, in turn, stands in a causal, existential relationship to the image.[28]

A perceptually realistic image is one which structurally corresponds to the viewer's audiovisual experience of three-dimensional space. Perceptually realistic images correspond to this experience because film-makers build them to do so. Such images display a nested hierarchy of cues which organize the display of light, color, texture, movement, and sound in ways that correspond with the viewer's own understanding of these phenomena in daily life. Perceptual realism, therefore, designates a relationship between the image or film and the spectator, and it can encompass both unreal images and those which are referentially realistic. Because of this, unreal images may be referentially fictional but perceptually realistic.

We should now return to, and connect this discussion back to, the issue of digital imaging. When lighting a scene becomes a matter of painting pixels, and capturing movement is a function of employing the correct algorithms for mass, inertia, torque, and speed (with the appropriate motion blur added as part of the mix), indexical referencing is no longer required for the appearance of photographic realism in the digital image. Instead, Gump's ping-pong ball and Spielberg's dinosaurs look like

---

[27]Elizabeth M. Perse and Rebecca B. Rubin, "Attribution in Social and Parasocial Relationships," *Communication Research*, vol. 16, no. 1 (February 1989), pp. 59–77.

[28]I am indebted to Carl Plantinga for clarification of some of these distinctions.

convincing photographic realities because of the complex sets of perceptual corre-
spondences that have been built into these images. These correspondences, which
anchor the computer-generated image in apparent three-dimensional space, routinely
include such variables as surface texture, color, light, shadow, reflectance, motion
speed and direction.

Embedding or compositing computer imagery into live action, as occurs when
Tom Hanks as Gump "hits" the CG ping-pong ball or when Sam Neill is "chased" by
the CG gallimimus herd, requires matching both environments. The physical proper-
ties and coordinates of the computer-generated scene components must be made to
correspond with those of the live-action scene. Doing this requires precise and time-
consuming creation and manipulation of multiple 3D perceptual cues. Kevin Mack,
at Digital Domain, and Chris Voellmann, a digital modeller and animator at Century
III Universal Studios, point out that light, texture, and movement are among the most
important cues to be manipulated in order to create a synthetic reality that looks as
real as possible.[29]

To simulate light properties that match both environments, a digital animator may
employ scan-line algorithms that calculate pixel coloration one scan line at a time, ray
tracing methods that calculate the passage of light rays through a modelled environ-
ment, or radiosity formulations that can account for diffuse, indirect illumination by
analyzing the energy transfer between surfaces.[30] Such techniques enable a success-
ful rendering[31] of perceptual information that can work to match live-action and com-
puter environments and lend credence and a sense of reality to the composited image
such that its computerized components *seem* to fulfill the indexicalized conditions of
photographic realism. When the velociraptors hunt the children inside the park's
kitchen in the climax of *Jurassic Park,* the film's viewer sees their movements reflected
on the gleaming metal surfaces of tables and cookware. These reflections anchor the
creatures inside Cartesian space and perceptual reality and provide a bridge between
live-action and computer-generated environments. In the opening sequence of *Forrest
Gump,* as a CG feather drifts and tumbles through space, its physical reality is
enhanced by the addition of a digitally painted reflection on an automobile windshield.

To complete this anchoring process, the provision of information about surface
texture and movement is extremely important and quite difficult, because the infor-
mation provided must seem credible. Currently, many of the algorithms needed for
convincing movement either do not exist or are prohibitively expensive to run on
today's computers. The animators and renderers at Industrial Light and Magic used
innovative software to texture-map[32] skin and wrinkles onto their dinosaurs and cal-
ibrated variations in skin jostling and wrinkling with particular movements of the

---

[29]Telephone interviews with the author, October 25, 1994.

[30]Stuart Feldman, "Rendering Techniques for Computer-Aided Design," *SMPTE Journal,* vol. 103, no.
1 (January 1994), pp. 7–12.

[31]With respect to digital-imaging practices, rendering is distinct from the phases of model-building and
animation and refers to the provision of texture, light, and color cues within a simulated environment.

[32]Texture-mapping is a process whereby a flat surface is detailed with texture, such as skin wrinkles,
and can then be wrapped around a three-dimensional model visualized in computer space. Some surfaces
texture-map more easily than others. Pat Byrne, at Post Effects, points out that spherical objects are prob-
lematic because the top and bottom tend to look pinched. Telephone interview with the author, October 25,
1994.

creatures. However, while bone and joint rotation are successfully visualized, complex information about the movement of muscles and tendons below the skin surface is lacking.

Kevin Mack describes this limit in present rendering abilities as the "human hurdle"[33]—that is, the present inability of computers to fully capture the complexities of movement by living organisms. Hair, for example, is extremely difficult to render because of the complexities of mathematically simulating properties of mass and inertia for finely detailed strands.[34] Chris Voellmann points out that today's software can create flexors and rotators but cannot yet control veins or muscles.

Multiple levels of information capture must be successfully executed to convincingly animate and render living movement because the viewer's eye is adept at perceiving inaccurate information.[35] These levels include locomotor mechanics—the specification of forces, torques, and joint rotations. In addition, "gait-specific rules"[36] must be specified. The *Jurassic Park* animators, for example, derived gait-specific rules for their dinosaurs by studying the movements of elephants, rhinos, komodo dragons, and ostriches and then making some intelligent extrapolations. Beyond these two levels of information control is the most difficult one—capturing the expressive properties of movement. Human and animal movement cannot look mechanical and be convincing; it must be expressive of mood and affect.

As the foregoing discussion indicates, available software and the speed and economics of present computational abilities are placing limits on the complexities of digitally rendered 3D cues used to integrate synthetic and live-action objects and environments. But the more important point is that present abilities to digitally simulate perceptual cues about surface texture, reflectance, coloration, motion, and distance provide an extremely powerful means of "gluing" together synthetic and live-action environments and of furnishing the viewer with an internally unified and coherent set of cues that establish correspondences with the properties of physical space and living systems in daily life. These correspondences in turn establish some of the most important criteria by which viewers can judge the apparent realism or credibility possessed by the digital image.

Obvious paradoxes arise from these judgements. No one has seen a living dinosaur. Even paleontologists can only hazard guesses about how such creatures might have moved and how swiftly. Yet the dinosaurs created at ILM have a palpable reality about them, and this is due to the extremely detailed texture-mapping, motion animation, and integration with live action carried out via digital imaging. Indexicality cannot furnish us with the basis for understanding this apparent photographic realism, but a correspondence-based approach can. Because the computer-generated images have been rendered with such attention to 3D spatial information, they acquire a very powerful perceptual realism, despite the obvious ontological problems

---

[33]Telephone interview with the author.

[34]Author's interview with Kevin Mack. See also Tsuneya Kurihara, Ken-ichi Anjyo, and Daniel Thalmann, "Hair Animation with Collision Detection," in *Models and Techniques in Computer Animation,* pp. 128–38.

[35]See Stephania Loizidou and Gordon J. Clapworthy, "Legged Locomotion Using HIDDS," in *Models and Techniques in Computer Animation,* pp. 257–69.

[36]Ibid., p. 258.

in calling them "realistic." These are falsified correspondences, yet because the perceptual information they contain is valid, the dinosaurs acquire a remarkable degree of photographic realism.

In a similar way, President Kennedy speaking in *Forrest Gump* is a falsified correspondence which is nevertheless built from internally valid perceptual information. Computer modelling of synthetic visual speech and facial animation relies on existing microanalyses of human facial expression and phonetic mouth articulations. The digital-effects artist used these facial cues to animate Kennedy's image and sync his mouth movements with the scripted dialogue. At the perceptual level of phonemic articulation and facial register, the correspondences established are true and enable the viewer to accept the photographic and dramatic reality of the scene. But these correspondences also establish a falsified relationship with the historical and archival filmic records of reality. The resulting image is perceptually realistic but referentially unreal, a paradox that present film theory has a hard time accounting for.

The profound impact of digital imaging, in this respect, lies in the unprecedented ways that it permits film-makers to extend principles of perceptual realism to unreal images. The creative manipulation of photographic images is, of course, as old as the medium of photography. For example, flashing film prior to development or dodging and burning portions of the image during printing will produce lighting effects that did not exist in the scene that was photographed. The tension between perceptual realism and referential artifice clearly predates digital imaging. It has informed all fantasy and special-effects work where film-makers strive to create unreal images that nevertheless seem credible. What is new and revolutionary about digital imaging is that it increases to an extraordinary degree a film-maker's control over the informational cues that establish perceptual realism. Unreal images have never before seemed so real.

Digital imaging alters our sense of the necessary relationship involving *both* the camera and the profilmic event. The presence of either is no longer an absolute requirement for generating photographic images that correspond to spatio-temporally valid properties of the physical world. If neither a camera nor an existent referent is necessary for the digital rendition of photographic reality, the application of internally valid perceptual correspondences with the 3D world *is* necessary for establishing the credibility of the synthetic reality. These correspondences establish bridges between what can be seen and photographed and that which can be "photographed" but not seen.

Because these correspondences between synthetic environments and real environments employ multiple cues, the induced realism of the final CG image can be extraordinarily convincing. The digital-effects artists interviewed for this essay resisted the idea that any one cue was more important than others and instead emphasized that their task was to build as much 3D information as possible into the CG image, given budgetary constraints, present computational limitations, and the stylistic demands of a given film. With respect to the latter, Kevin Mack pointed out that style coexists with the capability for making the CG images look as real as possible. The Swiss chateau composite in *True Lies* discussed earlier exemplifies this tension.

The apparent realism of digitally processed or created images, then, is a function of the way that multiple levels of perceptual correspondence are built into the image.

These establish reference points with the viewer's own experientially based understanding of light, space, motion, and the behavior of objects in a three-dimensional world. The resulting images may not contain photographable events, but neither do they represent purely illusory constructions. The reliability or nonreliability of the perceptual information they contain furnishes the viewer with an important framework for evaluating the logic of the screen worlds these images help establish.

The emphasis in contemporary film theory has undeniably shifted away from naive notions of indexical realism in favor of an attention to the constructedness of cinematic discourse. Yet indexicality remains an important point of origin even for perspectives that reincorporate it as a variant of illusionism, of the cinema's ability to produce a reality-effect. Bill Nichols notes that "Something of reality itself seems to pass through the lens and remain embedded in the photographic emulsion," while also recognizing that "Digital sampling techniques destroy this claim."[37] He concludes that the implications of this "are only beginning to be grasped,"[38] and therefore limits his recent study of the filmic representation of reality to non-digitized images.

Digital imaging exposes the enduring dichotomy in film theory as a false boundary. It is not as if cinema either indexically records the world or stylistically transfigures it. Cinema does both. Similarly, digital-imaging practices suggest that contemporary film theory's insistence upon the constructedness and artifice of cinema's discursive properties may be less productive than is commonly thought. The problem here is the implication of discursive equivalence, the idea that all cinematic representations are, in the end, equally artificial, since all are the constructions of form or ideology. But, as this essay has suggested, some of these representations, while being referentially unreal, are perceptually realistic. Viewers use and rely upon these perceptual correspondences when responding to, and evaluating, screen experience.

These areas of correspondence coexist in any given film with narrative, formal, and generic conventions, as well as intertextual determinants of meaning. Christopher Williams has recently observed that viewers make strong demands for reference from motion pictures, but in ways that simultaneously accommodate style and creativity: "We need films to be about life in one way or another, but we allow them latitude in how they meet this need."[39] Thus, Williams maintains that any given film will feature "the active interplay between the elements which can be defined as realist, and the others which function simultaneously and have either a nonrealist character (primarily formal, linguistic or conventional) or one which can be called anti-realist because the character of its formal, linguistic or conventional procedures specifically or explicitly tries to counteract the cognitive dimensions we have linked with realism."[40] Building 3D cues inside computer-generated images enables viewers to correlate those images with their own spatio-temporal experience, even when the digitally processed image fails in other ways to obey that experience (as when the Terminator

---

[37]Nichols, *Representing Reality,* p. 5.

[38]Ibid., p. 268.

[39]Christopher Williams, "After the Classic, the Classical and Ideology: the Differences of Realism," *Screen,* vol. 35, no. 3 (Autumn 1994), p. 282.

[40]Ibid., p. 289.

morphs out of a tiled floor to seize his victim). Satisfying the viewer's demand for reference permits, in turn, patterned or stylish deviations from reference.

Stressing correspondence-based transformational abilities enables us to maintain a link, a relationship, between the materials that are to be digitally transformed (elements of the 3D world) and their changed state, as well as providing a means for preserving a basis for concepts of realism in a digitized cinema. Before we can subject digitally animated and processed images, like the velociraptors stalking the children through the kitchens of *Jurassic Park*, to extended meta-critiques of their discursive or ideological inflections (and these critiques are necessary), we first need to develop a precise understanding of how these images work in securing for the viewer a perceptually valid experience which may even invoke, as a kind of memory trace, now historically superseded assumptions about indexical referencing as the basis of the credibility that photographic images seem to possess.

In the correspondence-based approach to cinematic representation developed here, perceptual realism, the accurate replication of valid 3D cues, becomes not only the glue cementing digitally created and live-action environments, but also the foundation upon which the uniquely transformational functions of cinema exist. Perceptual realism furnishes the basis on which digital imaging may be carried out by effects artists and understood, evaluated, and interpreted by viewers. The digital replication of perceptual correspondence for the film viewer is an enormously complex undertaking and its ramifications clearly extend well beyond film theory and aesthetics to encompass ethical, legal, and social issues. Film theory will need to catch up to this rapidly evolving new category of imaging capabilities and grasp it in all of its complexity. To date, theory has tended to minimize the importance of perceptual correspondences, but the advent of digital imaging demonstrates how important they are and have been all along. Film theory needs now to pay closer attention to what viewers see on the screen, how they see it, and the relation of these processes to the larger issue of how viewers see. Doing this may mean that film theory itself will change, and this essay has suggested some ways in which that might occur. Digital imaging represents not only the new domain of cinema experiences, but a new threshold for theory as well.

                                                                    1996

# III

# The Film Medium: Image and Sound

Film theory and film criticism have been largely concerned with one central issue: What is "cinematic"? Which paths should the cinema follow? Which should it reject? Attempts to answer this question inevitably take their lead from Lessing's classic essay, *Laocoön*, in which the eighteenth-century German dramatist and essayist attempted to demonstrate that the visual arts organize their materials spatially while the poetic arts organize their materials temporally. The materials, procedures, subjects, and effects of these two different forms (or "media") of artistic organization are therefore necessarily different. In this spirit, film theorists have attempted to discover the characteristics of the film medium, declaring those subjects, materials, procedures, and effects that "exploit" the characteristics of the medium proper, legitimate, and truly cinematic and those subjects, materials, procedures, and effects that "violate" the characteristics of the medium barren, misleading, and fundamentally uncinematic.

The concept of a medium is, of course, a difficult one. Is the medium to be defined in purely physical terms (that is, the projection of images at twenty-four frames per second on a screen) or rather in terms of an artistic language (angle and distance of shots, rhythms and patterns of editing, and so forth)? Does it include the main structural features of the art (such as plot) and its main historical conventions (say, its genres)? And how are we to determine which possibilities of the medium are legitimate? Is it legitimate to pursue any possibility inherent in the medium, or only those for which the medium has a special affinity? And how are we to judge what those special affinities are? May two different artistic media share those affinities or must an art confine itself, as certain purists urge, to realizing only those possibilities that it shares with no other art?

Erwin Panofsky, an art historian who was a contemporary of both Arnheim and Kracauer, has written the most influential discussion of the subject. He argues that an

283

art ought to exploit the "unique and specific" possibilities of its medium; and in the film medium these can be defined as the "dynamization of space" and the "spatialization of time." Both these features are visual ones, and Panofsky's primarily visual concept of the film medium is vulnerable to the objection that it accords an undue priority to the silent film, placing unwise restrictions on the use of speech in films. According to Panofsky's principle of "co-expressibility," "the sound, articulate or not, cannot express any more than is expressed, at the same time, by visible movement." Panofsky claims that the Shavian dialogue in the film version of Shaw's *Pygmalion* falls flat and suggests that Olivier's monologues in *Henry V* are successful only to the extent that Olivier's face becomes "a huge field of action" in oblique "close-up." But those who admire the brilliant Hollywood "dialogue" comedies of the 30s and early 40s and who recall that Olivier does not deliver the "St. Crispin's Day" speech in *Henry V* in close-up will receive these views with a measure of skepticism. Indeed, Panofsky modified them in the revised version of his essay that appears in this anthology.

Siegfried Kracauer acknowledges the difficulty of defining the film medium but also believes, nevertheless, that cinema has certain "inherent affinities." There are, in particular, certain subjects in the physical world that may be termed "cinematic" because they exert a peculiar attraction for the medium. Kracauer argues that cinema is predestined and even eager to exhibit them. Like Panofsky, Kracauer accepts the use of sound in films only under certain very restrictive conditions, and he especially dislikes the development of the "theatrical" film: "What even the most theatrical minded silent film could not incorporate—pointed controversies, Shavian witticisms, Hamlet's soliloquies—has been annexed to the screen." Kraucauer finds this annexation unfortunate; it in no way proves that such theatrical speeches are legitimate possibilities of the cinematic medium, for "popularity," in Kracauer's view, has no bearing on questions of aesthetic legitimacy.

Kracauer calls the comedies of Frank Capra and Preston Sturges borderline cases, but only on the ground that their witty dialogue is "complemented and compensated for" by "visuals of independent interest" (he means that they include slapstick sequences). Just as witty dialogue violates the visual requirements of the medium and requires "compensation," surrealistic projections of inner realities, expressionist dreams and visions, and experimental abstractions violate the realist requirements of the medium. On the other hand, certain types of movement—the chase and dancing—and certain types of objects—those that are normally too big or too small to be seen—are peculiarly appropriate subjects of cinema. But does the dance really have a greater affinity for the film than it does for the stage? Must the film avoid what is normally seen simply because it is the subject matter of other arts? One can agree with Kracauer that the close-up is a peculiarly cinematic technique, and even with the Hungarian filmmaker Béla Balász, that the close-up is responsible for the "discovery of the human face," without supposing that the film must devote itself exclusively to the exploitation of these "unique" potentialities.

Rudolf Arnheim shares Panofsky's and Kracauer's view that the film ought to stress the specific possibilities of the cinematic medium. But he feels obligated to refute the view that cinema is a mere mechanical reproduction of physical reality. If it were, it would not be an art. Arnheim therefore emphasizes the various discrepan-

cies between the film image and the standard perception of physical reality. The film image suffers a reduction of depth, a distortion of perspective, an accentuation of perspective overlapping, and, in the past, an absence of color and articulate speech. Arnheim asserts that the true task of cinema is to exploit these very "defects" and turn them to an advantage, just as painting exploits the fact that it is a two-dimensional, enclosed object. Perhaps a great art can be devised that confines itself to exploiting these defects (the silent film may have been such an art), but can we accept the suggestion that film must avoid exploiting the affinities with physical reality that Kracauer mentions, just because they conform to, rather than deviate from, reality? And should we regret the fact that we can remedy some of the "defects" of a medium rather than exploit them? Should we regret the development of sound, as all three of these theorists do?

Noël Carroll examines the logic underlying the specificity thesis that is assumed by all these theorists. He challenges the notion that what a medium does best will coincide with what differentiates it from other media. Indeed, he questions whether an art should confine itself either to doing what it does best or to what differentiates it from the other arts. In particular, Carroll's critique of Arnheim's *A New Laocoön* provides a very different view of the possibilities for combining language and visuals in the art of film.

Gerald Mast rejects the problem of defining the distinctively cinematic medium as any function of the method of recording moving images—photographic or otherwise. Instead, he regards the projection of images by light as the essential feature of any cinematic work. And the fact of projection permits him to distinguish the experience of cinema from that of theater, television, and painting. He also argues that a careful investigation of the characteristics of projected images undermines a number of commonly held opinions. Among them are the view that one must project photographic images—upon which Kracauer's theory (and that of all realist cinema theory) is founded, and the view that the projected image is two-dimensional and perceived as flat—claims upon which Arnheim's theory (and that of most puristic and modernistic cinema theory) is based.

Stanley Cavell does place great emphasis on the importance of projection and, more particularly, on the fact of projection onto a screen. The projected image is the image of a world, and of a world which, in contrast to the world of a painting, exists beyond the frame. Indeed, the only difference between the projected world and reality is that the projected world does not exist now. It is simultaneously absent and present. One function of the movie screen, then, is to screen that world from the audience. Another is to screen the audience from the projected world. Unlike the audience in a theater which is not present to the actors on stage by convention, the film medium renders the audience absent mechanically and automatically. By this enforced invisibility, movies give expression to our modern experience of privacy and anonymity. Man has longed for invisibility and the absence of responsibility it confers, and film satisfies precisely this wish. In watching a film we view a magically reproduced world while remaining invisible to it. This condition makes the experience of film essentially voyeuristic and even pornographic. It permits the audience a magical-sexual contact with the hypnotic Garbos, Dietrichs, and Gables of the screen.

However, unlike Panofsky and many other theorists, Cavell does not think that the aesthetic possibilities of the movie medium can be deduced from its physical or technical properties. A medium, in his unconventional construal, is simply something through which or by means of which something specific gets said or done in particular ways. In his view, only the art itself, and not a mere consideration of its physical medium, can discover its aesthetic possibilities.

Cavell argues that the issues of genre and of medium are inseparable, and that the classical Hollywood world was composed of three such media—stories or structures that revolve about the Military Man, the Dandy, and the Woman. The Military Man conquers evil for the sake of society (James Stewart in *The Man Who Shot Liberty Valance*, Gary Cooper in *Mr. Deeds Goes to Town*); the Dandy pursues his own interests, values, and self-respect (John Wayne in *Red River*, Cary Grant in anything); and the Woman attracts men as flames attract the moth (Garbo, Dietrich, Davis). With the loss of conviction in these genres, film reached (very belatedly in comparison to the other arts of the twentieth century) the condition of modernism, in which the self-conscious artist seeks to produce a new genre, a new medium, rather than simply producing more instances of a familiar one.

Jean-Louis Baudry concentrates his attention on the ideological effects of the cinematographic apparatus. The camera records a series of static images. However, projection on a screen restores the illusion of both continuous movement and temporal succession. In doing so, the cinematographic apparatus conceals work and imposes an idealistic ideology, rather than producing what Althusser calls a "knowledge effect." Limited by the framing, lined up, and put at the proper distance the world offers up an object endowed with meaning. This Husserlian intentional object implies the action of a transcendental subject or camera eye which views it. As the Lacanian mirror assembles the fragmented body in a sort of imaginary integration of the self, so the transcendental self unites the dislocated fragments of lived experienced into a metaphysic, a unified meaning. Thus, the cinema assumes the role played throughout Western history by various artistic formations. The ideology of representation and specularization form a singularly coherent system in the cinema. But the illusion they create is possible only if the instrumentation on which they depend is hidden and repressed. (The notion of the optically centered subject and of the ideological effects which attend this position are usefully questioned by Nick Browne in his "The Spectator-in-the-Text: The Rhetoric of *Stagecoach*" reprinted in Section I.)

As we have seen, many of the classic film theorists considered the cinema an essentially visual medium. Even those who admit the importance of the aural dimension of film have generally not paid as much attention to it as they have to the visual aspect of the medium. Christian Metz's essay suggests that this fact is to be explained by the primitive substantialism deeply rooted in our culture. This concept distinguishes sharply between primary qualities or substances and the attributes which characterize them. Visual qualities are regarded as primary or substantial while aural qualities are secondary or adjectival. (This assumption manifests itself in the incorrect description of some sound as "off-screen.") Metz suggests, however, that this phenomenological truth is socially constructed and in this sense ideological. The world as we apprehend it could be otherwise.

Even those who have welcomed, or at least endorsed, the exploitation of sound in cinema have had difficulty in agreeing on the terms of its admission to the film medium. Thus, in their "Statement" on sound, Eisenstein, Pudovkin, and Alexandrov acknowledge the use of sound as an important new resource for film. They believe, however, that the montage principle, to which they attribute the greatest achievement of film, would be undermined if sounds were synchronized with sights. As they see it, every adhesion of sound to a visual montage piece increases its inertia as a montage piece. They therefore endorse only the nonsynchronous use of sound, a use that would eschew "talking films" and propose that sound be used only in orchestral counterpoint to visual images. Avoiding the use of naturalistic "talk," films of this sort would strengthen the possibility of a truly international cinema.

Mary Ann Doane approaches the problem of sound from a psychoanalytic point of view and investigates the relation of sounds to the unified body reconstituted by the technology and practices of cinema. These technologies, which increasingly succeed in concealing the work of Jean-Louis Baudry's apparatus, reduce the distance between the object and its representation, and this reduction of distance, and the attendant loss of "aura" first noticed by Walter Benjamin (see Section VII), is particularly evident in the case of the reproduction of sound. Doane believes that a proper understanding of the relation between sound and image is crucial to explaining the pleasure of the spectator in mainstream cinema. She analyzes such techniques as voice-off, voice-over during a flashback, and the interior monologue and contrasts them with the disembodied voice-over commentary of the documentary. Its radical otherness with respect to the diegesis endows the voice-over with a certain authority. In the history of the documentary this voice has been for the most part male, and its guarantee of knowledge lies in its irreducibility to the spatiotemporal limits of the body on screen. The voice-over commentary speaks more or less directly to the spectator. More frequently, in the fiction film, the use of synchronous dialogue and the voice-off presupposes a spectator who overhears and, overhearing, is unheard and unseen himself. This activity with respect to the sound track is not unlike the voyeurism often exploited by the cinematic image. The use of voice in the cinema appeals to the spectator's desire to hear, what Jacques Lacan calls the invocatory drive.

Memories of the first experience of the voice, of the hallucinatory satisfaction it offered, circumscribe the pleasure of hearing and ground its relation to the "phantasmatic" body. Classical mise-en-scène has a stake in perpetuating the image of unity and identity sustained by his body and in staving off the fear of fragmentation. In certain "post-modernist" films, those of Jean-Luc Godard and Jean-Marie Straub come to mind, the image of the body is not one of imaginary cohesion but of dispersal, division, and fragmentation. This approach can be understood as an attempt to forge an oppositional political erotics of the voice. But this attempt is problematic, and the voice presents a particular problem for feminist theory. Over and against the theorization of the image as phallic, as the support for voyeurism and fetishism, the voice appears to provide an alternative to the image, as a politically viable means by which the woman can "make herself be heard." Luce Irigaray, for instance, claims that patriarchal culture has a heavier investment in seeing than in hearing. Doane warns, how-

ever, that while psychoanalyis delineates a pre-Oedipal scenario in which the voice of the mother dominates, the voice, in psychoanalysis, is also the instrument of the patriarchal order.

As we have seen, Baudry argues that the cinematic apparatus conceals work and presents as natural that which is in fact an ideological production. John Belton argues, however, that even though technological evolution performs an ideological function, the work of technology can never efface itself and disappear. It remains visible—or audible—in every film. For there is always present in the positioning of the camera or the microphones a consciousness that sees and hears and that coexists with that which is seen and heard.

According to John Ellis, television and cinema exploit image and sound in characteristically different ways and in a characteristically different balance. For Ellis the image remains the central reference for cinema. The cinema viewer is centered by the physical arrangement of cinema seats and by the customs of film viewing (unlike the TV viewer, the moviegoer does not move about the house). Consequently, in cinema sound follows the image or diverges from it. For TV, however, sound is primary and carries the fiction or the documentary, with the image playing a more illustrative role. TV employs a type of vision less intense than cinema's. It is a regime of the glance not the gaze. In psychoanalytic terms, TV exemplifies a displacement of the scopophiliac regime from seeing to the closest related sense, hearing. The TV viewer is copresent with the image, and it is familar and intimate. This contrasts with the voyeuristic mode of cinema that Cavell describes. TV is, in consequence, less concerned with the representation of the female body and of female sexuality, and its narratives lack the forward thrust of entertainment cinema. Rather, the activity of the glance calls for variety and the accumulation of segments rather than the accumulation of sequences that characterize cinematic narration. Ellis's account of the differences between the media of cinema and TV draws on their physical, psychological, and social characteristics. It does not, however, mount an argument in the *Laocoön* tradition. Ellis does not try to determine which features of their respective media cinema and TV should exploit or eschew.

# ERWIN PANOFSKY
## STYLE AND MEDIUM IN THE MOTION PICTURES

Film art is the only art the development of which men now living have witnessed from the very beginnings; and this development is all the more interesting as it took place under conditions contrary to precedent. It was not an artistic urge that gave rise to the discovery and gradual perfection of a new technique; it was a technical invention that gave rise to the discovery and gradual perfection of a new art.

From this we understand two fundamental facts. First, that the primordial basis of the enjoyment of moving pictures was not an objective interest in a specific subject matter, much less an aesthetic interest in the formal presentation of subject matter, but the sheer delight in the fact that things seemed to move, no matter what things they were. Second, that films—first exhibited in "kinetoscopes," viz., cinematographic peep shows, but projectable to a screen since as early as 1894—are, originally, a product of genuine folk art (whereas, as a rule, folk art derives from what is known as "higher art"). At the very beginning of things we find the simple recording of movements: galloping horses, railroad trains, fire engines, sporting events, street scenes. And when it had come to the making of narrative films these were produced by photographers who were anything but "producers" or "directors," performed by people who were anything but actors, and enjoyed by people who would have been much offended had anyone called them "art lovers."

The casts of these archaic films were usually collected in a "café" where unemployed supers or ordinary citizens possessed of a suitable exterior were wont to assemble at a given hour. An enterprising photographer would walk in, hire four or five convenient characters and make the picture while carefully instructing them what to do: "Now, you pretend to hit this lady over the head"; and (to the lady): "And you pretend to fall down in a heap." Productions like these were shown, together with those purely factual recordings of "movement for movement's sake," in a few small and dingy cinemas mostly frequented by the "lower classes" and a sprinkling of

youngsters in quest of adventure (about 1905, I happen to remember, there was only one obscure and faintly disreptuable *kino* in the whole city of Berlin, bearing, for some unfathomable reason, the English name of "The Meeting Room"). Small wonder that the "better classes," when they slowly began to venture into these early picture theaters, did so, not by way of seeking normal and possibly serious entertainment, but with that characteristic sensation of self-conscious condescension with which we may plunge, in gay company, into the folkloristic depths of Coney Island or a European kermis; even a few years ago it was the regulation attitude of the socially or intellectually prominent that one could confess to enjoying such austerely educational films as *The Sex Life of the Starfish* or films with "beautiful scenery," but never to a serious liking for narratives.

Today there is no denying that narrative films are not only "art"—not often good art, to be sure, but this applies to other media as well—but also, besides architecture, cartooning and "commercial design," the only visual art entirely alive. The "movies" have reestablished that dynamic contact between art production and art consumption which, for reasons too complex to be considered here, is sorely attenuated, if not entirely interrupted, in many other fields of artistic endeavor. Whether we like it or not, it is the movies that mold, more than any other single force, the opinions, the taste, the language, the dress, the behavior, and even the physical appearance of a public comprising more than 60 per cent of the population of the earth. If all the serious lyrical poets, composers, painters and sculptors were forced by law to stop their activities, a rather small fraction of the general public would become aware of the fact and a still smaller fraction would seriously regret it. If the same thing were to happen with the movies the social consequences would be catastrophic.

In the beginning, then, there were the straight recordings of movement no matter what moved, viz., the prehistoric ancestors of our "documentaries"; and, soon after, the early narratives, viz., the prehistoric ancestors of our "feature films." The craving for a narrative element could be satisfied only by borrowing from older arts, and one should expect that the natural thing would have been to borrow from the theater, a theater play being apparently the *genus proximum* to a narrative film in that it consists of a narrative enacted by persons that move. But in reality the imitation of stage performances was a comparatively late and thoroughly frustrated development. What happened at the start was a very different thing. Instead of imitating a theatrical performance already endowed with a certain amount of motion, the earliest films added movement to works of art originally stationary, so that the dazzling technical invention might achieve a triumph of its own without intruding upon the sphere of higher culture. The living language, which is always right, has endorsed this sensible choice when it still speaks of a "moving picture" or, simply, a "picture," instead of accepting the pretentious and fundamentally erroneous "screenplay."

The stationary works enlivened in the earliest movies were indeed pictures: bad nineteenth-century paintings and postcards (or waxworks à la Madame Tussaud's), supplemented by the comic strips—a most important root of cinematic art—and the subject matter of popular songs, pulp magazines and dime novels; and the films descending from this ancestry appealed directly and very intensely to a folk art mentality. They gratified—often simultaneously—first, a primitive sense of justice and

decorum when virtue and industry were rewarded while vice and laziness were punished; second, plain sentimentality when "the thin trickle of a fictive love interest" took its course "through somewhat serpentine channels," or when Father, dear Father returned from the saloon to find his child dying of diphtheria; third, a primordial instinct for bloodshed and cruelty when Andreas Hofer faced the firing squad, or when (in a film of 1893–94) the head of Mary Queen of Scots actually came off; fourth, a taste for mild pornography (I remember with great pleasure a French film of ca. 1900 wherein a seemingly but not really well-rounded lady as well as a seemingly but not really slender one were shown changing to bathing suits—an honest, straightforward *porcheria* much less objectionable than the now extinct Betty Boop films and, I am sorry to say, some of the more recent Walt Disney productions); and, finally, that crude sense of humor, graphically described as "slapstick," which feeds upon the sadistic and the pornographic instinct, either singly or in combination.

Not until as late as ca. 1905 was a film adaptation of *Faust* ventured upon (cast still "unknown," characteristically enough), and not until 1911 did Sarah Bernhardt lend her prestige to an unbelievably funny film tragedy, *Queen Elizabeth of England*. These films represent the first conscious attempt at transplanting the movies from the folk art level to that of "real art"; but they also bear witness to the fact that this commendable goal could not be reached in so simple a manner. It was soon realized that the imitation of a theater performance with a set stage, fixed entries and exits, and distinctly literary ambitions is the one thing the film must avoid.

The legitimate paths of evolution were opened, not by running away from the folk art character of the primitive film but by developing it within the limits of its own possibilities. Those primordial archetypes of film productions on the folk art level—success or retribution, sentiment, sensation, pornography, and crude humor—could blossom forth into genuine history, tragedy and romance, crime and adventure, and comedy, as soon as it was realized that they could be transfigured—not by an artificial injection of literary values but by the exploitation of the unique and specific possibilities of the new medium. Significantly, the beginnings of this legitimate development antedate the attempts at endowing the film with higher values of a foreign order (the crucial period being the years from 1902 to ca. 1905), and the decisive steps were taken by people who were laymen or outsiders from the viewpoint of the serious stage.

These unique and specific possibilities can be defined as *dynamization of space* and, accordingly, *spatialization of time*. This statement is self-evident to the point of triviality but it belongs to that kind of truths which, just because of their triviality, are easily forgotten or neglected.

In a theater, space is static, that is, the space represented on the stage, as well as the spatial relation of the beholder to the spectacle, is unalterably fixed. The spectator cannot leave his seat, and the setting of the stage cannot change, during one act (except for such incidentals as rising moons or gathering clouds and such illegitimate reborrowings from the film as turning wings or gliding backdrops). But, in return for this restriction, the theater has the advantage that time, the medium of emotion and thought conveyable by speech, is free and independent of anything that may happen in visible

space. Hamlet may deliver his famous monologue lying on a couch in the middle distance, doing nothing and only dimly discernible to the spectator and listener, and yet by his mere words enthrall him with a feeling of intensest emotional action.

With the movies the situation is reversed. Here, too, the spectator occupies a fixed seat, but only physically, not as the subject of an aesthetic experience. Aesthetically, he is in permanent motion as his eye identifies itself with the lens of the camera, which permanently shifts in distance and direction. And as movable as the spectator is, as movable is, for the same reason, the space presented to him. Not only bodies move in space, but space itself does, approaching, receding, turning, dissolving and recrystallizing as it appears through the controlled locomotion and focusing of the camera and through the cutting and editing of the various shots—not to mention such special effects as visions, transformations, disappearances, slow-motion and fast-motion shots, reversals and trick films. This opens up a world of possibilities of which the stage can never dream. Quite apart from such photographic tricks as the participation of disembodied spirits in the action of the *Topper* series, or the more effective wonders wrought by Roland Young in *The Man Who Could Work Miracles*, there is, on the purely factual level, an untold wealth of themes as inaccessible to the "legitimate" stage as a fog or a snowstorm is to the sculptor; all sorts of violent elemental phenomena and, conversely, events too microscopic to be visible under normal conditions (such as the life-saving injection with the serum flown in at the very last moment, or the fatal bite of the yellow-fever mosquito); full-scale battle scenes; all kinds of operations, not only in the surgical sense but also in the sense of any actual construction, destruction or experimentation, as in *Louis Pasteur* or *Madame Curie*; a really grand party, moving through many rooms of a mansion or a palace. Features like these, even the mere shifting of the scene from one place to another by means of a car perilously negotiating heavy traffic or a motorboat steered through a nocturnal harbor, will not only always retain their primitive cinematic appeal but also remain enormously effective as a means of stirring the emotions and creating suspense. In addition, the movies have the power, entirely denied to the theater, to convey psychological experiences by directly projecting their content to the screen, substituting, as it were, the eye of the beholder for the consciousness of the character (as when the imaginings and hallucinations of the drunkard in the otherwise overrated *Lost Weekend* appear as stark realities instead of being described by mere words). But any attempt to convey thought and feelings exclusively, or even primarily, by speech leaves us with a feeling of embarrassment, boredom, or both.

What I mean by thoughts and feelings "conveyed exclusively, or even primarily, by speech" is simply this: Contrary to naïve expectation, the invention of the sound track in 1928 has been unable to change the basic fact that a moving picture, even when it has learned to talk, remains a picture that moves and does not convert itself into a piece of writing that is enacted. Its substance remains a series of visual sequences held together by an uninterrupted flow of movement in space (except, of course, for such checks and pauses as have the same compositional value as a rest in music), and not a sustained study in human character and destiny transmitted by effective, let alone "beautiful," diction. I cannot remember a more misleading statement about the movies than Mr. Eric Russell Bentley's in the spring number of the *Kenyon Review*, 1945: "The potentialities of the talking screen differ from those of the silent screen in

adding the dimension of dialogue—which could be poetry." I would suggest: "The potentialities of the talking screen differ form those of the silent screen in integrating visible movement with dialogue which, therefore, had better not be poetry."

All of us, if we are old enough to remember the period prior to 1928, recall the old-time pianist who, with his eyes glued on the screen, would accompany the events with music adapted to their mood and rhythm; and we also recall the weird and spectral feeling overtaking us when this pianist left his post for a few minutes and the film was allowed to run by itself, the darkness haunted by the monotonous rattle of the machinery. Even the silent film, then, was never mute. The visible spectacle always required, and received, an audible accompaniment which, from the very beginning, distinguished the film from simple pantomime and rather classed it—*mutatis mutandis*—with the ballet. The advent of the talkie meant not so much an "addition" as a transformation: the transformation of musical sound into articulate speech and, therefore, of quasi pantomime into an entirely new species of spetacle which differs from the ballet, and agrees with the stage play, in that its acoustic component consists of intelligible words, but differs from the stage play and agrees with the ballet in that this acoustic component is not detachable form the visual. In a film, that which we hear remains, for good or worse, inextricably fused with that which we see; the sound, articulate or not, cannot express any more than is expressed, at the same time, by visible movement; and in a good film it does not even attempt to do so. To put it briefly, the play—or, as it is very properly called, the "script"—of a moving picture is subject to what might be termed the *principle of coexpressibility*.

Empirical proof of this principle is furnished by the fact that, wherever the dialogical or monological element gains temporary prominence, there appears, with the inevitability of a natural law, the "close-up." What does the close-up achieve? In showing us, in magnification, either the face of the speaker or the face of the listeners or both in alternation, the camera transforms the human physiognomy into a huge field of action where—given the qualification of the performers—every subtle movement of the features, almost imperceptible from a natural distance, becomes an expressive event in visible space and thereby completely integrates itself with the expressive content of the spoken word; whereas, on the stage, the spoken word makes a stronger rather than a weaker impression if we are not permitted to count the hairs in Romeo's mustache.

This does not mean that the scenario is a negligible factor in the making of a moving picture. It only means that its artistic intention differs in kind from that of a stage play, and much more from that of a novel or a piece of poetry. As the success of a Gothic jamb figure depends not only upon its quality as a piece of sculpture but also, or even more so, upon its integrability with the architecture of the portal, so does the success of a movie script—not unlike that of an opera libretto—depend, not only upon its quality as a piece of literature but also, or even more so, upon its integrability with the events on the screen.

As a result—another empirical proof of the coexpressibility principle—good movie scripts are unlikely to make good reading and have seldom been published in book form; whereas, conversely, good stage plays have to be severely altered, cut, and, on the other hand, enriched by interpolations to make good movie scripts. In Shaw's *Pygmalion*, for instance, the actual process of Eliza's phonetic education and,

still more important, her final triumph at the grand party, are wisely omitted; we see—or, rather, hear—some samples of her gradual linguistic improvement and finally encounter her, upon her return from the reception, victorious and splendidly arrayed but deeply hurt for want of recognition and sympathy. In the film adaptation, precisely these two scenes are not only supplied but also strongly emphasized; we witness the fascinating activities in the laboratory with its array of spinning disks and mirrors, organ pipes and dancing flames, and we participate in the ambassadorial party, with many moments of impending catastrophe and a little counterintrigue thrown in for suspense. Unquestionably these two scenes, entirely absent from the play, and indeed unachievable upon the stage, were the highlights of the film; whereas the Shavian dialogue, however severely cut, turned out to fall a little flat in certain moments. And wherever, as in so many other films, a poetic emotion, a musical out-burst, or a literary conceit (even, I am grieved to say, some of the wisecracks of Grou-cho Marx) entirely lose contact with visible movement, they strike the sensitive spec-tator as, literally, out of place. It is certainly terrible when a soft-boiled he-man, after the suicide of his mistress, casts a twelve-foot glance upon her photograph and says something less-than-coexpressible to the effect that he will never forget her. But when he recites, instead, a piece of poetry as sublimely more-than-coexpressible as Romeo's monologue at the bier of Juliet, it is still worse. Reinhardt's *Midsummer Night's Dream* is probably the most unfortunate major film ever produced; and Olivier's *Henry V* owes its comparative success, apart from the all but providential adaptability of this particular play, to so many *tours de force* that it will, God willing, remain an exception rather than set a pattern. It combines "judicious pruning" with the interpolation of pageantry, nonverbal comedy and melodrama; it uses a device perhaps best designated as "oblique close-up" (Mr. Olivier's beautiful face inwardly listening to but not pronouncing the great soliloquy); and, most notably, it shifts between three levels of archaeological reality: a reconstruction of Elizabethan Lon-don, a reconstruction of the events of 1415 as laid down in Shakespeare's play, and the reconstruction of a performance of this play on Shakespeare's own stage. All this is perfectly legitimate; but, even so, the highest praise of the film will always come from those who, like the critic of the *New Yorker*, are not quite in sympathy with either the movies *au naturel* or Shakespeare *au naturel*.

As the writings of Conan Doyle potentially contain all modern mystery stories (except for the tough specimens of the Dashiell Hammett school), so do the films pro-duced between 1900 and 1910 pre-establish the subject matter and methods of the moving picture as we know it. This period produced the incunabula of the Western and the crime film (Edwin S. Porter's amazing *Great Train Robbery* of 1903) from which developed the modern gangster, adventure, and mystery pictures (the latter, if well done, is still one of the most honest and genuine forms of film entertainment, space being doubly charged with time as the beholder asks himself not only "What is going to happen?" but also "What has happened before?"). The same period saw the emergence of the fantastically imaginative film (Méliès) which was to lead to the expressionist and surrealist experiments (*The Cabinet of Dr. Caligari*, *Sang d'un Poète*, etc.), on the one hand, and to the more superficial and spectacular fairy tales à la Arabian Nights, on the other. Comedy, later to triumph in Charlie Chaplin, the still

insufficiently appreciated Buster Keaton, the Marx Brothers and the pre-Hollywood creations of René Clair, reached a respectable level in Max Linder and others. In historical and melodramatic films the foundations were laid for movie iconography and movie symbolism, and in the early work of D. W. Griffith we find, not only remarkable attempts at psychological analysis (*Edgar Allan Poe*) and social criticism (*A Corner in Wheat*) but also such basic technical innovations as the long shot, the flashback and the close-up. And modest trick films and cartoons paved the way to Felix the Cat, Popeye the Sailor, and Felix's prodigious offspring, Mickey Mouse.

Within their self-imposed limitations the earlier Disney films, and certain sequences in the later ones,* represent, as it were, a chemically pure distillation of cinematic possibilities. They retain the most important folkloristic elements— sadism, pornography, the humor engendered by both, and moral justice—almost without dilution and often fuse these elements into a variation on the primitive and inexhaustible David-and-Goliath motif, the triumph of the seemingly weak over the seemingly strong; and their fantastic independence of the natural laws gives them the power to integrate space with time to such perfection that the spatial and temporal experiences of sight and hearing come to be almost interconvertible. A series of soap bubbles, successively punctured, emits a series of sounds exactly corresponding in pitch and volume to the size of the bubbles; the three uvulae of Willie the Whale— small, large and medium—vibrate in consonance with tenor, bass and baritone notes; and the very concept of stationary existence is completely abolished. No object in creation, whether it be a house, a piano, a tree or an alarm clock, lacks the faculties of organic, in fact anthropomorphic, movement, facial expression and phonetic articulation. Incidentally, even in normal, "realistic" films the inanimate object, provided that it is dynamizable, can play the role of a leading character as do the ancient railroad engines in Buster Keaton's *General* and *Niagara Falls*. How the earlier Russian films exploited the possibility of heroizing all sorts of machinery lives in everybody's

---

*I make this distinction because it was, in my opinion, a fall from grace when *Snow White* introduced the human figure and when *Fantasia* attempted to picturalize The World's Great Music. The very virtue of the animated cartoon is to animate, that is to say endow lifeless things with life, or living things with a different kind of life. It effects a metamorphosis, and such a metamorphosis is wonderfully present in Disney's animals, plants, thunderclouds and railroad trains. Whereas his dwarfs, glamourized princesses, hillbillies, baseball players, rouged centaurs and *amigos* from South America are not transformations but caricatures at best, and fakes or vulgarities at worst. Concerning music, however, it should be borne in mind that its cinematic use is no less predicated upon the principle of coexpressibility than is the cinematic use of the spoken word. There is music permitting or even requiring the accompaniment of visible action (such as dances, ballet music and any kind of operatic compositions) and music of which the opposite is true; and this is, again, not a question of quality (most of us rightly prefer a waltz by Johann Strauss to a symphony by Sibelius) but one of intention. In *Fantasia* the hippopotamus ballet was wonderful, and the Pastoral Symphony and "Ave Maria" sequences were deplorable, not because the cartooning in the first case was infinitely better than in the two others (*cf.* above), and certainly not because Beethoven and Schubert are too sacred for picturalization, but simply because Ponchielli's "Dance of the Hours" is coexpressible while the Pastoral Symphony and the "Ave Maria" are not. In cases like these even the best imaginable music and the best imaginable cartoon will impair rather than enhance each other's effectiveness.

Experimental proof of all this was furnished by Disney's recent *Make Mine Music* where The World's Great Music was fortunately restricted to Prokofieff. Even among the other sequences the most successful ones were those in which the human element was either absent or reduced to a minimum; Willie the Whale, the Ballad of Johnny Fedora and Alice Blue-Bonnet, and, above all, the truly magnificent Goodman Quartet.

memory; and it is perhaps more than an accident that the two films which will go down in history as the great comical and the great serious masterpiece of the silent period bear the names and immortalize the personalities of two big ships: Keaton's *Navigator* (1924) and Eisenstein's *Potemkin* (1925).

The evolution from the jerky beginnings to this grand climax offers the fascinating spectacle of a new artistic medium gradually becoming conscious of its legitimate, that is, exclusive, possibilities and limitations—a spectacle not unlike the development of the mosaic, which started out with transposing illusionistic genre pictures into a more durable material and culminated in the hieratic supernaturalism of Ravenna; or the development of line engraving, which started out as a cheap and handy substitute for book illumination and culminated in the purely "graphic" style of Dürer.

Just so the silent movies developed a definite style of their own, adapted to the specific conditions of the medium. A hitherto unknown language was forced upon a public not yet capable of reading it, and the more proficient the public became the more refinement could develop in the language. For a Saxon peasant of around 800 it was not easy to understand the meaning of a picture showing a man as he pours water over the head of another man, and even later many people found it difficult to grasp the significance of two ladies standing behind the throne of an emperor. For the public of around 1910 it was no less difficult to understand the meaning of the speechless action in a moving picture, and the producers employed means of clarification similar to those we find in medieval art. One of these were printed titles or letters, striking equivalents of the medieval *tituli* and scrolls (at a still earlier date there even used to be explainers who would say, *viva voce*, "Now he thinks his wife is dead but she isn't" or "I don't wish to offend the ladies in the audience but I doubt that any of them would have done that much for her child"). Another, less obtrusive method of explanation was the introduction of a fixed iconography which from the outset informed the spectator about the basic facts and characters, much as the two ladies behind the emperor, when carrying a sword and a cross respectively, were uniquely determined as Fortitude and Faith. There arose, identifiable by standardized appearance, behavior and attributes, the well-remembered types of the Vamp and the Straight Girl (perhaps the most convincing modern equivalents of the medieval personifications of the Vices and Virtues), the Family Man, and the Villain, the latter marked by a black mustache and walking stick. Nocturnal scenes were printed on blue or green film. A checkered tablecloth meant, once for all, a "poor but honest" milieu; a happy marriage, soon to be endangered by the shadows from the past, was symbolized by the young wife's pouring the breakfast coffee for her husband; the first kiss was invariably announced by the lady's gently playing with her partner's necktie and was invariably accompanied by her kicking out with her left foot. The conduct of the characters was predetemined accordingly. The poor but honest laborer who, after leaving his little house with the checkered tablecloth, came upon an abandoned baby could not but take it to his home and bring it up as best he could; the Family Man could not but yield, however temporarily, to the temptations of the Vamp. As a result these early melodramas had a highly gratifying and soothing quality in that events took shape, without the complications of individual psychology, according to a pure Aristotelian logic so badly missed in real life.

Devices like these became gradually less necessary as the public grew accustomed to interpret the action by itself and were virtually abolished by the invention of the talking film. But even now there survive—quite legitimately, I think—the remnants of a "fixed attitude and attribute" principle and, more basic, a primitive or folkloristic concept of plot construction. Even today we take it for granted that the diphtheria of a baby tends to occur when the parents are out and, having occurred, solves all their matrimonial problems. Even today we demand of a decent mystery film that the butler, though he may be anything from an agent of the British Secret Service to the real father of the daughter of the house, must not turn out to be the murderer. Even today we love to see Pasteur, Zola or Ehrlich win out against stupidity and wickedness, with their respective wives trusting and trusting all the time. Even today we much prefer a happy finale to a gloomy one and insist, at the very least, on the observance of the Aristotelian rule that the story have a beginning, a middle and an ending—a rule the abrogation of which has done so much to estrange the general public from the more elevated spheres of modern writing. Primitive symbolism, too, survives in such amusing details as the last sequence of *Casablanca* where the delightfully crooked and right-minded *préfet de police* casts an empty bottle of Vichy water into the wastepaper basket; and in such telling symbols of the supernatural as Sir Cedric Hardwicke's Death in the guise of a "gentleman in a dustcoat trying" (*On Borrowed Time*) or Claude Rains's Hermes Psychopompos in the striped trousers of an airline manager (*Here Comes Mister Jordan*).

The most conspicuous advances were made in directing, lighting, camera work, cutting and acting proper. But while in most of these fields the evolution proceeded continuously—though, of course, not without detours, breakdowns and archaic relapses—the development of acting suffered a sudden interruption by the invention of the talking film; so that the style of acting in the silents can already be evaluated in retrospect, as a lost art not unlike the painting technique of Jan van Eyck or, to take up our previous simile, the burin technique of Dürer. It was soon realized that acting in a silent film neither meant a pantomimic exaggeration of stage acting (as was generally and erroneously assumed by professional stage actors who more and more frequently condescended to perform in the movies), nor could dispense with stylization altogether; a man photographed while walking down a gangway in ordinary, everyday-life fashion looked like anything but a man walking down a gangway when the result appeared on the screen. If the picture was to look both natural and meaningful the acting had to be done in a manner equally different from the style of the stage and the reality of ordinary life; speech had to be made dispensable by establishing an organic relation between the acting and the technical procedure of cinephotography—much as in Dürer's prints color had been made dispensable by establishing an organic relation between the design and the technical procedure of line engraving.

This was precisely what the great actors of the silent period accomplished, and it is a significant fact that the best of them did not come from the stage, whose crystallized tradition prevented Duse's only film, *Cenere*, from being more than a priceless record of Duse. They came instead from the circus or the variety, as was the case of Chaplin, Keaton and Will Rogers; from nothing in particular, as was the case of Theda Bara, of her greater European parallel, the Danish actress Asta Nielsen, and

of Garbo; or from everything under the sun, as was the case of Douglas Fairbanks. The style of these "old masters" was indeed comparable to the style of line engraving in that it was, and had to be, exaggerated in comparison with stage acting (just as the sharply incised and vigorously curved *tailles* of the burin are exaggerated in comparison with pencil strokes or brushwork), but richer, subtler and infinitely more precise. The advent of the talkies, reducing if not abolishing this difference between screen acting and stage acting, thus confronted the actors and actresses of the silent screen with a serious problem. Buster Keaton yielded to temptation and fell. Chaplin first tried to stand his ground and to remain an exquisite archaist but finally gave in, with only moderate success (*The Great Dictator*). Only the glorious Harpo has thus far successfully refused to utter a single articulate sound; and only Greta Garbo succeeded, in a measure, in transforming her style in principle. But even in her case one cannot help feeling that her first talking picture, *Anna Christie*, where she could ensconce herself, most of the time, in mute or monosyllabic sullenness, was better than her later performances; and in the second, talking version of *Anna Karenina*, the weakest moment is certainly when she delivers a big Ibsenian speech to her husband, and the strongest when she silently moves along the platform of the railroad station while her despair takes shape in the consonance of her movement (and expression) with the movement of the nocturnal space around her, filled with the real noises of the trains and the imaginary sound of the "little men with the iron hammers" that drives her, relentlessly and almost without her realizing it, under the wheels.

Small wonder that there is sometimes felt a kind of nostalgia for the silent period and that devices have been worked out to combine the virtues of sound and speech with those of silent acting, such as the "oblique close-up" already mentioned in connection with *Henry V*; the dance behind glass doors in *Sous les Toits de Paris*; or, in the *Histoire d'un Tricheur*, Sacha Guitry's recital of the events of his youth while the events themselves are "silently" enacted on the screen. However, this nostalgic feeling is no argument against the talkies as such. Their evolution has shown that, in art, every gain entails a certain loss on the other side of the ledger; but that the gain remains a gain, provided that the basic nature of the medium is realized and respected. One can imagine that, when the cavemen of Altamira began to paint their buffaloes in natural colors instead of merely incising the contours, the more conservative cavemen foretold the end of paleolithic art. But paleolithic art went on, and so will the movies. New technical inventions always tend to dwarf the values already attained, especially in a medium that owes its very existence to technical experimentation. The earliest talkies were infinitely inferior to the then mature silents, and most of the present technicolor films are still inferior to the now mature talkies in black and white. But even if Aldous Huxley's nightmare should come true and the experiences of taste, smell and touch should be added to those of sight and hearing, even then we may say with the Apostle, as we have said when first confronted with the sound track and the technicolor film, "We are troubled on every side, yet not distressed; we are perplexed, but not in despair."

From the law of time-charged space and space-bound time, there follows the fact that the screenplay, in contrast to the theater play, *has no aesthetic existence inde-*

*pendent of its performance, and that its characters have no aesthetic existence out-*
*side the actors.*

The playwright writes in the fond hope that his work will be an imperishable jewel in the treasure house of civilization and will be presented in hundreds of performances that are but transient variations on a "work" that is constant. The script-writer on the other hand, writes for one producer, one director and one cast. Their work achieves the same degree of permanence as does his; and should the same or a similar scenario ever be filmed by a different director and a different cast there will result in an altogether different "play."

Othello or Nora are definite, substantial figures created by the playwright. They can be played well or badly, and they can be "interpreted" in one way or another; but they most definitely exist, no matter who plays them or even whether they are played at all. The character in a film, however, lives and dies with the actor. It is not the entity "Othello" interpreted by Robeson or the entity "Nora" interpreted by Duse; it is the entity "Greta Garbo" incarnate in a figure called Anna Christie or the entity "Robert Montgomery" incarnate in a murderer who, for all we know or care to know, may forever remain anonymous but will never cease to haunt our memories. Even when the names of the characters happen to be Henry VIII or Anna Karenina, the king who ruled England from 1509 to 1547 and the woman created by Tolstoy, they do not exist outside the being of Garbo and Laughton. They are but empty and incorporeal outlines like the shadows in Homer's Hades, assuming the character of reality only when filled with the lifeblood of an actor. Conversely, if a movie role is badly played there remains literally nothing of it, no matter how interesting the character's psychology or how elaborate the words.

What applies to the actor applies, *mutatis mutandis*, to most of the other artists, or artisans, who contribute to the making of a film: the director, the soundman, the enormously important cameraman, even the make-up man. A stage production is rehearsed until everything is ready, and then it is repeatedly performed in three consecutive hours. At each performance everybody has to be on hand and does his work; and afterward he goes home and to bed. The work of the stage actor may thus be likened to that of a musician, and that of the stage director to that of a conductor. Like these, they have a certain repertoire which they have studied and present in a number of complete but transitory performances, be it *Hamlet* today and *Ghosts* tomorrow, or *Life with Father per saecula saeculorum.* The activites of the film actor and the film director, however, are comparable, respectively, to those of the plastic artist and the architect, rather than to those of the musician and the conductor. Stage work is continuous but transitory; film work is discontinuous but permanent. Individual sequences are done piecemeal and out of order according to the most efficient use of sets and personnel. Each bit is done over and over again until it stands; and when the whole has been cut and composed everyone is through with it forever. Needless to say that this very procedure cannot but emphasize the curious consubstantiality that exists between the person of the movie actor and his role. Coming into existence piece by piece, regardless of the natural sequence of events, the "character" can grow into a unified whole only if the actor manages to be, not merely to play, Henry VIII or Anna Karenina throughout the entire wearisome period of shooting. I have it on

the best of authorities that Laughton was really difficult to live with in the particular six or eight weeks during which he was doing—or rather being—Captain Bligh.

It might be said that a film, called into being by a co-operative effort in which all contributions have the same degree of permanence, is the nearest modern equivalent of a medieval cathedral; the role of the producer corresponding, more or less, to that of the bishop or archbishop; that of the director to that of the architect in chief; that of the scenario writers to that of the scholastic advisers establishing the iconographical program; and that of the actors, cameramen, cutters, sound men, make-up men and the diverse technicians to that of those whose work provided the physical entity of the finished product, from the sculptors, glass painters, bronze casters, carpenters and skilled masons down to the quarry men and woodsmen. And if you speak to any one of these collaborators he will tell you, with perfect *bona fides*, that his is really the most important job—which is quite true to the extent that it is indispensable.

The comparison may seem sacrilegious, not only because there are, proportionally, fewer good films than there are good cathedrals, but also because the movies are commercial. However, if commercial art be defined as all art not primarily produced in order to gratify the creative urge of its maker but primarily intended to meet the requirements of a patron or a buying public, it must be said that noncommercial art is the exception rather than the rule, and a fairly recent and not always felicitous exception at that. While it is true that commercial art is always in danger of ending

Laurence Olivier in *Henry V* (1944). The film "uses a device perhaps best designated as 'oblique close-up' (Mr. Olivier's beautiful face inwardly listening to but not pronouncing the great soliloquy)." (PANOFSKY, page 294).

up as a prostitute, it is equally true that noncommercial art is always in danger of ending up as an old maid. Noncommercial art has given us Seurat's "Grande Jatte" and Shakespeare's sonnets, but also much that is esoteric to the point of incommunicability. Conversely, commercial art has given us much that is vulgar or snobbish (two aspects of the same thing) to the point of loathsomeness, but also Dürer's prints and Shakespeare's plays. For, we must not forget that Dürer's prints were partly made on commission and partly intended to be sold in the open market; and that Shakespeare's plays—in contrast to the earlier masques and intermezzi which were produced at court by aristocratic amateurs and could afford to be so incomprehensible that even those who described them in printed monographs occasionally failed to grasp their intended significance—were meant to appeal, and did appeal, not only to the select few but also to everyone who was prepared to pay a shilling for admission.

It is this requirement of communicability that makes commercial art more vital than noncommercial, and therefore potentially much more effective for better or for worse. The commercial producer can both educate and pervert the general public, and can allow the general public—or rather his idea of the general public—both to edu-

Caligari (Werner Krauss) feeding Cesare (Conrad Veidt) in *The Cabinet of Doctor Caligari* (1919). "The expressionist settings . . . could exert but little influence upon the general course of events. To prestylize reality prior to tackling it amounts to dodging the problem" (PANOFSKY, page 302). "Films of this type are not only intended as autonomous wholes but frequently ignore physical reality or exploit it for purposes alien to photographic veracity" (KRACAUER, page 153).

cate and to pervert himself. As is demonstrated by a number of excellent films that proved to be great box office successes, the public does not refuse to accept good products if it gets them. That it does not get them very often is caused not so much by commercialism as such as by too little discernment and, paradoxical though it may seem, too much timidity in its application. Hollywood believes that it must produce "what the public wants" while the public would take whatever Hollywood produces. If Hollywood were to decide for itself what it wants it would get away with it—even if it should decide to "depart from evil and do good." For, to revert to whence we started, in modern life the movies are what most other forms of art have ceased to be, not an adornment but a necessity.

That this should be so is understandable, not only from a sociological but also from an art-historical point of view. The processes of all the earlier representational arts conform, in a higher or lesser degree, to an idealistic conception of the world. These arts operate from top to bottom, so to speak, and not from bottom to top; they start with an idea to be projected into shapeless matter and not with the objects that constitute the physical world. The painter works on a blank wall or canvas which he organizes into a likeness of things and persons according to his idea (however much this idea may have been nourished by reality); he does not work with the things and persons themselves even if he works "from the model." The same is true of the sculptor with his shapeless mass of clay or his untooled block of stone or wood; of the writer with his sheet of paper or his dictaphone; and even of the stage designer with his empty and sorely limited section of space. It is the movies, and only the movies, that do justice to that materialistic interpretation of the universe which, whether we like it or not, pervades contemporary civilization. Excepting the very special case of the animated cartoon, the movies organize material things and persons, not a neutral medium, into a composition that receives its style, and may even become fantastic or pretervoluntarily symbolic, not so much by an interpretation in the artist's mind as by the actual manipulation of physical objects and recording machinery. The medium of the movies is physical reality as such: the physical reality of eighteenth-century Versailles—no matter whether it be the original or a Hollywood facsimile indistinguishable therefrom for all aesthetic intents and purposes—or of a suburban home in Westchester; the physical reality of the Rue de Lappe in Paris or of the Gobi Desert, of Paul Ehrlich's apartment in Frankfurt or of the streets of New York in the rain; the physical reality of engines and animals, of Edward G. Robinson and Jimmy Cagney. All these objects and persons must be organized into a work of art. They can be arranged in all sorts of ways ("arrangement" comprising, of course, such things as make-up, lighting and camera work); but there is no running away from them. From this point of view it becomes evident that an attempt at subjecting the world to artistic prestylization, as in the expressionist settings of *The Cabinet of Dr. Caligari* (1919), could be no more than an exciting experiment that could exert but little influence upon the general course of events. To prestylize reality prior to tackling it amounts to dodging the problem. The problem is to manipulate and shoot unstylized reality in such a way that the result has style. This is a proposition no less legitmate and no less difficult than any proposition in the older arts.

1934; revised 1947

# SIEGFRIED KRACAUER
## *FROM* THEORY OF FILM

## THE ESTABLISHMENT OF PHYSICAL EXISTENCE

In establishing physical existence, films differ from photographs in two respects: they represent reality as it evolves in time; and they do so with the aid of cinematic techniques and devices.

Consequently, the recording and revealing duties of the two kindred media coincide only in part. And what do they imply for film in particular? The hunting ground of the motion picture camera is in principle unlimited; it is the external world expanding in all directions. Yet there are certain subjects within that world which may be termed "cinematic" because they seem to exert a peculiar attraction on the medium. It is as if the medium were predestined (and eager) to exhibit them. The following pages are devoted to a close examination of these cinematic subjects. Several lie, so to speak, on the surface; they will be dealt with under the title "recording functions." Others would hardly come to our attention or be perceptible were it not for the film camera and/or the intervention of cinematic techniques; they will be discussed in the subsequent section "revealing functions." To be sure, any camera revelation involves recording, but recording on its part need not be revealing.

## RECORDING FUNCTIONS

### *Movement*

At least two groups of quite common external phenomena are naturals for the screen. As might be expected, one is made up of all kinds of movements, these being cinematic because only the motion picture camera is able to record them. Among them are three types which can be considered cinematic subjects par excellence.

## The Chase

"The chase," says Hitchcock, "seems to me the final expression of the motion picture medium." This complex of interrelated movements is motion at its extreme, one might almost say, motion as such—and of course it is immensely serviceable for establishing a continuity of suspenseful physical action. Hence the fascination the chase has held since the beginning of the century. The primitive French comedies availed themselves of it to frame their space-devouring adventures. Gendarmes pursued a dog who eventually turned the tables on them (*Course des sergeants de ville*); pumpkins gliding from a cart were chased by the grocer, his donkey, and passers-by through sewers and over roofs (*La Course des potirons, 1907*; English title: *The Pumpkin Race*). For any Keystone comedy to forgo the chase would have been an unpardonable crime. It was the climax of the whole, its orgiastic finale—a pandemonium, with onrushing trains telescoping into automobiles and narrow escapes down ropes that dangled above a lion's den.

But perhaps nothing reveals the cinematic significance of the reveling in speed more drastically than D. W. Griffith's determination to transfer, at the end of all his great films, the action from the ideological plane to that of his famous "last-minute rescue," which was a chase pure and simple. Or should one say, a race? In any case, the rescuers rush ahead to overwhelm the villains or free their victims at the very last moment, while simultaneously the inner emotion which the dramatic conflict has aroused yields to a state of acute physiological suspense called forth by exuberant physical motion and its immediate implications. Nor is a genuine Western imaginable without a pursuit or a race on horseback. As Flaherty put it, Westerns are popular "because people never get tired of seeing a horse gallop across the plains." Its gallop seems still to gain momentum by contrast with the immense tranquility of the faraway horizon.

## Dancing

The second type of specifically cinematic movement is dancing. This does not apply, of course, to the stage ballet which evolves in a space-time outside actuality proper. Interestingly enough, all attempts at "canning" it adequately have so far failed. Screen reproductions of theatrical dancing either indulge in a completeness which is boring or offer a selection of attractive details which confuse in that they dismember rather than preserve the original. Dancing attains to cinematic eminence only if it is part and parcel of physical reality. René Clair's early sound films have judiciously been called ballets. True, they are, but the performers are real-life Parisians who just cannot help executing dance movements when going about their love adventures and minor quarrels. With infinite subtlety Clair guides them along the divide between the real and unreal. Sometimes it appears as though these delivery boys, taxi drivers, girls, clerks, shopkeepers, and nondescript figures are marionettes banding together and parting from each other according to designs as delicate as lacework; and then again they are made to look and behave like ordinary people in Paris streets and bistros. And the latter impression prevails. For, even granted that they are drawn into an imaginary universe, this universe itself reflects throughout our real

world in stylizing it. What dancing there is, seems to occur on the spur of the moment; it is the vicissitudes of life from which these ballets issue.

Fred Astaire too prefers apparent impromptu performances to stage choreography; he is quite aware that this type of performance is appropriate to the medium. "Each dance," says he, "ought to spring somehow out of character or situation, otherwise it is simply a vaudeville act." This does not mean that he would dispense with theatrical production numbers. But no sooner does he perform in vaudeville fashion than he breaks out of the prison of prearranged stage patterns and, with a genius for improvisation, dances over tables and gravel paths into the everyday world. It is a one-way route which invariably leads from the footlights to the heart of camera-reality. Astaire's consummate dancing is meant to belong among the real-life events with which he toys in his musicals; and it is so organized that it imperceptibly emerges from, and disappears, in the flow of these happenings. . . .

## Nascent Motion

The third type of motion which offers special interest cinematically is not just another group of interrelated movements but movement as contrasted with motionlessness. In focusing upon this contrast, films strikingly demonstrate that objective movement—any movement, for that matter—is one of their choice subjects. Alexander Dovzhenko in both *Arsenal* and *Earth* frequently stops the action to resume it after a short lull. The first phase of this procedure—characters or parts of them abruptly ceasing to move—produces a shock effect, as if all of a sudden we found ourselves in a vacuum. The immediate consequence is that we acutely realize the significance of movement as an integral element of the external world as well as film.

But this is only part of the story. Even though the moving images on the screen come to a standstill, the thrust of their movement is too powerful to be discontinued simultaneously. Accordingly, when the people in *Arsenal* or *Earth* are shown in the form of stills, the suspended movement nevertheless perpetuates itself by changing from outer motion into inner motion. Dovzhenko has known how to make this metamorphosis benefit his penetrations of reality. The immobile lovers in *Earth* become transparent; the deep happiness which is moving them turns inside out. And the spectator on his part grasps their inward agitation because the cessation of external motion moves him all the more intensely to commune with them. Yet despite these rewarding experiences he cannot help feeling a certain relief when eventually the characters take on life again—an event which marks the second and final phase of the procedure. It is a return to the world of film, whose inherent motion alone renders possible such excursions into the whirlpool of the motionless. . . .

## Inanimate Objects

Since the inanimate is featured in many paintings, one might question the legitimacy of characterizing it as a cinematic subject. Yet it is a painter—Fernand Léger— who judiciously insists that only film is equipped to sensitize us, by way of big close-ups, to the possibilities that lie dormant in a hat, a chair, a hand, and a foot. Similarly Cohen-Séat: "And I? says the leaf which is falling.—And we? say the orange peel,

the gust of wind. . . . Film, whether intentionally or not, is their mouthpiece." Nor should it be forgotten that the camera's ability to single out and record the orange peel or the hand marks a decisive difference between screen and stage, so close to each other in some respects. Stage imagery inevitably centers on the actor, whereas film is free to dwell on parts of his appearance and detail the objects about him. In using its freedom to bring the inanimate to the fore and make it a carrier of action, film only protests its peculiar requirement to explore all of physical existence, human or non-human. Within this context it is of interest that in the early 'twenties, when the French cinema was swamped with theatrical adaptations and stage-minded dramas, Louis Delluc tried to put the medium on its own feet by stressing the tremendous impor-tance of objects. If they are assigned the role due to them, he argued, the actor too "is no more than a detail, a fragment of the matter of the world."

Actually, the urge to raise hats and chairs to the status of full-fledged actors has never completely atrophied. From the malicious escalators, the unruly Murphy beds, and the mad automobiles in silent comedy to the cruiser Potemkin, the oil derrick in *Louisiana Story* and the dilapidated kitchen in *Umberto D.*, a long procession of unforgettable objects has passed across the screen—objects which stand out as pro-tagonists and all but overshadow the rest of the case. Or remember the powerful pres-ence of environmental influences in *The Grapes of Wrath*, the part played by noctur-nal Coney Island in *Little Fugitive*, the interaction between the marshland and the guerilla fighters in the last episode of *Paisan*. Of course, the reverse hold true also: films in which the inanimate merely serves as a background to self-contained dia-logue and the closed circuit of human relationships are essentially uncinematic.

## REVEALING FUNCTIONS

"I ask that a film *discover* something for me" declares Luis Buñuel, who is himself a fiery pathfinder of the screen. And what are films likely to discover? The evidence available suggests that they assume three kinds of revealing functions. They tend to reveal things normally unseen; phenomena overwhelming consciousness; and certain aspects of the outer world which may be called "special modes of reality."

### Things Normally Unseen

The many material phenomena which elude observation under normal circum-stances can be divided into three groups. The first includes objects too small to be readily noticed or even perceived by the naked eye and objects so big that they will not be fully taken in either.

#### The Small and the Big

*The small.* The small is conveyed in the form of close-ups. D. W. Griffith was among the first to realize that they are indispensable for cinematic narration. He ini-tiated their use, as we now know it, in *After Many Years* (1908), an adaptation of Ten-nyson's *Enoch Arden*. There his memorable first close-up appeared within contexts which Lewis Jacobs describes as follows: "Going further than he had ventured before, in a scene showing Annie Lee brooding and waiting for her husband's return,

Griffith daringly used a large close-up of her face. . . . He had another surprise, even more radical, to offer. Immediately following the close-up of Annie, he inserted a picture of the object of her thoughts—her husband cast away on a desert isle."

On the surface, this succession of shots seems simply designed to lure the spectator into the dimension of her intimate preoccupations. He first watches Annie from a distance and then approaches her so closely that he sees only her face; if he moves on in the same direction, as the film invites him to do, it is logical that he should penetrate Annie's appearance and land inside her mind. Granting the validity of this interpretation, the close-up of her face is not an end in itself; rather, along with the subsequent shots, it serves to suggest what is going on behind that face—Annie's longing for reunion with her husband. A knowingly chosen detail of her physique thus would help establish the whole of her being in a dramatic interest.

The same obviously holds true of another famous Griffith closeup: Mae Marsh's clasped hands in the trial episode of *Intolerance*. It almost looks as if her huge hands with the convulsively moving fingers were inserted for the sole purpose of illustrating eloquently her anguish at the most crucial moment of the trial; as if, generally speaking, the function of any such detail exhausted itself in intensifying our participation in the total situation. This is how Eisenstein conceives of the close-up. Its main function, says he, is "not so much to *show* or to *present* as to *signify*, to *give meaning*, to *designate*." To designate what? Evidently something of importance to the narrative. And montage-minded as he is, he immediately adds that the significance of the close-up for the plot accrues to it less from its own content than from the manner in which it is juxtaposed with the surrounding shots. According to him, the close-up is primarily a montage unit.

But is this really its function? Consider again the combination of shots with the close-up of Annie's face: the place assigned to the latter in the sequence intimates that Griffith wanted us also to absorb the face for its own sake instead of just passing through and beyond it; the face appears before the desires and emotions to which it refers have been completely defined, thus tempting us to get lost in its puzzling indeterminacy. Annie's face is also an end in itself. An so is the image of Mae Marsh's hands. No doubt it is to impress upon us her inner condition, but besides making us experience what we would in a measure have experienced anyway because of our familiarity with the characters involved, this close-up contributes something momentous and unique—it reveals how her hands behave under the impact of utter despair.

Eisenstein criticizes the close-ups in Griffith films precisely for their relative independence of the contexts in which they occur. He calls them isolated units which tend "to show or to present"; and he insists that to the extent that they indulge in isolation they fail to yield the meanings which the interweaving processes of montage may elicit from them. Had Eisenstein been less possessed with the magic powers of montage he would certainly have acknowledged the cinematic superiority of the Griffith close-up. To Griffith such huge images of small material phenomena are not only integral components of the narrative but disclosures of new aspects of physical reality. In representing them the way he does, he seems to have been guided by the conviction that the cinema is all the more cinematic if it acquaints us with the physical origins, ramifications, and connotations of all the emotional and intellectual events which comprise the plot; that it cannot adequately account for these inner develop-

ments unless it leads us through the thicket of material life from which they emerge and in which they are embedded. . . .

*The big.* Among the large objects, such as vast plains or panoramas of any kind, one deserves special attention: the masses. No doubt imperial Rome already teemed with them. But masses of people in the modern sense entered the historical scene only in the wake of the industrial revolution. Then they became a social force of first magnitude. Warring nations resorted to levies on an unheard-of scale and identifiable groups yielded to the anonymous multitude which filled the big cities in the form of amorphous crowds. Walter Benjamin observes that in the period marked by the rise of photography the daily sight of moving crowds was still a spectacle to which eyes and nerves had to get adjusted. The testimony of sensitive contemporaries would seem to corroborate this sagacious observation: The Paris crowds omnipresent in Baudelaire's *Les Fleurs du mal* function as stimuli which call forth irritating kaleidoscopic sensations; the jostling and shoving passers-by who, in Poe's *Man of the Crowd*, throng gas-lit London provoke a succession of electric shocks.

At the time of its emergence the mass, this giant animal, was a new and upsetting experience. As might be expected, the traditional arts proved unable to encompass and render it. Where they failed, photography easily succeeded; it was technically equipped to portray crowds as the accidental agglomerations they are. Yet only film, the fulfillment of photography in a sense, was equal to the task of capturing them in motion. In this case the instrument of reproduction came into being almost simultaneously with one of its main subjects. Hence the attraction which masses exerted on still and motion picture cameras from the outset. It is certainly more than sheer coincidence that the very first Lumière films featured a crowd of workers and the confusion of arrival and departure at a railway station. Early Italian films elaborated upon the theme; and D. W. Griffith, inspired by them, showed how masses can be represented cinematically. The Russians absorbed his lesson, applying it in ways of their own. . . .

### The Transient

The second group of things normally unseen comprises the transient. Here belong, first, fleeting impressions—"the shadow of a cloud passing across the plain, a leaf which yields to the wind." Evanescent, like dream elements, such impressions may haunt the moviegoer long after the story they are called upon to implement has sunk into oblivion. The manes of the galloping horses—flying threads or streamers rather than manes—in the chariot race episode of Fred Niblo's *Ben Hur* are as unforgettable as the fiery traces of the projectiles that tear the night in *Desert Victory*. The motion picture camera seems to be partial to the least permanent components of our environment. It may be anticipated that the street in the broadest sense of the word is a place where impressions of this kind are bound to occur. "The cinema," says Aragon, delighting in its snapshot-like predilection for the ephemeral, "has taught us more about man in a few years than centuries of painting have taught: fugitive expressions, attitudes scarcely credible yet real, charm and hideousness."

Second, there are movements of so transitory a nature that they would be imperceptible were it not for two cinematic techniques: accelerated-motion, which condenses extremely slow and, hence, unobservable developments, such as the growth of

plants, and slow-motion, which expands movements too fast to be registered. Like the big close-up, these correlated techniques lead straight into "reality of another dimension." Pictures of stalks piercing the soil in the process of growing open up imaginary areas, and racing legs shown in slow-motion do not just slow down but change in appearance and perform bizarre evolutions—patterns remote from reality as we know it. Slow-motion shots parallel the regular close-ups; they are, so to speak, temporal close-ups achieving in time what the close-up proper is achieving in space. That, unlike the latter, they are used rather infrequently, may be traced to the fact that the enlargement of spatial phenomena, as effected by the close-up, seems more "natural" to us than the expansion of a given time interval. (On the other hand, it appears that film makers draw more readily on slow-motion than on the reverse technique—perhaps simply because it does not require so lengthy preparations.)

As contrived-reality pictures, the deviant images gained by both techniques, especially slow-motion, may well figure in nonrealistic experimental films. Yet they live up to the cinematic approach only if they are made to fulfill a revealing function within contexts focusing on physical existence. The late Jean Epstein, who felt so immensely attracted by "reality of another dimension," considered this their true destination. Referring to waves in slow-motion and clouds in accelerated-motion, he declared that for all their "startling physics and strange mechanics" they "are but a portrait—seen in a certain perspective—of the world in which we live."

### Blind Spots of the Mind

The third and last group of things normally unseen consists of phenomena which figure among the blind spots of the mind; habit and prejudice prevent us from noticing them. The role which cultural standards and traditions may play in these processes of elimination is drastically illustrated by a report on the reactions of African natives to a film made on the spot. After the screening the spectators, all of them still unacquainted with the medium, talked volubly about a chicken they allegedly had seen picking food in the mud. The film maker himself, entirely unaware of its presence, attended several performances without being able to detect it. Had it been dreamed up by the natives? Only by scanning his film foot by foot did he eventually succeed in tracing the chicken: it appeared for a fleeting moment somewhere in a corner of a picture and then vanished forever.

The following types of objects are cinematic because they stubbornly escape our attention in everyday life.

*Unconventional complexes.* Film may bare real-life complexes which the conventional figure-ground patterns usually conceal from view. Imagine a man in a room: accustomed as we are to visualize the human figure as a whole, it would take us an enormous effort to perceive instead of the whole man a pictorial unit consisting, say, of his right shoulder and arm, fragments of furniture and a section of the wall. But this is exactly what photography and, more powerfully, film may make us see. The motion picture camera has a way of disintegrating familiar objects and bringing to the fore—often just in moving about—previously invisible interrelationships between parts of them. These newly arising complexes lurk behind the things known and cut across their easily identifiable contexts. *Jazz Dance*, for instance, abounds with shots of ensembles built from human torsos, clothes, scattered legs, and what not—shapes

which are almost anonymous. In rendering physical existence, film tends to reveal configurations of semi-abstract phenomena. Sometimes these textures take on an ornamental character. In the Nazi propaganda film *Triumph of the Will* moving banners fuse into a very beautiful pattern at the moment when they begin to fill the screen.

*The refuse.* Many objects remain unnoticed simply because it never occurs to us to look their way. Most people turn their backs on garbage cans, the dirt underfoot, the waste they leave behind. Films have no such inhibitions; on the contrary, what we ordinarily prefer to ignore proves attractive to them precisely because of this common neglect. Ruttman's *Berlin* includes a wealth of sewer grates, gutters, and streets littered with rubbish; and Cavalcanti in his *Rien que les heures* is hardly less garbage-minded. To be sure, shots in this vein may be required by the action, but intrigues inspired by a sense of the medium are often so devised that they offer the camera ample opportunity to satisfy its inborn curiosity and function as a rag-picker; think of the old silent comedies—e.g. Chaplin's *A Dog's Life*—or pictures which involve crime, war, or misery. Since sights of refuse are particularly impressive after spectacles extolling the joy of living, film makers have repeatedly capitalized on the contrast between glamorous festivities and their dreary aftermath. You see a banquet on the screen and then, when everybody has gone, you are made to linger for a moment and stare at the crumpled tablecloth, the half-emptied glasses, and the unappetizing dishes. The classical American gangster films indulged in this effect. *Scarface* opens on a restaurant at dawn, with the remnants of the nocturnal orgy strewn over floors and tables; and after the gangster's ball in Sternberg's *Underworld* Bancroft totters through a maze of confetti and streamers left over from the feast.

*The familiar.* Nor do we perceive the familiar. It is not as if we shrank from it, as we do in the case of refuse; we just take it for granted without giving it a thought. Intimate faces, streets we walk day by day, the house we live in—all these things are part of us like our skin, and because we know them by heart we do not know them with the eye. Once integrated into our existence, they cease to be objects of perception, goals to be attained. In fact, we would be immobilized if we focused on them. This is confirmed by a common experience. A man entering his room will immediately feel disturbed if during his absence something has been changed in it. But in order to find out about the cause of his uneasiness he must discontinue his routine occupations; only in deliberately scrutinizing, and thus estranging, the room will be able to discover what it actually is that has been changed. Proust's narrator is acutely aware of this very estrangement when he suddenly sees his grandmother not as he always believed her to be but as she is or at least as she would appear to a stranger—a snapshot likeness severed from his dreams and memories.

Films make us undergo similar experiences a thousand times. They alienate our environment in exposing it. One ever-recurrent film scene runs as follows: Two or more people are conversing with each other. In the middle of their talk the camera, as if entirely indifferent to it, slowly pans through the room, inviting us to watch the faces of the listeners and various furniture pieces in a detached spirit. Whatever this may mean within the given context, it invariably dissolves a well-known total situation and thereby confronts the spectator with isolated phenomena which he previously neglected or overlooked as matter-of-course components of that situation. As

the camera pans, curtains become eloquent and eyes tell a story of their own. The way leads toward the unfamiliar in the familiar. How often do we not come across shots of street corners, buildings, and landscapes with which we were acquainted all our life; we naturally recognize them and yet it is as if they were virgin impressions emerging from the abyss of nearness. The opening sequence of Vigo's *Zéro de conduite* shows two boys traveling back to school by train. Is it just an ordinarily night trip? Vigo manages to transform a familiar railway compartment into a magic wigwam in which the two, drunk from their boasts and pranks, are floating through the air.

This transformation is partly achieved with the aid of a device, both photographic and cinematic, which deserves some attention—the use of uncommon camera angles. Vigo occasionally represents the railway compartment slantwise and from below so that the whole room seems to drift along in the haze from the cigars which the high-strung schoolboys are smoking, while little toy balloons hover to and fro before their pale faces. Proust knew about the alienating effect of this device. After having mentioned that certain photographs of scenery and towns are called "admirable," he continues: "If we press for a definition of what their admirers mean by that epithet, we shall find that it is generally applied to some unusual picture of a familiar object, a picture different from those that we are accustomed to see, unusual and yet true to nature, and for that reason doubly impressive because it startles us, makes us emerge from our habits, and at the same time brings us back to ourselves by recalling to us an earlier impression." And to concretize this definition, he refers to the picture of a cathedral which does not render it as it is normally seen—namely, in the middle of the town—but is taken from a point of view from which the building "will appear thirty times the height of the houses." . . .

## Phenomena Overwhelming Consciousness

Elemental catastrophes, the atrocities of war, acts of violence and terror, sexual debauchery, and death are events which tend to overwhelm consciousness. In any case, they call forth excitements and agonies bound to thwart detached observation. No one witnessing such an event, let alone playing an active part in it, should therefore be expected accurately to account for what he has seen. Since these manifestations of crude nature, human or otherwise, fall into the area of physical reality, they range all the more among the cinematic subjects. Only the camera is able to represent them without distortion.

Actually the medium has always shown a predilection for events of this type. There is practically no newsreel that would not indulge in the ravages of an inundation, a hurricane, an airplane crash, or whatever catastrophe happens to be at hand. The same applies to feature films. One of the first film strips ever made was *The Execution of Mary Queen of Scots* (1895); the executioner cuts off her head and then holds it in his uplifted hand so that no spectator can possibly avoid looking at the frightful exhibit. Pornographic motifs also emerged at a very early date. The path of the cinema is beset with films reveling in disasters and nightmarish incidents. Suffice it to pick out, at random, the war horrors in Dovzhenko's *Arsenal* and Pabst's *Westfront 1918*; the terrible execution sequence at the end of *Thunder over Mexico*, a film based on Eisen-

stein's Mexican material; the earthquake in *San Francisco*; the torture episode in Rossellini's *Open City*; the depiction of a Polish Nazi concentration camp in *The Last Stop*; the scene with the young hoodlums wantonly mistreating a blind man in Buñuel's *Los Olvidados*.

Because of its sustained concern with all that is dreadful and off limits, the medium has frequently been accused of a penchant for cheap sensationalism. What lends support to this verdict is the indisputable fact that films have a habit of dwelling on the sensational much longer than any moral purpose would seem to justify; it often is as if that purpose served merely as a pretext for rendering a savage murder or the like.

In defense of the medium one might argue that it would not be the main medium it is if it failed to provide stunning sensations; and that, in offering them, it only follows a venerable tradition. Since time immemorial, people have craved spectacles permitting them vicariously to experience the fury of conflagrations, the excesses of cruelty and suffering, and unspeakable lusts—spectacles which shock the shuddering and delighted onlooker into unseeing participation.

Yet this argument misses the point. The point is, rather, that the cinema does not simply imitate and continue the ancient gladiator fights or the *Grand Guignol* but adds something new and momentous: it insists on rendering visible what is commonly drowned in inner agitation. Of course, such revelations conform all the more to the cinematic approach if they bear on actual catastrophes and horrors. In deliberately detailing feats of sadism in their films, Rossellini and Buñuel force the spectator to take in these appalling sights and at the same time impress them on him as real-life events recorded by the imperturbable camera. Similarly, besides trying to put across their propaganda messages, the Russian films of the 'twenties convey to us the paroxysmal upheavals of real masses which, because of their emotional *and* spatial enormity, depend doubly upon cinematic treatment to be perceptible.

The cinema, then, aims at transforming the agitated witness into a conscious observer. Nothing could be more legitimate than its lack of inhibitions in picturing spectacles which upset the mind. Thus it keeps us from shutting our eyes to the "blind drive of things."

## *Special Modes of Reality*

Finally films may expose physical reality as it appears to individuals in extreme states of mind generated by such events as we have mentioned, mental disturbances, or any other external or internal causes. Supposing such a state of mind is provoked by an act of violence, then the camera often aspires to render the images which an emotionally upset witness or participant will from of it. These images also belong among the cinematic subjects. They are distorted from the viewpoint of a detached observer; and they differ from each other according to the varying states of mind in which they originate.

In his *Ten Days That Shook the World*, for instance, Eisenstein composes a physical universe reflecting exultation. This episode runs as follows: At the beginning of the October Revolution, worker delegates succeed in bringing a contingent of Cossacks over to their side; the Cossacks put their half-drawn swords with the ornamented pommels back into their sheaths, and then the two groups boisterously frat-

ernize in a state of euphoria. The ensuing dance scene is represented in the form of an accelerated montage sequence which pictures the world as experienced by the overjoyed. In their great joy, dancers and onlookers who constantly mingle cannot help perceiving incoherent pieces of their immediate environment in motion. It is a whirling agglomerate of fragments that surrounds them. And Eisenstein captures this jumble to perfection by having follow each other—in a succession which becomes ever faster with the growing ecstasy—shots of Cossack boots executing the *krakoviak*, worker legs dancing through a puddle, clapping hands, and faces inordinately broadened by laughter.

In the world of a panic-stricken individual laughter yields to grimacing and dazzling confusion to fearful rigidity. At any rate, this is how Ernö Metzner conceived of that world in his *Ueberfall*. Its "hero" is a wretched little fellow who gets a lucky break thanks to a coin he furtively picks up in the street and then stakes in a crap game. As he walks away with his wallet stuffed, a thug follows him at a steadily diminishing distance. The man is scared. No sooner does he take to his heels than all the objects about him make common cause with his pursuer. The dark railway underpass turns into a sinister trap; frozen threats, the dilapidated slum houses close ranks and stare at him. (It is noteworthy that these effects are largely due to accomplished photography.) Temporarily saved by a streetwalker, who puts him up in her room, the man knows that the thug continues to lie in wait for him down in the street. The curtain moves, and he feels that the room itself harbors dangers. There is no escape wherever he looks. He looks into the mirror: what shines out of it are distorted reflections of his mask-like features.

<div align="right">1960</div>

# BÉLA BALÁSZ
## *FROM* THEORY OF THE FILM

## THE CLOSE-UP

### THE FACE OF THINGS

The first new world discovered by the film camera in the days of the silent film was the world of very small things visible only from very short distances, the hidden life of little things. By this the camera showed us not only hitherto unknown objects and events: the adventures of beetles in a wilderness of blades of grass, the tragedies of day-old chicks in a corner of the poultry-run, the erotic battles of flowers and the poetry of miniature landscapes. It brought us not only new themes. By means of the close-up the camera in the days of the silent film revealed also the hidden main-springs of a life which we had thought we already knew so well. Blurred outlines are mostly the result of our insensitive short-sightedness and superficiality. We skim over the teeming substance of life. The camera has uncovered that cell-life of the vital issues in which all great events are ultimately conceived; for the greatest land-slide is only the aggregate of the movements of single particles. A multitude of close-ups can show us the very instant in which the general is transformed into the particular. The close-up has not only widened our vision of life, it has also deepened it. In the days of the silent film it not only revealed new things, but showed us the meaning of the old.

### VISUAL LIFE

The close-up can show us a quality in a gesture of the hand we never noticed before when we saw that hand stroke or strike something, a quality which is often more expressive than any play of the features. The close-up shows your shadow on the wall with which you have lived all your life and which you scarcely knew; it shows the speechless face and fate of the dumb objects that live with you in your

room and whose fate is bound up with your own. Before this you looked at your life as a concert-goer ignorant of music listens to an orchestra playing a symphony. All he hears is the leading melody, all the rest is blurred into a general murmur. Only those can really understand and enjoy the music who can hear the contrapuntal architecture of each part in the score. This is how we see life: only its leading melody meets the eye. But a good film with its close-ups reveals the most hidden parts in our polyphonous life, and teaches us to see the intricate visual details of life as one reads an orchestral score.

## LYRICAL CHARM OF THE CLOSE-UP

The close-up may sometimes give the impression of a mere naturalist preoccupation with detail. But good close-ups radiate a tender human attitude in the contemplation of hidden things, a delicate solicitude, a gentle bending over the intimacies of life-in-the-miniature, a warm sensibility. Good close-ups are lyrical; it is the heart, not the eye, that has perceived them.

Close-ups are often dramatic revelations of what is really happening under the surface of appearances. You may see a medium shot of someone sitting and conducting a conversation with icy calm. The close-up will show trembling fingers nervously fumbling a small object—sign of an internal storm. Among pictures of a comfortable house breathing a sunny security, we suddenly see the evil grin of a vicious head on the carved mantelpiece or the menacing grimace of a door opening into darkness. Like the *leitmotif* of impending fate in an opera, the shadow of some impending disaster falls across the cheerful scene.

Close-ups are the pictures expressing the poetic sensibility of the director. They show the faces of things and those expressions on them which are significant because they are reflected expressions of our own subconscious feeling. Herein lies the art of the true cameraman.

In a very old American film I saw this dramatic scene: the bride at the altar suddenly runs away from the bridegroom whom she detests, who is rich and who has been forced on her. As she rushes away she must pass through a large room full of wedding presents. Beautiful things, good things, useful things, things radiating plenty and security smile at her and lean towards her with expressive faces. And there are the presents given by the bridegroom: faces of things radiating touching attention, consideration, tenderness, love—and they all seem to be looking at the fleeing bride, because she looks at them; all seem to stretch out hands towards her, because she feels they do so. There are ever more of them—they crowd the room and block her path—her flight slows down more and more, then she stops and finally turns back. . . .

Having discovered the soul of things in the close-up, the silent film undeniably overrated their importance and sometimes succumbed to the temptation of showing "the hidden little life" as an end in itself, divorced from human destinies; it strayed away from the dramatic plot and presented the "poetry of things" instead of human beings. But what Lessing said in his *Laocoön* about Homer—that he never depicted anything but human actions and always described objects only inasmuch as they took part in the action—should to this day serve as a model for all epic and dramatic art as long as it centers around the presentation of man.

# THE FACE OF MAN

Every art deals with human beings, it is a human manifestation and presents human beings. To paraphrase Marx: "The root of all art is man." When the film close-up strips the veil of our imperceptiveness and insensitivity from the hidden little things and shows us the face of objects, it still shows us man, for what makes objects expressive are the human expressions projected on to them. The objects only reflect our own selves, and this is what distinguished art from scientific knowledge (although even the latter is to a great extent subjectively determined). When we see the face of things, we do what the ancients did in creating *gods* in man's image and breathing a human soul into them. The close-ups of the film are the creative instruments of this mighty visual anthropomorphism.

What was more important, however, than the discovery of the physiognomy of things, was the discovery of the human face. Facial expression is the most subjective manifestation of man, more subjective even than speech, for vocabulary and grammar are subject to more or less universally valid rules and conventions, while the play of features, as has already been said, is a manifestation not governed by objective canons, even though it is largely a matter of imitation. This most subjective and individual of human manifestations is rendered objective in the close-up.

## A NEW DIMENSION

If the close-up lifts some object or some part of an object out of its surroundings, we nevertheless perceive it as existing in space; we do not for an instant forget that the hand, say, which is shown by the close-up, belongs to some human being. It is precisely this connection which lends meaning to its every movement. But when Griffith's genius and daring first projected gigantic "severed heads" on to the cinema screen, he not only brought the human face closer to us in space, he also transposed it from space into another dimension. We do not mean, of course, the cinema screen and the patches of light and shadow moving across it, which being visible things, can be conceived only in space; we mean the expression on the face as revealed by the close-up. We have said that the isolated hand would lose its meaning, its expression, if we did not know and imagine its connection with some human being. The facial expression on a face is complete and comprehensible in itself and therefore we need not think of it as existing in space and time. Even if we had just seen the same face in the middle of a crowd and the close-up merely separated it from the others, we would still feel that we have suddenly been left alone with this one face to the exclusion of the rest of the world. Even if we have just seen the owner of the face in a long shot, when we look into the eyes in a close-up, we no longer think of that wide space, because the expression and significance of the face has no relation to space and no connection with it. Facing an isolated face takes us out of space, our consciousness of space is cut out and we find ourselves in another dimension: that of physiognomy. The fact that the features of the face can be seen side by side, i.e., in space—that the eyes are at the top, the ears at the sides and the mouth lower down—loses all reference to space when we see, not a figure of flesh and bone, but an expression, or in other words when we see emotions, moods, intentions and thoughts, things which

although our eyes can see them, are not in space. For feelings, emotions, moods, intentions, thoughts are not themselves things pertaining to space, even if they are rendered visible by means which are.

## MELODY AND PHYSIOGNOMY

We will be helped in understanding this peculiar dimension by Henri Bergson's analysis of time and duration. A melody, said Bergson, is composed of single notes which follow each other in sequence, i.e. in time. Nevertheless a melody has no dimension in time, because the first note is made an element of the melody only because it refers to the next note and because it stands in a definite relation to all other notes down to the last. Hence the last note, which may not be played for some time, is yet already present in the first note as a melody-creating element. And the last note completes the melody only because we hear the first note along with it. The notes sound one after the other in a time-sequence, hence they have a real duration, but the coherent line of melody has no dimension in time; the relation of the notes to each other is not a phenomenon occurring in time. The melody is not born gradually in the course of time but is already in existence as a complete entity as soon as the first note is played. How else would we know that a melody is begun? The single notes have duration in time, but their relation to each other, which gives meaning to the individual sounds, is outside time. A logical deduction also has its sequence, but premise and conclusion do not follow one another in time. The process of thinking as a psychological process may have duration; but the logical forms, like melodies, do not belong to the dimension of time.

Now facial expression, physiognomy, has a relation to space similar to the relation of melody to time. The single features, of course, appear in space; but the significance of their relation to one another is not a phenomenon pertaining to space, no more than are the emotions, thoughts and ideas which are manifested in the facial expressions we see. They are picture-like and yet they seem outside space; such is the psychological effect of facial expression.

## SILENT SOLILOQUY

The modern stage no longer uses the spoken soliloquy, although without it the characters are silenced just when they are the most sincere, the least hampered by convention: when they are alone. The public of today will not tolerate the spoken soliloquy, allegedly because it is "unnatural." Now the film has brought us the silent soliloquy, in which a face can speak with the subtlest shades of meaning without appearing unnatural and arousing the distaste of the spectators. In this silent monologue the solitary human soul can find a tongue more candid and uninhibited than in any spoken soliloquy, for it speaks instinctively, subconsciously. The language of the face cannot be suppressed or controlled. However disciplined and practisedly hypocritical a face may be, in the enlarging close-up we see even that it is concealing something, that is looking a lie. For such things have their own specific expressions superimposed on the feigned one. It is much easier to lie in words than with the face and the film has proved it beyond doubt.

In the film the mute soliloquy of the face speaks even when the hero is not alone, and herein lies a new great opportunity for depicting man. The poetic significance of the soliloquy is that it is a manifestation of mental, not physical, loneliness. Nevertheless, on the stage a character can speak a monologue only when there is no one else there, even though a character might feel a thousand times more lonely if alone among a large crowd. The monologue of loneliness may raise its voice within him a hundred times even while he is audibly talking to someone. Hence the most deep-felt human soliloquies could not find such expression, for the close-up can lift a character out of the heart of the greatest crowd and show how solitary it is in reality and what it feels in this crowded solitude.

The film, especially the sound film, can separate the words of a character talking to others from the mute play of features by means of which, in the middle of such a conversation, we are made to overhear a mute soliloquy and realize the difference between this soliloquy and the audible conversation. What a flesh-and-blood actor can show on the real stage is at most that his words are insincere and it is a mere convention that the partner in such a conversation is blinded to what every spectator can see. But in the isolated close-up of the film we can see to the bottom of a soul by means of such tiny movements of facial muscles which even the most observant partner would never perceive.

A novelist can, of course, write a dialogue so as to weave into it what the speakers think to themselves while they are talking. But by so doing he splits up the sometimes comic, sometimes tragic, but always awe-inspiring, unity between spoken word and hidden thought with which this contradiction is rendered manifest in the human face and which the film was the first to show us in all its dazzling variety.

## "POLYPHONIC" PLAY OF FEATURES

The film first made possible what, for lack of better description, I call the "polyphonic" play of features. By it I mean the appearance on the same face of contradictory expressions. In a sort of physiognomic chord a variety of feelings, passions and thoughts are synthesized in the play of the features as an adequate expression of the multiplicity of the human soul.

Asta Nielsen once played a woman hired to seduce a rich young man. The man who hired her is watching the results from behind a curtain. Knowing that she is under observation, Asta Nielsen feigns love. She does it convincingly: the whole gamut of appropriate emotion is displayed in her face. Nevertheless we are aware that it is only play-acting, that it is a sham, a mask. But in the course of the scene Asta Nielsen really falls in love with the young man. Her facial expression shows little change; she had been "registering" love all the time and done it well. How else could she now show that this time she was really in love? Her expression changes only by a scarcely perceptible and yet immediately obvious nuance—and what a few minutes before was a sham is now the sincere expression of a deep emotion. Then Asta Nielsen suddenly remembers that she is under observation. The man behind the curtain must not be allowed to read her face and learn that she is now no longer feigning, but really feeling love. So Asta now pretends to be pretending. Her face shows a new, by this time threefold, change. First she feigns love, then she genuinely shows

love, and as she is not permitted to be in love in good earnest, her face again registers a sham, a pretence of love. But now it is this pretence that is a lie. Now she is lying that she is lying. And we can see all this clearly in her face, over which she has drawn two different masks. At such times an invisible face appears in front of the real one, just as spoken words can by association of ideas conjure up things unspoken and unseen, perceived only by those to whom they are addressed.

In the early days of the silent film Griffith showed a scene of this character. The hero of the film is a Chinese merchant. Lillian Gish, playing a beggar-girl who is being pursued by enemies, collapses at his door. The Chinese merchant finds her, carries her into his house and looks after the sick girl. The girl slowly recovers, but her face remains stone-like in its sorrow. "Can't you smile?" the Chinese asks the frightened child who is only just beginning to trust him. "I'll try," says Lillian Gish, picks up a mirror and goes through the motions of a smile, aiding her face muscles with her fingers. The result is a painful, even horrible mask which the girl now turns towards the Chinese merchant. But his kindly friendly eyes bring a real smile to her face. The face itself does not change; but a warm emotion lights it up from inside and an intangible nuance turns the grimace into a real expression.

In the days of the silent film such a close-up provided an entire scene. A good idea of the director and a fine performance on the part of the actor gave as a result an interesting, moving, new experience for the audience.

## MICROPHYSIOGNOMY

In the silent facial expression, isolated from its surroundings, seemed to penetrate to a strange new dimension of the soul. It revealed to us a new world—the world of microphysiognomy which could not otherwise be seen with the naked eye or in everyday life. In the sound film the part played by this 'microphysiognomy' has greatly diminished because it is now apparently possible to express in words much of what facial expression apparently showed. But it is never the same—many profound emotional experiences can never be expressed in words at all.

Not even the greatest writer, the most consummate artist of the pen, could tell in words what Asta Nielsen tells with her face in close-up as she sits down to her mirror and tries to make up for the last time her aged, wrinkled face, riddled with poverty, misery, disease and prostitution, when she is expecting her lover, released after ten years in jail; a lover who has retained his youth in captivity because life could not touch him there.

## ASTA AT THE MIRROR

She looks into the mirror, her face pale and deadly earnest. It expresses anxiety and unspeakable horror. She is like a general who, hopelessly encircled with his whole army, bends once more, for the last time, over this maps to search for a way out and finds there is no escape. Then she begins to work feverishly, attacking that disgustingly riddled face with a trembling hand. She holds her lipstick as Michelangelo might have held his chisel on the last night of his life. It is a life-and-death struggle. The spectator watches with bated breath as this woman paints her face in front of her

mirror. The mirror is cracked and dull, and from it the last convulsions of a tortured soul look out on you. She tries to save her life with a little rouge! No good! She wipes it off with a dirty rag. She tries again. And again. Then she shrugs her shoulders and wipes it all off with a movement which clearly shows that she has now wiped off her

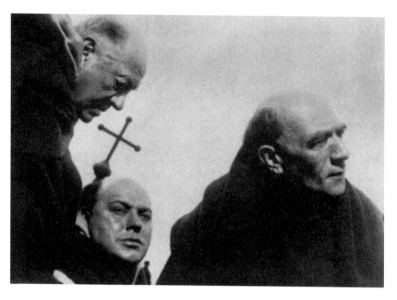

The accusers and Joan (Falconetti) in *The Passion of Joan of Arc* (1928). In "Dreyer's film . . . we move in the spiritual dimension of facial expression alone" (BALÁSZ, page 321). "It is a documentary of faces" (BAZIN, page 427).

life. She throws the rag away. A close-up shows the dirty rag falling on the floor and after it has fallen, sinking down a little more. This movement of the rag is also quite easy to understand—it is the last convulsion of a death agony.

In this close-up "microphysiognomy" showed a deeply moving human tragedy with the greatest economy of expression. It was a great new form of art. The sound film offers much fewer opportunities for this kind of thing, but by no means excludes it and it would be a pity if such opportunities were to be neglected, unnecessarily making us all the poorer. . . .

## MUTE DIALOGUES

In the last years of the silent film the human face had grown more and more visible, that is, more and more expressive. Not only had "microphysiognomy" developed but together with it the faculty of understanding its meaning. In the last years of the silent film we saw not only masterpieces of silent monologue but of mute dialogue as well. We saw conversations between the facial expressions of two human beings who understood the movements of each others' faces better than each others' words and could perceive shades of meaning too subtle to be conveyed in words.

A necessary result of this was . . . that the more space and time in the film was taken up by the inner drama revealed in the "microphysiognomic" close-up, the less was left of the predetermined 8,000 feet of film for all the external happenings. The silent film could thus dive into the depths—it was given the possibility of presenting a passionate life-and-death struggle almost exclusively by close-ups of faces.

Dreyer's film *Jeanne d'Arc* provided a convincing example of this in the powerful, lengthy, moving scene of the Maid's examination. Fifty men are sitting in the same place all the time in this scene. Several hundred feet of film show nothing but big close-ups of heads, of faces. We move in the spiritual dimension of facial expression alone. We neither see nor feel the space in which the scene is in reality enacted. Here no riders gallop, no boxers exchange blows. Fierce passions, thoughts, emotions, convictions battle here, but their struggle is not in space. Nevertheless this series of duels between looks and frowns, duels in which eyes clash instead of swords, can hold the attention of an audience for ninety minutes without flagging. We can follow every attack and riposte of these duels on the faces of the combatants; the play of their features indicates every strategem, every sudden onslaught. The silent film has here brought an attempt to present a drama of the spirit closer to realization than any stage play has ever been able to do. . . .

1945

# RUDOLF ARNHEIM
# *FROM* FILM AS ART

## FILM AND REALITY

Film resembles painting, music, literature, and the dance in this respect—it is a medium that may, but need not, be used to produce artistic results. Colored picture post cards, for instance, are not art and are not intended to be. Neither are a military march, a true confessions story, or a strip tease. And the movies are not necessarily film art.

There are still many educated people who stoutly deny the possibility that film might be art. They say, in effect: "Film cannot be art, for it does nothing but reproduce reality mechanically." Those who defend this point of view are reasoning from the analogy of painting. In painting, the way from reality to the picture lies via the artist's eye and nervous system, his hand and, finally, the brush that puts strokes on canvas. The process is not mechanical as that of photography, in which the light rays reflected from the object are collected by a system of lenses and are then directed onto a sensitive plate where they produce chemical changes. Does this state of affairs justify our denying photography and film a place in the temple of the Muses?

It is worth while to refute thoroughly and systematically the charge that photography and film are only mechanical reproductions and that they therefore have no connection with art—for this is an excellent method of getting to understand the nature of film art.

With this end in view, the basic elements of the film medium will be examined separately and compared with the corresponding characteristics of what we perceive "in reality." It will be seen how fundamentally different the two kinds of image are; and that it is just these differences that provide film with its artistic resources. We shall thus come at the same time to understand the working principles of film art.

# THE PROJECTION OF SOLIDS UPON A PLANE SURFACE

Let us consider the visual reality of some definite object such as a cube. If this cube is standing on a table in front of me, its position determines whether I can realize its shape properly. If I see, for example, merely the four sides of a square, I have no means of knowing that a cube is before me, I see only a square surface. The human eye, and equally the photographic lens, acts from a particular position and from there can take in only such portions of the field of vision as are not hidden by things in front. As the cube is now placed, five of its faces are screened by the sixth, and therefore this last only is visible. But since this face might equally well conceal something quite different—since it might be the base of a pyramid or one side of a sheet of paper, for instance—our view of the cube has not been selected characteristically.

We have, therefore, already established one important principle: If I wish to photograph a cube, it is not enough for me to bring the object within range of my camera. It is rather a question of my position relative to the object, or of where I placed it. The aspect chosen above gives very little information as to the shape of the cube. One, however, that reveals three surfaces of the cube and their relation to one another, shows enough to make it fairly unmistakable what the object is supposed to be. Since our field of vision is full of solid objects, but our eye (like the camera) sees this field from only one station point at any given moment, and since the eye can perceive the rays of light that are reflected from the object only by projecting them onto a plane surface—the retina—the reproduction of even a perfectly simple object is not a mechanical process but can be set about well or badly.

The second aspect gives a much truer picture of the cube than the first. The reason for this is that the second shows more than the first—three faces instead of only one. As a rule, however, truth does not depend on quantity. If it were merely a matter of finding which aspect shows the greatest amount of surface, the best point of view could be arrived at by purely mechanical calculation. There is no formula to help one choose the most characteristic aspect: it is a question of feeling. Whether a particular person is "more himself" in profile than full face, whether the palm or the outside of the hand is more expressive, whether a particular mountain is better taken from the north or the west cannot be ascertained mathematically—they are matters of delicate sensibility.

Thus, as a preliminary, people who contemptuously refer to the camera as an automatic recording machine must be made to realize that even in the simplest photographic reproduction of a perfectly simple object, a feeling for its nature is required which is quite beyond any mechanical operation. We shall see later, by the way, that in artistic photography and film, those aspects that best show the characteristics of a particular object are not by any means always chosen; others are often selected deliberately for the sake of achieving specific effects.

# REDUCTION OF DEPTH

How do our eyes succeed in giving us three-dimensional impressions even though the flat retinae can receive only two-dimensional images? Depth perception relies mainly on the distance between the two eyes, which makes for two slightly different

images. The fusion of these two pictures into one image gives the three-dimensional impression. As is well known, the same principle is used in the stereoscope, for which two photographs are taken at once, about the same distance apart as the human eyes. This process cannot be used for film without recourse to awkward devices, such as colored spectacles, when more than one person is to watch the projection. For a single spectator it would be easy to make a stereoscopic film. It would only mean taking two simultaneous shots of the same incident a couple of inches apart and then showing one of them to each eye. For display to a larger number of spectators, however, the problem of stereoscopic film has not yet been solved satisfactorily—and hence the sense of depth in film pictures is extraordinarily small. The movement of people or objects from front to back makes a certain depth evident—but it is only necessary to glance into a stereoscope, which makes everything stand out most realistically, to recognize how flat the film picture is. This is another example of the fundamental difference between visual reality and film.

The effect of film is neither absolutely two-dimensional nor absolutely three-dimensional, but something between. Film pictures are at once plane and solid. In Ruttmann's film *Berlin* there is a scene of two subway trains passing each other in opposite directions. The shot is taken looking down from above onto the two trains. Anyone watching this scene realizes, first of all, that one train is coming toward him and the other going away from him (three-dimensional image). He will then also see that one is moving from the lower margin of the screen toward the upper and the other from the upper toward the lower (plane image). This second impression results from the projection of the three-dimensional movement onto the screen surface, which, of course, gives different directions of motion.

The obliteration of the three-dimensional impression has as a second result a stronger accentuation of perspective overlapping. In real life or in a stereoscope, overlapping is accepted as due merely to the accidental arrangement of objects, but very marked cuts result from superimpositions in a plane image. If man is holding up a newspaper so that one corner comes across his face, this corner seems almost to have been cut out of his face, so sharp are the edges. Moreover, when the three-dimensional impression is lost, other phenomena, known to psychologists as the constancies of size and shape, disappear. Physically, the image thrown onto the retina of the eye by any object in the field of vision diminishes in proportion to the square of the distance. If an object a yard distant is moved away another yard, the area of the image on the retina is diminished to one-quarter of that of the first image. Every photographic plate reacts similarly. Hence in a photograph of someone sitting with his feet stretched out far in front of him the subject comes out with enormous feet and much too small a head. Curiously enough, however, we do not in real life get impressions to accord with the images on the retina. If a man is standing three feet away and another equally tall six feet away, the area of the image of the second does not appear to be only a quarter of that of the first. Nor if a man stretches out his hand toward one does it look disproportionately large. One sees the two men as equal in size and the hand as normal. This phenomenon is known as the constancy of size. It is impossible for most people—excepting those accustomed to drawing and painting, that is, artificially trained—to see according to the image on the retina. This fact, incidentally,

is one of the reasons the average person has trouble copying things "correctly." Now an essential for the functioning of the constancy of size is a clear three-dimensional impression; it works excellently in a stereoscope with an ordinary photograph, but hardly at all in a film picture. Thus, in a film picture, if one man is twice as far from the camera as another, the one in front looks very considerably the taller and broader.

It is the same with the constancy of shape. The retinal image of a table top is like the photograph of it; the front edge, being nearer to the spectator, appears much wider than the back; the rectangular surface becomes a trapezoid in the image. As far as the average person is concerned, however, this again does not hold good in practice: he sees the surface as rectangular and draws it that way too. Thus the perspective changes taking place in any object that extends in depth are not observed but are compensated unconsciously. That is what is meant by the constancy of form. In a film picture it is hardly operative at all—a table top, especially if it is near the camera, looks very wide in front and very narrow at the back.

These phenomena, as a matter of fact, are due not only to the reduction of three-dimensionality but also to the unreality of the film picture altogether—an unreality due just as much to the absence of color, the delimitation of the screen, and so forth. The result of all this is that sizes and shapes do not appear on the screen in their true proportions but distorted in perspective. . . .

## ABSENCE OF THE NONVISUAL WORLD OF THE SENSES

As regards the other senses: No one who went unprejudiced to watch a silent film missed the noises which would have been heard if the same events had been taking place in real life. No one missed the sound of walking feet, nor the rustling of leaves, nor the ticking of a clock. The lack of such sounds (speech, of course, is also one of them) was hardly ever apparent, although they would have been missed with a desperate shock in real life. People took the silence of the movies for granted because they never quite lost the feeling that what they saw was after all only pictures. This feeling alone, however, would not be sufficient to prevent the lack of sound being felt as an unpleasant violation of the illusion. That this did not happen is again connected with what was explained above: that in order to get a full impression it is not necessary for it to be complete in the naturalistic sense. All kinds of things may be left out which would be present in real life, so long as what is shown contains the essentials. Only after one has known talkies is the lack of sound conspicuous in a silent film. But that proves nothing and is not an argument against the potentialities of silent film, even since the introduction of sound.

It is much the same with the sense of smell. There may be people who if they see a Roman Catholic service on the screen imagine that they can smell incense; but no one will miss the stimulus. Sensations of smell, equilibrium, or touch are, of course, never conveyed in a film through direct stimuli, but are suggested indirectly through sight. Thence arises the important rule that it is improper to make films of occurrences whose central features cannot be expressed visually. Of course a revolver shot might occur as the central point of a silent film; a clever director could afford to dis-

pense with the actual noise of the shot. It is enough for the spectator to see the revolver being fired and possibly to see the wounded man fall. In Josef von Sternberg's *The Docks of New York* a shot is very cleverly made visible by the sudden rising of a flock of scared birds.

# THE MAKING OF A FILM

It has been shown above that the images we receive of the physical world differ from those on the movie screen. This was done in order to refute the assertion that film is nothing but the feeble mechanical reproduction of real life. The analysis has furnished us with the data from which we can hope to derive now the principles of film art.

By its very nature, of course, the motion picture tends to satisfy the desire for faithful reports about curious, characteristic, exciting things going on in this world of ours. The first sensation provided by film in its early music-hall days was to depict everyday things in a lifelike fashion on the screen. People were greatly thrilled by the sight of a locomotive approaching at top speed or the emperor in person riding down *Unter den Linden*. In those days, the pleasure given by film derived almost entirely from the subject matter. A film art developed only gradually when the movie makers began consciously or unconsciously to cultivate the peculiar possibilities of cinematographic technique and to apply them toward the creation of artistic productions. To what extent the use of these means of expression affects the large audiences remains a moot question. Certainly box-office success depends even now much more on what is shown than on whether it is shown artistically.

The film producer himself is influenced by the strong resemblance of his photographic material to reality. As distinguished from the tools of the sculptor and the painter, which by themselves produce nothing resembling nature, the camera starts to turn and a likeness of the real world results mechanically. There is serious danger that the filmmaker will rest content with such shapeless reproduction. In order that the film artist may create a work of art it is important that he consciously stress the peculiarities of his medium. This, however, should be done in such a manner that the character of the objects represented should not thereby be destroyed but rather strengthened, concentrated, and interpreted.

Our next task will be to bring examples to show how the various peculiarities of film material can be, and have been, used to achieve artistic effects.

## ARTISTIC USE OF PROJECTIONS UPON A PLANE SURFACE

In an earlier section I showed what conditions arise from the fact that in a photographic representation three-dimensional bodies and spaces are projected on a two-dimensional plane, that is, the surface of the picture. It was first demonstrated that an object can be reproduced characteristically or otherwise according to what view of it is chosen. When film art was in its infancy, nobody paid much attention to the subtleties of these problems. The camera was stationed well in front of the people to be

photographed in order that their faces and movements might be easily seen. If a house was to be shown, the cameraman placed himself straight in front of it at such a distance that nothing would be left out of the picture. It was only gradually that the particular effects that can be achieved by means of perspective projection were realized.

In Chaplin's film *The Immigrant* the opening scene shows a boat rolling horribly and all the passengers being seasick. They stagger to the side of the ship pressing their hands to their mouths. Then comes the first shot of Charlie Chaplin: he is seen hanging over the side with his back to the audience, his head well down, his legs kicking wildly—everyone thinks the poor devil is paying his toll to the sea. Suddenly Charlie pulls himself up, turns round and shows that he has hooked a large fish with his walking stick. The effect of surprise is achieved by making use of the fact that the spectator will be looking at the situation from a certain definite position. The idea underlying the scene is no longer "a man is doing such and such a thing, for example, he is fishing or being sick," but "a man is doing this and that, and at the same time the spectator is watching him from a particular station point." The element of surprise exists only when the scene is watched from one particular position. If the scene had been taken from the waterside, the audience would have realized at once that Charlie was not being sick but was fishing; and hence the wrong idea would not have first been implanted. The invention is no longer concerned merely with the subject matter but is cinematographic inasmuch as a definite feature of film technique is being used as a means to secure an effect.

## ARTISTIC UTILIZATION OF REDUCED DEPTH

Every object reproduced in film appears solid and at the same time flat. This fact contributes greatly to the impressive results achieved by the clever shots discussed in the last section. The worm's-eye view of a man appears as such a great distortion of nature because the depth effect is reduced. The same view looked at in a stereoscope seems much less distorted. The contrast between the vast bulk of the trunk and the disproportionately small head is much less forcible when it is perceived as being due to foreshortening. But if there is only a slight feeling of space and if the three-dimensional volume of the pictured object is flattened out, a huge body and a little head are seen.

The purely formal qualities of the picture come into prominence only because of the lack of depth. Every good film shot is satisfying in a purely formal sense as a linear composition. The lines are harmoniously disposed with reference to one another as well as to the margins. The distribution of light and shade in the shot is evenly balanced. Only because the spatial effect is so slight, the spectator's attention is drawn to the two-dimensional pattern of lines and shadow masses. These, after all, are actually the components of three-dimensional bodies and become elements of the surface composition only through being projected onto a plane. It has already been mentioned above how the skirt of a dancer seen through a pane of glass seemed to open and close like the petals of a flower. This is an entirely antifunctional effect in that it is not a normally characteristic feature of the skirt as a material object. The curious expansion and contraction of the edge of the skirt results only when it is looked at

from one particular viewpoint and then projected upon a flat surface. It would be less noticeable in a stereoscopic view. Only when the feeling of depth is reduced does the up-and-down movement of the skirt give the effect of being an in-and-out movement. It is one of the most important formal qualities of film that every object that is reproduced appears simultaneously in two entirely different frames of reference, namely, the two-dimensional and the three-dimensional, and that as one identical object it fulfills two different functions in the two contexts.

The reduction of depth serves, moreover, to emphasize the perspective superposition of objects. In a strongly stereoscopic picture of the manner in which these various objects are placed relative to one another does not impose itself any more than it does in real life. The concealing of certain parts of the various objects by others that come in front seems chance and unimportant. Indeed, the position of the camera in a stereoscopic picture seems itself to be a matter of indifference inasmuch as it is obvious that there is a three-dimensional space which may just as easily, and at the next moment probably will, be looked at from another point of view. If, however, the effect of depth is almost negligible, the perspective is conspicuous and compelling. What is visible and what is hidden strike one as being definitely intentional; one is forced to seek for a reason to be clear in one's own mind as to why the objects are arranged in this particular way and not in some other. There is no leeway between the objects: they are like flat surfaces stuck over one another, and seem almost to lie in the same plane.

Thus the lack of depth brings a very welcome element of unreality into the film picture. Formal qualities, such as the compositional and evocative significance of particular superimpositions, acquire the power to force themselves on the attention of the spectator. A shot like that described above where half of the girl's full face is cut off by the dark silhouette of the man's head, would possess only a fraction of its effectiveness if there were a strong feeling of space. In order to achieve the striking effect it is essential that the division across the face shall not seem accidental but intentional. The two faces must seem to be practically in one plane, with no leeway between them to show that they might easily be moved into different relative positions.

The fact that the lack of depth perception also leads to the almost total disappearance of the phenomena which the psychologist calls the "constancies" of size and form has already been discussed. The film artist takes advantage of their absence to produce remarkable effects. Everyone has seen a railway engine rushing on the scene in a film. It seems to be coming straight at the audience. The effect is most vivid because the dynamic power of the forward-rushing movement is enhanced by another source of dynamics that has no inherent connection with the object itself, that is, with the locomotive, but depends on the position of the spectator, or—in other words—of the camera. The nearer the engine comes the larger it appears, the dark mass on the screen spreads in every direction at tremendous pace (a dynamic dilation toward the margins of the screen), and the actual objective movement of the engine is strengthened by this dilation. Thus the apparent alteration in the size of an object which in reality remains the same size enhances its actual activity, and thus helps the film artist to interpret the impact of that activity visually. . . .

## ARTISTIC USE OF THE ABSENCE OF NONVISUAL SENSE EXPERIENCES

People who did not understand anything of the art of film used to cite silence as one of its most serious drawbacks. These people regard the introduction of sound as an improvement or completion of silent film. This opinion is just as senseless as if the invention of three-dimensional oil painting were hailed as an advance on the hitherto known principles of painting.

From its very silence film received the impetus as well as the power to achieve excellent artistic effects. Charles Chaplin wrote somewhere that in all his films there was not a single scene where he "spoke," that is, moved his lips. Hundreds of the most various situations in human relationships are shown in his films, and yet he did not feel the need to make use of such an ordinary faculty as speech. And nobody has missed it. The spoken word in Chaplin's films is as rule replaced by pantomime. He does not say that he is pleased that some pretty girls are coming to see him, but performs the silent dance, in which two bread rolls stuck on forks act as dancing feet on the table (*The Gold Rush*). He does not argue, he fights. He avows his love by smiling, swaying his shoulders, and moving his hat. When he is in the pulpit he does not preach in words, but acts the story of David and Goliath (*The Pilgrim*). When he is sorry for a poor girl, he stuffs money into her handbag. He shows renunciation by simply walking away (finale of *The Circus*). The incredible visual concreteness of every one of his scenes makes for a great part of Chaplin's art; and this should not be forgotten when it is said—as is often done and of course not without foundation— that his films are not really "filmic" (because his camera serves mainly as a recording machine).

Mention has already been made of the scene from Sternberg's *The Docks of New York* in which a revolver shot is illustrated by the rising of a flock of birds. Such an effect is not just a contrivance on the part of a director to deal with the evil of silence by using an indirect visual method of explaining to the audience that there has been a bang. On the contrary, a positive artistic effect results from the paraphrase. Such indirect representation of an event in a material that is strange to it, or giving not the action itself but only its consequences, is a favorite method in all art. To take an example at random: when Francesca da Rimini tells how she fell in love with the man with whom she was in the habit of reading, and only says "We read no more that day," Dante thereby indicates indirectly, simply by giving the consequences, that on this day they kissed each other. And this indirectness is shockingly impressive.

In the same way, the rising of the birds is particularly effective, and probably more so than if the actual sound of the pistol shot were heard. And then another factor comes in: the spectator does not simply *infer* that a shot has been fired, but he actually *sees* something of the quality of the noise—the suddenness, the abruptness of the rising birds, give visually the exact quality that the shot possess acoustically. In Jacques Feyder's *Les Nouveaux Messieurs* a political meeting becomes very uproarious, and in order to calm the rising emotions Suzanne puts a coin into a mechanical piano. Immediately the hall is lit up by hundreds of electric bulbs, and now the music chimes in with the agitative speech. The music is not heard: it is a silent film. But Fey-

der shows the audience excitedly listening to the speaker; and suddenly the faces soften and relax; all the heads begin quite gently to sway in time to the music. The rhythm grows more pronounced until at last the spirit of the dance has seized them all; and they swing their bodies gaily from side to side as if to an unheard word of command. The speaker has to give way to the music. Much more clearly than if the music were actually heard, this shows the power that suddenly unites all these discontented people, puts them into the same merry mood; and indicates as well the character of the music itself, its sway and rhythm. What is particularly noteworthy in such a scene is not merely how easily and cleverly the director makes visible something that is not visual, but by so doing, actually strengthens its effect. If the music were really heard, the spectator might simply realize that music was sounding, but by this indirect method, the particular point, the important part of this music—its rhythm, its power to unite and "move" men—is conspicuously brought out. Only these special attributes of the music are given, and appear as the music itself. Similarly the fact that a pistol shot is sudden, explosive, startling, becomes doubly impressive by transposition into the visible, because only these particular attributes and not the shot itself are given. Thus silent film derives definite artistic potentialities from its silence. What it wishes particularly to emphasize in an audible occurrence is transposed into something visual; and thus instead of giving the occurrence "itself," it gives only some of its telling characteristics, and thereby shapes and interprets it.

Owing to its insubstantiality silent film does not in any way give the effect of being dumb pantomime. Its silence is not noticed, unless the action happens to culminate in something acoustic for which nothing can be substituted, and which is therefore felt as missing—or unless one is accustomed to sound film. Because of sound film, in the future it will be possible only with great difficulty to show speech in a silent way. Yet this is a most effective artistic device. For if a man is heard speaking, his gestures and facial expression only appear as an accompaniment to underline the sense of what is said. But if one does not hear what is said, the meaning becomes indirectly clear and is artistically interpreted by muscles of the face, of the limbs, of the body. The emotional quality of the conversation is made obvious with a clarity and definiteness which are hardly possible in the medium of actual speech. Moreover, the divergence between reality and dumb show gives the actor and his director plenty of leeway for artistic invention. (The creative power of the artist can only come into play where reality and the medium of representation do not coincide.)

Dialogue in silent film is not simply the visible part of a real spoken dialogue. If a real dialogue is shown without the sound, the spectator will often fail to grasp what it is all about; he will find the facial expression and the gestures unintelligible. In silent film, the lips are no longer word-forming physical organs but a means of visual expression—the distortion of an excited mouth or the fast chatter of lips are not mere by-products of talking; they are communications in their own right. Silent laughter is often more effective than if the sound is actually heard. The gaping of the open mouth gives a vivid, highly artistic interpretation of the phenomenon "laughter." If, however, the sound is also heard, the opening of the mouth appears obvious and its value as a means of expression is almost entirely lost. This opportunity of the silent film was once used by the Russians in a most unusual and effective manner. A shot of a soldier who had gone mad in the course of a battle and was laughing hideously with his

mouth wide open was joined with a shot of the body of a soldier who had died of poison gas, and whose mouth was fixed in death in a ghastly, rigid grin.

The absence of the spoken word concentrates the spectator's attention more closely on the visible aspect of behavior, and thus the whole event draws particular interest to itself. Hence it is that very ordinary shots are often so impressive in silent films—such as a documentary shot of an itinerant hawker crying his wares with grandiose gestures. If his words could be heard the effect of the gestures would not be half as great, and the whole episode might attract very little attention. If, however, the words are omitted, the spectator surrenders entirely to the expressive power of the gestures. Thus by merely robbing the real event of something—the sound—the appeal of such an episode is greatly heightened. . . .

1933

# NOËL CARROLL
## *FROM* PHILOSOPHICAL PROBLEMS OF CLASSICAL FILM THEORY

### THE SPECIFICITY THESIS

The notion that each art form has its own special subject matter that it of all the arts is best suited to represent is an eighteenth-century idea. The idea grew in reaction to an earlier style of art theorizing, represented by words such as Abbé Charles Batteux's 1746 treatise called *The Fine Arts Reduced to the Same Principle*.[1] For Batteux, all the arts were similar because they all had the same subject—the imitation of the beautiful in nature. This tendency to reduce the arts to their common denominator was the dominant trend in pre-Enlightenment art theory. During the eighteenth century, however, thinkers began to oppose this type of theorizing. They began to focus on what differentiated the arts from one another. An important work in this new tendency was Abbé Jean Baptiste Dubos's *Critical Reflections on Painting and Poetry*.[2] Dubos claimed that poetry and painting differ, in that painting imitates the single moment whereas poetry imitates process. Similar analyses were offered in the works of James Harris and Moses Mendelsohn.[3] The best known work of this revisionist sort, entitled *Laocoön*, was published in 1766 by Gotthold Ephraim Lessing. That book contains several important presumptions of Arnheim's *Materialtheorie*: that the arts (1) differ from each other in terms of (2) what each represents (imitates) best, due to (3) the peculiar (specific) structure of its formal/physical medium.

Comparing painting and poetry, Lessing writes:

> I argue thus. If it be true that painting employs wholly different signs or means of imitation from poetry—the one using forms and colors in space and the other articulate

---

[1] In Monroe Beardsley, *Aesthetics: From Classical Greece to the Present* (New York: Macmillan, 1966; Alabama: University of Alabama Press, 1975), 160.

[2] Ibid.

[3] Ibid.

sounds in time—and if signs must unquestionably stand in convenient relation with the thing signified, then signs arranged side by side can represent only objects existing side by side, or whose parts so exist, while consecutive signs can express only objects which succeed each other in time.

Objects which exist side by side, or whose parts so exist, are called bodies. Consequently, bodies with their visible properties are the peculiar subjects of painting.

Objects which succeed each other, or whose parts succeed each other in time, are actions. Consequently, actions are the peculiar subjects of poetry.*

Here we see Lessing attempting to extrapolate from the structure of the medium—the structure of what, in advance of semiotics, he calls "signs"—to the appropriate subject matter of the medium. Arnheim, as well, attempts to move from the structural peculiarities of the medium to injunctions about the proper direction of filmmaking.

Before examining the specificity thesis in terms of truth or falsity, I would like to note that although for many reasons the thesis no longer seems acceptable, in its day it performed a useful service. The specificity thesis served as a corrective to the vagueness of the tendency to reduce all the arts to a common denominator. As a result, theorists began to look more closely at the various art forms. The gain was one of rigor. This does not, of course, entail that the specificity thesis is true. However, theorists like Arnheim who adopt it do tend to give very close, precise accounts of artistic structures. Thus, even if the specificity thesis is false, it has beneficial side effects.

One difference between Lessing and Arnheim is that Lessing focuses on the physical medium, of painting for example, and teases out of that an analysis of what the medium can represent at its best—what is most convenient for its signs to depict—whereas Arnheim, in *Film as Art*, examines cinematic devices to find where they fall short of successful representation. Lessing is concerned to find where a medium excels in representation, whereas Arnheim is most interested in where a medium falters in terms of perfect representation. In and of itself, this contrast does not present a problem for Arnheim. Arnheim, like Lessing, wants to establish a special domain for each medium. Film, he tells us, is the realm of the animated image. But here is a lacuna in this New Laocoön. For how do the various peculiarities that Arnheim points to—the lack of constancy of size and of the spatiotemporal continuum, and so forth—ever add up to or imply that film is concerned with the animated image? The peculiarities or specificities of the medium that Arnheim points to constitute a list of things that cinematic representations do not have. How do these amount to a positive commitment to the animated image? If the peculiar structures of the medium are what entail the medium's commitment to the animated image, it is not clear how Arnheim's examples show this.

Another problem with the specificity thesis is that Arnheim seems to believe that, as a matter of fact, every medium diverges from the referents it represents because of its own peculiar formal/physical structure. Arnheim says "representation never produces a replica of the object but its structural equivalent in a *given* medium" (*Art and Visual Perception*, 162). But if each medium automatically, so to speak, diverges not only from each referent but also from the depiction of such referents in other media,

---

*Gotthold Ephraim Lessing, *Laocoön* (New York: Noonday Press, 1969), 91.

then what point is there to the specificity thesis stated as an injunction? That is, why urge artists to make certain that they exploit the peculiarities of their medium if this is unavoidable and bound to happen anyway? Moreover, how can Arnheim rail against sound films? Sound films will automatically be differentiated from theater because the media are physically different. If one believes that every medium is automatically unique in terms of the structure of its symbols, then why fear that media will illegitimately spill over each others' boundaries? It will be impossible.

Arnheim's specificity thesis is not a description; it is a recommendation. Were the specificity thesis a description, there could be no problems involving the trespassing of the sound film in the domain of theater. It would make no sense to use the specificity thesis to attempt to chide filmmakers if the specificity thesis were a description—filmmakers would necessarily employ the peculiar (specific) characteristics of their medium.

As a recommendation, the specificity thesis appears to have two components. One component is the idea that there is something that each medium does best. The other is that each of the arts should do what differentiates it from the other arts. These two components can be called the excellence requirement and the differentiation requirement. The two can be combined in the imperative that each art form should explore only those avenues of development in which it exclusively excels above all other arts. The incorporation of "exclusively" in this formula sounds the differentiation requirement while the rest of the formula states the excellence requirement. Applied to Arnheim's film theory, the specificity thesis states that filmmakers should stress the differentiating features (the limitations) that enable the medium to portray animated action (what cinema does best).

Some of the problems with the specificity thesis are the result of the combination of the differentiation and excellence requirements. The assumption is that what a medium does best will coincide with what differentiates it. But why should this be so? For example, many media narrate. Film, drama, prose, and epic poetry all tell stories. For argument's sake, let us say narration is what each does best—that is, best of all the things each of them does. However, this does not differentiate these art forms. What does the specificity thesis require in such a situation? If film and the novel both excel in narration, should (1) neither art form narrate since narration fails to differentiate them? or (2) should film not narrate since narration will fail to differentiate it from the novel and the novel claimed the domain of narration first? or (3) should the novel give up narration and let the newcomer have its chance?

The first alternative is simply absurd; it would sacrifice a magnificent cultural invention—narration—for whatever bizarre satisfaction that could be derived from adherence to the differentation requirement. I am assuming that excellence is more important to us than differentiation.

The second alternative is also unattractive. In this case the specificity thesis would seem to confuse history with ontology. That is, film is to forswear narrating just because literature already has that turf staked out. But surely this is only an accident of history. What if movies had arisen before writing? Then would literature have to find some other occupation? Clearly such accidents of history should not preclude a medium from pursuing an area in which it excels. Nor should accidents of history be

palmed off as ontological necessities—another proclivity of the specificity thesis. The special subject matter of each medium supposedly follows from its nature. But the story is more complicated, since a medium specializes in what it excels in only if that area of special achievement differentiates it from other media. The question of differentiation is not simply a question about the nature of the medium; it is a question about the comparison of arts. And it is quite possible that a new art may be invented that excels in an area where an older art already excels. Awarding the domain to the older art just because it is already established seems arbitrary, as does the third alternative—awarding the domain to the younger art just because it is younger. If two arts both excel in domain, it seems natural to allow them both to explore it. That will enrich the culture by multiplying the number of excellent things. This is surely the case with narrative. The world is far richer for having novels *and* fiction films *and* epic poems *and* dramas *and* comic books *and* narrative paintings *and* operas, though the differentiation component of the specificity thesis would block this.

One point should be emphasized in the preceding discussion: narration does seem to be one instance where many arts do share the same pursuit. And yet specificity theorists, especially the major film theorists who champion the specificity thesis, rarely seem to be ruffled by this fact. It seems as though they are so concerned to differentiate film from theater that they fail to notice that film is similar to other narrative arts, such as the short story and the novel. These latter similarities or overlaps seem to be tolerable. Why? The only way I can account for this anomaly is that historical circumstances were such that only the canned theater argument against film vividly presented itself as so threatening that it had to be dealt with. For, of course, in the days when these arguments raged, theater and film could be thought of as directly competing for the same audience. They were locked in economic conflict as well as aesthetic struggle, which meant that more was at issue in the battle between them than in the relation between film and the other narrative arts. Thus, many film theorists who upheld the specificity thesis never noticed that they should have been exercised by the overlap with the other narrative arts, even though such an overlap should call into question the specificity thesis.

The specificity thesis has both an excellence component and a differentiation component. Perhaps one interpretation of the theory is that each art form should pursue those projects that fall in the area of intersection between what the art form excels in and what differentiates it from other art forms. But this does not seem to be an acceptable principle because, among other things, it entails that the reason an art form might not be employed to do what it does best is that some other art form also does it well. *The specificity thesis seems to urge us to sacrifice excellence on principle.* But excellence is, in fact, always the overriding consideration in deciding whether a particular practice or development is acceptable in art.

Indeed, I believe that what could be called the priority of excellence is the central telling point against the specificity thesis. To dramatize this, let us imagine that for some reason the only way that G. B. Shaw could get backing for *Pygmalion* was to make it as a talking picture—since in our possible world Shaw was known only as a successful screenwriter. Let us also suppose that in some sense it is true that theater

is a better showcase for aesthetically crafted language. Would we decide that *Pygmalion* should not be made? I think our answer is "no," because our intuitions are that the specificity thesis should not be allowed to stand between us and excellence.

Nor need the excellence in question be a matter of the highest excellence achievable in a given medium. The specificity thesis seems to urge that a medium pursue only what it does best. But if a medium does something well and the occasion arises to do it, why should it be inhibited because there is something it does better? Certain magical transformations—turning weaklings into werewolves for example—can be most vividly executed in cinema. But they can also be done quite efficiently on stage. Should this minor excellence be foregone in a stage adaptation of *Dr. Jekyll and Mr. Hyde*, either because transformation is not what theater does best or because film can do it better?

Another disturbing feature of the specificity thesis is that it appears to envision each art form on the model of a highly specialized tool with a range of determinate functions. A film, play, poem, or painting is thought of, it seems, analogous to something like a Phillips screwdriver. If you wish to turn a screw with a cross-shaped groove on top, use a Phillips screwdriver. If you wish to explore the potentials of aesthetically crafted language, use theater. If your topic is animated action, use film. Likewise, just as you should not use a Phillips screwdriver as a church key (though it can open a beer can), you should not, all things being equal, use cinema to perform theater's task, and vice versa. But I think it is incumbent on us to question whether this underlying metaphor has any applicability when it comes to art forms. Are art forms highly specialized tools? I think not. If art forms are like tools at all, then they are more like sticks than like Phillips screwdrivers. That is, they can be used to do many things; they have not been designed to perform a specific task. In most cases art forms are not designed—that is, they are not invented with a specific task in mind. Moreover, even with self-consciously invented arts like film, it is soon discovered that the form can perform many more tasks than the one it was originally designed for. Indeed, interest in art forms is to a large measure interest in how artists learn or discover new ways of using their medium. The idea of the artist discovering new ways of using the medium would make no sense if the medium were designed for a single purpose.

An artistic medium, including a self-consciously invented one, is such that many of its potentials remain to be discovered. But discovery would not be a relevant expectation to have of artists nor would an interest in it be relevant to an art form, if the task of the art form were as fixed as that of a Phillips screwdriver. A correlative fact against the idea of the fixedness of function of art forms is the fact that they very often continue to exist over time, obviously because they are periodically reinvented and new uses are found for them. But if art forms were as determinately set in their functions as are Phillips screwdrivers, one would expect them, or at least many of them, to pass away as their function becomes archaic. That they are readapted, reinvented, and redirected bodes ill for the metaphor of the art form as a specialized tool—a view that seems strongly suggested by the specificity thesis.

One consideration offered in favor of the specificity thesis proceeds by asking why else there would be *different* media unless they were supposed to pursue different ends? That is, the specificity thesis is, in this light, an inference to the best explanation. Given

the fact that we have a number of arts, we ask "Why?" The answer that seems most reasonable is that each art has, or should have, a different function.

This particular line of thought presupposes that it is legitimate to ask why we have different arts. It also supposes that it is legitimate to expect as an answer to this question something like a rational principle. Perhaps for idealists it is reasonable to expect a rationale or a rationalization here. But for others the issue appears to be a matter of historical accident. I believe that it was Wittgenstein who said that where there is no question, there is no answer. We can use this principle, I think, to rid ourselves of the preceding argument. For its question, when stated nonelliptically, is not "Why are there diverse arts?" but "What is the rationale that explains why we have exactly the diverse arts that we have?" Now there may be no single answer to this question. Rather we may have to settle for a series of answers to the former question—answers of a historical and anthropological variety. For example, we have film because Edison invented it to supplement the phonograph; we have painting because one day a Cro-Magnon splashed some adhesive victuals on a cave wall and it looked strikingly like a bison; and so on. But there is no answer to the second question: "What is the rationale for having exactly the several arts we do have?" Rather, each art arose due to a chain of events that led to its discovery or invention and to its popularization. The result is the *collection* of arts we have, which we only honorifically refer to as a *system*. There is no rationale for the system, for in truth it is only a collection. Thus, we have no need for the specificity thesis, for the question it answers—"Why is there a system of different arts?"—is really not an admissible question at all.*

Before concluding this section, some discussion of Arnheim's application of the specificity thesis to sound film is appropriate, for Arnheim's maledictions against the talking picture are undoubtedly the most notorious part of his film theory. Arnheim holds that if there is a truly composite art form, then none of the constituent media can be anything but fully developed. That is, in a truly composite art form none of the media combined would be subservient, nor would any be redundant, that is, merely repetitive of what is already conveyed by another, more dominant, medium. Each must function equally and be fully articulated on its own terms. For Arnheim, opera is not really a composite because music is the dominant constituent medium to which the language and the scenography are subservient. Nor are laconic talking films with functional dialogue acceptable composites, because such dialogue is subservient to the visuals and, for the most part, is redundant to the action. On the other hand, more fully developed dialogue tends to make the film medium subservient to speech, paralyzing the action and thwarting the medium's commitment to animated movement. Dialogue cannot be artistically expanded upon and articulated without interfering with the depiction of action, which will transform the work into a piece of theater, denying the camera the opportunity to represent what it alone portrays best (*FAA*, 228–30).

---

*For expanded and amplified arguments against the specificity thesis, see my "The Specificity of Media in the Arts," *The Journal of Aesthetic Education* 19 (Winter 1984), 5–20; and my "Medium Specificity Arguments and the Self-consciously Invented Arts: Film, Photography and Video." *Millennium Film Journal*, nos. 14/15 (1984–1985), 127–53.

There are two sides to this argument. Either dialogue is made to facilitate action, in which case the medium of speech is short-changed, or dialogue is developed artistically, in which case the action of the film is paralyzed. In neither case is the art truly composite. Instead, the sound film is a mongrel.

Of course, one wonders whether Arnheim's ideal of a truly composite art form is a worthwhile one. Why must a legitimate composite abide by such inflexible standards of equality between the constituent media? Often in nineteenth-century ballet the music was not so distinguished as the dancing, since the point of this form was to direct attention to the movement. Does this imply that ballet, or at least ballet done in this format, is not a truly composite art? But if ballet is not a truly composite art and neither is opera, then one suspects that Arnheim is defining the category of composite art out of existence. Moreover, if the example of nineteenth-century ballet is taken seriously, one horn of Arnheim's dilemma can be neutralized. It may be perfectly acceptable to have composite art forms where one medium is subservient to another. Specifically, there may be many sound films that, although their scripts do not make edifying reading, have perfectly serviceable dialogue supporting the visuals. Films like *Citizen Kane*, *Psycho*, and *Rules of the Game* surely are examples of this sort. Thus, questioning Arnheim's criterion for a truly composite medium dispels half of the dilemma.*

The other half can be dispelled by questioning whether it is impossible to combine language and visuals so that each is given full honor. Surely the opening scene of Olivier's *Henry V* fully honors both action and poetry. Other examples also come to mind, Polonsky's *Force of Evil* for one—a film whose highly poetic script was rhythmically integrated with the action.

Furthermore, several objections raised against the specificity thesis in general can be applied to its use in the context of the sound film. Undoubtedly, great moments in dialogue film—for example, Groucho's speech to the ministers in *Duck Soup*—are not begrudged because they were seen on celluloid rather than on stage. If the specificity thesis entails cutting this scene, then so much the worse for the specificity thesis. Of course, it may be held that the specificity theorist is not committed to disparaging this scene. Rather, such a theorist might praise the scene, but as theater rather than film. But this seems wrong. For part of what is excellent about the scene is that it is delivered by that man, Groucho Marx, with that voice, at that period of time (the Depression). These things fit together in a powerful expressive ensemble. Indeed, part of what is valuable about the scene is that it is a *recording* of a performance, exactly the aspect of cinema Arnheim is most disposed to denounce. Moreover, the black and white photography, the cut of the actor's clothing, their diction, their bearing all conspire to evoke a powerful feeling of "thirties-ness" that could not be replicated today on stage or film—not only because many of the actors are dead but also because films don't look and sound that way any more, and, in all likelihood, theater never did. That that specific performance is on film—film of a certain technological vintage—is part and parcel of the scene's power, no matter that it is dominated by speech.

1988

---

*Interestingly, Arnheim differs from other specificity theorists like Panofsky who are willing to accept functional dialogue as the proper means of keeping cinema pure while at the same time using sound.

# GERALD MAST
## *FROM* FILM/CINEMA/MOVIE

## PROJECTION

An obvious assumption of the preceding chapter is that the *aesthetic event* of cinema is the projection of the finished work—analogous to the reading of the type that is a novel, the attending to the motion and conversation that are a play, the listening to the sound that is a piece of music, or the looking at the color on canvas that is a painting. The creative process of shooting and assembling film is certainly a worthy subject of study—as are the notebooks of Henry James or the Georges Seurat sketches for *A Sunday Afternoon on the Island of La Grande Jatte*. To study this process reveals both the artist's specific choices and the general way he viewed his art and his craft. But it nonetheless studies the means to the end, and that end is experiencing the work of art itself, which remains its own testament and as solid a piece of evidence as any. With the cinema art it is perhaps an even solider piece of evidence than its maker's recollections of the creative process, since the memories of moviemakers are at least as prone to error as any, since the movie business encourages self-congratulation, and since the creative process of moviemaking is such an admittedly collective one.*

This emphasis on projection necessarily excludes certain interesting kinds of questions, among them some of the classic problems of film, cinema, and movie theory.

---

*Movie directors are notoriously unreliable. Frank Capra claims he watched Leo McCarey direct Laurel and Hardy at the Hal Roach studio in 1924 (L & H never worked together until 1927); Mack Sennett went to his grave claiming Buster Keaton was one of his Keystone Cops (never); Groucho Marx is under the impression that there are no musical numbers in *A Night at the Opera* (poor Kitty Carlisle and Allan Jones; or rather, poor us—because Groucho is unfortunately wrong). One of the consistent mistakes of film historians is to quote the recollections of moviemakers as gospel; the American Film Institute has invested both time and money in the recording of some four-hundred "oral histories" of their recollections. To preserve these thoughts and voices for posterity is undeniably valuable, but gospel it isn't.

It denies the notion of "the cinematic" altogether, since it assumes that any finished piece of cinema is indisputably a piece of cinema. The precise meaning of "cinematic" is "of or pertaining to the cinema," and its essence is merely that a succession of frames moves forward through the projector. You can, of course, then discuss whether that succession of frames is interesting or boring, beautiful or ugly, good or bad. True, the primitive film strips of Edison, Lumière, and most of their pre-Griffith contemporaries might properly be called "uncinematic," simply because they had no notion at all of one of the three principles of temporal succession (imagistic succession) and a very clumsy and undeveloped notion of another (structural succession). One of today's experimental, minimal films is certainly not uncinematic in the same way, for its maker was aware of all the possible principles of succession, but deliberately tried to extend or eliminate the use of some of them.

The insistence on projection has certain theoretical advantages. First, it clearly distinguishes cinema from a live theatrical performance, on the one hand, and from television on the other. The fact that film is projected alters its tense (it must necessarily *have been* photographed and processed in the past), whereas the tense of a live theatrical performance (dance, drama, opera) is the now. The fact that film is projected also means that it will be perceived and received differently from a live performance, particularly since projections are perceived and received as a series of different kinds of successions. In a live performance, although plot might parallel structural succession, there are no equivalents to the literal and imagistic successions of cinema; the stage movement is continuous, not successive. The visual power and concentration of cinema's successiveness (coupled with the kinetic power of the individual images) give the force of the spoken word a different (and lighter) "weight" in the cinema than in the drama (as noted and developed by Bazin). Television transmission is not a projection at all; nor is its literal succession identical to cinema's. These differences produce the reduced clarity, sublety, luminosity, density, and (for the present anyway) size of the television image. This reduction also guarantees a different emotional response and reaction to our perception of the weakened kinesis of the television image.

Indeed, the emphasis on projection as the aesthetic event consistently forces our attention on how a work of cinema is received and perceived rather than on what cinema is. Arnheim gets into all kinds of trouble with this problem since he constantly explores the ways in which the cinema image differs physically from natural vision. What he never unscrambles, however, is whether the cinema makes us perceive its differences from nature or whether it fools us by erasing those physical differences so that we perceive the image as apparently quite natural. For example, Arnheim's first principle is that photography converts three-dimensional space into a two-dimensional plane. He then develops the ways that this "fact" can be exploited artistically, some of those exploitations based on the way that the focal lengths of various lenses can alter the way we perceive relative distances between objects. One of his examples is that a newspaper appears to be "cut out" of the face of the person reading it; the converse effect would be the way that a wide-angle lens can make a hand holding a gun in the foreground appear ten times larger than the assailant's face, only an arm's length away.

But do we perceive the projected image as two-dimensional at all? The very fact that we call one object in the projected image apparently close to or far away from another implies that there is some kind of mental translation of the two-dimensional image into three-dimensional terms. In the cinema, when we see large and small, we translate our perception either into close and far (based on our awareness of relative distances and the sizes of objects in life) or into not so close or far but deliberately distorted for some effect by the lens (as in that hand-face example, which we know is based on an impossible relationship of size and distance in nature). We perceive the projected image as a kind of three-dimensional system, once we have learned to translate it (which means that we must learn to watch cinema, just as we must learn any system of translation—and just as we learn to translate sizes into distances in life).

The occasional 3-D movie (or the re-release of one from the Great Flurry of '52) proves that our perception of the projected three-dimensional image is nothing like that of the natural three-dimensional one either. The whole tendency of the 3-D image is to push the action and motion at us; not simply the deliberately hurled objects that sail toward our heads, but even the horizontal movement of walking from left to right feels as if it were thrusting toward us. Even the stationary walls seem to loom out at us, in a way that I do not usually perceive walls to do in life.

The projected cinema image does not appear to be flat; light on a screen is not perceived the same way as paint on canvas. Why not? First, paint is itself a hard, physical material that refracts light. That refraction is the physical stimulus that produces the effect of the painting (since light produces our perception of color by refraction); but it also reminds us of the flatness of the canvas and the material on it (because light bounces off the paint material itself, and that bouncing is perceived as a kind of surface refraction). Those painters who became self-conscious about the flatness of paint on canvas (for example, the evolving rough-textured brush strokes of Van Gogh) simply called attention to the essential flatness of the art by trying to avoid or exploit it. And what else was the development of perspective but a response to the flatness of canvas and paint? It was not the modernist response, however, as was Van Gogh's.

But the "material" of projected images is the immaterial operation of light itself; the images of cinema are produced by light's bouncing off the beaded surface of a screen, a refraction that is not, however, perceived as a refractive bouncing of light off a surface, but as the images themselves. The screen seems more to absorb the images (like a sponge) than to refract and bounce them, although such a refraction is literally what we see (but not perceive). The immateriality of light itself and the perception that the screen is a kind of translucent sponge (yet another cinema illusion) militate against the flatness of the projected image, convincing us that the image has a kind of depth (which it obviously does not).

Second, paintings are still and projected images are not. The two physical forms of cinema succession work upon the eye by keeping the photographed subjects constantly in motion. Not only is this motion a further diversion from any consciousness of the screen's flatness, but it is also a way of defining distance and dimensionality. The enlarging or shrinking of an object over a period of time or the length of time required to travel between two points are two familiar ways of defining terms like

"close" and "far." One of the striking effects of halting the cinema's motion—of the "freeze frame"—is the sudden reduction of the screen's apparent depth. Only by freezing the movement that is the essence of cinema's succession does one convert the photographed image into a truly two-dimensional plane.

The projection of successive images does not convert three-dimensional nature into a two-dimensional pattern, but changes three-dimensional nature into a different three-dimensional system using two-dimensional symbols. As always, there are exceptional films that attempt to make the projected image appear as flat as possible (the Zagreb animation films, any experimental films that deliberately use the static flatness of lettering and title cards, the films of Len Lye, Norman McLaren, Robert Breer, or anyone else who uses drawn figures of any kind). Walt Disney's entire career in animation can be chronicled as a progressive war against the flatness of cinema cartooning, as a struggle to make the drawn image as apparently three-dimensional as the photographed one. Like so many valuable cinema experiments, these uses or denials of two-dimensionality are ironic reversals or revelations of traits that seem inherent to cinema.

The insistence on projection also addresses whether cinema is or is not an "automatic" art (is for Bazin, Kracauer, Cavell, and their followers; is not for Arnheim, Eisenstein, and theirs). Projection is obviously "automatic," but is the shooting of a film equally "automatic"? And these theories of film as "automatic" art are all based on the recording, not the projection, process. There is *something* about the shooting of a film that is certainly automatic—the precise moment of etching the light on the film material itself. Other than that moment of recording, however, almost nothing about the shooting of a film is automatic. The creators control the intensity and quality of the light; even outdoor sequences use key lights, floodlights, reflectors, and scrims, as well as selecting the precise type of time of day for shooting—as Antonioni did in *Red Desert* or Mizoguchi did in all his films). They control the action within the shot, the setting, the colors, the objects, the details of décor. They control the specific lens that will be used, and the filters for it (if any), and the speed and type of film itself. To reduce the question to the absurd, could you call the shooting of an animated film automatic? Yes, the film captures the light automatically when the single frame is exposed. But no, the entire world that is so captured is the project of a human imagination.

The primacy of projection also solves the nature-nurture controversy in the cinema, since that controversy is a corollary of considering the shooting process as automatic (i.e., cinema automatically records the integrity of nature) or not (i.e., cinema is the artificial project of human choices, not a mechanical recording of nature). Obviously, the projection of a reel of film has nothing to do with nature—no more than does the reading of a novel or the looking at a painting. There may be a good deal of nature (or human life, or natural experience) in the work's succession of frames, images, and events, but there may also be a good deal of this same kind of nature in the content of a novel or the subject of a painting. To emphasize projection is to reiterate that the work of cinema is necessarily as artificial as any work of any art.

To emphasize projection is also to reiterate that an essential condition of the cinema experience is viewing flickering light in an enveloping darkness. This piercing of darkness by projected light is the source of cinema's hypnotic power, paralleling

the way that the professional hypnotist entrances a subject by focusing attention on a bright and rhythmically flickering source of light. This light-in-darkness also generates several paradoxes that infuse and influence our experiencing of cinema: we both sit in darkness and are bathed in light; the experience is both private and public at the same time; the projected images both speak to our personal dreams and fantasies and seem to depict the most public and familiar realities. Projection gives us both the concreteness of visual images and the abstract play of light itself.

1977

# STANLEY CAVELL
## *FROM* THE WORLD VIEWED

### PHOTOGRAPH AND SCREEN

Let us notice the specific sense in which photographs are of the world, of reality as a whole. You can always ask, pointing to an object in a photograph—a building, say—what lies behind it, totally obscured by it. This only accidentally makes sense when asked of an object in a painting. You can always ask, of an area photographed, what lies adjacent to that area, beyond the frame. This generally makes no sense asked of a painting. You can ask these questions of objects in photographs because they have answers in reality. The world of a painting is not continuous with the world of its frame; at its frame, a world finds its limits. We might say: A painting *is* a world; a photograph is *of* the world. What happens in a photograph is that *it* comes to an end. A photograph is cropped, not necessarily by a paper cutter or by masking but by the camera itself. The camera crops it by predetermining the amount of view it will accept; cutting, masking, enlarging, predetermine the amount after the fact. (Something like this phenomenon shows up in recent painting. In this respect, these paintings have found, at the extremest negation of the photographic, media that achieve the condition of photographs.) The camera, being finite, crops a portion from an indefinitely larger field; continuous portions of that field could be included in the photograph in fact taken; in principle, it could all be taken. Hence objects in photographs that run past the edge do not feel cut; they are aimed at, shot, stopped live. When a photograph is cropped, the rest of the world is cut *out*. The implied presence of the rest of the world, and its explicit rejection, are as essential in the experience of a photograph as what it explicitly presents. A camera is an opening in a box: that is the best emblem of the fact that a camera holding on an object is holding the rest of the world away. The camera has been praised for extending the senses; it may, as the world goes, deserve more praise for confining them, leaving room for thought.

The world of a moving picture is screened. The screen is not a support, not like a canvas; there is nothing to support, that way. It holds a projection, as light as light. A

screen is a barrier. What does the silver screen screen? It screens me from the world it holds—that is, makes me invisible. And it screens that world from me—that is, screens its existence from me. That the projected world does not exist (now) is its only difference from reality. (There is no feature, or set of features, in which it differs. Existence is not a predicate.) Because it is the field of a photograph, the screen has no frame; that is to say, no border. Its limits are not so much the edges of a given shape as they are the limitations, or capacity, of a container. The screen is a frame; the frame is the whole field of the screen—as a frame of film is the whole field of a photograph, like the framer of a loom or a house. In this sense, the screen-frame is a mold, or form.

The fact that in moving pictures successive film frames are fit flush into the fixed screen frame results in a phenomenological frame that is indefinitely extendible and contractible, limited in the smallness of the object it can grasp only by the state of its technology, and in largeness only by the span of the world. Drawing the camera back, and panning it, are two ways of extending the frame; a close-up is of a part of the body, or of one object or small set of objects, supported by and reverberating the whole frame of nature. The altering frame is the image of perfect attention. Early in its history the cinema discovered the possibility of *calling* attention to persons and parts of persons and objects; but it is equally a possibility of the medium not to call attention to them but, rather, to let the world happen, to let its parts draw attention to themselves according to their natural weight. This possibility is less explored than its opposite. Dreyer, Flaherty, Vigo, Renoir, and Antonioni are masters of it.

# AUDIENCE, ACTOR, AND STAR

The depth of the automatism of photography is to be read not alone in its mechanical production of an image of reality, but in its mechanical defeat of our presence to that reality. The audience in a theater can be defined as those to whom the actors are present while they are not present to the actors. But movies allow the audience to be mechanically absent. The fact that I am invisible and inaudible to the actors, and fixed in position, no longer needs accounting for; it is not part of a convention I have to comply with; the proceedings do not have to make good the fact that I do nothing in the face of tragedy, or that I laugh at the follies of others. In viewing a movie my helplessness is mechanically assured: I am present not at something happening, which I must confirm, but at something that has happened, which I absorb (like a memory). In this, movies resemble novels, a fact mirrored in the sound of narration itself, whose tense is the past.

It might be said: "But surely there is the obvious difference between a movie house and a theater that is not recorded by what has so far been said and that outweighs all this fiddle of differences. The obvious difference is that in a theater we are in the presence of an actor, in a movie house we are not. You have said that in both places the actor is in our presence and in neither are we in his, the difference lying in the mode of our absence. But there is also the plain fact that in a theater a real man is *there*, and in a movie no real man is there. That is obviously essential to the differences between

our responses to a play and to a film." What that means must not be denied; but the fact remains to be understood. Bazin meets it head on by simply denying that "the screen is incapable of putting us 'in the presence of' the actor"; it, so to speak, relays his presence to us, as by mirrors. Bazin's idea here really fits the facts of live television, in which the thing we are presented with is happening simultaneously with its presentation. But in live television, what is present to us while it is happening is not the world, but an event standing out from the world. Its point is not to reveal, but to cover (as with a gun), to keep something on view.

It is an incontestable fact that in a motion picture no live human being is up there. But a human *something* is, and something unlike anything else we know. We can stick to our plain description of that human something as "in our presence while we are not in his" (present at him, because looking at him, but not present to him) and still account for the difference between his live presence and his photographed presence to us. We need to consider what is present or, rather, since the topic is the human being, *who* is present.

One's first impulse may be to say that in a play the character is present, whereas in a film the actor is. That sounds phony or false: one wants to say that both are present in both. But there is more to it, ontologically more. Here I think of a fine passage of Panofsky's:

> Othello or Nora are definite, substantial figures created by the playwright. They can be played well or badly, and they can be "interpreted" in one way or another; but they most definitely exist, no matter who plays them or even whether they are played at all. The character in a film, however, lives and dies with the actor. It is not the entity "Othello" interpreted by Robeson or the entity "Nora" interpreted by Duse, it is the entity "Greta Garbo" incarnate in a figure called Anna Christie or the entity "Robert Montgomery" incarnate in a murderer who, for all we know or care to know, may forever remain anonymous but will never cease to haunt our memories.

If the character lives and dies with the actor, that ought to mean that the actor lives and dies with the character. I think that is correct, but it needs clarification. Let us develop it slightly.

For the stage, an actor works himself into a role; for the screen, a performer takes the role onto himself. The stage actor explores his potentialities and the possibilities of his role simultaneously; in performance these meet at a point in spiritual space— the better the performance, the deeper the point. In this respect, a role in a play is like a position in a game, say, third base: various people can play it, but the great third baseman is a man who has accepted and trained his skills and instincts most perfectly and matches them most intimately with his discoveries of the possibilities and necessities of third base. The screen performer explores his role like an attic and takes stock of his physical and temperamental endowment; he lends his being to the role and accepts only what fits; the rest is nonexistent. On the stage there are two beings, and the being of the character assaults the being of the actor; the actor survives only by yielding. A screen performance requires not so much training as planning. Of course, both the actor and the performer require, or can make use of, experience. The actor's role is his subject for study, and there is no end to it. But the screen performer is essentially not an actor at all: he *is* the subject of study, and a study not his own. (That is what the content of a photograph is—its subject.) On a screen the study is pro-

jected; on a stage the actor is the projector. An exemplary stage performance is one which, for a time, most fully creates a character. After Paul Scofield's performance in *King Lear*, we know who King Lear is, we have seen him in the flesh. An exemplary screen performance is one in which, at a time, a star is born. After *The Maltese Falcon* we know a new star, only distantly a person. "Bogart" means "the figure created in a given set of films." His presence in those films is who he is, not merely in the sense in which a photograph of an event is that event; but in the sense that if those films did not exist, Bogart would not exist, the name "Bogart" would not mean what it does. The figure it names is not only in our presence, we are in his, in the only sense we could ever be. That is all the "presence" he has.

But it is complicated. A full development of all this would require us to place such facts as these: Humphrey Bogart was a man, and he appeared in movies both before and after the ones that created "Bogart." Some of them did not create a new star (say, the stable groom in *Dark Victory*), some of them defined stars—anyway meteors—that may be incompatible with Bogart (e.g., Duke Mantee and Fred C. Dobbs) but that are related to that figure and may enter into our later experience of it. And Humphrey Bogart was both an accomplished actor and a vivid subject for a camera. Some people are, just as some people are both good pitchers and good hitters; but there are so few that it is surprising that the word "actor" keeps on being used in place of the more beautiful and more accurate word "star"; the stars are only to gaze at, after the fact, and their actions divine our projects. Finally, we must note the sense in which the creation of a (screen) performer is also the creation of a character—not the kind of character an author creates, but the kind that certain real people are: a type.

# TYPES; CYCLES AS GENRES

Our attention turns from the physical medium of cinema in general to the specific forms or genres the medium has taken in the course of its history.

Both Panofsky and Bazin begin at the beginning, noting and approving that early movies adapt popular or folk arts and themes and performers and characters: farce, melodrama, circus, music hall, romance, etc. And both are gratifyingly contemptuous of intellectuals who could not come to terms with those facts of life. (Such intellectuals are the alter egos of the film promoters they so heartily despise. Roxy once advertised a movie as "Art, in every sense of the word"; his better half declaims, "This is not art, in any sense of the word.") Our question is, why did such forms and themes and characters lend themselves to film? Bazin, in what I have read of him, is silent on the subject, except to express gratitude to film for reviving these ancient forms, and to justify in general the legitimacy of adaptation from one art to another. Arnold Hauser, if I understand him, suggests wrong answers, in a passage that includes the remark "Only a young art can be popular," a remark that not only is in itself baffling (did Verdi and Dickens and Shakespeare and Chaplin and Frank Loesser work in young arts?) but suggests that it was only natural for the movies to pick up the forms they did. It *was* natural—anyway it happened fast enough—but not because movies were destined to popularity (they were at first no more popular than other forms of entertainment). In

any case, popular arts are likely to pick up the forms and themes of high art for their material—popular theater naturally *burlesques*. And it means next to nothing to say that movies are young, because we do not know what the normal life span of an art is supposed to be, nor what would count as a unit of measure. Panofsky raises the question of the appropriateness of these original forms, but his answer is misleading.

> The legitimate paths of evolution [for the film] were opened, not by running away from the folk art character of the primitive film but by developing it within the limits of its own possibilities. Those primordial archetypes of film productions on the folk art level—success or retribution, sentiment, sensation, pornography, and crude humor—could blossom forth into genuine history, tragedy and romance, crime and adventure, and comedy, as soon as it was realized that they could be transfigured—not by an artifical injection of literary values but by the exploitation of the unique and specific possibilities of the new medium.

The instinct here is sound, but the region is full of traps. What are "the unique and specific possibilities of the new medium"? Panofsky defines them as dynamization of space and spatialization of time—that is, in a movie things move, and you can be moved instantaneously from anywhere to anywhere, and you can witness successively events happening at the same time. He speaks of these properties as "self-evident to the point of triviality" and, because of that, "easily forgotten or neglected." One hardly disputes this, or its importance. But we still do not understand what makes these properties "the possibilities of the medium." I am not now asking how one would know that these are *the* unique and specific possibilities (though I will soon get back to that); I am asking what it means to call them possibilities at all.

Why, for example, didn't the medium begin and remain in the condition of home movies, one shot just physically tacked on to another, cut and edited simply according to subject? (Newsreels essentially did, and they are nevertheless valuable, enough so to have justified the invention of moving pictures.) The answer seems obvious: narrative movies emerged because someone "saw the possibilities" of the medium—cutting and editing and taking shots at different distances from the subject. But again, these are mere actualities of film mechanics: every home movie and newsreel contains them. We could say: to make them "possibilities of the medium" is to realize what will give them *significance*—for example, the narrative and physical rhythms of melodrama, farce, American comedy of the 1930s. It is not as if film-makers saw these possibilities and then looked for something to apply them to. It is truer to say that someone with the wish to make a movie saw that certain established forms would give point to certain properties of film.

This perhaps sounds like quibbling, but what it means is that the aesthetic possibilities of a medium are not givens. You can no more tell what will give significance to the unique and specific aesthetic possibilities of projecting photographic images by thinking about them or seeing some, than you can tell what will give significance to the possibilities of paint by thinking about paint or by looking some over. You have to think about painting, and paintings; you have to think about motion pictures. What does this "thinking about them" consist in? Whatever the useful criticism of an art consists in. (Painters before Jackson Pollock had dripped paint, even deliberately. Pollock made dripping into a medium of painting.) I feel like saying: The first suc-

cessful movies—i.e., the first moving pictures accepted as motion pictures—were not applications of a medium that was defined by given possibilities, but the *creation of a medium* by their giving significance to specific possibilities. Only the art itself can discover its possibilities, and the discovery of a new possibility is the discovery of a new medium. A medium is something through which or by means of which some-thing specific gets done or said in particular ways. It provides, one might say, partic-ular ways to get through to someone, to make sense; in art, they are forms, like forms of speech. To discover ways of making sense is always a matter of the relation of an artist to his art, each discovering the other.

Panofsky uncharacteristically skips a step when he describes the early silent films as an "unknown language . . . forced upon a public not yet capable of reading it." His notion is (with good reason, writing when he did) of a few industrialists forcing their productions upon an addicted multitude. But from the beginning the language was not "unknown"; it was known to its creators, those who found themselves speaking it; and in the beginning there was no "public" in question; there were just some curious peo-ple. There soon was a public, but that just proves how easy the thing was to know. If we are to say that there was an "unknown" something, it was less like a language than like a fact—in particular, the fact that something is intelligible. So while it may be true, as Panofsky says, that "for a Saxon peasant of around 800 it was not easy to under-stand the meaning of a picture showing a man as he pours water over the head of another man," this has nothing special to do with the problems of a moviegoer. The meaning of that act of pouring in certain communities is still not easy to understand; it was and is impossible to understand for anyone to whom the practice of baptism is unknown. Why did Panofsky suppose that comparable understanding is essential, or uniquely important, to the reading of movies? Apparently he needed an explanation for the persistence in movies of "fixed iconography"—"the well-remembered types of the Vamp and the Straight Girl . . . the Family Man, and the Villain," characters whose conduct was "predetermined accordingly"—an explanation for the persistence of an obviously primitive or folkloristic element in a rapidly developing medium. For he goes on, otherwise inexplicably, to say that "devices like these became gradually less necessary as the public grew accustomed to interpret the action by itself and were vir-tually abolished by the invention of the talking film." In fact such devices persist as long as there are still Westerns and gangster films and comedies and musicals and romances. *Which* specific iconography the Villain is given will alter with the times, but that his iconography remains specific (i.e., operates according to a "fixed attitude and attribute" principle) seems undeniable: if Jack Palance in *Shane* is not a Villain, no honest home was ever in danger. Films have changed, but that is not because we don't need such explanations any longer; it is because we can't *accept* them.

These facts are accounted for by the actualities of the film medium itself: types are exactly what carry the forms movies have relied upon. These media created new types, or combinations and ironic reversals of types; but there they were, and stayed. Does this mean that movies can never create individuals, only types? What it means is that this is the movies' way of creating individuals: they create *individualities*. For what makes someone a type is not his similarity with other members of that type but his striking separateness from other people.

Until recently, types of black human beings were not created in film: black people were stereotypes—mammies, shiftless servants, loyal retainers, entertainers. We were not given, and were not in a position to be given, individualities that projected particular ways of inhabiting a social role; we recognized only the role. Occasionally the humanity behind the role would manifest itself; and the result was a revelation not of a human individuality, but of an entire realm of humanity becoming visible. When in *Gone With the Wind* Vivien Leigh, having counted on Butterfly McQueen's professed knowledge of midwifery, and finding her as ignorant as herself, slaps her in rage and terror, the moment can stun us with a question: What was the white girl assuming about blackness when she believed the casual claim of a black girl, younger and duller and more ignorant than herself, to know all about the mysteries of childbirth? The assumption, though apparently complimentary, is dehumanizing—with such creatures knowledge of the body comes from nowhere, and in general they are to be trusted absolutely or not at all, like lions in a cage, with whom you either do or do not know how to deal. After the slap, we are left with two young girls equally frightened in a humanly desperate situation, one limited by a distraction which expects and forgets that it is to be bullied, the other by an energetic resourcefulness which knows only how to bully. At the end of Michael Curtiz' *Breaking Point*, as the wounded John Garfield is carried from his boat to the dock, awaited by his wife and children and, just outside the circle, by the other woman in his life (Patricia Neal), the camera pulls away, holding on the still waiting child of his black partner who only the unconscious Garfield knows has been killed. The poignance of the silent and unnoticed black child overwhelms the yarn we had been shown. Is he supposed to symbolize the fact of general human isolation and abandonment? Or the fact that every action has consequences for innocent bystanders? Or that children are the real sufferers from the entangled efforts of adults to straighten out their lives? The effect here is to rebuke Garfield for attaching so much importance to the loss of his arm, and generally to blot out attention to individual suffering by invoking a massive social evil about which this film has nothing to say.

The general difference between a film type and a stage type is that the individuality captured on film naturally takes precedence over the social role in which that individuality gets expressed. Because on film social role appears arbitrary or incidental, movies have an inherent tendency toward the democratic, or anyway the idea of human equality. (But because of film's equally natural attraction to crowds, it has opposite tendencies toward the fascistic or populistic.) This depends upon recognizing film types as inhabited by figures we have met or may well meet in other circumstances. The recognized recurrence of film performers will become a central idea as we proceed. At the moment I am emphasizing only that in the case of black performers there was until recently no other place for them to recur in, except just the role within which we have already met them. For example, we would not have expected to see them as parents or siblings. I cannot at the moment remember a black person in a film making an ordinary purchase—say of a newspaper, or a ticket to a movie or for a train, let alone writing a check. (*Pinky* and *A Raisin in the Sun* prove the rule: in the former, the making of a purchase is a climactic scene in the film; in the latter, it provides the whole subject and structure.)

One recalls the list of stars of every magnitude who have provided the movie camera with human subjects—individuals capable of filling its need for individualities, whose individualities in turn, whose inflections of demeanor and disposition were given full play in its projection. They provided, and still provide, staples for impersonators: one gesture or syllable of mood, two strides, or a passing mannerism was enough to single them out from all other creatures. They realized the myth of singularity—that we can still be found, behind our disguises of bravado and cowardice, by someone, perhaps a god, capable of defeating our self-defeats. This was always more important than their distinction by beauty. Their singularity made them more like us—anyway, made their difference from us less a matter of metaphysics, to which we must accede, than a matter of responsibility, to which we must bend. But then that made them even more glamorous. That they should be able to stand upon their singularity! If one did that, one might be found, and called out, too soon, or at an inconvenient moment.

What was wrong with type-casting in films was not that it displaced some other, better principle of casting, but that factors irrelevant to film-making often influenced the particular figures chosen. Similarly, the familiar historical fact that there are movie cycles, taken by certain movie theorists as in itself a mark of unscrupulous commercialism, is a possibility internal to the medium; one could even say, it is the best emblem of the fact that a medium had been created. For a cycle is a genre (prison movies, Civil War movies, horror movies, etc.); and a genre is a medium.

As Hollywood developed, the original types ramified into individualities as various and subtle, as far-reaching in their capacities to inflect mood and release fantasy, as any set of characters who inhabited the great theaters of our world. We do not know them by such names of Pulcinella, Crispin, Harlequin, Pantaloon, the Doctor, the Captain, Columbine; we call them the Public Enemy, the Priest, James Cagney, Pat O'Brien, the Confederate Spy, the Army Scout, Randolph Scott, Gary Cooper, Gable, Paul Muni, the Reporter, the Sergeant, the Sheriff, the Deputy, the D.A., the Quack, the Shyster, the Other Woman, the Fallen Woman, the Moll, the Dance Hall Hostess. Hollywood was the theater in which they appeared, because the films of Hollywood constituted a world, with recurrent faces more familiar to me than the faces of the neighbors of all the places I have lived.

The great movie comedians—Chaplin, Keaton, W. C. Fields—form a set of types that could not have been adapted from any other medium. Its creation depended upon two conditions of the film medium mentioned earlier. These conditions seem to be necessities, not merely possibilities, so I will say that two necessities of the medium were discovered or expanded in the creation of these types. First, movie performers cannot project, but are projected. Second, photographs are of the world, in which human beings are not ontologically favored over the rest of nature, in which objects are not props but natural allies (or enemies) of the human character. The first necessity—projected visibility—permits the sublime comprehensibility of Chaplin's natural choreography; the second—ontological equality—permits his Proustian or Jamesian relationships with Murphy beds and flights of stairs and with vases on runners on tables on rollers: the heroism of momentary survival, Nietzsche's man as a tightrope across an abyss. These necessities permit not merely the locales of Keaton's

extrications, but the philosophical mood of his countenance and the Olympic resourcefulness of his body; permit him to be perhaps the only constantly beautiful and continuously hilarious man ever seen, as though the ugliness in laughter should be redeemed. They permit Fields to mutter and suffer and curse obsessively, but heard and seen only by us; because his attributes are those of the gentleman (confident swagger and elegant manners, gloves, cane, outer heartiness), he can manifest continuously with the remorselessness of nature, the psychic brutalities of bourgeois civilization.

# IDEAS OF ORIGIN

It is inevitable that in theorizing about film one at some point speculate about its origins, because despite its recentness, its origin remains obscure. The facts are well enough known about the invention and the inventors of the camera, and about improvements in fixing and then moving the image it captures. The problem is that the invention of the photographic picture is not the same thing as the creation of photography as a medium for making sense. The historical problem is like any other: a chronicle of the facts preceding the appearance of this technology does not explain why it happened when and as it did. Panofsky opens his study of film by remarking, "It was not an artistic urge that gave rise to the discovery and gradual perfection of a new technique; it was a technical invention that gave rise to the discovery and gradual perfection of a new art." We seem to understand this, but do we understand it? Panofsky assumes we know what it is that at any time has "given rise" to a "new art." He mentions an "artistic urge," but that is hardly a candidate to serve as an explanation; it would be about as useful as explaining the rise of modern science by appealing to "a scientific urge." There may be such urges, but they are themselves rather badly in need of explanation. Panofsky cites an artistic urge explicitly as the occasion for a new "technique." But the motion picture is not a new *technique*, any more than the airplane is. (What did we use to do that such a thing enables us to do better?) Yet some idea of flying, and an urge to do it, preceded the mechanical invention of the airplane. What is "given rise to" by such inventions as movable type or the microscope or the steam engine or the pianoforte?

It would be surprising if the history of the establishment of an artistic medium were less complex a problem for the historical understanding than (say) the rise of modern science. I take Bazin to be suggesting this when he reverses the apparent relation between the relevant technology and the idea of cinema, emphasizing that the idea preceded the technology, parts of it by centuries, and that parts of the technology preceded the invention of movies, some of it by centuries. So what has to be explained is not merely how the feat was technically accomplished but, for example, what stood in the way of its happening earlier. Surprisingly, Bazin, in the selection of essays I have read, does not include the contemporary condition of the related arts as a part of the ideological superstructure that elicited the new material basis of film. But it is certainly relevant that the burning issue during the latter half of the nineteenth century,

in painting and in the novel and in the theater, was realism. And unless film captured possibilities opened up by the arts themselves, it is hard to imagine that its possibilities as an artistic medium would have shown up as, and as suddenly as, they did.

The idea of and wish for the world re-created in its own image was satisfied *at last* by cinema. Bazin calls this the myth of total cinema. But it had always been one of the myths of art; each of the arts had satisfied it in its own way. The mirror was in various hands held up to nature. In some ways it was more fully satisfied in theater. (Since theater is on the whole not now a major art for us, it on the whole no longer makes contact with its historical and psychological sources; so we are rarely gripped by the trauma we must once have suffered when the leader of the chorus stopped contributing to a narrative or song and turned to face the others, suffering incarnation.)

What is cinema's way of satisfying the myth? Automatically, we said. But what does that mean—mean mythically, as it were? It means satisfying it without *my* having to do anything, satisfying it *by* wishing. In a word, *magically*. I have found myself asking: How could film be art, since all the major arts arise in some way out of religion? Now I can answer: Because movies arise out of magic; from *below* the world.

The better a film, the more it makes contact with this source of its inspiration; it never wholly loses touch with the magic lantern behind it. This suggests why movies of the fantastic (*The Cabinet of Dr. Caligari*, *Blood of a Poet*) and filmed scenes of magic (say, materialization and dematerialization), while they have provided moods and devices, have never established themselves as cinematic media, however strongly this "possibility" is suggested by the physical medium of film: they are technically and psychologically trivial compared with the medium of magic itself. It is otherwise if the presented magic is itself made technically or physically interesting (*The Invisible Man*, *Dr. Jekyll and Mr. Hyde*, *Frankenstein*, *2001: A Space Odyssey*), but then that becomes another way of confirming the physicality of our world. Science presents itself, in movies, as magic, which was indeed one source of science. In particular, projected science retains magic's mystery and forbiddenness. Science-fiction films exploit not merely certain obvious aspects of adventure, and of a physicality that special effects specialize in, but also the terrific mumbo-jumbo of hearsay science: "My God, the thing is impervious to the negative beta ray! We must reverse the atom recalcitration spatter, before it's too late!" The dialogue has the surface of those tinbox-and-lever contraptions that were sufficiently convincing in prime *Flash Gordon*. These films are carried by the immediacy of the fantasy that motivates them (say, destruction by lower or higher forms of life, as though the precariousness of human life is due to its biological stage of development); together with the myth of the one way and last chance in which the (external) danger can be averted. And certainly the beauty of forms and motions in Frankenstein's laboratory is essential to the success of *Frankenstein*; computers seem primitive in comparison. It always made more sense to steal from God than to try to outwit him.

How do movies reproduce the world magically? Not by literally presenting us with the world, but by permitting us to view it unseen. This is not a wish for power over creation (as Pygmalion's was), but a wish not to need power, not to have to bear its burdens. It is, in this sense, the reverse of the myth of Faust. And the wish for invisibility is old enough. Gods have profited from it, and Plato tells it at the end of the

*Republic* as the Myth of the Ring of Gyges. In viewing films, the sense of invisibility is an expression of modern privacy or anonymity. It is as though the world's projection explains our forms of unknownness and of our ability to know. The explanation is not so much that the world is passing us by, as that we are displaced from our natural habitation within it, placed at a distance from it. The screen overcomes our fixed distance; it makes displacement appear as our natural condition.

1971

# JEAN-LOUIS BAUDRY
# IDEOLOGICAL EFFECTS OF THE BASIC CINEMATOGRAPHIC APPARATUS

At the end of *The Interpretation of Dreams*, when he seeks to integrate dream elaboration and its particular "economy" with the psyche as a whole, Freud assigns to the latter an optical model: "Let us simply imagine the instrument which serves in psychic productions as a sort of complicated microscope or camera." But Freud does not seem to hold strongly to this optical model, which, as Derrida has pointed out,[1] brings out the shortcomings of graphic representation in the area earlier covered by his work on dreams. Moreover, he will later abandon the optical model in favor of a writing instrument, the "mystic writing pad." Nonetheless, this optical choice seems to prolong the tradition of Western science, whose birth coincides exactly with the development of the optical apparatus which will have as a consequence the decentering of the human universe, the end of geocentrism (Galileo).

But also, and paradoxically, the optical apparatus camera obscura will serve in the same period to elaborate in pictorial work a new mode of representation, *perspectiva artificalis*. This system, recentering or at least displacing the center (which settles itself in the eye), will ensure the setting up of the "subject"[2] as the active center and origin of meaning. One could doubtless question the privileged position which optical instruments seem to occupy on the line of intersection of science and ideological productions. Does the technical nature of optical instruments, directly attached to scientific practice, serve to conceal not only their use in ideological products but also the ideological effects which they may themselves provoke? Their scientific base would ensure them a sort of neutrality and help to avoid their being questioned.

---

[1] See on this subject Derrida's work "La Scène de l'écriture" in *L'Ecriture et la différence* (Paris: Seuil, 1967).

[2] [The term "subject" is used by Baudry and others to mean not the topic of discourse—though this is clearly involved—but rather the perceiving and ordering self, as in our term "subjective"—TRANS.]

355

But already a question: if we are to take account of the imperfections of these instruments, their limitations, by what criteria may these be defined? If, for example, one can speak of a restricted depth of field as a limitation, doesn't this term itself depend on a particular conception of reality for which such a limitation would not exist? Contemporary media are particularly in question here, to the extent that instrumentation plays a more and more important role in them and that their distribution is more and more extensive. It is strange (but is it so strange?) that emphasis has been placed almost exclusively on their influence, on the effects that they have as finished products, their content, the field of the signified if you like; the technical bases on which these effects depend and the specific characteristics of these bases have, however, been ignored. They have been protected by the inviolability that science is supposed to provide. We would like to establish for the cinema a few guidelines which will need to be completed, verified, improved.

We must first establish the place of the instrumental base in the set of operations which combine in the production of a film (we omit consideration of economic implications). Between "objective reality" and the camera, site of inscription, and between the inscription and the projection are situated certain operations, a *work* which has as its result a finished product. To the extent that it is cut off from the raw material ("objective reality") this product does not allow us to see the transformation which has taken place.

Equally distant from "objective reality" and the finished product, the camera occupies an intermediate position in the work process which leads from raw material to finished product. Though mutually dependent from other points of view, *découpage* [shot breakdown before shooting] and *montage* [editing, done afterward] must be distinguished because of the essential difference in the signifying raw material on which each operates: language (scenario) or image. Between the two complementary stages of production a mutation of signifying material takes place (neither translation nor transcription, obviously, for the image is not reducible to language) precisely in the place occupied by the camera. Finally, between the finished product (possessing exchange value, a commodity) and its consumption (use value) is introduced another operation effected by a set of instruments. Projector and screen restore the light lost in the shooting process, and transform a succession of separate images into an unrolling which also restores, but according to another scansion, the movement seized from "objective reality."

Cinematographic specificity thus refers to a *work*, that is, to a process of transformation. The question becomes: is the work made evident, does consumption of the product bring about a "knowledge effect" [Althusser], or is the work concealed? If the latter, consumption of the product will obviously be accompanied by ideological surplus value. On the practical level, this poses the question of by what procedures the work can in fact be made "readable" in its inscription. These procedures must of necessity call cinematographic technique into play. But, on the other hand, going back to the first question, one may ask, do the instruments (the technical base) produce specific ideological effects, and are these effects themselves determined by the dominant ideology? In which case, concealment of the technical base will also bring about an inevitable ideological effect. Its inscription, its manifestation as such, on the

other hand, would produce a knowledge effect, as actualization of the work process, as denunciation of ideology, and as critique of idealism.

## THE EYE OF THE SUBJECT

Central in the process of production[1] of the film, the camera—an assembly of optical and mechanical instrumentation—carries out a certain mode of inscription characterized by marking, by the recording of differences between the frames. Fabricated on the model of the camera obscura, it permits the construction of an image analogous to the perspective projections developed during the Italian Renaissance. Of course, the use of lenses of different focal lengths can alter the perspective of an image. But this much, at least, is clear in the history of cinema: it is the perspective construction of the Renaissance which originally served as a model. The use of different lenses, when not dictated by technical considerations aimed at restoring habitual perspective (such as shooting in limited or extended spaces which one wishes to expand or contract), does not destroy [traditional] perspective but rather makes it play the role of norm. Departure from the norm, by means of a wide-angle or telephoto lens, is clearly marked in comparison with so-called "normal" perspective. We will see in any case that the resulting ideological effect is still defined in relation to the ideology inherent in perspective. The dimensions of the image itself, the ratio between height and width, seem clearly taken from an average drawn from Western easel painting.

The conception of space which conditions the construction of perspective in the Renaissance differs from that of the Greeks. For the latter, space is discontinuous and heterogeneous (for Aristotle, but also for Democritus, for whom space is the location of an infinity of indivisible atoms), whereas with Nicholas of Cusa will be born a conception of space formed by the relation between elements which are equally near and distant from the "source of all life." In addition, the pictorial construction of the Greeks corresponded to the organization of their stage, based on a multiplicity of points of view, whereas the painting of the Renaissance will elaborate a centered space. ("Painting is nothing but the intersection of the visual pyramid following a given distance, a fixed center, and a certain lighting."—Alberti.) The center of this space coincides with the eye which Jean Pellerin Viator will so appropriately call the "subject." ("The principal point in perspective should be placed at eye level: this point is called fixed or subject.")[2] Monocular vision, which as Pleynet points out is what the camera has, calls forth a sort of play of "reflection." Based on the principle of a fixed point by reference to which the visualized objects are organized, it specifies in return the position of the "subject,"[3] the very spot it must necessarily occupy.

---

[1]Obviously we are not speaking here of investment of capital in the process.

[2]See L. Brion Guerry, *Jean Pellerin Viator* (Paris: Belles Lettres, 1962.)

[3]We understand the term "subject" here as a vehicle and as a place of intersection of the ideological implications which we are attempting progressively to make clear, and not as the structural function which analytic discourse attempts to locate. It would rather partially take the place of the *ego*, of which we know the deviations seen in the analytic field.

In focusing it, the optical construct appears to be truly the projection-reflection of a "virtual image" whose hallucinatory reality it creates. It lays out the space of an ideal vision and in this way assures the necessity of a transcendence—metaphorically (by the unknown to which it appeals—here we must recall the structural place occupied by the vanishing point) and metonymically (by the displacement that it seems to carry out: a subject is both "in place of" and "a part for the whole"). Contrary to Chinese and Japanese painting, Western easel painting, presenting as it does a motionless and continuous whole, elaborates a total vision which corresponds to the idealist conception of the fullness and homogenity of "being,"* and is, so to speak, representative of this conception. In this sense it contributes in a singularly emphatic way to the ideological function of art, which is to provide the tangible representation of metaphysics. The principle of transcendence which conditions and is conditioned by the perspective construction represented in painting and in the photographic image which copies from it seems to inspire all the idealist paeans to which the cinema has given rise:

> This strange mechanism, parodying man's spirit, seems better to accomplish the latter's own tasks. This mimetic play, brother and rival of the intelligence, is, finally, a means of the discovery of truth. (Cohen-Séat)

> Far from leading us down the path of determinism, as one could legitimately believe, this art—the most positive of all, insensible to all that is not brute fact, pure appearance—presents us on the contrary the idea of a hierarchical universe, ordered in terms of an ultimate end. Behind what film gives us to see, it is not the existence of atoms that we are led to seek, but rather the existence of an "other world" of phenomena, of a soul or of other spiritual principles. It is in this revelation, above all, of a spiritual presence, that I propose that we seek Poetry. (André Bazin)

## PROJECTION: DIFFERENCE DENIED

Nevertheless, whatever the effects proper to optics generally, the movie camera differs from still photography by registering through its mechanical instrumentation a series of images. It might thus seem to counter the unifying and "substantializing" character of the single-perspective image, taking what would seem to be instants of time or slices from "reality" (but always a reality already worked upon, elaborated, selected). This might permit the supposition, especially since the camera moves, of a multiplicity of points of view which would neutralize the fixed position of the eye-subject and even nullify it. But here we must turn to the relation between the succession of images inscribed by the camera and their projection, bypassing momentarily the place occupied by editing, which plays a decisive role in the strategy of the ideology produced.

The projection operation (projector and screen) restores continuity of movement and the temporal dimension to the sequence of static images. The relation between the individual frames and the projection would resemble the relation between points and a curve in geometry. But it is precisely this relation and the restoration of conti-

---

*The perspective "frame" which will have such an influence on cinematographic shooting has as its role to intensify, to increase the effect of the spectacle, which no divergence may be allowed to split.

nuity to discontinuous elements which poses a problem. The meaning effect produced does not depend only on the content of the images but also on the material procedures by which an illusion of continuity, dependent on persistence of vision, is restored from discontinuous elements. These separate frames have between them differences that are indispensible for the creation of an illusion of continuity, of a continuous passage (movement, time). But only on one condition can these differences create this illusion: they must be effaced as differences.*

Thus on the technical level the question becomes one of the adoption of a very small difference between images, such that each image, in consequence of an organic factor [presumably persistence of vision], is rendered incapable of being seen as such. In this sense we could say that film—and perhaps this instance is exemplary—lives on the denial of difference: difference is necessary for it to live, but it lives on its negation. This is indeed the paradox that emerges if we look directly at a strip of processed film: adjacent images are almost exactly repeated, their divergence being verifiable only by comparison of images at a sufficient distance from each other. We should remember, moreover, the disturbing effects which result during a projection from breakdowns in the recreation of movement, when the spectator is brought abruptly back to discontinuity—that is, to the body, to the technical apparatus which he had *forgotten*.

We might not be far from seeing what is in play on this material basis if we recall that the "language" of the unconscious, as it is found in dreams, slips of the tongue, or hysterical symptoms, manifests itself as continuity destroyed, broken and as the unexpected surging forth of a marked difference. Couldn't we thus say that cinema reconstructs and forms the mechanical model (with the simplifications that this can entail) of a system of writing [*écriture*] constituted by a material base and a counter-system (ideology, idealism) which uses this system while also concealing it? On the one hand, the optical apparatus and the film permit the marking of difference (but the marking is already negated, we have seen, in the constitution of the perspective image with its mirror effect). On the other hand, the mechanical apparatus both selects the minimal difference and represses it in projection, so that meaning can be constituted; it is at once direction, continuity, movement. The projection mechanism allows the differential elements (the discontinuity inscribed by the camera) to be suppressed, bringing only the relation into play. The individual images as such disappear so that movement and continuity can appear. But movement and continuity are the visible expression (one might even say, the projection) of their relations, derived from the tiny discontinuities between the images. Thus one may presume that what was already at work as the originating basis of the perspective image, namely the eye, the "subject," is put forth, liberated (in the sense that a chemical reaction liberates a sub-

---

*We know that the spectator finds it impossible to notice that the images which succeed one another before his eyes were assembled end to end, because the projection of film on the screen offers an impression of continuity although the images which compose it are, in reality, distinct, and are differentiated, moreover, by variations in space and time.

"In a film,there can be hundreds, even thousands of cuts and intervals. But if in the hands of specialists who know the art, the spectacle will not be divulged as such. Only an error or lack of competence will permit them to seize, and this is a disagreeable sensation, the changes of time and place of action." (V.I. Pudovkin, "Le Montage," in *Cinéma d'aujourd'hui et de demain* [Moscow, 1956].

stance) by the operation which transforms successive, discrete images (as isolated images they have, strictly speaking, no meaning, or at least no unity of meaning) into continuity, movement, meaning. With continuity restored, both meaning and consciousness are restored.[1]

## THE TRANSCENDENTAL SUBJECT

Meaning and consciousness, to be sure, at this point we must return to the camera. Its mechanical nature not only permits the shooting of differential images as rapidly as desired but also destines it to change position, to move. Film history shows that as a result of the combined inertia of painting, theater, and photography, it took a certain time to notice the inherent mobility of the cinematic mechanism. The ability to reconstitute movement is after all only a partial, elementary aspect of a more general capability. To seize movement is to become movement, to follow a trajectory is to become trajectory, to choose a direction is to have the possibility of choosing one, to determine a meaning is to give oneself a meaning. In this way the eye subject, the invisible base of artificial perspective (which in fact only represents a larger effort to produce an ordering, a regulated transcendence) becomes absorbed in, "elevated" to a vaster function, proportional to the movement which it can perform.

And if the eye which moves is no longer fettered by a body, by the laws of matter and time, if there are no more assignable limits to its displacement—conditions fulfilled by the possibilities of shooting and of film—the world will be constituted not only by this eye but for it.[2] The mobility of the camera seems to fulfill the most favorable conditions for the manifestation of the "transcendental subject." There is a phantasmatization of objective reality (images, sounds, colors)—but of an objective reality which, limiting its powers of constraint, seems equally to augment the possibilities or the power of the subject.[3] As it is said of consciousness—and in point of fact we are concerned with nothing less—the image *of* something; it must result from a deliberate act of consciousness [*visée intentionelle*]. "The word intentionality signifies nothing other than this peculiarity that consciousness has of being consciousness *of* something, of carrying in its quality of *ego* its *cogitatum* within itself."[4] In such a definition could perhaps be found the status of the cinematographic image, or rather of its operation, the mode of working which it carries out. For it to be an image of something, it has to constitute this something as meaning. The image seems to reflect the world but solely in the naive inversion of a founding hierarchy: "The domain of natural existence thus has only an authority of the second order, and always presupposes the domain of the transcendental."[5]

---

[1]It is thus first at the level of the apparatus that the cinema functions as a language: inscription of discontinuous elements whose effacement in the relationship instituted among them produces meaning.

[2]"In the cinema I am simultaneously in this action and outside it, in this space and out of this space. Having the power of ubiquity. I am everywhere and nowhere." Jean Mitry, *Esthétique et psychologie du cinéma* [Paris: Presses Universitaires de France, 1965], p. 179].

[3]The cinema manifests in a hallucinatory manner the belief in the omnipotence of thought, described by Freud, which plays so important a role in neurotic defense mechanisms.

[4]Husserl, *Les Méditations Cartesiennes* (Paris: Vrin, 1953), p. 28.

[5]*Ibid*, p. 18.

The world is no longer only an "open and indeterminate horizon." Limited by the framing, lined up, put at the proper distance, the world offers up an object endowed with meaning, an intentional object, implied by and implying the action of the "subject" which sights it. At the same time that the world's transfer as image seems to accomplish this phenomenological reduction, this putting into parentheses of its real existence (a suspension necessary, we will see, to the formation of the impression of reality) provides a basis for the apodicity[1] of the ego. The multiplicity of aspects of the object in view refers to a synthesizing operation, to the unity of this constituting subject: Husserl speaks of

> "aspects," sometimes of "proximity," sometimes of "distance," in variable modes of "here" and "there," as opposed to an absolute here (which is located—for me—in "my own body" which appears to me at the same time), the consciousness of which, though it remains *unperceived*, always accompanies them. [We will see moreover what happens with the body in the mise-en-scène of projection.—J.L.B.] Each "aspect" which the mind grasps, for example, this cube here in the sphere of proximity, is revealed in turn as a unity synthesized from a multiplicity of corresponding modes of presentation. The nearby object may present itself as the same, but under one or another "aspect." There may be variation of visual perspective, but also of "tacile," "acoustic" phenomena, or of other "modes of presentation"[2] as we can observe in directing our attention in the proper direction.[3]

For Husserl, "the original operation [of intentional analysis] is to *unmask the potentialities implied* in the present states of consciousness. And it is by this that will be carried out, from the noematic point of view, the eventual *explication, definition,* and *elucidation* of what is meant by consciousness, that is, its *objective meaning*.[4] And again in the *Cartesian Meditations*: "A second type of polarization now presents itself to us, another type of synthesis which embraces the particular multiplicities of *cogitationes*, which embraces them all and in a special manner, namely, as *cogitationes* of an identical self which, *active* or *passive*, lives in all the lived states of consciousness and which, through them, relates to all objects.[5]

Thus is articulated the relation between the continuity necessary to the constitution of meaning and the "subject" which constitutes this meaning: continuity is an attribute of the subject. It supposes the subject and it circumscribes its place. It appears in the cinema in the two complementary aspects of a "formal" continuity established through a system of negated differences and narrative continuity in the filmic space. The latter, in any case, could not have been conquered without exercising violence to the instrumental base, as can be discovered from most of the texts by filmmakers and critics: the discontinuity that had been effaced at the level of the image could have reappeared on the narrative level, giving rise to effects of rupture disturbing to the spectator (to a *place* which ideology must both conquer and, in the degree that it

---

[1]["Apodicity," in phenomenological terminology, indicates something of an irrefutable nature. See Husserl, *Les Méditations Cartesiennes*. Here, Baudry is using the term critically—in a sense *ironically*.—TRANS.]

[2]On this point it is true that the camera is revealed as incomplete. But this is only a technical imperfection which, since the birth of cinema, has already in large measure been remedied.

[3]*Ibid.*, p. 34, emphasis added.

[4]*Ibid.*, p. 40.

[5]*Ibid.*, p. 56.

already dominates it, must also satisfy: fill). "What is important in a film is the feeling of continuity which joins shots and sequences while maintaining unity and cohesion of movements. This continuity was one of the most difficult things to obtain.[1] Pudovkin defined montage as "the art of assembling pieces of film, shot separately, in such a way as to give the spectator the impression of continuous movement." The search for such narrative continuity, so difficult to obtain from the material base, can only be explained by an essential ideological stake projected in this point: it is a question of preserving at any cost the synthetic unity of the locus where meaning originates [the subject]—the constituting transcendental function to which narrative continuity points back as its natural secretion.[2]

## THE SCREEN-MIRROR: SPECULARIZATION AND DOUBLE IDENTIFICATION

But another supplementary operation (made possible by a special technical arrangement) must be added in order that the mechanism thus described can play its role effectively as an ideological machine, so that not only the reworked "objective reality" but also the specific type of identification we have described can be represented.

No doubt the darkened room and the screen bordered with black like a letter of condolence already present privileged conditions of effectiveness—no exchange, no circulation, no communication with any outside. Projection and reflection take place in a closed space, and those who remain there, whether they know it or not (but they do not), find themselves chained, captured, or captivated. (What might one say of the function of the head in this captivation: it suffices to recall that for Bataille materialism makes itself headless—like a wound that bleeds and thus transfuses.) And the mirror, as a reflecting surface, is framed, limited, circumscribed. *An infinite mirror would no longer be a mirror.* The paradoxical nature of the cinematic mirror-screen is without doubt that it reflects *images* but not "reality"; the word *reflect*, being transitive, leaves this ambiguity unresolved. In any case this "reality" comes from behind the spectator's head, and if he looked at it directly he would see nothing except the moving beams from an already veiled light source.

The arrangement of the different elements—projector, darkened hall, screen—in addition to reproducing in a striking way the mise-en-scène of Plato's cave (proto-

---

[1] Mitry, *Esthétique et psychologie*, p. 157.

[2] The lens, the "objective," is of course only a particular location of the "subjective," Marked by the idealist opposition interior/exterior, topologically situated at the meeting point of the two, it corresponds, one could say, to the empirical organ of the subjective, to the opening, the fault in the organs of meaning, by which the exterior world may penetrate the interior and assume meaning. "It is the interior which commands," says Bresson. "I know this may seem paradoxical in an art which is all exterior." Also the use of different lenses is already conditioned by camera movement as implication and trajectory of meaning, by this transcendental function which we are attempting to define: it is the possibility of choosing a field as accentuation or modification of the *visée intentionelle.*

No doubt this transcendental function fits without difficulty into the field of psychology. This, moreover, is insisted upon by Husserl himself, who indicates that Brentano's discovery, intentionality, "permits one truly to distinguish the method of a descriptive science of consciousness, as much philosophical and transcendental as psychological."

typical set for all transcendence and the topological model of idealism,)[1] reconstructs the situation necessary to the release of the "mirror stage" discovered by Lacan. This psychological phase, which occurs between six and eighteen months of age, generates via the mirror image of a unified body the constitution or at least the first sketches of the "I" as an imaginary function. "It is to this unreachable image in the mirror that the specular image gives its garments.[2] But for this imaginary constitution of the self to be possible, there must be—Lacan strongly emphasizes this point—two complementary conditions: immature powers of mobility and a precocious maturation of visual organization (apparent in the first few days of life). If one considers that these two conditions are repeated during cinematographic projection—suspension of mobility and predominance of the visual function—perhaps one could suppose that this is more than a simple analogy. And possibly this very point explains the "impression of reality" so often invoked in connection with the cinema, for which the various explanations proposed seem only to skirt the real problem. In order for this impression to be produced, it would be necessary that the conditions of a formative scene be reproduced. This scene would be repeated and reenacted in such a manner that the imaginary order (activated by a specularization which takes place, everything considered, in reality) fulfills its particular function of occultation or of filling the gap, the split, of the subject on the order of the signifier.[3]

On the other hand, it is to the extent that the child can sustain the look of another in the presence of a third party that he can find the assurance of an identification with the image of his own body. From the very fact that during the mirror stage a dual relationship is established, it constitutes, in conjunction with the formation of the self in the imaginary order, the nexus of secondary identification.[4] The origin of the self, as discovered by Lacan, in pertaining to the imaginary order effectively subverts the "optical machinery" of idealism which the projection room scrupulously reproduces.[5] But it is not as specifically "imaginary," nor as a reproduction of its first configuration, that the self finds a "place" in the cinema. This occurs, rather, as a sort of proof or verification of that function, a solidification through repetition.

The "reality" mimed by the cinema is thus first of all that of a "self." But because the reflected image is not that of the body itself but that of a world already given as meaning, one can distinguish two levels of identification. The first, attached to the image itself, derives from the character portrayed as a center of secondary identifications, carrying an identity which constantly must be seized and reestablished. The

---

[1]The arrangement of the cave, except that in the cinema it is already doubled in a sort of enclosure in which the camera, the darkened chamber, is enclosed in another darkened chamber, the projection hall.

[2]Jacques Lacan, *Ecrits* (Paris: Seuil, 1966). See in particular "Le Stade du miroir comme formateur de la fonction du je."

[3]We see that what has been defined as impression of reality refers less to the "reality" than to the apparatus which, although of a hallucinatory order, nonetheless founds this possibility. Reality will never appear except as relative to the images which reflect it, in some way inaugurated by a reflection anterior to itself.

[4]We refer here to what Lacan says of identifications in connection with the structure determined by an optical instrument (the mirror), as they are constituted, in the prevailing figuration of the ego, as lines of resistance to the advance of the analytic work.

[5]"That the ego be 'in the right' must be avowed, from experience, to be a function of misunderstanding" (Lacan, *Ecrits* p. 637).

second level permits the appearance of the first and places it "in action"—this is the transcendental subject whose place is taken by the camera which constitutes and rules the objects in the "world." Thus the spectator identifies less with what is represented, the spectacle itself, than with what stages the spectacle, makes it seen, obliging him to see what it sees: this is exactly the function taken over by the camera as a sort of relay.[1] Just as the mirror assembles the fragmented body in a sort of imaginary integration of the self, the transcendental self unites the discontinuous fragments of phenomena, of lived experience into unifying meaning. Through it each fragment assumes meaning by being integrated into an "organic" unity. Between the imaginary gathering of the fragmented body into a unity and the transcendentality of the self, giver of unifying meaning, the current is indefinitely reversible.

The ideological mechanism at work in the cinema seems thus to be concentrated in the relationship between the camera and the subject. The question is whether the former will permit the latter to constitute and seize itself in a particular mode of specular reflection. Ultimately, the forms of narrative adopted, the "contents" of the image, are of little importance so long as an identification remains possible.[2] What emerges here (in outline) is the specific function fulfilled by the cinema as support and instrument of ideology. It constitutes the "subject" by the illusory delimitation of a central location—whether this be that of a god or of any other substitute. It is an apparatus destined to obtain a precise ideological effect, necessary to the dominant ideology: creating a phantasmatization of the subject, it collaborates with a marked efficacy in the maintenance of idealism.

Thus the cinema assumes the role played throughout Western history by various artistic formations. The ideology of representation (as a principal axis orienting the notion of aesthetic "creation") and specularization (which organizes the mise-en-scène required to constitute the transcendental function) form a singularly coherent system in the cinema. Everything happens as if, the subject himself being unable— and for a reason—to account for his own situation, it was necessary to substitute secondary organs, grafted on to replace his own defective ones, instruments or ideological formations capable of filling his function as subject. In fact, this substitution is only possible on the condition that the instrumentation itself be hidden or repressed. Thus disturbing cinematic elements—similar, precisely, to those elements indicating the return of the repressed—signify without fail the arrival of the instrument "in flesh and blood," as in Vertov's *Man With a Movie Camera*. Both specular tranquility and the assurance of one's own identity collapse simultaneously with the revealing of the mechanism, that is, of the inscription of the film work.

The cinema can thus appear as a sort of psychic apparatus of substitution, corresponding to the model defined by the dominant ideology. The system of repression (primarily economic) has as its goal the prevention of deviations and of the active

---

[1]"That it sustains itself as 'subject' means that language permits it to consider itself as the stagehand or even the director of all the imaginary capturings of which it would otherwise only be the living marionette" (*Ibid.*, p. 637).

[2]It is on this point and in terms of the elements which we are trying to put in place that a discussion of editing could be opened. We will at a later date attempt to make some remarks on this subject.

exposure of this "model."* Analogously one could say that its "unconscious" is not recognized (we speak of the apparatus and not of the content of films, which have used the unconscious in ways we know all too well). to this unconscious would be attached the mode of production of film, the process of "work" in its multiple determinations, among which must be numbered those depending on instrumentation. This is why reflections on the basic apparatus ought to be possible to integrate into a general theory of the ideology of cinema.

1970

---

*J.-D. Pollet and Phillipe Sollers' *Mediterranée* (1963), which dismantles with exemplary efficiency the "transcendental specularization" which we have attempted to delineate, gives a manifest proof of this point. The film was never able to overcome the economic blockade.

# CHRISTIAN METZ
# AURAL OBJECTS

## ON PRIMITIVE SUBSTANTIALISM

There is a kind of primitive substantialism which is profoundly rooted in our culture (and without a doubt in other cultures as well, though not necessarily in all cultures) which distinguishes fairly rigidly the primary qualities that determine the list of objects (substances) and the secondary qualities which correspond to attributes applicable to these objects. This conception is reflected in the entire Western philosophic tradition beginning with notions put forth by Descartes and Spinoza. It is also clear that this "world view" has something to do with the subject-predicate structure particularly prevalent in Indo-European languages.

For us, the primary qualities are in general visual and tactile. Tactile because touch is traditionally the very criterion of materiality.[1] Visual because the identification processes necessary to present-day life and to production techniques rely on the eye above all the other senses (it is only in language that the auditory order is "rehabilitated," as if by compensation). The subject is too vast for this study. Nevertheless, it is possible to begin to discern certain qualities which seem to be "secondary": sounds (evoked above), olfactory qualities (a "scent" is barely an object), and even certain subdimensions of the visual order such as color.[2]

---

[1] I had already been led to this remark via a completely different route in my article "A propos de l'impression de réalité au cinéma" (1965), taken from pp. 13–24 of vol. 1 of *Essais sur la signification au cinéma* (Paris: Klincksieck, 1968), notably pp. 18–19.

[2] There is a reason why film without color, the black-and-white film, was "possible" (culturally, in relation to demand) for many years, and still is to a large extent, that the odor-film has no past or future development, that the "sound talkie" (today's usual film) is almost always more talk than sound, the noises being so impoverished and stereotyped. In fact, the only cinematographic aspects that interest everyone, and not just some specialists, are the image and speech.

In a clothing store, if two articles of clothing have the same cut, and are only distinguishable by color, they are considered to be "the *same* sweater (or pair of pants) in two different colors." Culture depends on the permanence of the object, language reaffirms it: only the adjective has varied. But if the two articles of clothing are the same color but have different cuts, no one will say or think that the store was offering "the same color in two different articles of clothing" (an incorrect formula, and not by accident, since color is in the grammatical position of subject). One would be more likely to say that these were "two articles of clothing," this scarf and this skirt, for example, "of the same color." The utterance put color back in its place, that of predicate: these are two distinct objects which have an attribute in common.

## "OFF-SCREEN SOUND" IN THE CINEMA

The division between primary and secondary qualities plays a large role in one of the classical problems of film theory, that of "off-screen sound." In a film a sound is considered "off" (literally off the screen) when in fact it is the sound's source that is off the screen; therefore an "off-screen voice" is defined as one which belongs to a character who does not appear (visually) on the screen. We tend to forget that a sound in itself in never "off": either it is audible or it doesn't exist. When it exists, it could not possibly be situated within the interior of the rectangle or outside of it, since the nature of sounds is to diffuse themselves more or less into the entire surrounding space: sound is simultaneously "in" the screen, in front, behind, around, and throughout the entire movie theater.*

On the contrary, when a visual element is said to be "off," it really is: it can be reconstructed by inference in relation to what is visible within the rectangle, but it is not seen. A well-known example would be "the lure": the presence of a person on a side of the screen is surmised when you can only see a hand or shoulder; the rest is out of the visual field.

The situation is clear: the language used by technicians and studios, without realizing it, conceptualizes sound in a way that makes sense only for the image. We claim that we are talking about sound, but we are actually thinking of the visual image of the sound's source.

This confusion is obviously reinforced by a characteristic of sound that is physical and not social: spatial anchoring of aural events is much more vague and uncertain than that of visual events. The two sensory orders don't have the same relationship to space, sound's relationship being much less precise, restrictive, even when it indi-

---

*This relates to another characteristic fact about present-day cinema. The visual events are only "reproduced" by means of certain distortions in perspective (absence of binocular depth, the rectangular screen which distorts real vision, etc.). But auditory aspects, providing that the recording is well done, undergo no appreciable loss in relation to the corresponding sound in the real world: in principle, nothing distinguishes a gunshot heard in a film from a gunshot heard on the street. Béla Balázs, the film theoretician, used to say that "sounds have no images." Thus the sounds of a film spread into space as do sounds in life, or almost. This difference in perceptual status between what is called "reproduction" in the case of the visible, and that to which the same name has been given in the case of the audible, already seemed important to me in "Problèmes actuels de théorie du cinéma," *Essais sur la signification au cinéma*, vol. 2, pp. 57–58 and in *Langage et cinéma* (Paris: Larousse, 1971), pp. 209–10.

cates a general direction (but it rarely indicates a really precise site, which on the contrary is the rule for the visible). It is perfectly understandable that film technicians should have based their classification on the less elusive of the two elements. (However, it should be remembered that the phylogenetic choice of a particular acoustic material, the sound of the voice, for the signifiers of human language, is probably due to similar reasons: phonic communication is not interrupted by darkness or by night. You can speak to someone who is in back of you, or who is behind something, or whose location is unknown. The relatively weak relation to space provides multiple advantages which the human race would not have benefited from had a visual language been chosen.)

But, to get back to off-screen sound, the laws of physics do not adequately explain this persistent confusion between the aural object itself and the visual image of its source (yet even the most literal definition of off-screen sound rests on this confusion). There is something else behind it, something cultural that we have already encountered in this study: the conception of sound as an attribute, as a nonobject, and therefore the tendency to neglect its own characteristics in favor of those of its corresponding "substance," which in this case is the visible object, which has emitted the sound.

## SEMIOLOGY AND PHENOMENOLOGY

The above heading poses an epistemological question which is not new. It seems to me that the semiological project in its entirety, because of its initial anchoring in a concern for the perceptible signifier and its perceptible transformations, defines itself in a certain way as the continuation of phenomenological inspiration. I myself have "admitted" to this necessary stage (this debt, also) in the first chapter of my first book.*

Of course, these "continuations" are also always reversals, reactions. The phenomenologists wanted to "describe" the spontaneous apprehension of things (and they sometimes did that with a correctness which will become less quickly outmoded than certain semiological overstatements). They were not sufficiently aware of the fact that this "apprehension" is in itself a product, that therefore it could very well be "otherwise" in cultures not of the describer. But (and I'm not trying to create paradoxes) it remains true that these conclusions are also beginnings. It is a great illusion of positivistic scientism to blind itself to all that is nonscientific in science, or in the effort toward science, without which it could not even exist. We are all, at some time, phenomenologists, and those who declare themselves as such at least have the merit of admitting to a certain kind of relationship to the world, which is not the only possible relationship, nor the only desirable one, but one which exists in everybody, even if it is hidden or unknown.

When I think about my own field of research, cinematographic analysis, how could I hide from myself—and why would I—the fact that an entire body of previous cultural knowledge, without which a "first viewing" of the film would not even be a *viewing* (nor would any of the subsequent "viewings," which become more frag-

---

*Essais sur la signification au cinéma*, published thanks to Mikel Dufrenne. . . .

mented, less descriptive, and, in another sense, more "semiological")—that an entire body of knowledge already present in my immediate perception is necessarily mobilized to make it possible for me to work? And how could I miss the fact that this body of knowledge is—that it is and isn't—the "perceptual *cogito*" of phenomenology? The content is the same, the status we grant it is not.

In this study, I wanted to show that the perceptual object is a constructed unity, *socially constructed*, and also (to some extent) a linguistic unity. We find ourselves quite far, you could say, from the "adverse spectacle" of subject and object, from the cosmological as well as existential (or at least transcendental) "there is" in which phenomenology wanted to place our presence in objects, and the presence of objects in us. I am not so sure, or else this "distance" is only along certain axes, and does not imply a complete rupture of the horizon. Obviously, I spoke of semes, of pertinent optical traits, etc., that is to say, of elements whose nature is to have no lived existence and which are on the contrary—on the contrary or for that very reason?—the conditions of possibility of the lives, the structures of production which create the lived and are abolished in it, which simultaneously find in it the site of their manifestation and their negation: the objective determinants of subjective feeling. To concentrate interest on this latent stratum is to stray from the phenomenological path. But the manifest stratum, besides the fact that it has its own reality, authorizing potential, or completed studies, is the only stratum available to us in the beginning, even though we soon leave it behind.

I have tried to understand why perception proceeds by means of objects. But I first felt, and felt strongly, that it does in fact proceed this way: phenomenologists have always made the same claim. In order for me to have tried to dismantle the "objects" which so strike the native (and at first, even in order for me to have had that desire), it was necessary that I be that native myself, and that I be struck by the same things as he. Every psychoanalytic project begins by a "phenomenology," according to the analyst's own terminology. This is true not only for this domain. Every time something is to be explained, it is more prudent to begin by experiencing it.

1975

# SERGEI EISENSTEIN, VSEVOLOD PUDOVKIN, AND GRIGORI ALEXANDROV
# STATEMENT ON SOUND

Our cherished dreams of a sound cinema are being realised. The Americans, having developed the technique of sound cinema, have embarked on the first stage towards its rapid practical implementation. Germany is working intensively in the same direction. The whole world now speaks of the 'silent' that has found its voice.

We who work in the USSR recognise that, given our technical capabilities, the practical implementation of sound cinema is not feasible in the near future. At the same time we consider it opportune to make a statement on a number of prerequisite theoretical principles, particularly as, according to reports reaching us, attempts are being made to use this new improvement in cinema for the wrong purposes. In addition, an incorrect understanding of the potential of the new technical invention might not only hinder the development and improvement of cinema as an art form but might also threaten to destroy all its formal achievements to date.

Contemporary cinema, operating through visual images, has a powerful effect on the individual and rightfully occupies one of the leading positions in the ranks of the arts.

It is well known that the principal (and sole) method which has led cinema to a position of such great influence is *montage*. The confirmation of montage as the principal means of influence has become the indisputable axiom upon which world cinema culture rests.

The success of Soviet pictures on world screens is to a significant extent the result of a number of those concepts of montage which they first revealed and asserted.

And so for the further development of cinema the significant features appear to be those that strengthen and broaden the montage methods of influencing the audience. If we examine every new discovery from this standpoint it is easy to distinguish the

insignificance of colour and stereoscopic cinema in comparison with the great sig-
nificance of *sound*.

Sound is a double-edged invention and its most probable application will be along
the line of least resistance, i.e. in the field of the *satisfaction of simple curiosity*.

In the first place there will be commercial exploitation of the most saleable goods,
i.e. of *talking pictures*—those in which the sound is recorded in a natural manner,
synchronising exactly with the movement on the screen and creating a certain 'illu-
sion' of people talking, objects making a noise, etc.

The first period of sensations will not harm the development of the new art; the
danger comes with the second period, accompanied by the loss of innocence and
purity of the initial concept of cinema's new textural possibilities can only intensify
its unimaginative use for 'dramas of high culture' and other photographed presenta-
tions of a theatrical order.

Sound used in this way will destroy the culture of montage, because every mere
*addition* of sound to montage fragments increases their inertia as such and their inde-
pendent significance; this is undoubtedly detrimental to montage which operates
above all not with fragments but through the *juxtaposition* of fragments.

*Only the contrapuntal use* of sound vis-à-vis the visual fragment of montage will
open up new possibilities for the development and perfection of montage.

*The first experiments in sound must aim at a sharp discord with the visual images.*
Only such a 'hammer and tongs' approach will produce the necessary sensation that
will result consequently in the creation of a new *orchestral counterpoint* of visual and
sound images.

The new technical discovery is not a passing moment in the history of cinema but
an organic escape for cinema's cultural avant-garde from a whole series of blind
alleys which have appeared inescapable.

We must regard as *the first blind alley* the intertitle and all the vain attempts to inte-
grate it into montage composition as a unit of montage (fragmentation of an interti-
tle, magnification or contraction of the lettering, etc.).

*The second blind alley* comprises *explanatory* sequences (e.g. long shots) which
complicate the composition of the montage and slow down the rhythm.

Every day the problems of theme and plot grow more complex; attempts to solve
them by methods of purely 'visual' montage either lead to insoluble problems or
involve the director in fantastic montage constructions, provoking a fear of abstruse-
ness and reactionary decadence.

Sound, treated as a new element of montage (as an independent variable combined
with the visual image), cannot fail to provide new and enormously powerful means
of expressing and resolving the most complex problems, which have been depressing
us with their insurmountability using the imperfect methods of a cinema operating
only in visual images.

The *contrapuntal method* of structuring a sound film not only does not weaken *the
international nature of cinema* but gives to its meaning unparalleled strength and cul-
tural heights.

With this method of construction the sound film will not be imprisoned within
national markets, as has happened with the theatrical play and will happen with the

'filmed' play, but will provide an even greater opportunity than before of speeding the idea contained in a film throughout the whole globe, preserving its world-wide viability.

1928

# MARY ANN DOANE
# THE VOICE IN THE CINEMA: THE ARTICULATION OF BODY AND SPACE

## SYNCHRONIZATION

The silent film is certainly understood, at least retrospectively and even (it is arguable) in its time, as incomplete, as lacking speech. The stylized gestures of the silent cinema, its heavy pantomime, have been defined as a form of compensation for that lack. Hugo Münsterberg wrote, in 1916, "To the actor of the moving pictures . . . the temptation offers itself to overcome the deficiency [the absence of "words and the modulation of the voice"] by a heightening of the gestures and of the facial play, with the result that the emotional expression becomes exaggerated."[1] The absent voice reemerges in gestures and the contortions of the face—it is spread over the body of the actor. The uncanny effect of the silent film in the era of sound is in part linked to the separation, by means of intertitles, of an actor's speech from the image of his/her body.

Consideration of sound in the cinema (in its most historically and institutionally privileged form—that of dialogue or the use of the voice) engenders a network of metaphors whose nodal point appears to be the body. One may readily respond that this is only "natural"—who can conceive of a voice without a body?[2] However, the body reconstituted by the technology and practices of the cinema is a *phantasmatic*

---

[1]Hugo Munsterberg, *The Film: A Psychology Study* (New York: Dover, 1970), p. 49.

[2]Two kinds of "voices without bodies" immediately suggest themselves—one theological, the other scientific (two poles which, it might be added, are not ideologically unrelated): (1) the voice of God incarnated in the Word; (2) the artificial voice of a computer. Neither seems to be capable of representation outside a certain anthropomorphism, however. God is pictured, in fact, as having a quite specific body—that of a male patriarchal figure. *Star Wars* and *Battlestar Galactica* illustrate the tendencies toward anthropomorphism in the depiction of computers. In the latter, even a computer (named Cora) deprived of mobility and the simulacrum of a human form, is given a voice which is designed to evoke the image of a sensual female body.

body, which offers a support as well as a point of identification for the subject addressed by the film. The purpose of this essay is simply to trace some of the ways in which this phantasmatic body acts as a pivot for certain cinematic practices of representation and authorizes and sustains a limited number of relationships between voice and image.

The attributes of this phantasmatic body are first and foremost unity (through the emphasis on a coherence of the senses) and presence-to-itself. The addition of sound to the cinema introduces the possibility of representing a fuller (and organically unified) body, and of confirming the status of speech as an individual property right. The potential number and kinds of articulations between sound and image are reduced by the very name attached to the new heterogeneous medium—the "talkie." Histories of the cinema ascribe the stress on synchronization to a "public demand"; "the public, fascinated by the novelty, wanting to be sure they were hearing what they saw, would have felt that a trick was being played on them if they were not shown the words coming from the lips of the actors."[3] In Lewis Jacobs' account, this fear on the part of the audience of being "cheated" is one of the factors which initially limits the deployment of sonorous material (as well as the mobility of the camera). From this perspective, the use of voice-off or voice over must be a late acquisition, attempted only after a certain "breaking-in" period during which the novelty of the sound film was allowed to wear itself out. But, whatever the fascination of the new medium (or whatever meaning is attached to it by retrospective readings of its prehistory), there is no doubt that synchronization (in the form of "lip-sync") has played a major role in the dominant narrative cinema. Technology standardizes the relation through the development of the synchronizer, the Moviola, the flatbed editing table. The mixing apparatus allows a greater control over the establishment of relationships between dialogue, music, and sound effects and, in practice, the level of the dialogue generally determines the levels of sound effects and music.[4] Despite a number of experiments with other types of sound/image relationships (those of Clair, Lang, Vigo, and more recently, Godard, Straub, and Duras), synchronous dialogue remains the dominant form of sonorous representation in the cinema.

Yet, even when asynchronous or "wild" sound is utilized, the phantasmatic body's attribute of unity is not lost. It is simply displaced—the body *in* the film becomes the body *of* the film. It senses work in tandem, for the combination of sound and image is described in terms of "totality" and the "organic."[5] Sound carries with it the potential risk of exposing the material heterogeneity of the medium; attempts to contain that risk surface in the language of the ideology or organic unity. In the discourse of technicians, sound is "married" to the image and, as one sound engineer puts it in an

[3]Lewis Jacobs, *The Rise of the American Film: A Critical History* (New York: Teachers College Press, 1968), p. 435.

[4]For a more detailed discussion of this hierarchy of sounds and of other relevant techniques in the construction of the sound track see M. Doane, "Ideology and the Practices of Sound Editing and Mixing," paper delivered at Milwaukee Conference on the Cinematic Apparatus, February, 1978, published in *The Cinematic Apparatus*, ed. Teresa de Lauretis and Stephen Heath (Bloomington: Indiana University Press; London: Macmillan, 1984).

[5]*Ibid.*

article on post-synchronization, "one of the basic goals of the motion picture indus-
try is to make the screen look alive in the eyes of the audience. . ."[6]

Concomitant with the demand for a lifelike representation is the desire for "pres-
ence," a concept which is not specific to the cinematic sound track but which acts as
a standard to measure quality in the sound recording industry as a whole. The term
"presence" offers a certain legitimacy to the wish for pure reproduction and becomes
a selling point in the construction of sound as a commodity. The television commer-
cial asks whether we can "tell the difference" between the voice of Ella Fitzgerald
and that of Memorex (and since our representative in the commercial—the ardent
fan—cannot, the only conclusion to be drawn is that owning a Memorex tape is
equivalent to having Ella in your living room). Technical advances in sound record-
ing (such as the Dolby system) are aimed at diminishing the noise of the system, con-
cealing the work of the apparatus, and thus reducing the distance perceived between
the object and its representation. The maneuvers of the sound recording industry offer
evidence which support Walter Benjamin's thesis linking mechanical reproduction as
a phenomenon with contemporary society's destruction of the "aura" (which he
defines as "the unique phenomenon of a distance, however close it may be").[7]
According to Benjamin,

> [the] contemporary decay of the aura . . . rests on two circumstances, both of which are
> related to the increasing significance of the masses in contemporary life. Namely, the
> desire of contemporary masses to bring things "closer" spatially and humanly, which is
> just as ardent as their bent toward overcoming the uniqueness of every reality by accept-
> ing its reproduction.[8]

Nevertheless, while the desire to bring things closer is certainly exploited in making
sound marketable, the qualities of uniqueness and authenticity are not sacrificed—it
is not any voice which the tape brings to the consumer but the voice of Ella Fitzger-
ald. The voice is not detachable from a body which is quite specific—that of the star.
In the cinema, cult value and the "aura" resurface in the star system. In 1930 a writer
feels the need to assure audiences that post-synchronization as a technique does not
necessarily entail substituting an alien voice for a "real" voice, that the industry does
not condone a mismatching of voices and bodies.[9] Thus, the voice serves as a support
for the spectator's recognition and his/her identification of, as well as with, the star.

Just as the voice must be anchored by a given body, the body must be anchored in
a given space. The phantasmatic visual space which the film constructs is supple-
mented by techniques designed to spatialize the voice, to localize it, give it depth, and
thus lend to the characters the consistency of the real. A concern for room tone, rever-
beration characteristics, and sound perspective manifests a desire to recreate, as one
sound editor describes it, "the bouquet that surrounds the words, the presence of the

[6]W. A. Pozner, "Synchronization Techniques," *Journal of the Society of Motion Picture Engineers* (Sep-
tember 1946), 47(3):191.
   [7]Walter Benjamin, "The Work of Art in the Age of Mechanical Reproduction," an *Illuminations*, ed.
Hannah Arendt, trans. Harry Zohn (New York: Schocken, 1969), p. 222.
   [8]*Ibid.*, p. 223.
   [9]George Lewin, "Dubbing and Its Relation to Sound Picture Production," *Journal of the Society of
Motion Picture Engineers* (January 1931), 16(1):48.

voice, the way it fits in with the physical environment."[10] The dangers of post-syn-
chronization and looping stem from the fact that the voice is disengaged from its
"proper" space (the space conveyed by the visual image) and the credibility of that
voice depends upon the technician's ability to return it to the side of its origin. Fail-
ure to do so risks exposure of the fact that looping is "narration masking as dia-
logue."[11] Dialogue is defined, therefore, not simply in terms of the establishment of
an I-you relationship but as the necessary spatializing of that relationship. Techniques
of sound recording tend to confirm the cinema's function as a mise-en-scène of
bodies.

## VOICE-OFF AND VOICEOVER

The spatial dimension which monophonic sound is capable of simulating is that
of depth—the apparent source of the sound may be moved forward or backward, but
the lateral dimension is lacking due to the fact that there is no sideways spread of
reverberation or of ambient noise.[12] Nevertheless, sound/image relationships estab-
lished in the narrative film work to suggest that sound does, indeed, issue from that
other dimension. In film theory, this work to provide the effect of a lateral dimension
receives recognition in the term "voice-off." "Voice-off" refers to instances in which
we hear the voice of a character who is not visible within the frame. Yet the film
establishes, by means of previous shots or other contextual determinants, the char-
acter's "presence" in the space of the scene, in the diegesis. He/she is "just over
there," just beyond the frameline, in a space which "exists" but which the camera
does not choose to show. The traditional use of voice-off constitutes a denial of the
frame as a limit and an affirmation of the unity and homogeneity of the depicted
space.

Because it is defined in terms of what is visible within the rectangular space of the
screen, the term "voice-off" has been subject to some dispute. Claude Bailblé, for
instance, argues that a voice-off must always be a "voice-in" because the literal
source of the sound in the theater is always the speaker placed behind the screen.[13]
Yet, the space to which the term refers is not that of the theater but the fictional space
of the diegesis. Nevertheless, the use of the term is based on the requirement that the
two spaces coincide, "overlap" to a certain extent. For the screen limits what *can be
seen* of the diegesis (there is always "more" of the diegesis than the camera can cover
at any one time). The placement of the speaker behind the screen simply confirms the
fact that the cinematic apparatus is designed to promote the impression of a homo-

---

[10]Walter Murch, "The Art of the Sound Editor: An Interview with Walter Murch," interview by Larry
Sturhahn, *Filmmaker's Newsletter* (December 1974), 8(2):23.
    [11]*Ibid.*
    [12]Stereo reduces this problem but does not solve it—the range of perspective effects is still limited.
Much of the discussion which follows is based on the use of monophonic sound, but also has implications
for stereo. In both mono and stereo, for instance, the location of the speakers is designed to ensure that the
audience hears sound "which is roughly coincident with the image." See Alec Nisbett, *The Technique of
the Sound Studio* (New York: Focal Press Limited, 1972), pp. 530, 532.
    [13]C. Bailblé, "Programmation de L'écoute (2)," *Cahiers du cinéma* (October 1978), no. 293, p. 9

geneous space—the senses of the phantasmatic body cannot be split. The screen is the space where the image is deployed, while the theater as a whole is the space of the deployment of sound. Yet, the screen is given precedence over the acoustical space of the theater—the screen is posited as the site of the spectacle's unfolding and all sounds must emanate from it. (Bailblé asks, "What would be, in effect, a voice-off which came from the back of the theater? Poor little screen . . ."[14]—in other words, its effect would be precisely to diminish the epistemological power of the image, to reveal its limitations.)

The hierarchical placement of the visible above the audible, according to Christian Metz, is not specific to the cinema but a more general cultural production.[15] And the term voice-off merely acts as a reconfirmation of that hierarchy. For it only appears to describe a sound—what it really refers to is the visibility (or lack of visibility) of the source of the sound. Metz argues that sound is never "off." While a visual element specified as "off" actually lacks visibility, a "sound-off" is always audible.

Despite the fact that Metz's argument is valid and we tend to repeat on the level of theory the industry's subordination of sound to image, the term voice-off does name a particular relationship between sound and image—a relationship which has been extremely important historically in diverse film practices. While it is true that sound is almost always discussed with reference to the image, it does not necessarily follow that this automatically makes sound subordinate. From another perspective, it is doubtful that any image (in the sound film) is uninflected by sound. This is crucially so, give the fact that in the dominant narrative cinema, sound extends from beginning to end of the film—sound is never absent (silence is, at the least, room tone). In fact, the lack of any sound whatsoever is taboo in the editing of the sound track.

The point is not that we "need" terms with which to describe, honor, and acknowledge the autonomy of a particular sensory material, but that we must attempt to think the heterogeneity of the cinema. This might be done more fruitfully by means of the concept of space than through the unities of sound and image. In the cinematic situation, three types of space are put into play:

(1) The space of the diegesis. This space has no physical limits; it is not contained or measurable. It is a virtual space constructed by the film and is delineated as having both audible and visible traits (as well as implications that its objects can be touched, smelled, and tasted).

(2) The visible space of the screen as receptor of the image. It is measurable and "contains" the visible signifiers of the film. Strictly speaking, the screen is not audible although the placement of the speaker behind the screen constructs that illusion.

(3) The acoustical space of the theater or auditorium. It might be argued that this space is also visible, but the film cannot visually activate signifiers in this space unless a second projector is used. Again, despite the fact that the speaker is behind the screen and therefore sound appears to be emanating from a focused point, sound is not "framed" in the same way as the image. In a sense, it *envelops* the spectator.

---

[14]*Ibid.* My translation.
[15]C. Metz, "Le Perçu et le nommé," in *Essais sémiotiques* (Paris: Klincksieck, 1977), pp. 153–59.

All these are spaces *for the spectator*, but the first is the only space which the characters of the fiction film can acknowledge (for the characters there are no voices-off). Different cinematic modes—documentary, narrative, avant-garde—establish different relationships between the three spaces. The classical narrative film, for instance, works to deny the existence of the last two spaces in order to buttress the credibility (legitimacy) of the first space. If a character looks at and speaks to the spectator, this constitutes an acknowledgment that the character is seen and heard in a radically different space and is therefore generally read as transgressive.

Nothing unites the three spaces but the signifying practice of the film itself, together with the institutionalization of the theater as a type of metaspace which binds together the three spaces, as the *place* where a unified cinematic discourse unfolds. The cinematic institution's stake in this process of unification is apparent. Instances of voice-off in the classical film are particularly interesting examples of the way in which the three spaces undergo an elaborate imbrication. For the phenomenon of the voice-off cannot be understood outside a consideration of the relationships established between the diegesis, the visible space of the screen, *and* the acoustical space of the theater. The place in which the signifier manifests itself is the acoustical space of the theater, but this is the space with which it is least concerned. The voice-off deepens the diegesis, gives it an extent which exceeds that of the image, and thus supports the claim that there is a space in the fictional world which the camera does not register. In its own way, it *accounts for* lost space. The voice-off is a sound which is first and foremost in the service of the film's construction of space and only indirectly in the service of the image. It validates both what the screen reveals of the diegesis and what it conceals.

Nevertheless, the use of the voice-off always entails a risk—that of exposing the material heterogeneity of the cinema. Synchronous sound masks the problem and this at least partially explains its dominance. But the more interesting question, perhaps, is: how can the classical film allow the representation of a voice whose source is not simultaneously represented? As soon as the sound is detached from its source, no longer anchored by a represented body, its potential work as a signifier is revealed. There is always something uncanny about a voice which emanates from a source outside the frame. However, as Pascal Bonitzer points out, the narrative film exploits the marginal anxiety connected with the voice-offs by incorporating its disturbing effects within the dramatic framework. Thus, the function of the voice-off (as well as that of the voiceover) becomes extremely important in *film noir*. Bonitzer takes as his example *Kiss Me Deadly*, a *film noir* in which the villain remains out of frame until the last sequences of the film. Maintaining him outside of the field of vision "gives to his sententious voice, swollen by mythological comparisons, a greater power of disturbing, the scope of an oracle—dark prophet of the end of the world. And, in spite of that, his voice is submitted to the destiny of the body . . . a shot, he falls—and with him in ridicule, his discourse with its prophetic accents."[16]

The voice-off is always "submitted to the destiny of the body" because it *belongs* to a character who is confined to the space of the diegesis, if not to the visible space

---

[16]Pascal Bonitzer, "Les Silences de la voix," *Cahiers du cinéma* (February–March 1975), no. 256, p. 25. My translation.

of the screen. Its efficacy rests on the knowledge that the character can easily be made visible by a slight reframing which would reunite the voice and its source. The body acts as an invisible support for the use of both the voiceover during a flashback and the interior monologue as well. Although the voiceover in a flashback effects a temporal dislocation of the voice with respect to the body, the voice is frequently returned to the body as a form of narrative closure. Furthermore, the voiceover very often simply initiates the story and is subsequently superseded by synchronous dialogue, allowing the diegesis to "speak for itself." In *Sunset Boulevard* the convention is taken to its limits: the voiceover narration is, indeed, linked to a body (that of the hero), but it is the body of a dead man.

In the interior monologue, on the other hand, the voice and the body are represented simultaneously, but the voice, far from being an extension of that body, manifests its inner lining. The voice displays what is inaccessible to the image, what exceeds the visible: the "inner life" of the character. The voice here is the privileged mark of interiority, turning the body "inside out."

The voiceover commentary in the documentary, unlike the voice-off, the voiceover during a flashback, or the interior monologue, is, in effect, a *disembodied* voice. While the latter three voices work to affirm the homogeneity and dominance of diegetic space, the voiceover commentary is necessarily presented as outside that space. It is its radical otherness with respect to the diegesis which endows this voice with a certain authority. As a form of direct address, it speaks without mediation to the audience, bypassing the "characters" and establishing a complicity between itself and the spectator—together they understand and thus *place* the image. It is precisely because the voice is not localizable, because it cannot be yoked to a body, that it is capable of interpreting the image, producing its truth. Disembodied, lacking any specification in space or time, the voiceover is, as Bonitzer points out, beyond criticism—it censors the questions "Who is speaking?," "Where?," "In what time?," and "For whom?"

> This is not, one suspects, without ideological implications. The first of these implications is that the voice-off[17] represents a power, that of disposing of the image and of what it reflects, from a space absolutely *other* with respect to that inscribed in the image-track. *Absolutely other and absolutely indeterminant.* Because it rises from the field of the Other, the voice-off is assumed to know: this is the essence of its power . . . The power of the voice is a stolen power, a usurpation.[18]

In the history of the documentary, this voice has been for the most part that of the male, and its power resides in the possession of knowledge and in the privileged, unquestioned activity of interpretation. This function of the voiceover has been appropriated by the television documentary and television news programs, in which sound carries the burden of "information" while the impoverished image simply fills the screen. Even when the major voice is explicitly linked with a body (that of the anchorman in television news), this body, in its turn, is situated in the nonspace of the studio. In film, on the other hand, the voiceover is quite often dissociated from any

---

[17]Bonitzer uses the term "voice-off" in a general sense which includes both voice-off and voiceover, but here he is referring specifically to voiceover commentary.

[18]Bonitzer, "Les Silences," p. 26. My translation.

specific figure. The guarantee of knowledge, in such a system, lies in its irreducibility to the spatiotemporal limitations of the body.

## THE PLEASURE OF HEARING

The means by which sound is deployed in the cinema implicate the spectator in a particular textual problematic—they establish certain conditions for understanding which obtain in the "intersubjective relation" between film and spectator. The voiceover commentary and, differently, the interior monologue and voiceover flashback speak more or less *directly* to the spectator, constituting him/her as an empty space to be "filled" with knowledge about events, character psychology, etc. More frequently, in the fiction film, the use of synchronous dialogue and the voice-off presuppose a spectator who *overhears* and, overhearing, is unheard and unseen himself. This activity with respect to the sound track is not unlike the voyeurism often exploited by the cinematic image. In any event, the use of the voice in the cinema appeals to the spectator's desire to hear, or what Lacan refers to as the invocatory drive.

In what does the pleasure of hearing consist? Beyond the added effect of "realism" which sound gives to the cinema, beyond its supplement of meaning anchored by intelligible dialogue, what is the specificity of the pleasure of hearing a voice with its elements escaping a strictly verbal codification—volume, rhythm, timbre, pitch? Psychoanalysis situates pleasure in the divergence between the present experience and the memory of satisfaction: "Between a (more or less inaccessible) memory and a very precise (and localizable) immediacy of perception is opened the gap where pleasure is produced."[19] Memories of the first experiences of the voice, of the hallucinatory satisfaction it offered, circumscribe the pleasure of hearing and ground its relation to the phantasmatic body. This is not simply to situate the experiences of infancy as the sole determinant in a system directly linking cause and effect but to acknowledge that the traces of archaic desires are never annihilated. According to Guy Rosolato, it is "the organization of the fantasm itself which implies a permanence, an insistence of the recall to the origin."[20]

Space, for the child, is defined initially in terms of the audible, not the visible: "It is only in a second phase that the organization of visual space insures the perception of the object as *external*" (p. 80). The first differences are traced along the axis of sound: the voice of the mother, the voice of the father. Furthermore, the voice has a greater command over space than the look—one can hear around corners, through walls. Thus, for the child the voice, even before language, is the instrument of demand. In the construction/hallucination of space and the body's relation to that space, the voice plays a major role. In comparison with sight, as Rosolato points out, the voice is reversible: sound is simultaneously emitted and heard, by the subject

---

[19]Serge Leclaire, *Démasquer le réel*, p. 64, quoted in C. Bailblé, "Programmation de l'écoute (3)," *Cahiers du cinéma* (February 1979), no. 297, p. 46.

[20]Guy Rosolato, "La Voix: entre corps et langage," *Revue française de psychanalyse* (January 1974), 38:83. My translation. My discussion of the pleasure of hearing relies heavily on the work of Rosolato. Further references to this article will appear in parentheses in the text.

himself. As opposed to the situation in seeing, it is as if "an 'acoustical' mirror were always in function. Thus, the images of entry and exit relative to the body are intimately articulated. They can therefore be confounded, inverted, favored one over the other" (p. 79). Because one can hear sounds behind oneself as well as those with sources *inside* the body (sounds of digestion, circulation, respiration, etc.), two sets of terms are placed in opposition: exterior/front/sight and interior/back/hearing. And "hallucinations are determined by an imaginary structuration of the body according to these oppositions . . ." (p. 80). The voice appears to lend itself to hallucination, in particular the hallucination of power over space effected by an extension or restructuration of the body. Thus, as Lacan points out, our mass media and our technology, as mechanical extensions of the body, result in "planeterizing" or "even stratospherizing" the voice.[21]

The voice also traces the forms of unity and separation *between* bodies. The mother's soothing voice, in a particular cultural context, is a major component of the "sonorous envelope" which surrounds the child and is the first model of auditory pleasure. An image of corporeal unity is derived from the realization that the production of sound by the voice and its audition coincide. The imaginary fusion of the child with the mother is supported by the recognition of common traits characterizing the different voices and, more particularly, of their potential for harmony. According to Rosolato, the voice in music makes appeal to the nostalgia for such an imaginary cohesion, for a "veritable incantation" of bodies.

> The harmonic and polyphonic unfolding in music can be understood as a succession of tensions and releases, of unifications and divergences between parts which are gradually stacked, opposed in successive chords only to be resolved ultimately into their simplest unity. It is therefore the entire dramatization of separated bodies and their reunion which harmony supports (p. 82)

Yet, the imaginary unity is associated with the earliest experience of the voice is broken by the premonition of difference, division, effected by the intervention of the father whose voice, engaging the desire of the mother, acts as the agent of separation and constitutes the voice of the mother as the irretrievably lost object of desire. The voice in this instance, far from being the narcissistic measure of harmony, is the voice of interdiction. The voice thus understood is an interface of imaginary and symbolic, pulling at once toward the signifying organization of language and its reduction of the range of vocal sounds to those it binds and codifies, and toward original and imaginary attachments, "representable in the fantasm by the body, or by the corporeal mother, the child at her breast" (p. 86).

At the cinema, the sonorous envelope provided by the theatrical space together with techniques employed in the construction of the sound track work to sustain the narcissistic pleasure derived from the image of a certain unity, cohesion, and hence, an identity grounded by the spectator's phantasmatic relation to his/her own body. The aural illusion of position constructed by the approximation of sound perspective and by techniques which spatialize the voice and endow it with "presence" guarantees the

---

[21]Jacques Lacan, *The Four Fundamental Concepts of Psycho-Analysis*, ed. Jacques-Alain Miller, trans. Alan Sheridan (London: Hogarth Press and the Institute of Psycho-Analysis, 1977), p. 274.

singularity and stability of a point of audition, thus holding at bay the potential trauma of dispersal, dismemberment, difference. The subordination of the voice to the screen as the site of the spectacle's unfolding makes vision and hearing work together in manufacturing the "hallucination" of a fully sensory world. Nevertheless, the recorded voice, which presupposes a certain depth, is in contradiction with the flatness of the two-dimensional image. Eisler and Adorno note that the spectator is always aware of this divergence, of the inevitable gap between the represented body and its voice. And for Eisler and Adorno this partially explains the function of film music: first used in the exhibition of silent films to conceal the noise of the projector (to hide from the spectator the "uncanny" fact that his/her pleasure is mediated by a machine), music in the "talkie" takes on the task of closing the gap between voice and body.[22]

If this imaginary harmony is to be maintained, however, the potential aggressivity of the voice (as the instrument of interdiction and the material support of the symptom—hearing voices—in paranoia) must be attenuated. The formal perfection of sound recording in the cinema consists in reducing not only the noise of the apparatus but any "grating" noise which is not "pleasing to the ear." On another level, the aggressivity of the filmic voice can be linked to the fact that sound is directed *at* the spectator—necessitating, in the fiction film, its deflection through dialogue (which the spectator is given only obliquely, to overhear) and, in the documentary, its mediation by the content of the image. In the documentary, however, the voiceover has come to represent an authority and an aggressivity which can no longer be sustained—thus, as Bonitzer points out, the proliferation of new documentaries which reject the absolute of the voiceover and, instead, claim to establish a democratic system, "letting the event speak for itself." Yet, what this type of film actually promotes is the illusion that reality speaks and is not spoken, that the film is not a constructed discourse. In effecting an "impression of knowledge," a knowledge which is given and not produced, the film conceals its own work and posits itself as a voice without a subject.[23] The voice is even more powerful in silence. The solution, then, is not to banish the voice but to construct *another* politics.

## THE POLITICS OF THE VOICE

The cinema presents a spectacle composed of disparate elements—images, voices, sound effects, music, writing—which the *mise-en-scène*, in its broadest sense, organizes and aims at the body of the spectator, sensory receptacle of the various stimuli. This is why Lyotard refers to classical *mise-en-scène* (in both the theater and the cinema) as a kind of somatography, or inscription on the body:

> The mise-en-scène turns written signifiers into speech, song, and movements executed by bodies capable of moving, singing, speaking; and this transcription is intended for other living bodies—the spectators—capable of being moved by these songs, movements, and words. It is this transcribing on and for bodies, considered as multi-sensory potentialities, which is the work characteristic of the mise-en-scène. Its elementary unity is polyesthetic like the human body: capacity to see, to hear, to touch, to move. . . . The idea of per-

[22]Hanns Eisler, *Composing for the Films* (New York: Oxford University Press, 1947), pp. 75–77.
[23]Bonitzer, "Les Silences," pp. 23–24.

formance . . . even if it remains vague, seems linked to the idea of inscription on the body.[24]

Classical mise-en-scène has a stake in perpetuating the image of unity and identity sustained by this body and in staving off the fear of fragmentation. The different sensory elements work in collusion, and this work denies the material heterogeneity of the "body" of the film. All the signifying strategies for the deployment of the voice discussed earlier are linked with such homogenizing effects: synchronization binds the voice to a body in a unity whose immediacy can only be perceived as a given; the voice-off holds the spectacle to a space—extended but still coherent; and the voiceover commentary places the image by endowing it with a clear intelligibility. In all of this, what must be guarded is a certain "oneness."

The "oneness" is the mark of a mastery and a control and manifests itself most explicitly in the tendency to confine the voiceover commentary in the documentary to a single voice. For, according to Bonitzer, "when one divides that voice or, what amounts to the same things, multiplies it, the system and its effects change. Off-screen space ceases to be that place of reserve and interiority of the voice. . . ."[25] This entails not only or not merely increasing the number of voices but radically changing their relationship to the image, effecting a disjunction between sound and meaning, emphasizing what Barthes refers to as the "grain" of the voice[26] over and against its expressivity or power of representation. In the contemporary cinema, the names which immediately come to mind are those of Godard (who, even in an early film such as *Vivre Sa Vie* which relies heavily upon synchronous sound, resists the homogenizing effects of the traditional use of voice-off by means of a resolute avoidance of the shot/reverse shot structure—the camera quickly panning to keep the person talking *in frame*) and Straub (for whom the voice and sound in general become the marks of a nonprogressive duration). The image of the body thus obtained is not one of imaginary cohesion but of dispersal, division, fragmentation. Lyotard speaks of the "post-modernist" text which escapes the closure of representation by creating its own addressee, "a disconcerted body, invited to stretch its sensory capacities beyond measure."[27] Such an approach, which takes off from a different image of the body, can be understood as an attempt to forge a politics based on an erotics. Bonitzer uses the two terms interchangeably, claiming that the scission of the voice can contribute to the definition of "another politics (or erotics) of the voice-off."[28] The problem is whether such an erotics, bound to the image of an extended or fragmented body and strongly linked with a particular signifying material, can found a political theory or practice.

There are three major difficulties with the notion of a political erotics of the voice. The first is that, relying as it does on the idea of expanding the range or redefining the power of the senses, and opposing itself to meaning, a political erotics is easily recu-

[24]Jean-François Lyotard, "The Unconscious as Mise-en-scène," in ed. *Performance in Post-modern Culture*, Michel Benamou and Charles Caramello (Madison: Coda Press, 1977), p. 88.

[25]Bonitzer, "Les Silences," p. 31.

[26]See Roland Barthes, "The Grain of the Voice," in *Image-Music-Text*, ed. trans. Stephen Heath (New York: Hill and Wang, 1977), pp. 179–89.

[27]Lyotard, "The Unconscious," p. 96.

[28]Bonitzer, "Les Silences," p. 31

perable as a form of romanticism or as a mysticism which effectively skirts problems of epistemology, loading itself firmly in a mind/body dualism. Secondly, the overemphasis upon the isolated effectivity of a single signifying material—the voice—risks a crude materialism wherein the physical properties of the medium have the inherent and final power of determining its reading. As Paul Willemen points out, a concentration upon the specificities of the various "technico-sensorial unities" of the cinema often precludes a recognition that the materiality of the signifier is a "second order factor" (with respect to language understood broadly as symbolic system) and tends to reduce a complex heterogeneity to a mere combination of different materials.[29] Yet, a film is not a simple juxtaposition of sensory elements but a discourse, an enunciation. This is not to imply that the isolation and investigation of a single signifying material such as the voice is a fruitless endeavor but that the establishment of a direct connection between the voice and politics is fraught with difficulties.

Third, the notion of a political erotics of the voice is particularly problematic from a feminist perspective. Over and against the theorization of the look as phallic, as the support of voyeurism and fetishism (a drive and a defense which, in Freud, are linked explicitly with the male),[30] the voice appears to lend itself readily as an alternative to the image, as a potentially viable means whereby the woman can "make herself heard." Luce Irigaray, for instance, claims that patriarchal culture has a heavier investment in seeing than in hearing.[31] Bonitzer, in the context of defining a political erotics, speaks of "returning the voice to women" as a major component. Nevertheless, it must be remembered that, while psychoanalysis delineates a pre-oedipal scenario in which the voice of the mother dominates, the voice, in psychoanalysis, is also the instrument of interdiction, of the patriarchal order. And to mark the voice as an isolated haven within patriarchy, or as having an essential relation to the woman, is to invoke the specter of feminine specificity, always recuperable as another form of "otherness." A political erotics which posits a new phantasmatic, which relies on images of an "extended" sensory body, is inevitably caught in the double bind which feminism always seems to confront: on the one hand, there is a danger in grounding a politics on a conceptualization of the body because the body has always been *the* site of woman's oppression, posted as the final and undeniable guarantee of a difference and a lack; but, on the other hand, there is a potential gain as well—it is precisely because the body has been a major site of oppression that perhaps it must be the site of the battle to be waged. The supreme achievement of patriarchal ideology is that it has no outside.

In light of the three difficulties outlined above, however, it would seem unwise to base any politics of the voice *solely* on an erotics. The value of thinking the deploy-

---

[29]Paul Willemen, "Cinema Thoughts," paper delivered at Milwaukee Conference on Cinema and Language, March 1979, pp. 12 and 3. [A version of this paper has since been published as "Cinematic Discourse: The Problem of Inner Speech" in *Cinema and Language*, ed. S. Heath and P. Mellencamp (Frederick MD: University Press of America and American Film Institute, 1983).

[30]See Laura Mulvey, "Visual Pleasure and Narrative Cinema," *Screen* (Autumn 1975), 16:6–18 [this edition, 833–844] and Stephen Heath, "Sexual Difference and Representation," *Screen* (Autumn 1978), 19:51–112.

[31]For a fuller discussion of the relationship some feminists establish between the voice and the woman see Heath, "Sexual Difference," pp. 83–84

ment of the voice in the cinema by means of its relation to the body (that of the char-
acter, that of the spectator) lies in an understanding of the cinema, from the perspec-
tive of a topology, as a series of spaces including that of the spectator—spaces which
are often hierarchized or masked, one by the other, in the service of a representational
illusion. Nevertheless, whatever the arrangement or interpenetration of the various
spaces, they constitute a *place* where signification intrudes. The various techniques
and strategies for the deployment of the voice contribute heavily to the definition of
the form that "place" takes.

1980

# JOHN BELTON
# TECHNOLOGY AND AESTHETICS
# OF FILM SOUND

Contemporary Marxist and psychoanalytic film theory regards technology, the evolution of technology, and the evolution of technique as products of an ideological demand that is, in turn, constituted by socioeconomic determinants.[1] Neither techniques nor technologies are natural, nor do they evolve naturally. Contrary to André Bazin's idealist notions of the history of technology and of cinematic forms, their evolution is not natural but "cultural," responding to the pressures of ideology. These pressures suppress signs of technique and technology. For Jean-Louis Baudry, the technological apparatus of the cinema, for example, the camera, transforms what is set before it but conceals the *work* of that transformation by effacing all traces of it.[2] Thus the basic apparatus reflects the actions of bourgeois ideology in general, which seeks to mask its operations and to present as "natural" that which is a product of ideology.

Recent studies of film sound by Rick Altman and Mary Ann Doane extend this argument to the study of the evolution of sound technology, viewing it as an ideologically determined progression toward self-effacement. For Altman, technological innovations "derive from a felt need to reduce all traces of the sound-work from the soundtrack."[3] And Doane argues that "technical advances in sound recording (such as the Dolby system) are aimed at diminishing the noise of the system, concealing the work of the apparatus."[4] Even though technological evolution performs an ideologi-

---

[1]Jean-Louis Comolli, "Technique et ideologie (part 2: Depth of Field: The Double Scene)," *Cahiers du cinéma*, nos. 229–31 (1971): 2a.2, trans. Chistopher Williams.

[2]Jean-Louis Baudry, "Ideological Effects of the Basic Cinematographic Apparatus," *Film Quarterly* 28 (Winter 1974–75):40, trans. Alan Williams.

[3]Rick Altman, "Introduction," *Cinema Sound: Yale French Studies*, no. 60 (1980):4.

[4]Mary Ann Doane, "The Voice in the Cinema: The Articulation of Body and Space," *Cinema/Sound: Yale French Studies*, no. 60 (1980):35.

cal function, I would argue that the work of technology can never quite become invisible. Work, even the work that seeks to efface itself, can never disappear. A fundamental law of physics tells us that energy, though it may change in form, can be neither created nor destroyed. Neither mass nor energy nor work is ever lost. Similarly, technology and the effects of technology—by which I mean the aesthetics and stylistic practices that grow out of it—remain visible, though to varying degrees, in every film. The work of sound technology, through its very efforts to remain inaudible, announces itself and, though concealed, becomes audible for those who choose to listen for it.

Russian formalist notions of the "laying bare" of devices, whereby the work announces itself, are rooted in theories that view art as a perceptual process that derives its effects from a prolongation of the processes of perception. Consideration of the perception of sound and of the prolongation of that process thus constitutes the first step in a study of the "audibility" of the sound track.

The perception of sound is necessarily bound up with perception of the image; the two are apprehended together, though sound is often perceived *through* or *in terms of* the image and, as a result, acquires a "secondary" status. For this reason, the psychology of the image differs from that of the sound track. The viewer perceives and regards the information presented on the sound track differently from that on the image "track," though in both cases the viewer, through his/her response to visual and aural cues, plays a decisive role in the realization of the events seen and heard on the screen.

Sound recording and mixing lack the psychology of the photographic image, which guarantees the authenticity of the reproduction.[1] The camera, recording the visible world set before it, produces images that—"no matter how distorted"—remain directly motivated by that world, the automatic and mechanical nature of the process of their production generating in viewers a "quality of credibility absent from all other picture-making."[2] At the same time, the image possesses a wholeness that serves as further testimony to its "integrity." The image, as Christian Metz points out, is a unity that cannot be broken down into smaller elements.[3] The microphone, however, records an invisible world—that of the audible—which consists of different categories of sound—dialogue, sound effects, and music—and which is regularly broken down into and experienced as separate elements. Not only does sound in general possess a different psychology from that of the image, but the psychology of each category of sound differs slightly. As Metz argues, sound is experienced not as a concrete object or thing but as an attribute or characteristic of it.[4] The voice (i.e., the dialogue category) is one of several attributes of the human body, which also produces noises and sounds that fall under the category of sound effects; sound effects, in turn, are the attributes of the world and of the objects within it (and include the body as object).

---

[1]See André Bazin. "The Ontology of the Photographic Image," *What is Cinema?*, vol. 1, trans. Hugh Gray (Berkeley: University of California Press, 1967), pp. 13–14; and Christian Metz, "On the Impression of Reality in the Cinema," *Film Language: A Semiotics of the Cinema*, trans. Michael Taylor (New York: Oxford University Press, 1974), pp. 5–6.

[2]Bazin, "Ontology," p. 13.

[3]Metz, "The Cinema: Language or Language System," *Film Language*," pp. 61–63.

[4]Christian Metz, "Aural Objects." *Cinema/Sound: Yale French Studies*, no. 60 (1980):26–27

Sound lacks "objectivity" (thus authenticity) not only because it is invisible but because it is an attribute and is thus incomplete in itself. Sound achieves authenticity only as a consequence of its submission to tests imposed upon it by other senses—primarily by sight. One of the conventions of sound editing confirms this. In order to assure an audience that the dialogue and/or sound effects are genuine, the editor must, as soon as possible in a scene, establish synchronization between sound and image, usually through lip-sync. Once that has been done, the editor is free to do almost anything with the picture and sound, confident that the audience now trust what they hear, since it corresponds to (or is not overtly violated by) what they see.

By the same token, dubbing, and especially the dubbing of foreign films in which one language is seen spoken but another heard, is "read" by audiences as false. As early as 1930, the industry noted "a public reaction against . . . voice doubling," forcing a discontinuation of that practice.[1] More recently, Jean Renoir, an advocate of realistic sound practices, wrote that "if we were living in the twelfth century . . . , the practitioners of dubbing would be burnt in the marketplace for heresy. Dubbing is equivalent to a belief in the duality of the soul."[2] The rather obvious intervention of technology involved with dubbing severely circumscribes our faith in both sound and image, provoking a crisis in their credibility.

This perceptual process of testing or attempting to identify sound can, through a system of delays that postpone the synchronism of sound and source, be manipulated to create suspense, both in the area of voice/dialogue and in that of sound effects, calling attention to sound as a device by playing with our perception of it. The identification of a voice with a body can be delayed, as in the case, say, of *The Wizard of Oz* (1939), in which the Wizard's unmasking occurs at the precise moment that synchronization is established; the achievement of synchronization creates a unity whose completeness spells the end of a hermeneutic chain within which an enigma is introduced, developed, prolonged, and resolved. Or in the more complex case of *Psycho* (1960), in which off-screen sound is employed to create a nonexistent character (Mrs. Bates), the particular revelation of the sound's source carefully avoids synchronism: we never see Bates speak in his mother's voice; even at the end, his/her request for a blanket comes from off-screen and his/her final monologue is interiorized. Image and sound here produce a tenuous, almost schizophrenic "synchronization" of character and voice, which precisely articulates the fragmented nature of the enigma's "resolution" and completes an "incompletable" narrative.

As for sound effects, their separation from their source can produce suspense that ranges from the familiar off-screen footsteps that stalk central characters, such as the helpless L. B. Jeffries trapped in his darkened apartment at the end of *Rear Window* (1954), to the mysterious noises and screeches throughout *The Haunting* (1963), whose effects, unlike the earlier example from *The Wizard of Oz*, remain unexplained and unidentified. Though off-screen diegetic sound—whether dialogue or sound effects—will, with few exceptions, ultimately be tied to seen (or unseen) sources and

---

[1]Jack Alicoate, ed., *The 1930 Film Daily Year Book of Motion Pictures* (New York: The Film Daily, 1930), p. 857.

[2]Jean Renoir, *My Life and My Films*, trans. Norman Denny (New York: Atheneum, 1974), p. 106.

thus be "explained" or "identified," we experience that sound through what we see on the screen. It is an extension or completion (or even denial) of the images, but it operates on a plane that is less concrete than that of the images. One could argue that even our experience of on-screen sound involves, though in a much less extreme form, a recognition of a reality of a different order, a reality one step removed from that of the images. The sound track corresponds not, like the image track, directly to "objective reality" but rather to a secondary representation of it, that is, to the images that, in turn, guarantee the objectivity of the sounds. The sound track, in other words, does not undergo the same tests of verisimilitude to which the images are subjected. Images attain credibility in the conformation to objective reality; sounds, in their conformation to the images of that reality, to a derivative reconstruction of objective reality. The rules the sound track obeys—for the spectator at least—are not those of the visible world or of external reality to which photographic images appear to correspond point by point but those of the audible world, which occupies part of the spectrum of phenomena that remain invisible. Paradoxically, the sound track can only duplicate the invisible by means of the visible. Thus sound defines itself in terms of the temporality and spatiality of the image, observing a synchronism and/or perspective dictated by the visuals. Its mimetic processes take as a model not the pro-filmic event but the recorded image of it. The sound track does not duplicate the world set before it; it realizes an imaginary world, endowing the space and objects within the story space with another dimension that complements their temporal and spatial existence as *representations*.

What the sound track seeks to duplicate is the sound of an image, not that of the world. The evolution of sound technology and, again, that of studio recording, editing, and mixing practice illustrate, to some degree, the quest for a sound track that captures an idealized reality, a world carefully filtered to eliminate sounds that fall outside of understanding or significance; every sound must signify. In other words, the goal of sound technology in reproducing sound is to eliminate any noise that interferes with the transmission of meaningful sound. As Mary Ann Doane points out, technical developments in sound recording, after the creation of the basic technology (which was in place by 1928–29), were inspired, in part, by attempts to improve the system's signal-to-noise ratio, to reduce noise and distortion introduced by recording, developing, printing, and projection or playback practices.* During 1929–30, blimps and "bungalows" are developed to encase and thus silence cameras. By 1930, electrical circuits for arc lighting systems are devised to eliminate hum, enabling cinematographers to return from incandescent to arc lighting. Materials used in the construction of sets and the design of costumes are changed to reduce excessive reverberation and rustling. Condenser microphones, which tend to "go noisy" in wet weather, are supplanted (ca. 1931) by the quieter dynamic microphone. By 1939, unidirectional microphones are designed, achieving a 10:1 ratio of "desired to undesired pickup" and effectively reducing "camera noise, floor squeaks, dolly

---

*Mary Ann Doane, "Ideology and the Practice of Sound Editing and Mixing," *The Cinematic Apparatus*, ed. Teresa De Lauretis and Stephen Heath (New York: St. Martin's 1980), p. 55.

noises, and sounds reflected from walls and other reflecting surfaces."[1] Biased recording and printing (ca. 1930–31) and push-pull recording (ca. 1935) reduce ground noise and harmonic distortion.[2] Nonslip printers (ca. 1934) further help control noise: by ensuring a more precise registration between negative and print films, they reduce the loss of quality formerly observed in the printing process. And throughout the thirties special fine-grain negative, intermediate, and print film stocks are developed, along with ultraviolet recording and printing lights (ca. 1936), producing a sharper, distortionless image on the sound track. Meanwhile, the frequency characteristics of recording and playback systems are improved from a range of 100 to 4,000 cycles per second in 1928–30 to that of 30 to 10,000 in 1938, expanding the range of the signal while holding the noise level down.[3] The evolutionary process culminates in the Dolby noise reduction and stereo sound system introduced into the cinema in 1975 in such musical films as *Tommy* and *Lisztomania*. By flattening, during recording, the response to low frequencies and boosting the highs and by reversing this process in playback, the Dolby system effectively masks out surface noise, producing a sound that is clean and that permits louder playback in the theater without increasing noise.

Yet the Dolby system also changes the characteristics of whatever sound it records, albeit only slightly. It cuts the very tops and bottoms off the sounds, resulting in a sound that is somewhat "unnatural." At the same time, the nearly total elimination of noise—the goal toward which sound technology has evolved, like that of camera movement "noise" with the perfection of the Steadicam in 1976 (see *Bound for Glory, Marathon Man, Rocky,* etc.)—results in a final product that is too perfect, that is ideal to a fault. In watching Claude Lelouch's Steadicamed opus *Another Man, Another Chance* (1977) or listening to Steven Spielberg's postrecorded and Dolby-ized *Raiders of the Lost Ark* (1981), one misses the rough, jittery camera movements, floor squeaks, and unmixed, ambient sound of films like Jean Renoir's *La Chienne* (1931). A certain amount of noise has become necessary to signify realism; its absence betokens a sound that has returned to an ideal state of existence, to a point just before it enters into the world and acquires the imperfections inherent in its own realization. The sound track has become artificially quiet, pushing beyond the realism of the outside world into an inner, psychological realism. The sound track duplicates what sound recordist Mark Dichter and sound designer Walter Murch refer to as the sound one hears in one's head,[4] a sound that has not been marked by any sys-

---

[1]G. R. Groves, "The Soundman," *JSMPTE* 48, no. 13 (March 1947):223.

[2]Biased recording effectively reduces the noise of film grain by reducing the amount of light that reaches the negative. As a result, the sound track on positive prints has a darker exposure. Thus less film-grain noise is reproduced during silent or low sound level passages. Push-pull recording involves doubling the width of the track, thereby increasing the useful area of modulated light and decibel output. One variety of push-pull recording splits the track into positive and negative parts of the sound waves. As a result, there is never any transparent or clear area on the track and, thus, ground noise is eliminated.

[3]The frequency range of the human ear extends from 16 to 20,00 cycles per second. Thus evolution in this area might be said to have as its goal the range of the human ear. Unless otherwise noted, technological data in this paragraph derive from material in Groves (see note 12); Edward W. Kellogg. "History of Sound Motion Pictures, Parts I-III," *JSMPTE* 48, nos. 6–8 (June-August 1955); Barry Salt, "Film Style and Technology in the Thirties," *Film Quarterly*, 30–31 (Fall 1976).

[4]Mark Dichter, interview with Elisabeth Weis (March 1975). Walter Murch, interview with F. Paine, *University Film Association Journal*, 33, no. 4 (1981):15–20.

tem noise nor by transmission through any medium, such as air, that might alter its fidelity to an ideal.

The technology and practice devoted to the duplication of sound's spatial properties have undergone a similar evolution, becoming unreal in a quest for realism. With the abandonment in 1927–29 of radio-style recording such as that in *The Lights of New York* (1928), in which performers speak into a stationary microphone and depth is "suggested" by changes in volume (e.g., when doors leading onto a dance floor open and close in the background), sound recording strives to model sound the way a cameraman models figures with light. The industry seeks to produce a track that reflects the space of the original scene. Carefully positioning the microphone to blend direct and reflected sound, soundmen record not only the informational "content" of an actor's speech or sound effects but also its spatial presence. The soundman, in effect, duplicates through sound the space seen on the screen: the microphone mimics the angle and distance of the camera, creating a sound perspective that matches the visual perspective of the image. The advent of wide-screen cinematography— whether the Grandeur system (1929–30), Cinerama (1952), CinemaScope (1953), or Todd-AO/70mm (1955)—provides a wider visual field for the sound track to duplicate, necessitating multiple track, stereo sound. In Fox's CinemaScope process, for example, four different tracks play on three separate speakers behind the screen and on one "surround" speaker.* The footsteps (or speech) of a character walking across the screen from right to left would originate first from the right horn, then from the center, and finally from the left, the source of the sound matching, point for point, the character's various positions on the screen. The final effect, however, is that of three sound perspectives rather than one. No matter how many speakers or tracks film technology develops, it can never quite duplicate the spatial qualities of the sound of the event seen on the screen. Every square inch of the screen would require a separate speaker and track to reflect the nearly limitless number of potential sources for sounds, while an infinite number of speakers and tracks would be needed to duplicate sounds emanating from off-screen space. Stereo systems that establish two, three, four, or even five sound sources, rather than creating a more perfect illusion of depth on the screen, call attention to the arbitrariness of their choice of sources. Instead of becoming better able to approximate the real and to efface its own presence, stereo sound remains marked by the nature of the system(s) it uses to create the illusion of real space. The infinite supply of original information has been *channeled* into a handful of tracks. We experience stereo soundtracks as a limited (rather than limitless) number of distinct sound sources. No matter how "noiseless" it becomes, the system never quite disappears.

At the same time, perspective undergoes stylistic as well as technological evolution. The careful correlation of aural and visual spaces achieved by Hollywood in the thirties gives way in the postwar period to the violation of perspective. Influenced in part by television sound, which tends to maintain constant close-up levels, ignoring

---

*These tracks are narratively coded. The behind-the-screen tracks contain on-screen sound while the surround track contains off-screen sound and voice-over commentary. The authority of a voice-over track is partly the result of its spatial qualities. It occupies a space that is beyond or outside that of the film, thus it can be either privileged (*Apocalypse Now*) or disadvantaged (*Days of Heaven*) in terms of its knowledge of information on the picture "track."

the nuances of perspective, contemporary cinema frequently "mismatches" long shots with close-up sound, as in *The Graduate* (1967) and any number of other films that combine long shots of a car on a highway with close-up sound of its occupants conversing. The current fondness for radio mikes, seen in the work of Robert Altman and others, involves a similar disruption of traditional spatial codes in sound recording. Radio microphones pick up speech (and body tone) *before* it is projected—that is, before it can acquire spatial properties. Though it can be given some perspective during the mixing process, the quality of the sound differs from that recorded by traditional microphones hung just beyond the camera's field of view. Though it permits more freedom in shooting and ensures good sound coverage, recording with radio microphones, like mismatched perspective, lends a surfacy quality to the image, which may suit certain modern stylists such as Altman but which plays havoc with more traditional, illusionistic notions of space. By the same token, contemporary sound editing, in which the sound cut often precedes the picture cut by six to eight frames or more (e.g., *Somebody Up There Likes Me*, 1956; *The Loneliness of the Long Distance Runner*, 1962; *Jaws*, 1975; any number of contemporary Hollywood films; and even recent Robert Bresson films like *L'Argent*, 1983), violates the invisible cutting of the thirties in which the picture cut often precedes the sound cut by a frame or two, the sound bridging and thus concealing the picture cut.

It is perhaps useful to distinguish at some point between technological and stylistic evolution, which do not always share a single goal, and to acknowledge the coexistence of disparate stylistic uses of a single technology. Theories of technological evolution are shaped by Darwinian notions of advancement and self-perfection; the tools that an artist (or culture) uses become more and more perfect, developing from lower into higher forms. But theories of stylistic evolution such as Bazin's are informed, in large part, by the "mimetic fallacy," and are clearly more problematical. As Heinrich Wolfflin argues, "It is a mistake [for art history] to work with the clumsy notion of the imitation of nature, as though it were merely a homogeneous process of increasing perfection."[1] For that matter, can art or even artists themselves be said to possess goals that it/they seek to realize? Is not that notion the height of idealistic thinking? As Jean-Luc Comolli has shown, Bazinian theories of the evolution of cinematic forms are essentially idealistic reconstructions of film history that fail to account for delays, gaps, and contradictions in their development.[2] Given that cinematic forms do not necessarily evolve in the direction of qualities that enable "a recreation of the world in its own image,"[3] can they be said to improve, or to perfect themselves over time? Is the style of a Fassbinder better or even more evolved than that of a Griffith? Is that of Picasso better than that of Rembrandt? No; it is merely *different*, reflecting the different technological, socioeconomic, and cultural systems within which each artist worked. If development can be gauged at all, it is not to be found in the comparison of individual artists or works but in that of different schools, groups, or periods, as Wolfflin has demonstrated. It is only in the area of dominant practice—the point of intersection between the timeliness of technology and the

[1]Heinrich Wolfflin, *Principles of Art History* (New York: Dover, n.d.), 13.
[2]Comolli, "Technique et ideologie," 1.7–1.17.
[3]Bazin, "The Myth of Total Cinema," *What Is Cinema?* vol. 1, p. 21.

timelessness of style, between tools and cultural/individual expression—that change can be charted and given a goal.

At each stage along the axis of technological development, recording, editing, and mixing practices change in response to linear changes in technology and to unpredictable shifts in stylistic concerns of a period, nation, or group of individuals. Thus dominant film practice conforms, more or less, to the direction taken by the technology that informs it, that is, toward self-perfection and invisibility, *and* to the attitudes of those who use that technology, attitudes that color its "invisibility."

Developments in the area of sound recording—especially in the use of radio microphones and Dolby—point, as we have seen, in the direction of the ideal: they culminate in the sounds one hears in one's head. Changes in editing and mixing practice reflect an increase in control over the sound track and in its ability to duplicate the sound not of the pro-filmic event but of that event's photographic image. The initial practice (ca. 1926–29) of mixing sound while it is being recorded and recording it (except for music that was often added later) at the same time that the image is recorded locks the sound indexically into the pro-filmic event of which it is the record, giving it an immediacy and integrity resembling that of the image. The introduction of rerecording and mixing in the early thirties breaks that indexical bond of sound to the pro-filmic event. Mixing now takes place *after* the film has been shot (and often even after it has been edited) during the phase of postproduction. At the same time, the sound track loses its wholeness: it is separated into dialogue, sound effects, and music tracks that are recorded at different times, dialogue and some sound effects being recorded during production, other sound effects, music, and even some dialogue during postproduction. Whereas initially the sound track was "recorded," now it is "built." Sound mixing no longer observes the integrity of any preexistent reality; it builds its own to match earlier recorded visual information. The growth of postproduction departments within the studio system institutionalizes the separation of sound and image that frees the former from its ties to the events that produced the latter. The building of the sound track, using the image rather than the pro-filmic event as a guide, now becomes a final stage in the "realization" of the image.

During the postwar period, even the recording of dialogue, which is traditionally tied, through concerns for synchronization, to the moment at which the image is recorded, is freed from its bonds to the pro-filmic event. The use of wide-angle lenses (which provide a wide field of view and thus force the microphone further away from its target, resulting in a less acceptable sound) and the practice of shooting on location (where ambient noise cannot be controlled as well as in the studio) result in the use of the "production" sound track as a guide track to cue the actor's dialogue during looping sessions back at the studio. The original track, at times, functions merely as a blueprint for an entirely new track created on the sound stage to match an image that has already been assembled in rough cut form. Again, changing practice reveals that it is the sound of the image that Hollywood strives to recreate.

Neither the cinematic institution, seen in its practices, nor the cinematic apparatus possesses a single identity. Practice seeks to produce a more realistic sound track by "unrealizing" its recording and rerecording methods. Its final product is thus marked as a product. Although Baudry and others argue to the contrary, the cinema never quite succeeds in masking the work that produces it. This is due, in large part, to the

very nature of the apparatus itself. The recording aspects of motion picture technology possess dual characteristics: they both transmit and transform. Though the cinematic apparatus becomes, decade by decade, a more perfect transmitter, reducing signs of its own existence by eliminating its system's noise, it inevitably reproduces not only the light and sound waves reflected and emitted by objective reality but also its own presence, which is represented by the perspective from which these waves are seen or heard. In the cinema, there is always present, in the positioning of the camera and the microphone(s), a consciousness that sees and (in the sound film) hears and that coexists with what is seen or heard. Even in the silent cinema, someone is always speaking and something is always spoken. In the sound cinema, we always see and hear events *through* images and sounds of them. The cinema remains the phenomenological art par excellence, wedding, if indeed not collapsing, consciousness with the world.

1985

# JOHN ELLIS
## *FROM* VISIBLE FICTIONS

## BROADCAST TV AS SOUND AND IMAGE

TV offers a radically different image from cinema, and a different relation between sound and image. The TV image is of a lower quality than the cinematic image in terms of its resolution of detail. It is far more apparent that the broadcast TV picture is composed of lines than it is that the cinema image is composed of particles of silver compounds. Not only this, but the TV image is virtually always substantially smaller than the cinema image. Characteristically, the size of TV sets ranges from the 12-inch portable to the 24-inch or sometimes 30-inch model: all these measurements refer to the distance across the screen diagonally. The TV image shows things smaller than they are, unless it is a close-up of a small object, or of a person in head and shoulders only, when they appear more or less their real size. Such simple observations have profound effects on the kind of representations and spectator attitudes that broadcast TV creates for itself.

First, it is a characteristic of broadcast TV that the viewer is larger than the image: the opposite of cinema. It seems to be a convention also that the TV image is looked down on, rather than up to as in cinema. TV sets that are produced with stands are about two feet off the floor, which gives the effect of being almost but not quite level with the eyes of an individual lounging in an easy chair (as indeed we are meant to watch TV according to the advertisements it screens for itself). TV takes place in domestic surroundings, and is usually viewed in normal light conditions, though direct sunlight reflects off the screen to an unacceptable degree. The regime of viewing TV is thus very different from the cinema: TV does not encourage the same degree of spectator concentration. There is no surrounding darkness, no anonymity of the fellow viewers, no large image, no lack of movement amongst the spectators, no rapt attention. TV is not usually the only thing going on, sometimes it is not even the principal thing. TV is treated casually rather than concentratedly. It is something of a last resort ('What's on TV tonight, then') rather than a special event. It has a

lower degree of sustained concentration from its viewers, but a more extended period
of watching and more frequent use than cinema.

This has two major effects on the kind of regime of represenation that has devel-
oped for TV. First, the role that sound plays in TV is extremely imporant. Second, it
engages the look and the glance rather than the gaze, and thus has a different relation
to voyeurism from cinema's. Sound on TV is a strange paradox; although it is mani-
festly important, the manufacturers of TV sets provide speakers of dismal quality,
even though the broadcast sound signal in many places has a wide tonal range. TV
sets come with speakers that are massively geared towards the acceptable reproduc-
tion of speech. Music, especially rock music, does not reproduce at all well. This pro-
vides an alibi for broadcast TV to provide a minimum of rock music, and to provide
the wasteful simultaneous stereo radio and TV transmissions of classical music on
occasions.

The role played by sound stems from the fact that it radiates in all directions,
whereas view of the TV image is sometimes restricted. Direct eye contact is needed
with the TV screen. Sound can be heard where the screen cannot be seen. So sound
is used to ensure a certain level of attention, to drag viewers back to looking at the
set. Hence the importance of programme announcements and signature tunes and, to
some extent, of music in various kinds of series. Sound holds attention more consis-
tently than image, and provides a continuity that holds across momentary lapses of
attention. The result is a slightly different balance between sound and image from that
which is characeristic of cinema. Cinema is guaranteed a centred viewer by the phys-
ical arrangement of cinema seats and customs of film viewing. Sound therefore fol-
lows the image or diverges from it. The image is the central reference in cinema. But
for TV, sound has a more centrally defining role. Sound carries the fiction or the doc-
umentary; the image has a more illustrative function. The TV image tends to be sim-
ple and straightforward, stripped of detail and excess of meanings. Sound tends to
carry the details (background noises, music). This is a tendency towards a different
sound/image balance than in cinema, rather than a marked and consistent difference.
Broadcast TV has areas which tend towards the cinematic, especially the areas of
serious drama or of various kinds of TV film. But many of TV's characteristic broad-
cast forms rely upon sound as the major carrier of information and the major means
of ensuring continuity of attention. The news broadcast, the documentary with voice-
over commentary, the bulk of TV comedy shows, all display a greater reliance on
sound than any form that cinema has developed for itself. The image becomes illus-
tration, and only occasionally provides material that is not covered by the sound track
(e.g., comedy sight gags, news actuality footage). Sound tends to anchor meaning on
TV, where the image tends to anchor it with cinema. In both, these are a matter of
emphasis rather than any simple reliance one upon another. Sound and image exist in
relation to each other in each medium rather than acting as separate entities. How-
ever, the difference of emphasis does exist between the two. It gives rise to two crit-
ical attitudes that are fundamental to the way in which newspaper critics and practi-
tioners alike tend to conceive of the two media. Any film that contains a large amount
of dialogue is open to the criticism that 'it could have been a radio play', as was
Bergman's *From the Life of Marionettes* (*Aus dem Leben der Marionetten*, 1980). A
similar accusation is never hurled at a TV play, however wordy. Instead, there are

unwritten rules that govern the image for TV. Especially in British broadcast TV (possibly the most hide-bound in the world), the image is to be kept literal for almost all the time. There are licensed exceptions (science fiction, rock music programmes) where experimentation with the physical composition of the video image can take place; but the rule is that the image must show whatever is before the camera with the minimum of fuss and conscious technique. The image is to be kept in its place. Both these attitudes refer to occasions in which the subservient partner in the sound/image relationship tends to assert itself too much: for cinema, it is sound; for TV it is the image.

TV's lower level of sustained concentration on the image has had another effect upon its characteristic regime of representation. The image on broadcast TV, being a lower grade image than cinema's, has developed in a particular way. Contrasting with cinema's profusion (and sometimes excess) of detail, broadcast TV's image is stripped-down, lacking in detail. The visual effects of this are immediately apparent: the fussy detail of a film shown on TV compared to the visual bareness of a TV cop series, where cars chase each other through endless urban wastes of bare walls and near-deserted streets. The broadcast TV image has to be certain that its meaning is obvious: the streets are almost empty so that the movement of the car is all the more obvious. The walls are bare so that no writing distracts attention from the segmental event. This is not an effect of parsimony of production investment (rather, it enables it to happen). It is a more fundamental aspect of the broadcast TV image coming to terms with itself. Being small, low definition, subject to attention that will not be sustained, the TV image becomes jealous of its meaning. It is unwilling to waste it on details and inessentials. So background and context tend to be sketched rather than brought forward and subject to a certain fetishism of details that often occurs in cinema, especially art cinema. The narratively important detail is stressed by this lack of other detail. Sometimes, it is also stressed by music, producing an emphasis that seems entirely acceptable on TV, yet would seem ludicrously heavy-handed in cinema. This is particularly so with American crime series, where speed of action and transition from one segment to another dictates the concentration of resources on to single meanings. Where detail and background are used in TV programmes, for example the BBC historical serials, action tends to slow down as a result. The screen displays historical detail in and for itself; characters are inserted around it, carrying on their lengthy conversations as best they can. Segments are drawn out, their meanings unfolding gradually. For historical dramas, especially of the Victorian and Edwardian era, this tends to lend greater authenticity to the fiction: these are assumed to have been the decades of leisure and grace.

The stripped-down image that broadcast TV uses is a central feature of TV production. Its most characteristic result is the TV emphasis on close-ups of people, which are finely graded into types. The dramatic close-up is of a face virtually filling the screen; the current affairs close-up is more distant, head-and-shoulders are shown, providing a certain distance, even reticence. Close-ups are regularly used in TV, to a much greater extent than in cinema. They even have their own generic name: talking heads. The effect is very different from the cinema close-up. Whereas the cinema close-up accentuates the difference between screen-figure and any attainable human figure by drastically increasing its size, the broadcast TV close-up produces a face

that approximates to normal size. Instead of an effect of distance and unattainability, the TV close-up generates an equality and even intimacy.

The broadcast TV image is gestural rather than detailed; variety and interest are provided by the rapid change of images rather than richness within one image. TV compensates for the simplicity of its single images by the techniques of rapid cutting. Again, the organisation of studios is designed for this style of work. The use of several cameras and the possibility of alternation between them produces a style of shooting that is specific to TV: the fragmentation of events that keeps strictly to the continuity of their performance. There is much less condensation of events in TV than in cinema. Events are shown in real time from a multiple of different points of camera view (all, normally, from the same side of the action). Cinema events are shot already fragmented and matched together in editing. Still today, video editing is expensive, and the use of the studio set-up (in which much is already invested: capital and skills alike) provides instantaneous editing as the images are being transferred to tape for later transmission. This enables a rapid alternation of images, a practice which also affects the editing of TV programmes made on film. The standard attitude is that an image should be held on screen only until its information value is exhausted. Since the information value of the TV image is deliberately honed-down, it is quickly exhausted. Variation is provided by changing the image shown rather than by introducing a complexity of elements into a single image. Hence the material nature of the broadcast TV image has two profound effects on the regime of representation and working practices that TV has adopted. It produces an emphasis on sound as the carrier of continuity of attention and therefore of meaning; it produces a lack of detail in the indivdual image that reduces the image to its information value and produces an aesthetic that emphasises the close-up and fast cutting with strict time continuity.

However, this is to compare the broadcast TV image with the cinema image. The TV image has further distinct qualities of its own, no doubt the result of a tenacious ideological operation, that mark it decisively as different from the cinema image with its photo effect. The broadcast TV image has the effect of immediacy. It is as though the TV image is a 'live' image, transmitted and received in the same moment that it is produced. For British broadcast TV, with its tight schedules and fear of controversy, this has not been true for a decade. Only news and sport are routinely live transmissions. However, the notion that broadcast TV is live still haunts the medium; even more so does the sense of immediacy of the image. The immediacy of the broadcast TV image does not just lie in the presumption that it is live, it lies more in the relations that the image sets up for itself. Immediacy is the effect of the directness of the TV image, the way in which it constitutes itself and its viewers as held in a relationship of co-present intimacy. Broadcast TV very often uses forms of direct address from an individual in close-up to individuals gathered around the set. This is very different from cinema's historic mode of narration, where events do not betray a knowledge that they are being watched. Broadcast TV is forever buttonholing, addressing its viewers as though holding a conversation with them. Announcers and newsreaders speak directly from the screen, simulating the eye contact of everyday conversation by looking directly out of the screen and occasionally looking down (a learned and constructed technique). Advertisements contain elements of direct address: questions, exhortations, warnings. Sometimes they go further, pro-

viding riddles and jokes that assume that their viewers share a common frame of reference with them. Hence advertisements for various staple commodities, beer for example, tend to make oblique and punning references to each other's advertising campaigns. The audience is expected to understand these references. This also is an operation of direct address: an ephemeral and immediate knowledge is assumed in the viewer, who otherwise would have no understanding of the reference or the joke. Hence these advertisements are addressing a viewer as an equal: 'we both know what we are talking about'.

Direct address is recognised as a powerful effect of TV. Its most obvious form, that of an individual speaking directly (saying 'I' and 'you'), is reserved for specific kinds of people. It can be used by those who are designated as politically neutral by TV itself (newsmen and women), or by those who have ultimate political power: heads of state. Otherwise, direct address is denied to individuals who appear on TV. Important personalities are interviewed in three-quarter face. Other strategies of address are open to them, that of recruiting the audience against the interviewer by appealing to a common sense that media persons do not share, for instance. Interviewers in their turn tend to construct themselves as asking questions on behalf of the viewers: 'what the public/the viewers/ordinary people *really* want to know is. . . .' This is also a form of highly motivated direct address. Again, it assumes an audience who is there simultaneously, for whom events are being played out.

Direct address is not the only form of construction of broadcast TV's effect of immediacy. Broadcast TV's own perpetual presence (there every night of the year), and its series formats, breed a sense of the perpetual present. Broadcast TV declares itself as being in the present tense, denying recording as effectively as cinema uses it. TV fictions take place to a very large extent as though they were transmitted directly from the place in which they were really happening. The soap opera is the most obvious example of this, where events in a particular milieu are everlastingly updated. Broadcast TV has a very marked sense of presence to its images and sounds which far outweighs any counterbalancing sense of absence, any sense of recording. The technical operation of the medium in its broadcast form strengthens this feeling. The tight scheduling that is favoured by most large broadcast operations means that an audience wanting to see a particular programme has to be present at a very precise time, or they miss it. This increases the sense that broadcast TV is of the specific present moment. In addition, unlike cinema, the signal comes from elsewhere, and can be sent live. The technical origin of the signal is not immediately apparent to the viewer, but all the apparatus of direct address and of contemporaneity of broadcast TV messages is very present. The broadcast signal is always available during almost all normal waking hours. It is ever-present.

The favoured dramatic forms of broadcast TV work within this framework of presence and immediacy. Besides the obvious forms of soap opera, entirely cast in a continuous present, the series format tends towards the creation of immediacy and presence. The open-ended series format of the situation comedy or the dramatic series tends to produce the sense of immediacy by the fact that it presents itself as having no definite end. Unlike the cinema narrative, the end of the episode and the end of the series alike leave events unresolved. They are presented as on-going, part of the texture of life. This sense even extends to the historical reconstruction dramas beloved

of the BBC, through the operation of a further mechanism that produces the effect of immediacy.

Immediacy is also produced by the logical extension of the direct address form: by echoing the presumed form of the TV audience within the material of the TV fiction itself. The institution of broadcast TV assumes its audience to be the family; it massively centres its fictional representations around the question of the family. Hence TV produces its effect of immediacy even within dramas of historically remote periods by reproducing the audience's view of itself within its fictions. Hence TV dramas are concerned with romance and the family, both conceived of within certain basic kinds of definition. Broadcast TV's view of the family is one which is at variance with the domestic practices of the majority of domestic units and of individuals in Britain at the moment. Yet broadcast TV's definition has a strength in that it participates in the construction of an idea of the normal family/domestic unit, from which other forms are experienced and remembered as temporary aberrations.

Broadcast TV dramas are constructed around the heterosexual romance in its normal and perverse forms, and the perpetual construction of standard families: wage-earning husband, housekeeping wife, two children. Situation comedies play on the discrepancies between this assumed norm and other forms of existence: male and female students sharing a flat (*Man About the House*), the childless, woman-dominated couple (*George and Mildred*), the landlord and his variegated bedsit tenants (*Rising Damp*), the rejuvenated divorced father (*Father Dear Father*). Historical dramas found their sense of the historical on the never-changing patterns of romance and family life: Edward VIII's *amour fou* (*Edward and Mrs Simpson*), the problems of the powerful career woman (*Elizabeth R*), the problems of male lust breaking the confines of the family (*The Six Wives of Henry VIII*), the consequences of one sexual transgression repercussing down the centuries (*The Forsyte Saga*, *Poldark*, etc.).

The centring of all kinds of broadcast TV drama upon the family (much as direct address assumes a family unit as its audience) produces a sense of intimacy, a bond between the viewers' conception of themselves (or how they ought to be) and the programme's central concerns. So a relationship of humanist sympathy is set up, along the lines of seeing how everyone is normal really, how much they really do desire the norm that our society has created for itself. But the intimacy that broadcast TV sets up is more than just this form of sympathy. It is made qualitatively different by the sense that the TV image carries of being a live event, which is intensified by the habit of shooting events in real time within any one segment, the self-contained nature of each segment, and the use of close-up and sound continuity. All of these factors contribute to an overall impression, that the broadcast TV image is providing an intimacy with events between couples and within families, an intimacy that gives the impression that these events are somehow co-present with the viewer, shared rather than witnessed from outside. The domestic nature of the characteristic use of broadcast TV certainly contributes here, but more important is the particular way in which TV has internalised this in its own representations. Broadcast TV has ingested the domestic and bases its dramas upon it. When it does not address its audience directly, it creates a sense of familiarity between its fictions and its audience, a familiarity based on a notion of the familial which is assumed to be shared by all.

Broadcast TV has a particular regime of representation that stresses the immediacy and co-presence of the TV representation. Its particular physical and social characteristics have created a very particular mode of representation that includes the image centred upon the significant at the cost of detail, and sound as carrier of continuity. It gives its audience a particular sense of intimacy with the events it portrays. All of these features of broadcast TV create and foster a form of looking by the TV viewer that is different from the kind of voyeurism (with fetishistic undertow) that cinema presents for its spectators.

TV's regime of vision is less intense than cinema's: it is a regime of the glance rather than the gaze. The gaze implies a concentration of the spectator's activity into that of looking, the glance implies that no extraordinary effort is being invested in the activity of looking. The very terms we habitually use to designate the person who watches TV or the cinema screen tend to indicate this difference. The cinema-looker is a spectator: caught by the projection yet separate from its illusion. The TV-looker is a viewer, casting a lazy eye over proceedings, keeping an eye on events, or, as the slightly archaic designation had it, 'looking in'. In psychoanalytic terms, when compared to cinema, TV demonstrates a displacement from the invocatory drive of scopophilia (looking) to the closest related of the invocatory drives, that of hearing. Hence the crucial role of sound in ensuring continuity of attention and producing the utterances of direct address ('I' to 'you').

The different balance between the activities of looking and listening produces a qualitatively different relation to the TV transmission. It is not that the experience is less intense than cinema; rather, it has a distinctive form of its own. In particular, there is far less separation between viewer and image than with cinema. Broadcast TV does not construct an image that is marked by present absence, its regime is one of co-presence of image and viewer. The image is therefore not an impossible one, defined by the separation of the viewer from it, but rather one that is familiar and intimate. The cost of this intimacy is that the voyeuristic mode cannot operate as intensely as in cinema. In particular, the broadcast TV viewer's look is not a controlling look in the same sense as that which operates in cinema. The cinema spectator is secure in the separation from the image that allows events to take place as though they were not watched. The broadcast TV image is quite often directly addressed to the viewer, in a simulation of everyday eye contact. In addition, the sense of cinema's consent to the act of being watched (implied in the event of the projection of a film for spectators) is radically absent from broadcast TV. TV continues whether a particular set is turned on or not. In this sense, it is not for the viewer in the way that the cinema projection is for the spectator. If no one turns up to a film screening, it can be cancelled, but if no one is watching a TV programme, it will be transmitted anyway in blithe ignorance of its lack of reception. The broadcast TV event is just there, it carries no sense with it of being for anyone as the cinema projection is for a definite group. This implies a lack of the consent by the representation to being watched that is vital to the construction of a regime of the voyeuristic gaze in cinema.

Broadcast TV can be left on with no one watching it, playing in the background of other activities in the home. This is perhaps a frequent event; certainly, it also makes

impossible the construction of a voyeuristic contract between looker and representation. Instead, broadcast TV uses sound to appeal to its audience, using a large degree of direct address whose function is to attract the look and attention of the viewer, and to hold it. The separation that this practice implies is different from that of cinematic voyeurism. It makes explicit a relationship between viewer and broadcast TV image, designating a TV first person singular or plural ('I', 'we') and a viewing second person ('you', beautifully flexible in its lack of singular/plural difference). Together these first and second person designations can observe and speculate about third persons: 'he', 'she', 'they'. The practice of segmentalising TV broadcasting means that direct address is present regularly to reaffirm this relationship. It surrounds the segments of dramatic material and comic material so that they become constituted as 'they': the people whom we *and television* both look in upon. But drama's characters are not constituted as a totally separate 'they'. TV drama is constructed around the presumed self-image of the audience: the family. The mobilisation of this sense of intimacy, together with TV's effect of co-presence both tend to push even dramatic material into this sense of first and second person togetherness. Characters in drama series on broadcast TV tend to become familiar figures, loved, or excused with a tolerance that is quite remarkable: it is more than is normally extended to members of the family or to neighbours. The construction of a 'real monster' in a TV series is a difficult process: this is perhaps why J.R. Ewing in *Dallas* excited such attention.

The community of address that broadcast TV is able to set up excludes a fully developed regime of voyeurism as found in cinema. This is perhaps why films screened on TV do not quite achieve the same intensity of experience as they would in the cinema, and why broadcast TV's adoption of the cinematic mode has not been more widespread. The community of address sets up a different relation between viewer and representation. The distance between viewer and image is reduced; but a compensatory distance is constructed and separation/between the 'I' and 'you' of the community of address and the third person outside that it constructs. The 'they' that is always implied and often stated in direct address forms becomes an other, a grouping outside the consensus that confirms the consensus. Certain characteristic attitudes are taken towards these outsiders: patronisation, hate, wilful ignorance, pity, generalised concern, indifference. These are encouraged by the complicity that broadcast TV sets up between itself and its viewers; a series of categories of 'they' has begun to appear, often creating curious dislocations in the operation of TV representations when they are used in news and current affairs. . . .

Dramatic forms of various kinds occur regularly within TV's direct address context, and are inflected by it to some extent. Dramatic forms are not constructed in broadcast TV for the voyeuristic gaze in the same way as cinematic forms. There is a sense of complicity of the institution of TV in the process of looking at dramatic events which increases their sense of co-presence with the viewer. The effects of immediacy, of segmentation, and of the series rather than strong narrative development, and the concentration of TV drama on the family (as a presumed reflection of its audience) all intensify this sense of TV drama as part of the consensus between broadcast TV and its audience. Hence drama is crucial in revising and altering the effects of news and current affairs rather more brutal division of its world into a series of 'theys' beyond the consensus of viewer and TV first persons. . . .

The final effects of TV's low emphasis on the construction of the voyeuristic position lie in the representation of the female body and of female sexuality, and in its characteristic forms of narration of events. Cinematic voyeurism, with its fetishistic counterpart, is centrally concerned with the representation of the female body and of female sexuality as a problem, constructed from the security of a definition of the masculine as positive. TV's concerns are not so heavily centred towards the investigation of the female. This is not only the result of the different mechanisms of self-censorship and imposed censorship that prevail in the two media, nor only of the different sense of the viewing conditions that the two media have of themselves. After all, Hollywood's relentless investigation of the female was carried out under codes of censorship in the 1940s that were every bit as vigilant as those operating in broadcast TV today. TV does not have its equivalents of the *film noir* or of the 'love interest'. Different conditions prevail. Broadcast TV's lack of an intense voyeuristic appeal produces a lack of the strong investigatory drive that is needed alike for tightly organised narration and for intense concern with the 'problem' of the female. Similarly, the regime of broadcast TV does not demonstrate a particular drift towards a fetishistic activity of viewing. Its forms of narration are not particularly repetitive in the fetishistic manner of obsessive replaying of events. The series and the segmental form construct a different pattern of repetition that has much more to do with constructing a pattern of familiarity. The fetishistic regime does operate to some extent, however, as does voyeurism. Its characteristic attention in broadcast TV is not directed towards the whole body, but to the face. The display of the female body on TV, in dance sequences or in a series like *Charlie's Angels*, is gestural rather than fascinating. The techniques of rapid cutting prevent the access of the gaze at the body being displayed. Instead, TV's displays of the female body, frequent and depressing enough as they are, provide material for the glance only. Details and complete bodies are both presented only to the extent that they can be registered as 'a bit of a body/a whole body'. The exception to this is the face, and specifically the female face. In some sense, the female body is hidden, made obscure, by the heavy emphasis that broadcast TV gives to the various kinds of close-up. . . . The close-up of the face is the one moment where the average TV image is more or less life-sized rather than less than life-size, and the equality of scale between image and viewer contributes to a dramatic reduction of separation between image and viewer that is one aspect of the fetishistic regime. The fetishism is still concentrated upon women, because of the generalised culture of sexual difference under which we suffer.

Broadcast TV's level of investment in voyeuristic activity is generally not intense enough to produce the investigatory and forward-moving narratives that are characteristic of entertainment cinema. Instead, the form of narration that corresponds with the activity of the glance rather than the gaze is one of providing variety. Broadcast TV provides a variety of segments rather than the progressive accumulation of sequences that characterises cinematic narration. The segment form corresponds to the regime of the glance. It is relatively coherent and assumes an attention span of relatively limited duration. Broadcast TV's characteristic form of multi-camera editing tends to give the segment the strong coherence of proceeding in real time; TV's characteristic use of a small number of actors in any one situation also increases the coherence of individual segments. Segmentation has been developed in broadcast TV

towards the provision of variety: segments of different kinds follow each other for
most of TV's output. Hence the TV cop series will present successively the dramatic
face-to-face confrontation, the comic routine, the chase sequence, the scene of
pathos. Soap operas tend to present a variety of different moods across each episode
by alternating between different kinds of segment. Broadcast TV's whole attitude to
scheduling is nothing other than the provision of this variety on a grand scale. Sched-
uling ensures that programmes of the same kind are not bunched together, that a
spread of different forms will be found over an evening's output. Such a conception
has virtually disappeared from the entertainment cinema, which is more and more
intent on presenting one film-text only.

Broadcast TV characteristically offers an image that is stripped down, with no
unnecessary details. Cutting produces forms of variation of visual information, and
sound has an important role in drawing the viewer's attention back to the screen. The
image and sound both tend to create a sense of immediacy, which produces a kind of
complicity between the viewer and the TV institution. This can provide a powerful
form of consensus, since it tends to define the domestic place of the TV set as a kind
of norm, against which the 'outside world' represented on TV can be measured. This
regime of image and sound, together with the segment and series forms, has created
a distinct form of narration in broadcast TV.

1982

# IV
# Film Narrative and the Other Arts

Theorists have often attempted to discover the special characteristics of the film medium by comparing it with other media, principally theater and the novel. Erwin Panofsky, for example, contrasts the theater's static use of space and its independence of the principle of coexpressibility with cinema's more dynamic use of space and its rigorous subjection to that principle. For Panofsky, this difference explains why film adaptations of plays are so unlikely to succeed. Any attempt to transfer theater's essentially verbal resources to the cinema violates the principle that no more should be expressed verbally than can be expressed visually. The cinema's business is not the photographing of theatrical decor, a prestylized reality, but the photographing of actual physical reality so that it has style. Panofsky finds cinema the only medium that does justice to the materialistic interpretation of the universe which pervades contemporary civilization.

Like Panofsky, Hugo Münsterberg, a Harvard psychologist and philosopher who was a colleague of both William James and George Santayana, attempted in 1916 to delineate the features of the silent "photoplay" by contrasting it with the theater. For Münsterberg, the representation of physical reality is the concern not of cinema, but of theater. In true cinema, "the massive outer world has lost its weight, it has been freed from space, time and causality, and it has been clothed in the forms of our consciousness." Theater is bound by the same laws that govern nature, but the cinema is free to be shaped by the inner movements of the mind. Theater therefore trespasses on the realm of cinema when it employs any analogue of the close-up or the flashback, and Münsterberg is as harsh a critic of "cinematified" theater as Panofsky is of "theatricalized" film.

For Münsterberg the true function of the close-up is not to provide a closer view of nature but to reproduce the mental act of attention. Similarly, the flashback (which he refers to as the cutback) provides a cinematic equivalent of human memory and is

alien to theater, which is bound by the laws of nature and the necessities of temporal succession. In the theater, "men of flesh and blood with really plastic bodies stand before us. They move like any moving body in our surroundings. Moreover, those happenings on the stage, just like events in life, are independent of our subjective attention and memory and imagination. They go their objective course." If it were the object of cinema, then, to "imitate" nature, film could hardly compete with theater. "The color of the world has disappeared, the persons are dumb, no sound reaches our ears. The depth of the scene appears unreal, the motion has lost its natural character. Worst of all, the objective course of events is falsified. . . ." The genius of cinema is not, then, to "imitate" nature; rather it is to display the triumph of mind over matter.

André Bazin elaborates this distinction between what film and theater accomplish by arguing both that many successful films have been adapted from plays and that cinematic effects have been employed successfully in the theater. Cocteau's *Les Parents Terribles* and Olivier's *Henry V*, he believes, are superb films. But he does not feel that one should "cinematify," simply "open up" the original play by moving around outdoors, in order to make a successful adaptation. Rather, "a good adaptation should result in a restoration of the essence and spirit" of the original play. Indeed, in films like Cocteau's and Olivier's, one is "no longer adapting, one is staging a play by means of cinema."

Bazin realizes that if the living actor's presence were essential to the effects of theater, the successful staging of a play by means of cinema would be impossible. He therefore argues that there is a sense in which the actor is present on the screen just as a person is "present" in a mirror. Although Bazin's refutation of the importance of presence is not very convincing (Stanley Cavell treats the issue much more systematically in *The World Viewed*), it allows him to assert that the primary difference between stage and screen is not one of living beings but of architecture. Bazin thinks that theatrical speech often fails in a film not because it was written for living speakers but because it was written to be uttered in a particular kind of world. The problem of filming a play is to find a decor that preserves the closed, microcosmic qualities of theatrical architecture for which the dialogue was written while at the same time preserving the natural realism of the screen. The screen is not a world in itself but a window on the world that consistently dwarfs and dissipates theatrical speech. Bazin believes this problem is worth solving, for even if original scripts are preferable to adaptations, truly distinguished ones are rare. The cinema cannot afford to ignore its theatrical heritage, any more than the drama can afford the loss of the audiences that film can bring it.

Like Bazin, Leo Braudy emphasizes the varying ways that film, theater, and literature have each dealt with the human image and the question of characterization. After broadly distinguishing in *The World in a Frame* between the visual and verbal ways of presenting character, he defines the basic nature of film character as an active omission of all knowledge but what we see immediately in front of us—including the inner life of the character as well as the actor's presence in other films. It is not merely the "presence" of the performer before us in the film that creates the character, but also the palpable absences and implications of that performance, particularly our basic knowledge that the performer is not really there. With a look back at historical styles of stage performance and conceptions of acting, he then explores this elusive-

ness of the film character in contrast with what he argues are the more patterned ways in which the novel and especially the stage construct character. Directly connected with these differing conceptions of character are very different demands made upon performers in the two visual media.

Similarly aware of the cultural inheritance of cinema, Sergei Eisenstein, as a film-maker himself, emphasizes the question of the ease and effectiveness of adapting one medium to another. He argues that Griffith learned montage, which Eisenstein considers the essence of film, from the pages of Dickens. Eisenstein plainly sees no theoretical bar to adapting novels successfully to the screen, as proved by his own attempt to adapt Dreiser's *An American Tragedy*. Indeed, it is not implausible to argue, as Bazin has, that the film's deepest affinities are with the novel, not with the play. The novel is "cinematic" in its fluid handling of time and space, in its "focused" narrative control, in its ability to alternate description with dialogue, and even in the privacy and isolation of its audiences. As a result, the film has adapted more fiction than drama.

Because of the commitment of many early writers to defining film in opposition to more traditional art-forms, the question of adaptation still remains a vexed one for most film theorists and in contemporary film criticism it is perhaps the least theoretically considered. This attitude has even been reinforced among later theorists who wish to disentangle not only film but also film study from that of literature or theater. Yet there is some reason to think that adaptation is a way into the processes of creation, since a good number of important filmmakers, like Eisenstein, have not felt the same compunctions about "impurity" that have worried many critics. It may also be a way into understanding the different ways that different media tell stories.

Seymour Chatman, who has written extensively on narrative and narrative processes in fiction and film, takes up this question in his essay. His perspective is predicated, as he says, on the ways in which narrative theorists have explored the storytelling structures that they claim are independent of medium, especially the distinction between story and discourse. The mechanism of adaptation is an especially intriguing way to test the kinds of transformations that narrative undergoes in the two media. Chatman's analysis of Jean Renoir's version of Maupassant's short story "Une Partie de campagne" emphasizes the way in which story elements, description, and point of view are changed in the metamorphosis from prose fiction to film, as Renoir creates a self-sufficient film that is yet clearly linked to its literary source.

Also beginning with some examples drawn from "Une Partie de campagne," Dudley Andrew expands the implications of Chatman's argument to a general consideration of the use of source material in the making of films. As Chatman concentrates on the underlying narrative similarities to illustrate differences, Andrew explores the points of contact between two artistic "signifying systems," the literary and the cinematic, that otherwise seem to achieve their effects in exactly reverse ways: film from perception to signification, literature from signification to perception. Rejecting those writers who therefore argue for sharp and unbridgeable distinctions between the media, Andrew moves the question of adaptation from the periphery of film study to its center: "the study of adaptation is logically tantamount to the study of cinema as a whole." What is needed, he concludes, is not a more refined set of medium-specific definitions but an effort to situate the transformations in a historical and sociological context of actual adaptors with their complex motivations.

In recent years, in part because of the interest in issues of film language that are discussed in Section I, questions of adaptation and the particular story-telling resources of the different media have been often rephrased in terms of more general questions of how film narrative works. The backdrop to these discussions is the contrast between classic film narrative, in which things seem to speak transparently for themselves, and a narrative that calls its own procedures into some question. (Compare the discussions of film realism in Section II.) Various theorists have analyzed narrative in various ways, but always in the service of making a primary distinction between a story and its telling, as well as between different aspects of that telling: its language, or discourse; its point-of-view, or enunciation. In a section from his book, *D. W. Griffith and the Origins of American Narrative Film*, Tom Gunning adapts the categories developed by the French literary theorist Gérard Genette and tests them against the body of work created by Griffith, and what Gunning calls the "excess of mimesis over meaning" that is inherent in the photographic and cinematic image. What tells the story in the narrative film as contrasted with the narrative of prose fiction? Gunning answers by focusing on the "profilmic"—what happens in front of the camera and how spectators actively receive and analyze its messages. At the end of this selection, Gunning diverges from the influential ideas of David Bordwell (*Narration in the Fiction Film*) and Edward Branigan (*Point of View in the Cinema*) by stressing the role of narration and even a narrator in opposition to their conception of a more depersonalized discourse. In this view even the most detached film still has readable designs on the viewer that can be described as a narrative presence.

Jerrold Levinson takes the issue of narration into the nonverbal narrative form of film music, both that "appropriated" from pre-existing sources and that composed particularly for the film. Levinson argues against those who claim that nondiegetic sound (sound without a visual source) is "inaudible" and not meant to be noticed, as well as those who say that there is no necessary narrative presence in film. He agrees with Chatman that wherever there is a narrative there is narrative agency. In fact, he says, when the various kinds of film music are considered, it becomes clear that there are actually two narrative presences: one concerned with what is fictional *in a film's story*" and the other with "what is fictional *in the world of a film*."

Kristin Thompson turns the focus away from narrative and narrative coherence to the issue of cinematic excess—which Gunning and others define as part of film realism—and which she sees as both counternarrative and counterunity. Taking Eisenstein's *Ivan the Terrible* as her example, she details the many diverse elements in the film that exceed any principles of unified motivation that otherwise would seem to hold the film together. As she argues, "[n]arratives are not logical in themselves; they only make use of logic." To recognize the importance of cinematic excess undermines any assumption that artistic intentionality necessarily creates a patterned unity. At the same time, it opens up the film to the viewer's free play of interpretation.

The idea of excess challenges traditional concepts of cinamatic coherence. Peter Wollen, a film theorist who later would make several independent films, discusses the innovations of Jean-Luc Godard in the 1970s. Wollen shows how the formal challenge of Godard's films to the mainstream narrative tradition of film yet itself draws upon formal devices and explorations that were pioneered by or have intriguing analogies in the novel, theater, and painting. Films do have resources that the other

artistic media may not, but, as Godard's films of the 1970s illustrate, the traditional critical identification of classical film narrative with literary or theatrical sources needs serious revision.

Finally in this section Jeffrey Sconce uses the question of narrative and stylistic excess to reexamine some of the basic questions of film study. Whereas Thompson's concept of excess leads toward a deeper consideration of those genres, like melodrama and horror, that especially exploit its techniques (see Section VI), and Wollen's invokes radical forms of synthesis with the other arts, Sconce's excess, which he calls "paracinema," is as much a sociological as an aesthetic phenomenon. Taking off from Pierre Bourdieu's discussion of the social anthropology of taste, Sconce considers not only the films themselves but also their audiences and critics. The aficionados of "trash cinema," he argues, reject the canonical narratives previously celebrated in film studies and are drawn to more marginal works, created outside the studio system or any other governing aesthetic, marked by their discontinuities and strangeness instead of their wholeness and control. In contrast with the presiding *auteurs* to be discussed in Section V on the film artist, the filmmakers here are distinguished by their surrealistic ineptness, and their films should be viewed "not only as bizarre works of art, but also as intriguing cultural documents."

# HUGO MÜNSTERBERG
## *FROM* THE FILM:
## A PSYCHOLOGICAL STUDY

### THE MEANS OF THE PHOTOPLAY

We have now reached the point at which we can knot together all our threads, the psychological and the esthetic ones. If we do so, we come to the true thesis of this whole book. Our esthetic discussion showed us that it is the aim of art to isolate a significant part of our experience in such a way that it is separate from our practical life and is in complete agreement within itself. Our esthetic satisfaction results from this inner agreement and harmony, but in order that we may feel such agreement of the parts we must enter with our own impulses into the will of every element, into the meaning of every line and color and form, every word and tone and note. Only if everything is full of such inner movement can we really enjoy the harmonious cooperation of the parts. The means of the various arts, we saw, are the forms and methods by which this aim is fulfilled. They must be different for every material. Moreover the same material may allow very different methods of isolation and elimination of the insignificant and reënforcement of that which contributes to the harmony. If we ask now what are the characteristic means by which the photoplay succeeds in overcoming reality, in isolating a significant dramatic story and in presenting it so that we enter into it and yet keep it away from our practical life and enjoy the harmony of the parts, we must remember all the results to which our psychological discussion in the first part of the book has led us.

We recognized there that the photoplay, incomparable in this respect with the drama, gave us a view of dramatic events which was completely shaped by the inner movements of the mind. To be sure, the events in the photoplay happen in the real space with its depth. But the spectator feels that they are not presented in the three dimensions of the outer world, that they are flat pictures which only the mind molds into plastic things. Again the events are seen in continuous movement; and yet the pictures break up the movement into a rapid succession of instantaneous impressions. We do not see the objective reality, but a product of our own mind which binds the

411

pictures together. But much stronger differences came to light when we turned to the processes of attention, of memory, of imagination, of suggestion, of division of interest and of emotion. The attention turns to detailed points in the outer world and ignores everything else: the photoplay is doing exactly this when in the close-up a detail is enlarged and everything else disappears. Memory breaks into present events by bringing up pictures of the past: the photoplay is doing this by its frequent cutbacks, when pictures of events long past flit between those of the present. The imagination anticipates the future or overcomes reality by fancies and dreams; the photoplay is doing all this more richly than any chance imagination would succeed in doing. But chiefly, through our division of interest our mind is drawn hither and thither. We think of events which run parallel in different places. The photoplay can show in intertwined scenes everything which our mind embraces. Events in three or four or five regions of the world can be woven together into one complex action. Finally, we saw that every shade of feeling and emotion which fills the spectator's mind can mold the scenes in the photoplay until they appear the embodiment of our feelings. In every one of these aspects the photoplay succeeds in doing what the drama of the theater does not attempt.

If this is the outcome of esthetic analysis on the one side, of psychological research on the other, we need only combine the results of both into a unified principle: *the photoplay tells us the human story by overcoming the forms of the outer world, namely, space, time, and causality, and by adjusting the events to the forms of the inner world, namely, attention, memory, imagination, and emotion.*

We shall gain our orientation most directly if once more, under this point of view, we compare the photoplay with the performance on the theater stage. We shall not enter into a discussion of the character of the regular theater and its drama. We take this for granted. Everybody knows that highest art form which the Greeks created and which from Greece has spread over Asia, Europe, and America. In tragedy and in comedy from ancient times to Ibsen, Rostand, Hauptmann, and Shaw we recognize one common purpose and one common form for which no further commentary is needed. How does the photoplay differ from a theater performance? We insisted that every work of art must be somehow separated from our sphere of practical interests. The theater is no exception. The structure of the theater itself, the framelike form of the stage, the difference of light between stage and house, the stage setting and costuming, all inhibit in the audience the possibility of taking the action on the stage to be real life. Stage managers have sometimes tried the experiment of reducing those differences, for instance, keeping the audience also in a fully lighted hall, and they always had to discover how much the dramatic effect was reduced because the feeling of distance from reality was weakened. The photoplay and the theater in this respect are evidently alike. The screen too suggests from the very start the complete unreality of the events.

But each further step leads us to remarkable differences between the stage play and the film play. In every respect the film play is further away from the physical reality than the drama and in every respect this greater distance from the physical world brings it nearer to the mental world. The stage shows us living men. It is not the real Romeo and not the real Juliet; and yet the actor and the actress have the ringing voices of true people, breathe like them, have living colors like them, and fill physical space

like them. What is left in the photoplay? The voice has been stilled: the photoplay is a dumb show. Yet we must not forget that this alone is a step away from reality which has often been taken in the midst of the dramatic world. Whoever knows the history of the theater is aware of the tremendous rôle which the pantomime has played in the development of mankind. From the old half-religious pantomimic and suggestive dances out of which the beginnings of the real drama grew to the fully religious pantomimes of medieval ages and, further on, to many silent mimic elements in modern performances, we find a continuity of conventions which make the pantomime almost the real background of all dramatic development. We know how popular the pantomimes were among the Greeks, and how they stood in the foreground in the imperial period of Rome. Old Rome cherished the mimic clowns, but still more the tragic pantomimics. "Their very nod speaks, their hands talk and their fingers have a voice." After the fall of the Roman empire the church used the pantomime for the portrayal of sacred history, and later centuries enjoyed very unsacred histories in the pantomimes of their ballets. Even complex artistic tragedies without words have triumphed on our present-day stage. *L'Enfant Prodigue* which came from Paris, *Sumurun* which came from Berlin, *Petroushka* which came from Petrograd, conquered the American stage; and surely the loss of speech, while it increased the remoteness from reality, by no means destroyed the continuous consciousness of the bodily existence of the actors.

Moreover the student of a modern pantomime cannot overlook a characteristic difference between the speechless performance on the stage and that of the actors of a photoplay. The expression of the inner states, the whole system of gestures, is decidedly different: and here we might say that the photoplay stands nearer to life than the pantomime. Of course, the photoplayer must somewhat exaggerate the natural expression. The whole rhythm and intensity of his gestures must be more marked than it would be with actors who accompany their movements by spoken words and who express the meaning of their thoughts and feelings by the content of what they say. Nevertheless the photoplayer uses the regular channels of mental discharge. He acts simply as a very emotional person might act. But the actor who plays in a pantomime cannot be satisfied with that. He is expected to add something which is entirely unnatural, namely a kind of artificial demonstration of his emotions. He must not only behave like an angry man, but he must behave like a man who is consciously interested in his anger and wants to demonstrate it to others. He exhibits his emotions for the spectators. He really acts theatrically for the benefit of the bystanders. If he did not try to do so, his means of conveying a rich story and a real conflict of human passions would be too meager. The photoplayer, with the rapid changes of scenes, has other possibilities of conveying his intentions. He must not yield to the temptation to play a pantomime on the screen, or he will seriously injure the artistic quality of the reel.

The really decisive distance from bodily reality, however, is created by the substitution of the actor's picture for the actor himself. Lights and shades replace the manifoldness of color effects and mere perspective must furnish the suggestion of depth. We traced it when we discussed the psychology of kinematoscopic perception. But we must not put the emphasis on the wrong point. The natural tendency might be to lay the chief stress on the fact that those people in the photoplay do not stand before

us in flesh and blood. The essential point is rather that we are conscious of the flat-
ness of the picture. If we were to see the actors of the stage in a mirror, it would also
be a reflected image which we perceive. We should not really have the actors them-
selves in our straight line of vision; and yet this image would appear to us equivalent
to the actors themselves, because it would contain all the depth of the real stage. The
process which leads from the living men to the screen is more complex than a mere
reflection in a mirror, but in spite of the complexity in the transmission we do, after
all, see the real actor in the picture. The photograph is absolutely different from those
pictures which a clever draughtsman has sketched. In the photoplay we see the actors
themselves and the decisive factor which makes the impression different from seeing
real men is not that we see the living persons through the medium of photographic
reproduction but that this reproduction shows them in a flat form. The bodily space
has been eliminated. We said once before that stereoscopic arrangements could repro-
duce somewhat this plastic form also. Yet this would seriously interfere with the char-
acter of the photoplay. We need there this overcoming of the depth, we want to have
it as a picture only and yet as a picture which strongly suggests to us the actual depth
of the real world. We want to keep the interest in the plastic world and want to be
aware of the depth in which the persons move, but our direct object of perception
must be without the depth. That idea of space which forces on us most strongly the
idea of heaviness, solidity and substantiality must be replaced by the light flitting
immateriality.

But the photoplay sacrifices not only the space values of the real theater; it disre-
gards no less its order of time. The theater presents its plot in the time order of real-
ity. It may interrupt the continuous flow of time without neglecting the conditions of
the dramatic art. There may be twenty years between the third and the fourth act, inas-
much as the dramatic writer must select those elements spread over space and time
which are significant for the development of his story. But he is bound by the funda-
mental principle of real time, that it can move only forward and not backward. What-
ever the theater shows us now must come later in the story than that which it showed
us in any previous moment. The strict classical demand for complete unity of time
does not fit every drama, but a drama would give up its mission if it told us in the third
act something which happened before the second act. Of course, there may be a play
within a play, and the players on the stage which is set on the stage may play events
of old Roman history before the king of France. But this is an enclosure of the past
in the present, which corresponds exactly to the actual order of events. The photoplay,
on the other hand, does not and must not respect this temporal structure of the phys-
ical universe. At any point the photoplay interrupts the series and brings us back to
the past. We studied this unique feature of the film art when we spoke of the psy-
chology of memory and imagination. With the full freedom of our fancy, with the
whole mobility of our association of ideas, pictures of the past flit through the scenes
of the present. Time is left behind. Man becomes boy; today is interwoven with the
day before yesterday. The freedom of the mind has triumphed over the unalterable
law of the outer world.

It is interesting to watch how playwrights nowadays try to steal the thunder of the
photoplay and experiment with time reversals on the legitimate stage. We are esthet-
ically on the borderland when a grandfather tells his grandchild the story of his own

youth as a warning, and instead of the spoken words the events of his early years come before our eyes. This is, after all, quite similar to a play within a play. A very different experiment is tried in *Under Cover*. The third act, which plays on the second floor of the house, ends with an explosion. The fourth act, which plays downstairs, begins a quarter of an hour before the explosion. Here we have a real denial of a fundamental condition of the theater. Or if we stick to recent products of the American stage, we may think of *On Trial*, a play which perhaps comes nearest to a dramatic usurpation of the rights of the photoplay. We see the court scene and as one witness after another begins to give his testimony the courtroom is replaced by the scenes of the actions about which the witness is to report. Another clever play, *Between the Lines*, ends the first act with a postman bringing three letters from the three children of the house. The second, third, and fourth acts lead us to the three different homes from which the letters came and the action in the three places not only precedes the writing of the letters, but goes on at the same time. The last act, finally, begins with the arrival of the letters which tell the ending of those events in the three homes. Such experiments are very suggestive but they are not any longer pure dramatic art. It is always possible to mix arts. An Italian painter produces very striking effects by putting pieces of glass and stone and rope into his paintings, but they are no longer pure paintings. The drama in which the later event comes before the earlier is an esthetic barbarism which is entertaining as a clever trick in a graceful superficial play, but intolerable in ambitious dramatic art. It is not only tolerable but perfectly natural in any photoplay. The pictorial reflection of the world is not bound by the rigid mechanism of time. Our mind is here and there, our mind turns to the present and then to the past: the photoplay can equal it in its freedom from the bondage of the material world.

But the theater is bound not only by space and time. Whatever it shows is controlled by the same laws of causality which govern nature. This involves a complete continuity of the physical events: no cause without following effect, no effect without preceding cause. This whole natural course is left behind in the play on the screen. The deviation from reality begins with that resolution of the continuous movement which we studied in our psychological discussions. We saw that the impression of movement results from an activity of the mind which binds the separate pictures together. What we actually see is a composite; it is like the movement of a fountain in which every jet is resolved into numberless drops. We feel the play of those drops in their sparkling haste as one continuous stream of water, and yet are conscious of the myriads of drops, each one separate from the others. This fountainlike spray of pictures has completely overcome the causal world.

In an entirely different form this triumph over causality appears in the interruption of the events by pictures which belong to another series. We find this whenever the scene suddenly changes. The processes are not carried to their natural consequences. A movement is started, but before the cause brings its results another scene has taken its place. What this new scene brings may be an effect for which we saw no causes. But not only the processes are interrupted. The intertwining of the scenes which we have traced in detail is itself such a contrast to causality. It is as if different objects could fill the same space at the same time. It is as if the resistance of the material world had disappeared and the substances could penetrate one another. In the inter-

lacing of our ideas we experience this superiority to all physical laws. The theater would not have even the technical means to give us such impressions, but if it had, it would have no right to make use of them, as it would destroy the basis on which the drama is built. We have only another case of the same type in those series of pictures which aim to force a suggestion on our mind. We have spoken of them. A certain effect is prepared by a chain of causes and yet when the causal result is to appear the film is cut off. We have the causes without the effect. The villain thrusts with his dagger—but a miracle has snatched away his victim.

*While the moving pictures are lifted above the world of space and time and causality and are freed from its bounds, they are certainly not without law.* We said before that the freedom with which the pictures replace one another is to a large degree comparable to the sparkling and streaming of the musical tones. The yielding to the play of the mental energies, to the attention and emotion, which is felt in the film pictures, is still more complete in the musical melodies and harmonies in which the tones themselves are merely the expressions of the ideas and feelings and will impulses of the mind. Their harmonies and disharmonies, their fusing and blending, is not controlled by any outer necessity, but by the inner agreement and disagreement of our free impulses. And yet in this world of musical freedom, everything is completely controlled by esthetic necessities. No sphere of practical life stands under such rigid rules as the realm of the composer. However bold the musical genius may be he cannot emancipate himself from the iron rule that his work must show complete unity in itself. All the separate prescriptions which the musical student has to learn are ultimately only the consequences of this central demand which music, the freest of the arts, shares with all the others. In the case of the film, too, the freedom from the physical forms of space, time, and causality does not mean any liberation from this esthetic bondage either. On the contrary, just as music is surrounded by more technical rules than literature, the photoplay must be held together by the esthetic demands still more firmly than is the drama. The arts which are subordinated to the conditions of space, time, and causality find a certain firmness of structure in these material forms which contain an element of outer connectedness. But where these forms are given up and where the freedom of mental play replaces their outer necessity, everything would fall asunder if the esthetic unity were disregarded.

This unity is, first of all, the unity of action. The demand for it is the same which we know from the drama. The temptation to neglect it is nowhere greater than in the photoplay where outside matter can so easily be introduced or independent interests developed. It is certainly true for the photoplay, as for every work of art, that nothing has the right to existence in its midst which is not internally needed for the unfolding of the unified action. Wherever two plots are given to us, we receive less by far than if we had only one plot. We leave the sphere of valuable art entirely when a unified action is ruined by mixing it with declamation, and propaganda which is not organically interwoven with the action itself. It may be still fresh in memory what an esthetically intolerable helter-skelter performance was offered to the public in *The Battlecry of Peace*. Nothing can be more injurious to the esthetic cultivation of the people than such performances which hold the attention of the spectators by ambitious detail and yet destroy their esthetic sensibility by a complete disregard of the fundamental principle of art, the demand for unity. But we recognized also that this unity involves complete

isolation. We annihilate beauty when we link the artistic creation with practical interests and transform the spectator into a selfishly interested bystander. The scenic background of the play is not presented in order that we decide whether we want to spend our next vacation there. The interior decoration of the rooms is not exhibited as a display for a department store. The men and women who carry out the action of the plot must not be people whom we may meet tomorrow on the street. All the threads of the play must be knotted together in the play itself and none should be connected with our outside interests. A good photoplay must be isolated and complete in itself like a beautiful melody. It is not an advertisement for the newest fashions.

This unity of action involves unity of characters. It has too often been maintained by those who theorize on the photoplay that the development of character is the special task of the drama, while the photoplay, which lacks words, must be satisfied with types. Probably this is only a reflection of the crude state which most photoplays of today have not outgrown. Internally, there is no reason why the means of the photoplay should not allow a rather subtle depicting of complex character. But the chief demand is that the characters remain consistent, that the action be developed according to inner necessity and that the characters themselves be in harmony with the central idea of the plot. However, as soon as we insist on unity we have no right to think only of the action which gives the content of the play. We cannot make light of the form. As in music the melody and rhythms belong together, as in painting not every color combination suits every subject, and as in poetry not every stanza would agree with every idea, so the photoplay must bring action and pictorial expression into perfect harmony. But this demand repeats itself in every single picture. We take it for granted that the painter balances perfectly the forms in his painting, groups them so that an internal symmetry can be felt and that the lines and curves and colors blend into a unity. Every single picture of the sixteen thousand which are shown to us in one reel ought to be treated with this respect of the pictorial artist for the unity of the forms.

*The photoplay shows us a significant conflict of human actions in moving pictures which, freed from the physical forms of space, time, and causality, are adjusted to the free play of our mental experiences and which reach complete isolation from the practical world through the perfect unity of plot and pictorial appearance.*

1916

# ANDRÉ BAZIN
## *FROM* WHAT IS CINEMA?

### THEATER AND CINEMA

The leitmotiv of those who despise filmed theatre, their final and apparently insuperable argument, continues to be the unparalleled pleasure that accompanies the presence of the actor. "What is specific to theater," writes Henri Gouhier, in *The Essence of Theater*, "is the impossibility of separating off action and actor." Elsewhere he says "the stage welcomes every illusion except that of presence; the actor is there is disguise, with the soul and voice of another, but he is nevertheless there and by the same token space calls out for him and for the solidity of his presence. On the other hand and inversely, the cinema accommodates every form of reality save one—the physical presence of the actor." If it is here that the essence of theater lies then undoubtedly the cinema can in no way pretend to any parallel with it. If the writing, the style, and the dramatic structure are, as they should be, rigorously conceived as the receptacle for the soul and being of the flesh-and-blood actor, any attempt to substitute the shadow and reflection of a man on the screen for the man himself is a completely vain enterprise. There is no answer to this argument. The successes of Laurence Olivier, of Welles, or of Cocteau can only be challenged—here you need to be in bad faith—or considered inexplicable. They are a challenge both to critics and philosophers. Alternatively one can only explain them by casting doubts on that commonplace of theatrical criticism "the irreplaceable presence of the actor."

### THE CONCEPT OF PRESENCE

At this point certain comments seem called for concerning the concept of "presence," since it would appear that it is this concept, as understood prior to the appearance of photography, that the cinema challenges.

Can the photographic image, especially the cinematographic image, be likened to other images and in common with them be regarded as having an existence distinct from the object? Presence, naturally, is defined in terms of time and space. "To be in the presence of someone" is to recognize him as existing contemporaneously with us and to note that he comes within the actual range of our senses—in the case of cinema of our sight and in radio of our hearing. Before the arrival of photography and later of cinema, the plastic arts (especially portraiture) were the only intermediaries between actual physical presence and absence. Their justification was their resemblance which stirs the imagination and helps the memory. But photography is something else again. In no sense is it the image of an object or person, more correctly it is its tracing. Its automatic genesis distinguishes it radically from the other techniques of reproduction. The photograph proceeds by means of the lens to the taking of a veritable luminous impression in light—to a mold. As such it carries with it more than mere resemblance, namely a kind of identity—the card we call by that name being only conceivable in an age of photography. But photography is a feeble technique in the sense that its instantaneity compels it to capture time only piecemeal. The cinema does something strangely paradoxical. It makes a molding of the object as it exists in time and, furthermore, makes an imprint of the duration of the object.

The nineteenth century with its objective techniques of visual and sound reproduction gave birth to a new category of images, the relation of which to the reality from which they proceed requires very strict definition. Even apart from the fact that the resulting aesthetic problems cannot be satisfactorily raised without this introductory philosophical inquiry, it would not be sound to treat the old aesthetic questions as if the categories with which they deal had in no way been modified by the appearance of completely new phenomena. Common sense—perhaps the best philosophical guide in this case—has clearly understood this and has invented an expression for the presence of an actor, by adding to the placards announcing his appearance the phrase "in flesh and blood." This means that for the man in the street the word "presence," today, can be ambiguous, and thus an apparent redundancy is not out of place in this age of cinema. Hence it is no longer as certain as it was that there is no middle stage between presence and absence. It is likewise at the ontological level that the effectiveness of the cinema has its source. It is false to say that the screen is incapable of putting us "in the presence of" the actor. It does so in the same way as a mirror—one must agree that the mirror relays the presence of the person reflected in it—but it is a mirror with a delayed reflection, the tin foil of which retains the image.* It is true

---

*Television naturally adds a new variant to the "pseudopresences" resulting from the scientific techniques for reproduction created by photography. On the little screen during live television the actor is actually present in space and time. But the reciprocal actor-spectator relationship is incomplete in one direction. The spectator sees without being seen. There is no return flow. Televised theater, therefore, seems to share something both of theater and of cinema: of theater because the actor is present to the viewer, of cinema because the spectator is not present to the actor. Nevertheless, this state of not being present is not truly an absence. The television actor has a sense of the millions of ears and eyes virtually present and represented by the electronic camera. This abstract presence is most noticeable when the actor fluffs his lines. Painful enough in the theater, it is intolerable on television since the spectator who can do nothing to help him is aware of the unnatural solitude of the actor. In the theater in similar circumstances a sort of understanding exists with the audience, which is a help to an actor in trouble. This kind of reciprocal relationship is impossible on television.

that in the theater Molière can die on the stage and that we have the privilege of liv-
ing in the biographical time of the actor. In the film about Manolete however we are
present at the actual death of the famous matador and while our emotion may not be
as deep as if we were actually present in the arena at that historic moment, its nature
is the same. What we lose by way of direct witness do we not recapture thanks to the
artificial proximity provided by photographic enlargement? Everything takes place as
if in the time-space perimeter which is the definition of presence. The cinema offers
us effectively only a measure of duration, reduced but not to zero, while the increase
in the space factor reestablishes the equilibrium of the psychological equation.

## OPPOSITION AND IDENTIFICATION

An honest appraisal of the respective pleasures derived from theater and cinema,
at least as to what is less intellectual and more direct about them, forces us to admit
that the delight we experience at the end of a play has a more uplifting, a nobler, one
might perhaps say a more moral, effect than the satisfaction which follows a good
film. We seem to come away with a better conscience. In a certain sense it is as if for
the man in the audience all theater is "Corneillian." From this point of view one could
say that in the best films something is missing. It is as if a certain inevitable lowering
of the voltage, some mysterious aesthetic short circuit, deprived us in the cinema of
a certain tension which is a definite part of theater. No matter how slight this differ-
ence it undoubtedly exists, even between the worst charity production in the theater
and the most brilliant of Olivier's film adaptations. There is nothing banal about this
observation and the survival of the theater after fifty years of cinema, and the prophe-
cies of Marcel Pagnol, is practical proof enough. At the source of the disenchantment
which follows the film one could doubtless detect a process of depersonalization of
the spectator. As Rosenkrantz wrote in 1937, in *Esprit*, in an article profoundly orig-
inal for its period, "The characters on the screen are quite naturally objects of identi-
fication, while those on the stage are, rather, objects of mental opposition because
their real presence gives them an objective reality and to transpose them into beings
in an imaginary world the will of the spectator has to intervene actively, that is to say,
to will to transform their physical reality into an abstraction. This abstraction being
the result of a process of the intelligence that we can only ask of a person who is fully
conscious." A member of a film audience tends to identify himself with the film's
hero by a psychological process, the result of which is to turn the audience into a
"mass" and to render emotion uniform. Just as in algebra if two numbers equal a
third, then they are equal to one another, so here we can say, if two individuals iden-
tify themselves with a third, they identify themselves with one another. Let us com-
pare chorus girls on the stage and on the screen. On the screen they satisfy an uncon-
scious sexual desire and when the hero joins them he satisfies the desire of the
spectator in the proportion to which the latter has identified himself with the hero. On
the stage the girls excite the onlooker as they would in real life. The result is that there
is no identification with the hero. He becomes instead an object of jealousy and envy.
In other words, Tarzan is only possible on the screen. The cinema calms the specta-
tor, the theater excites him. Even when it appeals to the lowest instincts, the theater

up to a certain point stands in the way of the creation of a mass mentality.* It stands in the way of any collective representation in the psychological sense, since theater calls for an active individual consciousness while the film requires only a passive adhesion.

These views shed a new light on the problem of the actor. They transfer him from the ontological to the psychological level. It is to the extent to which the cinema encourages identification with the hero that it conflicts with the theater. Put this way the problem is no longer basically insoluble, for it is a fact that the cinema has at its disposal means which favor a passive position or on the other hand, means which to a greater or lesser degree stimulate the consciousness of the spectator. Inversely the theater can find ways of lessening the psychological tension between spectator and actor. Thus theater and cinema will no longer be separated off by an unbridgeable aesthetic moat, they would simply tend to give rise to two attitudes of mind over which the director maintains a wide control.

Examined at close quarters, the pleasure derived from the theater not only differs from that of the cinema but also from that of the novel. The reader of a novel, physically alone like the man in the dark movie house, identifies himself with the character. That is why after reading for a long while he also feels the same intoxication of an illusory intimacy with the hero. Incontestably, there is in the pleasure derived from cinema and novel a self-satisfaction, a concession to solitude, a sort of betrayal of action by a refusal of social responsibility.

The analysis of this phenomenon might indeed be undertaken from a psychoanalytic point of view. Is it not significant that the psychiatrists took the term catharsis from Aristotle? Modern pedagogic research on psychodrama seems to have provided fruitful insights into the cathartic process of theater. The ambiguity existing in the child's mind between play and reality is used to get him to free himself by way of improvised theater from the repressions from which he suffers. This technique amounts to creating a kind of vague theater in which the play is of a serious nature and the actor is his own audience. The action that develops on these occasions is not one that is divided off by footlights, which are undoubtedly the architectural symbol of the censor that separates us from the stage. We delegate Oedipus to act in our guise and place him on the other side of a wall of fire—that fiery frontier between fantasy and reality which gives rein to Dionysiac monsters while protecting us from them. These sacred beasts will not cross this barrier of light beyond which they seem out of place and even sacrilegious—witness the disturbing atmosphere of awe which surrounds an actor still made up, like a phosphorescent light, when we visit him in his dressing room. There is no point to the argument that the theater did not always have footlights. These are only a symbol and there were others before them from the cothurnus and mask onwards. In the seventeenth century the fact that young nobles sat up on the stage is no denial of the role of the footlights, on the contrary, it confirms it, by way of a privileged violation so to speak, just as when today Orson Welles scatters actors around the auditorium to fire on the audience with revolvers. He does

---

*Crowd and solitude are not antinomies: the audience in a movie house is made up of solitary individuals. Crowd should be taken here to mean the opposite of an organic community freely assembled.

not do away with the footlights, he just crosses them. The rules of the game are also made to be broken. One expects some players to cheat.* With regard to the objection based on presence and on that alone, the theater and the cinema are not basically in conflict. What is really in dispute are two psychological modalities of a performance. The theater is indeed based on the reciprocal awareness of the presence of audience and actor, but only as related to a performance. The theater acts on us by virtue of our participation in a theatrical action across the footlights and as it were under the protection of their censorship. The opposite is true in the cinema. Alone, hidden in a dark room, we watch through half-open blinds a spectacle that is unaware of our existence and which is part of the universe. There is nothing to prevent us from identifying ourselves in imagination with the moving world before us, which becomes *the* world. It is no longer on the phenomenon of the actor as a person physically present that we should concentrate our analysis, but rather on the ensemble of conditions that constitute the theatrical play and deprive the spectator of active participation. We shall see that it is much less a question of actor and presence than of man and his relation to the decor.

## BEHIND THE DECOR

The human being is all-important in the theater. The drama on the screen can exist without actors. A banging door, a leaf in the wind, waves beating on the shore can heighten the dramatic effect. Some film masterpieces use man only as an accessory, like an extra, or in counterpoint to nature which is the true leading character. Even when, as in *Nanook* and *Man of Aran*, the subject is man's struggle with nature, it cannot be compared to a theatrical action. The mainspring of the action is not in man but nature. As Jean-Paul Sartre, I think it was, said, in the theater the drama proceeds from the actor, in the cinema it goes from the decor to man. This reversal of the dramatic flow is of decisive importance. It is bound up with the very essence of the *mise-en-scène*. One must see here one of the consequences of photographic realism. Obviously, if the cinema makes use of nature it is because it is able to. The camera puts at the disposal of the director all the resources of the telescope and the microscope. The last strand of a rope about to snap or an entire army making an assault on a hill are within our reach. Dramatic causes and effects have no longer any material limits to the eye of the camera. Drama is freed by the camera from all contingencies of time and space. But this freeing of tangible dramatic powers is still only a secondary aesthetic cause, and does not basically explain the reversal of value between the actor

---

*Here is a final example proving that presence does not constitute theater except in so far as it is a matter of a performance. Everyone either at his own or someone else's expense has known the embarrassment of being watched without knowing it or in spite of knowing it. Lovers who kiss on public benches offer a spectacle to the passerby, but they do not care. My concierge who has a feeling for the *mot juste* says, when she sees them, that is like being at the movies. Each of us has sometimes found himself forced to his annoyance to do something absurd before other people. On those occasions we experience a sense of angry shame which is the very opposite of theatrical exhibitionism. Someone who looks through a keyhole is not at the theater; Cocteau has rightly demonstrated in *Le sang d'un poète* that he was already at the cinema. And nevertheless there are such things as "shows," when the protagonists are present to us in flesh and blood but one of the two parties is ignorant of the fact or goes through with it reluctantly. This is not "play" in the theatrical sense.

and the decor. For sometimes it actually happens that the cinema deliberately deprives itself of the use of setting and of exterior nature—we have already seen a perfect instance of this in *Les Parents terribles*—while the theater in contrast uses a complex machinery to give a feeling of ubiquity to the audience. Is *La Passion de Jeanne d'Arc* by Carl Dreyer, shot entirely in close-up, in the virtually invisible and in fact theatrical settings by Jean Hugo, less cinematic than *Stagecoach*? It seems to me that quantity has nothing to do with it, nor the resemblance to certain theater techniques. The ideas of an art director for a room in *Les Dames aux camélias* would not noticeably differ whether for a film or a play. It's true that on the screen you would doubtless have some close-ups of the blood-stained handkerchief, but a skillful stage production would also know how to make some play with the cough and the handkerchief. All the close-ups in *Les Parents terribles* are taken directly from the theater where our attention would spontaneously isolate them. If film direction only differed from theater direction because it allows us a closer view of the scenery and makes a more reasonable use of it, there would really be no reason to continue with the theater and Pagnol would be a true prophet. For it is obvious that the few square yards of the decor of Vilar's *La Danse de la mort* contributed as much to the drama as the island on which Marcel Cravene shot his excellent film. The fact is that the problem lies not in the decor itself but in its nature and function. We must therefore throw some light on an essentially theatrical notion, that of the dramatic place.

There can be no theater without architecture, whether it be the cathedral square, the arena of Nîmes, the palace of the Popes, the trestle stage on a fairground, the semicircle of the theater of Vicenza that looks as if it were decorated by Bérard in a delirium, or the rococo amphitheaters on the boulevard houses. Whether as a performance or a celebration, theater of its very essence must not be confused with nature under penalty of being absorbed by her and ceasing to be. Founded on the reciprocal awareness of those taking part and present to one another, it must be in contrast to the rest of the world in the same way that play and reality are opposed, or concern and indifference, or liturgy and the common use of things. Costume, mask, or make-up, the style of the language, the footlights, all contribute to this distinction, but the clearest sign of all is the stage, the architecture of which has varied from time to time without ever ceasing to mark out a privileged spot actually or virtually distinct from nature. It is precisely in virtue of this *locus dramaticus* that decor exists. It serves in greater or less degree to set the place apart, to specify. Whatever it is, the decor constitutes the walls of this three-sided box opening onto the auditorium, which we call the stage. These false perspectives, these façades, these arbors, have another side which is cloth and nails and wood. Everyone knows that when the actor "retires to his apartment" from the yard or from the garden, he is actually going to his dressing room to take off his make-up. These few square feet of light and illusion are surrounded by machinery and flanked by wings, the hidden labyrinths of which do not interfere one bit with the pleasure of the spectator who is playing the game of theater. Because it is only part of the architecture of the stage, the decor of the theater is thus an area materially enclosed, limited, circumscribed, the only discoveries of which are those of our collusive imagination.

Its appearances are turned inward facing the public and the footlights. It exists by virtue of its reverse side and of anything beyond, as the painting exists by virtue of its

frame. Just as the picture is not to be confounded with the scene it represents and is not a window in a wall. The stage and the decor where the action unfolds constitute an aesthetic microcosm inserted perforce into the universe but essentially distinct from the Nature which surrounds it.

Theater in Cinema, Jean Marais, Yvonne de Bray, Gabrielle Dorziat, Marcel André, and Josette Day in *Les Parents Terribles* (1948). It "deliberately deprives itself of the use of setting and of exterior nature" (BAZIN, page 423). Anna Magnani onstage in the *commedia dell' arte* of *The Golden Coach* (1952). Renoir incorporates the artifice of the theater into the cinema without destroying "that realism of space without which moving pictures do not constitute cinema" (BAZIN, page 428).

It is not the same with cinema, the basic principle of which is a denial of any frontiers to action.

The idea of a *locus dramaticus* is not only alien to, it is essentially a contradiction of the concept of the screen. The screen is not a frame like that of a picture but a mask which allows only a part of the action to be seen. When a character moves off screen, we accept the fact that he is out of sight, but he continues to exist in his own capacity at some other place in the decor which is hidden from us. There are no wings to the screen. There could not be without destroying its specific illusion, which is to make of a revolver or of a face the very center of the universe. In contrast to the stage the space of the screen is centrifugal. It is because that infinity which the theater demands cannot be spatial that its area can be none other than the human soul. Enclosed in this space the actor is at the focus of a two-fold concave mirror. From the auditorium and from the decor there converge on him the dim lights of conscious human beings and of the footlights themselves. But the fire with which he burns is at once that of his inner passion and of that focal point at which he stands. He lights up in each member of his audience an accomplice flame. Like the ocean in a sea shell the dramatic infinities of the human heart moan and beat between the enclosing walls of the theatrical sphere. This is why this dramaturgy is in its essence human. Man is at once its cause and its subject.

On the screen man is no longer the focus of the drama, but will become eventually the center of the universe. The impact of his action may there set in motion an infinitude of waves. The decor that surrounds him is part of the solidity of the world. For this reason the actor as such can be absent from it, because man in the world enjoys no a priori privilege over animals and things. However there is no reason why he should not be the mainspring of the drama, as in Dreyer's *Jeanne d'Arc*, and in this respect the cinema may very well impose itself upon the theater. As actions *Phèdre* or *King Lear* are no less cinematographic than theatrical, and the visible death of a rabbit in *La Règle du jeu* affects us just as deeply as that of Agnès' little cat about which we are merely told.

But if Racine, Shakespeare, or Molière cannot be brought to the cinema by just placing them before the camera and the microphone, it is because the handling of the action and the style of the dialogue were conceived as echoing through the architecture of the auditorium. What is specifically theatrical about these tragedies is not their action so much as the human, that is to say the verbal, priority given to their dramatic structure. The problem of filmed theater at least where the classics are concerned does not consist so much in transposing an action from the stage to the screen as in transposing a text written for one dramaturgical system into another while at the same time retaining its effectiveness. It is not therefore essentially the action of a play which resists film adaptation, but above and beyond the phases of the intrigue (which it would be easy enough to adapt to the realism of the screen) it is the verbal form which aesthetic contingencies or cultural prejudices oblige us to respect. It is this which refuses to let itself be captured in the window of the screen. "The theater," says Baudelaire, "is a crystal chandelier." If one were called upon to offer in comparison a symbol other than this artificial crystal-like object, brilliant, intricate, and circular, which refracts the light which plays around its center and holds us prisoners of its aureole, we might say of the cinema that it is the little flashlight of the usher, moving

like an uncertain comet across the night of our waking dream, the diffuse space without shape or frontiers that surrounds the screen.

The story of the failures and recent successes of theater on film will be found to be that of the ability of directors to retain the dramatic force of the play in a medium that reflects it or, at least, the ability to give this dramatic force enough resonance to permit a film audience to perceive it. In other words, it is a matter of an aesthetic that is not concerned with the actor but with decor and editing. Henceforth it is clear that filmed theater is basically destined to fail whenever it tends in any manner to become simply the photographing of scenic representation even and perhaps most of all when the camera is used to try and make us forget the footlights and the backstage area. The dramatic force of the text, instead of being gathered up in the actor, dissolves without echo into the cinematic ether. This is why a filmed play can show due respect to the text, be well acted in likely settings, and yet be completely worthless. This is what happened, to take a convenient example, to *Le Voyageur sans bagages*. The play lies there before us apparently true to itself yet drained of every ounce of energy, like a battery dead from an unknown short. But over and beyond the aesthetic of the decor we see clearly both on the screen and on the stage that in the last analysis the problem before us is that of realism. This is the problem we always end up with when we are dealing with cinema.

## THE SCREEN AND THE REALISM OF SPACE

The realism of the cinema follows directly from its photographic nature. Not only does some marvel or some fantastic thing on the screen not undermine the reality of the image, on the contrary it is its most valid justification. Illusion in the cinema is not based as it is in the theater on convention tacitly accepted by the general public; rather, contrariwise, it is based on the inalienable realism of that which is shown. All trick work must be perfect in all material respects on the screen. The "invisible man" must wear pyjamas and smoke a cigarette.

Must we conclude from this that the cinema is dedicated entirely to the representation if not of natural reality at least of a plausible reality of which the spectator admits the identity with nature as he knows it? The comparative failure of German expressionism would seem to confirm this hypothesis, since it is evident that *Caligari* attempted to depart from realistic decor under the influence of the theater and painting. But this would be to offer an oversimplified explanation for a problem that calls for more subtle answers. We are prepared to admit that the screen opens upon an artificial world provided there exists a common denominator between the cinematographic image and the world we live in. Our experience of space is the structural basis for our concept of the universe. We may say in fact, adapting Henri Gouhier's formula, "The stage welcomes every illusion except the illusion of presence," that "the cinematographic image can be emptied of all reality save one—the reality of space."

It is perhaps an overstatement to say "all reality" because it is difficult to imagine a reconstruction of space devoid of all reference to nature. The world of the screen and our world cannot be juxtaposed. The screen necessarily substitutes for it since the very concept of a universe is spatially exclusive. For a time, a film is the Universe, the world, or if you like, Nature. We will see how the films that have attempted to sub-

stitute a fabricated nature and an artificial world for the world of experience have not all equally succeeded. Admitting the failure of *Caligari* and *Die Nibelungen* we then ask ourselves how we explain the undoubted success of *Nosferatu* and *La Passion de Jeanne d'Arc*, the criterion of success being that these films have never aged. Yet it would seem at first sight that the methods of direction belong to the same aesthetic family, and that viewing the varieties of temperament and period, one could group these four films together as expressionist as distinct from realist. However, if we examine them more closely we see that there are certain basic differences between them. It is clear in the case of R. Wiene and Murnau. *Nosferatu* plays, for the greater part of the time, against natural settings whereas the fantastic qualities of *Caligari* are derived from deformities of lighting and decor. The case of Dreyer's *Jeanne d'Arc* is a little more subtle since at first sight nature plays a nonexistent role. To put it more directly, the decor by Jean Hugo is no whit less artificial and theatrical than the settings of *Caligari*; the systematic use of close-ups and unusual angles is well calculated to destroy any sense of space. Regular cinéclub goers know that the film is unfailingly introduced with the famous story of how the hair of Falconetti was actually cut in the interest of the film and likewise, the actors, we are told, wore no makeup. These references to history ordinarily have no more than gossip value. In this case, they seem to me to hold the aesthetic secret of the film; the very thing to which it owes its continued survival. It is precisely because of them that the work of Dreyer ceases to have anything in common with the theater, and indeed one might say, with man. The greater recourse Dreyer has exclusively to the human "expression," the more he has to reconvert it again into Nature. Let there be no mistake, that prodigious fresco of heads is the very opposite of an actor's film. It is a documentary of faces. It is not important how well the actors play, whereas the pockmarks on Bishop Cauchon's face and the red patches of Jean d'Yd are an integral part of the action. In this drama-through-the-microscope the whole of nature palpitates beneath every pore. The movement of a wrinkle, the pursing of a lip are seismic shocks and the flow of tides, the flux and reflux of this human epidermis. But for me Dreyer's brilliant sense of cinema is evidenced in the exterior scene which every other director would assuredly have shot in the studio. The decor as built evoked a Middle Ages of the theater and of miniatures. In one sense, nothing is less realistic than this tribunal in the cemetery or this drawbridge, but the whole is lit by the light of the sun and the gravedigger throws a spadeful of real earth into the hole.*

It is these "secondary" details, apparently aesthetically at odds with the rest of the work, which give it its truly cinematic quality.

If the paradox of the cinema is rooted in the dialectic of concrete and abstract, if cinema is committed to communicate only by way of what is real, it becomes all the more important to discern those elements in filming which confirm our sense of natural reality and those which destroy that feeling. On the other hand, it certainly argues a lack of perception to derive one's sense of reality from these accumulations of

---

*This is why I consider the graveyard scene in *Hamlet* and the death of Ophelia bad mistakes on Olivier's part. He had here a chance to introduce sun and soil by way of counterpoint to the setting of Elsinore. Does the actual shot of the sea during the soliloquy of Hamlet show that he had sensed the need for this? The idea, excellent in itself, is not well handled technically.

factual detail. It is possible to argue that *Les Dames du Bois de Boulogne* is an eminently realistic film, though everything about it is stylized. Everything, except for the rarely noticeable sound of a windshield-wiper, the murmur of a waterfall, or the rushing sound of soil escaping from a broken vase. These are the noises, chosen precisely for their "indifference" to the action, that guarantee its reality.

The cinema being of its essence a dramaturgy of Nature, there can be no cinema without the setting up of an open space in place of the universe rather than as part of it. The screen cannot give us the illusion of this feeling of space without calling on certain natural guarantees. But it is less a question of set construction or of architecture or of immensity than of isolating the aesthetic catalyst, which it is sufficient to introduce in an infinitesimal dose, to have it immediately take on the reality of nature.

The concrete forest of *Die Nibelungen* may well pretend to be an infinite expanse. We do not believe it to be so, whereas the trembling of just one branch in the wind, and the sunlight, would be enough to conjure up all the forests of the world.

If this analysis be well founded, then we see that the basic aesthetic problem of filmed theater is indeed that of the decor. The trump card that the director must hold is the reconversion into a window onto the world of a space oriented toward an interior dimension only, namely the closed and conventional area of the theatrical play.

It is not in Laurence Olivier's *Hamlet* that the text seems to be rendered superfluous or its strength diminished by directorial interpretations, still less in Welles' *Macbeth*, but paradoxically in the stage productions of Gaston Baty, to the precise extent that they go out of their way to create a cinematographic space on the stage; to deny that the settings have a reverse side, thus reducing the sonority of the text simply to the vibration of the voice of the actor who is left without his "resonance box" like a violin that is nothing else but strings. One would never deny that the essential thing in the theater is the text. The latter conceived for the anthropocentric expression proper to the stage and having as its function to bring nature to it cannot, without losing its raison d'être, be used in a space transparent as glass. The problem then that faces the filmmaker is to give his decor a dramatic opaqueness while at the same time reflecting its natural realism. Once this paradox of space has been dealt with, the director, so far from hesitating to bring theatrical conventions and faithfulness to the text to the screen will find himself now, on the contrary, completely free to rely on them. From that point on it is no longer a matter of running away from those things which "make theater" but in the long run to acknowledge their existence by rejecting the resources of the cinema, as Cocteau did in *Les Parents terribles* and Welles in *Macbeth*, or by putting them in quotation marks as Laurence Olivier did in *Henry V*. The evidence of a return to filmed theater that we have had during the last ten years belongs essentially to the history of decor and editing. It is a conquest of realism—not, certainly, the realism of subject matter or realism of expression but that realism of space without which moving pictures do not constitute cinema.

1951

# LEO BRAUDY
## *FROM* THE WORLD IN A FRAME

## ACTING: STAGE VS. SCREEN

Acting in Europe and America has been historically defined by the varying inter-play of the heightened and the normal, the theatrical and the nonchalant, in the con-ception of the role. Until the Renaissance, there was little attempt to place any spe-cial value on the absorption of the rhythm, themes, and gestures of everyday life into drama or acting style. Aristotle had taught that the most intense feelings possible in drama were those in tragedy, when the characters and the acting style were on a much higher plane than the normal life of the audience. Everyday life, where the characters and the way they behave tend to be on the same or lower social levels than the audi-ence, was primarily a source of stylized comedy. The stage was raised above the audi-ence in part because the characters and their impersonators were not to be considered as individually as the audience might assess each other. In Greek, Roman, and medieval society, actors therefore tended to portray beings purer than the audience, the somber figures of myth and the caricatures of comedy—a division of acting labor not unlike that of the silent screen.

Shakespeare helped make an enormous change in this relation between the audi-ence and the actors by elaborating the analogies possible between the world and the stage. He began the European theater's effort to absorb and reflect the life of the audi-ence as much as to bring the audience out of itself into another world. Comedy could therefore become more serious because it was no longer necessary to involve emo-tions lower than the grand style of tragedy. More intimate theaters and better lighting permitted a more nuanced acting style. By the mid-eighteenth century David Garrick had become the first to attempt historical authenticity in costuming, once again asserting the need to ground the play and the style of acting in some possible and plausible setting rather than a special world of theater. The "fourth wall" theories of the latter nineteenth century further defined theatrical space and dramatic acting as an extension of the world of the audience. Stylized acting did not disappear, of course.

The broader styles remained in opera, ballet, and popular comedy, as well as revivals of classics, symbolic and proletarian drama, and the experiments with ritual theater from the end of World War Two to the present.

Acting on stage had necessarily developed a tradition of naturalness as well. In the eighteenth century Diderot had argued that the paradox of acting is that an actor must be cold and tranquil in order to project emotion. Actors who play from the soul, he said, are mediocre and uneven. We are not moved by the man of violence, but by the man who possesses himself. In the early twentieth century, Konstantin Stanislavsky turned Diderot's view of the actor self-possessed in passion into a whole style. He rejected theories of acting based on imitation and emphasized instead an actor's inner life as the source of energy and authenticity for his characterizations. More "mechanical" and expressionist styles of stage acting implicitly attacked Stanislavsky's methods by their emphasis on the intensity of emotion and the visual coherence of the stage ensemble. Minglings of the two traditions produced such hybrids as the Group Theater, in which the interplay between ensemble and individual produced a thematic tension often missing from Eisenstein's productions, whether on stage or in film. Elia Kazan's film style, for example, with its mixture of expressionistic, closed directorial style and open, naturalistic acting, is a direct descendant of this tradition.*

Our ability to learn what films can tell us about human character has suffered not only from preconceptions derived from the novel of psychological realism, but also from assumptions about acting that are drawn from the stage. We know much better what our attitude should be toward characters in fiction and drama. Unlike those forms, films emphasize acting and character, often at the expense of forms and language. Films add what is impossible in the group situation of the stage or the omniscient world of the novel: a sense of the mystery inside character, the strange core of connection with the face and body the audience comes to know so well, the sense of an individuality that can never be totally expressed in words or action. The stage cannot have this effect because the audience is constantly aware of the actor's impersonation. Character in film generally is more like character as we perceive it everyday than it is in any other representational art. The heightened style of silent film acting could be considered an extension of stage acting, but the more personal style allowed by sound film paradoxically both increased the appeal of films and lowered their intellectual status. The artistic was the timeless, Garbo not Dietrich, Valentino not Gable.

But character in sound film especially was not so much deficient as it was elusive. Films can be less didactic about character because the film frame is less confining than the fictional narrative or the theatrical proscenium. Sound films especially can explore the tension between the "real person" playing the role and the image projected on the screen. The line between film actor and part is much more difficult to draw than that between stage actor and role, and the social dimension of "role" contrasts appropriately with the personal dimension of "part." Film acting is less impersonation than personation, part of personality but not identifiable with it. "Can Ingrid Bergman commit murder?" ask the advertisements for *Murder on the Orient Express*

---

*Diderot's *Paradoxe sur le comédien* was not published until 1830, although it was written in the late 1760s. A later printing in 1902 may have had an influence on Stanislavsky's theories.

(Sidney Lumet, 1975); the casual substitution of actress for character crudely makes an assertion that better films explore more subtly. Unlike the stage actor, the film actor cannot get over the footlights. Although this technical necessity may seem to make him less "real" than the stage actor, it makes his relation to the character he plays much more real. Audiences demand to hear more about the private life of the film actor than the stage actor because film creates character by tantalizing the audience with the promise of the secret self, always just out of the grasp of final articulation and meaning. The other life of a stage character is the real life of the person who plays him. But the other life of a film character is the continuity in other films of the career of the actor who plays him. In plays the unrevealed self tends to be a reduced, meaner version of the displayed self; in films it is almost always a complex enhancement. Within the film a character may have a limited meaning. But the actor who plays him can potentially be a presence larger than that one part, at once more intimate and more distant than is ever possible on stage.*

Film preserves a performance that is superior to the script, whereas stage performances and plays are separate realities, with the performance often considered second best. The stage actor is performing a role: he may be the best, one of the best, the only, or one of many to play that role. But the role and its potentials will exist long after he has ceased to play it, to be interested in it, to be alive. The film actor does not so much perform a role as he creates a kind of life, playing between his characterization in a particular film and his potential escape from that character, outside the film and perhaps into other films. The stage actor memorizes an entire role in proper order, putting it on like a costume, while the film actor learns his part in pieces, often out of chronological order, using his personality as a kind of armature, or as painters will let canvas show through to become part of the total effect. If the movie is remade and another actor plays the part, there is little sense of the competition between actors that characterizes revivals on stage. "Revival" is a stage word and "remake" is a film word. Hamlet remains beyond Booth's or Olivier's or Gielgud's performance, but Alan Ladd as Gatsby and Robert Redford as Gatsby exist in different worlds.

Filmmaking is a discontinuous process, in which the order of filming is influenced more by economics than by aesthetics. Film actors must therefore either have stronger personalities than stage actors or draw upon the resources of personality much more than stage actors do. Strong film actors can never do anything out of character. Their presence defines their character and the audience is always ready for them to reveal more. Even though studio heads like Louis Mayer forced actors and actresses to appear "in character" offscreen as well, we sense and accept potential and variety from the greatest movie actors, while we may reject less flamboyant fictional characters as "unreal" or refer to the woodenness of stage characterization. Continuity in stage acting is thematic continuity: "Watch in happiness someone whom you will soon see in sorrow" is one of the fatalistic possibilities. But the discontinuities of film acting allow the actor to concentrate on every moment as if it were the only reality that existed. No matter how conventionalized the plot, the film actor can disregard

---

*In these remarks, I am obviously talking not so much about the craft of acting as about the effects of acting on the audience. I would hope, however, that what I say has implications for craft and method as well, at least in terms of a test of effectiveness beyond the pleasures of theory.

its clichés and trust instead to the force and continuity of his projected personality to satisfy beyond the more obvious forms of theme and incident. Because he must present his play in straightforward time, a stage director will work with the actor to get a "line" or a "concept" of the character that will permeate every scene. But movie acting, bound in time to the shooting schedule and the editing table, must use what is left out as well as what is expressed. The greatest difference between a film and a stage version of the same work is less in the "opening" of space that films usually emphasize than in the different sense of the inner life of the characters we get. . . .

Movies therefore stand between the strongly social emphasis of theater and the strongly individual emphasis of novels, incorporating elements of both. At a play we are always outside the group, at the footlights. But at a film we move between inside and outside, individual and social perspectives. Movie acting can therefore include stage acting better than stage acting can include movie acting. George C. Scott, for example, is essentially a stage actor who also can come across very well in film. When he was making *Patton* (Franklin Schaffner, 1970), he insisted that he repeat his entire first speech eight times to allow for the different camera angles; he refused to repeat only the sections that corresponded to the rephotographing. His sense of the

Marlene Dietrich and John Lodge in Josef von Sternberg's *The Scarlet Empress* (1934). "Films add what is impossible in the group situation of the stage or the omniscient world of the novel: a sense of the mystery inside character, the strange core of connection with the face and body the audience comes to know so well, the sense of an individuality that can never be totally expressed in words or action" (BRAUDY, page 430).

character was therefore what I have been describing as a stage sense of character, in which the continuity is linear and spelled out. The performance is excellent and effective, but Scott's way of doing it tells us nothing of the differences in stage and film acting. It may have a touch of the New York stage actor's almost traditional hostility to films. At best, it is only another example of the way a newer art can more comfortably embrace the methods of an older art than the other way around. In fact, virtuosity in films tends to be a characteristic of second leads or medium minor characters, not stars, and the Academy Awards perpetuate the stage-derived standards by giving so many awards to actors and actresses cast against type, that is, for stage-style "virtuosity."

The film actor emphasizes display, while the stage actor explores disguise. But stage acting is still popularly considered to be superior to film acting. An actor who does a good job disappears into his role, while the bad (read "film") actor is only playing himself. The true actor, the professional craftsman, may use his own experience to strengthen his interpretation. But the audience should always feel that he has properly distanced and understood that experience; it is another tool in his professional workchest. The false actor, the amateur actor, the film actor, on the other hand, works on his self-image, carries it from part to part, constantly projecting the same thing—"himself." Such a belief is rooted in an accurate perception; but it is a false interpretation of that perception. The stage actor does project a sense of holding back, of discipline and understanding, the influence of head over feelings, while the film actor projects effortlessness, nonchalance, immediacy, the seemingly unpremeditated response. Thus, when stage actors attack film actors, they attack in some puritanical way the lack of perceptible hard work, obvious professional craft, in the film actor's performance. Like many nonprofessionals in their audience, such stage actors assume that naïveté, spontaneity, "being yourself," are self-images that anyone in front of a camera can achieve. A frequent Actors Studio exercise, for example, is "Private Moment," in which the student is asked to act out before the group something he or she ordinarily does alone that would be very embarrassing if someone happened to see. Private self-indulgences and private games are thereby mined for their exposable, group potential. But the concentration of film, its ability to isolate the individual, makes every moment that way, and so the problem of the film actor may be to scale down intimacy rather than discover and exaggerate it.

How do we know the "themselves" film actors play except through the residue of their playing? How much do film actors, as opposed to stage actors, model their off-screen selves to continue or contrast with their screen images? To accuse an actor of "playing himself" implies that we have seen and compared the "real" and "false" selves of the actor and reached a conclusion. Film acting deposits a residual self that snowballs from film to film, creating an image with which the actor, the scriptwriter, and the director can play as they wish. Donald Richie has recorded that the Japanese director Yasujiro Ozu said: "I could no more write, not knowing who the actor was to be, than an artist could paint, not knowing what color he was using." Ozu's remark indicates how a director takes advantage of a previously developed image in order to create a better film. But the stage actor in a sense ceases to exist from play to play; we experience only the accumulation of his talent, his versatility. In our minds the stage actor stays within the architectures he has inhabited, while the film actor exists

in between as well, forever immediate to our minds and eyes, escaping the momentary enclosures that the individual films have placed around him.

"Playing yourself" involves one's interpretation of what is most successful and appealing in one's own nature and then heightening it. Film actors play their roles the way we play ourselves in the world. Audiences may now get sustenance from films and from film acting because they no longer are so interested in the social possibilities of the self that has been the metaphysic of stage acting since Shakespeare and the Renaissance, the place of role-playing in the life of the audience. The Shakespearean films of Laurence Olivier and Orson Welles clearly express the contrast. The tendency in stage acting is to subordinate oneself to the character, while the great film actor is generally more important than the character he plays. Our sense of Olivier, in his Shakespearean roles is one of distance and disguise: the purified patriotism of Henry V, in which all the play's negative hints about his character have been removed; the blond wig he uses to play Hamlet, so that, as he has said, no one will associate him with the part; the bent back, twisted fingers, and long black hair of Richard III. But Welles assimilates the roles to himself. Costume for Welles is less a disguise than a generation from within and so he presented it in various television appearances of the 1950s, gradually making up for his part while he explained the play to the audience, until he turned full face into the camera and spoke the lines. In theater we experience the gap between actor and role as expertise; in film it may be described as a kind of self-irony. The great stage actor combats the superiority of the text, its preexistence, by choosing his roles: Olivier will play Hamlet; Olivier will play a music-hall comic. The great film actor, assured that his image absorbs and makes real the script, may allow himself to be cast in unpromising roles, if only for visibility. In the audience we feel Welles's character to be part of his role, whereas we perceive not Olivier's character but his intelligence and his ability to immerse himself in a role. Olivier is putting on a great performance, but Welles feels superior enough to the Shakespearean text to cut, reorganize, and invent. Olivier is a great interpreter; Welles is an equal combatant. For both, Shakespeare is like a genre, similar to the western, that offers materials for a contemporary statement. But Olivier sticks closely to the language and form of the play itself. We judge Olivier finally by Shakespeare, but we judge Welles by other films. Both choose those Shakespearean plays that emphasize a central character. But Olivier's willingness to allow Shakespeare the last word frees him for the more assertive political roles, whereas Welles stays with the more domestic or even isolated figures of Macbeth and Othello. Olivier began his Shakespearean film career with the heroic self-confidence of Henry V, while Welles, at least for the moment, has ended his with Falstaff—the choice of the ironic imagination of film over the theatrical assertion of social power.

These distinctions between stage acting and film acting are, of course, not absolute but points on a slippery continuum. Marlon Brando's career, for example, is a constant conflict between his desire to be versatile—to do different kinds of films, use different accents, wear different costumes—and the demand of his audience that he elaborate his residual cinematic personality. Brando tries to get into his roles, and often sinks them in the process, while Cary Grant pumps them up like a balloon and watches them float off into the sky. The main trouble that Chaplin has in *A Countess from Hong Kong* (1967) is taking two actors (Brando and Sophia Loren), whose own

sense of their craft emphasizes naturalistic, historically defined character, and placing them within a film world where they would best exist as masks and stereotypes. Their efforts to ground their characters destroys the film. It may be funny if Chaplin or Cary Grant vomited out a porthole, but it's not funny when Brando does it. Brando can be funny in films only as a counterpoint to our sense of "Brando," for example in *Bedtime Story* (Ralph Levy, 1964). When he is acting someone else, the ironic sense of self-image that is natural to a film actor does not exist. We share Cary Grant's sense of distance from his roles, whether they are comic, melodramatic, or whatever, because it corresponds to our sense of personal distance from our daily roles in life. The sense of "putting it on" that we get from Brando's greatest roles—*A Streetcar Named Desire*, *Viva Zapata!*, *The Wild One*, *On the Waterfront*—stands in paradoxical relation to Method theories of submergence in the role. Brando's willingness to cooperate with Bernardo Bertolucci in the commentary on and mockery of his screen image that forms so much of the interest of *Last Tango in Paris* may indicate that he no longer holds to the theatrical definition of great acting. His progenitor role in *The Godfather* seems to have released him to create the paradox of the self-revealed inner life of a screen image elaborated by *Last Tango*. In the films of the 1970s, character, and therefore acting as well, has taken on the central importance in film. And the stage actor in film finds that his virtuosity is more a parlor trick than a technique of emotional and artistic power. Films make us fall in love with, admire, even hate human beings who may actually in the moment we watch them be dead and dust. But that is the grandeur of films as well: the preservation of human transience, the significance not so much of social roles as of fragile, fleeting feelings.

1976

# SERGEI EISENSTEIN
# DICKENS, GRIFFITH, AND OURSELVES
# [DICKENS, GRIFFITH, AND FILM TODAY]

. . . Griffith stood out as the most fascinating figure in this field. Because his works did not use cinema as a mere amusement or pastime but contained the rudiments of the art that, in the hands of a constellation of Soviet masters, was destined to cover Soviet film-making with undying glory in the pages of the history of world cinema, thanks to the novelty of the ideas, the unprecedented plots and the perfection of form in equal measure.

The intense curiosity about *construction* and *method* at that time soon identified the source of one of the most powerful influences of Griffith's pictures.

It was in the hitherto unfamiliar field that bears a name that we know of not from art, but from engineering and electronic equipment, and that appeared for the first time in the most progressive art—cinema.

This field, this method, this principle of construction and assembly was *montage*.

Montage, whose principles underlay American film culture, but which owed its full development, definitive interpretation and world recognition to our cinema.

Montage, which played a vital role in Griffith's works, and brought him his most glorious triumphs.

Griffith approached it through the device of parallel action and, essentially, he progressed no further, making it possible for film-makers from the other half of the globe, from another epoch and with a different class structure, to perfect the matter definitively.

But I am getting ahead of myself. Let us look at how montage came to Griffith—or Griffith came to montage.

Griffith came to it through the device of parallel action. But it was none other than Dickens who gave Griffith the idea of parallel action! . . .

What were Dickens' novels, for their time?

What were they for his readers?

There is one answer: the same as cinema is now for those same sections of the population.

They made the reader experience the same passions, making the same appeal to the good, the sentimental; like film, they made him shudder at vice, and provided the same escape from the humdrum, prosaic and everyday into something unaccustomed, unusual and fantastic. And at the same time it appears as nothing other than the everyday and prosaic.

And, illuminated by the reflection from the pages of novels to life, this ordinariness came to seem romantic, and the dull people of everyday life were grateful to the author for making them aware of potentially romantic figures.

Hence there was the same fascination for Dickens' novels as there is now for film. . . . And perhaps the secret is that what links Dickens to cinema is the astonishingly plastic quality of his novels. Their astonishing visual and optical quality.

Dickens' characters are just as plastically visible and ever so slightly exaggerated as the screen heroes of today.

These heroes deeply affect the viewers' emotions with their visible image: these villains are remembered for their twisted expressions, these heroes are invariably associated with that special, slightly unnatural shining gleam with which the screen lights them up.

Dickens' characters are just the same—that gallery of Pickwicks, Dombeys, Fagins, Tackletons and others that have been unerringly plastically captured and sketched with pitiless sharpness. . . .

You should not pursue analogies and similarities too far—they lose their conviction and charm and begin to sound contrived or garbled. I would hate it if my comparison between Dickens and Griffith were to lose its persuasiveness, by allowing this abundance of common features to slide into a game of anecdotal semblance between distinguishing features.

The more so as this examination of Dickens no longer concerns Griffith's skill as a film-maker, but has begun to touch on the craft of cinema in general.

But that is precisely why I have to dig more and more deeply into features of Dickens' cinema, using Griffith to show how instructive they were for future cinema.

So I shall expect indulgence if, when leafing through Dickens, I find 'dissolves'. How else can one term this description from *A Tale of Two Cities*?

> Along the Paris streets, the death-cars rumble, hollow and harsh. Six tumbrils carry the day's wine to La Guillotine . . .
>
> Six tumbrils roll along the streets. Change these back again to what they were, thou powerful enchanter, Time, and they shall be seen to be the carriages of absolute monarchs, the equipages of feudal nobles, the toilettes of flaring Jezebels, the churches that are not my Father's house but dens of thieves, the huts of millions of starving peasants!

How many such 'cinematic' surprises must be lurking in Dickens' pages!

But I shall gladly restrict myself to the chief constructs of montage which were shown crudely in Dickens' work, and later flourished as elements of film composition in Griffith's.

Let us take a peek under the curtains, at this rich and hitherto useful resource, by opening the first novel that comes to hand.

*Oliver Twist*, for example.

Let us open it at random. Suppose it is Chapter XXI.

We read the start:

# CHAPTER XXI*

1.

It was a cheerless morning when they got into the street; blowing and raining hard; and the clouds looking dull and stormy.

The night had been very wet: large pools of water had collected in the road: and the kennels were overflowing.

There was a faint glimmering of the coming day in the sky; but it rather aggravated then relieved the gloom of the scene: the sombre light only serving to pale that which the street lamps afforded, without shedding any warmer or brighter tints upon the wet housetops, and dreary streets.

There appeared to be nobody stirring in that part of the town; the windows of the houses were all closely shut; and the street through which they passed, were noiseless and empty.

2.

By the time they had turned into the Bethnal Green Road, the day had fairly begun to break. Many of the lamps were already extinguished;

a few country waggons were slowly toiling on, towards London;

now and then, a stage-coach, covered with mud, rattled briskly by;

the driver bestowing, as he passed, an admonitory lash upon the heavy waggoner who, by keeping on the wrong side of the road, had endangered his arriving at the office a quarter of a minute after his time.

The public-houses, with gas-lights burning inside, were already open.

By degrees, other shops began to be unclosed, and a few scattered people were met with.

Then, came straggling groups of labourers going to their work;

then, men and women with fish-baskets on their heads;

donkey-carts laden with vegetables;

chaise-carts filled with live-stock or whole carcasses of meat;

milk-women with pails;

an unbroken concourse of people, trudging out with various supplies to the eastern suburbs of the town.

3.

As they approached the City, the noise and traffic gradually increased;

when they threaded the streets between Shoreditch and Smithfield, it had swelled into a roar of sound and bustle.

It was as light as it was likely to be, till night came on again, and the busy morning of half the London population had begun . . .

4.

It was market-morning.

The ground was covered, nearly ankle-deep, with filth and mire;

a thick stream, perpetually rising from the reeking bodies of the cattle,

and mingling with the fog,

which seemed to rest upon the chimney-tops, hung heavily above . . .

---

*For purposes of clarity I have broken the beginning of this chapter into smaller fragments than did its author, and numbered them.

Countrymen,
butchers,
drovers,
hawkers,
boys,
thieves,
idlers,
and vagabonds of every low grade,
were mingled together in a mass;

5.
the whistling of drovers,
the barking of dogs,
the bellowing and plunging of oxen,
the bleating of sheep,
the grunting and squeaking of pigs,
the cries of hawkers,
the shouts, oaths, and quarrelling on all sides;
the ringing of bells
and roar of voices, that issued from every public-house;
the crowding, pushing, driving, beating,
whooping, and yelling;
the hideous and discordant din that resounded from every corner of the market;
and the unwashed, unshaven, squalid and dirty figures constantly running to and fro, and
bursting in and out of the throng; rendered it a stunning and bewildering scene, which
quite confounded the senses.

How often have we encountered this construction in Griffith's work!

Using a similarly strict development and acceleration of pace, with the same play
of light, from the burning street-lamps to those that are extinguished; from night to
dawn and from dawn to the brightness of full daylight ('It was light as it was likely
to be, till night came on again'); with its considered succession of purely visual ele-
ments interspliced with auditory ones, so that the initial indefinite rumble, echoing
from afar the gradual dawn, turns into a full-blooded road, and into constructions that
are purely auditory, and already concrete and objective (see section 5 of my break-
down), and with the same vignettes inserted *en passant*—like the coachman dashing
for the office before it opens; and finally, with the same amazingly typifying details,
such as the reeking bodies of the cattle, from which the steam rises and forms a com-
mon cloud with the morning fog, or the close-up of the foot that was 'nearly ankle-
deep, with filth and mire', conveying a complete picture of a market better than a
dozen pages of description could! . . .

If the examples cited above contain prototypes of the *montage expositions* that are
characteristic of Griffith, we have only to read *Oliver Twist* carefully to encounter
straight away another montage method typical of Griffith—*the montage progression
of parallel scenes, intercut*.

For this let me turn to the set of scenes in the famous episode where Mr Brownlow,
to show his faith in Oliver, chooses him to return books to the bookseller; and where
Oliver again falls prey to Sikes the burglar, his friend Nancy and old Fagin.

These scenes unfold in a way that is utterly Griffithian, both in their internal emo-
tional content and in the unusual way that the characters stand out—their delineation;
in the uncommon richness of their dramatic and comic features; and, finally, in the

typically Griffithian montage of parallel splicing of all the links between the separate episodes.

Let us look in particular detail at this last characteristic; it seems so unexpected in Dickens, and so typical of Griffith.

# CHAPTER XIV

*Comprising further Particulars of Oliver's Stay at Mr Brownlow's, with the remarkable Prediction which one Mr Grimwig uttered concerning him, when he went out on an Errand*

'Dear me, I am very sorry for that,' exclaimed Mr Brownlow; 'I particularly wished those books to be returned to-night.'

'Send Oliver with them,' said Mr Grimwig, with an ironical smile; 'he will be sure to deliver them safely, you know.'

'Yes; do let me take them, if you please, sir,' said Oliver. 'I'll run all the way, sir.'

The old gentleman was just going to say that Oliver should not go out on any account; when a most malicious cough from Mr Grimwig determined him that he should; and that, by his prompt discharge of the commission, he should prove to him the injustice of his suspicions: on this head at least: at once.

Oliver is prepared for his errand to the bookseller.

'I won't be ten minutes, sir,' replied Oliver, eagerly.

Mrs Bedwin, Mr Brownlow's housekeeper, gives Oliver directions and sends him off.

'Bless his sweet face!' said the old lady, looking after him. 'I can't bear, somehow, to let him go out of my sight.'

At this moment, Oliver looked gaily round, and nodded before he turned the corner. The old lady smilingly returned his salutation, and, closing the door, went back to her own room.

'Let me see; he'll be back in twenty minutes, at the longest,' said Mr Brownlow, pulling out his watch, and placing it on the table. 'It will be dark by that time.'

'Oh! you really expect him to come back, do you? inquired Mr Grimwig.

'Don't you?' asked Mr Brownlow, smiling.

The spirit of contradiction was strong in Mr Grimwig's breast, at the moment; and it was rendered stronger by his friend's confident smile.

'No,' he said, smiting the table with his fist, 'I do not. The boy has a new suit of clothes on his back, a set of valuable books under his arm, and a five-pound note in his pocket. He'll join his old friends the thieves, and laugh at you. If ever that boy returns, sir, I'll eat my head.'

With these words he drew his chair closer to the table; and there the two friends sat, in silent expectation, with the watch between them.

This is followed by a short 'insert' in the shape of a digression.

It is worthy of remark, as illustrating the importance we attach to our own judgments, and the pride with which we put forth our most rash and hasty conclusions, that, although Mr Grimwig was not by any means a bad-hearted man, and though he would have been unfeignedly sorry to see his respected friend duped and deceived, he really did most earnestly and strongly hope at that moment, that Oliver Twist might not come back.

And again a return to the two gentlemen:

> It grew so dark, that the figures on the dial-plate were scarcely discernible; but there the two old gentlemen continued to sit, in silence, with the watch between them.

The twilight tells us that a considerable period of time has elapsed; but the *close-up* of the watch, which has already been shown *twice* lying between the old gentlemen, tells us that a great deal of time has passed already. But then, at the same time as not only the two elderly gentlemen but also the kindly reader are drawn into the game of 'will he/won't he return', the worst apprehensions and the vague premonitions of the old lady are justified by the cut to a new scene—Chapter XV: 'Showing how very fond of Oliver Twist the merry old Jew and Miss Nancy were'. (This begins with a short scene in the public house between Sikes the bandit and his dog, old Fagin, and Miss Nancy, who was to spy out Oliver's place of residence.)

> 'You are on the scent, are you, Nancy?' inquired Sikes, proffering the glass.
> 'Yes I am, Bill,' replied the young lady, disposing of its contents; 'and tired enough of it I am, too . . .'

Then comes one of the best scenes in the whole book—at least, the scene which I remember best from childhood, together with the evil figure of Fagin: the scene in which Oliver, walking along with the books under his arm, is suddenly

> startled by a young woman screaming out very loud. 'Oh, my dear brother!' And he had hardly looked up, to see what the matter was, when he was stopped by having a pair of arms thrown tight around his neck.

With this polished manoeuvre, Nancy restores the desperately resisting Oliver—her 'prodigal brother'—to the bosom of Fagin's gang of thieves, while the whole street looks on in sympathy.

The same chapter finished with the now familiar montage phrase:

> The gas-lamps were lighted; Mrs Bedwin was waiting anxiously at the open door; the servant had run up the street twenty times to see if there were any traces of Oliver; and still the two old gentlemen sat, perseveringly, at the dark parlour, with the watch between them.

In Chapter XVI, Oliver has been reinstated in the thieves' den, and subjected to ridicule. Nancy rescues him from a beating:

> 'I won't stand by and see it done, Fagin,' cried the girl. 'You've got the boy and what more would you have?—Let him be—let him be—or I shall put that mark on some of you, that will bring me to the gallows before my time.'

(Incidentally, these sudden bursts of generosity from 'morally degraded' types are typical of both Dickens and Griffith and they unfailingly, if sentimentally, act upon even the most sceptical audiences and readers!)

At the end of the chapter, Oliver is in agonies, exhausted, and falls 'sound asleep'.

Here the physical unity of time is broken up—that evening and night are filled with events; but the montage unity of the episode that binds Oliver to Mr Brownlow, on the other hand, and Fagin's gang on the other, is not broken.

In Chapter XVII there follows the visit of the church beadle, Mr Bumble, responding to the announcement about the missing little boy, and Bumble's appearance at Mr Brownlow's, who is again in Grimwig's company.

The content and sense of their conversation is revealed by the chapter heading: 'Oliver's Destiny continuing unpropitious, brings a Great Man to London to injure His Reputation'.

> 'I fear it is all too true,' said the old gentleman sorrowfully, after looking over the papers, 'This is not much for your intelligence; but I would gladly have given you treble the money, if it had been favourable to the boy.'
>
> It is not improbable that if Mr Bumble had been possessed of this information at an earlier period of the interview, he might have imparted a very different colouring to his little history. It was too late to do it now, however; so he shook his head gravely, and, pocketing the five guineas, withdrew.
>
> Mr Brownlow paced the room to and fro for some minutes; evidently so much disturbed by the beadle's tale, that even Mr Grimwig forbore to vex him further.
>
> At length he stopped, and rang the bell violently.
>
> 'Mrs Bedwin,' said Mr Brownlow, when the housekeeper appeared; 'that boy, Oliver, is an impostor.'
>
> 'It can't be, sir. It cannot be.' said the old lady, energetically.
>
> 'I tell you he is,' retorted the old gentleman. 'What do you mean by can't be? We have just heard a full account of him from his birth; and he has been a thorough-paced little villain, all his life.'
>
> 'I never will believe it, sir,' replied the old lady, firmly. 'Never!'
>
> 'You old women never believe anything but quack-doctors, and lying story-books,' growled Mr Grimwig. 'I knew it all along. Why didn't you take my advice in the beginning; you would, if he hadn't had a fever, I suppose, eh! He was interesting, wasn't he? Interesting! Bah!' And Mr Grimwig poked the fire with a flourish.
>
> 'He was a dear, grateful, gentle child, sir,' retorted Mrs Bedwin, indignantly. 'I know what children are, sir; and have done these forty years; and people who can't say the same, shouldn't say anything about them. That's my opinion!'
>
> This was a hard hit at Mr Grimwig, who was a bachelor. As it extorted nothing from that gentleman but a smile, the old lady tossed her head, and smoothed down her apron preparatory to another speech, when she was stopped by Mr Brownlow.
>
> 'Silence!' said the old gentleman, feigning an anger he was far from feeling. 'Never let me hear the boy's name again. I rang to tell you that. Never. Never, on any pretence, mind! You may leave the room, Mrs Bedwin. Remember! I am in earnest.'

And the whole elaborate montage complex of the entire episode ends with the phrase: 'There were sad hearts at Mr Brownlow's that night.'

It is no accident that I have allowed myself to quote such detailed extracts, concerning not only the composition of the scene but also the delineation of the characters, for, in their very modelling, in their description and conduct, there is much that is typical of Griffith's style. This applies equally to his 'Dickensian' suffering, defenceless beings (think of Lillian Gish and Richard Barthelmess in *Broken Blossoms* or the Gish sisters in *Orphans of the Storm*) and to the characters of the two elderly gentlemen and Mrs Bedwin, who are no less typical of him; and finally to the cronies of Fagin—the merry old Jew—who was entirely characteristic of Griffith.[53]

With respect to our immediate task of analysing how Dickens organises the montage progression of the plot composition, the results may be set out in accordance with the following table:

1. *The elderly gentlemen.*
2. Oliver's departure.
3. *The elderly gentlemen and the watch. It is still light.*

4. Digression about Mr Grimwig's character.
5. *The elderly gentlemen and the watch. Gathering twilight.*
6. Fagin, Sikes and Nancy in the public house.
7. The street scene.
8. *The elderly gentlemen and the watch. The gas-lamps have been lit.*
9. Oliver is back with Fagin.
10. Digression at the beginning of Chapter XVII.
11. Mr Bumble's journey.
12. *The elderly gentlemen* and Mr Brownlow's instruction that Oliver be forgotten forever.

As we can see, we have before us a typical and, for Griffith, a model of the parallel montage of two storylines; the presence of one (the waiting gentlemen) emotionally heightens the suspense of the other (Oliver's misadventure)—which is dramatic enough as it is.

It is in the 'rescuers' who rush to save the 'damsel in distress' that Griffith earns his greatest laurels in the field of parallel montage!

But what is most curious is another 'insert' at the *very heart* of the episode we have chosen—a whole digression at the beginning of Chapter XVII which I have deliberately kept quiet about. Why is this digression noteworthy?

Because it is an idiosyncratic 'treatment' of the principles of that very same montage plot-construction, here executed so beautifully, that has passed from Dickens to Griffith.

Here it is:

It is the custom on the stage, in all good murderous melodramas, to present the tragic and the comic scenes, in as regular alternation, as the layers of red and white in a side of streaky bacon. The hero sinks upon his straw bed, weighed down by fetters and misfortunes; in the next scene, his faithful but unconscious squire regales the audience with a comic song. We behold, with throbbing bosoms, the heroine in the grasp of a proud and ruthless baron: her virtue and her life alike in danger, drawing forth her dagger to preserve the one at the cost of the other; and just as our expectations are wrought up to the highest pitch, a whistle is heard, and we are straightway transported to the great hall of the castle: where a grey-headed seneschal sings a funny chorus with a funnier body of vassals, who are free of all sorts of places, from church vaults to palaces, and roam about in company, carolling perpetually.

Such changes appear absurd; but they are not so unnatural as they would seem at first sight. The transitions in real life from well-spread boards to death-beds, and from mourning weeds to holiday garments, are not a whit less startling; only, there, we are busy actors, instead of passive lookers-on, which makes a vast difference. The actors in the mimic life of the theatre, are blind to violent transitions and abrupt impulses of passion or feeling, which, presented before the eyes of mere spectators, are at once condemned as outrageous and preposterous.

As sudden shiftings of the scene, and rapid changes of time and place, are not only sanctioned in books by long usage, but are by many considered as the greatest art of authorship: an author's skill in his craft being, by such critics, chiefly estimated with relation to the dilemmas in which he leaves his characters at the end of every chapter: this brief introduction to the present one may perhaps be deemed unnecessary.

There is something else of interest in this quoted 'treatment': we have, in his own words, a description of Dickens' direct link with theatrical melodrama.

Dickens hereby seems to establish himself as the connecting link between the future art of cinema, which could not have been guessed at, and the recent (for Dickens) past—the traditions of 'good murderous melodramas'.

The patriarch of American cinema could not have failed to notice this 'treatment', and his works often seem to rehearse the wise advice handed down to the twentieth-century film-maker by the great nineteenth-century novelist. Griffith is right not to conceal this, but to pay Dickens' memory a fitting homage.

Griffith used a similar construction on screen for the first time in the film *After Many Years* (a screen adaptation of Tennyson's *Enoch Arden*, 1908).

This film is also famous because the close-up was applied *meaningfully*, and *utilised*, for the first time.

These were the first close-ups in America since Edwin Porter's celebrated *The Great Train Robbery* [USA, 1903], produced five years earlier, which had one close-up at the most, and that was used for purely sensational effect: the criminal was shown shooting point-blank into the auditorium! . . .

I do not know about the reader, but I have always derived comfort from repeatedly telling myself that our cinema is not entirely without an ancestry and a pedigree, a past and traditions, or a rich cultural heritage from earlier epochs. Only very thoughtless or arrogant people could construct laws and aesthetic for cinema based on the dubious assumptions that this art came out of thin air!

Let Dickens and the whole constellation of ancestors, who go as far back as Shakespeare or the Greeks, serve as superfluous reminders that Griffith and our cinema alike cannot claim originality for themselves, but have a vast cultural heritage; and this causes neither one any difficulty in advancing the great art of cinema, each at their moment of world history. Let this heritage serve as a reproach to these thoughtless people with their excessive arrogance towards literature, which has contributed so much to this apparently unprecedented art, and most important, to the art of viewing—and I mean *viewing*, in both the senses of this term—not *seeing*.

1942

# SEYMOUR CHATMAN
## WHAT NOVELS CAN DO THAT
## FILMS CAN'T (AND VICE VERSA)

The study of narrative has become so popular that the French have honored it with a term—*la narratologie*. Given the escalating and sophisticated literature on the subject, its English counterpart, "narratology," may not be as risible as it sounds. Modern narratology combines two powerful intellectual trends: the Anglo-American inheritance of Henry James, Percy Lubbock, E. M. Forster, and Wayne Booth; and the mingling of Russian formalist (Viktor Shklovsky, Boris Eichenbaum, Roman Jakobson, and Vladimir Propp) with French structuralist approaches (Claude Lévi-Strauss, Roland Barthes, Gérard Genette, and Tzvetan Todorov). It's not accidental that narratology has developed during a period in which linguistics and cinema theory have also flourished. Linguistics, of course, is one basis for the field now called semiotics—the study of all meaning systems, not only natural language. Another basis is the work of the philosopher Charles S. Peirce and his continuator, Charles W. Morris. These trees have borne elegant fruit: we read fascinating semiotic analyses of facial communication, body language, fashion, the circus, architecture, and gastronomy. The most vigorous, if controversial, branch of cinema studies, the work of Christian Metz, is also semiotically based.

One of the most important observations to come out of narratology is that narrative itself is a deep structure quite independent of its medium. In other words, narrative is basically a kind of text organization, and that organization, that schema, needs to be actualized: in written words, as in stories and novels; in spoken words combined with the movements of actors imitating characters against sets which imitate places, as in plays and films; in drawings; in comic strips; in dance movements, as in narrative ballet and in mime; and even in music, at least in program music of the order of *Till Eulenspiegel* and *Peter and the Wolf*.

A salient property of narrative is double time structuring. That is, all narratives, in whatever medium, combine the time sequence of plot events, the time of the *histoire*

445

("story-time") with the time of the presentation of those events in the text, which we call "discourse-time." What is fundamental to narrative, regardless of medium, is that these two time orders are independent. In realistic narratives, the time of the story is fixed, following the ordinary course of a life: a person is born, grows from childhood to maturity and old age, and then dies. But the discourse-time order may be completely different: it may start with the person's deathbed, then "flashback" to childhood; or it may start with childhood, "flashforward" to death, then end with adult life. This independence of discourse-time is precisely and only possible because of the subsumed story-time. Now of course *all* texts pass through time: it takes x number of hours to read an essay, a legal brief, or a sermon. But the internal structures of these non-narrative texts are not temporal but logical, so that their discourse-time is irrelevant, just as the viewing time of a painting is irrelevant. We may spend half an hour in front of a Titian, but the aesthetic effect is as if we were taking in the whole painting at a glance. In narratives, on the other hand, the dual time orders function independently. This is true in any medium: flashbacks are just as possible in ballet or mime or opera as they are in a film or novel. Thus, in theory at least, any narrative can be actualized by any medium which can communicate the two time orders.

Narratologists immediately observed an important consequence of this property of narrative texts, namely, the translatability of a given narrative from one medium to another: *Cinderella* as verbal tale, as ballet, as opera, as film, as comic strip, as pantomime, and so on. This observation was so interesting, so much in keeping with structuralist theory, and so productive of further work in narrative analysis that it tended to concentrate attention exclusively on the constancies in narrative structure across the different media at the expense of interesting differences. But now the study of narrative has reached a point where the differences can emerge as objects of independent interest.

In the course of studying and teaching film, I have been struck by the sorts of changes typically introduced by screen adaptation (and vice versa in that strange new process "novelization," which transforms already exhibited films into novels). Close study of film and novel versions of the same narrative reveals with great clarity the peculiar powers of the two media. Once we grasp those peculiarities, the reasons for the differences in form, content, and impact of the two versions strikingly emerge. Many features of these narratives could be chosen for comparison, but I will limit myself to only two: description and point of view.

Critics have long recognized that descriptive passages in novels are different somehow in textual *kind* from the narrative proper. They have spoken of "blocks" or "islands" or "chunks" of description in early fiction and have noted that modern novels shy away from blatantly purple descriptive passages. Joseph Conrad and Ford Madox Ford formulated theories of what they called "distributed" exposition and description, in which the described elements were insinuated, so to speak, into the running narrative line. What has not emerged very clearly until recently, however, is a genuine theoretical explanation of novelistic description. The emphasis has been on the pictorial, the imaged. We read in typical handbooks like Thrall and Hibbard: "Description . . . has as its purpose the picturing of a scene or setting." But that is only part of the story; such a definition eliminates *inter alia* the description of an abstract state of affairs, or of a character's mental posture, or, indeed, of anything not strictly

visual or visualizable. Narratologists argue that a more correct and comprehensive account of description rests on temporal structure. As we have already noted, narrative proper requires a double and independent time ordering, that of the time line of the story and that of the time line of the discourse. Now what happens in description is that the time line of the story is interrupted and frozen. Events are stopped, though our reading or discourse-time continues, and we look at the characters and the setting elements as at a *tableau vivant*.

As an example of this process, consider a bit of the short story which underlies a film by Jean Renoir, Maupassant's "Une Partie de campagne" [A Country Excursion].* The story opens with a summary of events which clearly establishes story-time: "For five months they had been talking of going to lunch at some country restaurant. . . . They had risen very early that morning. Monsieur Dufour had borrowed the milkman's cart, and drove himself [on avait projeté depuis cinq mois d'aller déjeuner aux environs de Paris. . . . Aussi . . . s'était-on levé de fort bonne heure ce matin-là. M. Dufour, ayant emprunté la voiture du latier, conduisait lui-même]" (p. 63). There are three events, and, as we note from the use of the past perfect with "had," they predate the opening moment of the story proper, the moment of story-now, so to speak, which is the moment named by the expression "and drove himself." The story proper begins with the family *en voyage*, already in the midst of their excursion. The story sequence is *naturally* ordered: at some point in that past before the story proper began, someone first mentioned going to lunch in the country (let's call that event A); the family continued this discussion, thus event A was iterated (let's call that A sub-n since we don't know how many times the topic came up during those five months); next, Monsieur Dufour borrowed the milkman's cart, presumably the Saturday night before the trip (event B); then they arose early on Sunday morning (event C); and finally, here they are, driving along the road (event D). Notice, incidentally, the disparity between the story order and discourse order: story order is A, B, C, D; discourse order is A, C, B, D.

This first sentence, then, is straight narration which takes us out of the expository past into the narrative present. Now the very next sentence is clearly of a different order: ". . . it [the cart] had a roof supported by four iron posts to which were attached curtains, which had been raised so that they could see the countryside [. . . elle avait un toit supporté par quatre montants de fer où s'attachaient les rideaux qu'on avait relevés pour voir le paysage]" (p. 63). This is, of course, unadulterated description. Story-time stops as the narrator characterizes a story object, a prop. The sentence reflects the static character of the passage. The verb "to have" is clearly equivalent to the typical copula of description: it is not a verb of action and communicates no sense of an event but simply evokes the quality of an object or state of affairs. Maupassant could have—and more recent writers probably would have—avoided direct description by writing something like "The cart, its roof supported by four iron posts, rolled merrily down the road." This active syntax would have kept story-time going and would have eased in the characterization of the cart. Maupassant's prose provokes, rather, the start-and-stop effect customary to early fiction, a fashion now somewhat

---

*Guy de Maupassant, "Une Partie de campagne," *Boule de Suif* (Paris, n.d.), pp. 63–78; all further references will be cited parenthetically in the text; my translations.

dated. Not that the surface verb, the verb in the actual verbal medium, *needs* to be the copula "to be." It could be a perfectly active verb in the strict grammatical sense and still evoke the descriptive copula at the deep narrative level, as in the sentence that immediately follows: "The curtain at the back . . . fluttered in the breeze like a flag [celui de derrière, seul, flottait au vent, comme un drapeau]." "Fluttered" is an active verb, but from the textual point of view, the sentence is pure description; it is not tied into the event chain. The sentence could as easily be phrased, "In the back there *was* a curtain fluttering in the breeze like a flag."

The paragraph continues with a brief description of Mme Dufour and makes references to the grandmother, to Henriette, and to a yellow-haired youth who later becomes Henriette's husband. Paragraphs immediately thereafter continue the narrative by citing events: the passing of the fortifications at Porte Maillot; the reaching of the bridge of Neuilly; the pronouncement by M. Dufour that at last they have reached the country, and so on.

Let's consider the opening scene of Jean Renoir's 1936 film version of this story, also entitled *Une Partie de campagne*. (Ideally, you would watch the film as you read this essay, but something of the effect, I hope, can be communicated by the following illustrations.) The whole sequence introducing the Dufours takes only a minute of viewing time, so we don't have much time to remark on the details of their borrowed cart. But looking at a single frame enables us to examine it at our leisure (fig. 1).

We note, for instance, that the cart is absurdly small, has only two wheels, bears the name of the owner, "Ch. Gervais," painted on the side, and has a railing on the roof. There is no flapping curtain at the back but instead some kind of sun shield, and so on. Now these details are apparently of the same order as those in the story— remember the reference to the roof, the four iron posts, and the rolled up curtains. But there are some vital differences. For one thing, the number of details in Maupassant's sentence is limited to three. In other words, the selection among the possible number of details evoked was absolutely determined: the author, through his narrator, "selected" and named precisely three. Thus the reader learns only those three and can only expand the picture imaginatively. But in the film representation, the number of details is indeterminate, since what this version gives us is a simulacrum of a French carriage of a certain era, provenance, and so on. Thus the number of details that we could note is potentially large, even vast. In practice, however, we do not register many details. The film is going by too fast, and we are too preoccupied with the meaning of this cart, with what is going to happen next, to dwell upon its physical details. We simply label: we say to ourselves, "Aha, a cart with some people in it." We react that way because of a technical property of film texts: the details are not asserted as such by a narrator but simply presented, so we tend, in a pragmatic way, to contemplate only those that seem salient to the plot as it unrolls in our minds (in what Roland Barthes calls a "hermeneutic" inquiry). Now if you think about it, this is a rather odd aesthetic situation. Film narrative possesses a plenitude of visual details, an excessive particularity compared to the verbal version, a plenitude aptly called by certain aestheticians visual "over-specification" *überbestimmtheit*), a property that it shares, of course, with the other visual arts. But unlike those arts, unlike painting or sculpture, narrative films do not usually allow us time to dwell on plenteous details.

Pressure from the narrative component is too great. Events move too fast. The contemplation of beautiful framing or color or lighting is a pleasure limited to those who can see the film many times or who are fortunate enough to have access to equipment which will allow them to stop the frame. But watching a movie under normal circumstances in a cinema is not at all like being in a gallery or art museum. The management wants us up and out of the theater so that the 10:30 patrons can take our seats. And even sophisticated moviegoers who call a film "beautiful" are more likely to be referring to literary than to visual components. Indeed, there are movies (like Terence Malick's recent *Days of Heaven*) which are criticized because their visual effects are too striking for the narrative line to support. Narrative pressure is so great that the interpretation of even non-narrative films is sometimes affected by it—at least for a time, until the audience gets its bearings. For example, there is a film which presents a sequence of frozen frames, on the basis of which the audience is prompted to construct a story. Then, after the last frame, the camera pulls away to reveal that the frames were all merely part of a collage of photographs organized randomly. This last shot "denarrativizes" the film.

Narrative pressure similarly affects the genre of film that André Bazin writes about in his essay "Painting and Cinema," the kind in which the camera moves around close-up details of a single painting. An example of this genre is Alain Resnais' film on Picasso's *Guernica*. No less a personage than the Inspector General of Drawing of the French Department of Education complained: "However you look at it the film is not true to the painting. Its dramatic and logical unity establishes relationships that are chronologically false." The inspector was speaking about the relationships and chronology in the implied narrative of Picasso's development as an artist, but he might as well have been speaking of the relationships and chronology implicit in a narrative hypothecated on the visual deaths of *Guernica* itself. By controlling the viewer's order and duration of perceiving, a film scanning a painting might imply the double time structure of narrative texts. For example, if the camera wandering over *Guernica* were first focused on the head and lantern-bearing arm sweeping in through the window, then shifted to the screaming horse, then to the body on the ground with the broken sword and flower in its hand, the audience might read into the painting a story sequence which Picasso did not intend: first the alarm was heard, then the horse whinnied as the bombs fell, then one victim died.

The key word in my account of the different ways that visual details are presented by novels and films is "assert." I wish to communicate by that word the force it has in ordinary rhetoric: an "assertion" is a statement, usually an independent sentence or clause, that something is in fact the case, that it is a certain sort of thing, that it does in fact have certain properties or enter into certain relations, namely, those listed. Opposed to asserting there is mere "naming." When I say, "The cart was tiny; it came onto the bridge," I am asserting that certain property of the cart of being small in size and that certain relation of arriving at the bridge. However, when I say "The green cart came onto the bridge," I am asserting nothing more than its arrival at the bridge; the greenness of the cart is not asserted but slipped in without syntactic fuss. It is only named. Textually, it emerges by the way. Now, most film narratives seem to be of the latter textual order: it requires special effort for films to assert a property or relation. The dominant mode is presentational, not assertive. A film doesn't say, "This *is* the

state of affairs," it merely shows you that state of affairs. Of course, there could be a character or a voice-over commentator asserting a property or relation; but then the film would be using its sound track in much the same way as fiction uses assertive syntax. It is not cinematic description but merely description by literary assertion transferred to film. Filmmakers and critics traditionally show disdain for verbal commentary because it explicates what, they feel, should be implicated visually. So in its essential visual mode, film does not describe at all but merely presents; or better, it *depicts*, in the original etymological sense of that word: renders in pictorial form. I don't think that this is mere purism or a die-hard adherence to silent films. Film attracts that component of our perceptual apparatus which we tend to favor over the other senses. Seeing is, after all, believing.

That the camera depicts but does not describe seems confirmed by a term often used by literary critics to characterize neutral, "non-narrated" Hemingwayesque fiction—the *camera eye* style. The implication of "camera eye" is that no one recounts the events of, for example, "The Killers": they are just *revealed*, as if some instrument—some cross between a video tape recorder and speech synthesizer—had recorded visually and then translated those visuals into the most neutral kind of language.

Now, someone might counterargue: "You're forgetting obvious cinematic devices whose intention is arguably descriptive. What about the telling close-up? What about establishing shots?" But the close-ups that come immediately to mind seem introduced for plot unraveling, for hermeneutic purposes. Think of Hitchcock's famous close-ups: the villain's amputated little finger in *The Thirty-Nine Steps*; the poisoned coffee cup in *Notorious*; Janet Leigh's horribly open eye in the bloody shower in *Psycho*. For all their capacity to arrest our attention, these close-ups in no way invite aesthetic contemplation; on the contrary, they function as extremely powerful components in the structure of the suspense. They present, in the most dramatic fashion, that abiding narrative—hermeneutic question: "My God," they cry out, "what next?" Of course, a real description in a novel may also serve to build suspense. We curse Dickens for stopping the action at a critical moment to describe something. "Keep still," shouts the sudden, terrifying figure to Pip at the beginning of *Great Expectations*, "or I'll cut your throat." And then, as we dangle in suspense, a whole paragraph describes the man: the iron on his leg, his broken shoes, the rag tied around his head, and so on. Yes, we curse Dickens—and love every second of it. But in the movie version, the sense of continuing action could not stop. Even if there were a long pause to give us a chance to take in the fearsome details of Magwitch's person, we would still feel that the clock of story-time was ticking away, that that pause was *included* in the story and not just an interval as we perused the discourse. We might very well infer that the delay means something, perhaps that Magwitch was trying to decide what to do with Pip, or, in a supersophisticated "psychological" version, that Pip's own time scale had somehow been stretched out because of his great terror. In either case, the feeling that we were sharing time passage with a character would be a sure clue that not only our discourse-time but their story-time was continuing to roll. And if it is the case that story-time necessarily continues to roll in films, and if description entails precisely the arrest of story-time, then it is reasonable to argue that films do not and cannot describe.

Then what about establishing shots? An establishing shot, if you're not up on movie jargon, is defined as follows (in Ernest Lindgren's *The Art of the Film*): "A long shot introduced at the beginning of a scene to establish the interrelationship of details to be shown subsequently in nearer shots." Standard examples are the bird's-eye shots that open *The Lady Vanishes* and *Psycho*. In *The Lady Vanishes*, the camera starts high above a Swiss ski resort, then moves down, and in the next shot we're inside the crowded hotel; in *Psycho*, the camera starts high above Phoenix, then glides down into a room where a couple are making love. It is true that both of these shots are in a certain sense descriptive or at least evocative of place; but they seem to enjoy that status only because they occur at the very beginning of the films, that is to say, before any characters have been introduced. Now narrative in its usual definition is a causal chain of events, and since "narrative event" means an "action performed by or at least of some relevance to a character," we can see why precisely the absence of characters endows establishing shots with a descriptive quality. It is not that story-time has been arrested. It is just that it has not yet begun. For when the same kind of shot occurs in the middle of a film, it does not seem to entail an arrest or abeyance of story-time. For example, recall the scene in the middle of *Notorious* just at the moment when Cary Grant and Ingrid Bergman are flying into Rio de Janeiro. We see shots of the city from the air, typical street scenes, and so on. Yet our sense is not of a hiatus in the story-time but rather that Rio is down there waiting for Cary and Ingrid to arrive. All that street activity is felt to be transpiring while the two go about their business, the business of the plot, which because of its momentarily mundane character—landing, clearing customs, and so on—is allowed to happen off screen.

Even the literal arrest of the picture, the so-called freeze-frame, where the image is reduced to a projected still photograph, does not automatically convey a description. It was popular a dozen years ago to end films that way, *in medias res*. Remember how Truffaut's young hero Antoine Doinel was frozen on the beach in *The Four Hundred Blows*? Truffaut has continued to follow the Doinel character in an interesting way, as the actor Jean-Pierre Léaud has himself aged, but I for one had no idea when I originally saw *The Four Hundred Blows* that there would be sequels; for me the sense of the frozen ending was that Doinel was trapped in a fugitive way of life. I perceived not a description but a kind of congealed iteration of future behavior.

Why is it that the force of plot, with its ongoing march of events, its ticking away of story-time, is so hard to dispel in the movies? That's an interesting question, but a psychologist or psychologically oriented aesthetician will have to answer it. I can only hazard a guess. The answer may have something to do with the medium itself. Whereas in novels, movements and hence events are at best constructions imaged by the reader out of words, that is, abstract symbols which are different from them in kind, the movements on the screen are so iconic, so like the real life movements they imitate, that the illusion of time passage simply cannot be divorced from them. Once that illusory story-time is established in a film, even dead moments, moments when nothing moves, will be felt to be part of the temporal whole, just as the taxi meter continues to run as we sit fidgeting in a traffic jam.

Let's try these ideas out on a longer and more challenging passage of Maupassant's story, the third paragraph:

[1] Mademoiselle Dufour was trying to swing herself standing up, but she could not suc-
ceed in getting a start. [2] She was a pretty girl of about eighteen; [3] one of those women
who suddenly excite your desire when you meet them in the street, and who leave you
with a vague feeling of uneasiness and of excited senses. [4] She was tall, had a small
waist and large hips, with a dark skin, very large eyes, and very black hair. [5] Her dress
clearly marked the outlines of her firm, full figure, which was accentuated by the motion
of her hips as she tried to swing herself higher. [6] Her arms were stretched over her head
to hold the rope, so that her bosom rose at every movement she made. Her hat, which a
gust of wind had blown off, was hanging behind her, [7] and as the swing gradually rose
higher and higher, she showed her delicate limbs up to the knees at each time. . . . [p. 66]*

The first narrative unit, "Mademoiselle Dufour was trying to swing herself" and so
on, refers to an event. The second, "She was a pretty girl of about eighteen," seems
on the face of it a straightforward description; but look at it from the point of view of
a filmmaker. For one thing, "pretty" is not only descriptive but evaluative: one per-
son's "pretty" may be another person's "beautiful" and still a third person's "plain."
There will be some interesting variations in the faces selected by directors across cul-
tures and even across time periods: Mary Pickford might be just the face for the teens
and twenties, while Tuesday Weld may best represent the sixties. Renoir chose the
face of Sylvie Bataille. The interesting theoretical point to be made about evaluative
descriptions in verbal narrative is that they can invoke visual elaboration in the
reader's mind. If he or she requires one, each reader will provide just the mental
image to suit his or her own notions of prettiness. But the best a film (or theater) direc-
tor can hope for is some degree of consensus with the spectator's ideal of prettiness.
Even with the luckiest choice, some patrons will mutter, "I didn't think she was pretty
at all." A similar point could be made about age; Sylvie Bataille's Henriette seems
closer to thirty than eighteen, but that may be because of the costume she's wearing.
The more serious point is that visual appearance is only a rough sign of age. Again
the author's task is easier: correct attribution can be insured by simply naming the
attribute. The filmmaker, on the other hand, has to depend on the audience's agree-
ment to the justice of the visual clues.

Still another point to be made about this piece of description concerns the word
"about" and the whole of the next descriptive bit in the third unit. These not only
refine and add to the description but also make salient the voice of a narrator. "*About*
eighteen" stresses that the narrator himself is guessing. And, "one of those women
who suddenly excite your desire" tells us even more: the narrator is a man respon-
sive to female charms, perhaps a *roué*, at least a man-about-town. Such is the char-
acter of speech: it usually tells us something about the speaker. Long ago I. A.
Richards labeled this function "tone." The camera, poor thing, is powerless to invoke
tone, though it can present some alternatives to it. In this case, as we shall see,

---

*"Mlle Dufour essayait de se balancer debout, toute seule, sans parvenir à se donner un élan suffisant.
C'était une belle fille de dix-huit à vingt ans; une de ces femmes dont la rencontre dans la rue vous fouette
d'un désir subit, et vous laisse jusqu'à la nuit une inquiétude vague et un soulèvement des sens. Grande,
mince de taille et large des hanches, elle avait la peau très brune, les yeux très grands, les cheveux très
noirs. Sa robe dessinait nettement les plénitudes fermes de sa chair qu'accentuaient encore les efforts des
reins qu'elle faisait pour s'enlever. Ses bras tendus tenaient les cordes au-dessus de sa tête, de sorte que sa
poitrine se dressait, sans une secousse, à chaque impulsion qu'elle donnait. Son chapeau, emporté par un
coup de vent, était tombé derrière elle; et l'escarpolette peu à peu se lançait, montrant à chaque retour ses
jambes fines jusqu'au genou. . . ."

Renoir's sense of the need to show Henriette's innocent seductiveness seems to have prompted several amusing reaction shots which compensate for the camera's sexless objectivity.

The adjectives in our fourth segment are easier for film to handle: height, girth, skin, and hair color are features that film can communicate reliably. (The communication, of course, is always comparative, scalar: a character is tall relative to other people and objects in the film.) The motion of her hips bears a double function: the movement itself is an event, but it also contributes to the description of a part of Henriette's anatomy that the narrator finds quite absorbing. The same double role is played by the bosom and falling hat in segment six. As movements, these of course are simple for the film to convey; Henriette's voluptuousness, however, is not asserted but only suggestively depicted.

In the seventh segment, an odd ambiguity is introduced. The text says that as the swing rose, "she showed her delicate limbs up to the knees [montrant à chaque retour ses jambes fines jusqu'au genou]." The camera is certainly capable of presenting the requisite portion of anatomy. But what about the implications of "showed"? In both story and film, Henriette is generally represented as innocent; conscious exhibitionism does not go with her character, her family situation, or the times. The answer is perhaps an equivoque on the verb "to show": the definition of that word neither excludes nor includes conscious intention. And it is precisely an ambiguity that would go with the coquetry of a nineteenth-century maiden: to show but not *necessarily* to be conscious of showing. The camera, again, would seem unable to translate that verbal innuendo.

But see what Renoir makes of this problem. He elects to present Henriette first from the point of view of one of the two young boat men—not Henri, who is later to fall in love with her, but his comrade, Rodolphe. The term "point of view" means several things, but here I am using it in the strictly perceptual sense. Because the camera is behind Rodolphe's back as he looks out onto the garden through the window he's just opened, the camera, and hence the narrative point of view, identifies with him. It conspires, and invites us to conspire, with his voyeurism. Point of view is a complex matter worthy of a whole other discussion, but one theoretical observation is worth making here. The fact that most novels and short stories come to us through the voice of a narrator gives authors a greater range and flexibility than filmmakers. For one thing, the visual point of view in a film is always *there*: it is fixed and determinate precisely because the camera always need to be placed *somewhere*. But in verbal fiction, the narrator may or may not give us a visual bearing. He may let us peer over a character's shoulder, or he may represent something from a generalized perspective, commenting indifferently on the front, sides, and back of the object, disregarding how it is possible to see all these parts in the same glance. He doesn't have to account for his physical position at all. Further, he can enter solid bodies and tell what things are like inside, and so on. In the present case, Maupassant's narrator gives us a largely frontal view of Henriette on the swing, but he also casually makes observations about her posterior. And, of course, he could as easily have described the secret contents of her heart. The filmmaker, with his bulky camera, lights, tracks, and other machinery, suffers restrictions. But the very limitations, as Rudolf Arnheim has shown so eloquently, encourage interesting artistic solutions. Renoir uses precisely the camera's

need for placement to engage the problem of communicating the innocent yet seductive quality of Henriette's charms. Since seductiveness, like beauty, is in the eye of a beholder, Renoir requisitions Rodolphe's point of view to convey it. It is not Henriette so much as Rodolphe's reaction to Henriette, even on first seeing her, that shall establish her seductiveness and not only in his mind but in ours, because we cannot help but look on with him. Small plot changes help to make the scene plausible. Henri, disgusted with the Parisians invading his fishing sanctuary, does not even care to see what this latest horde looks like. It is Rodolphe who opens the window, flooding sunlight into the gloomy dining room and making a little stage in the deep background against which Henriette and her mother move like cute white puppets (fig. 2).

At this range, we can't see anything very clearly except the waving of Henriette's skirt in the wind, but the way that Rodolphe lowers his back and settles his body clearly communicates his intention to gaze, and we become his accomplices. After all, what is a stage except a space to gaze at? (Renoir often used stagelike frames in his films to suggest several planes of action; one of his more delightful later films is called *Le Petit Théâtre de Jean Renoir*.) Notice that the swing is so placed that Henriette's to-and-fro movement is toward Rodolphe's window, quite as if she were performing for him, although, of course, she is quite innocent of his existence. Here we begin to get something equivalent to the ambiguity of the word "show" that we found in the story: Henriette will display herself without being aware of it, she will reveal, yet *malgré elle*. And as if clearly to establish her innocence in the matter, Renoir's next shot (fig. 3) is very different: it is a homely, mundane view of her *en famille*, the black figure of her granny on the right and her father and fiancé, Anatole, talking to each other on the left. This is followed by a discussion with the *patron* M. Poulain (played by Renoir himself) about what and where to eat. The whole effect of this shot is to background Henriette, to make her again just a bourgeois daughter and not the inducer of vague feelings of uneasiness and excited senses.

There follows a shot of Henriette's joyous face (fig. 4). The shot is from below, and it wonderfully communicates her lightheartedness and euphoria at being aloft. Suddenly we are very much identified with Henriette's feelings: Rodolphe's voyeurism is forgotten. This identification also entails "point of view" but now in a transferred or even metaphorical sense of the term: it is not Henriette's perceptual point of view that the camera identifies with, since she is looking toward it. Rather, her movements and the infectious joy on her face incite us to share her emotional point of view; we empathize with her. For this effect I offer the term "interest" point of view.* We become identified with the fate of a character, and even if we don't see things or even think about them from his or her literal perspective, it still makes sense to say that we share the character's point of view. Renoir brilliantly communicates the effect by swaying the camera to and fro in rhythm with the to-and-fro motions of the swing.

The contrast with the banalities of the previous and following shots enhances the difference between the buoyant fresh girl, a product of nature, and the ponderous and torpid family, especially the father, who seems rooted to the ground by his heavy black jacket, absurd tie, and gross belly bulging out of checkered trousers (fig. 5). It would be ludicrous to see such a man swinging aloft among the trees. The mother is in a middle position: though a woman of some beauty, she has become too heavy and

---

*See my *Story and Discourse: Narrative Structure in Fiction and Film* (Ithaca, N.Y. and London, 1978).

maladroit to get her swing going on her own. She has lost the young girl's powers to
fly, though she still has inclinations (which she later ends up showing in a delicious
bacchanal with Rodolphe).

Now we get one of my favorite shots in the film (fig. 6). It starts out as another and
rather uninteresting view of mother and daughter on the swings. But then there is a
long pan over the apparently empty space of the garden, past granny and some trees.
Suddenly, completely unexpected figures appear—a column of young seminarians
shepherded by their teachers. Heads are down until one of them spots Henriette and
alerts his friend (fig. 7). Momentarily we're in their perceptual point of view, watch-
ing Henriette from their angle and distance. The shepherd prods the black sheep to
cast his eyes down again to avoid the sins of the flesh but manages to sneak a glance
of his own (fig. 8). There follows another shot of exhilarated Henriette, enjoying her
swing and totally oblivious to this new set of eyes watching her. To clinch the point,
Renoir then points the camera at a third set of voyeurs (fig. 9), five precocious boys
behind a hedge who exchange knowing glances. Another shot to and fro of Henriette
swinging up and down, and we cut back to the boat men, but now seen from *outside*
their window (fig. 10). By this time, Henriette's innocent movements have been
clearly established as the provocation for Rodolphe's libidinous thoughts.

Rodolphe's voyeurism becomes explicit in an intercut sequence. First there is a
shot of Henriette from Rodolphe's angle and distance; the comment in the subtitle,
"Wonderful invention—swings!," is, of course, Rodolphe's (fig. 11). The distance
preserves the illusion that it is through Rodolphe's vantage that we see Henriette. She
unconsciously grants his wish that she sit down so that he can see her legs better (fig.
12). So the camera moves in for a closer view (fig. 13), as if Rodolphe's erotic imag-
ination has given him extra optical magnification. We are carried along and risk being
implicated further in his gaze at that wondrous flurry of petticoats, though Henri com-
ments that nothing really can be seen. At this flourish, Rodolphe is shown in an amus-
ing reaction close-up, stroking his mustache and looking rather sheepish (fig. 14).

So even though Renoir had no direct way of communicating the ambivalences in
the expression "showed her legs," he created a sequence in which it can be argued that
Henriette is at once innocent and seductive. The sequence is a little masterpiece of
reaction editing, not only communicating the essential plot information but also pro-
viding a light commentary on French mores and the joys of youth and life, on the
birth, amid sunshine and trees, of the sexual impulse. But notice that the sequence
illustrates the point I was trying to make at the outset. No member of the audience
will formulate in so many words that Henriette was tall, had a small waist and large
hips, and so on. We may have a profound sense of Henriette's presence as incarnated
by Sylvie Bataille but not of the *assertion* of those details as such. The erotic effect
of her appearance explicitly described by the narrator of Maupassant's story is only
implicitly depicted in the film by the reaction shots. Something of her appeal is
caught by the looks on the faces of four ages of gazing men—the pubescent peekers
in the hedge, the seminarians, Rodolphe, and the older priest leading his students.

One final difference between the film and the story: the features of Henriette's
appearance that Maupassant's narrator asserts are given an order. First he mentions her
height, then her shape, her skin, eyes, hair, then her shape again, her arms, her bosom,
her hat, and finally her legs. The order itself seems at once clinical and caressing, going
up and down her body, confirming our impression of the narrator as a sensualist. There

A sequence from Jean Renoir's *Une Partie de Campagne* (1946), a film adaptation of Guy de Maupassant's short story. "Close study of film and novel versions of the same narrative reveals with great clarity the peculiar powers of the two media. Once we grasp those peculiarities, the reasons for the differences in form, content, and impact of the two versions strikingly emerge" (CHATMAN, p. 446).

1

2

3

4

5

6

7

8

9

10

11

12

13

14

is no such implication in Renoir's shots. The camera *could* have scanned her body in a cliché shot in the Hollywood mode accompanied by an offscreen wolf whistle. Renoir elected not to compromise the camera: it would have spoiled the whole effect of unconsciously seductive innocence. The camera is not required to share its viewpoint with Rodolphe and the three other groups of voyeurs. It maintains a clear distinction between shots from Rodolphe's point of view and those from a neutral point of view.*

So writer, filmmaker, comic strip artist, choreographer—each finds his or her own ways to evoke the sense of what the objects of the narrative look like. Each medium has its own properties, for better and worse usage, and intelligent film viewing and criticism, like intelligent reading, needs to understand and respect both the limitations these create and also the triumphs they invite.

1980

---

*Several participants in the narrative conference objected to my analysis of the point of view situation at this moment in Renoir's film. I hope I am correct in reporting their complaints: the chief objection was to the assumption that female members of the audience would identify with Rodolphe's voyeurism. Such identification, it was contended, would have to be limited to men—and only sexist men at that. The objection seemed to be not about the voyeurism itself but about the willingness of members of an audience to go along with it. (I hope I'm not simplifying the issue by using terms like "identify" and "going along with it"; if I am, I would welcome further clarification from interested readers.)

My response appeals largely and familiarly to the distinction, crucial to interpretation, as I see it, between aesthetics and ethics. The kind of identification that I was discussing is of course purely aesthetic. A reader must obviously be able to participate imaginatively in a character's set of mind, even if that character is a nineteenth-century lecher. One would think the days long gone in which we needed to apologize for donning the perceptual and conceptual clothing of objectionable fictional characters or unreliable narrators—Raskolnikovs or Verlocs or Jason Compsons or one of Celine's "hero" narrators. Imaginative participation in the point of view of fictional characters (need one say again?) in no way implies moral endorsement. It is simply the way we make sense—the way implied authors enable us to become implied readers who make sense—out of unusual or even downright alien viewpoints. We don't compromise our right thinking by engaging in that kind of participation; we don't condone the character's outlook. Why should female members of Renoir's audience have any more difficulty participating in Rodolphe's lecherous point of view than male members have in participating in the point of view of Molly Bloom? How responsible is an ideology which accuses critics of promulgating characters' viewpoints which they merely wish to analyze? Does a herpetologist become a snake by dissecting a snake? I cannot see how it can be denied that Renoir's presentation of four ages of voyeurs establishes a textual intention to show Henriette as a woman eminently worth looking at, albeit with lust in some men's hearts. For a woman to participate in a male character's doing so requires no greater act of imagination than for a man to participate in Scarlett O'Hara's lust for Rhett Butler. To deny that Renoir intended to communicate voyeurism (because that would make a classic film sexist) seems critically naive. Of course Maupassant and Renoir—or more properly the implied authors of these works—are sexist by modern standards. That doesn't mean that we become sexist by reading, studying, and, yes, even enjoying them.

A comment by Roy Schafer was more useful. Schafer argued that the close-up of Henriette on the swing conveyed to him something of *her* sexual pleasure. It is not difficult to agree that swinging is easily allied to sexuality. The attribution goes along perfectly with other motifs of innocent, preconscious sexuality, of "showing her limbs," and of the vague feelings of longing for even the tiny things that move under the leaves and grass that Henriette expresses to her mother a bit later in the film. I think Schafer is right: the point of view could also be attributed to Henriette. But that causes no theoretical problem. Two points of view can exist concurrently in a single shot. It is an interesting property of cinematic narrative that we can see through one character's eyes and feel through another's heart. The camera adopts a position, an angle, and a distance which by convention associates itself with the position, angle, and distance of a character's vision. But so great is its capacity to inspire identification with characters' thinking, feeling, and general situation that we tend to identify even when the character appears to us in a completely frontal view. This sympathetic or "interest" point of view (as I call it) is particularly strong in film narratives and can easily combine with the more conventionally marked perceptual point of view.

# DUDLEY ANDREW
## *FROM* CONCEPTS IN FILM THEORY

### ADAPTATION

### THE SOURCES OF FILMS

Frequently the most narrow and provincial area of film theory, discourse about adaptation is potentially as far-reaching as you like. Its distinctive feature, the matching of the cinematic sign system to prior achievement in some other system, can be shown to be distinctive of all representational cinema.

Let us begin with an example, *A Day in the Country*. Jean Renoir set himself the task of putting his knowledge, his troupe, and his artistry at the service of a tale by Guy de Maupassant. No matter how we judge the process or success of the film, its "being" owes something to the tale that was its inspiration and potentially its measure. That tale, "A Country Excursion," bears a transcendent relation to any and all films that adapt it, for it is itself an artistic sign with a given shape and value, if not a finished meaning. A new artistic sign will then feature this original sign as either its signified or its referent. Adaptations claiming fidelity bear the original as a signified, whereas those inspired by or derived from an earlier text stand in a relation of referring to the original.

The notion of a transcendent order to which the system of the cinema is beholden in its practice goes well beyond this limited case of adaptation.[1] What is a city symphony, for example, if not an adaptation of a concept by the cinema?[2] A definite notion of Berlin preexisted Walter Ruttman's 1927 treatment of that city. What is any

---

[1]For this idea I am indebted to a paper written by Dana Benelli in a class at the University of Iowa, autumn term 1979.

[2]The "city symphony" is a genre of the 1920s which includes up to fifteen films all built on formal or abstract principles, yet dedicated to the presentation of a single city, be it Berlin, Paris, Nice, Moscow, or the like.

documentary for that matter except the signification by the cinema of some prior whole, some concept of person, place, event, or situation. If we take seriously the arguments of Marxist and other social theorists that our consciousness is not open to the world but filters the world according to the shape of its ideology, then every cinematic rendering will exist in relation to some prior whole lodged unquestioned in the personal or public system of experience. In other words, no filmmaker and no film (at least in the representational mode) responds immediately to reality itself, or to its own inner vision. Every representational film *adapts* a prior conception. Indeed the very term "representation" suggests the existence of a model. Adaptation delimits representation by insisting on the cultural status of the model, on its existence in the mode of the text or the already textualized. In the case of those texts explicitly termed "adaptations," the cultural model which the cinema represents is already treasured as a representation in another sign system.

The broader notion of the process of adaptation has much in common with interpretation theory, for in a strong sense adaptation is the appropriation of a meaning from a prior text. The hermeneutic circle, central to interpretation theory, preaches that an explication of a text occurs only after a prior understanding of it, yet that prior understanding is justified by the careful explication it allows.* In other words, before we can go about discussing and analyzing a text we must have a global conception of its meaning. Adaptation is similarly both a leap and a process. It can put into play the intricate mechanism of its signifiers only in response to a general understanding of the signified it aspires to have constructed at the end of its process. While all representational films function this way (as interpretations of a person, place, situation, event, and so forth), we reserve a special place for those films which foreground this relation by announcing themselves as versions of some standard whole. A standard whole can only be a text. A version of it is an adaptation in the narrow sense.

Although these speculations may encourage a hopelessly broad view of adaptation, there is no question that the restricted view of adaptation from known texts in other art forms offers a privileged locus for analysis. I do not say that such texts are themselves privileged. Indeed, the thrust of my earlier remarks suggests quite the opposite. Nevertheless, the explicit, foregrounded relation of a cinematic text to a well-constructed original text from which it derives and in some sense strives to reconstruct provides the analyst with a clear and useful "laboratory" condition which should not be neglected.

The making of film out of an earlier text is virtually as old as the machinery of cinema itself. Well over half of all commercial films have come from literary originals—though by no means all of these originals are revered or respected. If we confine ourselves to those cases where the adaptation process is foregrounded, that is, where the original is held up as a worthy source or goal, there are still several possible modes of relation between the film and the text. These modes can, for convenience, be reduced to three: borrowing, intersection, and fidelity of transformation.

---

*In the theory of interpretation this is generally attributed to Wilhelm Dilthey, although Martin Heidegger has made much of it in our century.

# BORROWING, INTERSECTING, AND
# TRANSFORMING SOURCES

In the history of the arts, surely "borrowing" is the most frequent mode of adaptation. Here the artist employs, more or less extensively, the material, idea, or form of an earlier, generally successful text. Medieval paintings featuring biblical iconography and miracle plays based on Bible stories drew on an exceptional text whose power they borrowed. In a later, secular age the artworks of an earlier generation might be used as sacred in their own right. The many types of adaptations from Shakespeare come readily to mind. Doubtless in these cases, the adaptation hopes to win an audience by the prestige of its borrowed title or subject. But at the same time it seeks to gain a certain respectability, if not aesthetic value, as a dividend in the transaction. Adaptations from literature to music, opera, or paintings are of this nature. There is no question of the replication of the original in Strauss's *Don Quixote*. Instead the audience is expected to enjoy basking in a certain pre-established presence and to call up new or especially powerful aspects of a cherished work.

To study this mode of adaptation, the analyst needs to probe the source of power in the original by examining the use made of it in adaptation. Here the main concern is the generality of the original, its potential for wide and varied appeal; in short, its existence as a continuing form or archetype in culture. This is especially true of that adapted material which, because of its frequent reappearance, claims the status of myth: *Tristan and Isolde* for certain, and *A Midsummer Night's Dream* possibly. The success of adaptations of this sort rests on the issue of their fertility not their fidelity. Frank McConnell's ingenious *Storytelling and Mythmaking* catalogues the garden of culture by examining borrowing as the history of grafting and transplantation in the fashion of Northrop Frye or even Carl Jung.[1] This direction of study will always elevate film by demonstrating its participation in a cultural enterprise whose value is outside film and, for Jung and others, outside texts altogether. Adaptation is the name of this cultural venture at its most explicit, though McConnell, Frye, and Jung would all immediately want to extend their theories of artistic fertility to "original" texts which upon inspection show their dependence on the great fructifying symbols and mythic patterns of civilization.

This vast and airy mode of borrowing finds its opposite in that attitude toward adaptation I choose to call "intersecting." Here the uniqueness of the original text is preserved to such an extent that it is intentionally left unassimilated in adaptation. The cinema, as a separate mechanism, records its confrontation with an ultimately intransigent text. Undoubtedly the key film exhibiting this relation is Robert Bresson's *Diary of a Country Priest*. André Bazin, championing this film and this mode,[2] claimed that in this instance we are presented not with an adaptation so much as a refraction of the original. Because Bresson featured the writing of the diary and because he went out of his way to avoid "opening up" or in any other way cinematizing the original, Bazin claims that the film is the novel as seen by cinema. To

[1]Frank McConnell, *Storytelling and Mythmaking* (New York: Oxford University Press, 1979).
[2]André Bazin, *What Is Cinema?* (Berkeley: University of California Press, 1968), p. 142.

extend one of his most elaborate metaphors,* the original artwork can be likened to a crystal chandelier whose formal beauty is a product of its intricate but fully artificial arrangement of parts while the cinema would be a crude flashlight interesting not for its own shape or the quality of its light but for what it makes appear in this or that dark corner. The intersection of Bresson's flashlight and the chandelier of Bernanos's novel produces an experience of the original modulated by the peculiar beam of the cinema. Naturally a great deal of Bernanos fails to be lit up, but what is lit up is only Bernanos, Bernanos however as seen by the cinema.

The modern cinema is increasingly interested in just this sort of intersecting. Bresson, naturally, has given us his Joan of Arc from court records and his *Mouchette* once again from Bernanos. Straub has filmed Corneille's *Othon* and *The Chronicle of Anna Magdalena Bach*. Pasolini audaciously confronted Matthew's gospel with many later texts (musical, pictorial, and cinematic) which it inspired. His later *Medea, Canterbury Tales*, and *Decameron* are also adaptational events in the intersecting mode. All such works fear or refuse to adapt. Instead they present the otherness and distinctiveness of the original text, initiating a dialectical interplay between the aesthetic forms of one period with the cinematic forms of our own period. In direct contrast to the manner scholars have treated the mode of "borrowing," such intersecting insists that the analyst attend to the *specificity* of the original within the *specificity* of the cinema. An original is allowed its life, its own life, in the cinema. The consequences of this method, despite its apparent forthrightness, are neither innocent nor simple. The disjunct experience such intersecting promotes is consonant with the aesthetics of modernism in all the arts. This mode refutes the commonplace that adaptations support only a conservative film aesthetics.

Unquestionably the most frequent and most tiresome discussion of adaptation (and of film and literature relations as well) concerns fidelity and transformation. Here it is assumed that the task of adaptation is the reproduction in cinema of something essential about an original text. Here we have a clear-cut case of film trying to measure up to a literary work, or of an audience expecting to make such a comparison. Fidelity of adaptation is conventionally treated in relation to the "letter" and to the "spirit" of the text, as though adaptation were the rendering of an interpretation of a legal precedent. The letter would appear to be within the reach of cinema for it can be emulated in mechanical fashion. It includes aspects of fiction generally elaborated in any film script: the characters and their inter-relation, the geographical, sociological, and cultural information providing the fiction's context, and the basic narrational aspects that determine the point of view of the narrator (tense, degree of participation, and knowledge of the storyteller, and so on). Ultimately, and this was Bazin's complaint about faithful transformations, the literary work can readily become a scenario written in typical scenario form. The skeleton of the original can, more or less thoroughly, become the skeleton of a film.

More difficult is fidelity to the spirit, to the original's tone, values, imagery, and rhythm, since finding stylistic equivalents in film for these intangible aspects is the opposite of a mechanical process. The cinéaste presumably must intuit and reproduce the feeling of the original. It has been argued variously that this is frankly impossi-

---

*Bazin, p. 107.

ble, or that it involves the systematic replacement of verbal signifiers by cinematic signifiers, or that it is the product of artistic intuition, as when Bazin found the pervasive snowy decor in *Symphonie Pastorale* (1946) to reproduce adequately the simple past tense which Gide's verbs all bear in that tale.[1]

It is at this point that the specificity of these two signifying systems is at stake. Generally film is found to work from perception toward signification, from external facts to interior motivations and consequences, from the givenness of a world to the meaning of a story cut out of that world. Literary fiction works oppositely. It begins with signs (graphemes and words) building to propositions which attempt to develop perception. As a product of human language it naturally treats human motivation and values, seeking to throw them out onto the external world, elaborating a world out of a story.

George Bluestone, Jean Mitry, and a host of others find this opposition to be most graphic in adaptation.[2] Therefore they take pleasure in scrutinizing this practice even while ultimately condemning it to the realm of the impossible. Since signs name the inviolate relation of signifier to signified, how is translation of poetic texts conceivable from one language to another (where signifiers belong to diffferent systems); much less how is it possible to transform the signifiers of one material (verbal) to signifiers of another material (images and sounds)? It would appear that one must presume the global signified of the original to be separable from its text if one believes it can be approximated by other sign clusters. Can we attempt to reproduce the meaning of the *Mona Lisa* in a poem, or of a poem in a musical phrase, or even of a musical phrase in an aroma? If one accepts this possibility, at the very least one is forced to discount the primary articulations of the relevant language systems. One would have to hold that while the material of literature (graphemes, words, and sentences) may be of a different nature from the materials of cinema (projected light and shadows, identifiable sounds and forms, and represented actions), both systems may construct in their own way, and at higher levels, scenes and narratives that are indeed commensurable.

The strident and often futile arguments over these issues can be made sharper and more consequential in the language of E. H. Gombrich or the even more systematic language of semiotics. Gombrich finds that all discussion of adaptation introduces the category of "matching."[3] First of all, like Bazin he feels one cannot dismiss adaptation since it is a fact of human practice. We can and do correctly match items from different systems all the time: a tuba sound is more like a rock than like a piece of string; it is more like a bear than like a bird; more like a romanesque church than a baroque one. We are able to make these distinctions and insist on their public character because we are matching equivalents. In the system of musical instruments the tuba occupies an equivalent position to that enjoyed by the romanesque in its system of architectural styles. Nelson Goodman has treated this issue at length in *Languages*

---

[1]Bazin, p. 67.

[2]George Bluestone, *Novels into Film* (Berkeley: University of California Press, 1957), and Jean Mitry, "Remarks on the Problem of Cinematic Adaptation," *Bulletin of the Midwest Modern Language Association* 4, no. 1 (Spring 1971): 1–9.

[3]E. H. Gombrich, *Art and Illusion* (Princeton: Princeton University Press, 1960).

*of Art* pointing to the equivalence not of elements but of the position elements occupy vis-à-vis their different domains.[1] Names of properties of colors may thus metaphorically, but correctly, describe aspects of the world of sound (a blue note, a somber or bright tone). Adaptation would then become a matter of searching two systems of communication for elements of equivalent position in the systems capable of eliciting a signified at a given level of pertinence, for example, the description of a narrative action. For Gombrich adaptation is possible, though never perfect, because every artwork is a construct of elements built out of a traditional use of a system. Since humans have the general capacity to adapt to new systems with different traditions in achieving a like goal or construct, artistic adaptation poses no insurmountable obstacles. Nevertheless attention to such "proportional consistencies" demands that the study of adaptation include the study of both art forms in their proper *historic* context.

Gombrich and Goodman anticipated the more fashionable vocabulary of semiotics in their clarification of these issues. In *Film and Fiction, The Dynamics of Exchange*, Keith Cohen tries to justify this new, nearly scientific approach to questions of relations between these arts; he writes, citing Metz:

> A basic assumption I make is that both words and images are sets of signs that belong to systems and that, at a certain level of abstraction, these systems bear resemblances to one another. More specifically, within each such system there are many different codes (perceptual, referential, symbolic). What makes possible, then, a study of the relation between two separate sign systems, like novel and film, is the fact that the same codes may reappear in more than one system. . . . The very mechanisms of language systems can thus be seen to carry on diverse and complex interrelations: "one function, among others, of language is to name the units segmented by vision (but also to help segment them), and . . . one function, among others, of vision is to inspire semantic configurations (but also to be inspired by them)."[2]

Cohen, like Metz before him, suggests that despite their very different material character, despite even the different ways we process them at the primary level, verbal and cinematic signs share a common fate: that of being condemned to connotation. This is especially true in their fictional use where every signifier identifies a signified but also elicits a chain reaction of other relations which permits the elaboration of the fictional world. Thus, for example, imagery functions equivalently in films and novels. This mechanism of implication among signs leads Cohen to conclude that "narrativity is the most solid median link between novel and cinema, the most pervasive tendency of both verbal and visual languages. In both novel and cinema, groups of signs, be they literary or visual signs, are apprehended consecutively through time; and this consecutiveness gives rise to an unfolding structure, the diegetic whole that is never fully *present* in any one group yet always *implied* in each such group."[3]

---

[1]Nelson Goodman, *Languages of Art*, esp. pp. 143–48 (Indianapolis: Bobbs-Merrill, 1968).

[2]Keith Cohen, *Film and Fiction: The Dynamics of Exchange* (New Haven: Yale University Press, 1979), p. 4. Cohen's citation from Metz comes from Christian Metz, *Langage et cinéma* (Paris: Larçosse, 1971).

[3]Cohen, p. 92.

Narrative codes, then, always function at the level of implication or connotation. Hence they are potentially comparable in a novel and a film. The story can be the same if the narrative units (characters, events, motivations, consequences, context, viewpoint, imagery, and so on) are produced equally in two works. Now this production is, by definition, a process of connotation and implication. The analysis of adaptation then must point to the achievement of equivalent narrative units in the absolutely different semiotic systems of film and language. Narrative itself is a semiotic system available to both and derivable from both. If a novel's story is judged in some way comparable to its filmic adaptation, then the strictly separate but equivalent processes of implication which produced the narrative units of that story through words and audio-visual signs, respectively, must be studied. Here semiotics coincides with Gombrich's intuition: such a study is not comparative between the arts but is instead intensive within each art. And since the implicative power of literary language and of cinematic signs is a function of its use as well as of its system, adaptation analysis ultimately leads to an investigation of film styles and periods in relation to literary styles of different periods.

We have come round the other side of the argument now to find once more that the study of adaptation is logically tantamount to the study of the cinema as a whole. The system by which film involves us in fictions and the history of that system are ultimately the questions we face even when starting with the simple observation of an equivalent tale told by novel and film. This is not to my mind a discouraging arrival for it drops adaptation and all studies of film and literation out of the realm of eternal principle and airy generalization, and onto the uneven but solid ground of artistic history, practice, and discourse.

## THE SOCIOLOGY AND AESTHETICS OF ADAPTATION

It is time for adaptation studies to take a sociological turn. How does adaptation serve the cinema? What conditions exist in film style and film culture to warrant or demand the use of literary prototypes? Although adaptation may be calculated as a relatively constant volume in the history of cinema, its particular function in any moment is far from constant. The choices of the mode of adaptation and of prototypes suggest a great deal about the cinema's sense of its role and aspirations from decade to decade. Moreover, the stylistic strategies developed to achieve the proportional equivalences necessary to construct matching stories not only are symptomatic of a period's style but may crucially alter that style.

Bazin pointed to an important instance of this in the immediate post-war era when adaptations from the stage by Cocteau, Welles, Olivier, Wyler, and others not only developed new ways for the cinema to be adequate to serious theater, but also developed a kind of discipline in *mise-en-scène* whose consequences go far beyond the production of *Macbeth*, *Les Parents terribles*, *The Little Foxes*, and *Henry V*.[1] Cocteau's film, to take one example, derives its style from Welles's use of interior shooting in *Kane* and *Ambersons*, thus responding to a new conception of dramatic

---

[1]Bazin, *What Is Cinema?*, p. 76.

space; but at the same time his film helped solidify a shooting style that would leave its mark on Alexandre Astruc and André Michel among others. Furthermore his particular cinematic *écriture* would allow Truffaut to set him against the cinema of quality in the famous 1954 diatribe.[1] It is instructive to note that while Truffaut railed against the status quo for its literariness and especially for its method of adaptation, the directors he praised were also working with literary originals: Bresson adapting Bernanos, Ophuls adapting Maupassant and Schnitzler, and Cocteau adapting his own theater pieces. Like Bazin, Truffaut looked upon adaptation not as a monolithic practice to be avoided but as an instructive barometer for the age. The cinema *d'auteur* which he advocated was not to be pitted against a cinema of adaptation; rather one method of adaptation would be pitted against another. In this instance adaptation was the battleground even while it prepared the way for a stylistic revolution, the New Wave, which would for the most part avoid famous literary sources.

To take another sort of example, particular literary fashions have at times exercised enormous power over the cinema and, consequently, over the general direction of its stylistic evolution. The Romantic fiction of Hugo, Dickens, Dumas, and countless lesser figures originally set the stylistic requirements of American and mainstream French cinema at the end of the silent era. Similarly Zola and Maupassant, always of interest to French cinéastes, helped Jean Renoir muscularly reorient the style of world cinema in the 1930's. Not only that, through Luchino Visconti this naturalist impulse directly developed one strain of neorealism in his adaptations of Giovanni Verga (*La Terra Trema*) and James M. Cain (*Ossessione*).

This latter case forces us to recall that the "dynamics of exchange," as Cohen calls it, go both ways between film and fiction. Naturalist fiction helped cinema develop its interest in squalid subjects and a hard-hitting style. This in turn affected American hard-boiled novelists like Cain and Hammett, eventually returning to Europe in the film style of Visconti, Carné, Clouzot, and others. This general trading between film and literature in the currency of naturalism had some remarkable individual incidents associated with it. Renoir's adaptation of *The Lower Depths* can serve as an example. In 1881 Zola had cried out for a naturalist theater[2] and had described twenty years before the time precisely the sort of drama Gorki would write in *The Lower Depths*: a collection of real types thrown together without a domineering plot, the drama driven by the natural rhythms of little incidents and facts exposing the general quality of life in an era. Naturalism here coincided with a political need, with Gorki's play preceding the great uprisings in Russia by only a few years.

In another era and in response to a different political need, Renoir leapt at the chance to adapt the Gorki work. This was 1935, the year of the ascendancy of the Popular Front, and Renoir's treatment of the original is clearly marked by the pressures and aspirations of that moment. The film negotiates the mixture of classes which the play only hints at. Louis Jouvet as the Baron dominates the film, descending into the social depths and helping organize a collective undoing of Kastylylov, the

---

[1]François Truffaut, "A Certain Tendency in French Cinema," in Bill Nichols, *Movies and Methods*, I (Berkeley: University of California Press, 1976), pp. 224–36.
    [2]Emile Zola, "Naturalism and the Theater," in *The Experimental Novel and Other Essays*, tr. by Belle Sherman (New York: Haskell House, 1964).

capitalist landlord. Despite the gloomy theme, the murder, jailing, deaths by sickness and suicide, Renoir's version overflows with a general warmth evident in the airy setting by the Marne and the relaxed direction of actors who breathe languidly between their lines.

Did Gorki mind such an interpretation? We can never know, since he died a few months before its premier. But he did give Renoir his imprimatur and looked forward to seeing the completed version, this despite the fact that in 1932 he declared that the play was useless, out of date, and unperformable in socialist Russia. Perhaps these statements were the insincere self-criticism which that important year elicited from many Russian artists. I prefer, however, to take Gorki at his word. More far-sighted than most theorists, let alone most authors, he realized that *The Lower Depths* in 1932 Russia was by no means the same artwork as *The Lower Depths* in the France of the Popular Front. This is why he put no strictures on Renoir assuming that the cinéaste would deal with his play as he felt necessary. Necessity is, among other things, a product of the specific place and epoch of the adaptation, both historically and stylistically. The naturalist attitude of 1902, fleshing out the original plans of Zola, gave way to a new historic and stylistic moment, and fed that style that Renoir had begun elaborating ever since *La Chienne* in 1931, and that despite its alleged looseness and airiness in comparison to the Gorki, would help lead European cinema onto the naturalist path.

This sketch of a few examples from the sociology of adaptation has rapidly taken us into the complex interchange between eras, styles, nations, and subjects. This is as it should be, for adaptation, while a tantalizing keyhole for theorists, nevertheless partakes of the univeral situation of film practice, dependent as it is on the aesthetic system of the cinema in a particular era and on that era's cultural needs and pressures. Filmmaking, in other words, is always an event in which a system is used and altered in discourse. Adaptation is a peculiar form of discourse but not an unthinkable one. Let us use it not to fight battles over the essence of the media or the inviolability of individual art works. Let us use it as we use all cultural practices, to understand the world from which it comes and the one toward which it points. The elaboration of these worlds will demand, therefore, historical labor and critical acumen. The job of theory in all this is to keep the questions clear and in order. It will no longer do to let theorists settle things with a priori arguments. We need to study the films themselves as acts of discourse. We need to be sensitive to that discourse and to the forces that motivate it.

1984

# TOM GUNNING
# NARRATIVE DISCOURSE AND THE NARRATOR SYSTEM

Can film theory and film history interact in a treatment of a specific historical series of films? Because my intention is to deal with Griffith's Biograph films as both esthetic works and industrial products, esthetic forms as well as modes of production, distribution and exhibition are essential to this work. But I am trying to do more than apply two different approaches to these films, critical on the one hand and industrial economic and social on the other. Because I maintain that the change in narrative form that one can trace through the early Biograph films can in part be understood as a response to changes within the film industry and its role in American society, I also want these different approaches to intersect. To demonstrate a change in narrative form, I must define with theoretical precision the way narrative operates in film. To show the relation of this interior change to the broader horizons of the film industry and social discourse about film, I must have a model of how that industry was structured and a concept of how these interior and exterior structures affect each other. . . .

In investigating narrative, we are hardly faced with a chartless wilderness. The nature of narrative has been a theoretical topic since theoretical investigations began and has been particularly scrutinized in recent decades. But we can begin with basic observations. The structure of the word *storytelling* provides a starting point for definition—its essentially double nature involving both a story to be told and the telling of that story.

The work of the literary critic Gérard Genette has focused precisely on narrative discourse, the *telling* of storytelling, and will form my recurrent reference. Genette distinguishes three different meanings for the term *narrative* (*récit* in French). First, narrative can refer to the actual language of a text that tells a story, as Seymour Chatman puts it, "the means by which the [narrative] content is communicated."[1] The sec-

---

[1]Seymour Chatman, *Story and Discourse: Narrative Structure in Fiction and Film* (Ithaca: Cornell University Press, 1978), p. 19.

ond meaning of narrative refers to the content communicated by the discourse, "the succession of events, real or fictitious, that are the subject of this discourse" and which could be studied "without regard to the medium, linguistic or other" in which they are expressed. The third meaning refers to the event of "someone recounting something, the act of narrating in itself."[2] Genette analyzes narrative from these three perspectives: the means of expression, the events conveyed by these means, and the act of enunciation that expresses them.

Genette proposes the term *story* for the content conveyed by a narrative. The term *narrative* he reserves for the first meaning of the term, "the signifier, statement discourse or narrative text itself" which communicates the story. The act of telling a story, producing a narrative, Genette terms *narrating*.[3] I shall use Genette's terms with a slight modification. To avoid the equivocal term *narrative*, I shall call the means of expression of a story *narrative discourse*, a term Gennette often uses for the same concept. Genette's description of narrative discourse in literature provides a model for my treatment of Griffith, although my discussion is tailored to the demands of film rather than literature and to the requirements of a specific body of work.

My work on Griffith will not focus primarily on the analysis of story, but on narrative discourse. However, as Genette points out, the analysis of narrative discourse "implies a study of relationships," and to describe any one of the three aspects of narrative necessarily involves the other.[4] The logic of story can shape narrative discourse, marking how it begins, develops, and ends. Therefore some attention to the basic structure or logic of story is called for. Todorov, revising the Aristotelean beginning, middle, and end, offers the following useful definition of story structure (or in his terms *plot*): "The minimal complete plot consists in the passage from one equilibrium to another. An 'ideal' narrative begins with a stable situation which is disturbed by some power or force. There results a state of disequilibrium: by the action of a force directed in the opposite direction, the equilibrium is re-established; the second equilibrium is similar to the first, but the two are never identical."[5] As David Bordwell has pointed out, this equilibrium model corresponds to the "canonical story format," the story pattern most easily recognized and comprehended within our culture.[6] It also corresponds to the stories found in the majority of Griffith's Biograph films.

Narrative discourse is precisely the text itself—the actual arrangement of signifiers that communicate the story—words in literature, moving images and written titles in silent films. It is only through this means of expression that we come in contact with either story or the act of narrating. The story is an imaginary construction that the spectator or reader creates while reading the narrative discourse of the actual text. Likewise, access to the act of narrating (in written literature and in film, at least) is dependent on the traces of telling that exists in the text. The text itself, words, images,

---

[2]Gérard Genette, *Narrative Discourse: An Essay in Method*, trans. Jane E. Lewin (Ithaca: Cornell University Press, 1980), pp. 25–27.

[3]Genette, *Narrative Discourse*, p. 27.

[4]Ibid, pp. 27, 29.

[5]Todorov, *Introduction to Poetics*, p. 38.

[6]David Bordwell, *Narration in the Fiction Film* (Madison: University of Wisconsin Press, 1985), p. 35.

or both, is all that we have, and discussions of the other aspects of narrative must begin from the text and refer back to it.[7]

Within narrative discourse Genette defines three functions that relate to either story or the act of narration. The first two relate narrative discourse to story. The first of these is tense, which deals with the temporal relations between narrative discourse and story.[8] Narrative discourse can manipulate the temporal order and form of story events. This temporal patterning shapes and arranges the story, involving the reader or spectator in an often-complex activity of reconstruction. Within tense, Genette describes three principal manipulations of story events. The first, dealing with the succession of events in a narrative, is order. The second, duration, deals with the compression or extension of events within a narrative, while the third, frequency, describes the possibility of multiple retellings of a single event.

The second function of narrative discourse defined by Genette, mood, also relates the discourse to the story it tells. Controlling the reader's access to the events of the story, mood corresponds in many ways to what Anglo-American criticism has called point of view, the narration's perspective of the story told. Genette feels that "one can tell *more* or tell *less* what one tells, and can tell it *according to one point of view or another.*" Mood indicates the way the narrative discourse operates as a sort of screen between reader or spectator and the story as it unfolds: "the narrative can furnish the reader with more or fewer details, and in a more or less direct way, and can thus seem (to adopt a common and convenient spatial metaphor, which is not to be taken literally) to keep at a greater or lesser *distance* from what it tells."[9] This perspective on the action may correspond to the viewpoint of a particular character within the story, in which case we say the narrative adopts the character's point of view.

The last of Genette's categories, voice, deals with the relation between narrative discourse and the act of narrating—the traces of telling left in the text through which we sense a storyteller addressing an implied or real audience.[10] In literature this aspect would not only include such determinations as the person of the narrator (the familiar, first-, or third-person narrator), but also a wider range of means to reflect the act of narrating in the text, for example, the temporal relation between the story and the act of telling it, and a variety of ways in which the narrator asserts its presence.

My use of Genette comes from an appreciation of his precision and systematic analysis, rather than a belief that all film theory must be founded in linguistic or literary concepts. But are Genette's concepts applicable to film analysis, and if so, what short of transformations must they undergo? More fundamentally, should the terms *narrative* and *narration* be restricted to literature and verbal language? We speak quite commonly of narrative film, and even narrative dance, painting, and pantomime. What allows this concept to cross between diverse media?

The answer lies in the double nature of storytelling, its division into the story constructed by the reader or viewer and the specific discourse that tells the story. I strongly endorse André Gaudreault's statement, "Any message by means of which

---

[7]Genette, *Narrative Discourse*, pp. 28–29.
[8]Ibid., p. 31.
[9]Ibid., pp. 161–62.
[10]Ibid., p. 31.

any story whatsoever is communicated can rightfully be considered as a narrative."[11] Any communication of a story will be composed of Genette's triad of story, narrative discourse, and act of narrating. Because his narrative functions of tense, mood, and voice describe the interrelations between these universal aspects of narrative, I believe they apply to any narrative media.[12] But the task remains of describing film's specific narrative discourse. Genette clearly states that although story can be studied "without regard to the medium, linguistic or otherwise . . . ,"[13] narrative discourse (because it exists in actual text) cannot be divorced from its specific medium.

Fundamental differences between literature and film rush to meet us. These differences derive from the noncommensurable nature of the types of signs each medium employs. Whereas literature is never directly iconic, film, as a series of photographic representation signs, is. This aspect of the filmic sign gives it a unique narrative status. While in language, as Genette points out (using the vocabulary of the Anglo-American tradition of Lubbock and Booth), "Showing can only be a *way of telling*,"[14] film in contrast can show more immediately than it can tell.

But across the chasm between showing and telling the two narrative discourses seem to signal each other. Certain literary narratives have sought to give the impression of "showing" in spite of their lack of film's direct access to the visual. In literature the impression (or as Genette would put it, the illusion) of showing is the result of a narrator's consciously chosen and carefully devised strategy. Genette notes that a narrator may seem to abdicate the role of choosing only the most significant elements and instead gather a number of "useless and contingent" details in order to give the impression of showing.[15]

In film, this excess of mimesis over meaning appears automatically with the photographic image. Although a filmmaker can make images relatively abstract, they will still contain a plethora of information compared to a verbal description. For example, the first films that the Lumière brothers shot in the open air seem much more detailed and realistic than those the Edison Company shot against the dark background of the "Black Maria." But even Edison's films are crowded with the excess of photographic reality. Automatically present are details of posture, costuming, and gesture whose verbal description would overwhelm a written text (e.g., in Edison's kinetoscope film of Annie Oakley, her expression, the way she swings her rifle, the fringe on her costume, the puffs of smoke that seem to issue from the glass balls she shoots, etc.). Film *shows* automatically, recording a world of contingent events and unimportant details.

This dominance of showing over telling is the concealed reef over which the concept of the filmic narrator sails in peril. Does a film "tell" a story? Filmic discourse

---

[11]André Gaudreault, *Du Littéraire au filmique: System du récit* (Paris: Meridiens Klincksieck, 1988), p. 84 (my translation).

[12]See letter from Genette quoted in Gaudreault, *Du Littéraire*, p. 29 (footnote), which states in part: "Personally, I favor more and more a narrow definition of narrative, *haplé diégésis*, a statement of actions by a narrator who expresses the actions by verbal means (oral or written) and in this sense a theatrical or filmic narrative does not exist for me" (my translation). I am indebted to Gaudreault's work, including his dissertation, which he was kind enough to make available. Although some of my conclusions differ from his, I am constantly in debt to his thoroughness and clarity in approaching the issue.

[13]Genette, *Narrative Discourse*, p. 25.

[14]Ibid., p. 166.

[15]Ibid.

has an ability to appear nearly neutral. A single shot can seem to show a great deal while telling very little about it. If we approach film as a narrative form which presents stories to an audience, it nonetheless would be foolish to ignore a unique quality of its narrative discourse—its inherent photographic tendency toward mimesis, toward the representation of a world from which the filmic narrator can seem to be absent.

However, this aspect of film does not destroy the concept of the filmic narrator; rather it defines its roles. The primary task of the filmic narrator must be to overcome the initial resistance of the photographic material to telling by creating a hierarchy of narratively important elements within a mass of contingent details. Through filmic discourse, these images of the world become addressed to the spectator, moving from natural phenomenon to cultural products, meanings arranged for a spectator. The filmic narrator shapes and defines visual meanings.

This is partly accomplished by a fourth aspect of narrative discourse that I will add to Genette's triad of story, discourse, and the act of narrating—narrativization. This is less an aspect separate from the other three than a term for the bond among them, and one that takes on particular importance in film. Defined by Stephen Heath, narrativization is precisely what holds Genette's three aspects of narrative together.[16] The process of narrativization binds narrative discourse to story and rules the narrator's address to the spectator. It organizes discourse to tell a story, binding its elements into this single process. In this process the energies of a film are channeled toward the explication of a story, and through this channeling create and define a situation for the spectator.[17]

The concept of narrativization focuses the transformation of showing into telling, film's bending of its excessive realism to narrative purposes. Narrativization, which would be something of a tautology in a literary text where the signs are naturally predisposed to telling, regulates the balance between mimetic and narrative functions in the filmic sign. According to Heath, narrativization "seek[s] to maintain a tight balance between the photographic image as a reproduction of reality and the narrative as the sense, the intelligibility, of that reality." The narrative discourse of a film "picks up—indicating by framing, shot angle, lighting, dialogue mention, musical underscoring, and so on—the notable elements . . . ,"[18] thus carving a story out of a photographed reality.

Film's innate tendency toward mimesis becomes a sign of narrative realism, naturalizing the process of storytelling as the inclusion of apparently useless detail does in verbal narrative. Simultaneously the process of narrativization delivers a sense to this realism, through filmic discourse which "picks up" and selects precisely those

---

[16]See, Stephen Heath, *Questions of Cinema* (Bloomington: Indiana University Press, 1981), pp. 107–8 and passim.

[17]Heath, *Questions of Cinema*, p. 109.

[18]Ibid., p. 122. Heath's understanding of narrativization is dependent on the Lacanian theory of the constitution of the subject and the Althusserian theory of ideology. If I am bypassing a complete discussion of these issues in relation to Griffith's work, it is because I find the constant circulating of various film texts through this system to be a time-consuming process often undertaken at the expense of other essential issues. For those who would claim that no historical treatment of this material is valid without such an approach, I can only say that I am aware of these methods of analysis, and have certainly, but not exclusively, been influenced by them.

meanings necessary for the story to be told. In this way the filmic image, without losing (indeed, using) its capacity for showing, defines its unique way of telling.

The narrative discourse of film involves a unique transaction between showing and telling. The photographic image clearly possesses a unique ability to show. But how do films pick up and indicate the significant elements within this detailed and contingent reality and endow them with a narrative meaning? What is it that tells the story in a narrative film? What are the marks within the film (or to use David Bordwell's more psychological and dynamic term, the cues)[19] by which the film conveys its story to the viewer?

Describing the narrative discourse of film must involve cutting up the filmic text so that its dynamic forces are exposed. Of course a narrative text functions as a whole, and analysis only untangles the synthesis that makes it work. I believe film's narrative discourse can best be described as the interrelation of three different levels that interrelate and express narrative information: the pro-filmic, the enframed image, and the process of editing.[20] I do not claim that they function in isolation, nor do I construct a hierarchy of importance, although I will show that some levels perform some tasks more economically than others. Although I will primarily deal with these levels as they are perceived by viewers, it is not irrelevant that they roughly correspond to the essential stages of film production as well: the periods of before, during, and after shooting.

The pro-filmic refers to everything placed in front of the camera to be filmed. It includes such things as the actors (and therefore casting decisions and performance style), lighting, set design, selection of locations, and selection of props. Strictly speaking, pro-filmic elements do not appear on the screen except through the next level of discourse, their capture on film as enframed images. However film viewers see the images on the screen as images of things, and the selection of the things that make up the image plays an extremely important role in conveying narrative information. Every film makes a selection of elements based on a preexisting set of possibilities (this actor and performance style rather than that one; that sort of set design rather than another). Therefore, as narrative discourse the pro-filmic embodies a series of choices and reveals a narrative intention behind the choices. The viewer receives the results of these choices and makes inferences based on them.

Gaudreault, who in his book *Du Littéraire au filmique* (1988) has largely adopted my schema of filmic discourse, describes the manipulation by the narrator of the pro-filmic as "mise-en-scène," referring particularly to the theatrical sense of this term.[21] Too often ignored in narrative theories, the pro-filmic plays an important role in narrative discourse.[22] Many of Griffith's innovations in filmic discourse lay in this area (e.g., the "restraint in expression" in acting style mentioned in his New York *Dramatic Mirror* advertisement).

---

[19]Bordwell, *Narration*, pp. 31–33.

[20]This schema does not deal with the important issue of sound in film, which is not relevant to the films I examine herein, and would have to be approached as a fourth level, itself in need of subdividing.

[21]Gaudreault, *Du Littéraire*, p. 199.

[22]However both David Bordwell and George M. Wilson accord the pro-filmic considerable attention in their respective works, *Narration in the Fiction Film*, and *Narration in Light: Studies in Cinematic Point of View* (Baltimore: Johns Hopkins University Press, 1986).

The second level of filmic discourse is what I call the *enframed image*. At this level of filmic discourse the pro-filmic is transformed from preexistent events and objects into images on celluloid. The process is far from neutral. Placing an image within a frame entails arranging composition and spatial relations. The act of filming transforms the pro-filmic into a two-dimensional image, filmed from a particular point of view, framed within the camera aperture that geometrically defines the borders of the image. The whole host of formal devices that derive from the effects of perspective, selection of camera distance and angle, framing for composition, and the effects of movement within a frame determine specific choices available within this level of discourse. Whether on a conscious or preconscious level the viewer recognizes this construction of the image as a powerful narrative cue. Gaudreault borrows a term from Eisenstein, *mise-en-cadre*, the placement within the frame, to describe the activity responsible for this level of discourse.[23] New approaches in this level of filmic discourse, such as the role of composition in revealing characters's moods, are also seen in Griffith's Biograph work.

The enframed image can also involve a number of other procedures including setting exposure, control of focus, selection of lenses or film stocks with different properties, manipulations of camera speed, and placing devices in front of the lens (such as Bitzer's vignette-masking diaphragms). Camera movement also falls into this category. Putting the frame itself into motion, camera movement can be a powerful device, creating a strong sense of an intervening narrator and strongly marked narrative cues. I also include in this category the processes of filming that involve re-photography and are carried out after the principle photography, such as split screens, superimpositions, and matting processes.

The third level of filmic discourse consists of editing. In most production practices this occurs after the act of filming and involves the cutting and selection of shots as well as their assembly into syntagmas. This process of combination is stressed by Gaudreault's terminology for the activity of editing, the neologism *mise-en-chain*.[24] In Genette's enumeration of the functions of narrative discourse, one seems particularly suited to this level of discourse—that of tense. Tense deals with the differences that can arise between the temporality of events as presented in narrative discourse and their time relations within the story being told. The single unedited shot, outside of an edited sequence, allows few differentiations between the time of narrative discourse and that of story.[25] This is evident in temporal order, because it is only through editing that a flashback or flashforward can be clearly signified. There have been attempts to create temporal disjunctions within a single shot, as in *A Love in Germany* (Wadja, 1984) or the opening of *Him and Me* (Benning, 1982), but these remain rarities and involve imitations of editing processes through camera movement. Like-

---

[23]Gaudreault, *Du Litteraire*, p. 199.

[24]Ibid.

[25]See Genette, *Narrative Discourse*, p. 35. There are exceptions to this, however, that do not relate to Griffith's Biograph films but should be included theoretically. Within the level of the enframed image, which corresponds to the production stage of shooting and re-photography, there is the possibility of slow or fast motion, created by shooting or printing, which sets up a differentiation between story time and discourse time. Likewise, the soundtrack can set up a host of temporal relations, most obviously through voice-over, which are not described herein. This seems another indication that sound would operate as a fourth level of filmic discourse, with strong roles in all three of Genette's aspects of narrative discourse.

wise, the temporal relations between narrative discourse and story that Genette groups under duration, such as summary, ellipsis, or narrative pauses all have clear equivalents in editing processes, with only awkward semi-equivalents within the single shot.[26] Finally to the extent that the temporal relations that Genette groups under frequency can appear in film (e.g., the repetitive account of a single event, as in the multiple presentations of the rape in *Rashomon*), they seem strongly dependent on editing.

The particular suppleness of editing comes from the discontinuity between shots that allows articulation between them, including the temporal differentiations mentioned previously. But spatial articulations are equally important in the process of editing, such as the synthetic space created by continuity editing or the disjunctions of space that occur in other editing styles. Spatial articulations are less defined in literature than in film. They represent an element of the filmic narrator that has no direct equivalent in Genette's treatment of literary narrative discourse. However spatial figures in film tend to be closely interrelated with temporal articulations, and I will generally deal with them together.

In the history of film theory, discussions of the "essential nature" of film have often focused on editing. These have ranged from the proclamation of the supremacy of editing by the early Soviet theorists, through its deemphasis in the work of Bazin, to the reevaluation by theorists such as Marie Ropars-Wuilleumier and Gaudreault.[27] While editing represents a particularly supple level of filmic discourse, I maintain that all three levels must be considered in describing film's narrative discourse. As Bordwell has written, "all film techniques, even those involving the 'profilmic event,' function narrationally, constructing the story world for specific effects."[28]

The emphasis on editing in my analysis of Griffith therefore derives from Griffith's individual and historical situation rather than theoretical privileging. Production during this period favored editing over, for example, an elaborate system of camera movement such as appears in some film production after the 1930s. However, historical and technical determinants are not the sole factor. During the same period as Griffith's Biograph career, Louis Feuillade, as well as other directors at Gaumont, such as Léonce Perret and Georges Monca, created a narrative style less dependent on editing, favoring elements such as composition and lighting. The emphatic role of editing in Griffith's filmmaking must partly derive from his own choices. The importance of editing in this work therefore derives from the films I am discussing.

Each of these levels integrates the one before, transforming it as it does so. Their effects on a spectator is generally due to their interrelation, and I separate them for analysis. These three aspects of filmic discourse—the pro-filmic, the enframed image, and editing—almost always work in concert and represent the medication between story and spectator in film. They are how films "tell" stories. Taken together, they constitute the filmic narrator.

---

[26]Ibid., pp. 86–112.

[27]See, Gaudreault, *Du Littéraire*, pp. 105–15, and Marie-Claire Ropars-Wuilleumier, "Function du montage dans la constitution du récit au cinema," *Revue des sciences humaines* 36 (Jan.–March 1971): 51–52.

[28]Bordwell, *Narration*, p. 12.

Because film's narrative discourse represents the actual text of a film—its existence as a series of filmic images—no narrative film can exist except through its narrative discourse. It logically follows that every narrative film has a filmic narrator embodied by this discourse. The three levels of filmic discourse are not optional ornaments of style. They form the very mode of existence for any narrative film. But within a specific film, the particular stance and tone of its filmic narrator is determined by choices made within the levels of filmic discourse. Therefore the filmic narrator appears in a wide range of forms determined by specific choices within and among the three levels of filmic discourse (e.g., expressionist set design, high angle of camera, and match cutting). Relating these choices to the functions of narrative discourse that Genette lays out allows us to distinguish different types of filmic narrators. However, even if a certain type of narrator has a tendency to give the impression that "events seem to narrate themselves" without the intervention of a narrator (what the linguist Emile Benveniste calls *histoire*),[29] the narrator can never disappear entirely but can only be concealed. As Todorov writes, "Events never 'tell themselves'; the act of verbalization is irreducible."[30]

I would assert that the same is true in film. Although what has been termed "classical film narrative" labors to present the illusion of a direct presentation of events, this is always a labor of concealment, the construction of an illusion. As Paul Ricoeur has said of the ideology of literary transparency from which the classical style of film arises, "the rhetoric of dissimulation, the summit of the rhetoric of fiction, must not fool the critic, even if it may fool the reader."[31] As we shall see, Griffith plays an ambiguous role in the establishment of this classical style.

If the marks of enunciation in filmic discourse (which reveal the hand of the narrator) can only be camouflaged and not eradicated, we can establish a range of filmic narrators stretching from the apparent "invisibility" of the classical Hollywood film to the heavily rhetorical montage of, for example, Eisenstein—and it is significant that Griffith is often cited as a seminal influence on both extremes. Arranged synchronically, different degrees of assertiveness in the narrative discourse of films could distinguish among the narrative styles of different filmmakers, different cultures, or simply different films. Arranged diachronically, such differences could provide a historical view of the development of film narrative.

While narrative discourse embodies the telling of a story by a filmic narrator, the process of narration involves an interrelation between a narrator and what semioticians call a "narratee."[32] The dynamic aspect of this interaction should be stressed. Although implied by Genette, the role of the narratee has been discussed more explicitly by American film theorists whose concern with the activity of the viewer gives Genette's model a more dynamic twist.[33]

---

[29]Emile Benveniste, *Problems in General Linguistics* (Coral Gables: University of Miami Press, 1970), p. 208.

[30]Todorov, *Introduction*, p. 39.

[31]Paul Ricoeur, *Time and Narrative*, trans. Kathleen Blamey and David Pellauer (Chicago: University of Chicago Press, 1988), vol. 3, p. 161.

[32]Todorov, *Introduction*, p. 40.

[33]And in spite of his own apparent confusion on this matter, (see, for example, *Narration*, p. 63), the narratee corresponds precisely to Bordwell's conception of the spectator, "a hypothetical entity executing the operations relevant to constructing a story out of the film's representations," ibid., p. 30.

Edward Branigan, in *Point of View in the Cinema*, defines narration as an *activity*. This activity involves more than Genette's act of narrating because it involves the reader or viewer as well as the narrator. As Branigan puts it, narration is "a dialectical process between narrator and reader *through which* is realized a narrative."[34] We have already caught site of this activity in the simple fact that the reader or viewer constructs (or reconstructs) the story from the narrative discourse of the text. Bordwell's attempt to describe film narration through the concepts of Constructivist psychology similarly foregrounds the spectator's activity. According to Bordwell the spectator uses cues within the narrative texts "to make assumptions, draw inferences about current story events, and frame and test hypothesis about prior and upcoming events."[35]

Although my approach differs from Bordwell and Branigan's, I fully agree with their vision of an active spectator who contributes to the construction of the narrative. Their focus on the dynamic interaction between narrative discourse and reader or viewer allows me to specify that film's narrative discourse does not overpower a passive spectator but provides patterns within films that provoke active mental responses and set in motion the range of cognitive processes Bordwell describes. A particular narrative discourse addresses a spectator in a particular way, eliciting specific sorts of activities. The change Griffith brings to the way films are narrated is at the same time a change in the way films are viewed. Along with a new sort of filmic narrator, Griffith's transformation of filmic discourse constructs a new sort of spectator for film. Or to put it in a way that gives the spectator due, the spectator constructs a new sort of film experience as cued by Griffith's narrative discourse.

Both Branigan and Bordwell stress the role of the spectator at the expense of the narrator. In fact, they reject this term, preferring impersonal rubics, Branigan opting for "activity of narration"[36] and Bordwell for "narration." Their discomfort with the term *narrator* is in part understandable and methodologically useful and in part disturbing. Both authors stress the impersonal, text-immanent nature of narrative discourse and describe the narrator as an "anthropomorphic fiction."[37] It is theoretically important to avoid identifying a narrator with a biological person such as the author. Narrative discourse is made up of words and images, not flesh and blood. Such theoretical precisions are necessary to maintain the integrity of the esthetic text. I will occasionally use the term *narrative discourse* rather than *narrator* in order to stress that I am dealing with images and their construction rather than a person.

However, the depersonalization of narrative discourse brings its own theoretical blindspot that distorts the way films are received by spectators, and the way they function within history and society. Bordwell particularly seems to set aside the fact that in our perception of films we are aware of them as products, as entities manufactured by human beings with evident purposes and designs upon us. In spite of his emphasis on the spectator's role he distorts the address that films level at audiences. The alert and active spectator proposed by Bordwell's psychological description

---

[34]Edward R. Branigan, *Point of View in the Cinema: A Theory of Narration and Subjectivity in Classical Film* (Amsterdam: Mouton Publishers, 1984), p. 39.

[35]Bordwell, *Narration*, p. 39.

[36]Branigan, *Point of View*, p. 40.

[37]Ibid.; Bordwell, *Narration*, p. 62.

must realize that these images come from *somewhere*. When Bordwell declares that his theory of narration "presupposes a perceiver, but not a sender, of a message,"[38] one wonders what sort of message this is—and in what universe a receiver can respond to a message without wondering about a sender.

The limits of this depersonalization become particularly clear when Bordwell sets his model of narration in motion. What he has excluded in theory re-emerges in his practice. For Bordwell, narration can be "self conscious," can "voluntarily restrict itself," "refuse to mark," or can "flaunt its ability"[39]—to take only a few examples which indicate that he cannot avoid speaking of this impersonal function as volitional and endowed with something very much like human consciousness. Bordwell grounds some of his objection to the concept of the narrator in the transparency of the classical style, claiming that classical films are not endowed with a perceptible narrator, although certain modernist films do signal that the "spectator should construct a narrator." Only certain exceptional films therefore possess narrators, and even this sort of narrator "does not create the narration" but is constructed by the spectator.[40]

Bordwell's theory is not irrational; the narrative discourse of film with its tendency toward showing does possess a transparent quality that verbal discourse lacks. And certainly the narrator as the embodiment of narrative discourse does not stand outside the text. The narrator communicates to the spectator only through the spectator's engagement with the narrative discourse, so in a sense the spectator does construct the narrator, just as he or she does the story, from the narrative discourse. But story-telling implies a storyteller as surely as it does a story. We must be careful in describing the nature of this teller, this narrator.

In films and literature, the narrator is not a flesh-and-blood entity. The narrator, in my understanding of the term, is a theoretical entity, as divorced from an actual person as Bordwell's spectator is from a particular viewer. But preserving the more personal term *narrator* not only avoids academic abstraction but also responds to the experience a reader or spectator has of being addressed by a story. This address can be described by the volitional activities that slip back in Bordwell's window of praxis after being barred at his theoretical door. We receive a text as though it were saying something to us, as though, in the words of my colleague Robert Stein, it has designs on us. We experience it as an intentional object, designed to have certain effects on us.[41] More than a random set of cues, the narrator embodies the design organizing narrative discourse, the intentions which unify its effects. It corresponds to that force in narrative that Peter Brooks calls plot or plotting, "the design and intention of narrative, what shapes a story and gives it a certain direction or intent of meaning."[42] These designs do not exist outside the text but are evident in the rhetor-

---

[38]Bordwell, *Narration*, p. 62.

[39]Ibid., pp. 58, 65, 89, 146.

[40]Ibid., p. 62.

[41]I use the term *intentional* in its phenomenological meaning indicating a product of human consciousness, rather than its psychological meaning. I am not claiming that a particular definable intention lies behind every narrative, or that criticism should reconstruct this intention. This would lead of course to the intentional fallacy. The intention behind a narrative as an intentional object may remain unspecified, its very vagueness drawing a response from the reader or spectator.

[42]Peter Brooks, *Reading for the Plot: Design and Intention in Narrative* (New York: Random House, 1984), p. xi.

ical arrangement of its devices. The more active term *narrator* stresses that this discourse, to paraphrase Brooks, involves force as well as form. It is not only constructed by the reader or spectator, but also addresses and affects him or her through specific devices. Thus in describing film's narrative discourse I have described each level as activities which arrange and organize material in order to address a spectator. No narrative film exists, even the "transparent" films of the classical style, without making such an address.

Another reason for maintaining the term *narrator* is that although it is theoretically separate from the author and processes of production that created the work, it does provide, in the words of Ricoeur, the image of the author within the text. As a series of intentions it recalls the narrative's nature as a unified manufactured object, the product of human labor. As Ricoeur asserts, "the reader does not ascribe this unification to the rules of composition alone but extends it to the choices and to the norms that make the text, precisely, the work of some speaker, hence a work produced by someone and not by nature."[43] Bordwell's theory tends to occult the spectator's perception of a film as something produced. It belongs to the tendency Raymond Williams attacked of dealing with art works solely from the point of view of consumption, ignoring the process of production.[44] Griffith's films address us through their narrative discourse, which creates the sense of an intervening figure who has arranged the images on the screen in a particular manner with specific social consequences. The concept of the filmic narrator helps us relate filmic form to broader contexts.

1991

---

[43]Ricoeur, *Time and Narrative*, vol. 3, p. 162.
[44]Bordwell's own historical work pioneered a new serious consideration of the process of production. However I find a contradiction between his theoretical apparatus and his important scholarly work on production modes. Likewise, the brilliance of his analysis of the narrative discourse of films in *Narration in the Fiction Film* seems unencumbered by what I consider his theoretical weak spot, because intentionality actually reemerges in his specific analyses.

# JERROLD LEVINSON
# FILM MUSIC AND NARRATIVE AGENCY

## 1

In this essay I address certain issues about paradigmatic film music, that is, the music that is often heard in the course of a fiction film but that does not originate in or issue from the fictional world revealed on screen. What most interests me is the question that confronts every filmgoer at some level, and to which he or she must, explicitly or implicitly, accord an answer, of who or what is responsible for such music. That is to say, to what agency is film music assigned by a comprehending viewer, and what is this music understood to be doing, in relation either to the film's internal narrative, the viewer's experience of that narrative, or the film as an aesthetic whole? Furthermore, by what principle does a viewer assign, however tacitly, responsibility for the music he or she hears?

It will turn out that different answers to this question of agency are in order from one film to another, and even from one cue to another within a given film. The upshot is a basic division within the realm of film music, one I have not seen marked elsewhere, but which is probably more fundamental than others regularly noted.

## 2

I begin with some preliminaries. First, the music I am concerned with is usually designated *nondiegetic* film music, that is, music whose source is not the story (or *diegesis*) being conveyed by the film's sequence of images. It is sometimes also desig-

---

I thank David Bordwell and Noël Carroll for helpful comments on the style and substance of this essay. Needless to say, they do not agree with everything in it.

nated *soundtrack* as opposed to *source* music, and sometimes as *extrinsic,* as opposed to *intrinsic,* music.[1] Second, the films I am concerned with are all *narrative fiction* films, both of the "classical" (or "Hollywood") sort, and the "modernist" (or "art film") sort, though not any of the more extreme examples of the latter, in which the bounds of fictionality or narrative coherence are stretched to their limits.[2] Third, I will consider film music here only as an integral component of a complete film, and not as a genre of music which, in the form of suites or soundtracks, might be enjoyed and evaluated on its own.

Certain kinds of answers to our opening queries can be put aside immediately as not to the point. For instance, the source of nondiegetic film music might in one sense be said to be the composer who composes it, or the producer who commissions it, or the sound editor who integrates it into the finished film, but this does not address the question of where, in relation to the fictional world projected, the music is situated or positioned in comprehending the film. Similarly, the function of nondiegetic film music might be said to be, somewhat vaguely, the aesthetic enhancement of the film, or more specifically, the emotional manipulation of the film viewer, or more crassly, the augmentation of the film's marketability and secondary profits, but none of these answers addresses the question of how such music is understood to function in relation to the central narrative of sight and sound, and thus to contribute ultimately to a film's meaning.

It should be noted straight off that there are two basic sorts of musical score regularly encountered in the domain of the sound film: the first, more traditional sort consists of music composed specifically for the film in question, and generally tailored by the composer to the rough cut, scene by scene; the second sort consists of preexistent music chosen by the filmmaker, often in conjunction with a musical consultant, and applied or affixed to scenes or parts thereof. Call the former sort a *composed* score, and the latter an *appropriated* score.

We can make at least two observations about these two types of score. First, with appropriated scores the issue of specific imported associations, deriving from the original context of composition or performance or distribution, rather than just general associations carried by musical style or conventions, is likely to arise. Second, with appropriated as opposed to composed scores, there will, ironically, generally be more attention drawn to the music, both because it is often recognized as appropriated and located by the viewer in cultural space, and because the impression it gives of chosenness, on the part of the implied filmmaker, is greater. To these two observations I add a third, more contentious one, that later discussion will support: music composed *for* a film (for example, the soundtracks of *Vertigo* or *The Heiress* or *On the Waterfront* or *La Strada*), is more likely to be purely narrative in function than preexisting music appropriated *by* a filmmaker (for example, the sound tracks of *A Clockwork Orange* or *Barry Lyndon* or *Love and Death* or *Death in Venice*).

---

[1]For more on these categories, see David Bordwell and Kristin Thompson, *Film Art: An Introduction,* 4th ed. (New York: McGraw-Hill, 1993), pp. 295–303.

[2]For example, Snow's *Wavelength* or Resnais's *L'Annee Derniere à Marienbad.*

3

There are some theoretical claims prevalent in the recent literature on film with which I will be disagreeing, and it is best I signal what they are at the outset. One is that nondiegetic film music is standardly "inaudible," that is, is not, and is not meant to be, consciously heard, attended to, or noticed.[3] This seems to be clearly false, or at any rate, false for a wide range of films in which soundtrack music calls attention to itself unmistakenly, or requires the viewer to attend to it explicitly if he or she is not to miss something of narrative importance. The "inaudibility" claim seems most true for what is called *underscoring,* music at a low volume that serves as a sort of aural cushion for dialogue that remains the main order of business, or for melodically and rhythmically unmarked music helping to effect transitions between scenes of notably different character. Even here, when the music hovers in the penumbra of consciousness, it is rarely very far from being consciously focused, as is perhaps reflected in the fact of being immediately noticed if stopped. If nondiegetic film music were generally unheard, or not consciously noted by the viewer, then there would not be much of an interpretive issue for the viewer of how to construe such music in relation to the rest of what is going on in the film. But, with respect to many films, there manifestly *is* an issue of some significance. Finally, even if it were the case that casual viewing of films with significant music tracks often goes on without a viewer's explicit awareness of that music, it hardly follows that an aesthetically justified or optimal viewing of such films remains similarly oblivious.

Another idea with some currency is the disavowal of what might be called narration proper—the conveying of a story by an intelligent agent—as actually characterizing the standard fiction film. One variant of this has it that such films are not really narrated by anyone or anything within the film world, but instead narrate themselves. A second variant insists that such films are constituted as narratives only by the viewer, and contain no narration apart from that. A third variant maintains that such films are not only constituted as narratives by viewers, but are in fact narrated by viewers to themselves as well, in the course of viewing.[4]

I reject the first sort of disavowal on grounds of incoherence; if narration means anything, it is the conveying or imparting of a story by means that are distinct both from the story being conveyed and from that which is doing the conveying; if the film, or its processes, are the means of narration, then it, or they, cannot also be conceived to be the agent or source of narration. I reject the second and third sorts of disavowal because they seem based on conflating the viewer's actual task of comprehending a

[3]This is a central thesis in Claudia Gorbman's *Unheard Melodies: Narrative Film Music* (Bloomington: Indiana University Press, 1987), and is echoed by other recent psychoanalytically oriented writers on film.

[4]Though he argues vigorously against the third form of disavowal in his attack on *enonciation* theorists, there remains something of the first and second in the constructivism about film meaning defended by David Bordwell; see his *Narration in the Fiction Film* (Madison: University of Wisconsin Press, 1985) and *Making Meaning* (Cambridge: Harvard University Press, 1989). For a critique of this aspect of Bordwell's otherwise salutary approach to film, see Berys Gaut, "Making Sense of Films: Neoformalism and Its Limits," *Forum for Modern Language Studies* (forthcoming). Bordwell's rejection of narrative agents in film as such is also criticized by Seymour Chatman, *Coming to Terms* (Ithaca, N.Y.: Cornell University Press, 1990), chapter 8.

film's story and significance by actively reconstructing or piecing together the narrative on offer, with the viewer's literal creation of that narrative, which would thus not exist apart from the viewer. But this is unnecessarily fanciful; our responsibility as filmgoers is to grasp what the narrative is, so as to further reflect on what it might signify, rather than to create that narrative for ourselves. Furthermore, were we really to create the narrative for ourselves, its significance would not, at any rate, be that of the film we were putatively attempting to understand.

So I am going to assume, following Seymour Chatman,[5] that if there is narration of events in a fiction film, if a comprehensible story comprising them is being conveyed to us, then there is an agency or intelligence we are entitled, and in fact need, to imagine is responsible for doing this narrating—to wit, a narrator, though not necessarily an ordinary human being.

There are, of course, alternatives to this assumption. As noted above, there are those who propose that films or filmic processes are themselves the performers or executants of narration, there not being of necessity any narrator within the film's world on the same plane as the events being displayed. But in addition to the fundamental incoherence remarked above, this proposal, to the extent it can be made out, is simply less interpretively useful than that of a narrator, however minimally characterized, for every successful narration. My response to yet another alternative, that in many cases of filmic narration, we imagine we are presented directly with the events of the story, without imagining there is any agent presenting them to us,[6] is much the same: the postulate of narrative agency in cinema does a better job of accounting for how we, admittedly largely implicitly, make sense of films as conveyors of stories.

For those who yet balk at this postulate, I would offer this. What I want to say about assigning nondiegetic music to narrative agents as opposed to implied filmmakers can, I believe, be translated so as to require instead only the assumption of narrative processes or mere appearances of being narrated. So even if one does not regard the positing of internal narrators or presenters in film as inevitable, the issue will still remain whether soundtrack music is to be thought of as an element in the narrative process or as an appearance of narrative presentation, as opposed to an element, standing outside both the story and its narration, in the construction of the film by a filmmaker. It is that issue I hope to illuminate.

## 4

I will now review Chatman's brief for both cinematic narrators and cinematic implied authors (that is, implied filmmakers).[7] Chatman begins with an appeal to ordinary language, one hard to gainsay:

---

[5]See his *Coming to Terms,* especially chapters 5, 7, and 8. Another writer who seems to accept the necessity of positing narrative agency in narrative film, though he verges on abstracting this to the point of abandonment, is Edward Branigan, *Point of View in the Cinema* (Berlin: Mouton, 1984).

[6]A position taken, for example, by Gregory Currie, in "Visual Fictions," *Philosophy Quarterly* 41 (April 1991): 129–43. I respond to Currie in "Seeing, Imaginarily, at the Movies," *Philosophy Quarterly* 43 (January 1993): 70–78.

[7]All references that follow are to *Coming to Terms.*

It stands to reason that if shown stories are to be considered narratives, they must be "narrated" . . . I would argue that every narrative is by definition narrated—that is, narratively presented—and that narration . . . entails an agent even when the agent bears no signs of human personality (p. 115).

If narrative films are then necessarily narrated by a narrator, what kind of narrator is this? Not, of course, the essentially linguistic narrator of a standard literary fiction:

Film often has nothing like a narrative voice, no tell-er. Even the cinematic voice-over narrator is usually at the service of a larger narrative agent, the cinematic show-er. But that shower can reasonably be called a presenter . . . (p. 113). Films, in my view, are always presented—mostly and often exclusively shown, but sometimes partially told— by a narrator or narrators. The overall agent that does the showing I would call the cinematic narrator . . . The cinematic narrator is not be identified with the voice-over narrator . . . (pp. 133–34).[8]

Chatman also proposes that a cinematic narrator, operating mainly through the affording of sights and sounds, is closely analogous to the mute presenter of dialogue in a purely dialogic short story.

So though in a film a teller, whose standard format is that of the voice-over, is usually absent or secondary, a *shower*—or better, because the term covers more comfortably aural information, a *presenter*—can be taken to be invariably in place, and the primary agent of narration. The presenter in a film presents, or gives perceptual access to, the story's sights and sounds; the presenter in a film is thus, in part, a sort of *perceptual enabler*.[9] Such perceptual enabling is what we must implicitly posit to explain how it is we are, even imaginarily, perceiving what we are perceiving of the story, in the manner and order in which we are perceiving it. The notion of a presenter, whose main charge is the providing of perceptual access on the fictional world, is simply the best default assumption available for how we make sense of narrative fiction film.[10]

While I thus accept Chatman's postulate of narrative agency wherever there is narration, I do not endorse certain of his claims about the separation of narrators from the story worlds they are narratively presenting. Chatman says, for instance, that "the [literary] narrator, by definition, does not *see* things in the story world; only characters can do that, because only they occupy that world" (p. 120), and that "the narra-

---

[8]This formulation of Chatman's is actually somewhat off the mark: it's not the *film* that is presented by the narrator, but various perceptual *contents*, various *sights and sounds*, that is, what one is enabled to see and hear, courtesy of the presumed powers of such a narrator. The film as such is rather presented by the *filmmaker* or, interpretively, the *implied filmmaker*.

[9]This is not to deny that it is sometimes be in the purview of the cinematic narrator to present the mental contents of some character, for example, memories, fantasies, dreams, visualizations. But two points about this should be noted. One, it may be unclear in such cases whether it is the cinematic narrator, acting on the character's behalf, who shows the character's mentation, or rather the character, acting as his own narrator, who is doing so. Two, the possibility of this sort of presenting requires a background of presentings of perceptual reality at a more basic story level.

[10]Problems of terminology loom here which a preemptive strike of clarification might dispel. Of the three ideas, *cinematic narrator, filmic presenter,* and *perceptual enabler,* the first is perhaps the broadest and the third the narrowest. Certainly there are actions of the cinematic narrator which go beyond those of perceptual enabling or filmic presenting, most notably in this context, narrative pointing through nondiegetic music. Whether there is a distinction worth making between filmic presenter and perceptual enabler is less clear; if so, the former would include the latter but comprise in addition resources such as character voice-overs or mind-overs, affording access to the fictional world in a wider-than-perceptual vein.

tor cannot impinge on story space but must stay within the bounds of discourse space" (p. 123). It is, however, incoherent to postulate a narrator who offers us a window on or reportage concerning the doings of a set of individuals the narrator takes and presents as real, and yet insist the narrator is on a different plane, fictionally speaking, from those individuals, and in principle incapable of perceptual awareness of them. Chatman is confusing a narrator's *fictional level,* which must standardly be the same as that of the other characters whose doings he/she/it is purporting to convey,[11] and the narrator's *degree of story involvement,* which is variable, at often rather small, and at the limit, nil.[12]

A narrator and the events narrated by the narrator must be on the same fictional plane, otherwise cognitive relations posited between narrator and events would not make sense. The cinematic narrator's logical status vis-à-vis the film world is to be distinguished from the narrator's degree of involvement—causal, emotional, experiential—in the story, that is, what literary theorists mark as the narrator's being either homodiegetic or heterodiegetic. Being heterodiegetic, or an "outsider" to the events being related, does not remove a filmic narrator ontologically from the characters he/she/it serves to offer us perceptual access to. Chatman fails to see that the narrator must perforce share the fictional plane of the characters, since they are apparently real and reportable to that narrator, and this is true whether the narrator is homodiegetic, that is, involved in the story events, or heterodiegetic, that is, uninvolved in them, standing to those events in merely a witnessing and transmitting capacity.

I turn now to the notion of implied author in film. The need for this concept is clear from the fact that films, like novels

> present phenomena that cannot otherwise be accounted for, such as the discrepancies between what the cinematic narrator presents and what the film as a whole implies . . . unreliable narration presents the clearest but not the only case for the implied author [in film] (pp. 130–31).

> . . . in cinema as in literature, the implied author is the agent intrinsic to the story whose responsibility is the overall design—including the decision to communicate it through one or more narrators. Cinematic narrators are transmitting agents of narratives, not their creators (p. 132).

> In short, for films as for novels, we would do well to distinguish between a *presenter* of the story, the narrator (who is a component of the discourse), and the *inventor* of both the story and the discourse (including the narrator): that is, the implied author . . . (p. 133).

So in film we must generally distinguish between, on the one hand, the narrator or presenter of the story and, on the other hand, the ostensible inventor of (all of) the nar-

---

[11]Except when the narrator's relationship to the story being presented is clearly signaled, in the novel or film, as one of relating a fiction as such, for example, as through a disclaimer like "this is only a story, it never happened." But this is quite rare in fiction film; it is even rare in literary fiction, Thackeray's *Vanity Fair* standing as a classic example, and John Fowles's *French Lieutenant's Woman* as a recent, though more ambiguous, one. Kendall Walton, in *Mimesis as Make-Believe* (Cambridge: Harvard University Press, 1990), marks this distinction as one between *reporting narrators* and *storytelling narrators* (pp. 368–72). The overwhelming majority of narrators in narrative fiction are reporting narrators, and as Walton points out, in such cases narrator and events narrated necessarily belong to the same world.

[12]As in the event of a wholly "effaced" and "omniscient" third-person narrator, the norm for cinematic fictions.

rator, the story narrated, the narrative structure, and the cinematic entirety in which these are embodied—to wit, the implied filmmaker. The implied filmmaker is the agent who appears to have invented, arranged, and integrated the various narrative agents and aspects of narration involved in the film, as well as everything else required to constitute the film as a complete object of appreciation. The implied film-maker, in short, is the picture we construct of the film's maker—beliefs, aims, attitudes, values, and personality—on the basis of the film construed in its full context of creation.

A film's narrator presents the events of the film's world from within it, whereas the implied author of a film, if he or she can be said to present anything other than the film itself, presents the world of the film, at one doxastic remove, from a position external to it. For the implied filmmaker, as for the viewer, but in contrast to a film's narrator, the film's world is a fictional one, acknowledged as fictional throughout. The implied filmmaker can't be in the position of directly affording us—as with a silent gesture of "behold!"—the vision and audition of something that is only fictional with respect to himself, namely, the characters and their circumstances; that remains the prerogative of the film's narrator or presenter, who is, in a fundamental sense, and pace Chatman, "one of them."

<div align="center">5</div>

Before proceeding to my main concerns, I will address the worries about the general postulate of a filmic narrator formulated by George Wilson in his penetrating study, *Narration in Light*.[13] These worries are the most substantial and explicit of which I am aware, so if they can be allayed, the ground for such a postulate will be that much clearer.

A reason Wilson offers initially for being wary of a standing postulate of a cinematic narrator is that such is often conceived as an agent who is necessarily *observing* events, the image track being thus identified as the visual experience of that fictional observer. But this, as Wilson quickly notes, is unnecessary. The essential function of such a narrator is to *show* us what is to be seen—or more broadly, to present to us what is to be seen and heard—in other words, to enable perception, albeit fictional perception, of those events. The agent that shows, or permits us to see, need not be thought of as seeing as well. This is apparent in Wilson's own useful sketch of what a cinematic narrator would have to be: "a fictional or fictionalized being, presupposed in any viewing of the film narrative, who continuously provides to the audience, from within the general framework of the fiction, the successive views that open onto the action of the film."[14]

The alternative, then, is to conceive the cinematic narrator as a kind of perceptual pilot through the film world, rather than as an observer of it whom we opportunistically inhabit. "Considered in this fashion, the narrator is a fictional figure who, at each moment of the film, asserts the existence of certain fictional states of affairs by

---

[13]See *Narration in Light* (Baltimore: Johns Hopkins University Press, 1986), chapter 7. See also my review of it in *Journal of Aesthetics and Art Criticism* 47 (Summer 1989): 290–92.

[14]Wilson, *Narration in Light*, p. 132.

showing them to the audience demonstratively; that is, by ostending them within and by means of the boundaries of the screen. It is certainly part of our experience in film viewing that we feel, usually subliminally, a constant guidance and outside direction of our perception toward the range of predetermined fictional facts which we are meant to see."[15]

Having so well formulated this alternative, what problem does Wilson find with it? Just this: that the entity described is analogous not to the narrator of a novel, but rather to its implied author. His reason for this reluctant conclusion seems to be that although " . . . the exact style and manner of this guidance—the fine-grained articulation of the processes of showing—manifests traits of sensibility, intelligence, and character . . . ," these traits are ones we will naturally take to define the persona of the *filmmaker* as expressed through the film, or equivalently, the personality of the *film's implied author,* thus leaving no room for a filmic narrator as such.

This seems to me too quick. First, Wilson gives no reason why such traits should not be assigned, in some cases, to a filmic narrator, and in others, to the implied filmmaker. Second, Wilson fails to consider that the assignment of traits to the implied filmmaker might very well interpretively depend on the assignment of traits, the same or different ones, to such a narrator, much as our image of the implied author of a novel is necessarily based, in large part, on our image of the narrator and how the narrator is managed or positioned by the author.

But third, and most important, Wilson overlooks the fact that the implied filmmaker just cannot occupy the role of perceptual guide to the film's occurrences, and so, a fortiori, his particular mode of doing that cannot be what cues us to some of his traits. And that is because the implied filmmaker cannot logically be the presenter—the ostender—of events that are fictional with respect to him. That is to say, if we imagine anyone giving us access to those events, it cannot coherently be the filmmaker, in any guise. To be sure, the filmmaker can present representations of those events, that is, the shots or images the totality of which constitute the film, but he cannot offer us the vision and audition of those events themselves.[16] If he be allowed a surrogate, however, a narrating agent presupposed by the process of narration, and fictionally on the same level as its subject matter, then this difficulty disappears.

A fourth and related reason why the filmmaker cannot do duty for the film's narrator in this connection is this. Often we want not only to attribute traits of character, sensibility, or intellect to some agent connected with the film, but more specifically, attitudes or views concerning the story that is unfolding. But the filmmaker is not in the right cognitive position for this; that is to say, he or she will not actually have attitudes or views toward the fictional personages or occurrences involved in the story, knowing they are merely fictional.[17]

I suspect that Wilson is unable to find a place for, and thus underestimates the rationale for, the cinematic narrator, because he subtly conflates the devices or powers at the service of a director as crafter of a representation, and those in the command

---

[15]Ibid., pp. 133–34.

[16]Of course he can and does offer us the vision and audition of various events which took place during the filming, namely, the enacting of various roles by various actors—but that is another matter.

[17]Compare Walton, *Mimesis as Make-Believe,* p. 366.

of an imagined perceptual guide to the world such a representation makes fictional[18]; but these are different, and the ways they function to control our experience as viewers differ too. The filmic narrator allows us to perceive first this person, then that, at such and such an apparent range, and for so long, clearly or not so clearly, and so on, all of which manner of showing may give us a certain impression of the shower's attitudes or motivations; the filmmaker chooses or stages the profilmic events that are to be filmed, decides on the camera distances and movements required for a shot, determines the lighting and length of shots, orders those shots in a certain fashion, and so on, thus ultimately composing a narrative of a particular sort, with a particular sort of implied narrator, all of which manner of making may give us a certain impression of the maker's personality or outlook. But the view we form of the narrating agency or intelligence, from the way it carries out its main charge as perceptual facilitator, need not coincide with the view we form of the human maker of the film, from the way he or she fulfills the demands of filmmaking.[19]

Curiously, Wilson allows that we can indeed imagine a film where we would have "grounds for a distinction between a voyeuristic filmic narrator and a satirizing implied film maker. In such a case, there would be enough of a personification of the manner in which the action is shown and enough of a contrast between the personification and what is implied about the filmmaker's views of this to motivate the identification of [the former] as a narrator."[20] But to my mind, the very possibility of this kind of divergence is predicated on and presupposes the logical distinctness of the roles of filmic narrator and implied filmmaker, even if in most films, unlike the one Wilson conjures up, the personal traits ascribable to the occupants of the two roles tend to coincide.[21]

---

[18]Nor are supporters of the notion of a narrator internal to film immune to this confusion. Consider the formulation of Nick Browne, quoted by both Branigan and Chatman: "the authority which can be taken to rationalize the presentation of shots" [*The Rhetoric of Filmic Narration* (Ann Arbor: UMI Research Press, 1984), p. 1]. But since *shots* are constructional elements of films as made objects, that authority can only be the implied filmmaker; the authority, or agency, that Browne is really after is that which appears to rationalize the presentation of *views,* or sights and sounds.

[19]There are other sources of Wilson's reluctance to embrace filmic narrators on a standing basis. He suggests at one point that a filmic narrator distinct from the implied filmmaker would, by analogy to literature, have to be "a *character* that the text *depicts* directly or indirectly" (*Narration in Light,* p. 136). But this is only half right; the narrator is indeed a kind of fictional character, but not one that need be depicted, as I understand that term. If purely dialogic short stories, or purely epistolary novels, have narrators, then such narrators are not depicted, either directly or indirectly. So the fact that cinematic narrators are standardly not depicted, that is, nothing in films shows or announces them as such, is not a principled impediment to acknowledging them.

[20]Ibid., pp. 136–37.

[21]My discussion so far may give the impression that I regard the role of the implied presenter of a narrative film as confined to that of providing views on events understood as fully constituted independently of the shower's activity. But while I think that that is indeed the dominant role of a film's presenter, it need not be the exclusive one. The cinematic narrator might in part be thought of as a fashioner or shaper of events that are only *then* presented, more straightforwardly, in certain ways (for example, in certain lights, or in a certain order). This fashioning or shaping of fictional events thought of as existing, on a more basic level, prior to narrative attention, can be seen as a more subtle way of presenting events taken to belong to the underlying event structure with which narration is concerned. If so, then the narrative structuring of films is a two-stage affair, and that which is effected through camerawork and editing is subsequent to that understood to be achieved in the staging of action and the manipulation of setting. (For more on this dimension of cinematic narration, and the rationale of its recognition, see Bordwell, *Narration in the Fiction Film*).

As we have seen, Wilson questions whether every standard film narration must be understood to entail an implicit narrator distinct from the filmmaker. He maintains that in films governed by the classical paradigm of transparency, which covers almost all narrative film, we simply see the fictional events for ourselves, defeasibly taking the facts about them to be what we see them to be. But to my mind this sidesteps the question of *how it is* we are seeing what we are seeing, however reliable or unreliable it turns out to be. If this question, however, is not simply set aside, then the only satisfying answer to it is that we are being *shown* such and such, by some agent, in some perhaps unspecifiable manner. That is to say, the posit, however unvoiced, of an agency that is offering us sights and sights—an agency with certain powers, motivations, and limitations—seems inescapable if we are to justify our taking anything to be fictional in the film world, on the basis of the moving images that are the only thing we are literally confronted with. It is not enough to just say that, with fiction film, the film's world is made visible to us, perhaps adding that there is a convention to that effect. Reason—albeit reason operating in service of the imaginative understanding of fiction—demands an answer to how it is that a world is being made visible to us, and that demand, it appears, is only satisfied by the assumption of an agency responsible for that.

One might still seek to avoid this conclusion by adopting the following stance: it is, indeed, *as if* we are being shown such and such, from a given perspective, by an agent within the film's world, with certain powers to make views of that world available to us, but we need not assume that there *is* such an agent. Here, though, we arrive at a distinction virtually without a difference. If it seems to us, at some level, as if we are being shown such and such, are we not in effect imagining that we are being shown such and such, and thus, finally, that there is, on the imaginative plane, something doing the showing? So I would claim.

## 6

That nondiegetic music standardly serves to advance a film's narrative is something on which theorists of film appear to agree:

> Narrative is not constructed by visual means alone. By this I mean that music works as part of the process that transmits narrative information to the spectator. . . . [22]

> Voice-over is just one of many elements, including musical scoring, sound effects, editing, lighting, and so on, through which the cinematic text is narrated.[23]

> The moment we recognize to what degree film music shapes our perception of a narrative, we can no longer consider it incidental. . . . [24]

Another point widely agreed upon is that even if the primary purpose of nondiegetic film music is the advancing of the narrative, there may very well be others. Here is a typical admonition concerning film music's multiplicity of ends:

---

[22]Kathryn Kalinak, *Settling the Score: Music and Classical Hollywood Film* (Madison. University of Wisconsin Press, 1992), p. 30.

[23]Sarah Kozloff, *Invisible Storytellers: Voice-Over in American Fiction Film* (Berkeley: University of California Press, 1988), pp. 43–44.

[24]Gorbman, *Unheard Melodies,* p. 11.

There is not *one and only one* function that music can perform in relation to movies. Aaron Copland suggested five broad functions: creating atmosphere, underlining the psychological states of characters, providing background filler, building a sense of continuity, sustaining tension and then rounding it off with a sense of closure. These do not seem to be necessarily exclusive categories, nor do they exhaust the range of functions that music can perform in movies.[25]

Not surprisingly, I am happy to join this double consensus: film music often serves narrative in some way, but there is a range of other functions that such music sometimes performs. What I am concerned to demonstrate, however, goes beyond those two pieces of received wisdom. It is that the most fundamental division in the realm of film music concerns the viewer's assignment of responsibility for such music, that is, the agency the viewer posits, usually implicitly, as responsible for the music being heard. It will turn out that there is a rough coincidence between film music to which we intuitively accord narrative significance and film music for which we implicitly hold an internal cinematic narrator accountable, and between film music to which we do not accord narrative significance and film music that we implicitly assign directly to the implied filmmaker.

When, though, can film music be said to have narrative significance? When does nondiegetic music function narratively? In order to answer this question we must have a plausible criterion of narrativity or of actions within the purview of a narrator. In trying to arrive at one, it will be helpful to have before us a survey of the various functions that critics or theorists have observed film music to perform.

These functions include: (1) the indicating or revealing of something about a character's psychological condition, including emotional states, personality traits, or specific cognitions, as when the music informs you that the heroine is happy, or that the hero has just realized who the murderer was; (2) the modifying or qualifying of some psychological attribution to a character independently grounded by other elements of the film, as when the music tells you that a character's grief over a loss is intense; (3) the underlining or corroborating of some psychological attribution to a character independently grounded by other elements of the film, as when music emphasizes something about a situation on screen which is already fully evident; (4) the signifying of some fact or state of affairs in the film world other than the psychological condition of some character, for example, that a certain evil deed has occurred, off-screen; (5) the foreshadowing of a dramatic development in a situation being depicted on screen; (6) the projecting of a story-appropriate mood, attributable to a scene as a whole; (7) the imparting to the viewer of a sense that the happenings in the film are more important than those of ordinary life—the emotions magnified, the stakes higher, the significances deeper; (8) the suggesting to the viewer of how the presenter of the story regards or feels about some aspect of the story, for example, sympathetically; (9) the suggesting to the viewer of how he or she is to regard or feel about some aspect of the story, for example, compassionately; (10) the imparting of certain formal properties, such as coherence, cogency, continuity, closure, to the film or parts thereof; (11) the direct inducing in viewers of tension, fear, wariness, relaxation, cheerfulness, or other similar cognitive or affective state; (12) the lulling or mesmer-

---

[25]Noël Carroll, *Mystifying Movies* (New York: Columbia University Press, 1988), p. 216.

izing of the viewer, so as to facilitate emotional involvement in the fictional world to which the viewer would otherwise prove resistant; (13) the distracting of the viewer's attention from the technical features of the film as a constructed artifact, concern with which would prevent immersion in the filmic narrative; (14) the expressing by the filmmaker of an attitude toward, or view on, the fictional story or aspect thereof; (15) the embellishing or enriching of the film as an object of appreciation.

Without deciding, for each of these functions, which are properly considered narrative and which not, it would appear that some of them unequivocally are and some unequivocally are not. What I will do at this point is explore a number of suggestions as to what the criterion of narrativity might be in regard to nondiegetic film music, assessing them against the background of this array of observed functions, some of which, at any rate, would have to come out counting as narrative, some clearly not, and some having a status that might only be settled, clarifyingly, once a given suggestion is adopted.

One possible criterion is this: (C1) does the music seem to issue from, be in service of, the agency one imagines to be bringing one the sights and sounds of the film's world? If so, then it can be reckoned part of the narration proper, and assignable to the cinematic narrator. Perhaps an equivalent formulation would be: (C2) does the intelligence one thinks of as bringing one the music seem to be the same as that charged with conveying the story—as opposed to that charged with constructing the film? If so, then the music can be reckoned part of the narration, and assigned to the cinematic narrator.[26]

Though I think these criteria point in the right direction, there is an evident problem with them, insofar as we hope to look to them for guidance, especially in difficult cases. And that is that they are uncomfortably close to what they purport to analyze or elucidate, namely, whether a use of nondiegetic music is narrative or not. So if we are unsure whether a given cue is functioning narratively, we are likely to be almost equally unsure whether it feels as if it derives from the film's narrative agent. Thus, it would seem desirable to have some other mark, could we discover one, whose conceptual distinctness from the idea of narrative functioning was greater than that of C1 or C2.

Such a mark might be that of *making a difference* in the narrative. Instead of appealing directly to an intuition of a connection of the music to a film's internal narrator, we can appeal instead to the notion of *making fictional*, or generating fictional truths, in a film. A criterion of nondiegetic music having a narrative function, and thus being attributable to a narrative agent, could be thus: (C3) the music makes something fictionally true—true in the story being conveyed—that would not otherwise be true, or not to the same degree or with the same definiteness. A counterfactual form of the suggestion is perhaps more transparent: (C4) would deleting the music in a scene change its represented content (that is, what is fictional in it), or only how the scene affects viewers? If the former, then the music is an aspect of narration; if the latter, then not.

---

[26]Note that this would apply even when such music is unforegrounded: if it appears to respond to the demands of storytelling, broadly understood, then it can be construed as something like musical musing, *sotto voce,* on the cinematic narrator's part.

We must briefly discuss what it means to make something fictional in a work of fiction such as a narrative film. Something is fictional in a film, according to a well-developed recent account, if it is *to be imagined to be the case* by viewers concerned to experience the film properly.[27] What thus makes something—a proposition about the film's world—something that is to be imagined in the course of viewing is, in short, perceivable features of the film, a public object, taken as a prop for guided imaginings.

When we make believe in accord both with the features of artistic props and the usually tacitly grasped principles for imagining that are in effect in a given art form, we are engaged in tracing out imaginary worlds, ones in which things are *make-believedly,* or *fictionally,* so. The fictional world of a representational art work, unlike that of a daydream or fantasy, is as it is because features of the associated prop—text, canvas, film—properly construed, are the way they are; not all is up to the imaginer. Props, through their existence and nature, generate fictional truths independently of what individual perceivers might choose to imagine.

What does it mean for a proposition to be fictional, or true in a fictional world, in respect of a given work of art? Simply that there is a *prescription to imagine* it, a prescription encoded in the particulars of the artifact that serves as a prop for making believe, and whose force derives from underlying conventions of construing works of the sort in question. Being fictional thus has an ineliminable normative dimension: it is what *is to be* imagined in a given context, rather than merely what *may* be imagined.

For example, in *Citizen Kane,* Orson Welles's image on-screen being that of a large man makes it fictional that Charles Foster Kane is a large man; the opening shots—a series of lap dissolves—having a certain visual content makes it fictional that at the beginning of the story one is shown Kane's estate, Xanadu, from a distance and shrouded in mist, and then at progressively closer range; Ray Collins's voice saying certain things on the soundtrack in the scene at Susan Alexander's apartment makes it fictional that Collins's character, Jim Gettys, has threatened Kane; the way the shot of Kane expiring is sequenced in relation to others which are understood as a flashback to Kane's childhood, makes it fictional that Kane's dying word, "rosebud," refers to his beloved old sled, and so on. Of course, much of this generation will be indirect, dependent on various conventions of the medium in effect and on other things taken provisionally as fictional, and accordingly, much of our knowledge of such fictional truths will be inferential. And sometimes, what is made fictional by a film's narration is orthogonal to, or even the opposite of, what first appears to be the case, that is, what it initially seems we are to imagine is the case; unreliable, uninformed, or unforthcoming narrators, though not as common in film as in literature, are still a significant possibility.

Applying this suggestion to the issue of narrativity in film music, then, the question becomes, of a given cue, whether it generates, contributes to generating, or at a minimum, more firmly grounds, a fictional truth in the scene which it accompanies. Thus, film music that, when interpreted in light of prevailing conventions of the medium and the surrounding narrative context, indicated that a character was afraid

---

[27]See Walton, *Mimesis as Make-Believe.* For an entrée into this important work, see my critical notice, "Making Believe," *Dialogue* 32 (1993): 359–74.

or was remembering a past incident, or that a man had been executed or an agreement reached, or that a situation was fraught with danger or else full of hope, where these things would not be established, or not so definitely, without the music, would clearly count as narrative.[28]

We should note that nondiegetic music may, indeed, generate fictional truths even if only attended to with half a mind, or not consciously remarked at all while present. It will do this by causing a viewer to, say, perceive a scene as fraught with danger, even if the viewer is not aware of what is making her have that perception. Nevertheless, if such an imaginative perception is reliably produced in attuned viewers, and not undermined by subsequent aspects of the narration, then it may well be fictional that the scene is fraught with danger, even though the rest of the narrative indicators are insufficient to establish that and the viewer never realizes that it is the background music that in fact makes it so.

<div align="center">7</div>

It is time to look at a range of illustrative examples of film music. I begin with examples whose narrative functioning is obvious, and which conform, expectedly, to the making-fictional criterion proposed above. I then explore another range of examples, ones that exhibit a different sort of narrativity, and show how, on a more encompassing construal of the making-fictional criterion, these can be accommodated as well. Eventually, though, I turn to films containing nondiegetic music that is not, by that criterion or any other, reasonably construed as narrative. The music in such films instead serves other sorts of artistic function, ones attributable directly, I will argue, to implied filmmakers.

One of the least ambiguous narrative uses of soundtrack music in recent film occurs in Steven Spielberg's 1975 blockbuster, *Jaws*. I have in mind the "shark" motto devised by the composer, John Williams. This consists of an ostinato alternation of low staccato notes at the interval of a second—a kind of aural sawing. The motto has an unarguable informational mission, namely, to signal the presence of the shark. It is true that there is another, visual, indicator of the shark's presence when unseen, namely, shots from an offshore point of view, at the water line or slightly below it. But that indicator is not invariant in meaning, since it is sometimes employed when there is no shark about. The musical "shark" motto is the only reliable signifier of the shark, and so has an ineliminable fact-conveying function. Correspondingly, it is clear that it is the presence of that motto on the soundtrack at a given point that makes it fictional that the shark, though as yet unseen, is in the vicinity of what is shown.

David Raksin's ground-breaking score for Otto Preminger's *Laura* provides some further instances of straightforward narrative use of film music. The "Laura" theme, first encountered diegetically on a record player in the apartment of the ostensibly murdered heroine, pervades critic Waldo's (Clifton Webb) represented recollections

---

[28]"Film music . . . often contributes subtly but effectively to the generation of fictional truths—helping to establish, for example, that fictionally a character is nervous or cocky or ecstatic . . ." (*Mimesis as Make-Believe*, p. 172).

of the early days of his relationship with Laura (Gene Tierney), and signifies unmistakeably his joy and delight in her companionship. Subsequently we are treated to apprehensive versions of the "Laura" theme as detective McPherson (Dana Andrews), alone in Laura's apartment, studies the portrait of Laura over the fireplace; this cue then climaxes unsettlingly, revealing or underlining McPherson's frustration with his investigation at this point. The most striking cue, one much noted in the film music literature,[29] is a weird version of the theme which is produced by playing it on a piano but only recording the overtones of each note struck. This is heard as McPherson views Laura's portrait on a second occasion, before drinking too much and falling asleep, and it suggests the ghostly influence Laura is beginning to exert over this poor detective's mind. In each of the foregoing cases, the music is plausibly viewed as making, or contributing to making, something fictional in the story: that Waldo delighted in Laura inordinately, that McPherson is (earlier) almost terminally frustrated with Laura's case, that McPherson is (later) succumbing to bewitchment by Laura's spirit.

Another film rich in narrative pointing of a theoretically unproblematic sort is Martin Scorsese's *Taxi Driver.* Regarding a scene in which Travis (Robert De Niro), the film's semipsychotic protagonist, is induced to move his cab away from the Manhattan workplace of a girl he is infatuated with and back into the grime and disorder of the city, one writer affirms that "the music . . . here reveals that Travis's thoughts are not with the street but with Betsy." And of the bluesy, sensual saxophone tune itself, which stands for Betsy (Cybill Shepherd) in Travis's mind, the same writer has this to say: "Travis's vision of idealized womanhood, the music implies, is strongly erotic."[30] Thus, Bernard Herrmann's music does not serve merely to inform us about Travis's mental life, or to second redundantly what other elements of the film establish about his mentality, but rather enters into making it *fictional* in the film that Travis's mental life is a certain way at a certain time. Commenting on the blade-game fight scene in Nicholas Ray's *Rebel without a Cause,* Noël Carroll offers the following: "The uneasy, unstable quality of the music [by Leonard Rosenman] serves to characterize the psychological turmoil—the play of repression and explosive release—with which the scene, and the movie, is concerned."[31] If Carroll is right, the music of this scene, which intuitively seems an aspect of its narration, serves to underwrite as desired a fictional truth about the specific, highly volatile, character of the turmoil afflicting the young protagonists. Another instructive example from *Rebel without a Cause* occurs later in the film, and consists of a montage of two-way phone calls among various adults concerned with the whereabouts of three main youngsters. This montage is covered by tense nondiegetic music, displacing the dialogue that would ordinarily be heard, the music thus signifying that the conversations, whatever their specific contents, are anxious ones.

The opening of Elia Kazan's *On the Waterfront* affords another illuminating example. An establishing shot of city docks, ocean liner in the distance, gives way to a

---

[29]See Kalinak's informative discussion in *Settling the Score,* p. 178.

[30]Graham Bruce, *Bernard Herrmann: Film Music and Narrative* (Ann Arbor, Mich.: UMI Research Press, 1985), p. 68.

[31]*Mystifying Movies,* p. 217.

street scene in which longshoreman Terry (Marlon Brando) becomes the focus of attention. Leonard Bernstein's jazz-inflected score at this point involves a persistent drum tattoo overlaid with saxophone insinuations. Terry, in the darkening street, yells up to friend Joey's window, persuading him to go to the roof to recover one of his pet pigeons, where unbeknownst to Joey, two men are waiting for him. After Terry releases the pigeon he's been holding, and promises to join Joey in a moment, the score becomes loud, aggressive, and insistent, its rhythms more syncopated. The music telegraphs us that something bad is in store, that the men glimpsed on the roof are trouble; the music can be said to prefigure Joey's fall, pushed off the roof by thugs of the corrupt union boss, though without defining precisely what is about to happen. The cue is clearly narrative, and just as clearly, makes it fictional that Joey is in danger, even before he leaves the window for his fatal visit to the roof.

Later on, after the boss tells right-hand man Charley (Rod Steiger) to straighten out his brother Terry or else, Charley leaves union headquarters to do something, we know not what. Bernstein's music at this point is very dramatic and tense: a series of rising notes in the brass, leading to a rhythmic explosion, the whole heard twice. The cue arguably conveys Charley's complex state of mind, as he faces the necessity of keeping his errant brother, who is threatening to do the right thing, in line: a mixture of anger, shame, and angst. If it does not single-handedly make it fictional that that is Charley's state of mind, the cue contributes ineliminably to making it so. A dissolve leads directly to the famous conversation between the brothers in the rear of a taxi.

Consider, lastly, the final sequence in Fellini's *La Strada*. Five years ago, Zampano the strongman (Anthony Quinn) has abandoned his assistant, the childlike Gelsomina (Giuletta Masina), after she became too withdrawn and depressed to work. He now discovers, by accident, her fate. That evening he does his act perfunctorily, gets drunk, starts brawling, then goes down to the beach, which reminds us of where he first acquired Gelsomina from her impoverished family. He walks into the water, returns to the beach, looks up at the sky apprehensively, then starts to bawl and grasp at the sand, on which he has flung himself in despair. At this point the "La Strada" theme on the soundtrack removes all doubt as to what it is Zampano is bemoaning— namely, the loss of Gelsomina and her innocent love.

<div style="text-align:center">8</div>

Clearly, making something fictional in a film is a *sufficient* condition of musical narrativity. Is it, however, a necessary one? Though providing the basic fictional truths of a story may be the central activity of a narrator, there are others that are almost equally paradigmatic of narration. One is the evincing of attitudes or feelings on the narrator's part toward the story presented, in virtue of how the story is presented; another is the inviting of the viewer to adopt certain attitudes or feelings toward the story presented. In other words, in addition to giving access, in a particular manner, to the fictional states of affairs that constitute a story, a narrator generally manifests attitudes regarding the states of affairs to which access is afforded, and thereby suggests to the narratee attitudes to be adopted. In literature, for example, the narrator standardly tells us what happened, after his or her fashion, reveals, knowingly or

unknowingly, his or her view of these happenings, and also suggests, explicitly or implicitly, how we should view what we are told happened.[32]

Now it seems plain that such narrational effects are often achieved by appropriate nondiegetic music: the music tells you how the presenter of the story regards the events being presented, or else how he would like you to regard them. But on the surface, this does not appear to be a matter of establishing, nuancing, or even confirming a fictional state of affairs in the story. So in light of that, can making fictional be sustained as the effective mark of musical narrativity?

I believe so. We need to make a distinction between what is fictional *in a film's story* and what is fictional *in the world of a film*. The latter is a broader notion than the former. What is fictional in the film's world comprises, in addition to the facts of the story, the facts of its narration by the special, often almost effaced, fictional agent known as the narrator. All that is still within the sphere of the fictional, of propositions to be imagined by a viewer in comprehending the film. The film's story consists of what is fictional about the characters who figure in the action; the film's world includes, as well, what is fictional about the narrator, in relation to either the story narrated or the implied audience of that narration.[33]

Returning to film music, a plausible construal of some nondiegetic cue will often have the implication, not that it makes something fictional in the story, but that it makes it fictional either that the cinematic narrator has a certain attitude or feeling toward some event being presented, or that the narrator encourages viewers to have such an attitude or feeling toward it. In either case, musical narrativity will still correlate with music's making something fictional, only here it is a making fictional in the film's world, as opposed to a making fictional in the embedded story. Some examples will serve to clarify this more encompassing interpretation of musical narration in terms of making-fictional.

Music functions narratively, by any intuitive assessment, in Hitchcock's *Shadow of a Doubt,* particularly at junctures when a scrap of Lehar's "Merry Widow" waltz intrudes itself, suggesting the "Merry Widow Murders" that are central to the plot. Several characters are heard singing or humming the tune in the course of the film, these occurrences being of course diegetic, but the tune is heard, in an altered form, as early as Dmitri Tiomkin's title music, which accompanies a stylized shot of waltzing couples. Two notable nondiegetic occurrences after that are these. First, a few bars of the waltz theme in the cue that accompanies the family's greeting of Uncle Charlie (Joseph Cotten) at the train station, as they walk off to their car to take him home: a tracking shot of the group, heading toward the camera, is eventually reframed so that only Uncle Charlie is in view, and that is when the scrap of tune is heard. Second, a more prominent statement of the theme when Uncle Charlie gives young Charlie (Teresa Wright) an emerald ring, and she notices it is already engraved inside with an unknown someone's initials. In both cases, the music arguably serves

---

[32]In some literary fictions, for example, Hemingway's *The Killers* or Robbe-Grillet's *La jalousie,* this latter function may seem to have lapsed. But I would argue that even in such fictions there are attitudes the narrator implicitly invites the reader to adopt, precisely in virtue of so pointedly eschewing normal commentary.

[33]Of course, when a narrator in a film is also a character in the action, as with a homodiegetic voice-over narrator, then certain facts about such a narrator are also facts of the story.

to communicate something to the viewer about Charlie's identity, connecting him in some as yet unexplained way to the waltzing image presented at the beginning.

But does the music make, or even contribute to making, something true in the film's story as such, something that would not otherwise be the case? It is not clear that it does. To consider just the most obvious candidates, neither cue makes it true— even viewed in retrospect, when a connection to Lehar's tune is understood to import as well a connection to the "Merry Widow" murders—that Uncle Charlie is the murderer, nor does the second make it true, say, that young Charlie suspects that he is. The reason is that those fictional truths are firmly established, and independently, by other elements in the film.[34]

What, then, might they be doing? I suggest that the first cue makes it fictional that the narrator is obliquely hinting to viewers with regard to Uncle Charlie's identity, and the second makes it fictional that the narrator is, even more directly, connecting Uncle Charlie to something sinister in his past, though at that point viewers have no notion of what it might be. The second cue may, in addition, function as the narrator's proposing of a deep psychic link between Uncle Charlie and young Charlie, one that her subsequent moral corner-cutting, in dealing with an uncle she then knows to be an unhinged killer, partially bears out.[35] In any event, the status of these cues as narrative can be recovered in the guise of what is made fictional, not in the story as such, but in the narrator's attitudes or actions with respect to viewers.

But what of the curious musical image of waltzing couples first encountered in the title sequence, which recurs nondiegetically and unchangingly at three crucial points in the story? In each case the image is superimposed over the action already on view, which continues underneath. The first occurrence is after the interaction between Uncle Charlie and young Charlie over the emerald ring, as young Charlie goes off to clear the supper dishes, leaving only Uncle Charlie on screen. The second occurrence is at night in the town library, when young Charlie, after reading the newspaper account of the "Merry Widow" murders, gets up, almost reeling, as the camera tracks upward and away from her. The third and last is just as Uncle Charlie falls to his death beneath the wheels of a hurtling locomotive.

The first and second of these might be interpreted as the narrator's display of the mental contents of the character then in frame, in the one case signifying Uncle Charlie's meditation on his hidden identity, in the other, his niece's realization of that identity. But in addition to being implausible because not reflecting the very different emotional tones with which uncle and niece would have contemplated this identity,

---

[34]For example, that Uncle Charlie is the murderer is underwritten by his unexplained money in the opening hotel room scene, by his evident concern to keep an item in the daily newspaper unread, by his unreasonable aversion to being photographed, by his maniacal utterance at the dinner table about fat, wheezing, useless widows, by the already-inscribed ring itself, and so on. That young Charlie suspects him does not become true until she is informed about the manhunt by one of the two detectives who have been trailing Uncle Charlie—though of course there have been signs, intended for and readable by the viewer, well before that.

[35]Their psychic kinship is adumbrated earlier in the film, in the parallelism of our first views of them both, reclining on beds with their hands behind their heads, in the worried, almost cynical remarks about family values that young Charlie makes when we first hear her speak, and in the coincidence of young Charlie deciding to send her uncle a telegram just hours after he has, unbeknownst to her, sent one in her direction.

this sort of interpretation seems unavailable for the last occurrence, where ascription to the terrified and soon-to-be-obliterated Uncle Charlie of a contemplative thought about his past strains credulity to the breaking point.

This suggests that the recurrent waltzing image should be construed as a form of narrator's commentary: it is employed by the cinematic storyteller at crucial moments to underline in an intentionally jarring manner—because achieved through the elegance and innocence of a waltz—Uncle Charlie's horrific identity. Thus, what is made fictional by these musical cues is *not* that Uncle Charlie is the murderer, but that the *narrator* is adverting to that fact, almost sardonically, both before and after it is narratively established.

*Rebel without a Cause* provides another example whose analysis helps us to see our way here. The opening scene unfolds at a police station, where three juveniles whose lives will soon importantly intersect find themselves separately in trouble. At one point Jim Stark (James Dean), who has been talking with a sympathetic counselor, bangs and kicks a desk in frustration, at the counselor's explicit invitation. As his outburst concludes, dissonant music surges up briefly on the soundtrack. This undoubtedly adds tension to the scene, but does it contribute to defining the fictional world in any way? That Jim is wildly and angrily frustrated is fully established by what the perceptual enabler of the film has allowed us to see and hear of his outburst. What, then, is the music, which certainly seems to have narrative force, doing there in narrative terms?

Perhaps this: it serves to get across the phenomenology of Jim's feelings, giving viewers access to the quality of his outburst from the inside, supplementing the access afforded from the outside by the ordinary perceptual data of the scene. Suppose that is so. Then on the one hand, this could be construed as a subtle sort of making-fictional in the story, namely, making it fictional that the quality of feeling in Jim's outburst was precisely such and such—the quality the musical cue in question is expressive of. On the other hand, this could equally well be construed as a making-fictional concerning not Jim, whose emotional condition is perhaps overdetermined by other indicators in the scene, but instead the narrator's stance toward the audience. That is, perhaps the cue's cash value is that the narrator is inviting viewers to share in rather than merely observe what Jim was feeling, and as a consequence, encouraging viewers to adopt a sympathetic attitude to him. The cue's narrativity, in other words, may be a matter of its definition of the fictional world of the film, comprising both narrator and story narrated, rather than that of the story per se.

Consider now the common use of background music to create atmosphere in a scene, but without attributing mental states to any character therein. Is there anything that can thus be said to be made fictional in the film world? In cases where an appropriate atmosphere is created, that is, one that seems consonant with the way the story is otherwise told, what is made fictional might be that the narrator wants the viewer to assume a particular mood or frame of mind as certain events are presented for perception. In cases, though, where the atmosphere created does not gibe with the style or tone of narration already established, then even indirect fictional generation of that sort may be absent. The musical creation of mood may then have to be understood not as a narrative action, but rather one of aiming to immediately affect the viewer in a way

that has no fictional upshot. Where nondiegetic music adds atmosphere to a scene without plausibly making anything fictional in the film's world, simply producing a mood in viewers, it seems that responsibility for it, as for other nonnarrative, purely compositional elements of a film, must rest directly with the implied filmmaker.

Exploring the interpretive option just broached—of assigning musical cues to the implied filmmaker rather than the film's narrative agent—will be the focus of the remainder of this essay. But before turning to that I conclude this section with a brief look at narrative uses of nondiegetic music in Hitchcock's *Vertigo*. *Vertigo* boasts perhaps the greatest of classical film scores, and its greatness as a film is due, in no small measure, to that score and its masterful integration into the film in almost every respect.

The intrinsic interest and sophistication of Bernard Herrmann's score has been much discussed, but what is most striking about it in the context of the film is how significant a burden it bears for limning the mental states and traits of characters, by comparison with most other films. *Vertigo* abounds in occasions where not only are viewers fictionally *informed* about the inner lives of the characters through sound-track music, but the music is what in large part *makes* it fictional that their inner lives are to be so characterized.

When Scottie (James Stewart) first sees Madeleine/Judy (Kim Novak) at the rear of a restaurant in San Francisco, the music serves significantly to characterize her for us and for him: " . . . if the camera movement toward Madeleine lets us experience the physical nature of Scottie's immediate attraction to her, it is the music that most fully conveys the sensual mystery of the woman."[36] This scene is instructive in other ways as well. Madeleine gets up to leave, comes toward Scottie, pauses momentarily, and is very noticeably framed and lit in profile—shown, in effect, to best advantage. But who is doing that? The cinematic narrator, in order to indicate something about Madeleine and the overwhelming psychic effect she has on Scottie on first encounter. The filmmaker, Hitchcock, cannot do that—though he can do certain parallel things to Kim Novak and the set in order to bring about, on a fictional plane, the narrative result. The cinematic narrator is the one who, fictionally, showcases Madeleine, for our benefit as trackers of the story, and then underscores this showcasing through the musical resources under its control, for example, by crescendoing at the point of held close-up.[37]

After the crisis of the first part of the film, Scottie spends some time in a sanitorium, sunk deep in depression and aimless longing. Soon after his release, we are given a high pan over the front of Madeleine's apartment building, as the "love" motif—a four-note Tristan-like descending figure—is sounded romantically by French horns. This foreshadows Scottie's appearance in frame at the end of the camera movement, with Madeleine obviously in mind: he approaches a blonde woman in front of the building, about to get into what was Madeleine's car, only to discover that

---

[36]Bruce, *Bernard Herrmann*, p. 143.

[37]This scene illustrates nicely a narrative possibility mentioned above (see note 22), whereby a cinematic narrator might be thought of as presenting story events, conceived of as already existing fictionally at a basic level, *in a certain way*, through a partial shaping of the event being viewed.

it isn't her. The exact content of his hope and then disappointment is supplied by the musical cue.

Scottie's vertigo first occurs in the film's opening scene, while he is hanging from a rain gutter, high above the city, having slipped in the course of pursuing a fleeing felon. This is importantly recalled in the plot's pivotal event, occurring halfway through the film, which takes place at the Mission of San Juan Battista, from whose tower the real Madeleine, unwanted wife of Gavin Elster, will appear to have leapt to her death. As Madeleine rushes into the church, and Scottie begins to follow, Herrmann's music foretells the recurrence of Scottie's vertigo: " . . . milder variants of the clash of tonalities which were heard in the [opening] rooftop sequence hint at the probable effect climbing the tower will have upon Scottie. . . ."[38] The musical cue, it seems, generates the fictional truth, at the point it sounds, that Scottie is *going* to experience vertigo when he climbs, though he is not experiencing it *now*. In other words, that Scottie's vertigo is coming becomes something that is to be imagined by viewers at that point in the film. Alternatively, perhaps the truth is generated that *Scottie* knows it is coming, or is concerned that it might.[39] In the film's final scene, also set in this tower, the tremolo trills which are prominent during this, Scottie's second ascent, suddenly cease, suggesting he has at that point overcome his vertigo and will be able to complete his trip to the top.

At the start of the "letter" scene, the moto perpetuo string figures prominent in the opening rooftop scene recur, in an overwrought vein, accompanying Judy's detailed recollection of the tower incident and her role in the deception perpetrated there. This underscores sonically how emotively charged the incident remains for her, and helps us understand why she is ultimately unable to carry through the writing of the letter of confession. In the famous "nightmare" sequence, the habanera music associated with Carlotta—a dead woman with a tragic past with whom Madeleine appears to identify—becomes more discordant, almost parodic, through the addition of stereotypical castanets and tambourine, conveying unmistakeably the intensity of Scottie's oppression by Carlotta/Madeleine. But more specific psychological pointings yet have been laid at the door of the scoring in this film, with some plausibility. According to one writer, the rather banal music that accompanies a walk taken by Scottie and Judy in the park adjacent to the Palace of Fine Arts, soon after he meets her and senses a kinship with the lost Madeleine, "suggests Scottie's feeling of dissatisfaction with this working-class version of the elegant, sophisticated woman of his memory."[40]

I have tried to show, through the varied examples in this section, the viability of a "making-fictional" criterion of narrativity for nondiegetic film music. There is, I submit, an intuitive match between the concepts: any nondiegetic music we would regard as narrative in status is music that can be seen as contributing to making something fictional in the world of the film—and vice versa.

---

[38] Bruce, *Bernard Herrmann*, p. 173.

[39] Even more conservatively, perhaps the only fictional truth generated is that the *narrator* is reminding us of the possibility of Scottie's imminent vertigo, without it yet being fictional either that it is imminent, or that Scottie believes it is.

[40] Bruce, *Bernard Herrmann*, p. 163.

9

Narration, though, however broadly construed and however subtly carried off, is not always the basic charge of nondiegetic film music, and serving a narrative function not always the best explanation of its presence. I want now to consider films where nondiegetic music is featured that appears *not* to be of a narrative sort—where thus, in my terms, the music does not make anything fictional in the world of the film and is not reasonably assignable to the film's internal narrator. Instead, the music seems best understood as directly at the service of the implied filmmaker. I begin with some films that are in different ways intermediate or borderline in regard to the contrast I want eventually to draw.

In Fellini's semiautobiographical *8½*, Guido (Marcello Mastroianni), a famous but floundering director, has gone to a fashionable spa to try to recover his mental equanimity and decide on a direction for his new film. We find him in a spacious bathroom, as Wagner's "Ride of the Valkyries" begins on the soundtrack. There is a cut to masses of people taking the waters at the spa, walking in rows and carrying parasols, among whom Guido eventually takes his place and receives his allotted glass. We see a conductor conducting, though with no orchestra in sight, and later see that he is leading a small salon group—one that could not be the source of the music we hear in the form we hear it. That cue ends and Rossini's overture to *The Barber of Seville* immediately starts up, but with a robustness, once again, that surpasses the resources of the musicians visually established as present. The effect of both cues, it seems, is one of gentle mockery of the behavior and attitudes of the spa's clientele.

The musical soundtrack during this sequence is what one might call *quasi-diegetic*. That is to say, the music can be thought to be audible in the world of the story, because it is fictionally grounded in an observable source, and even confirmed later as something heard by a character (as by Guido's subsequent whistling of snatches of the Rossini)—but not in the precise form heard by the viewer, in respect of volume, instrumentation, or performance quality. The same quasi-diegetic status attaches to the music in the final scene, the press conference-cum-party—designed to launch Guido's supposed film—at the extravagantly erected "Spaceship" site. We hear Rota's excited music, which begins with a variant on Khatchaturian's "Saber Dance," and eventually brings in almost all the other motives heard earlier in the film, as Guido is mobbed by impatient questioners and alternately shielded or prodded by his handlers, all captured in swooping, restless camera movement. Once again, we are shown a small band set up on a platform, and can even observe at one point the synchronization of the soundtrack with the rhythm, visually apparent, of the band's drummer, but there is still a discrepancy between what we can hear of Rota's marvelous score and our sense of what sort of sound the band visually in evidence could have produced.

So, does such quasi-diegetic music serve a narrative function? To the extent the music is considered nondiegetic, its function seems to be, in the first scene, satirical commentary, and in the second, mood enhancement, both arguably from a point of view internal to the film. So despite their peculiar status, these cues, insofar as they are nondiegetic, are plausibly ascribable to the cinematic narrator. They make things fictional: in the first instance, that the narrator views the spa goings-on satirically,

and in the second, that the narrator wants to induce a certain mood in viewers with regard to the final episode. The soundtrack music's equivocal status as diegesis thus does not seem to yield anything correspondingly intermediate as regards narrative assignability.

Another example of intermediate status occurs in the "rogue auto" scene in Hitchcock's *North by Northwest,* in which the villain Vandamm's (James Mason) henchmen attempt to do in the hero, Thornhill (Cary Grant), by forcing him to drive down a dangerous cliff road while completely inebriated. I would claim that the music of this scene not only generates tension and underlines the driver's state of drunkenness, but at the same time signals, through its jokey style and lighthearted character, the absence of any real danger for Thornhill. Is this then a communication from the cinematic narrator, or from the implied filmmaker? That is to say, is it fictional that Thornhill is not truly in peril, or at least that the narrator knows he is not? Or is it rather that Hitchcock is telling us, on the sly, that he does not intend to do away with his main character at this point? It is hard to say which, but in a film whose borderline self-conscious (or modernist) character has often been remarked, this is perhaps not surprising.[41]

Most of the music in Peter Weir's *Witness,* composed by Maurice Jarre, functions in the by now familiar mood-setting, character-delineating, attitude-evincing, or thought-specifying way, and is unproblematically categorizable as narrative. It begins with floating, gently pulsating synthesized chords, as images of Amish farmers looking up out of fields and buggies traveling down roads occupy the screen.[42] What is conveyed is a sense of harmony and awe, a sense of the homogeneous spirituality of the world inhabited by the Amish, especially as compared with the vulgar and violent world of "Englishers" (the Amish term for their secular neighbors). During a sequence in which an Amish boy in Philadelphia's 30th St. Station gazes high above him at an erotic statue of two mythic figures in some sort of embrace, the pulsating music, in voice-like chords, comes back, suggesting his bewilderment and wonder at the statue and what it depicts. A variation of this gently pulsing music is prominent during detective John Book's (Harrison Ford) night of healing with Rachel (Kelly McGillis), a beautiful Amish widow, at whose farmstead he has ended up with a gunshot wound. The music serves to suggest the growing intimacy and spiritual bond between them. After the violent climax, in which Book manages to dispose of his corrupt pursuers—with the help of some Amish corn, providentially stored in a silo—the pulsing music underscores the long, silent glances of farewell between the two protagonists, reaffirming the essential goodness of their interaction, which stops poignantly short of actual love-making. In all the foregoing, the music is naturally construed either as establishing something about the characters or else as evincing the attitudes of the cinematic narrator toward them—attitudes we are clearly invited to share.

However, there is the virtuoso "Barn Raising" scene, located roughly in the center of the film, to consider. This provides the occasion of the film's main musical cue: an extended piece, lasting about four minutes, on the order of the Pachelbel's *Canon* (that is to say, variations on a ground bass). The image track shows us wagons laden with supplies, coming together, people on foot congregating, getting ready to work,

---

[41]See Wilson's discussion in *Narration in Light,* chapter 4.

[42]The particular look of these images owes to Weir's trademark use of idealizing telephoto shots.

and then, in stages, the raising of the barn, beginning with walls assembled at an earlier time, and finishing with the whole superstructure in place. The music, by means of its unity, solid flow, and arching sureness of direction, admirably symbolizes the strength of the Amish and the spirit of life-affirming communitarianism exemplified in the activity of cooperatively building a newlywed couple the barn they will need to sustain themselves.

What, then, gives any pause in regarding this cue as wholly narrative? Only this: the meter and rhythms of the music in this scene are largely and significantly, though not slavishly or mechanically, synchronized with the actions visually depicted. The pace and pattern of the visual editing seems to respond, not so much to any internal narrative demand, but rather, to the steady progression of the music. The cue is not so much designed to flesh out the scene as the scene seems designed to illustrate the cue. All told, this suggests assignment of the cue's music to the implied filmmaker, as opposed to the internal narrator, since the artful synchronization noted is most naturally taken as an aspect of the aesthetic construction of *the film* as the conjunction of an image track and a sound track, rather than an aspect of how the narrator is presenting, through resources available to him, *the story*. It seems plausible to regard the music of "Barn Raising" as attributable, at least in part, directly to the implied filmmaker.

The main cue in Hugh Hudson's *Chariots of Fire* occurs near the beginning of the film, accompanying a scene of athletes in training: two dozen or so men running along the ocean in gym whites, represented as the fifty-year-old memory of one of the runners. Vangelis's synthesized music, a tune of simple nobility over a throbbing bass with snare-drum-like accents, is heard throughout, as the credits roll. The cue lasts a few minutes, and the scene ends visually with the group of men cutting inland and returning to the grounds of a building in Kent, where they have gone to train in preparation for the 1928 Olympics.

Now this cue may contribute in part to narration—understood as making-fictional—by making more precise the state of the runners as exhilaration, as opposed to mere determinedness, or by evincing a narratorial attitude, for example, one of confident control, or by indicating a mood the narrator would like to impose on the viewer, for example, one of heroism. But there still seems to be a certain "surplus value," as it were, to the cue. Those narrative ends do not appear to exhaust the functioning of the cue; its scale and expressiveness seem more than is called for with respect to those ends, imparting to the activity of jogging on the beach an almost godly aspect, without it becoming fictional in the story that such activity really has such status, or even that the narrator believes that it does. Instead, it seems tempting to regard it as attributable, at least in part, to the implied filmmaker directly: it appears to testify to the almost religious regard in which he holds the athletic efforts of those young Britishers of yesteryear. The emotive "surplus value" of this cue, as far as plausible narrative functioning is concerned, is what points, it seems, to the implied filmmaker as a locus of attribution.

## 10

Having uncovered some cases of film music with equivocal or partial narrative status, we are now ready to contemplate cases of substantially, perhaps wholly, nonnar-

rative film music. My claim is that such music, which I characterize as *additive* (or *juxtapositional*) film music, is attributable directly to the implied maker of the film. Such music alters, often powerfully, the artistic content or effect of the complete film, but it does not do so by nuancing narration, that is, by making or helping to make things fictional in the film's world.

As a first example, consider Robert Bresson's *Mouchette*. There is only one significant musical cue in the film, a segment of Monteverdi's Magnificat. It is heard very near the opening, during which the titles are projected, and again at the end, when Mouchette, an abused country girl of thirteen or so, commits suicide by rolling in a sheet into a pond and drowning. Lindley Hanlon gives a sensitive reading of the music in this film that supports, I think, a large nonnarrative understanding of it, an understanding that connects it rather more closely with the filmmaker than with the film's internal storyteller:

> From *Mouchette* on, Bresson uses music only at the beginning or the end of a film unless the source of the music can emanate from the space and situation of the film narrative. . . . It is a more subtle, less intrusive means on Bresson's part of authorial commentary on the action of the film. . . . Recurring after Mouchette's death, the Monteverdi music seems to function as Bresson's requiem for the girl, who has wrapped herself in a shroudlike vestments. . . . The words of the "Magnificat" affirm the possibility of another life after death and sanctify Mouchette's decision to escape from the despair of her own life.[43]

The music here is most plausibly assigned to the implied filmmaker—as affirming the general possibility of grace as exemplified in the tale of Mouchette[44]—rather than to the film's relatively effaced internal presenter, especially as it seems to frame the fictional narrative from without, like a pair of musical bookends, as opposed to shaping it from within.

Terrence Malick's singular film *Badlands* provides an outstanding example of an appropriated score, consisting mainly of extracts from Carl Orff's "Musica Poetica" and Erik Satie's "Trois Morceaux en Forme de Poire." This score also serves as one of my key examples of nondiegetic film music that is not, in the main, usefully construed as narrative.

*Badlands,* based loosely on Charles Starkweather's 1958 shooting spree in the Midwest, contains a partially unreliable narration, since two components of it, the image track and the voice-over narration by one of the main characters, Holly (Sissy Spacek), are at odds with one another (in some respects, only at certain points, and in other respects, throughout). Here, as is customary, the visual representation is taken to be the more truthful, "on the convention that seeing is believing,"[45] and so when what is shown wars with what is told, we are inclined to credit the former.

Orff's and Satie's music, I maintain, is characteristically employed in *Badlands* in a mode of distanced and reflective juxtaposition to the story narrated, by an intelligence standing just outside that narration. It is not, in general, attributable to the

---

[43]"Sound in Bresson's *Mouchette*," in *Film Sound,* ed. Elisabeth Weis and John Belton (New York: Columbia University Press, 1985), pp. 329–30.

[44]In identifying this theme as of grace I of course rely on a knowledge of Bresson's oeuvre as a whole, and of the artist implicit in that oeuvre.

[45]Chatman, *Coming to Terms,* p. 136.

film's narrating agent, but only to the implied filmmaker. To make this point I examine at length one particular cue.

Fairly early on, we are shown Kit (Martin Sheen), the film's other main character, working cattle in a feedlot, after having been fired from his job as a garbage collector. On the soundtrack is a striking, far from inaudible, portion of Orff's score, consisting of sharply rhythmic xylophone or marimba music, built on an exotic scale, having no obvious connection with, or fittingness to, gritty scenes of cows being force-fed and almost expiring in the heat. That is to say, there is nothing in the character of the states of affairs depicted that the music could plausibly be thought to second, nor anything indeterminate about those states of affairs that the music might plausibly be thought to specify.

Could it be narrative in the sense of expressing the cinematic narrator's view of the situation depicted? This seems unlikely, if only because it is rather unclear what sort of attitude could be signaled by such music in relation to the events shown. In addition, the cinematic narrator, who often visually corrects or gainsays Holly's romantic and simplistic notions of what has transpired in her time with Kit, comes across as an agency too sober and straightforward, almost nonhuman in its detachedness—consider the odd montages of nature shots that occur occasionally during the film, giving the impression of an iguana-eye's point of view—to be credited with a sentiment as quirky and mischievous as that expressed by this musical cue.

Might the music be narrative in virtue of acting to characterize Holly's recollective impression of Kit's job at the feedlot? Such a hypothesis is multiply problematic. First, we haven't been given any reason to think the nondiegetic music is in the service of the voice-over narrator, but at most, the cinematic narrator operating from the point of view of or on behalf of some character; that is to say, there must be rather special indications, not here present, before we will think of nondiegetic music as a resource belonging to, rather than applied in elucidation of, a character in the story. Second, since there is reason not to regard the image track as an accurate version of Holly's memories—it regularly outstrips, and occasionally contradicts, her verbal narration of what happened—the ground for thinking of the soundtrack music as signifying Holly's impression of those sights seems lacking.[46] There is little reason to think, in particular, that she ever visited Kit at the feedlot or witnessed the kinds of scenes we see on screen. Third, whatever attitude we found such music to connote, it seems not to be one we would ascribe to hazy-minded Holly while the thought of Kit at the feedlot was before her mind.

This leaves as the only interpretively live possibility the assignment of the music to the implied filmmaker who, from a point outside both the story and its narration, has apparently added this music as a kind of counterpoint to the fictional drama. To what end? It is hard to say, especially without an interpretation of the film as a whole, but possibly one of aesthetic embellishment, or derangement of the viewer's moral

---

[46]The sequences that make it clearest the image track is not to be thought of as a reliable representation of Holly's occurrent memories are one in which we see Kit shoot a football and then hear Holly, a minute later, recount this event, and another in which we see Kit trying to outrun his police pursuers, stop his car, get out, shoot its left front tire flat, and then blatantly await capture, while Holly alludes to the incident, never observed by her, in a mode of speculation rather than reportage: "Many times I've wondered about why Kit didn't get away. He said he had a flat, but from the way he kept coming back to that, I doubt it."

compass, or refraction of the story's content in a distorting mirror, or external meditation on the film's happenings.

Now the music of Orff and Satie is characterized in general by an intentional simplicity, a primitiveness of musical materials, and a studied directness of effect, and that employed in this film is no exception. Thus perhaps the function of this music in the film—on a global plane, rather than scene-by-scene—could be said to be reflection of the basic childlikeness and obliviousness to social reality of the two principals, and especially that of Holly, the verbal narrator. I think that is so, but for the reasons given above this music, and that aspect of the film's content, is best laid at the door of the implied filmmaker, rather than any agent internal to the narrative.

My next examples come from Woody Allen's *Love and Death,* whose appropriated score is derived entirely from the suites to *Lt. Kije* and *Alexander Nevsky* by Prokofiev. The sleigh-like music from *Lt. Kije* starts up after Natasha (Diane Keaton) announces her engagement to a herring merchant, and extends through her riding off in a carriage and subsequent shots of Russian troops in training, marshalled to protect Russia against Napoleon. This music has a satirical effect, more properly attributed to Allen as *auteur,* than to Boris, Allen's character, as narrator, or even the cinematic narrator conceived as encompassing Boris's verbal narration. A farcical battle scene between Russian and French troops, shortly thereafter, is accompanied by the grim and heavy music for the "Battle on the Ice" from *Alexander Nevsky;* the mismatch is palpable, and the implied equation of the two battles laughable. Both the satirical intent inherent in this juxtaposition, and the frame of cultural reference with which it operates, seem to put it beyond ascription to either Boris or the cinematic narrator.

The last example I discuss of a film much of whose musical soundtrack is best seen as additive or juxtapositional, rather than narrative, is Stanley Kubrick's *A Clockwork Orange.* The opening credit—the words "A Clockwork Orange" on a garish orange field—is followed by a close-up of Alex (Malcolm McDowell) and his pals (droogs) in a bar that dispenses drugged milk (moloko) that disposes its consumers toward acts of "ultraviolence." Soon Alex's voice-over is heard, which establishes what we will soon see as Alex's recollections of his recent past. Walter Carlos's synthesized music here is a slow-moving, quasi-Handelian progression, with a hint of *Dies Irae.* It functions narratively in setting an appropriate mood, in suggesting something of the effect of moloko drinking, and in perhaps foreshadowing some of the grim doings the narrator, acting on Alex's behalf, has in store to present to us, in due course. But the appropriated music employed in the film, notably that of Rossini and Beethoven, functions rather differently.

Rossini's *La Gazza Ladra* Overture begins on the soundtrack as an old man is being beaten by Alex and his droogs, continues over a cut to another gang of youths assaulting a naked girl on a stage, leading to a fight between the two gangs, and covers the escape of Alex and his droogs from the scene by car, fading out only as they approach a house in the country whose occupants they are going to terrorize.

There is no obvious narrative appropriateness to the music: it seems neither to convey information about the events shown, nor to suggest the narrator's perspective on those events, nor to suggest an attitude that viewers should plausibly adopt toward them. I take it the first and third points will be granted without dissent; the second,

though, might be supported further, as follows. If the claim of narrative function is to be sustained on that ground, it seems we would have to posit either a perversely inhuman cinematic narrator, whose lighthearted view of the proceedings is reflected in the music, or else a psychologically more normal one who merely signals to us, through the music, Alex's perversely comic perspective on the violence he is perpetrating on others. The first possibility strikes me as unmotivated, while the second, though more promising, faces the problem that it casts Alex's reactions as on perhaps too high a level of sophistication.

Thus we arrive, once again, at the assignment of this music directly to the implied filmmaker as interpretively the most reasonable option. As such, how does it function? Pasted on to the scenes of violence presented by the film's internal narrator, it invites us, at least initially, to see them as a joke, thus making us complicit in the mindless pleasure of Alex and his pals in inflicting pain, in the expectation, presumably, of getting us to be even more horrified when we realize what we've been duped into. Kubrick, and not the cinematic narrator, is addressing us directly through this odd and unsettling juxtaposition of music and story.

A similar scene takes place in Alex's room at home, with two girls he has picked up in a record shop. It is filmed in extremely fast motion, to the accompaniment of Rossini's *William Tell* Overture. Here both the fast-motion filming and the superimposed frenetic music seem to reflect the activity of the implied filmmaker, as opposed to that of the film's perceptual enabler or internal commentator.

A related, though distinct, use of music occurs in a scene also set in Alex's room, to which he has repaired after the first night's round of ultraviolence. He deposits things in his booty drawer, checks on his pet python, and puts the scherzo of Beethoven's *Ninth Symphony* on his sound system. The music, here diegetic, is synched to a montage of close-ups of statue parts, as Alex imagines acts of sex and violence, recounted in voice-over. But this intrastory perversion of Beethoven by the protagonist echoes and parallels the implied filmmaker's superficially warped overlaying of Alex's recollections of occasions of torture and fornication with Rossini's diverting scores.[47]

Near the very end of the film, Alex is being questioned by a few intellectuals, including the writer he crippled earlier in the film, about behavioral conditioning via background music. It is not too much to suggest that this scene obliquely raises within the film the issue of film music's legitimacy and role, and of its possible subversive effects, for example, the undermining of autonomy or the blunting of rationality. This self-consciousness in the film about what we may call nonaesthetic or incidental uses of music reinforces the assignment of additive, as opposed to narrative, status to the Rossini overtures appropriated by Kubrick for *A Clockwork Orange*.[48]

---

[47]A contrasting, rather more cynical, view of the mode of film scoring of which *A Clockwork Orange* was perhaps the pioneer is provided in this recent commentary: "Faced with the task of differentiating their scenes of brutality and mayhem from all the other scenes of brutality and mayhem, film makers are using music to distance the viewer from violence—or to comment ironically on it. As the images get more explicit, the accompanying tunes seem to be getting more frothy. Everything from Bach to hook-laden pop-rock songs provides background for images of fist fights, shootings, stabbings and torture" (Kenneth Chanko, "It's Got A Nice Beat, You Can Torture To It," *New York Times*, Feb. 20, 1994).

[48]The scene may in fact be what Wilson calls a "rhetorical figure of narrative instruction," something offered by the filmmaker to the viewer as a key to interpreting the film's narration generally. See *Narration in Light*, pp. 49–50.

11

Though in many cases where nondiegetic film music is more reasonably as signed to the implied filmmaker rather than the film's narrative agent, we find that such music is being used ironically or satirically, for example, as with *Love and Death* and *A Clockwork Orange,* it is important to remember that that is not the only possibility. The examples of *Mouchette* and *Badlands,* and in a partial vein, *Witness* and *Chariots of Fire,* illustrate as much.[49] And we may also observe, at this point, that nondiegetic music is not the only music in a film responsibility for which may redound, without intermediary, to the implied filmmaker, and which may be read by us as a direct reflection of authorial stance or personality. Jane Campion's recent film *The Piano* offers a case of film music commissioned and composed for diegetic insertion in a film—Michael Nyman's music for mute protagonist Ada's pianism—rather than nondiegetic accompaniment. The music's characterization of its fictional originator—Ada—is a function that can only be assigned, it seems, to the implied filmmaker, as the agent who has chosen the characters, their actions, and their traits, in constructing and arranging the elements of the filmic object as she has.[50]

How does the distinction we have been exploring, of film music as additive versus film music as narrative, relate to another standard classification, namely that of film music as commentative? The answer is: not simply. The equation of narrative and commentative will not do, for two reasons. First, some music of clearly narrative function is not reasonably thought of as commentative, unless all information-conveying counts as commentary. Second, some additive music seems to supply a commentary, if oblique, on matters with which a film is concerned. In light of this, we might distinguish between *externally* commentative music, assignable to the implied filmmaker, and *internally* commentative music, assignable to the cinematic narrator.

Still, it is important to stress that musical commentary on the events of a fictional story as such, or the characters figuring in those events, remains a possibility only for the cinematic narrator internal to the fiction. Additive music, assignable to an implied filmmaker, might generate, as noted, a kind of commentary as well, but it could not be on the fictional events themselves, from a perspective internal to the fictional world, but at most on the representation of those events or on the significance of events of that type. The implied filmmaker of a fiction film is not on the same plane as the events of the film's world—which are for him, as for us, fictional—and so his direct commentary on those events is not a coherent option. For instance, if the Magnificat cue at the end of *Mouchette* expresses Bresson's attitude of consolation toward Mouchette's suicide, this has to be understood not as an attitude literally directed on

[49]Another intriguing case is Slava Tsukerman's *Liquid Sky* (1983), whose soundtrack employs an over-modulated synthesized harpsichord version of eighteenth century composer Marin Marais's hypnotically repetitive "Sonnerie de Ste. Genevieve du Mont." It is unclear to me (on the basis of a single viewing, ten years ago) whether that music belongs in the satirical or the nonsatirical subcategory of additive film music.

[50]One critic has remarked on the music for this film as follows: "Both the orchestral and solo keyboard music suggest a modern minimalist gloss of Chopin and Liszt but spun off plain, abrupt folk tunes . . . the pianism suggests someone doggedly trying to speak through the keyboard. . . . As distinctive as it is, the music is strangely cramped and emotionally arid . . . the solo piano passages sound too much like elementary practice exercises to soar into the stratosphere" (Stephen Holden, *New York Times,* Jan. 30, 1994).

the suicide of Mouchette—an event in which Bresson presumably does not believe—but instead as an attitude bound up with the film's representation of that event, or directed toward events of the sort represented by the film.

A standard function of nondiegetic film music, we have observed, is to reveal, confirm, or make precise a character's feelings or attitudes toward something or other in the story.[51] Such a function makes most sense in connection with a narrator, rather than an implied filmmaker, since it presupposes an agent on the same plane, fictionally, as the characters, whose existence the narrator believes in, and whose lives the narrator selectively presents to us. The deliverances of narrative film music seem to come from one who shares a world with the characters, rather than one who has invented them, and everything else in the fictional world, from whole cloth.

On the other hand, another standard function of nondiegetic film music is to bind the incidents of a film together in a common ambience. The thematic, instrumental, and stylistic continuities typical of film scores help to create a consistency of tone or feeling across the span of a film, especially where the events presented are not very tightly connected in a dramatic sense. Thus this, rather than any narrative task, seems to be the main function of Rota's score for Fellini's *Amarcord*. When nondiegetic film music has this function, it is more naturally ascribed to an implied filmmaker than to an internal cinematic narrator. Nondiegetic film music bridging scenes of different character, say, or smoothing over large lapses of time, is of this sort. Such music, like the presentational, voice-over, and mind-over narrators in a film, is understood primarily as constructed or arranged by the implied filmmaker in putting together the aesthetic object which is the total film, rather than as something used or employed by the cinematic narrator in its different narrative capacities.

Returning to the five functions of film music recognized by Copland, I would suggest that only two—underlining characters' psychological states and sustaining and releasing tension—are clearly assignable to the cinematic narrator. The others—ensuring continuity, providing background filler, and creating atmosphere—can with equal, or more, justice be thought of as activities of the implied filmmaker, in that they seem aimed directly at the viewer as an aesthetic subject, at causing his or her experience to be a certain way, rather than at defining or delineating the film's fictional world.[52] If we consider, similarly, the list of functions drawn up by Gorbman in her study of the operation of classical film music,[53] I would suggest that two—the signifying of emotion, and the referential and connotative cuing of narrative—are assignable to the cinematic narrator, while the remaining two—the provision of continuity and the achievement of unity—make most sense as the charge of the implied filmmaker.

What of my own list of fifteen functions of film music, drawn up earlier (section VI)? By present lights, I think they sort out as follows: functions (1), (2), (3), (4), (5), (6), (7), (8), and (9) are arguably narrative, in that they involve making something

---

[51]A function highlighted by Noël Carroll in *Mystifying Movies*, pp. 216–23; Carroll labels film music of this familiar type "modifying music."

[52]Though in regard to the last of these, creating atmosphere, it was suggested earlier how, in many cases, this can be understood as having narrative status, if the atmosphere involved is one the film's narrative agent can be plausibly thought of projecting.

[53]*Unheard Melodies*, p. 73.

fictional in the film, and so music functioning in such ways is assignable to the cine-
matic narrator. Functions (10), (11), (12), (13), (14), and (15) are arguably nonnarra-
tive, and are often achieved through music of additive status, assignable only to the
implied filmmaker. There is not, however, a perfect correspondence between the divi-
sion of functions as either narrative or nonnarrative, and the categorization of cues as
either narrative or additive, because a cue can have significant functions of both sorts.
What is true is roughly this: if a cue has significant narrative function, whether or not
it functions in addition nonnarratively, then it is a narrative cue, whereas if a cue has
no significant narrative function, then it is an additive cue.

   The question I have been exploring in the latter part of this essay can be put as fol-
lows: when is nondiegetic film music primarily a compositional element in a film, at
the command of the implied filmmaker, and when is it instead, or in addition, an
instrument we imagine as at the service of the cinematic narrator, generating truths in
the world of the film, either about the story as such or about the act of its narration?
But perhaps the same question poses itself, on close examination, for a number of
other filmic elements viewed initially just as compositional, for example, lighting or
camera angle. When is the dim or filtered quality of light in a scene—as in *Vertigo*,
when Judy reemerges into Scottie's presence as Madeleine—merely a directorial
choice and when a manifestation, as well, of narrative activity on the part of the film's
internal presenter, showing things in a light they would not otherwise appear in?
When is an off-kilter view of a man running across a square—as in *The Third Man*—
just a matter of the director's tilt of the camera in relation to the actor being filmed,
and when is it to be regarded as well as connoting an intervention of the cinematic
narrator, as showing us the character from an oblique perspective, with whatever that
suggests about either the character or the narrator's view of him? The issues
addressed here concerning the interpretation of nondiegetic film music resonate, I
suspect, across the whole spectrum of meaning-making elements in film.

                                                                              1996

# KRISTIN THOMPSON
# THE CONCEPT OF CINEMATIC EXCESS

"No, no, I'll take no less, than all in full excess."

<div align="right">HANDEL'S <em>Semele</em></div>

"Analytically there is something ridiculous about it."

<div align="right">ROLAND BARTHES[1]</div>

Recently certain writers have moved away from the traditional concept of criticism as an activity designed purely to explain the narratively functional aspects of the work. Following essentially, I believe, in the direction opened by the Russian Formalists, these critics have suggested that films can be seen as a struggle of opposing forces. Some of these forces strive to unify the work, to hold it together sufficiently that we may perceive and follow its structures. Outside any such structures lie those aspects of the work which are not contained by its unifying forces—the "excess." The term is used by Stephen Heath in his essay "Film and System: Terms of Analysis"; there he asserts:

> Just as narrative never exhausts the image, homogeneity is always an *effect* of the film and not the filmic system, which is precisely the production of that homogeneity. Homogeneity is haunted by the material practice it represses and the tropes of that repression, the forms of continuity, provoke within the texture of the film the figures—the edging, the margin—of the loss by which it moves; permanent battle for the resolution of that loss on which, however, it structurally depends, mediation between image and discourse, narrative can never contain the whole film which permanently exceeds its fictions. "Filmic system," therefore, always means at least this: the "system" of the film in so far as the film is the organization of a homogeneity *and* the material outside inscribed in the operation of that organization as its contradiction.[2]

"Homogeneity" is here the unifying effect I have mentioned. Heath suggests that the material of the image in film creates a play which goes beyond this unity. A film depends on materiality for its existence; out of image and sound it creates its structures, but it can never make all the physical elements of the film part of its set of

---

[1]Roland Barthes, "The Third Meaning," trans. Richard Howard, *Artforum* (January 1973), 11(5):47.
[2]Stephen Heath, "Film and System: Terms of Analysis, Pt. I," *Screen* (Spring 1975), 16(1):100.

smooth perceptual cues. The critic concentrates neither wholly upon the coherent elements nor wholly upon the excess; he/she deals with the tensions between them. I am using the Russian Formalist definition of narrative as an interplay between plot and story; plot is the actual presentation of events in the film, while story is the mental reconstruction by the spectator of these events in their "real," chronological order (partly on the basis of codes of cause and effect). Heath is talking about the classical Hollywood film, which typically strives to minimize excess by a thoroughgoing motivation. Other films outside this tradition do not always try to provide an apparent motivation for everything in the film, and thus they leave their potentially excessive elements more noticeable.

Roland Barthes' essay "The Third Meaning" ("Le Troisième sens") lays out a similar idea that the materiality of the image goes beyond the narrative structures of unity in a film. The choice of the term "meaning" is a misleading one, since these elements of the work are precisely those which do not participate in the creation of narrative or symbolic meaning; Barthes himself calls it "the obtuse meaning," and says: "it does not even indicate an *elsewhere* of meaning . . . it rather frustrates meaning—subverting not the content but the entire practice of meaning."[3] For this reason I prefer to use Heath's term, "excess," rather than Barthes'.

But Barthes is ultimately clearer as to what he considers part of this filmic excess. Heath's analysis of *Touch of Evil* provides examples that tend to confuse his term rather than clarify it. He calls the scenes in Tanya's place in that film excess because they "have no narrative function,"[4] even though this is clearly not the case. These scenes provide *relatively* little casual material to forward the proairetic, in comparison with the other scenes of the film. They do, however, contain a considerable amount of semic material about Hank Quinlan and hence provide motivation for his behavior in the rest of the film; Tanya's place provides the connection between Quinlan and Menzies that allows the latter to engage Quinlan in the final incriminating conversation. These are not the only narrative functions these scenes play, but they will serve to indicate that Heath has chosen a rather easy way out of the problem by dismissing whole scenes as excess when they are simply different from more casually dense portions of the narrative. Heath also resorts to a psychoanalytic explanation for excess, indicating that it is the material which must be repressed by the film; see, for example, his discussion of the character of the "night man" as a figure of excess.[5] But none of this comes to terms with Heath's own claim (possibly derived from Barthes) that the excess arises from the conflict between the *materiality* of a film and the unifying structures within it. Heath, in fact, never analyzes a scene into its material and structural components to find examples of excess.

Barthes' entire essay, on the other hand, is based specifically on the material aspects of film as the source of its excess. He in fact analyzes only still photographs, but his conclusions are applicable to film (and also to the material qualities of the film's sound, which Barthes ignores). At one point, Barthes claims that excess does not weaken the meaning of the structures it accompanies: "if the signification is

---

[3]Barthes, "The Third Meaning," p. 49.
[4]Heath, "Film and System," p. 67.
[5]*Ibid.*, pp. 73–74.

exceeded by the obtuse meaning, it is not thereby denied or blurred."[6] This seems doubtful, however. Presumably the only way excess can fail to affect meaning is if the viewer does not notice it; this is a matter of training and background. Certainly a steady and exclusive diet of classical narrative cinema seems to accustom people to ignoring the material aspects of the artwork, since these are usually so thoroughly motivated as to be unobtrusive. But the minute a viewer begins to notice style for its own sake or watch works which do not provide such thorough motivation, excess comes forward and must affect narrative meaning. Style is the use of repeated techniques which become *characteristic* of the work; these techniques are foregrounded so that the spectator will notice them and create connections between their individual uses. Excess does not equal style, but the two are closely linked because they both involve the material aspects of the film. Excess forms no specific patterns which we could say are characteristic of the work. But the formal organization provided by style does not exhaust the material of the filmic techniques, and a spectator's attention to style might well lead to a noticing of excess as well. Elsewhere Barthes acknowledges that his "obtuse meaning" does indeed affect our perception of meaning in a distractive way; speaking of certain qualities of photographic image, he asks, "are they not a kind of blunting of a too-obvious meaning, a too-violent meaning? . . . do they not cause my reading to skid?"[7] This image of a skidding perception is interesting, because it is not far from the kinds of metaphors the Russian Formalists chose to describe the effects of delaying devices in a narrative, such as "staircase construction." In each case, there is an attempt to describe a movement away from a direct progression through an "economical" structure. Barthes also speaks of the obtuse meaning as separate from the diegesis of the film; referring to a frame enlargement from *Ivan the Terrible*, he says:

> The obtuse meaning is clearly counternarrative itself. Diffused, reversible, caught up in its own time, it can, if one follows it, establish only another script that is distinct from the shots, sequences, and syntagmas. . . . Imagine "following" not Euphrosinia's machinations, nor even the character (as a diegetic entity or as a symbolic figure), nor even, further, the countenance of the Wicked Mother, but only, in this countenance, that grimace, that black veil, the heavy, ugly dullness of that skin. You will have another temporality, neither diegetic nor oneiric, you will have another film.[8]

Probably no one ever watches *only* these nondiegetic aspects of the image through an entire film. Nevertheless, they are constantly present, a whole "film" existing in some sense alongside the narrative film we tend to think of ourselves as watching.

The idea that the critic's job might include the pointing-out of this excess may startle some. But we have been looking at the neat aspects of artworks so long that we may forget their disturbing, rough parts. As Barthes say, "The *present* problem is not to destroy the narrative, but to subvert it."[9] For the critic, this means the realization that he/she needs to talk about those aspects of the work that are usually ignored because they don't fit into a tight analyses.

---

[6]Barthes, "The Third Meaning," p. 47.
[7]*Ibid.*
[8]*Ibid.*, p. 49.
[9]*Ibid.*, p. 50. Italics in original.

The concept of excess need not be used only in semiotic, structuralist, or post-structuralist analyses. It fits into a critical approach based on Russian Formalism as well. For, while the Formalists did not come up with the idea of excess as such, they did move in a direction that implied it. When Viktor Shklovski says, "the language of poetry is not a comprehensive language, but a semi-comprehensible one,"[10] we must assume that the incomprehensible elements are so because they do not fit neatly into the unified relationships in the work; they must be explained as tending toward excess. Shklovski also makes a distinction between "material" and "form"; in speaking of music he says, "We have found, not form and content, but rather material and form, i.e., sounds and the disposition of sounds."[11] The process of "disposition" of materials into structures does not eliminate their original materiality. Thus the Formalists seem to have at least approached the realization that excessive elements provide a large range of possibilities for the roughening of form; the material provides a perceptual play by inviting the spectator to linger over devices longer than their structured function would seem to warrant.

Of course, no element in a work is strictly excessive to the degree that it has no connections to the other elements (except perhaps simple technical errors—the airplane in the sky of a biblical epic scene). As the Soviet filmmakers of the postrevolutionary period realized, simply to place two things together is to create a perception of them as related. This is one reason why excess is so difficult to talk about: most viewers are determined to find a necessary function for any element the critic singles out. For some reason, the claim that a device has *no* function beyond offering itself for perceptual play is disturbing to many people. Perhaps this tendency is cultural, stemming from the fact that art is so often spoken of as unified and as creating perfect order, beyond that possible in nature.

But if part of the difficulty of talking about excess stems from its novelty as a concept, the critic is also faced with the fact that excess tends to elude analysis. For example, take Barthes' description of Efrosinia given in the above quotation. That one *can* look at the visual figure in the images quite apart from her narrative function seems reasonably certain; we may go further and say with some confidence that one can perceive the visual figure even while following the narrative function it fills. But a discussion of the *qualities* of the visual figure at which we look seems doomed to a certain subjectivity. We may not agree that the texture of Efrosinia's skin has a "heavy, ugly dullness." The fact, however, that we can agree it has *some* texture opens the possibility of analysis. The critic and his/her reader must resist the learned tendency to try and find a narrative significance in every detail, or at least they must realize that a narrative function does not exhaust the material presence of that detail. Our conclusion must be that, just as every film contains a struggle of unifying and disunifying structures, so every stylistic element may serve at once to contribute to the narrative and to distract our perception from it.

---

[10]Viktor Shklovski, "The Resurrection of the World," trans. Richard Sherwood, *20th Century Studies* (December 1972), nos. 7–8, p. 46.

[11]Viktor Shklovski, "Form and Material in Art," trans. Charles A. Moser and Patricia Blake, in *Dissonant Voices in Soviet Literature*, ed. Patricia Blake and Max Hayward (New York: Harper and Row, 1964), p. 21.

Excess is not only counternarrative; it is also counterunity. To discuss it may be to invite the partial disintegration of a coherent reading. But on the other hand, pretending that a work is exhausted by its functioning structures robs it of much that is strange, unfamiliar, and striking about it. If the critic's task is at least in part to renew and expand the work's power to defamiliarize, one way to do this would be precisely to break up old perceptions of the work and to point up its more difficult aspects.

I shall follow Barthes' essay in drawing my examples from *Ivan the Terrible*. The act of "pointing" must be my principal tool here, since other means of analysis are designed for nonexcessive structures. (Barthes says in his essay, "I am not describing, I cannot manage that, I am merely designating a site.")[12] Analysis implies finding relationships between devices. Excessive elements do not form relationships, beyond those of coexistence. The Russian Formalists, however, give us a tool which may at least make the process of pointing somewhat systematic: motivation.[13] Strong realistic or compositional motivation will tend to make excessive elements less noticeable; the perception of the narratively and stylistically significant will dominate. But at other times, a lack of these kinds of motivations may direct our attention to excess.

More precisely, excess implies a gap or lag in motivation. Even though the presence of a device may not be arbitrary, its motivation can never completely control our perception of the film as material object. To a large extent, the spectator's ability to notice excess is dependent upon his/her training in viewing films. The spectator who takes films to be simple copies of reality will probably tend to subsume the physicality of the image under a general category of verisimilitude; that shape on the screen looks as it does because "those things really look like that." Another spectator, trained to look at films as romantic expressions of the artist, might attempt to see every aspect of every shot as conveying "meaning," "personal vision," and the like; the image looks the way it does because that is how the artist saw the world. At the other extreme, the "art for art's sake" viewer—the "empty" formalist—will tend to ignore motivation in favor of a totally free play of the "aesthetic" elements. All these approaches tend to vitiate the tension in the work between unified and excessive elements. The current study attempts to suggest an alternative.

A film displays a struggle by the unifying structures to "contain" the diverse elements that make up its whole system. Motivation is the primary tool by which the work makes its own devices seem reasonable. At that point where motivation fails, excess begins. To see it, we need to stop assuming that artistic motivation creates complete unity (or that its failure to do so somehow constitutes a fault). There are at least four ways in which the material of the film exceeds motivation.

First, narrative function may justify the presence of a device, but it doesn't always motivate *the specific form that individual element will take*. Quite often, the device could vary considerably in form and still serve its function adequately. Perhaps its color is vital, but its shape could be different. With an infinite number of points in space, we must assume that there is some range of camera placements which would

[12]Barthes, "The Third Meaning," p. 48.

[13]Boris Tomashevski, "Thematics," in *Russian Formalist Criticism; Four Essays*, trans. and ed. Lee T. Lemon and Marion J. Reis (Lincoln: University of Nebraska Press, 1965), pp. 78–87.

frame the scene adequately to its function. In *Ivan the Terrible*, Ivan must be an impressive character, but his impressiveness could be created in many ways. The actual choices are relatively arbitrary: a pointed head, a musical theme, closeups with a crowd in deep focus, and so on.

Second, the medium of cinema is such that its devices exist through time. Motivation is insufficient to determine *how long* a device needs to be on the screen in order to serve its purpose. (Indeed, for different spectators, the requisite time is probably different.) We may notice a device immediately and understand its function, but it may then continue to be visible or audible for some time past this recognition. In this case, we may be inclined to study or contemplate it apart from its narrative or compositional function; such contemplation necessarily distracts from narrative progression. (In Russian Formalist terms, the perception of narrative progression involves the spectator's mental construction of a chronological set of story events "behind" the concrete presentation of plot action in the film.) On the other hand, the device may be more obscure and require a longer process of interpretation to make sense; how can motivation determine the length of time necessary for this perceptual activity? Noel Burch's concept of "legibility"[14] provides a rough guide. A large number of items within a single space will require a greater duration for complete scanning than a smaller number of items. But this determination can only be relative; the specific length must always be arbitrary to a certain degree. Repeated viewings of a film are likely to increase the excessive potentials of a scene's components; as we become familiar with the narrative (or other principle of progression), the innate interest of the composition, the visual aspects of the decor, or the structure of the musical accompaniment, may begin to come forward and capture more of our attention. The legibility has shifted for us; we now can simply *recognize* the unifying narrative elements, rather than having to perceive them for the first time. As a result, we now have time to contemplate the excessive aspects. The function of the material elements of the film is accomplished, but their perceptual interest is by no means exhausted in the process.

Third, a single bit of narrative motivation seems to be capable of functioning almost indefinitely. It may justify many devices which have virtually the same connotation, even though they may vary greatly in form. Thus Ivan's basic function in *Ivan the Terrible* is to formulate and embody the goal of unifying Russia. This symbolic position motivates the extremely redundant expression of Ivan's scenes in every cinematic channel; the film must confirm and reconfirm Ivan's adequacy to the goal he represents. This redundancy does not advance the narrative in every case; rather it tends to expand the narrative "vertically." After a point, the repeated use of multiple devices to serve similar functions tends to minimize the importance of their narrative implications; instead, they become foregrounded primarily through their own innate interest.

Fourth and last, a single motivation may serve to justify a device which is then repeated and varied many times. By this repetition, the device may far outweigh its original motivation and take on an importance greater than its narrative or compositional function would seem to warrant. This kind of excess is extremely common in *Ivan*. The introduction of the bird motif, for example, is realistically motivated; a cou-

---

[14]Noel Burch, *Theory of Film Practice*, trans. Helen R. Lane (New York: Praeger, 1973), p. 52.

ple of the objects in the coronation ceremony have historically authentic bird emblems on them (the scepter, the little rug on the dias). But later the birds become less integral to the action at hand. They have associations, but these associations are relatively arbitrary; the birds on the wall behind Ivan's throne during his argument with Philip, for example, have minimal narrative connotations. We cannot say that the various instances of birds in the film are unmotivated, for they all relate to each other and hence form a unified structure. But they do draw attention to themselves far beyond their importance in the functioning of the narrative.

With these characteristics of excess in mind, let us look at some examples from *Ivan*. Some of these may seem trivial; they will certainly not always be the kind of thing the critic ordinarily points out. But taken together, they should suggest the wealth of excessive details which make the film a rich perceptual field.

*Ivan*'s excess becomes readily apparent if we compare it with a more standardized usage like that of the classical Hollywood cinema. One critic whose approach is largely tied to the classical Hollywood narrative style, Pauline Kael, finds *Ivan* difficult to enjoy; while she admits its grandeur, she says, "we may stare at it in a kind of outrage. True, every frame looks great—it's a brilliant collection of stills—but as a movie, it's static, grandiose, and frequently ludicrous . . ."[15] In our terms, this "outrage" is in part the rejection of excess, the reluctance to consider the uneconomical or unjustified. *Ivan*, with its broken rhythms of acting, its systematic mismatches of mise-en-scène at cuts, and its constant heightening of stylistic devices, stands in contrast to the Hollywood cinema. Here style becomes foregrounded to an unusual degree, necessarily calling attention to the material of the film.

The composition of visual elements within the frame may become a rich source of excess. Striking arrangements abound in *Ivan*; they become particularly prominent because Eisenstein uses so many static or nearly static shots to explore space and further the narrative. The long shots of Ivan's tent on the hill at Kazan would be an example of this; the arrangement of curved lines of soldiers and a group of banners provide a striking composition in which little movement occurs (part 1, 281–82).[16] The series of shots of boyars and ambassadors in the courtyard at the beginning of the illness sequence in part 1 invites our attention to small shifts of space, to faces and textures of fur and brocade, to the changing visual overtone of the cathedral icon, and to the rhythmic chiming of the various bells. In the opening coronation scene, three bald European ambassadors speak and shake their heads, but of at least equal interest is the pattern formed by their heads in the center of three large white ruffs (1, 9).

The deep focus shots in the Alexandrov sequence of part I place Ivan in closeup with the crowd on the snow-covered plain beyond. In each shot, Ivan moves his head—up in the first, down in the second (796, 800). These head movements are unmotivated; they seem to exist only to play on shifting graphic relationships between Ivan's profile and the curved shape of the crowd beyond, the amazing juxtapositions of space and volume, the texture of Ivan's hair and skin against the whiteness, and the vertical montage relations of sound and image.

---

[15]Pauline Kael, *Kiss Kiss Bang Bang* (Boston: Little Brown, 1968), p. 288.

[16]Shot numbers are as given in Sergei Eisenstein, *Ivan the Terrible* (New York: Simon and Schuster, 1970).

The four shots of Ivan's return to Moscow in part 2 also play on formal values. Since all four shots show the same basic action—the galloping of the procession of Oprichniki and coach—we must conclude that one shot would convey as much narrative information as four (or six or eight). Formal interest rests in the rhythm of the fast music in conjunction with the swift movement and in the small shifts of the church spire in the background at the cuts. Shot 99 (the second of the segment) has almost the same setup as shot 98. Shot 100 shifts to a longer view of the whole scene, but shot 101 again has almost the same framing. These small changes (a violation of Hollywood's "30° rule" that every shot should be distinctly different from its neighbors in order to clearly motivate the cut) create variations that add nothing except as perceptual material.

The textures, colors, and shapes of the costumes are frequent sites for excess in *Ivan*. For example, the glitter of light on the costumes of Vladimir and Efrosinia in the beaver lullaby scene becomes very prominent. The contrast of Philip's plain black cloth cassock with Ivan's heavy fur clock provides the basis for considerable play in the scene of their argument early in part 2. In shot 213, Philip turns suddenly and moves to the throne to lean over and speak directly to Ivan; the shifting train swirls behind him and stretches into a series of diagonal folds as he moves. Later, as Philip stalks away, shouting his curse back to Ivan, the long shot frames the entire empty throneroom (216). First Philip moves away, turns briefly to shout back, then continues out; during this, Ivan moves right and then across left to follow Philip. The indirect, hesitating movements of the two men in black against the light flagstones on the floor set up swirling patterns of visual interest and excess. In the Livonian scene, Sigismund leans forward in closeup until his head seems to be suspended in the center of a set of radiating black and white lines (his ruff; shot 84, part 2). In the same scene, one knight wears armor decorated with huge, curling feathers, elaborately backlit (68).

Excess is present in the way things happen. The tassel of Pimen's rosary drags lightly over the carvings on the gold Bible in a closeup during the illness sequence (1, 455). Ivan's sweeping turn as he carries the poisoned cup to Anastasia is unnecessary in relation to the action. Efrosinia's behavior as she sings the lullaby is strange in a way which goes beyond the narrative connotations. Ivan's kiss on Malyuta's brow before the execution in part 2 slips away from the straightforward causal motivation of the scene.

The style of many devices is highly exaggerated in *Ivan*, compared to that in the classical narrative film. Elements of the acting like the sweeping gestures and the staring eyes stand out as strange; we may recognize their function in the filmic system, but this will not obliterate their peculiarity. ("Peculiar" and "strange" here have only positive connotations; these qualities are a large part of *Ivan*'s appeal.) The Hollywood norm has accustomed us to clear, seamless space; now we are confronted with frequent, pointless shifts and gaps. Ivan's device of cubistic editing constitutes a perceptual game.[17] If the spectator consciously notices the cubistic cuts, he/she may indeed be drawn aside from the smoother structures to notice more and more subtle instances of this spatial instability. Indeed, any stylistic disjunction may lead the

---

[17]See Burch's comparison of *Ivan*'s cutting to the painting style of Gris in *Theory of Film Practice*, pp. 37–39.

spectator into an awareness of excess—unless he/she strives too hard to recuperate them.

Problematic or unclear elements are likely to become excess. Many of the icons in the cathedral, for example, are never seen in their entirety. They are realistically motivated as portions of a reasonably authentic historical setting: but because they are only partially visible, they invite inspection in an attempt (necessarily fruitless) at identification. Half-glimpsed hallways, partially darkened corners of rooms, slightly out-of-focus backgrounds, and other similar visual presences may all tend to draw the eye, particularly on repeated viewings. What are we to make of the black-clad body that lies in the background of one shot of the execution scene of part 2 (285)? The body is not there in any other shot, nor is there the faintest narrative motivation for its presence; it is not one of the Boyars, nor is there any suggestion that an Oprichnik dies or faints in this scene. Beyond the frequent use of confused spatial cues in the cutting, there is also one point where the geography is flagrantly inconsistent. When Efrosinia leaves the wedding banquet to check on the progress of the riot, she goes out by a little door and emerges outside at the head of the stairway. Later, she receives Demyan's report in a little archway at the foot of this same stairway; yet when the pair go through the door in this archway, they (at least Efrosinia—Demyan has disappeared during the cut of the interior of the hall) are coming in the same little doorway by which Efrosinia has previously exited.

Certain props carry interest beyond their function in the narrative. The repeated closeups of the emblems of Riga, Reval, and Narva at the beginning of the poisoning sequence are only tangential to the narrative; we would undoubtedly be able to understand Ivan's speech without these "visual aids." But their carvings attract attention. Similarly, the coffin and its trappings in the scene of Ivan's mourning are striking and elaborate: Anastasia lies in a hollowed-out log, surrounded by a fan of shining decorations like a peacock's tail.

We may find some of the most extreme examples of excess in the Fiery Furnace play scene. The play's function in the narrative is clear, but its manner of execution tends toward excess. Barthes speaks briefly of this scene in discussing excess, pointing to the three boys and, "the schoolboy absurdity of their mufflers diligently wrapped around their necks."[18] The mufflers work in with the general principles of the playlet's style, with a heightening of signification accomplished in the various channels by adding a symbolic device to the literal one: the boys stand over fire, but also light candles to imply that they are in the fire; they are tied together, but also wear mufflers to heighten the concept of "bound-ness"; they step into the furnace, but the Chaldeans also turn cartwheels to mark the moment (to suggest a sense of falling or confusion?). But beyond this function, Barthes' description seems to me right; there *is* something about those mufflers that goes beyond their symbolic participation in the playlet. Their individual decorative pattern and strangeness in this context convey a quality which is perhaps, as Barthes says "absurd," perhaps amusing, touching, or all three. The same is true for other aspects of the scene: the Chaldeans' painted grimaces, the cymbal crashes, the boys' haloes, and the rest, all have qualities beyond their immediate functions.

---

[18]Barthes, "The Third Meaning," p. 48.

I have said almost nothing about sound, but clearly it can have its excessive fea-
tures as well. The strange, jangling bell toward which Vladimir glances in the court-
yard scene of the illness sequence of part 1 would be one example. Birds are heard
chirping in only one shot of the scene of the herald toward the end of part 1.
Malyuta's repetitions of the word "pes" (pronounced "pyos," meaning "dog") in his
conversation with Ivan before the executions in part 2 seem to me rather comic,
mainly because of the sound of the word itself and the injured tones in which he deliv-
ers the lines. In general, music has a great potential to call attention to its own formal
qualities apart from its immediate function in relation to the image track. The ten-
dency of the actors to speak their lines in separate bits with long pauses between also
tends, I suspect, to call attention to the sounds and rhythms of the dialogue.

A couple of obvious devices in the film that seem strongly excessive: the shifts
between color and black-and-white stock, which inevitably must cause a perceptual
shock dependent entirely upon the material of the images; and the use of two identi-
cal shots from the coronation sequence (1, 58–59) of two young women spectators in
the Fiery Furnace scene of part 2 (334–35). In the latter case, we can recuperate the
repetititon logically by positing that the device helps create a narrative parallel
between the two scenes; nevertheless the two shots stand out as disturbing elements
because we know they are physically the *same* shots—they violate our expectations
about the temporal distinctness of the two scenes.

These few indications from *Ivan* must suffice to help define the excess concretely.
I can do no more than indicate; a systematic analysis is impossible. Why then bother
with excess at all? What is its value? Beyond renewing the perceptual freshness of the
work, it suggests a different way of watching and listening to a film. It offers a poten-
tial for avoiding the traditional, conventionalized views of what film structure and
narrative should be—views which fit in perfectly with the methods of filmmaking
employed in the classical commercial narrative cinema. The spectator need not
assume that the entire film consists only of the unified system of structures we call
form and style; he/she need not assume that film is a means of communication
between artist and audience. Hence the spectator will not go to a film expecting to
discern what it is "trying to say," or to try and reassemble its parts into some assumed,
preordained whole.

An awareness of excess may help change the status of narrative in general for the
viewer. One of the great limitations for the viewer in our culture has been the attitude
that film equals narrative, and that entertainment consists wholly of an "escapism"
inherent in the plot. Such a belief limits the spectator's participation to understanding
only the chain of cause and effect. The fact that we call this understanding the ability
to "follow" the narrative is not accidental. The viewer goes along a preordained path,
trying to come to the "correct" conclusions; skillful viewing may consist of being
able to anticipate plot events before they occur (as with the detective story, which
becomes a game in guessing the identity of the criminal before the final revelation).
This total absorption in narrative has some unpleasant consequences for the act of
viewing. The viewer may be capable of understanding the narrative, but has no con-
text in which to place that understanding; the underlying arbitrariness of the narrative
is hidden by structures of motivation and naturalization. A narrative is a chain of

causes and effects, but, unlike the real world, the narrative world requires one initial cause which itself has no cause. The choice of this initial cause is one source of the arbitrariness of narrative. Also, once the hermeneutic and proairetic codes are opened in a narrative, there is nothing which logically determines how long the narrative will continue; more and more delays could prolong the chain of cause and effect indefinitely. Thus the initiation, progression, and closure of fictional narratives is largely arbitrary. Narratives are not logical in themselves; they only make use of logic. An understanding of the plot, then, is only a limited understanding of one (arbitrary) portion of the film. But if one looks beyond narrative, at both the unified and the excessive elements at work on other levels, the underlying principles of the film (such as the hermeneutic code and the patterns of motivation) may become apparent. The viewer is no longer caught in the bind of mistaking the causal structure of the narrative for some sort of inevitable, true, or natural set of events which is beyond questioning or criticism (except for superficial evaluation on the grounds of culturally defined conventions and canons of verisimilitude).

One example of the result of a willingness to view films for excess as well as for unified structures is the genre of experimental films which examines already-existing films. These often consist of optical printer alterations of the original film, emphasizing the material of the image. Ken Jacobs' *Tom, Tom, the Piper's Son* (1969) is one such film, which takes a short silent film of the primitive period and blows up and repeats portions of the various shots to create a feature-length film. Narrative begins to break down and tiny gestures, grain, and individual frames become foregrounded. Joseph Cornell made *Rose Hobart* (late 1930s) by taking an obscure American adventure picture (*East of Borneo*, 1932) and turning it into a play on the concept of narrative by isolating individual shots, cutting them together out of order, and repeating shots. He substituted a musical track for the original sound and specified that the film be shown through a purple filter. The result hints obliquely at the original narrative, but generally concentrates on the gestures and appearance of Rose Hobart, a minor Hollywood actress, and on the absurdly exotic studio jungle settings. These, as well as some of Stan Lauder's loop films, suggest the structural possibilities an awareness of excess can create. I don't mean to imply that the spectator and critic will be led to aesthetic creations of their own as a result of watching for excess. But Jacobs' and Cornell's films demonstrate the kinds of perceptual shifts which might take place once one becomes aware of excess.

Once the narrative is recognized as arbitrary rather than logical, the viewer is free to ask why individual events within its structures are as they are. The viewer is no longer constrained by conventions of reading to find a meaning or theme within the work as the solution to a sort of puzzle which has a right answer. Instead, the work becomes a perceptual field of structures which the viewer is free to study at length, going beyond the strictly functional aspects. Each film dictates the way it wants to be viewed by drawing upon certain conventions and ignoring or flouting others. But if the viewer recognizes these conventions and refuses to be bound by them, he/she may strive to avoid having limitations imposed upon his/her viewing without an awareness of that imposition. Obviously there is no completely free viewing situation; we are always guided by our knowledge and cultural tradition. But a perception of a film

which includes its excess implies an awareness of the structures (including conventions) at work in the film, since excess is precisely those elements which escape unifying impulses. Such an approach to viewing films can allow us to look further into a film, renewing its ability to intrigue us by its strangeness; it also can help us to be aware of how the whole film—not just its narrative—works upon our perception.

1981

# PETER WOLLEN
# GODARD AND COUNTER CINEMA: *VENT D'EST*

More and more radically Godard has developed a counter-cinema whose values are counterposed to those of orthodox cinema. I want simply to write some notes about the mean features of this counter-cinema. My approach is to take seven of the values of the old cinema, Hollywood–Mosfilm, as Godard would put it, and contrast these with their (revolutionary, materialist) counterparts and contraries. In a sense, the seven deadly sins of the cinema against the seven cardinal virtues. They can be set out schematically in a table as follows:

| | |
|---|---|
| Narrative transitivity | Narrative intransitivity |
| Identification | Estrangement |
| Transparency | Foregrounding |
| Single diegesis | Multiple diegesis |
| Closure | Aperture |
| Pleasure | Unpleasure |
| Fiction | Reality |

Obviously, these somewhat cryptic headings need further commentary. First, however, I should say that my overall argument is that Godard was right to break with Hollywood cinema and to set up his counter-cinema and, for this alone, he is the most important director working today. Nevertheless, I think there are various confusions in his strategy, which blunt its edges and even, at times, tend to nullify it—mainly, these concern his confusion over the series of terms: fiction/mystification/ideology/ lies/deception/illusion/representation. At the end of these notes, I shall touch on some of my disagreements. First, some remarks on the main topics.

*1. Narrative transivity v. narrative intransitivity*. (One thing following another v. gaps and interruptions, episodic construction, undigested digression.)

By narrative transivity, I mean a sequence of events in which each unit (each function that changes the course of the narrative) follows the one preceding it according to a chain of causation. In the Hollywood cinema, this chain is usually psychological and is made up, roughly speaking, of a series of coherent motivations. The beginning of the film starts with establishment, which sets up the basic dramatic situation—usually an equilibrium, which is then disturbed. A kind of chain reaction then follows, until at the end a new equilibrium is restored.

Godard began to break with this tradition very early. He did this, at first, in two ways, both drawn from literature. He borrowed the idea of separate chapters, which enabled him to introduce interruptions into the narrative, and he borrowed from the picaresque novel. The picaresque is a pseudo-autobiographical form which for tight plot construction substitutes a random and unconnected series of incidents, supposed to represent the variety and ups-and-downs of real life. (The hero is typically marginal to society, a rogue-errant, often an orphan, in any case without family ties, thrown hither and thither by the twists and turns of fortune.)

By the time he arrives at *Vent d'Est*, Godard has practically destroyed all narrative transitivity. Digressions which, in earlier films, represented interruptions to the narrative have hypertrophied until they dominate the film entirely. The basic story, as much of it as remains, does not have any recognizable sequence, but is more like a series of intermittent flashes. Sometimes it seems to be following a definite order in time, but sometimes not. The constructive principle of the film is rhetorical, rather than narrative, in the sense that it sets out the disposition of an argument, point by point, in a sequence of 1–7, which is then repeated, with a subsidiary sequence of Theories A and B. There are also various figures of amplification and digression within this structure.

There are a number of reasons why Godard has broken with narrative transitivity. Perhaps the most important is that he can disrupt the emotional spell of the narrative and thus force the spectator, by interrupting the narrative flow, to reconcentrate and re-focus his attention. (Of course, his attention may get lost altogether.) Godard's cinema, broadly speaking, is within the modern tradition established by Brecht and Artaud, in their different ways, suspicious of the power of the arts—and the cinema, above all—to 'capture' its audience without apparently making it think, or changing it.

2. *Identification v. estrangement.* (Empathy, emotional involvement with a character v. direct address, multiple and divided characters, commentary.)

Identification is a well-known mechanism though, of course, in the cinema there are various special features which mark cinematic identification off as a distinct phenomenon. In the first place, there is the possibility of double identification with the star and/or with the character. Second, the identification can only take place in a situation of suspended belief. Third, there are spatial and temporal limits either to the identification or, at any rate, to the presence of the imago. (In some respects, cinematic identification is similar to transference in analysis, though this analogy should not be taken too far.)

Again, the breakdown of identification begins early in Godard's films and then develops unevenly after that, until it reaches a new level with *Le Gai Savoir*. Early devices include non-matching of voice to character, introduction of 'real people' into

the fiction, characters addressing the audience directly. All these devices are also used in *Vent d'Est*, which takes especially far the device of allowing voices to float off from characters into a discourse of their own on the soundtrack, using the same voice for different characters, different voices for the same character. It also introduces the 'real-life' company into the film itself and, in a rather complicated figure, introduces Gian Maria Volonte, not simply as an actor (Godard shows the actors being made-up) but also as intervening in the process of 'image-building'. As well as this, there is a long and extremely effective direct address sequence in which the audience is described—somewhat pejoratively—from the screen and invited into the world of representation.

It is hardly necessary, after the work of Brecht, to comment on the purpose of estrangement-effects of this kind. Clearly, too, they are closely related to the breakup of narrative transitivity. It is impossible to maintain 'motivational' coherence, when characters themselves are incoherent, fissured, interrupted, multiple and self-critical. Similarly, the ruse of direct address breaks not only the fantasy identification but also the narrative surface. It raises directly the question, 'What is this film for?', superimposed on the orthodox narrative questions, 'Why did that happen?' and 'What is going to happen next?' Any form of cinema which aims to establish a dynamic relationship between film maker and spectator naturally has to consider the problem of what is technically the register of discourse, the content of the enunciation, as well as its designation, the content of the enunciate.

3. *Transparency v. foregrounding.* ('Language wants to be over-looked'—Siertsema v. making the mechanics of the film/text visible and explicit.)

Traditional cinema is in the direct line of descent from the Renaissance discovery of perspective and reformulation of the art of painting, expressed most clearly by Alberti, as providing a window on the world. The camera, of course, is simply the technological means towards achieving a perfect perspective construction. After the Renaissance the painting ceased to be a text which could be 'read,' as the iconographic imagery and ideographic space of pre-Renaissance painting were gradually rejected and replaced by the concept of pure representation. The 'language' of painting became simply the instrument by which representation of the world was achieved. A similar tendency can be seen at work with attitudes to verbal language. From the seventeenth century onwards, language was increasingly seen as an instrument which should efface itself in the performance of its task—the conveyance of meaning. Meaning, in its turn, was regarded as representation of the world.

In his early films Godard introduced the cinema as a topic in his narrative—the 'Lumière' sequence in *Les Carabiniers*, the film within a film in *Le Mépris*. But it was not until his contribution to *Loin du Vietnam* that the decisive step was taken, when he simply showed the camera on screen. In the post-1968 films the process of production is systematically highlighted. In *Vent d'Est* this shows itself not simply in taking the camera behind the scenes, as it were, but also in altering the actual film itself: thus the whole worker's control sequence is shown with the film marked and scratched, the first time that this has happened in Godard's work. In previous films, he had not gone further than using special film stock (*Les Carabiniers*) or printing sequences in negative (*Les Carabiniers, Alphaville*).

At first sight, it looks as if the decision to scratch the surface of the film brings Godard into line with other avant-garde film makers, in the American 'underground'

especially. However this is not really the case. In the case of the American film makers, marking the film is best seen alongside developments in painting that have dominated, particularly in the USA, in recent years. Broadly speaking, this involves a reduction of film to its 'optical' substrate. Noise is amplified until, instead of being marginal to the film, it becomes its principal content. It may then be structured according to some calculus or algorithm or submitted to random coding. Just as, in painting, the canvas is foregrounded so, in cinema, the film is foregrounded.

Godard, however, is not interested in this kind of 'de-signification' of the image by foregrounding 'noise' and then introducing a new constructive principle appropriate to this. What he seems to be doing is looking for a way of expressing negation. It is well known that negation is the founding principle of verbal language, which marks it off both from animal signal-systems and from other kinds of human discourse, such as images. However, once the decision is made to consider a film as a process of writing in images, rather than a representation of the world, then it becomes possible to conceive of scratching the film as an erasure, a virtual negation. Evidently the use of marks as erasures, crossing-out an image, is quite different from using them as deliberate noise or to foreground the optical substrate. It pre-supposes a different concept of 'film-writing' and 'film-reading'.

Some years ago, Astruc, in a famous article, wrote about *le caméra-stylo*. His concept of writing—*écriture*—was closer to the idea of style. Godard, like Eisenstein before him, is more concerned with 'image-building' as a kind of pictography, in which images are liberated from their role as elements of representation and given a semantic function within a genuine iconic code, something like the baroque code of emblems. The sequences in which the image of Stalin is discussed are not simply—or even principally—about Stalin's politics, as much as they are about the problem of finding an image to signify 'repression'. In fact, the whole project of writing in images must involve a high degree of foregrounding, because the construction of an adequate code can only take place if it is glossed and commented upon in the process of construction. Otherwise, it would remain a purely private language.

*4. Single diegesis v. multiple diegesis.* (A unitary homogeneous world v. heterogeneous worlds. Rupture between different codes and different channels.)

In Hollywood films, everything shown belongs to the same world, and complex articulations within that world—such as flash-backs—are carefully signalled and located. The dominant aesthetic is a kind of liberalized classicism. The rigid constraints of the dramatic unities have been relaxed, but mainly because they were over-strict and limiting, whereas the basic principle remains unshaken. The world represented on the cinema must be coherent and integrated, though it need not observe compulsory, statutory constraints. Time and space must follow a consistent order. Traditionally, only one form of multiple diegesis is allowed—the play within a play—whereby the second, discontinuous diegetic space is embedded or bracketed within the first. (It should be added that there are some exemplary cases of transgression of single diegesis within literature, such as Hoffmann's *Life of Tomcat Murr*, which consists of Tomcat Murr's life—the primary diegesis—interleaved at random with pages from another text—the life of Kreisler—supposedly bound into the book by mistake by the bookbinder. The pages from the secondary diegesis begin and end in the middle of sentences and are in the wrong order, with some missing. A novel

like Sterne's *Tristram Shandy*, however, simply embeds a number of different diegeses on the play-within-a-play model. Of course, by recursion this principle can be taken to breaking-point, as Borges has often pointed out.)

Godard uses film-within-a-film devices in a number of his early works. At the same time the primary diegesis begins to develop acute fissures and stresses. In *Le Mépris*, for example, there is not only a film-within-a-film, but many of the principal characters speak different languages and can only communicate with each other through an interpreter (an effect entirely lost in some dubbed versions, which have to give the interpreter meaningless remarks to speak). The first radical break with single diegesis, however, comes with *Weekend*, when characters from different epochs and from fiction are interpolated into the main narrative: Saint-Just, Balsamo, Emily Brontë. Instead of a single narrative world, there is an interlocking and interweaving of a plurality of worlds.

At the same time that Godard breaks down the structure of the single diegesis, he also attacks the structure of the single, unitary code that expressed it. Not only do different characters speak different languages, but different parts of the film do too. Most strikingly, there is a rupture between soundtrack and images: indeed, the elaboration of this rupture dominates both *Le Gai Savoir* and *Pravda*. The text becomes a composite structure, like that of a medieval macaronic poem, using different codes and semantic systems. Moreover, these are not simply different, but also often contradictory. *Vent d'Est*, for instance, presents alternative ways of making a film (the Glauber Rocha sequence) only to reject them. It is one of the assumptions of contemporary linguistics that a language has a single, unitary semantic component, just as it has a single syntax. In fact, this is surely not the case. The semantic component of a language is composite and contradictory, permitting understanding on one level, misunderstanding on another. Godard systematically explores the areas of misunderstanding.

*5. Closure v. aperture.* (A self-contained object, harmonized within its own bounds, v. open-endedness, overspill, intertextuality—allusion, quotation and parody.)

It has often been pointed out that in recent years, the cinema has become 'self-conscious', in contrast to the 'innocent' days of Hollywood. In itself, however, 'self-consciousness' is quite compatible with closure. There is a use of quotation and allusion that simply operates to provide a kind of 'surplus' of meaning, as the scholastics used to say, a bonus for those who catch the allusion. The notorious 'Tell me lies' sequence in *Le Petit Soldat*, borrowed from *Johnny Guitar*, is of this kind: it does not make much difference whether you recognise it or not and, even if you do, it has no effect on the meaning of the sequence. Or else quotation can be simply a sign of eclecticism, primarily a stylistic rather than semantic feature. Or, as with Makavejev's use of quotation, the objective may be to impose a new meaning on material by inserting it into a new context: a form of irony.

Godard, however, uses quotation in a much more radical manner. Indeed, his fondness for quotation has always been one of the distinguishing characteristics of his films. At the beginning of his career, Godard used to give instructions to the cameraman almost entirely in terms of shots from previous films and, at a more explicit level, there are endless direct quotes, both from films and from painting and literature. Whole films contain obvious elements of pastiche and parody: *Une Femme est une*

*Femme* is obviously derivative from the Hollywood musical, *Les Carabiniers* from Rossellini, *Le Mépris* is 'Hawks and Hitchcock shot in the manner of Antonioni' . . . it would be possible to go on endlessly.

However, as Godard's work developed, these quotations and allusions, instead of being a mark of eclecticism, began to take on an autonomy of their own, as structural and significant features within the films. It becomes more and more impossible to understand whole sequences and even whole films without a degree of familiarity with the quotations and allusions which structure them. What seemed at first to be a kind of jackdaw mentality, a personality trait of Godard himself, begins to harden into a genuine polyphony, in which Godard's own voice is drowned out and obliterated behind that of the authors quoted. The film can no longer be seen as a discourse with a single subject, the film maker/auteur. Just as there is multiplicity of narrative worlds, so too there is a multiplicity of speaking voices.

Again, this takes us back to the period before the rise of the novel, the representational painting, to the epoch of the battle of the books, the logomachia. Perhaps the author who comes most to mind is Rabelais, with his endless counterposition of quotations, his parodies, his citation of authorities. The text/film can only be understood as an arena, a meeting-place in which different discourses encounter each other and struggle for supremacy. Moreover these discourses take on an independent life of their own. Instead of each being corked up in its bottle with its author's name on it as a label, the discourses escape, and like genies, are let out to intermingle and quarrel.

In this sense, Godard is like Ezra Pound or James Joyce who, in the same way, no longer insist on speaking to us in their own words, but can be seen more as ventriloquist's dummies, through whom are speaking—or rather being written—palimpsests, multiple *Niederschriften* (Freud's word) in which meaning can no longer be said to express the intention of the author or to be a representation of the world, but must like the discourse of the unconscious be understood by a different kind of decipherment. In orthodox logic and linguistics, context is only important as an arbiter between alternative meanings (amphibologies, as they are called in logic). In Godard's films, the opposite process is at work: the juxtaposition and re-contextualization of discourses leads not to a separating-out of meanings but to a confrontation.

6. *Pleasure v. unpleasure*. (Entertainment, aiming to satisfy the spectator v. provocation, aiming to dissatisfy and hence change the spectator.)

The attack on 'entertainment' cinema is part of a broader attack on the whole of 'consumer society'. Cinema is conceived of as a drug that lulls and mollifies the militancy of the masses, by bribing them with pleasurable dreams, thus distracting them from the stern tasks which are their true destiny. It is hardly necessary to insist on the asceticism and Puritanism—repressiveness—of this conception that unflinchingly seeks to put the reality-principle in command over the pleasure-principle. It is true that the short-term (cinematic) dream is sometimes denounced in the name of a long-term (millenarian) dream, and short-term (false, illusory, deceptive) satisfactions contrasted with long-term (real, genuine, authentic) satisfactions, but this is exactly the kind of argument which is used to explain the accumulation of capital in a capitalist society by the saving principle and postponement of consumption.

Brecht was careful never to turn his back on entertainment and, indeed, he even quotes Horace in favour of pleasure as the purpose of the arts, combined, of course,

with instruction. This is not to say that a revolutionary cinema should distract its spectators from realities, but that unless a revolution is desired (which means nothing less than coinciding with and embodying collective fantasies) it will never take place. The reality-principle only works together with the pleasure-principle when survival itself is at stake, and though this may evidently be the case in a revolutionary situation, it is not so in the advanced capitalist countries today. In a situation in which survival is—at least relatively—nonproblematic, the pleasure-principle and the reality-principle are antagonistic and, since the reality-principle is fundamentally adaptive, it is from the pleasure-principle that change must stem. This means that desire, and its representation in fantasy, far from being necessary enemies of revolutionary politics—and its cinematic auxiliary—are necessary conditions.

The problem, of course, concerns the nature of the fantasies on the one hand, and the way in which they are presented in the text/film on the other hand, the way in which fantasy scenarios are related to ideologies and beliefs and to scientific analysis. A revolutionary cinema has to operate at different levels—fantasy, ideology, science—and the articulation of these levels, which involve different modes of discourse and different positions of the subject, is a complicated matter.

In *Vent d'Est* the 'struggle against the bourgeois notion of representation' certainly does not rule out the presence of fantasy: fantasy of shooting the union delegate, fantasies of killing shoppers in a supermarket. Indeed, as long as there are images at all, it is impossible to eliminate fantasy. But the fantasies are almost entirely sado-masochistic in content, and this same fantasy content also seems to govern the relationship between film maker and spectator, rather on the lines of the relationship between the flute-player in the film and his audience. A great many of the devices Godard uses are designed to produce a collective working relationship between film maker and audience, in which the spectator can collaborate in the production/consumption of meaning. But Godard's view of collective work is conceived of in very imprecise terms. 'Criticism' consists of insults and interrogation. The fantasy content of the film is not articulated correctly with the ideology or political theory. This, in turn, seems to spring from a suspicion of the need for fantasy at all, except perhaps in the sado-masochistic form of provocation.

7. *Fiction v. reality*. (Actors wearing make-up, acting a story v. real life, the breakdown of representation, truth.)

Godard's dissatisfaction with fiction cinema begins very early. Already in *Vivre sa vie* non-fiction is introduced—the chapter on the economics and sociology of prostitution. There is almost no costume drama in Godard's career, until—ironically enough—*Vent d'Est*. Even within the framework of fiction, he has stuck to contemporary life. His science-fiction films (*Alphaville*, *Anticipation*) have all been set in a kind of future-in-the-present, without any paraphernalia of special effects or sets.

As with all the features I have described, the retreat from (and eventually attack on) fiction has proceeded unevenly through Godard's career, coming forward strongly in, for instance, *Deux ou trois choses*, then receding again. Especially since May 1968, the attack on fiction has been given a political rationale (fiction = mystification = bourgeois ideology) but, at the beginning, it is much more closely connected with Godard's fascination (Cartesian, rather than Marxist) with the misleading and dissembling nature of appearances, the impossibility of reading an essence from a phe-

nomenal surface, of seeing a soul through and within a body or telling a lie from a truth. At times Godard seems almost to adopt a kind of radical Romanticism, which sees silence (lovers' silence, killers' silence) as the only true communication, when reality and representation, essence and appearance, irreducibly coincide: the moment of truth.

Obviously, too, Godard's attitude to fiction is linked with his attitude to acting. This comes out most clearly in *Une Femme Mariée*, when the actor is interrogated about his true self, his relationship to his roles. Godard is obsessed with the problem of true speech, lying speech and theatrical speech. (In a sense, these three kinds of speech, seen first in purely personal terms, are eventually politicized and given a class content. The bourgeoisie lies, the revisionists lie, though they should speak the truth, the revolutionaries speak the truth, or, rather, stammer an approach to the truth.) Godard has long shown a horror of acting, based originally on a 'logocentric' antipathy to anybody who speaks someone else's words, ironic in the circumstances. Eventually, Godard seems to have reformulated his attitude so that actors are distrusted for speaking other people's words as if they were their own. This accompanies his growing recognition that nobody ever speaks in their own words, hence the impossibility of genuine dialogue and the reduction of dialogue to reciprocal—or often unilateral—interviewing. In *Vent d'Est* there is almost no dialogue at all (only a number of variants of monologue) and this must relate to the caricature of collective work Godard puts forward.

Interviewing is, of course, the purest form of linguistic demand, and the demand Godard makes is for the truth. Yet it never seems to be forthcoming, not surprisingly, since it cannot be produced on demand. It is as if Godard has a lingering hope that if people could find their own words, they might produce it miraculously in our presence, but if not, then it has to be looked for in books, which are the residues of real words. This kind of problematic has been tormenting Godard throughout his cinematic career. In *A Bout de souffle*, for instance, there is the central contrast between Michel Poiccard/Laszlo Kovacs—an honest impostor—and Patricia, whose mania for honesty reveals her in the end as a deceiver.

The early films tend to explore this kind of problem as one between different levels, but in the post-1968 films, there seems to have been a kind of flattening out, so that fiction = acting = lying = deception = representation = illusion = mystification = ideology. In fact, as anybody reflecting on Godard's earlier films must surely know, these are all very different categories. Ideology, for instance, does not depend primarily on lies. It depends on the acceptance of common values and interests. Similarly mystification is different from deception: a priest does not deceive his congregation about the miracle of the mass in the same way that a conjurer deceives his audience, by hiding something from them. Again, the cinema is a form of representation, but this is not the same as illusion or 'trompe l'oeil'. It is only possible to obliterate these distinctions by defining each of them simply in terms of their departure from truth.

The cinema cannot show the truth, or reveal it, because the truth is not out there in the real world, waiting to be photographed. What the cinema can do is produce meanings, and meanings can only be plotted, not in relation to some abstract yardstick or criterion of truth, but in relation to other meanings. This is why Godard's objective of

producing a counter-cinema is the right objective. But he is mistaken if he thinks that such a counter-cinema can have an absolute existence. It can only exist in relation to the rest of the cinema. Its function is to struggle against the fantasies, ideologies and aesthetic devices of one cinema with its own antagonistic fantasies, ideologies and aesthetic devices. In some respects this may bring it closer—or seem to bring it closer—to the cinema it opposes than *Vent d'Est* would suggest. *Vent d'Est* is a pioneering film, an avant-garde film, an extremely important film. It is the starting-point for work on a revolutionary cinema. But it is not that revolutionary cinema itself.

1972

# JEFFREY SCONCE
# 'TRASHING' THE ACADEMY: TASTE, EXCESS, AND AN EMERGING POLITICS OF CINEMATIC STYLE

Nobody likes movies like *Teenagers from Outer Space* or *Wrestling Women vs. the Aztec Mummy* save any loon sane enough to realize that the whole concept of Good Taste is concocted to keep people from having a good time, from reveling in a crassness that passeth all understanding.... But fuck those people who'd rather be watching *The Best Years of Our Lives* or *David and Lisa*. We got our own good tastes ... [1]

Written five years before Pierre Bourdieu published his monumental study on the social construction of taste, Lester Bangs's diatribe against a nebulously defined group of cultural custodians epitomizes Bourdieu's contention that 'tastes are perhaps first and foremost distastes, disgust provoked by horror or visceral intolerance of the tastes of others'. 'It is no accident', writes Bourdieu, 'that when they have to be justified, they are asserted negatively, by the refusal of other tastes'.[2] Thus, in the spirit of Lester Bangs, the editors of *Zontar,* a Boston-based fanzine devoted primarily to the promotion of 'badfilm', note that their publication 'is *not* for the delicate tastebuds of the pseudo-genteel cultural illiterati who enjoy mind-rotting, soul-endangering pabulum like *Joseph Campbell and the Power of Myth* and the other white-boy 'new-age' puke-shit served up from the bowels of PBS during pledge-week'.[3] Meanwhile, a 1990 issue of *Subhuman,* a fanzine featuring articles on cinematic manifestations of 'necrophilia, 3-D surrealism, animal copulation, pregnant strippers, horror nerdism, and bovine flatulence', labels itself a journal of 'eccentric film and video kulture'.[4]

---

[1] Lester Bangs, *Psychotic Reactions and Carburetor Dung* (New York: Vintage Books, 1988), pp. 122–3.

[2] Pierre Bourdieu, *Distinction: A Social Critique of the Judgment of Taste* (Cambridge MA: Harvard University Press, 1984), p. 57.

[3] *Zontar's Ejecto-Pod,* vol. 1, no. 1, n.p.

[4] *Subhuman,* no. 15, front cover.

The stridently confrontational tastes espoused by Bangs, *Zontar* and *Subhuman* over this fifteen-year period describe the gradual emergence of a growing and increasingly articulate cinematic subculture, one organized around what are among the most critically disreputable films in cinematic history. Publications devoted to this 'trash' cinema include such magazines, fanzines and makeshift journals as *Psychotronic Video, Zontar, Subhuman, Trashola, Ungawa, Pandemonium,* and the RE/Search volume, *Incredibly Strange Films.*[5] The most visible document of this film community is Michael Weldon's *Psychotronic Encyclopedia of Film,* a subterranean companion to Leonard Maltin's *Movies On TV,* which catalogues hundreds of bizarre titles culled from Weldon's late-night television viewing marathons in New York City. Taken together, the diverse body of films celebrated by these various fanzines and books might best be termed 'paracinema'. As a most elastic textual category, paracinema would include entries from such seemingly disparate subgenres as 'badfilm', splatterpunk, 'mondo' films, sword and sandal epics, Elvis flicks, government hygiene films, Japanese monster movies, beach-party musicals, and just about every other historical manifestation of exploitation cinema from juvenile delinquency documentaries to soft-core pornography. Paracinema is thus less a distinct group of films than a particular reading protocol, a counter-aesthetic turned subcultural sensibility devoted to all manner of cultural detritus. In short, the explicit manifesto of paracinematic culture is to valorize all forms of cinematic 'trash', whether such films have been either explicitly rejected or simply ignored by legitimate film culture. In doing so, paracinema represents the most developed and dedicated of cinephilic subcultures ever to worship at 'the temple of schlock'.[6]

The caustic rhetoric of paracinema suggests a pitched battle between a guerrilla band of cult film viewers and an elite cadre of would-be cinematic tastemakers. Certainly, the paracinematic audience likes to see itself as a disruptive force in the cultural and intellectual marketplace. As a short subject, this audience would be more inclined to watch a bootlegged McDonald's training film than *Man with a Movie Camera,* although, significantly, many in the paracinematic community would no doubt be familiar with this more respectable member of the avant-garde canon. Such calculated negation and refusal of 'elite' culture suggests that the politics of social stratification and taste in paracinema is more complex than a simple high-brow/low-brow split, and that the cultural politics of 'trash culture' are becoming ever more ambiguous as this 'aesthetic' grows in influence. In recent years, the paracinematic community has seen both the institutionalization and commercialization of their once renegade, neo-camp aesthetic. Although paracinematic taste may have its roots in the world of 'low-brow' fan culture (fanzines, film conventions, memorabilia collections, and so on), the paracinematic sensibility has recently begun to infiltrate the avant garde, the academy, and even the mass culture on which paracinema's ironic reading strategies originally preyed. Art museums that once programmed only Italian Neo-Realism or German Neo-Expressionism now feature retrospectives of 1960s Biker films and career overviews of exploitation auteurs such as Herschell Gordon Lewis

---

[5]'Fanzines' are home-produced, photocopied magazines circulated among fans and devoted to an often narrow area of interest in popular culture.

[6]*Temple of Schlock* is another fanzine dedicated to this cinema.

and Doris Wishman. No doubt to the dismay and befuddlement of cultural hygienists like Allan Bloom and James Twitchell, academic courses in film studies increasingly investigate 'sleazy' genres such as horror and pornography. Recently, the trash aesthetic has even made inroads into mainstream popular taste. The ironic reading strategies honed by the badfilm community through countless hours of derisive interaction with late-night science fiction are now prepackaged for cable in programmes such as *Mystery Science Theatre 3000*. Similarly, Turner Network Television now presents a weekly sampling of the paracinematic pantheon in Friday night, '100% Weird' triple features. Even Blockbuster video, America's corporate bastion of cinematic conservatism, features a 'le bad' section in many of their stores, where patrons can find the work of John Waters, William Castle and other 'disreputable' filmmakers. Perhaps most incredibly, *Batman*'s director Tim Burton recently directed a multi-million dollar biopic of Ed Wood Jr, the director of such paracinematic classics as *Plan 9 From Outer Space* (1959) and *Glen or Glenda* (1953), an artist who himself never spent over a few thousand dollars on any one picture.[7] Clearly, in cinematic circles of all kinds, there has been a significant realignment on the social terrain of taste, a powerful response to what has been termed 'the siren song of crap'.

At first glance, the paracinematic sensibility, in all its current manifestations, would seem to be identical to the 'camp' aesthetic outlined by Susan Sontag some thirty years ago. Without a doubt, both sensibilities are highly ironic, infatuated with the artifice and excess of obsolescent cinema. What makes paracinema unique, however, is its aspiration to the status of a 'counter-cinema'. Whereas 'camp' was primarily a reading strategy that allowed gay men to rework the Hollywood cinema through a new and more expressive subcultural code, paracinematic culture seeks to promote an alternative vision of cinematic 'art', aggressively attacking the established canon of 'quality' cinema and questioning the legitimacy of reigning aesthete discourses on movie art. Camp was an aesthetic of ironic colonization and cohabitation. Paracinema, on the other hand, is an aesthetic of vocal confrontation.

Who, exactly, is the paracinematic audience at war with, and what is at stake in such a battle? Consider the following diatribe from *Zontar*:

> Where the philosophical pygmies search the snob-ridden art galleries, flock to the false comfort of PBS-produced pseudo-gentility, WE look elsewhere. We seek the explanations for the decline of Hu-Manity in the most debased and misunderstood manifestations of the IDIOT CULTURE. Monster movies, comic books, cheap porn videos, TV preachers, of course!!! But we search ever deeper into the abyss. The Home Shopping Network. Late-Night Cable TV-Product Worship-Testimonial Shows. Tiffany Videos. We leave purity to those other assholes. The search for BADTRUTH is only for the brave few, like you, whose all-consuming HATE is powerful enough to resist the temptations of REFINEMENT, TASTE, and ESCAPISM—the miserable crumbs tossed from the table by the growing mass of REPUBLICAN THIRTYSOMETHING COUNTRY-CLUB CHRISTIAN ZOMBIES who now rule this wretched planet.[8]

The paracinematic audience promotes their tastes and textual proclivities in opposition to a loosely defined group of cultural and economic elites, those purveyors of the

---

[7]In a fittingly perverse tribute to Wood, Burton's film won widespread critical acclaim and yet bombed at the box office, making less than six million dollars on its initial release in the USA.

[8]*Zontar*, no. 8, n.p.

status quo who not only rule the world, but who are also responsible for making the contemporary cinema, in the paracinematic mind, so completely boring. Nor does the paracinematic community care much for the activities of film scholars and critics. For example, an editor of *Zontar's Ejecto-Pod,* a sister publication of *Zontar,* encourages readers to hone their knowledge of trash-culture classics ridiculed by the academy (in this case the sword and sandal epic, *The Silver Chalice* [Victor Saville, 1954]), thereby 'amazing your friends and embarrassing the jargon-slinging empty-headed official avatars of critical discourse'.[9]

At times, factions of the paracinematic audience have little patience even for one another. This rift is perhaps most pointedly embodied by the competing agendas of *Film Threat* and *Psychotronic Video,* two fanzines turned magazines with international circulations that promote rival visions of the 'trash' aesthetic. While *Psychotronic* concentrates on the sizable segment of this community interested in uncovering and collecting long lost titles from the history of exploitation, *Film Threat* looks to transgressive aesthetics/genres of the past as avant-garde inspiration for contemporary independent filmmaking, championing such 'underground' auteurs as Nick Zedd and Richard Kern. In a particularly nasty swipe, a subscription form for *Film Threat* features a drawing of the 'typical' *Film Threat* reader, portrayed as a dynamic, rockabilly-quiffed hipster surrounded by admiring women. This is juxtaposed with a drawing of the 'typical' *Psychotronic* reader, depicted as passive, overweight and asexual, with a bad complexion.

Despite such efforts at generating counter-distinction within the shared cultural project of attacking 'high-brow' cinema, the discourses characteristically employed by paracinematic culture in its valorization of 'low-brow' artefacts indicate that this audience, like the film elite (academics, aesthetes, critics), is particularly rich with 'cultural capital' and thus possesses a level of textual/critical sophistication similar to the cineastes they construct as their nemesis. In terms of education and social position, in other words, the various factions of the paracinematic audience and the elite cineastes they commonly attack would appear to share what Bourdieu terms a 'cultural pedigree'.[10] Employing the terminology of US sociologist Herbert Gans, these groups might be thought of as radically opposed 'taste publics' that are nevertheless involved in a common 'taste culture'. As Gans writes: 'Taste cultures are not cohesive value systems, and taste publics are not organized groups; the former are aggregates of similar values and usually but not always similar content, and the latter are aggregates of people with usually but not always similar values making similar choices from available offerings of culture'.[11]

Whether thought of as a subculture, an aesthetic or a sensibility, the recent flourishing of paracinema represents not just a challenge to aesthete taste, but the larger fragmentation of a common taste culture, brought about by various disaffected segments of middle-class youth. Although it would be difficult to define the precise dimensions or identify the exact constituency of this particular taste public, I would argue that the paracinematic community, like the academy and the popular press,

[9]*Zontar's Ejecto-Prod,* vol. 1, no. 1, n.p.
[10]For a more detailed discussion of the cultural pedigree, see Bourdieu, *Distinction,* p. 63.
[11]Herbert Gans, *Popular Culture and High Culture* (New York: Basic Books, 1974), pp. 69–70.

embodies primarily a male, white, middle-class, and 'educated' perspective on the cinema. Representations of this 'community' are rare, but can be glimpsed, among other places, at the fringes of Richard Linklater's ode to baby-buster anomie, *Slacker* (1991). Linklater documents the desultory activities of bored students, would-be bohemians and miscellaneous cranks, all of whom exist at the economic and cultural periphery of a typical college town.[12] In a more reflexive turn, a fanzine from San Francisco describes the world of 'low-life scum', disheveled men in their twenties manifesting 'a fascination with all things sleazy, bizarre, and macabre'.[13] Paracinematic interests also often intersect with the more familiar subcultures of science-fiction fandom. Regardless of their individual interests and ultimate allegiances, however, the paracinematic audience cultivates an overall aesthetic of calculated disaffection, marking a deviant taste public disengaged from the cultural hierarchies of their overarching taste culture.

Such acrimonious battles within a single taste culture are not uncommon.[14] As Bourdieu writes: 'Explicit aesthetic choices are in fact often constituted in opposition to the choices of the groups closest in social space, with whom the competition is most direct and most immediate, and more precisely, no doubt, in relation to those choices most clearly marked by the intention (perceived as pretension) of marking distinction vis-a-vis lower groups'.[15] As the alienated faction of a social group high in cultural capital, the paracinematic audience generates distinction within its own social space by celebrating the cultural objects deemed most noxious (low-brow) by their taste culture as a whole. Paracinema thus presents a direct challenge to the values of aesthete film culture and a general affront to the 'refined' sensibility of the parent taste culture. It is a calculated strategy of shock and confrontation against fellow cultural elites, not unlike Duchamp's notorious unveiling of a urinal in an art gallery. As Bourdieu states: 'The most intolerable thing for those who regard themselves as the possessors of legitimate culture is the sacrilegious reuniting of tastes which taste dictates shall be separated'.[16] By championing films like *2000 Maniacs* (Herschell Gordon Lewis, 1964), *Bad Girls Go to Hell* (Doris Wishman, 1965), and *The Incredibly Strange Creatures Who Stopped Living and Became Mixed-Up Zombies* (Ray Dennis Steckler, 1963), and by associating themselves with home shopping networks, pornography and TV preachers, this community is, in effect, renouncing its 'cultural pedigree' and attempting to distance itself from what it perceives as elite (and elitist) taste.

Despite the paracinematic community's open hostility to the 'jargon-slinging avatars of critical discourse', many scholars see this trend towards the valorization of 'trash' at work in the academy itself, especially in the realm of media studies. In '"High culture" revisited', for example, Jostein Gripsrud argues that a major segment

---

[12]In the film's most explicit nod to the paracinematic mentality, one particularly deranged character bases his elaborate conspiracy theories on the 'truth' to be found in late-night, science-fiction movies.

[13]*Murder Can Be Fun*, no. 5, n.p.

[14]This particular struggle over cinematic taste also takes place in a variety of cultural contexts. For an account of the cultivation of a disreputable aesthetic in Swedish youth culture, see Göran Bolin, 'Beware! Rubbish! Popular culture and strategies of distinction'. *Young: Nordic Journal of Youth Research,* vol. 2, no. 1 (1994), pp. 33–49.

[15]Bourdieu, *Distinction,* p. 60.

[16]Ibid., pp. 56–7.

of contemporary media scholars routinely attacks all forms of high culture while indiscriminately valorizing mass culture in its place. As Gripsrud states somewhat sarcastically, 'Presenting oneself as a soap-fan in scholarly circles could be considered daring or provocative some ten years ago. Nowadays it is more of a prerequisite for legitimate entry into the academic discourse on soaps in some Anglo-American fora.'[17] Gripsrud speculates that this proclivity among many contemporary scholars to condemn high culture and valorize mass culture is a function of their unique trajectory in social space. 'Such upwardly mobile subjects are placed in a sort of cultural limbo, not properly integrated in the lower-class culture they left, nor in the upper-class high culture they have formally entered. Since they are newcomers, they are faced with a need to make choices concerning what to do in and with their acquired position.'[18] Gripsrud believes that the valorization of mass culture serves as a form of 'symbolic homecoming' that allows such scholars to 'strive for or pretend re-integration into the classes they once left, preferably as "leaders" in some sense, "voices" for the people'.[19]

Gripsrud's depiction of the intellectual in limbo is a particularly apt description of the contemporary graduate student, the figure within the institution of the academy who is perched the most precariously between the domains of cultural, educational and economic capital. Not surprisingly, paracinematic culture is a particularly active site of investment for many contemporary graduate students in film studies. Often, the connections between graduate film study and paracinematic culture are quite explicit, since many students now pursuing an advanced degree in film began as fans of exploitation genres such as horror and science fiction. Some students retain their interest in trash culture as a secret, guilty pleasure. Others, however, increasingly seek to focus their work on these previously marginalized and debased forms of cinema. Influenced by the importation of cultural studies to the USA during the 1980s, and writing in the wake of film scholars who were increasingly willing to address traditionally 'untouchable' cinematic genres such as horror and pornography, many students in media studies wish to continue pushing the limits of the traditional cinematic canon and the constraints of conventional academic enterprise. At stake is a sense of both institutional and cultural distinction. As John Fiske writes, 'Many young fans are successful at school and are steadily accumulating official cultural capital, but wish to differentiate themselves, along the axis of age at least, from the social values and cultural tastes (or habitus) of those who currently possess the cultural and economic capital they are still working to acquire'.[20] As paracinematic texts and concerns increasingly infiltrate film studies, however, many graduate students find themselves caught between the institutional discourses (and agendas) of the film elite as represented by the academy, and the 'fan' activities of the paracinematic community with which they feel a previous affinity. Raised in mass culture, such students are not always willing to give up the excesses of the drive-in for the discipline of Dreyer. The question is what to do with such textual experience and expertise.

---

[17]Jostein Gripsrud, '"High culture" revisited', *Cultural Studies,* vol. 3, no. 2 (1989), p. 198.

[18]Ibid., pp. 196–7.

[19]Ibid., p. 197.

[20]John Fiske, 'The cultural economy of fandom', in Lisa Lewis (ed.), *The Adoring Audience* (New York: Routledge, 1992), pp. 33–4.

Debate within the academy over the politics of the canon is not new. Nor is it unusual for 'fan' cultures to make themselves heard within the academy (most film scholars, one would assume, study the cinema because they were fans first). What is unusual in paracinematic culture's gradual infiltration of the academy is the manner in which this group so explicitly foregrounds the cultural politics of taste and aesthetics, not just in society at large, but within the academy itself. Graduate students with an interest in 'trash' cinema often find themselves in the ironic position of challenging the legitimacy of the very institution they are attending in order to obtain cultural validation and authority over issues of politics and taste. Such students are struggling to make the transition from a mere fan to an accredited scholar. Though both fan and scholar may be equally dedicated (and even knowledgeable) in their involvement with a particular cultural form, they differ tremendously in terms of their respective status within society as a whole. In a hierarchical social system marked by the differential circulation of cultural and economic capital, graduate students seeking to make this crucial transition of accreditation must submit themselves, quite literally, to the *discipline* of film studies in both its institutional and punitive forms. In doing so, the discipline works to shape both knowledge and taste, linking them in a process that is every bit as political in the academy as it is in the culture the academy seeks to study. As Bourdieu notes, 'At stake in every struggle over art there is also the imposition of an art of living, that is, the transmutation of an arbitrary way of living into the legitimate way of life which casts every other way of living into arbitrariness'.[21] In this way, the legitimizing function of the academy in issues of knowledge, taste and aesthetics works to conceal relations of power and control, both within the institution itself and the society that sanctions that institution's cultural authority.

By challenging this disciplinary authority, the paracinematic audience, both academic and non-academic, epitomizes what Bourdieu terms the 'new style autodidact'. As described by Bourdieu, the autodidact is a figure alienated from the legitimate mode of educational and cultural acquisition. Estranged or excluded from legitimate modes of acquisition, autodidacts invest in alternative forms of cultural capital, those not fully recognized by the educational system and the cultural elite. Bourdieu describes two backgrounds typical of this new style autodidact:

> 'middle-ground' arts such as cinema, jazz, and, even more, strip cartoons, science-fiction or detective stories are predisposed to attract the investments either of those who have entirely succeeded in converting their cultural capital into educational capital or those who, not having acquired legitimate culture in the legitimate manner (i.e., through early familiarization), maintain an uneasy relationship with it, subjectively or objectively, or both. These arts, not yet fully legitimate, which are disdained or neglected by the big holders of educational capital, offer a refuge or a revenge to those who, by appropriating them, secure the best return on their cultural capital (especially if it is not fully recognized scholastically) while at the same time taking credit for contesting the established hierarchy of legitimacies and profits.[22]

The autodidact is a person who invests in unsanctioned culture either because he or she can 'afford' to, having already made a successful conversion of legitimate cultural

---

[21]Bourdieu, *Distinction*, pp. 57–8.
[22]Ibid., p. 87.

and educational capital into economic capital, or who feel, because of their tentative and at times alienated relationship with 'legitimate culture', that such disreputable investments are more durable and potentially more 'rewarding'.

It should not be surprising, then, that paracinematic fans, as exiles from the legitimizing functions of the academy, and many graduate students, as the most disempowered faction within the academy itself, both look to trash culture as a site of 'refuge and revenge'. Such autodidacticism constitutes, for Bourdieu, a form of 'counterculture', one working to free itself from 'the constraints of the scholastic market'. 'They strive to do so by producing another market with its own consecrating agencies', writes Bourdieu, 'capable of challenging the pretension of the educational system to impose the principles of evaluation of competencies and manners which reign in the scholastic market.'[23] For its audience, paracinema represents a final textual frontier that exists beyond the colonizing powers of the academy, and thus serves as a staging ground for strategic raids on legitimate culture and its institutions by those (temporarily) lower in educational, cultural and/or economic capital. Such a struggle demonstrates that battles over the canon, in any discipline, are as much conflicts over the processes and politics by which an entire academic field validates its very existence and charts its own future, fought by groups within the academy as stratified in their institutional power as society at large is stratified in terms of cultural and economic power.

On one hand, it would be easy to explain the turn towards trash cinema as yet another example of the generational politics of the canon in the academy, a struggle that legitimated cinema in the face of literature, Hollywood in the face of art cinema and, most recently, television in the face of Hollywood. But there is more here than a struggle over the canon and the politics of object choice. The study of trash cinema suggests a struggle over the task of cinema scholarship as a whole, especially in terms of defining the relationship between aesthetics and cultural criticism. Whether attacking traditional cultural markets and intellectual institutions as a fan, or attempting to bridge the two worlds as a student, the paracinematic audience presents in its often explicit opposition to the agendas of the academy a dispute over *how* to approach the cinema as much as a conflict over *what* cinema to approach. At issue is not only which films get to be studied, but which questions are to be asked about the cinema in the first place. What I am interested in exploring in the remainder of this essay is the relationship between paracinematic culture and the aesthete culture this group associates with the academy, as well as the place of the contemporary graduate film student in bridging these two often antagonistic sensibilities. How are these groups similar, how do they differ and, perhaps most importantly, how might the trash aesthetic ultimately impact the academy? I am particularly interested in how the two communities approach issues of cinematic 'style' and 'excess'. I will argue that paracinema hinges on an aesthetic of excess, and that this paracinematic interest in excess represents an explicitly political challenge to reigning aesthete discourses in the academy. The cultural politics involved in this struggle, however, can be clarified by first examining similarities between aesthete and paracinematic discourses on cinema.

---

[23]Ibid., p. 96.

## COUNTER-CINEMAS

Throughout the history of cinema studies as a discipline, the cultivation of various counter-cinemas, exclusive cinematic canons that do not easily admit the textual pleasures of more 'commonplace' audiences, has been a crucial strategy in maintaining a sense of cultural distinction for film scholars. Frequently, the promotion of such counter-cinemas has been organized around what has become a dominant theme in academic film culture: namely, the sense of loss over the medium's unrealized artistic and political potential. From this perspective, the cinema once held the promise of a revolutionary popular art form when, as Annette Michelson writes, 'a certain euphoria enveloped . . . early filmmaking and theory'. '[T]here was', she continues, 'a very real sense in which the revolutionary aspirations of the modernist movement in literature and arts, on the one hand, and of a Marxist or Utopian tradition, on the other hand, could converge in the hopes and promises, as yet undefined, of the new medium'.[24] Instead, these hopes were dashed by the domination of the public taste and mind by Hollywood cinema. And while there has never been a shortage of critical interest in the classical Hollywood cinema, championing counter-cinemas that break with the conventions of Hollywood production and representation remains a central project of film aesthetes and academics. This critical programme proceeds both artistically, by valorizing a body of 'art' films over the mainstream, commercial cinema, and politically, by celebrating those filmmakers who seem to disrupt the conventional narrative machinery of Hollywood.[25]

In cultivating a counter-cinema from the dregs of exploitation films, paracinematic fans, like the academy, explicitly situate themselves in opposition to Hollywood cinema and the mainstream US culture it represents. United with the film elite in their dislike of Hollywood banality and yet frequently excluded from the circles of academic film culture, the paracinematic community nonetheless often adopts the conventions of 'legitimate' cinematic discourse in discussing its own cinema. As Fiske notes, fan groups are often 'aware that their object of fandom [is] devalued by the criteria of official culture and [go] to great pains to argue against this misevaluation. They frequently [use] official cultural criteria such as 'complexity' or 'subtlety' to argue that their preferred texts [are] as 'good' as the canonized ones and constantly [evoke] legitimate culture . . . as points of comparison.'[26] Elite discourse often appears either earnestly or parodically in discussions of paracinematic films. A fanzine review of the obscure 1964 film, *The Dungeons of Harrow,* is typical. The fanzine describes the film as 'a twisted surreal marvel, a triumph of spirit and vision over technical incompetence and abysmal production values. The film can be seen as a form of art brut—crude, naive, pathetic—but lacking the poetry and humor often associated with this style. Perhaps art brutarian would better serve to describe this almost indescribable work.[27]

---

[24]Annette Michelson, 'Film and the radical aspiration', in Gerald Mast and Marshall Cohen (eds), *Film Theory and Criticism* (New York: Oxford University Press, 1974), p. 472.

[25]For an influential account of such an agenda, see Peter Wollen's 'Godard and counter-cinema: *Vent d'Est,*' in Philip Rosen (ed.), *Narrative, Apparatus, Ideology* (New York: Columbia University Press, 1986), pp. 120–29 [this edition, pp. 525–33].

[26]Fiske, 'The cultural economy of fandom', p. 36.

[27]*Subhuman,* no. 16, p. 3.

As in the academic film community, the paracinematic audience recognizes Hollywood as an economic and artistic institution that represents not just a body of films, but a particular mode of film production and its accompanying signifying practices. Furthermore, the narrative form produced by this institution is seen as somehow 'manipulative' and 'repressive', and linked to dominant interests as a form of cultural coercion. In their introduction to *Incredibly Strange Films,* V. Vale and Andrea Juno, two of the most visible cultural brokers in the realm of paracinema, describe why low-budget films helmed by idiosyncratic visionaries are so often superior to mainstream, Hollywood cinema.

> The value of low-budget films is: they can be transcendent expressions of a single person's individual vision and quirky originality. When a corporation decides to invest $20 million in a film, a chain of command regulates each step, and no one person is allowed free rein. Meetings with lawyers, accountants, and corporate boards are what films in Hollywood are all about. . . . Often [low-budget] films are eccentric—even extreme—presentations by individuals freely expressing their imaginations, who throughout the filmmaking process improvise creative solutions to problems posed by either circumstance or budget—mostly the latter. Secondly, they often present unpopular—even radical—views addressing social, political, racial or sexual inequities, hypocrisy in religion or government; or, in other ways they assault taboos related to the presentation of sexuality, violence, and other mores.[28]

Such rhetoric could just as easily be at home in an elite discussion of the French New Wave or the American New Cinema. Products of a shared taste culture, paracinematic cinephiles, like the scholars and critics of the academy, continue to search for unrecognized talent and long forgotten masterpieces, producing a pantheon that celebrates a certain stylistic unity and/or validates the diverse artistic visions of unheralded 'auteurs'.

*Zontar,* for example, devotes almost all of its attention to the work of Larry Buchanan, who is celebrated as 'the greatest director of all time' and as a maker of films that must be regarded as 'absolute and unquestionable holy writ'.[29] Elsewhere, *Zontar* hails Buchanan as 'a prophet of transcendental banality . . . who eclipses Bergman in evoking a sense of alienation, despair and existential angst'.[30] As this rather tongue-in-cheek hyperbole suggests, paracinematic culture, like that of the academy, continues to generate its own forms of internal distinction by continually redefining its vanguard, thereby thwarting unsophisticated dilettantes and moving its audience as a whole on to increasingly demanding and exclusive paracinematic films. In its contemporary and most sophisticated form, paracinema is an aggressive, esoteric and often painfully ascetic counter-aesthetic, one that produces, in its most extreme manifestations, an ironic form of reverse elitism. 'The fine art of great bad-film is not a laughing matter to everybody', says one fan. 'Its adherents are small in number, but fanatical in pickiness. Badness appreciation is the most acquired taste, the most refined.'[31]

---

[28]V. Vale. Andrea Juno and Jim Morton (eds), *Incredibly Strange Films* (San Francisco: RE/search Publications, 1986), p. 5.

[29]*Zontar,* no. 8, n.p.

[30]Ibid.

[31]Ibid.

Invoking Larry Buchanan, the mastermind of films like *Mars Needs Women* (1966) and *Zontar the Thing from Venus* (1966), as a greater director than Ingmar Bergman, however, reaffirms that the paracinematic community defines itself in opposition not only to mainstream Hollywood cinema, but to the (perceived) counter-cinema of aesthetes and the cinematic academy. Again, as with any taste public, this elite cadre of 'aesthetes' cannot be definitively located in a particular author, methodology, or school of academic/journalistic criticism. Paracinematic vitriol also often ignores the fact that low-budget exploitation films have increasingly become legitimized as a field of study within the academy.[32] For purposes of distinction, however, all that is required is a nebulous body of those who do not actively advance a paracinematic aesthetic. As Vale and Juno state broadly in their introduction to *Incredibly Strange Films:*

> This is a functional guide to territory largely neglected by the film-criticism establishment. . . . Most of the films discussed test the limits of contemporary (middle-class) cultural acceptability, mainly because in varying ways they don't meet certain 'standards' utilized in evaluating direction, acting, dialogue, sets, continuity, technical cinematography, etc. Many of the films are overtly 'lower-class' or 'low-brow' in content and art direction.[33]

Vale and Juno go on to celebrate this cinema for its vitality and then identify what is at stake in this battle over the status of these films within the critical community. In a passage reminiscent of Bangs and Bourdieu, they state, 'At issue is the notion of 'good taste', which functions as a filter to block out entire areas of experience judged—and damned—as unworthy of investigation'.[34]

## STYLE AND EXCESS

Graduate students entering the academy with an interest in trash cinema often wish to question why these 'areas of experience' have been 'judged and damned' by earlier scholars. But though they may attempt to disguise or renounce their cultural pedigree by aggrandizing such scandalous cultural artefacts, their heritage in a 'higher' taste public necessarily informs their textual and critical engagement of even the most abject 'low culture' forms. Gripsrud argues that 'egalitarian' attempts on the part of the culturally privileged to collapse differences between 'high' and 'low' culture, as noble as they might be, often ignore issues of 'access' to these two cultural realms. As Gripsrud writes, 'Some people have access to both high and low culture, but the majority has only access to the low one'.[35] Gripsrud describes high culture audiences that also consume popular cultural artefacts as having 'double access', and notes that this ability to participate in both cultural realms is not randomly distributed through society. As Gripsrud observes, 'The double access to the codes and practices of both high and low culture is a *class privilege*'.[36]

---

[32]For examples of work on exploitation cinema produced within an academic context, see Thomas Doherty. *Teenagers and Teenpics: The Juvenilization of American Movies in the 1950s* (Boston: Unwin Hyman, 1988); and Eric Schaefer, '"Bold! Daring! Shocking! True!": a history of exploitation films, 1919–1959' (Dissertation: University of Texas at Austin, 1994).

[33]Vale, Juno and Morton (eds), *Incredibly Strange Films,* p. 4.

[34]Ibid.

[35]Gripsrud, 'High culture revisited', p. 199.

[36]Ibid.

The phenomenon of double access raises a number of interesting political issues concerning the trash aesthetic. For example, when Vale and Juno write that these films address 'unpopular—even radical—views' and 'assault taboos related to the presentation of sexuality [and] violence', this does not mean that paracinema is a uniformly 'progressive' body of cinema. In fact, in subgenres ranging from the often rabidly xenophobic travelogues of the 'mondo' documentaries to the library of 1950s sex-loop star Betty Page, many paracinematic texts would run foul of academic film culture's political orthodoxy. But, of course, this is precisely why such films are so vociferously championed by certain segments of the paracinematic audience, which then attempts to 'redeem' the often suspect pleasures of these films through appeals to ironic detachment. Double access, then, foregrounds one of the central riddles of postmodern textuality: is the 'ironic' reading of a 'reactionary' text necessarily a 'progressive' act?[37]

As pivotal as double access is in considering conventional debates over representational politics, the influence of high cultural capital is equally foregrounded in how the academy, the paracinematic audience, and the students who claim membership in both realms attend to the question of cinematic style. Of course, the ability to attend critically to a concept such as style, whether it manifests itself in Eisenstein or a Godzilla movie, is a class privilege, requiring a certain textual sophistication in issues of technique, form and structure. Though paracinematic viewers may explicitly reject the pretensions of high-brow cinema, their often sophisticated rhetoric on the issue of style can transform low-brow cinema into an object every bit as obtuse and inaccessible to the mainstream viewer as some of the most demanding works of the conventional avant garde. Both within the academy and the paracinematic community, viewers address the complex relationship between cinematic 'form' and 'content', often addressing style for style's sake. This is not to say, however, that the paracinematic community simply approaches trash cinema in the same terms that aesthetes and academics engage art cinema. There is, I would argue, a major political distinction between aesthete and paracinematic discourses on cinematic style, a distinction that is crucial to the paracinematic project of championing a counter-cinema of trash over that of the academy. In other words, though the paracinematic community may share with academic aesthetes an interest in counter-cinema as technical execution, their respective agendas and approaches in attending to questions of style and technique vary tremendously.

For example, film aesthetes, both in the academy and in the popular press, frequently discuss counter-cinematic style as a strategic intervention. In this scenario, the film artist self-consciously employs stylistic innovations to differentiate his or her (usually his) films from the cultural mainstream. James Monaco's discussion of the French New Wave is typical in this regard. 'It is this fascination with the forms and structures of the film medium . . . that sets their films apart from those that preceded them and marks a turning point in film history'.[38] Similarly, according to David Bord-

---

[37]Such debates, in turn, should not instantly assume that there only exists an impoverished, 'single access' reading of these films within 'low culture', suggesting formations that are without irony. It is difficult to imagine, for example, that an audience of any historical moment or cinematic habitus ever watched Russ Meyer's odes to castration anxiety and breast fetishism with a 'straight' face.

[38]James Monaco, *The New Wave* (New York: Oxford University Press, 1976), p. 9.

well's concept of parametric narration, a filmmaker may systematically manipulate a certain stylistic parameter independent of the demands of the plot. Such films are rare and are typically produced by figures associated with 'art cinema' (Bordwell identifies Ozu, Bresson and Godard as among those having produced parametric films). The emphasis here is on applied manipulation of style as a form of systematic artistic experimentation and technical virtuosity. 'In parametric narration, style is organized across the film according to distinct principles, just as a narrative poem exhibits prosodic patterning or an operatic scene fulfills a musical logic.[39]

Paracinematic films such as *The Corpse Grinders* (Ted V. Mikels, 1972) and *She Devils on Wheels* (Herschell Gordon Lewis, 1968) rarely exhibit such pronounced stylistic virtuosity as the result of a 'conscious' artistic agenda. But this is not to say that issues of style and authorship are unimportant to the paracinematic community. However, rather than explore the systematic application of style as the elite techniques of a cinematic artist, paracinematic culture celebrates the systematic 'failure' or 'distortion' of conventional cinematic style by 'auteurs' who are valued more as 'eccentrics' than as artists, who work within the impoverished and clandestine production conditions typical of exploitation cinema. These films deviate from Hollywood classicism not necessarily by artistic intentionality, but by the effects of material poverty and technical ineptitude. As director Frank Henenlotter (of the *Basket Case* series) comments, 'Often, through bad direction, misdirection, inept direction, a film starts assuming surrealistic overtones, taking a dreadfully cliched story into new frontiers—you're sitting there shaking your head, totally excited, totally unable to guess where this is going to head next, or what the next loony line out of somebody's mouth is going to be. Just as long as it isn't stuff you regularly see.'[40] Importantly, paracinematic films are not ridiculed for this deviation but are instead celebrated as unique, courageous and ultimately subversive cinematic experiences. For this audience, paracinema thus constitutes a true counter-cinema in as much as 'it isn't stuff you regularly see', both in terms of form and content. Henenlotter continues, 'I'll never be satisfied until I see every sleazy film ever made—as long as it's different, as long as it's breaking a taboo (whether deliberately or by misdirection). There's a thousand reasons to like these films.'[41]

While the academy prizes conscious transgression of conventions by a filmmaker looking to critique the medium aesthetically and/or politically, paracinematic viewers value a stylistic and thematic deviance born, more often than not, from the systematic failure of a film aspiring to *obey* dominant codes of cinematic representation. For this audience, the 'bad' is as aesthetically defamiliarizing and politically invigorating as the 'brilliant'. A manifesto on acting from *Zontar* further illustrates the aesthetic appeal of such stylistic deviation among this audience:

Transparent play-acting; mumbling incompetence; passionate scenery-chewing; frigid woodenness; barely disguised drunkenness or contempt for the script;—these are the secrets of Zontarian acting at its best. Rondo Hatton's exploited acromegalic condition;

---

[39]David Bordwell, *Narration in the Fiction Film* (Madison: University of Wisconsin Press, 1985). p. 275.
[40]Vale, Juno and Morton (eds.). *Incredibly Strange Films*. p. 11.
[41]Ibid.

Acquanetta's immobile dialogue readings; the drunken John Agar frozen to his chair in *Curse of the Swamp Creature;*—these great performances loom massively as the ultimate classics of ZONTARISM. These are not so much performances as revelations of Human truth. We are not 'entertained,' we rather sympathize with our suffering soul-mates on screen. These performances are not escapist fantasy, but a heavy injection of BADTRUTH.[42]

The Zontarian moment of the 'badtruth' is not unlike the Surrealist notion of the 'marvellous' (and indeed, the Surrealists were perhaps the first cinephiles with an interest in bad cinema).[43] As with the marvellous, the badtruth, as a nodal point of paracinematic style, provides a defamiliarized view of the world by merging the transcendentally weird and the catastrophically awful. Thus, rather than witness the Surrealists' vision of the exquisite chance meetings of umbrellas and sewing machines on a dissecting table, the paracinematic viewer thrills instead to such equally fantastic fabrications as women forced to duel in a syringe fight in the basement of a schizophrenic vaudevillian who has only moments earlier eaten his cat's left eyeball (*Maniac!* [Dwain Esper, 1934]), Colonial era witches and warlocks crushed to death by men in Levis corduroys who hurl bouncing Styrofoam boulders (*Blood-Orgy of the She-Devils* [Ted V. Mikels, 1973]), a down and out Bela Lugosi training a mutant bat to attack people wearing a certain type of shaving lotion (*The Devil Bat* [Jean Yarborough, 1941]), and leaping, pulsating brains that use their prehensile spinal cords to strangle unwary soldiers and citizens on a Canadian rocket base (*Fiend Without a Face* [Arthur Crabtree, 1958]).

Paracinematic taste involves a reading strategy that renders the bad into the sublime, the deviant into the defamiliarized, and in so doing, calls attention to the aesthetic aberrance and stylistic variety evident but routinely dismissed in the many subgenres of trash cinema. By concentrating on a film's formal bizarreness and stylistic eccentricity, the paracinematic audience, much like the viewer attuned to the innovations of Godard or capable of attending to the patterns of parametric narration described by Bordwell, foregrounds structures of cinematic discourse and artifice so that the material identity of the film ceases to be a structure made invisible in service of the diegesis, but becomes instead the primary focus of textual attention. It is in this respect that the paracinematic aesthetic is closely linked to the concept of 'excess'.

Kristin Thompson describes excess as a value that exists beyond a cinematic signifier's 'motivated' use, or, as 'those aspects of the work which are not contained by its unifying forces.'[44] 'At the point where motivation ends', Thompson writes, 'excess begins'.[45] '[T]he minute the viewer begins to notice style for its own sake or watch works which do not provide such thorough motivation, excess comes forward and must affect narrative meaning. . . . Excess does not equal style, but the two are closely linked because they both involve the material aspects of the film.'[46] Thomp-

[42]*Zontar,* no. 8, n.p.
[43]For an example of this literature, see Ado Kyrou. 'The popular is marvelous', in Paul Hammond (ed.), *The Shadow and Its Shadow* (London: British Film Institute, 1978).
[44]Kristin Thompson, 'The concept of cinematic excess', in Rosen (ed.), *Narrative, Apparatus, Ideology,* p. 130.
[45]Thompson, 'The concept of cinematic excess', p. 135.
[46]Ibid., p. 132.

son writes of excess as an intermittent textual phenomenon, a brief moment of self-conscious materiality that interrupts an otherwise conventional, 'non-excessive' film: 'Probably no one ever watches only these non-diegetic aspects of the image through an entire film.' But, Thompson writes further, these non-diegetic aspects are nevertheless always present, 'a whole "film" existing in some sense alongside the narrative film we tend to think of ourselves as watching'.[47]

I would argue that the paracinematic audience is perhaps the one group of viewers that *does* concentrate exclusively on these 'non-diegetic aspects of the image' during the entire film, or at least attempts to do so. Like their counterparts in the academy, trash cinema fans, as active cinephiles practising an aesthetic founded on the recognition and subsequent rejection of Hollywood style, are extremely conscious of the cinema's characteristic narrative forms and stylistic strategies. But, importantly, while cinematic aesthetes attend to style and excess as moments of artistic bravado in relation to the creation of an overall diegesis, paracinematic viewers instead use excess as a gateway to exploring profilmic and extratextual aspects of the filmic object itself. In other words, by concentrating so intently on 'non-diegetic' elements in these films, be they unconvincing special effects, blatant anachronisms, or histrionic acting, the paracinematic reading attempts to activate the 'whole 'film' existing . . . alongside the narrative film we tend to think of ourselves as watching'. One could say that while academic attention to excess often foregrounds aesthetic strategies within the text as a closed formal system, paracinematic attention to excess, an excess that often manifests itself in a film's failure to conform to historically delimited codes of verisimilitude, calls attention to the text as a cultural and sociological document and thus dissolves the boundaries of the diegesis into profilmic and extratextual realms. It is here that the paracinematic audience most dramatically parts company with the aesthetes of academia. Whereas aesthete interest in style and excess always returns the viewer to the frame, paracinematic attention to excess seeks to push the viewer beyond the formal boundaries of the text.

## PARACINEMATIC EXCESS: ED WOOD, JR AND LARRY BUCHANAN

Ed Wood, Jr's status has long been high in the paracinematic community. Wood was an independent filmmaker in Hollywood during the 1950s, known primarily for his work with Bela Lugosi. His films are remarkably incompetent from a conventional perspective. Wood's dialogue was often awful, his actors alternately wooden and histrionic, and his sets pathetic and threadbare. Throughout his long career as a filmmaker, Wood was unable (or unwilling) to master the basics of continuity, screen direction or the construction of cinematic space. His *Plan 9 From Outer Space* is perhaps the most famous 'badfilm' of all, having become badfilm's equivalent of *Citizen Kane* as an inventory of characteristically paracinematic stylistic devices. Though Wood's films were initially read as camp, the critical discourse within paracinematic literature surrounding Wood has since shifted from bemused derision to active celebration. No longer regarded as a hack, Wood is now seen, like Godard, as a unique

---

[47]Ibid., pp. 132–3.

talent improvising outside the constrictive environment of traditional Hollywood production and representation. As one fanzine comments, 'Wood's films are now appreciated less as models of incompetence, and more as the products of a uniquely personal and obsessive sensibility that best expresses itself through madly deconstructed narratives enacted by a gallery of grotesque castoffs from the fringes of Hollywood bohemia'.[48] This is certainly the perspective that dominates Tim Burton's cinematic treatment of Wood's career, *Ed Wood* (1994).

Wood's most notorious film and the movie that is central to his status as a paracinematic filmmaker is *Glen or Glenda*. As detailed extensively in Burton's biopic, Wood shot *Glen or Glenda* in 1953 to capitalize on the public hysteria surrounding the Christine Jorgenson sex-change operation. Also released under the titles *I Led Two Lives* and *I Changed My Sex,* the film purports to be an investigative examination of the sex-change issue. Instead, the film is an odd plea for public tolerance of transvestitism. The film's protagonist is a young man named Glen, a transvestite struggling with the decision of whether or not to tell his fiancee of his secret before their marriage. From this central conflict, Wood fashions a vertiginous film that in a bizarre and at times hallucinatory manner argues the virtues of transvestitism, giddily shifting from documentary to horror film, from police drama to sexploitation picture. In the midst of this generic turmoil, Bela Lugosi appears from time to time as a metanarrational figure who punctuates the diegetic action with incomprehensible comments and bizarre non sequiturs.

A casebook example of stylistic deviation as the result of the unique conditions of production in exploitation cinema, *Glen or Glenda* is of particular interest for paracinematic viewers because of the extratextual identity of Ed Wood, Jr: Wood was himself a transvestite. He not only wrote and directed *Glen or Glenda,* but also starred as the troubled young transvestite, Glen. Fan legends (based on interviews with surviving crew members) have it that Wood directed most of the film while wearing his favourite chiffon housecoat and that he had an obsession with cashmere sweaters (a fetish dramatically enacted in the film's final scene). After his movie career ended in the 1960s, Wood went on to write a number of adult novels with transvestite storylines.[49]

This extratextual information about Wood is key to the paracinematic positioning of his films as a form of counter-cinema. Knowing this information allows the paracinematic fan to more fully appreciate the complexity of the cultural codes at work in a film like *Glen or Glenda*. John Fiske argues that the cultural elite 'use information about the artist to enhance or enrich the appreciation of the work'. Within fan culture, on the other hand, 'such knowledge increases the power of the fan to "see through" to the production processes normally hidden by the text and thus inaccessible to the non-fan.[50] In the case of Ed Wood, Jr, the paracinematic aesthetic combines an elite interest in 'enriched appreciation' with a popular interest in seeing through 'production processes.' Paracinematic fans use their knowledge of Wood's real life to

---

[48]*Zontar,* no. 8, n.p.

[49]For a more complete biography of Wood, see Rudolph Grey. *Nightmare of Ecstasy: The Life and Art of Edward D. Wood, Jr* (Los Angeles: Feral House, 1992).

[50]Fiske. 'The cultural economy of fandom', p. 24.

'enhance or enrich' their engagement in his films, much as elites use their knowledge of Godard's various positions in relation to Marxism to inform their viewings. Vital to paracinematic pleasure, however, is this process of 'seeing through' the diegesis. For a sophisticated paracinematic viewer, *Glen or Glenda* is compelling because it seemingly presents both the textual and extratextual struggles of a man set against the repressive constraints of 1950s sexuality, encoded in a style that also challenges the period's conventions of representation. Paracinematic fans appreciate films such as *Glen or Glenda* not only as bizarre works of art, but as intriguing cultural documents, as socially and historically specific instances of artifice and commentary. Set against the bland cultural miasma of the Eisenhower years, Wood and his film stand out as truly remarkable figures.

This interest in collapsing the textual and the extratextual, the filmic and the pro-filmic, is especially pronounced in Zontarian interest in Larry Buchanan, a Dallas film-maker who made a number of AIP films for television in the mid sixties. Buchanan's films rank among the most low-budget productions ever attempted in commercial filmmaking. Often following scripts from old black and white features, these films were reshot in colour for the television market in two or three days for often less than a few thousand dollars. The finished products are a test of even the most dedicated paracinematic viewer's patience. With no money or time to reshoot, mistakes in dia-logue, camera movement and sound recording remain in each film. The films are unwatchable for most mainstream viewers, and consequently have assumed an exalted status among the 'hardcore' badfilm faction of paracinematic culture.

As with the other visionary stylists in paracinema's shadow realm of autuerism, Buchanan is valorized for his unique artistic vision. *Zontar* positions Buchanan as a poor man's Carl Dreyer, celebrating his particularly bleak and sombre approach. Importantly, however, this bleak and sombre tone is as much a function of the condi-tions of production as the product of Buchanan's 'genius'. A common strategy when discussing Buchanan is to transform his films into profilmic parables of artistic tragedy. Differentiating Buchanan from the more accessible Ed Wood, Jr, for exam-ple, *Zontar*'s editors write, 'where Ed Wood's films ultimately reassure the comfort-ably "hip" viewer of the dynamic force of even the most downtrodden and despised corners of human experience, the films of Larry Buchanan can only induce a pro-found feeling of desperation, anxiety and terminal boredom. The texture is not that of a tatty side-show, but that of the endless despair and futility of human existence as reflected on the concrete pavement of a Dallas parking lot.'[51] The Zontarian transfor-mation of Buchanan's work thus shifts the diegetic frame so that the action on the screen becomes but the trace of an isolated moment of desperate human activity, a farcical attempt at 'art' taking place on a particular day many years ago in someone's garage, on a Dallas parking lot.

A contributor to *Zontar* describes this moment of profilmic nausea as personally experienced in the climatic revelation of the monster in the concluding scenes of Buchanan's *Curse of the Swamp Creature:*

> Seldom, if ever, has a more disappointing final monster revelation scene been filmed. . . . The monster is unbelievably, spectacularly cheap. . . . 'It' appears dressed in

---

[51]*Zontar,* no. 8, n.p.

a white hospital smock, with rubber monster-gloves and a minimal mask-piece consisting of two painted PING-PONG BALL EYES set into a rubber bow. A skin-head wig and a couple of cruddy fangs complete the 'monster suit' . . . which is more embarrassing than scary . . . the CREATURE itself must be the least convincing creation in monster movie history. This is, of course, a subjective area, but I would rate it far worse than the ROBOT MONSTER and at least as bad as the CREEPING TERROR . . . though of a different order, naturally. THE MASTER DIRECTOR actually compounds the failure of his creature by withholding it for so long. By building to his epic anti-climax Buchanan makes the SWAMP CREATURE itself the essence of disappointment and failure . . . translated into cheap rubber and ping-pong ball eyes. The SWAMP CREATURE'S scaly rubber fright-mask is composed of the very substance of despair.[52]

The swamp creature, intended to be a startling and menacing cinematic revelation, is, in the last analysis, simply an overweight actor standing in weeds with ping-pong balls attached to his eyes on a hot day in Dallas in 1966. For the paracinematic community, such moments of impoverished excess are a means toward collapsing cinema's fourth wall, allowing the profilmic and the extratextual to mesh with the diegetic drama. The 'surface' diegesis becomes precisely that, the thin and final veil that is the indexical mark of a more interesting drama, that of the film's construction and sociohistorical context.

## THE POLITICS OF EXCESS

Thompson argues that the importance of excess is that it renews 'the perceptual freshness of the work' and 'suggests a different way of watching and listening to a film'.

> The viewer is no longer caught in the bind of mistaking the causal structure of the narrative for some sort of inevitable, true, or natural set of events which is beyond questioning or criticism. . . . Once narrative is recognized as arbitrary rather than logical, the viewer is free to ask why individual events within its structures are as they are. The viewer is no longer constrained by conventions of reading to find a meaning or theme within the work as the solution to a sort of puzzle which has a right answer.[53]

Excess provides a freedom from constraint, an opportunity to approach a film with a fresh and slightly defamiliarized perspective. As Thompson argues, through excess 'the work becomes a perceptual field of structures which the viewer is free to study at length, going beyond the strictly functional aspects.'[54] What the critical viewer does with this newfound freedom provided by the phenomenon of excess is, I would argue, a political question, and one that lies at the heart of the conflict between the counter-cinema of the academy and that promoted by paracinematic culture. The very concept of excess, after all, as a relativistic term that posits a self-evident 'norm', is an inherently political evaluation. Exploring these politics of excess presents a key area where students who possess a trash aesthetic may impact the academic institutions to which they belong by questioning the goals, strategies and techniques of academically enshrined versions of 'art' cinema and the 'avant garde'.

Specifically, the trash aesthetic offers a potential critique of two highly influential methodologies in film studies: neoformalist analysis and theories of 'radical' textual-

---

[52]Ibid.
[53]Thompson, 'The concept of cinematic excess', pp. 140–1.
[54]Ibid., p. 141.

ity. Paracinema suggests that the neoformalist emphasis on art as defamiliarization might be more complicated than the cataloguing of innovative, text-bound 'devices'. If the paracinematic community celebrates a film, either earnestly or parodically, as an invigorating artistic experience precisely because of its utter banality, does that constitute a form of defamiliarization? For whom and under what circumstances is any film defamiliarizing? Since any notion of aesthetics is inextricably linked to historical issues of representation and reception, what are the politics of a neoformalist analysis that ultimately constructs a hierarchy of 'skilled' and 'unskilled' audiences, artistic and non-artistic films? (Do we really want to claim that *Last Year at Marienbad* is somehow more 'artistic' than *Sweet Badass's Badass Song* or even *E.T.?* What exactly is the purpose of such aesthetic valuations other than to empower a certain critic or a certain cinema?) If nothing else, the trash aesthetic serves as a reminder that all forms of poetics and aesthetic criticism are ultimately linked to issues of taste; and taste, in turn, is a social construct with profoundly political implications.

Paracinema also offers a critique of the 'radical' aesthetic that seeks to liberate, or at least politically agitate, audiences through the application of disruptive textual devices, a project that coalesced in theoretical and critical writings in film studies during the 1970s and which continues to inform much work on avant-garde textuality. In many respects, paracinematic discourses on excess greatly resemble the symptomatic criticism so central to film studies during this formative period. As with the devotees of Sirk, Minnelli and Lewis, paracinematic viewers are interested in reading films 'against the grain', ever on the alert for the trash film equivalents of Comolli and Narboni's celebrated 'category e' films.[55] And, as in the counter-cinemas explicitly designed by Godard or covertly implanted by Sirk, paracinema's retrospective reconstruction of an avant garde through the ironic engagement of exploitation cinema's history is a 'politicized' cinema to the extent that it demonstrates the limitations and interests of dominant cinematic style by providing a striking counter-example of deviation.[56]

But while segments of academic film culture often appeal to a refined code of aesthetics to apprehend and explain the potentially disruptive forces of style and excess (an aesthetics most often intentionally applied by an 'artist' to be successfully decoded by an elite cinephile in a rarefied and exclusive circuit of textual exchange), paracinematic culture celebrates excess as a product of cultural as well as aesthetic deviance. Once excess cues the elite viewer to the arbitrary structure of a narrative, he or she can then study the 'perceptual field of structures' in the work itself in appreciation of artistic craftsmanship within a closed formal system. The paracinematic viewer's recognition of a narrative's artifice, however, is the first step in examining a

---

[55]See Jean-Luc Comolli and Jean Narboni. 'Cinema/ideology/criticism, Part I', *Screen,* vol. 12. no. 1 (1971), pp. 27–36 [see this edition, pp. 812–19.]

[56]In Wollen's account of Godard's significance as a radical filmmaker, he identifies 'seven cardinal virtues' of Godard's aesthetic that oppose the 'seven deadly sins' of orthodox cinema. Godard's counter-cinema is thus argued to feature 'narrative intransitivity' rather than 'narrative transitivity'—'estrangement vs identification, foregrounding vs transparency, multiple diegesis vs single diegesis, aperture vs closure, un-pleasure vs pleasure, and reality vs fiction'. One cannot help but be struck by how certain paracinematic titles, especially genre hybrids like *Glen or Glenda,* match Wollen's criteria point by point. For a more complete account of these distinctions, see Wollen, 'Godard and counter-cinema: *Vent d'Est*'.

field of structures within the culture as a whole, a passageway into engaging a larger field of contextual issues surrounding the film as a socially and historically specific document. As a consequence, paracinema might be said to succeed where earlier more 'radical' avant gardes have failed. It is doubtful that *Tout Va Bien* (Jean-Luc Godard/Jean-Pierre Gorin, 1973), or *Written on the Wind* (Douglas Sirk, 1956) for that matter, ever 'radicalized' anyone other than fellow academy aesthetes. Perhaps paracinema has the potential, at long last, to answer Brecht's famous call for an anti-illusionist aesthetic by presenting a cinema so histrionic, anachronistic and excessive that it compels even the most casual viewer to engage it ironically, producing a relatively detached textual space in which to consider, if only superficially, the cultural, historical and aesthetic politics that shape cinematic representation. In this respect, one might argue that while academy icons such as Godard and Sirk may have employed complex aesthetic strategies to problematize issues such as the construction of gender, Ed Wood Jr, by his own admission, actually fought in the Pacific during World War II with a pink bra and knickers worn underneath his combat fatigues. As to which form of political engagement and subsequent critical promotion by the academy will prove more provocative and productive, it is open for debate.

1995

# V

# The Film Artist

The infant American film business grew into a multi-million-dollar industry in the first decade of the twentieth century. By the mid-1910s, in the years during and just after the First World War, that industry organized itself according to what came to be called the Hollywood studio system (although, in fact, the final power of the system resided not in the Hollywood studios where the films were made but in the New York business offices where they were financed and distributed). Consolidated at the same time as Henry Ford's automobile assembly plant, the Hollywood studio also resembled a factory where goods—motion picture entertainments—were manufactured for a mass audience. The films rolled down the assembly line, like one of Henry Ford's Model A's, through story departments, past departments of scenic and costume design, and onto the set where technicians (scenic and make-up craftsmen, camera and lighting crews) and actors united to help shape the final product. Then it continued down the line to the cutting and release departments, until it was shipped to the company's showrooms—whether the small-town Bijous or the big-city Movie Palaces.

From its beginnings, this industrialized studio system provoked a predictable question: how can a work of art result from such varied intentions and collective labors? For years, most American critics argued (or simply assumed) that, whatever the product of this mechanized assembly of disparate talents was, it was not art. They considered it to be, instead, mere commercial entertainment that could not be compared to the "art films" of Europe or the "underground" films of the personal, experimental filmmaker. Ford's assembly line may have made the luxury of automobile ownership possible for a majority of Americans. But when Hollywood similarly brought drama and comedy into the lives of millions, the result, according to such critics, was not the expansion of art but its debasement.

One early reply to this argument was to deny that a purely aesthetic intention or the vision of a single artist is necessary to create a work of art. Erwin Panofsky specifically compares the making of a film to the building of a cathedral, for the cathedral was built for the greater glory of God and was the result of the collective labor of as many specialists as a Hollywood film. François Truffaut, beginning in 1954 with his *Cahiers du cinéma* essay, "On a Certain Tendency of the French Cinema," took the opposite tack and argued instead for a theory of film art that drew upon older ideas of aesthetic creation. His *"politique des auteurs"* defended the Hollywood studio film by maintaining that, although unappreciated or even unnoticed, the work of an author, an *auteur*, could be seen in many Hollywood films. This *auteur* was not the film's scriptwriter, however, but the film's director whose "signature" could be discerned by the sensitive critic who bothered to look for it. Truffaut's aim in this and succeeding articles, along with that of his follow-*auteuristes* at *Cahiers du Cinéma*, was somewhere between a theory of film creation and a theory of film taste. He was reacting against mainstream French film criticism, which had emphasized the "tradition of quality," extolling the polished literary adaptations of such scenarists as Jean Aurenche and Pierre Bost (*La Symphonie Pastorale, The Red and the Black, The Idiot*) at the expense of the genuinely cinematic thinking of Jacques Tati, Jean Renoir, or Robert Bresson.

Truffaut's emphasis on the director as the prime film artist became a critical mainstay of the pioneering French film magazine *Cahiers du Cinéma*, which quickly expanded his focus on the French tradition to encompass the Soviet, German, and especially the American. The essays by Andrew Sarris and Peter Wollen illustrate some of the fierce arguments that subsequently arose over artistic authority. In general, according to what became known as the *auteur* theory, a director's "style" or "basic motifs," as Wollen calls them, can only be discerned by viewing his work as a whole, because the true marks of an *auteur* will appear in all of them, despite any differences in writers, cinematographers, or stars. Andrew Sarris, the primary American spokesman for the *auteur* theory, suggests not only that the distinguishable personality of the director is a criterion of value but also that the "meaning" which he is able to impose on the material with which he must work is the "ultimate" glory of the cinema. This observation raises problems about where exactly the *auteur*'s imprint is most clearly to be found. Is it in style (e.g., the use of deep-focus photography) or in basic motifs (e.g., the elements of a western), or in some undefined combination of the two? A few months after the essay included here, in a special issue of *Film Culture* dedicated to American directors, Sarris published an analysis of the careers of more than one hundred directors (not confined to Americans), including a "pantheon" of twelve—all guaranteed to generate endless argument. Some—such as Charles Chaplin, D. W. Griffith, and Jean Renoir—were already acknowledged masters, but, most surprising to Sarris's audience, others he praised were, at least in the early 1960s, considered by most writers on film only Hollywood drudges: John Ford, Howard Hawks, and Alfred Hitchcock.

Sarris, like Pauline Kael and others who attacked his views, was a working film critic required to review many films a year. To a great extent, both his desire to categorize films in terms of their directors, as well as the responses by Kael and others, spring from a similar need to find evaluative standards more general than the vagaries

of their own taste. Sarris, like those who originally proposed the *auteur* theory, was not simply arguing that an artist's personality will manifest itself in his works. In the face of a general denigration of American film as an art, he sought to establish that there was, indeed, an artist at work where many had never believed one existed. In doing so, he unquestionably helped to establish or re-establish the reputations of certain directors who worked within the Hollywood system, directors who did not exert much more control over the total project than many studio hacks, but who managed to make the kind of personal, significant statement that Ford or (as Wollen shows) Hawks did. But Sarris's insistence on the sheer value of an artist's triumphing over the limitations of his materials also raises an intriguing psychological question about the relative importance of limitation and freedom in the creation of a great work. This is certainly a useful strategy for rescuing some Hollywood reputations and rediscovering otherwise forgotten films, but does it also lay the wrong groundwork for demonstrating the merits of directors that Sarris most admires? At important times in their careers, Lubitsch, Renoir, Chaplin, Welles, and Keaton in fact enjoyed a large measure of individual control over scripts, shooting, and cutting—although, at other times, several of them also faced severe limitations. Whether there is any direct relation between the quality of a film and the degree of directorial control thus remains unclear.

Two very different challenges have been offered to the exclusive emphasis on the *auteur*: first, that other facets of film language and method are more responsible for a film's ultimate success than the will of an individual; and second, that other artists—scriptwriters, cinematographers, stars, producers—better, or at least equally, deserve to be called *auteurs*. Peter Wollen thus combines the *auteur* theory's emphasis on the individual creator with a structuralist and semiotic account of film meaning. For Wollen, the *auteur* theory allows "an operation of decipherment" that distinguishes between *auteur* films in which the meaning is not just conveyed through style but is "deeply within" and *metteur-en-scène* films in which the meaning is merely cinematically translated from the script or another medium. His prime example is Howard Hawks, who worked in the studio system and yet was able to create a personal set of attitudes and motifs that permeate his films whatever their ostensible genre or subject matter. In a series of afterthoughts added to a second edition of *Signs and Meaning in the Cinema*, Wollen expands his basic effort to detach the *auteur* theory from any adulation of the creative personality as such, or any search for the creator behind (rather than in) the work.

As Wollen insists, the essential role of the critic is to show that the film, which appears so directly to us, is not a transparent text, but one that requires interpretive work. But rather than undermine the creator, such an approach may usher in many creators. With film scholarship looking more closely at all the works of the past, rather than the small number of designated classics, critics and historians have been able to describe the special contributions of those in charge of lighting, sound, and set decoration, while more polemic writers have argued the crucial importance of cinematographers and composers for determining the overall effect of a film.

The most serious challenge for any theory that stresses the central importance of one or another of these invisible filmmakers is the visible presence of the star on the screen in front of us. Many stars have made the most decisive contributions to the films

in which they appear, and their unique "presence," like that of the director, scriptwriter, and so on, can also be determined by viewing the totality of their works. In *The World Viewed* Stanley Cavell remarks how surprising he found the *auteur* theory, for it never previously occurred to him that anyone *made* a Hollywood film. For Cavell, the world of film revolved about, and was determined by, the star.

Yet in much film theory, especially that influenced by the montage emphasis of Pudovkin and Eisenstein, the star and the star's performance have been undervalued in favor of the greater expressive meaning of editing (and the greater creative importance of the director and the editor). In Kuleshov's legendary experiment, the same shot of an actor's face was juxtaposed with that of a plate of soup, a coffin, and a little girl playing. The audience response, according to Pudovkin, was to ascribe hunger, sorrow, and joy respectively to what was in fact an unchanging expression. Similarly, in many formalist theories of film, the performer, if mentioned at all, becomes almost indistinguishable from other patterns generated by the film medium. The semiotic perspective of Roland Barthes straddles these two possibilities by implying that Greta Garbo's "face" is both the main object of interest and the main conveyor of meaning in most of the films in which she appears.

Another response to arguments against the significance of stars and performance has been first to stress the importance of performance in general to the fabric of film, and then to make a distinction—akin to Wollen's between *metteurs-en-scène* and *auteurs*—between the cinematic performer and the star who might reasonably be considered a creative force. Reflecting Braudy's formulation in *The World in a Frame* that film acting employs an "aesthetics of omission," John Ellis emphasizes not only the star within the film and within a series of films but also the star as existing in other formats—fan magazines, studio publicity, radio and television appearances, and so on—outside the film. These corollary aspects of the star image enhance the way in which the audience experiences the star as both present and absent, ordinary and extraordinary, at the same time.

Robert C. Allen's case study of the career of Joan Crawford further demonstrates the way the studio system, often with the active collusion of the stars themselves, created screen images through such means as promotion and publicity. These images, he argues, are by no means simple, but embody contradictions in the desires of historically specifiable audience. Drawing on categories devised by Richard Dyer, Allen illustrates how Crawford's image mutated through various transformations, each establishing a particular "look" that was reaffirmed by the films in which she appeared—from the flapper of the 1920s to the independent woman of the 1930s and beyond.

In a return from questions of star image to the interplay of forces within a film, Molly Haskell points out the way in which many films of the 1940s, especially those of Howard Hawks, find their shape through the presence of strong female stars. Such actresses often in themselves constitute a "point of view" that their casting brings into the story, even in some contrast or resistance to what the script and perhaps the director demand from them. Unlike Garbo, whose face is a palimpsest of audience projections, Bette Davis, says Haskell, deliberately plays against easy audience sympathy, while Rosalind Russell and Katharine Hepburn similarly upset expectations of pat or traditional distinctions between male and female traits.

An even better candidate for *auteur* is the film star who not only performs in the scripts of others (like Garbo) but also writes or directs his or her own scripts. Between such a star's onscreen and offscreen characters there is often a symbiotic relation that invites the audience to read one into the other. Mae West is one example of such a star and Clint Eastwood another. But it is pre-eminently the two great silent clowns, Buster Keaton and Charlie Chaplin, who wrote, directed, starred in, and, in Chaplin's case, also composed the music for their films. Gilberto Perez in *The Material Ghost* argues that both particularly conceived of the screen world as a special kind of space—Keaton's more outdoor, Chaplin's more determined by the frame of the studio set—in which the prime continuity was that of the actor's body. From this conception of the space around the actor came as well a view of the social world within the film and the main character's relation to it, Keaton as "a visitor forever having to borrow the world's uniforms, and uncomfortable in any one of them," and Chaplin's Tramp rejected by virtually everyone but the audience.

Miriam Hansen brings together John Ellis's emphasis on the star outside the film and Gilberto Perez's on the actor within the film by raising questions that center on the issue of film spectatorship and how an audience engages with a performer. (For more on the issue of the film spectator, see Section VII.) Hansen argues that Rudolph Valentino's performances, with their combination of the male desire to look and the female to be looked at, actively undermine the nominal plots of his films and forcefully defy the 1920s American idea of masculinity. If the *auteur* theory means to indicate where the center of a film's greatest interest lies, it is in the many conflicting attitudes brought together in Valentino's cinematic presence.

Returning to the discussion of the *auteur*, Richard B. Jewell, the author of a history of RKO studios, focuses on that prime example of the auteurist director Howard Hawks to show how Hawks's *Bringing Up Baby* was also the result of choices made within the context of the studio system in reaction to different economic and organizational pressures. Nevertheless, he concludes, a knowledge of the external pressures on artistic decision-making does not undermine any estimate of Hawks as an artist but helps only to illustrate again Hawks's central creative power. Jewell explicitly critiques the Ford assembly line metaphor of the movie business with which we began—business and art can be equally served, although in ways neither can predict or anticipate.

Finally, in a more all-out attack on the individual film artist, Thomas Schatz points out that the *auteur* theory has essentially distorted at least American film history by emphasizing the works and careers of a "few dozen heroic directors." In fact, the studio system makes it impossible to designate any particular individual as the sole creative force. Instead, Schatz argues that it is the producer, who has both the authority and power to make final decisions, whose role ought to be investigated if we are truly to understand the special interplay between individual artistry and collective organization that defines the Hollywood film. Such social issues indicate that the study of film art and the film artist cannot be isolated from the functions of that art and artist in the society as a whole—an issue that will become a concern of this volume's final section.

# ANDREW SARRIS
# NOTES ON THE AUTEUR THEORY IN 1962

... As far as I know, there is no definition of the *auteur* theory in the English language, that is, by any American or British critic. Truffaut has recently gone to great pains to emphasize that the *auteur* theory was merely a polemical weapon for a given time and a given place, and I am willing to take him at his word. But, lest I be accused of misappropriating a theory no one wants anymore, I will give the *Cahiers* critics full credit for the original formulation of an idea that reshaped my thinking on the cinema. First of all, how does the *auteur* theory differ from a straightforward theory of directors. Ian Cameron's article "Films, Directors, and Critics," in *Movie* of September, 1962, makes an interesting comment on this issue: "The assumption that underlies all the writing in *Movie* is that the director is the author of a film, the person who gives it any distinctive quality. There are quite large exceptions, with which I shall deal later." So far, so good, at least for the *auteur* theory, which even allows for exceptions. However, Cameron continues: "On the whole, we accept the cinema of directors, although without going to the farthest-out extremes of the *la politique des auteurs*, which makes it difficult to think of a bad director making a good film and almost impossible to think of a good director making a bad one." We are back to Bazin again, although Cameron naturally uses different examples. That three otherwise divergent critics like Bazin, Roud, and Cameron make essentially the same point about the *auteur* theory suggests a common fear of its abuses. I believe there is a misunderstanding here about what the *auteur* theory actually claims, particularly since the theory itself is so vague at the present time.

First of all, the *auteur* theory, at least as I understand it and now intend to express it, claims neither the gift of prophecy nor the option of extracinematic perception. Directors, even *auteurs*, do not always run true to form, and the critic can never assume that a bad director will always make a bad film. No, not always, but almost always, and that is the point. What is a bad director, but a director who has made many bad films?

561

What is the problem then? Simply this: The badness of a director is not necessarily considered the badness of a film. If Joseph Pevney directed Garbo, Cherkassov, Olivier, Belmondo, and Harriet Andersson in *The Cherry Orchard*, the resulting spectacle might not be entirely devoid of merit with so many subsidiary *auteurs* to cover up for Joe. In fact, with this cast and this literary property, a Lumet might be safer than a Welles. The realities of casting apply to directors as well as to actors, but the *auteur* theory would demand the gamble with Welles, if he were willing.

Marlon Brando has shown us that a film can be made without a director. Indeed, *One-Eyed Jacks* is more entertaining than many films with directors. A director-conscious critic would find it difficult to say anything good or bad about direction that is nonexistent. One can talk here about photography, editing, acting, but not direction. The film even has personality, but, like *The Longest Day* and *Mutiny on the Bounty*, it is a cipher directorially. Obviously, the *auteur* theory cannot possibly cover every vagrant charm of the cinema. Nevertheless, the first premise of the *auteur* theory is the technical competence of a director as a criterion of value. A badly directed or an undirected film has no importance in a critical scale of values, but one can make interesting conversation about the subject, the script, the acting, the color, the photography, the editing, the music, the costumes, the decor, and so forth. That is the nature of the medium. You always get more for your money than mere art. Now, by the *auteur* theory, if a director has no technical competence, no elementary flair for the cinema, he is automatically cast out from the pantheon of directors. A great director has to be at least a good director. This is true in any art. What constitutes directorial talent is more difficult to define abstractly. There is less disagreement, however, on this first level of the *auteur* theory than there will be later.

The second premise of the *auteur* theory is the distinguishable personality of the director as a criterion of value. Over a group of films, a director must exhibit certain recurrent characteristics of style, which serve as his signature. The way a film looks and moves should have some relationship to the way a director thinks and feels. This is an area where American directors are generally superior to foreign directors. Because so much of the American cinema is commissioned, a director is forced to express his personality through the visual treatment of material rather than through the literary content of the material. A Cukor, who works with all sorts of projects, has a more developed abstract style than a Bergman, who is free to develop his own scripts. Not that Bergman lacks personality, but his work has declined with the depletion of his ideas largely because his technique never equaled his sensibility. Joseph L. Mankiewicz and Billy Wilder are other examples of writer-directors without adequate technical mastery. By contrast, Douglas Sirk and Otto Preminger have moved up the scale because their miscellaneous projects reveal a stylistic consistency.

The third and ultimate premise of the *auteur* theory is concerned with interior meaning, the ultimate glory of the cinema as an art. Interior meaning is extrapolated from the tension between a director's personality and his material. This conception of interior meaning comes close to what Astruc defines as *mise en scène*, but not quite. It is not quite the vision of the world a director projects nor quite his attitude toward life. It is ambiguous, in any literary sense, because part of it is imbedded in the stuff of the cinema and cannot be rendered in noncinematic terms. Truffaut has called it

the temperature of the director on the set, and that is a close approximation of its professional aspect. Dare I come out and say what I think it to be is an *élan* of the soul?

Lest I seem unduly mystical, let me hasten to add that all I mean by "soul" is that intangible difference between one personality and another, all other things being equal. Sometimes, this difference is expressed by no more than a beat's hesitation in the rhythm of a film. In one sequence of *La Règle du Jeu*, Renoir gallops up the stairs, turns to his right with a lurching movement, stops in hoplike uncertainty when his name is called by a coquettish maid, and, then, with marvelous postreflex continuity, resumes his bearishly shambling journey to the heroine's boudoir. If I could describe the musical grace note of that momentary suspension, and I can't, I might be able to provide a more precise definition of the *auteur* theory. As it is, all I can do is point at the specific beauties of interior meaning on the screen and, later, catalogue the moments of recognition.

The three premises of the *auteur* theory may be visualized as three concentric circles: the outer circle as technique; the middle circle, personal style; and the inner circle, interior meaning. The corresponding roles of the director may be designated as those of a technician, a stylist, and an *auteur*. There is no prescribed course by which a director passes through the three circles. Godard once remarked that Visconti had evolved from a *metteur en scène* to an *auteur*, whereas Rossellini had evolved from an *auteur* to a *metteur en scène*. From opposite directions, they emerged with comparable status. Minnelli began and remained in the second circle as a stylist; Buñuel was an *auteur* even before he had assembled the technique of the first circle. Technique is simply the ability to put a film together with some clarity and coherence. Nowadays, it is possible to become a director without knowing too much about the technical side, even the crucial functions of photography and editing. An expert production crew could probably cover up for a chimpanzee in the director's chair. How do you tell the genuine director from the quasichimpanzee? After a given number of films, a pattern is established.

In fact, the *auteur* theory itself is a pattern theory in constant flux. I would never endorse a Ptolemaic constellation of directors in a fixed orbit. At the moment, my list of *auteurs* runs something like this through the first twenty: Ophuls, Renoir, Mizoguchi, Hitchcock, Chaplin, Ford, Welles, Dreyer, Rossellini, Murnau, Griffith, Sternberg, Eisenstein, von Stroheim, Buñuel, Bresson, Hawks, Lang, Flaherty, Vigo. This list is somewhat weighted toward seniority and established reputations. In time, some of these *auteurs* will rise, some will fall, and some will be displaced either by new directors or rediscovered ancients. Again, the exact order is less important than the specific definitions of these and as many as two hundred other potential *auteurs*. I would hardly expect any other critic in the world fully to endorse this list, especially on faith. Only after thousands of films have been revaluated, will any personal pantheon have a reasonably objective validity. The task of validating the *auteur* theory is an enormous one, and the end will never be in sight. Meanwhile, the *auteur* habit of collecting random films in directorial bundles will serve posterity with at least a tentative classification.

Although the *auteur* theory emphasizes the body of a director's work rather than isolated masterpieces, it is expected of great directors that they make great films every

so often. The only possible exception to this rule I can think of is Abel Gance, whose greatness is largely a function of his aspiration. Even with Gance, *La Roue* is as close to being a great film as any single work of Flaherty's. Not that single works matter that much. As Renoir has observed, a director spends his life on variations of the same film.

Two recent films—*Boccaccio '70* and *The Seven Capital Sins*—unwittingly reinforced the *auteur* theory by confirming the relative standing of the many directors involved. If I had not seen either film, I would have anticipated that the order of merit in *Boccaccio '70* would be Visconti, Fellini, and De Sica, and in *The Seven Capital Sins* Godard, Chabrol, Demy, Vadim, De Broca, Molinaro. (Dhomme, Ionesco's stage director and an unknown quantity in advance, turned out to be the worst of the lot.) There might be some argument about the relative badness of De Broca and Molinaro, but, otherwise, the directors ran true to form by almost any objective criterion of value. However, the main point here is that even in these frothy, ultracommercial servings of entertainment, the contribution of each director had less in common stylistically with the work of other directors on the project than with his own previous work.

Sometimes, a great deal of corn must be husked to yield a few kernels of internal meaning. I recently saw *Every Night at Eight*, one of the many maddeningly routine films Raoul Walsh has directed in his long career. This 1935 effort featured George Raft, Alice Faye, Frances Langford, and Patsy Kelly in one of those familiar plots about radio shows of the period. The film keeps moving along in the pleasantly unpretentious manner one would expect of Walsh until one incongruously intense scene with George Raft thrashing about in his sleep, revealing his inner fears in mumbling dream-talk. The girl he loves comes into the room in the midst of his unconscious avowals of feeling and listens sympathetically. This unusual scene was later amplified in *High Sierra* with Humphrey Bogart and Ida Lupino. The point is that one of the screen's most virile directors employed an essentially feminine narrative device to dramatize the emotional vulnerability of his heroes. If I had not been aware of Walsh in *Every Night at Eight*, the crucial link to *High Sierra* would have passed unnoticed. Such are the joys of the *auteur* theory.

1962

# PETER WOLLEN
# *FROM* SIGNS AND MEANING IN THE CINEMA

## THE AUTEUR THEORY

The *politique des auteurs*—the *auteur* theory, as Andrew Sarris calls it—was developed by the loosely knit group of critics who wrote for *Cahiers du Cinéma* and made it the leading film magazine in the world. It sprang from the conviction that the American cinema was worth studying in depth, that masterpieces were made not only by a small upper crust of directors, the cultured gilt on the commercial gingerbread, but by a whole range of authors, whose work had previously been dismissed and consigned to oblivion. There were special conditions in Paris which made this conviction possible. Firstly, there was the fact that American films were banned from France under the Vichy government and the German Occupation. Consequently, when they reappeared after the Liberation they came with a force—and an emotional impact—which was necessarily missing in the Anglo-Saxon countries themselves. And, secondly, there was a thriving ciné-club movement, due in part to the close connections there had always been in France between the cinema and the intelligentsia: witness the example of Jean Cocteau or André Malraux. Connected with this ciné-club movement was the magnificent Paris *Cinémathèque*, the work of Henri Langlois, a great *auteur*, as Jean-Luc Godard described him. The policy of the *Cinémathèque* was to show the maximum number of films, to plough back the production of the past in order to produce the culture in which the cinema of the future could thrive. It gave French *cinéphiles* an unmatched perception of the historical dimensions of Hollywood and the careers of individual directors.

The *auteur* theory grew up rather haphazardly; it was never elaborated in programmatic terms, in a manifesto or collective statement. As a result, it could be interpreted and applied on rather broad lines; different critics developed somewhat different methods within a loose framework of common attitudes. This looseness and diffuseness of the the-

A revised and expanded edition of *Signs and Meaning in the Cinema* was published by the British Film Institute in 1997.

ory has allowed flagrant misunderstandings to take root, particularly among critics in Britain and the United States. Ignorance has been compounded by a vein of hostility to foreign ideas and a taste for travesty and caricature. However, the fruitfulness of the *auteur* approach has been such that it has made headway even on the most unfavorable terrain. For instance, a recent straw poll of British critics, conducted in conjunction with a Don Siegel Retrospective at the National Film Theatre, revealed that, among American directors most admired, a group consisting of Budd Boetticher, Samuel Fuller and Howard Hawks ran immediately behind Ford, Hitchcock and Welles, who topped the poll, but ahead of Billy Wilder, Josef Von Sternberg and Preston Sturges.

Of course, some individual directors have always been recognised as outstanding: Charles Chaplin, John Ford, Orson Welles. The *auteur* theory does not limit itself to acclaiming the director as the main author of a film. It implies an operation of decipherment; it reveals authors where none had been seen before. For years, the model of an author in the cinema was that of the European director, with open artistic aspirations and full control over his films. This model still lingers on; it lies behind the existential distinction between art films and popular films. Directors who built their reputations in Europe were dismissed after they crossed the Atlantic, reduced to anonymity. American Hitchcock was contrasted unfavourably with English Hitchcock, American Renoir with French Renoir, American Fritz Lang with German Fritz Lang. The *auteur* theory has led to the revaluation of the second, Hollywood careers of these and other European directors; without it, masterpieces such as *Scarlet Street* or *Vertigo* would never have been perceived. Conversely, the auteur theory has been sceptical when offered an American director whose salvation has been exile to Europe. It is difficult now to argue that *Brute Force* has ever been excelled by Jules Dassin or that Joseph Losey's recent work is markedly superior to, say, *The Prowler*.

In time, owing to the diffuseness of the original theory, two main schools of *auteur* critics grew up: those who insisted on revealing a core of meanings, of thematic motifs, and those who stressed style and *mise en scène*. There is an important distinction here, which I shall return to later. The work of the *auteur* has a semantic dimension, it is not purely formal; the work of the *metteur en scène*, on the other hand, does not go beyond the realm of performance, of transposing into the special complex of cinematic codes and channels a pre-existing text: a scenario, a book or a play. As we shall see, the meaning of the films of an *auteur* is constructed *a posteriori*; the meaning—semantic, rather than stylistic or expressive—of the films of a *metteur en scène* exists *a priori*. In concrete cases, of course, this distinction is not always clear-cut. There is controversy over whether some directors should be seen as *auteurs* or *metteurs en scène*. For example, though it is possible to make intuitive ascriptions, there have been no really persuasive accounts as yet of Raoul Walsh or William Wyler as *auteurs*, to take two very different directors. Opinions might differ about Don Siegel or George Cukor. Because of the difficulty of fixing the distinction in these concrete cases, it has often become blurred; indeed, some French critics have tended to value the *metteur en scène* above the *auteur*. MacMahonism sprang up, with its cult of Walsh, Lang, Losey and Preminger, its fascination with violence and its notorious text: "Charlton Heston is an axiom of the cinema." What André Bazin called "aesthetic cults of personality" began to be formed. Minor directors were acclaimed before they had, in any real sense, been identified and defined.

Yet the *auteur* theory has survived despite all the hallucinating critical extravagan-
zas which it has fathered. It has survived because it is indispensable. Geoffrey Nowell-
Smith has summed up the *auteur* theory as it is normally presented today:

> One essential corollary of the theory as it has been developed is the discovery that the
> defining characteristics of an author's work are not necessarily those which are most
> readily apparent. The purpose of criticism thus becomes to uncover behind the superfi-
> cial contrasts of subject and treatment a hard core of basic and often recondite motifs. The
> pattern formed by these motifs . . . is what gives an author's work its particular structure,
> both defining it internally and distinguishing one body of work from another.

It is this "structural approach," as Nowell-Smith calls it, which is indispensable for
the critic.

The test case for the *auteur* theory is provided by the work of Howard Hawks. Why
Hawks, rather than, say, Frank Borzage or King Vidor? Firstly, Hawks is a director
who has worked for years within the Hollywood system. His first film, *Road to Glory*,
was made in 1926. Yet throughout his long career he has only once received general
critical acclaim, for his wartime film, *Sergeant York*, which closer inspections reveals
to be eccentric and atypical of the main *corpus* of Hawks's films. Secondly, Hawks
has worked in almost every genre. He has made westerns, (*Rio Bravo*), gangsters
(*Scarface*), war films (*Air Force*), thrillers (*The Big Sleep*), science fiction (*The Thing
from Another World*), musicals (*Gentlemen Prefer Blondes*), comedies (*Bringing up
Baby*), even a Biblical epic (*Land of the Pharaohs*). Yet all of these films (except per-
haps *Land of the Pharaohs*, which he himself was not happy about) exhibit the same
thematic preoccupations, the same recurring motifs and incidents, the same visual
style and tempo. In the same way that Roland Barthes constructed a species of *homo
racinianus*, the critic can construct a *homo hawksianus*, the protagonist of Hawksian
values in the problematic Hawksian world.

Hawks achieved this by reducing the genres to two basic types: the adventure
drama and the crazy comedy. These two types express inverse views of the world, the
positive and negative poles of the Hawksian vision. Hawks stands opposed, on the
one hand, to John Ford and, on the other hand, to Budd Boetticher. All these directors
are concerned with the problem of heroism. For the hero, as an individual, death is an
absolute limit which cannot be transcended: it renders the life which preceded it
meaningless, absurd. How then can there be any meaningful individual action during
life? How can individual action have any value—be heroic—if it cannot have tran-
scendent value, because of the absolutely devaluing limit of death? John Ford finds
the answer to this question by placing and situating the individual within society and
within history, specifically within American history. Ford finds transcendent values
in the historic vocation of America as a nation, to bring civilisation to a savage land,
the garden to the wilderness. At the same time, Ford also sees these values themselves
as problematic; he begins to question the movement of American history itself. Boet-
ticher, on the contrary, insists on a radical individualism. "I am not interested in mak-
ing films about mass feelings. I am for the individual." He looks for values in the
encounter with death itself: the underlying metaphor is always that of the bull-fighter
in the arena. The hero enters a group of companions, but there is no possibility of
group solidarity. Boetticher's hero acts by dissolving groups and collectives of any
kind into their constituent individuals, so that he confronts each person face-to-face;

the films develop, in Andrew Sarris's words, into "floating poker games, where every character takes turns at bluffing about his hand until the final showdown." Hawks, unlike Boetticher, seeks transcendent values beyond the individual, in solidarity with others. But, unlike Ford, he does not give his heroes any historical dimension, any destiny in time.

For Hawks the highest human emotion is the camaraderie of the exclusive, self-sufficient, all-male group. Hawk's heroes are cattlemen, marlin-fishermen, racing-drivers, pilots, big-game hunters, habituated to danger and living apart from society, actually cut off from it physically by dense forest, sea, snow or desert. Their aero-dromes are fog-bound; the radio has cracked up; the next mail-coach or packet-boat does not leave for a week. The *élite* group strictly preserves its exclusivity. It is nec-essary to pass a test of ability and courage to win admittance. The group's only inter-nal tensions come when one member lets the other down (the drunk deputy in *Rio Bravo*, the panicky pilot in *Only Angels Have Wings*) and must redeem himself by some act of exceptional bravery, or occasionally when too much 'individualism' threatens to disrupt the close-knit circle (the rivalry between drivers in *Red Line 7000*, the fighter pilot among the bomber crew in *Air Force*). The group's security is the first commandment: "You get a stunt team in acrobatics in the air—if one of them is no good, then they're all in trouble. If someone loses his nerve catching animals, then the whole bunch can be in trouble." The group members are bound together by ritu-als (in *Hatari!* blood is exchanged by transfusion) and express themselves univocally in communal sing-songs. There is a famous example of this in *Rio Bravo*. In *Dawn Patrol* the camaraderie of the pilots stretches even across the enemy lines: a captured German ace is immediately drafted into the group and joins in the sing-song; in *Hatari!* hunters of different nationality and in different places join together in a song over an intercom radio system.

Hawks's heroes pride themselves on their professionalism. They ask: "How good is he? He'd better be good." They expect no praise for doing their job well. Indeed, none is given except: 'The boys did all right.' When they die, they leave behind them only the most meagre personal belongings, perhaps a handful of medals. Hawks him-self has summed up this desolate and barren view of life:

> It's just a calm acceptance of a fact. In *Only Angels Have Wings*, after Joe dies, Cary Grant says: "He just wasn't good enough." Well, that's the only thing that keeps people going. They just have to say: "Joe wasn't good enough, and I'm better than Joe, so I go ahead and do it." And they find out they're not any better than Joe, but then it's too late, you see.

In Ford films, death is celebrated by funeral services, an impromptu prayer, a few staves of "Shall we gather at the river?"—it is inserted into an ongoing system of rit-ual institutions, along with the wedding, the dance, the parade. But for Hawks it is enough that the routine of the group's life goes on, a routine whose only relieving fea-tures are "danger" (*Hatari!*) and "fun." Danger gives existence pungency: "Every time you get real action, then you have danger. And the question, 'Are you living or not living?' is probably the biggest drama we have." This nihilism, in which 'living' means no more than being in danger of losing your life—a danger entered into quite

gratuitously—is augmented by the Hawksian concept of having "fun." The word "fun" crops up constantly in Hawks's interviews and scripts. It masks his despair.

When one of Hawks's *élite* is asked, usually by a woman, why he risks his life, he replies: "No reason I can think of makes any sense. I guess we're just crazy." Or Feathers, sardonically, to Colorado in *Rio Bravo*: "You haven't even the excuse I have. We're all fools." By "crazy" Hawks does not mean psychopathic: none of his characters are like Turkey in Peckinpah's *The Deadly Companions* or Billy the Kid in Penn's *The Left-Handed Gun*. Nor is there the sense of the absurdity of life which we sometimes find in Boetticher's films: death, as we have seen, is for Hawks simply a routine occurrence, not a *grotesquerie*, as in *The Tall T* ('Pretty soon that well's going to be chock-a-block') or *The Rise and Fall of Legs Diamond*. For Hawks "craziness" implies difference, a sense of apartness from the ordinary, everyday, social world. At the same time, Hawks sees the ordinary world as being "crazy" in a much more fundamental sense, because devoid of any meaning or values. "I mean crazy reactions—I don't think they're crazy, I think they're normal—but according to bad habits we've fallen into they seemed crazy." Which is the normal, which the abnormal? Hawks recognises, inchoately, that to most people his heroes, far from embodying rational values, are only a dwindling band of eccentrics. Hawks's 'kind of men' have no place in the world.

The Hawksian heroes, who exclude others from their own *élite* group, are themselves excluded from society, exiled to the African bush or to the Arctic. Outsiders, other people in general, are perceived by the group as an undifferentiated crowd. Their role is to gape at the deeds of the heroes whom, at the same time, they hate. The crowd assembles to watch the showdown in *Rio Bravo*, to see the cars spin off the track in *The Crowd Roars*. The gulf between the outsider and the heroes transcends enmities among the *élite*: witness *Dawn Patrol* or Nelse in *El Dorado*. Most dehumanised of all is the crowd in *Land of the Pharaohs*, employed in building the Pyramids. Originally the film was to have been about Chinese labourers building a "magnificent airfield" for the American army, but the victory of the Chinese Revolution forced Hawks to change his plans. ("Then I thought of the building of the Pyramids; I thought it was the same kind of story.") But the presence of the crowd, of external society, is a constant covert threat to the Hawksian *élite*, who retaliate by having "fun." In the crazy comedies ordinary citizens are turned into comic butts, lampooned and tormented: the most obvious target is the insurance salesman in *His Girl Friday*. Often Hawks's revenge becomes grim and macabre. In *Sergeant York* it is "fun" to shoot Germans "like turkeys"; in *Air Force* it is "fun" to blow up the Japanese fleet. In *Rio Bravo* the geligniting of the badmen "was very funny." It is at these moments that the *élite* turns against the world outside and takes the opportunity to be brutal and destructive.

Besides the covert pressure of the crowd outside, there is also an overt force which threatens: woman. Man is woman's "prey." Women are admitted to the male group only after much disquiet and a long ritual courtship, phased round the offering, lighting and exchange of cigarettes, during which they prove themselves worthy of entry. Often they perform minor feats of valour. Even then though they are never really full members. A typical dialogue sums up their position:

*Woman:* You love him, don't you?
*Man* (embarrassed): Yes . . . I guess so. . . .
*Woman:* How can I love him like you?
*Man:* Just stick around.

The undercurrent of homosexuality in Hawks's films is never crystallised, though in *The Big Sky*, for example, it runs very close to the surface. And he himself described *A Girl in Every Port* as "really a love story between two men." For Hawks men are equals, within the group at least, whereas there is a clear identification between women and the animal world, most explicit in *Bringing Up Baby, Gentlemen Prefer Blondes* and *Hatari!* Man must strive to maintain his mastery. It is also worth noting that, in Hawks's adventure dramas and even in many of his comedies, there is no married life. Often the heroes were married or at least intimately committed, to a woman at some time in the distant past but have suffered an unspecified trauma, with the result that they have been suspicious of women ever since. Their attitude is "Once bitten, twice shy." This is in contrast to the films of Ford, which almost always include domestic scenes. Woman is not a threat to Ford's heroes; she falls into her allotted social place as wife and mother, bringing up the children, cooking, sewing, a life of service, drudgery and subordination. She is repaid for this by being sentimentalised. Boetticher, on the other hand, has no obvious place for women at all; they are phantoms, who provoke action, are pretexts for male modes of conduct, but have no authentic significance in themselves. "In herself, the woman has not the slightest importance."

Hawks sees the all-male community as an ultimate; obviously it is very retrograde. His Spartan heroes are, in fact, cruelly stunted. Hawks would be a lesser director if he was unaffected by this, if his adventure dramas were the sum total of his work. His real claim as an author lies in the presence, together with the dramas, of their inverse, the crazy comedies. They are the agonised exposure of the underlying tensions of the heroic dramas. There are two principal themes, zones of tension. The first is the theme of regression: of regression to childhood, infantilism, as in *Monkey Business*, or regression to savagery: witness the repeated scene of the adult about to be scalped by painted children, in *Monkey Business* and in *The Ransom of Red Chief*. With brilliant insight, Robin Wood has shown how *Scarface* should be categorised among the comedies rather than the dramas: Camonte is perceived as savage, child-like, subhuman. The second principal comedy theme is that of sex-reversal and role-reversal. *I Was A Male War Bride* is the most extreme example. Many of Hawks's comedies are centred round domineering women and timid, pliable men: *Bringing Up Baby* and *Man's Favourite Sport*, for example. There are often scenes of male sexual humiliation, such as the trousers being pulled off the hapless private eye in *Gentlemen Prefer Blondes*. In the same film, the Olympic Team of athletes are reduced to passive objects in an extraordinary Jane Russell song number; big-game hunting is lampooned, like fishing in *Man's Favourite Sport*; the theme of infantilism crops up again: "The child was the most mature one on board the ship, and I think he was a lot of fun."

Whereas the dramas show the mastery of man over nature, over woman, over the animal and childish; the comedies show his humiliation, his regression. The heroes become victims; society, instead of being excluded and despised, breaks in with

irruptions of monstrous farce. It could well be argued that Hawks's outlook, the alternative world which he constructs in the cinema, the Hawksian heterocosm, is not one imbued with particular intellectual subtlety or sophistication. This does not detract from its force. Hawks first attracted attention because he was regarded naïvely as an

Howard Hawks's battle between the sexes. Carole Lombard and John Barrymore in *Twentieth Century* (1934), Cary Grant and Katharine Hepburn in *Bringing Up Baby* (1938). "Besides the covert pressure of the crowd outside, there is also an overt force which threatens: woman. Man is woman's prey" (WOLLEN, page 569).

action director. Later, the thematic content which I have outlined was detected and revealed. Beyond the stylemes, semantemes were found to exist; the films were anchored in an objective stratum of meaning, a plerematic stratum, as the Danish linguist Hjelmslev would put it. Thus the stylistic expressiveness of Hawks's films was shown to be not purely contingent, but grounded in significance.

Something further needs to be said about the theoretical basis of the kind of schematic exposition of Hawks's work which I have outlined. The 'structural approach' which underlies it, the definition of a core of repeated motifs, has evident affinities with methods which have been developed for the study of folklore and mythology. In the work of Olrik and others, it was noted that in different folk-tales the same motifs reappeared time and time again. It became possible to build up a lexicon of these motifs. Eventually Propp showed how a whole cycle of Russian fairy-tales could be analysed into variations of a very limited set of basic motifs (or moves, as he called them). Underlying the different, individual tales was an archi-tale, of which they were all variants. One important point needs to be made about this type of structural analysis. There is a danger, as Lévi-Strauss has pointed out, that by simply noting and mapping resemblances, all the texts which are studied (whether Russian fairy-tales or American movies) will be reduced to one, abstract and impoverished. There must be a moment of synthesis as well as a moment of analysis: otherwise, the method is formalist, rather than truly structuralist. Structuralist criticism cannot rest at the perception of resemblances or repetitions (redundancies, in fact), but must also comprehend a system of differences and oppositions. In this way, texts can be studied not only in their universality (what they all have in common) but also in their singularity (what differentiates them from each other). This means of course that the test of a structural analysis lies not in the orthodox canon of a director's work, where resemblances are clustered, but in films which at first sight may seem eccentricities.

In the films of Howard Hawks a systematic series of oppositions can be seen very near the surface, in the contrast between the adventure dramas and the crazy comedies. If we take the adventure dramas alone it would seem that Hawks's work is flaccid, lacking in dynamism; it is only when we consider the crazy comedies that it becomes rich, begins to ferment: alongside every dramatic hero we are aware of a phantom, stripped of mastery, humiliated, inverted. With other directors, the system of oppositions is much more complex: instead of there being two broad strata of films there are a whole series of shifting variations. In these cases, we need to analyse the roles of the protagonists themselves, rather than simply the worlds in which they operate. The protagonists of fairy-tales or myths, as Lévi-Strauss has pointed out, can be dissolved into bundles of differential elements, pairs of opposites. Thus the difference between the prince and the goose-girl can be reduced to two antinomic pairs: one natural, male versus female, and the other cultural, high versus low. We can proceed with the same kind of operation in the study of films, though, as we shall see, we shall find them more complex than fairy tales. . . .

It is instructive, for example, to consider three films of John Ford and compare their heroes: Wyatt Earp in *My Darling Clementine*, Ethan Edwards in *The Searchers* and Tom Doniphon in *The Man Who Shot Liberty Valance*. They all act within the recog-

nizable Ford world, governed by a set of oppositions, but their *loci* within that world are very different. The relevant pairs of opposites overlap; different pairs are fore-grounded in different movies. The most relevant are garden versus wilderness, plough-share versus sabre, settler versus nomad, European versus Indian, civilised versus savage, book versus gun, married versus unmarried, East versus West. These antimonies can often be broken down further. The East, for instance, can be defined either as Boston or Washington and, in *The Last Hurrah*, Boston itself is broken down into the antipodes of Irish immigrants versus Plymouth Club, themselves bundles of such differential elements as Celtic versus Anglo-Saxon, poor versus rich, Catholic versus Protestant, Democrat versus Republican, and so on. At first sight, it might seem that the oppositions listed above overlap to the extent that they become practi-cally synonymous, but this is by no means the case. As we shall see, part of the devel-opment of Ford's career has been the shift from an identity between civilised versus savage and European versus Indian to their separation and final reversal, so that in *Cheyenne Autumn* it is the Europeans who are savage, the victims who are heroes.

The master antinomy in Ford's films is that between the wilderness and the garden. As Henry Nash Smith has demonstrated, in his magisterial book *Virgin Land*, the con-trast between the image of America as a desert and as a garden is one which has dom-inated American thought and literature, recurring in countless novels, tracts, political speeches, and magazine stories. In Ford's films it is crystallised in a number of strik-ing images. *The Man Who Shot Liberty Valance*, for instance, contains the image of the cactus rose, which encapsulates the antinomy between desert and garden which pervades the whole film. Compare with this the famous scene in *My Darling Clemen-tine*, after Wyatt Earp has gone to the barber (who civilises the unkempt), where the scent of honeysuckle is twice remarked upon: an artificial perfume, cultural rather than natural. This moment marks the turning-point in Wyatt Earp's transition from wandering cowboy, nomadic, savage, bent on personal revenge, unmarried, to mar-ried man, settled, civilised, the sheriff who administers the law.

Earp, in *My Darling Clementine*, is structurally the most simple of the three pro-tagonists I have mentioned: his progress is an uncomplicated passage from nature to culture, from the wilderness left in the past to the garden anticipated in the future. Ethan Edwards, in *The Searchers*, is more complex. He must be defined not in terms of past versus future or wilderness versus garden compounded in himself, but in rela-tion to two other protagonists: Scar, the Indian chief, and the family of homesteaders. Ethan Edwards, unlike Earp, remains a nomad throughout the film. At the start, he rides in from the desert to enter the log-house; at the end, with perfect symmetry, he leaves the house again to return to the desert, to vagrancy. In many respects, he is sim-ilar to Scar; he is a wanderer, a savage, outside the law: he scalps his enemy. But, like the homesteaders, of course, he is a European, the mortal foe of the Indian. Thus Edwards is ambiguous; the antinomies invade the personality of the protagonist him-self. The oppositions tear Edwards in two; he is a tragic hero. His companion, Mar-tin Pawley, however, is able to resolve the duality; for him, the period of nomadism is only an episode, which has meaning as the restitution of the family, a necessary link between his old home and his new home.

Ethan Edwards's wandering is, like that of many other Ford protagonists, a quest, a search. A number of Ford films are built round the theme of the quest for the

Promised Land, an American re-enactment of the biblical exodus, the journey through the desert to the land of milk and honey, the New Jerusalem. This theme is built on the combination of the two pairs: wilderness versus garden and nomad versus settler; the first pair precedes the second in time. Thus, in *Wagonmaster*, the Mormons cross the desert in search of their future home; in *How Green Was My Valley* and *The Informer*, the protagonists want to cross the Atlantic to a future home in the United States. But, during Ford's career, the situation of home is reversed in time. In *Cheyenne Autumn* the Indians journey in search of the home they once had in the past; in *The Quiet Man*, the American Sean Thornton returns to his ancestral home in Ireland. Ethan Edwards's journey is a kind of parody of this theme: his object is not constructive, to found a home, but destructive, to find and scalp Scar. Nevertheless, the weight of the film remains orientated to the future: Scar has burned down the home of the settlers, but it is replaced and we are confident that the homesteader's wife, Mrs Jorgensen, is right when she says: 'Some day this country's going to be a fine place to live.' The wilderness will, in the end, be turned into a garden.

The Man Who Shot Liberty Valance has many similarities with *The Searchers*. We may note three: the wilderness becomes a garden—this is made quite explicit, for Senator Stoddart has wrung from Washington the funds necessary to build a dam which will irrigate the desert and bring real roses, not cactus roses; Tom Doniphon shoots Liberty Valance as Ethan Edwards scalped Scar; a log-home is burned to the ground. But the differences are equally clear: the log-home is burned after the death of Liberty Valance; it is destroyed by Doniphon himself; it is his own home. The burning marks the realisation that he will never enter the Promised Land, that to him it means nothing; that he has doomed himself to be a creature of the past, insignificant in the world of the future. By shooting Liberty Valance he has destroyed the only world in which he himself can exist, the world of the gun rather than the book; it is as though Ethan Edwards has perceived that by scalping Scar, he was in reality committing suicide. It might be mentioned too that, in *The Man Who Shot Liberty Valance*, the woman who loves Doniphon marries Senator Stoddart. Doniphon when he destroys his log-house (his last words before doing so are 'Home, sweet home!') also destroys the possibility of marriage.

The themes of *The Man Who Shot Liberty Valance* can be expressed in another way. Ransom Stoddart represents rational-legal authority, Tom Doniphon represents charismatic authority. Doniphon abandons his charisma and cedes it, under what amounts to false pretences, to Stoddart. In this way charismatic and rational-legal authority are combined in the person of Stoddart and stability thus assured. In *The Searchers* this transfer does not take place; the two kinds of authority remain separated. In *My Darling Clementine* they are combined naturally in Wyatt Earp, without any transfer being necessary. In many of Ford's late films—*The Quiet Man, Cheyenne Autumn, Donovan's Reef*—the accent is placed on traditional authority. The island of Ailakaowa, in *Donovan's Reef*, a kind of Valhalla for the homeless heroes of *The Man Who Shot Liberty Valance*, is actually a monarchy, though complete with the Boston girl, wooden church, and saloon made familiar by *My Darling Clementine*. In fact, the character of Chihuahua, Doc Holliday's girl in *My Darling Clementine*, is split into two: Miss Lafleur and Lelani, the native princess. One represents the saloon entertainer, the other the non-American in opposition to the respectable Bostonians,

Amelia Sarah Dedham and Clementine Carter. In a broad sense, this is a part of a general movement which can be detected in Ford's work to equate the Irish, Indians, and Polynesians as traditional communities, set in the past, counterposed to the march forward to the American future, as it has turned out in reality, but assimilating the values of the American future as it was once dreamed.

It would be possible, I have no doubt, to elaborate on Ford's career, as defined by pairs of contrasts and similarities, in very great detail, though—as always with film criticism—the impossibility of quotation is a severe handicap. My own view is that Ford's work is much richer than that of Hawks and that this is revealed by a structural analysis; it is the richness of the shifting relations between antinomies in Ford's work that makes him a great artist, beyond being simply an undoubted *auteur*. Moreover, the *auteur* theory enables us to reveal a whole complex of meaning in films such as *Donovan's Reef*, which a recent filmography sums up as just 'a couple of Navy men who have retired to a South Sea island now spend most of their time raising hell.' Similarly, it throws a completely new light on a film like *Wings of Eagles*, which revolves, like *The Searchers*, round the vagrancy versus home antinomy, with the difference that when the hero does come home, after flying round the world, he trips over a child's toy, falls down the stairs and is completely paralysed so that he cannot move at all, not even his toes. This is the macabre *reductio ad absurdum* of the settled.

Perhaps it would be true to say that it is the lesser *auteurs* who can be defined, as Nowell-Smith put it, by a core of basic motifs which remain constant, without variation. The great directors must be defined in terms of shifting relations, in their singularity as well as their uniformity. Renoir once remarked that a director spends his whole life making one film; this film, which it is the task of the critic to construct, consists not only of the typical features of its variants, which are merely its redundancies, but of the principle of variation which governs it, that is its esoteric structure, which can only manifest itself or 'seep to the surface', in Lévi-Strauss's phrase, 'through the repetition process'. Thus Renoir's 'film' is in reality a 'kind of permutation group, the two variants placed at the far ends being in a symmetrical, though inverted, relationship to each other.' In practice, we will not find perfect symmetry, though as we have seen, in the case of Ford, some antinomies are completely reversed. Instead, there will be a kind of torsion within the permutation group, within the matrix, a kind of exploration of certain possibilities, in which some antinomies are foregrounded, discarded, or even inverted, whereas others remain stable and constant. The important thing to stress, however, is that it is only the analysis of the whole *corpus* which permits the moment of synthesis when the critic returns to the individual film.

Of course, the director does not have full control over his work; this explains why the *auteur* theory involves a kind of decipherment, decryptment. A great many features of films analysed have to be dismissed as indecipherable because of 'noise' from the producer, the cameraman, or even the actors. This concept of 'noise' needs further elaboration. It is often said that a film is the result of a multiplicity of factors, the sum total of a number of different contributions. The contribution of the director—the 'directorial factor', as it were—is only one of these, though perhaps the one which carries the most weight. I do not need to emphasize that this view is quite the contrary of the *auteur* theory and has nothing in common with it at all. What the

*auteur* theory does is to take a group of films—the work of one director—and analyse their structure. Everything irrelevant to this, everything non-pertinent, is considered logically secondary, contingent, to be discarded. Of course, it is possible to approach films by studying some other feature; by an effort of critical ascesis we could see films, as Von Sternberg sometimes urged, as abstract light-show or as histrionic feasts. Sometimes these separate texts—those of the cameraman or the actors—may force themselves into prominence so that the film becomes an indecipherable palimpsest. This does not mean, of course, that it ceases to exist or to sway us or please us or intrigue us; it simply means that it is inaccessible to criticism. We can merely record our momentary and subjective impressions.

Myths, as Lévi-Strauss has pointed out, exist independently of style, the syntax of the sentence, or musical sound, euphony or cacophony. The myth functions 'on an especially high level where meaning succeeds practically in *"taking off"* from the linguistic ground on which it keeps rolling.' *Mutatis mutandis*, the same is true of the *auteur* film. 'When a mythical schema is transmitted from one population to another, and there exist differences of language, social organization, or way of life which make the myth difficult to communicate, it begins to become impoverished and confused.' The same kind of impoverishment and confusion takes place in the film studio, where difficulties of communication abound. But none the less the film can usually be discerned, even if it was a quickie made in a fortnight without the actors or the crews that the director might have liked, with an intrusive producer and even, perhaps a censor's scissors cutting away vital sequences. It is as though a film is a musical composition rather than a musical performance, although, whereas a musical composition exists *a priori* (like a scenario), an *auteur* film is constructed *a posteriori*. Imagine the situation if the critic had to construct a musical composition from a number of fragmentary, distorted versions of it, all with improvised passages or passages missing. . . .

What the *auteur* theory demonstrates is that the director is not simply in command of a performance of a pre-existing text; he is not, or need not be, only a *metteur en scène*. Don Siegel was asked on television what he took from Hemingway's short story for his film, *The Killers*; Siegel replied that 'the only thing taken from it was the catalyst that a man has been killed by somebody and he did not try to run away.' The word Siegel chose—'catalyst'—could not be bettered. Incidents and episodes in the original screenplay or novel can act as catalysts; they are the agents which are introduced into the mind (conscious or unconscious) of the *auteur* and react there with the motifs and themes characteristic of his work. The director does not subordinate himself to another author; his source is only a pretext, which provides catalysts, scenes which fuse with his own preoccupations to produce a radically new work. Thus the manifest process of performance, the treatment of a subject, conceals the latent production of a quite new text, the production of the director as an *auteur*.

Of course, it is possible to value performances as such, to agree with André Bazin that Olivier's *Henry V* was a great film, a great rendering, transposition into the cinema, of Shakespeare's original play. The great *metteurs en scène* should not be discounted simply because they are not *auteurs*: Vincente Minnelli, perhaps, or Stanley Donen. And, further than that, the same kind of process can take place that occurred in painting: the director can deliberately concentrate entirely on the stylistic and

expressive dimensions of the cinema. He can say, as Josef Von Sternberg did about *Morocco*, that he purposely chose a fatuous story so that people would not be distracted from the play of light and shade in the photography. Some of Busby Berkeley's extraordinary sequences are equally detached from any kind of dependence on the screenplay: indeed, more often than not, some other director was entrusted with the job of putting the actors through the plot and dialogue. Moreover, there is no doubt that the greatest films will be not simply *auteur* films but marvellous expressively and stylistically as well: *Lola Montès, Shinheike Monogatari, La Règle du Jeu, La Signora di Tutti, Sansho Dayu, Le Carrosse d'Or.*

The *auteur* theory leaves us, as every theory does, with possibilities and questions. We need to develop much further a theory of performance, of the stylistic, of graded rather than coded modes of communication. We need to investigate and define, to construct critically the work of enormous numbers of directors who up to now have only been incompletely comprehended. We need to begin the task of comparing author with author. There are any number of specific problems which stand out: Donen's relationship to Kelly and Arthur Freed, Boetticher's films outside the Ranown cycle. Welles's relationship to Toland (and—perhaps more important—Wyler's), Sirk's films outside the Ross Hunter cycle, the exact identity of Walsh or Wellman, the decipherment of Anthony Mann. Moreover there is no reason why the *auteur* theory should not be applied to the English cinema, which is still utterly amorphous, unclassified, unperceived. We need not two or three books on Hitchcock and Ford, but many, many more. We need comparisons with authors in the other arts: Ford with Fenimore Cooper, for example, or Hawks with Faulkner. The task which the critics of *Cahiers du Cinéma* embarked on is still far from completed.

1969

. . . At this point, it is necessary to say something about the *auteur* theory since this has often been seen as a way of introducing the idea of the creative personality into the Hollywood cinema. Indeed, it is true that many protagonists of the *auteur* theory do argue in this way. However, I do not hold this view and I think it is important to detach the *auteur* theory from any suspicion that it simply represents a 'cult of personality' or apotheosis of the director. To my mind, the *auteur* theory actually represents a radical break with the idea of an 'art' cinema, not the transplant of traditional ideas about 'art' into Hollywood. The 'art' cinema is rooted in the idea of creativity and the film as the expression of an individual vision. What the *auteur* theory argues is that any film, certainly a Hollywood film, is a network of different statements, crossing and contradicting each other, elaborated into a final 'coherent' version. Like a dream, the film the spectator sees is, so to speak, the 'film façade', the end-product of 'secondary revision', which hides and masks the process which remains latent in the film 'unconscious'. Sometimes this 'façade' is so worked over, so smoothed out, or else so clotted with disparate elements, that it is impossible to see beyond it, or rather to see anything in it except the characters, the dialogue, the plot, and so on. But in other cases, by a process of comparison with other films, it is possible to decipher, not a coherent message or world-view, but a structure which underlies the film and shapes it, gives it a certain pattern of energy cathexis. It is this structure which *auteur* analysis disengages from the film.

The structure is associated with a single director, an individual, not because he has played the role of artist, expressing himself or his own vision in the film, but because it is through the force of his preoccupations that an unconscious, unintended meaning can be decoded in the film, usually to the surprise of the individual involved. The film is not a communication, but an artefact which is unconsciously structured in a certain way. *Auteur* analysis does not consist of retracing a film to its origins, to its creative source. It consists of tracing a structure (not a message) within the work, which can then *post factum* be assigned to an individual, the director, on empirical grounds. It is wrong, in the name of a denial of the traditional idea of creative subjectivity, to deny any status to individuals at all. But Fuller or Hawks or Hitchcock, the directors, are quite separate from 'Fuller' or 'Hawks' or 'Hitchcock', the structures named after them, and should not be methodologically confused. There can be no doubt that the presence of a structure in the text can often be connected with the presence of a director on the set, but the situation in the cinema, where the director's primary task is often one of coordination and rationalisation, is very different from that in the other arts, where there is a much more direct relationship between artist and work. It is in this sense that it is possible to speak of a film *auteur* as an unconscious catalyst.

However, the structures discerned in the text are often attacked in another way. Robin Wood, for example, has argued that the '*auteur*' film is something like a Platonic Idea. It posits a 'real' film, of which the actual film is only a flawed transcript, while the archi-film itself exists only in the mind of the critic. This attack rests on a misunderstanding. The main point about the Platonic Idea is that it predates the empirical reality, as an archetype. But the '*auteur*' film (or structure) is not an archi-film at all in this sense. It is an explanatory device which specifies partially how any individual film works. Some films it can say nothing or next-to-nothing about at all. *Auteur* theory cannot simply be applied indiscriminately. Nor does an *auteur* analysis exhaust what can be said about any single film. It does no more than provide one way of decoding a film, by specifying what its mechanics are at one level. There are other kinds of code which could be proposed, and whether they are of any value or not will have to be settled by reference to the text, to the films in question.

Underlying the anti-Platonic argument, however, there is often a hostility towards any kind of explanation which involves a degree of distancing from the 'lived experience' of watching the film itself. Yet clearly any kind of serious critical work—I would say scientific, though I know this drives some people into transports of rage— must involve a distance, a gap between the film and the criticism, the text and the meta-text. It is as though meteorologists were reproached for getting away from the 'lived experience' of walking in the rain or sunbathing. Once again, we are back with the myth of transparency, the idea that the mark of a good film is that it conveys a rich meaning, an important truth, in a way which can be grasped immediately. If this is the case, then clearly all the critic has to do is to describe the experience of watching the film, reception of a signal, in such a way as to clear up any little confusions or enigmas which still remain. The most that the critic can do is to put the spectator on the right wavelength so that he can see for himself as clearly as the critic, who is already tuned in.

The *auteur* theory, as I conceive it, insists that the spectator has to work at reading the text. With some films this work is wasted, unproductive. But with others it is not. In these cases, in a certain sense, the film changes, it becomes another film—as far as experience of it is concerned. It is no longer possible to look at it 'with the same eyes'. There is no integral, genuine experience which the critic enjoys and which he tries to guide others towards. Above all, the critic's experience is not essentially grounded in or guaranteed by the essence of the film itself. The critic is not at the heart of the matter. The critic is someone who persists in learning to see the film differently and is able to specify the mechanisms which make this possible. This is not a question of 'reading in' or projecting the critic's own concerns in to the film; any reading of a film has to be justified by an explanation of how the film itself works to make this reading possible. Nor is it the single reading, the one which gives us the true meaning of the film; it is simply a reading which produces more meaning.

Again, it is necessary to insist that since there is no true, essential meaning there can therefore be no exhaustive criticism, which settles the interpretation of a film once and for all. Moreover, since the meaning is not contained integrally in any film, any decoding may not apply over the whole area of it. Traditional criticism is always seeking for the comprehensive code which will give the complete interpretation, covering every detail. This is a wild goose chase, in the cinema, above all, which is a collective form. Both Classical and Romantic aesthetics hold to the belief that every detail should have a meaning—Classical aesthetics because of its belief in a common, universal code; Romantic aesthetics because of its belief in an organic unity in which every detail reflects the essence of the whole. The *auteur* theory argues that any single decoding has to compete, certainly in the cinema, with noise from signals coded differently. Beyond that, it is an illusion to think of any work as complete in itself, an isolated unity whose intercourse with other films, other texts, is carefully controlled to avoid contamination. Different codes may run across the frontiers of texts at liberty, meet and conflict within them. This is how language itself is structured, and the failure of linguistics, for instance, to deal with the problem of semantics, is exemplified in the idea that to the unitary code of grammar (the syntactic component of language) there must correspond a unitary semantic code, which would give a correct semantic interpretation of any sentence. Thus the idea of 'grammaticality' is wrongly extended to include a quite false notion of 'semanticity'. In fact, no headway can be made in semantics until this myth is dispelled.

The *auteur* theory has important implications for the problem of evaluation. Orthodox aesthetics sees the problem in predictable terms. The 'good' work is one which has both a rich meaning and a correspondingly complex form, wedded together in a unity (Romantic) or isomorphic with each other (Classical). Thus the critic, to demonstrate the value of a work, must be able to identify the 'content', establish its truth, profundity, and so forth, and then demonstrate how it is expressed with minimum loss or leakage in the signals of the text iself, which are patterned in a way which gives coherence to the work as a whole. 'Truth' of content is not envisaged as being like scientific truth, but more like 'human' truth, a distillation of the world of human experience, particularly interpersonal experience. The world itself is an untidy place, full of loose ends, but the artefact can tie all these loose ends together and thus

convey to us a meaningful truth, an insight, which enables us to go back to the real world with a reordered and recycled experience which will enable us to cope better, live more fully, and so on. In this way art is given a humanistic function, which guarantees its value.

All this is overthrown when we begin to see loose ends in works of art, to refuse to acknowledge organic unity or integral content. Moreover, we have to revise our whole idea of criteria, of judgement. The notion behind criteria is that they are timeless and universal. They are then applied to a particular work and it is judged accordingly. This rigid view is varied to the extent that different criteria may apply to different kinds of works or that slightly different criteria may reflect different points of view or kinds of experience, though all are rooted in a common humanity. But almost all current theories of evaluation depend on identifying the work first and then confronting it with criteria. The work is then criticised for falling short on one score or another. It is blemished in some way. Evidently, if we reject the idea of an exhaustive interpretation, we have to reject this kind of evaluation. Instead, we should concentrate on the *productivity* of the work. This is what the 'modern movement' is about. The text, in Octavio Paz's words, is something like a machine for producing meaning. Moreover, its meaning is not neutral, something to be simply absorbed by the consumer.

The meaning of texts can be destructive—of the codes used in other texts, which may be the codes used by the spectator or the reader, who thus finds his own habitual codes threatened, the battle opening up in his own reading. In one sense, everybody knows this. We know that *Ulysses* or *Finnegans Wake* are destructive of the nineteenth-century novel. But it seems difficult to admit this destructiveness into court when judgements are to be made. We have to. To go to the cinema, to read books, or to listen to music is to be a partisan. Evaluation cannot be impartial. We cannot divorce the problem of codes from the problem of criteria. We cannot be passive consumers of films who then stand back to make judgements from above the fray. Judgements are made in the process of looking or reading. There is a sense in which to reject something as unintelligible is to make a judgement. It is to refuse to use a code. This may be right or wrong, but it is not the same thing as decoding a work before applying criteria. A valuable work, a powerful work at least, is one which challenges codes, overthrows established ways of reading or looking, not simply to establish new ones, but to compel an unending dialogue, not at random but productively. . . .

1972

# RICHARD B. JEWELL
## HOW HOWARD HAWKS BROUGHT *BABY* UP: AN *APOLOGIA* FOR THE STUDIO SYSTEM

When the merging of studios, exchanges and theaters into a few large corporations, and the extravagances of the "out-spending" era, had brought an end to the independent production, the inelastic methods of bureaucracy replaced the loose practices of democracy in picture making. Now a new idea, instead of having to win the "O.K." of one autocrat of a little kingdom, had to run the gauntlet of editorial boards, production committees, and conferences of various sorts. A multitude of alleged experts awaited the fellow with the new thought, and when his innovation had completed the circuit of the studio's intricate system there was seldom a trace of originality left in it. The sharp shears and heavy smoothing-irons of the experts had transformed the wild, crazy idea to one of the rigid patterns in favor, at the time, with the studio head and his yes-men and yes-women.

<div align="right">BENJAMIN B. BAMPTON, 1931</div>

Production methods under this rigid system became mechanized: the "assembly line" appeared in Hollywood. The resulting standardization of pictures caused the downfall of the most important directors during the late twenties. The various branches of production were divided and specialized so specifically and minutely that directors had a lessening opportunity to contribute to the whole. Most directors became "glorified foremen" under the producer-supervisors.

<div align="right">LEWIS JACOBS, 1939</div>

Many books and articles dealing with the American cinema have been written since Benjamin Hampton and Lewis Jacobs completed their pioneering studies in the 1930s. Yet the basic descriptions which these two men applied to the studio system, and the general hostility which they expressed toward it, still predominate in contemporary scholarship. No fewer than six recent and major books utilize Jacobs's "factory" and "assembly-line" analogies in their discussions of Hollywood's major studios. Although most qualify their assessments to some extent, the authors of these books tend to agree with Hampton and Jacobs that the studios were bureaucratic,

1

582            THE FILM ARTIST

impersonal, conservative, rigidly structured, and antagonistic to technical innovation and artistic achievement. Men and women of taste, intelligence, and imagination are often portrayed as being destroyed by this system—either squandering their talents by producing the formulaic, escapist entertainment demanded by the system, or rebelling against it, only to be crushed (e.g., Von Stroheim) by its steamrolling, assembly-line operations.

The authors often find themselves with a major predicament when they move beyond these general evaluations of the studios to more specific discussions of the filmmakers who worked for them. The writers admire the works of many of these directors, so they are faced with explaining how their favorites could make exemplary films within such a restrictive organizational structure. Here is one representative attempt to reconcile the contradiction:

> These Hollywood directors worked under studio rule, presumably as journeymen employees involved in the mass production of popular entertainment. They were assigned a script rather than choosing one. They were given a cast of performers and told by a producer to shoot the film in so many days. . . . Yet despite all these restrictions and enforced collaborations, somehow these directors, over the years, managed to make films which were stamped with their particular vision.

This type of argument is wonderfully romantic. It conjures up visions of an elite cadre of auteur supermen bending an iron-clad system to their wills or, at the very least, of a slippery band of Houdinis able to wriggle out of their studio straitjackets and "be free." Unfortunately, the explanation does not provide a clue as to how the directors managed these feats of creative hocus-pocus.

The recent availability of studio records—dusty and unmagical though they may be—will help fill in many important gaps in Hollywood scholarship and provide some specific answers to the studio versus auteur dilemma. By studying the production histories of individual films, we gain a more complete understanding of how the studios actually functioned and how auteur directors managed to protect and project their styles and visions while employed by the studios.

My test case is *Bringing Up Baby,* the screwball comedy par excellence, directed by Howard Hawks and released by RKO Radio Pictures in 1938. The story of the making of *Baby* has been pieced together from files in RKO's West Coast archive.

In order to understand how this comedic treasure came to be produced, it is necessary to flash back to late 1935, when Samuel Briskin took charge of production at RKO. Briskin was brought from Columbia to RKO by Leo Spitz, the company's newly appointed corporate president. Although in receivership at the time, RKO was holding its own. *Roberta, Alice Adams, The Informer,* and *Top Hat* had been released in 1935, and each had received excellent critical notices and performed well at the box office. These films were the product of a unit production system overseen by B. B. Kahane and J. R. McDonough—two executives who allowed their staff producers to handle their pictures with minimal supervision or interference from the front office.

Despite the fine results generated by the system, Spitz followed a well-established principle of corporate management and brought in his "own man" to superintend the studio's filmmaking activities. Sam Briskin had developed a reputation as a tough, stubborn, aggressive executive at Columbia. He was, in the words of Frank Capra, a

"hit-first type." Highly ambitious, Briskin must have been delighted to be the top man at RKO after laboring in Harry Cohn's shadow for many years. Briskin's initial move as production chief was to do precisely what Leo Spitz had done—recruit his own staff. By mid-1936, Edward Small, Jesse Lasky, and Howard Hawks were members of the Briskin team, developing projects which he hoped would become hits and strengthen his position at RKO.

Producer-director Hawks was given an exclusive two-year contract that called for a salary of $2500 per week, plus a percentage of the profits from his pictures. The first project to interest him was *Gunga Din*. Staff producer Edward Small had brought the rights to the famous Kipling poem with him to RKO and, after some negotiations, agreed to turn the property over to Hawks for development. Hawks, in turn, interested one of the top writing teams in Hollywood, Ben Hecht and Charles MacArthur, in doing the script, and all three went to New York to work on it. There the writing proceeded at a very leisurely pace; this exasperated Briskin, who periodically informed the threesome of his impatience, but he was powerless to speed them along. Hawks did inform his employer that the story would require three virile male leads, so Briskin began putting out feelers to other studios, hoping to borrow the right stars since RKO had no suitable prospects under contract.

In April 1937, the Hecht-MacArthur script was ready, but Sam Briskin was not. He had failed to convince Louis B. Mayer to lend him Clark Gable, Spencer Tracy, and Franchot Tone, and Ronald Colman had also refused to do the picture. Briskin had no choice but to put *Gunga Din* on the shelf until an appropriate cast could be secured. He, therefore, instructed Hawks to develop something else.

By this time, Howard Hawks had been working for RKO for more than a year without shooting a single frame of film. This reflected negatively on Briskin; a production head's job was to turn out a steady stream of commercially successful pictures, not to pay big salaries to directors who were not making a contribution. Although Briskin might grumble about the length of time required to complete the *Gunga Din* script, he knew that Hawks was not to blame for its postponement. Still, he needed a Hawks film and he needed a good one, for his RKO tenure was not developing as he had hoped. The films made by Briskin's other handpicked producers had, by and large, been an undistinguished and unprofitable lot.

In addition, Sam Briskin had a crucial star problem to solve. Katharine Hepburn had been considered RKO's top female performer when Briskin joined RKO. Beginning with *Sylvia Scarlett,* the studio's first release of 1936, Miss Hepburn had appeared in one flop after another, thereby tarnishing her box office image and diminishing RKO's star roster. This was much more upsetting than the Hawks situation because, compared to its major competitors, RKO was sadly lacking in star power. Since a company sold its product blocks largely by promising to deliver a certain number of films featuring public favorites, it was considered imperative to boost Hepburn back to the lofty position she had once occupied in the show business hierarchy.

Miss Hepburn did not come to mind immediately when Hawks informed Briskin in May that he wished to make a film based on a *Collier's* magazine story entitled "Bringing Up Baby." The RKO story departments had recommended "Baby" for purchase in April, and its head, Robert Sparks, had encouraged Briskin to hire the story's author, Hagar Wilde. Briskin, however, had shown no interest until Hawks made his decision.

Then everything changed. Dudley Nichols, one of RKO's top writers, went to work on the story with Hawks, Miss Wilde was brought out from the East to collaborate with the director and screenwriter, and, in short order, a decision was made to star Katharine Hepburn. The role of daffy socialite Susan Vance would be unlike any part she had played before; perhaps the public would embrace this new Hepburn persona.

The writing continued through the summer of 1937. While Nichols and Wilde developed the script, Briskin and Hawks hunted for the right male lead. Fredric March, Ray Milland, Fred MacMurray, and Leslie Howard were considered before Cary Grant won the job. Grant and Hepburn had worked together before in *Sylvia Scarlett*.

Budget was a matter of special concern to Sam Briskin. Realizing that public hostility to Katharine Hepburn was real enough, at least for the moment, he calculated that *Bringing Up Baby* had little chance of making a profit if it cost much more than a half million dollars. He told Hawks that the script should be prepared so that $600,000 would be the absolute maximum expenditure. Despite this admonition, the director and his writers gave their imaginations free rein. The first estimating script weighed in at a hefty 242 pages, the revised draft at 194 pages, and the final shooting script at 202 pages. Given a certain amount of "overwriting," this still represented a mammoth amount of material. By the time the film was ready to go before the cameras, the budget had been estimated at $767,000 for a fifty-one-day shooting schedule.

Briskin now had three apparent options. He could scrap the film altogether because of the excessive cost; postpone it until script and budget could be brought into line; or allow it to go forward, but instruct Hawks that he must prune the script so that the film would cost no more than $600,000. In reality, the latter was the only viable option. Briskin could not afford to cancel the project for several reasons, including the money that had already been invested in it (Hawks's salary, the writers' salaries, set construction costs, etc.) and the company's need to provide exhibitors with "A" pictures. He could not postpone the film either, because of the nature of the studio commitment system, which, for example, gave RKO the services of Cary Grant for a limited period of time. If Grant were not used during that time, RKO lost him but had to pay his salary anyway.

Therefore, Briskin reluctantly gave Hawks the go-ahead, hoping the director would find a way to whittle down the script and budget. Briskin had become a truly beleaguered executive by this time. His major productions (*The Woman I Love, New Faces of 1937,* and *The Toast of New York*) had proved to be highly disappointing, and he had had more difficulty meeting release schedules than any previous RKO production head. When a company's distribution network promised a film to its most important customers on a certain date and then failed to deliver the picture as promised, it caused shock waves throughout the entire corporate system. Publicity and advertising were disrupted, a mad scramble ensued to find an adequate filler picture, and the film in question often entered the marketplace at a less-than-opportune release time. Most important, the situation damaged the credibility of the studio itself, making exhibitors wary of buying blocks of films from the company in the future.

Briskin definitely needed a breakthrough film to release the pressure that was building against him, and he must have felt that *Bringing Up Baby* could be that film.

*Baby* did not even have to be a blockbuster; it would be enough if it returned Katharine Hepburn to public favor, thus breathing life into RKO's moribund star contingent.

Howard Hawks certainly understood all this. He realized that a great deal was riding on *Bringing Up Baby,* and he also realized that, politically speaking, he occupied the true position of power. About six weeks before the film went into production, Briskin's assistant Lou Lusty sent the following memo to his boss. It serves both to confirm the basic auteur contentions about Hawks and to reveal how a cagey director could manipulate the system.

> I know, because the gentleman has said so in so many words that he's only concerned with making a picture that will be a personal credit to Mr. Hawks regardless of its cost— and your [Briskin's] telling him the other day that it would be suicidal to make a Hepburn picture for seven or eight hundred thousand dollars I know made no impression on him at all. . . . Hawks is determined in his own quiet, reserved, soft-spoken manner to have his way about the making of this picture. . . . With the salary he's been getting he's almost indifferent to anything that might come to him on a percentage deal—that's why he doesn't give a damn about how much the picture will cost to make—and you know so well that you couldn't even break even if a Hepburn show cost eight hundred grand. All the directors in Hollywood are developing producer-director complexes and Hawks is going to be particularly difficult.

Shooting commenced on September 27, 1937. In order to protect the studio's interests, Briskin assigned an associate producer to the film. The man chosen was Cliff Reid, a veteran who had worked in the same capacity on John Ford's award-winning RKO film *The Informer.* Reid's job was to "remind" Hawks that the script had to be cut and to make sure the production ran smoothly and efficiently. Reid, however, turned out to be something of a pushover. Disregarding the pressure from both Reid and Briskin, Hawks proceeded at a deliberate pace. Every day the dialogue would be rewritten on the set, causing the company to shoot less than the production department had estimated. Katharine Hepburn had some difficulty learning how to play screwball comedy, so Hawks introduced her to Walter Catlett, who tutored her throughout the rest of the production. Hepburn also missed seven full days due to illness, and Hawks never got around to removing anything from the script. For these and other reasons, the picture quickly fell behind schedule. It soon became obvious that it would go beyond its projected date of completion and exceed its already excessive budget estimate.

These facts did not elude Leo Spitz or the RKO board of directors. A little over one month into the production, Briskin was forced to resign. Although certainly not the sole reason, the chronicle of *Bringing Up Baby* was a factor in Briskin's departure. Production reports indicate that the shooting pace slackened even more after Briskin left. The major question at this point is why RKO did not simply fire Hawks and turn the film over to someone else. One can only speculate, though the reasons seem obvious: the insertion of a new director, who was unfamiliar with both the story and its treatment, would have caused confusion and resentment on the part of cast and crew and, quite probably, have slowed things down even more. It might also have ruined the picture altogether.

Hawks went on working past the November date when the original schedule indicated completion, beyond the holidays and into the new year. Finally, on January 8,

1938, the shooting was completed. The original, fifty-one-day schedule had bal-
looned to ninety-three days, and the final budget amounted to $1,073,000.

The aftermath was fairly predictable. *Bringing Up Baby* was released to mixed
critical notices and average box office business. It did not seem to do much for
Katharine Hepburn's career either. Briskin proved to be right in his prediction that a
Hepburn film costing more than $700,000 could not make a profit. The final RKO loss
on *Baby* amounted to $365,000. It also turned out to be Hepburn's last RKO picture.
After a loan-out to Columbia for *Holiday,* she returned to her home studio, refused to
appear in *Mother Carey's Chickens,* and was released from her contract. The RKO
braintrust were convinced that she was washed up, but she would prove them wrong
at MGM, beginning in 1940.

Likewise, Hawks found himself out of a job. *Gunga Din* had been reactivated while
*Bringing Up Baby* was shooting. Knowing that it would be a much more ambitious
and complicated picture than *Baby,* new executive producer Pandro Berman decided
to turn it over to a more reliable director: George Stevens. (Ironically, Stevens devel-
oped his own perfectionist qualities on *Gunga Din,* which went $700,000 over
budget.) Hawks's brother and agent, William, was called into the studio and informed
that Howard would be terminated. The director was upset by this—not because he
would be giving up his $2500 weekly salary but because he would not have an oppor-
tunity to direct *Gunga Din,* which was precisely the type of male adventure saga he
loved best. Nevertheless, his contract was canceled upon payment of $40,000 sever-
ance money.

It might seem that the system had prevailed over Hawks after all, since he was now
branded as profligate and undependable and was out of a job. But, of course, the sys-
tem was much larger than RKO Radio Pictures; within a short time, Hawks was back
at work at Columbia on *Only Angels Have Wings.* It is important to note that that pic-
ture and Hawks's next effort, *His Girl Friday,* both starred Cary Grant. Hawks and
Grant had obviously established a solid working relationship on *Bringing Up Baby,*
which suggests that Hawks had actually increased his industry clout on *Baby,* rather
than decreasing it. In addition to making memorable comedy, he had forged an
alliance with a star whose career was rising rapidly. If Cary Grant wanted to work
with Howard Hawks, Hawks's pictures would be made by one studio or another.

Now that we have surveyed the making of *Bringing Up Baby,* I would like to offer
the following modest proposals:

The time has come to dispense with the assembly-line analogy for studio produc-
tion. Although the moguls no doubt wished their operations could be as efficient and
predictable as those of a Ford plant, their product mitigated against standardization.*
It is true, of course, that the production history of *Bringing Up Baby* is not typical;
the film resulted from a special set of circumstances which enabled its director to con-
trol the picture more completely than would normally have been the case. Still, the

---

*Even at the "B" level, where production elements were more strictly controlled than at the "A" level,
the "assembly-line" conception is inaccurate. The creative team that worked on the Val Lewton films at
RKO, for example, had ample leeway to develop a new strain of psychologically penetrating horror films.
Their budgets were limited, but, otherwise, their innovative efforts were unencumbered by studio policies
and procedures.

departmental structures and operating methods of studios never turned filmmaking into a conveyor-belt business. Most pictures presented special problems which could not have been solved by inflexible, factory-inspired methods.

Leo Rosten, who studied the studio system when it was at its peak, has described it very well:

> Movie making is not a systematized process in which ordered routine can prevail, or in which costs can be absolute and controlled. Too many things can and do go awry, every day, every hour, during the manufacture of a movie. Movies are made by ideas and egos, not from blueprints and not with machines. Every story offers fresh and exasperating problems; every actor, director, writer carries within him curious preferences and needs; and the omnipresent hand of a mutable public throws sudden switches in the traffic of ideas through which the making of movies flows. The movie business moves with relentless speed, change is of the essence, and Hollywood must respond to change with short-spanned flexibility.

Unfortunately, most scholars have preferred the depersonalized studio characterizations of Hampton and Jacobs to the somewhat nebulous, but more accurate, depiction of Rosten.

The power and influence of the movie industry's "A"-level talent during the studio years have been seriously underestimated. The conception of the artist as corporate slave was fueled by periodic tirades against the moguls and their methods. One need only recall Frank Capra's 1939 letter to the *New York Times* in which he claimed that "80% of the directors today shoot scenes exactly as they are told to shoot them without any changes whatsoever, and . . . 90% of them have no voice in the story or in the editing" or Bette Davis's well-publicized battles to prevent Jack Warner from forcing her to appear in mediocre pictures. Nevertheless, studio records contradict the impressions produced by these and other angry outbursts against the system. Most major actors and actresses could and did turn down parts they did not like (even at Warner Brothers), and it was normal for "A" directors to have considerable freedom in their choice of material, to work with writers on the preparation of the script, to have the strongest voice in casting decisions, and to be left alone when they were directing the film. These basic conventions might be breached if a picture went widely over budget or if the studio executive felt the footage was no good. Still, as in the case of *Bringing Up Baby,* a studio rarely fired a director or halted production, even if the film did run over in both time and money.

The last proposal is for an open-minded reevaluation of the system itself and of each individual studio. There is more scholarly work to be done if we are to move beyond the one-sided generalizations that prevail in the current literature. We need, first of all, to recognize the complexity of these organizations. It is wrong to lump MGM, Paramount, Warner Brothers, Twentieth Century-Fox, RKO, and, oftentimes, Columbia, Universal, and United Artists together and treat them as if they were carbon copies of one another. Each of these companies had its own special characteristics, and each underwent significant changes during the studio system era. Each was a world unto itself with its own ways of making movies and making money. It is also time that we recognize the intrinsic genius of the system. There were both sound business sense and artistic advantage in the assembling of a diverse group of specialists under one umbrella structure. These talented individuals were able to grow and learn

and work together in ways that enriched them all, as well as the capitalistic organizations they served.

A modern systems analyst studying the old Hollywood studios would certainly find them grossly inefficient and honeycombed with flaws. Ironically, these very weaknesses enabled the studios' more imaginative employees to make pictures that are still studied and appreciated today. The studios have taken enough punishment; we should give them a second look, recognizing that they may represent the best system for commercial filmmaking thus far developed in world cinema.

1984

# ROLAND BARTHES
## THE FACE OF GARBO

Garbo still belongs to that moment in cinema when capturing the human face still plunged audiences into the deepest ecstasy, when one literally lost oneself in a human image as one would in a philtre, when the face represented a kind of absolute state of the flesh, which could be neither reached nor renounced. A few years earlier the face of Valentino was causing suicides; that of Garbo still partakes of the same rule of Courtly Love, where the flesh gives rise to mystical feelings of perdition.

It is indeed an admirable face-object. In *Queen Christina*, a film which has again been shown in Paris in the last few years, the make-up has the snowy thickness of a mask: it is not a painted face, but one set in plaster, protected by the surface of the colour, not by its lineaments. Amid all this snow at once fragile and compact, the eyes alone, black like strange soft flesh, but not in the least expressive, are two faintly tremulous wounds. In spite of its extreme beauty, this face, not drawn but sculpted in something smooth and friable, that is, at once perfect and ephemeral, comes to resemble the flour-white complexion of Charlie Chaplin, the dark vegetation of his eyes, his totem-like countenance.

Now the temptation of the absolute mask (the mask of antiquity, for instance) perhaps implies less the theme of the secret (as is the case with Italian half mask) than that of an archetype of the human face. Garbo offered to one's gaze a sort of Platonic Idea of the human creature, which explains why her face is almost sexually undefined, without however leaving one in doubt. It is true that this film (in which Queen Christina is by turns a woman and a young cavalier) lends itself to this lack of differentiation; but Garbo does not perform in it any feat of transvestism; she is always herself, and carries without pretence, under her crown or her wide-brimmed hats, the same snowy solitary face. The name given to her, *the Divine*, probably aimed to convey less a superlative state of beauty than the essence of her corporeal person, descended from a heaven where all things are formed and perfected in the clearest

589

light. She herself knew this: how many actresses have consented to let the crowd see the ominous maturing of their beauty. Not she, however; the essence was not to be degraded, her face was not to have any reality except that of its perfection, which was intellectual even more than formal. The Essence became gradually obscured, progressively veiled with dark glasses, broad hats and exiles: but it never deteriorated.

And yet, in this deified face, something sharper than a mask is looming: a kind of voluntary and therefore human relation between the curve of the nostrils and the arch of the eyebrows; a rare, individual function relating two regions of the face. A mask is but a sum of lines; a face, on the contrary, is above all their thematic harmony. Garbo's face represents this fragile moment when the cinema is about to draw an existential from an essential beauty, when the archetype leans towards the fascination

Greta Garbo in *Love* (1927). "Garbo still belongs to that moment in cinema when capturing the human face still plunged audiences into the deepest ecstasy . . ." (BARTHES, page 589).

of mortal faces, when the clarity of the flesh as essence yields its place to a lyricism of Woman.

Viewed as a transition the face of Garbo reconciles two iconographic ages, it assures the passage from awe to charm. As is well known, we are today at the other pole of this evolution: the face of Audrey Hepburn, for instance, is individualized, not only because of its peculiar thematics (woman as child, woman as kitten) but also because of her person, of an almost unique specification of the face, which has nothing of the essence left in it, but is constituted by an infinite complexity of morphological functions. As a language, Garbo's singularity was of the order of the concept, that of Audrey Hepburn is of the order of the substance. The face of Garbo is an Idea, that of Hepburn, an Event.

1957

Greta Garbo in *Anna Christie* (1930) ". . . where she could ensconce herself, most of the time, in mute or monosyllable sullenness . . ." (PANOFSKY, page 298). "Garbo's face represents this fragile moment when the cinema is about to draw an existential from an essential beauty, when the archetype leans towards the fascination of mortal faces . . ." (BARTHES, pages 590–91).

# GILBERTO PEREZ
## *FROM* THE MATERIAL GHOST

## [KEATON AND CHAPLIN]

Keaton and Chaplin are great actors and great filmmakers, and in their work the actor and the filmmaker are one. Both began in the theater, the popular theater, at a very young age (Keaton at three, in his parents' act in vaudeville). Coming to films after a formative experience acting in that integral space, the stage, where no such thing as a cut is allowed to interrupt a performance, both brought to films a respect for the actor's continuity and a wariness of the editor's scissors: in their craft as film directors both take care to preserve on the screen the integrity of the actor's space.

The actor's discomfort with the disjunctions of film editing is expressed in that wonderful sequence from *Sherlock Junior* in which Buster, asleep on his job as a movie projectionist, dreams that he walks up to the screen and into the movie being projected. It's as if Keaton had stepped into a movie directed by D. W. Griffith, and didn't like it: the locale keeps shifting on him, by abrupt cutting, while he remains continuously himself, in the same place on the screen from one shot to the next through all the cuts disconcertingly transporting him from one place to another, his performance uninterrupted even as he finds himself now amid city traffic, now up on a mountain, now by a choppy sea, now surrounded by beasts in the jungle. This sequence is a special case of the visitor's situation recurrent with Keaton: here he's a visitor not anywhere on earth but in the world of somebody else's movie, a movie made in a style, foreign to his own, denying him a unified space for his performance.

Such a unified space for the actor to act in is established on the screen by Chaplin and Keaton alike. Chaplin's peerless pantomimes—his mock sermon on David and Goliath in *The Pilgrim* (1923), for example, or his little dance with the buns in *The Gold Rush*—unfold in such a *space,* commanding the camera's undivided attention; and in such a space Keaton displays his intricate acrobatics, convincing us that they are actual feats rather than tricks of the cutting room. It is a different kind of space, however, with Chaplin and with Keaton. Chaplin's space recalls the stage not only in

592

its integrity but in its quality of enclosure, in our sense of a demarcated area—the area of a pulpit during the mock sermon, the area of a table during the bun dance—within which each scene is contained. The size of that area may vary, but its boundaries are usually well defined, and the action rarely extends beyond them for the duration of the scene—quite unlike the action in Keaton, which regularly spreads out over a field of indefinite size.

Chaplin's practice of shooting in the studio, and in sets at least slightly stylized, partly accounts for this feeling of confinement; but the studio can be made to yield the illusion of a much larger area, and Chaplin's sets feel nearly as confined as stage sets. Conversely, the use of actual locations by no means ensures the sense of an open space we get in Keaton's films: actual locations can be treated much like a stage back-drop—as indeed Chaplin treats them on the occasions in which he uses them—but Keaton is one of the few directors who truly engages an environment and makes us aware that the screen can hardly encompass the dimensions of the actual place. More than in their choice of settings, Chaplin and Keaton differ in the basic conformation of the space they inhabit, a space corresponding, in Chaplin's films, to the stage, and in Keaton's, to the world.

In both cases the actor's space befits the kind of character he plays. "Chaplin's Tramp," wrote Robert Warshow,

> represented the good-hearted and personally cultivated individual in a heartless and vul-gar society. The society was concerned only with the pursuit of profit, and often not even with that so much as with the mere preservation of the ugly and impersonal machinery by which the profit was gained; the Tramp was concerned with the practice of personal relations and the social graces. Most of all the Tramp was like an aristocrat fallen on hard times, for what he attempted in all his behavior was to maintain certain standards of refinement and humanity, to keep life dignified and make it emotionally and aesthetically satisfying.

The Tramp, then, is the man who stands apart, the exceptional individual misunder-stood and rejected by the society around him, a better grade of human being whose unfitness for the tasks of that society only underscores his personal superiority, his interest in higher things. Although Chaplin's films carry a social protest, an appeal for change, he does not propose his character as any sort of revolutionary, for the Tramp would be as unfit to take any action against the society as he is to work within its con-strictions; moreover, he is too insular to show much solidarity with the poor and too singular to be regarded as typical of them. We are to side with the Tramp for his intrin-sic human qualities, for what he is in himself, apart from anything he does or could do or anything he stands for beyond himself. His strongest bond is with us, the spec-tators, rather than with any of the other characters in the film: he communicates with us (to borrow Louise Brooks's phrase) "in a kind of intense isolation," tacitly address-ing us with an entreaty for us to recognize his fine qualities and the injustice of a soci-ety that does not. Sometimes he gets the girl, but never as a result of his having under-taken any conventional courtship: he gets her because she, like us, is sensitive enough to appreciate his personal worth. (In *The Gold Rush*, the one film in which the Tramp makes good, ending up as a millionaire, the logic of the character demands that he come to his money fortuitously, not through his own efforts, and that the girl, when he runs into her aboard a ship at the end, accepts him *as a tramp*, in a scene arranged

so that she thinks he's a stowaway and offers to pay for his passage, before she finds out about his money.)

It would be an exaggeration to say that Chaplin needs no space outside of himself to realize his character: something like a bare stage would not do for the Tramp, who exists in relation to a milieu that Chaplin's sets pithily evoke. In Chaplin's circumscribed space, however, the setting becomes strictly subordinate to the character, and that little fellow scraping through on the outskirts of society assumes on the screen his rightful place at the center of things. That place, due him by virtue of his higher humanity and denied him in a society that has no place for that humanity, must be granted him, Chaplin implies, in a space closed off from the world and constituted for the little fellow's benefit. The man who stands apart from that vulgar milieu deserves, in Chaplin's view, a space set apart for the proper display of his unique attributes. Unlike the Tramp, Keaton's character wants a place in the world, not just in our hearts, and not a special place but one like everybody else's, so Buster accordingly inhabits a space that seems as large as the world and in which he enjoys no primacy over his surroundings.

If the society will not accommodate the Tramp, that is for Chaplin sufficient reason to condemn it, and he concentrates our attention on his character's personal qualities, upholding them against an order that callously discounts them. The world Keaton depicts, though not so inimical to the character, is even more impersonal, even more indifferent to the claims of individuality. Now and again the Tramp comes across a responsive soul—a girl, a kid, men such as the artist who befriends him in *The Immigrant* (1917) or the alcoholic millionaire in *City Lights* (1931), who, when sober, rebuffs him but who at least intermittently takes him to his heart. Nobody in Keaton's world ever departs from the established patterns of behavior; there are no exceptions made in this or that individual case, no exemptions from the rules of courtship granted on account of personal niceness. And Buster has no expectations that things will be otherwise: he accepts the formulistic nature of the world he inhabits and attempts to integrate himself into its formulas, knowing that considerations of personality will have no more effect on the conduct of its inhabitants than on the fall of an apple from a tree.

Even when the Tramp finds himself all alone, rejected by everyone in the film, he still has us, the main recipients of his personal appeal. His directing that appeal to us of course stresses his alienation from his milieu, but it also indicates Chaplin's confidence that the appeal will be heeded, and thus his hope that the established order will be changed. Buster seems to have no thought for us, occupied as he always is with some demanding task at hand—and convinced, we may surmise, that soliciting anybody's sympathy, ours included, is not going to make any difference. (In *The Cameraman* [1928], the first picture Keaton made for MGM after he lost his independence, we can tell that the studio gagmen have tampered with his conception the moment the girl is drawn to Buster because she feels sorry for him.) Keaton's universe is beyond condemnation, and beyond appeal: if it refuses to accommodate personality, there is no point in contesting that, in insisting that things ought not to be so. Whereas the Tramp, above all, projects his personality, Buster suppresses his as much as he can, given that it fits nowhere in a set scheme of things. Personal feelings, which Buster has nonetheless, he might as well not be having, and so tries not to display:

hence that famous Keaton face, which is not expressionless at all but on which the expression surfaces as if against his will.

Finding himself in a world of inexorable interlocking systems such as Hawthorne describes in "Wakefield," Buster would not risk stepping aside in his pursuit of a place in the scheme of things; any diversion might lead to his falling hopelessly out of step with the world around him. Other people are nicely adjusted to that world; they play their sports, carry on their feuds, wage their wars, go about their daily business with unruffled expertise in the way things are done: as they belong in the world, so too Buster aspires to belong. But they are natives, and their procedures are to him like an arduous and convoluted foreign language that requires his intent application and that, try as he may, he can never master with their sure fluency. Truly to belong in that immense machine that is Keaton's world, a man must conduct himself with the unthinking proficiency of a machine, and that's not something Buster can manage. The impersonal skills of the acrobat, his best resource in dealing with the scheme of things, he yet fails to make wholly impersonal: the movements of his body remain distinctively his own, unmistakable even in extreme long shot. And on his face his thoughts and feelings are equally unmistakable: they persist in showing through that would-be blank countenance.

It is Keaton's genius as an actor to keep a face so nearly deadpan and yet render it, by subtle inflections, so vividly expressive of inner life. His large deep eyes are the most eloquent feature; with merely a stare he can convey a wide range of emotions, from longing to mistrust, from puzzlement to sorrow. A poignant instance occurs in *Sherlock Junior* during a visit Buster pays to the girl he's courting. He has brought her the conventional present of a box of candies, and she responds with the conventional gesture of putting her hand between them on the couch where they're both sitting. Then, not quite daring to hold her hand but stirred by her offering it, he shuts his eyes in a moment of bashful bliss. She doesn't notice this, nor does the camera come in closer to give it emphasis; it's a private moment, and his eyes, by a very little, betray its subdued intensity.

Keaton rightly avoids close-ups in portraying a character who tries so hard to avoid isolation from his environment. Through other means, however, he brings his character's face into prominence. A strategy he often employs, and one of his invention, is the frontal view taken from some distance, the long shot or sometimes medium shot that, while showing Buster in the midst of things, singles out his face by showing him looking almost straight at the camera. In *The General* there are many such shots: when Buster looks up to discover the troops around him, for example; or when, inspecting the tracks ahead, he blinks in astonishment at the disappearance of the reappeared car; or when, giving up his initial attempt to enlist in the Confederate army, he addresses the recruiting officer who has turned him down, and says with a hurt expression, "Don't blame me if you lose this war." At the end of *Sherlock Junior,* Buster and the girl are reconciled in the booth where he's at work projecting a movie, and unsure of how to proceed with her, he seeks instruction in the ways of romance from the lovers in the movie, turning periodically to the screen to see what he should do next. Here too he's photographed head-on, through the booth window as he looks out, which points up his inquisitive gaze—and eventually his bewildered stare when

the movie to which he looks for guidance skips all the intermediary steps between a kiss and a marriage with children.

Perhaps the most striking of these frontal shots is the one in *Steamboat Bill, Jr.* that shows Buster changing hats. Brought to a haberdashery by his father, who disapproves of the beret he's been wearing and aims to get him a proper hat, he stands before a mirror while variegated hats are tried on him in succession, each making him seem different, as if he were rapidly donning and discarding a succession of identities, all of them imposed on him from the outside, none of them consonant with the inside we perceive through his forlorn eyes. Here his eyes are fixed on the camera for the longest stretch of all, since no cuts are needed to show us what he's looking at: the camera takes the place of the mirror, and Buster stares at it as at his own reflection. In each of these frontal shots, it must be stressed, the object of Buster's gaze is clearly established as something specific in his environment, so that his eyes appear directed not at the camera itself but at some point past it that claims his attention. We never get the feeling that he's looking at us: the effect, instead, is of our looking into him.

Before the mirror in *Steamboat Bill,* however, the object of his attention happens to be his own image, and that shot has the quality of an introspective monologue, an apprehensive meditation on his own condition. Literally his view of himself, that shot becomes an epitome of Keaton's view of the self as a foreign entity in the world, a visitor forever having to borrow the world's uniforms, and uncomfortable in any of them. The collegiate outfit that Buster affects at the beginning of this film was the fashion in Boston, but in a Southern river town his father is appalled to encounter an arriving son in a beret and a little mustache who is playing a ukelele and singing and dancing to it. (Buster is trying to pacify a baby he accidentally caused to cry, but his father doesn't know about the baby, and concludes that his son is in the habit of breaking into song and dance in the street.) The steamboat captain proceeds to strip away an outfit he finds offensively effeminate: the beret must be replaced, the mustache he has a barber shave off, the ukelele he crushes under his foot. More than these particular items, the principles on which Buster has based his life till now are thrown into question. At the haberdashery, without the trappings of a Boston collegian, he stares into the mirror and sees for the first time the hopeless discrepancy between his inner being and any of the roles he may have to assume in his dealings with the external world.

Such a dawning of self-consciousness usually occurs early on in Keaton's films, as when the rich boy in *The Navigator,* all dressed up on his first morning on board for a breakfast that nobody is there to serve him, comes to realize that the ocean liner is deserted. In *Sherlock Junior,* the format of a film within the film delays that dawning until the end, when the projectionist is left staring out of the booth window and scratching his head. At that point, in any case, Buster is led to a fearful reappraisal. The unexamined life of the rich boy who expected everything to be done for him, or of the projectionist who looked to the model of fictional detectives, or of the college boy who followed the Bostonian fashion, can no longer continue: Buster comes to the recognition that he must drop his previous assumptions and make a new start, taking nothing for granted in the endeavor, so much more difficult than he thought, of setting up residence in the world. From then on he looks at life with perpetually ques-

tioning eyes, knowing he cannot afford to relax his vigilant scrutiny; even amid the urgency of action, while executing some wondrous feat, he retains that perplexed, pondering gaze, which attests to his self-consciousness.

Robert Bresson—another practitioner of the deadpan approach, in a different way from Keaton's but with a similar sense that life is not a matter of personality—once defined originality as the failed attempt to do the same as everybody else, a definition that applies exactly to Buster. For all his efforts to join in, and all his eventual successes in meeting the forces outside, inside he cannot shake off the sense of his singularity. He thinks, therefore he stands alone in a world where no other minds are discernible, only systems of behavior. Ultimately he remains even more isolated than Chaplin's Tramp, since it's not Buster's individual qualities that single him out—these he hardly lets interfere in his transactions with others—but the very fact of his individuality, of his possessing the inner dimension of a self in the realm of the formula.

Buster is not, then, Grierson's "romantic achiever of all things" but a bewildered equilibrist whose mind runs counter to the achievements of his body: a new kind of clown who may not so often trip over physical objects but who, so to speak, keeps tripping over his thoughts. The charming incompetence of the traditional clown was the conception of an earlier time, with more room for eccentricity than has been allowed in our ruthless century. Things were not so good then, of course—things never have been—but at least the clown could thumb his nose at the world and expect the world to let him be. He would puncture our lofty pretensions with his reminder of the claims of the body, of the fact that in our flesh and blood we all fumble our way through life. That conception hasn't lost its validity, and Chaplin can still use it to portray a doughboy in *Shoulder Arms* (1918) or a factory worker in *Modern Times;* but he was looking back to a Victorian humanism that decidedly fails him when portraying a Jew under the Nazis in *The Great Dictator* (1940). Keaton reverses that conception: to our age of increasing mindlessness he offers a comedy of mind. Although he never dealt with contemporary issues as Chaplin did, he accurately depicts the landscape of our time in its vast inhuman organization. He reminds us of the claims of consciousness against a mechanistic order, of the fact that our expert procedures and outward accomplishments take no account of our inner nature. Whereas the old clowns would assert our right to our idiosyncrasies, he asserts our need to live with one another in a community that does justice to our individuality. The sadness that emerges at the end of *College* underlies all of Keaton's happy endings: it is the sadness of inescapable isolation, of knowing that he does not in the end, any more than he did at the beginning, belong in a world where happiness is available only as a convention. Yet Buster has done his best, and leaves us with the haunting image of his solemn and solitary figure, at once purposeful and detached, bravely attempting the impossible.

1998

# JOHN ELLIS
# *FROM* VISIBLE FICTIONS

## STARS AS A CINEMATIC PHENOMENON

Stars have a similar function in the film industry to the creation of a 'narrative image': they provide a foreknowledge of the fiction, an invitation to cinema. Stars are incomplete images outside the cinema: the performance of the film is the moment of completion of images in subsidiary circulation, in newspapers, fanzines, and so on. Further, a paradox is present in these subsidiary forms. The star is at once ordinary and extraordinary, available for desire and unattainable. This paradox is repeated and intensified in cinema by the regime of presence-yet-absence that is the filmic image. Further, the star's particular performance in a film is always more than the culmination of the star images in subsidiary circulation: it is a balancing act between fiction and cultism. It may well be that a similar creation of stars is impossible for broadcast TV (which fosters 'personalities'), but does take place in the rock music industry.

The basic definition of a star is that of a performer in a particular medium whose figure enters into subsidiary forms of circulation, and then feeds back into future performances. Hence the tradition of the 'star' stretches back beyond cinema, into theatre, and especially into opera. The discovery of stars by cinema is a well-documented legend. The 'Trust', the MPPC set up by the manufacturers of equipment in 1908 to muscle in on the profits of the nickelodeon boom, had a primitive concept of marketing. They relied on selling the experience of cinema (and the newer experience of cinema fiction) alone: all films were treated as fundamentally similar. However, exhibitors realised that some performers had a greater value than others, and some producers began to offer them in roles with the same name: Little Mary, Bronco Bill, etc. The Trust could see perfectly well where this would lead, but other independent producers decided that they were willing to take the risk, so they offered some hitherto anonymous performers a billing with the film's title, subsidiary publicity, and substantially more pay. The Trust were indeed correct in their supposition that inflation in salaries to performers would result. Amongst a small group it was

astronomic. Some (Chaplin, Pickford, Fairbanks) pricing themselves out of the market entirely (hence United Artists). However, the star became very quickly a standard item of marketing: so much so that films like DeMille's post-1918 'scandal + haute couture' specials were billed as 'all-star' productions (i.e., no-star productions).

The star arrived as a marketing strategy in American cinema at the point at which the initial expansion of cinema had taken place. The nickelodeon boom was over: basic patterns had been established (centralised production, distribution by rental, atomised exhibition) which were to last almost to the 1920s. Marketing of films began to develop. Films needed to be distinguished from each other so that they could be recognisable to exhibitors and audiences, so that they could attract their particular fragments of the mass audience. Increasingly, narrative forms settled into genres, recognisable from posters, reviews, and gossip, if not named by a specific label. Increasingly, the supposed personality of the performer became a means of describing or specifying a particular film. The performer's supposed personality was not the ostensible subject of many films, however. It was discussed and promoted elsewhere, in other media, and very quickly it became one of the staple functions of the film industry to supply 'appropriate' material to those other media. The 'image' of the star began to become a major part of the creation of narrative images. The importance of the star image in the creation of narrative images is that the star is also an incomplete and paradoxical phenomenon.

There is always a temptation to think of a 'star image' as some kind of fixed repertory of fixed meanings (Joan Crawford = tough, independent, ruthless, threateningly sexy, etc.). However, this seems to simplify the process, and to misstate the role of the star in producing meanings in films and beyond films. Star images are paradoxical. They are composed of elements which do not cohere, of contradictory tendencies. They are composed of clues rather than complete meanings, of representations that are less complete, less stunning, than those offered by cinema. The star image is an *incoherent* image. It shows the star both as an ordinary person and as an extraordinary person. It is also an *incomplete* image. It offers only the face, only the voice, only the still photo, where cinema offers the synthesis of voice, body, and motion. The star image is paradoxical and incomplete so that it functions as an invitation to cinema, like the narrative image. It proposes cinema as the completion of its lacks, the synthesis of its separate fragments.

The relationship is not, however, only that of star-image = incomplete: film performance = completion. It is also one where the process of the star image echoes, repeats, and develops a fundamental aspect of cinema itself. The star image rests on the paradox that the star is ordinary and extraordinary at the same time. The cinematic image (and the film performance) rests on the photo effect, the paradox that the photograph presents an absence that is present. In this sense, the star image is not completed by the film performance, because they both rest on the same paradox. Instead the star image promises cinema. It restates the terms of the photo effect, renews the desire to experience this very particular sense of present-absence. So the star image is incomplete and paradoxical. It has a double relationship to the film performance: it proposes that the film performance will be more complete than the star image; and it echoes and promotes the photo effect which is fundamental to cinema as a regime of representation.

The process of circulation of a star image has been broadly the same whether it has been undertaken by a centralised studio agency (the form of classic Hollywood) or by a specialised enterprise contracted by the stars themselves (the current form). The star's activities are presented in a number of media, some associated quite directly with the film industry, others using the film industry as one raw material amongst many. In the classic period of Hollywood, stars would 'feature' both in newspapers and magazines of general interest, and in magazines associated with cinema, fan magazines (or as we can now call them, fanzines). They appeared in advertisements, endorsing products. They appeared on radio, both in news, chat-shows, and fiction. At certain points, they appeared directly as products and merchandise effects. The first star to do so was (probably) Mickey Mouse. In all of these media, the star appears directly as face, body, and voice; and as a figure constructed by writing. There are photographs of the star; there are written descriptions of the star's activities; there are the voices of stars speaking (or singing) on the radio, from the mid-1920s onward. Each of these forms of appearance is less than that offered by sound cinema, which will present the animated, talking figure of the star. So on the simplest level, through the presentation of the star in photos, writing, and radio, the elements of the star's person are offered to the public, but in discrete bits and without movement. The promise of these various presentations is that the film performance will present the completeness of the star, the real mystery at which these only hint. Hence the presentation of Marlene Dietrich to the American audience. Already a star in Europe because of *The Blue Angel* (1930), a film not then released in America, she arrived to film *Morocco* (1930). Her image (photographic and written) appeared in the press; she had already 'proved' herself in another unavailable film; her mystery was well cultivated. So *Morocco* appeared, its narrative multiply punning on that of *The Blue Angel*, and its publicity announced: 'Now you can see . . .'. The film revealed what the star image in its subsidiary circulation could only hint at or describe in a veiled meta-language.

The particular nature of the copy, the photos, and the broadcasts made by/from stars reveals the other side of the star image's relation to the cinema. The stars are presented both as stars and as ordinary people: as very special beings, and as beings just like the readers. This seems to be the case both for male and for female stars, but sexual difference inevitably colours what kinds of roles are shown. Thus we have Bette Davis's recipes but Tyrone Power's baseball achievements; Audrey Hepburn's affinity for Givenchy clothes but Errol Flynn's big game hunting. Photographs similarly will show stars in the most mundane of postures, feeding babies, or just relaxing in old clothes; and then in the most exotic, performing stunts at a lavish party or meeting the King of England. These are the general rules that govern the specific coverage given to stars: there are two aspects, one the ordinariness of the star and the other the totally exceptional nature of the star, endowed with some special talent and position.

These general characteristics of the coverage are inflected in different ways by the different kinds of publications which make use of stars. It could be said that mass circulation daily and Sunday newspapers tend to use stars as a kind of moral barometer, whereas fanzines push the paradoxical constitution of the star image to its limits. Mass newspapers use stars for their own ends: they can be the occasion of scandals,

and they provide a repertory of figures who are in the public eye, yet have no political power. Stars provide newspapers with the vehicle for discussion of sexuality, of the domain of the personal and the familial. This is relatively absent from public political life, so the stars perform a valuable function in newspapers: they provide the dimension of the personal. This dimension is that which is inhabited by most of their readers, yet is not that of the events portrayed in the news. Stars have a soldering function: they hold the news and the personal together by being both public and intimate, by being news only in so far as they are persons.

Fanzines are a different kind of publication, very much more directly linked in to the industry itself. They emphasise stars-as-workers much more than other publications, with details of the punishing studio schedules, the indignities of make-up and costume for some parts, the hard training for dancing and stunts, even the lousy facilities offered by studios. Yet at the same time they can present the extraordinary aspects of the star as well, because they are generally high-quality printing jobs with glossy, high-definition full-page photos. These photos present both male and female stars with all the sophisticated techniques that are available. These are images of faces (sometimes bodies as well) in all their impossibility: smooth, free of blemishes, clear-eyed, every feature perfect. Often, the two aspects cross over each other in the same feature: pieces about the hard work of rehearsal dive into sentences which stress 'nevertheless' the exceptional talent of the performer.

Perhaps the living and dynamic paradox that is the star image was captured in Ophuls's *Caught* (1948): we are shown a page of a fanzine covered by a photo of a luxurious mansion with pool, accompanied by the headline: "Would you be happy in these surroundings? *We would.*' The photo is then animated into a moving picture, the camera dollies in to reveal Barbara Bel Geddes a former shopgirl who, having married into this luxury, is indeed miserable, and for very good reasons. *Caught* constantly plays on the paradox in the star image that it can oscillate between two opposing poles. A desperately attractive James Mason is cast as the ordinary doctor in a poor district with whom Bel Geddes falls in love. Mason, the matinee idol, is meant to incarnate the ordinary and the honest against Robert Ryan's neurotic millionaire. The film multiplies the indications of ordinariness around him, spectacularly since this is an Ophuls film. Yet it only succeeds in intensifying the paradox of the star image, perhaps expressed by the melodrama's audience as 'if only *my* boss was like James Mason.'

The star image functions in two ways. First it is the invitation to cinema, posing cinema as synthesising all the disparate and scattered elements of the star image. Second, it repeats the cinematic experience by presenting an impossible paradox: people who are both ordinary and extraordinary. This is the same paradox as the photo effect. The oscillation between the ordinariness and the extraordinariness of the star implies a whole series of features which echo the photo effect. The star is ordinary, and hence leads a life like other people, is close to them, shares their hopes and fears: in short, the star is present in the same social universe as the potential film viewer. At the same time the star is extraordinary, removed from the life of mere mortals, has rarified and magnified emotions, is separate from the world of the potential film viewer. The circulation of the contradictory star image therefore operates a kind of summary or reminder of the photo effect of cinema. Yet it is more than that as well. The figure of

the star crystallises the equivocal relationship to the viewer's desire that can be said to be produced by the photo effect.

By presenting a present-absence, by making statements in the impossible mode of 'this is was', the photo effect awakens a series of psychic mechanisms which involve various impossible images: the narcissistic experience of the mirror phase; the masculine fetishistic refusal (yet acknowledgment) of the fact of sexual difference; and at the same time, a particular variant of the voyeuristic contract. The photo effect can be said to be involved with a series of psychic mechanisms which participate in the construction of the polyvalent desires of both male and female viewers. The star is an impossible image, like the cinematic image. The star is tantalisingly close and similar, yet at the same time remote and dissimilar. Further, the star is a legitimate object for the desire of the viewer in so far as the star is like the viewer, and an impossible object for the desire of the viewer in so far as the star is extraordinary, unlike the viewer. There is a complicated game of desires that plays around the figure of the star: every feature in it is counteracted by another feature. The male and female star can be desired by either sex, yet that desire has access to its object only on condition that its object is presented as absent. Desire is both permitted and encouraged, yet knows it cannot achieve any tangible form of satisfaction, except the satisfactions of looking. The phenomenon of stardom relies on the photo effect for its full expression; it is equally a summary of the photo effect, making explicit the relationship between the photographic and the realm of desire. Constituted by a central paradox, the star system is both a promise of cinema ('this is the photo effect'), and an invitation to cinema ('these are clues; cinema synthesises them'). The film performance of a star both animates the desire that plays around the star's published image, yet holds that desire in place by the operations of the fiction. The use of the fiction always exceeds the star's image and the star's presence in a film, except at that single point where the fiction is suspended in favour of the pure performance: the 'fetishistic' moment.

The star's performances in individual films have a particular relationship with the images in subsidiary circulation. In the period of classic Hollywood at least, each star's figure was around all the time in subsidiary forms of circulation, but was seen in the cinema only occasionally: in two or three films a year. The film performance was therefore rare; the subsidiary circulation was commonplace. The film performance was a special event. The film performance of a star also involved a large degree of overt fiction, which the star in circulation outside the cinema did not. The construction of a star's image in subsidiary circulation must have routinely involved forms of fiction, but these were offered as though they were true facts. The fictional element of a star's film performance is acknowledged by all concerned, performers, filmmakers, and audiences alike. These two features of the film performance, its comparative rarity and its explicit use of fiction, mark it as a rather separate phenomenon from the circulation of star images in other areas.

The film performance of the star takes up and furthers the star image from other media. The relation between the figure of the star and the desire of the spectator is animated and intensified. The play between the possibility and impossibility of the star as an object of desire is intensified by the photo effect of presence-absence. The star finally appears as a physical figure observable over an extended period by the film audience: no longer a disembodied radio voice, a frozen photo image, or a character

in a piece of journalistic writing. Introduced here is a whole new dimension of the star: not just the star-in-movement, but also the incidental aspects of that movement. The star's performance in a film reveals to the viewer all those small gestures, particular aspects of movement and expression, unexpected similarities to acquaintances or even to self. Acres of writing have been produced to celebrate this or that phenomenon in such or such a star: Garbo's laugh, Cary Grant's eyes, the way Rock Hudson bites his lip in *All That Heaven Allows* (1955). . . . The journalistic apotheosis of these moments witnesses the feeling that the star is caught unawares in them. They are things, it seems, that could hardly have been planned or foreseen. They mark the absorption of the star into the fictional character. The star seems to be feeling the emotion of the role at that point as his or her own emotion. The star is not performing here, so much as 'being'. In other words, what the film performance permits is moments of pure voyeurism for the spectator, the sense of overlooking something which is not designed for the onlooker but passively allows itself to be seen. This is different from the star's image in other forms of circulation, where the elements of intentionality are very marked. The fanzine photo is obviously constructed for the look; the magazine interview or the radio broadcast participate in forms of direct address where the star is present as an intentional 'I'.

This sense of overlooking the incidental and the unmotivated aspects of the star's figure has two consequences which tend to outrun the film-as-fiction. First, it pushes the photo effect to its limits, especially with a star who is dead. This effect is an epidemic with stars like Garland or Monroe, whose presence on the screen brings with it the widespread myths of their tragic lives, the stories of their absence. It also radically compromises the stoic strength of Agnes Moorehead or the shrill complaints of Gloria Grahame. Less spectacular tragedies, both of these: the tragedies of women who always inhabited the films of others, whose careers never provided them with a definitive role. In both cases, the combination of the extra-filmic circulation of a star's tragic story with their film performance promotes a voyeuristic relation to the performance. Rather than identifying the role in the fiction with the life of the star (a comparatively rare possibility), the incidental moments are promoted to the forefront of attention. These 'poignant' moments thus become the only remaining route to the truth or the essence of the star's personality. The incidental moments of the star caught unawares seem to provide a glimpse of the secret personality that disappeared (or destroyed itself) leaving behind the perpetual, unresolvable paradox of the star image. The film photograph constructs the possibility of a voyeuristic effect of catching the star unawares. The paradox of the star's image (especially Monroe's) exacerbates this effect, sending the desiring viewer off to the film itself as the only remaining physical manifestation of the star amid the welter of photo sessions, TV and film biographies, memoirs of associates both would-be and real. The viewer glimpses something, perhaps only a trick of the light. But it is only glimpsed during the film performance. Then the circuit begins again: more consumption of forms of subsidiary circulation, the desire to see more films, and even films-that-never-were: the outtakes, the screen-tests and so on. . . .

The star performance in the fiction can have three kinds of relation to the star image in subsidiary circulation. The fiction can content itself with performing the image in those rare cases where the star's image outside of cinema is fairly stable. This is per-

haps more possible for male stars, whose characters can be defined by their activities. Such is the case perhaps with Errol Flynn, whose roles seem to a large extent the kind of exploit for which he became famous. The second, more usual, relation is that in which the fiction exceeds the circulated image. At its limits, the fictional figure can go against the grain of the circulated image, creating a specific tension in the film. Such is the case with Hitchcock's *Suspicion* (1941) where Cary Grant is cast as the likely murderer and swindler. The whole film is constructed on this dislocation in order to render Joan Fontaine's suspicions incongruous at first, and then increasingly irrefutable even to the most incredulous audience as the 'evidence' mounts. Despite the reconciliatory ending, this film represents something more than 'casting against type'. *Suspicion* needs the star image of Cary Grant in order to function at all. Its effect would have been totally different with Reginald Denny.

More usually, the fictional figure is 'to one side' of the star's general image, where this can be established. Certain elements of the publicly circulated star image complex are used by the film, other elements are refused, further elements are added. Doris Day's films display her in a much wider range of characters than her image would suggest. Certain elements of her image are always present (sometimes her pervasive ordinariness or directness of approach to people), but they are not always the same elements. Further characteristics are accumulated to her fictional personas that have little or nothing to do with her star images. Yet the star image continues in circulation, feeding off the films where it can, trying to ignore aspects of her past as well as aspects of her fictional roles. The importance of Doris Day as a star phenomenon is the way in which her star images have obliterated the memory of her films. Doris Day's fictional roles are very much 'to one side' of her circulated images. It is possible that the circulated images are unperformable in a film: they provided so little scope for any dramatic action that there were few attempts to narrativise them. However, they provided acceptable and 'useful' themes in other, less narrative, less fictional, forms of circulation. Hence the endurance of 'Doris Day' as a touchstone of respectability, moral probity, young Americanicity, unrestrained enthusiasm, and other characteristics that play around her figure without constituting a fixed identity.

The star's place in a film thus seems to be a difficult one. The film is constructed by the process of the star image as the point at which the paradox of the image will be explicated, and the disparate elements of the image will come together. The star performance thus animates the star image, and animates the desire which circulates in it. In doing so, the performance exceeds the circulated image in two usually mutually compensating ways. First, the performance is fictional, placing the star in a role whose characteristics have to be fairly stable. This role can have a number of different relationships to the circulated image: it can resemble it to a large degree; it can contradict it; it can be to one side of it. In most cases, the fictional context of the star's performance is enough to hold in check or to balance a second way in which the star's performance exceeds the star's circulated image. This second excess is the way in which desire is animated toward the performing figure. The performance produces the effect that, in its incidental rather than intended moments, it reveals something of the essence of the star's personality. Occasionally, effects either from within the film (Von Sternberg) or from beyond the film (Monroe) foster this effect and allow it to

escape the effects of the fiction. The result is a cultism, of an inquisitive voyeuristic kind, or a fascinated fetishistic type.

For the star him- or herself, two options for performance are offered by this regime. One is that of drastically underperforming in comparison to the 'unknown' section of the cast; and the other is to overperform in order to emphasise the work of acting. Underperformance is not a question of restraint or lack of histrionics. It is a question of producing the effect of behaving rather than performing. This is always a comparative effect, generated by a disparity within any one film between the styles of acting of the star-group and the supporting group. The supporting group have to produce emphases in their gestures, delivery of lines, and expression simply in order to signify the required meanings. For the star, it is different. The star has the attention of the audience and is a recognised figure, with a recognised voice, face, and figure, even if no stable meanings accumulate to those features in the star image. Having the audience's attention, (and the camera's, and the fiction's), anything that the star does becomes significant. Hence the star is permitted to underact, compared to the supporting cast, and this underacting produces the effect that the star behaves rather than acts. However, some stars have been dissatisfied with this state of affairs and the whispered remarks that it produces ('so-and-so can't act', etc.). So a certain section of the star firmament at any one time will be seeking to reverse this tendency toward underacting in order to produce an effect of 'performance'. Some stars produce a very explicit regime of expression which is again divergent from that of the supporting cast. In Hollywood, it has often been those actors who are most concerned with the artistic nature of their work (Bette Davis, for instance). More recently, a craft approach has been adopted to performance under the influence of the Method Acting theory. Examples are the antics of Marlon Brando or the disguises of Peter Sellers. Finally, a more traditional overacting is characteristic of certain stars, especially those from the British stage: Glenda Jackson for instance. All of these stars tend to offer a supplementary signification: they are there as star; they are there as fictional role; but they are also there as actor, saying, 'Look at me, I can perform.'

1982

# ROBERT C. ALLEN
## *FROM* FILM HISTORY: THEORY AND PRACTICE

### THE ROLE OF THE STAR IN FILM HISTORY
### [JOAN CRAWFORD]

If social film history has not produced a simple, universally recognized formula for extracting the social meaning from films, it has engaged in the less ambitious but more achievable task of identifying, describing, and understanding some of the social dimensions of film history. It is one of these dimensions, stardom, that will be discussed in the case study for this chapter. Using an approach adapted from that of Richard Dyer in his book *Stars*,[1] this case study asks, How have movie stars been social phenomena? and How can any particular star be studied historically?

### WHAT IS A STAR?

Since the early 1910s, the movie star has been one of the defining characteristics of the American cinema. Stars have also been and continue to be prominent features of other national cinemas as well—from Berlin to Bombay. In the early 1920s it is quite probable that Mary Pickford and Douglas Fairbanks were the most famous living people in the world. For well over a half a century, the smallest details of the off-screen lives of stars have been broadcast (both literally and figuratively) to millions.

The term "star," now applied to rock stars, athletes, and soap opera actors, has been so overused as to become almost meaningless. Viewed in terms of film history, however, we can define the constituent elements of stardom more precisely. At its most basic, the concept of stardom would seem to involve a duality between actor and character. To audiences of *Casablanca*, Humphrey Bogart *is* the character Rick, but he is also the actor Humphrey Bogart *playing* the character of Rick. In *Les Stars*, sociologist Edgar Morin defines a star as the combination of screen role and actor, of filmic persona and off-screen personality. "Once the film is over, the actor becomes an actor

---

[1]Richard Dyer, *Stars* (London: British Film Institute, 1979).

again, the character remains a character, but from their union is born a composite creature who participates in both, envelops them both: the star."[2] In this sense, stars are actors "with biographies." In some cases (Jayne Mansfield or Brigitte Bardot, for example) their "biographies" almost completely overshadow their "works." Essential to the concept of stardom, says Morin, is that the stars' private lives must be public.

It is also clear that the public does not "know" a star's off-screen personality directly, but only certain representations of that star mediated through a variety of sources: the films themselves and their attendant publicity materials, gossip columns, interviews, newspaper articles, and so on. What the public knows, in short, is not the star as a person, but rather the star as an image. To Dyer, a star is a "structured polysemy": "the finite multiplicity of meanings and affects they [stars] embody and the attempt so to structure them so that some meanings and affects are foregrounded and others masked or displaced."[3]

Stars, then, are complex images containing multiple meanings. Their polysemic (literally: many-meaning) nature enables different people to see different things in the image of a particular star. However, the star image is not a random jumble of representations and qualities open to any interpretation. It is a *structured* polysemy, the decoding of which is conditioned by the reinforcement of some aspects of the image and the suppression of others. Thus the social film historian derives the image of a star from the texts that collectively embody that image, not for the purpose of determining the "correct" meaning of that star, but rather to determine how the image has been structured, the range of possible meanings at any given time, and the changes that might have occurred to that image over time. This type of historical analysis leaves aside the important but more difficult question of how the various possible meanings of a star are used by various groups within society (how, for example, the meanings of Marilyn Monroe might have been different for men and women), but it does enable us to better understand what meanings were available to *be used* by individuals and groups within society at a point in history.

It is clear that stars form an aesthetic intertext that audiences use to derive meaning and pleasure from films, but we have not yet addressed the question of what makes stars *social phenomena* as well. Several writers on the subject have made the case that stars exist because they crystalize in their personae certain collective needs, dreams, fantasies, and obsessions. To Richard Griffith, for example, stars are "made" "in the depths of the collective unconscious." According to this view, studying the most popular stars of a particular era would reveal to us something of the inner workings of society—a desire for innocence in the 1910s as evidenced by the meteoric ascendancy of Mary Pickford, or, perhaps, repressed rebelliousness in the 1950s expressed by Marlon Brando,. While star-types have changed over time, the assumption that this change is a direct result of changes in the "collective unconscious" is just that—an assumption. As an assumption it begs many of the same questions (because it makes the same basic claim) as *From Caligari to Hitler*; nor is the mechanism by which stars are empowered to express the inner workings of society any more clear.

---

[2]Edgar Morin, *Les Stars*, trans. Richard Howard (New York: Grove Press, 1960).
[3]Dyer, *Stars*, p. 3.

Dyer's analysis of stardom is basically Marxist. Hollywood films, he says, are produced within and convey the dominant ideology of Western society. Like any dominant ideology, that of Western society establishes itself not as *one* way of looking at the world acting in the interests of *one* class in society, but rather as *the* natural and consensual assumptions of the entire society. In order to maintain the status quo (its dominance), the dominant ideology must deny the validity or relevance of opposing ideologies and continually disguise or displace its own inevitable contradictions. These contradictions arise from the fact that the dominant ideology must always appear to be that which it never is: the one "correct" world view equally valid for all members of society.

The overall ideological function of the movie star is to help preserve the status quo and thereby the power of the dominant ideology. The star image represents to Dyer an attempt to manage, mask, or displace some of the contradictions inherent in the dominant ideology; it renders fundamental problems unproblematic, defuses possible threats to the dominant ideology, and makes social-class issues appear to be personal ones. Dyer recognizes that not all star images successfully reconcile their oppositions and that some stars' images can even be read as subversive (Mae West or James Dean, for example), but these, he says, are exceptional cases.

One does not have to share Dyer's Marxism to see his formulation of the star (as polysemic image structured around a set of contradictions) as a useful starting point for the historical analysis of stardom and individual star-images. Non-Marxist sociologist Francesco Alberoni views the notion of stardom as inherently anomolous and contradictory. Stars constitute a "powerless elite," in that their actual political or social power is almost nonexistent, but their "charisma" enables them to be the objects of tremendous public fascination. Furthermore, he says, stars are idolized but not resented. They enjoy wealth and prestige far beyond that of their fans, but because the social position of stardom is, theoretically at least, open to all, even stars' most outrageous extravagances do not provoke the antagonism of their fans.

Nearly every scholar who has investigated the phenomenon has commented on the set of paradoxes that lie at the basis of stardom. The star is powerless, yet powerful; different from "ordinary" people, yet at one time was "just like us." Stars make huge salaries, yet the work for which they are handsomely paid does not appear to be work on the screen. Talent would seem to be a requisite for stardom, yet there has been no absolute correlation between acting ability and stardom. The star's private life has little if anything to do with his or her "job" of acting in movies, yet a large portion of a star's image is constructed on the basis of "private" matters: romance, marriage, tastes in fashion, and home life.

These and other paradoxes or contradictions are by their very nature social. The individual star image—ostensibly a single member of society—provides a convenient focus for a set of issues that reverberate within the society as a whole: success, wealth, romance, "acceptable" social behavior, and consumption, among others. This is not to say that an individual star-image somehow reflects the hidden desires of an entire society, but as structured polysemies, stars do form a social as well as an aesthetic discourse. Within this social discourse of stardom, the historian can see certain social tensions or paradoxes or contradictions (depending on one's viewpoint) at

work. Dyer sees the very concept of stardom as organized around the themes of success, consumption, and romance. These themes or social issues provide a consistent framework within which any given star-image is constructed. Obviously, each star-image structures these themes differently and might involve other themes as well—for example, in the case of Garbo, the desire of a "public" figure to have a private life; in the cases of Jane Fonda and Ronald Reagan, the overt political dimensions of stardom.

How does the film historian go about reconstituting the image of a particular star? According to Dyer, the star image is embodied in four categories of texts: (1) promotion, (2) publicity, (3) films, and (4) criticism and commentary. In examining the role each plays in establishing and maintaining the star persona, we will draw examples from the star-image of Joan Crawford, whose career spanned more than forty years (1926–1970) and eighty films. In the words of her filmographer, she was "a typically American film star."[4] Obviously, space does not allow a full consideration of the Crawford image (a fascinating task yet to be tackled), rather the references below are meant merely as illustrations of more general points.

## PROMOTION

Dyer defines promotion as "texts which are produced as part of the deliberate creation/manufacture of a particular image or image context for a particular star." Promotional materials would include those designed to establish the general contours of the star persona (studio press releases, posed photographs arranged for and distributed by the studio, and public appearances), plus advertising matter accompanying particular films of that star (advertisements, lobby cards, posters, and trailers).

The enormous amount of control the Hollywood studios exercised over the creation of the star persona in the 1920s and 1930s was given legal sanction through the terms of the standard actor's contract. The actor's agreement to "act, pose, sing, speak, or otherwise appear and perform solely and exclusively" for the contracting studio was only the beginning of the actor's commitment to the studio and the studio's power to fashion, change, and exploit his or her public image. The contract barred the actor from making any public or private appearance in any way connected with the movies, sound recording, or the theater, *and* from engaging in any other occupation without the written consent of the studio.

When sound was innovated in the late 1920s, contracts were amended to allow the studio to substitute the voice of another person for that of the actor under contract. The actor agreed not only to act in films over whose selection he or she had no control, but to promote these films through personal appearance tours arranged by the studio. The actor relinquished to the studio all control over the use of his or her name and physical likeness, which the studio could use in advertising, publicity (whether or not connected with the actor's films), or even to sell other products through advertising "tie-ins." Bette Davis described her legal battles against the studio contract system in the late 1930s as

[4]Lawrence J. Quirk, *The Films of Joan Crawford* (New York: Citadel Press, 1974), p. 79.

. . . a fight against slavery from the standpoint that, according to the standard motion pic-
ture contracts of the day, I could be forced to do anything the studio told me to do. They
could even ask a contract player to appear in a burlesque house. The only recourse was
to refuse, and then you were suspended without pay. These original documents were so
one-sided in favor of the studio that . . . when under suspension from your contract, with
no salary, you could not even work in a five-and-dime store. You could only starve, which
of necessity often made you give in to the demands of the studio.[5]

Perhaps most indicative of the power of the studio to create a star-image out of the
"raw material" provided by the actor is this paragraph from a typical studio contact
of 1936.

The Producer [studio] shall have the privilege at all times during the term of this contract,
or any extensions thereof, to change the name of the Artist [actor] from time to time and
at its discretion to such professional name or names as the Producer might think best, and
should the Producer use a professional name for the Artist in connection with any pic-
tures produced hereunder the Producer shall be entitled to at all times use such profes-
sional name or names, even after the expiration of this contract and after any and all
extensions thereof, it being the intention of the parties hereto that any professional name
used by the Artist during his term of employment hereunder shall be a property right
belonging exclusively to the Producer and in which no one other than the Producer shall
have any right, title or interest.[6]

When Joan Crawford arrived in Hollywood in January of 1925, her name was
Lucille Le Sueur. It was as Lucille Le Sueur that she signed a contract with MGM for
$75 per week (which obligated her to the studio for five years but obligated the stu-
dio to her for only six months at a time), and that she appeared in her first two films.
When she was cast in her first major role opposite child-star Jackie Coogan, the
MGM publicity department decided that her name did not "fit." At this early point in
Le Sueur/Crawford's career it was unclear what her image would be, but fairly clear
what it would *not* be. She would not be molded as the exotic foreign beauty—as was
Greta Garbo, who also signed with MGM in 1925. Le Sueur's dancing ability, pho-
tographic image as the active "modern girl," and initial screen role as the poor but
wholesome friend of Jackie Coogan lent themselves more to the creation of an "All-
American" persona. "Lucille Le Sueur" was too foreign in its connotation, and the
MGM publicity department feared fans would find it too difficult to spell and pro-
nounce. However, rather than simply give her a more appropriate name and present
it to the public as a *fait accompli*, MGM decided to allow the public to help "create"
one of its stars by selecting Le Sueur's new name.

Through an article in *Movie Weekly*, MGM offered fans an opportunity to win
$1000 by suggesting the best new name for Lucille Le Sueur. Even at this early stage
in the creation of Crawford's persona there were the outlines of an image of which
her name was to be a part. Readers of the *Movie Weekly* article were told that she "is
an auburn-haired, blue-eyed beauty . . . of French and Irish descent. Second only to
her career is her interest in athletics and she devotes much of her spare time to swim-
ming and tennis." She had been selected by MGM executives from among hundreds

---

[5]Quoted in Whitney Stine, *Mother Goddam* (New York: Hawthorne Books, 1974), p. 79.
[6]Contract between Warner Bros., Inc. and Olivia de Haviland, April 14, 1936, Warner Bros. Collection,
University of Southern California. De Haviland managed to have this paragraph struck from her contract
and thus preserved the right to keep her own name.

of young women in New York as the one who best personified the "ideal young American girl of today." Le Sueur herself, the article said, was "thrilled" by the prospect of a new name and would "personally favor one which is easy to pronounce and spell and also easy to remember." "Joan Crawford" was the name given to Lucille Le Sueur, despite the fact that she objected to it so much that she introduced herself for several years as "Jo-Ann" Crawford.[7]

# PUBLICITY

Dyer defines publicity as publicly disseminated material on stars that does not appear to be directly promotional. Publicity would include star interviews, stories about a star's private life and plans, and gossip column items. Obviously there is considerable leakage between the two categories. Articles about stars were frequently "planted" by studio publicity departments, and interviews were (and are) often arranged by the studio as a pretext for promoting the star's latest film. As Dyer points out, however, the importance of publicity in generating the star-image lies in its *appearance* of being uncontrolled by the studio and hence of being more authentic. Publicity, as Dyer uses the term, is material generated in the "news" coverage of the star as celebrity. Through publicity we like to think we are able to pierce through the facade constructed for the star by the studio and get at the inside and unauthorized details of the star's persona—hence the exposé quality of much star publicity.

Although a full examination of the publicity devoted to Crawford between her signing with MGM in 1925 and her death in 1977 is well beyond the scope of this study, a look at the articles published on her in *Photoplay* during her tenure at MGM (1925–1943) helps to establish the framework, at least, within which the Crawford image was constructed.

Veteran Hollywood reporter and gossip columnist Louella Parsons is quoted as saying that Crawford "manufactured herself," that she "drew up a blueprint, decided what she wanted to look like and sound like, and then put that person into existence."[8] The manner in which Crawford received her name testifies to the fact that she was by no means solely responsible for the creation of her star persona. However, in the articles on and interviews with Crawford in *Photoplay* in the 1920s and 1930s it is clear that the idea of the "self-made star" becomes one of the structuring elements of the Crawford image.

It took several years for a distinctive Crawford image to emerge. Initially, her persona was fashioned in terms of the "flapper": the modern American young woman who was carefree, single, fun-loving, and, in terms of the 1920s at least, "liberated." Paramount's Clara Bow enjoyed considerable success playing flapper roles in several films of the mid-1920s, and Crawford was represented as a Clara Bow "type." A fan magazine described her in 1926 as

. . . the symbol of everything the younger generation is supposed to be. You look at her and automatically stock phrases come to mind: bobbed hair—rolled stocking—defi-

---

[7]The *Movie Weekly* article is reproduced in Larry Carr, *Four Fabulous Faces* (New York: Penguin, 1978), pp. 224–225. See also, Bob Thomas, *Joan Crawford* (New York: Bantam Books, 1979), pp. 28–43.
[8]Quoted in Carr, *Four Fabulous Faces*, p. 218.

The star as a phenomenon both inside and outside her films. Joan Crawford in a publicity shot. "... the star's particular performance in a film is always more than the culmination of the star images in subsidiary circulation: it is a balancing act between fiction and cultism" (ELLIS, page 598). "... by the mid-1930s, Crawford had become, in the vernacular of the industry, a 'clothes-horse,' and her wardrobe frequently drew more (and more positive) critical response than her acting" (ALLEN, page 617).

ance—topless roadsters . . . "Hey-Hey"—jazz—short skirts—slang—little hats banged over one eye—high heels and all the rest.[9]

Crawford's image as the "Hey-Hey Girl" was solidified by frequent mention in gossip columns of her penchant for dancing and by her role as "Dangerous Diana," the quintessential flapper in *Our Dancing Daughters* (1928). The success of Crawford in that film lifted her out of the ranks of contract-players and established her as a potential star.

The year 1928 also marks the beginning of the process by which Crawford became an individual star-image—a persona distinguishable from the "type" to which it

[9]Ibid., p. 232.

might have once belonged. The more negative facets of Crawford's flapper image (hard-drinking, fun-loving, reckless, cynical) were quickly suppressed and a set of more positive qualities took their place. Crawford became an object lesson in perseverance and proof that strength of character could overcome all material obstacles. In the fall of 1928, *Photoplay* ran a three-part autobiography of Crawford, "The Story of a Dancing Girl," in which she describes a "childhood as cheerless as any depicted by Charles Dickens," degrading jobs as a chorus girl, navigating her way through "a cesspool of all licentiousness" on Broadway, and, finally, the screen test that resulted in her MGM contract and a chance for stardom. From all accounts it does appear that Crawford's early years were miserable. Her father left the family while she was but an infant. Her mother was forced to put Crawford to work in a boarding school at the age of ten, where she was overworked and mistreated.

The truth or falsity of the events related in these and subsequent accounts of Crawford's life is not at issue here. What is important in terms of the image of Joan Crawford is how the revelation of events of her life functioned to help structure her public persona. Positing Crawford's dogged determination and indomitable spirit as reasons for her rapid rise to stardom helped to offset the devil-may-care aspects of her persona, which her on- and off-screen escapades had foregrounded. The first installment of the *Photoplay* series was headlined, "Every ambitious girl who is struggling for success against odds should read this story of Joan Crawford's brave fight."[10]

This shift in Crawford's image in 1928 also prepared her public for the announcement of her engagement to Douglas Fairbanks, Jr.—an announcement made in the final installment of the *Photoplay* series. Fairbanks, son of the famous silent film star and stepson of Mary Pickford, belonged to the most socially prominent family in Hollywood and one of the most famous families in the world. Fairbanks and Pickford regularly entertained diplomats, royalty, and powerful industrialists. They were the very embodiment of propriety, rectitude, and status. As Crawford the "Hey-Hey Girl," whose highly publicized engagement to a Detroit meat-packing heir had been ended by the objections of his mother, and who had been named as corespondent in several divorces, she made an incongruous match for the urbane and well-connected Fairbanks. However, as Crawford the star, undeterred by a tragic past, her marriage to Fairbanks seems a fitting reward for her struggles. Crawford (through her ghost writer, Ruth Biery) wrote in the concluding installment,

> I have said that I would never marry . . . But then I had not met the man I wanted to marry. I made that statement in all honesty. But there is always one man who answers every need for a woman. I am going to marry Douglas Fairbanks, Jr. This is an announcement of our engagement.

The contradiction in Crawford's image between the values represented by the "Hey-Hey Girl" and those of the wife of Douglas Fairbanks, Jr., was addressed directly in a 1931 *Photoplay* article entitled "Why They Said Joan was 'High Hat,' " by Katherine Albert. Albert defends Crawford against charges that her success as an actor and her marriage to Fairbanks had made her an elitist snob. Crawford's flapper

---

[10]*Photoplay* (September 1928): 34. The other two installments appeared in the October (pp. 68–69, 114+) and November (pp. 42–43, 133) issues.

manifestation, says Albert, was merely indicative of the difficulty anyone would have in adjusting to life in Hollywood, especially someone whose recent past had been one of "keen misery." What Crawford needed at this time was someone who could see through her veneer of gaiety to "the deep, latent powers of the girl, the fine uncultivated brain she had."

This process of self-realization was begun by MGM producer Paul Bern, who taught her "the beauty of words on paper, the feeling for musical harmony, the appreciation of form and color upon canvas." The transformation begun under Bern's tutelage was now being completed by Fairbanks, she says, so that "today Joan Crawford is no more Lucille Le Sueur than Will Rogers is Mahatma Gandhi." In short, as Mrs. Douglas Fairbanks, Crawford is a new person who has "done everything to improve herself."[11]

Even as one contradiction is "resolved" by this article, however, another is exposed. Crawford's metamorphosis is seen as both the result of self-creation ("Joan has become a woman. . . . She has done everything to improve herself.") *and*, at the same time, as the product of the shaping influence of some other, significantly male person. The Pygmalion analogy is nearly explicit in the final line of the article: "Her loyalty to those who have stood by her and gloried for her in her blossoming is like some fine marble statue." This self-made/"man"-made dichotomy is also present in the autobiographical essays and recurs throughout publicity on Crawford through the 1930s. Describing her decision to leave Kansas City for a stage career, Crawford speaks in the 1928 *Photoplay* series of having to leave behind her sweetheart, the only person to have faith in her dancing abilities:

> How often does ambition force a woman to face such a separation? Yet, if she subjugates her career for a man, she may spend the rest of her life wondering to what heights she might have climbed had she followed her inclinations. And if she goes, there comes a time when she wonders if, after all, home and innocence-of-the-world might not have meant a more pacific, happy existence.

The implication of the above—reinforced by Crawford's screen persona of the 1930s—is that a woman is doomed either way. Except, perhaps, in Hollywood. Publicity on Crawford's marriages (to Fairbanks in 1929, Franchot Tone in 1935, Phillip Terry in 1943, and Alfred Steele in 1955) emphasizes her domesticity (she waxes her own floors, makes some of her own clothes) and the role played by her current husband in expanding her horizons. In a 1936 *Photoplay* article Tone is given almost the identical role as that played by Fairbanks in Crawford's development. Crawford is quoted as saying, "He began showing me things in books and music that I'd never known were there. It was like a new world opening before me. . . . It was as if I'd been hungry all my life without-realizing it, and now I was being fed."[12] Articles on Crawford's married life mask the tensions between ambition and marriage (as seen by 1930s society) by suggesting that in Crawford's case the latter aids in the realization of the former.

[11]Katherine Albert, "Why They Said Joan Was 'High Hat,'" *Photoplay* (August 1931): 64–65, 112.
[12]Ida Zeitlin, "Why Joan Crawford Remains Great," *Photoplay* (October 1936): 44–45, 96–97. See also, Dorothy Manners, "Second Marriage and Joan Crawford Tone," *Photoplay* (May 1936): 24–25, 122

Especially during the times in the 1930s when Crawford was not married (1933–1935 and 1938–1943) the self-made, independent woman side of her image reasserts itself in publicity on her. A 1935 *Photoplay* profile begins, "She had carved a monumental career out of nothing. She had satisfied a consuming inner demand to be somebody." It goes on to describe how her every spare minute is spent improving herself through dance lessons, experimental drama performances in her backyard theater, and operatic voice training. Interestingly, she is depicted here as Tone's mentor: "She even started [him] . . . singing, thereby uncovering a very impressive basso-profundo voice."[13]

By the mid-1930s, Crawford had become not only the self-made star, but the regenerating star. Each new marriage, phase of her career, and avocational interest was seen as evidence of Crawford's unique power to transform herself to meet whatever new set of demands presented itself. In the accounts of her self-renewals there is both an invocation and an erasure of her past. For example, in "Adela Rogers St. Johns Presents Joan Crawford Starring in 'The Dramatic Rise of a Self-Made Star,' " a three-part *Photoplay* series of 1937, St. Johns once again tells the story of Crawford's early tribulations, explaining Crawford's continuing success in terms of the "instincts" she developed as a child. Each "new" Crawford is but another facet of the ever-struggling Lucille Le Sueur:

> You're a great movie star, but you're a great person because you, alone and unaided, pulled yourself up by your bootstraps, you aspired to better things, you dreamed better dreams, and you made them come true. If you'd always been just what you are today, you couldn't possibly be so closely identified with us, with all that's American in us, with all that's human in us.

In a 1935 article, however, Crawford is described as "the girl without a past," in the sense that her longevity derives from her unique ability to escape from the past: "Every phase of Joan is a stranger to the last one."[14]

## FILMS

As Dyer points out, the films of stars are frequently "star vehicles," in that the film has been fashioned to provide a character or genre associated with its star. Certainly in the 1930s, Hollywood studios attempted to "fit" a property to the image of their biggest stars. Warner Bros., for example, continually had difficulty finding the "right" films for Bette Davis, in part because she did not conform to any existing star-type.[15]

By the mid-1930s Joan Crawford had become identified with one cinematic genre, the woman's film, which drew from and reinforced her star-image. As Jeanine

---

[13]"The New Ambitions of Joan Crawford," *Photoplay* (February 1935): 76–77, 101 See also, "Fan Experiences with the Stars," *Photoplay* (December 1936): 16; and Frazier Hunt, "I Meet Miss Crawford," *Photoplay* (October 1934): 36–37, 114.

[14]Adela Rogers St. Johns, "Adela Rogers St. Johns Presents Joan Crawford Starring in 'The Dramatic Rise of a Self-Made Star,' " *Photoplay* (October 1937): 26–27, 69–70; (November 1937): 64–65, 75–76; (December 1937); 70–71, 91. Dorothy Manners, "The Girl Without a Past," *Photoplay* (October 1935): 32–33, 56.

[15]Joanne L. Yeck, "The Woman's Film at Warner Bros., 1935–1950," Ph.D. dissertation, University of Southern California, 1982, p. 48.

Bassinger has defined it, the woman's film focuses on a contemporary woman as its central character. The plots of these films, staples of Hollywood production in the 1930s and 1940s, concerned

> ... women who were struggling to get on their own two feet. Then when they got on them, they struggled to forge ahead and struggled some more to get on top. After they got on top, they struggled with themselves and their guilts. Finally, society overcame them. They went down struggling, found "true love," and prepared to resume life's struggle in a state that was acceptable to society.[16]

The woman's film was also designed to appeal to a female audience. Within the woman's film genre, the role played most often by Joan Crawford was the "independent" woman: the woman who through choice or circumstance was forced to survive in modern society on her own. Her social station varied from film to film. She was a prostitute in *Rain* (1932), a maid in *Sadie McKee* (1934), and a factory worker in *Possessed* (1931), but a wealthy socialite in *Letty Lynton* (1932), *No More Ladies* (1935), *I Live My Life* (1935), *Love on the Run* (1936), and *The Last of Mrs. Cheyney* (1937). The nature of her dilemma, however, did not change. Her problems were what were thought to be "women's problems" in the 1930s: finding the "right" man, being in love with the "wrong" man, raising children, and earning a living in a "man's world." Bassinger argues that the "message" of these films was that a woman who achieved economic or sexual power did so at the expense of her ability to have a meaningful relationship with a man. Thus in many of the woman's films what the heroine strives so hard to achieve is given up at the end of the film in favor of the "happy ending"; a chance to be a traditional wife and mother. Audiences, Bassinger says, "felt reassured by the endings in which the woman they admired on screen told them that what they had was better than what they had just enjoyed watching." Crawford's own image provided a "happy ending" to her films even where their narratives did not, and the constant reiteration of Crawford's own early struggles in publicity about her no doubt made her screen roles all the more convincing. It is unnecessary (not to mention simplistic) to draw point-to-point correspondences between the woman's film heroines Crawford played and her off-screen persona; however, it is clear that both were structured around the same themes: the "choice" between career and romance, finding the "right" man, climbing the social ladder—in short, asking the question, How independent can a woman be and at what price?

Crawford's woman's film roles are related to her more general star-image iconographically as well as narratively. As Joanne Yeck has pointed out, visually the woman's film genre was singularly uninnovative, occupying a position near the most conservative pole of the classical Hollywood narrative style. The pace of the woman's film was slow, locales confined to interior spaces, and actions limited to dialogue.[17] The stylistic featurelessness of the woman's film functioned to focus attention on the star's face *and* costume. Kay Francis, the Warner Bros. woman's film star of the early 1930s, remarked of one of her vehicles, "If [it] . . . does better than my other films, it's because I parade thirty-six costumes instead of sixteen."[18] Similarly, by the mid-

---

[16]Jeanine Bassinger, "When Women Wept," *American Film* 2 (September 1977): 52–57.
[17]Yeck, "The Woman's Film," p. 71.
[18]Ibid., p. 47.

1930s, Crawford had become, in the vernacular of the industry, a "clothes-horse," and her wardrobe frequently drew more (and more positive) critical response than her acting. *Motion Picture Herald* wrote of *Letty Lynton* (1932), "The gowns which Miss Crawford wears will be the talk of your town for weeks after. . . ." *Chained* (1934), in which Crawford appeared in a different dress and hairstyle in almost every scene, prompted the *New York Times* critic to remark, "Miss Crawford adds to the general attractiveness of . . . this offering by an unusually extensive wardrobe and a variety of changes in her coiffure."[19]

Crawford became associated with a single "look": heavily lined eyes, emphasized cheekbones, dramatically outlined and darkened lips, and, especially, the square-shouldered dresses and "masculine" tailored suits designed for her by MGM's top designer, Adrian. Crawford's costumes provided an appropriate visual correlative to the "independent woman" character she so frequently played. Visually, if not narratively, her heroines overwhelmed their male counterparts. Less remembered about Crawford's screen iconography is the fact that her look "above the neck" changed enormously from film to film. She wore her hair in almost every conceivable style, length, and color. Her eyebrows went from narrow, plucked, and penciled in the early 1930s to full and heavily darkened in *Mildred Pierce* (1945). The platinum-blonde Crawford of *This Modern Age* (1931) looks no more than a distant relative of the Crawford in *The Bride Wore Red* (1937). Thus while Crawford's roles helped to anchor her "independent woman" image, the changes she was able to effect in her very appearance from film to film contributed to the notion of self-regeneration found in publicity representations of her in the 1930s. Crawford constantly seemed to be making herself over on-screen and off.

## CRITICISM AND COMMENTARY

Dyer defines this category as appreciations or interpretations of the star's performances. Included would be reviews, books and articles on the star's films, obituaries, and media profiles of the star's work. Although reviewers and critics frequently work for the same media industries that promote and publicize stars, their role in the construction of the star-image is distinctive in that they appear to be speaking on behalf of the audience. Their voice is that of response to an image rather than, ostensibly at least, creation of it. For this reason, says Dyer, criticism helps to add complexity to the star-image and helps to account for changes in public reception of a star. Criticism can also act back upon both promotion and publicity. Favorable reviews might influence the selection of future star vehicles or co-stars. Critics might pick up on one aspect of a star's screen performance, which is then foregrounded in publicity materials.

Until the late 1940s, Joan Crawford's screen performances received much less critical attention than those of her contemporary stars. For the most part, the films she appeared in were not highly regarded by critics. As has been noted, the style of the woman's film was invisible, and films of that genre were seldom adapted from critically acclaimed novels or plays. The public appeal of Crawford's films was seen by

---

[19]Quirk, *Films of Joan Crawford*, pp. 100, 113.

critics to be based on her screen presence and wardrobe rather than on any extraordinary acting ability.

Ironically, the most important "review" Crawford received in the 1930s came not from a critic per se but rather from a poll of theater owners. In May of 1938 the trade paper *Hollywood Reporter* ran the results of a survey conducted of the membership of the Independent Theatre Owners Association. In it, she (along with Mae West, Greta Garbo, and Katharine Hepburn) was voted "box-office poison," meaning that her star status and correspondingly high salary were unjustified by ticket sales of her films. One of the top ten box-office attractions each year between 1933 and 1936, Crawford had declined in popularity by 1938. Critics complained that the films she was given by MGM were hackneyed and her roles stale—a view she privately shared. Crawford's biographer argues the MGM studio head Louis B. Mayer believed the public to be tired of the older stars on his roster (Crawford, Garbo, Norma Shearer) and wanted to replace them with fresh faces (Judy Garland, Lana Turner, Hedy Lamarr, and Greer Garson). The "box-office poison" designation gave him all the more reason to invest more in the company's younger stars and consign Crawford and other "declining" MGM luminaries to the oblivion of program pictures. Crawford asked to be released from her MGM contract in 1943 and signed with Warner Bros. For two years she did not appear on the screen, waiting for the appropriate vehicle to serve as her first non-MGM film.

The film she finally did agree to make in 1945 was *Mildred Pierce*, based on the 1941 James M. Cain novel. During her hiatus, Crawford had hired a new agent. Even before shooting on the film was finished, he planted the rumor among gossip columnists that Crawford's performance was such that she was sure to be nominated for an academy award. By the time *Mildred Pierce* was released in October 1945, Crawford was being prominently mentioned as an Oscar candidate, and, as Bob Thomas, Crawford's biographer, puts it, "reviewers joined the bandwagon" by lauding her performance.[20] In the spring of 1946, Crawford vindicated the self-appointed prophets of her success by winning the "Best Actress" award.

At issue here is not the merit of Crawford's acting or whether the Oscar was "deserved," but how both the charge that she was poison at the box office and the accolades given her performance in *Mildred Pierce* functioned in her overall star-image. At the time, the "poison" label seemed to many to signal the end of Crawford's career. In 1938 Crawford had been appearing in films for more than a decade, out-lasting most of the stars whose careers had begun before the introduction of sound. Furthermore, at age thirty-two she was considerably older than the top female stars of the day (Shirley Temple, Sonja Henie, Alice Faye, and Myrna Loy), and the ingenue roles most female stars were expected to play became less plausible for Crawford with each passing year.

With the critical success of *Mildred Pierce*, however, the "poison" episode was integrated into the Crawford image as one more obstacle she had been able to overcome. Crawford had done it again, triumphed against all odds, renewed herself once again—this time Phoenix-like out of the ashes of her nearly extinguished career. Columnist Louella Parsons wrote in *Photoplay* that "the too-plump chorus girl, who

---

[20]Thomas, *King Cohn*, pp. 135–138.

had come here twenty years ago and who had known triumph and defeat in that time, had come back after two years of idleness to be crowned queen of them all!" Parsons could not help but remind readers that even in this moment of Crawford's greatest success she was undergoing yet another tragedy, her divorce from Phillip Terry.[21]

## CONCLUSIONS

This case study has merely hinted at the complex polysemy that is the image of a star such as Joan Crawford. Stars do not reflect society in some magical but straightforward way; rather, they embody in their images certain paradoxes or contradictions inherent in the larger social formation. In the case of Crawford these contradictions involve notions of success and how it might be achieved, and expectations about women and their roles in society. Dyer's formulation of promotion, publicity, films, and commentary provide the film historian with a means of locating the star image, examining it in its complexity, and charting changes over time.

Recognition of the star as a "structured polysemy" also suggests something of the complexity of social film history in general. Of the four traditional categories of film historical research, social film history presents the greatest challenge. Since films were first publicly shown in the 1890s, the film viewing situation has represented the point of convergence for three distinct social processes: that which produced the film on the screen, that which brought the audience to the theater, and the process of social representation occurring on the screen within the filmic text. Hence, the seemingly straightforward questions posed at the beginning of this chapter (Who made the movies and why? and so forth) lead inevitably from this point of convergence in the movie theater outward to larger social processes and institutions.

By multiplying the social event enacted at every public film screening by the number of those screenings since 1896 and then by the number of persons participating in them over the past ninety years, we can begin to sense the dimensions of the social phenomenon film production and reception represent. To this must be added our encounters with "the movies" outside the theater: reportage, publicity, advertisements, and the promotion of stars, among other forms of discourse about the movies. The scope of social film history is not limited to these aspects, however, for we have yet to consider the social dynamics of the typical viewing situation in most countries of the world for most of the course of film history: an audience from one culture confronting a filmic text produced not within and for its own culture, but imported from abroad.

The enormous popularity of the movies throughout the world and their centrality as a form of entertainment and leisure activity in Western culture for nearly a century have long tempted film and cultural historians to construct grand explanations of our fascination with the movies and to regard films as coded messages from the cultural unconscious. However, the complexity of the social processes involved in film production and reception precludes easy generalizations. Nowhere is the "open system" quality of the film historian's object of study more apparent than in social film history.

1985

---

[21]Louella Parsons, "You're Welcome, Joan," *Photoplay* (June 1946): 34–35, 128.

# MOLLY HASKELL
# *FROM* FROM REVERENCE TO RAPE

## FEMALE STARS OF THE 1940s

The preoccupation of most movies of the forties, particularly the "masculine" genres, is with man's soul and salvation, rather than with woman's. It is man's prerogative to follow the path from blindness to discovery, which is the principal movement of fiction. In the bad-girl films like *Gilda* and *Out of the Past*, it is the man who is being corrupted, his soul which is in jeopardy. Women are not fit to be the battleground for Lucifer and the angels; they are something already decided, simple, of a piece. Donna Reed finally refused to make any more movies with Alan Ladd because he always had a scene (it was in his contract) in which he would leave the little woman in the outer office, or some equivalent, while he went off to deal with the Big Problem that only a man could handle. Even the musicals of the forties—the Donen–Kelly collaborations—concentrate on man's quest, on his rather than her story.

In the penumbral world of the detective story, based on the virile and existentially skeptical work of writers like Hammett, Chandler, Cain, and David Goodis (which found its way into crime films like *Dark Passage*, *The Blue Dahlia*, *Farewell My Lovely*, *Double Indemnity*, *I Wake Up Screaming*, and *The Big Sleep*), the proliferation of women—broads, dames, and ladies in as many shapes and flavors, hard and soft centers as a Whitman's sampler—was a way of not having to concentrate on a single woman, and again, of reducing woman's stature by siphoning her qualities off into separate women.

Although Howard Hawks would seem to fall into this tradition with *The Big Sleep*, in which he actually increases the number of women from the Chandler novel, there is something in the women and in Hawks' conception of them that suggests a real, if not entirely articulated, sense of a woman's point of view (or at least an antisexist point of view) that will become increasingly apparent in the work of this supposed "man's director." In contrast to most crime melodramas, where plot and its unravel-

620

ing are all, the plot of *The Big Sleep* is next to incomprehensible, and the women are what it is all about: Lauren Bacall's sleek feline lead, Martha Vickers' spoiled, strung-out younger sister, Dorothy Malone's deceptively dignified bookstore clerk, Peggy Knudsen's petulant gangster's moll, and an unbilled woman taxi driver. Their lechery is as playful as the plot, and they are not stock figures of good and evil but surprisingly mixed and vivid, some of them in roles lasting only a few moments.

By including women in traditionally male settings (the newspaper office in *His Girl Friday*, the trapping party in *The Big Sky*, the big-game hunters in *Hatari!*), Hawks reveals the tension that other directors conceal or avoid by omitting women or by relegating them to the home. Many of Ford's thirties' and forties' films have no women in them at all, whereas even in Hawks' most rough-and-tumble, male-oriented films, the men are generally seen in relation to women, and women are the point of reference and exposition.

Hawks is both a product of sexual puritanism and male supremacy, and, in the evolution of his films and the alternation-compensation between tragedy and comedy, a critic of it. In the group experience of filmmaking, he lives out the homoerotic themes of American life, literature, and his own films. Thus, the John Wayne older-man figure in *Rio Bravo* and its companion westerns seems finally to have developed into a "complete" man, to the point where he is able to go it alone, to find his self-esteem within himself rather than from the admiration of his friends, and to greet a "complete" woman on her own terms. Like most American men, Hawks and Ford and their protagonists become more at ease with women as they grow older. In his early adventure films, in which the women repeatedly break up male friendships and the men do little to resist what filmwriter Robin Wood has called the "lure of irresponsibility," Hawks betrays the sensibility of an arrested adolescent. His fear of woman is twofold: (1) as the emotional and "unmanly" side of human nature, and (2) as its progenitor. He is like the young boy who, in recoiling from his mother's kiss, refuses to acknowledge his debt of birth to her and who simultaneously fears revealing his own feelings of love and dependency.

In *Only Angels Have Wings*, Jean Arthur provides an alternative to the all-male world of stoical camaraderie on the one hand, and to the destructive femininity represented by Rita Hayworth on the other, but what an alternative! A man dies trying to land a plane in a storm in time for a date with her, she breaks down in defiance of the prevailing stiff-upper-lip ethic, and thereafter she hangs around like a puppy dog waiting for Cary Grant to fall in love with her. For female Hawksians, this is the film most difficult to accept, more difficult than the early films in which women figure only as devils *ex machina*. Although the relationship Jean Arthur offers Grant seems to have been conceived as something "different but equal," women feel it (as Hawks seems to have felt it) as second best. In the all-male community of civil aviators Grant heads up, the central relationship is the tacit, mutual devotion between Grant and Thomas Mitchell. In a milieu of constant, physical danger and sublimated feelings, Arthur's emotionalism is a threat—but it is also, or it is meant to be, a release. The trouble is that Arthur, deprived of the pepperiness and sense of purpose she has in her other thirties' and forties' films (or the sweetly misplaced glamour of *Easy Living*), becomes a sobbing stone around the collective neck of civil aviation; and she doesn't have the easy come–easy go sexual confidence with which Lauren Bacall and Angie

Dickinson invest Slim and Feathers, Hawks' most sensually aggressive, European-style heroines. Still, technically, *Only Angels Have Wings* is a transition film. When Mitchell dies, Arthur takes his place, marking the progression of woman from second to first string.

*Ball of Fire* is a perfect fusion of Hawks' dialectics and those of Brackett and Wilder, who wrote the screenplay. When Barbara Stanwyck as a fast-talking gang-ster's moll invades the sanctuary of a group of lexicographers headed by Gary Cooper, it is as if Hawks had recognized the sclerotic danger of male camaraderie—and was resisting it. But Sugarpuss O'Shea is as much a Wilder–Brackett creation, a worldly, romantic sensualist who shakes up a group of typically American fuddy-duddies and "regenerates" them. Stanwyck is as emotionally responsive as Jean Arthur, but tougher; she brings her own world of jive and street talk with her, and manages to "corrupt" the ivory-tower purity of the scholars—and expand their vision. Her humanizing influence paves the way for the rapprochement of the sexes that occurs in Hawks' subsequent films, particularly in the Bogart–Bacall melodramas, and in the John Wayne–Angie Dickinson relationship in *Rio Bravo*. If the highest tribute Hawks can pay a woman is to tell her she has performed like a man (Bogey's "You're good, you're awful good"), isn't that, at least partly, what the American woman has always wanted to be told? Hasn't she always wanted to join the action, to be appreciated for her achievements rather than for her sex? But one often seems to have been gained at the expense of the other, the performing excellence at the cost of the "womanly" awareness. Hawks' sensitivity to the American girl's anxiety, to her shame at "being a girl," expresses itself later in such fifties' characters as Charlene Holt in *Red Line 7000*, and Paula Prentiss in *Man's Favorite Sport?* As actresses, and as characters, they lack the usual coordinates of "sex appeal"; both their athletic abil-ity and their anxiety bespeak a lack of sexual confidence that is disturbingly real. In *Man's Favorite Sport?* it is Paula Prentiss who makes Rock Hudson take the plunge into the sport (fishing, or, on an allegorical level, sex) on which he is supposed to be an authority. He has written a "how to" book without ever having gotten his feet wet.

In Hawks' best films, there is a sense of playacting for real, of men and women thrusting themselves ironically at each other, auditioning for acceptance but finding out in the process who they really are. In *To Have and Have Not*, Bacall combines intelligence and sensuality, pride and submission. She holds her own. She is a singer and is as surrounded by her "musical world" as Bogart is by his underground one, and she combines with him to create one of the great perfectly balanced couples, as highly defined by fantasy and wit as Millamant and Mirabell in *The Way of the World*, or as Emma Woodhouse and Mr. Knightley in *Emma*. For the Hawks' heroine, the vocal quality, the facial and bodily gestures are the equivalent of the literary heroine's words, and with these she engages in a thrust-and-parry as highly inflected and intri-cate as the great love duels of literature.

The fable of *To Have and Have Not*, like so many of the action melodramas dur-ing the forties (for example, *Casablanca*) is that of the tough guy who "doesn't believe in" patriotic action or sticking his neck out, and who eventually sticks his neck out farther and more heroically than anyone else. In *To Have and Have Not*, it is Bogart's willingness to risk death, pshawing all the while, to bring a French Resis-

tance fighter into Martinique, under the eyes of the Vichy government. But there is an additional, and even more important, meaning to the idea of involvement in Hawks, the involvement of a man with a woman, a scarier and deeper risk of oneself, perhaps, than death.

Typically, a man (in *Only Angels Have Wings*, *To Have and Have Not*, and *Rio Bravo*) is avoiding women like the plague. He has been badly burned and he doesn't want to get involved. But he, we are entitled to think, doth protest too much. Like the woman's child obsession in the woman's film, which conceals a secret desire to be rid of her offspring, the single man's retreat from marriage conceals a contrary desire. Otherwise, why would he leave so many strings for her to seize upon? (There are very few such "strings," and little sense of heterosexual need, in the action films of the sixties and seventies, which is one of the differences between then and now, and between Hawks and his colleagues and successors.) But it is the woman who has to bring the man around to seeing and claiming the invisible ties (in *To Have and Have Not*, Bacall asks Bogey to walk around her, and then says, "See? No strings," while he is tripping over them without realizing it). The man backs off, using as a pretext or real motive his disapproval of the woman's past. They exchange roles: The woman "proves herself" by playing it his way, by showing her physical courage or competence. And through a respect for her, first on his own terms, then on hers, he is brought around to a more "feminine" point of view.

Because proving themselves to each other is so fundamentally important for the action here, and for Hawks' men, a woman who is (behaves, thinks) like a man is the transitional step to heterosexual love. In some ways this tribute to love means more coming from a "man's director" than if it had come from a "woman's director." *To Have and Have Not* is so far from the machismo mold of the Hemingway original that the Resistance Frenchman's courage is not in being willing to die, but in having brought along the woman whose presence "weakened" him, by making him concerned for her safety. His heroism, for which he will win no medals, is to have accepted the consequences of heterosexual love. And she, as a spoiled, destructive girl, redeems herself when she understands this. *To Have and Have Not* ultimately contradicts the mystique of those forties' films that, in pretending to deprecate heroics, are most infatuated with them as judged by and performed for men themselves. In the end of *Casablanca*, it is with Claude Rains that Bogart walks off into the Moroccan mist, the equivalent of the lovers' sunset; in *To Have and Have Not*, it is with Lauren Bacall. *Casablanca* reaps the conventional glory for an act—rejection—that is easiest; *To Have and Have Not*, opting for the love that is least honored in the virility ethic, is more truly glorious.

Under Hawks' supervision (being forced, the story goes, to yell at the top of her lungs on a mountaintop, to deepen her voice), Lauren Bacall's Slim is one of film's richly superior heroines and a rare example of a woman holding her own in a man's world. Her characters in *The Big Sleep* and *To Have and Have Not* are romantic paragons, women who have been conceived in what remains, essentially, a "man's world." But in the forties, certain movie stars emerged with distinctive, highly intelligent points of view (strong women like Davis, Crawford, Hepburn, and Russell), which they imposed openly or surreptitiously on the films they made. In this, either

as stars or in the parts they played, they corresponded to certain kinds of women that literature had abstracted, over the years, from life. Because society dictated the proper, and severely restricted, domain for women, those who didn't "fit"—the "extraordinary women"—were tortured and frustrated; hence, the "neurotic woman." Finding no outlet for her brains or talent except as wife and mother, she dissipates her energies, diverts them, or goes outside society. Of such women, literature gives us two basic types, one European, the other Anglo-Saxon.

The first, and basically European model, is the "superfemale"—a woman who, while exceedingly "feminine" and flirtatious, is too ambitious and intelligent for the docile role society has decreed she play. She is uncomfortable, but not uncomfortable enough to rebel completely; her circumstances are too pleasurable. She remains within traditional society, but having no worthwhile project for her creative energies, turns them onto the only available material—the people around her—with demonic results. Hedda Gabler, Emma Bovary, and Emma Woodhouse are literary superfemales of the first order.

The other type is the "superwoman"—a woman who, like the "superfemale," has a high degree of intelligence or imagination, but instead of exploiting her femininity, adopts male characteristics in order to enjoy male prerogatives, or merely to survive. In this category are the transsexual impersonators (Shakespeare's Rosalind and Viola) who arrogate male freedoms along with their clothes, as well as the Shavian heroines who assume "male logic" and ideology to influence people—and who lose friends and, most triumphantly, make enemies in the process.

Scarlett and Jezebel, Vivien Leigh and Bette Davis, are superfemales. Sylvia Scarlett and Vienna, Joan Crawford and (often) Katharine Hepburn, are superwomen. The southern heroine, because of her conditioning and background, is a natural superfemale. Like the European woman, she is treated by men and her society with something close to veneration, a position she is not entirely willing to abandon for the barricades. Rather than rebel and lose her status, she plays on her assets, becomes a self-exploiter, uses her sex (without ever surrendering it) to gain power over men. Romantically attractive, even magnetic, she is not sexual (though more so than her northern counterpart, hence the incongruity, even neurosis, in the New England Davis' southern belle performances); she is repressed more from Victorianism than puritanism, and instinctively resists any situation in which she might lose her self-control. (The distinction between North and South obtains in the literary "superfemales" as well; the "Northern European" types, Hedda Gabler and Emma Woodhouse, suggest respectively sexual frigidity and apathy; Mme Bovary, being more Mediterranean, is more likely to have found sexual satisfaction.)

Bette Davis, superfemale and sometime southern belle, was not born in the South at all, but in Lowell, Massachusetts, of an old, respectable Protestant family. The only clue in her background to the seething polarities of toughness and vulnerability expressed in her roles was the trauma (glossed over in her autobiography) of her father's desertion of the family when she was only a child. She was supported in her theatrical career by her mother, Ruthie, who was also her lifelong friend, even as she progressed (or regressed) from the guardian of her struggling daughter to the spoiled charge of her successful one. All this might or might not explain the conflicting impulses of the Davis persona (in tandem or from film to film): the quicksilver shifts

between distrust and loyalty, the darting, fearful eyes, and the bravura, the quick wit of the abruptly terminated sentences, the defensiveness, and the throttled passion.

She was the wicked girl who sometimes was, sometimes wasn't, so bad underneath, while Crawford was the self-made gracious lady with ice water for blood. At some point (Crawford in *Rain* and *A Woman's Face*) each of them was bisected by the puritan ethic into two mutually exclusive extremes of good and evil. But even in her double role in *A Stolen Life*, when she played Katy, the sweet-and-passive sister and her bitch twin, Pat, Davis did not really draw a radical distinction between the two (as de Haviland did in *The Dark Mirror*), thus suggesting the interdependence of the two halves.

In the beginning of her career, Davis was just plain Katy ("the cake," as Glenn Ford describes her, in contrast to Pat, "without the frosting"). In her first picture, *Bad Sister*, reportedly one of the worst films ever made, Davis was not the eponymous hellion (that was Zasu Pitts) but her simpering, virtuous sibling. "Embarrassment always made me have a one-sided smile," she recounts in her autobiography, "and since I was constantly embarrassed in front of a camera, I constantly smiled in a one-sided manner."

She was universally considered unsexy, not to say unusable: still, when her contract expired she managed to hang on until she was taken up by Warners. Her lack of success or star status became an asset, as she was able to take parts—like Mildred in *Of Human Bondage*—that nobody else would touch. This was her first villainess, and her enthusiasm extended to the makeup, which she persuaded director John Cromwell to let her apply herself. In so doing, she thus gained the upper hand, which she would use whenever she could (and not always to her own advantage), and demonstrated that feeling for greasepaint grotesque that only she could get away with, and sometimes even she could not.

She determined to make it very clear "that Mildred was not going to die of a dread disease looking as if a deb had missed her noon nap. The last stages of consumption, poverty and neglect are not pretty and I intended to be convincing-looking. We pulled no punches and Mildred emerged as a reality—as immediate as a newsreel and as starkly real as a pestilence." (Actually, Davis' notions of feminine vanity and excesses, daring as they often are, have led her into those parodies of womanhood that are closer to Grand Guignol than newsreel, and that have surrounded her with camp followers whose image of her obliterates her real strengths.)

From then on, she was one of the few actresses willing—even eager—to play against audience sympathy. In her southern belle phase, she managed to combine the vanity of the "deb" with the venality of Mildred. Even in her superfemale roles, the charm has a cutting edge—the taunting Julie Marsden of *Jezebel* (the consolation role for missing out on Scarlett); the "jinx" actress, Joyce Heath, patterned on Jeanne Eagels, in *Dangerous* (for which she won the consolation Academy Award denied her for *Of Human Bondage*); the mortally ill socialite, Judith Traherne, in *Dark Victory*; and the frivolous Fanny Trellis of *Mr. Skeffington*.

The superfemale is an actress by nature; what is flirtation, after all, but role-playing? Coquetry is an art, and Davis exulted in the artistry. In *Jezebel*, she captivates her beaux but with less natural effervescence than Scarlett. Davis is more neurotic than Vivien Leigh, less cool. When coolness is called for, Davis gives us a cold

chill: when warmth, a barely suppressed passion. Her charm, like her beauty, is something willed into being. It is not a question of whether she is inside or outside the part (for curiously she is both) but of the intensity of her conviction, a sense of character in the old-fashioned sense of "moral fiber." Through sheer, driving guts she turns herself into a flower of the Old South, and in that one determined gesture reveals the bedrock toughness of the superfemale that we discover only by degrees in Scarlett.

Davis' reputation is based on a career composed of equal parts art, three-star trash, and garbage, sometimes all in the same film—which makes fine critical distinctions difficult. Warners gave her a hard time, and she reciprocated. (She even brought a lawsuit against them once, which she lost, but in so doing, she paved the way for future action on actors' behalf.) William Wyler was her toughest and best director— on *Jezebel*, *The Letter*, and *The Little Foxes*—but she broke with him over *The Little Foxes*. She was in an invisible competition with Tallulah Bankhead, who had played Regina brilliantly on Broadway, and from whom she also inherited (and probably improved upon) *Jezebel* and *Dark Victory*. Surely none of these films was a "betrayal" of the original stage play, and as to who outshone whom, only those who have witnessed both can decide—and even they, given the fierce, partisan loyalties these two women inspire, are not entirely trustworthy.

For all her enmities, Davis really was a friend to other actresses, content to take the back seat and let them run with the showy parts. (Actually, some of her "back-seat" parts—the sweet-tempered but strong girl in *The Great Lie*—are some of her most appealing and underrated roles.) Mary Astor tells the story of how she and Davis built her—Mary's—part in *The Great Lie* into an Academy Award-winning performance. Every day before shooting they added material to the screen play, to make Mary look good as well as to enliven the movie, and between them (and with the sympathetic direction of Edmund Goulding) they created one of the most complex women's relationships in a woman's film. They are cast as stereotypes: Astor, the sophisticated and selfish concert pianist who wants George Brent more than his baby; Davis, Brent's Baltimore bride, who makes a deal with Astor for the baby when they think Brent is dead. Their relationship during Astor's delivery alternates between tenderness and spite, love and hate, as Davis plays the "father" (in jodhpurs, pacing the floor) to Astor's mother.

Part of Davis' greatness lies in the sheer, galvanic force she brought to the most outrageous and unlikely roles, giving an intensity that saved them, usually, from camp. Even when she is "outside" a part (through its, or her, unsuitability), she is dynamic. As the harridan housewife of *Beyond the Forest*, she surveys her despised domestic kingdom and says "What a dump!" and we are with her. By the time Martha in *Who's Afraid of Virginia Woolf?* says the same line, it has already been consecrated as camp. In spite of the fact that the only way we can think of Davis as a femme fatale is if she contemplates murder or literally kills somebody (*The Letter*, *The Little Foxes*), she makes us accept her as a girl men fight duels over and die for. She is constantly being cast against type as a heartbreaker, and then made to pick up the pieces when foolish hearts shatter. As the actress "witch" (*Dangerous*) whose stage presence has caused suicides and inspired epiphanies, she is made to do penance, for the rest

of her life, with her Milquetoast husband. But if we look closely, here and elsewhere, it is not she but others who insist on her supernatural evil, who throw up a smoke screen of illusions, who invoke mystical catchwords to explain her "magic" or her "jinx," why she is "different" from other women.

In her film career, Davis casts a cold eye, and not a few dampening remarks, on sentimentality. When Claude Rains, as the doting Mr. Skeffington, tells her "A woman is beautiful only when she is in love," Davis, miserable over the discovery of her pregnancy, replies, "A woman is beautiful if she has eight hours of sleep and goes to the beauty parlor every day. And bone structure has a lot to do with it."

In King Vidor's *Beyond the Forest*, her wildest and most uncompromising film, one she herself dislikes, she plays the evil Rosa Moline, married to Joseph Cotton's small-town doctor. He is seen as "good" because he goes without, and makes his wife go without, so his impecunious patients won't have to pay their bills—and will "love" the good doctor. His "virtue" succeeds in driving his wife into further malice. One of the earliest discontented housewives on record, Rosa sashays around wearing a long black wig, like her surly housekeeper, Dona Drake, who is a dark-skinned lower-class parody of her. Davis' obsession is to go to Chicago, and to this end she wrecks every-one's lives. In one of the film's most modern, *angst*-ridden scenes, she wanders the back streets of Chicago, staggering through the rain (having been turned out of a bar where women "'without escorts" are not allowed), looking like another star who would later claim her influence—Jeanne Moreau in *La Notte*.

"I don't want people to love me," Rosa says—one of the most difficult things for a woman to bring herself to say, ever, and one of the most important. It is something Davis the actress must have said. Thus, does the superfemale become the super-woman, by taking life into her own hands, her own way.

Davis' performance in *Beyond the Forest*, as a kind of female W. C. Fields, and Vidor's commitment to her, are astonishing. Even though she is contrasted with a "good woman" (Ruth Roman) to show that she is the exception, that all women are not like that (a moralistic pressure that Hollywood is not the only one to exercise—the French government made Godard change the title of *The Married Woman* to *A Married Woman*), the Ruth Roman character has little moral weight or value. As Rosa Moline, Davis creates her own norms, and is driven by motives not likely to appeal to the average audience. She is ready and eager to give up husband, position, secu-rity, children (most easily, children), even lover; for what? Not for anything so noble as "independence" in terms of a job, profession, or higher calling, but to be rich and fancy in Chicago! And here is Davis, not beautiful, not sexy, not even young, con-vincing us that she is all these things—by the vividness of her own self-image, by the vision of herself she projects so fiercely that we have no choice but to accept it. She is smart, though, smarter than everyone around her. She says it for all smart dames when David Brian tells her he no longer loves her, that he's found the "pure" woman of his dreams. "She's a book with none of the pages cut," he says.

"Yeah," Davis replies, "and nothing on them!"

Since she began as a belle and emerged as a tough (in *Beyond the Forest* she is a crack shot and huntress), Davis' evolution from superfemale to superwoman was the most dramatic, but she was by no means the only actress in the forties to undergo such

a transformation.* Perhaps reflecting the increased number of working women during the war and their heightened career inclinations, other stars made the transition from figurative hoop skirts to functional shoulder pads, and gained authority without necessarily losing their femininity.

The war was *the* major turning point in the pattern and attitudes of (and toward) working women. From 1900 to 1940, women in the labor force had been mostly young, unmarried women in their early twenties who were biding their time until marriage. Suddenly, to fill men's places and aid in the expanded war industries, older, married women were recruited, and from that time to the present (when the typical working woman is forty and married) the median age rose with the percentage of women in the labor force. A poll of working women taken during the war came up with the startling fact that 80 percent wanted to keep their jobs after it was over. After a sharp drop-off following the end of the war—when women were fired with no regard for seniority—married women *did* go back to work, although as late as 1949 it was still frowned upon. This, of course, is the source of the tremendous tension in films of the time, which tried, by ridicule, intimidation, or persuasion, to get women out of the office and back to the home, to get rid of the superwoman and bring back the superfemale.

Rosalind Russell came out of the superfemale closet into superwoman roles fairly early in her career. But in *Craig's Wife*, an adaptation of the George Kelly play, she is not only a superfemale but the definitive superfemale, the housewife who becomes obsessive about her home, the perfectionist housekeeper for whom, finally, nothing else exists. It would be comforting to look upon this film, directed by Dorothy Arzner, as a protest against the mindlessness of housewifery, but, like *The Women*, of which the same claim has been made, it is not so much a satire as an extension, in high relief, of the tics and intellectual tremors of a familiar American type. In *The Women*, as the malicious (and funny and stylish) Mrs. Fowler, Russell is the superfemale par excellence; but in *His Girl Friday*, as the newspaper reporter, in *My Sister Eileen*, as the short-story writer, and in *Take a Letter, Darling*, as the business executive, she begins pulling her own weight in a man's world, risks making enemies and losing lovers, becomes, that is, a superwoman.

In *Take a Letter, Darling*, she is the partner in an advertising firm where she began as a secretary. She runs the operation while Robert Benchley, the titular head of the firm, plays miniature golf in his office. He is, to Russell, the kind of benign father figure that Charles Coburn was to Jean Arthur and Irene Dunne. Not in the least bitter at Russell's success, he is quite happy to have been "kicked upstairs" and gives her support and advice whenever she comes to him. At one point, he complains that her competitors—all men, of course—don't understand her:

---

*In a characteristically perverse fashion, Ida Lupino went in the opposite direction, from the superwoman matriarch of *The Man I Love* and *The Hard Way* (1942), in which she channels all of her ambitions into promoting her younger sister, to *The Bigamist* (1953), which she herself directed, and in which she plays Edmund O'Brien's mousy, submissive mistress against Joan Fontaine's aggressive career woman. Although Lupino takes the standard anti-career woman position in her treatment of Fontaine, the film presents a positive case for bigamy, or at least suggests that the binary system—one man, one woman, married for life without loopholes—is not the most flexible or realistic arrangement.

"They don't know the difference between a woman and a . . ."
"A what?" Russell asks.
"I don't know," Benchley replies, "there's no name for you."

In *My Sister Eileen*, Russell plays the writer-sister trying to sell her stories to a prestigious national magazine. Although the stories concern the escapades of her pretty and popular sister, Russell steals the show as the cerebral one, and gets editor Brian Aherne, too. (The difference in attitudes between the forties and fifties can be seen in the shift of emphasis in the musical remake of *My Sister Eileen* in 1955, in which Betty Garrett retains little dignity as the intellectual sister, but is overshadowed—and shamed—by the popularity of the sister played by Janet Leigh.)*

Katharine Hepburn made the transition from superfemale to superwoman most easily and most successfully of all—perhaps because she was already halfway there to begin with. In her second film, Dorothy Arzner's *Christopher Strong*, she played an aviatrix torn between her profession and her man. Flying presents an appropriately extreme metaphor for the freedom of the single woman that has to be surrendered once the idea of a family becomes a concrete reality. Torn apart by these conflicting pulls, Hepburn finally dies in a plane crash—that is, she propels herself, like the dancer in *The Red Shoes*, into the abyss between love and career. In both cases, the ending is not just a cautionary warning to deflect women from careers, but a true reflection of the dynamics of the situation: A woman has only so much energy, so much "self" to give; is there enough for profession (especially if it is a dangerous or demanding one), lover, and children? *Christopher Strong* raises these questions, but doesn't really pursue them, and as a consequence it is a less interesting film than it should be, less interesting than Arzner's more "feminist" film, *Dance, Girl, Dance*. But, for all its weaknesses, *Christopher Strong* leaves us with a blazingly electric image of Katharine Hepburn unlike that of any other film: a woman in a silver lamé body-stocking which covers everything but her face—and suggests the chrysalis of the superwoman of the future.

Hepburn, like most tomboy actresses, played Jo in *Little Women*, and shortly thereafter played the eponymous "transvestite" of *Sylvia Scarlett*, one of George Cukor's most enchanting and least-known films. Disguised as a boy, she accompanies her father, a crook on the lam, through the hills of Cornwall. They join forces with a troupe of wandering actors, led by Cary Grant, and embark on a free, magical, oneiric adventure, giving plays in the moonlight. Cukor's feeling for the conventions of theater, where he began his career, leads him into a world halfway between theater and life, a world in which disguises are often worn more easily and more "honestly" than native hues. The milieu and the story of *Sylvia Scarlett* have a Shakespearian feel to them, harking back to an age and a theatrical convention in which sex-exchange was permissible. This is Cukor's first film (and last for a while) in which he dared to challenge, in a lyrical stage whisper, our traditional assumptions about male-female roles.

The delicate equilibrium between a man and a woman and between a woman's need to distinguish herself and the social demands on her become the explicit theme

---

*If Columbia had used the Bernstein musical, with Rosalind Russell retaining her stage role, the move might have been better but no less sexist, with its rousing point-by-point denunciation of feminism: "100 Ways to Lose a Man."

of Cukor's great films of the late forties and early fifties, specifically the Judy Holli-
day films and Hepburn-Tracy vehicles written by the husband-and-wife team of Ruth
Gordon and Garson Kanin. Gordon and Kanin wrote a series of seven screenplays for
Cukor, three of which dealt, comically and sublimely, with the problems and the
chemistry of individuals.

Almost as a parody of the extraordinary individuals represented by Hepburn and
Tracy in *Adam's Rib* and *Pat and Mike*, Aldo Ray and Judy Holliday were a typical,
dumb, middle-class, well-meaning, ordinary married couple in Cukor's *The Marry-
ing Kind*. Almost a parody, but not quite. For it is one of the glories of the film that
the two characters, without ever being patronized and at the same time without ever
being lifted above the class and the cliché in which they are rooted, are intensely mov-
ing. Ray and Holliday, on the brink of divorce, have come to a woman judge (who, in
her relationship with her male assistant, shows both authority and warmth). Through
a series of flashbacks reconstructing their marriage we, and they, come to realize that
together they are something they never were apart: a unit, a whole. Two ordinary,
less-than-complete individuals who have grown into each other to the point where
they can be defined only by the word "couple" have no right to divorce. Separately,
they are two more swallowers of the American myth, two more victims of its fraud-
ulence: but together, with their children, they add up to something full and affirma-
tive. In losing their child, they are at first destroyed—their "meaning" evaporates. But
in that nothingness, old roles dissolve and they must rediscover themselves. Cukor,
Gordon, and Kanin are very much aware of the sexual insecurities that arise from too
rigid a concept of male-female roles, and suggest, in the visual and verbal motifs of
these "companion" films, that through some kind of "merger" of identities, through
a free exchange of traits (as when Holliday, in defiance of the law whereby it is the
man who "storms out" of the house in a fight, throws herself into the night), a truer
sense of the self may emerge.

In the growing isolation of the New York cultural elite from the rest of America in
the sixties, this is the side of marriage and the middle class that has been lost to us. We
seem to be able to approach middle-America only through giggles of derision (*The
Graduate*, *Sticks and Bones*, "All in the Family"): and, in dismissing the housewife as
a lower form of life, women's lib confirms that the real gap is cultural and economic
rather than sexual. In the difference between the couples in *The Marrying Kind* and
*Adam's Rib*, Cukor and company acknowledge the most fundamental intellectual,
spiritual, and economic inequality between the educated elite and the less privileged
and less imaginative members of lower-middle-class America; but they never deprive
them of their dignity, or deny them joys and sorrows and a capacity to feel as great as
the poets of the earth. The true emotional oppression—the oppression of blacks by
whites, of housewives by working women, is pity. For in such lessons in life as we get
from suffering, degrees are granted without reference to class or sex. Finally, most
honestly, Holliday's Florence and Ray's Chet are the sheep of the world rather than its
shepherds: They are the victims of emotions they haven't the words to express, the
tools of a mechanical-industrial society they haven't the knowledge to resist. Their
greatest defense against its monolithic oppressiveness, against being overwhelmed by
routine, inhumanity, and their "proletarian" identity, is each other, is their identity as a
couple. In the final, quite noble strength we feel in them as a couple, they confirm the

theory Cukor, Gordon, and Kanin seem to be endorsing: that marriage is an institution ideally suited to the people at both the bottom and the top—the truly ordinary and the truly extraordinary, those who are preserved and protected by it, and those who can bend it to their will.

Hepburn and Tracy were nothing if not extraordinary. While preserving their individuality, they united to form a whole greater than the sum of its parts. As Tracy says to Hepburn in *Pat and Mike*, in a line that could have been written by Kanin–Gordon, Cukor, or Tracy himself and that finally tapers off into infinity, "What's good for you is good for me is good for you. . . ."

This was true of them professionally. They came together at a time when their careers were foundering: misfits in the Hollywood mold, they were not in any way typical romantic leads. Hepburn had grown older, the face that once blushed in gracious concession to femininity now betrayed in no uncertain terms the recalcitrant New England spirit. And Tracy, too short and dumpy for conventional leading roles, hadn't found the woman who could lure him from the rugged, masculine world he inhabited. Out of their complementary incongruities, they created one of the most romantic couples the cinema has ever known. His virility acts as a buffer to her intelligence: she is tempered by him just as he is sharpened by her, and their self-confidence is increased, rather than eroded, by their need for each other.

*Adam's Rib*, that *rara avis*, a commercial "feminist" film, was many years ahead of its time when it appeared in 1949, and, alas, still is. Even the slightly coy happy ending testifies to the fact that the film strikes deeper into the question of sexual roles than its comic surface would indicate and raises more questions than it can possible answer.

Tracy and Hepburn play a couple of married lawyers who find themselves on opposite sides of a case: he is the prosecuting attorney, and she, seizing upon the crime and its implications, takes it upon herself to defend the accused. A dopey young wife—Judy Holliday, in her first major movie role—has shot, but not killed, her husband (Tom Ewell) over another woman. Hepburn, reading an account in the newspaper, is outraged by the certainty that the woman will be dealt with harshly while a man in that position would be acquitted by the courts and vindicated by society. Hepburn goes to visit Holliday at the woman's prison, and, in a long, lovely single-take scene, Holliday spills out her story, revealing, comically and pathetically, her exceptionally low consciousness. One of the constant and most relevant sources of comedy in the film is the lack of rapport between Hepburn's militant lawyer, constructing her case on feminist principles, and Holliday's housewife, contrite and idiotically eager to accept guilt. The film raises the means-and-end dilemma which has long been the philosophical thorn in the side of our thinking about the rights and reparations of minority groups. Hepburn marshals evidence of women's accomplishments to prove their equality with men, even to the point of having a lady wrestler lift Tracy onto her shoulders and make a laughingstock of him. She goes *too* far and humiliates him, while he remains a gentleman. She stoops to unscrupulous methods while he maintains strict honor and decorum. But, then, he can afford to, since the law was created by and for him.

Even down to his animal magnetism, Tracy wears the spoiled complacency of the man, but Hepburn, ambitious and intelligent, scrapes the nerves of male authority. An

acute sense of the way male supremacy is institutionalized in the "games people play" occurs in two contrasting situations of one-upmanship: Hepburn, fiery about the case she is about to take, is describing it to Tracy on the telephone: Tracy, in a familiar male (or marital) riposte, effectively cuts her off by teasing, "I love you when you get caus-y." This is greeted with delight by audiences, who usually disapprove of Hepburn's "emasculation" of Tracy in court, a more obvious but perhaps a less damaging tactic of bad faith. Cukor gives Hepburn an ally in the Cole Porter-type composer played by David Wayne, a character who seems to stand, at least partially, for Cukor himself. He identifies with Hepburn and, in marital feuds, takes her side against the virile, meat-and-potatoes "straight" played by Tracy. Thus the neutral or homosexual character, when he is sympathetic, can help to restore some of the balance in the woman's favor. But as soon as the Hepburn–Wayne collusion becomes devious or bitchy, the balance shifts, and our sympathy goes, as it should, to Tracy.

The film brilliantly counterpoints and reconciles two basic assumptions: (1) that there are certain "male" qualities—stability, stoicism, fairness, dullness—possessed by Tracy, and that there are certain "female" qualities—volatility, brilliance, intuition, duplicity—possessed by Hepburn; and (2) that each can, and must, exchange these qualities like trading cards. It is important for Hepburn to be ethical, just as it is important for Tracy to be able to concede defeat gracefully, and if she can be a bastard, he can fake tears. If each can do everything the other can do, just where, we begin to wonder, are the boundaries between male and female? The question mark is established most pointedly and uncomfortably when, during the courtroom session, the faces of Holliday and Ewell are transposed, each becoming the other.

But Hepburn and Tracy are not quite so interchangeable, and the success of their union derives from the preservation of their individuality, not rigidly but through a fluctuating balance of concession and assertion. Tracy can be humiliated and still rebound without (too much) loss of ego. Hepburn occasionally can defer to him and still not lose her identity. A purely political-feminist logic would demand that she be given Tracy's head, in unqualified triumph (an ending that some small part of us would like to see), rather than make an equivocal, "feminine" concession to his masculinity. But marriage and love do not flourish according to such logic. Their love is the admission of their incompleteness, of their need and willingness to listen to each other, and their marriage is the certification—indeed, the celebration—of that compromise.

This finally is the greatness of Hepburn's superwoman, and Davis' and Russell's too—that she is able to achieve her ends in a man's world, to insist on her intelligence, to insist on using it, and yet be able to "dwindle," like Millamant in *The Way of the World*, "into marriage," but only after an equal bargain has been struck of conditions mutually agreed on. It is with just such a bargain, and a contract, that Cukor's great Tracy-Hepburn film of the fifties, *Pat and Mike*, is concerned.

For the most part, the superwoman, with her angular personality and acute, even abrasive, intelligence, begins to disappear in the fifties. The bad-girl is whitewashed, or blown up into some pneumatic technicolor parody of herself. Breast fetishism, a wartime fixation of the G.I.'s, came in in the fifties. (Its screen vogue was possibly retarded by the delay in releasing Howard Hughes' *The Outlaw*, introducing Jane

Russell's pair to the world.) But even amidst the mostly vulgar fumblings toward sensuality, Cukor was there—with Ava Gardner in *Bhowani Junction* and Sophia Loren in *Heller in Pink Tights*—to give some dignity to the sex goddesses and, in films like *The Actress* and *Born Yesterday*, to pay tribute to the enterprising woman.

1974

# MIRIAM HANSEN
# PLEASURE, AMBIVALENCE, IDENTIFICATION

## VALENTINO AND FEMALE SPECTATORSHIP

In the context of discussions on cinematic spectatorship, the case of Rudolph Valentino demands attention, on historical as well as theoretical grounds. Increasingly, women spectators were perceived as a socially and economically significant group and films were explicitly addressed to a female spectator, regardless of the actual composition of the audience. As Hollywood manufactured the Valentino legend, promoting the fusion of real life and screen persona that makes a star, Valentino's female admirers in effect became part of that legend. Never before was the discourse on fan behaviour so strongly marked by the terms of sexual difference, and never again was spectatorship so explicitly linked to the discourse on female desire. This conjunction was to inform Valentinian mythology for decades to come—as the cover prose from two biographies illustrates:

> Lean, hot-eyed and Latin, Valentino was every woman's dream. . . . The studio telephones could not handle the thousands of calls from women. They begged for any job that would permit even a momentary glimpse of Valentino. Gladly they offered to work without pay.[1]

---

This is an abridged version of an article published in *Cinema Journal*, 25, 4 (Summer 1986), c. 1986 by the Board of Trustees of the University of Illinois. This essay appears in revised and expanded form in Miriam Hansen's *Babel and Babylon: Spectatorship in American Silent Film*, Harvard University Press, 1991.

[1]Brad Steiger and Chaw Mank, *Valentino: An Intimate and Shocking Expose* (New York: MacFadden, 1966) and Irving Shulman, *Valentino* (1967; New York: Pocket Books, 1968). Also see Vincent Tajiri, *Valentino: The True Life Story* (New York: Bantam, 1977); Noel Botham and Peter Donnelly, *Valentino: The Love God* (New York: Ace Books, 1977); Edouard Ramond, *La Vie amoureuse de Rudolph Valentino* (Paris: Librarie Baudiniere, n.d.). For a filmography and bibliography, compiled by Diane Kaiser Koszarski, see Eva Orbanz, ed., *There Is A New Star in Heaven . . . : Valentino* (Berlin: Volker Spiess, 1979) and Alexander Walker, *Rudolph Valentino* (Harmondsworth: Penguin, 1976).

While these biographies rarely agree on any facts concerning Valentino's life, they stereotypically relate his personal success and suffering to the ongoing crisis of American cultural and social values.[2] Valentino's body, in more than one sense, became the site of contradictions that had erupted with the First World War. The particular historical constellation that made him as well as destroyed him includes the upheaval of gender relations during the war, such as the massive integration of women into the work force and their emergence as a primary target in the shift to a consumer economy; the partial breakdown of gender-specific divisions of labour and a blurring of traditional delimitations of public and private; the need to redefine notions of femininity in terms other than domesticity and motherhood; the image of the New Woman promoted along with a demonstrative liberalisation of sexual behaviour and lifestyles; the emergence of the companionate marriage.[3]

However one may interpret the dialectics of women's so-called emancipation and their integration into a consumer culture, women did gain a considerable degree of public visibility in those years, and the cinema was one of the places in which this increased social and economic significance was acknowledged, in whatever distorted manner. The orientation of the market towards a female spectator/consumer opened up a potential gap between traditional patriarchal ideology on the one hand and the recognition of female experience, needs, fantasies on the other, albeit for the purposes of immediate commercial exploitation and eventual containment.[4] It is in this gap that the Valentino phenomenon deserves to be read, as a significant yet precarious moment in the changing discourse on femininity and sexuality. Precarious, not least, because it sidetracked that discourse to question standards of masculinity, destabilising them with connotations of sexual ambiguity, social marginality and ethnic/racial otherness.

Valentino also presents a challenge to feminist film theory, in particular as it developed during the 1970s within the framework of psychoanalysis and semiology. This debate inescapably returns to Laura Mulvey's essay on 'Visual Pleasure and Narrative Cinema' (1975) which first spelled out the implications of Lacanian-Althusserian

---

[2]Valentino came to symbolise the failure of the American Dream, especially to more highbrow critics of culture like H. L. Mencken (*Prejudices, Sixth Series*, 1927) and John Dos Passos (*The Big Money*, 1936). Ken Russell's film, *Valentino* (1977), based on the Steiger/Mank biography and starring Rudolf Nureyev in the title role, articulates this theme through its pervasive references to *Citizen Kane*, such as the use of *post mortem* multiple flashback narration and other corny allusions.

[3]Among the many reassessments of the period, see Estelle B. Freedman, 'The New Woman: Changing views of women in the 1920s', *Journal of American History*, 56, 2 (September 1974), 372–93; Mary P. Ryan, *Womanhood in America*, second edn (New York: New Viewpoints, 1979), ch. 5; Julie Matthaei, *An Economic History of Women in America* (New York: Schocken, 1982), especially chps 7–9.

[4]This hypothesis implies a concept of the public sphere, in particular that of an alternative or counter public sphere as developed by Oskar Negt and Alexander Kluge in *Öffentlichkeit und Erfahrung/Public Sphere and Experience* (Frankfurt: Suhrkamp, 1972). For a review in English, see Eberhard Knödler-Bunte, 'The proletarian public sphere and political organization', *New German Critique*, 4 (Winter 1975), 51–75; and my own paraphrase of Negt and Kluge in 'Early silent cinema: whose public sphere?' *New German Critique*, 29 (Spring/Summer 1983), 155–9. The role of the cinema for women during this period of transition is discussed in Judith Mayne, 'Immigrants and spectators', *Wide Angle*, 5, 2 (1982), 32–41; Elizabeth Ewen, 'City lights: immigrant women and the rise of the movies', *Signs*, 5, 3 (1980), S45–S65; Mary Ryan, 'The projection of a new womanhood: the movie moderns in the 1920s', in *Our American Sisters: Women in American Life and Thought*, second edn, Jean E. Friedman and William G. Shade, (eds) (Boston: Allyn and Bacon, 1976), 366–84.

models of spectatorship for a critique of patriarchal cinema. Whatever its limitations and blind spots, the significance of Mulvey's argument lies in her description of the ways in which the classical Hollywood film perpetuates sexual imbalance in the very conventions through which it engages its viewer as subject—its modes of organising vision and structuring narratives. These conventions, drawing on psychic mechanisms of voyeurism, fetishism and narcissism, depend upon and reproduce the conventional polarity of the male as the agent of the 'look' and the image of woman as object of both spectacle and narrative. In aligning spectatorial pleasure with a hierarchical system of sexual difference, classical American cinema inevitably entails what Mulvey calls 'a "masculinization" of the spectator position, regardless of the actual sex (or possible deviance) of any real life movie-goer'.[5]

Besides its somewhat monolithic notion of classical cinema and provocatively Manichean stance on visual pleasure, Mulvey's argument has been criticised frequently for the difficulty of conceptualising a female spectator other than in terms of an absence.[6] In the decade since Mulvey's essay was published, however, feminist critics have attempted to rescue female spectatorship from its 'locus of impossibility', in particular in areas elided by the focus on women's systematic exclusion, for example, the 'woman's film' of the 1940s and other variants of melodrama centering on female protagonists and their world.

Another area of feminist investigation, less clearly delineated, is the question of pleasure and attendant processes of identification experienced by women spectators (including feminist critics) in the actual reception of mainstream films, even with genres devoted to male heroes and activities, such as the Western or the gangster film. The female viewer of masculine genres does not fit the mould of the spectator/subject anticipated by these films, and in many of them narcissistic identification with female characters is of marginal interest at best, especially when the spectacle is more dispersed (over landscape and action scenes) than in genres like the musical or romantic comedy which concentrate pleasure around the image of the female body. But neither is reception on the woman's part merely accidental, arbitrary or individual—failing with regard to the meaning-potential of the film. Rather, one might say that the oscillation and instability (which Mulvey and others have observed)[7] in female spectatorship constitutes a meaningful deviation—a deviation that has its historical basis in the spectator's experience of belonging to a socially differentiated group called women. As a subdominant and relatively indeterminate collective formation, female specta-

[5]Laura Mulvey, 'Afterthoughts . . . inspired by *Duel in the Sun*', *Framework*, 15–17 (1981), 12; 'Visual pleasure and narrative cinema' originally appeared in *Screen*, 16, 3 (Autumn 1977), 6–18.

[6]For a still useful discussion of Mulvey in a larger context of directions of recent theory, see Christine Gledhill, 'Developments in feminist film criticism' (1978), rpt in *Re-Vision: Essays in Feminist Film Criticism*, Mary Ann Doane, Patricia Mellencamp, Linda Williams (eds) (Los Angeles: AFI Monograph Series, 1983), 18–48. Among articles devoted primarily to a critique of Mulvey, see David Rodowick, 'The difficulty of difference', *Wide Angle*, 5, 1 (1982), 4–15; Janet Walker, 'Psychoanalysis and feminist film theory', *Wide Angle*, 6, 3 (1984), 16–23. For discussions challenging the Metzian/Mulveyan paradigm of spectatorship altogether, see Gaylyn Studlar, 'Masochism and the perverse pleasures of the cinema', *Quarterly Review of Film Studies*, 9, 4 (Fall 1984), 267–82; Gertrud Koch, 'Exchanging the gaze: re-visioning feminist film theory', *New German Critique*, 34 (Winter 1985), 139–53.

[7]Mulvey, 'Afterthoughts', 12.

torship is certainly contingent upon dominant subject positions, and thus not outside or above ideology, but it cannot be reduced to an either/or modality.

Ann Kaplan points out the necessity of distinguishing between the historical spectator, the hypothetical spectator constructed through the film's strategies and the contemporary female spectator with a feminist consciousness. But the textually constructed spectator/subject does not have any objective existence apart from our reading of the film, which is always partial and, if we choose, partisan. Therefore, the question of hermeneutics is not only one of measuring historical scopes of reception against each other, but also one of the politics of reading,[8] a question of how to establish a usable past for an alternative film practice. If all the time, desire and money spent by women watching mainstream films should be of any consequence whatsoever for a feminist countertradition, then this activity has to be made available through readings, in full awareness of its complicity and contingency upon the dominant structures of the apparatus, but none the less as a potential of resistance to be reappropriated.[9]

The distinctiveness of the Valentino films lies in focusing spectatorial pleasure on the image of a male hero/performer. If a man is made to occupy the place of erotic object, how does this affect the organisation of vision? If the desiring look is aligned with the position of a female viewer, does this open up a space for female subjectivity and, by the same token, an alternative conception of visual pleasure?

At first sight, Valentino's films seem to rehearse the classical choreography of the look almost to the point of parody, offering point-of-view constructions that affirm the cultural hierarchy of gender in the visual field. Between 1921 (*The Four Horsemen of the Apocalypse*) and 1926, the year of his premature death, Valentino starred in fourteen films, produced by different studios and under different directors.[10] Illustrating the significance of the star as *auteur* as much as the economic viability of vehicles, each of these films reiterates a familiar pattern in staging the exchange of looks between Valentino and the female characters. Whenever Valentino lays eyes on a woman first, we can be sure that she will turn out to be the woman of his dreams, the legitimate partner in the romantic relationship; whenever a woman initiates the look, she is invariably marked as a vamp, to be condemned and defeated in the course of the narrative.

---

[8]See Jürgen Habermas's critique of Gadamer, *Zur Logik dur Sozialwissenschaften* (Frankfurt: Suhrkamp, 1970), 174ff; 'Der Universalitätsanspruch der Hermeneutik', *Kultur und Kritik* (Frankfurt: Suhrkamp, 1973), 264–301.

[9]This project obviously involves some 'reading against the grain' but ultimately has a different objective: rather than merely to expose, from film to film, the textual contradictions symptomatic of the repression of female subjectivity under patriarchy, a rewriting of film history in a feminist sense seeks to discover traces of female subjectivity even in the most repressive and alienated form of consumer culture. The paradigm I have in mind is Benjamin's huge work on the Paris Arcades which Susan Buck-Morss (in a forthcoming book) reads as a dialectical *Ur*-history of mass culture. Also see Habermas, 'Consciousness-raising or redemptive criticism: the contemporaneity of Walter Benjamin' (1972), *New German Critique*, 17 (Spring 1979), 30–59.

[10]A more consistent trait of Valentino's history with the industry is the high number of women in the production of his films, although this was generally more often the case before 1930. His most important films had scripts written by women, in particular June Mathis who 'discovered' him, but also Frances Marion; *Blood and Sand* was brilliantly edited by Dorothy Arzner; Alla Nazimova and Matacha Rambova, a designer and also his second wife, exerted their artistic and spiritual(ist) influence on many productions, with or without credit.

This pattern can be observed in *Blood and Sand* (1922): Doña Sol (Nita Naldi), the president's niece, is shown admiring the victorious torero through binoculars before he looks at her; thus, she is syntactically marked as a vamp. His future wife Carmen (Lila Lee), on the other hand, is singled out by the camera within his point of view. A close-up of his face signals the awakening desire, alternating with an indecipherable long shot of a crowd. The repetition of the desiring look, provoking a dissolve that extricates her from the crowd, resolves the picture puzzle for the spectator and, by the same logic of vision, establishes her as the legitimate companion (further sanctioned by the inclusion of his mother in the point-of-view construction that follows). Thus the legitimate female figure is deprived of the initiative of the erotic look and relegated to the position of scopic object within the diegesis. In relation to the spectator, however, *she shares this position of scopic object with Valentino himself.*

Valentino's appeal depends, to a large degree, on the manner in which he combines masculine control of the look with the feminine quality of 'to-be-looked-at-ness', to use Mulvey's rather awkward term. When Valentino falls in love—usually at first sight—the close-up of his face clearly surpasses that of the female character in its value as spectacle. In a narcissistic doubling, the subject of the look constitutes itself as object, graphically illustrating Freud's formulation of the autoerotic dilemma: 'Too bad that I cannot kiss myself'.[11] Moreover, in their radiant pictorial quality, such shots temporarily arrest the metonymic drive of the narrative, similar in effect to the visual presence of the woman which, as Mulvey observes, tends 'to freeze the flow of action in moments of erotic contemplation'.[12] In Valentino's case, however, erotic contemplation governs an active as well as passive mode, making both spectator and character the subject of a double game of vision.

To the extent that Valentino occupies the position of primary object of spectacle, this entails a systematic feminisation of his persona. Many of the films try to motivate this effect by casting him as a performer (torero, dancer) or by situating him in a historically removed or exotic *mise en scène*; in either case, the connotation of femininity persists through the use of costumes—in particular flared coats and headdresses reminiscent of a bridal wardrobe, as well as a general emphasis on dressing and disguises.

Before considering the possibilities of identification implied in this peculiar choreography of vision, I wish to recapitulate some thoughts on female visual pleasure and its fate under the patriarchal taboo. Particularly interesting in this context are certain aspects of scopophilia that Freud analyses through its development in infantile sexuality, a period in which the child is still far from having a stable sense of gender identity. Stimulated in the process of mutual gazing between mother and child, the female scopic drive is constituted with a *bisexual* as well as an *autoerotic* component. While these components subsequently succumb to cultural hierarchies of looking which tend to fixate the woman in a passive, narcissistic-exhibitionist role, there remains a basic ambivalence in the structure of vision as a component drive. As Freud argues in 'Instincts and their Vicissitudes' (1915), the passive component of a drive

[11]Sigmund Freud, 'Three essays on the theory of sexuality' (1905), *Standard Edition* (hereafter *SE*), 7: 182.
[12]Mulvey, 'Visual pleasure', 11.

represents a reversal of the active drive into its opposite, redirecting itself to the sub-
ject. Such a contradictory constitution of libidinal components may account for the
co-existence, in their later fixation as perversion, of diametrically opposed drives
within one and the same person, even if one tendency usually predominates. Thus a
voyeur is always to some degree an exhibitionist and vice versa, just as the sadist
shares the pleasures of masochism.[13]

The notion of ambivalence appears crucial to a theory of female spectatorship, pre-
cisely because the cinema, while enforcing patriarchal hierarchies in its organisation
of the look, also offers women an institutional opportunity to violate the taboo on
female scopophilia. The success of a figure like Valentino, himself overdetermined as
both object and subject of the look, urges us to insist upon the ambivalent constitu-
tion of scopic pleasure. Moreover, as one among a number of the more archaic par-
tial drives whose integration is always and at best precarious, scopophilia could be
distinguished from a socially more complicit voyeurism, as defined by the one-sided
regime of the keyhole and the norms of genitality.[14]

Equally pertinent to an alternative conception of visual pleasure appears the
potential dissociation of sexual and survival instincts, discussed in Freud's analy-
sis of cases of psychogenic disturbance of vision. The eye serves both a practical
function for the individual's orientation in the external world and the function of
an erotogenic zone. If the latter takes over, if it refuses to accept its subservient role
in forepleasure, the balance between sexual and survival instincts is threatened and
the ego may react by repressing the dangerous component drive; psychogenic dis-
turbance of vision in turn represents the revenge of the repressed instinct, retro-
spectively interpreted by the individual as the voice of punishment.

This potentially antithetical relationship of sexual and survival instincts could also
be taken to describe the cultural and historical differentiation of male and female
forms of vision. Although the neurotic dissociation may occur in patients of both
sexes, the balance effected in so-called normal vision appears more typical of the psy-
chic disposition by means of which the male subject controls the practical world as
well as the sexual field. Suffice it here to allude to the historical construction of
monocular vision in western art since the Renaissance, the instrumental standards
imposed upon looking in technical and scientific observation and other disciplines,
areas of cultural activity from which women were barred for centuries; on the flip-
side of this coin, we find a variety of social codes enforcing the taboo on female
scopophilia, ranging from make-up fashions like belladonna through the once popu-
lar injunction, parodied by Dorothy Parker, not to 'make passes at girls who wear
glasses'.

The construction of femininity within patriarchal society, however, contains the
promise of being incomplete. Women's exclusion from the mastery of the visual field
may have diminished the pressure of the ego instincts towards the component drives,

[13]Sigmund Freud, 'Instincts and their vicissitudes', *SE*, 14: 128ff; 'Three essays', *SE*, 7: 156ff., 199f.
and passim.

[14]I am much indebted here to the work of Gertrud Koch; for essays available in translation, see 'Why
women go to the movies', *Jump Cut*, 27 (July 1982); and 'Female sensuality: past joys and future hopes',
*Jump Cut*, 30 (March 1985). Also see Christian Metz's distinction between cinematic and theatrical
voyeurism in *The Imaginary Signifier* (Bloomington: Indiana University Press, 1982), 64–6, 91–8.

which are probably insufficiently subordinated to begin with. If such generalisation is at all permissible, women might be more likely to indulge—without immediately repressing—in a sensuality of vision which contrasts with the goal-oriented discipline of the one-eyed masculine look. Christa Karpenstein speaks in this context of 'an unrestrained scopic drive, a swerving and sliding gaze which disregards the meanings and messages of signs and images that socially determine the subject, a gaze that defies the limitations and fixations of the merely visible'.[15]

If I seem to belabour this notion of an undomesticated gaze as a historical aspect of female subjectivity, I certainly don't intend to propose yet another variant of essentialism. To the extent that sexual difference is culturally constructed to begin with, the subversive qualities of a female gaze may just as well be shared by a male character.

The feminine connotation of Valentino's 'to-be-looked-at-ness', however, destabilises his own glance in its very origin, makes him vulnerable to temptations that jeopardise the sovereignty of the male subject. When Valentino's eyes become riveted on the woman of his choice, he seems paralysed rather than aggressive or menacing, occupying the position of the rabbit rather than that of the snake. Struck by the beauty of Carmen, in *Blood and Sand*, his activity seems blocked, suspended; it devolves upon Carmen throwing him a flower to get the narrative back into gear. Later in the film, at the height of his career as a torero, Valentino raises his eyes to the president's box, an individual centred under the benevolent eye of the State, when his gaze is side-tracked, literally decentred, by the sight of Doña Sol in the box to the right. The power of Valentino's gaze depends upon its weakness—enhanced by the fact that he was actually nearsighted and cross-eyed—upon its oscillating between active and passive, between object and ego libido. The erotic appeal of the Valentinian gaze, staged as a look within the look, is one of reciprocity and ambivalence, rather than mastery and objectifications.

The peculiar organisation of the Valentinian gaze corresponds, on the level of narrative, to conflict between the pleasure and the reality principle. Whenever the hero's amorous interests collide with the standards of male social identity—career, family, paternal authority, or a vow of revenge—the spectator can hope that passion will triumph over pragmatism to the point of self-destruction.[16] As the generating vortex of such narratives, the Valentinian gaze far exceeds its formal functions of providing diegetic coherence and continuity; it assumes an almost figural independence. Thus the films advance an identification with the gaze itself; not with either source or

---

[15]Christa Karpenstein, 'Bald führt der Blick das Wort ein, bald leitet das Wort den Blick', *Kursbuch*, 49 (1977), 62. Also see Jutta Brückner's important essay on pornography, 'Der Blutfleck im Auge der Kamera', *Frauen und Film*, 30 (December 1981), 13–23; Brückner links the historical 'underdevelopment' of women's vision with the modality of dreams, as a more archaic form of consciousness; 'This female gaze, which is so precise precisely because it is not too precise, because it also has this inward turn, opening itself to fantasy images which it melts with the more literal images on the screen, this gaze is the basis for a kind of identification which women in particular tend to seek in the cinema' (19).

[16]Two of Valentino's most popular films, *The Four Horsemen* and *Blood and Sand*, actually culminate in the protagonist's death, bringing into play the deep affinity of eros and death drive which Freud observes in his fascinating paper on 'The theme of the three caskets' (1913), *SE*, 12: 289–301. According to Enno Patalas, Valentino himself identified much more strongly with these two roles than with the superficial heroism of the Sheik, *Sozialgeschichte der Stars* (Hamburg: Marion von Schröder Verlag, 1963), 96f.

object, but with the gaze as erotic medium which promises to transport the spectator out of the world of means and ends into the realm of passion.

The discussion of gendered patterns of vision inevitably opens up into the larger question of identification as the linchpin between film and spectator, the process that organises subjectivity in visual and narrative terms. Most productively, feminist film theorists have taken up the debate by insisting on the centrality of sexual difference, questioning the assumption of a single or neutral spectator position constructed in hierarchically ordered, linear processes of identification. The difficulty of conceptualising a female spectator has led feminists to recast the problem of identification in terms of instability, mobility, multiplicity, and, I would add, temporality. Likewise, a number of feminist critics are trying to complicate the role of sexual difference in identification with the differences of class and race, with cultural and historical specificity. The question of who is the subject of identification is also and not least a question concerning which part of the spectator is engaged and how: which layers of conscious or unconscious memory and fantasy are activated, and how we, both as viewers and as critics, choose to interpret this experience.[17]

It seems useful at this point to invoke Mary Ann Doane's distinction between at least three instances of identification opening in the viewing process: (1) identification *with* the representation of a person (character/star); (2) recognition of particular objects, persons, or action *as* such (stars, narrative images); (3) identification with the 'look', with oneself as the condition of perception, which Metz, in analogy with Lacan's concept of the mirror phase, has termed 'primary'.[18]

The first form of identification with the integral person filmed engages the female viewer transsexually insofar as it extends to the Valentino character; thus, it raises the problem of spectatorial cross-dressing—unless we consider other possibilities of transsexual identification beside the transvestite one. The alternative option for the woman spectator, passive-narcissistic identification with the female star as erotic object, appears to have been a position primarily advertised by the industry,[19] but it appears rather more problematic in view of the specular organisation of the films.

If we can isolate an instance of 'primary' identification at all—which is dubious on theoretical grounds[20]—the Valentino films challenge the assumption of perceptual mastery implied in such a concept by their foregrounding of the gaze as an erotic medium, a gaze that fascinates precisely because it transcends the socially imposed

---

[17]See Janet Walker, 'Psychoanalysis and feminist film theory' (note 6), 20ff.; de Lauretis, 'Aesthetic and feminist theory', *New German Critique*, 34 (Winter 1985), 164ff.

[18]Doane, 'Misrecognition and identity', *Ciné-Tracts*, 3, 3 (Fall 1980), 25; Metz, *The Imaginary Signifier*, 46ff., 56ff. and passim.

[19]This option actually prevails in contemporary statements of female spectators; see Herbert Blumer, *Movies and Conduct* (New York: Macmillan, 1933), 69–70. In retrospect, however, as I frequently found in conversations with women who were in their teens at the time, the female star has faded into oblivion as much as the narrative, whereas Valentino himself is remembered with great enthusiasm and vividness of detail.

[20]Doane, 'Misrecognition and identity', 28ff.; Doane's major objection to Metz's concept of primary identification is that, based as it is on the analogy with the Lacanian mirror stage and thus the hypothetical constitution of the male subject, the concept perpetuates, on a theoretical level, the patriarchal exclusion of female spectatorship.

subject/object hierarchy of sexual difference. Moreover, the contradictions of the female address are located in the very space where the registers of the look and those of narrative and mise-en-scène intersect. In offering the woman spectator a position which is structurally analogous to that of the vamp within the diegesis (looking at Valentino independently of his initiating of the look), identification with the desiring gaze is both granted and incriminated, or, one might say, granted on the condition of its illegitimacy. This may be why the vamp figures in Valentino films (with the exception of *Blood and Sand*) are never totally condemned, inasmuch as they acknowledge a subliminal complicity between Valentino and the actively desiring female gaze.

The least equivocal instance of identification operating in the Valentino films is that which feeds on recognition, the memory-spectacle rehearsed with each appearance of the overvalued erotic object, the star.[21] The pleasure of recognition involved in the identification of and with a star is dramatised, in many Valentino films, through a recurrent narrative pattern, which in turn revolves around the precarious cultural construction of the persona of the Latin Lover. Often, the Valentino character combines two sides of a melodramatic dualism, which he acts out in a series of disguises and anonymous identities. Thus, in *The Sheik* (1921), the barbaric son of the desert turns out to be of British descent; in *Moran of the Lady Letty* (1922), the San Francisco dandy proves himself a hearty sailor and authentic lover; the Duke of Chartres in exile becomes Monsieur Beaucaire; and the Black Eagle pursues courtship instead of revenge under the assumed identity of Monsieur LeBlanc.[22] The spectator recognizes her star in all his masks and disguises—unlike the female protagonist whose trial of love consists of 'knowing' him regardless of narrative misfortune or social status.

Like most star vehicles, Valentino films have notoriously weak narratives and would probably fail to engage any viewer if it weren't for their hero's charisma. Many of his films are adapted from well-known popular novels, preferably costume dramas.[23] While there is some delight in action, in the sense of activity, physical movement, and gesture, there is very little suspense, very little of the game of concealing and revealing, of the dialectic of desire, knowledge, and power that has led theorists like Barthes, Bellour, and Heath to define all narrative as predicated on Oedipus. Identification in terms of narrative movement is likely to fall short of the plot in its totality, while closure tends to reside in smaller units, cutting across visual and narrative registers, defined by the succession of masks, disguises, milieus, and scenarios.

The emphasis on costumes, disguises, on rituals of dressing and undressing, undermines, in tendency, the voyeuristic structure of spectatorship in that it acknowledges the spectator as part of the theatrical display. This is emblematic in the famous dressing scene in *Monsieur Beaucaire*, during which Valentino punctuates the exercise in

[21] See Richard Dyer, *Stars* (London: BFI, 1979).

[22] This pattern of combining dark and light oppositions in one and the same character must have been perceived as typical of the Valentino text; see the change of Dubrovsky's alias in *The Eagle* from Pushkin's Monsieur Deforge to Valentino's Monsieur LeBlanc.

[23] Alexander Walker, *Rudolph Valentino* (Harmondsworth: Penguin, 1977), 54f.

procrastination with occasional asides in the direction of the camera.[24] Such mutual recognition, in conjunction with the viewer's epistemological superiority over the female protagonist, encourages identification via a fantasy in which the spectator herself authorises the masquerade; the publication, as late as 1979, of a Valentino paper-doll book would testify to the persistence of this phantasy in popular iconography.

But this is not the only type of scenario which organises identification in the Valentino films. Pervasively, in these films, spectatorial pleasure is imbricated with self-consciously sadomasochistic rituals.[25] The more interesting instances of sado-masochistic role-playing take place in the context of the legitimate, romantic relationship. In *The Eagle*, Mascha turns out to be the daughter of the odious landowner against whom Valentino, in his persona as the Black Eagle, has pledged revenge on his father's deathbed. At one point, his men kidnap her and proudly present the catch to their leader. As he gets off his horse and steps toward her with a whip ready to lash out, the genre seems to slide into porn: the masks, the whip, phallic hats—insignia of anonymous lust, traces of the search for nonidentity in eros.[26] That Valentino actually directs the whip against his own men is the alibi the narrative provides for a kinky shot, the *défilement* into propriety; yet it does not diminish the subliminal effect. Valentino recognises Mascha and, protected by his unilateral anonymity, continues the game in a more or less playful manner. This game is accomplished within the legitimate relationship only by means of the mask which temporarily suspends the mutuality of the romantic gaze in Valentino's favour.

The emphasis on the sadistic aspects of the Valentino persona echoes the publicity pitch advertising him to female audiences as the 'he-man', the 'menace', reiterated, as late as 1977, by one of his biographers: 'Women were to find in *The Sheik* a symbol of the omnipotent male who could dominate them as the men in their own lives could not.'[27] And, when in the film of that title the son of the desert forces the blue-eyed Lady Diana on his horse, ostensibly for her own pleasure ('lie still you little fool'), millions of women's hearts were said to have quivered at the prospect of being

---

[24]As Tom Gunning points out, such instances of direct address were rather common in erotic films before 1908, but thereafter persist only in the pornographic tradition—"the seeming acknowledgment of the presence of the spectator-voyeur gives these films much of their erotic power'. 'An unseen energy swallows space: the space in early film and its relation to American avant-garde film', in *Film Before Griffith*, John Fell (ed.) (Berkeley: University of California Press, 1983), 359.

[25]A number of critics have recently commented upon the role of sadomasochistic structures in cinematic identification: Rodowick, 'The difficulty of difference' (note 6, above); Doane, 'The woman's film', *Re-vision*; 67–82; Kaja Silverman, 'Masochism and subjectivity' (on Cavani's *Portiere di Notte*), *Framework*, 12 (1980), 2–9. Also see Jessica Benjamin, 'Master and slave: the fantasy of erotic domination', in *Powers of Desire: The Politics of Sexuality*, ed. Ann Snitow *et al.* (New York: Monthly Review Press, 1983), 280–99.

[26]Koch, 'Schattenreich der Körper: Zum pornographischen Kino', in *Lust und Elend: Das erotische Kino* (Munich: Bucher, 1981), 35; 'The Body's Shadow Realm' in *October*, 50 (Fall 1989), 3–29. The investment in eros as a negation of the principle of social identity is, of course, a topos of the Frankfurt School, especially in the work of Adorno; see his and Horkheimer's critique of the subject under patriarchy and monopoly capitalism in *Dialectic of Enlightenment* (Amsterdam: Querido, 1947), his aphorisms and fragments, dating back to the period of exile, in *Minima Moralia* (Frankfurt: Suhrkamp, 1951), as well as later essays in cultural criticism such as "Sexualtabus und Recht heute', *Eingriffe* (Frankfurt: Suhrkamp, 1963), 104.

[27]Tajiri (note 1), 63.

humiliated by the British-bred barbarian. Despite the display of virility in *The Sheik* (1922; based on the novel by Edith Maude Hull), however, this film initiated the much publicised rejection of Valentino by male moviegoers, which had more to do with the threat he presented to traditional norms of masculinity than with the actual composition of audience.[28] Not only the stigma of effeminacy but also, equally threatening, a masochistic aura was to haunt Valentino to his death and beyond. There were widespread rumours about his private life—homosexuality, impotence, unconsummated marriages with lesbians, dependency on domineering women, the platinum 'slave bracelet' given to him by his second wife, Natasha Rambova. More systematically, the masochistic elements in the Valentino persona were enforced by the sadistic placement of the spectator in the films themselves. There is hardly a Valentino film that does not display a whip, in whatever marginal function, and most of them feature seemingly insignificant subplots in which the spectator is offered a position that entails enjoying the tortures inflicted on Valentino or others.[29]

The oscillation of the Valentino persona between sadistic and masochistic positions is yet another expression of the ambivalence that governs the specular organisation of the films. I wish to return to Freud's essay, 'A child is being beaten' (1919), not only for its focus on female instances of sadomasochistic fantasy, but also because it elucidates a particular aspect of the Valentino figure as fantasmatic object.[30] The formula, 'a child is being beaten', which, regardless of any actually experienced corporal punishment, may dominate masturbation fantasies of the latency period, is remarkable in that it stereotypically reiterates the mere description of the event, while subject, object and the role of the person fantasising remain indeterminate. On the basis of jealousy feelings aroused by the Oedipal constellation, Freud proceeds to reconstruct three different phases with explicit reference to female adolescents: (1) 'My father is beating the child that I hate' (presumably a younger sibling); therefore, 'he loves only me'; (2) 'I am being beaten [therefore loved] by my father' (the regressive substitute for the incestuous relationship); (3) 'a child is being beaten.' While the second, sexually most threatening phase succumbs to repression, the first phase is reduced to its merely descriptive part and thus results in the third, in

---

[28]The male contingent among Valentino fans is not to be underestimated, including Elvis Presley, Kenneth Anger and other luminaries; see Kenneth Anger, 'Rudy's rep', in *Hollywood Babylon* (London: Straight Arrow Books, 1975; New York: Dell, 1981); and his contribution to a catalogue of the Berlin Film Festival retrospective of Valentino's work, 'Sich an Valentino erinnern heisst Valentino entdecken', discussed by Karsten Witte, in 'Fetisch-Messen', *Frauen und Film*, 38 (May 1985), 72–8. Ken Russell's film (see note 2) both exploits and disavows Valentino's place in the homosexual tradition. More important than biographical fact is the question of how Valentino challenged dominant standards of masculinity, which is also a question of their social and historical variability and changeability.

[29]The sadistic spicing of cinematic pleasure (far from being the exclusive domain of Von Stroheim) is still rather common in pre-Code films, though seldom with such strong effects on the sexual persona of the protagonist. Consider, for instance, a sequence early on in the Pickford vehicle *Sparrows* (1926) in which the villain (Gustav von Seyffertitz) crushes a doll sent, by an absent mother, to one of the children he keeps as slaves; the camera lingers, close-up, on the remnants of the doll as it slowly disappears in the swamp. The fascination deployed in such a shot far exceeds narrative motivation; i.e. its function for establishing Mr Grimes is irredeemably evil.

[30]Freud, 'A child is being beaten', *SE*, 17, 186. The essay has been much discussed in recent film theory; for example, Rodowick, 'The difficulty of difference' (see n.6), and Doane, 'The woman's film' (see n. 25).

which the father is usually replaced by a more distant male authority figure. Thus the fantasy is sadistic only in its form—but grants masochistic gratification by way of identification with the anonymous children who are being beaten. This series of transformations reduces the sexual participation of the girl to the status of spectator, desexualising both content and bearer of the fantasy (which, as Freud remarks, is not the case in male variants of the beating fantasy). Just as important in the present context, however, is the observation that in both male and female versions of the sadomasochistic fantasy the children who are being beaten generally turn out to be male. In the case of the female fantasy, Freud employs the concept of the 'masculinity complex', which makes the girl imagine herself as male and thus allows her to be represented, in her daydreams, by these anonymous whipping boys.

The deepest, most effective layer of the Valentino persona is that of the whipping boy—in which he resembles so many other heroes of popular fiction devoured by adolescent girls (one of the examples Freud cites is *Uncle Tom's Cabin*). Freud's analysis of the sadomasochistic fantasy suggests that we distinguish between the sadistic appeal articulated in point-of-view structures on the one hand, and the masochistic pleasure in the identification with the object on the other. Transsexual identification, instead of being confined to simple cross-dressing, relies here as much on the feminine qualities of the male protagonist as it does on residual ambiguity in the female spectator. The simultaneity of identificatory positions is enabled by an interactional structure, a scenario whose libidinal force, protected by a series of repressive/rhetorical transformations, can be traced back to the nursery.

Unlike the one-sided masochistic identification with a female protagonist encouraged by the 'woman's film', female identification in Valentino films could be construed to entail the full range of transformations proposed by Freud. As Valentino slips into and out of the part of the whipping boy, intermittently relegating the woman to the position of both victim and perpetrator, he may succeed in recuperating the middle phase of the female fantasy from repression ('I am being beaten—and therefore loved—by my father') and thus in resexualising it. This possibility is suggested above all by the unmistakable incestuous aura surrounding the Valentino persona; however, the appeal here is less that of a relationship between father and daughter than one between brother and sister, which turns on the desire of both for an inaccessible mother.[31]

In making sadomasochistic rituals an explicit component of the erotic relationship, Valentino's films subvert the socially imposed dominance/submission hierarchy of gender roles, dissolving subject/object dichotomies into erotic reciprocity. The vulnerability Valentino displays in his films, the traces of feminine masochism in his persona, may partly account for the threat he posed to prevalent standards of masculinity—the sublimation of masochistic inclinations after all being the token of the male subject's sexual mastery, his control over pleasure.

Sadomasochistic role-playing most strikingly intersects with the choreography of vision in *The Son of the Sheik* (1926; based on another novel by E. M. Hull), Valentino's last and probably most perverse film. Due to a misunderstanding that

---

[31]This incestuous-narcissistic aura is encapsulated in a portrait showing Valentino and Rambova in profile and, obviously, in the nude; rpt in Walker, 73; and Anger, *Hollywood Babylon*, 160–1.

propels the narrative, Yasmin (Vilma Banky) represents a combination of both female types, vamp and romantic companion. Although transparent to the spectator, the misunderstanding on Ahmed/Valentino's part—that Yasmin lured him into a trap, thus causing him to be captured and whipped by her father's gang—has carefully been planted early on in the film by means of an editing device. The film's first close-up shows the face of Yasmin, lost in erotic yearning, which dissolves into a matching close-up of Valentino; a somewhat mismatched cut in turn reveals him to be looking at her legs as she is dancing for a crowd. A dissolve back to Yasmin's face eventually confirms the status of the sequence as a flashback which stages the usual discovery of the woman through Valentino's look; the objectification here is compounded by the demeaning situation, the fragmentation of Yasmin's body as well as the emphasis on money in the deployment of the romantic gaze. The potential misreading of the flashback as a point-of-view shot on the part of the woman falsely implicates Yasmin as a transgressor, thus supporting her double inscription as victim later on in the film, as both scopic and masochistic object. Herself ignorant of her lover's misunderstanding, Yasmin is kidnapped by him and imprisoned in his tent. His revenge accordingly consists in refusing her the mutuality of the erotic look and culminates in a veritable one-eyed stare with which he transfixes her to the point of rape. Valentino's unilateral transgression of the romantic pact is supposedly vindicated by the powerful image of him crucified, humiliated and whipped earlier on in the film. This image of Valentino as victim, however, erroneously ascribed to Yasmin's authorship and not even witnessed by her, is primarily designed for the benefit of the spectator. No doubt there remains an asymmetry in the sadomasochistic role reversal on the diegetic level: a female character can assume an active part only at the price of being marked as a vamp; sadistic pleasure is specularised, reserved for the woman in front of the screen.

The multiple ambiguities articulated on the specular level of *The Son of the Sheik* contrast with the more flatly patriarchal discourse of the narrative, not to mention the simple-minded sexist and racist title prose. As if to conceal—and thus unofficially to acknowledge and exploit—this gap between narrative and visual pleasure, the Oedipal scenario is overinscribed to the point of parody. Valentino's private love/revenge affair meets with strong resistance on the part of his father who bends an iron rod with his mere hands in order to demonstrate his paternal power; Valentino, a chip off the old block, responds by straightening it out again. Only when his understanding mother, Lady Diana (Agnes Ayres), invokes a flashback to her own kidnapping in *The Sheik* does the father recognise and accept his successor. They reconcile in the course of yet another kidnapping scene, this time rescuing Yasmin from her father's gang: in the midst of tumultuous swashbuckling father and son shake hands, temporarily losing sight of the woman, the object of their endeavour.

Beneath this Oedipal pretext, as it were, the film offers a connotative wealth of deviations which radiate in a dialectic of repression and excess from the Valentino character to all levels of *mise en scène* and cinematography. Exotic costumes, oriental decor and desert landscape provoke a sensuality of vision which constantly undermines the interest in the development of the narrative. Extreme long shots show Valentino riding through a sea of sand shaped like breasts and buttocks; he prefers the skin-folds of his tent to the parental palace, and he experiences in the allegorical moonlit ruin the pitfalls of adult sexuality, the threat of castration. Though conceal-

ing dangerous abysses, the eroticised landscape becomes a playground of polymor-
phous desire, in which the signs of virility—sables, pistols, cigarettes—remain phal-
lic toys at best. The screen itself becomes a maternal body, inviting the component
drives to revolt against their subordination. These textured surfaces do not project a
realistic space which the hero, traversing it, would be obligated to subject. Rather,
they construct an oneiric stage which cannot be bothered with perspective and
verisimilitude. With a degree of unreality of which the silent screen was yet capable,
Valentino's last film admits to the reality of a fantasy that assimilates the Oedipal sce-
nario for its own purposes. Not only does it force the father to identify with the phal-
lic caprices of his youth, but it even more thoroughly subverts the Oedipal script in
its casting: Valentino himself plays the role of the father in whose mirror image the
son achieves a presumably adult male identity which inevitably—and barely
masked—reveals itself as both narcissistic and incestuous.

The appeal of the Valentino fantasy is certainly regressive, beckoning the female
spectator (to revise Mulvey) beyond the devil of phallic identification into the deep
blue sea of polymorphous perversity. Such an appeal cannot but provoke the conno-
tation of monstrosity which the films displace on to figures like the vamp or the
sadomasochistic dwarf in *The Son of the Sheik*, a vicious caricature of Orientalism.
The threat posed by Valentino's complicity with the woman who looks, like the affin-
ity of monster and woman in Linda Williams's reading of the horror film, is not a
threat merely of sexual difference but of a different *kind* of sexuality, different from
the norm of heterosexual, genital sexuality.[32] While playing along with narrative con-
ventions that assert the latter (e.g. the figure of couple formation), the Valentino films
allow their spectators to repeat and acknowledge the more archaic component drives,
reminders of the precarious constructedness of sexual identity. Moreover, in locating
pleasure in the tension—if not excess—of partial libido in relation to genitality, they
project a realm of the erotic as distinct from the socially cultivated ideal of a 'healthy
sex life'.[33]

To claim a subversive function for polymorphous perversity as such is highly prob-
lematic, as Foucault asserts, given the degree to which disparate sexualities themselves
have been appropriated by a discourse binding pleasure and power. It is therefore all

---

[32]Williams, 'When the woman looks', *Re-Vision*, 83–96. The point Williams makes with regard to a
number of classic horror films also elucidates the function of the dark/light split in the Valentino charac-
ter: 'the power and potency of the monster body . . . should not be interpreted as an eruption of the nor-
mally repressed animal sexuality of the civilized male (the monster as double for the male viewer and char-
acters in the film), but as feared power and potency of a different kind of sexuality (the monster as double
for the woman)' (87).

[33]Adorno, 'Sexualtabus' (note 26), 104–5; the phrase is used in English and without quotation marks; also
see 'This side of the pleasure principle', *Minima Moralia: Reflections from Damaged Life* (London: New Left
Books, 1974). Marcuse's plea for polymorphous perversity in *Eros and Civilization* (1955; Boston: Beacon
Press, 1966) is more problematic, especially in light of the Foucaultian analysis of the 'perverse implantation'
(*The History of Sexuality*, 1), but Marcuse himself takes a more pessimistic view in his 'Political Preface
1966', while maintaining a utopian distinction between sexual liberty and erotic/political freedom (xiv–xv).
Already during the 1920s, the prophets of a 'healthy sex life' were numerous, drawing on the essentialist sex-
ual psychology of Havelock Ellis, on the newly discovered 'doctrine' of psychoanalysis, as well as libertarian
positions developed among the Greenwich Village boheme, although not necessarily all that liberating for
women; see writings by Hutchings Hapgood, Max Eastman, V. F. Calverton and—probably the single most
repressive instance of sexual hygiene—Floyd Dell, *Love in the Machine Age: A Psychological Study of the
Transition from Patriarchal Society* (New York: Farrar & Rinehart, 1930).

the more important to reconsider the historical moment at which Valentino enters that discourse, marking its conjunction with other discourses, in particular those of social mobility and racial otherness. In a liberal gesture, Alexander Walker ponders the paradox of the Valentino craze; that is, that it took place alongside the progressive liberation of American women from traditional roles: "It was a perverse way of celebrating your sex's emancipation.'[34] Perverse, yes, but not so paradoxical. As revisionist historians have argued, the New Woman was usually not as emancipated as her image suggested, and her access to consumer culture often entailed an underpaid job, loneliness and social insecurity or, in the case of married women, the multiple burdens of wage labour, housework and childrearing.[35] The period's demonstrative obsession with sexual reform may well confirm Foucault's argument on sexuality as discourse at large; still, this discourse must have had different implications for women than for men, or for single working women as compared, for instance, to upper-middle-class housewives.

However complicit and recuperable in the long run, the Valentino films articulated the possibility of female desire outside of motherhood and family, absolving it from Victorian double standards;[36] instead, they offered a morality of passion, an ideal of erotic reciprocity. Moreover, unlike the feminine reaction of sexual liberation in the shape of Elinor Glyn (the Edwardian novelist who invented the 'it' girl), Valentino did not render the erotic a matter of social etiquette to be rehearsed by the aspiring female subject.[37] Rather, in focusing pleasure on a male protagonist of ambiguous and deviant identity, he appealed to those who most strongly felt the effects—freedom as well as frustration—of transition and liminality, the precariousness of a social mobility predicated on consumerist ideology.

If the Valentino films had no other critical function, they did present, by way of negation, a powerful challenge to myths of masculinity in American culture between the wars. The heroes of the American screen were men of action, like Douglas Fairbanks or William S. Hart, whose energy and determination was only enhanced by a certain lack of social graces, especially toward women. Even the more romantic stars, like Richard Barthelmess or John Barrymore, seemed to owe their good looks to a transcendent spirituality rather than anything related to their bodies and sexuality. Valentino not only inaugurated an explicitly sexual discourse on male beauty, but he also undercut standards of instrumental rationality that were culturally associated with masculine behaviour; his resistance to expectations of everyday pragmatism, his swerving from the matter-of-fact and reasonable, may after all account for his subterranean popularity with male movie-goers, whether homosexual or heterosexual.

---

[34]Walker, *Rudolph Valentino*, 8, 47 and passim.

[35]See works cited above, note 3.

[36]*Blood and Sand*, closest to the melodramatic matrix, is the only film that makes Valentino's mate a mother; by contrast, most other female characters opposite Valentino have tomboyish qualities (especially Moran in *Moran of the Lady Letty*), an air of independence, owing to either a superior social status or work and, above all, a certain 'mischievous vivacity' (Ryan, see n. 4) that was associated with the New Woman.

[37]Glyn actually endorsed Valentino's sex appeal, and he starred in *Beyond the Rocks* (1922), based on one of her novels. Still, the focus on a male star distinguishes the Valentino films from films that more immediately functioned to train their audiences in 'fashionable femininity'; Ryan, 'Projection' (note 4), 370f.

But Valentino's otherness cannot be explained exclusively in terms of masculinity and its discontents. Beyond the feminine connotations of his persona, his appeal was that of a 'stranger'. Whatever distinguished previous and contemporary male stars from each other, they were all Americans; that is, they did not display any distinct ethnic features other than those that were already naturalised as American. Valentino, however, bore the stigma of the first-generation, non-Anglo-Saxon immigrant—and was cast accordingly. He began his career as a seducer/villain of dark complexion, male counterpart of the figure of the vamp. When female audiences adopted him, despite the moral/racist injunction, he developed the persona of the Latin Lover, marketed as a blend of sexual vitality and romantic courtship. It is not surprising, then, that the paragons of virility responded to the threat he posed in a strongly nativist tone.[38] Yet more systematically, the films themselves both thematised and contained the scandal of his otherness through a recurrent pattern of the double identity mentioned earlier—a pattern which has to be read as a textual symptom of the repression of racial difference.

Valentino's darker self is ostensibly southern European, somewhat redeemed by a veneer of French manners; in the context of American cinema and American culture, however, he could not have escaped the discursive economy of race and sex, encapsulated in the fear and repressed desire of miscegenation.[39] Sexual paranoia towards black men, rampant since the mid-1890s, reached a new pitch during the 1920s, precipitated by the imagined effects of women's sexual liberation. In terms of this economy, Valentino would have thrived on the fascination with the mulatto, a figure notoriously inscribed with sexual excess (cf. *The Birth of a Nation*), while historically inseparable from the white masters' abuse of black women. Whether or not Valentino touched upon that particular nerve, the connotation of racial otherness was masked by a discourse of exoticism—the Arab sheik, the Indian rajah, the Latin-American gaucho—allowing the female spectator to indulge in the fantasy at a safe distance. Sure enough, the respective narratives reveal the passionate Arab to be of British descent, like Tarzan, just as the lascivious gaucho in *The Four Horsemen* proves himself worthy of his French blood by dying on the field of honour. In such operations of fascination and disavowal, the Valentino films illustrate the ambivalence and fetishism characteristic of all racial stereotypes, the interdependence of racial and sexual difference.[40] At the same time, they mark a historical shift—if not, considering the force of repression provoked, an accidental leap or lapse—which enforced a transvaluation of the taboo and thus its partial recognition, albeit under the guise of the exotic.

Some afterthoughts on the psycho-social enigma posed by the cult of Valentino seems appropriate here. While we may speculate on the appeal of the Valentino per-

---

[38]See the notorious 'Pink powder puff' attack in the *Chicago Tribune*, 18 July 1926, reported in *Hollywood Babylon*, 156–8.

[39]For this aspect of the Valentino persona I am indebted to Virginia Wright Wexman as well as to Richard Dyer's work on Paul Robeson; Winifred Stewart and Jean Hady, who remember the Valentino cult during their teenage years in Martinsburg, West Virginia, further encouraged the following speculations. Also see Jacqueline Hall, ' "The mind that burns in each body": women, rape, and racial violence', in *Powers of Desire* (note 25), 337.

[40]Homi K. Bhabha, 'The other question: the stereotype and colonial discourse', *Screen*, 24, 6 (November–December 1983), 18–36.

sona for both a textually and historically constructed female spectator, the massive impact of this appeal and the social forms it assumed remain quite mysterious. Roland Barthes speaks of the cult of the Valentinian face: 'truly feminine Bacchanalia which all over the world were dedicated to the memory of a collectively revealed beauty'.[41] Inevitably, however, such Dionysian rites are contaminated by the mechanisms of the mass media; the voyeuristic and fetishistic aspects of the Valentino excesses cannot be explained away. How could millions of women have indulged in such specifically male perversions? Barthes may ascribe the cult of Valentino to the aura of his face ('*visage*' vs. '*figure*'); yet for Valentino himself and his female admirers it was certainly no less a cult of his body. In scores of publicity stills Valentino poses working out semi-nude, and in *Blood and Sand* and *Monsieur Beaucaire* he insisted on including dressing scenes that would display individual parts of his body (note the close-up of his foot in *Blood and Sand*). Such exhibitionism, given the mechanisms of the apparatus, cannot escape fetishisation: the male body, in its entire beauty, assumes the function of a phallic substitute. The more desperately Valentino himself emphasised attributes of physical prowess and virility, the more perfectly he played the part of the male impersonator, brilliant counterpart to the female 'female' impersonators of the American screen such as Mae West or the vamps of his own films.

For the history of American cinema, on the threshold of its classical period, Valentino represents a unique instance of subversive irony—in that the commodity marketed as an idol of virility should have proven its success in the shape of a phallic fetish, a symbol of the missing penis. Valentino's miraculous career as a male impersonator illuminates the basic discrepancy between the penis and its symbolic representation, the phallus, thus revealing the male subject's position within the symbolic order as based upon a misreading of anatomy.[42] If women's fascination with Valentino, on whatever level of consciousness, expressed a recognition of that discrepancy, their massive and collective identification with this peculiar fetish also, and not least, asserted the claim to share in the reputation and representation of phallic power.

In the interaction with female audiences, however, the fetishisation of Valentino's body assumed forms of theatricality which tended to subvert the mechanisms of separation intrinsic to cinematic voyeurism and fetishism. His female fans actively assailed the barriers that classical cinema was engaged in reaffirming, taking the star system more literally than the institution might have intended, while the media on their part short-circuited the dialectics of public and private for the narrative of Valentino's life. Once women had found a fetish of their own, they were not content with merely gazing at it, but strove actually to touch it, Moreover, they expected him to reciprocate their fetishistic devotion: Valentino received intimate garments in the mail with the request to kiss and return them (which he did). The cult of Valentino's body finally extended to his corpse and led to the notorious necrophilic excesses:

---

[41]Roland Barthes, 'Visages et figures', *Espirit*, 204 (July 1953), 6.

[42]Richard Dyer suggests that all representations of the male body, especially however, of male nudity, share this fate, since the actual sight of the penis, whether limp or erect, is bound to be awkward, thus revealing the discrepancy between it and the symbolic claims made in its name, the hopeless assertion of phallic mastery; 'Don't look now: The male pin-up', *Screen*, 23, 3–4 (Sept.–Oct. 1982).

Valentino's last will specifying that his body be exhibited to his fans provoked a fetishistic run for buttons of his suit, or at least candles and flowers from the funeral home.[43] The collective *mise en scène* of fainting spells, hysterical grief and, to be accurate, a few suicides, cannot be reduced to a mere spectacle of mass-cultural manipulation. It may be read, among other things, as a kind of rebellion, a desperate protest against the passivity and one-sidedness with which patriarchal cinema supports the subordinate position of women in the gender hierarchy. In such a reading, even the commercially distorted manifestation of female desire might articulate a utopian claim—to have the hollow promises of screen happiness be released into the mutuality of erotic practice.

1991

---

[43]Any Valentino biography will elaborate on these events with great gusto. For the most detailed account, including an astonishing chapter on Valentino's afterlife ('Act V: Cuckooland'), see Shulman's book (note 1).

# THOMAS SCHATZ
## *FROM* THE GENIUS OF THE SYSTEM

### "THE WHOLE EQUATION OF PICTURES"

Walking at dawn in the deserted Hollywood streets in 1951 with David [Selznick], I listened to my favorite movie boss topple the town he had helped to build. The movies, said David, were over and done with. Hollywood was already a ghost town making foolish efforts to seem alive. . . .

But now that the tumult was gone, what had Hollywood been?

<div align="right">BEN HECHT, 1954</div>

. . . The collapse of the studio system was bound to provoke questions like Ben Hecht's—"What had Hollywood been?"—and the answers have been plentiful but less than adequate. Hecht himself answered as so many of his industry colleagues did, with an anecdotal, self-serving memoir laced with venom for the "system" and for the "Philistines" who controlled it—and who paid Hecht up to $5,000 a week for his services as a screenwriter. Hecht was an essential part of that system, of course, though he hardly saw things that way, and his reminiscence was less revealing of Hollywood filmmaking than of the attitudes of eastern-bred writers toward the priorities and the power structure in the movie industry. Hecht's answer did provide yet another piece of evidence to be factored in, along with countless other interviews and autobiographies, critical studies, and economic analyses. But the accumulated evidence scarcely adds up, and our sense of what Hollywood had been remained a vague impression, fragmented and contradictory, more mythology than history.

Promising to change all that, a cadre of critics and historians in the 1960s and 1970s cultivated a "theory of film history" based on the notion of directorial authorship. As the New Hollywood emerged from the ashes of the studio era, proponents of the "auteur theory" proclaimed that what the Old Hollywood had been was a director's cinema. They proclaimed, too, that the only film directors worthy of canonization as author-artists were those whose personal style emerged from a certain antagonism

toward the studio system at large—the dehumanizing, formulaic, profit-hungry machinery of Hollywood's studio-factories. The auteurist's chief proponent was Andrew Sarris, who in his landmark study, *The American Cinema: Directors and Directions, 1929–1968*, cast the studio boss as the heavy in Hollywood's epic struggle and reduced American film history to the careers of a few dozen heroic directors. Keying on an observation by director George Stevens that as the industry took shape, "the filmmaker became the employee, and the man who had time to attend to the business details became the head of the studio," Sarris developed a simplistic theory of his own, celebrating the director as the sole purveyor of Film Art in an industry overrun with hacks and profitmongers. The closing words of his introduction said it all: "He [the director] would not be worth bothering with if he were not capable now and then of a sublimity of expression almost miraculously extracted from his money-oriented environment."

Auteurism itself would not be worth bothering with if it hadn't been so influential, effectively stalling film history and criticism in a prolonged stage of adolescent romanticism. But the closer we look at Hollywood's relations of power and hierarchy of authority during the studio era, at its division of labor and assembly-line production process, the less sense it makes to assess filmmaking or film style in terms of the individual director—or *any* individual, for that matter. The key issues here are style and authority—creative expression and creative control—and there were indeed a number of Hollywood directors who had an unusual degree of authority and a certain style. John Ford, Howard Hawks, Frank Capra, and Alfred Hitchcock are good examples, but it's worth noting that their privileged status—particularly their control over script development, casting, and editing—was more a function of their role as producers than as directors. Such authority came only with commercial success and was won by filmmakers who proved not just that they had talent but that they could work profitably within the system. These filmmakers were often "difficult" for a studio to handle, perhaps, but no more so than its top stars or writers. And ultimately they got along, doing what Ford called "a job of work" and moving on to the next project. In fact, they did their best and most consistent work on calculated star vehicles for one particular studio, invariably in symbiosis with an authoritative studio boss.

Consider Ford's work with Darryl Zanuck at Twentieth Century-Fox on a succession of Henry Fonda pictures: *Young Mr. Lincoln*, *Drums Along the Mohawk*, and *The Grapes of Wrath*. Or Alfred Hitchcock doing *Spellbound* and *Notorious*, two psychological dramas scripted by Ben Hecht and prepared by David Selznick for his European discovery, Ingrid Bergman. Or Howard Hawks working for Jack Warner on *To Have and Have Not* and *The Big Sleep*, two hard-boiled thrillers with Bogart and Bacall that were steeped in the Warners' style. These were first-rate Hollywood films, but they were no more distinctive than other star-genre formulations turned out by routine contract directors; Universal's horror films with Boris Karloff directed by James Whale, for instance, or the Paul Muni biopics directed by William Dieterle for Warners. Whale and Dieterle are rarely singled out for their style or artistry, and each would have been lost without the studio's resources and regimented production process. But that doesn't diminish the integrity of films like *Frankenstein*, *The Old Dark House*, and *The Bride of Frankenstein*, or *The Story of Louis Pasteur* and *The Life of Emile Zola*.

The quality and artistry of all these films were the product not simply of individual human expression, but of a melding of institutional forces. In each case the "style" of a writer, director, star—or even a cinematographer, art director, or costume designer—fused with the studio's production operations and management structure, its resources and talent pool, its narrative traditions and market strategy. And ultimately any individual's style was no more than an inflection on an established studio style. Think of Jimmy Cagney in *Public Enemy*, staggering down that dark, rain-drenched street after a climactic shoot-out with rival gangsters, gazing just past the camera and muttering "I ain't so tough," then falling face-down into the gutter. That was a signature Warner Bros. moment, a narrative-cinematic epiphany when star and genre and technique coalesced into an ideal expression of studio style, vintage 1931. Other studios had equally distinctive styles and signature moments, involving different stars and story types and a different "way of seeing" in both a technical and an ideological sense. On a darkened, rain-drenched street at MGM, for instance, we might expect to find a glossy, upbeat celebration of life and love—Mickey Rooney in another Andy Hardy installment, struggling to get the top up on his old jalopy while his date gets soaked, or Gene Kelly dancing through puddles and singin' in the rain. Over at Universal a late-night storm was likely to signal something more macabre: Count Dracula on the prowl, perhaps, or Dr. Frankenstein harnessing a bolt of lightning for some horrific experiment.

These are isolated glimpses of a larger design, both on screen and off. Each top studio developed a repertoire of contract stars and story formulas that were refined and continually recirculated through the marketplace. Warners in the 1930s, for example, cranked out urban crime films with Cagney and Edward G. Robinson, crusading biopics with Paul Muni, backstage musicals with Dick Powell and Ruby Keeler, epic swashbucklers with Errol Flynn and Olivia de Haviland, and in a curious counter to the studio's male ethos, a succession of "women's pictures" starring Bette Davis. These stars and genres were the key markers in Warners' Depression-era style, the organizing principles for its entire operation from the New York office to the studio-factory across the continent. They were a means of stabilizing marketing and sales, of bringing efficiency and economy into the production of some fifty feature films per year, and of distinguishing Warners' collective output from that of its competitors.

The chief architects of a studio's style were its executives, which any number of Hollywood chroniclers observed at the time. Among the more astute chroniclers was Leo Rosten, who put it this way in *Hollywood: The Movie Colony*, an in-depth study published in 1940:

> Each studio has a personality; each studio's product shows special emphases and values. And, in the final analysis, the sum total of a studio's personality, the aggregate pattern of its choices and its tastes, may be traced to its producers. For it is the producers who establish the preferences, the prejudices, and the predispositions of the organization and, therefore, of the movies which it turns out.

Rosten was not referring to the "supervisors" and "associated producers" who monitored individual productions, nor to the pioneering "movie moguls" who controlled economic policy from New York. He was referring to studio production executives like Louis B. Mayer and Irving Thalberg at MGM, Jack Warner and Hal Wallis at Warner Bros., Darryl Zanuck at Twentieth Century-Fox, Harry Cohn at Columbia,

and major independent producers like David Selznick and Sam Goldwyn. These men—and they were always men—translated an annual budget handed down by the New York office into a program of specific pictures. They coordinated the operations of the entire plant, conducted contract negotiations, developed stories and scripts, screened "dailies" as pictures were being shot, and supervised editing until a picture was ready for shipment to New York for release. These were the men Frank Capra railed against in an open letter to *The New York Times* in April 1939, complaining that "about six producers today pass on about 90 percent of the scripts and edit 90 percent of the pictures." And these were the men that F. Scott Fitzgerald described on the opening page of *The Last Tycoon*, the Hollywood novel he was writing at the time of his death, in 1940. "You can take Hollywood for granted like I did," wrote Fitzgerald, "or you can dismiss it with the contempt we reserve for what we don't understand. It can be understood too, but only dimly and in flashes. Not a half dozen men have been able to keep the whole equation of pictures in their heads."

Fitzgerald was thinking of Irving Thalberg when he wrote that passage, and it would be difficult to find a more apt description of Thalberg's role at MGM. Nor could we find a clearer and more concise statement of our objective here: to calculate the whole equation of pictures, to get down on paper what Thalberg and Zanuck and Selznick and a very few others carried in their heads. After digging through several tons of archival materials from various studios and production companies, I have developed a strong conviction that these producers and studio executives have been the most misunderstood and undervalued figures in American film history. So in a sense this is an effort to reconsider their contributions to Hollywood filmmaking; but I don't want to overstate their case or misstate my own. Hollywood's division of labor extended well into the executive and management ranks, and isolating the producer or anyone else as artist or visionary gets us nowhere. We would do well, in fact, to recall French film critic André Bazin's admonition to the early auteurists, who were transforming film history into a cult of personality. "The American cinema is a classical art," wrote Bazin in 1957, "so why not then admire in it what is most admirable—i.e., not only the talent of this or that filmmaker, but the genius of the system."

It's taken us a quarter-century to appreciate that insight, to consider the "classical Hollywood" as precisely that: a period when various social, industrial, technological, economic, and aesthetic forces struck a delicate balance. That balance was conflicted and ever shifting but stable enough through four decades to provide a consistent system of production and consumption, a set of formalized creative practices and constraints, and thus a body of work with a uniform style—a standard way of telling stories, from camera work and cutting to plot structure and thematics. It was the studio system at large that held those various forces in equilibrium; indeed, the "studio era" and the classical Hollywood describe the same industrial and historical phenomenon. The sites of convergence for those forces were the studios themselves, each one a distinct variation on Hollywood's classical style. . . .

The movies were a "vertical" industry in that the ultimate authority belonged to the owners and top corporate officers in New York. But the New York office couldn't make movies, nor could it dictate audience interest and public taste. And whatever the efforts to regulate production and marketing, moviemaking remained a competitive

and creative enterprise. In the overall scheme of things, the West Coast management team was the key to studio operations, integrating the company's economic and creative resources, translating fiscal policy into filmmaking practice. This demanded close contact with New York and a feel for the company's market skew, but also an acute awareness of the studio's resources and heavy interaction with the top filmmakers on the lot, particularly the directors, writers, and stars.

Because of the different stakes involved for each of these key players, studio filmmaking was less a process of collaboration than of negotiation and struggle—occasionally approaching armed conflict. But somehow it worked, and it worked well. What's most remarkable about the classical Hollywood, finally, is that such varied and contradictory forces were held in equilibrium for so long. The New Hollywood and commercial television indicate all too clearly what happens when that balance is lost, reminding us what a productive, efficient, and creative system was lost back in the 1950s. There was a special genius to the studio system, and perhaps when we understand that we will learn, at long last, what Hollywood had been.

                                                                                                1988

# VI
# Film Genres

The study of artistic genres is as old as Aristotle, and at least one of his generic terms, "comedy," has been regularly applied to films. (Significantly, tragedy has not established itself as a film genre.) The generic approach to art has frequently been attacked, however, for its terms are often imprecise and its methods of categorization unclear. What, precisely, is a documentary film or a screwball comedy? Are films to be classified by their physical properties (silent, color), by their subject matter (gangster, western), or by their purpose or effect (comic, horror)? Further, are these categories legitimate? Of what interest is a category like the "educational" film? In any case, is it even proper to arrange works of art in classes, viewing them as instances of types? Benedetto Croce, the influential Italian philosopher and critic, argued that generic criticism was necessarily incompatible with an aesthetic point of view, which always treats works of art as individual and unique. Croce wrote at the beginning of the twentieth century and, as we have noted in Section V, the privileged position of the single creator and the single work has been severely criticized since then. With a new interest in general issues of language, cultural context, and film history, the concept of genre continues to be employed in film theory and criticism, as it is in all art theory and criticism, and with important results.

The most familiar system by which films are generically classified distinguishes between the different kinds of fictional narrative (almost inevitably American) feature films: westerns, gangster films, newspaper pictures, detective dramas, screwball comedies, courtroom dramas, *films noirs*, musicals, war films, spy films, prison films, horror films, science fictions, fantasies, thrillers. An obvious difficulty with such commonly used categories is that they overlap; a film might combine gangsters, detectives, newspapermen, a courtroom, a prison, suspense, and a bleak, *noir* atmosphere; a film might combine screwball comedy, newspapermen, and prisons (as *His Girl Friday* does), or screwball comedy, the western, and the musical (as *Calamity*

*Jane* and *Annie Get Your Gun* do). In classifying such a film one would have to rely on a judgment about what is important. Or one might decide to employ a compound category. But this sort of adjustment does not present genre criticism with an insoluble difficulty, for to be able to speak of a compound genre at all implies that elemental genres exist in order to be mixed.

Another problem of classifying fictional narrative films in this way arises when we ask if such categories have any impact on either the making of films or our responses to films. Are they critical and commercial conveniences, designed merely to help market a film or to describe a film for those who have not seen it? How conscious are filmmakers of their use of generic conventions? How conscious are audiences of these conventions? How do we recognize that a film does indeed represent a particular genre? How do the conventions of a genre evolve over the history of film? Are such evolutions the result of changing artistic conventions in films, of developing cultural standards in society, or both? Despite these questions, there can be no doubt that treating a film as a representative of a familiar and perceptively formulated genre is often essential to a proper understanding of it.

For Leo Braudy the concept of genre must first be rescued from the presumption that it can only describe a debased and degraded kind of art. "Genre films offend our most common definition of artistic excellence: the uniqueness of the art object, whose value can in part be defined by its desire to be uncaused and unfamiliar, as much as possible unindebted to any tradition, popular or otherwise." After tracing this critical prejudice to its roots in the aesthetic and literary theories of the Romantic Era, Braudy posits the two kinds of connection that genre films achieve. First, genre films forge a deliberate connection between each new instance of the genre and its past tradition and manifestations. Second, genre films, because of their popularity and familiarity, have a more powerful impact on their audience—and a highly democratic one—converting that audience into a unified cultural force: "Genre films strike beneath our intellectual appreciation of high art and make us one with a large mass audience, often despite our more articulate and elitist views." His specific look at musicals of the 1930s and 1940s demonstrates the way that the genre, especially as embodied in the contrast between Fred Astaire and Gene Kelly, sought to interject energy and spontaneity into the repetitiveness of everyday social reality, either by Astaire's escape into the perfect world of dance or by Kelly's making the imperfect world more perfect by bringing it together in dance.

Robert Warshow, the influential American analyst of the popular arts in the era just after the Second World War, would agree with Braudy's observation that the popular genre film makes connections both with its filmic past and with the temperaments of its contemporary viewers. Although he would be less willing to grant the general artistic importance to genre films that Braudy does, he does consider the gangster and the westerner as the two most important creations of American movies. The power of both genres derives from their concern with the problem of violence. The hero of the western asserts his honor and demonstrates the possibility of "style" in the face of inevitable defeat. He asserts that even in killing and being killed we are not freed from the necessity of establishing an admirable mode of behavior. Because the pattern of the classical western is so firmly fixed, our pleasure is that of the connoisseur. We must appreciate minor variations in the characteristics of the actors who play the

hero's role, and it is only in virtue of the film's ability to record such variations that these films can remain interesting to us. Any attempt to break the set pattern (to violate the "rules" of the genre), either by turning the western into a "social drama" (as in *The Ox-Bow Incident*) or by aestheticizing it (as in *Shane*), destroys its power. According to Warshow, part of our pleasure in this kind of complete and self-contained art derives precisely from its contrast with the more complex, uncertain, and self-conscious creations of modernism. The art of the western is not an art that precedes modernism (as it is for Stanley Cavell), but one that is contemporary with it and draws strength from the contrast.

In the face of those who would dismiss genre films as a lower form of art, Warshow tries to salvage their importance by emphasizing their invariable and almost ritual qualities. But a frequent preoccupation of genre criticism in both literature and film has been to try to define and enumerate the specific characteristics that distinguish one genre from another. Rick Altman criticizes this prescriptive view as ahistorical, whether it comes from genre purists, from semioticians and structuralists in search of the elements of film language, or from myth critics (like Warshow) analyzing the social psychology of the audience. Using the western as his model, Altman proposes instead a language-oriented analysis, which distinguishes the semantics of genre (for example, outlaws, deserts, horses) from the syntactics of genre (for example, cattlemen v. farmers, nature v. technology, East v. West). Not only, he argues, does this distinction clarify questions about individual genres but it also enables an account of how genres change and interrelate historically.

Although Altman emphasizes the spectator as the mediator of semantic and syntactic elements (and in his later work has gone on to emphasize the audience's role even more), his use of linguistic categories also seems to invite the detachment from history that he otherwise criticizes. Thomas Schatz stresses instead the central connection of the Hollywood studio system and the mass audience to genre's cultural position as "a social problem-solving operation." Exploring the genre film's challenge to critical concepts like the *auteur* director, he rejects the internal account of genre history he finds in writers influenced by linguistic models. Instead, he suggests that there is an "evolution" in the history of at least a few major genres (western, musical) "from straightforward storytelling to self-conscious formalism."

Schatz, like Braudy and to a certain extent Altman, roots genre history in the ongoing cultural life of its audience, as a negotiation between seemingly incompatible urges (in the western, for example, to peace or to violence, to communal values or to individual desires). Robin Wood surveys this aspect of the genre question from a Marxist point of view, not the older Marxist aesthetics that assumes a passive and manipulated audience, but a more recent Marxism cultural criticism that stresses the ideological contradictions inherent in genre films, as well as in the audience's response to them. Unlike those who would create a taxonomy that distinguishes and separates individual genres, Wood considers them all to be connected but "different strategies for dealing with the same ideological tensions."

A prime characteristic of the "high" or "classic" art to which genre is so often negatively compared is its creation by a great artist. Genre art, in this account, can never reach the heights of greatness because its creators are too tied to artistic precedents and are therefore not "original." The countervailing argument asserts that genre cre-

ativity is defined by exactly that manipulation of past motifs to create a new work. Drawing upon the legacy of the auteur controversy over who should receive the creative "credit" for filmmaking (see Section V, especially the articles by Sarris and Wollen), Wood continues his argument by focusing especially on the way in which Frank Capra and Alfred Hitchcock embed genre themes and motifs in their films.

Much genre criticism takes one genre—often the western—and tries to derive general principles from analyzing it. The essays by Linda Williams, Tania Modleski, and Cynthia A. Freeland focus on a genre that in the last decade has become one of the prime sites of genre analysis—the horror film—in part because horror, of all the easily identifiable genres, has had the longest and most continuous history. For cultural critics, horror, with its threatening and unsettled landscape, also offers the clearest ground for general social criticism and analysis. Linda Williams connects this "spectacle of a body caught in the grip of intense sensation or emotion" with a general atmosphere of excess that differentiates genre films from "classical" Hollywood narrative. Emphasizing pornography, horror, and melodrama as three prime "body genres," she discusses the lack of distance in such works between the body on the screen and the spectator's body in the audience—as similar emotions course through both. But that emotional response is, again, in no way an indication of audience passivity, "but a cultural form of problem solving" or at least problem-formulating of deep-rooted questions of sexual identity.

Many writers who have discussed genre have made a direct equation between its aesthetic use of conventional formulas and what they believe to be its innate political conservatism. Tania Modleski begins her essay on the contemporary horror film by attacking theories of genre (and popular culture in general) that connect aesthetic formulas with a politically passive audience. She emphasizes instead the socially subversive elements of the horror genre, particularly focusing on the ways in which the pleasure that the audience derives from watching such films is not passive or complacent but critically energizing. Contemporary horror films especially, she finds, expose to satire and scrutiny a wide range of conventional values, including the nuclear bourgeois family, consumerism, and technology itself.

Modleski notes that one distinctive focus of the horror film's subversive critique is the violence done to the human body, often male but usually female. Expanding on this basic element in the horror genre, Cynthia A. Freeland situates the discussion of horror films specifically in the context of feminist film theory and criticism. Rejecting the psychodynamic interpretation of the film experience, which emphasizes a reductive view of gender difference (see Mulvey in Section VII), she stresses instead the "real human psychology of actual viewers." Gender is only one element of identity, she argues, and accounts that privilege its importance ignore racial and social difference, as well as the great diversity of horror subgenres that make the attempt to find a univocal "feminist theory of horror" fruitless. Although she too is in search of a "feminist ideological critique" of horror films, she refuses what she considers to be the easy Marxist answers that ascribe overwhelming and determinative power to the forces of production. Once again, as in many more recent critiques, it is the active assimilative power of the audience that is more crucial.

Finally in this section, David Bordwell tests the limits of a genre approach by considering whether the European "art film" can be considered in those terms. Since the

directors of such films have generally been treated as consummate film artists and their films as unique products of their genius, the genre terminology of convention and tradition seems totally inappropriate. But Bordwell succinctly demonstrates that there are enough similarities of history and production, as well as formal qualities (for example, the loosening of cause-effect links in narrative), that make it a fruitful way of understanding these films. His analysis might be usefully compared with those of the films of Jean-Luc Godard, by Brian Henderson (Section I) and Peter Wollen (Section IV), as well as the discussions of the *auteur* theory in Section V. For here Bordwell makes "authorial expressivity," the felt presence of the filmmaker in his film, into a genre characteristic.

# LEO BRAUDY
## *FROM* THE WORLD IN A FRAME

## GENRE: THE CONVENTIONS OF CONNECTION

Actually I do not think that there are any wrong reasons for liking a statue or a picture . . . There are wrong reasons for disliking a work of art.

<div align="right">

E. H. GOMBRICH,
*The Story of Art*

</div>

No part of the film experience has been more consistently cited as a barrier to serious critical interest than the existence of forms and conventions, whether in such details as the stereotyped character, the familiar setting, and the happy ending, or in those films that share common characteristics—westerns, musicals, detective films, horror films, escape films, spy films—in short, what have been called *genre* films. Films in general have been criticized for their popular and commercial appeal, seemingly designed primarily for entertainment and escape rather than enlightenment. Genre films especially are criticized because they seem to appeal to a preexisting audience, while the film "classic" creates its own special audience through the unique power of the filmmaking artist's personal creative sensibility. Too often in genre films the creator seems gone and only the audience is present, to be attacked for its bad taste and worse politics for even appreciating this debased art.

The critical understanding of genre films therefore becomes a special case of the problem of understanding films in general. Genre films offend our most common definition of artistic excellence: the uniqueness of the art object, whose value can in part be defined by its desire to be uncaused and unfamiliar, as much as possible unindebted to any tradition, popular or otherwise. The pure image, the clear personal style, the intellectually respectable content are contrasted with the impurities of convention, the repetitions of character and plot. We undervalue their attractions and inner dynamics because there seems to be no critical vocabulary with which to talk about them without condescending, and therefore no aesthetic criteria by which to judge them, no way of

<div align="center">663</div>

understanding why one horror film scares us and another leaves us cold, why one musical is a symphony of style and another a clashing disarray.

Critics have ignored genre films because of their prejudice for the unique. But why should art be restricted only to works of self-contained intensity, while many other kinds of artistic experience are relegated to the closet of aesthetic pleasure, unfit for the daylight? Genre films, in fact, arouse and complicate feelings about the self and society that more serious films, because of their bias toward the unique, may rarely touch. Within film the pleasures of originality and the pleasures of familiarity are at least equally important. Following Marcel Duchamp and Antonin Artaud, Andy Warhol in the early 1960s announced "no more classics." In painting and sculpture this meant an attack on the canonization of museum art and the acceptance of previously unacceptable, often popular, forms. For films, the problem has usually been the other way around. "No more classics" for film might mean no more films defined as separate from the popular forms that are the great energy of film, artistically as well as thematically.

The modern prejudice against genre in art can be traced to the aesthetic theories of the Romantic period. In the later eighteenth century the older idea of poetic inspiration began to be expanded into a major literary theory by works like Edward Young's *Conjectures on Original Composition* (1759). Poetic "imitation," the building of creativity on the achievements of the past, began to fade as the standard of personal vision became more important. Only conventions that could be understood liberally survived, and the eighteenth-century unwillingness to accord imaginative sympathy to convention received its most famous expression in Samuel Johnson's attack on John Milton's *Lycidas*, a poem in the form of a pastoral elegy, which drew upon a tradition of lament that went back to Theocritus and Vergil. The English and German Romantic writers consolidated this trend by establishing originality not only as a criterion of art, but, in their crudest statements, the only criterion of art. Art could owe nothing to tradition or the past because that debt qualified the power and originality of the individual creator. The poet was inspired by what he saw and experienced, and the intervention of any prior categories for that experience doomed the work to secondary value unless the forms that intervened were primitive forms—the folktale or the ballad—that had none of the hated sophistication of the art of the previous age. Any use of genre and convention as such necessarily debarred a work and its author from the status of true art. If poetry were defined as the spontaneous outpouring of strong feelings, how could a work that employed stock characters and stock situations, stock images and stock resolutions, have any art or originality in it? Folk art or popular art could be used because it was generally assumed that serious art was the purity of which popular art was the degeneracy, and that purity necessarily precedes degeneracy.* Poetic inspiration and self-sufficiency occupied the higher peaks of art,

---

*Ballad-collectors like Bishop Percy or Sir Walter Scott could therefore argue that their rewritings were an effort to restore the ballads to the form in which the "Bard" originally created them, before they were passed on to the fumbling brains of the folk. Pop Art has revived this theory in a somewhat different form. Ostensibly making us look at the common objects of the world with new intensity, Pop Art also conveys the idea that serious art and artists make popular themes and motifs worthy (read "self-conscious") by putting them into museum settings and charging high prices. Warhol may have first done this to satirize the whole elitist-popular division, but the joke seems to have run thin.

while hack work and despised formulas inhabited the more populated and bourgeois valleys. Genre and convention were the fare of the multitudes, while originality and storming self-assertion, without a past, without any controls, was the caviar of the truly aware audience.

Until the eighteenth century, artists had generally been distinguished by their class, their education, and their patrons. But, with the growth of a mass society and a mass culture, the hierarchy shifted from distinctions in genealogy to distinctions in sensibility. Almost all of the great eighteenth-century English novelists and essayists had spent some time in Grub Street, that world created to serve the new hunger for the printed word. But the Romantic sensibility turned Grub Street into a synonym for the convention-ridden enemies of art. The true artist was noncommercial, struggling on the fringes of human existence, with neither society nor companions (and hardly any publishers), alone with his indomitable self. Only Byron, the most eighteenth-century of the Romantics, could have said, "I awoke to find myself famous" (on the publication of *Childe Harold*); such an obvious interest in the approval of a book-buying public was disdained in the Romantics' image of their calling. And Byron himself preoccupied much of his writing with the depiction of solitary heroes, striding mountainsides to challenge gloomy fates. The Romantic artist tried to make his work unique to escape from the dead hand of traditional form. The only serious use of the past was the contemplation of vanished greatness, to raise the artist out of what he believed to be an uncultured present and establish for himself a continuity with what has been best before the triumph of modern degeneracy. Like T. S. Eliot in *The Wasteland*, the serious, unpopular artist was the only one in a corrupt age who could summon up the artistic Eden of the past and collect its fragments into some coherence.

Such absolute creativity is finally a fraud because all art must exist in some relation to the forms of the past, whether in contrast or continuation. Both the generic work and the more self-contained work expand our sense of the possibilities of art. But the nineteenth-century stress on literary originality and freedom has inhibited our responses, both intellectual and emotional, to works that try to complicate our appreciation of tradition and form, works that may in fact embody a more radical critique of the past than those which ignore it. More people dislike westerns or musicals because such film genres outrage their inherited and unexamined sense of what art *should* be than because the films are offensive in theme, characterization, style, or other artistic quality. Every lover of musicals, for example, has heard the complaint that musicals are unrealistic and the viewer gets embarrassed when people start singing or dancing. But the relationship between realism and stylization is a central issue in musicals, not an absurd convention. When auteur critics applaud the studio director for triumphing over his material and point to the glimmers of original style shining through the genre assignment, they may awaken us to the merits of an individual artist. But they also fall into the Romantic trap of searching for only what is obviously original and personal in a work. In auteur theory, genre directors with large popular audiences become transformed into embattled Romantic artists trying to establish their personal visions in the face of an assembly-line commercialism. Frank Capra has pointed out the opposite possibility: in the days of big studio monopoly, there was a great deal of freedom to experiment because every film had guaranteed distribution, whereas now, with increased independent production, films have

become more uniform and compromised, because each has to justify itself finan-
cially. Underground and avant-garde films with their emphasis on the individual cre-
ative sensibility above all, are naturally enough the most hostile to genre. But the bulk
of films fall between pure personal expression and pure studio exploitation, mingling
the demands of art and culture, creativity and talent. By their involvement in collec-
tive creativity, film directors have, at least practically, moved away from the image of
the isolated Romantic artist, no matter how they may indulge that image in their pub-
lic statements.

Instead of dismissing genre films from the realm of art, we should therefore exam-
ine what they accomplish. Genre in films can be the equivalent of conscious reference
to tradition in the other arts—the invocation of past works that has been so important
a part of the history of literature, drama, and painting. Miró's use of Vermeer,
Picasso's use of Delacroix are efforts to distinguish their view of the proper ends of
painting. Eliot's use of Spenser or Pynchon's of Joyce make similar assertions of con-
tinuity and difference. The methods of the western, the musical, the detective film, or
the science-fiction film are also reminiscent of the way Shakespeare infuses old sto-
ries with new characters to express the tension between past and present. All pay
homage to past works even while they vary their elements and comment on their
meaning.

Perhaps the main difference between genre films and classic films is the way that
genre films invoke past forms while classic films spend time denying them. The joy
in genre is to see what can be dared in the creation of a new form or the creative
destruction and complication of an old one. The ongoing genre subject therefore
always involves a complex relation between the compulsions of the past and the free-
doms of the present, an essential part of the film experience. The single, unique work
tries to be unforgettable by solving the whole world at once. The genre work, because
of its commitment to pre-existing forms, explores the world more slowly. Its hallmark
is less the flash of inspiration than the deep exploration of craft. Like Ford's *Stage-
coach* or Aldrich's *Ulzana's Raid* (1972) it can exist both in itself and as the latest in
a line of works like it, picking and choosing among possible conventions, refusing
one story or motif to indulge another, avoiding one "cliché" in order to show a self-
conscious mastery of the cliché that has been avoided. After all, the reason that an
artistic element becomes a cliché is that it answers so well to the experience, intelli-
gence, and feelings of the audience. Subsequent artists, perceiving the same aptness,
want to exercise its power themselves, even in a potentially hostile new context, to
discover if all the possibilities of the form have thoroughly been explored. The only
test is its continuing relevance, and a genre will remain vital, as the western has, and
the musical has not, so long as its conventions still express themes and conflicts that
preoccupy its audience. When either minority or majority art loses contact with its
audience, it becomes a mere signpost in history, an aesthetic rather than an art.

Genre films affect their audience especially by their ability to express the warring
traditions in society and the social importance of understanding convention. When
Irene Dunne, in *The Awful Truth* (Leo McCarey, 1937), disguises herself as Cary
Grant's (fictitious) sister and arrives drunk and raucous at a society gathering where
Grant is trying to establish himself, we can open a critical trapdoor and say that the
other people at the party, who already know her, don't recognize her in her flimsy dis-

guise because of the necessities of plot and comic form. But we must go on to say that this particular convention, used with all its force, allows McCarey, without dropping the general humorous tone, to point out that she is unrecognized because the upper classes base their estimates and knowledge of character on dress, voice, and manners—a theme supported by the rest of the film as well. The conflict between desire and etiquette can define both a social comedy like *The Awful Truth* and even a more obviously stylized genre work like *Dr. Jekyll and Mr. Hyde* (Rouben Mamoulian, 1932); it parallels in the plot the aesthetic contrast between the individual film and the conventions to which it plays a complex homage.

Genre demands that we know the dynamics of proper audience response and may often require a special audience because of the need to refer the latest instance to previous versions. But response is never invariable. Convention isn't only whatever we don't have to pay attention to. Explaining Shakespeare's use of soliloquies by observing that the practice was an Elizabethan dramatic convention tells us as little as saying that Picasso used blue because it was cheap or that Edward Everett Horton appeared in so many Fred Astaire-Ginger Rogers films because comic relief was needed. Why a soliloquy *now*? What does Horton's presence mean *here*? The possibility exists in all art that convention and comment coexist, that overlapping and even contradictory assumptions and conventions may be brought into play to test their power and make the audience reflect on why they were assumed. The genre film lures its audience into a seemingly familiar world, filled with reassuring stereotypes of character, action, and plot. But the world may actually be not so lulling, and, in some cases, acquiescence in convention will turn out to be bad judgment or even a moral flaw—the basic theme of such Hitchcock films as *Blackmail* (1929), *Rear Window* (1954), and *Psycho*. While avant-garde and original works congratulate the audience by implying it has the capacity to understand them, genre films can exploit the automatic conventions of response for the purposes of pulling the rug out from under their viewers. The very relaxing of the critical intelligence of the audience, the relief that we need not make decisions—aesthetic, moral, metaphysical—about the film, allows the genre film to use our expectations against themselves, and, in the process, reveal to us expectations and assumptions that we may never have thought we had. They can potentially criticize the present, because it too automatically *accepts* the standards of the past, to build subversion within received forms and thereby to criticize the forms instead of only setting up an alternate vision.*

Through a constant interplay between the latest instance and the history of a particular form, genre films can call upon a potential of aesthetic complexity that would be denied if the art defined itself only in terms of its greatest and most inimitable works. Because of the existence of generic expectations—how a plot "should" work,

---

*The three main American critics who appreciated such films before the New Wave popularized them critically—Otis Ferguson, James Agee, and Manny Farber—were less interested in them for their formal qualities than for their action and unpretentiousness, aspects of energy related to their formal self-consciousness. But both Agee and Farber (and Pauline Kael is their true heir in this) wanted to protect at all costs their beloved movies from any charge of art. As far as the definition of art they were attacking goes, they were right. But to continue such attacks now confuses where it once illuminated. One virtue of the French New Wave critics was that they didn't have to defend themselves simultaneously against pompous ideas of high art, the myth of the American tough guy artist, and the specter of Hollywood commercialism.

what a stereotyped character "should" do, what a gesture, a location, an allusion, a line of dialogue "should" mean—the genre film can step beyond the moment of its existence and play against its own aesthetic history. Through genre, movies have drawn upon their own tradition and been able to reflect a rich heritage unavailable to the "high" arts of the twentieth century which are so often intent upon denying the past and creating themselves totally anew each time out. Within the world of genre films one finds battles, equivalent to those in the history of literature, drama, and painting, between artists who are willing to reproduce a tradition through their own vision because they believe it still has the ability to evoke the emotional response that made it a satisfying artistic form to begin with, and those who believe the form has dried up and needs an injection, usually of "realism." Poets, for example, may contrast the city and the country because that opposition answers to some real beliefs in their audience and because the choice of the rural virtues of the country satisfactorily resolves the conflict. Others might question the authenticity of the traditional materials: did shepherds really play their pipes in singing contests? isn't the elaborate language untrue to rural idioms? or, to extend the analogy, did cowboys really respect law and justice so much? do people really break into dances on the street when they're happy, and does the neighborhood automatically join in? The later generations may feel an emotional pull in the form, but they might want to destylize it and make it more real. The directors of the "adult" western of the 1950s accepted the vitality of the western but thought that a more realistic treatment would strengthen its inherent virtues. If controversy were part of film tradition, we might have an argument between John Ford and Fred Zinnemann on the essence of the western like that between Alexander Pope and Ambrose Phillips on the pastoral, Ford and Pope arguing for the value of form and style, while Zinnemann and Phillips press the need to make the characters of art as close as possible to the real persons who live or lived in that place.

Genre films share many of the characteristics of the closed films I have described in the previous chapter. But, instead of being framed visually, genre films are primarily *closed by convention*. Of course, they may be visually enclosed as well, as, for example, are horror films and 1930s musicals; but the more important enclosure is the frame of pre-existing motifs, plot turns, actors, and situations—in short everything that makes the film a special place with its own rules, a respite from the more confusing and complicated worlds outside. The frame of genre, the existence of expectations to be used in whatever way the intelligence of the filmmaker is capable, allows freedoms within the form that more original films cannot have because they are so committed to a parallel between form and content. The typical genre situation is a contrast between form and content. With the expectations of stock characters, situations, or narrative rhythms, the director can choose areas of free aesthetic play within. In genre films the most obvious focus of interest is neither complex characterization nor intricate visual style, but pure story. Think about the novel we can't put down. That rare experience in literature is the common experience in film, where we stay only because we want to, where we often must be intrigued by the first five minutes or not at all, and where we know that once we leave the spell is broken. Like fairy tales or classical myths, genre films concentrate on large contrasts and juxtapositions. Genre plots are usually dismissed with a snide synopsis (a process that is never very

kind to drama that employs conventions, like Shakespeare's plays). But, amid the conventions and expectations of plot, other kinds of emphasis can flourish. To the unsympathetic eye, the pleasures of variation are usually invisible, whether they appear in the medieval morality play, the Renaissance sonnet, the Restoration comedy, the eighteenth-century portrait, the Chopinesque étude, the horror film, the romantic comedy, the musical, or the western. When we can perceive the function of vampire-film conventions in *Persona* or boxing-film conventions in *On the Waterfront* as clearly as we note the debt of Kurosawa's samurai films to American westerns, or that of the New Wave films to American crime films of the 1950s, then we will be able to appreciate more fully the way in which films can break down the old visions between elite and popular art to establish, almost unbeknown to aesthetics and criticism, a vital interplay between them. . . .*

The epic sweep of the early westerns could be conveyed by the silent screen, but musicals necessarily begin their real film career with sound (and sound films begin, appropriate enough, with *The Jazz Singer*). The Charleston sequences of the silent *Our Dancing Daughters* (Harry Beaumont, 1928) look oddly impersonal and detached today, hardly more real than the bunny-costumed Rockettes. Sound not only individualizes the performer, but also provides a bridge of music between otherwise separate visual moments, a continuity against which the image can play, potentially freeing the film from a strict adherence to a one-to-one relation between sight and sound. Once sound frees image from the necessity to appear logical and casual, the director can experiment with different kinds of nonlogical, noncausal narrative. But, after the first years of sound and such experiments with the new form as René Clair's *Under the Roofs of Paris* (1929), Lang's *M* (1931), Renoir's *Boudu Saved from Drowning* (1932), and Ernst Lubitsch's *Trouble in Paradise* (1932), primarily musicals explored its possibilities. The western may be self-conscious about its myths, but the musical is self-conscious about its stylization, the heightened reality that is its norm. The games with continuous narrative that Busby Berkeley plays in the musical numbers of *Footlight Parade* (1933), *42nd Street* (1933), or *Gold Diggers of 1935* are hardly attempted by nonmusical directors until the jumpcutting achronicity of the New Wave.

Berkeley's films show how the stylistic self-consciousness of musicals directly concerns the relation of their art to the everyday world outside the confines of the film. His camera presses relentlessly forward, through impossible stages that open up endlessly, expanding the inner space of film and affirming the capacity of the world of style to mock the narrowness of the "real" world outside the theater walls, populated by bland tenors, greedy producers, and harried directors. Ford uses theater in *Liberty Valance* to purify his genre vision. But Berkeley uses theater, the impossible theater available to film artifice, to give a sense of exuberance and potential. Playing

---

*The way in which television "cannibalizes" material therefore has less to do with its constant demand than with the speed with which such material becomes outdated. When the audience accepts material as generic and ritualistic—situation comedy, talk shows, sports, news, weather—the form can include an infinite variety of nuance. But when the paradigms are no longer emotionally appealing, formal variety will do no good and there arises a desperate, cannibalizing, attempt to discover the new form of audience solace, whether the subject matter is Dick Cavett or the Vietnam War. Thus the whole process of cultural history is speeded up through successive purgations of used-up subject matter and style.

with space, Berkeley in *Footlight Parade* creates an incredible extravaganza supposedly taking place in miniature within a waterfall, with pyramids of swimming girls, diving cameras, and fifty-foot fountains.

Berkeley's real problem, however, is his concentration on the production number and the spectacle. The sense of play and opulence he brought to the musical, his effort to make its stage artifice a source of strength, was, if we look back upon the direction the musical took, a minor stream in its history. His influence appears in the show business biography (*A Star Is Born*, 1937; *The Jolson Story*, 1946; *Funny Girl*, 1968), the production story (*Summer Stock*, 1950; *The Band Wagon*, 1953), and that great amalgam of realized style and stylized realism, *Singin' in the Rain* (1952). There is also a darker side apparent in a film like *All About Eve* (1950), in which the urge to theater is considered to be manipulative, a reduction of the self rather than an expansion. The dark side may be the truer side of Berkeley's inheritance, because his musicals lack any sense of the individual. The strange melancholy of the "Lullaby of Broadway" number from *Gold Diggers of 1935*, in which, after some elaborately uplifting production numbers, an unsuccessful showgirl commits suicide, combines comedy and the tragedy of sentimental realism in a way that only penetrated serious films in the late 1940s. It presages the urbane tragedies of fatality in a theatrical setting that mark the late films of Julien Duvivier (*Flesh and Fantasy*, 1943) and Max Ophuls (*La Ronde*, 1950; *Lola Montès*, 1955). The showgirl commits suicide in "Lullaby of Broadway" in part because the Berkeley ensemble of faceless dancers holds no place for her at all, perhaps because of her lack of talent, but more clearly because her individuality is contrary to the demands of the uniform musical group. Like Eisenstein or the Lang of *Metropolis*, Berkeley magisterially juxtaposes sequences and articulates crowds with ritual symmetry. Berkeley's attitude toward individuals is that of a silent film director, iconographic and symmetric. The community of the Berkeley girls is cold and anonymous, like Lang's workers, a community created by a nonparticipating choreographer-director. But the kind of musical that had the greatest popular strength, spawned the largest number of descendants, and historically defined the American musical film, is the musical in which the dancer-choreographer himself was a participant, in which an individual man danced with an individual woman, and in which the theme of the individual energy of the dance, the relation of the dancer to his own body, became the main theme of the film. Obviously I am referring to the films of Fred Astaire and Ginger Rogers.*

*Shall We Dance* (1937, songs by George and Ira Gershwin), the last film of the basic Astaire-Rogers series, is a model of their films, perhaps not least because it contains a final sequence that seems to be an implicit attack against the Berkeley emphasis on anonymous spectacle. Astaire plays the Great Petrov, star of the Russian ballet, who is in reality Peter P. Peters, from Philadelphia. The basic conflict of the film is established in the first scene, when Petrov's manager Jeff (Edward Everett Horton) comes into his rehearsal room to find Petrov improvising a dance to a jazz record.

---

*Rouben Mamoulian in *Love Me Tonight* (1932, songs by Rodgers and Hart) focuses on individuals (Jeanette MacDonald and Maurice Chevalier), but the style of the film is still one of directional control rather than a performer's energy. The most impressive song settings are those in which parts of the song are sung and played by people in isolated places, visually linked by the director's wit and style (for example, "Isn't It Romantic?").

"The Great Petrov doesn't dance for fun," he tells him, emphasizing that ballet is a serious business to which the artist must devote his full time. "But I do," responds Astaire. "Remember me? Pete Peters from Philadelpha, P.A.?" Horton points to the taps on Astaire's ballet shoes and continues his insistence that whatever Astaire is doing, it's not art. "Maybe it's just the Philadelphia in me," says Astaire, and begins dancing again. The forces have been set in motion: the dancing that Astaire likes to do when he is alone directly expresses his personal emotions as well as his real iden-tity—the American tap dancer under the high-culture disguise of the Russian ballet dancer. Horton, as he usually does in these films, comically combines a commitment to high culture (and high society) with a definite antagonism to emotion and feeling. When Astaire falls in love with Linda Keene (Ginger Rogers), a nightclub dancer, after seeing a series of movie-like flip cards of her dancing, Horton speaks darkly of the danger to Astaire's "serious" career and the need to be personally pure (i.e., non-sexual and nonemotional) for art. Like so many musicals, *Shall We Dance* contrasts the emotionally detached and formal patterns of high art with the involved and spon-taneous forms of popular art. (Vincente Minnelli's *Meet Me in St. Louis*, 1944, for example, establishes the same relationship between serious music and popular music, and many musicals include parodies of serious theater by vaudevillians.) The 1930s musical may have its historical roots in the silent-film urge to the respectablity of the-ater, the importation of theatrical performers both to give the young industry tone and to banish the generally lower-class associations that film had from its vaudeville beginnings. But the sound musical—like so many genres of the 1930s, comedies and horror films included—begins to mock this respect for older forms just as it parodies the upper class in general. Tap dancing is superior to ballet as movies are superior to drama, not merely because they are more popular, but because they contain more life and possibility. The flip-card stills that turn into a sequence of Rogers dancing pre-sent her as a creature of the film, not the stage. Like Astaire in the film, Rogers is also an American, but more proudly: she doesn't like the "hand-kissing heel-clickers of Paris" and rejects Peters when he attempts to impress her by coming on as the formal Petrov. Berkeley attacks theater in favor of film and dance by destroying the limits of theatrical space. But Astaire and Rogers (and their directors, especially Mark San-drich and choreographer Hermes Pan) attack all high art in favor of the new dancing forms of spontaneity, American style. The Berkeleyan world spawns the myth of show-business biography that success on stage buys only unhappiness in one's per-sonal life. But the silvery world of Astaire and Rogers celebrates the ability of indi-vidual energy to break away from the dead hand of society, class and art as well. The open space of the western that offers a chance to build becomes in the musical the endless inner energy released in dance.

*Shall We Dance* is defined by the collision between the forces of inertia and stasis and the forces of vitality, between Astaire as Petrov—the commitment to high art and personal repression—and Astaire as Peters—the commitment to an art that attempts to structure individual energy instead of excluding it. Musical comedy therefore also attacks any theories of acting in which character comes from the past. Character in musical comedy is physiological and external: the ability to dance and the way danc-ing functions in specific situations becomes a direct expression of the tensions within the self. In the first scene Astaire dances along at the proper speed; and then, when

the machine needs to be wound up again, he slows down as the record itself slows down. On the ship that takes him and Rogers back to America, he descends into the engine room and dances there in time to the pistons while black members of the crew who are taking a musical break play for him. In both sequences the energy of the dance—the personal emphasis in the first, the relation to jazz and black music in the second ("Slap That Bass")—draws upon the analogy between body and machine. But here, unlike literary attacks against the machine, the film, true to its mechanical and technological origins, celebrates the machine as a possible element in the liberation of the individual rather than in his enslavement (similar to the ambivalence about machines that characterizes *Metropolis*). Machines are outside class, purifiers of movement. The real threat to individual energy and exuberance is not the machine, but the forces of society and respectability—the impresario Jeff, the rich suitor Jim with the weak chin (William Brisbane), who wants to take Rogers away from show business, and the punctilious hotel manager Cecil Flintridge (Eric Blore). Here they are comic, but they nevertheless play the same repressive roles as they would in the more melodramatic world of the western.*

At the end of *Shall We Dance*, the comically hostile forces (including an outside world of publicity and gossip) are reconciled by Astaire's typical process of self-realization—the search for the perfect partner. The perfect partner is always a dancing partner, since it is within the world of dance that true communication and complementarity can be achieved: the male-female dance duo is a model of male-female relationship in general. Dancing isn't a euphemism for sex; in Astaire-Rogers films at least, dancing is much better. Two sequences in *Shall We Dance* constitute the dance of courtship and they appear after the first dancing sequences, which establish the separate personalities of Astaire and Rogers. In the first, "They All Laughed," Astaire begins with ballet-like steps while Rogers stands still. Then she begins to tap, and he responds, first with a ballet version of the tapping, then a straight tap. In the second such number, "Let's Call the Whole Thing Off," the importance of the dancing situation to their relationship is further underlined. They are taking a walk in a stage-set Central Park and decide to go skating, even though neither of them has skated in a long time. They begin very haltingly, with frequent stumbles. But, as soon as the music starts, they skate perfectly together. Then, at the end of the song, as the music ends, they hit the grass outside the skating rink and fall down. Once the magic world of dance and its ability to idealize personal energy into a model of relationship has vanished, Astaire and Rogers again become separate and even bickering individuals. "Let's Call the Whole Thing Off" memorializes their differences, even while it provides a context for their relationship. The next musical number, "They Can't Take That Away from Me," contains no dancing. It takes place at night on a ferry between New Jersey and New York and emphasizes the problems of their relationship, especially the seeming conflict between their real feelings, which can be expressed at night, and the public and social demands on them that the daylight world of the rest

---

*The positive interpretation of the machine analogy to the body is a constant theme in musicals, most recently expressed in the Ken Russell film of *Tommy* (1975, words and music by Peter Townshend and The Who), in which the deaf, dumb, and blind boy first discovers his real nature through his symbiotic relation with pinball machines.

of the film exerts. Like Astaire and Rogers themselves, who feel the pressure to continue their successful film partnership despite their own wishes, Peter Peters and Linda Keene have been forced into marriage primarily so they can get divorced. The publicity generated by their managers is meant to connect them, but it succeeds only in driving them apart, as aesthetic as well as emotional partners.

Astaire solves the conflict and rejoins Rogers in the remarkable final sequence. In a theatrical setting reminiscent of the roof of the Winter Garden, an open space within the city, Astaire stages a show that summarizes the main elements of the film. In the early sequences Astaire plays a Russian ballet dancer; Rogers appears; he loses her. Meanwhile, the real Rogers, the comic Claudius in this mousetrap, sits in a box, part of the audience, but separate from it. Astaire reprises "You Can't Take That Away from Me" to lead into a sequence in which a whole group of dancing partners appear—all wearing a mask with Rogers' face on it. The song then becomes ironic, since the memory of her uniqueness that it celebrates has been confused in the many Rogers of the present. Ruby Keeler is obviously pleased to be multiplied into many images for the adoration of Dick Powell in Berkeley's *Dames* (1934), but the Ginger Rogers in the audience of *Shall We Dance* cannot take this anonymous crowd of Busby Berkeley chorus girls all wearing her face. Astaire's message makes the same plea: deliver me from the life of a single man amid innumerable faceless girls by asserting the perfection of our relationship. Rogers goes backstage and puts on one of the masks. She comes onstage, briefly reveals herself to Astaire, and then glides back into the anonymity of the many Rogers. Which is the real Rogers among the false, the reality and energy of the individual beneath the generalized artifice of the image? Astaire finds her and together they sing and dance the final song, "Shall We Dance," an invitation to let the dancing, emotional energetic self out, to reject depression and the forms of society, and to accept the frame of theater that allows one, through the exuberance of dance, to be free.

The figure of Fred Astaire implies that dance is the perfect form, the articulation of motion that allows the self the most freedom at the same time that it includes the most energy. The figure of Gene Kelly implies that the true end of dance is to destroy excess and attack the pretensions of all forms in order to achieve some new synthesis. Kelly the sailor teaching Jerry the Mouse to dance in *Anchors Aweigh* (George Sidney, 1945) stands next to Bill Robinson teaching Shirley Temple to dance in *The Little Colonel* (David Butler, 1935). Astaire may move dance away from the more formal orders of the ballet, but Kelly emphasizes its appeal to the somewhat recalcitrant, not quite socialized part of the self, where the emotions are hidden. Astaire and Kelly are part of the same continuum of themes and motifs in musicals (an interesting study could be done of the interaction of their images in the 1940s and 1950s). There are many contrasts that can be made between the way they use dance and the way they appear in their films, but the basic fact of their continuity should be remembered. The question of personal energy, which I have characterized as the musical's basic theme, once again appears centrally. The social world against which Astaire defined himself in the 1930s no longer had the same attraction to movie audiences in the 1940s; it was a hangover from the early days of film and their simultaneous fascination with the 1920s high life and the higher seriousness of theater, in a double

effort both to imitate and to mock. Astaire is the consummate theatrical dancer, while Kelly is more interested in the life outside the proscenium. The energy that Astaire defines within a theatrical and socially formal framework Kelly takes outside, into a world somewhat more "real" (that is, similar to the world of the audience) and therefore more recalcitrant. Kelly's whole presence is therefore more rugged and less ethereal than Astaire's. Both Astaire and Kelly resemble Buster Keaton, their prime ancestor in dancing's paean to the freedom and confinement of the body. But Astaire is the spiritual Keaton while Kelly is the combative, energetic Keaton, compounded with the glee of Douglas Fairbanks. Kelly has more obvious physical presence than Astaire, who hides his well-trained body in clothes that give the impression he has nothing so disruptive as muscles, so that the form of his dancing is even more an ideal and a mystery. Astaire often wears suits and tuxedos, while Kelly generally wears open-collared shirts, slacks, white socks, and loafers—a studied picture of informality as opposed to Astaire's generally more formal dress. Astaire wears the purified Art Deco makeup of the 1930s, but Kelly keeps the scar on his cheek visible—an emblem of the interplay between formal style and disruptive realism in his definition of the movie musical.*

Astaire may mock social forms for their rigidity, but Kelly tries to explode them. Astaire purifies the relation between individual energy and stylized form, whereas Kelly tries to find a new form that will give his energy more play. Astaire dances onstage or in a room, expanding but still maintaining the idea of enclosure and theater; Kelly dances on streets, on the roofs of cars, on tables, in general bringing the power of dance to bear on a world that would ordinarily seem to exclude it. (Astaire absorbs this ability of Kelly's to reorganize normal space and integrates it with his own lighter-than-air quality in the dancing on the walls sequence in *Royal Wedding*, 1951, directed by Kelly's favorite collaborator Stanley Donen.) Astaire usually plays a professional dancer; Kelly sometimes does and sometimes does not, although he is usually an artist of some kind, often, as in *The Pirate*, a popular artist, or, as in *Summer Stock*, a director, associated with the stage but not totally inside it. Kelly therefore merges the director emphasis of Berkeley with the performer emphasis of Astaire. To complement the distance from theatrical form Kelly maintains, his whole style of acting is self-mocking, while Astaire's is almost always serious and heartfelt, at far as comedy will allow. Because the film attitude toward serious art is less defensive in the 1940s than in the 1930s, Kelly can include ballet and modern dance in his films, although always in a specifically theatrical setting (the pirate dream ballet in *The Pirate*, the gangster ballet in *Les Girls*). Theater and style in Astaire's films reconcile the conflict between personal life and social pressures, and allow the self to repair and renovate its energy. Many of his films have more or less autobiographical elements in them, not the autobiography of Astaire's private life, but the autobiography of Astaire's professional life: the effect to get a new partner after Ginger Rogers

---

*I have been using Astaire and Kelly to represent the change in the movie musical as much as I have been describing what they do themselves. A full account would also have to include a close consideration of Eleanor Powell, whose fantastic exuberance and bodily freedom often threatened to destroy the generally theatrical plots in which she was encased. The most important film for these purposes might be *Broadway Melody of 1940* (Normal Taurog), in which she and Astaire dance together with an equality of feeling and ability that presages the teaming of Kelly and Judy Garland.

decided to do dramatic films instead (*Easter Parade*, Charles Walters, 1948, with Judy Garland), the celebration of Rogers' return to dance after several "serious" films (*The Barkleys of Broadway*, Charles Walters, 1949). Kelly, however, far from taking refuge in theater, wants to make theater take over daily life. His films are hardly ever autobiographical; unlike Astaire's, they have stories in which Kelly plays a role.

Fred Astaire among the many masks of Ginger Rogers in *Shall We Dance* (1937). "Which is the real Rogers among the false, the reality and energy of the individual beneath the generalized artifice of the image? Astaire finds her and together they sing and dance, 'Shall We Dance', an invitation to let the dancing, emotional energetic self out . . ." (BRAUDY, page 673). Gene Kelly and cast at the end of the "Gotta Dance" production number in *Singing' in the Rain* (1952), "another statement of Kelly's belief that dancing is a compulsion from within more authentic than the forms imposed from without" (BRAUDY, page 679).

Astaire may dance by himself, with a partner, or with a company of dancers. Kelly wants to galvanize a community of nondancers as well. Astaire and his partner are professionals; Kelly and his partner are often amateurs, but everyone they meet knows the steps to their dances and the words to their songs.[1]

A Kelly film that highlights the differences and similarities between the two great definers of the American musical comedy is Vincent Minnelli's *The Pirate* (1948, songs by Cole Porter, story by Frances Goodrich and Albert Hackett). In the beginning of *The Pirate*, Manuela (Judy Garland), the poor niece of a wealthy family on an eighteenth-century Caribbean island, is leafing through a book detailing the highly romanticized adventures of the pirate Macoco. She dreamily desires the embraces of Macoco but is realistically resigned to marrying the unromantic, fat town mayor (Walter Slezak), who courts her with propriety and respect. One of her companions tells her that the life of Macoco is pure fantasy and she responds by expressing the sense of separate worlds she feels within her: "I realize there's a practical world and a dream world. I won't mix them"[2] Enter Serafin (Gene Kelly), the head of a traveling company of players. He flirts with Manuela, and falls in love with her. By accidental hypnosis the reserved Manuela changes into a manic performer, and she and Serafin dance and sing together in a funny scene in which Serafin thinks he's tricked this pretty girl into dancing with him, while the exuberance released in Manuela by the hypnosis threatens to knock him off the stage. Horrified at what she's done, Manuela leaves for her hometown away from the big city to prepare for her marriage to the mayor. Serafin follows her and recognizes the mayor as the real Macoco. He threatens to expose him unless the mayor allows Serafin to pretend that he is Macoco, since Serafin knows of Manuela's hero-worship. The mayor agrees, until he sees that Manuela's attraction to Serafin is increased by the impersonation. The mayor then arrests Serafin and is about to hang him when Serafin, asking for the opportunity to do a last act on stage, plays a scene with Manuela that reveals to the mayor her actual love for Macoco the Pirate. Unaware of the game, the mayor announces that he is the real Macoco and therefore Manuela should love him. He is arrested, and the united Kelly and Garland appear in the last scene as stage partners singing "Be a Clown" to the audience.

Through the personalities of Garland and Kelly, *The Pirate* explores the theme of identity I have discussed in Astaire's films in a very different way. Serafin's courtship of Manuela reveals that her desire for Macoco is a desire for a romantic individualism outside society—a theme made especially strong by setting the film in an eighteenth-century Spanish Roman Catholic country with all its elaborate social forms and ceremonies. Kelly hypnotizes her with a spinning mirror—an image of the many

---

[1] It is worth mentioning that Astaire and Kelly are appropriately enough the two supreme examples of Hollywood stars who never really gave their private lives in any way over to the fan magazines or the mechanism of offscreen publicity, since their screen presences are personal enough.

[2] Observers of Vincente Minnelli have often pointed out the constant interest in the clash of reality and dream in his films. Here, of course, I am considering these themes in terms of the larger issue of the history of musicals as a genre. The way specific directors, with their own thematic and stylistic preoccupations, interact with pre-existing conventions to change those conventions and clarify their own interests at the same time is a topic that requires much more minute examination than I can give it here.

possible selves. The Manuela that is released, the self below the social surface, is a singing, dancing self. Her exuberance indicates that Serafin has in fact released more than he expects or may want. He is a professional artist. But she gets her art directly from her inner life, untamed by society or by learned craft. Garland is perfect for this kind of role because she projects so clearly the image of a restrained, almost mouse-like person until she begins to sing and dance. (Her first important film, *The Wizard of Oz*, Victor Fleming, 1939, solidified this tension in Garland between the acceptance of daily life in a world of drabness and moral boredom, and the possibility of escape to an exuberant singing, dancing world of dream. It appeared as well in *Meet Me in St. Louis*, 1944, another Minnelli film, where the pattern of stability and release is more parallel to that of *The Pirate*.)

Serafin is the alternative to Macoco in more ways than one. The real pirate has changed from an antisocial adventurer to a socially dictatorial mayor, thus rejecting the Macoco side of himself to become almost the opposite. But Kelly instead tries to mediate individuality and community. His first song in the film is "Niña," a typical Kelly dance in a street fair, where he sings and dances with half the surprised people there to weave together a kind of community of otherwise isolated individuals and objects through the catalyst of his own personality and artistic ability. The song relates how he calls every girl he meets "niña," that is, little girl. At the end of the song Garland appears and the amazed Kelly asks her what her name is. Like Rogers at the end of *Shall We Dance*, she stands apart from communal anonymity. Serafin is the articulate adventurer, the popular artist, who sees his art to be part of a creation of community; she is the individual artist, whose art is less craft than a swelling sense of herself from within. We admire and feel friendly to him because he includes us in his dance. But we identify with her, for she, like us, is not professional, even in the loose sense in which Serafin is professional. Serafin realizes this and therefore pretends to be Macoco to win her. In the climactic moment, when he is plotting to get the real Macoco to reveal himself and brings out the mirror to rehypnotize Garland, Slezak breaks the mirror. But it doesn't matter. Manuela is willing to go along with Serafin's plot, as Garland accepts Kelly's choreography and control. Her energy, once released, can be controlled, especially within the context of love and theater. *The Pirate* is therefore a next step from the themes of the Astaire-Rogers films. Kelly makes the perfect couple the center of an ideal community created by dance, a world of harmony where everyone on the street not only sympathizes with the exuberance you feel because you're in love, but also knows all the words and dance steps that express your feelings.

The context of the ideal, the place where the true self can be revealed, is still theatrical space. The final song, "Be a Clown," emphasizes the responsible escape of art, especially popular art, in a way very reminiscent of the title song at the end of *Shall We Dance*. But the inclusion of the Garland figure—the nonprofessional dancer from the heart—indicates the direction that Kelly has taken the musical, as does the fact that Kelly and Garland are not elegant in their world of theater, but clownish and self-mocking, more willing than Astaire and Rogers to include the potential disruptiveness of the world outside them and the world within. Astaire and Rogers dance for us, looking at each other primarily to integrate their dancing. Kelly and Garland convey

a much friendlier and more personal relationship. We may watch Astaire and Rogers. But we empathize with Kelly and Garland.*

Kelly in *The Pirate* is an entertainer. But the emphasis of the film is less on his dancing and singing than on the world that dance and theater can create together. The stylization and historical setting of *The Pirate* emphasize the release from the stultifying social self dance allows; the contemporary setting of most other Kelly films further highlights Kelly's effort to bring his dancing out of the enclosed world of theater and make the whole world a theater, responsive to and changed by his energy. Astaire's dances define a world of perfect form, while Kelly's often reach out to include improvisation, spontaneity, and happenstance. The scene that contrasts best with Astaire's imitation of the record player and the machines in *Shall We Dance* is Kelly's marvelous interweaving of a creaky board and a piece of paper left on the stage in *Summer Stock* (1950). Kelly's self-mocking smile reflects the way most of his films continue the attack of Astaire's films against artistic pretension. Embodying the catalytic possibilities of dance to create a new coherence for the nontheatrical world, Kelly journeys through parody and realism, attacking formal excesses on the one hand and transforming everyday reality on the other.

*Singin' in the Rain* (Kelly and Stanley Donen, 1952), is one aspect of his effort and *On the Town* (Kelly and Stanley Donen, 1949) is the other. The frame of *Singin' in the Rain* is a full-scale parody of the early days of sound film (an appropriate subject for the musical), complete with an attack on artistic high seriousness in favor of the comic exuberance of popular art. The essential scene is Donald O'Connor's incredible acrobatic dance "Make 'Em Laugh" (unfortunately often cut for television), like "Be a Clown" a description of the popular artist's relation to his audience. But this time, instead of being on a stage, the number is done amid a welter of different film sets depicting different worlds, with stagehands moving through the scene. O'Connor's partner for a while is a featureless, uncostumed dummy that he makes seem alive (a reminiscence of the Ginger Rogers dummy in *Shall We Dance*), and for a finale he starts walking up the set walls and finally jumps right through them. In the early scenes of the film, Kelly, the phony silent-screen lover, needs to set up a sound stage and props before he can tell Debbie Reynolds he loves her and sings "You Were Meant for Me." But the declaration becomes acceptable as real emotion only when, in the next scene, he and Donald O'Connor parody the demands of their diction coach in "Moses Supposes." By this time, to parallel his change from form to substance, Kelly has left his suits and tuxedoes behind and dresses in the more familiar open-collared shirt and loafers. Once again, the scar on his cheek is an emblem of the reality that will emerge. In *Singin' in the Rain* silent films are artificial in their stylized actions and hoked-up emotions; only sound is real. The discovery of communication

---

*The strength of Minnelli's own vision obviously has its place in understanding *The Pirate* (1948), although the comparative visual stasis and the commitment to the values of stability that characterize *Meet Me in St. Louis* (1944) indicate the importance of Kelly in changing his style and his ideas. Minnelli's musicals may try to celebrate the triumph of the individual through art, but just as often (for example, in *The Band Wagon*, 1953) they catch a tint of gloom from his more melancholic nonmusical films, which often deal with artistic compromise and disintegration, either in the context of the world of film (*The Bad and the Beautiful*, 1952; *Two Weeks in Another Town*, 1962) or the other arts (*Lust for Life*, 1956; *Some Came Running*, 1958). Only in the pure world of the musical can art and individuality succeed without compromise.

with an audience changes clearly from "Shall We Dance" to "Be a Clown" to "Make 'Em Laugh," with an increasing emphasis on the place of informality and personal style. The solution of the plot of *Singin' in the Rain* is to make the bad serious film into the parodic musical; almost all the dances in the film contain parodies of earlier dances and dancers, in the same somewhat mocking homage that characterizes the attitude to Impressionism in *An American in Paris* (Minnelli, 1951). This is the essence of the kind of energy Kelly's film embodies: theater, like the ability to dance, is a manner of inner perspective on the world outside. The reality of sound film that Kelly discovers follows his own curve of increased dancing in the film until the great set piece of "Gotta Dance," another statement of Kelly's belief that dancing is a compulsion from within more authentic than the forms imposed from without. The final scene, in which Debbie Reynolds is revealed as the voice of Jean Hagen from behind the curtain, repeats on still another level the basic theme of outer form and inner reality. Music and dance are the real spirit of film in the same way they are the real soul and energy of New York in *On the Town*, or Paris in *An American in Paris*.

Kelly's dancing tries not to be the aesthetic escape of Astaire's. It is more utopian because it aims to bring the world together. Astaire's films often imply that dance and therefore energy itself can be a refuge from a stuffy world of social forms; Kelly's films imply that dance and the individual can change the world. The three sailors on leave in *On the Town*—Kelly, Frank Sinatra, and Jules Munshin—are searching for the perfect partner and all find their girls, not in a purified world of dance, but in a real New York (the first musical made on location) that embraces both their dancing and their search. The women—Vera-Ellen, Ann Miller, and Betty Garrett—are all at least the equals of the men in exuberance, energy, and wit. They make their own space in a public world, like Kelly in the "Singin' in the Rain" sequence, splashing through puddles of chance and nature. The great pretenders in *On the Town* are Kelly and Vera-Ellen, the small-town kids who come on to each other as sophisticates. The moral is that of almost all Kelly films: don't worry about the true self; it will turn out to be better than the one you're pretending to be. Kelly's kind of musical doesn't retreat from reality. It tries to subvert reality through its new energy, an energy available to everyone in the audience through Kelly's insistence on the nonprofessional character, the musical self that wells from inside instead of being imposed from without, whether by training, tradition, or society. . . .

1976

# RICK ALTMAN
## A SEMANTIC/SYNTACTIC APPROACH TO FILM GENRE

What is a genre? Which films are genre films? How do we know to which genre they belong? As fundamental as these questions may seem, they are almost never asked—let alone answered—in the field of cinema studies. Most comfortable in the seemingly uncomplicated world of Hollywood classics, genre critics have felt little need to reflect openly on the assumptions underlying their work. Everything seems so clear. Why bother to theorize, American pragmatism asks, when there are no problems to solve? We all know a genre when we see one. Scratch only where it itches. According to this view, genre theory would be called for only in the unlikely event that knowledgeable genre critics disagreed on basic issues. The task of the theorist is then to adjudicate among conflicting approaches, not so much by dismissing unsatisfactory positions but by constructing a model that reveals the relationship between differing critical claims and their function within a broader cultural context. Whereas the French clearly view theory as a first principle, we Americans tend to see it as a last resort, something to turn to when all else fails.

Even in this limited, pragmatic view, whereby theory is to be avoided at all costs, the time for theory is nevertheless upon us. The clock has struck thirteen; we had best call in the theoreticians. The more genre criticism I read, the more uncertainty I note in the choice or extent of essential critical terms. Often what appears as hesitation in the terminology of a single critic will turn into a clear contradiction when studies by two or more critics are compared. Now, it would be one thing if these contradictions were simply a matter of fact. On the contrary, however, I suggest that these are not temporary problems, bound to disappear as soon as we have more information or better analysts. Instead, these uncertainties reflect constitutive weaknesses of current notions of genre. Three contradictions in particular seem worthy of a good scratch.

When we establish the corpus of a genre we generally tend to do two things at once, and thus establish two alternate groups of texts, each corresponding to a differ-

ent notion of corpus. On the one hand, we have an unwieldly list of texts corresponding to a simple, tautological definition of the genre (e.g., western = film that takes place in the American West, or musical = film with diegetic music). This *inclusive* list is the kind that gets consecrated by generic encyclopedias or checklists. On the other hand, we find critics, theoreticians, and other arbiters of taste sticking to a familiar canon that has little to do with the broad, tautological definition. Here the same films are mentioned again and again, not only because they are well known or particularly well made, but because they somehow seem to represent the genre more fully and faithfully than other apparently more tangential films. This *exclusive* list of films generally occurs not in a dictionary context, but instead in connection with attempts to arrive at the overall meaning or structure of a genre. The relative status of these alternate approaches to the constitution of a generic corpus may easily be sensed from the following typical conversation:

> "I mean, what do you do with Elvis Presley films? You can hardly call them musicals."

> "Why not? They're loaded with songs and they've got a narrative that ties the numbers together, don't they?"

> "Yeah, I suppose. I guess you'd have to call *Fun in Acapulco* a musical, but it's sure no *Singin' in the Rain*. Now there's a real musical."

When is a musical not a musical? When it has Elvis Presley in it. What may at first have seemed no more than an uncertainty on the part of the critical community now clearly appears as a contradiction. Because there are two competing notions of generic corpus on our critical scene, it is perfectly possible for a film to be simultaneously included in a particular generic corpus and excluded from that same corpus.

A second uncertainty is associated with the relative status of theory and history in genre studies. Before semiotics came along, generic titles and definitions were largely borrowed from the industry itself; what little generic theory there was tended therefore to be confused with historical analysis. With the heavy influence of semiotics on generic theory over the last two decades, self-conscious *critical* vocabulary came to be systematically preferred to the now-suspect *user* vocabulary. The contributions of Propp, Lévi-Strauss, Frye, and Todorov to genre studies have not been uniformly productive, however, because of the special place reserved for genre study within the semiotic project. If structuralist critics systematically chose as the object of their analysis large groups of popular texts, it was in order to cover a basic flaw in the semiotic understanding of textual analysis. Now, one of the most striking aspects of Saussure's theory of language is his emphasis on the inability of any single individual to effect change within that language.[1] The fixity of the linguistic community thus serves as justification for Saussure's fundamentally synchronic approach to language. When literary semioticians applied this linguistic model to problems of textual analysis, they never fully addressed the notion of interpretive community implied by Saussure's linguistic community. Preferring narrative to narration, system to process, and *histoire* to *discours*, the first semiotics ran headlong into a set of restrictions and contradictions that eventually spawned the more process-oriented second

---

[1]Ferdinand de Saussure, *Course in General Linguistics*, edited by Charles Bally and Albert Sechehaye, translated by Wade Baskin (New York: McGraw-Hill, 1959), pp. 14–17.

semiotics. It is in this context that we must see the resolutely synchronic attempts of Propp, Lévi-Strauss, Todorov, and many another influential genre analyst.[2] Unwilling to compromise their systems by the historical notion of linguistic community, these theoreticians instead substituted the generic context for the linguistic community, as if the weight of numerous "similar" texts were sufficient to locate the meaning of a text independently of a specific audience. Far from being sensitive to concerns of history, semiotic genre analysis was by definition and from the start devoted to bypassing history. Treating genres as neutral constructs, semioticians of the sixties and early seventies blinded us to the discursive power of generic formations. Because they treated genres as the interpretive community, they were unable to perceive the important role of genres in exercising influence on the interpretive community. Instead of reflecting openly on the way in which Hollywood uses its genres to short-circuit the normal interpretive process, structuralist critics plunged headlong into the trap, taking Hollywood's ideological effect for a natural ahistorical cause.

Genres were always—and continue to be—treated as if they spring full-blown from the head of Zeus. It is thus not surprising to find that even the most advanced of current genre theories, those that see generic texts as negotiating a relationship between a specific production system and a given audience, still hold to a notion of genre that is fundamentally ahistorical in nature.[3] More and more, however, as scholars come to know the full range of individual Hollywood genres, we are finding that genres are far from exhibiting the homogeneity that this synchronic approach posits. Whereas one Hollywood genre may be borrowed with little change from another medium, a second genre may develop slowly, change constantly, and surge recognizably before settling into a familiar pattern, while a third may go through an extended series of paradigms, none of which may be claimed as dominant. As long as Hollywood genres are conceived as Platonic categories, existing outside the flow of time, it will be impossible to reconcile *genre theory*, which has always accepted as given the timelessness of a characteristic structure, and *genre history*, which has concentrated on chronicling the development, deployment, and disappearance of this same structure.

A third contradiction looms larger still, for it involves the two general directions taken by genre criticism as a whole over the last decade or two. Following Lévi-Strauss, a growing number of critics throughout the seventies dwelled on the mythical qualities of Hollywood genres and thus on the audience's ritual relationship to genre film. The film industry's desire to please and its need to attract consumers were viewed as the mechanism whereby spectators were actually able to designate the kind of films they wanted to see. By choosing the films it would patronize, the audience revealed its preferences and its beliefs, thus inducing Hollywood studios to produce films reflecting its desires. Participation in the genre film experience thus reinforces

[2]Especially in Vladimir Propp, *Morphology of the Folktale* (Bloomington: Indiana Research Center in Anthropology, 1958); Claude Lévi-Strauss, "The Structural Study of Myths," in *Structural Anthropology*, trans. Claire Jacobson and Brooke Grundfest Schoepf (New York: Basic Books, 1963), pp. 206–231; Tzvetan Todorov, *Grammaire du Décaméron* (The Hague: Mouton, 1969); and Tzvetan Todorov, *The Fantastic*, translated by Richard Howard (Ithaca: Cornell University Press, 1975).
[3]Even Stephen Neale's recent discursively oriented study falls prey to this problem. See *Genre* (London: British Film Institute, 1980).

spectator expectations and desires. Far from being limited to mere entertainment, filmgoing offers a satisfaction more akin to that associated with established religion. Most openly championed by John Cawelti, this ritual approach appears as well in books by Leo Braudy, Frank McConnell, Michael Wood, Will Wright, and Tom Schatz.[4] It has the merit not only of accounting for the intensity of identification typical of American genre film audiences, but it also encourages the placing of genre film narratives into an appropriately wider context of narrative analysis.

Curiously, however, while the ritual approach was attributing ultimate authorship to the audience, with the studios simply serving, for a price, the national will, a parallel ideological approach was demonstrating how audiences are manipulated by the business and political interests of Hollywood. Starting with *Cahiers du Cinéma* and moving rapidly to *Screen, Jump Cut,* and a growing number of journals, this view has recently joined hands with a more general critique of the mass media offered by the Frankfurt school.[5] Looked at in this way, genres are simply the generalized, identifiable structures through which Hollywood's rhetoric flows. Far more attentive to discursive concerns than the ritual approach, which remains faithful to Lévi-Strauss in emphasizing narrative systems, the ideological approach stresses questions of representation and identification previously left aside. Simplifying a bit, we might say that it characterizes each individual genre as a specific type of life, an untruth whose most characteristic feature is its ability to masquerade as truth. Whereas the ritual approach sees Hollywood as responding to societal pressure and thus expressing audience desires, the ideological approach claims that Hollywood takes advantage of spectator energy and psychic investment in order to lure the audience into Hollywood's own positions. The two are irreducibly opposed, yet these irreconcilable arguments continue to represent the most interesting and well defended of recent approaches to Hollywood genre film.

Here we have three problems that I take to be not limited to a single school of criticism or of a single genre but implicit in every major field of current genre analysis. In nearly every argument about the limits of a generic corpus, the opposition of an inclusive list to an exclusive canon surfaces. Wherever genres are discussed, the divergent concerns of theorists and historians are increasingly obvious. And even

---

[4]John Cawelti, *The Six-Gun Mystique* (Bowling Green: Bowling Green University Popular Press, [1970]), and John Cawelti, *Adventure, Mystery and Romance* (Chicago: University of Chicago Press, 1976); Leo Braudy, *The World in a Frame: What We See in Films* (Garden City: Anchor Books, 1977); Frank McConnell, *The Spoken Seen: Films and the Romantic Imagination* (Baltimore: Johns Hopkins University Press, 1975); Michael Wood, *America in the Movies,* or *Santa Maria, It Had Slipped My Mind* (New York: Delta, 1975); Will Wright, *Sixguns and Society: A Structural Study of the Western* (Berkeley: University of California Press, 1975); Thomas Schatz, *Hollywood Genres: Formulas, Film-making, and the Studio System* (New York: Random House, 1981).

[5]See especially the collective text *"Young Mr. Lincoln* de John Ford," *Cahiers du Cinéma,* no. 223 (August 1970): 29–47, translated in *Screen* 14, no. 3 (Autumn 1973): 29–43; and Jean-Louis Comolli's six-part article "Technique et idéologie," *Cahiers du Cinéma,* nos. 229–241 (1971–1972). The entire *Screen* project has been usefully summarized, with extensive bibliographical notes, by Philip Rosen, *"Screen* and the Marxist Project in Film Criticism," *Quarterly Review of Film Studies* 2, no. 3 (August 1977): 273–287; on *Screen's* approach to ideology, see also Stephen Heath, "On Screen, in Frame: Film and Ideology," *Quarterly Review of Film Studies* 1, no. 3 (August 1976): 251–265. The most important influence on all these positions is Louis Althusser, "Ideology and Ideological State Apparatuses," in *Lenin and Philosophy and Other Essays,* translated by Ben Brewster (New York: Monthly Review Press, 1971), pp. 127–186.

when the topic is limited to genre theory alone, no agreement can be found between those who propose a ritual function for film genres and those who champion an ideological purpose. We find ourselves desperately in need of a theory which, without dismissing any of these widely held positions, would explain the circumstances underlying their existence, thus paving the way for a critical methodology that encompasses and indeed thrives on their inherent contradictions. If we have learned anything from poststructuralist criticism, we have learned not to fear logical contradictions but instead to respect the extraordinary energy generated by the play of contradictory forces within a field. What we need now is a new critical strategy enabling us simultaneously to understand and to capitalize on the tensions existing in current generic criticism.

In assessing theories of genre, critics have often labeled them according to a particular theory's most salient features or the type of activity to which it devotes its most concentrated attention. Paul Hernadi, for example, recognizes four general classes of genre theory: expressive, pragmatic, structural, and mimetic.[6] In his extremely influential introduction to *The Fantastic*, Tzvetan Todorov opposes historical to theoretical genres, as well as elementary genres to their complex counterparts.[7] Others, like Frederic Jameson, have followed Todorov and other French semioticians in distinguishing between semantic and syntactic approaches to genre.[8] While there is anything but general agreement on the exact frontier separating semantic from syntactic views, we can as a whole distinguish between generic definitions that depend on a list of common traits, attitudes, characters, shots, locations, sets, and the like—thus stressing the semantic elements that make up the genre—and definitions that play up instead certain constitutive relationships between undesignated and variable placeholders—relationships that might be called the genre's fundamental syntax. The semantic approach thus stresses the genre's building blocks, while the syntactic view privileges the structures into which they are arranged.

The difference between semantic and syntactic definitions is perhaps most apparent in familiar approaches to the western. Jean Mitry provides us with a clear example of the most common definition. The western, Mitry proposes, is a "film whose action, situated in the American West, is consistent with the atmosphere, the values, and the conditions of existence in the Far West between 1840 and 1900."[9] Based on the presence or absence of easily identifiable elements, Mitry's nearly tautological definition implies a broad, undifferentiated generic corpus. Marc Vernet's more detailed list is more sensitive to cinematic concerns, yet overall it follows the same semantic model. Vernet outlines general atmosphere ("emphasis on basic elements, such as earth, dust, water, and leather"), stock characters ("the tough/soft cowboy, the lonely sheriff, the faithful or treacherous Indian, and the strong but tender woman"),

---

[6]Paul Hernadi, *Beyond Genre: New Directions in Literary Classification* (Ithaca: Cornell University Press, 1972).

[7]Todorov, *The Fantastic*.

[8]Fredric Jameson, "Magical Narratives: Romance as Genre," *New Literary History* 7 (1975): 135–163. It should be noted here that my use of the term "semantic" differs from Jameson's. Whereas he stresses the overall semantic input of a text, I am dealing with the individual semantic units of the text. His term thus approximates the sense of "global meaning," while mine is closer to "lexical choices."

[9]Jean Mitry, *Dictionnaire du cinéma* (Paris: Larousse, 1963), p. 276.

as well as technical elements ("use of fast tracking and crane shots").[10] An entirely different solution is suggested by Jim Kitses, who emphasizes not the vocabulary of the western but the relationships linking lexical elements. For Kitses the western grows out of a dialectic between the West as garden and as desert (between culture and nature, community and individual, future and past).[11] The western's vocabulary is thus generated by this syntactic relationship, and not vice-versa. John Cawelti attempts to systematize the western in a similar fashion: the western is always set on or near a frontier, where man encounters his uncivilized double. The western thus takes place on the border between two lands, between two eras, and with a hero who remains divided between two value systems (for he combines the town's morals with the outlaw's skills).[12]

In passing we might well note the divergent qualities associated with these two approaches. While the semantic approach has little explanatory power, it is applicable to a larger number of films. Conversely, the syntactic approach surrenders broad applicability in return for the ability to isolate a genre's specific meaning-bearing structures. This alternative seemingly leaves the genre analyst in a quandary: choose the semantic view and you give up *explanatory power*; choose the syntactic approach and you do without *broad applicability*. In terms of the western, the problem of the so-called "Pennsylvania western" is instructive here. To most observers it seems quite clear that films like *High, Wide and Handsome* (Rouben Mamoulian, 1937), *Drums along the Mohawk* (John Ford, 1939), and *Unconquered* (Cecil B. DeMille, 1947) have definite affinities with the western. Employing familiar characters set in relationships similar to their counterparts west of the Mississippi, these films construct plots and develop a frontier structure clearly derived from decades of western novels and films. But they do it in Pennsylvania, and in the wrong century. Are these films westerns because they share the syntax of hundreds of films we call westerns? Or are they not westerns, because they don't fit Mitry's definition?

In fact, the "Pennsylvania western" (like the urban, spaghetti, and sci-fi varieties) represents a quandary only because critics have insisted on dismissing one type of definition and approach in favor of another. As a rule, semantic and syntactic approaches to genre have been proposed, analyzed, evaluated, and disseminated separately, in spite of the complementarity implied by their names. Indeed, many arguments centering on generic problems have arisen only when semantic and syntactic theoreticians have simply talked past each other, each unaware of the other's divergent orientation. I maintain that these two categories of generic analysis are complementary, that they can be combined, and in fact that some of the most important questions of genre study can be asked only when they *are* combined. In short, I propose a semantic/syntactic approach to genre study.

Now, in order to discover whether the proposed semantic/syntactic approach provides any new understanding, let us return to the three contradictions delineated earlier. First, there is the split corpus that characterizes current genre study—on the one side an inclusive list, on the other an exclusive pantheon. It should now be quite clear

[10]Marc Vernet, *Lectures du film* (Paris: Albatros, 1976), pp. 111–112.
[11]Jim Kitses, *Horizons West* (Bloomington: Indiana University Press, 1969), pp. 10–14.
[12]Cawelti, *The Six-Gun Mystique*.

that each corpus corresponds to a different approach to generic analysis and defini-
tion. Tautological semantic definitions, with their goal of broad applicability, outline
a large genre of semantically similar texts, while syntactic definitions, intent as they
are on explaining the genre, stress a narrow range of texts that privilege specific syn-
tactic relationships. To insist on one of these approaches to the exclusion of the other
is to turn a blind eye on the necessarily dual nature of any generic corpus. For every
film that participates actively in the elaboration of a genre's syntax there are numer-
ous others content to deploy in no particular relationship the elements traditionally
associated with the genre. We need to recognize that not all genre films relate to their
genre in the same way or to the same extent. By simultaneously accepting semantic
and syntactic notions of genre we avail ourselves of a possible way to deal critically
with differing levels of "genericity." In addition, a dual approach permits a far more
accurate description of the numerous intergeneric connections typically suppressed
by single-minded approaches. It is simply not possible to describe Hollywood cinema
accurately without the ability to account for the numerous films that innovate by com-
bining the syntax of one genre with the semantics of another. In fact, it is only when
we begin to take up problems of genre history that the full value of the semantic/syn-
tactic approach becomes obvious.

As I pointed out earlier, most genre theoreticians have followed the semiotic model
and steered clear of historical considerations. Even in the relatively few cases where
problems of generic history have been addressed, as in the attempts of Metz and
Wright to periodize the western, history has been conceptualized as nothing more
than a discontinuous succession of discrete moments, each characterized by a differ-
ent basic version of the genre—that is, by a different syntactic pattern that the genre
adopts.[13] In short, genre theory has up to now aimed almost exclusively at the elabo-
ration of a synchronic model approximating the syntactic operation of a specific
genre. Now, quite obviously, no major genre remains unchanged over the many
decades of its existence. In order to mask the scandal of applying synchronic analy-
sis to an evolving form, critics have been extremely clever in their creation of cate-
gories designed to negate the notion of change and to imply the perpetual self-identity
of each genre. Westerns and horror films are often referred to as "classic," the musi-
cal is defined in terms of the so-called "Platonic ideal" of integration, the critical cor-
pus of the melodrama has largely been restricted to the postwar efforts of Sirk and
Minnelli, and so on. Lacking a workable hypothesis regarding the historical dimen-
sion of generic syntax, we have insulated that syntax, along with the genre theory that
studies it, from the flow of time.

As a working hypothesis, I suggest that genres arise in one of two fundamental
ways: either a relatively stable set of semantic givens is developed through syntactic
experimentation into a coherent and durable syntax, or an already existing syntax
adopts a new set of semantic elements. In the first case, the genre's characteristic
semantic configuration is identifiable long before a syntactic pattern has become sta-
bilized, thus justifying the previously mentioned duality of the generic corpus. In
cases of this first type, description of the way in which a set of semantic givens devel-

---

[13]See, for example, Christian Metz, *Language and Cinema* (The Hague: Mouton, 1974), pp. 148–161;
and Wright, *Sixguns and Society*, passim.

ops into a henceforth relatively stable syntax constitutes the history of the genre while at the same time identifying the structures on which genre theory depends. In dealing with the early development of the musical, for example, we might well follow the attempts during the 1927–1930 period to build a backstage or night-club semantics into a melodramatic syntax, with music regularly reflecting the sorrow of death or parting. After the slack years of 1931–1932, however, the musical began to grow in a new direction; while maintaining substantially the same semantic materials, the genre increasingly related the energy of music-making to the joy of coupling, the strength of the community, and the pleasures of entertainment. Far from being exiled from history, the musical's characteristic syntax can be shown by the generic historian to grow out of the linking of specific semantic elements at identifiable points. A measure of continuity is thus developed between the task of the historian and that of the theoretician, for the tasks of both are now redefined as the study of the interrelationships between semantic elements and syntactic bonds.

This continuity between history and theory is operative as well in the second type of generic development posited earlier. When we analyze the large variety of wartime films that portray the Japanese or Germans as villains, we tend to have recourse to extrafilmic events in order to explain particular characterizations. We thus miss the extent to which films like *All Through the Night* (Vincent Sherman, 1942), *Sherlock Holmes and the Voice of Terror* (John Rawlins, 1942), or the serial *The Winslow Boy* (Anthony Asquith, 1948) simply transfer to a new set of semantic elements the righteous cops-punish-criminals syntax that the gangster genre of the early thirties had turned to starting with *G-Men* (William Keighley, 1935). Again, it is the interplay of syntax and semantics that provides grist for both the historical and the theoretical mill. Or take the development of the science fiction film. At first defined only by a relatively stable science fiction semantics, the genre first began borrowing the syntactic relationships previously established by the horror film, only to move in recent years increasingly toward the syntax of the western. By maintaining simultaneous descriptions according to both parameters, we are not likely to fall into the trap of equating *Star Wars* (George Lucas, 1977) with the western (as numerous recent critics have done), even though it shares certain syntactic patterns with that genre. In short, by taking seriously the multiple connections between semantics and syntax, we establish a new continuity, relating film analysis, genre theory, and genre history.

But what is it that energizes the transformation of a borrowed semantics into a uniquely Hollywood syntax? Or what is it that justifies the intrusion of a new semantics into a well-defined syntactic situation? Far from postulating a uniquely internal, formal progression, I would propose that the relationship between the semantic and the syntactic constitutes the very site of negotiation between Hollywood and its audience, and thus between ritual and ideological uses of genre. Often, when critics of opposing persuasions disagree over a major issue, it is because they have established within the same general corpus two separate and opposed canons, each supporting one point of view. Thus, when Catholics and Protestants or liberals and conservatives quote the Bible, they are rarely quoting the same passages. The striking fact about ritual and ideological genre theoreticians, however, is that they regularly stress the same canon, that small group of texts most clearly reflecting a genre's stable syntax. The films of John Ford, for example, have played a major role in the development of ritual

and ideological approaches alike. From Sarris and Bogdanovich to Schatz and Wright, champions of Ford's understanding and transparent expression of American values have stressed the communitarian side of his films, while others, starting with the influential *Cahiers du Cinéma* study of *Young Mr. Lincoln* (1939), have shown how a call to community can be used to lure spectators into a carefully chosen, ideologically determined subject position. A similar situation obtains in the musical, where a growing body of ritual analyses of the Astaire-Rogers and postwar MGM Freed unit films is matched by an increasing number of studies demonstrating the ideological investment of those very same films.[14] The corpus of nearly every major genre has developed in the same way, with critics of both camps gravitating toward and eventually basing their arguments on the same narrow range of films. Just as Minnelli and Sirk dominate the criticism of melodrama, Hitchcock has become nearly synonymous with the thriller. Of all major genres, only the film noir has failed to attract critics of both sides to a shared corpus of major texts—no doubt because of the general inability of ritual critics to accommodate the genre's anticommunitarian stance.

This general agreement on a canon stems, I would claim, from the fundamentally bivalent nature of any relatively stable generic syntax. If it takes a long time to establish a generic syntax and if many seemingly promising formulas or successful films never spawn a genre, it is because only certain types of structure, within a particular semantic environment, are suited to the special bilingualism required of a durable genre. The structures of Hollywood cinema, like those of American popular mythology as a whole, serve to mask the very distinction between ritual and ideological functions. Hollywood does not simply lend its voice to the public's desires, nor does it simply manipulate the audience. On the contrary, most genres go through a period of accommodation during which the public's desires are fitted to Hollywood's priorities (and vice-versa). Because the public doesn't want to know that it is being manipulated, the successful ritual/ideological "fit" is almost always one that disguises Hollywood's potential for manipulation while playing up its capacity for entertainment.

Whenever a lasting fit is obtained—which it is whenever a semantic genre becomes a syntactic one—it is because a common ground has been found, a region where the audience's ritual values coincide with Hollywood's ideological ones. The development of a specific syntax within a given semantic context thus serves a double function: it binds element to element in a logical order, at the same time accommodating audience desires to studio concerns. The successful genre owes its success not alone to its reflection of an audience ideal, nor solely to its status as apology for the Hollywood enterprise, but to its ability to carry out both functions simultaneously. It is this sleight of hand, this strategic overdetermination, that most clearly characterizes American film production during the studio years.

The approach to genre sketched out in this article of course raises some questions of its own. Just where, for example, do we locate the exact border between the semantic and the syntactic? And how are these two categories related? Each of these ques-

---

[14]This relationship is especially interesting in the work of Richard Dyer and Jane Feuer, both of whom attempt to confront the interdependence of ritual and ideological components. See in particular Richard Dyer, "Entertainment and Utopia," in *Genre: The Musical*, edited by Rick Altman (London and Boston: Routledge and Kegan Paul, 1981), pp. 175–189; and Jane Feuer, *The Hollywood Musical* (Bloomington: Indiana University Press, 1982).

tions constitutes an essential area of inquiry, one that is far too complex to permit full treatment here. Nevertheless, a few remarks may be in order. A reasonable observer might well ask why my approach attributes such importance to the seemingly banal distinction between a text's materials and the structures into which they are arranged. Why this distinction rather than, for example, the more cinematic division between diegetic elements and the technical means deployed in representing them? The answer to these questions lies in a general theory of textual signification that I have expounded elsewhere.[15] Briefly, that theory distinguishes between the primary, linguistic meaning of a text's component parts and the secondary or textual meaning that those parts acquire through a structuring process internal to the text or to the genre. Within a single text, therefore, the same phenomenon may have more than one meaning depending on whether we consider it at the linguistic or textual level. In the western, for example, the horse is an animal that serves as a method of locomotion. This primary level of meaning, corresponding to the normal extent of the concept "horse" within the language, is matched by a series of other meanings derived from the structures into which the western sets the horse. Opposition of the horse to the automobile or locomotive ("iron horse") reinforces the organic, nonmechanical sense of the term "horse" already implicit in the language, thus transferring that concept from the paradigm "method of locomotion" to the paradigm "soon-to-be-outmoded preindustrial carry-over."

In the same way, horror films borrow from a nineteenth-century literary tradition their dependence on the presence of a monster. In doing so, they clearly perpetuate the linguistic meaning of the monster as "threatening inhuman being," but at the same time, by developing new syntactic ties, they generate an important new set of textual meanings. For the nineteenth century, the appearance of the monster is invariably tied to a romantic overreaching, the attempt of some human scientist to tamper with the divine order. In texts like Mary Shelley's *Frankenstein*, Balzac's *La Recherche de l'absolu*, or Stevenson's *Dr. Jekyll and Mr. Hyde*, a studied syntax equates man and monster, attributing to both the monstrosity of being outside nature as defined by established religion and science. With the horror film, a different syntax rapidly equates monstrosity not with the overactive nineteenth-century mind, but with an equally overactive twentieth-century body. Again and again, the monster is identified with his human counterpart's unsatisfied sexual appetite, thus establishing with the same primary "linguistic" materials (the monster, fear, the chase, death) entirely new textual meanings, phallic rather than scientific in nature.

The distinction between the semantic and the syntactic, in the way I have defined it here, thus corresponds to a distinction between the primary, linguistic elements of which all texts are made and the secondary, textual meanings that are sometimes constructed by virtue of the syntactic bonds established between primary elements. This distinction is stressed in the approach to genre presented here not because it is convenient nor because it corresponds to a modish theory of the relation between language and narrative, but because the semantic/syntactic distinction is fundamental to a theory of how meaning of one kind contributes to and eventually establishes meaning of another. Just as individual texts establish new meanings for familiar terms only by

[15]Charles F. Altman, "Intratextual Rewriting: Textuality as Language Formation," in *The Sign in Music and Literature*, edited by Wendy Steiner (Austin: University of Texas Press, 1981), pp. 39–51.

subjecting well-known semantic units to a syntactic redetermination, so generic meaning comes into being only through the repeated deployment of substantially the same syntactic strategies. It is in this way, for example, that making music—at the linguistic level primarily a way of making a living—becomes in the musical a figure for making love—a textual meaning essential to the constitution of that syntactic genre.

We must of course remember that, while each individual text clearly has a syntax of its own, the syntax implied here is that of the genre, which does not appear as *generic* syntax unless it is reinforced numerous times by the syntactic patterns of individual texts. The Hollywood genres that have proven the most durable are precisely those that have established the most coherent syntax (the western, the musical); those that disappear the quickest depend entirely on recurring semantic elements, never developing a stable syntax (reporter, catastrophe, and big-caper films, to name but a few). If I locate the border between the semantic and the syntactic at the dividing line between the linguistic and the textual, it is thus in response not just to the theoretical but also to the historical dimension of generic functioning.

In proposing such a model, however, I may leave too much room for one particular type of misunderstanding. It has been a cliché of the last two decades to insist that structure carries meaning, while the choice of structured elements is largely negligible in the process of signification. This position, most openly championed by Lévi-Strauss in his cross-cultural methodology for studying myth, may seem to be implied by my model, but is in fact not borne out by my research.[16] Spectator response, I believe, is heavily conditioned by the choice of semantic elements and atmosphere, because a given semantics used in a specific cultural situation will recall to an actual interpretive community the particular syntax with which that semantics has traditionally been associated in other texts. This *syntactic expectation*, set up by a *semantic signal*, is matched by a parallel tendency to expect specific syntactic signals to lead to predetermined semantic fields (e.g., in western texts, regular alternation between male and female characters creates expectation of the semantic elements implied by romance, while alternation between two males throughout a text has implied—at least until recently—confrontation and the semantics of the duel). This interpenetration of the semantic and the syntactic through the agency of the spectator clearly deserves further study. Suffice it to say for the present that linguistic meanings (and thus the import of semantic elements) are in large part derived from the textual meanings of previous texts. There is thus a constant circulation in both directions between the semantic and the syntactic, between the linguistic and the textual.

Still other questions, such as the general problem of the "evolution" of genres through semantic or syntactic shifts, deserve far more attention than I have given them here. In time, I believe, this new model for the understanding of genre will provide answers for many of the questions traditional to genre study. Perhaps more important still, the semantic/syntactic approach to genre raises numerous questions for which other theories have created no space.

<div style="text-align: right">1984</div>

---

[16]The most straightforward statement of Lévi-Strauss's position is in "The Structural Study of Myths." For a useful elucidation of that position, see Edmund Leach, *Claude Lévi-Strauss* (New York: Viking Press, 1970).

# THOMAS SCHATZ
## *FROM* HOLLYWOOD GENRES

### FILM GENRE AND THE GENRE FILM

Because it is essentially a narrative system, a film genre can be examined in terms of its fundamental structural components: plot, character, setting, thematics, style, and so on. We should be careful, though, to maintain a distinction between the *film genre* and the *genre film*. Whereas the genre exists as a sort of tacit "contract" between filmmakers and audience, the genre film is an actual event that honors such a contract. To discuss the Western genre is to address neither a single Western film nor even all Westerns, but rather that system of conventions which identifies Western films as such.

There is a sense, then, in which a film genre is both a *static* and a *dynamic* system. On the one hand, it is a familiar formula of interrelated narrative and cinematic components that serves to continually reexamine some basic cultural conflict: one could argue, for example, that all Westerns confront the same fundamental issues (the taming of the frontier, the celebration of the hero's rugged individualism, the hero's conflicts with the frontier community, etc.) in elaborating America's foundation ritual and that slight formal variations do not alter those static thematic characteristics. On the other hand, changes in cultural attitudes, new influential genre films, the economics of the industry, and so forth, continually refine any film genre. As such, its nature is continually evolving. For example, the evolution of Western heroes from agents of law and order to renegade outlaws or professional killers reflect a genuine change in the genre. One could even argue that the term "Western" means something different today from what it did two or three decades ago.

Thus genre experience, like all human experience, is organized according to certain fundamental perceptual processes. As we repeatedly undergo the same type of experience we develop expectations which, as they are continually reinforced, tend to harden into "rules." The clearest example of this process in any culture is in its games. A game is a system of immutable rules (three strikes in baseball) and compo-

nents determining the nature of play. Yet no two games in a sport are alike, and a theoretically infinite number of variations can be played within the "arena" that the rules provide. Similarly, certain styles of traditional or popular music involve a variations-on-a-theme approach both within and among individual pieces. In folk and blues traditions, for example, most compositions are generated from a very few chord progressions.

The analogies between film genres and other cultural systems are virtually endless. What such examples seem to highlight is the dual nature of any "species" (or "genus," the root for the word *genre*), that is, it can be identified either by its rules, components, and function (by its static deep structure) or conversely by the individual members which comprise the species (by its dynamic surface structure).

Think of a Western movie, or a musical, or a gangster film. Probably you won't think of any individual Western or musical or gangster film, but rather of a vaguely defined amalgam of actions and attitudes, of characters and locales. For as one sees more genre films, one tends to negotiate the genre less by its individual films than by its deep structure, those rules and conventions which render this film a Western and that film a musical. This distinction between deep and surface structures—between a genre and its films—provides the conceptual basis for any genre study. Of all the analogies we might use to better understand this distinction, the most illuminating involves the "deepest" of human structures: language.

# THE LANGUAGE ANALOGY

What is natural to mankind is not oral speech but the faculty of constructing a language, i.e. a system of distinct signs corresponding to distinct ideas.

FERDINAND DE SAUSSURE

Among other things, the commercial cinema is a communication system—it structures and delivers meaning. Throughout its history, evocative phrases like "the grammar of film" and "the cinematic language system" have suggested that filmic communication is comparable to verbal communication, although the extent and usefulness of that comparison are limited. Most recently, the film-language analogy has undergone renewed interest within the growing field of *semiology* (or semiotics), a science that proposes to study human interaction as a vast network of social and interpersonal communication systems. Semiology is itself the brain child of Swiss linguist Ferdinand de Saussure, who suggested that language provides the "master pattern" for the study of cultural signification. According to de Saussure, verbal language is the one sign system shared by all cultures; its basic structure informs every system of social communication.

That language study and its jargon are a metaphor for genre study should be obvious. Through the "circuit of exchange" involving box-office "feedback," the studios and the mass audience hold a virtual "conversation" whereby they gradually refine the "grammar" of cinematic "discourse." Thus a genre can be studied, like a language, as a formalized sign system whose rules have been assimilated, consciously or otherwise, through cultural consensus. Our shared knowledge of the rules of any

film genre enables us to understand and evaluate individual genre films, just as our shared knowledge of English grammar enables me to write this sentence and you to interpret it. The distinction between *grammar* and *usage*, closely akin to that between deep structure and surface structure, originates in de Saussure's distinction between *langue* and *parole* in verbal language. For de Saussure, the speaker's and listener's shared knowledge of the grammatical rules that make up the language system (*la langue*) enables them to develop and understand a virtually unlimited range of individual utterances (*la parole*). American linguist Noam Chomsky has described this distinction in terms of *competency* and *performance*; he suggests that we should differentiate between our inherent capacity to speak and interpret on the one hand and our actually doing so on the other.

If we extend these ideas into genre study, we might think of the *film genre* as a specific grammar or system of rules of expression and construction and the individual genre films as a manifestation of these rules. Of course, film differs from language in that our verbal competence is relatively consistent from speaker to speaker, whereas our generic competence varies widely. If each of us had the same exposure to Hollywood's thousands of genre films, a critical theory would probably be easier to construct. But obviously not everyone has a minimal understanding of even the most popular and widespread genres, let alone the obscure structural delights of such "subgenres" as the beach-blanket movies of the '60s or the car-chase movies of the '70s.

Moreover, although verbal language systems are essentially neutral and meaningless, film genres are not. As a system, English grammar is not meaningful either historically or in socially specific terms. It is manipulated by a speaker to *make* meaning. A film genre, conversely, has come into being precisely because of its cultural significance as a meaningful narrative system. Whereas a verbal statement represents a speaker's organization of neutral components into a meaningful pattern, a genre film represents an effort to *re*organize a familiar, meaningful system in an original way.

Another interesting aspect of the language analogy concerns the tension between grammar and usage. Grammar in language is absolute and static, essentially unchanged by the range and abuses of everyday usage. In the cinema, however, individual genre films seem to have the capacity to affect the genre—an utterance has the potential to change the grammar that governs it. Even in film technology (the impact of widescreen on the Western, for example, or of technicolor on the musical), we can see that individual usage influences both viewers and other filmmakers, and hence encourages them in effect to renegotiate the generic contract. Whether or not some static nuclear deep structure exists, which defines the genre and somehow eludes the effects of time and variation, we cannot overlook the gradual changes (as revealed in individual genre films) in form and substance on the genre's surface. Genres evolve, and they tend to evolve quite rapidly due to the demands of the commercial popular media. But whether this evolution represents mere cosmetic changes in the surface structure (equivalent to fashionable clichés or idioms in verbal language) or whether it reflects substantial changes in the deep structure (the generic system itself) will remain, at least for now, an open question.

Perhaps the ultimate value of the film-language analogy is as a sort of method or methodological model. That is, the similarities between a language and a genre as communication systems should encourage the analyst to approach individual genre

films in much the same way that the linguist approaches individual utterances. Like all signifying systems, languages and genres exist essentially within the minds of their users: No single study of English grammar or of a film genre could possibly describe the system completely. In this sense, studying film genre is not unlike going to school as competent six-year-old speakers of English and then being taught English grammar. In each case, we study the system that is the basis for our existing competence.

In all of this, we should not lose sight of the critical, evaluative factor that motivates the genre critic, while it is virtually irrelevant to the linguist. The linguist's concern is the process whereby we verbally communicate meaning; any concern for the *quality* of that communication falls under the domain of rhetoric. As such, the film genre critic must be both linguist and "rhetor"—that is, he or she is concerned with both the process and the quality of any generic communication. The critic develops competence, a familiarity with the system, by watching and interpreting movies and noting similarities. Ultimately, he or she is concerned with recognizing, appreciating, and articulating *differences* among these movies. As critics, we understand genre films because of their similarity with other films, but we appreciate them because of their difference. Therefore an outline of a basic grammar of genre filmmaking should precede any critical analysis of individual films within a genre.

## TOWARD A GRAMMAR OF FILM GENRE

At this stage, we are somewhere "between" the point of departure (watching movies) and the point of arrival (appreciating and articulating difference—i.e., being critical). We can appreciate difference only when we begin to examine films systematically, when we consider the systems whereby an individual film "makes meaning." Thus far, we have considered the commercial and formal systems involved in Hollywood filmmaking from a rather superficial perspective. In narrowing our focus to examine the workings of Hollywood genres, we will begin to understand how commercial and formal systems are realized in actual production. Genre production itself should be addressed on three distinct levels of inquiry: those characteristics shared by virtually all genre films (and thus by all genres), those characteristics shared by all the films within any individual genre, and those characteristics that set one genre film off from all other films.

Our ultimate goal is to discern a genre film's quality, its social and aesthetic value. To do this, we will attempt to see its relation to the various systems that inform it. For example, in examining a film like *The Searchers*, it is not enough simply to isolate the formal characteristics that identify it as belonging to a particular genre. Nor is it enough to isolate the elements that make it superior. Initially we have to discern those traits that make the film—and indeed the Western form itself—generic. To repeat Wood's observation: we are so accustomed to dealing with genres, with familiar filmic narrative types, that we tend to isolate these types from one another, thus overlooking many of their shared social and aesthetic features. Before considering the Western, gangster, musical, and other Hollywood genres as individual narrative systems, then, we will discuss the qualities that identify these forms as genres.

A genre film, like virtually any story, can be examined in terms of its fundamental narrative components: plot, setting, and character. These components have a privileged status for the popular audience, due to their existence within a familiar formula that addresses and reaffirms the audience's values and attitudes. Thus the genre film's narrative components assume a preordained thematic significance that is quite different from non-generic narratives. Each genre film incorporates a specific cultural context—what Warshow termed its "field of reference"—in the guise of a familiar *social community*. This generic context is more than the physical setting, which some genre critics have argued defines the genre as such. The American frontier or the urban underworld is more than a physical locale which identifies the Western or the gangster film; it is a cultural milieu where inherent thematic conflicts are animated, intensified, and resolved by familiar characters and pattern of action. Although all drama establishes a community that is disturbed by conflict, in the genre film both the community and the conflict have been conventionalized. Ultimately, our familiarity with any genre seems to depend less on recognizing a specific setting than on recognizing certain dramatic conflicts that we associate with specific patterns of action and character relationships. There are some genres, in fact, like the musical and the screwball comedy, that we identify primarily through conventions of action and attitude, and whose settings vary widely from one film to the next.

From this observation emerges a preliminary working hypothesis: the determining, identifying feature of a film genre is its cultural context, its community of interrelated character types whose attitudes, values, and actions flesh out dramatic conflicts inherent within that community. The generic community is less a specific place (although it may be, as with the Western and gangster genres) than a network of characters, actions, values, and attitudes. Each genre's status as a distinct cultural community is enhanced by Hollywood's studio production system, in that each generic context is orchestrated by specialized groups of directors, writers, producers, performers, sets, studio lots, and even studios themselves. (Consider Warner Brothers' heavy production of gangster films in the early '30s and MGM's musicals in the late '40s.)

A genre, then, represents a *range of expression* for filmmakers and a *range of experience* for viewers. Both filmmakers and viewers are sensitive to a genre's range of expression because of previous experiences with the genre that have coalesced into a system of value-laden narrative conventions. It is this system of conventions—familiar characters performing familiar actions which celebrate familiar values—that represents the genre's narrative context, its meaningful cultural community. . . .

## CHARACTER AND SETTING: COMMUNITIES IN CONFLICT

In discussing the grammar (or system of conventions) of any Hollywood film genre, it is important to note that the *material economy*, which motivated the studios to refine story formulas, translated into *narrative economy* for filmmakers and viewers. Each genre incorporates a sort of narrative shorthand whereby significant dramatic conflicts can intensify and then be resolved through established patterns of action and by familiar character types. These dramatic conflicts are themselves the identifying feature of any genre; they represent the transformation of some social,

historical, or even geographical (as in the Western) aspect of American culture into one locus of events and characters.

Although the dramatic conflicts are basic to the generic "community," we cannot identify that community solely by its physical setting. If film genres were identified by setting alone, then we would have to deal with an "urban" genre that includes such disparate forms as gangster films, backstage musicals, and detective films. Because the setting provides an *arena* for conflicts, which are themselves determined by the actions and attitudes of the *participants*, we must look to the generic character types and the conflicts they generate in identifying any genre. And we might consider a generic community and its characters in relation to the system of values which both define the problem and eventually are appealed to in solving it.

What emerges as a social problem (or dramatic conflict) in one genre is not necessarily a problem in another. Law and order is a problem in the gangster and detective genres, but not in the musical. Conversely, courtship and marriage are problems in the musical but not in the gangster and detective genres. Individualism is celebrated in the detective genre (through the hero's occupation and world view) and in the gangster film (through the hero's career and eventual death), while the principal characters in the musical compromise their individuality in their eventual romantic embrace and thus demonstrate their willingness to be integrated into the social community. In each of these genres, the characters' identities and narrative roles (or "functions") are determined by their relationship with the community and its value structure. As such, the generic character is psychologically static—he or she is the physical embodiment of an attitude, a style, a world view, of a predetermined and essentially unchanging cultural posture. Cowboy or Indian, gangster or cop, guy or doll, the generic character is identified by his or her function and status within the community.

The static vision of the generic hero—indeed of the entire constellation of familiar character types—helps to define the community and to animate its cultural conflicts. For example, the Western hero, regardless of his social or legal standing, is necessarily an agent of civilization in the savage frontier. He represents both the social order and the threatening savagery that typify the Western milieu. Thus he animates the inherent dynamic qualities of the community, providing a dramatic vehicle through which the audience can confront generic conflicts.

This approach also enables us to distinguish between such seemingly similar "urban crime" formulas as the gangster and detective genres. Usually, both genres are set in a contemporary urban milieu and address conflicts principally between social order and anarchy and between individual morality and the common good. But because of the characteristic attitudes and values of the genre's principal characters, these conflicts assume a different status in each genre and are resolved accordingly. The detective, like the Westerner, represents the man-in-the-middle, mediating the forces of order and anarchy, yet somehow remaining separate from each. He has opted to construct his own value system and behavioral code, which happens (often, almost accidentally) to coincide with the forces of social order. But the detective's predictable return to his office retreat at film's end and his refusal to assimilate the values and lifestyle of the very society he serves ultimately reaffirm his—and the genre's—ambiguous social stance. The gangster film, conversely, displays little the-

matic ambiguity. The gangster has aligned himself with the forces of crime and social disorder, so both his societal role and his conflict with the community welfare demand his eventual destruction.

All film genres treat some form of threat—violent or otherwise—to the social order. However, it is the attitudes of the principal characters and the resolutions precipitated by their actions which finally distinguish the various genres from one another. Nevertheless, there is a vital distinction between kinds of generic settings and conflicts. Certain genres (Western, detective, gangster, war, et al.) have conflicts that, indigenous to the environment, reflect the physical and ideological struggle for its control. These conflicts are animated and resolved either by an individual male hero or by a collective (war, science fiction, cavalry, certain recent Westerns). Other genres have conflicts that are not indigenous to the locale but are the result of the conflict between the values, attitudes, and actions of its principal characters and the "civilized" setting they inhabit. Conflicts in these genres (musical, screwball comedy, family melodrama) generally are animated by a "doubled" hero—usually a romantic couple whose courtship is complicated and eventually ideologically resolved. A musical's setting may be a South Pacific island or the backstage of a Broadway theater, but we relate to the film immediately by its treatment of certain sexual and occupational conflicts and also by our familiarity with the type of characters played by its "stars."

Thus, it is *not* the musical numbers themselves which identify these films as musicals. Many Westerns and gangster films, for example, contain musical numbers and still aren't confused with musicals (Westerns like *Dodge City* and *Rio Bravo*, for instance, or gangster films like *The Roaring Twenties* and *The Rise and Fall of Legs Diamond*). The frontier saloon and the gangster's speakeasy may be conventional locales within their respective communities, but their entertainment function clearly is peripheral to the central issue. However, in "musical Westerns" like *Annie Get Your Gun*, *The Harvey Girls*, and *Oklahoma!*, the nature and resolution of the dramatic conflicts as well as the characterization clearly are expressed via the musical formula. In *The Harvey Girls*, for instance, the narrative centers around the exploits of several dozen women—including Judy Garland and Cyd Charisse, which should provide us with a generic cue—who migrate West to work in a restaurant. Certain Western conventions are nodded to initially: the girls are told aboard the train headed West that "You're bringing civilization. . . . You girls are bringing order to the West"; later, there is a comic brawl between these "Harvey Girls" and the local saloon girls. But the Western genre's fundamental traits (the individual male hero responding to the threat of savagery and physical violence within an ideologically unstable milieu) are not basic to the film. Once the characters and conflicts are established, the setting might as well be Paris or New York City or even Oz.

As I hope these examples indicate, the various Hollywood genres manipulate character and social setting quite differently in developing dramatic conflicts. We might consider a broad distinction between genres of *determinate space* and those of *indeterminate space*, between genres of an ideologically contested setting and an ideologically stable setting. In a genre of determinate space (Western, gangster, detective, et al.), we have a symbolic arena of action. It represents a cultural realm in which

fundamental values are in a state of sustained conflict. In these genres, then, the contest itself and its necessary arena are "determinate"—a specific social conflict is violently enacted within a familiar locale according to a prescribed system of rules and behavioral codes.

The iconographic arena in determinate genres is entered by an individual or collective hero, at the outset, who acts upon it, and finally leaves. This entrance-exit motif recurs most in genres characterized by an individual hero: for example, the Westerner enters a frontier community, eliminates (or perhaps causes) a threat to its survival, and eventually rides "into the sunset"; the detective takes the case, investigates it, and returns to his office; the gangster, introduced to urban crime, rises to power, and finally is killed or jailed. In these genres, the individual hero incorporates a rigid, essentially static attitude in dealing with his very dynamic, contested world.

In contrast, genres of indeterminate space generally involve a doubled (and thus dynamic) hero in the guise of a romantic couple who inhabit a "civilized" setting, as in the musical, screwball comedy, and social melodrama. The physical and ideological "contest" which determines the arena of action in the Western, gangster, and detective genres is not an issue here. Instead, genres of indeterminate space incorporate a civilized, ideologically stable milieu, which depends less upon a heavily coded place than on a highly conventionalized value system. Here conflicts derive not from a struggle over control of the environment, but rather from the struggle of the principal characters to bring their own views in line either with one another's or, more often, in line with that of the larger community.

Unlike genres of determinate space, these genres rely upon a progression from romantic antagonism to eventual embrace. The kiss or embrace signals the integration of the couple into the larger cultural community. In addition, these genres use iconographic conventions to establish a social setting—the proscenium or theater stage with its familiar performers in some musicals, for example, or the repressive small-town community and the family home in the melodrama. But because the generic conflicts arise from attitudinal (generally male-female) oppositions rather than from a physical conflict, the coding in these films tends to be less visual and more ideological and abstract. This may account for the sparse attention they have received from genre analysts, despite their widespread popularity.

Ultimately, genres of indeterminate, civilized space (musical, screwball comedy, social melodrama) and genres of determinate, contested space (Western, gangster, detective) might be distinguished according to their differing ritual functions. The former tend to celebrate the values of *social integration*, whereas the latter uphold the values of *social order*. The former tend to cast an attitudinally unstable couple or family unit into some representative microcosm of American society, so that their emotional and/or romantic "coupling" reflects their integration into a stable environment. The latter tend to cast an individual, violent, attitudinally static male into a familiar, predetermined milieu to examine the opposing forces vying for control. In making this distinction, though, we should not lose sight of these genres' shared social function. In addressing basic cultural conflicts and celebrating the values and attitudes whereby these conflicts might be resolved, all film genres represent the filmmakers' and audience's cooperative efforts to "tame" those beasts, both actual and imaginary, which threaten the stability of our everyday lives.

# PLOT STRUCTURE: FROM CONFLICT TO RESOLUTION

As a popular film audience, our shared needs and expectations draw us into the movie theater. If we are drawn there by a genre film, we are familiar with the ritual. In its animation and resolution of basic cultural conflicts, the genre film celebrates our collective sensibilities, providing an array of ideological strategies for negotiating social conflicts. The conflicts themselves are significant (and dramatic) enough to ensure our repeated attendance. The films within a genre, representing variations on a cultural theme, will employ different means of reaching narrative resolution, but that closure is generally as familiar as the community and its characters. (Think of the general discomfort felt upon realizing, even quite early in seeing a genre film, that Cagney's heroic gangster would "get his" or that Tracy and Hepburn would cease their delightful hostilities and embrace in time for the closing credits.)

Actually, the most significant feature of any generic narrative may be its resolution—that is, its efforts to solve, even if only temporarily, the conflicts that have disturbed the community welfare. The Western, for example, despite its historical and geographical distance from most viewers, confronts real and immediate social conflicts: individual versus community, town versus wilderness, order versus anarchy, and so on. If there is anything escapist about these narratives, it is their repeated assertion that these conflicts can be solved, that seemingly timeless cultural oppositions can be resolved favorably for the larger community.

In a Hollywood Western, as in virtually any Hollywood genre film, plot development is effectively displaced by setting and character: once we recognize the familiar cultural arena and the players, we can be fairly certain how the game will be played and how it will end. Because the characters, conflicts, and resolution of the non-generic narrative are unfamiliar and unpredictable, we negotiate them less by previous filmic experiences than by previous "real-world" (personal and social) experiences. Clearly, both generic and non-generic narratives must rely to some degree upon real-world and also upon previous narrative-filmic experiences in order to make sense. In the genre film, however, the predictability of conflict and resolution tends to turn our attention away from the linear, cause-and-effect plot, redirecting it to the conflict itself and the opposed value systems it represents. Instead of a linear chain of events, which are organized by the changing perceptions of an individual protagonist, the genre film's plot traces the intensification of some cultural opposition which is eventually resolved in a predictable fashion.

Thus, we might describe the plot structure of a genre film in the following way:

> *establishment* (via various narrative and iconographic cues) of the generic community with its inherent dramatic conflicts;
> *animation* of those conflicts through the actions and attitudes of the genre's constellation of characters;
> *intensification* of the conflict by means of conventional situations and dramatic confrontations until the conflict reaches crisis proportions;
> *resolution* of the crisis in a fashion which eliminates the physical and/or ideological threat and thereby celebrates the (temporarily) well-ordered community.

In this plot structure, linear development is subordinate to and qualified by the *oppositional* narrative strategy. Opposing value systems are either mediated by an

individual or a collective, which eliminates one of the opposing systems. Or else these oppositions are actually embodied by a doubled hero whose (usually romantic) coupling signals their synthesis. In either instance, resolution occurs, even if only temporarily, in a way that strokes the collective sensibilities of the mass audience. It is in this context that the genre film's function as cultural ritual is most evident.

In their formulaic narrative process, genre films celebrate the most fundamental ideological precepts—they examine and affirm "Americanism" with all its rampant conflicts, contradictions, and ambiguities. Not only do genre films establish a sense of continuity between our cultural past and present (or between present and future, as with science fiction), but they also attempt to eliminate the distinctions between them. As social ritual, genre films function to stop time, to portray our culture in a stable and invariable ideological position. This attitude is embodied in the generic hero— and in the Hollywood star system itself—and is ritualized in the resolution precipitated by the hero's actions. Whether it is a historical Western or a futuristic fantasy, the genre film celebrates inviolate cultural attributes.

Ultimately, the sustained success of any genre depends upon at least two factors: the thematic appeal and significance of the conflicts it repeatedly addresses and its flexibility in adjusting to the audience's and filmmakers' changing attitudes toward those conflicts. These can be seen, for example, in the Western hero's status as both rugged individualist and also as agent of a civilization that continually resists his individualism. The degree to which that opposition has evolved over the past seventy-five years has accommodated changes in our cultural sensibilities. Or consider science fiction, a literary and cinematic genre that realized widespread popularity in the late '40s and early '50s. This genre articulated the conflicts and anxieties that accompanied the development of atomic power and the prospect of interplanetary travel. Because science fiction deals with so specialized a cultural conflict—essentially with the limits and value of human knowledge and scientific experimentation—it is considerably less flexible, but no less topical, than the Western. Nevertheless, each genre has a static nucleus that manifests its thematic oppositions or recurring cultural conflicts. And each genre has, through the years, dynamically evolved as shown by the ways its individual films manipulate those oppositions. If we see genre as a problem-solving strategy, then, the static nucleus could be conceived as the problem and the variety of solutions (narrative resolutions) as its dynamic surface structure.

In this sense, a genre's basic cultural oppositions or inherent dramatic conflicts represent its most basic determining feature. Also the sustained popularity of any genre indicates the essentially unresolvable, irreconcilable nature of those oppositions. Resolution involves a point of dramatic closure in which a compromise or temporary solution to the conflict is projected into a sort of cultural and historical timelessness. The threatening external force in contested space is violently destroyed and eliminated as an ideological threat; in uncontested space the vital lover's spontaneity and lack of social inhibition are bridled by a domesticating counterpart in the name of romantic love. In each, philosophical or ideological conflicts are "translated" into emotional terms—either violent or sexual, or both—and are resolved accordingly. In the former, the emotive resolution is externalized, in the latter it is internalized. Still, the resolution does not function to *solve* the basic cultural conflict. The conflict is

simply recast into an emotional context where it can be expeditiously, if not always logically, resolved.

As a rule, generic resolution operates by a process of *reduction*: the polar opposition is reduced, either through the elimination of one of the forces (in genres of determinate, contested space) or through the integration of the forces into a single unit (in genres of indeterminate, civilized space). The contest in determinate space generally is physically violent. Frequently, up until the resolution, there is more tension than action. The violent resolution usually helps the community, but only rarely does the hero assimilate its value system. In fact, his insistence that he maintain his individuality emerges as a significant thematic statement. As such, these films often involve a dual celebration: the hero's industrious isolationism offsets the genre's celebration of the ideal social order.

There is a certain logic and symmetry in the gangster's death, the Westerner's fading into the sunset, the detective's return to his office to await another case. Each of these standard epilogues implicitly accepts the contradictory values of its genre, all of which seem to center around the conflict between individualism and the common good. The built-in ambiguity of this dual celebration serves, at least partially. to minimize the *narrative rupture* resulting from the effort to resolve an unresolvable cultural conflict. This violation of narrative logic is itself fundamental to all of Hollywood's story formulas, in that the demand for a "happy ending" resists the complexity and deep-seated nature of the conflict.

Because genres of social order invariably allow the individual hero his formalized flight from social integration and from the compromising of his individuality, the narrative rupture is usually less pronounced than in genres of social integration. The cultural conflicts in genres of integration are revealed through the doubling of the principal characters—that is, through their opposed relationship, usually expressed as romantic antagonism. With the integration of their opposing attitudes into a cohesive unit (the married couple, the family), the conflicts are resolved and basic communal ideals are ritualized. But the cultural contradictions that inhibit integration throughout these films—between spontaneous individual expression and social propriety, for example—cannot be resolved without severely subverting the characters' credibility and motivation.

Are we to assume that the screwball couple's madcap social behavior and mutual antagonism will magically dissolve once they are wed? Or that the conflicts, which have separated the song-and-dance team throughout rehearsals, will somehow vanish after the climactic show? To avoid these questions and to minimize the sense of rupture, these genre films synthesize their oppositions through some formal celebration or social ritual: a Broadway show, a betrothal, a wedding, and so on. In this way, they don't actually resolve their conflicts; they reconstitute them by concluding the narrative at an emotive climax, at precisely the moment when the doubled principals acquiesce to each other's demands. The suggestion of living "happily ever after" tends to mask or gloss over the inevitable loss associated with each character's compromise. What is celebrated is the collective value of their integration into an idealized social unit.

This sense of loss accompanies the resolution of all genre films because of the contradictory, irreconcilable nature of their conflicts. Through violent reduction or

romantic coupling, however, the loss is masked. It is, in effect, effectively redressed in the emotional climax. What is to become, we might very well ask ourselves, once the film ends, of the uninhibited music man after he weds the gold-hearted domesticator—and what's to become of her as well? What's to become of the savage frontier lawman once the social order he instills finally arrives? These are questions which, unless initiated by the films themselves, we know better than to ask. Genre films not only project an idealized cultural self-image, but they project it into a realm of historical timelessness. Typically, films produced later in a genre's development tend to challenge the tidy and seemingly naive resolutions of earlier genre films, and we will discuss this tendency in some detail when we examine generic evolution. What we should note here, through, and what is being masked by such a resolution is the fundamental appeal of both sides in a dramatic conflict. Whatever oppositions we examine in genre films—individual versus community, man versus woman, work versus play, order versus anarchy—these do not represent "positive" and "negative" cultural values. For one of the reasons for a genre's popularity is the sustained significance of the "problem" that it repeatedly addresses. Thus, generic conflict and resolution involve opposing systems of values and attitudes, *both of which* are deemed significant by contemporary American culture.

1991

# ROBERT WARSHOW
# MOVIE CHRONICLE: THE WESTERNER

They that have power to hurt and will do none,
That do not do the thing they most do show,
Who, moving others, are themselves as stone,
Unmoved, cold, and to temptation slow;
They rightly do inherit heaven's graces,
And husband nature's riches from expense;
They are the lords and owners of their faces,
Others but stewards of their excellence.

The two most successful creations of American movies are the gangster and the Westerner: men with guns. Guns as physical objects, and the postures associated with their use, form the visual and emotional center of both types of films. I suppose this reflects the importance of guns in the fantasy life of Americans; but that is a less illuminating point than it appears to be.

The gangster movie, which no longer exists in its "classical" form, is a story of enterprise and success ending in precipitate failure. Success is conceived as an increasing power to work injury, it belongs to the city, and it is of course a form of evil (though the gangster's death, presented usually as "punishment," is perceived simply as defeat). The peculiarity of the gangster is his unceasing, nervous activity. The exact nature of his enterprises may remain vague, but his commitment to enterprise is always clear, and all the more clear because he operates outside the field of utility. He is without culture, without manners, without leisure, or at any rate his leisure is likely to be spent in debauchery so compulsively aggressive as to seem only another aspect of his "work." But he is graceful, moving like a dancer among the crowded dangers of the city.

Like other tycoons, the gangster is crude in conceiving his ends but by no means inarticulate; on the contrary, he is usually expansive and noisy (the introspective

gangster is a fairly recent development), and can state definitely what he wants: to take over the North Side, to own a hundred suits, to be Number One. But new "frontiers" will present themselves infinitely, and by a rigid convention it is understood that as soon as he wishes to rest on his gains, he is on the way to destruction.

The gangster is lonely and melancholy, and can give the impression of a profound worldly wisdom. He appeals most to adolescents with their impatience and their feeling of being outsiders, but more generally he appeals to that side of all of us which refuses to believe in the "normal" possibilities of happiness and achievement; the gangster is the "no" to that great American "yes" which is stamped so big over our official culture and yet has so little to do with the way we really feel about our lives. But the gangster's loneliness and melancholy are not "authentic"; like everything else that belongs to him, they are not honestly come by: he is lonely and melancholy not because life ultimately demands such feelings but because he has put himself in a position where everybody wants to kill him and eventually somebody will. He is wide open and defenseless, incomplete because unable to accept any limits or come to terms with his own nature, fearful, loveless. And the story of his career is a nightmare inversion of the values of ambition and opportunity. From the window of Scarface's bulletproof apartment can be seen an electric sign proclaiming: "The World Is Yours," and, if I remember, this sign is the last thing we see after Scarface lies dead in the street. In the end it is the gangster's weakness as much as his power and freedom that appeals to us; the world is not ours, but it is not his either, and in his death he "pays" for our fantasies, releasing us momentarily both from the concept of success, which he denies by caricaturing it, and from the need to succeed, which he shows to be dangerous.

The Western hero, by contrast, is a figure of repose. He resembles the gangster in being lonely and to some degree melancholy. But his melancholy comes from the "simple" recognition that life is unavoidably serious, not from the disproportions of his own temperament. And his loneliness is organic, not imposed on him by his situation but belonging to him intimately and testifying to his completeness. The gangster must reject others violently or draw them violently to him. The Westerner is not thus compelled to seek love; he is prepared to accept it, perhaps, but he never asks of it more than it can give, and we see him constantly in situations where love is at best an irrelevance. If there is a woman he loves, she is usually unable to understand his motives; she is against killing and being killed, and he finds it impossible to explain to her that there is no point in being "against" these things: they belong to his world.

Very often this woman is from the East and her failure to understand represents a clash of cultures. In the American mind, refinement, virtue, civilization, Christianity itself, are seen as feminine, and therefore women are often portrayed as possessing some kind of deeper wisdom, while the men, for all their apparent self-assurance, are fundamentally childish. But the West, lacking the graces of civilization, is the place "where men are men"; in Western movies, men have the deeper wisdom and the women are children. Those women in the Western movies who share the hero's understanding of life are prostitutes (or, as they are usually presented, barroom entertainers)—women, that is, who have come to understand in the most practical way how love can be an irrelevance, and therefore "fallen" women. The gangster, too, associates with prostitutes, but for him the important things about a prostitute are her

passive availability and her costliness: she is part of his winnings. In Western movies, the important thing about a prostitute is her quasi-masculine independence: nobody owns her, nothing has to be explained to her, and she is not, like a virtuous woman, a "value" that demands to be protected. When the Westerner leaves the prostitute for a virtuous woman—for love—he is in fact forsaking a way of life, though the point of the choice is often obscured by having the prostitute killed by getting into the line of fire.

The Westerner is *par excellence* a man of leisure. Even when he wears the badge of a marshal or, more rarely, owns a ranch, he appears to be unemployed. We see him standing at a bar, or playing poker—a game which expresses perfectly his talent for remaining relaxed in the midst of tension—or perhaps camping out on the plains on some extraordinary errand. If he does own a ranch, it is in the background; we are not actually aware that he owns anything except his horse, his guns, and the one worn suit of clothing which is likely to remain unchanged all through the movie. It comes as a surprise to see him take money from his pocket or an extra shirt from his saddlebags. As a rule we do not even know where he sleeps at night and don't think of asking. Yet it never occurs to us that he is a poor man; there is no poverty in Western movies, and really no wealth either: those great cattle domains and shipments of gold which figure so largely in the plots are moral and not material quantities, not the objects of contention but only its occasion. Possessions too are irrelevant.

Employment of some kind—usually unproductive—is always open to the Westerner, but when he accepts it, it is not because he needs to make a living, much less from any idea of "getting ahead." Where could he want to "get ahead" to? By the time we see him, he is already "there": he can ride a horse faultlessly, keep his countenance in the face of death, and draw his gun a little faster and shoot it a little straighter than anyone he is likely to meet. These are sharply defined acquirements, giving to the figure of the Westerner an apparent moral clarity which corresponds to the clarity of his physical image against his bare landscape; initially, at any rate, the Western movie presents itself as being without mystery, its whole universe comprehended in what we see on the screen.

Much of this apparent simplicity arises directly from those "cinematic" elements which have long been understood to give the Western theme its special appropriateness for the movies: the wide expanses of land, the free movement of men on horses. As guns constitute the visible moral center of the Western movie, suggesting continually the possibility of violence, so land and horses represent the movie's material basis, its sphere of action. But the land and the horses have also a moral significance: the physical freedom they represent belongs to the moral "openness" of the West—corresponding to the fact that guns are carried where they can be seen. (And, as we shall see, the character of land and horses changes as the Western film becomes more complex.)

The gangster's world is less open, and his arts not so easily identifiable as the Westerner's. Perhaps he too can keep his countenance, but the mask he wears is really no mask: its purpose is precisely to make evident the fact that he desperately wants to "get ahead" and will stop at nothing. Where the Westerner imposes himself by the appearance of unshakable control, the gangster's pre-eminence lies in the suggestion that he may at any moment lose control; his strength is not in being able to shoot

faster or straighter than others, but in being more willing to shoot. "Do it first," says Scarface expounding his mode of operation, "and keep doing it!" With the Westerner, it is a crucial point of honor *not* to "do it first"; his gun remains in its holster until the moment of combat.

There is no suggestion, however, that he draws the gun reluctantly. The Westerner could not fulfill himself if the moment did not finally come when he can shoot his enemy down. But because that moment is so thoroughly the expression of his being, it must be kept pure. He will not violate the accepted forms of combat though by doing so he could save a city. And he can wait. "When you call me that—smile!"— the villain smiles weakly, soon he is laughing with horrible joviality, and the crisis is past. But it is allowed to pass because it must come again: sooner or later Trampas will "make his play," and the Virginian will be ready for him.

What does the Westerner fight for? We know he is on the side of justice and order, and of course it can be said he fights for these things. But such broad aims never correspond exactly to his real motives; they only offer him his opportunity. The Westerner himself, when an explanation is asked of him (usually by a woman), is likely to say that he does what he "has to do." If justice and order did not continually demand his protection, he would be without a calling. Indeed, we come upon him often in just that situation, as the reign of law settles over the West and he is forced to see that his day is over; those are the pictures which end with his death or with his departure for some more remote frontier. What he defends, at bottom, is the purity of his own

*Stagecoach* (1939). ". . . guns constitute the visible moral center of the Western movie, suggesting continually the possibility of violence. . . . But the land and the horses have also a moral significance: the physical freedom they represent belongs to the moral 'openness' of the West—corresponding to the fact that that guns are carried where they can be seen" (WARSHOW, page 705).

image—in fact his honor. This is what makes him invulnerable. When the gangster is killed, his whole life is shown to have been a mistake, but the image the Westerner seeks to maintain can be presented as clearly in defeat as in victory: he fights not for advantage and not for the right, but to state what he is, and he must live in a world which permits that statement. The Westerner is the last gentleman, and the movies which over and over again tell his story are probably the last art form in which the concept of honor retains its strength.

Of course I do not mean to say that ideas of virtue and justice and courage have gone out of culture. Honor is more than these things: it is a style, concerned with harmonious appearances as much as with desirable consequences, and tending therefore toward the denial of life in favor of art. "Who hath it? he that dies o' Wednesday." On the whole, a world that leans to Falstaff 's view is a more civilized and even, finally, a more graceful world. It is just the march of civilization that forces the Westerner to move on; and if we actually had to confront the question it might turn out that the woman who refuses to understand him is right as often as she is wrong. But we do not confront the question. Where the Westerner lives it is always about 1870—not the real 1870, either, or the real West—and he is killed or goes away when his position becomes problematical. The fact that he continues to hold our attention is evidence enough that, in his proper frame, he presents an image of personal nobility that is still real for us.

John Wayne and Montgomery Clift in the finale of *Red River* (1948). "In a Hollywood Western, as in virtually any Hollywood genre film, plot development is effectively displaced by setting and character: once we recognize the familiar cultural arena and the players, we can be fairly certain how the game will be played and how it will end" (SCHATZ, page 699).

Clearly, this image easily becomes ridiculous: we need only look at William S. Hart or Tom Mix, who in the wooden absoluteness of their virtue represented little that an adult could take seriously; and doubtless such figures as Gene Autry or Roy Rogers are no better, though I confess I have seen none of their movies. Some film enthusiasts claim to find in the early, unsophisticated Westerns a "cinematic purity" that has since been lost; this idea is as valid, and finally as misleading, as T. S. Eliot's statement that *Everyman* is the only play in English that stays within the limitations of art. The truth is that the Westerner comes into the field of serious art only when his moral code, without ceasing to be compelling, is seen also to be imperfect. The Westerner at his best exhibits a moral ambiguity which darkens his image and saves him from absurdity; this ambiguity arises from the fact that, whatever his justifications, he is a a killer of men.

In *The Virginian*, which is an archetypal Western movie as *Scarface* or *Little Caesar* are archetypal gangster movies, there is a lynching in which the hero (Gary Cooper), as leader of a posse, must supervise the hanging of his best friend for stealing cattle. With the growth of American "social consciousness," it is no longer possible to present a lynching in the movies unless the point is the illegality and injustice of the lynching itself; *The Ox-Bow Incident*, made in 1943, explicitly puts forward the newer point of view and can be regarded as a kind of "anti-Western." But in 1929, when *The Virginian* was made, the present inhibition about lynching was not yet in force; the justice, and therefore the necessity, of the hanging is never questioned— except by the school-teacher from the East, whose refusal to understand serves as usual to set forth more sharply the deeper seriousness of the West. The Virginian is thus in a tragic dilemma where one moral absolute conflicts with another and the choice of either must leave a moral stain. If he had chosen to save his friend, he would have violated the image of himself that he had made essential to his existence, and the movie would have had to end with his death, for only by his death could the image have been restored. Having chosen instead to sacrifice his friend to the higher demands of the "code"—the only choice worthy of him, as even the friend understands—he is none the less stained by the killing, but what is needed now to set accounts straight is not his death but the death of the villain Trampas, the leader of the cattle thieves, who had escaped the posse and abandoned the Virginian's friend to his fate. Again the woman intervenes: Why must there be *more* killing? If the hero really loved her, he would leave town, refusing Trampas's challenge. What good will it be if Trampas should kill him? But the Virginian does once more what he "has to do," and in avenging his friend's death wipes out the stain on his own honor. Yet his victory cannot be complete: no death can be paid for and no stain truly wiped out; the movie is still a tragedy, for though the hero escapes with his life, he has been forced to confront the ultimate limits of his moral ideas.

This mature sense of limitation and unavoidable guilt is what gives the Westerner a "right" to his melancholy. It is true that the gangster's story is also a tragedy—in certain formal ways more clearly a tragedy than the Westerner's—but it is a romantic tragedy, based on a hero whose defeat springs with almost mechanical inevitability from the outrageous presumption of his demands: the gangster is *bound* to go on until he is killed. The Westerner is a more classical figure, self-contained and limited to begin with, seeking not to extend his dominion but only to assert his personal

value, and his tragedy lies in the fact that even this circumscribed demand cannot be fully realized. Since the Westerner is not a murderer but (most of the time) a man of virtue, and since he is always prepared for defeat, he retains his inner invulnerability and his story need not end with his death (and usually does not); but what we finally respond to is not his victory but his defeat.

Up to a point, it is plain that the deeper seriousness of the good Western films comes from the introduction of a realism, both physical and psychological, that was missing with Tom Mix and William S. Hart. As lines of age have come into Gary Cooper's face since *The Virginian*, so the outlines of the Western movie in general have become less smooth, its background more drab. The sun still beats upon the town, but the camera is likely now to take advantage of this illumination to seek out more closely the shabbiness of buildings and furniture, the loose, worn hang of cloth-ing, the wrinkles and dirt of the faces. Once it has been discovered that the true theme of the Western movie is not the freedom and expansiveness of frontier life, but its lim-itations, its material bareness, the pressures of obligation, then even the landscape itself ceases to be quite the arena of free movement it once was, but becomes instead a great empty waste, cutting down more often than it exaggerates the stature of the horseman who rides across it. We are more likely now to see the Westerner struggling against the obstacles of the physical world (as in the wonderful scenes on the desert and among the rocks in *The Last Posse*) then carelessly surmounting them. Even the horses, no longer the "friends" of man or the inspired chargers of knight-errantry, have lost much of the moral significance that once seemed to belong to them in their careering across the screen. It seems to me the horses grow tired and stumble more often than they did, and that we see them less frequently at the gallop.

In *The Gunfighter*, a remarkable film of a couple of years ago, the landscape has virtually disappeared. Most of the action takes place indoors, in a cheerless saloon where a tired "bad man" (Gregory Peck) contemplates the waste of his life, to be senselessly killed at the end by a vicious youngster setting off on the same futile path. The movie is done in cold, quiet tones of gray, and every object in it—faces, cloth-ing, a table, the hero's heavy mustache—is given an air of uncompromising authen-ticity, suggesting those dim photographs of the nineteenth-century West in which Wyatt Earp, say, turns out to be a blank untidy figure posing awkwardly before some uninteresting building. This "authenticity," to be sure, is only aesthetic; the chief fact about nineteenth-century photographs, to my eyes at any rate, is how stonily they refuse to yield up the truth. But that limitation is just what is needed: by preserving some hint of the rigidity of archaic photography (only in tone and décor, never in composition), *The Gunfighter* can permit us to feel that we are looking at a more "real" West than the one the movies have accustomed us to—harder, duller, less "romantic"—and yet without forcing us outside the boundaries which give the West-ern movie its validity.

We come upon the hero of *The Gunfighter* at the end of a career in which he has never upheld justice and order, and has been at times, apparently, an actual criminal; in this case, it is clear that the hero has been wrong and the woman who has rejected his way of life has been right. He is thus without any of the larger justifications, and knows himself a ruined man. There can be no question of his "redeeming" himself in any socially constructive way. He is too much the victim of his own reputation to turn

The aging Westerner—Gary Cooper (with Mary Brian) in *The Virginian* (1929) and (with Grace Kelly) in *High Noon* (1952). "As lines of age have come into Gary Cooper's face since *The Virginian*, so the outlines of the Western movie in general have become less smooth, its background more drab . . . In *High Noon* we find Gary Cooper still the upholder of order that he was in *The Virginian*, but twenty-four years older, stooped, slower moving . . . the flesh sagging . . ." (WARSHOW, pages 709, 712).

marshal as one of his old friends has done, and he is not offered the sentimental solution of a chance to give up his life for some good end; the whole point is that he exists outside the field of social value. Indeed, if we were once allowed to see him in the days of his "success," he might become a figure like the gangster, for his career has been aggressively "anti-social" and the practical problem he faces is the gangster's problem: there will always be somebody trying to kill him. Yet it is obviously absurd to speak of him as "anti-social," not only because we do not see him acting as a criminal, but more fundamentally because we do not see his milieu as a society. Of course it has its "social problems" and a kind of static history: civilization is always just at the point of driving out the old freedom; there are women and children to represent the possibility of a settled life; and there is the marshal, a bad man turned good, determined to keep at least his area of jurisdiction at peace. But these elements are not, in fact, a part of the film's "realism," even though they come out of the real history of the West; they belong to the conventions of the form, to that accepted framework which makes the film possible in the first place, and they exist not to provide a standard by which the gunfighter can be judged, but only to set him off. The true "civilization" of the Western movie is always embodied in an individual, good or bad is more a matter of personal bearing than of social consequences, and the conflict of good and bad is a duel between two men. Deeply troubled and obviously doomed, the gunfighter is the Western hero still, perhaps all the more because his value must express itself entirely in his own being—in his presence, the way he holds our eyes—and in contradiction to the facts. No matter what he has done, he *looks* right, and he remains invulnerable because, without acknowledging anyone else's right to judge him, he has judged his own failure and has already assimilated it, understanding—as no one else understands except the marshal and the barroom girl—that he can do nothing but play out the drama of the gun fight again and again until the time comes when it will be he who gets killed. What "redeems" him is that he no longer believes in this drama and nevertheless will continue to play his role perfectly: the pattern is all.

The proper function of realism in the Western movie can only be to deepen the lines of that pattern. It is an art form for connoisseurs, where the spectator derives his pleasure from the appreciation of minor variations within the working out of a preestablished order. One does not want too much novelty: it comes as a shock, for instance, when the hero is made to operate without a gun, as has been done in several pictures (e.g., *Destry Rides Again*), and our uneasiness is allayed only when he is finally compelled to put his "pacifism" aside. If the hero can be shown to be troubled, complex, fallible, even eccentric, or the villain given some psychological taint or, better, some evocative physical mannerism, to shade the colors of his villainy, that is all to the good. Indeed, that kind of variation is absolutely necessary to keep the type from becoming sterile; we do not want to see the same movie over and over again, only the same form. But when the impulse toward realism is extended into a "reinterpretation" of the West as a developed society, drawing our eyes away from the hero if only to the extent of showing him as the one dominant figure in a complex social order, then the pattern is broken and the West itself begins to be uninteresting. If the "social problems" of the frontier are to be the movie's chief concern, there is no longer any point in reexamining these problems twenty times a year; they have been

solved, and the people for whom they once were real are dead. Moreover, the hero himself, still the film's central figure, now tends to become its one unassimilable element, since he is the most "unreal."

The *Ox-Bow Incident*, by denying the convention of the lynching, presents us with a modern "social drama" and evokes a corresponding response, but in doing so it almost makes the Western setting irrelevant, a mere backdrop of beautiful scenery. (It is significant that *The Ox-Bow Incident* has no hero; a hero would have to stop the lynching or be killed in trying to stop it, and then the "problem" of lynching would no longer be central.) Even in *The Gunfighter* the women and children are a little too much in evidence, threatening constantly to become a real focus of concern instead of simply part of the given framework; and the young tough who kills the hero has too much the air of juvenile criminality: the hero himself could never have been like that, and the idea of a cycle being repeated therefore loses its sharpness. But the most striking example of the confusion created by a too conscientious "social" realism is in the celebrated *High Noon*.

In *High Noon* we find Gary Cooper still the upholder of order that he was in *The Virginian*, but twenty-four years older, stooped, slower moving, awkward, his face lined, the flesh sagging, a less beautiful and weaker figure, but with the suggestion of greater depth that belongs almost automatically to age. Like the hero of *The Gunfighter*, he no longer has to assert his character and is no longer interested in the drama of combat; it is hard to imagine that he might once have been so youthful as to say, "When you call me that—smile!" In fact, when we come upon him he is hanging up his guns and his marshal's badge in order to begin a new, peaceful life with his bride, who is a Quaker. But then the news comes that a man he had sent to prison has been pardoned and will get to town on the noon train; three friends of this man have come to wait for him at the station, and when the freed convict arrives the four of them will come to kill the marshal. He is thus trapped; the bride will object, the hero himself will waver much more than he would have done twenty-four years ago, but in the end he will play out the drama because it is what he "has to do." All this belongs to the established form (there is even the "fallen woman" who understands the marshal's position as his wife does not). Leaving aside the crudity of building up suspense by means of the clock, the actual Western drama of *High Noon* is well handled and forms a good companion piece to *The Virginian*, showing in both conception and technique the ways in which the Western movie has naturally developed.

But there is a second drama along with the first. As the marshal sets out to find deputies to help him deal with the four gunmen, we are taken through the various social strata of the town, each group in turn refusing its assistance out of cowardice, malice, irresponsibilty, or venality. With this we are in the field of "social drama"— of a very low order, incidentally, altogether unconvincing and displaying a vulgar anti-populism that has marred some other movies of Stanley Kramer's. But the falsity of the "social drama" is less important than the fact that it does not belong in the movie to begin with. The technical problem was to make it necessary for the marshal to face his enemies alone; to explain *why* the other townspeople are not at his side is to raise a question which does not exist in the proper frame of the Western movie, where the hero is "naturally" alone and it is only necessary to contrive the physical absence of those who might be his allies, if any contrivance is needed at all. In addi-

tion, though the hero of *High Noon* proves himself a better man than all around him, the actual effect of this contrast is to lessen his stature: he becomes only a rejected man of virtue. In our final glimpse of him, as he rides away through the town where he has spent most of his life without really imposing himself on it, he is a pathetic rather than a tragic figure. And his departure has another meaning as well; the "social drama" has no place for him.

But there is also a different way of violating the Western form. This is to yield entirely to its static quality as legend and to the "cinematic" temptations of its landscape, the horses, the quiet men. John Ford's famous *Stagecoach* (1938) had much of this unhappy preoccupation with style, and the same director's *My Darling Clementine* (1946), a soft and beautiful movie about Wyatt Earp, goes further along the same path, offering indeed a superficial accuracy of historical reconstruction, but so loving in execution as to destroy the outlines of the Western legend, assimilating it to the more sentimental legend of rural America and making the hero a more dangerous Mr. Deeds. (*Powder River*, a recent "routine" Western shamelessly copied from *My Darling Clementine*, is in most ways a better film; lacking the benefit of a serious director, it is necessarily more concerned with drama than with style.)

The highest expression of this aestheticizing tendency is in George Stevens' *Shane*, where the legend of the West is virtually reduced to its essentials and then fixed in the dreamy clarity of a fairy tale. There never was so broad and bare and lovely a landscape as Stevens puts before us, or so unimaginably comfortless a "town" as the little group of buildings on the prairie to which the settlers must come for their supplies and to buy a drink. The mere physical progress of the film, following the style of *A Place in the Sun*, is so deliberately graceful that everything seems to be happening at the bottom of a clear lake. The hero (Alan Ladd) is hardly a man at all, but something like the Spirit of the West, beautiful in fringed buckskins. He emerges mysteriously from the plains, breathing sweetness and a melancholy which is no longer simply the Westerner's natural response to experience but has taken on spirituality; and when he has accomplished his mission, meeting and destroying in the black figure of Jack Palance a Spirit of Evil just as metaphysical as his own embodiment of virtue, he fades away again into the more distant West, a man whose "day is over," leaving behind the wondering little boy who might have imagined the whole story. The choice of Alan Ladd to play the leading role is alone an indication of this film's tendency. Actors like Gary Cooper or Gregory Peck are in themselves, as material objects, "realistic," seeming to bear in their bodies and their faces mortality, limitation, the knowledge of good and evil. Ladd is a more "aesthetic" object, with some of the "universality" of a piece of sculpture; his special quality is in his physical smoothness and serenity, unworldly and yet not innocent, but suggesting that no experience can really touch him. Stevens has tried to freeze the Western myth once and for all in the immobility of Alan Ladd's countenance. If *Shane* were "right," and fully successful, it might be possible to say there was no point in making any more Western movies; once the hero is apotheosized, variation and development are closed off.

*Shane* is not "right," but it is still true that the possibiities of fruitful variation in the Western movie are limited. The form can keep its freshness through endless repetitions only because of the special character of the film medium, where the physical difference between one object and another—above all, between one actor and

another—is of such enormous importance, serving the function that is served by the variety of language in the perpetuation of literary types. In this sense, the "vocabulary" of films is much larger than that of literature and falls more readily into pleasing and significant arrangements. (That may explain why the middle levels of excellence are more easily reached in the movies than in literary forms, and perhaps also why the status of the movies as art is constantly being called into question.) But the advantage of this almost automatic particularity belongs to all films alike. Why does the Western movie especially have such a hold on our imagination?

The lawyer from the East learns the law of the West: John Wayne and James Stewart in John Ford's *The Man Who Shot Liberty Valance* (1962). "Ford's . . . preoccupation with style" has the tendency "to destroy the outlines of the Western legend, assimilating it to the more sentimental legend of rural America and making the hero a more dangerous Mr. Deeds . . ." (WARSHOW, page 713).

Chiefly, I think, because it offers a serious orientation to the problem of violence such as can be found almost nowhere else in our culture. One of the well-known peculiarities of modern civilized opinion is its refusal to acknowledge the value of violence. This refusal is a virtue, but like many virtues it involves a certain willful blindness and it encourages hypocrisy. We train ourselves to be shocked or bored by cultural images of violence, and our very concept of heroism tends to be a passive one: we are less drawn to the brave young men who kill large numbers of our enemies than to the heroic prisoners who endure torture without capitulating. In art, though we may still be able to understand and participate in the values of the Iliad, a modern writer like Ernest Hemingway we find somewhat embarrassing: there is no doubt that he stirs us, but we cannot help recognizing also that he is a little childish. And in the criticism of popular culture, where the educated observer is usually under the illusion that he has nothing at stake, the presence of images of violence is often assumed to be in itself a sufficient ground for condemnation.

These attitudes, however, have not reduced the element of violence in our culture but, if anything, have helped to free it from moral control by letting it take on the aura of "emancipation." The celebration of acts of violence is left more and more to the irresponsible: on the higher cultural levels to writers like Céline, and lower down to Mickey Spillane or Horace McCoy, or to the comic books, television, and the movies. The gangster movie, with its numerous variations, belongs to this cultural "underground" which sets forth the attractions of violence in the face of all our higher social attitudes. It is a more "modern" genre than the Western, perhaps even more profound, because it confronts industrial society on its own ground—the city—and because, like much of our advanced art, it gains its effects by a gross insistence on its own narrow logic. But it is anti-social, resting on fantasies of irresponsible freedom. If we are brought finally to acquiesce in the denial of these fantasies, it is only because they have been shown to be dangerous, not because they have given way to a better vision of behavior.*

In war movies, to be sure, it is possible to present the uses of violence within a framework of responsibility. But there is the disadvantage that modern war is a cooperative enterprise; its violence is largely impersonal, and heroism belongs to the group more than to the individual. The hero of a war movie is most often simply a leader, and his superiority is likely to be expressed in a denial of the heroic: you are not supposed to be brave, you are supposed to get the job done and stay alive (this too, of course, is a kind of heroic posture, but a new—and "practical"—one). At its best, the war movie may represent a more civilized point of view than the Western, and if it were not continually marred by ideological sentimentality we might hope to find it developing into a higher form of drama. But it cannot supply the values we seek in the Western.

---

*I am not concerned here with the actual social consequences of gangster movies, though I suspect they could not have been so pernicious as they were thought to be. Some of the compromises introduced to avoid the supposed bad effects of the old gangster movies may be, if anything, more dangerous, for the sadistic violence that once belonged only to the gangster is now commonly enlisted on the side of the law and thus goes undefeated, allowing us (if we wish) to find in the movies a sort of "confirmation" of our fantasies.

Those values are in the image of a single man who wears a gun on his thigh. The gun tells us that he lives in a world of violence, and even that he "believes in violence." But the drama is one of self-restraint: the moment of violence must come in its own time and according to its special laws, or else it is valueless. There is little cruelty in Western movies, and little sentimentality; our eyes are not focused on the sufferings of the defeated but on the deportment of the hero. Really, it is not violence at all which is the "point" of the Western movie, but a certain image of man, a style, which expresses itself most clearly in violence. Watch a child with his toy guns and you will see: what most interests him is not (as we so much fear) the fantasy of hurting others, but to work out how a man might look when he shoots or is shot. A hero is one who looks like a hero.

Whatever the limitations of such an idea in experience, it has always been valid in art, and has a special validity in an art where appearances are everything. The Western hero is necessarily an archaic figure; we do not really believe in him and would not have him step out of his rigidly conventionalized background. But his archaicism does not take away from his power; on the contrary, it adds to it by keeping him just a little beyond the reach both of common sense and of absolutized emotion, the two usual impulses of our art. And he has, after all, his own kind of relevance. He is there to remind us of the possibility of style in an age which has put on itself the burden of pretending that style has no meaning, and, in the midst of our anxieties over the problem of violence, to suggest that even in killing or being killed we are not freed from the necessity of establishing satisfactory modes of behavior. Above all, the movies in which the Westerner plays out his role preserve for us the pleasures of a complete and self-contained drama—and one which still effortlessly crosses the boundaries which divide our culture—in a time when other, more consciously serious art forms are increasingly complex, uncertain, and ill-defined.

1954

# ROBIN WOOD
# IDEOLOGY, GENRE, AUTEUR

The truth lies not in one dream but in many.

*Arabian Nights* (PIER PAOLO PASOLINI, 1974)

Each theory of film so far has insisted on its own particular polarization. Montage theory enthrones editing as the essential creative act at the expense of other aspects of film; Bazin's realist theory, seeking to right the balance, merely substitutes its own imbalance, downgrading montage and artifice; the revolutionary theory centered in Britain in *Screen* (but today very widespread) rejects—or at any rate seeks to "deconstruct"—realist art in favor of the so-called open text. Auteur theory, in its heyday, concentrated attention exclusively on the fingerprints, thematic or stylistic, of the individual artist; recent attempts to discuss the complete "filmic text" have tended to throw out ideas of personal authorship altogether. Each theory has, given its underlying position, its own validity—the validity being dependent upon and restricted by the position. Each can offer insights into different areas of cinema and different aspects of a single film.

I have suggested elsewhere* the desirability for critics—whose aim should always be to see the work as wholly as possible, as it is—to be able to draw on the discoveries and particular perceptions of each theory, each position, without committing themselves exclusively to any one. The ideal will not be easy to attain, and even the attempt raises all kinds of problems, the chief of which is the validity of evaluative criteria that are not supported by a particular system. For what, then, *do* they receive support? No critic, obviously, can be free from a structure of values, nor can he or she afford to withdraw from the struggles and tensions of living to some position of "aes-

---

*Robin Wood, "Old Wine, New Bottles: Structuralism or Humanism?" *Film Comment* 12, no. 6 (November–December 1976): 22–25.

thetic" contemplation. Every critic who is worth reading has been, on the contrary, very much caught up in the effort to define values beyond purely aesthetic ones (if indeed such things exist). Yet to "live historically" need not entail commitment to a system or a cause; rather, it can involve being alive to the opposing pulls, the tensions, of one's world.

The past two decades have seen a number of advances in terms of the opening up of critical possibilities, of areas of relevance, especially with regard to Hollywood: the elaboration of auteur theory in its various manifestations; the interest in genre; the interest in ideology. I want here tentatively to explore some of the ways in which these disparate approaches to Hollywood movies might interpenetrate, producing the kind of synthetic criticism I have suggested might now be practicable.

In order to create a context within which to discuss *It's a Wonderful Life* (Frank Capra, 1946) and *Shadow of a Doubt* (Alfred Hitchcock, 1943), I want to attempt (at risk of obviousness) a definition of what we mean by American capitalist ideology—or, more specifically, the values and assumptions so insistently embodied in and reinforced by the classical Hollywood cinema. The following list of components is not intended to be exhaustive or profound, but simply to make conscious, prior to a discussion of the films, concepts with which we are all perfectly familiar:

1. Capitalism, the right of ownership, private enterprise, personal initiative; the settling of the land.

2. The work ethic: the notion that "honest toil" is in itself and for itself morally admirable, this and concept 1 both validating and reinforcing each other. The moral excellence of work is also bound up with the necessary subjugation or sublimation of the libido: "the Devil finds work for idle hands." The relationship is beautifully epitomized in the zoo-cleaner's song in *Cat People* (Jacques Tourneur, 1942):

> Nothing else to do,
> Nothing else to do,
> I strayed, went a-courting
> 'cause I'd nothing else to do.

3. Marriage (legalized heterosexual monogamy) and family—at once the further validation of concepts 1 and 2 (the homestead is built for the woman, whose function is to embody civilized values and guarantee their continuance through her children) and an extension of the ownership principle to personal relationships ("*My* house, *my* wife, *my* children") in a male-dominated society.

4a. Nature as agrarianism; the virgin land as Garden of Eden. A concept into which, in the western, concept 3 tends to become curiously assimilated (ideology's function being to "naturalize" cultural assumptions): for example, the treatment of the family in *Drums along the Mohawk* (John Ford, 1939).

4b. Nature as the wilderness, the Indians, on whose subjugation civilization is built; hence by extension the libido, of which in many westerns the Indians seem an extension or embodiment, as in *The Searchers* (Ford, 1956).

5. Progress, technology, the city ("New York, New York, it's a wonderful town").

6. Success and wealth—a value of which Hollywood ideology is also deeply ashamed, so that, while hundreds of films play on its allure, very few can allow themselves openly to extol it. Thus its ideological "shadow" is produced.

7. The Rosebud syndrome. Money isn't everything; money corrupts; the poor are happier. A very convenient assumption for capitalist ideology; the more oppressed you are, the happier you are, as exemplified by the singing "darkies" of *A Day at the Races* (Sam Wood, 1937).

8. America as the land where everyone is or can be happy; hence the land where all problems are solvable within the existing system (which may need a bit of reform here and there but no *radical* change). Subversive systems are assimilated wherever possible to serve the dominant ideology. Andrew Britton, in a characteristically brilliant article on Hitchcock's *Spellbound* (1945), argues that there even Freudian psychoanalysis becomes an instrument of ideological repression.[1] Above all, this assumption gives us that most striking and persistent of all classical Hollywood phenomena, the happy ending: often a mere "emergency exit" (Sirk's phrase)[2] for the spectator, a barely plausible pretense that the problems the film has raised are now resolved. *Hilda Crane* (Philip Dunne, 1950) offers a suitably blatant example among the hundreds possible.

Out of this list logically emerge two ideal figures:

9. The ideal male: the virile adventurer, the potent, untrammeled man of action.

10. The ideal female: wife and mother, perfect companion, the endlessly dependable mainstay of hearth and home.

Since these combine into an ideal couple of quite staggering incompatibility, each has his or her shadow:

11. The settled husband/father, dependable but dull.

12. The erotic woman (adventuress, gambling lady, saloon "entertainer"), fascinating but dangerous, liable to betray the hero or turn into a black panther.

The most striking fact about this list is that it presents an ideology that, far from being monolithic, is *inherently* riddled with hopeless contradictions and unresolvable tensions. The work that has been done so far on genre has tended to take the various genres as "given" and discrete, defining them in terms of motifs, iconography, conventions, and themes. What we need to ask, if genre theory is ever to be productive, is less *what* than *why*. We are so used to the genres that the peculiarity of the phenomenon itself has been too little noted. The idea I wish to put forward is that the development of the genres is rooted in the sort of ideological contradictions my list of concepts suggests. One impulse may be the attempt to deny such contradiction by eliminating one of the opposed terms, or at least by a process of simplification.

Robert Warshow's seminal essays on the gangster hero and the westerner (still fruitfully suggestive, despite the obvious objection that he took too little into account) might be adduced here. The opposition of gangster film and western is only one of many possibilities. *All* the genres can be profitably examined in terms of ideological oppositions, forming a complex interlocking pattern: small-town family comedy/

---

[1] Andrew Britton, "Hitchcock's *Spellbound*: Text and Counter-Text," *Cine-Action!* no. 3/4 (January 1986): 72–83.

[2] See *Sirk on Sirk*, edited by Jon Halliday (London: Secker & Warburg/British Film Institute, 1971).

sophisticated city comedy; city comedy/film noir; film noir/small-town comedy, and so on. It is probable that a genre is ideologically "pure" (i.e., safe) only in its simplest, most archetypal, most aesthetically deprived and intellectually contemptible form—such as the Hopalong Cassidy films or Andy Hardy comedies.

The Hopalong Cassidy films (in which Indians, always a potentially disruptive force in ideological as well as dramatic terms, are, in general, significantly absent), for example, seem to depend on two strategies for their perfect ideological security: the strict division of characters into good and evil, with no "grays"; and Hoppy's sexlessness (he never becomes emotionally entangled). Hence the possibility of evading all the wandering/settling tensions on which aesthetically interesting westerns are generally structured. (An intriguing alternative: the ideal American family of Roy Rogers/Dale Evans/Trigger.) *Shane* (George Stevens, 1953) is especially interesting in this connection. A deliberate attempt to create an "archetypal" western, it also represents an effort to resolve the major ideological tensions harmoniously.

One of the greatest obstacles to any fruitful theory of genre has been the tendency to treat the genres as discrete. An ideological approach might suggest why they can't be, however hard they may appear to try: at best, they represent different strategies for dealing with the same ideological tensions. For example, the small-town movie with a contemporary setting should never be divorced from its historical correlative, the western. In the classical Hollywood cinema motifs cross repeatedly from genre to genre, as can be made clear by a few examples. The home/wandering opposition that Peter Wollen rightly sees as central to Ford* is not central only to Ford or even to the western; it structures a remarkably large number of American films covering all genres, from *Out of the Past* (Tourneur, 1947) to *There's No Business Like Show Business* (Walter Lang, 1954). The explicit comparison of women to cats connects screwball comedy (*Bringing Up Baby*, Howard Hawks, 1938), horror film (*Cat People*), melodrama (*Rampage*, Phil Karlson, 1963), and psychological thriller (*Marnie*, Hitchcock, 1964). Another example brings us to this essay's specific topic: notice the way in which the potent male adventurer, when he enters the family circle, immediately displaces his "shadow," the settled husband/father, in both *The Searchers* and *Shadow of a Doubt*.

Before we attempt to apply these ideas to specific films, however, one more point needs to be especially emphasized: the presence of ideological tensions in a movie, though it may give it an interest beyond Hopalong Cassidy, is not in itself a reliable evaluative criterion. It seems probable that artistic value has always been dependent on the presence—somewhere, at some stage—of an individual artist, whatever the function of art in the particular society and even when (as with the Chartres cathedral) one no longer knows who the individual artists were. It is only through the medium of the individual that ideological tensions come into particular focus, hence become of aesthetic as well as sociological interest. It can perhaps be argued that works are of especial interest when the defined particularities of an auteur interact with specific ideological tensions and when the film is fed from more than one generic source.

---

*Peter Wollen, *Signs and Meaning in the Cinema*, 3d. ed. (Bloomington and London: Indiana University Press, 1972), pp. 94–101.

The same basic ideological tensions operate in both *It's a Wonderful Life* and *Shadow of a Doubt*. They furnish further reminders that the home/wandering antinomy is by no means the exclusive preserve of the western. Bedford Falls and Santa Rosa can be seen as the frontier town seventy or so years on; they embody the development of the civilization whose establishment was celebrated around the same time by Ford in *My Darling Clementine* (1946). With this relationship to the western in the background (but in Capra's film made succinctly explicit), the central tension in both films can be described in terms of genre: the disturbing influx of film noir into the world of small-town domestic comedy. (It is a tension clearly present in *Clementine* as well: the opposition between the daytime and nighttime Tombstones.)

The strong contrast presented by the two films testifies to the decisive effect of the intervention of a clearly defined artistic personality in an ideological-generic structure. Both films have as a central ideological project the reaffirmation of family and small-town values that the action has called into question. In Capra's film this reaffirmation is magnificently convincing (but with full acknowledgment of the suppressions on which it depends and, consequently, of its precariousness); in Hitchcock's it is completely hollow. The very different emotional effects of the films—the satisfying catharsis and emotional fullness of Capra's, the "bitter taste" (on which so many have commented) of Hitchcock's—are very deeply rooted not only in our response to two opposed directorial personalities but in our own ideological structuring.

One of the main ideological and thematic tensions of *It's a Wonderful Life* is beautifully encapsulated in the scene in which George Bailey (James Stewart) and Mary (Donna Reed) smash windows in a derelict house as a preface to making wishes. George's wish is to get the money to leave Bedford Falls, which he sees as humdrum and constricting, and travel about the world; Mary's wish (not expressed in words, but in its subsequent fulfillment—confirming her belief that wishes don't come true if you speak them) is that she and George will marry, settle down, and raise a family in the same derelict house, a ruined shell that marriage-and-family restores to life.

This tension is developed through the extended sequence in which George is manipulated into marrying Mary. His brother's return home with a wife and a new job traps George into staying in Bedford Falls to take over the family business. With the homecoming celebrations continuing inside the house in the background, George sits disconsolately on the front porch; we hear an off-screen train whistle, to which he reacts. His mother (the indispensable Beulah Bondi) comes out and begins "suggesting" that he visit Mary; he appears to go off in her direction, physically pointed that way by his mother, then reappears and walks away past the mother—in the opposite direction.

This leads him, with perfect ideological/generic logic, to Violet (Gloria Grahame). The Violet/Mary opposition is an archetypally clear rending of that central Hollywood female opposition that crosses all generic boundaries—as with Susan (Katherine Hepburn) and Alice (Virginia Walker) in *Bringing Up Baby*, Irene (Simone Simon) and Alice (Jane Randolph) in *Cat People*, Chihuahua (Linda Darnell) and Clementine (Cathy Downs) in *My Darling Clementine*, Debby (Gloria Grahame) and Katie (Jocelyn Brando) in *The Big Heat* (Fritz Lang, 1953). But Violet (in front of an amused audience) rejects his poetic invitation to a barefoot ramble over the hills in the moonlight; the good-time gal offers no more solution to the hero's wanderlust than the wife-mother figure.

So back to Mary, whom he brings to the window by beating a stick aggressively against the fence of the neat, enclosed front garden—a beautifully precise expression of his ambivalent state of mind: desire to attract Mary's attention warring with bitter resentment of his growing entrapment in domesticity. Mary is expecting him; his mother has phoned her, knowing that George would end up at her house. Two ideological premises combine here: the notion that the "good" mother always knows, precisely and with absolute certitude, the workings of her son's mind; and the notion that the female principle is central to the continuity of civilization, that the "weaker sex" is compensated with a sacred rightness.

Indoors, Mary shows George a cartoon she has drawn of George, in cowboy denims, lassoing the moon. The moment is rich in contradictory connotations. It explicitly evokes the western and the figure of the adventurer-hero to which George aspires. Earlier, it was for Mary that George wanted to "lasso the moon," the adventurer's exploits motivated by a desire to make happy the woman who will finally entrap him in domesticity. From Mary's point of view, the picture is at once affectionate (acknowledging the hero's aspirations), mocking (reducing them to caricature), and possessive (reducing George to an image she creates and holds within her hands).

The most overtly presented of the film's structural oppositions is that between the two faces of capitalism, benign and malignant. On the one hand, there are the Baileys (father and son) and their building and loan company, its business practice based on a sense of human needs and a belief in human goodness; on the other, there is Potter (Lionel Barrymore), described explicitly as a spider, motivated by greed, egotism, and miserliness, with no faith in human nature. Potter belongs to a very deeply rooted tradition. He derives most obviously from Dickens's Scrooge (the film is set at Christmas)—a Scrooge disturbingly unrepentant and irredeemable—but his more distant antecedents are in the ogres of fairy tales.

The opposition gives us not only two attitudes to money and property but two father images (Bailey, Sr., and Potter), each of whom gives his name to the land (Bailey Park, in small-town Bedford Falls, and Pottersville, the town's dark alternative). Most interestingly, the two figures (representing American choices, American tendencies) find their vivid ideological extensions in Hollywood genres: the happy, sunny world of small-town comedy (Bedford Falls is seen mostly in the daytime) and the world of film noir, the dark underside of Hollywood ideology.

Pottersville—the vision of the town as it would have been if George had never existed, shown him by his guardian angel (Henry Travers)—is just as "real" as (or no more stylized than) Bedford Falls. The iconography of small-town comedy is exchanged, unmistakably, for that of film noir, with police sirens, shooting in the streets, darkness, vicious dives, alcoholism, burlesque shows, strip clubs, and the glitter and shadows of noir lighting. George's mother, embittered and malevolent, runs a seedy boardinghouse; the good-time gal/wife-mother opposition, translated into noir terms, becomes an opposition of prostitute and repressed spinster-librarian. The towns emerge as equally valid images of America—validated by their generic familiarity.

Beside *Shadow of a Doubt*, *It's a Wonderful Life* manages a convincing and moving affirmation of the values (and value) of bourgeois family life. Yet what is revealed, when disaster releases George's suppressed tensions, is the intensity of his resentment of the family and desire to destroy it—and with it, in significant relationship,

his work (his culminating action is furiously to overthrow the drawing board with his plans for more small-town houses). The film recognizes explicitly that behind every Bedford Falls lurks a Pottersville, and implicitly that within every George Bailey lurks an Ethan Edwards of *The Searchers*. Potter, tempting George, is given the devil's insights into his suppressed desires. His remark, "You once called me a warped, frustrated old man—now you're a warped, frustrated *young* man," is amply supported by the evidence the film supplies. What is finally striking about the film's affirmation is the extreme precariousness of its basis; and Potter survives without remorse, his crime unexposed and unpunished. It may well be Capra's masterpiece, but it is more than that. Like all the greatest American films—fed by a complex generic tradition and, beyond that, by the fears and aspirations of a whole culture— it at once transcends its director and would be inconceivable without him.

*Shadow of a Doubt* has always been among the most popular of Hitchcock's middle-period films, with critics and public alike, but it has been perceived in very different, almost diametrically opposed ways. On its appearance it was greeted by British critics as the film marking Hitchcock's coming to terms with America; his British films were praised for their humor and "social criticism" as much as for their suspense, and the early American films, notably *Rebecca* (1940) and *Suspicion* (1941), seemed like attempts artificially to reconstruct England in Hollywood. In *Shadow of a Doubt* Hitchcock (with the aid of Thornton Wilder and Sally Benson) at last brought to American middle-class society the shrewd, satirical, affectionate gaze previously bestowed on the British. A later generation of French critics (notably Rohmer and Chabrol in their Hitchcock book) praised the film for very different reasons, establishing its strict formalism (Truffaut's "un film fondé sur le chiffre 2") and seeing it as one of the keys to a consistent Catholic interpretation of Hitchcock, a rigorous working out of themes of original sin, the loss of innocence, the fallen world, the exchange (or interchangeability) of guilt.* The French noted the family comedy beloved of British critics, if at all, as a mildly annoying distraction.

That both these views correspond to important elements in the film and throw light on certain aspects of it is beyond doubt; both, however, now appear false and partial, dependent upon the abstracting of elements from the whole. If the film is, in a sense, completely dominated by Hitchcock (nothing in it is unmarked by his artistic personality), a complete reading would need to see the small-town-family elements and the Catholic elements are threads weaving through a complex fabric in which, again, ideological and generic determinants are crucial.

The kind of "synthetic" analysis I have suggested (going beyond an interest in the individual auteur) reveals *It's a Wonderful Life* as a far more potentially subversive film than has been generally recognized, but its subversive elements are, in the end, successfully contained. In *Shadow of a Doubt* the Hollywood ideology I have sketched is shattered beyond convincing recuperation. One can, however, trace through the film its attempts to impose itself and render things "safe." What is in jeopardy is above all the family—but, given the family's central ideological significance, once that is in jeopardy, everything is. The small town (still rooted in the agrarian

---

*See Eric Rohmer and Claude Chabrol, *Hitchcock: The First Forty-Four Films*, translated by Stanley Hochman (New York: Ungar, 1979), p. 72.

dream, in ideals of the virgin land as a garden of innocence) and the united happy family are regarded as the real sound heart of American civilization; the ideological project is to acknowledge the existence of sickness and evil but preserve the family from their contamination.

A number of strategies can be discerned here: the attempt to insist on a separation of Uncle Charlie from Santa Rosa; his death at the end of the film as the definitive purging of evil; the production of the young detective (the healthy, wholesome, small-town male) as a marriage partner for Young Charlie so that the family may be perpetuated; above all, the attribution of Uncle Charlie's sexual pathology to a childhood accident as a means of exonerating the family of the charge of producing a monster, a possibility the American popular cinema, with the contemporary overturning of traditional values, can now envisage—for example, *It's Alive* (Larry Cohen, 1974).

The famous opening, with its parallel introductions of Uncle Charlie and Young Charlie, insists on the city and the small town as *opposed*, sickness and evil being of the city. As with Bedford Falls/Pottersville, the film draws lavishly on the iconography of usually discrete genres. Six shots (with all movement and direction—the bridges, the panning, the editing—consistently rightward) leading up to the first interior of Uncle Charlie's room give us urban technology, wreckage both human (the down-and-outs) and material (the dumped cars by the sign "No Dumping Allowed"), children playing in the street, the number 13 on the lodging-house door. Six shots (movement and direction consistently left) leading to the first interior of Young Charlie's room give us sunny streets with no street games (Santa Rosa evidently has parks), an orderly town with a smiling, paternal policeman presiding over traffic and pedestrians.

In Catholic terms, this is the fallen world against a world of apparent prelapsarian innocence; but it is just as valid to interpret the images, as in *It's a Wonderful Life*, in terms of the two faces of American capitalism. Uncle Charlie has money (the fruits of his crimes and his aberrant sexuality) littered in disorder over table and floor; the Santa Rosa policeman has behind him the Bank of America. The detailed paralleling of uncle and niece can of course be read as comparison as much as contrast, and the opposition that of two sides of the same coin. The point is clearest in that crucial, profoundly disturbing scene where film noir erupts into Santa Rosa itself: the visit to the Til Two bar, where Young Charlie is confronted with her alter ego Louise the waitress, her former classmate. The scene equally invites Catholic and Marxist commentaries; its force arises from the revelation of the fallen world/capitalist-corruption-and-deprivation at the heart of the American small town. The close juxtaposition of genres has implications that reach throughout the whole generic structure of the classical Hollywood cinema.

The subversion of ideology within the film is everywhere traceable to Hitchcock's presence, to the skepticism and nihilism that lurk just behind the jocular facade of his public image. His Catholicism is in reality the lingering on in his work of the darker aspects of Catholic mythology: hell without heaven. The traces are clear enough. Young Charlie wants a "miracle"; she thinks of her uncle as "the one who can save us" (and her mother immediately asks, "What do you mean, save us?"); when she finds his telegram, in the very act of sending hers, her reaction is an ecstatic "He heard

me, he heard me!" Hitchcock cuts at once to a low-angle shot of Uncle Charlie's train rushing toward Santa Rosa, underlining the effect with an ominous crashing chord on the sound track.

Uncle Charlie is one of the supreme embodiments of the key Hitchcock figure: ambiguously devil and lost soul. When he reaches Santa Rosa, the image is blackened by its smoke. From his first appearance, Charlie is associated consistently with a cigar (its phallic connotations evident from the outset, in the scene with the landlady) and repeatedly shown with a wreath of smoke curling around his head (no one else in the film smokes except Joe, the displaced father, who has a paternal pipe, usually unlit). Several incidents (the escape from the policemen at the beginning, the garage door slammed as by remote control) invest him with a quasi-supernatural power. Rather than restrict the film to a Catholic reading, it seems logical to connect these marks with others: the thread of superstition that runs through the film (the number 13; the hat on the bed; "Sing at table and you'll marry a crazy husband"; the irrational dread of the utterance, however innocent, of the forbidden words "Merry Widow") and the telepathy motif (the telegrams, the tune "jumping from head to head")—the whole Hitchcockian sense of life at the mercy of terrible, unpredictable forces that have to be kept down.

The Hitchcockian dread of repressed forces is characteristically accompanied by a sense of the emptiness of the surface world that represses them, and this crucially affects the presentation of the American small-town family in *Shadow of a Doubt*. The warmth and togetherness, the mutual responsiveness and affection that Capra so beautifully creates in the Bailey families, senior and junior, of *It's a Wonderful Life* are here almost entirely lacking—and this despite the fact, in itself of great ideological interest, that the treatment of the family in *Shadow of a Doubt* has generally been perceived (even, one guesses, by Hitchcock himself) as affectionate.

The most striking characteristic of the Spencers is the separateness of each member; the recurring point of the celebrated overlapping dialogue is that no one ever listens to what anyone else is saying. Each is locked in a separate fantasy world: Emmy in the past, Joe in crime, Anne in books that are read apparently less for pleasure than as a means of amassing knowledge with which she has little emotional contact (though she also believes that everything she reads is "true"). The parents are trapped in a petty materialism (both respond to Young Charlie's dissatisfaction with the assumption that she's talking about money) and reliance on "honest toil" as the means of using up energies. In *Shadow of a Doubt* the ideological image of the small-town happy family becomes the flimsiest facade. That so many are nonetheless deceived by it testifies only to the strength of the ideology—one of whose functions is of course to inhibit the imagining of radical alternatives.

I have argued elsewhere that the key to Hitchcock's films is less suspense than sexuality (or, alternatively, that his "suspense" always carries a sexual charge in ways sometimes obvious, sometimes esoteric); and that sexual relationships in his work are inevitably based on power, the obsession with power and dread of impotence being as central to his method as to his thematic. In *Shadow of a Doubt* it is above all sexuality that cracks apart the family facade. As far as the Hays Code permitted, a double incest theme runs through the film: Uncle Charlie and Emmy, Uncle Charlie and

Young Charlie. Necessarily, this is expressed through images and motifs, never becoming verbally explicit; certain of the images depend on a suppressed verbal play for their significance.

For the reunion of brother and sister, Hitchcock gives us an image (Emmy poised left of screen, arrested in mid-movement, Charlie right, under trees and sunshine) that iconographically evokes the reunion of lovers (Charlie wants to see Emmy again as she was when she was "the prettiest girl on the block"). And Emmy's breakdown, in front of her embarrassed friends and neighbors, at the news of Charlie's imminent departure is eloquent. As for uncle and niece, they are introduced symmetrically lying on beds, Uncle Charlie fondling his phallic cigar, Young Charlie, prone, hands behind head. When Uncle Charlie gets off the train he is bent over a stick, pretending to be ill; as soon as he sees Young Charlie, he "comes erect," flourishing the stick. One of his first actions on taking over her bedroom is to pluck a rose for his buttonhole ("deflowering"). More obviously, there is the business with the ring, which, as a symbolic token of engagement, not only links Charlie sexually with her uncle, but also links her, through its previous ownership, to his succession of merry widows. The film shows sexual pathology at the heart of the American family, the necessary product of its repressions and sublimations.

As for the "accident"—that old critical stumbling block—it presents no problem at all, provided one is ready to acknowledge the validity of a psychoanalytical reading of movies. Indeed, it provides a rather beautiful example of the way in which ideology, in seeking to impose itself, succeeds merely in confirming its own subversion. The "accident" (Charlie was "riding a bicycle" for the first time, which results in a "collision") can be read as an elementary Freudian metaphor for the trauma of premature sexual awakening (after which Charlie was "never the same again"). The smothering sexual/possessive devotion of a doting older sister may be left to provide a clue to the sexual motivation behind the merry-widow murders; Charlie isn't interested in money. Indeed, Emmy is connected to the merry widows by an associative chain in which important links are her own practical widowhood (her ineffectual husband is largely ignored), her ladies' club, and its leading light, Mrs. Potter, Uncle Charlie's potential next-in-line.

A fuller analysis would need to dwell on the limitations of Hitchcock's vision, nearer the nihilistic than the tragic; on his inability to conceive of repressed energies as other than evil and the surface world that represses them as other than shallow and unfulfilling. This explains why there can be no heaven corresponding to Hitchcock's hell, for every vision of heaven that is not merely negative is rooted in a concept of the liberation of the instincts, the resurrection of the body, which Hitchcock must always deny. But my final stress is less on the evaluation of a particular film or director than on the implications for a criticism of the Hollywood cinema of the notions of interaction and multiple determinacy I have been employing. Its roots in the Hollywood genres, and in the very ideological structure it so disturbingly subverts, make *Shadow of a Doubt* so much more suggestive and significant a work than Hitchcock the bourgeois entertainer could ever have guessed.

1977

# LINDA WILLIAMS
# FILM BODIES:
# GENDER, GENRE, AND EXCESS

When my seven-year-old son and I go to the movies we often select from among categories of films that promise to be sensational, to give our bodies an actual physical jolt. He calls these movies "gross." My son and I agree that the fun of "gross" movies is in their display of sensations that are on the edge of respectable. Where we disagree—and where we as a culture often disagree, along lines of gender, age, or sexual orientation—is in which movies are over the edge, too "gross." To my son the good "gross" movies are those with scary monsters like Freddy Krueger (of the *Nightmare on Elm Street* series) who rip apart teenagers, especially teenage girls. These movies both fascinate and scare him; he is actually more interested in talking about than seeing them.

A second category, one that I like and my son doesn't, are sad movies that make you cry. These are gross in their focus on unseemly emotions that may remind him too acutely of his own powerlessness as a child. A third category, of both intense interest and disgust to my son (he makes the puke sign when speaking of it), he can only describe euphemistically as "the 'K' word." K is for kissing. To a seven-year-old boy it is kissing precisely which is obscene.

There is no accounting for taste, especially in the realm of the "gross." As a culture we most often invoke the term to designate excesses we wish to exclude; to say, for example, which of the Robert Mapplethorpe photos we draw the line at, but not to say what form and structure and function operate within the representations deemed excessive. Because so much attention goes to determining where to draw the line, discussions of the gross are often a highly confused hodgepodge of different categories

I owe thanks to Rhona Berenstein, Leo Braudy, Ernest Callenbach, Paul Fitzgerald, Jane Gaines, Mandy Harris, Brian Henderson, Marsha Kinder, Eric Rentschler, and Pauline Yu for generous advice on drafts of this essay.

of excess. For example, pornography is today more often deemed excessive for its violence than for its sex, while horror films are excessive in their displacement of sex onto violence. In contrast, melodramas are deemed excessive for their gender- and sex-linked pathos, for their naked displays of emotion; Ann Douglas once referred to the genre of romance fiction as "soft-core emotional porn for women" (Douglas, 1980).

Alone or in combination, heavy doses of sex, violence, and emotion are dismissed by one faction or another as having no logic or reason for existence beyond their power to excite. Gratuitous sex, gratuitous violence and terror, gratuitous emotion are frequent epithets hurled at the phenomenon of the "sensational" in pornography, horror, and melodrama. This essay explores the notion that there may be some value in thinking about the form, function, and system of seemingly gratuitous excesses in these three genres. For if, as it seems, sex, violence, and emotion are fundamental elements of the sensational effects of these three types of films, the designation "gratuitous" is itself gratuitous. My hope, therefore, is that by thinking comparatively about all three "gross" and sensational film body genres we might be able to get beyond the mere fact of sensation to explore its system and structure as well as its effect on the bodies of spectators.

## BODY GENRES

The repetitive formulas and spectacles of film genres are often defined by their differences from the classical realist style of narrative cinema. These classical films have been characterized as efficient action-centered, goal-oriented linear narratives driven by the desire of a single protagonist, involving one or two lines of action, and leading to definitive closure. In their influential study of the Classical Hollywood Cinema, Bordwell, Thompson, and Staiger call this the Classical Hollywood style (1985).

As Rick Altman has noted in a recent article (1989), both genre study and the study of the somewhat more nebulous category of melodrama has long been hampered by assumptions about the classical nature of the dominant narrative to which melodrama and some individual genres have been opposed. Altman argues that Bordwell, Thompson, and Staiger, who locate the Classical Hollywood Style in the linear, progressive form of the Hollywood narrative, cannot accommodate "melodramatic" attributes like spectacle, episodic presentation, or dependence on coincidence except as limited exceptions or "play" within the dominant linear causality of the classical (Altman, 1988, 346).

Altman writes: "Unmotivated events, rhythmic montage, highlighted parallelism, overlong spectacles—these are the excesses in the classical narrative system that alert us to the existence of a competing logic, a second voice." (345–6) Altman, whose own work on the movie musical has necessarily relied upon analyses of seemingly "excessive" spectacles and parallel constructions, thus makes a strong case for the need to recognize the possibility that excess may itself be organized as a system (347). Yet analyses of systems of excess have been much slower to emerge in the genres whose non-linear spectacles have centered more directly upon the gross display of the human body. Pornography and horror films are two such systems of excess. Pornography is the lowest in cultural esteem, gross-out horror is next to lowest.

Melodrama, however, refers to a much broader category of films and a much larger system of excess. It would not be unreasonable, in fact, to consider all three of these genres under the extended rubric of melodrama, considered as a filmic mode of stylistic and/or emotional excess that stands in contrast to more "dominant" modes of realistic, goal-oriented narrative. In this extended sense melodrama can encompass a broad range of films marked by "lapses" in realism, by "excesses" of spectacle and displays of primal, even infantile emotions, and by narratives that seem circular and repetitive. Much of the interest of melodrama to film scholars over the last fifteen years originates in the sense that the form exceeds the normative system of much narrative cinema. I shall limit my focus here, however, to a more narrow sense of melodrama, leaving the broader category of the sensational to encompass the three genres I wish to consider. Thus, partly for purposes of contrast with pornography, the melodrama I will consider here will consist of the form that has most interested feminist critics—that of "the woman's film" or "weepie." These are films addressed to women in their traditional status under patriarchy—as wives, mothers, abandoned lovers, or in their traditional status as bodily hysteria or excess, as in the frequent case of the woman "afflicted" with a deadly or debilitating disease.[1]

What are the pertinent features of bodily excess shared by these three "gross" genres? First, there is the spectacle of a body caught in the grip of intense sensation or emotion. Carol Clover, speaking primarily of horror films and pornography, has called films which privilege the sensational "body" genres (Clover, 189). I am expanding Clover's notion of low body genres to include the sensation of overwhelming pathos in the "weepie." The body spectacle is featured more sensationally in pornography's portrayal of orgasm, in horror's portrayal of violence and terror, and in melodrama's portrayal of weeping. I propose that an investigation of the visual and narrative pleasures found in the portrayal of these three types of excess could be important to a new direction in genre criticism that would take as its point of departure—rather than as an unexamined assumption—questions of gender construction, and gender addresses in relation to basic sexual fantasies.

Another pertinent feature shared by these body genres is the focus on what could probably best be called a form of ecstasy. While the classical meaning of the original Greek word is insanity and bewilderment, more contemporary meanings suggest components of direct or indirect sexual excitement and rapture, a rapture which informs even the pathos of melodrama.

Visually, each of these ecstatic excesses could be said to share a quality of uncontrollable convulsion or spasm—of the body "beside itself" with sexual pleasure, fear and terror, or overpowering sadness. Aurally, excess is marked by recourse not to the coded articulations of language but to inarticulate cries of pleasure in porn, screams of fear in horror, sobs of anguish in melodrama.

---

[1]For an excellent summary of many of the issues involved with both film melodrama and the "women's film," see Christine Gledhill's introduction to the anthology *Home Is Where the Heart Is: Studies in Melodrama and the Woman's Film* (Gledhill, 1987). For a more general inquiry into the theatrical origins of melodrama, see Peter Brooks's (1976) *The Melodramatic Imagination*. And for an extended theoretical inquiry and analysis of a body of melodramatic women's films, see Mary Ann Doane (1987), *The Desire to Desire*.

Looking at, and listening to, these bodily ecstasies, we can also notice something else that these genres seem to share: though quite differently gendered with respect to their targeted audiences, with pornography aimed, presumably, at active men and melodramatic weepies aimed, presumably, as passive women, and with contemporary gross-out horror aimed at adolescents careening wildly between the two masculine and feminine poles, in each of these genres the bodies of women figured on the screen have functioned traditionally as the primary *embodiments* of pleasure, fear, and pain.

In other words, even when the pleasure of viewing has traditionally been constructed for masculine spectators, as is the case in most traditional heterosexual pornography, it is the female body in the grips of an out-of-control ecstasy that has offered the most sensational sight. So the bodies of women have tended to function, ever since the eighteenth-century origins of these genres in the Marquis de Sade, Gothic fiction, and the novels of Richardson, as both the *moved* and the *moving*. It is thus through what Foucault has called the sexual saturation of the female body that audiences of all sorts have received some of their most powerful sensations (Foucault, 104).

There are, of course, other film genres which both portray and affect the sensational body—e.g., thrillers, musicals, comedies. I suggest, however, that the film genres that have had especially low cultural status—which have seemed to exist as excesses to the system of even the popular genres—are not simply those which sensationally display bodies on the screen and register effects in the bodies of spectators. Rather, what may especially mark these body genres as low is the perception that the body of the spectator is caught up in an almost involuntary mimicry of the emotion or sensation of the body on the screen along with the fact that the body displayed is female. Physical clown comedy is another "body" genre concerned with all manner of gross activities and body functions—eating shoes, slipping on banana peels. Nonetheless, it has not been deemed gratuitously excessive, probably because the reaction of the audience does not mimic the sensations experienced by the central clown. Indeed, it is almost a rule that the audience's physical reaction of laughter does not coincide with the often dead-pan reactions of the clown.

In the body genres I am isolating here, however, it seems to be the case that the success of these genres is often measured by the degree to which the audience sensation mimics what is seen on the screen. Whether this mimicry is exact, e.g., whether the spectator at the porn film actually orgasms, whether the spectator at the horror film actual shudders in fear, whether the spectator of the melodrama actually dissolves in tears, the success of these genres seems a self-evident matter of measuring bodily response. Examples of such measurement can be readily observed: in the "peter meter" capsule reviews in *Hustler* magazine, which measure the power of a porn film in degrees of erection of little cartoon penises; in horror films which measure success in terms of screams, fainting, and heart attacks in the audience (horror producer William Castle specialized in this kind of thing with such films as *The Tingler*, 1959); and in the long-standing tradition of women's films measuring their success in terms of one-, two-, or three-handkerchief movies.

What seems to bracket these particular genres from others is an apparent lack of proper esthetic distance, a sense of over-involvement in sensation and emotion. We

feel manipulated by these texts—an impression that the very colloquialisms of "tear jerker" and "fear jerker" express—and to which we could add pornography's even cruder sense as texts to which some people might be inclined to "jerk off." The rhetoric of violence of the jerk suggests the extension to which viewers feel too directly, too viscerally manipulated by the text in specifically gendered ways. Mary Ann Doane, for example, writing about the most genteel of these jerkers—the maternal melodrama—equates the violence of this emotion to a kind of "textual rape" of the targeted female viewer, who is "feminized through pathos" (Doane, 1987, 95).

Feminist critics of pornography often evoke similar figures of sexual/textual violence when describing the operating of this genre. Robin Morgan's slogan "pornography is the theory, and rape is the practice" is well known (Morgan, 139). Implicit in this slogan is the notion that women are the objectified victims of pornographic representations, that the image of the sexually ecstatic woman so important to the genre is a celebration of female victimization and a prelude to female victimization in real life.

Less well known, but related, is the observation of the critic of horror films, James Twitchell, who notices that the Latin *horrere* means to bristle. He describes the way the nape hair stands on end during moments of shivering excitement. The aptly named Twitchell thus describes a kind of erection of the hair founded in the conflict between reactions of "fight and flight" (Twitchell, 10). While male victims in horror films may shudder and scream as well, it has long been a dictum of the genre that women make the best victims. "Torture the women!" was the famous advice given by Alfred Hitchcock.[2]

In the classic horror film the terror of the female victim shares the spectacle along with the monster. Fay Wray and the mechanized monster that made her scream in *King Kong* is a familiar example of the classic form. Janet Leigh in the shower in *Psycho* is a familiar example of a transition to a more sexually explicit form of the tortured and terrorized woman. And her daughter, Jamie Lee Curtis in *Halloween*, can serve as the more contemporary version of the terrorized woman victim. In both of these later films the spectacle of the monster seems to take second billing to the increasingly numerous victims slashed by the sexually disturbed but entirely human monsters.

In the woman's film a well-known classic is the long-suffering mother of the two early versions of *Stella Dallas* who sacrifices herself for her daughter's upward mobility. Contemporary film goers could recently see Bette Midler going through the same sacrifice and loss in the film *Stella*. Debra Winger in *Terms of Endearment* is another familiar example of this maternal pathos.

With the above genre stereotypes in mind we should now ask about the status of bodily excess in each of these genres. Is it simply the unseemly, "gratuitous" presence of the sexually ecstatic woman, the tortured woman, the weeping woman—and the accompanying presence of the sexual fluids, the blood and the tears that flow from her body and which are presumably mimicked by spectators—that mark the excess of each type of film? How shall we think of these bodily displays in relation to one

---

[2]Carol J. Clover (1987) discusses the meanings of this famous quote in her essay: "Her Body/Himself: Gender in the Slasher Film."

another, as a system of excess in the popular film? And finally, how excessive are they really?

The psychoanalytic system of analysis that has been so influential in film study in general and in feminist film theory and criticism has been remarkably ambivalent about the status of excess in its major tools of analysis. The categories of fetishism, voyeurism, sadism, and masochism frequently invoked to describe the pleasures of film spectatorship are by definition perversions. Perversions are usually defined as sexual excesses, specifically as excesses which are deflected away from "proper" end goals onto substitute goals or objects—fetishes instead of genitals, looking instead of touching, etc.—which seems excessive or gratuitous. Yet the perverse pleasures of film viewing are hardly gratuitous. They have been considered so basic that they have often been presented as norms. What is a film, after all, without voyeurism? Yet, at the same time, feminist critics have asked, what is the position of women within this pleasure geared to a presumably sadistic "male gaze"? (Mulvey, 1976) To what extent is she its victim? Are the orgasmic woman of pornography and the tortured woman of horror merely in the service of the sadistic male gaze? And is the weeping woman of melodrama appealing to the abnormal perversions of masochism in female viewers?

These questions point to the ambiguity of the terms of perversion used to describe the normal pleasures of film viewing. Without attempting to go into any of the complexities of this discussion here—a discussion which must ultimately relate to the status of the term perversion in theories of sexuality themselves—let me simply suggest the value of not invoking the perversions as terms of condemnation. As even the most cursory reading of Freud shows, sexuality is by definition perverse. The "aims" and "objects" of sexual desire are often obscure and inherently substitutive. Unless we are willing to see reproduction as the common goal of the sexual drive, we have to admit, as Jonathan Dollimore has put it, that we are all perverts. Dollimore's goal of retrieving the "concept of perversion as a category of cultural analysis"—as a structure intrinsic to all sexuality rather than extrinsic to it—is crucial to any attempt to understand cultural forms—such as our three body genres—in which fantasy predominates.[3]

## STRUCTURES OF PERVERSION IN THE "FEMALE BODY GENRES"

Each of the three body genres I have isolated hingers on the spectacle of a "sexually saturated" female body, and each offers what many feminist critics would agree to be spectacles of feminine victimization. But this victimization is very different in each type of film and cannot be accounted for simply by pointing to the sadistic power and pleasure of masculine subject positions punishing or dominating feminine objects.

Many feminists have pointed to the victimization of the woman performers of pornography who must actually do the acts depicted in the film, as well as to the victimization of characters within the films (Dworkin, 1979; MacKinnon, 1987).

---

[3]Dollimore (1990, 13). Dollimore's project, along with Teresa de Lauretis's more detailed examination of the term perversion in Freudian psychoanalysis (in progress) will be central to any more detailed attempts to understand the perverse pleasures of these gross body genres.

Pornography, in this view, is fundamentally sadistic. In women's weepies, on the other hand, feminists have pointed to the spectacles of intense suffering and loss as masochistic.

In horror films, while feminists have often pointed to the women victims who suffer simulated torture and mutilation as victims of sadism (Williams, 1983), more recent feminist work has suggested that the horror film may present an interesting, and perhaps instructive, case of oscillation between masochistic and sadistic poles. This more recent argument, advanced by Carol J. Clover, has suggested that pleasure, for a masculine-identified viewer, oscillates between identifying with the initial passive powerlessness of the abject and terrorized girl-victim of horror and her later, active empowerment (Clover, 1987).

This argument holds that when the girl-victim of a film like *Halloween* finally grabs the phallic knife, or ax, or chain saw to turn the tables on the monster-killer, that viewer identification shifts from an "abject terror gendered feminine" to an active power with bisexual components. A gender-confused monster is foiled, often sym-

*Stella Dallas* (1937). Stella (Barbara Stanwyck), after sacrificing herself for her daughter, stands in the rain with a crowd of curious passersby to watch the wedding. "But even in the most extreme displays of feminine masochistic suffering, there is always a component of either power or pleasure for the woman victims. . . . In melodramatic woman's weepies, feminine subject positions appear to be constructed which achieve a modicum of power and pleasure within the given limits of patriarchal constraints on women" (WILLIAMS, page 734).

bolically castrated by an "androgynous" "final girl" (Cover, 206–209). In slasher films, identification with victimization is a roller-coaster ride of sadomasochistic thrills.

We could thus initially schematize the perverse pleasures of these genres in the following way: pornography's appeal to its presumed male viewers would be characterized as sadistic, horror films' appeal to the emerging sexual identities of its (frequently adolescent) spectators would be sadomasochistic and women's films appeal to presumed female viewers would be masochistic.

The masochistic component of viewing pleasure for women has been the most problematic term of perversion for feminist critics. It is interesting, for example, that most of our important studies of masochism—whether by Deleuze (1971), Silverman (1980; 1988) or Studlar (1985)—have all focused on the exoticism of masculine masochism rather than the familiarity of female masochism. Masochistic pleasure for women has paradoxically seemed either too normal—too much the normal yet intolerable condition of women—or too perverse to be taken seriously as pleasure.

There is thus a real need to be clearer than we have been about what is in masochism for women—how power and pleasure operate in fantasies of domination which appeal to women. There is an equal need to be clearer than we have about what is in sadism for men. Here the initial opposition between these two most gendered genres—women's weepies and male heterosexual pornography—needs to be complicated. I have argued elsewhere, for example, that pornography has too simplistically been allied with a purely sadistic fantasy structure. Indeed, those troubling films and videos which deploy instruments of torture on the bodies of women have been allied so completely with masculine viewing pleasures that we have not paid enough attention to their appeal to women except to condemn such appeal as false consciousness (Williams, 1989, 184–228).

One important complication of the initial schema I have outlined would thus be to take a lesson from Clover's more bisexual model of viewer identification in horror film and stress the sadomasochistic component of each of these body genres through their various appropriations of melodramatic fantasies that are, in fact, basic to each. All of these genres could, for example, be said to offer highly melodramatic enactments of sexually charged, if not sexually explicit, relations. This sub-genre of sadomasochistic pornography, with its suspension of pleasure over the course of prolonged sessions of dramatic suffering, offers a particularly intense, almost parodic, enactment of the classic melodramatic scenario of the passive and innocent female victim suffering at the hands of a leering villain. We can also see in horror films of tortured women a similar melodramatization of the innocent victim. An important difference, of course, lies in the component of the victim's overt sexual pleasure in the scenario of domination.

But even in the most extreme displays of feminine masochistic suffering, there is always a component of either power or pleasure for the woman victim. In slasher horror films we have seen how identification seems to oscillate between powerlessness and power. In sadomasochistic pornography and in melodramatic woman's weepies, feminine subject positions appear to be constructed which achieve a modicum of power and pleasure within the given limits of patriarchal constraints on women. It is worth noting as well that *non*-sadomasochistic pornography has historically been one

of the few types of popular film that has not punished women for actively pursuing their sexual pleasure.

In the subgenre of sadomasochistic pornography, however, the female masochist in the scenario must be devious in her pursuit of pleasure. She plays the part of passive sufferer in order to obtain pleasure. Under a patriarchal double standard that has rigorously separated the sexually passive "good" girl from the sexually active "bad" girl, masochistic role-playing offers a way out of this dichotomy by combining the good girl with the bad: the passive "good girl" can prove to her witnesses (the superego who is her torturer) that she does not will the pleasure that she receives. Yet the sexually active "bad" girl enjoys this pleasure and has knowingly arranged to endure the pain that earns it. The cultural law which decides that some girls are good and others are bad is not defeated but within its terms pleasure has been negotiated and "paid for" with a pain that conditions it. The "bad" girl is punished, but in return she receives pleasure.[4]

In contrast, the sadomasochistic teen horror films kill off the sexually active "bad" girls, allowing only the non-sexual "good" girls to survive. But these good girls become, as if in compensation, remarkably active, to the point of appropriating phallic power to themselves. It is as if this phallic power is granted so long as it is rigorously separated from phallic or any other sort of pleasure. For these pleasures spell sure death in this genre.

In the melodramatic woman's film we might think to encounter a purer form of masochism on the part of female viewers. Yet even here the female viewer does not seem to be invited to identify wholly with the sacrificing good woman, but rather with a variety of different positions, including those which empathically look on at her own suffering. While I would not argue that there is a very strong sadistic component to these films, I do argue that there is a strong mixture of passivity and activity, and a bisexual oscillation between the poles of each, in even this genre.

For example, the woman viewer of a maternal melodrama such as *Terms of Endearment* or *Steel Magnolias* does not simply identify with the suffering and dying heroines of each. She may equally identify with the powerful matriarchs, the surviving mothers who preside over the deaths of their daughters, experiencing the exhilaration and triumph of survival. The point is simply that identification is neither fixed nor entirely passive.

While there are certainly masculine and feminine, active and passive, poles to the left and right of the chart on which we might position these three genres (see below), the subject positions that appear to be constructed by each of the genres are not as gender-linked and as gender-fixed as has often been supposed. This is especially true today as hard-core pornography is gaining appeal with women viewers. Perhaps the most recent proof in this genre of the breakdown of rigid dichotomies of masculine and feminine, active and passive is the creation of an alternative, oscillating category of address to viewers. Although heterosexual hard core once addressed itself exclusively to heterosexual men, it has now begun to address itself to heterosexual couples and women as well; and in addition to homosexual hard core, which has addressed

---

[4] I discuss these issues at length in a chapter on sadomasochistic pornography in my book *Hard Core* (1989).

itself to gay and (to a lesser extent) lesbian viewers, there is now a new category of video called bisexual. In these videos men do it with women, women do it with women, men do it with men and then all do it with one another, in the process breaking down a fundamental taboo against male-to-male sex.[5]

A related interpenetration of once more separate categories of masculine and feminine is what has come to be known in some quarters as the "male weepie." These are mainstream melodramas engaged in the activation of the previously repressed emotions of men and in breaking the taboos against male-to-male hugs and embraces. The father-son embrace that concludes *Ordinary People* (1980) is exemplary. More recently, paternal weepies have begun to compete with the maternal—as in the conventional *Dad* (1989) or the less conventional, wild paternal displays of *Twin Peaks*.

The point is certainly not to admire the "sexual freedom" of this new fluidity and oscillation—the new femininity of men who hug and the new masculinity of women who leer—as if it represented any ultimate defeat of phallic power. Rather, the more useful lesson might be to see what this new fluidity and oscillation permits in the construction of feminine viewing pleasures once thought not to exist at all. (It is instructive, for example, that in the new bisexual pornography women characters are shown verbally articulating their visual pleasure as they watch men perform sex with men.)

The deployment of sex, violence, and emotion would thus seem to have very precise functions in these body genres. Like all popular genres, they address persistent problems in our culture, in our sensualities, in our very identities. The deployment of sex, violence, and emotion is thus in no way gratuitous and in no way strictly limited to each of these genres; it is instead a cultural form of problem solving. As I have argued in *Hard Core*, pornographic films now tend to present sex as a problem, to which the performance of more, different, or better sex is posed as the solution (Williams, 1989). In horror a violence related to sexual difference is the problem, more violence related to sexual difference is also the solution. In women's films the pathos of loss is the problem, repetitions and variations of this loss are the generic solution.

## STRUCTURES OF FANTASY

All of these problems are linked to gender identity and might be usefully explored as genres of gender fantasy. It is appropriate to ask, then, not only about the structures of perversion, but also about the structures of fantasy in each of these genres. In doing so, we need to be clear about the nature of fantasy itself. For fantasies are not, as is sometimes thought, wish-fulfilling linear narratives of mastery and control leading to closure and the attainment of desire. They are marked, rather, by the prolongation of desire, and by the lack of fixed position with respect to the objects and events fantasized.

In their classic essay "Fantasy and the Origins of Sexuality," Jean Laplanche and J. B. Pontalis (1968) argue that fantasy is not so much a narrative that enacts the quest

---

[5]Titles of these relatively new (post 1986) hard-core videos include: *Bisexual Fantasies*; *Bi-Mistake*; *Karen's Bi-Line*; *Bi-Dacious*; *Bi-Night*; *Bi and Beyond*; *The Ultimate Fantasy*; *Bi and Beyond II*; *Bi and Beyond III: Hermaphrodites*.

for an object of desire as it is a setting for desire, a place where conscious and uncon-scious, self and other, part and whole meet. Fantasy is the place where "desubjecti-fied" subjectivities oscillate between self and other occupying no fixed place in the scenario (16).

In the three body genres discussed here, this fantasy component has probably been better understood as belonging to the "fantastic." However, it has been less well understood in pornography and women's film melodrama. Because these genres dis-play fewer fantastic special effects and because they rely on certain conventions of realism—the activation of social problems in melodrama, the representation of real sexual acts in pornography—they seem less obviously fantastic. Yet the usual criti-cisms that these forms are improbable, that they lack psychological complexity and

### An Anatomy of Film Bodies

| Genre | Pornography | Horror | Melodrama |
|---|---|---|---|
| Bodily excess | sex | violence | emotion |
| Ecstasy: –shown by | ecstatic sex orgasm ejaculation | ecstatic violence shudder blood | ecstatic woe sob tears |
| Presumed audience: | men (active) | adolescent boys (active/passive) | girls, women (passive) |
| Perversion: | sadism | sadomasochism | masochism |
| Originary fantasy: | seduction | castration | origin |
| Temporality of fantasy: | on time! | too early! | too late! |
| Genre cycles: "classic" | stag films (20's-40's) *The Casting Couch* | "classic" horror: *Dracula* *Frankenstein* *Dr. Jekyll/Mr. Hyde* *King Kong* | "classic" women's films: maternal melodrama: *Stella Dallas* *Mildred Pierce* romance: *Back Street* *Letter from an Unknown Woman* |
| contemporary | feature-length hard core porn: *Deep Throat*, etc. *The Punishment of Anne* Femme Productions Bi-sexual Tri-sexual | post-Psycho: *Texas Chainsaw Massacre* *Halloween* *Dressed to Kill* *Videodrome* | male and female "weepies" *Steel Magnolias* *Stella* *Dad* |

narrative closure, and that they are repetitious, become moot as evaluation if such features are intrinsic to their engagement with fantasy.

There is a link, in other words, between the appeal of these forms and their ability to address, if never *really* to "solve," basic problems related to sexual identity. Here, I would like to forge a connection between Laplanche and Pontalis's structural understanding of fantasies as myths of origins which try to cover the discrepancy between two moments in time and the distinctive temporal structure of these particular genres. Laplanche and Pontalis argue that fantasies which are myths of origins address the insoluble problem of the discrepancy between an irrecoverable original experience presumed to have actually taken place—as in the case, for example, of the historical primal scene—and the uncertainty of its hallucinatory revival. The discrepancy exists, in other words, between the actual existence of the lost object and the sign which evokes both this existence and its absence.

Laplanche and Pontalis maintain that the most basic fantasies are located at the juncture of an irrecoverable real event that took place somewhere in the past and a totally imaginary event that never took place. The "event" whose temporal and spatial existence can never be fixed is thus ultimately, according to Laplanche and Pontalis, that of "the origin of the subject"—an origin which psychoanalysts tell us cannot be separated from the discovery of sexual difference (11).

It is this contradictory temporal structure of being situated somewhere between the "too early" and the "too late" of the knowledge of difference that generates desire that is most characteristic of fantasy. Freud introduced the concept of "original fantasy" to explain the mythic function of fantasies which seem to offer repetitions of and "solutions" to major enigmas confronting the child (Freud, 1915). These enigmas are located in three areas: the enigma of the origin of sexual desire, an enigma that is "solved," so the speak, by the fantasy of seduction; the enigma of sexual difference, "solved" by the fantasy of castration; and finally the enigma of the origin of self, "solved" by the fantasy of family romance or return to origins (Laplanche and Pontalis, 1968, 11).

Each of the three body genres I have been describing could be seen to correspond in important ways to one of these original fantasies: pornography, for example, is the genre that has seemed to endlessly repeat the fantasies of primal seduction, of meeting the other, seducing or being seduced by the other in an ideal "pornotopia" where, as Steven Marcus has noted, it is always bedtime (Marcus, 269). Horror is the genre that seems to endlessly repeat the trauma of castration as if to "explain," by repetitious mastery, the originary problem of sexual difference. And melodramatic weepie is the genre that seems to endlessly repeat our melancholic sense of the loss of origins—impossibly hoping to return to an earlier state which is perhaps most fundamentally represented by the body of the mother.

Of course each of these genres has a history and does not simply "endlessly repeat." The fantasies activated by these genres are repetitious, but not fixed and eternal. If traced back to origins each could probably be shown to have emerged with the formation of the bourgeois subject and the intensifying importance to this subject of specified sexualities. But the importance of repetition in each genre should not blind us to the very different temporal structure of repetition in each fantasy. It could be, in fact, that these different temporal structures constitute the different utopian compo-

nent of problem-solving in each form. Thus the typical (non-sadomasochistic) porno-graphic fantasies of seduction operate to "solve" the problem of the origin of desire. Attempting to answer the insoluble question of whether desire is imposed from with-out through the seduction of the parent or whether it originates within the self, pornography answers this question by typically positing a fantasy of desire coming from within the subject *and* from without. Non-sadomasochistic pornography attempts to posit the utopian fantasy of perfect temporal coincidence: a subject and object (or seducer and seduced) who meet one another "on time!" and "now!" in shared moments of mutual pleasure that it is the special challenge of the genre to portray.

In contrast to pornography, the fantasy of recent teen horror corresponds to a tem-poral structure which raises the anxiety of not being ready, the problem, in effect, of "too early!" Some of the most violent and terrifying moments of the horror film genre occur in moments when the female victim meets the psycho-killer-monster unexpect-edly, before she is ready. The female victims who are not ready for the attack die. This surprise encounter, too early, often takes place at a moment of sexual anticipation when the female victim thinks she is about to meet her boyfriend or lover. The mon-ster's violent attack on the female victims vividly enacts a symbolic castration which often functions as a kind of punishment for an ill-time exhibition of sexual desire. These victims are taken by surprise in the violent attacks which are then deeply felt by spectators (especially the adolescent male spectators drawn to the slasher subgenre) as linked to the knowledge of sexual difference. Again the key to the fantasy is tim-ing—the way the knowledge of sexual difference too suddenly overtakes both char-acters and viewers, offering a knowledge for which we are never prepared.

Finally, contrast to pornography's meeting "on time!" and horror's unexpected meeting "too early!," we can identify melodrama's pathos of the "too late!" In these fantasies the quest to return to and discover the origin of the self is manifest in the form of the child's fantasy of possessing ideal parents in the Freudian family romance, in the parental fantasy of possessing the child in maternal or paternal melo-drama, and even in the lovers' fantasy of possessing one another in romantic weepies. In these fantasies the quest for connection is always tinged with the melancholy of loss. Origins are already lost, the encounters always take place too late, on death beds or over coffins. (Neale, 1988).

Italian critic Franco Moretti has argued, for example, that literature that makes us cry operates via a special manipulation of temporality: what triggers our crying is not just the sadness or suffering of the character in the story but a very precise moment when characters in the story catch up with and realize what the audience already knows. We cry, Moretti argues, not just because the characters do, but at the precise moment when desire is finally recognized as futile. The release of tension produces tears—which become of kind of homage to a happiness that is kissed goodbye. Pathos is thus a surrender to reality but it is a surrender that pays homage to the ideal that tried to wage war on it (Moretti, 1983, 179). Moretti thus stresses a subversive, utopian component in what has often been considered a form of passive powerless-ness. The fantasy of the meeting with the other that is always too late can thus be seen as based upon the utopian desire that it not be too late to remerge with the other who was once part of the self.

Obviously there is a great deal of work to be done to understand the form and function of these three body genres in relation to one another and in relation to the fundamental appeal as "original fantasies." Obviously also the most difficult work of understanding this relation between gender, genre, fantasy, and structures of perversion will come in the attempt to relate original fantasies to historical context and specific generic history. However, there is one thing that already seems clear: these "gross" body genres which may seem so violent and inimical to women cannot be dismissed as evidence of a monolithic and unchanging misogyny, as either pure sadism for male viewers or masochism for females. Their very existence and popularity hinges upon rapid changes taking place in relations between the "sexes" and by rapidly changing notions of gender—of what it means to be a man or a woman. To dismiss them as bad excess whether of explicit sex, violence, or emotion, or as bad perversions, whether of masochism or sadism, is not to address their function as cultural problem-solving. Genres thrive, after all, on the persistence of the problems they address; but genres thrive also in their ability to recast the nature of these problems.

Finally, as I hope this most recent example of the melodrama of tears suggests, we may be wrong in our assumption that the bodies of spectators simply reproduce the sensations exhibited by bodies on the screen. Even those masochistic pleasures associated with the powerlessness of the "too late!" are not absolutely abject. Even tear jerkers do not operate to force a simple mimicry of the sensation exhibited on the screen. Powerful as the sensations of the jerk might be, we may only be beginning to understand how they are deployed in generic and gendered cultural forms.

1991

## Works Cited

Altman, Rick. 1989. "Dickens, Griffith, and Film Theory Today." *South Atlantic Quarterly* 88:321–359.

Bordwell, David, Janet Staiger and Kristin Thompson. 1985. *The Classical Hollywood Cinema: Film Style and Mode of Production to 1960.* New York: Columbia University Press.

Clover, Carol J. 1987. "Her Body, Himself: Gender in the Slasher Film." *Representations* 20 (Fall): 187–228.

Deleuze, Gilles. 1971. *Masochism: An Interpretation of Coldness and Cruelty.* Translated by Jean McNeil. New York: Braziller.

Doane, Mary Ann. 1987. *The Desire to Desire: The Woman's Film of the 1940's.* Bloomington: Indiana University Press.

Doane, Mary Ann, Patricia Mellencamp, and Linda Williams, eds. 1983. *Re-vision: Essays in Feminist Film Criticism.* American Film Institute Monograph Series, vol. 3. Frederick, MD: University Publications of America.

Dollimore, Jonathan. 1990. "The Cultural Politics of Perversion: Augustine, Shakespeare, Freud, Foucault." *Genders* 8.

Douglas, Ann. 1980. "Soft-Porn Culture." *The New Republic*, 30 August 1980.

Dworkin, Andrea. 1979. *Pornography: Men Possessing Women.* New York: Perigee Books.

Foucault, Michel. 1978. *The History of Sexuality* Vol. 1: *An Introduction.* Translated by Robert Hurley. New York: Pantheon Books.

Freud, Sigmund. 1915. "Instincts and their Vicissitudes." Vol. 14 of the *Standard Edition of The Complete Psychological Works of Sigmund Freud.* London: Hogarth. 14.

Laplanche, Jean, J. B. Pontalis. 1968. "Fantasy and the Origins of Sexuality." *The International Journal of Psycho-Analysis.* 49:1–18.

MacKinnon. 1987. *Feminism Unmodified: Discourses on Life and Law.* Cambridge, MA: Harvard University Press.

Marcus, Steven, 1964/74. *The Other Victorians: A Study of Sexuality and Pornography in Mid-Nineteenth Century England.* New York: New American Library.

Morgan, Robin, 1980. "Theory and Practice: Pornography and Rape." In *Take Back the Night: Women on Pornography*, edited by Laura Lederer. New York: Morrow.

Moretti, Franco. 1983. "Kindergarten." In *Signs Taken for Wonders*. London: Verso.

Mulvey, Laura. 1975. "Visual Pleasure and Narrative Cinema." *Screen* 16, no. 3: 6–18.

Neale, Steve. 1986. "Melodrama and Tears." *Screen* 27 (Nov.–Dec.): 6–22.

Silverman, Kaja. 1980. "Masochism and Subjectivity." *Framework* 12:2–9.

———. 1988. "Masochism and Male Subjectivity." *Camera Obscura* 17: 31–66.

Studlar, Gaylyn. 1985. *In the Realm of Pleasure: Von Sternberg, Dietrich and the Masochistic Aesthetic*. Urbana: University of Illinois Press.

Twitchell, James. 1985. *Dreadful Pleasures: An Anatomy of Modern Horror*. New York: Oxford.

Williams, Linda. 1983. "When the Woman Looks." In *Re-Vision: Essays in Feminist Film Criticism.* See Doane (1983).

———. 1989. *Hard Core: Power, Pleasure and the "Frenzy of the Visible."* Berkeley: University of California Press.

# CYNTHIA A. FREELAND
# FEMINIST FRAMEWORKS FOR HORROR FILMS

The horizon for feminists studying horror films appears bleak. Since *Psycho*'s infamous shower scene, the big screen has treated us to Freddie's long razor-nails emerging between Nancy's legs in the bathtub (*A Nightmare on Elm Street I*), De Palma's exhibitionist heroine being power-drilled into the floor (*Body Double*), and Leatherface hanging women from meat hooks (*The Texas Chain Saw Massacre*). Even in a film with a strong heroine like *Alien,* any feminist point is qualified by the monstrousness of the alien mother, the objectification of Sigourney Weaver in her underwear, and her character Ripley's forced assumption of a maternal role.

Despite all this, there has been some feminist work on horror, and I believe there is room for more. In the first part of this paper I shall survey and criticize currently dominant psychodynamic feminist approaches to horror. In the second part, I propose an alternative framework for constructing feminist interpretations of horror films by critically interrogating their gender ideologies. My proposal focuses less on the psychology of viewers than on the nature of films as artifacts with particular structures and functions. In the third part I illustrate my recommended framework by sketching readings of *Jurassic Park* (Spielberg 1993), *The Fly* (Cronenberg 1986), and *Repulsion* (Polanski 1965).

## PART I: PSYCHOANALYTIC FEMINIST
## APPROACHES TO HORROR

Most current feminist studies of horror films are psychodynamic. That is, though they may consider films as artifacts, recognizing such aspects as plot, narrative, or point of view, their chief emphasis is on viewers' motives and interests in watching horror films, and on the psychological effects such films have. Typically this sort of feminist film theory relies upon a psychoanalytic framework in which women are

742

described as castrated or as representing threats evoking male castration anxiety. These theories also standardly presume some connection between gazing, violent aggression, and masculinity, and they suggest that there are particularly "male" motivations for making, watching, and enjoying horror films.

Feminist psychodynamic approaches to film in general were launched by Laura Mulvey's influential essay "Visual Pleasure and Narrative Cinema" (1975).[1] Mulvey's model presupposes a Lacanian psychoanalytic perspective and draws upon key Lacanian conceptions of castration anxiety and visual fetishism, and the association of the "Law of the Father" or patriarchy with such traditional film features as narrative order. Mulvey argued that narrative forms characteristic of mainstream Hollywood cinema differentially use women and serve men. There is a dual analogy between the woman and the screen (the object of the look), and between the man and the viewer (the possessor of the look). A tension arises in the viewer between libido and ego needs, and this tension is resolved by a process of identification, whereby the [male] viewer identifies with the [male] protagonist in the film. Thus possessing the film character of the woman by proxy, the viewer can proceed to focus energy on achieving a satisfactory narrative resolution.

Mulvey's view has come in for a number of persuasive criticisms by other feminist film theorists, and she has even revised it herself.[2] Nevertheless, it will be instructive to begin by extrapolating from her basic model so as to generate a simple feminist, psychoanalytic account of horror, as follows: The tension between the viewer's desire to look and the ongoing narrative of a film is especially acute in the horror film. Typically in horror, the woman or visual object is also the chief victim sacrificed to the narrative desire to know about the monster. Horror flirts directly with the threat of castration underlying the fetish or visual appearance of the woman, and this means that looking (visual pleasure) is even more immediately at odds with narrative in horror films than in other mainstream Hollywood movies. The woman's flesh, the reality behind the surface appearance, *is* made visible, and horror shows the "wound" that we are revolted to look upon. To make up for this horror, this account continues, the viewer must turn attention to the narrative thrust of the investigator, typically a male, who will complete the story for us.

---

[1]Laura Mulvey, "Visual Pleasure and Narrative Cinema," originally published in *Screen* 16 (1975); reprinted in Mulvey, *Visual and Other Pleasures* (Bloomington: Indiana University Press, 1990); my page references are to the reprinted version in *Issues in Feminist Film Criticism,* ed. Patricia Erens (Bloomington: Indiana University Press, 1990), pp. 28–40.

[2]Feminist critics have argued against Mulvey on various grounds, particularly that she ignores the social and historical conditions of gendered subjects and oversimplifies the role of the viewer/director/camera (so that, for example, a subtler view may be necessary to account for the ambivalence of certain film directors like Hitchcock). See, for example, Mary Ann Doane, "Film and the Masquerade, Theorizing the Female Spectator," in *Issues in Feminist Film Criticism,* pp. 41–57; Jane Gaines, "Women and Representation: Can We Enjoy Alternative Pleasure?" also in *Issues in Feminist Film Criticism,* pp. 75–92; Marian Keane, "A Closer Look at Scophilia: Mulvey, Hitchcock, and Vertigo," in *The Hitchcock Reader,* ed. Marshall Dentelbaum and Leland Poague (Ames: Iowa State University Press, 1986), pp. 231–248; and Naomi Scheman, "Missing Mothers/Desiring Daughters: Framing the Sight of Women," *Critical Inquiry* 15 (Autumn 1988): 62–89. Mulvey's revisions of her view may be found in "Afterthoughts on Visual Pleasure and Narrative Cinema," in *Visual and Other Pleasures.* But for limitations that seem to persist in this volume, see my critical review of *Visual and Other Pleasures* in the *APA Newsletter on Feminism and Philosophy* 89, 2 (Winter 1990):52–55.

For example, in *Psycho,* we, like Janet Leigh, see the vague blurred and threaten-
ing shape of the attacker behind the shower curtain. But after this central murder
scene, the audience and camera look into the blind eye of the victim. Since the
woman herself can no longer see, and her beautiful body no longer be looked upon,
we viewers are forced to proceed beyond her vision. And once our identification with
the woman/victim has been disrupted, it shifts to the male investigators who will
solve the crime and identify the murderer, and ultimately to the male psychiatrist
who, in the film's words, "has all the answers."

A modified version of the simple Mulveyan schema I have just sketched is offered
by Linda Williams, who scrutinizes one of the more vulnerable aspects of Mulvey's
theory, her straitjacketed association between males and the pleasures of looking or
spectatorship.[3] Williams points out that often in horror, contrary to mainstream cin-
ema, women do possess "the gaze." That is, they are typically the first to get to see,
inquire about, and know the monster. Similarly, although monsters may threaten the
bodies of women in horror, even so, the fates of women and monsters are often linked.
Both may somehow seem to stand outside the patriarchal order. (Think of vampire
stories, for example, where a fascinating foreign Dracula seduces women away from
their husbands and fathers, undermining the patriarchal institutions of law, marriage,
motherhood, medicine, and religion.) Despite these observations about the short-
comings of a Mulveyan account, Williams's account remains consistent in its outlines
with the sort of Mulveyan view I have just sketched. Williams argues that women
who possess the gaze in horror, and who become aligned with monsters, are typically
shown themselves to represent threats to patriarchy and hence to require punishment.
In the end Williams seems to accept the basic idea that horror films reinforce con-
ceptions of the active (sadistic) male viewer and the passive (suffering) female object.
Women are punished for their appropriation of "the gaze," and a sort of masculine
narrative order (what Lacan would call the Law of the Father) is restored.

More recently, feminist film theorists have turned to the work of one of Lacan's
successors, the French feminist psychoanalyst Julia Kristeva. Kristeva's book *Pow-
ers of Horror: An Essay on Abjection*[4] focuses on literature and not film, but her
views have been adapted to the study of visual horror by Barbara Creed, in a 1986
*Screen* article about *Alien,* and in her more recent book *The Monstrous-Feminine:
Film, Feminism, Psychoanalysis.*[5] Kristeva locates the sources and origins of horror
not in castration anxiety, but in the preoedipal stage of the infant's ambivalence
toward the mother as it struggles to create boundaries and forge its own ego identity.
The mother is "horrific" in the sense of being all-engulfing, primitive, and impure or
defiled by bodily fluids—particularly breast milk and flowing menstrual blood. Kris-
teva uses the term "abjection" to designate the psychic condition inspired by this
image of the horrific mother. For Kristeva, horror is fundamentally about bound-

---

[3]Linda Williams, "When the Woman Looks," in *Re-Vision: Essays in Feminist Film Criticism,* ed. Mary
Ann Doane, Patricia Mellencamp, and Linda Williams (American Film Institute, 1984), pp. 83–99, and
"Film Bodies: Gender, Genre, and Excess," *Film Quarterly* 44 (Summer 1991): 2–13.

[4]Julia Kristeva, *Powers of Horror: An Essay on Abjection,* tran. Leon Roudiez (New York: Columbia
University Press, 1982).

[5]Barbara Creed, "Horror and the Monstrous-Feminine: An Imaginary Abjection," *Screen* 27, 1 (1986):
45–70, and *The Monstrous-Feminine: Film, Feminism, Psychoanalysis* (London: Routledge, 1993).

aries—about the threat of transgressing them, and about the need to do so. Hence she emphasizes the duality of our attraction/repulsion to the horrific.

In applying this theory to *Alien,* Creed stresses the film's repeated birth scenarios and numerous versions of the engulfing, threatening, voracious, horrific Alien mother, "a toothed vagina, the monstrous-feminine as the cannibalistic mother." Creed also offers an explanation of why, in the final scenes of *Alien* (notoriously), Sigourney Weaver undresses before the camera, strolls around in her thin undershirt, and eventually returns to her sleeping pod with the small orange cat she has rescued: "Ripley's body is pleasurable and reassuring to look at. She signifies the 'acceptable' form and shape of woman."

Creed departs in certain important respects from the simplistic Mulveyan model I sketched. She emphasizes, contra the Mulveyan-Lacanian position, that horror importantly concerns not just women as victims—women who are attacked because they present a horrific vision of a castrated body—but also monstrous women who threaten to castrate men. "Virtually all horror texts represent the monstrous-feminine in relation to Kristeva's notion of maternal authority and the mapping of the self's clean and proper body."[6] More specifically, Creed thinks that horror texts all serve to illustrate "the work of abjection."[7] They do so in three basic ways. First, horror depicts images of abjection, such as corpses and bodily wastes; second, horror is concerned with borders, with things that threaten the stability of the symbolic order; and third, horror constructs the maternal figure as abject.

Let me pause now for some assessment. As I have noted, both the Mulvey-Lacanian and Creed-Kristevan frameworks for feminist film theory build upon a psychoanalytic foundation. Despite all the details of their different pictures, each view construes the familiar tensions of horror in terms of an opposition between "female" and "male" aspects, where these are understood or defined within the terms of depth psychology. There is, in other words, a tension between spectacle or the horrific feminine (associated with the castrated woman, preoedipal mother, or castrating woman), and plot or narrative resolution (associated with the patriarchal order that the child achieves after resolving the Oedipal complex). In broader ways that go beyond psychoanalysis, in all these theories (Mulvey's, Creed's, and Williams's) the focus is also psychodynamic—that is, there is some presumed general or universal psychological theory that grounds their analysis. To back up speculations of this sort Creed, for example, begins her book by appealing to both universal cultural practices and classical mythology. Psychodynamic feminist theorists speculate about why "we" are interested in horror and more basically about why certain things are horrifying. These kinds of question are seen to require an answer within a psychological theory, which remains the chief concern even when the theorist speaks about how to "interpret" such films or about what various aspects of these films "represent." The "deep" explanations offered are (putative) psychological explanations. For instance, here is Creed on *The Exorcist:*

> Regan's carnivalesque display of her body reminds us quite clearly of the immense appeal of the abject. Horror emerges from the fact that woman has broken with her proper

---

[6]Creed, *The Monstrous-Feminine,* p. 13.
[7]Ibid., p. 10.

feminine role—she has "made a spectacle of herself"—put her unsocialized body on display. And to make matters worse, she has done all of this before the shocked eyes of two male clerics.[8]

The theoretical approaches of feminist film analysts like Creed, Mulvey, and Williams are significantly constrained by their psychodynamic framing, and more particularly (and significantly) by the theoretical apparatus of psychoanalysis. I here present six objections to such approaches.

First, psychoanalysis is itself a very problematic enterprise that is far from achieving anything like general acceptance as a psychological theory. Feminists adapting the views of Lacan or Kristeva do so either in ignorance of or indifference to forceful philosophical critiques of psychoanalysis offered by Crews, Grünbaum, Deleuze and Guattari, and others.[9] Attempts to defend psychoanalysis by reconceiving it as hermeneutic explanation are also problematic, because they loosen the theory from its crucial underpinnings in causal hypothesizing, leaving key theses, about, say, abject preoedipal mothers, castration anxiety, and so on, as, at best, hermeneutical aids to reading film "texts." Such hermeneutical aids should be taken seriously only insofar as they produce valid readings. But typically in film studies, psychoanalytic interpretations are advanced a priori, rather than in an open-minded spirit of testing how well they actually work. Though a Kristevan reading may seem illuminating for *Alien,* with its many birth scenarios and theme of monstrous mothering, why should we believe in advance that it will work equally for all kinds of examples of horror? The notion of abjection expands in Creed's theory so as to be almost vacuous, because we are to understand in advance that all the varieties of horrific monstrousness we can think of really just are "illustrations" of the "work" of abjection. This includes an astonishing variety, ranging from *Alien*'s monstrous mother to the disintegrating cannibalistic zombies in *Night of the Living Dead,* or from Seth Brundle's hideously gooey and amoral fly to the *Texas Chain Saw Massacre*'s cannibalistic family. In what sense is a psychological theory of abjection "explanatory" when it becomes so broad? And in any case, why can't it be the case that there are unique, distinctive, sui generis human fears of a variety of things? Keep in mind that abjection in a Kristevan framework always refers at bottom to the necessity of separation from the primal mother. Why must all other fears somehow equal or be reduced to fear of the primal mother?

Second, even supposing one were to grant that psychoanalysis is a worthy psychological theory, this is not an argument for the particular psychoanalytic views of Lacan or Kristeva. There are many alternatives; so why settle on these? Lacan makes problematic and philosophically disputable metaphysical assertions about the self, the nature of desire, and so on.[10] Kristeva makes equally problematic quasi-empirical claims about, say, the infant's acquisition of language. Her views are quite contro-

---

[8]Ibid., p. 42.

[9]See Frederick Crews, "The Unknown Freud," *The New York Review of Books* 11, 19 (November 18, 1993): 55–66; Adolf Grünbaum, *The Philosophical Foundations of Psychoanalysis* (Berkeley: University of California Press, 1984): Gilles Deleuze and Félix Guattari, *Anti-Oedipus,* trans. by Robert Hurley et al. (New York: Viking, 1977).

[10]See my "Woman, Revealed or Reveiled? An Approach to Lacan via the *Blithedale Romance* of Nathaniel Hawthorne," *Hypatia, a Journal for Feminist Philosophy* (Fall 1986): 49–70.

versial even within feminism; she has been criticized for, variously, essentialist theorizing, promoting anarchy, idealizing maternity, or adopting views that are fascistic, apolitical, or ahistorical.[11] Luce Irigaray offers both scathing critiques of Lacan and intriguing alternatives to some of Kristeva's most basic claims.[12]

Clearly, within psychoanalysis, we can identify many alternatives to Lacanian or Kristevan frameworks that might also be fruitful for film studies. Stanley Cavell, for example, borrows from traditional Freudian psychoanalysis to offer quite subtle and complex accounts of viewers' desires and interests in relation to both male and female actors' embodiments of film characters' roles.[13] He seems to provide a promising framework for the analysis of certain types of films, such as melodrama or the genre he calls the "comedy of remarriage." Alternatively, for all we know, Jungian or Reichian psychoanalytic theories might be intriguing psychological theories to put to the test in film studies. Jungians, with their theory of universal unconscious archetypal structures, might pay more attention to cross-cultural considerations in films, or to films' links with various kinds of fairy tales and myths. Reichians have the virtue of emphasizing concrete external sociomaterial factors in identity formation and repression. Perhaps Horney's notion of womb envy or Klein's of the bad mother would enable us to offer better interpretations of certain films, like *Frankenstein* or *The Brood*.

Third, moving away from the particular restrictions of psychoanalysis, I find that psychodynamic theories often tend to be weak as film readings because they are too reductive. They tend to utilize a one-dimensional system of symbolic interpretation. For example, even when a Kristevan interpretation seems illuminating for certain aspects of a film, as for example it does when Creed uses it to comment on horrific aspects of the climactic birth scene in *The Brood*, her focus on this aspect of the film alone seems to lead her to neglect many other important features of the film.[14] In my view this film offers a critique of several concrete contemporary social problems: the evils of charismatic psychotherapists, and the ways in which child abuse gets perpetuated from one generation to the next. It is limiting to translate a social critique into a depth-psychological thesis about how we all (allegedly) have deep ambivalences about our abjected mothers. Even more of a problem is the fact that Creed's framework locates the film's chief source of horror in the freakish mother (Samantha Eggar), setting aside the film's apparent depiction of the megalomaniac psychiatrist, Dr. Hal Raglan (Oliver Reed), as its central villain. Creed's account thereby becomes insensitive to historical allusions the film makes (and that Cronenberg quite typically makes) to the tradition of mad scientist horror films. She also misrepresents the structure of the film's plot, which depicts an appropriate punishment that Dr. Raglan suffers for his hubris—as he is destroyed by the monstrous children he has so freakishly "fathered."

---

[11]See Kelly Oliver, *Reading Kristeva: Unraveling the Double-Bind* (Bloomington: Indiana University Press, 1993), introduction, "Oscillation Strategies," and chapter 1, "The Prodigal Child."

[12]See ibid., chapter 7, for discussion of Irigaray's differences with Kristeva.

[13]Stanley Cavell, *Pursuits of Happiness: The Hollywood Comedy of Remarriage* (Cambridge: Harvard University Press, 1981); for feminist departures that build upon Cavell's work, see Naomi Scheman, "Missing Mothers/Desiring Daughters: Framing the Sight of Women," *Critical Inquiry* 15 (Autumn 1988): 62–89.

[14]Creed, *The Monstrous-Feminine*, pp. 43–58.

Fourth, psychodynamic film theories that depend upon very basic distinctions between males and females—whether as viewers, objects of the gaze, or pursuers of distinct sorts of pleasures—rely upon certain notions of gender that are themselves problematic and under question by feminists. Many feminist and other critics have pointed out that assertions about fears of castration, or about the masculinity of logic and language, may be radically culture- and era-bound. To make very broad generalizations about "male" or "female" viewers blocks the recognition of significant individual differences among viewers that surely affect how they experience films. These include significant differences of social class, sexual orientation, age, race, and so on. For example, given that racial identity seems an important factor in some horror movies, such as *Night of the Living Dead* and its sequel *Dawn of the Dead,* it seems unreasonable to presume that white and black female viewers will experience the film, its "gazes" and its "visual objects" in just the same ways. These films seem explicitly to pair white females and black males as sharing a certain "victim" status.[15]

Even the most basic assumption of psychodynamic feminist film theorists, that it is conceptually useful and appropriate to distinguish between male and female viewers, and even between heterosexual and homosexual men or women, have been placed under attack in recent theoretical work in queer and performance theory by writers like Judith Butler and Eve Sedgwick. A focused awareness of issues in queer theory could lead, for example, to intriguing re-visions of a movie like. *The Silence of the Lambs.* I have in mind not the obvious problems with the film's homophobic depiction of the "Buffalo Bill" character, but critical textures that may be added to readings of the film when we focus on its strange pairing of Jodie Foster, who was at the time of the film's release controversially "outed" by ActUp, with the villainous yet charming "Hannibal Lecter" character whose fussy mannerisms allow him to be read as "an old queen."[16]

Fifth, another difficulty with a psychodynamic, especially a psychoanalytic, framework for feminist film studies is that this view has mysteriously acquired a predominance within feminist film theory that is completely disproportionate to its status within contemporary feminist theorizing in general. British, American, and French feminists differ from one another and among themselves, not to mention from Third World anticolonialist feminists, and major books in both popular and academic feminism in the United States have adopted widely divergent theoretical bases—but these are typically not psychoanalytic. Instead, they range from a rather vague and standard liberalism grounded in the tradition of John Stuart Mill, to more radical forms of Marxist socialism; and from Foucauldian emphases on disciplinary techniques of knowledge and bodily control to new, visionary feminist work on ecosystems and the possibly liberating role of technology. Surely these diverse and flourishing forms of feminist theory also have something to offer to film studies. Many of them focus, for example, on subjectivity and desire, on visual objectification and

---

[15]For a particularly acute critique of feminist film theory's neglect of race issues, see Jane Gaines, "White Privilege and Looking Relations: Race and Gender in Feminist Film Theory," in ed. *Issues in Feminist Film Criticism,* pp. 197–214.

[16]This observation was made by Douglas Crimp in a lecture he delivered at the University of Houston in the fall of 1991.

equality, or on technologies of representation in ways that would seem readily adaptable to film studies.

Sixth and last, I doubt that whatever insights are produced by psychodynamic readings of horror films require a grounding in some particular psychogenetic theory that allegedly explains viewers' interests and responses in general filmic narratives and representations. As I have noted, psychoanalytic feminists construct genderized accounts of the tensions in horror between key features of spectacle and plot. But it is entirely possible to construct a theory of horror that emphasizes these same tensions without genderizing them. As far back as the ancient world, Aristotle's account of tragedy in the *Poetics* recognized a tension between the aesthetic effects evoked by tragedy and its narrative structures.[17] Noël Carroll's *The Philosophy of Horror* follows Aristotle and similarly pays central attention to the dichotomy horror typically depends upon between the cognitive pleasures of following out the narrative and the emotional pain of art-horror associated with monsters and spectacles.[18] If an account like Carroll's grasps these same tensions and offers reasonable explanations of them without alluding to either gender or depth psychology, it is hard to see why as feminists thinking about horror we need to resort to such theorizing. To my own mind, if there is any particular merit in the sort of comment that Creed makes about *The Exorcist* in the passage I quoted above, we can make this judgment by looking at the movie, without any special devotion to or even knowledge of the intricate theoretical grounding (and jargon) of Kristevan psychoanalysis.

Some of the general problems I have just enumerated will likely arise for other psychodynamic feminist approaches to horror, even ones that do not begin from a strictly psychoanalytic framework, such as Carol Clover's "gender rezoning" proposal in her recent book *Men, Women, and Chain Saws: Gender in the Modern Horror Film.*[19] Clover's approach does have much to recommend it: she discusses subgenres of horror rather than trying to create a wholly uniform theory; she attempts to locate horror films within their sociocultural context; and she recognizes and indeed focuses on some of the elusiveness of gender categories. Her theory is much less subject, then, to my fourth objection listed above.[20]

Yet even so, Clover's account is problematic because, in the place of psychoanalysis, she assumes the validity of an alternative theory of gender and of our psycholog-

---

[17]Of course, certain of Aristotle's sexist assumptions may have had an impact on his evaluational schema for tragedies; for more on this, see my "Plot Imitates Action: Aesthetic Evaluation and Moral Realism in Aristotle's *Poetics*," in *Essays on Aristotle's Poetics,* ed. Amelie Rorty (Princeton: Princeton University Press, 1992), esp. pp. 126–28.

[18]Noël Carroll, *The Philosophy of Horror: Paradoxes of the Heart* (New York: Routledge, 1990).

[19]Carol J. Clover, *Men, Women, and Chain Saws: Gender in the Modern Horror Film* (Princeton: Princeton University Press, 1992). See also my review in *Afterimage* (March 1993).

[20]Despite her attention to "rezoning" of gender distinctions and to social factors in horror film plots, Clover still seems at times to fall prey to reductive generalizations or rather simplistic dichotomies and associations between viewer characteristics and stereotyped gender notions. By her own admission, she is mainly interested in why the predominantly male viewers of horror subject themselves to being "hurt" (= "feminized") by the genre. Her fourth chapter, "The Eye of Horror," examines the role of eyes, watching, and gazing in horror films like *Peeping Tom* (1960). On the one hand, Clover argues that this film depicts what she calls the "assaultive gaze" of the camera, which is "figured as masculine" ("A hard look and a hard penis mean the same thing"); but on the other hand, it also critiques that gaze and showcases the "reactive gaze," "figured as feminine, of the spectator" (p. 181).

ical conceptualizations of it—Thomas Laqueur's "one sex" model. According to Laqueur, sex is primitively conceived as involving one norm, masculinity, of which femininity is a defective version. Clover thinks this model is somehow operative both in the construction and in the experience of works in the horror genre. There are several distinct questions to raise here. First, one might ask on what basis we should be persuaded to adopt this particular theory of gender. Laqueur is a historian of science whose views are by no means universally accepted, and so relying on his theory is a rather strange and arbitrary choice. It seems doubtful to me that any book of film theory can argue convincingly for the truth of a particular psychological theory of gender. Next, we might ask Clover to argue for the applicability of this theory of gender to the horror genre. She does make a stab at this, but only vaguely, by asserting that horror originated in the time of the rather primitive science that Laqueur is analyzing. This claim itself needs more detailed defense. Does it even hold of the early works *Frankenstein* and *Dracula* for instance? I doubt it. Finally, even granted that her historical claim about the psychological theories prevalent during the creation of early works of horror were correct, Clover ought to recognize that such a theory is hardly predominant any longer. Accordingly, it would seem reasonable for us to expect more recent forms of horror to reflect the current state of public knowledge and scientific theorizing about sex. My doubts about all the gaps in Clover's exposition lead me to question her particular observations about individual films. Again, where I find such observations insightful, I am inclined to think that their value stems more from how acutely they "read" film texts than from how accurately they reflect the real human psychology of actual viewers.

## PART 2: A PROPOSED FEMINIST FRAMEWORK FOR READING HORROR FILMS

In Part 1 I described various approaches to horror within contemporary feminist film studies and identified problems in these approaches, some involving specific psychoanalytic tenets, others, more general problems about psychodynamic approaches. But the feminist theorists I have examined are limited by more than their problematic universalizing views about human psychosexual development. They also lack a deep and well-grounded historical awareness of horror's roots and varieties. Clover's book does focus on a range of horror plots and on their social and cultural contexts, but only on horror films of the past two decades. Horror has a much longer, more complex history. It originated from the gothic novel, a fact in itself important for feminists to note because of the unusual prevalence of women as both writers and readers in this genre.[21] Much good feminist work has been done in recent years concerning gothic romance and the origins of horror in works like those of Mary Shelley.[22] Ideally, feminist readings of horror films would benefit from awareness of this research and of related work

[21]Eugenia de la Motte, *Perils of the Night: A Feminist Study of Nineteenth-Century Gothic* (New York: Oxford University Press, 1990)

[22]See Anne K. Mellor, *Mary Shelley: Her Life, Her Fiction, Her Monsters* (New York: Methuen, 1988); and Susan Gilbert and Susan Gubar, *The Madwoman in the Attic*) (New Haven: Yale University Press, 1979), especially chapter 7, pp. 213–47.

in cultural studies that examines the history of horror in relation to specific sociocultural contexts.[23]

Further, feminist psychodynamic accounts do not seem sensitive to the dazzling diversity of horror's subgenres: gothic, mad scientist, alien invader, slasher-psycho, rape revenge, B-movie, cult film, science fiction, monster, possession film, zombie, comedy, Japanese horror (Godzilla), and so on—even music video horror (Michael Jackson's *Thriller*)! In light of all this genre diversity, I doubt there can be any one "feminist theory of horror." Reflecting on the astounding variety of styles, nuances, and tones within this genre would also lead me to doubt any particular theory that associates gender with the kind of looking, or monstrousness, or victimization that is typical of horror, or with some "work" of abjection that horror films necessarily "illustrate." Films within a single subgenre like the vampire film may present male monsters as distinctive as the emaciated Kinski Nosferatu, the campy Bela Lugosi, the languid Frank Langella, the sinister Christopher Lee, and the macabre ball-goers of Polanski. A quite horrific and gory movie can also be wildly funny (*Texas Chain Saw Massacre II, An American Werewolf in London*). Horror films can be very eerie and subtly creepy (*The Dead Zone*), or they can revel in over-the-top, hair-raising, outrageous effects (*Evil Dead II*). They can be depth-psychological "family romances" (*Repulsion*) or virtual cartoons (*Predator 2*). They can be historical costume dramas (Herzog's *Nosferatu,* Coppola's *Bram Stoker's Dracula*) or technophilic futuristic visions (*Alien*). They can be vividly realistic (*Jurassic Park*) or ridiculously fake (*Godzilla*). They can be incredibly original (*Scanners, Brain Dead*), mindlessly imitative (*Silent Madness, Orca*), or a little of both (*Body Double*).

I assume, then, that a promising feminist approach to cinematic horror should be historically aware and also broad and open enough to work for all of these varieties of horror. In light of these observations, as well as the list of six criticisms I made in Part 1, the task of building a "feminist theory of horror" may seem monumental. And in fact, this is not exactly what I aim at here. My proposal is perhaps best understood not as a "theory" of horror, but as an attempt to begin making good on some of the deficiencies and positive requirements I have outlined. I suggest a strategy or framework for constructing feminist readings of horror films. My strategy would emphasize the structure of horror films and place special weight on their gender ideologies, in a sense I shall explain further below.

First, it is useful to distinguish various roles that feminism can play in film studies. For convenience I shall label these roles, somewhat pretentiously, the "extra-filmic" and "intra-filmic." By the "extra-filmic" role, I mean to refer to feminist investigations, in a sociological, anthropological, or historical vein, into actual concrete issues concerning the historical context, production, and reception of horror films. In this role, feminist critics would ask questions, for example, about women's motives and experiences in producing, writing, directing, editing, and acting in horror films. Alternatively, they might explore reception theory, looking at actual examples of how various kinds of periodicals and audiences, such as feminist and lesbian audiences,

---

[23]See James Twitchell, *Dreadful Pleasures: An Anatomy of Modern Horror* (Oxford: Oxford University Press, 1985), and Andrew Tudor, *Monsters and Mad Scientists: A Cultural History of the Horror Movie* (London: Basil Blackwell, 1989).

review and read horror films—perhaps in unusually creative and nonstandard ways.[24] Another type of extra-filmic exploration would be that of the cultural historian who aims to locate specific periods or varieties of horror movies within the sort of historical and social context that I find absent in most current feminist theorizing. In this role, feminist critics could examine the links between horror films and related works of literature.

Though I consider all the types of extra-filmic exploration that I have just mentioned very important, my own focus, stemming in part from my own perspective in philosophy—a notoriously nonempirical discipline—will instead be on what I call the intra-filmic questions about horror. My proposal for producing feminist readings or interpretations of horror films is that we should focus on their representational contents and on the nature of their representational practices, so as to scrutinize how the films represent gender, sexuality, and power relations between the sexes. I suggest that feminist readings of a horror film proceed by looking at various crucial sorts of film elements. Some of these elements concern the representation of women and monsters within films. Others explore how the film is structured and how it works. Within my recommended framework, we must shift attention away from the psychodynamics of viewing movies, and onto the nature of films as artifacts that may be studied by examining both their construction and their role in culture. To study their construction we look at such standard features as plot, characters, and point of view. To study their role in culture—that is, to inquire about this as feminists—we examine their gender ideology. This is my chief goal in producing feminist readings of horror films.

Let me offer some clarifying comments here about my proposal. The label "ideology" I borrow from Marxist theory, supposing that an ideology is a distorted representation of existing relations of power and domination. In the particular project I am interested in, obviously, these would be relations of patriarchy or male domination (together with any relevant associated relations of class or race dominance). Feminist ideology critique is a deep interpretive reading that criticizes or analyzes a film's presentation of certain naturalized messages about gender—messages that the film takes for granted and expects its audience to agree with and accept. These will typically be messages that perpetuate the subordination and exploitation of women; they present gender hierarchy or genderized roles and relations that are somehow portrayed as normal in the discourse of the film.[25] Or, occasionally and more interestingly, an analysis of the film's ideology might show that the film itself is raising questions about "normal" relations of gender dominance.

---

[24]As a parallel, see "Illicit Pleasures: Feminist Spectators and *Personal Best*," by Elizabeth Ellsworth, in *Issues in Feminist Film Criticism*, pp. 183–96.

[25]For another example of an ideological examination of horror films that takes a different approach from mine, see Tania Modleski's "The Terror of Pleasure: The Contemporary Horror Film and Postmodern Theory," in *Studies in Entertainment: Critical Approaches to Mass Culture*, Tania Modleski, ed. (Bloomington: University of Indiana Press, 1986), pp. 155–66. Modleski advances a complicated set of reasons for rejecting the ways in which certain postmodern theorists have championed some horror films for allegedly deconstructing the self, revealing the primacy of spectacle, and so on. She sees these films as attacking the feminine through their attacks on representatives of the family or consumer culture; examples she discusses are *Halloween* and *Dawn of the Dead*). [See this edition, pp. 764–73.]

It might be thought that the strategy I favor resembles a somewhat old-fashioned feminist approach to film studies, the "images of women" approach.[26] On this approach, one would analyze a genre of horror like the slasher film, say, by observing how images of women are presented in these films. Thus, typically, young women are shown either as tomboys or as teenaged sex fiends who somehow deserve their dismemberment at the hands of a Jason or Michael Myers. I do recommend that to explore a film's gender ideology, we ask various questions that would also be asked on this approach, such as, How does the film depict/represent women—as agents, patients, knowers, sufferers? or, What role do women play vis-a-vis men in the film? However, I take feminist ideology critique to go beyond this rather simple set of questions in two main ways.

First, I want to emphasize films as complex functioning artifacts composed of a wide variety of elements, including more than simply the representation of characters. Obviously, films also include technical and formal filmic features such as editing, visual point of view, lighting, sound, and costuming, as well as features shared with literary works such as plots, dialogue, audience point of view, and narrative structure. Feminist ideology critique will explore any or all of these features that seem relevant to understanding a film's presentation of gender ideology. This may include focusing on what Noël Carroll has called rhetorical strategies, such as the elicitation of audience presumptions in completing gaps in the story.[27] So on my approach we would ask questions like these: How do the film's structures of narrative, point of view, and plot construction operate in effecting a depiction of gender roles and relations? Does the film offer a "heroic modernist" narrative of mastery, centered upon a male character, offering up either a clear resolution or a noble tragedy? Or, is there a nonstandard narrative centered upon female characters, offering, perhaps, a more open-ended and ambiguous conclusion? Does the film reference historical or genre precedents—say, a particular earlier vampire film, or the mad scientist genre in general—and if so, how does it comment upon, replicate, parody, or revise the gender thematics of its predecessors? What are the film's implicit rhetorical presuppositions about natural gender roles and relations? Does the film present possibilities of questioning or challenging these presumptions?

Second, I do mean something by calling feminist ideological critique of horror a "deep" interpretive reading. An interesting and creative feminist reading of a film may look "below" its surface representations of male or female characters to consider gaps, presumptions, and even what is "repressed," by which I mean simply blocked, omitted, or avoided, in these representations. My strategy accords with advice laid out by the French feminist Luce Irigaray in her discussions of how to construct disruptive feminist readings of the discourse of the male western philosophical tradition:

---

[26]For discussion of this approach, see Noël Carroll, "The Image of Women in Film. A Defense of a Paradigm," *The Journal of Aesthetics and Art Criticism* 48, 4 (Fall 1990): 349–60.

[27]Noël Carroll has discussed a somewhat different notion of the ideological effects of cinema. The particular conception Carroll criticizes, the "Althusserian Model," rather narrowly alleges that films' contents and formal structures function to present a certain distorted picture of the viewing subject. Carroll offers persuasive objections to this approach and considers an alternative rhetorical analysis that draws upon Aristotle's, to show how "rhetorical strategies may be implemented in narrative film" (p. 223). Noël Carroll, "Film, Rhetoric, and Ideology," in *Explanation and Value in the Arts,* ed. Salim Kemal and Ivan Gaskell (Cambridge: Cambridge University Press, 1973), pp. 215–37.

"The issue is not one of elaborating a new theory of which woman would be the subject or the object, but of jamming the theoretical machinery itself, of suspending its pretension to the production of a truth and of a meaning that are excessively univocal."[28] Referencing Irigaray may seem inconsistent on my part, given that she operates within the Lacanian psychoanalytic tradition. However, Irigaray has in fact written some of the strongest feminist critiques I have read of the most basic assumptions of Freudian and Lacanian psychoanalytic theory. Further, I do not believe that a use of her recommended strategies of reading—for philosophy, literature, or film—must rely on any specific psychosexual assumptions. That is, as strategies of *reading* they work much like deconstructive textual strategies that are logically separable from those psychological assumptions. A brief example may help show this.

Irigaray has written critically about Plato's and Aristotle's treatment of form and matter in their metaphysics. She shows how they regard form as more valuable because they associate it with masculinity and order. Now, it could well be said that Irigaray proceeds by offering some sort of depth psychological reading of how these philosophers treat matter: Plato, as the "womb," Cave, or receptacle; Aristotle as the "envelope" or penis sheath. This sort of reading could be regarded as an analysis of their motives or of the ongoing appeal of Greek philosophical frameworks to subsequent, mostly male philosophers. However, it strikes me that Irigaray's critique functions equally as a deconstructive reading that enables one to question some of the most basic assumptions of the discourse she is examining, in this case, ancient metaphysics. One can find actual passages in which these philosophers associated form with masculinity. So, Irigaray's "deep" reading conforms with my conception of ideology critique, in that she questions the most basic ways in which an apparently neutral and objective field, metaphysics, conceals and contains hierarchized gender notions. One need not accept any psychoanalytic tenets to use this style of reading so as to query the particular discourse at issue, asking in this case, not only why form was associated with masculinity and considered by the ancient Greeks as more valuable than matter, but also what an alternative metaphysical schema would look like.[29]

Similarly, to try to transfer the point of this last paragraph to film studies, Carol Clover, in her examination of the depiction of the feminine in slasher films, has provided something like an Irigarayan "deep reading" that criticizes an existing form of discourse. She points out first, the obvious, that these films typically show young women as somehow bad—too sexy and alluring—before they are attacked by a male. Beyond this, she offers a "deeper" reading by arguing that slashers also reinforce cul-

---

[28]Luce Irigaray, "The Power of Discourse," in Irigaray, *This Sex Which Is Not One,* tran. Catherine Porter (Ithaca, N.Y.: Cornell University Press, 1985), p. 78.

[29]For more thoughts about the usefulness of Irigaray's approach for a nonpsychoanalytic feminist analytic philosophical reading of historical texts, see my "Nourishing Speculation: A Feminist Reading of Aristotelian Science," in *Engendering Origins: Critical Feminist Essays on Plato and Aristotle,* ed. Bat-Ami Bar On (Albany, N.Y.: SUNY Press, 1994), pp. 145–87, and "Reading Irigaray Reading Aristotle," in *Re-Reading the Canon: Feminist Essays on Aristotle,* ed. Cynthia Freeland (Pennsylvania University Press: forthcoming), pp. 126–42. Kelly Oliver offers a somewhat similar approach, which she also calls ideology critique in drawing upon both Irigaray and Kristeva's theories, in her article "The Politics of Interpretation: The Case of Bergman's *Persona,*" in *Philosophy and Film,* ed. Cynthia A. Freeland and Thomas E. Wartenberg (New York: Routledge, 1995), pp. 233–48. However, I believe that Oliver shows much more sympathy to psychoanalytic accounts of, say, "the maternal" than I do.

tural messages about the virtues of masculinity by presenting a villain who is defectively masculine—often someone pudgy, awkward, shy, or seemingly impotent—and a heroine (the "Final Girl") who is more masculine than feminine. I would call this a "deep" reading because it shows that the apparently male villains are actually bad because they are culturally coded as feminine. Where I part ways with Clover is that I reject her assumptions about the need for grounding this sort of reading in the truth of a given psychosexual model (Laqueur's), or about the processes through which slasher audience's psychological investment (and hence pleasure) in these movies alleged reflects certain standard, universal, gender-associated psychological interests.

My recommended approach is continuous with previous approaches to artworks in the Western aesthetic tradition, ranging from Aristotle's account of tragedy in the *Poetics* and Kant's *Critique of Judgment* to more contemporary works like Kendall Walton's *Mimesis as Make-Believe.* Philosophers have typically supposed that it is appropriate in aesthetic theory to discuss aspects of the psychology of our response to artworks, but they have done so without presuming any particularly detailed theory of the psyche. They emphasize that paintings, tragedies, or even landscape gardens are a particular kind of phenomenon, intentionally created and structured to produce a certain kind of effect—catharsis, aesthetic distance, the free play of the imagination, and so on. It is enough for purposes of philosophical aesthetics to employ commonsense, everyday notions of human psychology, to assume that we are capable of being frightened, excited, horrified, and so on, by artistic representations, and then proceed to try to analyze how this occurs.

Adopting my proposed framework means simply that a feminist critic will construct a reading that focuses on gender representation within a film, beginning with a list of specific questions that can vary as appropriate—according to the film's own period, style, and tone. Distinct feminist readings of the same horror film could easily be constructed. It is indeed always possible that a film may not have much to say that is particularly exciting or illuminating on the subject of gender. Also, and importantly, a feminist reading need not be a "complete" reading of the movie that purports to attend to all its many elements.

I believe that my proposal to use a basic set of questions about gender ideology as a broad strategy for feminist film readings helps overcome some of the defects of current feminist film theorizing I enumerated in Part 1, and I want to explain more here how I see it as an improvement. Recall that my first two objections concerned the problematic assumptions of a particular psychoanalytic theory or of psychoanalysis generally. Obviously, my proposed strategy does not encounter these problems. It does not adopt any particular psychodynamic theory or theory of sexual or gender difference. My third objection queried currently dominant presumptions about gender dichotomies between, for example, the aggressive masculine gaze and the passive female spectacular body. I avoid these sorts of assumptions about gender precisely by foregrounding as my first question the issue of *how* a film depicts gender. My fourth objection was a challenge to the theoretical reductivism of dominant feminist film criticism; on this point, I would hope that my strategy opens out to connected issues concerning race, class, and so on.

My fifth objection concerned the narrowness of psychodynamic feminism in comparison to other important forms of feminist theorizing. One could use the map I

propose in combination with many types of feminism. For example, to diagnose the gender ideology of a film, one could adopt the viewpoint of a Marxist or liberal feminist; in either case I would suppose one could be critical, though of different aspects of the film, and to different ends. Similarly, a feminist theorist steeped in Foucault or Donna Haraway might ask about some of my questions by looking at very different features of a film—at, for instance, how it portrays disciplines of the female body, or how it depicts women in relation to technology.

My sixth objection stated that one might equally well achieve the insights of feminist psychoanalytic film theory without its propping in a psychodynamic theory. I think that some of the questions I have listed above actually do this, that is, would work to take the place of others posed on the more problematic basis of, for instance, depth psychoanalysis. Questions about "the gaze," the sadistic male viewer, the masculine narrative order, and so forth, are replaced here by questions about whether the film presents women as primarily suffering and tortured physical beings, or whether they are also shown to be alert, curious, intelligent, capable of independent investigation, and so on, and also by questions about whether the women characters help move the narrative along, or are simply targets of the horrific spectacle. I would hope that a careful consideration of these questions would avert reductivism and allow flexibility in recognizing that horror movies often have very complex, mixed representations of women.

## PART 3: ILLUSTRATIONS

It is time to illustrate how I would use my own recommended strategy to generate critical feminist readings of horror films and their gender ideologies. I will first discuss *Jurassic Park* and *The Fly,* films I choose specifically because, on the surface at least, they seem to present positive images of strong, intelligent, and active women. This makes them especially interesting to read for underlying ideologies. Next I shall compare these films to *Repulsion,* a film that on the surface seems problematic because it features a horrific female slasher/murderer, but which I find to present a surprisingly radical questioning of existing gender ideology.

I begin with *Jurassic Park.* First, how does the film represent women? Superficially at least, it displays a contemporary, 1990s feminist vision of women and girls. The female paleobotanist Dr. Ellie Sattler (Laura Dern) is presumably well-educated and authoritative in her own field; she shows enthusiasm and expertise in classifying the ancient plants in the park. She is courageous and physically active, and she makes cracks about the other characters' sexism. And the young girl is said to be a computer hacker.

Nevertheless, we can hardly call the movie an unmitigated feminist achievement. The paleobotanist's own scientific expertise is never treated as especially deep or relevant. It is rather the male scientist Dr. Alan Grant (Sam Neill) who espouses a controversial theory (about dinosaurs' close relation to birds) that will get tested and confirmed in the park. Ellie is shown enthusiastically identifying plant species in the park but, importantly, the plants themselves are not intrinsically interesting here but function only as fodder for the dinosaurs. Thus, even in her scientific role, the woman could be said to be chiefly concerned with nourishment and caregiving. Amazingly,

she has never heard of chaos theory, and the male mathematician Ian Malcolm (Jeff Goldblum) explains it to her in the context of a teasing sex scene that treats her like a silly teenage bimbo. This sort of depiction is further enforced by the fact that she is blonde, pretty, slender, and at least ten years younger than her male scientist colleague and lover. Further, through most of the film she, unlike any of the male characters, consistently wears little shorts that show off her long coltish legs.

Similarly, the young girl (Ariana Richards) spends most of the film in abject fear of the T-rex. She is even afraid of the large gentle brontosaurus, who sneezes all over her and makes her look ridiculous. The fact that she is a computer hacker is introduced rather casually and coincidentally toward the end of the film and does not seem especially well integrated into her character. When she manages to get into the computer system, her task is the relatively minor one of figuring out how to get a door to close properly.

Next, how is monstrousness in the film related to femininity? All the monsters (dinosaurs) in the movie are female, but initially it seems that not much is made of this—nothing particularly horrific about primal mothers on the scale of *Alien,* at least. It is not easy to read the femininity of the monsters here, since it is not uniform, but seems to permit a great range of difference: some varieties are huge and voracious; others (the raptors) are smaller, clever, and vicious; yet others are large, gentle, cow-like beings vulnerable to indigestion or colds. I would suggest that the film presents a standard array of culturally coded, negative messages about females through its depiction of these various dinosaurs. Some dinosaurs, like some women, are fat, sweet, and gentle; and others are thin, vicious, and scheming. (There can be, in other words, no sweet, smart dinosaurs!) One could go further in noting that from the perspective of the male scientists who create and study the park, all female dinosaurs have a mysterious sexuality that is "other": their peculiar threat lies in their frog-derived ability to convert their sex so as to be able to reproduce independently. Thus on a deep reading, the female dinosaurs represent a culturally coded threat centering upon a kind of uncontrolled, rampant female sexuality, as well as awesome reproductive abilities.

Another question to ask about in assessing a film's gender ideology concerns who moves the narrative along, who its chief agents are; here, clearly in *Jurassic Park* it is not the woman or girl. There are no women involved in the creation or operation of the park itself. The key human agents of the movie who initiate the chain of events presenting the movie's central problem—the park mogul, the shark lawyer, and the computer wizard—are all men. Men are thus shown in the film as running the show in all the relevant senses: setting up the problematic situations, making them worse, and then resolving them. True, girls can be hackers and scientists, but this seems peripheral to their chief roles, since during most of the action sequences of the movie they are relegated to functions of nurturing the ill or taking care of men. Ellie is not at the center of the key scenes that depict the children's being threatened, then escaping, the tyrannosaurus. Instead, the male scientist/father figure does this, while she is confined mainly to nursing, first the sick triceratops, then the wounded mathematician. Her sudden interest in the sick triceratops seems poorly explained by her alleged scientific expertise in the plants it eats, but it furthers a general depiction of her as caring and nurturing. She has, literally, the ideal human mother's ability to deal with mounds of shit!

On the whole, then, the gender ideology of *Jurassic Park* seems to be to confirm that women, even when they are brave and scientific, must remain pretty, flirtatious, and nurturing. From the very start the film represents it as a central aim in Ellie's life to convince her lover to have children. Thus in the film's trajectory, Grant fulfills his chief aim, demonstrating his scientific hypothesis about dinosaurs, while she fulfills hers in parallel, as one of the film's closing scenes shows her smiling happily (in a view we share) at Alan, now appropriately fatherly, sleeping with the two children he has saved cuddled in his arms. The film's ending thus depicts a resolution that produces a happy, relieved, and idealized nuclear family. It includes none of the foreigners who are lowly park laborers, no computer nerds, no greedy lawyers, and no black members—just the white surrogate parents and grandfather whose regret signifies that he is to be exonerated for his mistakes in the otherwise "innocent" desire to entertain people. Even more significantly, the very last scene of the film is a vision of flying birds—pelicans who, seen in silhouette over the water, resemble pterodactyls. Thus the film concludes with a subtle message that reinforces the "heroic" male scientist's creative vision and theoretical achievement in hypothesizing correctly about the bird-like nature of dinosaurs.

I move now to my second example, David Cronenberg's remake of *The Fly*. In this film, the heroine, Veronica Quaife (Geena Davis), is represented as an ambitious, intelligent, pragmatic, and successful career woman, a science writer. She is also charming, funny, beautiful, and sexually forward—either a fantasy woman who falls straight into bed with men, or the confident new woman assertive about her own sexual desires. True, she could be said to behave in unprofessional ways (having first slept with one of her college professors, who is now her editor, and later with the subject of her current research article)—but so do the men in the movie. More problematic is the fact that she only seems to exist in the film in relations of subordination to men. As a science writer her position is more lowly than that of the creative scientists whose genius she will simply record and report on to the world. Similarly as a writer, she is subordinate to her editor at the science magazine.

These relations of subordination parallel Veronica's position in the film's plot and narrative structure. She exists in the movie primarily in a dependent relationship to the male scientist Dr. Seth Brundle (Jeff Goldblum). The film is a variant on the mad scientist genre, and Brundle is the mad scientist at the center of its narrative trajectory. If this film reaches greater tragic heights than many other mad scientist movies, that may be because it fulfills some of Aristotle's criteria for a tragic plot: the hero is a great man, sympathetic, deserving of our pity, who engages in action that involves some sort of fatal mistake and hubris bringing about his downfall.[30] This film is a narrative about *the man's* activities, his heroism, and tragic downfall. Veronica functions in it as an aspect of his tragedy and loss, and also as a modern variant on the ancient Greek chorus guiding our responses of pity and fear (or in this case, horror). The film often puts viewers into her viewpoint, forcing us to observe from

---

[30]For some thoughts about the sexism implicit in Aristotle's basic articulation of the nature of tragic plot, see my "Plot Imitates Action: Aesthetic Evaluation and Moral Realism in the *Poetics*," in *Essays on Aristotle's Poetics,* ed. Amelie Rorty (Princeton: Princeton University Press, 1992), pp. 111–32.

closer up, so to speak, the hideous transformations that occur as the fly takes him over.[31]

The particular horrific threat of this movie is an invasion by the other species of *both* the male and female body. It does take a specific turn against women when the scientist seeks his own rescue by demanding to use, and corrupt, her reproductive abilities (showcased in a disgusting nightmare she has of giving birth to a giant maggot). Yet ultimately it is he and not she who suffers; he is punished for his scientific hubris, as she fights for survival (with some male assistance, but nevertheless she is very courageous) and resists his final appeals to sacrifice herself for him. It is difficult to force a reading of the monstrousness here as a feminization of his body; what makes more sense is to see these transformations as metaphors for aging or for ravaging illnesses like cancer or AIDS.

*The Fly's* narrative has a very traditional, male-centered and male-driven form: the male scientist exceeds his role and must pay for it. The male acts, the woman feels. She occupies a traditional role in the sense that her emotions and perceptions are clues to guide us, the film viewer, to regard the man, despite his hubris, with love, pity, and sympathy. In *The Fly* as in *Jurassic Park,* the mad scientist who creates the crux of the story is a man, and the woman has to deal with the man's problem; love and empathy are the key female traits. There is no real challenge to this gendered division of labor or to the idea that stories are primarily about men, only secondarily about the women who love them. Consider, for example, the fact that Veronica's own tragedy in this movie is in itself a subordinate tragedy brought about by Brundle's mistake, and one centered in the realm of her body and her emotional life: the loss of a lover, together with a forced abortion. The movie makes absolutely nothing of the fact that she loses out on what could easily be the biggest scientific scoop of her journalistic career! (Indeed, wouldn't the savvy and competitive woman journalist she seemed to be at the start immediately begin writing up the whole thing, complete with video illustrations?) In other words, just as in *Jurassic Park,* beneath the surface depiction of an independent career woman in *The Fly* lies the ideological message that women are primarily creatures of their emotions who exist first and foremost in their love relations to men and potential offspring.

These are two examples of films I have chosen because they seem to offer positive depictions of independent women characters which I believe are undermined by deeper ideological messages. Further, they are interesting to examine in contrast with typical feminist psychoanalytic views because their depictions of the horrific monsters are not the typical ones of castrating woman or primal mother. Instead I would locate the most problematic aspects in their gender ideology at the level of their narrative, which is in each case predominantly a narrative focused on male energies, activities, triumphs, or tragedies.

---

[31]David Bordwell has suggested that a "reading against the grain" approach might take this film to be a subversive exposé of the mad scientist's "hypermasculinity" ("Nerd becomes barroom thug and rapacious seducer"). While this is an intriguing line of interpretation, I do not think it can work, mainly because of the film's continued sympathy for Brundle. Here again, as I suggest, the fact that Veronica's love and pity persist despite his ugly behavior and transformation is meant to be our guide as to how to react. I think my interpretation of the movie as a high-end horror mad scientist tragedy is more in accord with the plot and its ultimate conclusion when the creature mutely asks to be put out of its misery.

Now let me shift and describe a very different example of a horror movie with a quite different logic, *Repulsion*. Again I want to argue that surface appearances can be deceiving. On the surface this is a horror story in which a very beautiful and sexy woman, Carol Ledoux (Catherine Deneuve) becomes a mad slasher and villain who attacks and destroys men. One might initially suppose then that this is a sort of film noir anticipating the recent genre of *Fatal Attraction*-style villainess females. Carol seems to be depicted as the alluring yet shy and inhibited femme fatale whose repressed sexuality must unleash itself ultimately in horrific acts of violence against the men she desires. This view of her as repressed and even voyeuristic might seem to be confirmed by various aspects of the plot and the filmic depiction of her; she dresses demurely, speaks in a low voice, hides behind her hair, constantly peers out the windows of her flat, listens in on her sister's sexual moans and cries, inspects and throws away the shaving glass used by her sister's lover, and so on.

However, I think that this surface reading does not capture much that is going on in this film. Many of the point-of-view shots in the movie identify the audience members with leering men, from her erstwhile boyfriend to the construction workers who jeer and whistle at Carol as she walks past them on the sidewalk. On the other hand the film also switches to adopt the young woman's own viewpoint as she is chased and visually assaulted by these men. In doing so, it shows her to be a victim who merits our sympathy and empathy. Thus the feeling of the scene where she overhears her sister's lovemaking is less one of voyeurism than one of tormented embarrassment and the desire to escape. Clearly she feels threatened by her sister's involvement with the man and by her departure with him for vacation. Once she is alone in the flat, Carol becomes increasingly psychotic and delusional. As she goes mad, the audience shares her heightened perceptions, nightmares, and hallucinations. Polanski shocks and frightens us in parallel with her by showing faces that suddenly materialize in mirrors, hands that reach out from rubbery walls, or menacing shadows creeping from above on the bedroom ceiling, accompanied by weird and threatening grunting noises. Given this increasingly deranged system of perceptions, we can actually be persuaded that Carol's reaction as she reacts and kills men who enter her apartment is a reasonable one. This is particularly true when she repulses the advances of her lecherous landlord, who has offered to accept something other than money for his rental payments.

This means that what is really horrific in this movie is not the female killer (as it is, say, in *Basic Instinct* or *Fatal Attraction*); it is instead lechery, male attitudes of lust toward such a beautiful woman. The film highlights Carol's victimization by men and strongly hints that her psychosis and sexual repression stem from a history of child sexual abuse. She cannot escape the pursuit of men who wolf-whistle at her on the street, press her for dates, or attack her in her own apartment. Her sister's lover has carelessly scattered his personal hygiene items all around in the bathroom. She is even trapped in her job as a manicurist in the industry of making women beautiful so as to please men. By repeated shots linking Carol to the naked, stripped rabbit that rots uncooked on an empty plate in her flat, she is represented as childlike, vulnerable, and psychically decaying.

The overall narrative structure of *Repulsion* reflects a logic of disruption and fragmentation rather than resolution; of suffering and reacting, rather than action. The

story could not be said to be a tragedy in the classic sense, even one like that of *The Fly*. That is, *Repulsion* does not offer a narrative of a deed and its consequences, or a heroine whose action is somehow flawed, precipitating her tragic downfall. Instead this is a sort of antinarrative that presents an inability to act, a continual waiting, passivity, and suffering. Even Carol's final acts of killing the two men seem to be reactions rather than genuinely intended deeds. Surely Carol does not "deserve" her suffering, nor is she an evil *Fatal Attraction*-style femme fatale. To be sure, this film is not visionary in the sense of offering up an alternative model of gender roles. Nevertheless, it certainly does call existing roles and attitudes into question in a particularly interesting way, by implicating the audience in watching this woman—who is indeed very beautiful—by following her as she walks down the street, by extreme close-ups of her face and appearance—so much so that she begins to seem to want to hide from the camera itself behind her long pale hair.

In *The Fly* too the heroine's story revolves around her emotional suffering, but as I interpreted that film's gender ideology, it represented such suffering as appropriate for a woman character whose fate is basically subordinated to that of the male hero. Her suffering functions as a cue for us in the audience, guiding us to react "appropriately" to Brundle with sympathy and pity. By contrast, in my view *Repulsion* presents a certain gender ideology in such a way as to raise a number of serious questions about it. It constructs a surprisingly critical representation of male sexual desire and the accompanying objectification of women, and it even links this kind of visual objectification to acts of violence and sexual abuse like incest. Moreover, and finally, it suggests that when women fight back against such violence and abuse, their actions may be reasonable and warranted. But it does *not* suggest, as do many movies in the recent "rape revenge" genre, that women who fight back against such abuse will achieve psychological satisfaction or be backed by a powerful judicial system.[32] It would be a less good movie, in my mind, if it did so—more problematically ideological—because it would misrepresent and gloss over existing power and dominance relations within patriarchy.

## CONCLUSION

In closing, I would like to make one cautionary point about my recommended framework for producing readings of horror films that focus on their gender ideologies. One reason I distinguish my recommended feminist ideological critique from an ordinary Marxist sort is that I want to resist a certain sort of Marxist line that places great power within the hands of the productive apparatuses of Hollywood, and correspondingly little power in the hands of audience members, treated generically as members of one social class. I believe that audience members have the power to create individual, often subversive readings of films. To speak of a film's ideology suggests that some powerful agent is distorting a message for sinister purposes of domination and control. This is misleading, I think, both because the nature of the agency in question in filmic representation is actually very diffuse, and also because it makes

---

[32]On the rape revenge genre, see Carol J. Clover, *Men, Women, and Chain Saws,* chapter 3, "Getting Even," pp. 114–65.

viewers into powerless Pavlovian dogs. Horror movie viewers are in fact often highly sophisticated and critical; horror movie screenings, in my experience, may be much more participatory than other forms of films. If the dominance relations distorted by ideology in my approach are those of patriarchy, I believe that individual viewers, in particular female viewers, may either see through such relations or reread intended ones in subversive ways.

This means that even when a film presents a problematic image of women, the audience reaction may subvert or undercut it. For example, the audience may react so as to bring out the potential dark humor of a scene. Let me offer an example here. Douglas Kellner and Michael Ryan, in their book *Camera Politica,* adopted a more standardly Marxist view of film ideology than my own. Ryan and Kellner discuss, among other topics, sexist ideologies of horror films in the early 1980s, which they interpret as expressing male backlash against feminist advances of the time.[33] They are highly critical, for instance, of the bondage scenes in *Cat People;* their discussion seems to assume that the filmmakers had an agenda that would determine audience responses by buying into their assumed agreement, that is, a shared resistance to new feminist values. Yet when I saw the film in a crowded theater in New York at the time of its release, the audience hooted derisively at just these scenes. That is, they seemed to see through this maneuver of the filmmakers so as to resist the film's surface ideology. Horror films seem often to solicit just such cynical, subversive audience responses.

In this paper I have presented not so much a feminist *theory* of horror films as a framework that I hope will prove useful for producing readings of horror films. I would like to emphasize that in my view, for any given film, a number of feminist readings might be possible. Feminist film readings interpret how films function as artifacts, and to do this they may successfully explore such diverse aspects of a film as its plot, editing, sound track, point of view, dialogue, character representations, use of rhetoric, or narrative structures. But film artifacts function within a context, and the context is constantly changing. I do not contend, for example, that the sort of reading of *Repulsion* I have offered here would have been possible or even appropriate in 1965 when the movie was released. We may see this film differently in retrospect, for example, against the contemporary background of *Fatal Attraction* and *Basic Instinct,* as well as by comparison with the recently emerging genre of the rape revenge movie. Further, there is much greater social awareness in 1995 than in 1965 of problems of incest and child sexual abuse, and these might significantly affect how a feminist of today sees certain slight allusions in the film.

My quick sketch here of film readings of *Jurassic Park, The Fly,* and *Repulsion,* is only that, a sketch. I have mainly intended to suggest how such critical feminist readings can be engaged in, and prove potentially fruitful, without psychodynamic underpinnings. Again, I emphasize films as functioning complex artistic artifacts, and I emphasize audience's critical readings rather than purportedly universal or totalizing psychological responses. My readings ask a set of central questions about films' rep-

---

[33]Michael Ryan and Douglas Kellner, *Camera Politica: The Politics and Ideology of Contemporary Hollywood Film* (Bloomington: Indiana University Press, 1988), pp. 136–67.

resentations of gender roles and relations, the horrific monster, and the type of reso-
lution presented. I believe that my proposal offers a more flexible, potentially illumi-
nating framework than psychodynamic approaches for constructing creative feminist
readings of horror films.[34]

1996

---

[34]For a more extended illustration, see my discussion of *Henry: Portrait of a Serial Killer* in "Realist Horror," in *Philosophy and Film* (New York: Routledge, 1995).

# TANIA MODLESKI
# THE TERROR OF PLEASURE:
# THE CONTEMPORARY HORROR FILM
# AND POSTMODERN THEORY

In the *Grundrisse*, Karl Marx's description of the capitalist as a werewolf turns into an enthusiastic endorsement of that creature's activities. Marx tells us that the capitalist's "werewolf hunger," which drives him continually to replace "living labor" with "dead labor" (that is, human beings with machines), will lead to a mode of production in which "labour time is no longer the sole measure and source of wealth."[1] Thus, in the words of one commentator, "capitalism furnishes the material basis for the eventual realization of an age-old dream of humankind: the liberation from burdensome toil."[2] Marx's critics have tended to place him in the role of mad scientist, with his vision of the miracles to be wrought by feeding the werewolf's insatiable appetite. Writers from Jacques Ellul to Isaac Balbus have argued (to mix narratives here) that allowing the capitalist his unhindered experimentation in the "workshops of filthy creation"—his accumulation of more and more specimens of dead labor— cannot possibly provide a blessing to humankind.

These critics claim that rather than truly liberating humanity by freeing it from burdensome toil, the proliferation of dead labor—of technology—has resulted in the invasion of people's mental, moral, and emotional lives, and thus has rendered them incapable of desiring social change. To quote Jacques Ellul, who has traced the intrusion of technique into all aspects of human existence, "as big city life became for the most part intolerable, techniques of amusement were developed. It became indispensable to make urban suffering acceptable by furnishing amusements, a necessity which

I would like to thank the Graduate School at the University of Wisconsin-Milwaukee for funding this project by generously awarding me a summer research grant in 1984.

[1] Karl Marx, *Grundrisse: Foundations of the Critique of Political Economy* (Middlesex, England: Penguin, 1973), p. 706.

[2] Isaac Bulbus, *Marxism and Domination* (Princeton, NJ: Princeton University Press, 1982), p. 41.

was to assure the rise, for example, of a monstrous motion picture industry."[3] In advanced capitalism, the narrative shifts, though the genre remains the same: physical freedom—that is, increased leisure time—is bought at the price of spiritual zombieism. The masses, it is said, are offered various forms of easy, false pleasure as a way of keeping them unaware of their own desperate vacuity. And so, apparently, we are caught in the toils of the great monster, mass culture, which certain critics, including some of the members of the Frankfurt School and their followers, have equated with ideology. For the Frankfurt School, in fact, mass culture effected a major transformation in the nature of ideology from Marx's time: once "socially necessary illusion," it has now become "manipulative contrivance," and its power is such that, in the sinister view of T. W. Adorno, "conformity has replaced consciousness."[4]

Today many people tend to believe that other, more sophisticated approaches to the issue have superseded the Frankfurt School's conception of mass culture as a monstrous and monolithic ideological machine. The work of Roland Barthes is often cited as an example of such an advance. But when Barthes offers the converse of the proposition that mass culture (for example, the cinema) is ideology and contends rather that "ideology is the Cinema of society," we are entitled, I think, to question just how far this removes us from many of the premises we think we have rejected.[5] Isn't Barthes here implying that both cinema and ideology, being seamless and without gaps or contradictions, create what the Frankfurt School called the "spurious harmony" of a conformist mass society?

According to many of the members of the Frankfurt School, high art was a subversive force capable of opposing spurious harmony. On this point especially, certain contemporary theorists have disagreed. In The Anti-Aesthetic, a recent collection of essays on postmodern culture, the editor, Hal Foster, suggests the need to go beyond the idea of the aesthetic as a negative category, claiming that the critical importance of the notion of the aesthetic as subversive is now "largely illusory."[6] However, despite such pronouncements, which are common enough in the literature of postmodernism, I believe it can be shown that many postmodernists do in fact engage in the same kind of oppositional thinking about mass culture that characterized the work of the Frankfurt School. Take, for example, Barthes' writings on pleasure. Although it is inaccurate to maintain, as critics sometimes do, that Barthes always draws a sharp distinction between pleasure and jouissance (since in The Pleasure of the Text Barthes straightaway denies any such strenuous opposition), whenever Barthes touches on the subject of mass culture, he is apt to draw a fairly strict line—placing pleasure on the side of the consumer, and jouissance in contrast to pleasure. Here is a remarkable passage from The Pleasure of the Text, in which Barthes begins by discussing the supe-

---

[3]Jacques Ellul, The Technological Society, trans. John Wilkinson (New York: Vintage, 1964), pp. 113–14.

[4]Theodor W. Adorno, "Culture Industry Reconsidered," trans. Anson G. Rabinbach, New German Critique 6 (Fall 1975):17.

[5]Roland Barthes, "Upon Leaving the Movie Theater," trans. Bertrand Augst and Susan White, University Publishing 6 (Winter 1979):3.

[6]Hal Foster, "Postmodernism: A Preface," The Anti-Aesthetic: Essays on Postmodern Culture, ed. Hal Foster (Port Townsend, WA: Bay Press, 1983), p. xv.

riority of a textual reading based on disavowal and ends by casually condemning
mass culture:

> Many readings are perverse, implying a split, a cleavage. Just as the child knows its
> mother has no penis and simultaneously believes she has one . . . so the reader can keep
> saying: *I know these are only words, but all the same*. . . . Of all readings that of tragedy
> is the most perverse: I take pleasure in hearing myself tell a story *whose end I know*: I
> know and I don't know, I act toward myself as though I did not know: I know perfectly
> well Oedipus will be unmasked, that Danton will be guillotined, *but all the same*. . . .
> Compared to a dramatic story, which is one whose outcome is unknown, there is here an
> effacement of pleasure and a progression of *jouissance* (today, in mass culture, there is
> an enormous consumption of "dramatics" and little *jouissance*).[7]

Anyone who has read Christian Metz's persuasive argument that disavowal is *consti-
tutive* of the spectator's pleasure at the cinema will find it difficult to give ready assent
to Barthes' contention that mass culture deprives the consumer of this "perverse"
experience.[8] And anyone who is acquainted with the standardized art products—the
genre and formula stories—which proliferate in a mass society will have to admit that
their import depends precisely upon our suspending our certain knowledge of their
outcome—for example, the knowledge that, as the critics say, the gangster "will
eventually lie dead in the streets." Barthes' remarks are illuminating, then, not for any
direct light they shed on the high/mass culture debate, but because they vividly exem-
plify the tendency of critics and theorists to make mass culture into the "other" of
whatever, at any given moment, they happen to be championing—and, moreover, to
denigrate that other primarily because it allegedly provides pleasure to the consumer.

While Barthes' *The Pleasure of the Text* has become one of the canonical works of
postmodernism, in this respect it remains caught up in older modernist ideas about
art. In an essay entitled "The Fate of Pleasure," written in 1963, the modernist critic
Lionel Trilling speculated that high art had dedicated itself to an attack on pleasure
in part because pleasure was the province of mass art: "we are repelled by the idea of
an art that is consumer-oriented and comfortable, let alone luxurious."[9] He went on
to argue that, for the modernist, pleasure is associated with the "specious good"—
with bourgeois habits, manners, and morals—and he noted, "the destruction of what
is considered to be specious good is surely one of the chief literary enterprises of our
age."[10] Hence, Trilling has famously declared, aesthetic modernity is primarily
adversarial in impulse.

The "specious good," or "bourgeois taste," remains an important target of contem-
porary thinkers, and postmodernism continues to be theorized as its adversary.
Indeed, it might be argued that post-modernism is valued by many of its proponents
insofar as it is considered *more* adversarial than modernism, and is seen to wage war

---

[7]Roland Barthes, *The Pleasure of the Text*, trans. Richard Miller (New York: Hill and Wang, 1975), pp.
47–48. Earlier Barthes remarks that "no significance (no *jouissance*) can occur, I am convinced, in a mass
culture . . . for the model of this culture is petit bourgeois" (p. 38).

[8]Christian Metz, *The Imaginary Signifier: Psychoanalysis and the Cinema*, trans. Celia Britton, Annwyl
Williams, Ben Brewster, and Alfred Guzzetti (Bloomington: Indiana University Press, 1982), pp. 99–148.

[9]Lionel Trilling, "The Fate of Pleasure: Wordsworth to Dostoevsky," *Partisan Review* (Summer
1963):178.

[10]Ibid., p. 182.

on a greatly expanded category of the "specious good," which presently includes meaning (Barthes speaks of the "regime of meaning") and even form.[11] For example, in an essay entitled "Answering the Question: What is Postmodernism?" Jean-François Lyotard explicitly contrasts postmodernism to modernism in terms of their relation to "pleasure." For Lyotard, modernism's preoccupation with form meant that it was still capable of affording the reader or viewer "matter for solace and pleasure, [whereas the postmodern is] that which denies itself the solace of good forms, the consensus of a taste which would make it possible to share collectively the nostalgia for the unattainable."[12] It is important to recognize the extent to which Lyotard shares the same animus as the Frankfurt School, although his concern is not merely to denounce *spurious* harmony, but to attack *all* harmony—consensus, collectivity—as spurious, that is, on the side of "cultural policy," the aim of which is to offer the public "well-made" and "comforting" walks of art.[13]

Although Lyotard has elsewhere informed us that "thinking by means of oppositions does not correspond to the liveliest modes of postmodern knowledge," he does not seem to have extricated himself entirely from this mode.[14] Pleasure (or "comfort" or "solace") remains the enemy for the postmodernist thinker because it is judged to be the means by which the consumer is reconciled to the prevailing cultural policy, or the "dominant ideology." While this view may well provide the critic with "matter for solace and pleasure," it is at least debatable that mass culture today is on the side of the specious good, that it offers, in the words of Matei Calinescu, "an ideologically manipulated illusion of taste," that it lures its audience to a false complaceny with the promise of equally false and insipid pleasures.[15] Indeed, the contemporary horror film—the so-called exploitation film or slasher film—provides an interesting counterexample to such theses. Many of these films are engaged in an unprecedented assault on all that bourgeois culture is supposed to cherish—like the ideological apparatuses of the family and the school. Consider Leonard Maltin's capsule summary of an exemplary film in the genre, *The Brood*, directed by David Cronenberg and starring Samantha Eggar: "Eggar eats her own afterbirth while midget clones beat grandparents and lovely young school teachers to death with mallets."[16] A few of the films, like *The Texas Chainsaw Massacre*, have actually been celebrated for their adversarial relation to contemporary culture and society. In this film, a family of men, driven out of the slaughterhouse business by advanced technology, turns to cannibalism. The film deals with the slaughter of a group of young people travelling in a van and dwells at great length on the pursuit of the last survivor of the group, Sally, by the man named Leatherface, who hacks his victims to death with a chainsaw. Robin Wood has analyzed the film as embodying a critique of capitalism, since the film shows the hor-

---

[11]Roland Barthes, *Image, Music, Text*, trans. Stephen Heath (New York: Hill and Wang, 1977), p. 167.

[12]Jean-François Lyotard, "Answering the Question: What is Postmodernism?" trans. Régis Durand, *Innovation/Renovation: New Perspectives on the Humanities*, ed. Ihab Hassan and Sally Hassan (Madison: The University of Wisconsin Press, 1983), p. 340.

[13]Ibid., p. 335.

[14]Jean-François Lyotard, *La Condition postmoderne* (Paris: Minuit, 1979), p. 29.

[15]Matei Calinescu, *Faces of Modernity: Avant-Garde, Decadence, Kitsch* (Bloomington: Indiana University Press, 1977), p. 240.

[16]Leonard Maltin, *T.V. Movies*, revised edition (New York: Signet, 1981–82), p. 95.

ror both of people quite literally living off other people, and of the institution of the family, since it implies that the monster is the family.[17]

In some of the films the attack on contemporary life strikingly recapitulates the very terms adopted by many culture critics. In George Romero's *Dawn of the Dead*, the plot involves zombies taking over a shopping center, a scenario depicting the worst fears of the culture critics who have long envisioned the will-less, soul-less masses as zombie-like beings possessed by the alienating imperative to consume. And in David Cronenberg's *Videodrome,* video itself becomes the monster. The film concerns a plot, emanating from Pittsburgh, to subject human beings to massive doses of a video signal which renders its victims incapable of distinguishing hallucination from reality. One of the effects of this signal on the film's hero is to cause a gaping, vagina-like wound to open in the middle of his stomach, so that the villains can program him by inserting a video cassette into his body. The hero's situation becomes that of the new schizophrenic described by Jean Baudrillard in his discussion of the effects of mass communication:

> No more hysteria, no more projective paranoia, properly speaking, but this state of terror proper to the schizophrenic: too great a proximity of everything, the unclean promiscuity of everything which touches, invests, and penetrates without resistance, with no halo of private protection, not even his own body, to protect him anymore. . . . The schizo is bereft of every scene, open to everything in spite of himself, living in the greatest confusion.[18]

"You must open yourself completely to us," says one of *Videodrome*'s villains, as he plunges the cassette into the gaping wound. It would seem that we are here very far from the realm of what is traditionally called "pleasure" and much nearer to so-called *jouissance,* discussions of which privilege terms like "gaps," "wounds," "fissures," "splits," "cleavages," and so forth.

Moreover, if the text is "an anagram for our body," as Roland Barthes maintains, the contemporary text of horror could aptly be considered an anagram for the schizophrenic's body, which is so vividly imaged in Cronenberg's film.[19] It is a ruptured body, lacking the kind of integrity commonly attributed to popular narrative cinema. For just as Baudrillard makes us aware that terms like "paranoia" and "hysteria," which film critics have used to analyze both film characters and textual mechanisms, are no longer as applicable in mass culture today as they once were, so the much more global term "narrative pleasure" is similarly becoming outmoded.

What is always at stake in discussions of "narrative pleasure" is what many think of as the ultimate "spurious harmony," the supreme ideological construct—the "bourgeois ego." Contemporary film theorists insist that pleasure is "ego-reinforcing" and that narrative is the primary means by which mass culture supplies and regulates this pleasure. For Stephen Heath, Hollywood narratives are versions of the nineteenth-century "novelistic," or "family romance," and their function is to "remember

---

[17]Robin Wood, *American Nightmare: Essays on the Horror Film* (Toronto: Festival of Festivals, 1979), pp. 20–22.

[18]Jean Baudrillard, "The Ectasy of Communication," trans. John Johnston, *The Anti-Aesthetic*, pp. 132–33.

[19]Barthes, *The Pleasure of the Text*, p. 17. Barthes, however, specifies the "erotic body."

the history of the individual subject" through processes of identification, through narrative continuity, and through the mechanism of closure.[20] Julia Kristeva condemns popular cinema in similar terms in her essay on terror in film, "Ellipsis on Dread and the Specular Seduction":

> [The] terror/seduction node . . . becomes, through cinematic commerce, a kind of cut-rate seduction. One quickly pulls the veil over the terror, and only the cathartic relief remains; in mediocre potboilers, for example, in order to remain within the range of petty bourgeois taste, film plays up to narcissistic identification, and the viewer is satisfied with "three-buck seduction."[21]

But just as the individual and the family are *dis*-membered in the most gruesomely literal way in many of these films, so the novelistic as family romance is also in the process of being dismantled.

First, not only do the films tend to be increasingly open-ended in order to allow for the possibility of countless sequels, but they also often delight in thwarting the audiences' expectations of closure. The most famous examples of this tendency are the surprise codas of Brian de Palma's films—for instance, the hand reaching out from the grave in *Carrie*. And in *The Evil Dead*, *Halloween*, and *Friday the Thirteenth*, the monsters and slashers rise and attempt to kill over and over again each time they are presumed dead. At the end of *The Evil Dead*, the monsters, after defying myriad attempts to destroy them, appear finally to be annihilated as they are burned to death in an amazing lengthy sequence. But in the last shot of the film, when the hero steps outside into the light of day, the camera rushes toward him, and he turns and faces it with an expression of horror. In the final sequence of *Halloween*, the babysitter looks at the spot where the killer was apparently slain and, finding it vacant, says, "It really was the bogey man."

Secondly—and this is the aspect most commonly discussed and deplored by popular journalists—these films tend to dispense with or drastically minimize the plot and character development that is thought to be essential to the construction of the novelistic. In Cronenberg's *Rabid*, the porn star Marilyn Chambers plays a woman who receives a skin transplant and begins to infect everyone around her with a kind of rabies. The symptom of her disease is a vagina-like wound in her armpit out of which a phallic-shaped weapon springs to slash and mutilate its victims. While the film does have some semblance of a plot, most of it comprises disparate scenes showing Marilyn, or her victims, or her victims' victims, on the attack. Interestingly, although metonymy has been considered to be the principle by which narrative is constructed, metonymy in this film (the contagion signified by the title) becomes the means by which narrative is *disordered*, revealing a view of a world in which the center no longer holds. Films like *Maniac* and *Friday the Thirteenth* and its sequels go even further in the reduction of plot and character. In *Friday the Thirteenth*, a group of young people are brought together to staff a summer camp and are randomly murdered whenever they go off to make love. The people in the film are practically inter-

---

[20]Stephen Heath, *Questions of Cinema* (Bloomington: Indiana University Press, 1981), p. 157.
[21]Julia Kristeva, "Ellipsis on Dread and the Specular Seduction," trans. Dolores Burdick, *Wide Angle* 3, no. 3 (1979):46.

James Woods hypnotized by a television image in *Videodrome* (1983). "In some of the films the attack on contemporary life strikingly recapitulates the very terms adopted by many culture critics. . . . In David Cronenberg's *Videodrome*, video itself becomes the monster" (MODLESKI, page 768).

changeable, since we learn nothing about them as individuals, and there is virtually no building of a climax—only variations on the theme of slashing, creating a pattern that is more or less reversible.

Finally, it should scarcely need pointing out that when villains and victims are such shadowy, undeveloped characters and are portrayed equally unsympathetically, narcissistic identification on the part of the audience becomes increasingly difficult. Indeed, it could be said that some of the films elicit a kind of *anti*-narcissistic identification, which the audience delights in indulging just as it delights in having its expectations of closure frustrated. Of *The Texas Chainsaw Massacre*, Robin Wood writes, "Watching it recently with a large, half-stoned youth audience who cheered and applauded every one of Leatherface's outrages against their representatives on the screen was a terrifying experience."[22] The same might be said of films like *Halloween* and *Friday the Thirteenth*, which adopt the point of view of the slasher, placing the spectator in the position of an unseen nameless presence which, to the audiences' great glee, annihilates one by one their screen surrogates. This kind of joyful self-destructiveness on the part of the masses has been discussed by Jean Baudrillard in another context—in his analysis of the Georges Pompidou Center in Paris to which

---

[22]Wood, p. 22.

tourists flock by the millions, ostensibly to consume culture, but also to hasten the collapse of the structurally flawed building.[23] There is a similar paradox in the fact that *Dawn of the Dead*, the film about zombies taking over a shopping center, has become a midnight favorite at shopping malls all over the United States. In both cases the masses are revelling in the demise of the very culture they appear most enthusiastically to support. Here, it would seem, we have another variant of the split, "perverse" response favored by Roland Barthes.

The contemporary horror film thus comes very close to being "the other film" that Thierry Kuntzel says the classic narrative film must always work to conceal: "a film in which the initial figure would not find a place in the flow of a narrative, in which the configuration of events contained in the formal matrix would not form a progressive order, in which the spectator/subject would never be reassured ... within the dominant system of production and consumption, this would be a film of sustained *terror*."[24] Both in form and in content, the genre confounds the theories of those critics who adopt an adversarial attitude toward mass culture. The type of mass art I have been discussing—the kind of films which play at drive-ins and shabby downtown theaters, and are discussed on the pages of newsletters named *Trashola*, and *Sleazoid Express*— is as apocalyptic and nihilistic, as hostile to meaning, form, pleasure, and the specious good as many types of high art. This is surely not accidental. Since Jean-François Lyotard insists that postmodernism is an "aesthetic of the sublime," as Immanuel Kant theorized the concept, it is interesting to note that Kant saw an intimate connection between the literature of the sublime and the literature of terror, and moreover saw the difference as in part a matter of audience education: "In fact, without the development of moral ideas, that which, thanks to preparatory culture, we call sublime, merely strikes the untutored man as terrifying."[25] And there is certainly evidence to suggest that the converse of Kant's statement has some truth as well, since a film like *The Texas Chainsaw Massacre*, which might seem designed principally to terrify the untutored man, strikes a critic like Robin Wood as sublime—or at least as "authentic art." Wood writes, "*The Texas Chainsaw Massacre* ... achieves the force of authentic art. .... As a 'collective nightmare,' it brings to a focus a spirit of negativity, an undifferentiated lust for destruction that seems to lie not far below the surface of the modern collective consciousness."[26] It is indeed possible for the tutored critic versed in preparatory film culture to make a convincing case for the artistic merit of a film like *The Texas Chainsaw Massacre*, as long as art continues to be theorized in terms of negation, as long as we demand that it be uncompromisingly oppositional.

However, instead of endorsing Wood's view, we might wish to consider what these films have to teach us about the *limits* of an adversarial position which makes a virtue of "sustained terror." Certainly women have important reasons for doing so. In Trilling's essay, "The Fate of Pleasure," he notes almost parenthetically that, according to the *Oxford English Dictionary*, "Pleasure in the pejorative sense is sometimes

---

[23]Jean Baudrillard, *L'Effet beaubourg: implosion et dissuasion* (Paris: Galilée, 1977), pp. 23–25.

[24]Thierry Kuntzel, "The Film Work 2," trans. Nancy Huston, *Camera Obscura* 5 (1980):24–25.

[25]Immanuel Kant, *Critique of Judgment*, trans. James Creed (Oxford: Clarendon, 1952), p. 115, quoted in Franco Moretti, *Signs Taken for Wonders* (London: Verso, 1983), p. 253 n. See his chapter on "The Dialectic of Fear" for a very different reading of the vampire image in Marx.

[26]Wood, p. 22.

personified as a female deity."[27] Now, when pleasure has become an almost wholly pejorative term, we might expect to see an increasing tendency to incarnate it as a woman. And, indeed, in the contemporary horror film it is personified as a lovely young school teacher beaten to death by midget clones (*The Brood*), as a pretty blond teenager threatened by a maniac wielding a chainsaw (*The Texas Chainsaw Massacre*), or as a pleasant and attractive babysitter terrorized throughout the film *Halloween* by a grown-up version of the little boy killer revealed in the opening sequence. Importantly, in many of the films the female is attacked not only because, as has often been claimed, she embodies sexual pleasure, but also because she represents a great many aspects of the specious good—just as the babysitter, for example, quite literally represents familial authority. The point needs to be stressed, since feminism has occasionally made common cause with the adversarial critics on the grounds that we too have been oppressed by the specious good. But this is to overlook the fact that in some profound sense we have also been historically and psychically identified with it.

Further, just as Linda Williams has argued that in the horror film woman is usually placed on the side of the monster even when she is its pre-eminent victim, so too in the scenario I outlined at the beginning woman is frequently associated with the monster mass culture.[28] This is hardly surprising since, as we have seen, mass culture has typically been theorized as the realm of cheap and easy pleasure—"pleasure in the pejorative sense." Thus, in Ann Douglas's account, the "feminization of American culture" is synonymous with the rise of mass culture.[29] And in David Cronenberg's view, mass culture—at least the video portion of it—is terrifying because of the way it feminizes its audience. In *Videodrome*, the openness and vulnerability of the media recipient are made to seem loathsome and fearful through the use of feminine imagery (the vaginal wound in the stomach) and feminine positioning: the hero is raped with a video cassette. As Baudrillard puts it, "no halo of private protection, not even his own body . . . protect[s] him anymore." Baudrillard himself describes massmediated experience in terms of rape, as when he speaks of "the unclean promiscuity of everything which touches, invests and penetrates without resistance." No resistance, no protection, no mastery. Or so it might seem. And yet the mastery that these popular texts no longer permit through effecting closure or eliciting narcissistic identification is often reasserted through projecting the experience of submission and defenselessness onto the female body. In this way the texts enable the male spectator to distance himself somewhat from the terror. And, as usual, it is the female spectator who is *truly* deprived of "solace and pleasure." Having been denied access to pleasure, while simultaneously being scapegoated for seeming to represent it, women are perhaps in the best position to call into question an aesthetic wholly opposed to it. At the very least, we might like to experience more of it before deciding to denounce it.

---

[27]Trilling, p. 22.

[28]Linda Williams, "When the Woman Looks," *Re-vision: Essays in Feminist Film Criticism*, ed. Mary Ann Doane, Patricia Mellencamp, and Linda Williams, The American Film Institute Monograph Series, Vol. III (Frederick, MD: University Publications of America, 1984), pp. 85–88.

[29]Ann Douglas, *The Feminization of American Culture* (New York: Avon, 1977).

Beyond this, it remains for the postmodernist to ponder the irony of the fact that when critics condemn a "monstrous motion picture industry" they are to a certain extent repeating the gestures of texts they repudiate. And the question then becomes: How can an adversarial attitude be maintained toward an art that is itself increasingly adversarial? In *The Anti-Aesthetic*, Hal Foster considers modernism to be postmodernism's other, and he pointedly asks, "how can we exceed the modern? How can we break with a program that makes a value of crisis . . . or progress beyond the era of Progress . . . or *transgress the ideology of the transgressive?*"[30] Foster does not acknowledge the extent to which mass culture has also served as postmodernism's other, but his question is pertinent here too.

Part of the answer may lie in the fact that for many artists, transgression is not as important a value as it is for many theorists. A host of contemporary artistic endeavors may be cited as proof of this, despite the efforts of some critics to make these works conform to an oppositional practice. In literature, the most famous and current example of the changed, friendly attitude toward popular art is Umberto Eco's *The Name of the Rose*, which draws on the Sherlock Holmes mystery tale. Manual Puig's novels (his *Kiss of the Spider Woman*, for example) have consistently explored the pleasures of popular movies. In the visual arts, Cindy Sherman's self-portraiture involves the artist's masquerading as figures from old Hollywood films. The "Still Life" exhibition organized by Marvin Heiferman and Diane Keaton consists of publicity stills from the files of Hollywood movie studios. In film, Rainer Werner Fassbinder continually paid homage to Hollywood melodramas; Wim Wenders and Betty Gordon return to *film noir*; Mulvey and Wollen to the fantastic; Valie Export to science fiction; and so on.

A few theorists have begun to acknowledge these developments, but usually only to denounce them. In a recent article entitled "Post-modernism and Consumer Society," Fredric Jameson concludes by deploring the fact that art is no longer "explosive and subversive," no longer "critical, negative, contestatory, . . . oppositional, and the like."[31] Instead, says Jameson, much recent art appears to incorporate images and stereotypes garnered from our pop cultural past. However, instead of sharing Jameson's pessimistic view of this tendency, I would like to end on a small note of comfort and solace. Perhaps the contemporary artist continues to be subversive by being nonadversarial in the modernist sense, and has returned to our pop cultural past partly in order to explore the site where pleasure was last observed, before it was stoned by the gentry and the mob alike, and recreated as a monster.

                                                                                1986

---

[30]Foster, p. ix. My emphasis.
[31]Fredric Jameson, "Postmodernism and Consumer Society," *The Anti-Aesthetic*, p. 125.

# DAVID BORDWELL
# THE ART CINEMA AS A MODE
# OF FILM PRACTICE

*La Strada, 8¹/₂, Wild Strawberries, The Seventh Seal, Persona, Ashes and Diamonds, Jules et Jim, Knife in the Water, Vivre sa vie, Muriel*: whatever else one can say about these films, cultural fiat gives them a role altogether different from *Rio Bravo* on the one hand and *Mothlight* on the other. They are "art films," and, ignoring the tang of snobbishness about the phrase, we can say that these and many other films constitute a distinct branch of the cinematic institution. My purpose in this essay is to argue that we can usefully consider the "art cinema" as a distinct mode of film practice, possessing a definite historical existence, a set of formal conventions, and implicit viewing procedures. Given the compass of this paper, I can only suggest some lines of work, but I hope to show that constructing the category of the art cinema is both feasible and illuminating.

It may seem perverse to propose that films produced in such various cultural contexts might share fundamentally similar features. Yet I think there are good reasons for believing this, reasons which come from the films' place in history. In the long run, the art cinema descends from the early *film d'art* and such silent national cinema schools as German Expressionism and Neue Sachlichkeit and French Impressionism.[1] (A thorough account of its sources would also have to include literary modernism, from Proust and James to Faulkner and Camus.) More specifically, the art cinema as a distinct mode appears after World War II when the dominance of the Hollywood cinema was beginning to wane. In the United States, the courts' divorcement

I am grateful to Edward Branigan, Noel Carroll, Bruce Jenkins, Bob Self, Janet Staiger, and Kristin Thompson for their helpful criticism of this essay.

[1]More radical avant-garde movements, such as Soviet montage filmmaking, Surrealism, and *cinéma pur* seem to have been relatively without effect upon the art cinema's style. I suspect that those experimental styles which did not fundamentally change narrative coherence were the most assimilable to the postwar art cinema.

decrees created a shortage of films for exhibition. Production films needed overseas markets and exhibitors needed to compete with television. In Europe, the end of the war reestablished international commerce and facilitated film export and coproductions. Thomas Guback has shown how, after 1954, films began to be made for international audiences.[2] American films sponsored foreign production, and foreign films helped American exhibitors fill screen time. The later Neorealist films may be considered the first postwar instances of the international art cinema, and subsequent examples would include most works of the New Wave, Fellini, Resnais, Bergman, De Sica, Kurosawa, Pasolini, et al. While the art cinema is of little economic importance in the United States today, it evidently continues, as such international productions as *The Serpent's Egg* or *Stroszek* show.

Identifying a mode of production/consumption does not exhaustively characterize the art cinema, since the cinema also consists of formal traits and viewing conventions. To say this, however, is to invite the criticism that the creators of such films are too inherently different to be lumped together. Yet I shall try to show that whereas stylistic devices and thematic motifs may differ from director to director, the overall *functions* of style and theme remain remarkably constant in the art cinema as a whole. The narrative and stylistic principles of the film constitute a logically coherent mode of cinematic discourse.

## REALISM, AUTHORSHIP, AMBIGUITY

The classical narrative cinema—paradigmatically, studio feature filmmaking in Hollywood since 1920—rests upon particular assumptions about narrative structure, cinematic style, and spectatorial activity. While detailing those assumptions is a task far from complete,[3] we can say that in the classical cinema, narrative form motivates cinematic representation. Specifically, cause-effect logic and narrative parallelism generate a narrative which projects its action through psychologically-defined, goal oriented characters. Narrative time and space are constructed to represent the cause-effect chain. To this end, cinematic representation has recourse to fixed figures of cutting (e.g., 180° continuity, crosscutting, "montage sequences"), mise-en-scene (e.g., three-point lighting, perspective sets), cinematography (e.g., a particular range of camera distances and lens lengths), and sound (e.g., modulation, voice-over narration). More important than these devices themselves are their functions in advancing the narrative. The viewer makes sense of the classical film through criteria of verisimilitude (is x plausible?), of generic appropriateness (is x characteristic of this sort of film?) and of compositional unity (does x advance the story?). Given this background set, we can start to mark off same salient features of the art cinema.

First, the art cinema defines itself explicitly against the classical narrative mode, and especially against the cause-effect linkage of events. These linkages become looser, more tenuous in the art film. In *L'Avventura*, for example, Anna is lost and

---

[2]See Thomas Guback, *The International Motion Picture Industry* (Bloomington: Indiana University Press, 1969), *passim*.

[3]See, for example, Philip Rosen, "Difference and Displacement in *Seventh Heaven*," *Screen* XVIII, 2 (Summer 1977), 89–104.

never found; in *A bout de souffle*, the reasons for Patricia's betrayal of Michel remain unknown; in *Bicycle Thieves*, the future of Antonio and his son is not revealed. It will not do, however, to characterize the art film solely by its loosening of causal relations. We must ask what motivates that loosening, what particular modes of unity follow from these motivations, what reading strategies the film demands, and what contradictions exist in this order of cinematic discourse.

The art cinema motivates its narratives by two principles: realism and authorial expressivity. On the one hand, the art cinema defines itself as a realistic cinema. It will show us real locations (Neorealism, the New Wave) and real problems (contemporary "alienation," "lack of communication," etc.). Part of this reality is sexual; the aesthetics and commerce of the art cinema often depend upon an eroticism that violates the production code of pre-1950 Hollywood. *A Stranger Knocks* and *And God Created Woman* are no more typical of this than, say *Jules et Jim* and *Persona* (whereas one can see *Le Mépris* as consciously working upon the very problem of erotic spectacle in the art cinema). Most important, the art cinema uses "realistic"— that is, psychologically complex—characters.

The art cinema is classical in its reliance upon psychological causation; characters and their effects on one another remain central. But whereas the characters of the classical narrative have clear-cut traits and objectives, the characters of the art cinema lack defined desires and goals. Characters may act for inconsistent reasons (Marcello in *La Dolce Vita*) or may question themselves about their goals (Borg in *Wild Strawberries* and the Knight in *The Seventh Seal*). Choices are vague or nonexistent. Hence a certain drifting episodic quality to the art film's narrative. Characters may wander out and never reappear; events may lead to nothing. The Hollywood protagonist speeds directly toward the target; lacking a goal, the art-film character slides passively from one situation to another.

The protagonist's itinerary is not completely random; it has a rough shape: a trip (*Wild Strawberries, The Silence, La Strada*), an idyll (*Jules et Jim, Elvira Madigan, Pierrot le fou*), a search (*L'Avventura, Blow-up, High and Low*), even the making of a film (*8½, The Clowns, Fellini Roma, Day for Night, The Last Movie, Le Mépris*). Especially apt for the broken teleology of the art film is the biography of the individual, in which events become pared down toward a picaresque successivity (*La Dolce Vita, The Apu Trilogy, Alfie*). If the classical protagonist struggles, the drifting protagonist traces an itinerary, an encyclopedic survey of the film's world. Certain occupations (stockbroking in *L'Eclisse*, journalism in *La Dolce Vita* and *The Passenger*, prostitution in *Vivre sa vie* and *Nights of Cabiria*) favor a survey form of narrative. Thus the art film's thematic of *la condition humaine*, its attempt to pronounce judgements on "modern life" as a whole, proceeds from its formal needs: had the characters a goal, life would no longer seem so meaningless.

What is essential to any such organizational scheme is that it be sufficiently loose in its causation as to permit characters to express and explain their psychological states. Slow to act, these characters tell all. The art cinema is less concerned with action than reaction; it is a cinema of psychological effects in search of their causes. The dissection of feeling is often represented explicitly as therapy and cure (e.g., *Through a Glass Darkly, Persona*), but even when it is not, the forward flow of causation is braked and characters pause to seek the aetiology of their feelings. Charac-

ters often tell one another stories: autobiographical events (especially from child-hood), fantasies, and dreams. (A recurring line: "I had a strange dream last night.") The hero becomes a supersensitive individual, one of those people on whom nothing is lost. During the film's survey of its world, the hero often shudders on the edge of breakdown. There recurs the realization of the anguish of ordinary living, the dis-covery of unrelieved misery: compare the heroines of *Europa 51*, *L'Avventura*, *Deserto rosso*, and *Une femme mariée*. In some circumstances the characters must attribute their feelings to social situations (as in *Ikiru*, *I Live in Fear*, and *Shame*). In *Europe 51*, a communist tells Irene that individuals are not at fault; "If you must blame something, blame our postwar society." Yet there is seldom analysis at the level of groups or institutions; in the art cinema, social forces become significant insofar as they impinge upon the psychologically sensitive individual.

A conception of realism also affects the film's spatial and temporal construction, but the art cinema's realism here encompasses a spectrum of possibilities. The options range from a documentary factuality (e.g., *Il posto*) to intense psychological subjectivity (*Hiroshima mon amour*). (When the two impulses meet in the same film, the familiar "illusion/reality" dichotomy of the art cinema results.) Thus room is left for two reading strategies. Violations of classical conceptions of time and space are justified as the intrusion of an unpredictable and contingent daily reality or as the sub-jective reality of complex characters. Plot manipulations of story order (especially flashbacks) remain anchored to character subjectivity as in $8^{1}/_{2}$ and *Hiroshima mon amour*. Manipulations of duration are justified realistically (e.g., the *temps morts* of early New Wave films) or psychologically (the jump cuts of *A bout de souffle* signal-ing a jittery lifestyle). By the same token, spatial representation will be motivated as documentary realism (e.g., location shooting, available light), as character revelation, or in extreme cases as character subjectivity. Andre Bazin may be considered the first major critic of the art cinema, not only because he praised a loose, accidental narra-tive structure that resembled life but also because he pin-pointed privileged stylistic devices for representing a realistic continuum of space and time (deep-focus, deep space, the moving camera, and the long take). In brief, a commitment to both objec-tive and subjective verisimilitude distinguished the art cinema from the classical nar-rative mode.[4]

Yet at the same time, the art cinema foregrounds the *author* as a structure in the film's system. Not that the author is represented as a biographical individual (although some art films, e.g., Fellini's, Truffaut's, and Pasolini's, solicit confessional readings), but rather the author becomes a formal component, the overriding intelli-gence organizing the film for our comprehension. Over this hovers a notion that the art-film director has a creative freedom denied to her/his Hollywood counterpart.[5]

---

[4]This point is taken up in Christian Metz, "The Modern Cinema and Narrativity," *Film Language*, tr. by Michael Taylor (New York: Oxford University Press, 1974), 185–227.

[5]Arthur Knight compares the Hollywood film to a commodity and the foreign film to an art work: "Art is not manufactured by committees. Art comes from an individual who has something that he must express. . . . This is the reason why we hear so often that foreign films are 'more artistic' than our own. There is in them the urgency of individual expression, an independence of vision, the coherence of a sin-gle-minded statement." In Michael F. Mayer, *Foreign Films on American Screens* (New York: Arco, 1965). vii.

Within this frame of reference, the author is the textual force "who" communicates (what is the film *saying*?) and "who" expresses (what is the artist's *personal vision*?). Lacking identifiable stars and familiar genres, the art cinema uses a concept of authorship to unify the text.

Several conventions operate here. The competent viewer watches the film expecting not order in the narrative but stylistic signatures in the narration: technical touches (Truffaut's freeze frames, Antonioni's pans) and obsessive motifs (Buñuel's anticlericalism, Fellini's shows, Bergman's character names). The film also offers itself as a chapter in an *oeuvre*. This strategy becomes especially apparent in the convention of the multi-film work (*The Apu Trilogy*, Bergman's two trilogies, Rohmer's "Moral Tales," and Truffaut's Doinel series). The initiated catch citations: references to previous films by the director or to works by others (e.g., the New Wave homages).

A small industry is devoted to informing viewers of such authorial marks. International film festivals, reviews and essays in the press, published scripts, film series, career retrospectives, and film education all introduce viewers to authorial codes. What is essential is that the art film be read as the work of an expressive individual. It is no accident, then, that the *politique de auteurs* arose in the wake of the art cinema, that *Cahiers du cinéma* admired Bergman and Antonioni as much as Hawks and Minnelli, that Robin Wood could esteem both Preminger and Satayajit Ray. As a critical enterprise, *auteur* analysis of the 1950s and 1960s consisted of applying art-cinema reading strategies to the classical Hollywood cinema.[6]

How does the author come forward in the film? Recent work in *Screen* has shown how narrational marks can betray the authorial code in the classical text, chiefly through gaps in motivation.[7] In the art-cinema text, the authorial code manifests itself as recurrent violations of the classical norm. Deviations from the classical canon— an unusual angle, a stressed bit of cutting, a prohibited camera movement, an unrealistic shift in lighting or setting—in short any breakdown of the motivation of cinematic space and time by cause-effect logic—can be read as "authorial commentary." The credits for the film, as in *Persona* or *Blow-up*, can announce the power of the author to control what we see. Across the entire film, we must recognize and engage with the shaping narrative intelligence. For example, in what Norman Holland calls the "puzzling film,"[8] the art cinema foregrounds the narrational act by posing enigmas. In the classic detective tale, however, the puzzle is one of *story*: who did it?

---

[6]"The strategy was to talk about Hawks, Preminger, etc. as artists like Buñuel and Resnais" (Jim Hillier, "The Return of *Movie*," *Movie* no. 20 [Spring 1975], 17). I do not mean to imply that auteur criticism did not at times distinguish between the classical narrative cinema and the art cinema. A book like V. G. Perkins's *Film as Film* (Baltimore: Penguin, 1978) insists not only upon authorial presence but also upon the causal motivation and the stylistic economy characteristic of the classical cinema. Thus Perkins finds the labored directorial touches of Antonioni and Bergman insufficiently motivated by story action. Nevertheless, Perkins' interpretation of the jeep sequence in *Carmen Jones* in terms of characters' confinement and liberation (pp. 80–82) is a good example of how Hollywood cutting and camera placement can be invested with symbolic traces of the author.

[7]See, for instance, Mark Nash, "*Vampyr* and the Fantastic," *Screen* XVII, 3 (Autumn 1976), 29–67, and Paul Willemen, "The Fugitive Subject," *Raoul Walsh*, ed. by Phil Hardy (London: Edinburgh Film Festival, 1974), 63–89.

[8]Norman Holland, "The Puzzling Movies: Three Analyses and a Guess at Their Appeal," *Journal of Social Issues* XX, 1 (January 1964), 71–96.

how? why? In the art cinema, the puzzle is one of *plot*: who is telling this story? how is this story being told? why is this story being told this way? Another example of such marking of narration is the device of the flashforward—the plot's representation of a future story action. The flashforward is unthinkable in the classical narrative cinema, which seeks to retard the ending and efface the mode of narration. But in the art cinema, the flashforward functions perfectly to stress authorial presence: we must notice how the narrator teases us with knowledge that no character can have. Far from being isolated or idiosyncratic, such instances typify the tendency of the art film to throw its weight onto plot, not story; we play a game with the narrator.

Realism and authorial expressivity, then, will be the means whereby the art film unifies itself. Yet these means now seem contradictory. Verisimilitude, objective or subjective, is inconsistent with an intrusive author. The surest signs of authorial intelligibility—the flashforward, the doubled scene in *Persona*, the color filters at the start of *Le Mépris*—are the least capable of realistic justification. Contrariwise, to push the realism of psychological uncertainty to its limit is to invite a haphazard text in which the author's shaping hand would not be visible. In short, a realist aesthetic and an expressionist aesthetic are hard to merge.

The art cinema seeks to solve the problem in a sophisticated way: by the device of *ambiguity*. The art film is nonclassical in that it foregrounds deviations from the classical norm—there are certain gaps and problems. But these very deviations are *placed*, resituated as realism (in life things happen this way) or authorial commentary (the ambiguity is symbolic). Thus the art film solicits a particular reading procedure: Whenever confronted with a problem in causation, temporality, or spatiality, we first seek realistic motivation. (Is a character's mental state causing the uncertainty? Is life just leaving loose ends?) If we're thwarted, we next seek authorial motivation. (What is being "said" here? What significance justifies the violation of the norm?) Ideally, the film hesitates, suggesting character subjectivity, life's untidiness, and author's vision. Whatever is excessive in one category must belong to another. Uncertainties persist but are understood as such, as *obvious* uncertainties, so to speak. Put crudely, the slogan of the art cinema might be, "When in doubt, read for maximum ambiguity."

The drama of these tendencies can play across an entire film, as *Giulietta degli spiriti* and *Deserto rosso* illustrate. Fellini's film shows how the foregrounding of authorial narration can collapse before the attempt to represent character subjectivity. In the hallucinations of Giulietta, the film surrenders to expressionism. *Deserto rosso* keeps the elements in better balance. Putting aside the island fantasy, we can read any scene's color scheme in two registers simultaneously: as psychological verisimilitude (Giulietta sees her life as a desert) or as authorial commentary (Antonioni-as-narrator says that this industrial landscape is a desert.)

If the organizational scheme of the art film creates the occasion for maximizing ambiguity, how to conclude the film? The solution is the open-ended narrative. Given the film's episodic structure and the minimization of character goals, the story will often lack a clear-cut resolution. Not only is Anna never found, but the ending of *L'Avventura* refuses to specify the fate of the couple. At the close of *Les 400 coups*, the freeze-frame becomes the very figure of narrative irresolution, as does the car halted before the two roads at the end of *Knife in the Water*. At its limit, the art cinema creates an *8¹/₂* or a *Persona*, a film which, lacking a causally adequate ending,

seems to conclude several distinct times. A banal remark of the 1960s, that such films make you leave the theatre thinking, is not far from the mark: the ambiguity, the play of thematic interpretation, must not be halted at the film's close. Furthermore, the pensive ending acknowledges the author as a peculiarly humble intelligence; s/he knows that life is more complex than art can ever be, and the only way to respect this complexity is to leave causes dangling, questions unanswered. With the open and arbitrary ending, the art film reasserts that ambiguity is the dominant principle of intelligibility, that we are to watch less for the tale than the telling, that life lacks the neatness of art and *this art knows it.*

## THE ART CINEMA IN HISTORY

The foregoing sketch of one mode of cinema needs more detailed examination, but in conclusion it may be enough to suggest some avenues for future work.

We cannot construct the art cinema in isolation from other cinematic practices. The art cinema has neighbors on each side, adjacent modes which define it. One such mode is the classical narrative cinema (historically, the dominant mode). There also exists a modernist cinema—that set of formal properties and viewing protocols that presents, above all, the radical split of narrative structure from cinematic style, so that the film constantly strains between the coherence of the fiction and the perceptual dis-

Vacationers on an island look for a missing friend they will never find in Antonioni's *L'Avventura* (1960). ". . . the art cinema defines itself explicitly against the classical narrative mode, and especially against the cause-effect linkage of events. . . . Whereas the characters of the classical narrative have clear-cut traits and objectives, the characters of the art cinema lack defined desires and goals" (BORDWELL, pages 775–76).

junctions of cinematic representation. It is worth mentioning that the modernist cinema is not ambiguous in the sense that the art cinema is; perceptual play, not thematic ambivalence, is the chief viewing strategy. The modernist cinema seems to me manifested (under various circumstances) in films like *October*, *La Passion de Jeanne d'Arc*, *Lancelot du lac*, *Playtime*, and *An Autumn Afternoon*. The art cinema can then be located in relation to such adjacent modes.

We must examine the complex historical relation of the art cinema to the classical narrative cinema. The art film requires the classical background set because deviations from the norm must be registered as such to be placed as realism or authorial expression. Thus the art film acknowledges the classical cinema in many ways, ranging from Antonioni's use of the detective story to explicit citations in New Wave films. Conversely, the art cinema has had an impact on the classical cinema. Just as the Hollywood silent cinema borrowed avant-garde devices but assimilated them to narrative ends, so recent American filmmaking has appropriated art-film devices. Yet such devices are bent to causally motivated functions—the jumpcut for violence or comedy, the sound bridge for continuity or shock effect, the elimination of the dissolve, and the freeze frame for finality. (Compare the narrative resolution of the freeze frame in *Les 400 coups* with its powerful closure in *Butch Cassidy and the Sundance Kid*). More interestingly, we have seen an art cinema emerge in Hollywood. The open endings of *2001* and *Five Easy Pieces* and the psychological ambiguity of *The Conversation*, *Klute*, and *Three Women* testify to an assimilation of the conventions of the art film. (Simplifying brusquely, we might consider *The Godfather I* as a classical narrative film and *The Godfather II* as more of an art film) Yet if Hollywood is adopting traits of the art cinema, that process must be seen as not simple copying but complex transformation. In particular, American film genres intervene to warp art-cinema conventions in new directions (as the work of Altman and Coppola shows).[9]

It is also possible to see that certain classical filmmakers have had something of the art cinema about them. Sirk, Ford, and Lang all come to mind here, but the preeminent instance is Alfred Hitchcock. Hitchcock has created a textual persona that is in every way equal to that of the art-cinema author's; of all classical films, I would argue, Hitchcock's foreground the narrational process most strikingly. A film like *Psycho* demonstrates how the classical text, with its psychological causality, its protagonist/antagonist struggle, its detective story, and its continuous time and homogeneous space, can under pressure exhibit the very negation of the classical system: psychology as inadequate explanation (the psychiatrist's account); character as only a position, an empty space (the protagonist is successively three characters, the antagonist is initially two, then two-as-one); and crucially stressed shifts in point-of-view which raise the art-film problem of narrational attitude. It may be that the attraction of Hitchcock's cinema for both mass audience and English literature professor lies in its successful merger of classical narrative and art-film narration.

---

[9]See Steve Neal, "New Hollywood Cinema," *Screen* 17, 2 (Summer 1976), 117–122, and Paul Willemen, "Notes on Subjectivity: On Reading Edward Branigan's 'Subjectivity Under Siege,' " *Screen* XIX, 1 (Spring 1978), 59–64; cf. Robin Wood, "Smart-Ass and Cutie Pie: Notes toward an Evaluation of Altman," *Movie* no. 21 (Autumn 1975), 1–17.

Seen from the other side, the art cinema represents the domestication of modernist filmmaking. The art cinema softened modernism's attack on narrative causality by creating mediating structures—"reality," character subjectivity, authorial vision— that allowed a fresh coherence of meaning. Works of Rossellini, Eisenstein, Renoir, Dreyer, and Ozu have proven assimilable to art-cinema reading strategies: each director has been assigned a distinct authorial world-view. Yet modernist cinema has responded in ways that make the art cinema in its turn, an important point of departure. By the 1960s, the art cinema enabled certain filmmakers to define new possibilities. In *Gertrud*, Dreyer created a perceptual surface so attenuated that all ambiguity drains away, leaving a narrative vacuum.[10] In *L'Année dernière à Marienbad*, Resnais dissolved causality altogether and used the very conventions of art cinema to shatter the premise of character subjectivity. In *Nicht Versöhnt*, Straub and Huillet took the flashback structure and *temps morts* of the art cinema and orchestrated empty intervals into a system irreducible to character psychology or authorial commentary. Nagisha Oshima turned the fantasy-structures and the narrational marks of the New Wave to political-analytical ends in *The Ceremony* and *Death by Hanging*. Most apparently, Godard, one of the figureheads of the 1960s art cinema, had by 1968 begun to question it. (*Deux ou trois choses que je sais d'elle* can be seen as a critique of *Deserto rosso*, or even of *Une femme mariée*). Godard also reintroduced the issue of montage, a process which enabled *Tout va bien* and subsequent works to use Brechtian principles to analyze art-film assumptions about the unity of ideology. If, as some claim, a historical-materialist order of cinema is now appearing, the art cinema must be seen as its necessary background, and its adversary.

1979

---

[10]See David Bordwell, *The Films of Carl Theodor Dreyer* (Berkeley: University of California Press, 1981).

# VII

# Film: Psychology, Ideology, and Technology

What are the nature and sources of film's psychological and political power? Is there something special about the film medium that confers this power? Is this power repressive or liberating? Can it be criticized and controlled? Questions of this sort have always been asked about cinema, but in recent years film studies have focused on them with unusual intensity. Many of these studies have relied on the Marxist notions of superstructure and ideology and on Freudian ideas about the development and constitution of the self. Writers in this tradition have been committed to exposing the ideological biases of classic narrative film and, in the writings of feminist critics, to revealing its sexist procedures and assumptions. Earlier sections have included essays that apply these perspectives to such perennial issues as the nature of film reality, the film medium, and film genre. In this section the reader will find some of the most arresting writing on the psychological, social, and technological bases of film.

In his classic essay, the Marxist critic Walter Benjamin reflects on alterations in the artistic superstructure that the capitalist mode of production produces. In the past, art works have been unique objects, possessing "aura" and traditional "authority." They played a ritual role, contemplated by men who kept a "natural" distance from them. But the contemporary masses want to see things closer, spatially and humanly. They overcame the uniqueness of the work of art by accepting a mechanical reproduction of it as an equivalent. These reproductions are no longer hallowed cult objects but consumer goods sold on the market; rather than absorbing their beholders, they are absorbed by them. Reactions to these "works of art" are rarely personal and are almost completely determined by the mass audience to which the individual is subordinated. Indeed, films have now become one of the most powerful agents of mass political movements—in them the mass has for the first time come face to face with itself. In Benjamin's view, the film and the audience's relation to it are so different

from all that has gone before that he is inclined to think that photography has transformed the very nature of art.

Jean-Luc Comolli and Jean Narboni, editors of *Cahiers du cinéma,* were, in the period subsequent to the student uprisings in Paris in 1968, central to the discussions represented in this section. In their Marxist view film produced in the West today has two aspects. On the one hand, it is a commodity produced by labor and exchanged according to the laws of the market. On the other hand, it is part of the ideological superstructure determined by the capitalist economic system. One assumption of the prevailing ideological system is that cinema "reproduces" reality but, in fact, it only reproduces the world of the dominant ideology. As Louis Althusser formulates it, men express in their ideologies not their actual relation to the conditions of their existence, but their reactions to it. The filmmaker's primary task is, therefore, to expose the cinema's alleged "depiction of reality." If the filmmaker can do this, there is some chance that we will be able to disrupt and sever the connection between cinema and its ideological function.

Some filmmakers are simply imbued with the dominant ideology and reflect it in both the form and content of their works. The task of the film critic, in these cases, is to exhibit the film's blindness to the ideology it presents. Other films attack their ideological assimilation on two levels. On the level of the signified they engage in direct political action while on the level of the signifier they try to break down the traditional way of depicting reality. These levels, which it is the critic's task to display, are indissolubly linked.

Another category of film appears to be completely within the dominant ideology yet can be shown to be so only in an ambiguous manner. John Ford's *Young Mr. Lincoln* is a film of this type and is the subject of a famous analysis by the editors of *Cahiers.* They urge that the film attempts to suppress the realities of politics by presenting Lincoln's career as one based on an idealist morality superior to mere politics. Yet Ford, who is consciously sympathetic to that ideology, nevertheless shows us a Lincoln characterized by a violence which displays his truly repressive character. According to J. P. Oudart this shows the distance Ford, in his "writing," keeps between himself and the idealist propositions he deploys.

If Comolli and Narboni draw on the theories of Marx and Althusser in analysing the situation of the film spectator, Christian Metz, in his later work, extends the investigations of Freud and Lacan. In particular, he appeals to Lacan's conceptions of the imaginary, the symbolic, and the real in understanding the child's changing perception of the world. For Metz the uniqueness of the cinema lies in the duality of its signifier. As a machine of the visible, films give us an unprecedented range of perceptions. Yet at the same time those perceptions are "stamped with unreality to an unusual degree" because we perceive on screen no actual object—because it is really not there—but rather its absence, "its phantom, its double, its *replica* in a new kind of mirror." In the primordial mirror postulated by Lacan, which the mother holds before the child, the child perceives its own image, and its ego is formed by its identification with this likeness. But in the mirror of cinema, from which the spectator is absent, the identification is with perception itself, that is, with the camera.

These passions of cinematic perception—to see and to hear—differ, says Metz, from other sexual drives because they are defined not by a distant but by an absent

object. This phenomenon grounds desire in lack and results in an unending pursuit of the imaginary. The voyeurism or scopophilia of the cinematic spectator exists therefore without the direct consent of the object of desire. It thereby more properly resembles the Oedipal situation of the Freudian primal scene, in which the child sees but cannot participate, than it does the exhibitionist and potentially interactive art of theater. The lure of cinema is thus similar to that of the unauthorized and taboo perception of the primal scene, now institutionalized and made socially permissible, but still a peephole opening onto something more crazy and less acceptable than what one does the rest of the time.

One result of this connection to the buried psychology of the cinematic spectator is the fetishizing of the cinematic experience and the disavowal of the actual object of perception in preference for what is associated with it. But because, as Freud argued, fetishism was linked to the fear of castration and the child's belief that the mother has been castrated, the fetish simultaneously attempts to make up for the lack, even as it also affirms the lack—mirroring the dual feeling of presence and absence, belief and disavowal, instilled by the objects seen on film. The concept of the fetish may thus be expanded to cinema itself, and the attraction of its apparatus, its effects, and the exploits of its technical performance, as an expression of the viewer's ability to forget the actual absence and replace it with love.

Metz's psychoanalytic conception of the film viewer emphasizes general human traits, influenced but not crucially determined by gender. (He never, for example, addresses the issue of the relevance of his Oedipal model for women in the audience.) Laura Mulvey, working from similar Freudian and Lacanian assumptions, specifically differentiates the male and the female perspectives in an effort to help explain the pleasure and "unpleasure" offered by narrative film. She argues that narrative film provides what Freud calls "scopophilic" pleasure, the pleasure of viewing another as an erotic object. In a narrative film, this activity characteristically takes the form of looking at women as erotic objects. But narrative film, echoing the experience of the child at Lacan's mirror, also provides the contrasting narcissistic pleasure of identification with the projected images, in particular with that of the male character, who makes things happen and controls them. Woman is, however, also a source of unpleasure since she represents the threat of castration and, in so being, motivates the voyeuristic and fetishistic mechanisms that attempt to circumvent her threat. (Mulvey studies their operation in the films of Sternberg and Hitchcock.)

None of these mechanisms is, says Mulvey, intrinsic to film, and the male-oriented pleasures of mainstream film can be challenged by breaking down the cinematic codes and the formative external structures that support them. Indeed, radical filmmakers have already begun to undermine the ideologically inspired illusion of three-dimensional space in which the spectator's surrogate performs and in which the look of the spectator is denied intrinsic force. This deconstruction is accomplished by freeing the look of the camera into its materiality in space and time and by transforming the scopophilic gaze of the audience into a detached and dialectical one. These changes destroy the pleasures and privilege of the "invisible guest" and highlight the ways film has depended on voyeuristic mechanisms. Women, whose images have continually been stolen and used for this purpose, cannot view the decline of traditional film with anything more than sentimental regret.

Tania Modleski questions Mulvey's claim that Hitchcock's *Rear Window* is cut to the measure of male desire. To be sure, the film seems to confine us to the hero's vision of events and to insist on that vision by stressing his point of view throughout. The film spectator apparently has no choice but to identify with the male protagonist, who exerts an active, controlling gaze over a passive female object. But a closer look at the film calls these assumptions into doubt. The impotence of the immobilized Jeff is suggested by the enormous cast on his leg. By contrast Lisa is anything but helpless and incapable despite Mulvey's characterization of her a "passive image of perfection." Indeed our first view of her is of an overwhelmingly powerful, self-assured presence. She is continually shown to be physically superior to the hero, not only in her physical movements but also in her dominance within the frame: she towers over Jeff in nearly every shot in which they both appear. In view of all this, and of Lisa's aggressive sexuality, it seems odd that Mulvey sees in the image of Lisa only a passive object of the male gaze.

For Modleski, the film increasingly stresses a dual point of view. Both Jeff and Lisa intently stare out of the window but from different points of view. Lisa is less interested in spying and relates to characters through empathy and identification. Lisa is able to provide the missing evidence because she claims a special knowledge of women that men lack. And at the climatic moment in the film, the scene in which Lisa is flung around the room by Thorwald, Jeff himself—and, by extension the male film viewer—is forced to identify with Lisa. Jeff becomes aware of his own passivity and helplessness in relation to the events unfolding before his eyes. When Thorwald finally attacks Jeff, the "feminization" process is complete and Jeff finds himself in the role previously played by Mrs. Thorwald and then by Lisa—a victim of male violence. Jeff ends up with two broken legs while Lisa has become the mirror image of the man—dressed in masculine clothes and reading a book of male adventure while Jeff sleeps. The film gives her the last look. And we are left with the suspicion that while men sleep and dream their dreams of omnipotence over a safely reduced world, women are hardly locked into the male "view" of them, imprisoned in their master's dollhouse.

Tom Gunning adds a historical perspective to the discussion of film spectatorship. Referring to, among others, Metz's description of the first silent film audiences as terrorized and overcome by its experience of the illusion of film, Gunning criticizes this distinction between the credulous and incredulous aspects of spectatorship along with the "legend" of the naive spectator of early film. He argues instead for an aware audience for whom film was an extension of illusionistic theater. It is an informed amazement at film's power rather than a child's incomprehension that is at work in what Gunning calls this "cinema of attractions," characteristic of the first decade of early film—"an encounter with modernity" in all its fragmentation. The moment of spectacle, then, which Mulvey defines more narrowly as the stopping of narrative in order to gaze at the image of woman, thus goes back to the beginning of film's preoccupation with spectacle of many kinds, including today's action films with their grandiose special effects.

Robert Stam and Louise Spence believe that studies of racism and anti-colonialism need to make the kind of methodological leap made by feminist criticism when journals like *Screen* and *Camera Obscura* transcended the usefully angry, but method-

ologically flawed, "image" analysis practiced by such critics as Molly Haskell and Majorie Rosen. They wish to pose questions concerning the apparatus, the position of the spectator, and the specifically cinematic codes. These studies should apply, as well, to the understanding of other oppressions including sexism, class subordination, and anti-Semitism, indeed, to all situations in which difference is transformed into "other"-ness and exploited or penalized by and for power. The approaches that Stam and Spence wish to supersede tend to focus on issues of social portrayal, plot, and character. While making an invaluable contribution by alerting us to the hostile distortion and affectionate condescension with which the colonized have been treated, these approaches have often been marred by a certain naivete. While posing legitimate questions concerning narrative plausibility and mimetic accuracy, negative stereotypes and positive images, their emphasis on realism had often betrayed an exaggerated faith in the possibilities of verisimilitude in art in general and cinema in particular, avoiding the fact that films are inevitably constructs, fabrications, representations. It is important, therefore, that we pay attention to the mediations which intervene between "reality" and representation. The emphasis should be on narrative structure, genre convention, and cinematic style rather than on perfect correctness of representation or fidelity to an original "real" model or prototype.

One important mediation specific to cinema is spectator positioning. Stam and Spence cite Tom Engelhardt to note that the paradigmatic filmic encounters between whites and Indians in the western typically involve images of encirclement. The attitude toward the Indian is premised on exteriority. The besieged wagon train or fort is the focus of our attention and sympathy, and from this center our familiars sally out against unknown attackers characterized by inexplicable customs and irrational hostility. The possibility of sympathetic identifications with the Indians is simply ruled out by the point-of-view conventions. The spectator is unwittingly sutured into a colonialist perspective. But such techniques are not inevitably colonialist in their operation. One of the innovations of Pontocorvo's *Battle of Algiers* is to invert the imagery of encirclement and exploit the identificatory mechanisms of cinema in behalf of the colonized rather than the colonizer. It is from within the casbah that we see and hear the French troops and helicopters. This time it is the colonized who are encircled and menaced and with whom we identify. The sequence in which three Algerian women dress in European style in order to pass the French checkpoints is particularly effective in controverting traditional patterns through the mechanisms of cinematic identification: scale (close shots individualize the three women); off-screen sound (we hear the sexist comments as if from the women's aural perspective); and especially point-of-view editing. By the time the women plant the bombs, our identification is so complete that we are not terribly disturbed by a series of close shots of the bombs' potential victims.

Other narrative and cinematic strategies in this sequence solicit support for the three women. Its narrative placement presents their action as the fulfillment of the FLN promise, made in the previous sequence, to respond to the French terror bombing of the casbah. The filmic experience must inevitably be infected by the cultural awareness of the audience itself, constituted outside the text and traversed by sets of social relations such as race, class, and gender. Stam and Spence argue that we must allow, therefore, for the possibility of aberrant readings, readings which go against the grain

of the discourse. Although fiction films are persuasive machines designed to produce specific impressions and emotions, they are not all-powerful, and they may be read differently by different audiences. Hollywood's ill-informed portrayals of Latin American life were sometimes laughed off the screen within Latin America itself, and black Americans, presumably, never took Stepin Fetchit to be an accurate representation of their race as a whole. We must be aware, too, of the institutionalized expectations, the mental machinery, that serve as the subjective support to the film industry and that lead us to consume films in a certain way. This apparatus has adapted most of us to the consumption of films with high production values. But many Third World filmmakers find such a model, if not repugnant, at least inappropriate—not only because of their critique of dominant cinema, but also because the Third World, with its scarcer capital and higher costs, simply cannot afford it. To expect to find First World production values in Third World films is to be both naive and ethnocentric. The objective of the study of filmic colonialism and racism is, finally, not to hurl charges of racism at individual filmmakers or critics. Rather, is to learn how to decode and deconstruct racist image and sounds. Racism is not permanently inscribed in celluloid or in the human mind; it forms part of a constantly changing dialectical process within which, we must never forget, we are far from powerless.

Manthia Diawara focuses the discussion of film spectatorship on black spectatorship in particular. As Mulvey argued that the classical Hollywood film is made for the pleasure of the male spectator, Diawara argues that the dominant cinema situates black characters primarily for the pleasure of white spectators (male or female). In response, and using examples from *The Birth of a Nation* and *The Color Purple,* Diawara develops the concept of what he calls "resisting" spectatorship. On this approach the film's presentation of characters and events can be read by its audience in a way that complicates and even contradicts what seem to be its basic intentions. Thus, the resisting spectator rejects the representation of the Little Colonel in *The Birth of a Nation* as an authoritative figure as well as the narrative proposition that lynching is a means of restoring the racial and symbolic order of the South. Yet the question of how some black spectators identify with the representation of blacks in dominant cinema remains to be explored. However that may be, resisting spectators are transforming the problem of passive identification into active criticism which both informs and interrelates with contemporary oppositional filmmaking. Black directors like Charles Barnett practice a "cinema of the real" in which there is no manipulation of the look to bring the spectator to a passive state of uncritical identification. This type of film constructs a critical position for the spectator in relation to the "real" and its representation. Other directors use a mixed form of fiction and documentary in which the documentary element serves to deconstruct the illusion created by the fiction and makes the spectator question the representation of "reality" through the contrast of the different modes. As more audiences discover such independent black films, spectator resistance to Hollywood's figuration of blacks will become increasingly focused and sharpened.

Finally, it is necessary to look into the future of cinema and, in particular, to consider the phenomenon of digitization. John Belton notes that this technological development has arrived in stages. For audiences it began in the realm of special effects—a field now dominated by computer-generated imagery. Then came digital sound, and

we are now seeing a very slow movement toward digital production using digital cameras and digital projection. George Lucas, whose *Star Wars: The Phantom Menace,* was digitally projected in four theaters in 1999, wrote, "In the twentieth century cinema was celluloid: the cinema of the twenty-first century will be digital. . . . Film is going to be photographed and projected digitally. The recorded image will go automatically into a computer and most postproduction will take place in a computer. . . . We made it through the silent era to the sound era and from the black-and-white era to the color era, and I'm sure we'll make it through to the digital era. . . . The creator's palette has been continually widened." Like others, Lucas compared the digital revolution to earlier revolutions in motion picture technology. But Belton questions whether the digital revolution is a technological revolution on the order of those to which it has been compared. In Belton's view digital projection as it exists today does not, in any way, transform the nature of the motion picture experience. Digital projection does not provide a new experience for the audience. What is being offered is simply something that is potentially equivalent to the projection of traditional 35mm film. It may be digital for George Lucas at his end of the chain, but for the audience it might as well be analog. Current digital projection is not interactive and does not enable the audience to relate to the cinema in ways similar to those provided by the computer or the Internet. In Belton's opinion the only transformation of the motion picture experience that has taken place in the last forty years or so has been the development of stadium seating.

For Lucas, digital cinema is clearly the realization of his dreams, a revolution in filmmaking. His commitment to sci-fi demands that he find new ways of realizing fantasy. Sci-fi and special-effects have become the dogs that wag Hollywood's tail, but there are other genres that rely less on special effects and fantasy and more on realistically conceived characters in more or less realistic settings. Indeed, the danger is that an all-digital cinema might very well lead to an all-fantasy cinema—to essentially one genre. In short, digital cinema is a revolutionary technological innovation for filmmakers like Lucas and for the interests of corporate synergy that currently drive Hollywood. It is also a potential boon—in the form of cost savings—for film distributors. The problem here is, however, that exhibitors cannot afford it. The studios and distributors would have to foot the bill and are unlikely to do so. Theaters around the world would have to be equipped (Hollywood barely breaks even on domestic rentals), and the cost of constant technological upgrades and of piracy would be great. In addition, the problems of the long-term preservation of information in digital form are formidable. At present the digital projection revolution is stalled and it is unclear what will drive it. Digital projection has no novelty value for audiences for whom it can do little aside from eliminating jitter, weave, dirt, and scratches from the projected image.

In contrast to Belton, Anne Friedberg argues that the cinema, a popular form of entertainment for almost a century, has been dramatically transformed. It has become embedded in—or perhaps lost in—the new technologies that surround it. The differences between the media of movies, television, and computers are rapidly diminishing. This is true both for the technologies of production and for the technologies of reception and display. The movie screen, the home television screen, and the computer screen retain their separate locations, yet the types of image seen on each of them are losing their medium-based specificity. Marshall McLuhan famously claimed that the

medium is the message, but more recently, as she points out, Nicholas Negroponte argued, "The medium is not the message in the digital world. It is the embodiment of it. A message might have several embodiments automatically derivable from the same data." Digital imaging, delivery, and display effectively erase the "messages" implicit in the source "medium." In the 1970s and 1980s a number of technologies began to erode the historical differences between television and film. The video cassette recorder, the television remote control, and the growth of cable television significantly altered the terms of both televisual and cinematic viewing. These developments led to a convergence of film and television technologies that began without fiber-optic cable, occurred before the digitalization of imagery, and preceded the advent of the home computer. As a result of these initial reconfigurations and as our visual field has been transformed by newer technologies, the field of "film studies" finds itself at a transitional moment. We must add computer screens (and digital technologies) and television screens (and interactive video formats) to our conceptualization (both historical and theoretical) of the cinema and its screens. Screens are now "display and deliver" formats—variable in versions of projection screen, television screen, computer screen, or headset device. Film is a "storage" medium—variable in versions of video, computers disks, compact discs (CDs), high-density compact video-disc players (DVDs), databanks, and on-line servers. Spectators are "users" with an "interface"— variable in versions of remotes, mice keyboards, touch screens, joysticks, goggles, and gloves and body suits. The apparatus we came to know as "the cinema" is being displaced by systems of circulation and transmission which abolish the projection screen and begin to link the video screens of the computer and television with the dialogic interactivity of the telephone. Multimedia home stations combining telephone, television, and computer will further reduce the technical differentiation of film, television, and the computer. Once thought to be the province of "information science" and not part of the study of "visual culture," histories of the telephone and the computer become significant tributaries in the converging multimedia stream.

The history of "film studies" in its own way parallels the history of film itself, with a lag of perhaps forty years. In what has been called the "classical" Hollywood period of film history there was a consensus not only as to what constituted narrative "content" but also as to the size, shape, color, and scope of the screen. Similarly, during the "classical" period of film studies there has been a general agreement as to what constitutes the size, shape, and scope of the discipline's objects. Now, a variety of screens—long and wide and square, large and small, composed of grains, composed of pixels—compete for our attention without any arguments about hegemony. Our concept of "film history" needs to be reconceptualized in light of these changes in technology because assumptions about "spectatorship" have lost their theoretical validity. As screens have changed, so have our relations to them.

# WALTER BENJAMIN
# THE WORK OF ART IN THE AGE OF MECHANICAL REPRODUCTION

Our fine arts were developed, their types and uses were established, in times very different from the present, by men whose power of action upon things was insignificant in comparison with ours. But the amazing growth of our techniques, the adaptability and precision they have attained, the ideas and habits they are creating, make it a certainty that profound changes are impending in the ancient craft of the Beautiful. In all the arts there is a physical component which can no longer be considered or treated as it used to be, which cannot remain unaffected by our modern knowledge and power. For the last twenty years neither matter nor space nor time has been what it was from time immemorial. We must expect great innovations to transform the entire technique of the arts, thereby affecting artistic invention itself and perhaps even bringing about an amazing change in our very notion of art.

PAUL VALÉRY, *Pièces sur l'art*,
"La Conquète de l'ubiquité," Paris

## PREFACE

When Marx undertook his critique of the capitalistic mode of production, this mode was in its infancy. Marx directed his efforts in such a way as to give them prognostic value. He went back to the basic conditions underlying capitalistic production and through his presentation showed what could be expected of capitalism in the future. The result was that one could expect it not only to exploit the proletariat with increasing intensity, but ultimately to create conditions which would make it possible to abolish capitalism itself.

The transformation of the superstructure, which takes place far more slowly than that of the substructure, has taken more than half a century to manifest in all areas of culture the change in the conditions of production. Only today can it be indicated what form this has taken. Certain prognostic requirements should be met by these

statements. However, theses about the art of the proletariat after its assumption of power or about the art of a classless society would have less bearing on these demands than theses about the developmental tendencies of art under present conditions of production. Their dialectic is no less noticeable in the superstructure than in the economy. It would therefore be wrong to underestimate the value of such theses as a weapon. They brush aside a number of outmoded concepts, such as creativity and genius, eternal value and mystery—concepts whose uncontrolled (and at present almost uncontrollable) application would lead to a processing of data in the Fascist sense. The concepts which are introduced into the theory of art in what follows differ from the more familiar terms in that they are completely useless for the purposes of Fascism. They are, on the other hand, useful for the formulation of revolutionary demands in the politics of art.

I

In principle a work of art has always been reproducible. Man-made artifacts could always be imitated by men. Replicas were made by pupils in practice of their craft, by masters for diffusing their works, and, finally, by third parties in the pursuit of gain. Mechanical reproduction of a work of art, however, represents something new. Historically, it advanced intermittently and in leaps at long intervals, but with accelerated intensity. The Greeks knew only two procedures of technically reproducing works of art: founding and stamping. Bronzes, terra cottas, and coins were the only art works which they could produce in quantity. All others were unique and could not be mechanically reproduced. With the woodcut graphic art became mechanically reproducible for the first time, long before script became reproducible by print. The enormous changes which printing, the mechanical reproduction of writing, has brought about in literature are a familiar story. However, within the phenomenon which we are here examining from the perspective of world history, print is merely a special, though particularly important, case. During the Middle Ages engraving and etching were added to the woodcut; at the beginning of the nineteenth century lithography made its appearance.

With lithography the technique of reproduction reached an essentially new stage. This much more direct process was distinguished by the tracing of the design on a stone rather than its incision on a block of wood or its etching on a copperplate and permitted graphic art for the first time to put its products on the market, not only in large numbers as hitherto, but also in daily changing forms. Lithography enabled graphic art to illustrate everyday life, and it began to keep pace with printing. But only a few decades after its invention, lithography was surpassed by photography. For the first time in the process of pictorial reproduction, photography freed the hand of the most important artistic functions which henceforth devolved only upon the eye looking into a lens. Since the eye perceives more swiftly than the hand can draw, the process of pictorial reproduction was accelerated so enormously that it could keep pace with speech. A film operator shooting a scene in the studio captures the images at the speed of an actor's speech. Just as lithography virtually implied the illustrated newspaper, so did photography foreshadow the sound film. The technical reproduction of sound was tackled at the end of the last century. These convergent endeavors made predictable a situation which Paul Valéry pointed up in this sentence: "Just as

water, gas, and electricity are brought into our houses from far off to satisfy our needs in response to a minimal effort, so we shall be supplied with visual or auditory images, which will appear and disappear at a simple movement of the hand, hardly more than a sign." Around 1900 technical reproduction had reached a standard that not only permitted it to reproduce all transmitted works of art and thus to cause the most profound change in their impact upon the public; it also had captured a place of its own among the artistic processes. For the study of this standard nothing is more revealing than the nature of the repercussions that these two different manifestations—the reproduction of works of art and the art of the film—have had on art in its traditional form.

## II

Even the most perfect reproduction of a work of art is lacking in one element: its presence in time and space, its unique existence at the place where it happens to be. This unique existence of the work of art determined the history to which it was subject throughout the time of its existence. This includes the changes which it may have suffered in physical condition over the years as well as the various changes in its ownership.[1] The traces of the first can be revealed only by chemical or physical analyses which it is impossible to perform on a reproduction; changes of ownership are subject to a tradition which must be traced from the situation of the original.

The presence of the original is the prerequisite to the concept of authenticity. Chemical analyses of the patina of a bronze can help to establish this, as does the proof that a given manuscript of the Middle Ages stems from an archive of the fifteenth century. The whole sphere of authenticity is outside technical—and, of course, not only technical—reproducibility.[2] Confronted with its manual reproduction, which was usually branded as a forgery, the original preserved all its authority; not so vis à vis technical reproduction. The reason is twofold. First, process reproduction is more independent of the original than manual reproduction. For example, in photography, process reproduction can bring out those aspects of the original that are unattainable to the naked eye yet accessible to the lens, which is adjustable and chooses its angle at will. And photographic reproduction, with the aid of certain processes, such as enlargement or slow motion, can capture images which escape natural vision. Secondly, technical reproduction can put the copy of the original into situations which would be out of reach for the original itself. Above all, it enables the original to meet the beholder halfway, be it in the form of a photograph or a phonograph record. The cathedral leaves its locale to be received in the studio of a lover of art; the choral production, performed in an auditorium or in the open air, resounds in the drawing room.

---

[1] Of course, the history of a work of art encompasses more than this. The history of the "Mona Lisa," for instance, encompasses the kind and number of its copies made in the 17th, 18th, and 19th centuries.

[2] Precisely because authenticity is not reproducible, the intensive penetration of certain (mechanical) processes of reproduction was instrumental in differentiating and grading authenticity. To develop such differentiations was an important function of the trade in works of art. The invention of the woodcut may be said to have struck at the root of the quality of authenticity even before its late flowering. To be sure, at the time of its origin a medieval picture of the Madonna could not yet be said to be "authentic." It became "authentic" only during the succeeding centuries and perhaps most strikingly so during the last one.

The situations into which the product of mechanical reproduction can be brought may not touch the actual work of art, yet the quality of its presence is always depreciated. This holds not only for the art work but also, for instance, for a landscape which passes in review before the spectator in a movie. In the case of the art object, a most sensitive nucleus—namely, its authenticity—is interfered with whereas no natural object is vulnerable on that score. The authenticity of a thing is the essence of all that is transmissible from its beginning, ranging from its substantive duration to its testimony to the history which it has experienced. Since the historical testimony rests on the authenticity, the former, too, is jeopardized by reproduction when substantive duration ceases to matter. And what is really jeopardized when the historical testimony is affected is the authority of the object.[3]

One might subsume the eliminated element in the term "aura" and go on to say: that which withers in the age of mechanical reproduction is the aura of the work of art. This is a symptomatic process whose significance points beyond the realm of art. One might generalize by saying: the technique of reproduction detaches the reproduced object from the domain of tradition. By making many reproductions it substitutes a plurality of copies for a unique existence. And in permitting the reproduction to meet the beholder or listener in his own particular situation, it reactivates the object reproduced. These two processes lead to a tremendous shattering of tradition which is the obverse of the contemporary crisis and renewal of mankind. Both processes are intimately connected with the contemporary mass movements. Their most powerful agent is the film. Its social significance, particularly in its most positive form, is inconceivable without its destructive, cathartic aspect, that is, the liquidation of the traditional value of the cultural heritage. This phenomenon is most palpable in the great historical films. It extends to ever new positions. In 1927 Abel Gance exclaimed enthusiastically: "Shakespeare, Rembrandt, Beethoven will make films . . . all legends, all mythologies and all myths, all founders of religion, and the very religions . . . await their exposed resurrection, and the heroes crowd each other at the gate." Presumably without intending it, he issued an invitation to a far-reaching liquidation.

III

During long periods of history, the mode of human sense perception changes with humanity's entire mode of existence. The manner in which human sense perception is organized, the medium in which it is accomplished, is determined not only by nature but by historical circumstances as well. The fifth century, with its great shifts of population, saw the birth of the late Roman art industry and the Vienna Genesis, and there developed not only an art different from that of antiquity but also a new kind of perception. The scholars of the Viennese school, Riegl and Wickhoff, who resisted the weight of classical tradition under which these later art forms had been buried, were the first to draw conclusions from them concerning the organization of percep-

---

[3]The poorest provincial staging of *Faust* is superior to a Faust film in that, ideally, it competes with the first performance at Weimar. Before the screen it is unprofitable to remember traditional contents which might come to mind before the stage—for instance, that Goethe's friend Johann Heinrich Merck is hidden in Mephisto, and the like.

tion at the time. However far-reaching their insight, these scholars limited themselves to showing the significant, formal hallmark which characterized perception in late Roman times. They did not attempt—and, perhaps, saw no way—to show the social transformations expressed by these changes of perception. The conditions for an analogous insight are more favorable in the present. And if changes in the medium of contemporary perception can be comprehended as decay of the aura, it is possible to show its social causes.

The concept of aura which was proposed above with reference to historical objects may usefully be illustrated with reference to the aura of natural ones. We define the aura as the unique appearance of a distance, however close it may be. If, while resting on a summer afternoon, you follow with your eyes a mountain range on the horizon or a branch which casts its shadow over you, you experience the aura of those mountains, of that branch. This image makes it easy to comprehend the social bases of the contemporary decay of the aura. It rests on two circumstances, both of which are related to the increasing significance of the masses in contemporary life. Namely, the desire of contemporary masses to bring things "closer" spatially and humanly, which is just as ardent as their bent toward overcoming the uniqueness of every reality by accepting its reproduction. Every day the urge grows stronger to get hold of an object at very close range by way of its image, or, rather, its copy.[4] Unmistakably, reproduction as offered by picture magazines and newsreels differs from the image seen by the unarmed eye. Uniqueness and permanence are as closely linked in the latter as are transitoriness and reproducibility in the former. To pry an object from its shell, to destroy its aura, is the mark of a perception whose "sense of the universal equality of things" has increased to such a degree that it extracts it even from a unique object by means of reproduction. Thus is manifested in the field of perception what in the theoretical sphere is noticeable in the increasing importance of statistics. The adjustment of reality to the masses and of the masses to reality is a process of unlimited scope, as much for thinking as for perception.

## IV

The uniqueness of a work of art is inseparable from its being imbedded in the fabric of tradition. This tradition itself is thoroughly alive and extremely changeable. An ancient statue of Venus, for example, stood in a different traditional context with the Greeks, who made it an object of veneration, than with the clerics of the Middle Ages, who viewed it as an ominous idol. Both of them, however, were equally confronted with its uniqueness, that is, its aura. Originally the contextual integration of art in tradition found its expression in the cult. We know that the earliest art works originated in the service of a ritual—first the magical, then the religious kind. It is significant that the existence of the work of art with reference to its aura is never entirely sepa-

---

[4]To satisfy the human interest of the masses may mean to have one's social function removed from the field of vision. Nothing guarantees that a portraitist of today, when painting a famous surgeon at the breakfast table in the midst of his family, depicts his social function more precisely than a painter of the 17th century who portrayed his medical doctors as representing this profession, like Rembrandt in his "Anatomy Lesson."

rated from its ritual function.[5] In other words, the unique value of the "authentic" work of art has its basis in ritual, the location of its original use value. This ritualistic basis, however remote, is still recognizable as secularized ritual even in the most profane forms of the cult of beauty.[6] The secular cult of beauty, developed during the Renaissance and prevailing for three centuries, clearly showed that ritualistic basis in its decline and the first deep crisis which befell it. With the advent of the first truly revolutionary means of reproduction, photography, simultaneously with the rise of socialism, art sensed the approaching crisis which has become evident a century later. At the time, art reacted with the doctrine of *l'art pour l'art*, that is, with a theology of art. This gave rise to what might be called a negative theology in the form of the idea of "pure" art, which not only denied any social function of art but also any categorizing by subject matter. (In poetry, Mallarmé was the first to take this position.)

An analysis of art in the age of mechanical reproduction must do justice to these relationships, for they lead us to an all-important insight: for the first time in world history, mechanical reproduction emancipates the work of art from its parasitical dependence on ritual. To an ever greater degree the work of art reproduced becomes the work of art designed for reproducibility.[7] From a photographic negative, for example, one can make any number of prints; to ask for the "authentic" print makes no sense. But the instant the criterion of authenticity ceases to be applicable to artistic production, the total function of art is reversed. Instead of being based on ritual, it begins to be based on another practice—politics.

---

[5]The definition of the aura as a "unique phenomenon of a distance however close it may be" represents nothing but the formulation of the cult value of the work of art in categories of space and time perception. Distance is the opposite of closeness. The essentially distant object is the unapproachable one. Unapproachability is indeed a major quality of the cult image. True to its nature, it remains "distant, however close it may be." The closeness which one may gain from its subject matter does not impair the distance which it retains in its appearance.

[6]To the extent to which the cult value of the painting is secularized the ideas of its fundamental uniqueness lose distinctness. In the imagination of the beholder the uniqueness of the phenomena which hold sway in the cult image is more and more displaced by the empirical uniqueness of the creator or of his creative achievement. To be sure, never completely so; the concept of authenticity always transcends mere genuineness. (This is particularly apparent in the collector who always retains some traces of the fetishist and who, by owning the work of art, shares in its ritual power.) Nevertheless, the function of the concept of authenticity remains determinate in the evaluation of art; with the secularization of art, authenticity displaces the cult value of the work.

[7]In the case of films, mechanical reproduction is not, as with literature and painting, an external condition for mass distribution. Mechanical reproduction is inherent in the very technique of film production. This technique not only permits in the most direct way but virtually causes mass distribution. It enforces distribution because the production of a film is so expensive that an individual who, for instance, might afford to buy a painting no longer can afford to buy a film. In 1927 it was calculated that a major film, in order to pay its way, had to reach an audience of nine million. With the sound film, to be sure, a setback in its international distribution occurred at first: audiences became limited by language barriers. This coincided with the Fascist emphasis on national interests. It is more important to focus on this connection with Fascism than on this setback, which was soon minimized by synchronization. The simultaneity of both phenomena is attributable to the Depression. The same disturbances which, on a larger scale, led to an attempt to maintain the existing property structure by sheer force led the endangered film capital to speed up the development of the sound film. The introduction of the sound film brought about a temporary relief, not only because it again brought the masses into the theaters but also because it merged new capital from the electrical industry with that of the film industry. Thus, viewed from the outside, the sound film promoted national interests, but seen from the inside it helped to internationalize film production even more than previously.

V

Works of art are received and valued on different planes. Two polar types stand out: with one, the accent is on the cult value; with the other, on the exhibition value of the work.[8] Artistic production begins with ceremonial objects destined to serve in a cult. One may assume that what mattered was their existence, not their being on view. The elk portrayed by the man of the Stone Age on the walls of his cave was an instrument of magic. He did expose it to his fellow men, but in the main it was meant for the spirits. Today the cult value would seem to demand that the work of art remain hidden. Certain statues of gods are accessible only to the priest in the cella; certain Madonnas remain covered nearly all year round; certain sculptures on medieval cathedrals are invisible to the spectator on ground level. With the emancipation of the various art practices from ritual go increasing opportunities for the exhibition of their products. It is easier to exhibit a portrait bust that can be sent here and there than to exhibit the statue of a divinity that has its fixed place in the interior of a temple. The same holds for the painting as against the mosaic or fresco that preceded it. And even though the public presentability of a mass originally may have been just as great as that of a symphony, the latter originated at the moment when its public presentability promised to surpass that of the mass.

With the different methods of technical reproduction of a work of art, its fitness for exhibition increased to such an extent that the quantitative shift between its two poles

---

[8]This polarity cannot come into its own in the aesthetics of Idealism. Its idea of beauty comprises these polar opposites without differentiating between them and consequently excludes their polarity. Yet in Hegel this polarity announces itself as clearly as possible within the limits of Idealism. We quote from his *Philosophy of History*:

Images were known of old. Piety at an early time required them for worship, but it could do without *beautiful* images. These might even be disturbing. In every beautiful painting there is also something nonspiritual, merely external, but its spirit speaks to man through its beauty. Worshipping, conversely, is concerned with the work as an object, for it is but a spiritless stupor of the soul. . . . Fine art has arisen . . . in the church . . . . , although it has already gone beyond its principle as art.

Likewise, the following passage from *The Philosophy of Fine Art* indicates that Hegel sensed a problem here.

We are beyond the stage of reverence for works of art as divine and objects deserving our worship. The impression they produce is one of a more reflective kind, and the emotions they arouse require a higher test. . . .—G. W. F. Hegel, *The Philosophy of Fine Art*, trans., with notes, by F. P. B. Osmaston, Vol. 1, p. 12, London, 1920.

The transition from the first kind of artistic reception to the second characterizes the history of artistic reception in general. Apart from that, a certain oscillation between these two polar modes of reception can be demonstrated for each work of art. Take the Sistine Madonna. Since Hubert Grimme's research it has been known that the Madonna originally was painted for the purpose of exhibition. Grimme's research was inspired by the question: What is the purpose of the molding in the foreground of the painting which the two cupids lean upon? How, Grimme asked further, did Raphael come to furnish the sky with two draperies? Research proved that the Madonna had been commissioned for the public lying-in-state of Pope Sixtus. The Popes lay in state in a certain side chapel of St. Peter's. On that occasion Raphael's picture had been fastened in a nichelike background of the chapel, supported by the coffin. In this picture Raphael portrays the Madonna approaching the papal coffin in clouds from the background of the niche, which was demarcated by green drapes. At the obsequies of Sixtus a pre-eminent exhibition value of Raphael's picture was taken advantage of. Some time later it was placed on the high altar in the church of the Black Friars at Piacenza. The reason for this exile is to be found in the Roman rites which forbid the use of paintings exhibited at obsequies as cult objects on the high altar. This regulation devalued Raphael's picture to some degree. In order to obtain an adequate price nevertheless, the Papal See resolved to add to the bargain the tacit toleration of the picture above the high altar. To avoid attention the picture was given to the monks of the far-off provincial town.

turned into a qualitative transformation of its nature. This is comparable to the situation of the work of art in prehistoric times when, by the absolute emphasis on its cult value, it was, first and foremost, an instrument of magic. Only later did it come to be recognized as a work of art. In the same way today, by the absolute emphasis on its exhibition value the work of art becomes a creation with entirely new functions, among which the one we are conscious of, the artistic function, later may be recognized as incidental.[9] This much is certain: today photography and the film are the most serviceable exemplifications of this new function.

## VI

In photography, exhibition value begins to displace cult value all along the line. But cult value does not give way without resistance. It retires into an ultimate retrenchment: the human countenance. It is no accident that the portrait was the focal point of early photography. The cult of remembrance of loved ones, absent or dead, offers a last refuse for the cult value of the picture. For the last time the aura emanates from the early photographs in the fleeting expression of a human face. This is what constitutes their melancholy, incomparable beauty. But as man withdraws from the photographic image, the exhibition value for the first time shows its superiority to the ritual value. To have pinpointed this new stage constitutes the incomparable significance of Atget, who, around 1900, took photographs of deserted Paris streets. It has quite justly been said of him that he photographed them like scenes of crime. The scene of a crime, too, is deserted; it is photographed for the purpose of establishing evidence. With Atget, photographs become standard evidence for historical occurrences, and acquire a hidden political significance. They demand a specific kind of approach; free-floating contemplation is not appropriate to them. They stir the viewer; he feels challenged by them in a new way. At the same time picture magazines begin to put up signposts for him, right ones or wrong ones, no matter. For the first time, captions have become obligatory. And it is clear that they have an altogether different character than the title of a painting. The directives which the captions give to those looking at pictures in illustrated magazines soon become even more explicit and more imperative in the film where the meaning of each single picture appears to be prescribed by the sequence of all preceding ones.

## VII

The nineteenth-century dispute as to the artistic value of painting versus photography today seems devious and confused. This does not diminish its importance, however; if anything, it underlines it. The dispute was in fact the symptom of a historical transformation the universal impact of which was not realized by either of the rivals.

---

[9]Bertolt Brecht, on a different level, engaged in analogous reflections: "If the concept of 'work of art' can no longer be applied to the thing that emerges once the work is transformed into a commodity, we have to eliminate this concept with cautious care but without fear, lest we liquidate the function of the very thing as well. For it has to go through this phase without mental reservation, and not as noncommittal deviation from the straight path; rather, what happens here with the work of art will change it fundamentally and erase its past to such an extent that should the old concept be taken up again—and it will, why not?—it will no longer stir any memory of the thing it once designated."

When the age of mechanical reproduction separated art from its basis in cult, the semblance of its autonomy disappeared forever. The resulting change in the function of art transcended the perspective of the century; for a long time it even escaped that of the twentieth century, which experienced the development of the film.

Earlier much futile thought had been devoted to the question of whether photography is an art. The primary question—whether the very invention of photography had not transformed the entire nature of art—was not raised. Soon the film theoreticians asked the same ill-considered question with regard to the film. But the difficulties which photography caused traditional aesthetics were mere child's play as compared to those raised by the film. Whence the insensitive and forced character of early theories of the film. Abel Gance, for instance, compares the film with hieroglyphs: "Here, by a remarkable regression, we have come back to the level of expression of the Egyptians. . . . Pictorial language has not yet matured because our eyes have not yet adjusted to it. There is as yet insufficient respect for, insufficient cult of, what it expresses." Or, in the words of Séverin-Mars: "What art has been granted a dream more poetical and more real at the same time! Approached in this fashion the film might represent an incomparable means of expression. Only the most high-minded persons, in the most perfect and mysterious moments of their lives, should be allowed to enter its ambience." Alexandre Arnoux concludes his fantasy about the silent film with the question: "Do not all the bold descriptions we have given amount to the definition of prayer?" It is instructive to note how their desire to class the film among the "arts" forces these theoreticians to read ritual elements into it—with a striking lack of discretion. Yet when these speculations were published, films like *L'Opinion publique* and *The Gold Rush* had already appeared. This, however, did not keep Abel Gance from adducing hieroglyphs for purposes of comparison, nor Séverin-Mars from speaking of the film as one might speak of paintings by Fra Angelico. Characteristically, even today ultrareactionary authors give the film a similar contextual significance—if not an outright sacred one, then at least a supernatural one. Commenting on Max Reinhardt's film version of *A Midsummer Night's Dream*, Werfel states that undoubtedly it was the sterile copying of the exterior world with its streets, interiors, railroad stations, restaurants, motorcars, and beaches which until now had obstructed the elevation of the film to the realm of art. "The film has not yet realized its true meaning, its real possibilities . . . these consist in its unique faculty to express by natural means and with incomparable persuasiveness all that is fairylike, marvelous, supernatural."

## VIII

The artistic performance of a stage actor is definitely presented to the public by the actor in person; that of the screen actor, however, is presented by a camera, with a twofold consequence. The camera that presents the performance of the film actor to the public need not respect the performance as an integral whole. Guided by the cameraman, the camera continually changes its position with respect to the performance. The sequence of positional views which the editor composes from the material supplied him constitutes the completed film. It comprises certain factors of movement which are in reality those of the camera, not to mention special camera angles, close-

ups, etc. Hence, the performance of the actor is subjected to a series of optical tests. This is the first consequence of the fact that the actor's performance is presented by means of a camera. Also, the film actor lacks the opportunity of the stage actor to adjust to the audience during his performance, since he does not present his performance to the audience in person. This permits the audience to take the position of a critic, without experiencing any personal contact with the actor. The audience's identification with the actor is really an identification with the camera. Consequently the audience takes the position of the camera; its approach is that of testing.[10] This is not the approach to which cult values may be exposed.

## IX

For the film, what matters primarily is that the actor represents himself to the public before the camera, rather than representing someone else. One of the first to sense the actor's metamorphosis by this form of testing was Pirandello. Though his remarks on the subject in his novel *Si Gira* were limited to the negative aspects of the question and to the silent film only, this hardly impairs their validity. For in this respect, the sound film did not change anything essential. What matters is that the part is acted not for an audience but for a mechanical contrivance—in the case of the sound film, for two of them. "The film actor," wrote Pirandello, "feels as if in exile—exiled not only from the stage but also from himself. With a vague sense of discomfort he feels inexplicable emptiness: his body loses its corporeality, it evaporates, it is deprived of reality, life, voice, and the noises caused by his moving about, in order to be changed into a mute image, flickering an instant on the screen, then vanishing into silence. . . . The projector will play with his shadow before the public, and he himself must be content to play before the camera." This situation might also be characterized as follows: for the first time—and this is the effect of the film—man has to operate with his whole living person, yet forgoing its aura. For aura is tied to his presence; there can be no replica of it. The aura which, on the stage, emanates from Macbeth, cannot be separated for the spectators from that of the actor. However, the singularity of the shot in the studio is that the camera is substituted for the public. Consequently, the aura that envelops the actor vanishes, and with it the aura of the figure he portrays.

It is not surprising that it should be a dramatist such as Pirandello who, in characterizing the film, inadvertently touches on the very crisis in which we see the theater. Any thorough study proves that there is indeed no greater contrast than that of the stage play to a work of art that is completely subject to or, like the film, founded in, mechanical reproduction. Experts have long recognized that in the film "the greatest effects are almost always obtained by 'acting' as little as possible. . . ." In 1932

---

[10]"The film . . . provides—or could provide—useful insight into the details of human actions. . . . Character is never used as a source of motivation; the inner life of the persons never supplies the principal cause of the plot and seldom is its main result." (Bertolt Brecht, *Versuche*, "Der Dreigroschenprozess," p. 268.) The expansion of the field of the testable which mechanical equipment brings about for the actor corresponds to the extraordinary expansion of the field of the testable brought about for the individual through economic conditions. Thus, vocational aptitude tests become constantly more important. What matters in these tests are segmental performances of the individual. The film shot and the vocational aptitude test are taken before a committee of experts. The camera director in the studio occupies a place identical with that of the examiner during aptitude tests.

Rudolf Arnheim saw "the latest trend . . . in treating the actor as a stage prop chosen for its characteristics and . . . inserted at the proper place."[11] With this idea something else is closely connected. The stage actor identifies himself with the character of his role. The film actor very often is denied this opportunity. His creation is by no means all of a piece; it is composed of many separate performances. Besides certain fortuitous considerations, such as cost of studio, availability of fellow players, décor, etc., there are elementary necessities of equipment that split the actor's work into a series of mountable episodes. In particular, lighting and its installation require the presentation of an event that, on the screen, unfolds as a rapid and unified scene, in a sequence of separate shootings which may take hours at the studio; not to mention more obvious montage. Thus a jump from the window can be shot in the studio as a jump from a scaffold, and the ensuing flight, if need be, can be shot weeks later when outdoor scenes are taken. Far more paradoxical cases can easily be construed. Let us assume that an actor is supposed to be startled by a knock at the door. If his reaction is not satisfactory, the director can resort to an expedient: when the actor happens to be at the studio again he has a shot fired behind him without his being forewarned of it. The frightened reaction can be shot now and be cut into the screen version. Nothing more strikingly shows that art has left the realm of the "beautiful semblance" which, so far, had been taken to be the only sphere where art could thrive.

X

The feeling of strangeness that overcomes the actor before the camera, as Pirandello describes it, is basically of the same kind as the estrangement felt before one's own image in the mirror. But now the reflected image has become separable, transportable. And where is it transported? Before the public.[12] Never for a moment does

---

[11]Rudolf Arnheim, *Film als Kunst*, Berlin, 1932, pp. 176 f. In this context certain seemingly unimportant details in which the film director deviates from stage practices gain in interest. Such is the attempt to let the actor play without make-up, as made among others by Dreyer in his *Jeanne d'Arc*. Dreyer spent months seeking the forty actors who constitute the Inquisitors' tribunal. The search for these actors resembled that for stage properties that are hard to come by. Dreyer made every effort to avoid resemblances of age, build, and physiognomy. If the actor thus becomes a stage property, this latter, on the other hand, frequently functions as actor. At least it is not unusual for the film to assign a role to the stage property. Instead of choosing at random from a great wealth of examples, let us concentrate on a particularly convincing one. A clock that is working will always be a disturbance on the stage. There it cannot be permitted its function of measuring time. Even in a naturalistic play, astronomical time would clash with theatrical time. Under these circumstances it is highly revealing that the film can, whenever appropriate, use time as measured by a clock. From this more than from many other touches it may clearly be recognized that under certain circumstances each and every prop in a film may assume important functions. From here it is but one step to Pudovkin's statement that "the playing of an actor which is connected with an object and is built around it . . . is always one of the strongest methods of cinematic construction." (W. Pudovkin, *Filmregie und Filmmanuskript*, Berlin, 1928, p. 126.) The film is the first art form capable of demonstrating how matter plays tricks on man. Hence, films can be an excellent means of materialistic representation.

[12]The change noted here in the method of exhibition caused by mechanical reproduction applies to politics as well. The present crisis of the bourgeois democracies comprises a crisis of the conditions which determine the public presentation of the rulers. Democracies exhibit a member of government directly and personally before the nation's representatives. Parliament is his public. Since the innovations of camera and recording equipment make it possible for the orator to become audible and visible to an unlimited number of persons, the presentation of the man of politics before camera and recording equipment becomes paramount. Parliaments, as much as theaters, are deserted. Radio and film not only affect the function of the professional actor but likewise the function of those who also exhibit themselves before this

the screen actor cease to be conscious of this fact. While facing the camera he knows that ultimately he will face the public, the consumers who constitute the market. This market, where he offers not only his labor but also his whole self, his heart and soul, is beyond his reach. During the shooting he has as little contact with it as any article made in a factory. This may contribute to that oppression, that new anxiety which, according to Pirandello, grips the actor before the camera. The film responds to the shriveling of the aura with an artificial build-up of the "personality" outside the studio. The cult of the movie star, fostered by the money of the film industry, preserves not the unique aura of the person but the "spell of the personality," the phony spell of a commodity. So long as the movie-makers' capital sets the fashion, as a rule no other revolutionary merit can be accredited to today's film than the promotion of a revolutionary criticism of traditional concepts of art. We do not deny that in some cases today's films can also promote revolutionary criticism of social conditions, even of the distribution of property. However, our present study is no more specifically concerned with this than is the film production of Western Europe.

It is inherent in the technique of the film as well as that of sports that everybody who witnesses its accomplishments is somewhat of an expert. This is obvious to anyone listening to a group of newspaper boys leaning on their bicycles and discussing the outcome of a bicycle race. It is not for nothing that newspaper publishers arrange races for their delivery boys. These arouse great interest among the participants, for the victor has an opportunity to rise from delivery boy to professional racer. Similarly, the newsreel offers everyone the opportunity to rise from passer-by to movie extra. In this way any man might even find himself part of a work of art, as witness Vertoff's *Three Songs About Lenin* or Ivens' *Borinage*. Any man today can lay claim to being filmed. This claim can best be elucidated by a comparative look at the historical situation of contemporary literature.

For centuries a small number of writers were confronted by many thousands of readers. This changed toward the end of the last century. With the increasing extension of the press, which kept placing new political, religious, scientific, professional, and local organs before the readers, an increasing number of readers became writers—at first, occasional ones. It began with the daily press opening to its readers space for "letters to the editor." And today there is hardly a gainfully employed European who could not, in principle, find an opportunity to publish somewhere or other comments on his work, grievances, documentary reports, or that sort of thing. Thus, the distinction between author and public is about to lose its basic character. The difference becomes merely functional; it may vary from case to case. At any moment the reader is ready to turn into a writer. As expert, which he had to become willy-nilly in an extremely specialized work process, even if only in some minor respect, the reader gains access to authorship. In the Soviet Union work itself is given a voice. To present it verbally is part of a man's ability to perform the work. Literary license is now

---

mechanical equipment, those who govern. Though their tasks may be different, the change affects equally the actor and the ruler. The trend is toward establishing controllable and transferrable skills under certain social conditions. This results in a new selection, a selection before the equipment from which the star and the dictator emerge victorious.

founded on polytechnic rather than specialized training and thus becomes common property.[13]

All this can easily be applied to the film, where transitions that in literature took centuries have come about in a decade. In cinematic practice, particularly in Russia, this change-over has partially become established reality. Some of the players whom we meet in Russian films are not actors in our sense but people who portray *themselves*—and primarily in their own work process. In Western Europe the capitalistic exploitation of the film denies consideration to modern man's legitimate claim to being reproduced. Under these circumstances the film industry is trying hard to spur the interest of the masses through illusion-promoting spectacles and dubious speculations.

## XI

The shooting of a film, especially of a sound film, affords a spectacle unimaginable anywhere at any time before this. It presents a process in which it is impossible to assign to a spectator a viewpoint which would exclude from the actual scene such extraneous accessories as camera equipment, lighting machinery, staff assistants, etc.—unless his eye were on a line parallel with the lens. This circumstance, more than any other, renders superficial and insignificant any possible similarity between a scene in the studio and one on the stage. In the theater one is well aware of the place from which the play cannot immediately be detected as illusionary. There is no such place for the movie scene that is being shot. Its illusionary nature is that of the second degree, the result of editing. That is to say, in the studio the mechanical equip-

---

[13]The privileged character of the respective techniques is lost. Aldous Huxley writes:

Advances in technology have led . . . to vulgarity. . . . Process reproduction and the rotary press have made possible the indefinite multiplication of writing and pictures. Universal education and relatively high wages have created an enormous public who know how to read and can afford to buy reading and pictorial matter. A great industry has been called into existence in order to supply these commodities. Now, artistic talent is a very rare phenomenon; whence it follows . . . that, at every epoch and in all countries, most art has been bad. But the proportion of trash in the total artistic output is greater now than at any other period. That it must be so is a matter of simple arithmetic. The population of Western Europe has a little more than doubled during the last century. But the amount of reading—and seeing—matter has increased, I should imagine, at least twenty and possibly fifty or even a hundred times. If there were n men of talent in a population of x millions, there will presumably be 2n men of talent among 2x millions. The situation may be summed up thus. For every page of print and pictures published a century ago, twenty or perhaps even a hundred pages are published today. But for every man of talent then living, there are now only two men of talent. It may be of course that, thanks to universal education, many potential talents which in the past would have been stillborn are now enabled to realize themselves. Let us assume, then, that there are now three or even four men of talent to every one of earlier times. It still remains true to say that the consumption of reading—and seeing—matter has far outstripped the natural production of gifted writers and draughtsmen. It is the same with hearing-matter. Prosperity, the gramophone and the radio have created an audience of hearers who consume an amount of hearing-matter that has increased out of all proportion to the increase of population and the consequent natural increase of talented musicians. It follows from all this that in all the arts the output of trash is both absolutely and relatively greater than it was in the past; and that it must remain greater for just so long as the world continues to consume the present inordinate quantities of reading-matter, seeing-matter, and hearing-matter.—Aldous Huxley, *Beyond the Mexique Bay. A Traveller's Journal*, London, 1949, pp. 274 ff. First published in 1934.

This mode of observation is obviously not progressive.

ment has penetrated so deeply into reality that its pure aspect, freed from the foreign substance of equipment, is the result of a special procedure, namely, shooting from a particular camera angle and linking the shot with other similar ones. The equipment-free aspect of reality here has become the height of artifice; the sight of immediate reality has become the [unattainable] blue flower in the land of technology.

Even more revealing is the comparison of these circumstances, which differ so much from those of the theater, with the situation in painting. Here the question is: How does the cameraman compare with the painter? To answer this we take recourse to an analogy with a surgical operation. The surgeon represents the polar opposite of the magician. The magician heals a sick person by the laying on of hands; the surgeon cuts into the patient's body. The magician maintains the natural distance between the patient and himself; though he reduces it very slightly by the laying on of hands, he greatly increases it by virtue of his authority. The surgeon does exactly the reverse; he greatly diminishes the distance between himself and the patient by penetrating into the patient's body, and increases it but little by the caution with which his hand moves among the organs. In short, in contrast to the magician—who is still hidden in the medical practitioner—the surgeon at the decisive moment abstains from facing the patient man to man; rather, it is through the operation that he penetrates into him.

Magician and surgeon compare to painter and cameraman. The painter maintains in his work a natural distance from reality, the cameraman penetrates deeply into its web.[14] There is a tremendous difference between the pictures they obtain. That of the painter is a total one, that of the cameraman consists of multiple fragments which are assembled under a new law. Thus, for contemporary man the representation of reality by the film is incomparably more significant than that of the painter, since it offers, precisely because of the thoroughgoing permeation of reality with mechanical equipment, an aspect of reality which is free of all equipment. And that is what one is entitled to ask from a work of art.

## XII

Mechanical reproduction of art changes the reaction of the masses toward art. The reactionary attitude toward a Picasso painting changes into the progressive reaction toward a Chaplin movie. The progressive reaction is characterized by the direct, intimate fusion of visual and emotional enjoyment with the orientation of the expert. Such fusion is of great social significance. The greater the decrease in the social significance of an art form, the sharper the distinction between criticism and enjoyment

---

[14]The boldness of the cameraman is indeed comparable to that of the surgeon. Luc Durtain lists among specific technical sleights of hand those "which are required in surgery in the case of certain difficult operations. I choose as an example a case from oto-rhinolaryngology; . . . the so-called endonasal perspective procedure; or I refer to the acrobatic tricks of larynx surgery which have to be performed following the reversed picture in the laryngoscope. I might also speak of ear surgery which suggests the precision work of watchmakers. What range of the most subtle muscular acrobatics is required from the man who wants to repair or save the human body! We have only to think of the couching of a cataract where there is virtually a debate of steel with nearly fluid tissue, or of the major abdominal operations (laparotomy)."—Luc Durtain, *op. cit.*

by the public. The conventional is uncritically enjoyed, and the truly new is criticized with aversion. With regard to the screen, the critical and the receptive attitudes of the public coincide. The decisive reason for this is that individual reactions are predetermined by the mass audience response they are about to produce, and this is nowhere more pronounced than in the film. The moment these responses become manifest they control each other. Again, the comparison with painting is fruitful. A painting has always had an excellent chance to be viewed by one person or by a few. The simultaneous contemplation of paintings by a large public, such as developed in the nineteenth century, is an early symptom of the crisis of painting, a crisis which was by no means occasioned exclusively by photography but rather in a relatively independent manner by the appeal of art works to the masses.

Painting simply is in no position to present an object for simultaneous collective experience, as it was possible for architecture at all times, for the epic poem in the past, and for the movie today. Although this circumstance in itself should not lead one to conclusions about the social role of painting, it does constitute a serious threat as soon as painting, under special conditions and, as it were, against its nature, is confronted directly by the masses. In the churches and monasteries of the Middle Ages and at the princely courts up to the end of the eighteenth century, a collective reception of paintings did not occur simultaneously, but by graduated and hierarchized mediation. The change that has come about is an expression of the particular conflict in which painting was implicated by the mechanical reproducibility of paintings. Although paintings began to be publicly exhibited in galleries and salons, there was no way for the masses to organize and control themselves in their reception.[15] Thus the same public which responds in a progressive manner toward a grotesque film is bound to respond in a reactionary manner to surrealism.

## XIII

The characteristics of the film lie not only in the manner in which man presents himself to mechanical equipment but also in the manner in which, by means of this apparatus, man can represent his environment. A glance at occupational psychology illustrates the testing capacity of the equipment. Psychoanalysis illustrates it in a different perspective. The film has enriched our field of perception with methods which can be illustrated by those of Freudian theory. Fifty years ago, a slip of the tongue passed more or less unnoticed. Only exceptionally may such a slip have revealed dimensions of depth in a conversation which had seemed to be taking its course on the surface. Since the *Psychopathology of Everyday Life* things have changed. This book isolated and made analyzable things which had heretofore floated along unnoticed in the broad stream of perception. For the entire spectrum of optical, and now also acoustical, perception the film has brought about a similar deepening of apper-

---

[15]This mode of observation may seem crude, but as the great theoretician Leonardo has shown, crude modes of observation may at times be usefully adduced. Leonardo compares painting and music as follows: "Painting is superior to music because, unlike unfortunate music, it does not have to die as soon as it is born. . . . Music which is consumed in the very act of its birth is inferior to painting which the use of varnish has rendered eternal." (*Trattato* I, 29.)

ception. It is only an obverse of this fact that behavior items shown in a movie can be analyzed much more precisely and from more points of view than those presented on paintings or on the stage. As compared with painting, filmed behavior lends itself more readily to analysis because of its incomparably more precise statements of the situation. In comparison with the stage scene, the filmed behavior item lends itself more readily to analysis because it can be isolated more easily. This circumstance derives its chief importance from its tendency to promote the mutual penetration of art and science. Actually, of a screened behavior item which is neatly brought out in a certain situation, like a muscle of a body, it is difficult to say which is more fascinating, its artistic value or its value for science To demonstrate the identity of the artistic and scientific uses of photography which heretofore usually were separated will be one of the revolutionary functions of the film.[16]

By close-ups of the things around us, by focusing on hidden details of familiar objects, by exploring common place milieus under the ingenious guidance of the camera, the film, on the one hand, extends our comprehension of the necessities which rule our lives; on the other hand, it manages to assure us of an immense and unexpected field of action. Our taverns and city streets, our offices and furnished rooms, our railroad stations and our factories appeared to have us locked up beyond hope. Then came film and burst this prison-world asunder by the dynamite of the tenth of a second, so that now, in the midst of its far-flung ruins and debris, we calmly and adventurously go traveling. With the close-up, space expands; with slow motion, movement is extended. The enlargement of a snapshot does not simply render more precise what in any case was visible, though unclear: it reveals entirely new structural formations of the subject. So, too, slow motion not only presents familiar qualities of movement but reveals in them entirely unknown ones "which, far from looking like retarded rapid movements, give the effect of singularly gliding, floating, supernatural motions." Evidently a different nature speaks to the camera than opens to the naked eye—if only because an unconsciously penetrated space is substituted for a space consciously explored by man. Even if one has a general knowledge of the way people walk, one knows nothing of a person's posture during the fractional second of a stride. The act of reaching for a lighter or a spoon is familiar routine, yet we hardly know what really goes on between hand and metal, not to mention how this fluctuates with our moods. Here the camera intervenes with the resources of its lowerings and liftings, its interruptions and isolations, it extensions and accelerations, its enlargements and reductions. The camera introduces us to unconscious optics as does psychoanalysis to unconscious impulses.

---

[16]Renaissance painting offers a revealing analogy to this situation. The incomparable development of this art and its significance rested not least on the integration of a number of new sciences, or at least of new scientific data. Renaissance painting made use of anatomy and perspective, of mathematics, meteorology, and chromatology. Valéry writes: "What could be further from us than the strange claim of a Leonardo to whom painting was a supreme goal and the ultimate demonstration of knowledge? Leonardo was convinced that painting demanded universal knowledge, and he did not even shrink from a theoretical analysis which to us is stunning because of its very depth and precision. . . ."—Paul Valéry, Pièces sur l'art, "Autour de Corot," Paris, p. 191.

XIV

One of the foremost tasks of art has always been the creation of a demand which could be fully satisfied only later.[17] The history of every art form shows critical epochs in which a certain art form aspires to effects which could be fully obtained only with a changed technical standard, that is to say, in a new art form. The extravagances and crudities of art which thus appear, particularly in the so-called decadent epochs, actually arise from the nucleus of its richest historical energies. In recent years, such barbarisms were abundant in Dadaism. It is only now that its impulse becomes discernible: Dadaism attempted to create by pictorial—and literary—means the effects which the public today seeks in the film.

Every fundamentally new, pioneering creation of demands will carry beyond its goal. Dadaism did so to the extent that it sacrificed the market values which are so characteristic of the film in favor of higher ambitions—though of course it was not conscious of such intentions as here described. The Dadaists attached much less importance to the sales value of their work than to its usefulness for contemplative immersion. The studied degradation of their material was not the least of their means to achieve this uselessness. Their poems are "word salad" containing obscenities and every imaginable waste product of language. The same is true of their paintings, on which they mounted buttons and tickets. What they intended and achieved was a relentless destruction of the aura of their creations, which they branded as reproductions with the very means of production. Before a painting of Arp's or a poem by August Stramm it is impossible to take time for contemplation and evaluation as one would before a canvas of Derain's or a poem by Rilke. In the decline of middle-class society, contemplation became a school for asocial behavior; it was countered by distraction as a variant of social conduct.[18] Dadaistic activities actually assured a rather vehement distraction by making works of art the center of scandal. One requirement was foremost: to outrage the public.

---

[17]"The work of art," says André Breton, "is valuable only in so far as it is vibrated by the reflexes of the future." Indeed, every developed art form intersects three lines of development. Technology works toward a certain form of art. Before the advent of the film there were photo booklets with pictures which flitted by the onlooker upon pressure of the thumb, thus portraying a boxing bout or a tennis match. Then there were the slot machines in bazaars; their picture sequences were produced by the turning of a crank.

Secondly, the traditional art forms in certain phases of their development strenuously work toward effects which later are effortlessly attained by the new ones. Before the rise of the movie the Dadaists' performances tried to create an audience reaction which Chaplin later evoked in a more natural way.

Thirdly, unspectacular social changes often promote a change in receptivity which will benefit the new art form. Before the movie had begun to create its public, pictures that were no longer immobile captivated an assembled audience in the so-called *Kaiserpanorama*. Here the public assembled before a screen into which stereoscopes were mounted, one to each beholder. By a mechanical process individual pictures appeared briefly before the stereoscopes, then made way for others. Edison still had to use similar devices in presenting the first movie strip before the film screen and projection were known. This strip was presented to a small public which stared into the apparatus in which the succession of pictures was reeling off. Incidentally, the institution of the *Kaiserpanorama* shows very clearly a dialectic of the development. Shortly before the movie turned the reception of pictures into a collective one, the individual viewing of pictures in these swiftly outmoded establishments came into play once more with an intensity comparable to that of the ancient priest beholding the statue of a divinity in the cella.

[18]The theological archetype of this contemplation is the awareness of being alone with one's God. Such awareness, in the heyday of the bourgeoisie, went to strengthen the freedom to shake off clerical tutelage. During the decline of the bourgeoisie this awareness had to take into account the hidden tendency to withdraw from public affairs those forces which the individual draws upon in his communion with God.

From an alluring appearance or persuasive structure of sound the work of art of the Dadaists became an instrument of ballistics. It hit the spectator like a bullet, it happened to him, thus acquiring a tactile quality. It promoted a demand for the film, the distracting element of which is also primarily tactile, being based on changes of place and focus which periodically assail the spectator. Let us compare the screen on which a film unfolds with the canvas of a painting. The painting invites the spectator to contemplation; before it the spectator can abandon himself to his associations. Before the movie frame he cannot do so. No sooner has his eye grasped a scene than it is already changed. It cannot be arrested. Duhamel, who detests the film and knows nothing of its significance, though something of its structure, notes this circumstance as follows: "I can no longer think what I want to think. My thoughts have been replaced by moving images." The spectator's process of association in view of these images is indeed interrupted by their constant, sudden change. This constitutes the shock effect of the film, which, like all shocks, should be cushioned by heightened presence of mind.[19] By means of its technical structure, the film has taken the physical shock effect out of the wrappers in which Dadaism had, as it were, kept it inside the moral shock effect.[20]

XV

The mass is a matrix from which all traditional behavior toward works of art issues today in a new form. Quantity has been transmuted into quality. The greatly increased mass of participants has produced a change in the mode of participation. The fact that the new mode of participation first appeared in a disreputable form must not confuse the spectator. Yet some people have launched spirited attacks against precisely this superficial aspect. Among these, Duhamel has expressed himself in the most radical manner. What he objects to most is the kind of participation which the movie elicits from the masses. Duhamel calls the movie "a pastime for helots, a diversion for uneducated, wretched, worn-out creatures who are consumed by their worries . . . , a spectacle which requires no concentration and presupposes no intelligence . . . , which kindles no light in the heart and awakens no hope other than the ridiculous one of someday becoming a 'star' in Los Angeles." Clearly, this is at bottom the same ancient lament that the masses seek distraction whereas art demands concentration from the spectator. That is a commonplace. The question remains whether it provides a platform for the analysis of the film. A closer look is needed here. Distraction and concentration form polar opposites which may be

---

[19]The film is the art form that is in keeping with the increased threat to his life which modern man has to face. Man's need to expose himself to shock effects is his adjustment to the dangers threatening him. The film corresponds to profound changes in the apperceptive apparatus—changes that are experienced on an individual scale by the man in the street in big-city traffic, on a historical scale by every present-day citizen.

[20]As for Dadaism, insights important for Cubism and Futurism are to be gained from the movie. Both appear as deficient attempts of art to accommodate the pervasion of reality by the apparatus. In contrast to the film, these schools did not try to use the apparatus as such for the artistic presentation of reality, but aimed at some sort of alloy in the joint presentation of reality and apparatus. In Cubism, the premonition that this apparatus will be structurally based on optics play a dominant part; in Futurism, it is the premonition of the effects of this apparatus which are brought out by the rapid sequence of the film strip.

stated as follows: A man who concentrates before a work of art is absorbed by it. He enters into this work of art the way legend tells of the Chinese painter when he viewed his finished painting. In contrast, the distracted mass absorbs the work of art. This is most obvious with regard to buildings. Architecture has always represented the prototype of a work of art the reception of which is consummated by a collectivity in a state of distraction. The laws of its reception are most instructive.

Buildings have been man's companions since primeval times. Many art forms have developed and perished. Tragedy begins with the Greeks, is extinguished with them, and after centuries its "rules" only are revived. The epic poem, which had its origin in the youth of nations, expires in Europe at the end of the Renaissance. Panel painting is a creation of the Middle Ages, and nothing guarantees its uninterrupted existence. But the human need for shelter is lasting. Architecture has never been idle. Its history is more ancient than that of any other art, and its claim to being a living force has significance in every attempt to comprehend the relationship of the masses to art. Buildings are appropriated in a twofold manner: by use and by perception—or rather, by touch and sight. Such appropriation cannot be understood in terms of the attentive concentration of a tourist before a famous building. On the tactile side there is no counterpart to contemplation on the optical side. Tactile appropriation is accomplished not so much by attention as by habit. As regards architecture, habit determines to a large extent even optical reception. The latter, too, occurs much less through rapt attention than by noticing the object in incidental fashion. This mode of appropriation, developed with reference to architecture, in certain circumstances acquires canonical value. For the tasks which face the human apparatus of perception at the turning points of history cannot be solved by optical means, that is, by contemplation, alone. They are mastered gradually by habit, under the guidance of tactile appropriation.

The distracted person, too, can form habits. More, the ability to master certain tasks in a state of distraction proves that their solution has become a matter of habit. Distraction as provided by art presents a covert control of the extent to which new tasks have become soluble by apperception. Since, moreover, individuals are tempted to avoid such tasks, art will tackle the most difficult and most important ones where it is able to mobilize the masses. Today it does so in the film. Reception in a state of distraction, which is increasing noticeably in all fields of art and is symptomatic of profound changes in apperception, finds in the film its true means of exercise. The film with its shock effect meets this mode of reception halfway. The film makes the cult value recede into the background not only by putting the public in the position of the critic, but also by the fact that at the movies this position requires no attention. The public is an examiner, but an absent-minded one.

## EPILOGUE

The growing proletarianization of modern man and the increasing formation of masses are two aspects of the same process. Fascism attempts to organize the newly created proletarian masses without affecting the property structure which the masses strive to eliminate. Fascism sees its salvation in giving these masses not their right,

but instead a chance to express themselves.[21] The masses have a right to change property relations; Fascism seeks to give them an expression while preserving property. The logical result of Fascism is the introduction of aesthetics into political life. The violation of the masses, whom Fascism, with its *Führer* cult, forces to their knees, has its counterpart in the violation of an apparatus which is pressed into the production of ritual values.

All efforts to render politics aesthetic culminate in one thing: war. War and war only can set a goal for mass movements on the largest scale while respecting the traditional property system. This is the political formula for the situation. The technological formula may be stated as follows: Only war makes it possible to mobilize all of today's technical resources while maintaining the property system. It goes without saying that the Fascist apotheosis of war does not employ such arguments. Still, Marinetti says in his manifesto on the Ethiopian colonial war: "For twenty-seven years we Futurists have rebelled against the branding of war as antiaesthetic. . . . Accordingly we state: . . . War is beautiful because it establishes man's dominion over the subjugated machinery by means of gas masks, terrifying megaphones, flame throwers, and small tanks. War is beautiful because it initiates the dreamt-of metalization of the human body. War is beautiful because it enriches a flowering meadow with the fiery orchids of machine guns. War is beautiful because it combines the gunfire, the cannonades, the cease-fire, the scents, and the stench of putrefaction into a symphony. War is beautiful because it creates new architecture, like that of the big tanks, the geometrical formation flights, the smoke spirals from burning villages, and many others. . . . Poets and artists of Futurism! . . . remember these principles of an aesthetics of war so that your struggle for a new literature and a new graphic art . . . may be illumined by them!"

This manifesto has the virtue of clarity. Its formulations deserve to be accepted by dialecticians. To the latter, the aesthetics of today's war appears as follows: If the natural utilization of productive forces is impeded by the property system, the increase in technical devices, in speed, and in the sources of energy will press for an unnatural utilization, and this is found in war. The destructiveness of war furnishes proof that society has not been mature enough to incorporate technology as its organ, that technology has not been sufficiently developed to cope with the elemental forces of society. The horrible features of imperialistic warfare are attributable to the discrepancy between the tremendous means of production and their inadequate utilization in the process of production—in other words, to unemployment and the lack of markets. Imperialistic war is a rebellion of technology which collects, in the form of "human

---

[21]One technical feature is significant here, especially with regard to newsreels, the propagandist importance of which can hardly be overestimated. Mass reproduction is aided especially by the reproduction of masses. In big parades and monster rallies, in sports events, and in war, all of which nowadays are captured by camera and sound recording, the masses are brought face to face with themselves. This process, whose significance need not be stressed, is intimately connected with the development of the techniques of reproduction and photography. Mass movements are usually discerned more clearly by a camera than by the naked eye. A bird's-eye view best captures gatherings of hundreds of thousands. And even though such a view may be as accessible to the human eye as it is to the camera, the image received by the eye cannot be enlarged the way a negative is enlarged. This means that mass movements, including war, constitute a form of human behavior which particularly favors mechanical equipment.

material," the claims to which society has denied its natural material. Instead of drain-
ing rivers, society directs a human stream into a bed of trenches; instead of dropping
seeds from airplanes, it drops incendiary bombs over cities; and through gas warfare
the aura is abolished in a new way.

"*Fiat ars—pereat mundus*," says Fascism, and, as Marinetti admits, expects war to
supply the artistic gratification of a sense perception that has been changed by tech-
nology. This is evidently the consummation of "*l'art pour l'art*." Mankind, which in
Homer's time was an object of contemplation for the Olympian gods, now is one for
itself. Its self-alienation has reached such a degree that it can experience its own
destruction as an aesthetic pleasure of the first order. This is the situation of politics
which Fascism is rendering aesthetic. Communism responds by politicizing art.

1935

# JEAN-LUC COMOLLI AND
# JEAN NARBONI
## CINEMA/IDEOLOGY/CRITICISM

Scientific criticism has an obligation to define its field and methods. This implies awareness of its own historical and social situation, a rigorous analysis of the proposed field of study, the conditions which make the work necessary and those which make it possible, and the special function it intends to fulfill.

It is essential that we at *Cahiers du Cinéma* should now undertake just such a global analysis of our position and aims. Not that we are starting entirely from zero. Fragments of such an analysis have been coming out of material we have published recently (articles, editorials, debates, answers to readers' letters) but in an imprecise form and as if by accident. They are an indication that our readers, just as much as we ourselves, feel the need for a clear theoretical base to which to relate our critical practice and its field, taking the two to be indivisible. 'Programmes' and 'revolutionary' plans and declarations tend to become an end in themselves. This is a trap we intend to avoid. Our objective is not to reflect upon what we 'want' (would like) to do, but upon what we *are* doing and what we *can* do, and this is impossible without an analysis of the present situation.

### WHERE?

(a) First, our situation. *Cahiers* is a group of people working together; one of the results of our work appearing as a magazine.* A magazine, that is to say, a particular product, involving a particular amount of work (on the part of those who write it, those who produce it and, indeed, those who read it). We do not close our eyes to the fact that a product of this nature is situated fairly and squarely inside the economic

---

*Others include distribution, screening, and discussion of films in the provinces and the suburbs, sessions of theoretical work.

system of capitalist publishing (modes of production, spheres of circulation, etc.). In any case it is difficult to see how it could be otherwise today, unless one is led astray by Utopian ideas of working 'parallel' to the system. The first step in the latter approach is always the paradoxical one of setting up a false front, a 'neo-system' alongside the system from which one is attempting to escape, in the fond belief that it will be able to negate the system. In fact all it can do is reject it (idealist purism) and consequently it is very soon jeopardized by the enemy upon which it modelled itself.[1] This 'parallelism' works from one direction only. It touches only one side of the wound, whereas we believe that both sides have to be worked upon. And the danger of the parallels meeting all too speedily in infinity seems to us sufficient to argue that we had better stay in the finite and allow them to remain apart.

This assumed, the question is: what is our attitude to our situation? In France the majority of films, like the majority of books and magazines, are produced and distributed by the capitalist economic system and within the dominant ideology. Indeed, strictly speaking all are, whatever expedient they adopt to try and get around it. This being so, the question we have to ask is: which films, books, and magazines allow the ideology a free, unhampered passage, transmit it with crystal clarity, serve as its chosen language? And which attempt to make it turn back and reflect itself, intercept it, make it visible by revealing its mechanisms, by blocking them?

(b) For the situation in which we are *acting* is the field of cinema (*Cahiers* is a film magazine),[2] and the precise object of our study is the history of a film: how it is produced, manufactured, distributed,[3] understood.

What is the film today? This is the relevant question; not, as it possibly once was: what is the cinema? We shall not be able to ask that again until a body of knowledge, of theory, has been evolved (a process to which we certainly intend to contribute) to inform what is at present an empty term, with a concept. For a film magazine the question is also: what work is to be done in the field constituted by films? And for Cahiers in particular: what is our specific function in this field? What is to distinguish us from other 'film magazines'?

## THE FILMS

What is a film? On the one hand it is a particular product, manufactured within a given system of economic relations, and involving labour (which appears to the capitalist as money) to produce—a condition to which even 'independent' filmmakers and the 'new cinema' are subject—assembling a certain number of workers for this pur-

---

[1] Or tolerated, and jeopardized by this very toleration. Is there any need to stress that it is the tried tactic of covertly repressive systems not to harass the protesting fringe? They go out of their way to take no notice of them, with the double effect of making one half of the opposition careful not to try their patience too far and the other half complacent in the knowledge that their activities are unobserved.

[2] We do not intend to suggest by this that we want to erect a corporatist fence round our own field, and neglect the infinitely larger field where so much is obviously at stake politically. Simply, we are concentrating on that precise point of the spectrum of social activity in this article, in response to precise operational needs.

[3] A more and more pressing problem. It would be inviting confusion to allow it to be tackled in bits and pieces and obviously we have to make a unified attempt to pose it theoretically later on. For the moment we leave it aside.

pose (even the director, whether he is Moullet or Oury, is in the last analysis only a
film worker). It becomes transformed into a commodity, possessing exchange value,
which is realized by the sale of tickets and contracts, and governed by the laws of the
market. On the other hand, as a result of being a material product of the system, it is
also an ideological product of the system, which in France means capitalism.*

No filmmaker can, by his own individual efforts, change the economic relations
governing the manufacture and distribution of his films. (It cannot be pointed out too
often that even filmmakers who set out to be 'revolutionary' on the level of message
and form cannot effect any swift or radical change in the economic system—deform
it, yes, deflect it, but not negate it or seriously upset its structure. Godard's recent
statement to the effect that he wants to stop working in the 'system' takes no account
of the fact that any other system is bound to be a reflection of the one he wishes to
avoid. The money no longer comes from the Champs-Elysées but from London,
Rome, or New York. The film may not be marketed by the distribution monopolies
but it is shot on film stock from another monopoly—Kodak.) Because every film is
part of the economic system it is also a part of the ideological system, for 'cinema'
and 'art' are branches of ideology. None can escape, somewhere, like pieces in a jig-
saw, all have their own allotted place. The system is blind to its own nature, but in
spite of that, indeed because of that, when all the pieces are fitted together they give
a very clear picture. But this does not mean that every filmmaker plays a similar role.
Reactions differ.

It is the job of criticism to see where they differ, and slowly, patiently, not expect-
ing any magical transformations to take place at the wave of a slogan, to help change
the ideology which conditions them.

A few points, which we shall return to in greater detail later: *every film is political*,
inasmuch as it is determined by the ideology which produces it (or within which it is
produced, which stems from the same thing). The cinema is all the more thoroughly
and completely determined because unlike other arts or ideological systems its very
manufacture mobilizes powerful economic forces in a way that the production of lit-
erature (which becomes the commodity 'books', does not—though once we reach the
level of distribution, publicity, and sale, the two are in rather the same position).

Clearly, the cinema 'reproduces' reality: this is what a camera and film stock are
for—so says the ideology. But the tools and techniques of filmmaking are a part of

---

*Capitalist ideology. This term expresses our meaning perfectly, but as we are going to use it without
further definition in this article, we should point out that we are not under any illusion that it has some kind
of 'abstract essence'. We know that it is historically and socially determined, and that it has multiple forms
at any given place and time, and varies from historical period to historical period. Like the whole category
of 'militant' cinema, which is totally vague and undefined at present. We must (a) rigorously define the
function attributed to it, its aims, its side effects (information, arousal, critical reflection, provocation
'which always has *some* effect' . . .); (b) define the exact political line governing the making and screen-
ing of these films—'revolutionary' is too much of a blanket term to serve any useful purpose here; and (c)
state whether the supporters of militant cinema are in fact proposing a line of action in which the cinema
would become the poor relation, in the illusion that the less the cinematic aspect is worked on, the greater
the strength and clarity of the 'militant' effect will be. This would be a way of avoiding the contradictions
of 'parallel' cinema and getting embroiled in the problem of deciding whether 'underground' films should
be included in the category, on the pretext that their relationship to drugs and sex, their preoccupation with
form, might possibly establish new relationships between film and audience.

'reality' themselves, and furthermore 'reality' is nothing but an expression of the prevailing ideology. Seen in this light, the classic theory of cinema that the camera is an impartial instrument which grasps, or rather is impregnated by, the world in its 'concrete reality' is an eminently reactionary one. What the camera in fact registers is the vague, unformulated, untheorized, unthought-out world of the dominant ideology. Cinema is one of the languages through which the world communicates itself to itself. They constitute its ideology for they reproduce the world as it is experienced when filtered through the ideology. (As Althusser defines it, more precisely: 'Ideologies are perceived-accepted-suffered cultural objects, which work fundamentally on men by a process they do not understand. What men express in their ideologies is not their true relation to their conditions of existence, but how they react to their conditions of existence; which presupposes a real relationship and an imaginary relationship.) So, when we set out to make a film, from the very first shot, we are encumbered by the necessity of reproducing things not as they really are but as they appear when refracted through the ideology. This includes every stage in the process of production: subjects, 'styles', forms, meanings, narrative traditions; all underline the general ideological discourse. The film is ideology presenting itself to itself, talking to itself, learning about itself. Once we realize that it is the nature of the system to turn the cinema into an instrument of ideology, we can see that the filmmaker's first task is to show up the cinema's so-called 'depiction of reality'. If he can do so there is a chance that we will be able to disrupt or possibly even sever the connection between the cinema and its ideological function.

The vital distinction between films today is whether they do this or whether they do not.

(a) The first and largest category comprises those films which are imbued through and through with the dominant ideology in pure and unadulterated form, and give no indication that their makers were even aware of the fact. We are not just talking about so-called 'commercial' films. The *majority* of films in all categories are the unconscious instruments of the ideology which produces them. Whether the film is 'commercial' or 'ambitious', 'modern' or 'traditional', whether it is the type that gets shown in art houses, or in smart cinemas, whether it belongs to the 'old' cinema or the 'young' cinema, it is most likely to be a re-hash of the same old ideology. For all films are commodities and therefore objects of trade, even those whose discourse is explicitly political—which is why a rigorous definition of what constitutes 'political' cinema is called for at this moment when it is being widely promoted. This merging of ideology and film is reflected in the first instance by the fact that audience demand and economic response have also been reduced to one and the same thing. In direct continuity with political practice, ideological practice reformulates the social need and backs it up with a discourse. This is not a hypothesis, but a scientifically established fact. The ideology is talking to itself; it has all the answers ready before it asks the questions. Certainly there is such a thing as public demand, but 'what the public wants' means 'what the dominant ideology wants'. The notion of a public and its tastes was created by the ideology to justify and perpetuate itself. And this public can only express itself via the thought-patterns of the ideology. The whole thing is a closed circuit, endlessly repeating the same illusion.

The situation is the same at the level of artistic form. These films totally accept the established system of depicting reality: 'bourgeois realism' and the whole conservative box of tricks: blind faith in 'life', 'humanism', 'common sense', etc. A blissful ignorance that there might be something wrong with this whole concept of 'depiction' appears to have reigned at every stage in their production, so much so, that to us it appears a more accurate gauge of pictures in the 'commercial' category than box-office returns. Nothing in these films jars against the ideology or the audience's mystification by it. They are very reassuring for audiences for there is no difference between the ideology they meet every day and the ideology on the screen. It would be a useful complementary task for film critics to look into the way the ideological system and its products merge at all levels: to study the phenomenon whereby a film being shown to an audience becomes a monologue, in which the ideology talks to itself, by examining the success of films by, for instance, Melville, Oury, and Lelouch.

(b) A second category is that of films which attack their ideological assimilation on two fronts. Firstly, by direct political action, on the level of the 'signified', that is, they deal with a directly political subject. 'Deal with' is here intended in an active sense: they do not just discuss an issue, reiterate it, paraphrase it, but use it to attack the ideology (this presupposes a theoretical activity which is the direct opposite of the ideological one). This act only becomes politically effective if it is linked with a breaking down of the traditional way of depicting reality. On the level of form, *Unreconciled*, *The Edge* and *Earth in Revolt* all challenge the concept of 'depiction' and mark a break with the tradition embodying it.

We would stress that only action on both fronts, 'signified' and 'signifiers'[1] has any hope of operating against the prevailing ideology. Economic/political and formal action have to be indissolubly wedded.

(c) There is another category in which the same double action operates, but 'against the grain'. The content is not explicitly political, but in some way becomes so through the criticism practised on it through its form.[2] To this category belong

---

[1]We are not shutting our eyes to the fact that it is an oversimplification (employed here because operationally easier) to make such a sharp distinction between the two terms. This is particularly so in the case of the cinema, where the signified is more often than not a product of the permutations of the signifiers, and the sign has dominance over the meaning.

[2]This is not a magical doorway out of the system of 'depiction' (which is particularly dominant in the cinema) but rather a rigorous, detailed, large-scale work on this system—what conditions make it possible, what mechanisms render it innocuous. The method is to draw attention to the system so that it can be seen for what it is, to make it serve one's own ends, condemn itself out of its own mouth. Tactics employed may include 'turning cinematic syntax upside-down' but it cannot be just that. Any old film nowadays can upset the normal chronological order in the interests of looking vaguely 'modern'. But *The Exterminating Angel* and *The Diary of Anna Magdalena Bach* (though we would not wish to set them up as a model) are rigorously chronological without ceasing to be subversive in the way we have been describing, whereas in many a film the mixed-up time sequence simply covers up a basically naturalistic conception. In the same way, perceptual confusion (avowed intent to act on the unconscious mind, changes in the texture of the film, etc.) are not sufficient in themselves to get beyond the traditional way of depicting 'reality'. To realize this, one has only to remember the unsuccessful attempts there have been of the 'lettriste' or 'zacum' type to give back its infinity to language by using nonsense words or new kinds of onomatopoeia. In the one and the other case only the most superficial level of language is touched. They create a new code, which operates on the level of the impossible, and has to be rejected on any other, and is therefore not in a position to transgress the normal.

*Méditerranée*, *The Bellboy*, *Persona*. . . . For *Cahiers* these films (b and c) constitute the essential in the cinema, and should be the chief subject of the magazine.

(d) Fourth case: those films, increasingly numerous today, which have an explicitly political content (Z is not the best example as its presentation of politics is unremittingly ideological from first to last; a better example would be *Le Temps de Vivre*) but which do not effectively criticize the ideological system in which they are embedded because they unquestioningly adopt its language and its imagery.

This makes it important for critics to examine the effectiveness of the political criticism intended by these films. Do they express, reinforce, strengthen the very thing they set out to denounce? Are they caught in the system they wish to break down . . . ? (see a)

(e) Five: films which seem at first sight to belong firmly within the ideology and to be completely under its sway, but which turn out to be so only in an ambiguous manner. For though they start from a nonprogressive standpoint, ranging from the frankly reactionary through the conciliatory to the mildly critical, they have been worked upon, and work, in such a real way that there is a noticeable gap, a dislocation, between the starting point and the finished product. We disregard here the inconsistent—and unimportant—sector of films in which the director makes a *conscious* use of the prevailing ideology, but leaves it absolutely straight. The films we are talking about throw up obstacles in the way of the ideology, causing it to swerve and get off course. The cinematic framework lets us see it, but also shows it up and denounces it. Looking at the framework one can see two moments in it: one holding it back within certain limits, one transgressing them. An internal criticism is taking place which cracks the film apart at the seams. If one reads the film obliquely, looking for symptoms; if one looks beyond its apparent formal coherence, one can see that it is riddled with cracks: it is splitting under an internal tension which is simply not there in an ideologically innocuous film. The ideology thus becomes subordinate to the text. It no longer has an independent existence: It is *presented* by the film. This is the case in many Hollywood films, for example, which while being completely integrated in the system and the ideology end up by partially dismantling the system from within. We must find out what makes it possible for a filmmaker to corrode the ideology by restating it in the terms of his film: if he sees his film simply as a blow in favour of liberalism, it will be recuperated instantly by the ideology; if on the other hand, he conceives and realizes it on the deeper level of imagery, there is a chance that it will turn out to be more disruptive. Not, of course, that he will be able to break the ideology itself, but simply its reflection in his film. (The films of Ford, Dreyer, Rossellini, for example.)

Our position with regard to this category of films is: that we have absolutely no intention of joining the current witch-hunt against them. They are the mythology of their own myths. They criticize themselves, even if no such intention is written into the script, and it is irrelevant and impertinent to do so for them. All we want to do is to show the process in action.

(f) Films of the 'live cinema' (*cinéma direct*) variety, group one (the larger of the two groups). These are films arising out of political (or, it would probably be more exact to say: social) events or reflections, but which make no clear differentiation between themselves and the nonpolitical cinema because they do not challenge the

cinema's traditional, ideologically conditioned method of 'depiction'. For instance a miner's strike will be filmed in the same style as *Les Grandes Familles*. The makers of these films suffer under the primary and fundamental illusion that if they once break off the ideological filter of narrative traditions (dramaturgy, construction, domination of the component parts by a central idea, emphasis on formal beauty) reality will then yield itself up in its true form. The fact is that by doing so they only break off one filter, and not the most important one at that. For reality holds within itself no hidden kernel of self-understanding, of theory, of truth, like a stone inside a fruit. We have to manufacture those. (Marxism is very clear on this point, in its distinction between 'real' and 'perceived' objects.) Compare *Chiefs* (Leacock) and a good number of the May films.

This is why supporters of *cinéma direct* resort to the same idealist terminology to express its role and justify its successes as others use about products of the greatest artifice: 'accuracy', 'a sense of lived experience', 'flashes of intense truth', 'moments caught live', 'abolition of all sense that we are watching a film' and finally: fascination. It is that magical notion of 'seeing is understanding': ideology goes on display to prevent itself from being shown up for what it really is, contemplates itself but does not criticize itself.

(g) The other kind of 'live cinema'. Here the director is not satisfied with the idea of the camera 'seeing through appearances', but attacks the basic problem of depiction by giving an active role to the concrete stuff of his film. It then becomes productive of meaning and is not just a passive receptacle for meaning produced outside it (in the ideology): *La Règne du Jour*, *La Rentrée des Usines Wonder*.

## CRITICAL FUNCTION

Such, then, is the field of our critical activity: these films, within the ideology, and their different relations to it. From this precisely defined field spring four functions: (1) in the case of the films in category (a): show what they are blind to; how they are totally determined, moulded, by the ideology; (2) in the case of those in categories (b), (c) and (g), read them on two levels, showing how the films operate critically on the level of signified and signifiers; (3) in the case of those of types (d) and (f), show how the signified (political subject matter) is always weakened, rendered harmless, by the absence of technical/theoretical work on the signifiers; (4) in the case of those in group (e) point out the gap produced between film and ideology by the way the films work, and show how they work.

There can be no room in our critical practice either for speculation (commentary, interpretation, de-coding even) or for specious raving (of the film-columnist variety). It must be a rigidly factual analysis of what governs the production of a film (economic circumstances, ideology, demand, and response) and the meanings and forms appearing in it, which are equally tangible.

The tradition of frivolous and evanescent writing on the cinema is as tenacious as it is prolific, and film analysis today is still massively predetermined by idealistic presuppositions. It wanders farther abroad today, but its method is still basically empirical. It has been through a necessary stage of going back to the material elements of a film, its signifying structures, its formal organization. The first steps here were

undeniably taken by André Bazin, despite the contradictions that can be picked out in his articles. Then followed the approach based on structural linguistics (in which there are two basic traps, which we fell into—phenomenological positivism and mechanistic materialism). As surely as criticism had to go through this stage, it has to go beyond. To us, the only possible line of advance seems to be to use the theoretical writing of the Russian filmmakers of the twenties (Eisenstein above all) to elaborate and apply a critical theory of the cinema, a specific method of apprehending rigorously defined objects, in direct reference to the method of dialectical materialism.

It is hardly necessary to point out that we know that the 'policy' of a magazine cannot—indeed, should not—be corrected by magic overnight. We have to do it patiently, month by month, being careful in our own field to avoid the general error of putting faith in spontaneous change, or attempting to rush into a 'revolution' without the preparation to support it. To start proclaiming at this stage that the truth has been revealed to us would be like talking about 'miracles' or 'conversion'. All we should do is to state what work is already in progress and publish articles which relate to it, either explicitly or implicitly.

We should indicate briefly how the various elements in the magazine fit into this perspective. The essential part of the work obviously takes place in the theoretical articles and the criticisms. There is coming to be less and less of a difference between the two, because it is not our concern to add up the merits and defects of current films in the interests of topicality, nor, as one humorous article put it 'to crack up the product'. The interviews, on the other hand, and also the 'diary' columns and the list of films, with the dossiers and supplementary material for possible discussion later, are often stronger on information than theory. It is up to the reader to decide whether these pieces take up any critical stance, and if so, what.

1969

# CHRISTIAN METZ
## *FROM* THE IMAGINARY SIGNIFIER

### IDENTIFICATION, MIRROR

. . . Among the specific features of the cinematic signifier that distinguish the cinema from literature, painting, etc. which ones by nature call most directly on the type of knowledge that psychoanalysis alone can provide?

### PERCEPTION, IMAGINARY

The cinema's signifier is *perceptual* (visual and auditory). So is that of literature, since the written chain has to be *read*, but it involves a more restricted perceptual register: only graphemes, writing. So too are those of painting, sculpture, architecture, photography, but still within limits, and different ones: absence of auditory perception, absence in the visual itself of certain important dimensions such as time and movement (obviously there is the time of the look, but the object looked at is not inscribed in a precise and ordered time sequence forced on the spectator from outside). Music's signifier is perceptual as well, but, like the others, less "extensive" than that of the cinema: here it is vision which is absent, and even in the auditory, extended speech (except in song). What first strikes one then is that the cinema is *more perceptual*, if the phrase is allowable, than many other means of expression; it mobilises a larger number of the axes of perception. (That is why the cinema has sometimes been presented as a "synthesis of all the arts"; which does not mean very much, but if we restrict ourselves to the quantitative tally of the registers of perception, it is true that the cinema contains within itself the signifiers of other arts: it can present pictures to us, make us hear music, it is made of photographs, etc.)

Nevertheless, this as it were numerical "superiority" disappears if the cinema is compared with the theatre, the opera and other spectacles of the same type. The latter too involve sight and hearing simultaneously, linguistic audition and nonlinguistic audition, movement, real temporal progression. Their difference from the cinema

lies elsewhere: they do not consist of *images*, the perceptions they offer to the eye and the ear are inscribed in a true space (not a photographed one), the same one as that occupied by the public during the performance; everything the audience hear and see is actively produced in their presence, by human beings or props which are themselves present. This is not the problem of fiction but that of the definitional characteristics of the signifier: whether or not the theatrical play mimes a fable, its *action*, if need be mimetic, is still managed by real persons evolving in real time and space, *on the same stage or "scene" as the public.* The "other scene," which is precisely not so called, is the cinematic screen (closer to phantasy from the outset): what unfolds there may, as before, be more or less fictional, but the unfolding itself is fictive: the actor, the "décor," the words one hears are all absent, everything is *recorded* (as a memory trace which is immediately so, without having been something else before), and this is still true if what is recorded is not a "story" and does not aim for the fictional illusion proper. For it is the signifier itself, and as a whole, that is recorded, that is absence: a little rolled up perforated strip which "contains" vast landscapes, fixed battles, the melting of the ice on the River Neva, and whole life-times, and yet can be enclosed in the familiar round metal tin, of modest dimensions, clear proof that it does not "really" contain all that.

At the theatre, Sarah Bernhardt may tell me she is Phèdre or, if the play were from another period and rejected the figurative regime, she might say, as in a type of modern theatre, that she is Sarah Bernhardt. But at any rate, I should see Sarah Bernhardt. At the cinema, she could make the same two kinds of speeches too, but it would be her shadow that would be offering them to me (or she would be offering them in her own absence). Every film is a fiction film.

What is at issue is not just the actor. Today there are a theatre and a cinema without actors, or in which they have at least ceased to take on the full and exclusive function which characterises them in classical spectacles. But what is true of Sarah Bernhardt is just as true of an object, a prop, a chair for example. On the theatre stage, this chair may, as in Chekhov, pretend to be the chair in which the melancholy Russian nobleman sits every evening; on the contrary (in Ionesco), it can explain to me that it is a theatre chair. But when all is said and done it is a chair. In the cinema, it will similarly have to choose between two attitudes (and many other intermediate or more tricky ones), but it will not be there when the spectators see it, when they have to recognise the choice; it will have delegated its reflection to them.

What is characteristic of the cinema is not the imaginary that it may happen to represent, but the imaginary that it *is* from the start, the imaginary that constitutes it as a signifier (the two are not unrelated; it is so well able to represent it because it is it; however it is it even when it no longer represents it). The (possible) reduplication inaugurating the intention of fiction is preceded in the cinema by a first reduplication, always-already achieved, which inaugurates the signifier. The imaginary, by definition, combines within it a certain presence and a certain absence. In the cinema it is not just the fictional signified, if there is one, that is thus made present in the mode of absence, it is from the outset the signifier.

Thus the cinema, "more perceptual" than certain arts according to the list of its sensory registers, is also "less perceptual" than others once the status of these perceptions is envisaged rather than their number or diversity; for its perceptions are all in

a sense "false." Or rather, the activity of perception which it involves is real (the cinema is not a phantasy), but the perceived is not really the object, it is its shade, its phantom, its double, its *replica* in a new kind of mirror. It will be said that literature, after all, is itself only made of replicas (written words, presenting absent objects). But at least it does not present them to us with all the really perceived detail that the screen does (giving more and taking as much, i.e., taking more). The unique position of the cinema lies in this dual character of its signifier: unaccustomed perceptual wealth, but at the same time stamped with unreality to an unusual degree, and from the very outset. More than the other arts, or in a more unique way, the cinema involves us in the imaginary: it drums up all perception, but to switch it immediately over into its own absence, which is nonetheless the only signifier present.

## THE ALL-PERCEIVING SUBJECT

Thus film is like the mirror. But it differs from the primordial mirror in one essential point: although, as in the latter, everything may come to be projected, there is one thing and one thing only that is never reflected in it: the spectator's own body. In a certain emplacement, the mirror suddenly becomes clear glass.

In the mirror the child perceives the familiar household objects, and also its object par excellence, its mother, who holds it up in her arms to the glass. But above all it perceives its own image. This is where primary identification (the formation of the ego) gets certain of its main characteristics: the child sees itself as an other, and beside another. This other other is its guarantee that the first is really it: by her authority, her sanction, in the register of the symbolic, subsequently by the resemblance between her mirror image and the child's (both have a human form). Thus the child's ego is formed by identification with its like, and this in two senses simultaneously, metonymically and metaphorically: the other human being who is in the glass, the own reflection which is and is not the body, which is like it. The child identifies with itself as an object.

In the cinema, the object remains: fiction or no, there is always something on the screen. But the reflection of the own body has disappeared. The cinema spectator is not a child and the child really at the mirror stage (from around six to around eighteen months) would certainly be incapable of "following" the simplest of films. Thus, what *makes possible* the spectator's absence from the screen—or rather the intelligible unfolding of the film despite that absence—is the fact that the spectator has already known the experience of the mirror (of the true mirror), and is thus able to constitute a world of objects without having first to recognise himself within it. In this respect, the cinema is already on the side of the symbolic (which is only to be expected): the spectator knows that objects exist, that he himself exists as a subject, that he becomes an object for others: he knows himself and he knows his like: it is no longer necessary that this similarity be literally *depicted* for him on the screen, as it was in the mirror of his childhood. Like every other broadly "secondary" activity, the practice of the cinema presupposes that the primitive undifferentiation of the ego and the non-ego has been overcome.

But *with what*, then, does the spectator identify during the projection of the film? . . .

The spectator is absent from the screen: contrary to the child in the mirror, he cannot identify with himself as an object, but only with objects which are there without him. In this sense the screen is not a mirror. The perceived, this time, is entirely on the side of the object, and there is no longer any equivalent of the own image, of that unique mix of perceived and subject (of other and I) which was precisely the figure necessary to disengage the one from the other. At the cinema, it is always the other who is on the screen; as for me, I am there to look at him. I take no part in the perceived, on the contrary, I am *all-perceiving*. All-perceiving as one says all-powerful (this is the famous gift of "ubiquity" the film makes its spectator); all-perceiving, too, because I am entirely on the side of the perceiving instance: absent from the screen, but certainly present in the auditorium, a great eye and ear without which the perceived would have no one to perceive it, the instance, in other words, which *constitutes* the cinema signifier (it is I who make the film). If the most extravagant spectacles and sounds or the most unlikely combination of them, the combination furthest removed from any real experience, do not prevent the constitution of meaning (and to begin with do not *astonish* the spectator, do not really astonish him, not intellectually: he simply judges the film as strange), that is because he knows he is at the cinema.

In the cinema the *subject's knowledge* takes a very precise form without which no film would be possible. This knowledge is dual (but unique). I know I am perceiving something imaginary (and that is why its absurdities, even if they are extreme, do not seriously disturb me), and I know that it is I who am perceiving it. This second knowledge divides in turn: I know that I am really perceiving, that my sense organs are physically affected, that I am not phantasising, that the fourth wall of the auditorium (the screen) is really different form the other three, that there is a projector facing it (and thus it is not I who am projecting, or at least not all alone), and I also know that it is I who am perceiving all this, that this perceived-imaginary material is deposited in me as if on a second screen, that it is in me that it forms up into an organised sequence, that therefore I am myself the place where this really perceived imaginary accedes to the symbolic by its inauguration as the signifier of a certain type of institutionalised social activity called the "cinema."

In other words, the spectator *identifies with himself*, with himself as a pure act of perception (as wakefulness, alertness): as the condition of possibility of the perceived and hence as a kind of transcendental subject, which comes before every *there is*.

A strange mirror, then, very like that of childhood, and very different. Very like, as Jean-Louis Baudry has emphasized, because during the showing we are, like the child, in a sub-motor and hyper-perceptive state; because, like the child again, we are prey to the imaginary, the double, and are so paradoxically through a real perception. Very different, because this mirror returns us everything but ourselves, because we are wholly outside it, whereas the child is both in it and in front of it. As an *arrangement* (and in a very topographical sense of the word), the cinema is more involved on the flank of the symbolic, and hence of secondariness, than is the mirror of childhood. This is not surprising, since it comes long after it, but what is more important to me is the fact that it is inscribed in its wake with an incidence at once so direct and so oblique, which has no precise equivalent in other apparatuses of signification.

## IDENTIFICATION WITH THE CAMERA

The preceding analysis coincides in places with others which have already been proposed and which I shall not repeat: analyses of *quattrocento* painting or of the cinema itself which insist on the role of monocular perspective (hence of the *camera*) and the "vanishing point" that inscribes an empty emplacement for the spectator-subject, an all-powerful position which is that of God himself, or more broadly of some ultimate signified. And it is true that as he identifies with himself as look, the spectator can do no other than identify with the camera, too, which has looked before him at what he is now looking at and whose stationing (= framing) determines the vanishing point. During the projection this camera is absent, but it has a representative consisting of another apparatus, called precisely a "projector." An apparatus the spectator has behind him, *at the back of his head*, that is, precisely where phantasy locates the "focus" of all vision. All of us have experienced our own look, even outside the so-called *salles obscures* [= cinemas], as a kind of searchlight turning on the axis of our own necks (like a pan) and shifting when we shift (a tracking shot now): as a cone of light (without the microscopic dust scattered through it and streaking it in the cinema) whose vicariousness draws successive and variable slices of obscurity from nothingness wherever and whenever it comes to rest. (And in a sense that is what perception and consciousness are, a *light*, as Freud put it, in the double sense of an illumination and an opening, as in the arrangement of the cinema, which contains both, a limited and wandering light that only attains a small part of the real, but on the other hand possesses the gift of casting light on it.) Without this identification with the camera certain facts could not be understood, though they are constant ones: the fact, for example, that the spectator is not amazed when the image "rotates" (= a pan) and yet he knows he has not turned his head. The explanation is that he has no need to turn it really, he has turned it in his all-seeing capacity, his identification with the movement of the camera being that of a transcendental, not an empirical subject.

All vision consists of a double movement: projective (the "sweeping" searchlight) and introjective: consciousness as a sensitive recording surface (as a screen). I have the impression at once that, to use a common expression, I am "casting" my eyes on things, and that the latter, thus illuminated, come to be deposited within me (we then declared that it is these things that have been "projected," on to my retina, say). A sort of stream called the look, and explaining all the myths of magnetism, must be sent out over the world, so that objects can come back up this stream in the opposite direction (but using it to find their way), arriving at last at our perception, which is now soft wax and no longer an emitting source.

The technology of photography carefully conforms to this (banal) phantasy accompanying perception. The camera is "trained" on the object like a fire-arm (= projection) and the object arrives to make an imprint, a trace, on the receptive surface of the film-strip (= introjection). The spectator himself does not escape these pincers, for he is part of the apparatus, and also because pincers, on the imaginary plane (Melanie Klein), mark our relation to the world as a whole and are rooted in the primary figures of orality. During the performance the spectator is the searchlight I have described, duplicating the projector, which itself duplicates the camera, and he is also the sensitive surface duplicating the screen, which itself duplicates the film-strip.

There are two cones in the auditorium: one ending on the screen and starting both in the projection box and in the spectator's vision insofar as it is projective, and one starting from the screen and "deposited" in the spectator's perception insofar as it is introjective (on the retina, a second screen). When I say that "I see" the film, I mean thereby a unique mixture of two contrary currents: the film is what I receive, and it is also what I release, since it does not pre-exist my entering the auditorium and I only need close my eyes to suppress it. Releasing it, I am the projector, receiving it, I am the screen; in both these figures together, I am the camera, which points and yet which records.

Thus the constitution of the signifier in the cinema depends on a series of mirror-effects organised in a chain, and not on a single reduplication. In this the cinema as a topography resembles that other "space," the technical equipment (camera, projector, film-strip, screen, etc.), the objective precondition of the whole institution: as we know, the apparatuses too contain a series of mirrors, lenses, apertures and shutters, ground glasses, through which the cone of light passes: a further reduplication in which the equipment becomes a metaphor (as well as the real source) for the mental process instituted. Further on we shall see that it is also its fetish.

In the cinema, as elsewhere, the constitution of the symbolic is only achieved through and above the play of the imaginary: projection-introjection, presence-absence, phantasies accompanying perception, etc. Even when acquired, the ego still depends in its underside on the fabulous figures thanks to which it has been acquired and which have marked it lastingly with the stamp of the lure. The secondary process does no more than "cover" (and not always hermetically) the primary process which is still constantly present and conditions the very possibility of what covers it.

Chain of many mirrors, the cinema is at once a weak and a robust mechanism: like the human body, like a precision tool, like a social institution. And the fact is that it is really all of these at the same time.

And I, at this moment, what am I doing if not to add to all these reduplications one more whereby theory is attempting to set itself up? Am I not looking at myself looking at the film? This *passion for seeing* (and also hearing), the foundation of the whole edifice, am I not turning it, too, on (against) that edifice? Am I not still the voyeur I was in front of the screen, now that it is this voyeur who is being seen, thus postulating a second voyeur, the one writing at present, myself again? . . .

There are various sorts of subjective image and I have tried elsewhere (following Jean Mitry) to distinguish between them. Only one of them will detain me for the moment, the one which "expresses the viewpoint of the film-maker" in the standard formula (and not the viewpoint of a character, another traditional sub-case of the subjective image): unusual framings, uncommon shot-angles, etc. as for example in one of the sketches which make up Julien Duvivier's film *Carnet de bal* (the sketch with Pierre Blanchar, shot continuously in tilted framings). In the standard definitions one thing strikes me: I do not see why these uncommon angles should express the viewpoint of the film-maker any more than perfectly ordinary angles, closer to the horizontal. However, the definition is comprehensible even in its inaccuracy: precisely because it is uncommon, the uncommon angle makes us more aware of what we had

merely forgotten to some extent in its absence: an identification with the camera (with "the author's viewpoint"). The ordinary framings are finally felt to be non-framings: I espouse the film-maker's look (without which no cinema would be possible), but my consciousness is not too aware of it. The uncommon angle reawakens me and (like the cure) teaches me what I already knew. And then, it obliges my look to stop wandering freely over the screen for the moment and to scan it along more precise lines of force which are imposed on me. Thus for a moment I became directly aware of the *emplacement* of my own presence-absence in the film simply because it has changed.

Now for looks. In a fiction film, the characters look at one another. It can happen (and this is already another "notch" in the chain of identifications) that a character looks at another who is momentarily out-of-frame, or else is looked at by him. If we have gone one notch further, this is because everything out-of-frame *brings us closer to the spectator*, since it is the peculiarity of the latter to be out-of-frame (the out-of-frame character thus has a point in common with him: he is looking at the screen). In certain cases the out-of-frame character's look is "reinforced" by recourse to another variant of the subjective image, generally christened the "character's point of view": the framing of the scene corresponds precisely to the angle from which the out-of-frame character looks at the screen. (The two figures are dissociable moreover: we often know that the scene is being looked at by someone other than ourselves, by a character, but it is the logic of the plot, or an element of the dialogue, or a previous image that tells us so, not the position of the camera, which may be far from the presumed emplacement of the out-of-frame onlooker.)

In all sequences of this kind, the identification that founds the signifier is *twice relayed*, doubly duplicated in a circuit that leads it to the heart of the film along a line which is no longer hovering, which follows the inclination of the looks and is therefore governed by the film itself: the spectator's look (= the basic identification), before dispersing all over the surface of the screen in a variety of intersecting lines (= looks of the characters in the frame = second duplication), must first "go through"—as one goes through a town on a journey, or a mountain pass—the look of the character out-of-frame (= first duplication), himself a spectator and hence the first delegate of the true spectator, but not to be confused with the latter since he is inside, if not the frame, then at least the fiction. This invisible character, supposed (like the spectator) to be seeing, will collide obliquely with the latter's look and play the part of an obligatory intermediary. By offering himself as a crossing for the spectator, he inflects the circuit followed by the sequence of identifications and it is only in this sense that he is himself seen: as we see through him, we see ourselves not seeing him.

Examples of this kind are much more numerous and each of them is much more complex than I have suggested here. At this point textual analysis of precise film sequences is an indispensable instrument of knowledge. I just wished to show that in the end there is no break in continuity between the child's game with the mirror and, at the other extreme, certain localised figures of the cinematic codes. The mirror is the site of primary identification. Identification with one's own look is secondary with respect to the mirror, i.e. for a general theory of adult activities, but it is the founda-

tion of the cinema and hence primary when the latter is under discussion: it is *primary cinematic identification* proper ("primary identification" would be inaccurate from the psychoanalytic point of view; "secondary identification," more accurate in this respect, would be ambiguous for a cinematic psychoanalysis). As for identifications with characters, with their own different levels (out-of-frame character, etc.), they are secondary, tertiary cinematic identifications, etc.; taken as a whole in opposition to the identification of the spectator with his own look, they constitute secondary cinematic identification in the singular.

## "SEEING A FILM"

Freud noted, *vis-à-vis* the sexual act, that the most ordinary practices depend on a large number of psychical functions which are distinct but work consecutively, so that all of them must be intact if what is regarded as a normal performance is to be possible (it is because neurosis and psychosis dissociate them and put some of them out of court that a kind of commutation is made possible whereby they can be listed retrospectively by the analyst). The apparently very simple act of *seeing a film* is no exception to this rule. As soon as it is subjected to analysis it reveals to us a complex, multiply interconnected imbrication of the functions of the imaginary, the real and the symbolic, which is also required in one form or another for every procedure of social life, but whose cinematic manifestation is especially impressive since it is played out on a small surface. (To this extent the theory of the cinema may some day contribute something to psychoanalysis, even if, through force of circumstances, this "reciprocation" remains very limited at the moment, the two disciplines being very unevenly developed.)

In order to understand the fiction film, I must both "take myself" for the character (= an imaginary procedure) so that he benefits, by analogical projection, from all the schemata of intelligibility that I have within me, and not take myself for him (= the return to the real) so that the fiction can be established as such (= as symbolic): this is *seeming-real*. Similarly, in order to understand the film (at all), I must perceive the photographed object as absent, its photograph as present, and the presence of this absence as signifying. The imaginary of the cinema presupposes the symbolic, for the spectator must first of all have known the primordial mirror. But as the latter instituted the ego very largely in the imaginary, the second mirror of the screen, a symbolic apparatus, itself in turn depends on reflection and lack. However, it is not phantasy, a "purely" symbolic-imaginary site, for the absence of the object and the codes of that absence are really produced in it by the *physis* of an equipment: the cinema is a body (a *corpus* for the semiologist), a fetish that can be loved.

## THE PASSION FOR PERCEIVING

The practice of the cinema is only possible through the perceptual passions: the desire to see (= scopic drive, scopophilia, voyeurism), which was alone engaged in the art of the silent film, the desire to hear which has been added to it in the sound cinema (this is the "*pulsion invocante*," the invocatory drive, one of the four main sex-

ual drives for Lacan; it is well known that Freud isolated it less clearly and hardly deals with it as such).

These two sexual drives are distinguished from the others in that they are more dependent on a lack, or at least dependent on it in a more precise, more unique manner, which marks them from the outset, even more than the others, as being on the side of the imaginary.

However, this characteristic is to a greater or lesser degree proper to all the sexual drives insofar as they differ from purely organic instincts or needs (Lacan), or in Freud from the self-preservation drives (the "ego drives" which he tended subsequently to annex to narcissism, a tendency he could never quite bring himself to pursue to its conclusion). The sexual drive does not have so stable and strong a relationship with its "object" as do for example hunger and thirst. Hunger can only be satisfied by food, but food is quite certain to satisfy it; thus instincts are simultaneously more and less difficult to satisfy than drives; they depend on a perfectly real object for which there is no substitute, but they depend on nothing else. Drives, on the contrary, can be satisfied up to a point outside their objects (this is sublimation, or else, in another way, masturbation) and are initially capable of doing without them without putting the organism into immediate danger (hence repression). The needs of self-preservation can neither be repressed nor sublimated; the sexual drives are more labile and more accommodating, as Freud insisted (more radically perverse, says Lacan). Inversely, they always remain more or less unsatisfied, even when their object has been attained; desire is very quickly reborn after the brief vertigo of its apparent extinction, it is largely sustained by itself as desire, it has its own rhythms, often quite independent of those of the pleasure obtained (which seemed nonetheless its specific aim); the lack is what it wishes to fill, and at the same time what it is always careful to leave gaping, in order to survive as desire. In the end it has no object, at any rate no real object; through real objects which are all substitutes (and all the more numerous and interchangeable for that), it pursues an imaginary object (a "lost object") which is its truest object, an object that has always been lost and is always desired as such.

How, then, can one say that the visual and auditory drives have a stronger or more special relationship with the absence of their object, with the infinite pursuit of the imaginary? Because, as opposed to other sexual drives, the "perceiving drive"—combining into one the scopic drive and the invocatory drive—*concretely represents the absence of its object* in the distance at which it maintains it and which is part of its very definition: distance of the look, distance of listening. Psychophysiology makes a classic distinction between the "senses at a distance" (sight and hearing) and the others all which involve immediate proximity and which it calls the "senses of contact" (Pradines): touch, taste, smell, coenaesthetic sense, etc. Freud notes that voyeurism, like sadism in this respect, always keeps apart the *object*. (Here the object looked at) and the *source* of the drive, i.e. the generating organ (the eye); the voyeur does not look at his eye. With orality and anality, on the contrary, the exercise of the drive inaugurates a certain degree of partial fusion, a coincidence (= contact, tendential abolition of distance) of source and aim, for the aim is to obtain pleasure at

the level of the source organ (= "organ pleasure"): e.g. what is called "pleasure of the mouth."

It is no accident that the main socially acceptable arts are based on the senses at a distance, and that those which depend on the senses of contact are often regarded as "minor" arts (e.g. the culinary arts, the art of perfumes, etc.). Nor is it an accident that the visual or auditory imaginaries have played a much more important part in the histories of societies than the tactile or olfactory imaginaries.

The voyeur is very careful to maintain a gulf, an empty space, between the object and the eye, the object and his own body: his look fastens the object at the right distance, as with those cinema spectators who take care to avoid being too close to or too far from the screen. The voyeur represents in space the fracture which forever separates him from the object; he represents his very dissatisfaction (which is precisely what he needs as a voyeur), and thus also his "satisfaction" insofar as it is of a specifically voyeuristic type. To fill in this distance would threaten to overwhelm the subject, to lead him to consume the object (the object which is now too close so that he cannot see it any more), to bring him to orgasm and the pleasure of his own body, hence to the exercise of other drives, mobilising the senses of contact and putting an end to the scopic arrangement. *Retention* is fully part of perceptual pleasure, which is thereby often coloured with anality. Orgasm is the object rediscoverd in a state of momentary illusion; it is the phantasy suppression of the gap between object and subject (hence the amorous myths of "fusion"). The looking drive, except when it is exceptionally well developed, is less directly related to orgasm than are the other component drives; it favours it by its excitatory action, but it is not generally sufficient to produce it by its figures alone, which thus belong to the realm of "preparatives." In it we do not find that illusion, however brief, of a lack filled, of a non-imaginary, of a full relation to the object, better established in other drives. If it is true of all desire that it depends on the infinite pursuit of its absent object, voyeuristic desire, along with certain forms of sadism, is the only desire whose principle of distance symbolically and spatially evokes this fundamental rent. . . .

## THE SCOPIC REGIME OF THE CINEMA

However, although this set of features seems to me to be important, it does not yet characterise the signifier of the cinema proper, but rather that of all means of expression based on sight or hearing, and hence, among other "languages," that of practically all the arts (painting, sculpture, architecture, music, opera, theatre, etc.). What distinguishes the cinema is an extra reduplication, a supplementary and specific turn of the screw bolting desire to the lack. . . .

What defines the specifically cinematic *scopic regime* is not so much the distance kept, the "keeping" itself (first figure of the lack, common to all voyeurism), as the absence of the object seen. Here the cinema is profoundly different from the theatre as also from more intimate voyeuristic activities with a specifically erotic aim (there are intermediate genres, moreover: certain cabaret acts, strip-tease, etc.): cases where voyeurism remains linked to exhibitionism, where the two faces, active and passive, of the component drive are by no means so dissociated; where the object seen is present

and hence presumably complicit; where the perverse activity—aided if need be by a certain dose of bad faith and happy illusion, varying from case to case, moreover, and sometimes reducible to very little, as in true perverse couples—is rehabilitated and reconciled with itself by being as it were undividedly taken in charge by two actors assuming its constitutive poles (the corresponding phantasies, in the absence of the actions, thus becoming interchangeable and shared by the play of reciprocal identification). In the theatre, as in domestic voyeurism, the passive actor (the one seen), simply because he is bodily present, because he does not go away, is presumed to consent, to cooperate deliberately. It may be that he really does, as exhibitionists in the clinical sense do, or as, in a sublimated fashion, does that oft noted triumphant exhibitionism characteristic of theatrical acting, counterposed even by Bazin to cinematic representation. It may also be that the object seen has only accepted this condition (thus becoming an "object" in the ordinary sense of the word, and no longer only in the Freudian sense) under the pressure of more or less powerful external constraints, economic ones for example with certain poor strippers. (However, they must have consented at some point; rarely is the degree of acceptance zero, except in the case of *victimisation*, e.g. when a fascist militia strips its prisoners; the specific characteristics of the scopic arrangement are then distorted by the overpowerful intervention of another element, sadism.) Voyeurism which is not too sadistic (there is none which is not so at all) rests on a kind of *fiction*, more or less justified in the order of the real, sometimes institutionalised as in the theatre or strip-tease, a fiction that stipulates that the object "agrees," that it is therefore exhibitionist. Or more precisely, what is necessary in this fiction for the establishment of potency and desire is presumed to be sufficiently guaranteed by the physical presence of the object: "Since it is there, it must like it," such, hypocritical or no, deluded or no, is the retrenchment needed by the voyeur so long as sadistic infiltrations are insufficient to make the object's refusal and constraint necesary to him. Thus, despite the distance instituted by the look—which transforms the object into a *picture* (a "*tableau vivant*") and thus tips it over into the imaginary, even in its real presence—that presence, which persists, and the active consent which is its real or mythical correlate (but always real as myth) re-establish in the scopic space, momentarily at least, the illusion of a fullness of the object relation, of a state of desire which is not just imaginary.

It is this last recess that is attacked by the cinema signifier, it is in its precise emplacement (*in its place*, in both senses of the word) that it installs a new figure of the lack, the physical absence of the object seen. In the theatre, actors and spectators are present at the same time and in the same location, hence present one to another, as the two protagonists of an authentic perverse couple. But in the cinema, the actor was present when the spectator was not (= shooting), and the spectator is present when the actor is no longer (= projection): a failure to meet of the voyeur and the exhibitionist whose approaches no longer coincide (they have "missed" one another). The cinema's voyeurism must (of necessity) do without any very clear mark of consent on the part of the object. There is no equivalent here of the theatre actors' final "bow." And then the latter could see their voyeurs, the game was less unilateral, slightly better distributed. In the darkened hall, the voyeur is rally left alone (or with other voyeurs, which is worse), deprived of his other half in the mythical hermaphrodite (a hermaphrodite not necessarily constituted by the distribution of the sexes but

rather by that of the active and passive poles in the exercise of the drive). Yet still a voyeur, since there is something to see, called the film, but something in whose definition there is a great deal of "flight": not precisely something that hides, rather something that *lets* itself be seen without *presenting* itself to be seen, which has gone out of the room before leaving only its trace visible there. This is the origin in particular of that "recipe" of the classical cinema which said that the actor should never look directly at the audience (= the camera).

Thus deprived of rehabilitatory agreement, of a real or supposed consensus with the other (which was also the Other, for it had the status of a sanction on the plane of the symbolic), cinematic voyeurism, *unauthorised* scopophilia, is from the outset more strongly established than that of the theater in direct line from the primal scene. Certain precise features of the institution contribute to this affinity: the obscurity surrounding the onlooker, the aperture of the screen with its inevitable keyhole effect. But the affinity is more profound. It lies first in the spectator's solitude in the cinema: those attending a cinematic projection do not, as in the theatre, constitute a true "audience," a temporary collectivity; they are an accumulation of individuals who, despite appearances, more closely resemble the fragmented group of readers of a novel. It lies on the other hand in the fact that the filmic spectacle, the object seen, is more radically ignorant of its spectator, since he is not there, than the theatrical spectacle can ever be. A third factor, closely linked to the other two, also plays a part: the *segregation of spaces* that characterises a cinema performance and not a theatrical one. The "stage" and the auditorium are no longer two areas set up in opposition to each other within a single space; the space of the film, represented by the screen, is utterly heterogeneous, it no longer communicates with that of the auditorium: one is real, the other perspective: a stronger break than any line of footlights. For its spectator the film unfolds in that simultaneously very close and definitively inaccessible "elsewhere" in which the child *sees* the amorous play of the parental couple, who are similarly ignorant of it and leave it alone, a pure onlooker whose participation is inconceivable. In this respect the cinematic signifier is not only "psychoanalytic"; it is more precisely Oedipal in type.

# DISAVOWAL, FETISHISM

As can be seen, the cinema has a number of roots in the unconscious and in the great movements illuminated by psychoanalysis, but they can all be traced back to the specific characteristics of the institutionalised signifier. I have gone a little way in tracing some of these roots, that of mirror identification, that of voyeurism and exhibitionism. There is also a third, that of fetishism.

Since the famous article by Freud that inaugurated the problem, psychoanalysis has linked fetish and fetishism closely with castration and the fear it inspires. Castration, for Freud, and even more clearly for Lacan, is first of all the mother's castration, and that is why the main figures it inspires are to a certain degree common to children of both sexes. The child who sees its mother's body is constrained by way of perception, by the 'evidence of the senses', to accept that there are human beings deprived of a penis. But for a long time—and somewhere in it for ever—it will not interpret

this inevitable observation in terms of an anatomical difference between the sexes (= penis/vagina). It believes that all human beings originally have a penis and it therefore understands what it has seen as the effect of a mutilation which redoubles its fear that it will be subjected to a similar fate (or else, in the case of the little girl after a certain age, the fear that she has already been subjected to it). Inversely, it is this very terror that is projected on to the spectacle of the mother's body, and invites the reading of an absence where anatomy sees a different conformation. The scenario of castration, in its broad lines, does not differ whether one understands it, like Lacan, as an essentially symbolic drama in which castration takes over in a decisive metaphor all the losses, both real and imaginary, that the child has already suffered (birth trauma, maternal breast, excrement, etc.), or whether on the contrary one tends, like Freud, to take that scenario slightly more literally. Before this *unveiling of a lack* (we are already close to the cinema signifier), the child, in order to avoid too strong an anxiety, will have to double up its belief (another cinematic characteristic) and from then on forever hold two contradictory opinions (proof that in spite of everything the real perception has not been without effect): 'All human beings are endowed with a penis' (primal belief) and 'Some human beings do not have a penis' (evidence of the senses). In other words, it will, perhaps definitively, retain its former belief *beneath* the new one, but it will also hold to its new perceptual observation while *disavowing* it on another level (= denial of perception, disavowal, Freud's '*Verleugnung*'). Thus is established the lasting matrix, the affective prototype of all the splittings of belief which man will henceforth be capable of in the most varied domains, of all the infinitely complex unconscious and occasionally conscious interactions which he will allow himself between 'believing' and 'not believing' and which will on more than one occasion be of great assistance to him in resolving (or denying) delicate problems. (If we were all a little honest with ourselves, we would realise that a truly integral belief, without any 'underside' in which the opposite is believed, would make even the most ordinary everyday life almost impossible.)

At the same time, the child, terrified by what it has seen or glimpsed, will have tried more or less successfully in different cases, to *arrest* its look, for all its life, at what will subsequently become the fetish: at a piece of clothing, for example, which masks the frightening discovery, or else precedes it (underwear, stockings, boots, etc.). The fixation on this 'just before' is thus another form of disavowal, of retreat from the perceived, although its very existence is dialectical evidence of the fact that the perceived has been perceived. The fetishistic prop will become a precondition for the establishment of potency and access to orgasm [*jouissance*], sometimes an indispensable precondition (true fetishism); in other developments it will only be a favourable condition, and one whose weight will vary with respect to the other features of the erotogenic situation as a whole. (It can be observed once again that the defence against desire itself becomes erotic, as the defence against anxiety itself becomes anxiogenic; for an analogous reason: what arises 'against' an affect also arises 'in' it and is not easily separated from it, even if that is its aim.) Fetishism is generally regarded as the 'perversion' par excellence, for it intervenes itself in the 'tabulation' of the others, and above all because they, like it (and this is what makes it their model), are based on the avoidance of castration. The fetish always represents the penis, it is always a substi-

tute for it, whether metaphorically (= it masks its absence) or metonymically (= it is contiguous with its empty place). To sum up, the fetish signifies the penis as absent, it is its negative signifier; supplementing it, it puts a 'fullness' in place of a lack, but in doing so it also affirms that lack. It resumes within itself the structure of disavowal and multiple belief.

These few reminders are intended above all to emphasise the fact that the dossier of fetishism, before any examination of its cinematic extensions, contains two broad aspects which coincide in their depths (in childhood and by virtue of structure) but are relatively distinct in their concrete manifestations, i.e. the problems of belief (= disavowal) and that of the fetish itself, the latter more immediately linked to eroto-genicity, whether direct or sublimated.

## STRUCTURES OF BELIEF

I shall say very little about the problems of belief in the cinema because I have already discussed them in this part apropos of identification and the mirror: I have tried to describe, outside the special case of fiction, a few of the many and successive twists, the 'reversals' (reduplications) that occur in the cinema to articulate together the imaginary, the symbolic and the real; each of these twists presupposes a division of belief; in order to work, the film does not only require a splitting, but a whole series of stages of belief, imbricated together into a chain by a remarkable machinery. In the third place, because the subject has already been largely dealt with by Octave Man-noni in his remarkable studies of the theatrical illusion, with reference to the fictional theatre. Of course, I have said above that theatrical fiction and cinematic fiction are not fictional in the same way; but this deviation concerned the representation, the sig-nifying material and not the represented, i.e. the fiction-fact as such, in which the deviation is much smaller (at any rate so long as one is dealing with *spectacles* such as theatre and cinema—written fiction obviously presents somewhat different prob-lems). Mannoni's analyses are just as valid for the fiction film, with the single reser-vation that the divergences in representation that I have already discussed are borne in mind.

I shall rest content to adapt these analyses to a cinematic perspective, and not feel obliged to repeat them (not so well) in detail. It is understood that the audience is not duped by the diegetic illusion, it 'knows' that the screen presents no more than a fic-tion. And yet, it is of vital importance for the correct unfolding of the spectacle that this make-believe be scrupulously respected (or else the fiction film is declared 'poorly made'), that everything is set to work to make the deception effective and to give it an air of truth (this is the problem of *verisimilitude*). Any spectator will tell you that he 'doesn't believe it', but everything happens as if there were nonetheless some-one to be deceived, someone who really would 'believe in it'. (I shall say that behind any fiction there is a second fiction: the diegetic events are fictional, that is the first; but everyone pretends to believe that they are true, and that is the second; there is even a third: the general refusal to admit that somewhere in oneself one believes they are genuinely true.) In other words, asks Mannoni, since it is 'accepted' that the audience is incredulous, *who is it who is credulous* and must be maintained in his credulous-

ness by the perfect organisation of the machinery (of the machination)? This credulous person is, of course, another part of ourselves, he is still seated *beneath* the incredulous one, or in his heart, it is he who continues to believe, who disavows what he knows (he for whom all human beings are still endowed with a penis). But by a symmetrical and simultaneous movement, the incredulous person disavows the credulous one; no one will admit that he is duped by the 'plot'. That is why the instance of credulousness is often projected into the outer world and constituted as a separate person, a person completely abused by the diegesis: thus, in Corneille's *L'Illusion comique*, a play with a significant title, the character Pridamant, the *naïf*, who does not know what theatre is, and *for whom*, by a reversal foreseen in Corneille's plot itself, the representation of the play is given. By a partial identification with this character, the spectators can sustain their credulousness in all incredulousness.

This instance which believes and also its personified projection have fairly precise equivalents in the cinema: for example, the credulous spectators at the '*Grand Café*' in 1895, frequently and complacently evoked by the incredulous spectators who have come *later* (and are no longer children), those spectators of 1895 who fled their seats in terror when the train entered La Ciotat station (in Lumière's famous film), because they were afraid it would run them down. Or else, in so many films, the character of the 'dreamer'—the sleeping dreamer—who during the film believed (as we did!) that it was true, whereas it was he who saw it all in a dream and who wakes up at the end of the film (as we do again). Octave Mannoni compares these switches of belief with those the ethnologist observes in certain populations in which his informers regularly declare that 'long ago we used to believe in the masks' (these masks are used to deceive children, like our Father Christmas, and adolescents learn at their initiation ceremonies that the 'masks' were in fact adults in disguise); in other words, these societies have always 'believed' in the masks, but have always relegated this belief to a 'long ago': they still believe in them, but always in the aorist tense (like everyone). This 'long ago' is childhood, when one really was duped by masks; among adults, the beliefs of 'long ago' irrigate the unbelief of today, but irrigate it by denegation (one could also say: *by delegation*, by attributing credulity to the child and to former times).

Certain cinematic sub-codes inscribe disavowal into the film in the form of less permanent and more localised figures. They should be studied separately in this perspective. I am not thinking only of films which have been 'dreamt' in their entirety by one of their characters, but also of all the sequences accompanied by a 'voice-off' commentary, spoken sometimes by a character, sometimes by a kind of anonymous 'speaker'. This voice, precisely a voice 'off', beyond jurisdiction, represents the rampart of unbelief (hence it is the opposite of the Pridamant character, yet has the same effect in the last analysis). The distance it establishes between the action and ourselves comforts our feeling that we are not duped by that action: thus reassured (behind the rampart), we can allow ourselves to be duped by it a bit longer (it is the speciality of naive distanciations to resolve themselves into alibis). There are also all those 'films within a film' which downgear the mechanism of our belief-unbelief and anchor it in several stages, hence more strongly: the included film was an illusion, so the including film (the film as such) was not, or was somewhat less so.

# THE CINEMA AS TECHNIQUE

As for the fetish itself, in its cinematic manifestations, who could fail to see that it consists fundamentally of the equipment of the cinema (= its 'technique'), or of the cinema as a whole as equipment and as technique, for fiction films and others? It is no accident that in the cinema some cameramen, some directors, some critics, some spectators demonstrate a real 'fetishism of technique', often noted or denounced as such ('fetishism' is taken here in its ordinary sense, which is rather loose but does contain within it the analytical sense that I shall attempt to disengage). As strictly defined, the fetish, like the apparatus of the cinema, is a *prop*, the prop that disavows a lack and in doing so affirms it without wishing to. A prop, too, which is as it were placed on the body of the object; a prop which is the penis, since it negates its absence, and hence a partial object that makes the whole object lovable and desirable. The fetish is also the point of departure for specialised practices, and as is well known, desire in its modalities is all the more 'technical' the more perverse it is.

Thus with respect to the desired body—to the body of desire rather—the fetish is in the same position as the technical equipment of the cinema with respect to the cinema as a whole. A fetish, the cinema as a technical performance, as prowess, as an *exploit*, an exploit that underlines and denounces the lack on which the whole arrangement is based (the absence of the object, replaced by its reflection), an exploit which consists at the same time of making this absence forgotten. The cinema fetishist is the person who is enchanted at what the machine is capable of, at the *theatre of shadows* as such. For the establishment of his full potency for cinematic enjoyment [*jouissance*] he must think at every moment (and above all *simultaneously*) of the force of presence the film has and of the absence on which this force is constructed. He must constantly compare the result with the means deployed (and hence pay attention to the technique), for his pleasure lodges in the gap between the two. Of course, this attitude appears most clearly in the 'connoisseur', the cinephile, but it also occurs, as a partial component of cinematic pleasure, in those who just go to the cinema: if they do go it is partly in order to be carried away by the film (or the fiction, if there is one), but also in order to *appreciate* as such the machinery that is carrying them away: they will say, precisely when they have been carried away, that the film was a 'good' one, that it was 'well made' (the same thing is said in French of a harmonious body).

It is clear that fetishism, in the cinema as elsewhere, is closely linked to the good object. The function of the fetish is to restore the latter, threatened in its 'goodness' (in Melanie Klein's sense) by the terrifying discovery of the lack. Thanks to the fetish, which covers the wound and itself becomes erotogenic, the object as a whole can become desirable again without excessive fear. In a similar way, the whole cinematic institution is as it were *covered* by a thin and omni-present garment, a stimulating prop through which it is consumed: the ensemble of its equipment and its tricks—and not just the celluloid strip, the *'pellicule'* or 'little skin' which has been rightly mentioned in this connection—of the equipment which *needs* the lack in order to stand out in it by contrast, but which only affirms it insofar as it ensures that it is forgotten, and which lastly (its third twist) needs it also not to be forgotten, for fear that at the same stroke the fact that *it* caused it to be forgotten will be forgotten.

The fetish is the cinema in its *physical* state. A fetish is always material: insofar as one can make up for it by the power of the symbolic alone one is precisely no longer a fetishist. At this point it is important to recall that of all the arts the cinema is the one that involves the most extensive and complex equipment; the 'technical' dimension is more obtrusive here than elsewhere. Along with television, it is the only art that is also an industry, or at least is so from the outset (the others become industries subsequently: music through the gramophone record or the cassette, books by mass printings and publishing trusts, etc.). In this respect only architecture is a little like it; there are 'languages' that are *heavier* than others, more dependent on 'hardware'.

At the same time as it localises the penis, the fetish represents by synecdoche the whole body of the object as desirable. Similarly, interest in the equipment and technique is the privileged representative of *love for the cinema*. . . .

## FETISH AND FRAME

Just like the other psychical structures that constitute the foundation of the cinema, fetishism does not intervene only in the constitution of the signifier, but also in certain of its more particular configurations. Here we have *framings* and also certain *camera movements* (the latter can anyway be defined as progressive changes in framing).

Cinema with directly erotic subject matter deliberately plays on the edges of the frame and the progressive, if need be incomplete revelations allowed by the camera as it moves, and this is no accident. Censorship is involved here: censorship of films and censorship in Freud's sense. Whether the form is static (framing) or dynamic (camera movements), the principle is the same; the point is to gamble simultaneously on the excitation of desire and its non-fulfilment (which is its opposite and yet favours it), by the infinite variations made possible precisely by the studios' technique on the exact emplacement of the *boundary* that bars the look, that puts an end to the 'seen', that inaugurates the downward (or upward) tilt into the dark, towards the unseen, the guessed-at. The framing and its displacements (that determine the *emplacement*) are in themselves forms of 'suspense' and are extensively used in suspense films, though they retain this function in other cases. They have an inner affinity with the mechanisms of desire, its postponements, its new impetus, and they retain this affinity in other places than erotic sequences (the only difference lies in the *quantum* which is sublimated and the *quantum* which is not). The way the cinema, with its wandering framings (wandering like the look, like the caress), finds the means to reveal space has something to do with a kind of permanent undressing, a generalised strip-tease, a less direct but more perfected strip-tease, since it also makes it possible to dress space again, to remove from view what it has previously shown, to *take back* as well as to retain (like the child at the moment of the birth of the fetish, the child who has already seen, but whose look beats a rapid retreat): a strip-tease pierced with 'flash-backs', inverted sequences that then give new impetus to the forward movement. These veiling-unveiling procedures can also be compared with certain cinematic 'punctuations', especially slow ones strongly marked by a concern for control and expectation (slow fade-ins and fade-outs, irises, 'drawn out' lap-dissolves like those of Sternberg).

1975

# LAURA MULVEY
# VISUAL PLEASURE AND
# NARRATIVE CINEMA

## I. INTRODUCTION

### A. A Political Use of Psychoanalysis

This paper intends to use psychoanalysis to discover where and how the fascination of film is reinforced by pre-existing patterns of fascination already at work within the individual subject and the social formations that have moulded him. It takes as starting point the way film reflects, reveals and even plays on the straight, socially established interpretation of sexual difference which controls images, erotic ways of looking and spectacle. It is helpful to understand what the cinema has been, how its magic has worked in the past, while attempting a theory and a practice which will challenge this cinema of the past. Psychoanalytic theory is thus appropriate here as a political weapon, demonstrating the way the unconscious of patriarchal society has structured film form.

The paradox of phallocentrism in all its manifestations is that it depends on the image of the castrated woman to give order and meaning to its world. An idea of woman stands as lynch pin to the system: it is her lack that produces the phallus as a symbolic presence, it is her desire to make good the lack that the phallus signifies. Recent writing in *Screen* about psychoanalysis and the cinema has not sufficiently brought out the importance of the representation of the female form in a symbolic order in which, in the last resort, it speaks castration and nothing else. To summarise briefly: the function of woman in forming the patriarchal unconscious is two-fold, she first symbolises the castration threat by her real absence of a penis and second thereby raises her child into the symbolic. Once this has been achieved, her meaning in the process is at an end, it does not last into the world of law and language except as a memory which oscillates between memory of maternal plenitude and memory of

837

lack. Both are posited on nature (or on anatomy in Freud's famous phrase). Woman's desire is subjected to her image as bearer of the bleeding wound, she can exist only in relation to castration and cannot transcend it. She turns her child into the signifier of her own desire to possess a penis (the condition, she imagines, of entry into the symbolic). Either she must gracefully give way to the word, the Name of the Father and the Law, or else struggle to keep her child down with her in the half-light of the imaginary. Woman then stands in patriarchal culture as signifier for the male other, bound by a symbolic order in which man can live out his phantasies and obsessions through linguistic command by imposing them on the silent image of woman still tied to her place as bearer of meaning, not maker of meaning.

There is an obvious interest in this analysis for feminists, a beauty in its exact rendering of the frustration experienced under the phallocentric order. It gets us nearer to the roots of our oppression, it brings an articulation of the problem closer, it faces us with the ultimate challenge: how to fight the unconscious structured like a language (formed critically at the moment of arrival of language) while still caught within the language of the patriarchy. There is no way in which we an produce an alternative out of the blue, but we can begin to make a break by examining patriarchy with the tools it provides, of which psychoanalysis is not the only but an important one. We are still separated by a great gap from important issues for the female unconscious which are scarcely relevant to phallocentric theory: the sexing of the female infant and her relationship to the symbolic, the sexually mature woman as nonmother, maternity outside the signification of the phallus, the vagina. . . . But, at this point, psychoanalytic theory as it now stands can at least advance our understanding of the status quo, of the patriarchal order in which we are caught.

## B. Destruction of Pleasure Is a Radical Weapon

As an advanced representation system, the cinema poses questions of the ways the unconscious (formed by the dominant order) structure ways of seeing and pleasure in looking. Cinema has changed over the last few decades. It is no longer the monolithic system based on large capital investment exemplified at its best by Hollywood in the 1930's, 1940's and 1950's. Technological advances (16mm, etc.) have changed the economic conditions of cinematic production, which can now be artisanal as well as capitalist. Thus it has been possible for an alternative cinema to develop. However self-conscious and ironic Hollywood managed to be, it always restricted itself to a formal mise-en-scène reflecting the dominant ideological concept of the cinema. The alternative cinema provides a space for a cinema to be born which is radical in both a political and an aesthetic sense and challenges the basic assumptions of the mainstream film. This is not to reject the latter moralistically, but to highlight the ways in which its formal preoccupations reflect the psychical obsessions of the society which produced it, and, further, to stress that the alternative cinema must start specifically by reacting against these obsessions and assumptions. A politically and aesthetically avant-garde cinema is now possible, but it can still only exist as a counterpoint.

The magic of the Hollywood style at its best (and of all the cinema which fell within its sphere of influence) arose, not exclusively, but in one important aspect, from its skilled and satisfying manipulation of visual pleasure. Unchallenged, main-

stream film coded the erotic into the language of the dominant patriarchal order. In the highly developed Hollywood cinema it was only through these codes that the alienated subject, torn in his imaginary memory by a sense of loss, by the terror of potential lack in phantasy, came near to finding a glimpse of satisfaction: through its formal beauty and its play on his own formative obsessions. This article will discuss the interweaving of that erotic pleasure in film, its meaning, and in particular the central place of the image of woman. It is said that analysing pleasure, or beauty, destroys it. That is the intention of this article. The satisfaction and reinforcement of the ego that represent the high point of film history hitherto must be attacked. Not in favour of a reconstructed new pleasure, which cannot exist in the abstract, nor of intellectualised unpleasure, but to make way for a total negation of the ease and plenitude of the narrative fiction film. The alternative is the thrill that comes from leaving the past behind without rejecting it, transcending outworn or oppressive forms, or daring to break with normal pleasurable expectations in order to conceive a new language of desire.

## II. PLEASURE IN LOOKING/FASCINATION WITH THE HUMAN FORM

A. The cinema offers a number of possible pleasures. One is scopophilia. There are circumstances in which looking itself is a source of pleasure, just as, in the reverse formation, there is pleasure in being looked at. Originally, in his *Three Essays on Sexuality*, Freud isolated scopophilia as one of the component instincts of sexuality which exist as drives quite independently of the erotogenic zones. At this point he associated scopophilia with taking other people as objects, subjecting them to a controlling and curious gaze. His particular examples centre around the voyeuristic activities of children, their desire to see and make sure of the private and the forbidden (curiosity about other people's genital and bodily functions, about the presence or absence of the penis and, retrospectively, about the primal scene). In this analysis scopophilia is essentially active. (Later, in *Instincts and their Vicissitudes*, Freud developed his theory of scopophilia further, attaching it initially to pre-genital autoeroticism, after which the pleasure of the look is transferred to others by analogy. There is a close working here of the relationship between the active instinct and its further development in a narcissistic form.) Although the instinct is modified by other factors, in particular the constitution of the ego, it continues to exist as the erotic basis for pleasure in looking at another person as object. At the extreme, it can become fixated into a perversion, producing obsessive voyeurs and Peeping Toms, whose only sexual satisfaction can come from watching, in an active controlling sense, an objectified other.

At first glance, the cinema would seem to be remote from the undercover world of the surreptitious observation of an unknowing and unwilling victim. What is seen of the screen is so manifestly shown. But the mass of mainstream film, and the conventions within which it has consciously evolved, portray a hermetically sealed world which unwinds magically, indifferent to the presence of the audience, producing for them a sense of separation and playing on their voyeuristic phantasy. Moreover, the extreme contrast between the darkness in the auditorium (which also isolates the

spectators from one another) and the brilliance of the shifting patterns of light and shade on the screen helps to promote the illusion of voyeuristic separation. Although the film is really being shown, is there to be seen, conditions of screening and narrative conventions give the spectator an illusion of looking in on a private world. Among other things, the position of the spectators in the cinema is blatantly one of repression of their exhibitionism and projection of the repressed desire on to the performer.

B. The cinema satisfies a primordial wish for pleasurable looking, but it also goes further, developing scopophilia in its narcissistic aspect. The conventions of mainstream film focus attention on the human form. Scale, space, stories are all anthropomorphic. Here, curiosity and the wish to look intermingle with a fascination with likeness and recognition: the human face, the human body, the relationship between the human form and its surroundings, the visible presence of the person in the world. Jacques Lacan has described how the moment when a child recognises its own image in the mirror is crucial for the constitution of the ego. Several aspects of this analysis are relevant here. The mirror phase occurs at a time when the child's physical ambitions outstrip his motor capacity, with the result that his recognition of himself is joyous in that he imagines his mirror image to be more complete, more perfect than he experiences his own body. Recognition is thus overlaid with mis-recognition: the image recognised is conceived as the reflected body of the self, but its misrecognition as superior projects this body outside itself as an ideal ego, the alienated subject, which, re-introjected as an ego ideal, gives rise to the future generation of identification with others. This mirror-moment predates language for the child.

Important for this article is the fact that it is an image that constitutes the matrix of the imaginary, of recognition/misrecognition and identification, and hence of the first articulation of the "I," of subjectivity. This is a moment when an older fascination with looking (at the mother's face, for an obvious example) collides with the initial inklings of self-awareness. Hence it is the birth of the long love affair/despair between image and self-image which has found such intensity of expression in film and such joyous recognition in the cinema audience. Quite apart from the extraneous similarities between screen and mirror (the framing of the human form in its surroundings, for instance), the cinema has structures of fascination strong enough to allow temporary loss of ego while simultaneously reinforcing the ego. The sense of forgetting the world as the ego has subsequently come to perceive it (I forgot who I am and where I was) is nostalgically reminiscent of that pre-subjective moment of image recognition. At the same time the cinema has distinguished itself in the production of ego ideals as expressed in particular in the star system, the stars centering both screen presence and screen story as they act out a complex proccess of likeness and difference (the glamorous impersonates the ordinary).

C. Sections II. A and B have set out two contradictory aspects of the pleasurable structures of looking in the conventional cinematic situation. The first, scopophilic, arises from pleasure in using another person as an object of sexual stimulation through sight. The second, developed through narcissism and the constitution of the ego, comes from identification with the image seen. Thus, in film terms, one implies

a separation of the erotic identity of the subject from the object on the screen (active scopophilia), the other demands identification of the ego with the object on the screen through the spectator's fascination with and recognition of his like. The first is a function of the sexual instincts, the second of ego libido. This dichotomy was crucial for Freud. Although he saw the two as interacting and overlaying each other, the tension between instinctual drives and self-preservation continues to be a dramatic polarisation in terms of pleasure. Both are formative structures, mechanisms not meaning. In themselves they have no signification, they have to be attached to an idealisation. Both pursue aims in indifference to perceptual reality, creating the imagised, eroticised concept of the world that forms the perception of the subject and makes a mockery of empirical objectivity.

During its history, the cinema seems to have evolved a particular illusion of reality in which this contradiction between libido and ego has found a beautifully complementary phantasy world. In *reality* the phantasy world of the screen is subject to the law which produces it. Sexual instincts and identification processes have a meaning within the symbolic order which articulates desire. Desire, born with language, allows the possibility of transcending the instinctual and the imaginary, but its point of reference continually returns to the traumatic moment of its birth: the castration complex. Hence the look, pleasurable in form, can be threatening in content, and it is woman as representation/image that crystallises this paradox.

## III. WOMAN AS IMAGE, MAN AS BEARER OF THE LOOK

A. In a world ordered by sexual imbalance, pleasure in looking has been split between active/male and passive/female. The determining male gaze projects its phantasy on to the female figure which is styled accordingly. In their traditional exhibitionist role women are simultaneously looked at and displayed, with their appearance coded for strong visual and erotic impact so that they can be said to connote *to-be-looked-at-ness*. Women displayed as sexual object is the leit-motiff of erotic spectacle: from pin-ups to strip-tease, from Ziegfeld to Busby Berkeley, she holds the look, plays to and signifies male desire. Mainstream film neatly combined spectacle and narrative. (Note, however, how in the musical song-and-dance numbers break the flow of the diegesis.) The presence of woman is an indispensible element of spectacle in normal narrative film, yet her visual presence tends to work against the development of a story line, to freeze the flow of action in moments of erotic contemplation. This alien presence then has to be integrated into cohesion with the narrative. As Budd Boetticher has put it:

> What counts is what the heroine provokes, or rather what she represents. She is the one, or rather the love or fear she inspires in the hero, or else the concern he feels for her, who makes him act the way he does. In herself the woman has not the slightest importance.

(A recent tendency in narrative film has been to dispense with this problem altogether; hence the development of what Molly Haskell has called the "buddy movie," in which the active homosexual eroticism of the central male figures can carry the story without distraction.) Traditionally, the woman displayed has functioned on two levels: as erotic object for the characters within the screen story, and as erotic object

for the spectator within the auditorium, with a shifting tension between the looks on either side of the screen. For instance, the device of the show-girl allows the two looks to be unified technically without any apparent break in the diegesis. A woman performs within the narrative, the gaze of the spectator and that of the male characters in the film are neatly combined without breaking narrative verisimilitude. For a moment the sexual impact of the performing woman takes the film into a no-man's-land outside its own time and space. Thus Marilyn Monroe's first appearance in *The River of No Return* and Lauren Bacall's songs in *To Have or Have Not*. Similarly, conventional close-ups of legs (Dietrich, for instance) or a face (Garbo) integrate into the narrative a different mode of eroticism. One part of a fragmented body destroys the Renaissance space, the illusion of depth demanded by the narrative, it gives flatness, the quality of a cut-out or icon rather than verisimilitude to the screen.

B. An active/passive heterosexual division of labour has similarly controlled narrative structure. According to the principles of the ruling ideology and the psychical structures that back it up, the male figure cannot bear the burden of sexual objectification. Man is reluctant to gaze at his exhibitionist like. Hence the split between spectacle and narrative supports the man's role as the active one of forwarding the story, making things happen. The man controls the film phantasy and also emerges as the representative of power in a further sense: as the bearer of the look of the spectator, transferring it behind the screen to neutralise the extra-diegetic tendencies represented by woman as spectacle. This is made possible through the processes set in motion by structuring the film around a main controlling figure with whom the spectator can identify. As the spectator identifies with the main male* protagonist, he projects his look on to that of his like, his screen surrogate, so that the power of the male protagonist as he controls events coincides with the active power of the erotic look, both giving a satisfying sense of omnipotence. A male movie star's glamourous characteristics are thus not those of the erotic object of the gaze, but those of the more perfect, more complete, more powerful ideal ego conceived in the original moment of recognition in front of the mirror. The character in the story can make things happen and control events better than the subject/spectator, just as the image in the mirror was more in control of motor coordination. In contrast to woman as icon, the active male figure (the ego ideal of the identification process) demands a three-dimensional space corresponding to that of the mirror-recognition in which the alienated subject internalised his own representation of this imaginary existence. He is a figure in a landscape. Here the function of film is to reproduce as accurately as possible the so-called natural conditions of human perception. Camera technology (as exemplified by deep focus in particular) and camera movements (determined by the action of the protagonist), combined with invisible editing (demanded by realism) all tend to blur the limits of screen space. The male protagonist is free to command the stage, a stage of spatial illusion in which he articulates the look and creates the action.

---

*There are films with a woman as main protagonist, of course. To analyse this phenomenon seriously here would take me too far afield. Pam Cook and Claire Johnston's study of *The Revolt of Mamie Stover* in Phil Hardy, ed.: *Raoul Walsh*, Edinburgh 1974, shows in a striking case how the strength of this female protagonist is more apparent than real.

C.1 Sections III. A and B have set out a tension between a mode of repres
of woman in film and conventions surrounding the diegesis. Each is associ
a look: that of the spectator in direct scopophilic contact with the female form dis-
played for his enjoyment (connoting male phantasy) and that of the spectator fasci-
nated with the image of his like set in an illusion of natural space, and through him
gaining control and possession of the woman within the diegesis. (This tension and
the shift from one pole to the other can structure a single text. Thus both in *Only
Angels Have Wings* and in *To Have and Have Not*, the film opens with the woman as
object of the combined gaze of spectator and all the male protagonists in the film. She
is isolated, glamourous, on display, sexualised. But as the narrative progresses she
falls in love with the main male protagonist and becomes his property, losing her out-

Marilyn Monroe and Robert Mitchum in a publicity shot from *River of No Return* (1954). "As
the spectator identifies with the main male protagonist, he projects his look on to that of his
like, his screen surrogate, so that the power of the male protagonist as he controls events coin-
cides with the active power of the erotic look, both giving a satisfying sense of omnipotence"
(MULVEY, page 842).

ward glamorous characteristics, her generalised sexuality, her show-girl connota-
tions; her eroticism is subjected to the male star alone. By means of identification
with him, through participation in his power, the spectator can indirectly possess her
too.)

But in psychoanalytic terms, the female figure poses a deeper problem. She also
connotes something that the look continually circles around but disavows: her lack of
penis, implying a threat of castration and hence unpleasure. Ultimately, the meaning
of woman is sexual difference, the absence of the penis as visually ascertainable, the
material evidence on which is based the castration complex essential for the organi-
sation of entrance to the symbolic order and the law of the father. Thus the woman as
icon, displayed for the gaze and enjoyment of men, the active controllers of the look,
always threatens to evoke the anxiety it originally signified. The male unconscious
has two avenues of escape from this castration anxiety: preoccupation with the re-
enactment of the original trauma (investigating the woman, demystifying her mys-
tery), counterbalanced by the devaluation, punishment or saving of the guilty object
(an avenue typified by the concerns of the *film noir*); or else complete disavowal of
castration by the substitution of a fetish object or turning the represented figure itself
into a fetish so that it becomes reassuring rather than dangerous (hence over-
valuation, the cult of the female star). This second avenue, fetishistic scopophilia,
builds up the physical beauty of the object, transforming it into something satisfying
in itself. The first avenue, voyeurism, on the contrary, has associations with sadism:
pleasure lies in ascertaining guilt (immediately associated with castration), asserting
control and subjecting the guilty person through punishment or forgiveness. This
sadistic side fits in well with narrative. Sadism demands a story, depends on making
something happen, forcing a change in another person, a battle of will and strength,
victory/defeat, all occurring in a linear time with a beginning and an end. Fetishistic
scopophilia, on the other hand, can exist outside linear time as the erotic instinct is
focussed on the look alone. These contradictions and ambiguities can be illustrated
more simply by using works by Hitchcock and Sternberg, both of whom take the look
almost as the content or subject matter of many of their films. Hitchcock is the more
complex, as he uses both mechanisms. Sternberg's work, on the other hand, provides
many pure examples of fetishistic scopophilia.

C.2 It is well known that Sternberg once said he would welcome his films being
projected upside down so that story and character involvement would not interfere
with the specator's undiluted appreciation of the screen image. This statement is
revealing but ingenuous. Ingenuous in that his films do demand that the figure of the
woman (Dietrich, in the cycle of films with her, as the ultimate example) should be
identifiable. But revealing in that it emphasises the fact that for him the pictorial space
enclosed by the frame is paramount rather than narrative or identification processes.
While Hitchcock goes into the investigative side of voyeurism, Sternberg produces
the ultimate fetish, taking it to the point where the powerful look of the male protag-
onist (characteristic of traditional narrative film) is broken in favour of the image in
direct erotic rapport with the spectator. The beauty of the woman as object and the
screen space coalesce; she is no longer the bearer of guilt but a perfect product, whose
body, stylised and fragmented by close-ups, is the content of the film, and the direct

recipient of the spectator's look. Sternberg plays down the illusion of scre his screen tends to be one-dimensional, as light and shade, lace, steam, fo streamers, etc, reduce the visual field. There is little or no mediation of the look through the eyes of the main male protagonist. On the contrary, shadowy presences like La Bessière in *Morocco* act as surrogates for the director, detached as they are from audience identification. Despite Sternberg's insistence that his stories are irrelevant, it is significant that they are concerned with situation, not suspense, and cyclical rather than linear time, while plot complications revolve around misunderstanding rather than conflict. The most important absence is that of the controlling male gaze within the screen scene. The high point of emotional drama in the most typical Dietrich films, her supreme moments of erotic meaning, take place in the absence of the man she loves in the fiction. There are other witnesses, other spectators watching her on the screen, their gaze is one with, not standing in for, that of the audience. At the end of *Morocco*, Tom Brown has already disappeared into the desert when Amy Jolly kicks off her gold sandals and walks after him. At the end of *Dishonoured*, Kranau is indifferent to the fate of Magda. In both cases, the erotic impact, sanctified by death, is displayed as a spectacle for the audience. The male hero misunderstands and, above all, does not see.

In Hitchcock, by contrast, the male hero does see precisely what the audience sees. However, in the films I shall discuss here, he takes fascination with an image through scopophilic eroticism as the subject of the film. Moreover, in these cases the hero portrays the contradictions and tensions experienced by the spectator. In *Vertigo* in particular, but also in *Marnie* and *Rear Window*, the look is central to the plot, oscillating between voyeurism and fetishistic fascination. As a twist, a further manipulation of the normal viewing process which in some sense reveals it, Hitchcock uses the process of identification normally associated with ideological correctness and the recognition of established morality and shows up its perverted side. Hitchcock has never concealed his interest in voyeurism, cinematic and non-cinematic. His heroes are exemplary of the symbolic order and the law—a policeman (*Vertigo*), a dominant male possessing money and power (*Marnie*)—but their erotic drives lead them into compromised situations. The power to subject another person to the will sadistically or to the gaze voyeuristically is turned on to the woman as the object of both. Power is backed by a certainty of legal right and the established guilt of the woman (evoking castration, psychoanalytically speaking). True perversion is barely concealed under a shallow mask of ideological correctness—the man is on the right side of the law, the woman on the wrong. Hitchcock's skilful use of identification processes and liberal use of subjective camera from the point of view of the male protagonist draw the spectators deeply into his position, making them share his uneasy gaze. The audience is absorbed into a voyeuristic situation within the screen scene and diegesis which parodies his own in the cinema. In his analysis of *Rear Window*, Douchet takes the film as a metaphor for the cinema. Jeffries is the audience, the events in the apartment block opposite correspond to the screen. As he watches, an erotic dimension is added to his look, a central image to the drama. His girlfriend Lisa had been of little sexual interest to him, more or less a drag, so long as she remained on the spectator side. When she crosses the barrier between his room and the block opposite, their relationship is re-born erotically. He does not merely watch her through his lens, as a

distant meaningful image, he also sees her as a guilty intruder exposed by a danger-ous man threatening her with punishment, and thus finally saves her. Lisa's exhibi-tionism has already been established by her obsessive interest in dress and style, in being a passive image of visual perfection: Jeffries' voyeurism and activity have also been established through his work as a photo-journalist, a maker of stories and cap-tor of images. However, his enforced inactivity, binding him to his seat as a specta-tor, puts him squarely in the phantasy position of the cinema audience.

In *Vertigo*, subjective camera predominates. apart from one flash-back from Judy's point of view, the narrative is woven around what Scottie sees or fails to see. The audience follows the growth of his erotic obsession and subsequent despair precisely from his point of view. Scottie's voyeurism is blatant: he falls in love with a woman he follows and spies on without speaking to. Its sadistic side is equally blatant: he has chosen (and freely chosen, for he had been a successful lawyer) to be a policeman, with all the attendant possibilities of pursuit and investigation. As a result, he follows, watches and falls in love with a perfect image of female beauty and mystery. Once he actually confronts her, his erotic drive is to break her down and force her to tell by persistent cross-questioning. Then, in the second part of the film, he re-enacts his obsessive involvement with the image he loved to watch secretly. He reconstructs Judy as Madeleine, forces her to conform in every detail to the actual physical appear-ance of his fetish. Her exhibitionism, her masochism, make her an ideal passive coun-terpart to Scottie's active sadistic voyeurism. She knows her part is to perform, and only by playing it through and then replaying it can she keep Scottie's erotic interest. But in the repetition he does break her down and succeeds in exposing her guilt. His curiosity wins through and she is punished. In *Vertigo*, erotic involvement with the look is disorientating: the spectator's fascination is turned against him as the narra-tive carries him through and entwines him with the processes that he is himself exer-cising. The Hitchcock hero here is firmly placed within the symbolic order, in narra-tive terms. He has all the attributes of the patriarchal super-ego. Hence the spectator, lulled into a false sense of security by the apparent legality of his surrogate, sees through his look and finds himself exposed as complicit, caught in the moral ambi-guity of looking. Far from being simply an aside on the perversion of the police, *Ver-tigo* focuses on the implications of the active/looking, passive/looked-at split in terms of sexual difference and the power of the male symbolic encapsulated in the hero. Marnie, too, performs for Mark Rutland's gaze and masquerades as the perfect to-be-looked-at image. He, too, is on the side of the law until, drawn in by obsession with her guilt, her secret, he longs to see her in the act of committing a crime, make her confess and thus save her. So he, too, becomes complicit as he acts out the implica-tions of his power. He controls money and words, he can have his cake and eat it.

## IV. SUMMARY

The psychoanalytic background that has been discussed in this article is relevant to the pleasure and unpleasure offered by traditional narrative film. The scopophilic instinct (pleasure in looking at another person as an erotic object), and, in contradis-tinction, ego libido (forming identification processes) act as formations, mechanisms, which this cinema has played on. The image of woman as (passive) raw material for

the (active) gaze of man takes the argument a step further into the structure of representation, adding a further layer demanded by the ideology of the patriarchal order as it is worked out in its favourite cinematic form—illusionistic narrative film. The argument turns again to the psychoanalytic background in that woman as representation signifies castration, inducing voyeuristic or fetishistic mechanisms to circumvent her threat. None of these interacting layers is intrinsic to film, but it is only in the film form that they can reach a perfect and beautiful contradiction, thanks to the possibility in the cinema of shifting the emphasis of the look. It is the place of the look that defines cinema, the possibility of varying it and exposing it. This is what makes cinema quite different in its voyeuristic potential from, say, strip-tease, theatre, shows, etc. Going far beyond highlighting a woman's to-be-looked-at-ness, cinema builds the way she is to be looked at into the spectacle itself. Playing on the tension between film as controlling the dimension of time (editing, narrative) and film as controlling the dimension of space (changes in distance, editing), cinematic codes create a gaze, a world, and an object, thereby producing an illusion cut to the measure of desire. It is these cinematic codes and their relationship to formative external structures that must be broken down before mainstream film and the pleasure it provides can be challenged.

To begin with (as an ending), the voyeuristic-scopophilic look that is a crucial part of traditional filmic pleasure can itself be broken down. There are three different looks associated with cinema: that of the camera as it records the pro-filmic event, that of the audience as it watches the final product, and that of the characters at each other within the screen illusion. The conventions of narrative film deny the first two and subordinate them to the third, the conscious aim being always to eliminate intrusive camera presence and prevent a distancing awareness in the audience. Without these two absences (the material existence of the recording process, the critical reading of the spectator), fictional drama cannot achieve reality, obviousness and truth. Nevertheless, as this article has argued, the structure of looking in narrative fiction film contains a contradiction in its own premises: the female image as a castration threat constantly endangers the unity of the diegesis and bursts through the world of illusion as an intrusive, static, one-dimensional fetish. Thus the two looks materially present in time and space are obsessively subordinated to the neurotic needs of the male ego. The camera becomes the mechanism for producing an illusion of Renaissance space, flowing movements compatible with the human eye, an ideology of representation that revolves round the perception of the subject; the camera's look is disavowed in order to create a convincing world in which the spectator's surrogate can perform with verisimilitude. Simultaneously, the look of the audience is denied an intrinsic force: as soon as fetishistic representation of the female image threatens to break the spell of illusion, and the erotic image on the screen appears directly (without mediation) to the spectator, the fact of fetishisation, concealing as it does castration fear, freezes the look, fixates the spectator and prevents him from acheiving any distance from the image in front of him.

This complex interaction of looks is specific to film. The first blow against the monolithic accumulation of traditional film conventions (already undertaken by radical film-makers) is to free the look of the camera into its materiality in time and space and the look of the audience into dialectics, passionate detachment. There is no doubt

that this destroys the satisfaction, pleasure and privilege of the 'invisible guest', and highlights how film has depended on voyeuristic active/passive mechanisms. Women, whose image has continually been stolen and used for this end, cannot view the decline of the traditional film form with anything much more than sentimental regret.*

1975

---

*This article is a reworked version of a paper given in the French Department of the University of Wisconsin, Madison, in the Spring of 1973.

# TANIA MODLESKI
# *FROM* THE WOMEN WHO KNEW TOO MUCH: HITCHCOCK AND FEMINIST THEORY

## THE MASTER'S DOLLHOUSE: *REAR WINDOW*

In "Visual Pleasure and Narrative Cinema," Laura Mulvey uses two Hitchcock films to exemplify her theory. According to Mulvey, both *Rear Window* (1954) and *Vertigo* (1958) are films "cut to the measure of male desire"—tailored, that is, to the fears and fantasies of the male spectator, who, because of the threat of castration posed by the woman's image, needs to see her fetishized and controlled in the course of the narrative.[1] Certainly, these two films appear perfectly to support Mulvey's thesis that classic narrative film negates woman's view, since each of them seems to confine us to the hero's vision of events and to insist on that vision by literally stressing the man's point of view throughout. The film spectator apparently has no choice *but* to identify with the male protagonist, who exerts an active, controlling gaze over a passive female object. In *Rear Window,* Mulvey writes, "Lisa's exhibitionism [is] established by her obsessive interest in dress and style, in being a passive image of visual perfection; Jeffries's voyeurism and activity [are] established through his work as a photojournalist, a maker of stories and captor of images. However, his enforced inactivity, binding him to his seat as a spectator, puts him squarely in the phantasy position of the cinema audience."[2]

This last observation connects Mulvey to a tradition of criticism of the film that begins with the work of the French critic Jean Douchet and that sees the film as a metacinematic commentary: spectators identifying with the chair-bound, voyeuristic protagonist find themselves in complicity with his guilty desires.[3] Because of Hitch-

---

[1]Laura Mulvey, "Visual Pleasure and Narrative Cinema," *Screen* 16, no. 3 (1975): 17.
[2]Mulvey, "Visual Pleasure," p. 16.
[3]Jean Douchet, "Hitch et son Public," *Cahiers du Cinéma,* no. 113 (November 1960): 10. For the most recent discussion of the film in relation to questions of spectatorship, see R. Barton Palmer, "The Metafictional Hitchcock: The Experience of Viewing and the Viewing of Experience in *Rear Window* and *Psycho,*" *Cinema Journal* 26, no. 2 (Winter 1986): 4–29.

cock's relentless insistence on the male gaze, even critics like Robin Wood, who are anxious to save the film for feminism, restrict themselves to discussing the film's critique of the position of the hero and, by extension, of the *male* spectator whose "phantasy position the hero occupies."[4] But what happens, in the words of a recent relevant article by Linda Williams, "when the woman looks"?[5] I shall argue, against the grain of critical consensus, that the film actually has something to say about this question.[6]

*Rear Window* is the story of photojournalist, L. B. Jeffries (James Stewart), who, as a result of an accident on the job, is confined to a wheel chair in his apartment, where he whiles away the time spying on his neighbors. These include a middle-aged, alcoholic musician with composer's block; a newlywed couple who spend all their time in bed behind closed shades; a childless couple who sleep on the balcony at night and own a little dog; a voluptuous dancer, "Miss Torso," who practices her suggestive dance routines as she goes about her daily chores; "Miss Lonelyhearts," who fantasizes about gentlemen callers; and Lars Thorwald, a costume jewelry salesman with a nagging, invalid wife.

The film opens with the camera panning the courtyard of a lower east side housing development and then moving back through a window where we see L. B. Jeffries asleep, his chair turned away from the window, beads of sweat on his face. There is a cut to a thermometer, which registers over ninety degrees, and then the camera tilts down Jeffries's body to reveal that his leg is in a cast. The camera proceeds to explore the apartment, calling our attention to some smashed camera equipment, a photograph of a car accident, some other photographs Jeff has taken in his travels, and, finally, a negative of a blonde woman's face followed by a "positive" photograph of her on the cover of *Life* magazine. When Jeff wakes up, he begins to observe his neighbors and then complains on the phone to his editor that if he doesn't get back to the job soon, he's going to do "something drastic like get married." While he speaks of the horrors of marriage, we watch from his point of view as Thorwald (Raymond Burr) returns home to be greeted by a nagging wife.

Soon after, Stella (Thelma Ritter), the insurance company nurse, comes in to give Jeff a massage. She immediately begins to scold him for being a Peeping Tom, and tries to persuade him to marry Lisa Freemont, claiming that his lukewarm attitude to the woman he claims is "too perfect" is abnormal. Later that evening, Lisa (Grace Kelly) comes to visit, dressed in an $1100 gown and accompanied by a waiter from the Twenty One Club, who is delivering their dinner. Lisa and Jeff have an argument as he tells her that marriage to him, given his grueling life style and her pampered one, is out of the question. When she goes home, Jeff begins to watch the neighbors again and observes some strange movements on the part of Lars Thorwald. Eventually Jeff falls asleep, and we see Thorwald and a woman leaving Thorwald's apart-

[4]Robin Wood, "Fear of Spying," *American Film* (November 1982): 31–32.

[5]Linda Williams, "When the Woman Looks," in *Revision: Essays in Feminist Film Criticism,* ed. Mary Ann Doane. Patricia Mellencamp, and Williams. The American Film Institute Monograph Series, Vol. 3 (Frederick, MD: University Publications of America, 1984).

[6]Robert Stam and Roberta Pearson do, however, devote one brief paragraph to this issue in their article, "Hitchcock's *Rear Window:* Reflexivity and the Critique of Voyeurism," *Enclitic* 7, no. 1 (Spring 1983): 143.

ment. The next day Jeff notices that Mrs. Thorwald has gone, and he becomes convinced that Thorwald has murdered his wife—a conviction that becomes more and more obsessive as the film progresses—to the point where he uses first binoculars and then a huge telephoto lens to see more closely. He attempts to persuade Lisa, Stella, and his friend, policeman Tom Doyle (Wendell Corey), of his interpretation of the events across the way. Though Doyle remains skeptical, the women eventually come to accept Jeff's view and actually go looking for clues.

Lisa is caught by Thorwald as she searches his apartment for the wedding ring that will prove Jeff's theory, and Jeff is forced to look helplessly on as Thorwald pushes her around. Jeff warns the police, whom he has just contacted on the phone to alert them that Miss Lonelyhearts is about to take an overdose of pills. The police arrive in time to prevent any harm from befalling Lisa, and they take her to jail. After Jeff sends Stella off with the bail money, he finds himself face to face with the guilty Thorwald, who asks, "What is it you want of me?" and steps forward menacingly. Jeff tries to keep him at bay by popping off flashbulbs in his face, but Thorwald manages to grab him and, during a struggle, Jeff falls to the ground from a window ledge.

The film ends with another pan around the courtyard. The various plots featuring the neighbors have been resolved: workmen are repainting the bathroom of Thorwald's apartment, where blood had splattered when Thorwald murdered his wife and cut her up in pieces; Miss Lonelyhearts, whose suicide was prevented when she heard the musician's beautiful song, has formed a relationship with the musician; Miss Torso's little soldier boyfriend Stanley arrives and asks what's in the refrigerator; the childless couple, whose dog was murdered by Thorwald because it was digging in the flower garden where evidence was buried (the dog who "knew too much," as Lisa puts it), have gotten another dog; and the newlywed wife is nagging her husband because he has lost his job. The camera tracks back into the window to show L.B. asleep, as before, only this time both his legs are in casts. The camera movement ends on a medium shot of Lisa lying on Jeff's bed, in pants and shirt, and reading a book entitled *Beyond the High Himalayas*. She steals a glance at Jeff to make sure he is still asleep, puts down the book, and picks up a copy of Harper's *Bazaar*. On the soundtrack is the musician's song, "Lisa," finally completed, like the narrative itself.

A number of critics, most of whom center their analyses around the film's critique of voyeurism, have pointed out that the film's protagonist is fixated at an infantile level of sexual development and must in the course of the narrative grow into "mature sexuality": "Jeffries's voyeurism goes hand in hand with an absorbing fear of mature sexuality. Indeed, the film begins by hinting at a serious case of psychosexual pathology. The first image of Jeffries, asleep with hand on thigh is quietly masturbatory, as if he were an invalid who had just abused himself in the dark."[7] By the end of the film Jeff has supposedly learned his lesson and "has realized the corollary psychic costs of both voyeurism and solitude": he is now ready for the marriage he has all along resisted and for the "mature" sexual relation that this implies. Yet there is a sense in which the image of Lisa in masculine clothes, absorbed in "masculine" interests only places Jeff—and the audience—more squarely than ever in the Imaginary. For as the

---

[7]Stam and Pearson, "Hitchcock's *Rear Window*: Reflexivity," p. 140.

narrative proceeds, the sexuality of the woman, which is all along presented as threat-
ening, is first combated by the fantasy of female dismemberment and then, finally, by
a re-membering of the woman according to the little boy's fantasy that the female is
no different from himself.[8]

Jeff claims that Lisa is "too perfect." On the face of it, of course, this reason for
resisting marriage is patently absurd, as Stella does not fail to point out. (This absurd-
ity leads one critic to argue that the project of the film is to stimulate the audience's
desire for the couple's union by inducing frustration at "Jeff's indifference to her
allure."[9]) But, while it may indeed be "unrealistic" that any red-blooded man would
reject Grace Kelly, there is a certain psychological plausibility in Jeff's fear of Lisa's
"perfection"—a fear that is related to man's fear of women's difference and his sus-
picion that they may not, after all, be mutilated (imperfect) men, may not be what, as
Susan Lurie puts it, *men* would be if they lacked penises—"bereft of sexuality, help-
less, incapable."[10] Lurie's words certainly describe the situation of Jeff, whose impo-
tence is suggested by the enormous cast on his leg and his consequent inability to
move about, so that ultimately he is unable to rescue the woman he loves from dan-
ger. By contrast, Lisa Freemont is anything but helpless and incapable, despite Mul-
vey's characterization of her as a "passive image of visual perfection"—and this is
where the "problem" lies.

In our very first view of her, Lisa is experienced as an overwhelmingly powerful
presence. Jeff is asleep in his chair, the camera positioned over him, when suddenly
an ominous shadow crosses his face. There is a cut to a closeup of Grace Kelly, a
vision of loveliness, bending down toward him and us: the princess-to-be waking
Sleeping Beauty with a kiss. These two shots—shadow and vibrant image—suggest
the underlying threat posed by the desirable woman and recall the negative and pos-
itive images of the woman on the cover of *Life*. When Jeff jokingly inquires, "Who
are you?" Lisa turns on three lamps, replies, "Reading from top to bottom, Lisa
... Carol ... Freemont," and strikes a pose. While the pose confirms the view of her
as exhibitionist, her confident nomination of herself reveals her to be extremely self-
possessed—in contrast to the man who is known by only one of *his* three names. The
two engage in small talk as Lisa sets about preparing the dinner brought in from the
Twenty One Club, and Jeff makes continual jibes about married life. Lisa ends the
conversation by claiming, "At least you can't say the dinner's not alright," and over a
shot of a very appetizing meal, Jeff replies, exasperated, "Lisa, it's perfect, as
*always*." In the meantime we have witnessed Thorwald taking dinner in to his wife,
who pushes it from her in disgust and flings away the rose he has placed on the tray.

Important parallels are thus set up between Lisa and Thorwald, on the one hand, and
Jeff and the wife, on the other. Critics have seldom picked up on this parallelism, pre-
ferring instead to stress a symmetry along sexual lines—that is, Jeff's similarity to

---

[8]A constant theme in the writings of Stephen Heath is the way cinema works to "remember" the (male)
spectator: e.g., "the historical reality it encounters [is] a permanent crisis of identity that must be perma-
nently resolved by remembering the history of the individual subject." "Film Performance," *Questions of
Cinema* (Bloomington: Indiana University Press, 1981), p. 125.

[9]Ruth Perlmutter, "*Rear Window*: A Construction Story," *Journal of Film and Video* 37 (Spring 1985):
59.

[10]Susan Lurie, "Pornography and the Dread of Women: The Male Sexual Dilemma," *Take Back the
Night: Women on Pornography,* ed. Laure Lederer (New York: William Morrow, 1980), p. 166.

Thorwald and Lisa's resemblance to the blonde wife. Interestingly, Hitchcock himself was quite explicit about the gender reversal: "The symmetry is the same as in *Shadow of a Doubt*. On one side of the yard you have the Stewart-Kelly couple, with him immobilized by his leg in a cast, while she can move about freely. And on the other side there is a sick woman who's confined to her bed, while the husband comes and goes."[11] Raymond Bellour has shown how in classic cinema a binary opposition between movement and stasis generally works to establish male superiority in classical narrative cinema.[12] In *Rear Window*, however, the *woman* is continually shown to be physically superior to the hero, not only in her physical movements but also in her dominance within the frame: she towers over Jeff in nearly every shot in which they both appear.

Given this emphasis on the woman's mobility, freedom, and power, it seems odd that an astute critic like Mulvey sees in the image of Lisa Freemont only a passive object of the male gaze. Mulvey bases her judgment on the fact that Lisa appears to be "obsessed with dress and style," continually putting herself on visual display for Jeff so that he will notice her and turn his gaze away from the neighbors.[13] (In this respect, the "project" of the film resembles that of *Rebecca,* which also deals with a woman's efforts to get the man she loves to look at her.) It is important, however, not to dismiss out of hand Lisa's professional and personal involvement with fashion but to consider all the ways this involvement *functions* in the narrative. This is no simple matter. For if, on the one hand, woman's concern with fashion quite obviously serves patriarchal interests, on the other hand, this very concern is often denigrated and ridiculed by men (as it is by Jeff throughout the film)—thus putting women in a familiar double bind by which they are first assigned a restricted place in patriarchy and then condemned for occupying it. For feminist criticism to ignore the full complexity of woman's contradictory situation is to risk acquiescing in masculine contempt for female activities. In *A Room of One's Own,* Virginia Woolf suggested that a necessary, if not sufficient, feminist strategy must be to reclaim and revalue women's actual experience under patriarchy. The example Woolf gives of the double literary standard operating against this experience is telling, and relevant to our discussion here: "Speaking crudely, football and sport are important, the worship of fashion, the buying of clothes trivial, and these values are inevitably transferred from life to fiction."[14] Certainly these two sets of values are counterpoised in the fiction of *Rear Window* (Jeff has, after all, broken his leg at a *sporting* event, where he stepped in front of an oncoming race car to get a spectacular photograph) and are the source of the couple's quarrels. Jeff dwells on the hardships of his manly life style and belittles Lisa's work when she enthusiastically describes her day to him. In the film, then, "fashion" is far from representing woman's unproblematic assimilation to the patriarchal system, but functions to some extent as a signifier of feminine desire and female sexual difference.

---

[11]François Truffaut, *Hitchcock* (New York: Simon and Schuster, 1983), p. 166.

[12]This point is developed at great length in Raymond Bellour, *"The Birds:* Analysis of a Sequence," Mimeograph, The British Film Institute Advisory Service, n. d.

[13]That he is so reluctant to do so provides an interesting confirmation of Christian Metz's thesis that in narrative cinema, it is the story, rather than any particular character, that "exhibits itself." "History/discourse: a note on two voyeurisms," *Theories of Authorship,* ed. John Caughie (London: Routledge & Kegan Paul, 1981), p. 231.

[14]Virginia Woolf, *A Room of One's Own* (New York: Harbinger, 1957), p. 77.

Throughout the film, Lisa's exquisite costumes give her the appearance of an alien presence in Jeff's milieu, more strange and marvelous than the various exotic wonders he has encountered in his travels—a strangeness that is fascinating and threatening at the same time. The threat becomes especially evident in the sequence in which Lisa boldly acts on her desire for Jeff and comes to spend the night with him. Significantly, this is the night when she becomes convinced of the truth of Thorwald's guilt. Jeff has just observed Thorwald talking on the phone and sorting through some jewelry, which includes a wedding ring, in his wife's purse. In Hitchcock's films, women's purses (and their jewelry) take on a vulgar Freudian significance relating to female sexuality and to men's attempts to investigate it. One might think, for example, of the purse in the opening closeup shot of *Marnie* (1964) that contains Marnie's "identity" cards and the booty of her theft from patriarchy. In *Rear Window,* Lisa concludes that Mrs. Thorwald *must* have been murdered rather than, as Tom Doyle believes, sent on a trip because no woman would leave behind her favorite purse (to say nothing of her wedding ring). As she muses, Lisa picks up her own designer purse, which we discover is a kind of "trick" purse; it is really a tiny suitcase, and in one of her many lines that sound like sexual double entendres (this one unwittingly echoing the Freudian notion of male and female sexuality, but reversing their values since it takes the latter as the standard), she says, "I'll bet *yours* isn't this small." When she opens the case, an elaborate and expensive negligee comes tumbling out, along with a pair of lovely slippers. The purse connects Lisa to the victimized woman, as does the negligee, since the invalid Mrs. Thorwald was always seen wearing a nightgown; but it also, importantly, connects her to the criminal, Lars Thorwald, and so is an overdetermined image like the images in the Freudian dreamwork. Thus when Tom Doyle comes to Jeff's apartment later in the evening, he keeps casting meaningful glances at the nightgown as if it were an incriminating object; when Jeff asks why Thorwald didn't tell his landlord where he was going, Doyle looks at the suitcase and asks pointedly, "Do you tell *your* landlord everything?" After Doyle has gone, Lisa picks up the suitcase, offering Jeff a "preview of coming attractions," and as she goes into the bathroom to change, she asks, "Do you think Mr. Doyle thought I stole this case?"

Lisa's aggressive sexuality, which is thus humorously labelled "criminal," would seem to provoke in Jeff and the male spectator a retaliatory aggression that finds an outlet in Thorwald's acts of murder and dismemberment. The interpretation of *Rear Window* which critics like Robin Wood take to be primary—that Lars Thorwald's murder of his wife enacts a wish on the part of Jeff to be rid of Lisa—is persuasive as far as it goes, but this wish may further be analyzed as a response to the male fear of impotence and lack. Jeff's impairment—his helplessness, passivity, and invalidism— impel him to construct a story that, in the words of Kaja Silverman (describing the male's psychic trajectory), attempts to "resituate . . . loss at the level of the female anatomy, thereby restoring to the [male] an imaginary wholeness."[15] Hence the fan-

---

[15]Kaja Silverman, "Lost Objects and Mistaken Subjects: Film Theory's Structuring Lack," *Wide Angle* 7, nos. 1–2 (1985): 24. In many respects, Silverman's position is close to Lurie's. However, Lurie, in common with many "American" feminists (as opposed to French or French-influenced feminists), seems to share to some extent the little boy's fantasy, which he comes to deny, of woman's "wholeness," whereas for Silverman all subjects are inevitably divided, but in patriarchal culture men are able to project division on to women, thus maintaining the illusion of their own completeness.

tasy of female dismemberment that pervades the film: not only are there many grue-some jokes about Lars Thorwald's cutting up his wife's body, but Jeff also names the women across the way according to body parts: Miss Lonelyhearts and Miss Torso—yet another decapitated woman.[16]

This response is a psychic consequence of Jeff's placement at the mirror stage of development, a placement that, as critics like to point out, makes him very much like Christian Metz's cinematic spectator, who occupies a transcendent, godlike position in relation to the screen.[17] To some extent, however, this analogy between the windows across the way and the cinema screen is misleading, since it is the very *difference* between the world observed by Jeff and the larger-than-life-world of most films that accounts for the strong effect of transcendence evoked by *Rear Window*. For Jeff's world is a miniature one, like a dollhouse—a world, as Susan Stewart writes, "of inversion [wherein] contamination and crudeness are controlled . . . by an absolute manipulation of space and time."[18] Resembling other fantasy structures, . . . even sleep," the miniature, according to Stewart, "tends toward tableau rather than narrative" and "is against speech, particularly as speech reveals an inner dialectical, or dialogic, nature. . . . All senses are reduced to the visual, a sense which in its transcendence remains ironically and tragically remote" (pp. 66–67).[19] It is significant that in *Rear Window* only little snatches of conversation may be heard across the way; generally the events proceed mutely, with diegetic noises and music filling the soundtrack (one song even proclaims the primacy of the visual: Bing Crosby's "To See You is to Love You," playing, ironically, while Miss Lonelyhearts entertains a phantom lover). Moreover, the tableau-like spaces of the microscreens across the way find their temporal equivalent in the device of the fade which punctuates the film, likewise creating a sense of a sealed-off fantasy world impervious to the dialogic, "contaminated" world of lived experience.

Just as the cinema, in its resemblance to the mirror at the mirror stage, offers the viewer an image of wholeness and plenitude, so too does the dollhouse world of the apartment buildings Jeff watches. In fact, one of the reasons the miniature is so appealing is that it suggests completeness and "perfection," as in the description of Tom Thumb quoted by Stewart: "No mis-shapen limbs, no contorted features were there, but all was sweet and beautiful" (p. 46; unlike, say, Gulliver's ugly Brobding-nags, whose every imperfection is magnified a hundredfold). But just as this passage must raise the spectre of physical mutilation in order to banish it, the mirror phase—

---

[16]On this point see Perlmutter, "*Rear Window*: A Construction Story," p. 58.

[17]Metz speaks of "that *other mirror,* the cinema screen, in this respect a veritable psychical substitute, a prosthesis for our primally dislocated limbs." Quoted in Stam and Pearson, "Hitchcock's *Rear Window:* Reflexivity," p. 138.

[18]Susan Stewart, *On Longing: Narratives of the Miniature, the Gigantic, the Souvenir, the Collection* (Baltimore: Johns Hopkins University Press, 1984), p. 63. It is important to recognize, as John Belton has pointed out, that Jeff does not merely watch, but actively manipulates his neighbors, "writing a blackmail letter ('What have you done with her?') which keeps the suspected killer from leaving town and later luring him out of his apartment with a phone call so that it can be searched." *Cinema Stylists* (Metuchen, N. J.: Scarecrow, 1983), p. 15. Stewart hereafter cited in the text.

[19]In his meditation on the miniature in *The Poetics of Space,* Gaston Bachelard makes a similar point. However, unlike Stewart, Bachelard celebrates the tendency of the miniature to place us in a position of transcendence. See *The Poetics of Space,* trans. Maria Jolas (Boston: Beacon, 1964), pp. 148–82.

the phase at which the child first "anticipates . . . the apprehension and mastery of its bodily unity"—evokes retroactively in the child a phantasy of "*the-body-in pieces.*"[20] This fantasy, according to Lacan, corresponds to the autoerotic stage preceding the formation of the ego (precisely the stage evoked by the "quietly masturbatory" image of the "mutilated" Jeff at the film's opening).[21] On the one hand, then, there is the anticipation of bodily "perfection" and unity which is, importantly, first promised by the body of the woman; on the other hand, the fantasy of dismemberment, a fantasy that gets disavowed by projecting it onto the body of the woman, who, in an inter-pretation which reverses the state of affairs the male child most fears, eventually comes to be perceived as castrated, mutilated, "imperfect."

Similarly, Jeff's interpretation of the events he sees across the way—his piecing together the fragments of evidence he observes in the Thorwald apartment into a coherent narrative—is designed to reverse the situation in his own apartment, to invalid-ate the female and assure his own control and dominance. It is not enough, however, for him to construct an interpretation that victimizes woman; for patriarchal interpretations to work, they require her assent: man's conviction must become woman's conviction—in a double sense. Those critics who emphasize the film's restriction of point of view to the male character neglect the fact that it increasingly stresses a *dual* point of view, with the reverse shots finding *both* Jeff and Lisa intently staring out the window at the neighbors across the way. It seems possible, then, to consider Lisa as a representative of the *female* spectator at the cinema. And through her, we can ask if it is true that the female spectator simply acquiesces in the male's view or, if, on the contrary, her relationship to the spectacle and the narrative is dif-ferent from his?

From the outset, Lisa is less interested than Jeff in spying on the neighbors and adopting a transcendent and controlling relation to the texts of their lives; rather, she relates to the "characters" through empathy and identification. Early in the film, Jeff jokingly points out a similarity between her apartment and that of Miss Torso, who at the time is seen entertaining several men. Jeff says, "she's like a queen bee with her pick of the drones," to which Lisa responds, "I'd say she's doing a woman's hardest job—juggling wolves." Miss Torso accompanies one of the men onto the balcony where she kisses him briefly and tries to go back inside while he attempts to restrain her. Jeff says, "she sure picked the most prosperous looking one," and Lisa dispar-ages this notion, claiming, "she's not in love with *him*—or with any of them for that matter." When Jeff asks her how she can be so certain, she replies, "you *said* it resem-bled my apartment didn't you?" Later the same man forces himself on Miss Torso, who has to fight him off, and still later—at the end of the film—Miss Torso's true love, Stanley, will come to visit her. Thus despite critics' emphasis on the film's lim-ited point of view, Lisa and Jeff have very *different* interpretations about the woman's desire in this scene fraught with erotic and violent potential, and it is *Lisa's* interpre-tation, arrived at through identification, that is ultimately validated.

---

[20]Jean Laplanche and J.-B. Pontalis, *The Language of Psychoanalysis,* Trans. Donald Nicholson Smith (London: Hogarth, 1973), p. 251.

[21]Jacques Lacan, *Ecrits: A Selection,* trans. Alan Sheridan (New York: Norton, 1977), pp. 1–7.

Whereas Jeff sees Miss Torso as "queen bee," Lisa significantly changes the metaphor: Miss Torso is prey to "wolves." In fact, Lisa's increasing absorption in Jeff's story, her fascination with his murderous, misogynist tale, is accompanied by a corresponding discovery of women's victimization at the hands of men. At one point in the film, Lisa can be seen staring even more intently than Jeff: that is, when Miss Lonelyhearts picks up a young man at a bar and brings him home, only to be assaulted by him. As Lisa stares and Jeff looks away in some embarrassment, the song "Mona Lisa" is heard, sung by drunken revellers at the musician's party. The title of the song suggests an important link between the two women ("is it only cause you're *lonely,* Mona *Lisa*"), and between the male fantasies that are projected onto woman ("Mona Lisa, Mona Lisa, men have named you"; and "many dreams have been brought to your doorstep") and the brutal reality of male violence to which women are frequently subjected.

Of course, the most brutal act of all is Thorwald's butchering of his wife's body—an act devoutly desired by Jeff—and later, by Lisa herself. At one level, *Rear Window* may be seen as a parable of the dangers involved for women of becoming invested in male stories and male interpretations. Or perhaps we should say "overinvested"—unable, as Mary Ann Doane maintains, to adopt, as men do, the appropriate, voyeuristic distance from the text.[22] Rather, women supposedly "enter into" films so thoroughly that they tend to confuse the very boundary between fantasy and reality—like Lisa crossing over and merging into the "screen" opposite Jeff's window. This merger is a logical extension of her ready identification with the victimized woman, an identification that actually leads to the solution of the crime. Lisa is able to provide the missing evidence because she claims a special knowledge of women that men lack: the knowledge, in this case, that no woman would go on a trip and leave behind her purse and her wedding ring. Lisa appeals to the authority of Stella, asking her if she would ever go somewhere without her ring, and Stella replies, "They'd have to cut off my finger."

Embarking on a search for this incriminating ring, Lisa becomes trapped in Thorwald's apartment when he returns unobserved by Stella and Jeff, who have been preoccupied by the sight of Miss Lonelyhearts about to kill herself. Jeff alerts the police and then watches in agonized helplessness as Lisa is flung about the room by Thorwald. The police arrive in time to prevent another woman from being cut up, and as Lisa stands with her back to the screen—caught, like so many Hitchcock heroines, between the criminal and the legal authorities—she points to the wedding ring on her finger. François Truffaut has admired this touch:

> One of the things I enjoyed in the film was the dual significance of that wedding ring. Grace Kelly wants to get married but James Stewart doesn't see it that way. She breaks into the killer's apartment to search for evidence and she finds the wedding ring. She puts it on her finger and waves her hand behind her back so that James Stewart, looking over from the other side of the yard with his spyglasses, can see it. To Grace Kelly, that ring

---

[22]I again refer the reader to the opening pages of Mary Ann Doane's *The Desire to Desire: The Woman's Film of the 1940's* (Bloomington: Indiana University Press, 1987).

is a double victory; not only is it the evidence she was looking for, but who knows, it may inspire Stewart to propose to her. After all, she's already got the ring.[23]

Thus speaks the male critic, who has habitually considered the film to be a reflection on marriage from the man's point of view. A female spectator of *Rear Window* may, however, use her special knowledge of women and their position in patriarchy to see another kind of significance in the ring; to the woman identifying, like Lisa herself, with the female protagonist of the story, the episode may be read as pointing up the victimization of women by men. Just as Miss Lonelyhearts, pictured right below Lisa in a kind of "split screen" effect, has gone looking for a little companionship and romance and ended up nearly being raped, so Lisa's ardent desire for marriage leads straight to a symbolic wedding with a wife-murderer. For so many women in Hitchcock—and this is the point of his continual reworking of the "female Gothic"—"wedlock is deadlock" indeed.[24]

But it is not only the female spectator who is bound to identify with Lisa at this climactic moment in the story—the moment which seems actually to be the point of the film. Jeff himself—and, by extension, the male film viewer—is forced to identify with the woman and to become aware of his *own* passivity and helplessness in relation to the events unfolding before his eyes. Thus, all Jeff's efforts to repudiate the feminine identification the film originally sets up (Jeff and Anna Thorwald as mirror images) end in resounding failure, and he is forced to be, in turn, the victim of *Hitchcock's* cinematic manipulations of space and time. In a discussion with Truffaut about his theory of suspense, Hitchcock uses this scene with Grace Kelly as his chief example of how to create "the public's identification" with an endangered person, even when that person is an unlikable "snooper." "Of course," he explains, "when the character is attractive, as for instance Grace Kelly in *Rear Window,* the public's emotion is greatly intensified" (p. 73). The implication here is that in scenes of suspense, which in Hitchcock films, as in other thrillers, usually take woman as their object as well as their subject, our identification is generally with the imperiled woman. In this respect, we do in fact all become masochists at the cinema—and it is extremely interesting to note that Theodor Reik considered suspense to be a major factor in masochistic fantasies.[25]

Suspense, Truffaut has claimed, "is simply the dramatization of a film's narrative material, or, if you will, the most intense presentation possible of dramatic situations"; suspense is not "a minor form of the spectacle," but "*the* spectacle in itself" (p. 15). Granted this equivalence between suspense and "*the* spectacle," *the* narrative, might we not then say that spectatorship and "narrativity" are themselves "feminine" (to the male psyche) in that they place the spectator in a passive position and in a submissive relation to the text? Robert Scholes has observed that "narrativity"—the

---

[23]Truffaut, *Hitchcock,* p. 223. Hereafter cited in the text.

[24]The phrase is taken from James B. McLaughlin's excellent discussion of Hitchcock's *Shadow of a Doubt,* "All in the Family: Alfred Hitchcock's *Shadow of a Doubt,*" *Wide Angle* 4, no. 1 (1980): 18.

[25]Theodor Reik, *Masochism and Modern Man,* trans. Margaret H. Biegel and Gertrud M. Kurth (New York: Farrar, Straus, 1941), pp. 59–71. On the primacy of masochism in human development, see Jean Laplanche, *Life and Death in Psychoanlysis,* trans. Jeffrey Mehlman (Baltimore: Johns Hopkins University Press, 1976), p. 89.

"process by which a perceiver actively constructs a story from the fictional data provided by any narrative medium,"[26] (the process, that is, which is inscribed in *Rear Window* through the character of Jeff)—is a situation of "licensed and benign paranoia" in that "it assumes a purposefulness in the activities of narration which, if it existed in the world, would be truly destructive of individuality and personality as we know them" (p. 396).[27] Narrativity involves, in Scholes's words, a "quality of submission and abandon" (we may recall the paranoid Dr. Schreber's attitude of "voluptuousness" toward God's grand narrative which featured a plot to impregnate the feminized doctor). This quality once noted by Scholes leads him to call for stories which reward the "most energetic and rigorous kinds of narrativity" as a means of exercising control over the text that seeks to manipulate and seduce its audience (p. 397). Of course, it is precisely Jeff's suspicion that there is a "purposefulness" to the activities across the way that impels him to adopt an "energetic and rigorous"—i.e., controlling, transcendent, and, above all, "*masculine*"—narrativity.

At this moment in the film the camera traces a triangular trajectory from Jeff's gaze at the ring to Thorwald, who sees the ring and then looks up at Jeff, returning the gaze for the first time. And then Thorwald proceeds to complete the "feminization" process by crossing over to Jeff's apartment and placing Jeff in the role previously played by Mrs. Thorwald and then by Lisa—that of victim to male violence. Jeff's "distancing" techniques, of course, no longer work, and the flashing bulbs only manage to slow Thorwald down a bit. Like Lisa, Jeff finally becomes a participant in his story, though *his* identification with the female character is involuntary, imposed on him by Thorwald, whose visit comes like the return of the repressed.

Although Jeff's interpretation of the Thorwald story has been validated by the end of the film, Jeff himself remains *invalided,* ending up with *two* broken legs, the body less "perfect" than ever, while Lisa, lounging on the bed, has become the mirror image of the man—dressed in masculine clothes and reading a book of male adventure. No longer representing sexual difference, nominating herself and speaking her own desire, Lisa is now spoken *by* the male artist—by the musician, whose completed song "Lisa" plays on the soundtrack ("men have named you," indeed), and ultimately by Hitchcock himself, who earlier made his appearance in the musician's apartment. More clearly than most, the film's ending and its "narrative image" of Lisa in masculine drag[28] reveals the way in which acceptable femininity is a construct of male narcissistic desire; despite Freud's claim that women tend to be more narcissistic than

---

[26]Robert Scholes, "Narration and Narrativity in Film," in *Film Theory and Criticism,* ed. Gerald Mast and Marshall Cohen (New York: Oxford University Press, 1985), p. 393. Hereafter cited in the text.

[27]Peter Brooks speaks of the same activity in similar terms, terms recalling the way in which "femininity" is perceived and constructed under patriarchy: "The assumption of another's story, the entry into narratives not one's own, runs the risk of an alienation from self that in Balzac's work repeatedly evokes the threat of madness and aphasia." See his *Reading for the Plot: Design and Intention in Narrative* (New York: Vintage, 1985), p. 219.

[28]Teresa de Lauretis borrows this term, "narrative image," from Stephen Heath: "In cinema . . . woman properly represents the fulfillment of the narrative promise (made, as we know, to the little boy), and that representation works to support the male status of the mythical subject. The female position, produced as the end result of narrativization, is the figure of narrative closure, the narrative image in which the film, as Heath says, 'comes together.'" *Alice Doesn't: Feminism, Semiotics, Cinema* (Bloomington: Indiana University Press, 1984), p. 140.

men, who supposedly possess a greater capacity for object love.[29] The film has con-
sistently shown the opposite state of affairs to be the case, and in particular has
revealed Jeff to be unable to care for Lisa except insofar as she affirms and mirrors
him: significantly, he becomes erotically attracted to her only when she begins to cor-
roborate his interpretation of the world around him (the first time he looks at her with
real desire is not, as Mulvey claims, when she goes into the Thorwald apartment and
becomes the object of his voyeurism, but when she begins to supply arguments in
favor of his version of events).

    One of the most highly reflexive of films, *Rear Window* indicates that what Jean-
Louis Baudry has argued to be characteristic of the cinematic apparatus as a whole—
and in particular of *projection*—is also true at the level of narrative, which functions
as masculine fantasy *projected* onto the body of woman. Baudry maintains that
because film projection depends on negation of the individual image as such "we
could say that film . . . lives on the denial of difference: the difference is necessary for
it to live, but it lives on its negation."[30] Similarly, much narrative cinema negates the
*sexual* difference that nevertheless sustains it—negates it in the dual sense of trans-
forming women into Woman and Woman into man's mirror. (Thus Baudry's analogy
between cinema and woman is more revealing than he seems to know: speaking of
our tendency to "go to movies before deciding which film we want to see," Baudry
writes that cinéphiles "seem just as blind in their passion as those lovers who imag-
ine they love a woman because of her qualities or because of her beauty. They need
good movies, but most of all, to rationalize their need for cinema."[31] Any woman, like
any movie, will do to fulfill man's "need." Put a paper bag over their heads and all
women are like Miss Torso or the headless "Hunger" sculpture of the female artist in
Jeff's courtyard, both of whom function, like the cinematic apparatus itself, to dis-
place male fears of fragmentation. "What might one say," Baudry asks, "of the func-
tion of the head in this captivation [of the spectator at the movies]: it suffices to recall
that for Bataille materialism makes itself headless—like a wound that bleeds and thus
transfuses."[32])

    That "difference is necessary" for cinema to live and therefore can never be
destroyed, but only continually negated, is implied by the ending of *Rear Window.*
Jeff is once again asleep, in the same position as he was at the film's opening, and
Lisa, after assuring herself that he is *not* watching her (in contrast to former times
when she had worked so hard to attract his gaze), puts away his book and picks up
her own magazine. As important as this gesture is, even more important is the fact that
the film gives her the last look. This is, after all, the conclusion of a movie that all crit-

---

[29]Sigmund Freud, "On Narcissism: An Introduction," *The Standard Edition of the Complete Psycho-
logical Works of Sigmund Freud,* Vol. 14, trans. James Strachey (London: Hogarth, 1974), pp. 88–89.
    [30]Jean-Louis Baudry, "Ideological Effects of the Basic Cinematographic Apparatus," trans. Alan
Williams, *Apparatus: Cinematographic Apparatus: Selected Writings,* ed. Theresa Hak Kyung Cha (New
York: Tanam, 1980), p. 29.
    [31]Jean-Louis Baudry, "Author and Analyzable Subject," in *Apparatus,* p. 68.
    [32]Baudry, "Ideological Effects," p. 32. In light of the "headless woman" motif in Hitchcock, consider
the following remark by Joan Copjec, "We know that the dreamer dreams of himself when he dreams of a
person whose head he cannot see." "The Anxiety of the Influencing Machine," *October* 23 (Winter 1982):
44.

ics agree is about the power the man attempts to wield through exercising the gaze. We are left with the suspicion (a preview, perhaps, of coming attractions) that while men sleep and dream their dreams of omnipotence over a safely reduced world, women are not where they appear to be, locked into male "views" of them, imprisoned in their master's dollhouse.

<div align="right">1988</div>

# TOM GUNNING
# AN AESTHETIC OF ASTONISHMENT: EARLY FILM AND THE (IN)CREDULOUS SPECTATOR

### TERROR IN THE AISLES

The damming of the stream of real life, the moment when its flow comes to a standstill, makes itself felt as reflux: this reflux is astonishment.

WALTER BENJAMIN, "What Is Epic Theatre?" (first version)

In traditional accounts of the cinema's first audiences, one image stands out: the terrified reaction of spectators to Lumière's *Arrival of a Train at the Station*. According to a variety of historians, spectators reared back in their seats, or screamed, or got up and ran from the auditorium (or all three in succession). As with most myths of origin, the source for these accounts remains elusive. It does not figure in any report of the first screening at the Salon Indien of the Grand Café that I have located.[1] And as with such myths, its ideological uses demand probing as much as

---

[1] Accounts of the first exhibitions can be read in most standard film histories. Georges Sadoul, in *Histoire générale du cinéma*, t. I. *L'Invention du cinéma 1832–1897* (Paris: Denoël, 1948), p. 288, describes the panic of the crowds before *The Arrival of a Train*, but, curiously, the testimony he cites refers to a Lumière street scene, rather than the train film. Other testimonies sometimes cited, such as Maxim Gorky's article discussed below, or the article Lynne Kirby quotes from *L'Illustration* (30 May 1896), describe the threat inscribed in the image itself, but do not indicate actual panic in the audience (see Lynne Kirby, "Male Hysteria and Early Cinema," *Camera Obscura* 17 (May 1988), 130. Recent histories are content to cite Sadoul, or simply repeat the legend. However, Charles Musser tells me that his research on early travelling exhibitor Lyman H. Howe has uncovered a number of references to spectators screaming during early projections of train films, although not at the first Lumière screenings.

I would like to indicate here the inspiration provided by Kirby's article and her ongoing work on early cinema and trains. I feel few writers have so well grasped the importance of shock in early cinema, even if I view its implications for early spectatorship somewhat differently than she does. I would also like to acknowledge the conversations with NYU graduate student Richard Decroix, which stimulated my thinking about this essay.

862

its veracity. This panicked and hysterical audience has provided the basis for further myths about the nature of film history and the power of the film image.

The first audiences, according to this myth, were naive, encountering this threatening and rampant image with no defenses, with no tradition by which to understand it. The absolute novelty of the moving image therefore reduced them to a state usually attributed to savages in their primal encounter with the advanced technology of Western colonialists, howling and fleeing in impotent terror before the power of the machine. This audience of the first exhibitions exists outside of the willing suspension of disbelief, the immediacy of their terror short-circuiting even disavowal's detour of "I know very well . . . but all the same." Credulity overwhelms all else, the physical reflex signaling a visual trauma. Thus conceived, the myth of initial terror defines film's power as its unprecedented realism, its ability to convince spectators that the moving image was, in fact, palpable and dangerous, bearing towards them with physical impact. The image had taken life, swallowing, in its relentless force, any consideration of representation—the imaginary perceived as real.

Furthermore, this primal scene at the cinema underpins certain contemporary theorisations of spectatorship. The terrorised spectator of the Grand Café still stalks the imagination of film theorists who envision audiences submitting passively to an all-dominating apparatus, hypnotised and transfixed by its illusionist power. Contemporary film theorists have made careers out of underestimating the basic intelligence and reality-testing abilities of the average film viewer and have no trouble treating previous audiences with similar disdain. The most subtle reading of this initial terror comes from Metz. But Metz's admirable subtlety tenders his analysis all the more deficient from a historical point of view. Metz describes this panicked reaction on the part of the Grand Café audience as a displacement of the contemporary viewer's credulity onto a mythical childhood of the medium. Like the childhood when one still believed in Santa Claus, like the dawn of time when myths were still believed literally, belief in this legendary audience, Metz claims, allows us to disavow our own belief in the face of the cinema. *We* don't believe in the screen image in the manner that *they* did. Our credulity is displaced onto an audience from the infancy of cinema.[2]

---

[2]Christian Metz, *The Imaginary Signifier: Psychoanalysis and the Cinema*, tr. Celia Britton, Annwyl Williams, Ben Brewster, and Alfred Guzzetti (Bloomington: Indiana University Press, 1982), pp. 72–73. Ben Singer has pointed out the limitations of Metz's application of Freud's concept of the fetish to cinema in his article, "Film, Photography and Fetish: The Analyses of Christian Metz," *Cinema Journal* 27/4 (Summer 1988). However, my main problem with Metz's always stimulating discussion lies in its ahistorical nature, which leads to an oversimplified view of cinema spectatorship. At the same time, I find that the lack Metz finds at the centre of the cinematic image is a profound insight, worthy of more than a metapsychological treatment.

Charles Musser (in his volume in the History of American Film Series, vol. I, *The Emergence of Cinema in America*) points out that in *Ars magna lucis et umbrae* of 1671—the first full treatment of the catoptric lamp, a forerunner of the magic lantern—Athanasius Kircher declared that demystifying illusion is essential to any display of the apparatus, absolutely forbidding any understanding of the spectacle as magic. The religious and social motivations (Kircher was a Jesuit) for such a demystification are obvious. Musser makes the provocative claim that this moment "suggests a decisive turning point for screen practice when the observer of projected/reflected images became the historically constituted subject we now call the spectator" (p. 31). In other words, Musser would see demystification as essential to the existence of the spectator, and points out that a tradition of screen spectatorship preceded Lumière by centuries.

Metz's penetrating analysis of the mythical role of this first audience does not lead to demythologisation. He instead introjects this primal audience, removing it from historical analysis by internalising it as an aspect of a presumably timeless cinema viewer. No longer a historical spectator in the Grand Café in 1895, the naive spectator "is still seated *beneath* the incredulous one, or in his heart."[3] Thus removed from place and time, this inner credulous viewer supplies the motive power for Metz's understanding of the fetishistic viewer, wavering between the credulous position of believing the image and the repressed, anxiety-causing, knowledge of its illusion. The historical panic at the Grand Café would be, according to Metz, simply a projection of an inner deception onto the mythical site of cinema's "once upon a time."

Although I have my doubts whether actual panic took place in the Grand Café's Salon Indien, there is no question that a reaction of astonishment and even a type of terror accompanied many early projections. I therefore don't intend to simply deny this founding myth of the cinema's spectator, but rather to approach it historically. We cannot simply swallow whole the image of the naive spectator, whose reaction to the image is one of simple belief and panic; it needs digesting. The impact of the first film projections cannot be explained by a mechanistic model of a naive spectator who, in a temporary psychotic state, confuses the image for its reality. But what context does account for the well-attested fact that the first projections caused shock and astonishment, an excitement pushed to the point of terror, if we exclude childlike credulity? And, equally important, how could this agitating experience be understood as part of the *attraction* of the new invention, rather than a disturbing element that needed to be removed? And what roles does an illusion of reality play in this terrified reception?

Only a careful consideration of the historical context of these earliest images can restore an understanding of the uncanny and agitating power they exerted on audiences. This context includes the first modes of exhibition, the tradition of turn-of-the-century visual entertainments, and a basic aesthetic of early cinema I have called the cinema of attractions, which envisioned cinema as a series of visual shocks. Restored to its proper historical context, the projection of the first moving images stands at the climax of a period of intense development in visual entertainments, a tradition in which realism was valued largely for its uncanny effects. We need to recognise this tradition and speculate on its role at the turn of the century.

As I have shown elsewhere, many early spectators recognised the first projection of films as a crowning achievement in the extremely sophisticated developments in the magic theatre, as practiced by Méliès at the Théâtre Robert Houdin and his English mentor Maskelyne at London's Egyptian Hall.[4] At the turn of the century, this tradition used the latest technology (such as focused electric light and elaborate stage

---

[3]Metz, op. cit., p. 72.

[4]See my article "Primitive Cinema: A Frame Up? or The Trick's On Us," in *Cinema Journal* 29/2 (Winter 1988–89). Accounts of Méliès's theatrical illusions can be found in Madeliene Maltete-Méliès, ed., *Méliès et la naissance du spectacle cinématographique* (Paris: Klincksieck, 1984), esp. pp. 53–58, and in Pierre Jenn, *Méliès, Cinéaste* (Paris: Albatros, 1984), pp. 139–68. Paul Hammond's *Marvellous Méliès* (London: Gordon Fraser, 1974, pp. 15–26) also includes a discussion of Méliès's stage work and an indication of his debt to Maskelyne.

machinery) to produce apparent miracles. The seeming transcendence of the laws of the material universe by the magical theatre defines the dialectical nature of its illusions. The craft of late nineteenth-century stage illusions consisted of making visible something which could not exist, of managing the play of appearances in order to confound the expectations of logic and experience. The audience this theatre addressed was not primarily gullible country bumpkins, but sophisticated urban pleasure seekers, well aware that they were seeing the most modern techniques in stage craft. Méliès's theatre is inconceivable without a widespread decline in belief in the marvellous, providing a fundamental rationalist context. The magic theatre laboured to make visual that which it was impossible to believe. Its visual power consisted of a trompe l'oeil play of give-and-take, an obsessive desire to test the limits of an intellectual disavowal—I know, but yet I see.

Trompe l'oeil as a genre of aesthetic illusion underscores the problematic role perfect illusion plays within traditional aesthetic reception. As Martin Battersby puts it, trompe l'oeil aims not simply at accuracy of representation, but at causing "a feeling of disgust in the mind of the beholder." This disquiet arises from "a conflict of messages": on the one hand, the knowledge that one is seeing a painting, and on the other, a visual experience sufficiently convincing as "to warrant a closer examination and even the involvement of the sense of touch."[5] The realism of the image is at the service of a dramatically unfolding spectator experience, vacillating between belief and incredulity. Although trompe l'oeil shares with *The Arrival of a Train* and the magic theatre a pleasurable vacillation between belief and doubt, it also displays important differences from them. The usually small scale of trompe l'oeil paintings and the desire to reach out and touch them contrast sharply with the "grandeur naturale"[6] of the Lumière train film and the viewer's impulse to rear back before it, as well as with the spectator's physical distance from the illusions of the magic theatre. But all three forms show that, rather than being a simple reality effect, the illusionistic arts of the nineteenth century cannily exploited their unbelievable nature, keeping a conscious focus on the fact that they were only illusions.

In fact, in the most detailed and articulate account we have of an early Lumière projection, Maxim Gorky (reporting on a showing at the Nizhny-Novgorod Fair in July of 1896) stresses the uncanny effect of the new attraction's mix of realistic and non-realistic qualities. For Gorky, the cinématographe presents a world whose vividness and vitality have been drained away: "before you a life is surging, a life deprived of words and shorn of the living spectrum of colours—the grey, the soundless, the bleak and dismal life." The cinématographe, Gorky explains, presents not life but its

---

[5]Martin Battersby, *Trompe l'Oeil: The Eye Deceived* (London: Academy Editions, 1974), p. 19. I must signal here that my essay has been both inspired and provoked by Mary Ann Doane's fascinating essay "When the Direction of the Force Acting on the Body Is Changed: The Moving Image," *Wide Angle* 7/2-3. There is a great deal of convergence in the topics covered by my essay and hers, as well as a great deal of divergence in method and conclusion.

[6]The importance of the large scale of the original Lumière projections, particularly in competition with the Edison kinetoscope, has been pointed out by Jacques and Marie André in their volume *Une Saison Lumière à Montpellier* (Perpignan, France: Institut Jean Vigo, 1987), pp. 64–75.

shadow, and he allows no possibility of mistaking this cinematic shade for substance. Describing *The Arrival of a Train*, Gorky senses its impending threat: "It speeds right at you—watch out! It seems as though it will plunge into the darkness in which you sit, turning you into a ripped sack full of lacerated flesh and splintered bones." But, he adds, "this too is but a train of shadows." Belief and terror are larded with an awareness of illusion and even, to Gorky's sophisticated palate, the ennui of the insubstantial, the bleak disappointment of the ungraspable phantom of life.[7]

One might dismiss Gorky's reaction as the sophisticated disdain of a cultured intellectual, deliberately counter to the more common reception of early film images. Gorky's negative assessment of the cinema *was* unusual in a period when new advances in the technology of entertainment were generally hailed with excitement and satisfaction. But his recognition that the film image combined realistic effects with a conscious awareness of artifice may correspond more closely to general audience reaction than the screaming dupes of traditional accounts. While contemporary accounts of audience responses, particularly unsophisticated viewers, are hard to come by, the very mode of presentation of the Lumière screenings (and of other early filmmakers as well) contains an important element which served to undermine a naive experience of realism. It is too infrequently pointed out that in the earliest Lumière exhibitions the films were initially presented as frozen unmoving images, projections of still photographs. Then, flaunting a mastery of visual showmanship, the projector began cranking and the image moved. Or as Gorky described it, "suddenly a strange flicker passes through the screen and the picture stirs to life."[8]

While such a presentation would seem to forbid any reading of the image as reality—a real physical train—it strongly heightened the impact of the moment of movement. Rather than mistaking the image for reality, the spectator is astonished by its transformation through the new illusion of projected motion. Far from credulity, it is the incredible nature of the illusion itself that renders the viewer speechless. What is displayed before the audience is less the impending speed of the train than the force of the cinematic apparatus. Or to put it better, the one demonstrates the other. The astonishment derives from a magical metamorphosis rather than a seamless reproduction of reality. The initial impact of this transformation at the Lumière premiere is described by an expert in such effects, Georges Méliès:

> a *still* photograph showing the place Bellecour in Lyon was projected. A little surprise, I just had time to say to my neighbor:
> "They got us all stirred up for projections like this? I've been doing them for over ten years."
> I had hardly finished speaking when a horse pulling a wagon began to walk towards us, followed by other vehicles and then pedestrians, in short all the animation of the street.

---

[7]Gorky's account is included as an appendix in Jay Leyda, *Kino: A History of the Russian and Soviet Film* (London: Allen & Unwin, 1960), pp. 407–9. The translation is by "Leda Swan."

[8]Ibid., p. 407. I must add that it was Annette Michelson who first pointed out this fact to me when I was a graduate student years ago. Her discussion of the *frisson* of this instance of motion was a generative point for this essay. One might point out that a possibly equally rich projection trope can be found in Lumière's *Destruction of a Wall*, which was projected first forwards and then in reverse, creating the magical effect of the wall reassembling and rising to its original height. A Montpellier journalist noted that this film "has always drawn applause from its admirers" (André, *Une Sasion Lumière*, p. 84, my translation).

Before this spectacle we sat with gaping mouths, struck with amazement, astonished beyond all expression."[9]

This coup de théâtre, the sudden transformation from still image to moving illusion, startled audiences and displayed the novelty and fascination of the cinématographe. Far from being placed outside a suspension of disbelief, the presentation acts out the contradictory stages of involvement with the image, unfolding, like other nineteenth-century visual entertainments, a vacillation between belief and incredulity. The moving image reverses and complicates the trajectory of experience solicited by a trompe l'oeil still life. The film first presents itself as merely an image, rather than appearing to be the actual butterflies, postcards, or cameos which the initial apperception of a trompe l'oeil canvas seems to reveal. Instead of a gradual disquiet arising from the divergence of what we know and what we see, the shock of the film image comes from a sudden transformation while the hardly novel projected photograph (Gorky also stressed his initial disappointment at this "all too familiar scene"[10]) gives way to the astonishing moment of movement. The audience's sense of shock comes less from a naive belief that they are threatened by an actual locomotive than from an unbelievable visual transformation occurring before their eyes, parallel to the greatest wonders of the magic theatre.

As in the magic theatre the apparent realism of the image makes it a successful illusion, but one understood as an illusion nonetheless. While such a transformation would be quite capable of causing a physical or verbal reflex in the viewer, one remains aware that the film is merely a projection. The initial still image demonstrated that irrefutably. But this still projection takes on motion, becomes endowed with animation, and it is this unbelievable moving image that so astounds. The initial projection of a still image, withholding briefly the illusion of motion which is the apparatus's raison d'être, brought an effect of suspense to the first film shows. The audience knew that motion was precisely what the cinématographe promised (hence Méliès's restlessness). By delaying its appearance. the Lumière's exhibitor not only highlights the device but signals his allegiance to an aesthetic of astonishment which goes beyond a scientific interest in the reproduction of motion.

Another account of early projections, this time from the other side of the Atlantic, further demonstrates the theatricality of this device and clearly aligns the terror of early spectators with a conscious delectation of shocks and thrills. The memoirs of Albert E. Smith, one of the founders of the Vitagraph company, describe his early years as a travelling exhibitor with Vitagraph cofounder J. Stuart Blackton. Smith had toured earlier with quick-sketch artist Blackton as an illusionist combining "sleight of hand and invisible mechanical appliances of his own invention."[11] But like a large number of stage illusionists, they had turned to the exhibition of moving pictures as

---

[9]Quoted in Georges Sadoul, *Histoire Général du Cinéma*, p. 271 (my translation).

[10]Erik Barnouw, *The Magician and the Cinema* (New York: Oxford University Press, 1981), p. 75. The phrase is quoted from an 1899 article in the magical trade periodical *Mahatma*.

[11]Albert E. Smith, in collaboration with Phil A. Koury, *Two Reels and a Crank* (Garden City, N.Y.: Doubleday, 1952), p. 39. Smith's book is notoriously inaccurate, as Charles Musser has shown. However, most of these errors seem to be misleading claims of fanciful achievements (e.g., filming in Cuba during the Spanish American War) and don't necessarily lessen the value of the description of his film shows.

the most technologically advanced form of visual entertainments. Smith contributed a mechanical improvement to the Edison projecting kinetoscope—a water cell between the film and the light source that absorbed heat and allowed the film to be projected as a still image a bit longer without danger of the celluloid bursting into flames.

The most popular item on Smith and Blackton's exhibition tours was *The Black Diamond Express*, a one-shot film of a locomotive rushing towards the camera. As in most early film shows, a patter spoken by Blackton accompanied the projection, preparing the audience for the film and providing dramatic atmosphere. Smith describes Blackton's role in presenting *The Black Diamond Express* as that of a "terrorist mood setter." As he recalled it, Blackton's lecture (delivered over the frozen image of the locomotive) went like this:

> Ladies and gentlemen you are now gazing upon a photograph of the famous Black Diamond Express. In just a moment, a cataclysmic moment, my friends, a moment without equal in the history of our times, you will see this train take life in a marvellous and most astounding manner. It will rush towards you, belching smoke and fire from its monstrous iron throat.

Although Smith's memory of Blackton's oration decades later may not be entirely reliable, it captures the address of the first film shows and places the audience's terror in a new light. Blackton directly addresses the audience, mediating between it and the film and stressing the actual act of display. Like a fairground barker, he builds an atmosphere of expectation, a pronounced curiosity leavened with anxiety as he stresses the novelty and astonishing properties which the attraction about to be revealed will possess. This sense of expectation, sharpened to an intense focus on a single instant of transformation, heightened the startling impact of the first projections. Far from being a simple reality effect, the impact derives from a moment of crisis, prepared for and delayed, then bursting upon the audience. This suspenseful presentation of an impossible transformation, Smith reports, caused women to scream and men to sit aghast.[12]

## THE AESTHETIC OF ATTRACTIONS

There came a day when a new and urgent need for stimuli was met by the film. In a film, perception in the form of shocks was established as a formal principle.

WALTER BENJAMIN, "Some Motifs in Baudelaire"

While these early films of on-coming locomotives present the shock of cinema in an exaggerated form, they also express an essential element of early cinema as a whole. I have called the cinema that precedes the dominance of narrative (and this period lasts for nearly a decade, until 1903 or 1904) The cinema of attractions.[13] The

---

[12]Ibid., pp. 39–40.

[13]See Tom Gunning, "The Cinema of Attraction: Early Film, Its Spectator and the Avant-Garde," *Wide Angle* 8/3-4. This term was first introduced by myself and André Gaudreault in a paper delivered to the colloquium Nouvelles approches de l'histoire du cinéma at Cerisy in 1985, called "Cinéma des premiers temps: un défi à l'histoire du cinéma?" Conversations with Adam Simon, a teaching assistant at the Carpenter Center of Visual and Environmental Studies of Harvard University, 1984–85, were also influential

aesthetic of attraction addresses the audience directly, sometimes, as in these early train films, exaggerating this confrontation in an experience of assault. Rather than being an involvement with narrative action or empathy with character psychology, the cinema of attractions solicits a highly conscious awareness of the film image engaging the viewer's curiosity. The spectator does not get lost in a fictional world and its drama, but remains aware of the act of looking, the excitement of curiosity and its fulfilment. Through a variety of formal means, the images of the cinema of attractions rush forward to meet their viewers. These devices range from the implied collision of the early railroad films to the performance style of the same period, when actors nodded and gestured at the camera (e.g., Méliès on screen directing attention to the transformations he causes) or when a showman lecturer presented the views to the audience. This cinema addresses and holds the spectator, emphasising the act of display. In fulfilling this curiosity, it delivers a generally brief dose of scopic pleasure.

And pleasure is the issue here, even if pleasure of a particularly complicated sort. When a Montpellier journalist in 1896 described the Lumière projections as provoking "an excitement bordering on terror," he was praising the new spectacle and explaining its success.[14] If the first spectators screamed, it was to acknowledge the power of the apparatus to sweep away a prior and firmly entrenched sense of reality. This vertiginous experience of the frailty of our knowledge of the world before the power of visual illusion produced that mixture of pleasure and anxiety which the purveyors of popular art had labelled sensations and thrills and on which they founded a new aesthetic of attractions. The on-rushing train did not simply produce the negative experience of fear but the particularly modern entertainment form of the thrill, embodied elsewhere in the recently appearing attractions of the amusement parks (such as the roller coaster), which combined sensations of acceleration and falling with a security guaranteed by modern industrial technology. One Coney Island attraction, the Leap Frog Railway, literalised the thrill of *The Arrival of a Train*. Two electric cars containing as many as forty people were set towards each other at great speed on a collision course. Just before impact one car was lifted up on curved rails and skimmed over the top of the other. Lynne Kirby has also noted the popularity of staged collisions between railroad locomotives at the turn of the century, both at county fairs and in such films as Edison's 1904 *The Railroad Smash-Up*.[15]

Confrontation rules the cinema of attractions in both the form of its films and their mode of exhibition. The directness of this act of display allows an emphasis on the

in developing these ideas. The term *attractions* refers backwards to a popular tradition and forwards to an avant-garde subversion. The tradition is that of the fairground and carnival, and particularly its development during the turn of the century in such modern amusement parks as Coney Island. The avant-garde radicalisation of this term comes in the theoretical and practical work in theatre and film of Sergei Eisenstein, whose theory of the montage of attractions intensified this popular energy into an aesthetic subversion, through a radical theoreticisation of the power of attractions to undermine the conventions of bourgeois realism. For a clear account of this theory and a discussion of its roots in popular culture, see Jacques Aumont's *Montage Eisenstein*, tr. Lee Hildreth, Constance Penley, and Andrew Ross (Bloomington: Indiana University Press, 1987), pp. 41–48, as well as Eisenstein's own essays "The Montage of Attractions" and "The Montage of Film Attractions," in Eisenstein, *Writings*, vol. I 1922–1934, ed. and tr. Richard Taylor (Bloomington, University of Indiana Press, 1988).

[14]Quoted in Jacques and Marie André, *Une Saison Lumière*, p. 66.

[15]John F. Kasson, *Amusing the Millions: Coney Island at the Turn of the Century* (New York: Hill & Wang, 1978), pp. 77–78. Lynne Kirby, (from *L'Illustration*), pp. 119–120.

thrill itself—the immediate reaction of the viewer. The film lecturer focuses attention on the attraction, sharpening viewer curiosity. The film then performs its act of display and fades away. Unlike psychological narrative, the cinema of attractions does not allow for elaborate development; only a limited amount of delay is really possible. But such a film program consists of a series of attractions, a concatenation of short films all of which offer the viewer a moment of revelation. The succession of thrills is potentially limited only by viewer exhaustion. This concatenation may have some thematic structuring and builds toward a climactic moment, a final *clou* (such as Smith and Blackton's *Black Diamond Express*). The showman rather than the films themselves gives the program an overarching structure, and the key role of exhibitor showman underscores the act of monstration that founds the cinema of attractions.[16]

A film like Edison's *Electrocuting an Elephant* from 1903 shows the temporal logic of this scenography of display. The elephant is led onto an electrified plate, and secured. Smoke rises from its feet and after a moment the elephant falls on its side. The moment of technologically advanced death is neither further explained nor dramatised. Likewise a fictional film produced by the Biograph Company in 1904, *Photographing a Female Crook*, presents a single shot of a woman held between two uniformed policemen who try to steady her for a mug shot. The camera tracks in on this group, ending by framing the woman in medium close-up. Attempting to sabotage the photographing of her face for identification purposes, the female crook mugs outrageously, contorting her face. The inward movement by the movie camera and the progressive enlargement of the woman's face emphasise the act of display which underlies the film. While both these films show considerable formal differences from *The Arrival of a Train*, they all three demonstrate the solicitation of viewer curiosity and its fulfilment by the brief moment of revelation typical of the cinema of attractions. This is a cinema of instants, rather than developing situations.

As I have stated elsewhere,[17] the scenography of the cinema of attractions is an exhibitionist one, opposed to the cinema of the unacknowledged voyeur that later narrative cinema ushers in. This display of unique view belongs most obviously to the period before the dominance of editing, when films consisting of a single shot—both actualities and fictions—made up the bulk of film production. However, even with the introduction of editing and more complex narratives, the aesthetic of attraction can still be sensed in periodic doses of non-narrative spectacle given to audiences (musicals and slapstick comedy provide clear examples). The cinema of attractions persists in later cinema, even if it rarely dominates the form of a feature film as a whole. It provides an underground current flowing beneath narrative logic and diegetic realism, producing those moments of cinematic *dépaysement* beloved by the surrealists.[18]

---

[16]The role of the exhibitor showman in early American cinema has been brilliantly demonstrated in the work of Charles Musser, particularly in his article "The Nickelodeon Era Begins, Establishing the Framework for Hollywood's Mode of Representation" (*Framework*, Autumn 1983), as well as his forthcoming volumes on Edwin S. Porter and Lyman Howe.

[17]Gunning, "Cinema of Attraction," p. 64. This issue is also discussed in my book *D. W. Griffith and the Origins of American Narrative Cinema* (Urbana: University of Illinois Press, 1991).

[18]On the surrealist love of disorienting images in the cinema, see Paul Hammond, ed., *The Shadow and Its Shadow: Surrealist Writings on the Cinema* (London: British Film Institute, 1978), particularly Breton's essay "As in a Wood" (p. 14).

This aesthetic so contrasts with prevailing turn-of-the-century norms of artistic reception—the ideals of detached contemplation—that it nearly constitutes an anti-aesthetic. The cinema of attractions stands at the antipode to the experience Michael Fried, in his discussion of eighteenth-century painting, calls absorption.[19] For Fried, the painting of Greuze and others created a new relation to the viewer through a self-contained hermetic world which makes no acknowledgement of the beholder's presence. Early cinema totally ignores this construction of the beholder. These early films explicitly acknowledge their spectator, seeming to reach outwards and confront. Contemplative absorption is impossible here. The viewer's curiosity is aroused and fulfilled through a marked encounter, a direct stimulus, a succession of shocks.

By tapping into a visual curiosity and desire for novelty, attractions draw upon what Augustine, at the beginning of the fifth century, called *curiositas* in his catalogue of "the lust of the eyes." In contrast to visual *voluptas* (pleasure), *curiositas* avoids the beautiful and goes after its exact opposite "simply because of the lust to find out and to know." *Curiositas* draws the viewer towards unbeautiful sights, such as a mangled corpse, and "because of this disease of curiosity monsters and anything out of the ordinary are put on show in our theatres." For Augustine, *curiositas* led not only to a fascination with seeing, but a desire for knowledge for its own sake, ending in the perversions of magic and science.[20] While beauty in Augustine's Platonic schema may form the first rung of an ascent to the ideal, *curiositas* possesses only the power to lead astray. Attractions imply the danger of distraction, a cardinal sin in Augustine's contemplative and vigilant model of Christian life.

The aesthetic of attractions developed in fairly conscious opposition to an orthodox identification of viewing pleasure with the contemplation of beauty. A nineteenth-century satirical engraving shows London's Egyptian Hall (which existed as a home for natural curiosities—freaks and artifacts of natural history—before it became the home of Maskelyne's magic theatre) proclaiming itself "the Hall of Ugliness" and advertising the "Ne Plus Ultra of Hideousness."[21] This attraction to the

---

[19]Michael Fried, *Absorption and Theatricality: Painting and Beholder in the Age of Diderot* (Berkeley and Los Angeles: University of California Press, 1980). See, for example, pp. 64, 104. A similar exclusion of the spectator is evident in the scenography and style of the nineteenth-century naturalist theatre, embodied in the idea of the fourth wall.

[20]St. Augustine, *The Confessions*, tr. Rex Warner (New York: New American Library, 1963), pp. 245–47.

[21]This satirical drawing is reproduced in Richard D. Altick, *The Shows of London* (Cambridge, Mass.: Harvard University Press, 1978), p. 254. As Miriam Hansen has pointed out to me, Michael Fried's discussion of Thomas Eakins' painting "Gross Clinic" raises issues relevant to the aesthetic of attractions and its relation to repulsion. Although Fried convincingly places the painting within a tradition of absorption, the foci of Gross' bloodstained fingers and scalpel and the patient's open wound seem to provide another experience, which "mixes pain and pleasure, violence and voluptuousness, repulsion and fascination" (Fried, "Realism, Writing and Disfiguration in Thomas Eakins' Gross Clinic," *Representations*, 9, Winter 1985, 71). As Fried says, "It is above all the conflictedness of that situation that grips and excruciates and in the end stupefies us before the picture" (p. 73). This seems to me to describe the essential experience of the aesthetic of attractions; however, it is somewhat unclear to me how Fried sees this in relation to the experience of absorption. Fried does not relate this conflict to the tradition of the sublime, which clearly represents the acceptable form of the aesthetic of attractions (recall that Burke defines astonishment as the effect of the sublime in the highest degree). The relation of popular entertainment to the sublime is a basically unexplored and potentially fascinating topic, beyond the confines of this essay. But it is not irrelevant to point out that Fried follows Thomas Weiskel in associating the effect of the sublime with a Freudian understanding of the terror of castration. Although I am not inclined at the moment to pursue it, speculation in this

repulsive was frequently rationalised by appealing to that impulse which Augustine found equally dubious, intellectual curiosity. Like the early film exhibitions, freak shows and other displays of curiosities were described as instructive and informing. Similarly, a popular and longlasting genre of the cinema of attractions consisted of educational actualities (such as Charles Urban's *Unseen World* series beginning in 1903), which presented magnified images of cheese mites, spiders and water fleas.[22] As late as 1914 a proponent of the reform movement in cinema objected to the vulgarity of films displaying such "slimy and unbeautiful abominations," which he claimed repulsed spectators with more refined sensibilities.[23] But showmen were well aware that a thrill needed an element of repulsion or a controlled threat of danger. Louis Lumière understood that his films, which directed physical action out at the audience, added a vital energy alongside the scientific curiosity addressed by his reproduction of motion and daily life.

## DISTRACTION AND THE AMBIVALENCE OF SHOCK

The film corresponds to profound changes in the apperceptive apparatus—changes that are experienced on an individual scale by the man in the street in big city traffic, on a historical scale by every present day individual.

WALTER BENJAMIN, "The Work of Art in the Age of Mechanical Reproduction"

While the impulse to *curiositas* may be as old as Augustine, there is no question that the nineteenth century sharpened this form of "lust of the eyes" and its commercial exploitation. Expanding urbanisation with its kaleidoscopic succession of city sights, the growth of consumer society with its new emphasis on stimulating spending through visual display, and the escalating horizons of colonial exploration with new peoples and territories to be categorised and exploited all provoked the desire for images and attractions. It is not surprising that city street scenes, advertising films, and foreign views all formed important genres of early cinema. The enormous popularity of foreign views (already developed and exploited by the stereoscope and magic lantern) expresses an almost unquenchable desire to consume the world through images. The cinema was, as the slogan of one early film company put it, an invention which put the world within your grasp. Early cinema categorised the visible world as a series of discrete attractions, and the catalogues of the first production companies present a nearly encyclopoedic survey of this new hyper-visible topology, from landscape panoramas to microphotography, from domestic scenes to the beheading of prisoners and the electrocution of elephants.

If not all the attractions of early cinema express the violence of an on-rushing train, some sense of wonder or surprise nonetheless underlies all these films, if only won-

---

direction about the trauma produced by the first projections could provide a new way of approaching the issue of fetishism in early cinema, locating the trauma that Metz did little to isolate. The interest of this speculation could be considerable if approached from a historical point of view, as in Benjamin's and Schivelbusch's understanding (which I will discuss later in this essay) of the Freudian concept of the stimulus shield as a response to modern experience, rather than a biological principle.

[22]Urban's series of films is described in Rachel Low and Roger Manvell, *The History of the British Film, Vol. I 1896–1906*, (London: Allen & Unwin, 1948), p. 60.

[23]Harry Furniss, *Our Lady Cinema*, reprint of 1914 ed. (New York: Garland Publishing, 1978), p. 41.

der at the illusion of motion. Even a filmed landscape panorama does not lend itself to pure aesthetic contemplation. One is fully aware of the machine which mediates the view, the camera pivoting on its tripod. The most common form of landscape panorama—films show from the front or back of trains—doubled this effect, invoking not only the motion picture machine but the locomotive which pulls the seated viewer through space. These train films provide an even more technologically mediated example of what Wolfgang Schivelbusch, in his description of the transformation of perception occasioned by the railway journey, calls panoramic perception. In contrast to the traditional traveller's experience of a landscape, the train passenger "no longer belongs to the same space as the perceived objects; the traveller sees the objects, landscapes, etc., *through* the apparatus which moves him through the world."[24] A film taken from the front of a train, an "unseen energy swallowing space" (as one journalist described the experience of such a train panorama[25]), doubled this effect imposed by industrial apparatuses, intensifying the alienation *and* the dynamic sensation of train travel. Such train films might turn the on-rushing Black Diamond Express inside out, but still provoked viewer amazement through a technologically mediated experience of space and movement.

Ultimately the encyclopedic ambition of this impulse of early cinema, transforming all of reality into cinematographical views, recalls Gorky's vague discomfort and depression before the cinématographe. While the cinema of attractions fulfills the curiosity it excites, it is in the nature of curiosity, as the lust of the eye, never to be satisfied completely. Thus the obsessional nature of early film production and the early film show the potentially endless succession of separate attractions. But beyond the unlimited metonymy of curiosity, Gorky's unease derived from the abstraction and alienation of this new pursuit of thrills.

Gorky also found a pervasive ennui in the dreamworld home of attractions, Coney Island (which he visited in 1906), calling it "a slavery to a varied boredom." For Gorky, Coney Island purveyed "an amazement in which there is neither transport nor joy."[26] While the tone of a European intellectual's distaste for the mass pleasures of a capitalist society is unmistakable, Gorky also provides insight into the need for thrills in an industrialised and consumer-oriented society. The peculiar pleasure of screaming before the suddenly animated image of a locomotive indicates less an audience willing to take the image for reality than a spectator whose daily experience has lost the coherence and immediacy traditionally attributed to reality. This loss of experience creates a consumer hungry for thrills.

The cinema of attractions not only exemplifies a particularly modern form of aesthetics but also responds to the specifics of modern and especially urban life, what Benjamin and Kracauer understood as the drying up of experience and its replacement by a culture of distraction. While Benjamin's writing provides the most brilliantly dialectical (and ambivalent) description of the modern transformation of perception

---

[24]Wolfgang Schivelbusch, *The Railway Journey* (New York: Urizen Press, 1979), p. 66.

[25]From the *New York Mail and Express* (25 September 1897), reprinted in Kemp R. Niver, *The Biograph Bulletins 1896–1908* (Los Angeles: Locare Research Group, 1971), p. 27. The journalist was commenting on a Biograph film shot from a locomotive going through the Haverstraw Tunnel.

[26]Maxim Gorky, "Boredom," *The Independent* (8 August 1907), 311–12.

and experience,[27] Kracauer's essay "The Cult of Distraction: On Berlin's Picture Palaces" provides a specific focus on the role of cinema and particularly that element foregrounded by the cinema of attractions—exhibition.[28]

Lost sight of now after decades of text-obsessed film analysis, the exhibition situation transforms and structures a film's mode of address to an audience. In early cinema, the act of presentation was stressed by both exhibition context and the direct address of the films themselves. By the 1920s, when Kracauer wrote, the architecture of the picture palace and the variety format of the evening's program played a major role in defining movie-going as a succession of attractions, what Kracauer describes as the "fragmented sequence of splendid sense impressions."[29] The opulence and design of the Berlin movie theatres served to offset the coherence that classical narrative cinema had brought to film. As Kracauer described it:

> The interior design of the movie theatres served one sole purpose: to rivet the audience's attention to the peripheral so that they will not sink into the abyss. The stimulations of the senses succeed each other with such rapidity that there is no room left for even the slightest contemplation to squeeze in between them.[30]

The spectacular design of the theatre itself (accented and temporalised by elaborate manipulations of light) interacted with the growing tendency to embed the film in a larger program, a revue which included music and live performance. The film was only one element in an experience that Kracauer describes as a "total artwork of effects" which "assaults every one of the senses using every possible means."[31] For Kracauer, the discontinuity and variety of this form of cinema program (juxtaposing a two-dimensional film with three-dimensional live performances) strongly undermined film's illusionistic power. The projected film "recedes into the flat surface and the deception is exposed."[32] As in the first projections, the very aesthetic of attraction runs counter to an illusionistic absorption, the variety format of the picture palace program continually reminding the spectator of the act of watching by a succession of sensual assaults. As if in defiance of the increased length and the voyeuristic fic-

---

[27]The key essays are, of course, "The Work of Art in the Age of Mechanical Reproduction" (in *Illuminations*, ed. Hannah Arendt, tr. Harry Zohn: New York: Schocken Books, 1969) and the two drafts of the essay on Baudelaire (in *Charles Baudelaire: A Lyric Poet in the Era of High Capitalism*, tr. Harry Zohn: London: NLB, 1973). My understanding of Benjamin's work has been shaped by Miriam Hansen's masterful essay "Benjamin, Cinema and Experience: The Blue Flower in the Land of Technology," *New German Critique* 40 (Winter 1987). This essay and Hansen's forthcoming work on the spectator of American silent film, *Babel and Babylon*, provide an essential background to my own essay. Her influence has been pervasive, and I see my ideas as developing out of a dialogue with her, without in any way implicating her in their final formulation. I also wish to thank her for her comments on a draft of this essay. [For Benjamin, see this edition, pp. 731–751.]

[28]Siegfried Kracauer, "The Cult of Distraction," *New German Critique* 40 (Winter 1987). I would also like to indicate my debt to Heide Schlüpmann's penetrating essay on Kracauer's early film theory, "Phenomenology of Film: On Siegfried Kracauer's Writings of the 1920s" (in the same issue), as well as the valuable discussions of Kracauer contained in the essays by Thomas Elsaesser, Patrice Petro, and Sabine Hake in this extraordinary issue on Weimar Film Theory.

[29]Kracauer, ibid., p. 94.

[30]Ibid.

[31]Ibid., p. 92.

[32]Ibid., p. 96.

tional address of the featured films, the effect of a discontinuous suite of attractions still dominates the evening.

But in spite of (or rather motivating) this smorgasbord of sensual thrills, Kracauer discerns an experience of lack not unrelated (even if differently interpreted) to Gorky's malaise. The unifying element of the cult of distraction lies in what Kracauer calls pure externality. And this celebration of the external responds to a central lack in the life of its audience, particularly that of the working masses:

> an essentially formal tension which fills their day without making it fulfilling. Such a lack demands to be compensated, but this need can only be articulated in terms of the same surface which imposed the lack in the first place. The form of entertainment necessarily corresponds to that of enterprise.[33]

The sudden, intense, and external satisfaction supplied by the succession of attractions was recognised by Kracauer as revealing the fragmentation of modern experience. The taste for thrills and spectacle, the particularly modern form of *curiositas* that defines the aesthetic of attractions, is moulded by a modern loss of fulfilling experience. Once again, Wolfgang Schivelbusch's understanding of the changes in modern perception brought about by railway travel provides a theoretical tool. Crossbreeding Freud's metapsychological formulations with the urban sociology of Simmel (and thus following a trajectory traced by Benjamin), Schivelbusch describes a stimulus shield, which inhabitants of the overstimulated environments of the modern world develop in order to ward off its constant assaults.[34] But one could also point out that this stimulus shield dulls the edge of experience, and more intense aesthetic energies are required to penetrate it. As Miriam Hansen points out in her reading of Benjamin, the modern experience of shock corresponds to "[t]he adaptation of human perception of industrial modes of production and transportation, especially the radical restructuration of spatial and temporal relations."[35] Shock becomes not only a mode of modern experience, but a strategy of a modern aesthetic of astonishment. Hence the exploitation of new technological thrills that flirt with disaster.

Attractions are a response to an experience of alienation, and for Kracauer (as for Benjamin) cinema's value lay in exposing a fundamental loss of coherence and authenticity. Cinema's deadly temptation lay in trying to attain the aesthetic coherence of traditional art and culture. The radical aspiration of film must lie along the path of consciously heightening its use of discontinuous shocks, or as Kracauer puts it, "must aim radically towards a kind of distraction which exposes disintegration rather than masking it."[36] As Hansen has indicated, Benjamin's analysis of shock has a fundamental ambivalence, moulded certainly by the impoverishment of experience

---

[33]Ibid., p. 93.

[34]Schivelbusch, *The Railway Journey*, pp. 156–7.

[35]Miriam Hansen, *Benjamin, Cinema*, p. 184. Lynne Kirby observes about the popularity of staged railroad smash-ups: "As a spectacularisation of technological destruction based on an equation of pleasure with terror, the 'imagination of disaster' says volumes about the kinds of violent spectacle demanded by a modern public, and the transformation of 'shock' into eagerly expected, digestible spectacle" (Kirby, from *L'Illustration*, p. 120).

[36]Kracauer, "Cult of Distraction," p. 96.

in modern life, but also capable of assuming "a strategic significance—as an artificial means of propelling the human body into moments of recognition."[37]

The panic before the image on the screen exceeds a simple physical reflex, similar to those one experiences in a daily encounter with urban traffic or industrial production. In its double nature, its transformation of still image into moving illusion, it expresses an attitude in which astonishment and knowledge perform a vertiginous dance, and pleasure derives from the energy released by the play between the shock caused by this illusion of danger and delight in its pure illusion. The jolt experienced becomes a shock of recognition. Far from fulfilling a dream of total replication of reality—the *apophantis* of the myth of total cinema—the experience of the first projections exposes the hollow centre of the cinematic illusion. The thrill of transformation into motion depended on its presentation as a contrived illusion under the control of the projectionist showman. The movement from still to moving image accented the unbelievable and extraordinary nature of the apparatus itself. But in doing so, it also undid any naive belief in the reality of the image.

Cinema's first audiences can no longer serve as a founding myth for the theoreticalisation of the enthralled spectator. History reveals fissures along with continuities, and we must recognise that the experience of these audiences was profoundly different from the classical spectator's absorption into an empathetic narrative. Placed within a historical context and tradition, the first spectators' experience reveals not a childlike belief, but an undisguised awareness (and delight in) film's illusionistic capabilities. I have attempted to reverse the traditional understanding of this first onslaught of moving images. Like a demystifying showman, I have frozen the image of crowds scattered before the projection of an on-rushing train and read it allegorically rather than mythically. This arrest should astonish us with the realisation that these screams of terror and delight were well prepared for by both showmen and audience. The audience's reaction was the antipode to the primitive one: it was an encounter with modernity. From the start, the terror of that image uncovered a lack, and promised only a phantom embrace. The train collided with no one. It was, as Gorky said, a train of shadows, and the threat that it bore was freighted with emptiness.

1989

---

[37]Hansen, *Benjamin, Cinema*, pp. 210–211.

# ROBERT STAM AND LOUISE SPENCE
## COLONIALISM, RACISM, AND REPRESENTATION: AN INTRODUCTION

Racism and colonialism in the cinema have been the subject of many books and essays. The stereotyping of black Americans has been explored by Thomas Cripps in *Slow Fade to Black*,[1] by Daniel Leab in *From Sambo to Superspade*,[2] and by Donald Bogle in *Toms, Coons, Mulattoes, Mammies and Bucks*.[3] The pernicious distortion of African history and culture has been denounced by Richard Maynard in *African on Film: Myth and Reality*.[4] Ralph Friar and Natasha Friar's *The Only Good Indian*[5] chronicles the imagistic mistreatment dealt out to the Native American. Lester Friedman's *Hollywood's Image of the Jew*[6] documents the process by which most screen Jews have had to sacrifice all ethnic specificity in order to conform to a WASP-dominated assimilationist creed. Allen Woll's *The Latin Image in American Film*[7] focuses on the stereotypical 'bandidos' and 'greasers' common in Hollywood films about Latin America, while Pierre Boulanger's *Le Cinéma colonial*[8] exposes the caricatural vision of North Africa and the Near East displayed in such films as *Pépé le Moko* and *Lawrence of Arabia*. And Tom Engelhardt's essay 'Ambush at Kamakazi Pass'[9] places screen anti-Asiatic racism within the context of the war in Vietnam.

We would like to express our appreciation to the members of the study group in racism, all graduate students in the Cinema Studies Program at New York University, for their suggestions and insights: Pat Keeton, Charles Musser, Richard Porton, Susan Ryan, Ella Shochat, and Ed Simmons.

[1]Oxford, 1977.
[2]Houghton Mifflin, 1976.
[3]Bantam, 1974.
[4]Hayden, 1974.
[5]Drama, 1972.
[6]Ungar, 1982.
[7]UCLA Publications, 1980.
[8]Seghers, 1974.
[9]*Bulletin of Concerned Asian Scholars*, vol. 3 no. 1, Winter–Spring 1971.

Our purpose here is not to review the research or criticise the conclusions of the aforementioned texts. Rather, we would like to sketch out the background of the questions raised in them, offer some preliminary definitions of key terms, and propose the outlines of a methodology in the form of a series of concerns addressable to specific texts and their representations. We would like both to build on and go beyond the methodologies implicit in existing studies. These studies of filmic colonialism and racism tend to focus on certain dimensions of film—social portrayal, plot, and character. While such studies have made an invaluable contribution by alerting us to the hostile distortion and affectionate condescension with which the colonised have been treated in the cinema, they have often been marred by a certain methodological naiveté. While posing legitimate questions concerning narrative plausibility and mimetic accuracy, negative stereotypes and positive images, the emphasis on realism has often betrayed an exaggerated faith in the possibilities of verisimilitude in art in general and the cinema in particular, avoiding the fact that films are inevitably constructs, fabrications, representations. The privileging of social portrayal, plot and character meanwhile, has led to the slighting of the specifically cinematic dimensions of the film; the analyses might easily have been of novels or plays rather than films. The insistence on 'positive images', finally, obscures the fact that 'nice' images might at times be as pernicious as overtly degrading ones, providing a bourgeois facade for paternalism, a more pervasive racism.

Although we are quite aware of the crucial importance of the *contextual*, that is, of those questions bearing on the cinematic industry, its processes of production, distribution and exhibition, those social institutions and production practices which construct colonialism and racism in the cinema, our emphasis here will be *textual* and *intertextual*.[10] An anti-colonialist analysis, in our view, must make the same kind of methodological leap effected by feminist criticism when journals like *Screen* and *Camera Obscura* critically transcended the usefully angry but methodologically flawed 'image' analysis of such critics as Molly Haskell and Marjorie Rosen in order to pose questions concerning the apparatus, the position of the spectator, and the specifically cinematic codes.[11] Our discussion draws from, and hopefully applies by extension to, the analysis of other oppressions, such as sexism, class subordination and anti-Semitism, to all situations, that is, in which difference is transformed into 'other'-ness and exploited or penalised by and for power.

## SOME DEFINITIONS

We should begin, however, with some preliminary definitions. What do we mean by 'colonialism', 'the Third World' and 'racism'? By colonialism, we refer to the process by which the European powers (including the United States) reached a position of economic, military, political and cultural domination in much of Asia, Africa

---

[10]For a discussion of the contextual dimension of racism in cinema, see "Racism in the Cinema: Proposal for a Methodological Model of Investigation," by Louise Spence and Robert Stam, with the collaboration of Pat Keeton, Charles Musser, Richard Porton, Susan Ryan, Ella Shochat, and Ed Simmons, to be published in a forthcoming issue of *Critical Arts: A Journal for Media Studies*.

[11]See, for example, Molly Haskell, *From Reverence to Rape* (New York: Holt, Rinehart and Winston, 1974) and Marjorie Rosen, *Popcorn Venus* (New York: Avon, 1974).

and Latin America. This process, which can be traced at least as far back as the 'voyages of discovery' and which had as its corollary the institution of the slave trade, reached its apogee between 1900 and the end of World War I (at which point Europe had colonised roughly 85 percent of the earth) and began to be reversed only with the disintegration of the European colonial empires after World War II.

The definition of the 'Third World' flows logically out of this prior definition of colonialism, for the 'Third World' refers to the historical victims of this process—to the colonised, neo-colonised or de-colonised nations of the world whose economic and political structures have been shaped and deformed within the colonial process. The colonial relation has to do with *structural* domination rather than with crude economic ('the poor'), racial ('the non-white'), cultural ('the backward') or geographical categories.[12]

Racism, finally, although not limited to the colonial situation (anti-Semitism being a case in point), has historically been both an ally and a product of the colonisation process. It is hardly accidental that the most obvious victims of racism are those whose identity was forged within the colonial process: blacks in the United States, Asians and West Indians in Great Britain, Arab workers in France, all of whom share an oppressive situation and the status of second-class citizens. We will define racism, borrowing from Albert Memmi, as 'the generalized and final assigning of values to real or imaginary differences, to the accuser's benefit and at his victim's expense, in order to justify the former's own privilege or aggression'.[13] Memmi's definition has the advantage of calling attention to the *uses* to which racism is put. Just as the logic of sexism leads to rape, so the logic of racism leads to violence and exploitation. Racism, for Memmi, is almost always a rationale for an already existing or contemplated oppression. Without ignoring the accumulated prejudices and cultural attitudes which prepared the way for racism, there is a sense in which it can be argued that racism comes 'in the wake' of concrete oppressions. Amerindians were called 'beasts' and 'cannibals' *because* white Europeans were slaughtering them and expropriating their land; blacks were slandered as 'lazy' *because* they were being exploited as slaves; Mexicans were caricatured as 'greasers' and 'bandidos' *because* the United States had seized half of their territory; and the colonised were ridiculed as lacking in culture and history *because* colonialism, in the name of profit, was destroying the basis of that culture and the memory of that history.

The same Renaissance humanism which gave birth to the code of perspective—subsequently incorporated, as Baudry points out, into the camera itself—also gave birth to the 'rights of man'. Europe constructed its self-image on the backs of its equally constructed Other—the 'savage', the 'cannibal'—much as phallocentrism sees its self-flattering image in the mirror of woman defined as lack. And just as the camera might therefore be said to inscribe certain features of bourgeois humanism, so the cinematic and televisual apparatuses, taken in their most inclusive sense, might

---

[12]These notions of the Third World are imprecise because the Third World nations are not necessarily poor in resources (Mexico, Venezuela and Kuwait are rich in petroleum), nor culturally backward (as witnessed by the brilliance of contemporary Latin American literature), nor non-industrialised (Brazil is highly industrialised) nor non-white (Argentina is predominantly white).

[13]Albert Memmi, *Dominated Man* (Boston: Beacon Press, 1968), p. 186.

be said to inscribe certain features of European colonialism. The magic carpet provided by these apparatuses flies us around the globe and makes us, by virtue of our subject position, its audiovisual masters. It produces us as subjects, transforming us into armchair conquistadores, affirming our sense of power while making the inhabitants of the Third World objects of spectacle for the First World's voyeuristic gaze.

Colonialist representation did not begin with the cinema: it is rooted in a vast colonial intertext, a widely disseminated set of discursive practices. Long before the first racist images appeared on the film screens of Europe and North America, the process of colonialist image-making, and resistance to that process, resonated through Western literature. Colonialist historians, speaking for the 'winners' of history, exalted the colonial enterprise, at bottom little more than a gigantic act of pillage whereby whole continents were bled of their human and material resources, as a philanthropic 'civilising mission' motivated by a desire to push back the frontiers of ignorance, disease and tyranny. Daniel Defoe glorified colonialism in *Robinson Crusoe* (1719), a novel whose 'hero becomes wealthy through the slave trade and through Brazilian sugar mills, and whose first thought, upon seeing human footprints after years of solitude, is to 'get (him) a servant'.[14]

Other European writers responded in more complex and ambiguous ways. The French philosopher Montaigne, writing at the end of the sixteenth century, suggested in 'Des Cannibales' that the Amerindian cannibalising of dead enemy warriors paled in horror when compared to the internecine warfare and torture practiced by European Christians in the name of a religion of love. Shakespeare has Caliban in *The Tempest*, whose name forms an annagram of 'cannibal', curse the European Prospero for having robbed him of his island: 'for I am all the subjects that you have/which first was mine own king'. (Aimé Césaire had to alter Shakespeare's character but slightly, in his 1969 version, to turn him into the anti-colonialist militant Caliban X.[15]) And Jonathan Swift, a century later in *Gulliver's Travels* (1726), portrays colonialism in satirical images that in some ways anticipate Herzog's *Aguirre*:

> A crew of pyrates are driven by a storm they know not whither; at length a Boy discovers Land from the Topmast; they go on shore to rob and plunder; they see an harmless people, are entertained with kindness, they give the country a new name, they take formal possession of it for the king, they set up a rotten plank or a stone for a memorial, they murder two or three dozen of the natives, bring away a couple more by force for a sample, return home and get their Pardon. . . . And this execrable crew of butchers employed in so pious an expedition, is a modern colony sent to convert and civilise an idolatrous and barbarous people.[16]

The struggle over images continues, within literature, into the period of the beginnings of the cinema. Conrad's *Heart of Darkness* (1902), published but a few years

---

[14]Buñuel's film version of the novel mocks Defoe's protagonist by haunting him with surrealist dreams, turning him into a transvestite, and making it singularly difficult for him to make rational sense out of the tenets of Christianity to an inquisitive Friday. The film *Man Friday*, which we have not seen, reportedly tells the story from Friday's point of view. And in a recent Brazilian adaptation of the novel, black actor Grande Otelo subverts Defoe's classic by playing a Friday who refuses the coloniser's power to name, repeatedly telling the Englishman: 'Me Crusoe, *You* Friday!'

[15]See Aimé Césaire, *Une Tempête* (Paris; Seuil, 1969).

[16]Jonathan Swift, *Gulliver's Travels* (New York: Random House, 1958), p. 241.

after the first Lumière screenings, describes colonialism in Africa as 'just robbery with violence, aggravated murder on a grand scale' and emphasises its racist underpinnings. 'The conquest of the earth, which mostly means the taking it away from those who have a different complexion or slightly flatter noses than ourselves,' Conrad has his narrator say, 'is not a pretty thing when you look into it too much.'[17] 'The settler,' Fanon writes, 'makes history; his life is an epoch, an Odyssey,' while against him 'torpic creatures, wasted by fevers, obsessed by ancestral customs, form an almost inorganic background for the innovating dynamism of colonial mercantilism.'[18] Since the beginnings of the cinema coincided with the height of European imperialism, it is hardly surprising that European cinema portrayed the colonised in an unflattering light. Indeed, many of the misconceptions concerning Third World people derive from the long parade of lazy Mexicans, shifty Arabs, savage Africans and exotic Asiatics that have disgraced our movie screens. Africa was portrayed as a land inhabited by cannibals in the Lubin comedy *Rastus in Zululand* (1910), Mexicans were reduced to 'greasers' in films like *Tony the Greaser* (1911) and *The Greaser's Revenge* (1914), and slavery was idealised, and the slaves degraded, in *The Birth of a Nation* (1915). Hundreds of Hollywood westerns turned history on its head by making the Native Americans appear to be intruders on what was originally their land, and provided a paradigmatic perspective through which to view the whole of the non-white world.

The colonialist inheritance helps account for what might be called the tendentiously flawed mimesis of many films dealing with the Third World. The innumerable ethnographic, linguistic and even topographical blunders in Hollywood films are illuminating in this regard. Countless safari films present Africa as the land of 'lions in the jungle' when in fact only a tiny proportion of the African land mass could be called 'jungle' and when lions do not live in jungle but in grasslands. Hollywood films, in any case, show disproportionate interest in the animal, as opposed to the human life of Africa. And as regards human beings, the Western world has been oddly fascinated by Idi Amin, in many ways an atypical leader in the continent of Nyerere, Mugabe and Machel.

At times the 'flaw' in the mimesis derives not from the *presence* of distorting stereotypes but from the *absence* of representations of an oppressed group. *King of Jazz* (1930), for example, paid tribute to the origins of jazz by pouring (through superimposition) a series of musical ensembles, representing diverse European ethnic groups, into a gigantic melting pot, completely bypassing both Africa and Afro-Americans. Black Brazilians, similarly, formed a structuring absence within Brazilian cinema during the first few decades of this century, as film-makers exalted the already annihilated and mythically connoted 'Indian warrior' in preference to the more problematically present black, victim of a slavery abolished just ten years before the founding of Brazilian cinema. Many American films in the fifties gave the impression that there were no black people in America. The documentary-like *The Wrong Man* (Hitchcock, 1957), for example, shows the subways and even the prisons of New York City as totally devoid of blacks.

[17]Joseph Conrad, *Heart of Darkness* (New York: New American Library, 1950), p. 69.
[18]Frantz Fanon, *The Wretched of the Earth* (New York: Grove Press, 1968), p. 51.

At other times the structuring absence has to do not with the people themselves but with a dimension of that people's history or institutions. A whole realm of Afro-American history, the slave revolts, is rarely depicted in film or is represented (as in the television series *Roots*) as a man, already dead, in a ditch. The revolutionary dimension of the black church, similarly, is ignored in favour of a portrayal which favours charismatic leaders and ecstatic songs and dancers.[19] The exclusion of whites from a film, we might add paradoxically, can also be the result of white racism. The all-black Hollywood musicals of the twenties and thirties, like present-day South African films made by whites for black audiences, tend to exclude whites because their mere presence would destroy the elaborate fabric of fantasy constructed by such films.

The absence of the language of the colonised is also symptomatic of colonialist attitudes. The languages spoken by Third World peoples are often reduced to an incomprehensible jumble of background murmurs, while major 'native' characters are consistently obliged to meet the coloniser on the coloniser's linguistic turn (here westerns, with their Indian-pidgin English, again provide the paradigm). Anna, in *The King and I*, teachers the Siamese natives 'civilised' manners along with English. Even *Cuba* (directed by Richard Lester, 1980), a generally sympathetic portrait of the Cuban revolution, perpetuates a kind of linguistic colonialism by having the Cubans speak English in a variety of accents (many of which have nothing Hispanic about them beyond an occasional rolled *r*) not only to English-speaking characters, but also to one another. In other films, major nations are mistakenly attributed the wrong language. In *Latin Lovers* (directed by Mervyn Leroy, 1953), for example, Portuguese-speaking Brazilians, when they are not speaking English, are made to speak Spanish.[20]

In response to such distortions, the Third World has attempted to write its own history, take control of its own cinematic image, speak in its own voice. The colonialist wrote the colonised *out* of history, teaching Vietnamese and Senegalese children, for example, that their 'ancestors' were the Gauls. A central impulse animating many Third World films is precisely the effort to reclaim the past. Thus *Ganga Zumba* (directed by Carlos Diegues, 1963) memorialises the proud history of black rebellion in Brazil by focusing on the seventeenth-century fugitive slave republic called Palmares. *Emitai* (directed by Ousmane Sembene, 1972) deals with French colonialism and Senegalese resistance during the period of the Second World War. *Chronicle of the Years of Embers* (directed by Lakdar Hamina, 1975) recounts the Algerian revolution and *The Promised Land* (directed by Miguel Littin, 1973) renders homage to the short-lived 'socialist republic' of Marmaduke Grove as a way to examine both the contradictions and the revolutionary potential of the Chile of the Allende period.

Many oppressed groups have used 'progressive realism' to unmask and combat hegemonic images. Women and Third World film-makers have attempted to counterpose the objectifying discourse of patriarchy and colonialism with a vision of them-

---

[19]A recent example of this tendency is the ecstatic song led by James Brown in *The Blues Brothers* (directed by John Landis, 1980).

[20]For a discussion of Hollywood's view of Brazil, see Sergio Augusto, "Hollywood Looks at Brazil: From Carmen Miranda to Moonraker", in Randal Johnson and Robert Stam, *Brazilian Cinema* (East Brunswick: Associated University Presses, 1982).

selves and their reality as seen 'from within'. But this laudable intention is not always unproblematic. 'Reality' is not self-evidently given and 'truth' cannot be immediately captured by the camera. We must distinguish, furthermore, between realism as a goal—Brecht's 'laying bare the causal network'—and realism as a style or constellation of strategies aimed at producing an illusionistic 'reality effect'. Realism as a goal is quite compatible with a style which is reflexive and deconstructive, as is eloquently demonstrated by *El Otro Francisco* (directed by Sergio Giral, 1974), a Cuban film which deconstructs a romantic abolitionist novel by highlighting the historical realities (economic motivations on the part of the whites, armed resistance on the part of the blacks) elided by it, while at the same time underlining its own processes of construction as a filmic text.

## POSITIVE IMAGES?

Much of the work on racism in the cinema, like early work on the representation of women, has stressed the issue of the 'positive image'. This reductionism, though not wrong, is inadequate and fraught with methodological dangers. The exact nature of 'positive', first of all, is somewhat relative: black incarnations of patience and gradualism, for example, have always been more pleasing to whites than to blacks. A cinema dominated by positive images, characterised by a bending-over-backwards-not-to-be-racist attitude, might ultimately betray a lack of confidence in the group portrayed, which usually itself has no illusions concerning its own perfection. ('Just because you're black don't make you right,' one black brother tells another in *Ashes and Embers*, directed by Haile Gerima.) A cinema in which all black actors resembled Sidney Poitier might be as serious a cause for alarm as one in which they all resembled Stepin Fetchit.

We should be equally suspicious of a naive integrationism which simply inserts new heroes and heroines, this time drawn from the ranks of the oppressed, into the old functional roles that were themselves oppressive, much as colonialism invited a few assimilated 'natives' to join the club of the 'elite'. A film like *Shaft* (1971) simply substitutes black heroes into the actantial slot normally filled by white ones, in order to flatter the fantasies of a certain (largely male) sector of the black audience. *Guess Who's Coming to Dinner* (directed by Stanley Kramer, 1967), as its title suggests, invites an elite black into the club of the truly human, but always on white terms. Other films, such as *In the Heat of the Night* (1967), *Pressure Point* (1962), or the television series *Mod Squad*, place black characters in the role of law-enforcers. The ideological function of such images is not dissimilar to that pointed out in Barthes's famous analysis of the *Paris Match* cover which shows a black soldier in French uniform, eyes upraised, saluting what we presume to be the French flag. All citizens, regardless of their colour, can serve law and order, and the black soldier's zeal in serving the established law is the best answer to critics, black and white, of that society. The television series *Roots*, finally, exploited positive images in what was ultimately a cooptive version of Afro-American history. The series's subtitle, 'the saga of an American family', reflects an emphasis on the European-style nuclear family (retrospectively projected onto Kunta's life in Africa) in a film which casts blacks as just another immigrant group making its way toward freedom and prosperity in democratic America.

The complementary preoccupation to the search for positive images, the exposure of negative images or stereotypes, entails similar methodological problems. The positing and recognition of these stereotypes has been immensely useful, enabling us to detect structural patterns of prejudice in what had formerly seemed random phenomena. The exclusive preoccupation with images, however, whether positive or negative, can lead both to the privileging of characterological concerns (to the detriment of other important considerations) and also to a kind of essentialism, as the critic reduces a complex diversity of portrayals to a limited set of reified stereotypes. Behind every black child performer, from Farina to Gary Coleman, the critic discerns a 'pickaninny', behind every sexually attractive black actor a 'buck' and behind every attractive black actress a 'whore'. Such reductionist simplifications run the risk of reproducing the very racism they were initially designed to combat.

The analysis of stereotypes must also take cultural specificity into account. Many North American black stereotypes are not entirely congruent with those of Brazil, also a multi-ethnic New World society with a large black population. While there are analogies in the stereotypical images thrown up by the two cultures—the 'mammy' is certainly a close relation to the '*mae preta*' (black Mother), there are disparities as well. Brazilian historian Emilia Viotti da Costa argues, for instance, that the 'sambo' figure never existed, as reality or stereotype, in Brazilian colonial society.[21] The themes of the 'tragic mulatto' and 'passing for white', similarly, find little echo in the Brazilian context. Since the Brazilian racial spectrum is not binary (black *or* white) but nuances its shades across a wide variety of racial descriptive terms, and since Brazil, while in many ways oppressive to blacks, has never been a rigidly *segregated* society, no figure exactly corresponds to the North American 'tragic mulatto', schizophrenically torn between two radically separate social worlds.

An ethnocentric vision rooted in North American cultural patterns can lead, similarly, to the 'racialising', or the introjection of racial themes into, filmic situations which Brazilians themselves would not perceive as racially connoted. *Deus e Diabo na Terra do Sol* (*God and the Devil in the Land of the Sun*, directed by Glauber Rocha, 1964) was mistranslated into English as *Black God, White Devil*, suggesting a racial dichotomy not emphasized either in the original title or in the film itself. The humour of *Macunaíma* (1969), similarly, depends on an awareness of Brazilian cultural codes. Two sequences in which the title character turns from black to white, for example, occasionally misread as racist by North Americans, are in fact sardonic comments on Brazil's putative 'racial democracy'.

A comprehensive methodology must pay attention to the *mediations* which intervene between 'reality' and representation. Its emphasis should be on narrative structure, genre conventions, and cinematic style rather than on perfect correctness of representation or fidelity to an original 'real' model or prototype. We must beware of mistakes in which the criteria appropriate to one genre are applied to another. A search for positive images in *Macunaíma*, for example, would be fundamentally misguided, for that film belongs to a carnivalesque genre favouring what Mikhail Bakhtin calls 'grotesque realism'. Virtually all the film's characters are two-dimensional grotesques

---

[21]See Emilia Viotti da Costa, "Slave Images and Realities", in *Comparative Perspectives on Slavery in New World Plantation Societies* (New York: New York Academy of Sciences, 1977).

rather than rounded three-dimensional characters, and the grotesquerie is democratically distributed among all the races, while the most archly grotesque characters are the white industrialist cannibal and his ghoulish spouse. Satirical or parodic films, in the same way, may be less concerned with constructing positive images than with challenging the stereotypical expectations an audience may bring to a film. *Blazing Saddles* lampoons a whole range of ethnic prejudices, mocking audience expectations by having the whites sing 'Ole Man River' while the blacks sing "I Get No Kick from Champagne'.

## POLITICAL POSITIONING

One mediation specific to cinema is spectator positioning. The paradigmatic filmic encounters of whites and Indians in the western, as Tom Engelhardt points out, typically involve images of encirclement. The attitude toward the Indian is premised on exteriority. The besieged wagon train or fort is the focus of our attention and sympathy, and from this centre our familiars sally out against unknown attackers characterised by inexplicable customs and irrational hostility: 'In essence, the viewer is forced behind the barrel of a repeating rifle and it is from that position, through its gun sights, that he [sic] receives a picture history of western colonialism and imperialism.'[22] The possibility of sympathetic identifications with the Indians is simply ruled out by the point-of-view conventions. The spectator is unwittingly sutured into a colonialist perspective.

A film like *The Wild Geese* (directed by Andrew McLaglen, 1978) inherits the conventions of anti-Indian westerns and extends them to Africa. This glorification of the role of white mercenaries in Africa makes the mercenaries, played by popular heroic actors Richard Burton, Richard Harris and Roger Moore, the central focus of our sympathy. Even the gamblers and opportunists among them, recruited from the flotsam and jetsam of British society, are rendered as sympathetic, lively and humorous. Killing Africans *en masse*, the film implies, fosters camaraderie and somehow brings out their latent humanity. White Europe's right to determine Africa's political destiny, like the white American right to Indian land in the western, is simply assumed throughout the film.[23]

In *The Wild Geese*, the imagery of encirclement is used against black Africans, as the spectator, positioned behind the sight of mercenary machine guns, sees them fall in their hundreds. One of the crucial innovations of *Battle of Algiers* (directed by Gillo Pontecorvo, 1966) was to invert this imagery of encirclement and exploit the

---

[22]Engelhardt, *op. cit.*

[23]In the racist hierarchies of *The Wild Geese*, white males stand at the apex, while women are treated as comically dispensible and blacks are relegated to the bottom. The film camouflages its racism, however, by two plot devices involving positive images: first, by including a token black (a positive image?) as a member of the mercenary force (genocide rendered palatable by 'integrating' its perpetrators) and second, by having the entire operation be undertaken on behalf of a black leader characterised as 'the best there is'. The African 'best', however, is embodied by a sick, helpless, dying 'good Negro' who must be literally carried on the backs of whites. In this white rescue fantasy, the black leader of the 70s speaks the Sidney Poitier dialogue of the 50s; he pleads for racial understanding. The blacks, he says, must forgive the white past, and whites must forgive the black present. Thus centuries of colonialism are cancelled out in the misleading symmetry of an aphorism.

identificatory mechanisms of cinema on behalf of the colonised rather than the coloniser. Algerians, traditionally represented in cinema as shadowy figures, picturesquely backward at best and hostile and menacing at worst, are here treated with respect, dignified by close-ups, shown as speaking subjects rather than as manipulable objects. While never caricaturing the French, the film exposes the oppressive logic of colonialism and consistently fosters our complicity with the Algerians. It is through Algerian eyes, for example, that we witness a condemned Algerian's walk to his execution. It is from *within* the casbah that we see and hear the French troops and helicopters. This time it is the colonised who are encircled and menaced and with whom we identify.

One sequence, in which three Algerian women dress in European style in order to pass the French checkpoints and plant bombs in the European sector, is particularly effective in controverting traditional patterns of identification. Many critics, impressed with the film-makers' honesty in showing that the FLN committed terrorist acts against civilians, lauded this sequence for its 'objectivity'. (Objectivity, as Fanon pointed out, almost always works against the colonised.) But that *Battle of Algiers* shows such acts is ultimately less important than *how* it shows them; the signified of the diegesis (terrorist actions) is less important than the mode of address and the positioning of the spectator. The film makes us want the women to complete their task, not necessarily out of political sympathy but through the mechanisms of cinematic identification: scale (close shots individualise the three women); off-screen sound (we hear the sexist comments as if from the women's aural perspective); and especially point-of-view editing. By the time the women plant the bombs, our identification is so complete that we are not terribly disturbed by a series of close shots of the bombs' potential victims. Close-ups of one of the women alternate with close-ups of French people in a cafe, the eyeline matches suggesting that she is contemplating the suffering her bomb will cause. But while we might think her cruel for taking innocent life, we are placed within her perspective and admire her for having the courage to perform what has been presented as a dangerous and noble mission.

Other narrative and cinematic strategies are deployed in this sequence to solicit support for the three women. The narrative placement of the sequence itself presents their action as the fulfilment of the FLN promise, made in the previous sequence, to respond to the French terror bombing of the casbah. Everything here contributes to the impression that the bombing will be an expression of the rage of an entire people rather than the will of a fanatical minority. It is constructed, therefore, not as an individual emotional explosion but as a considered political task undertaken with reluctance by an organised group. The sequence consequently challenges the image of anti-colonialist guerrillas as terrorist fanatics lacking respect for human life. Unlike the Western mass media, which usually restrict their definition of 'terror' to anti-establishment violence—state repression and government-sanctioned aerial bombings are not included in the definition—*Battle of Algiers* presents anti-colonialist terror as a response to colonialist violence. We are dealing here with what might be called the political dimension of syntagmatic organisation; while the First World media usually present colonial repression as a response to 'leftist subversion', *Battle of Algiers* inverts the sequencing. Indeed, examining the film as a whole, we might say that Pontecorvo 'highjacks' the techniques of mass-media reportage—

hand-held cameras, frequent zooms, long lenses—to express a political point of view rarely encountered in establishment-controlled media.

The *mise-en-scène*, too, creates a non-sexist and anti-colonialist variant on the classic cinematic *topos*: women dressing in front of a mirror. The lighting highlights the powerful dignity of the women's faces as they remove their veils, cut their hair and apply make-up so as to look European. The mirror here is not the instrument of *vanitas*, but a revolutionary tool. The women regard themselves, without coyness, as if they were putting on a new identity with which they do not feel entirely comfortable. They perform their task in a disciplined manner and without vindictive remarks about their future victims.

The film also highlights the larger social dimension of the drama in which the women are involved. The colonial world, writes Fanon, is a world cut in two: 'In the colonies it is the policeman and the soldier who are the official instituted go-betweens, the spokesmen of the settler and his rule of oppression.'[24] The background imagery, readable thanks to the depth of field, shows that the French have imposed their regime by what amounts to military occupation. The French are in uniform, the Algerians in civilian dress. The casbah is the Algerian's home; for the French it is an outpost on a frontier. The barbed wire and checkpoints remind us of other occupations, thus eliciting our sympathy for a struggle against a foreign occupant. The proairetic 'code of actions', meanwhile, shows the soldiers treating the Algerians with racist scorn and suspicion, while they greet the Europeans with a friendly 'bonjour'. They misperceive the three women as French and flirtatious when in fact they are Algerian and revolutionary. Their sexism, furthermore, prevents them from seeing women, generally, as potential revolutionaries. In the negative dialectic of oppression, the slave (the colonised, the black, the woman) knows the mind of the master better than the master knows the mind of the slave.

Western attitudes toward non-Western peoples are also played on here. Hassiba is first seen in traditional Arab costume, her face covered by a veil. So dressed, she is a reminder of Arab women in other films who function as a sign of the exotic. But as the sequence progresses, we become increasingly close to the three women, though paradoxically, we become close to them only as they strip themselves of their safsaris, their veils, and their hair. They transform themselves into Europeans, people with whom the cinema more conventionally allows the audience to identify. At the same time, we are made aware of the absurdity of a system in which people warrant respect only if they look and act like Europeans. The French colonialist myth of 'assimilation', the idea that select Algerians could be first-class French citizens, is demystified. Algerians can assimilate, it is suggested, but only at the price of shedding everything that is characteristically Algerian about them—their religion, their clothes, their language.[25]

If *Battle of Algiers* exploits conventional identification mechanisms on behalf of a group traditionally denied them, other films critique colonialism and colonialist

---

[24]Frantz Fanon. *op. cit.*, p. 38.

[25]For a fuller discussion of this film, see Joan Mellen, *Filmguide to the Battle of Algiers* (Bloomington, Indiana University Press, 1973), and Robert Stam, *The Battle of Algiers: Three Women, Three Bombs*, Macmillan Films Study Extract, 1975.

point-of-view conventions in a more ironic mode.[26] *Petit à Petit* (directed by Jean Rouch, 1969) inverts the hierarchy often assumed within the discipline of anthropology, the academic offspring of colonialism, by having the African protagonist Damouré 'do anthropology' among the strange tribe known as the Parisians, interrogating them about their folkways. Europe, usually the bearer of the anthropological gaze, is here subjected to the questioning regard of the other. *How Tasty Was My Little Frenchman* (directed by Nelson Pereira dos Santos, 1971), meanwhile, updates Montaigne by persuading us to sympathise with Tupinamba cannibals.[27] The film plays ironically on the traditional identification with European heroes by placing the camera, initially, on American shores, so that the Amerindian discovers the European rather than the reverse. By the final shot, which shows the Frenchman's Tupinamba lover dining on him while manifesting no emotion beyond ordinary culinary pleasure, our 'natural' identification with the coloniser has been so completely subverted that we are quite indifferent to his fate.

The question of point of view is crucial then, but it is also more complex than might at first appear. The granting of point-of-view shots to the oppressed does not guarantee a non-colonialist perspective, any more than Hitchcock's granting of subjective shots to the female protagonist of *Marnie* inoculates that film from what is ultimately a patriarchal and infantilising discourse. The arch-racist *The Birth of a Nation* grants Gus, the sexually aggressive black man, a number of subjective shots as he admires little Flora. The racism in such a case may be said to be displaced from the code of editing onto the code of character construction, here inflected by the projection of white sexual paranoia onto the black male, in the case of Gus, and of patriarchal chivalry (tinged perhaps with authorial desire), in the case of Flora. The Brazilian film *João Negrinho* (directed by Oswaldo Censoni, 1954) is entirely structured around the perspective of its focal character, an elderly ex-slave. The film apparently presents all events from João's point of view so as to elicit total sympathy, yet what the film elicits sympathy *for* is in fact a paternalistic vision in which 'good' blacks are to leave their destiny in the hands of well-intentioned whites.

## CODES AND COUNTER STRATEGIES

A more comprehensive analysis of character status as speaking subject as against spoken object would attend to cinematic and extra-cinematic codes, and to their interweaving within textual systems. In short, it must address the instances through which

---

[26]Some Left critics dismissed *The Battle of Algiers* as a Hollywooden Z-style exercise in political melodrama. Such critiques run the dangers of being (1) *ahistorical* (we must situate the film in the context of 1966); (2) politically *counter-productive* (the Left deprives itself of a powerful instrument of anti-colonialist persuasion); and (3) *ethnocentric* (offering an example of a kind of Left colonialism). While the Right asks all pro–Third World films to display high production values and be entertaining, a certain Left asks all pro–Third World films to be disconstructive, reflexive, and to display the precise variant of Marxism that the particular First World critic finds most sympathetic.

[27]Montaigne's essay "Des Cannibales", was, ironically, based on interviews with Brazilian Indians then on display in Europe. The Indians, according to Montaigne, asked him three questions, only two of which he could remember: (1) Why were some people rich and others poor? (2) Why did Europeans worship kings who were no bigger than other people? Lévi-Strauss, more than three centuries later, claims to have been asked the same questions by Brazilian Indians.

film speaks—composition, framing, scale, off- and on-screen sound, music—as well as questions of plot and character. Questions of image scale and duration, for example, are intricately related to the respect afforded a character and the potential for audience sympathy, understanding and identification. Which characters are afforded close-ups and which are relegated to the background? Does a character look and act, or merely appear, to be looked at and acted upon? With whom is the audience permitted intimacy? If there is off-screen commentary or dialogue, what is its relation to the image? *Black Girl* (directed by Ousmane Sembene, 1966) uses off-screen dialogue to foster intimacy with the title character, a Senegalese maid working in France. Shots of the maid working in the kitchen coincide with overhead slurs from her employers about her 'laziness'. Not only do the images point up the absurdity of the slurs—indeed, she is the *only* person working—but also the coincidence of the off-screen dialogue with close shots of her face makes us hear the comments as if through her ears.

An emphasis on identification, however, while appropriate to fiction films in the realist mode, fails to allow for films which might *also* show sensitivity to the point of view, in a more inconclusive sense, of the colonised or the oppressed, but in a rigorously distanced manner. A film like *Der Leone Have Sept Cabeças* (directed by Glauber Rocha, 1970), whose multi-lingual title already subverts the cultural positioning of the spectator by mingling the languages of five of Africa's colonisers, allows identification with none of its characters, because it is essentially a Brechtian 'tricontinental' fable which animates emblematic figures representing the diverse incarnations of coloniser and colonised in the Third World. 'Zumbi', named after the founder of the Brazilian fugitive slave republic Palmares, encapsulates the revolution in Africa and among the black diaspora; 'Samba' embodies the power of Afroculture; and 'Xobu' figures in caricatural form the corruption of the black puppets of colonialism. To condemn such a film for not creating identification with the oppressed is to reduce the broad question of the articulation of narrative, cinematic and cultural codes to the single question of the presence or absence of a particular sub-code of editing.

The music track can also play a crucial role in the establishment of a political point of view and the cultural positioning of the spectator. Film music has an emotional dimension: it can regulate our sympathies, extract our tears or trigger our fears. The Ray Budd score in *The Wild Geese* consistently supports the mercenaries, waxing martial and heroic when they are on the attack, and maudlin when they emote. At one point, the Borodin air 'This Is My Beloved' musically eulogises one of the slain mercenaries. In many classical Hollywood films, African polyrhythms became aural signifiers of encircling savagery, a kind of synecdochic acoustic shorthand for the atmosphere of menace implicit in the phrase 'the natives are restless'. *Der Leone Have Sept Cabeças*, in contrast, treats African polyrhythms with respect, as music, while ironically associating the puppets of colonialism with 'La Marseillaise'. *Black and White in Color* employs music satirically by having the African colonised carry their colonial masters, while singing—in their own language—satirical songs about them ('My master is so fat, how can I carry him? . . . Yes, but mine is so ugly. . . .').

In many consciously anti-colonialist films, a kind of textual uneven development makes the film politically progressive in some of its codes but regressive in others.

*Burn!* (directed by Gillo Pontecorvo, 1970), for example, a didactic assault on neo-colonialism, partially vitiates its message by imposing highly Europeanised choral music on its Third World setting.[28] *Compasso de Espera* (*Marking Time*, directed by Antunes Filho, 1973), a denunciation of Brazilian-style racism, subverts its pro-black position with a music track that mixes Erik Satie and Blood Sweat and Tears while ignoring the rich Afro-Brazilian musical heritage. On the other hand *Land in Anguish* (directed by Glauber Rocha, 1967) uses music to the opposite effect. Here, in a film dealing with Brazil's white political elite, Afro-Brazilian music serves as a constant reminder of the existence of the marginalised majority of blacks and mulattoes absent from the screen and not represented by that elite. Brazilian films in general, perhaps because of the ethnically 'poly-phonic' nature of that society, are particularly rich in inter-codic contradiction, at times instituting a veritable battle of the codes on the music tracks. *The Given Word* (directed by Anselmo Duarte, 1962) sets in motion a cultural conflict between the Afro-Brazilian *berimbau* instrument and the bells of the Catholic Church, while *Tent of Miracles* (directed by Nelson Pereira dos Santos, 1976) counterpoints opera and samba to represent a larger conflict between Bahia's white elite and its subjugated *mestizos*.

## ABERRANT READINGS

The filmic experience must inevitably be infected by the cultural awareness of the audience itself, constituted outside the text and traversed by sets of social relations such as race, class and gender. We must allow, therefore, for the possibility of aberrant readings, reading which go against the grain of the discourse. Although fiction films are persuasive machines designed to produce specific impressions and emotions, they are not all-powerful; they may be read differently by different audiences. Hollywood's ill-informed portrayals of Latin-American life were sometimes laughed off the screen within Latin America itself. The Spanish version of *Dracula*, for example, made concurrently with the 1931 Bela Lugosi film, mingles Cuban, Argentine, Chilean, Mexican and peninsular Spanish in a linguistic hodge-podge that struck Latin-American audiences as quite ludicrous.

A particular audience's knowledge or experience can also generate a counter-pressure to colonialist representations. Black Americans, presumably, never took Stepin Fetchit to be an accurate representation of their race as a whole. *One Potato Two Potato* (directed by Larry Peerce, 1964), a film about interracial marriage, provides a poignant narrative example, in which the experience of oppression inflects a character's reading of the film-within-the-film. The black husband, enraged by a series of racially motivated slights, attends a western in a drive-in movie theatre. Projecting his anger, he screams his support for the Indians, whom he sees as his analogues in suffering, and his hatred for the whites. His reading goes against the grain of the colonialist discourse.

---

[28]The film also made the mistake of pitting one of the First World's most charismatic actors (Marlon Brando), as the coloniser, against a former peasant non-actor (Evaristo Marques), as the colonised, thus disastrously tipping the scales of interest, if not sympathy, in favour of the coloniser.

The movement of an aberrant reading can also proceed in the opposite direction; an anti-racist film, when subjected to the ethnocentric prejudices of a particular critic or interpretative community, can be read in a racist fashion. A sequence in *Masculine, Feminine*, a quotation from LeRoi Jones's play *The Dutchman*, shows a blonde white woman in the metro accompanied by two black men. At the conclusion of the sequence, a shot of the woman's hand holding a revolver gives way, shortly thereafter, to the sound of gunfire and a title 'Nothing but a Woman/and a Man/And a Sea of Blood.' Andrew Sarris, in his account of the sequence, ignores the visual and written evidence that it is the woman who wields the gun: '. . . a Negro nationalist draws out a gun with phallic fury in the metro."[29] Here, cultural expectations inform the very perceptions of the viewer, who projects his own racial and sexual expectations onto the film.[30]

We must be aware, then, of the cultural and ideological assumptions spectators bring to the cinema. We must be conscious, too, of the institutionalised expectations, the mental machinery that serves as the subjective support to the film industry, and which leads us to consume films in a certain way. This apparatus has adapted most of us to the consumption of films which display high production values. But many Third World film-makers find such a model, if not repugnant, at least inappropriate—not only because of their critique of dominant cinema, but also because the Third World, with its scarcer capital and higher costs, simply cannot *afford* it. Significantly, such film-makers and critics argue for a model rooted in the actual circumstances of the Third World: a 'third cinema' (Solanas-Gettino), 'an aesthetic of hunger' (Rocha), and 'an imperfect cinema' (Espinosa). To expect to find First World production values in Third World films is to be both naive and ethnocentric. To prospect for Third World auteurs, similarly, is to apply a regressive analytical model which implicitly valorises dominant cinema and promises only to invite a few elite members of the Third World into an already established pantheon.

The objective of this study of filmic colonialism and racism, finally, is not to hurl charges of racism at individual film-makers or critics—in a systematically racist society few escape the effects of racism—but rather to learn how to decode and deconstruct racist images and sounds. Racism is not permanently inscribed in celluloid or in the human mind; it forms part of a constantly changing dialectical process within which, we must never forget, we are far from powerless.

1983

---

[29]From Sarris's review in the *Village Voice*, September 29–October 6, 1966, included in *Masculine, Feminine* (New York: Grove Press, 1969), pp. 275–79.

[30]In the case of Cuban films, ethnocentrism merges with anti-communism to distort the perception of First World critics. Many American critics, for example, identified very strongly with the alienated artist-intellectual protagonist of Alea's *Memories of Underdevelopment* (1968) and with his disabused view of the Cuban people. Seeing the film as an auteurist lament concerning the low level of cultural life in Cuba and the repressive nature of the Cuban regime, Andrew Sarris spoke for these critics (in his explanation of the award given the film by the National Society of Film Critics) when he claimed that what struck them most favourably was the film's 'personal and very courageous confrontation of the artist's doubts and ambivalences regarding the Cuban revolution'. Such critics completely missed the film's critique both of the protagonist and of pre-revolutionary Cuba.

# MANTHIA DIAWARA
## BLACK SPECTATORSHIP: PROBLEMS OF IDENTIFICATION AND RESISTANCE

Whenever blacks are represented in Hollywood, and sometimes when Hollywood omits blacks from its films altogether, there are spectators who denounce the result and refuse to suspend their disbelief. The manner in which black spectators may circumvent identification and resist the persuasive elements of Hollywood narrative and spectacle informs both a challenge to certain theories of spectatorship and the aesthetics of Afro-American independent cinema. In this article I posit the interchangeability of the terms 'black spectator' and 'resisting spectator' as a heuristic device to imply that just as some blacks identify with Hollywood's images of blacks, some white spectators, too, resist the racial representations of dominant cinema. Furthermore, by exploring the notion of the resisting spectator my aim is to reassess some of the claims of certain theories of spectatorship which have not so far accounted for the experiences of black spectators.

Since the mid-'70s much has been written on the subject of spectatorship. Early landmarks in the debate, such as articles like Christian Metz's on the Imaginary Signifier[1], Laura Mulvey's on Visual Pleasure and Narrative Cinema[2] and Stephen Heath's on Difference[3] with their recourse to Freud and Lacan, tended to concentrate the argument around gendered spectatorship. More recently, debates have begun to focus on issues of sexuality as well as gender, yet with one or two exceptions[4], the prevailing approach has remained colour-blind. The position of the spectator in the cinematic apparatus has been described by recourse to the psychoanalytic account of the mirror phase, suggesting that the metapsychology of identification (with the

---

[1]Christian Metz, 'The Imaginary Signifier', *Screen* Summer 1975, vol 16 no 2, pp 14–76.
[2]Laura Mulvey, 'Visual Pleasure and Narrative Cinema', *Screen* Autumn 1975, vol 16 no 3, pp 6–18.
[3]Stephen Heath, 'Difference', *Screen* Autumn 1978, vol 19 no 3, pp 51–112.
[4]Homi K. Bhabha, 'The Other Question', *Screen* November–December 1983, vol 24 no 6, pp 18–36.

camera or point of enunciation) entails a narcissistic form of regression which leads to a state similar to the infant's illusion of a unified ego. But since spectators are socially and historically as well as psychically constituted, it is not clear whether the experiences of black spectators are included in this analysis. Indeed, there are instances of film consumption which reveal the inadequacies of this approach and which implicitly question certain aspects of the prevailing problematic around spectatorship. To examine these instances, from the specific perspective of my own position as a black male spectator, I want to suggest that the components of 'difference' among elements of race, gender and sexuality give rise to different readings of the same material. Specifically, as an African film scholar based in the North American context, I am interested in the way that Afro-American spectators may, at times, constitute a particular case of what I call resisting spectatorship. From the specificity and limitations of my own position as a black male spectator the aim is to consider what insights this particular formation of spectatorship can bring to the analysis of Hollywood films.

To illustrate my argument I have chosen to begin with a sequence from *The Birth of a Nation* (directed by D W Griffith, 1915) to demonstrate how aspects of a dominant film can be read differently once the alternative readings of Afro-American spectators are taken into account, as the black spectator's reluctance to identify with the dominant reading of this archetypical Hollywood text also underpins the protest elicited by a film as recent as *The Color Purple* (directed by Steven Spielberg, 1986). The five minute sequence from *The Birth of a Nation* involves the pursuit of a young white girl by a black man, often referred to as the 'Gus chase' sequence. It takes place in the second part of the film, set in the period of Reconstruction in the South. Prior to this sequence, Senator Stoneman, one of the leading Northern white liberals, sends Silas Lynch, his mulatto protegé, to run for the seat of Lieutenant Governor in a Southern state. Silas conspires with 'carpetbaggers' to deny whites the right to vote and wins the election by means of the new black vote. Soon, the new leaders of the South lift the ban on inter-racial marriages and the whites, in response, form the Ku Klux Klan to protect themselves from what they call 'the new tyrants'.

The 'Gus chase' sequence begins with 'Little Sister', from the plantocrat Confederate Cameron family, going to a secluded stream in the woods and ends with her death in her brother's arms. The sequence contains about 105 shots in six narrational units: 1) Little Sister on her way to the stream/ Gus, the black man, following her unseen. 2) Little Sister playing with a squirrel/ Gus watching her unseen. 3) Gus confronting Little Sister and proposing to her/ Little Colonel looking for Little Sister. 4) Gus chasing Little Sister/ Little Colonel coming towards the stream to look for his sister. 5) Gus pursuing Little Sister to the top of the cliff where she jumps off/ Little Colonel approaching the scene. 5) Gus, seeing Little Colonel, fleeing/ Little Colonel taking his dying sister in his arms. The sequence is situated between two intertitles, one stating that Little Sister went into the woods despite her brother's warning, and the other that the gates of heaven will welcome her. Each alternated section is made up of several shots, some of which are repeated within the sequence. The rhythm of the editing is faster when Gus chases Little Sister and slower when Little Colonel takes her in his arms. Bright lights are cast on Little Sister and her brother while Gus is cast in dark shadows. Where Little Colonel wears a suit befitting his title and his

sister wears a modest dress, Gus does not wear his captain's uniform and his broken English confirms his 'inferiority' and otherness.

The dominant reading of this sequence supports a Manichean world view of race in which Gus represents absolute evil and Little Colonel and his sister embody absolute good. Editing, *mise-en-scène*, narrative content all combine to compel the spectator to regard Gus as the representation of danger and chaos: he is the alien, that which does not resemble oneself, that from which one needs protection. Whether black or white, male or female, the spectator is supposed to identify with the Camerons and encouraged to hate Gus. Similarly, the popular Tarzan movies position all spectators, white and black, to identify with the white hero; likewise, the Blaxploitation genre is intelligible to white spectators only if they suspend their critical judgement and identify with the black heroes like Shaft in the film of that name (1971). What is at issue in this fragment from *The Birth of a Nation* is the contradiction between the rhetorical force of the story—the dominant reading compels the black spectator to identify with the racist inscription of the black character—and the resistance, on the part of Afro-American spectators, to this version of US history, on account of its Manichean dualism.

In discussing the structure of myths, A J Griemas argues that at the basis of every story is a confrontation between *desire* and *law*.[5] The Oedipus myth provides a point of reference for certain theories of spectatorship which argue that each story fascinates the spectator to the extent that it retells the primordial Oedipus narrative, with its confrontation of desire and patriarchal order. But does this account for the positioning of the black spectator of *The Birth of a Nation*? At the beginning of the story Gus enters the scene as the wrong-doer, and his punishment starts with the arrival of Little Colonel as part of a process to restore order and harmony in the South. Such an endeavour entails the resolution of the narrative fragment through Gus' punishment. The narrative thus proposes Little Colonel as the representative of the symbolic *white/Father* who will restore the law of patriarchal order by castrating the rebellious black, Gus. It is Little Colonel who persuades the other whites to form a Klan to terrorise and discipline the blacks who threaten to destroy the social and symbolic order of the South. Thus Gus's desire for Little Sister is a transgression: the narrative of miscegenation links isomorphically with the Oedipal narrative of incestuous desire, an assault on the symbolic order of the Father which merits the most serious punishment—lynching. At the level of spectator identification, the narrative function summarised by the narrational sequence—'death of Little Sister'—is organised to position the spectator as the subject who desires to see, in the words of the intertitle, the 'punishment and discipline of Gus and the black race he symbolises'.

The resisting spectator, however, refutes the representation of Little Colonel as an authoritative father figure and the narrative proposition that lynching is a means of restoring the racial and symbolic order of the South. By the time the film was made, the Civil War was understood by most Afro-Americans as a revolutionary war which emancipated the slaves and united the nation. The father figures and heroes of the story should, therefore, have come from the side of the victors, not that of the Klan

---

[5]A. J. Greimas, *Sémantique Structurale*, Paris, Larousse, 1966, p 213.

which symbolised resistance to the ideals of democracy. *The Birth of a Nation* appears to misread history for ideological reasons: Not only is Little Colonel a fake father and hero, but the black experience is rendered absent in the text. The argument that blacks in the South were docile and happy with their condition as slaves and that black Northerners were only rebellious mulattos aspiring to be white is totally unconvincing once it is compared to historical accounts of the black American experience.[6]

It would be worthwhile to note how spectatorial resistance to the racist ideology encoded in *The Birth of a Nation* is expressed, often in 'realist' terms, by invoking an alternative account based on Afro-American historical experience. This response has been recently echoed in certain reactions to *The Color Purple*. Pointing to the many racial stereotypes that it features, Rita Dandridge argues that, 'Spielberg's credentials for producing *The Color Purple* are minimal. He is not a Southerner. He has no background in the black experience, and he seems to know little about feminism'.[7] Bearing this point in mind I want to consider the image of the punished and disciplined black man in contemporary films such as *Rocky II* (1979), *A Soldier's Story* (1984) and *Forty-Eight Hours* (1982) as well as *The Color Purple* itself.

It seems to me that the re-inscription of the image of the 'castrated' black male in these contemporary Hollywood films can be illuminated by a perspective similar to that advanced by feminist criticism. Laura Mulvey argues that the classical Hollywood film is made for the pleasure of the male spectator. However, as a *black* male spectator, I wish to argue, in addition, that the dominant cinema situates black characters primarily for the pleasure of white spectators (male or female). To illustrate this point, one may note how black male characters in contemporary Hollywood films are made less threatening to whites either by white domestication of black customs and culture—a process of deracination and isolation—or by stories in which blacks are depicted playing by the rules of white society and losing.

In considering recent mainstream films, Eddie Murphy presents an interesting case for the analysis of the problematic 'identification' between the black (male) spectator and the image of the black (male) character. Throughout the films in which Murphy has starred—*Trading Places* (1983), *Forty-Eight Hours*, and *Beverley Hills Cop* I and II (1984 and 1987)—his persona is that of the street-wise Afro-American dude, which might appear somewhat threatening. Yet in each narrative Murphy's character is deterritorialised from a black milieu and transferred to a predominantly white world. As the *Beverley Hills Cop* he leaves Detroit for an assignment in Los Angeles, and in *Forty-Eight Hours* he leaves the prison (scene of punishment) to team up with the white policeman played by Nick Nolte. In this story, Murphy's character, Reggie Hammond, is a convict enlisted by the police to help track down two fellow prisoners who have escaped. Murphy's persona invokes the image of the criminalised black male, and yet he is called upon to protect and enforce the law, given a gun, a police-badge and handcuffs, all of which symbolise the same order that has punished and

---

[6]Reactions to *Birth of a Nation* and its place in Hollywood's history of racial representation are discussed in Donald Bogle, *Toms, Coons, Mulattos and Bucks*, New York, Bantam, 1974; Daniel Leab, *From Sambo to Superspade*, New York, Houghton Mifflin, 1976; Thomas Cripps, *Slow Fade to Black*, New York, Oxford University Press, 1977.

[7]Rita Dandridge, 'The Little Book (and Film) that Started the Big War', *Black Film Review* vol 2 no 2, 1986, p 28.

disciplined him. The two male protagonists are presented as antagonistic, but in the eyes of the black/resisting spectator it is clear that he is only there to complement the white character as an authority figure. Nolte's character, Jack Cates, is tough, persevering and just, whereas Murphy's is exhibitionistic, inconsistent (swaying between good and evil) and inauthentic (he is to Nolte's character what Gus is to Little Colonel): Reggie Hammond transgresses the boundaries of the law established by Jack Cates as the representative of white authority. In one scene, which takes place in a 'red neck' bar, Hammond asks Cates, the white policeman, to give him his gun and the badge temporarily, so that he can use them to obtain information from people in the bar. But Hammond cannot even get their attention until he starts an exhibition, shouting and screaming and throwing a glass which breaks on a mirror. It is interesting to compare this exhibitionist act to an earlier shot of a partially-naked (white) female 'go-go' dancer, the image of which frames the beginning and ending of this bar-room sequence. Hammond takes the place of the woman as he becomes the object of the look of the men in the bar—and figure of the white spectator's fascination. In the fight between the two protagonists played by Nolte and Murphy, which takes place after the bar scene, Cates cannot get the desired information from Hammond, but on the other hand the fight is also motivated by the way that Hollywood requires that the black character must be punished after he has behaved like a hero (albeit a comic one) and humiliated the white people in the bar. *Forty-Eight Hours* mixes genres (the police story and the comedy, the serious and the fake authority figures) and achieves a 'balance' whereby the black character is only good at subverting order, while the white character restores narrative order—in the end Hammond returns to jail. For the Afro-American audience, however, this racial tension and balance preempts any sense of direct 'identification' with Murphy's character because ultimately his 'transgressions' are subject to the same process of discipline and punishment—he is not the hero of the story, although he may be the star of the show. Black protagonists, such as Apollo Creed in *Rocky II*, receive a similar narrative treatment in which their defeat is necessary to establish the white male character, Rocky, as the hero. In both cases, the Afro-American spectator is denied the possibility of identification with black characters as credible or plausible personalities. Thus, it cannot be assumed that black (male or female) spectators share in the 'pleasures' which such films are able to offer to white audiences.

Alongside the textual deracination or isolation of blacks, the narrative pattern of blacks playing by hegemonic rules and *losing* also denies the pleasure afforded by spectatorial identification. In terms of the Oedipal analogy in the structure of such narrative patterns, the black male subject always appears to lose in the competition for the symbolic position of the father or authority figure. And at the level of spectatorship, the black spectator, regardless of gender or sexuality, fails to enjoy the pleasures which are at least available to the white male heterosexual spectator positioned as the subject of the films' discourse. Moreover, the pleasures of narrative resolution—the final tying-up of loose ends in the hermeneutic code of detection—is also an ambiguous experience for black spectators. In *A Soldier's Story*, for example, Captain Davenport (Howard E. Rollins), a black lawyer from Washington, comes to an army base in a small Southern town to investigate the murder of a black sergeant. The dead sergeant had been hated by the enlisted blacks because he blamed them for the

problems caused by racism in the army. He was opposed to any expression of black culture by the soldiers and is revealed at the end of the story of have been responsible for the death of Private CJ, who sang the blues, told folktales and played sports, thus asserting elements of black culture. The black soldiers resented the conflation of standard army behaviour with white culture and accused the sergeant of wanting to pass for white. Captain Davenport also represses his racial identity and idealises the US army, yet while the sergeant displays his weakness through tears, uncontrollable laughter and alcoholism, the captain is cold, austere and businesslike. He rejects the probable but easy solution that the murder of the black soldier was committed by the Klan, and embarks instead on a search for 'the truth'. The complex psychology of the two characters is not explored; the film simply idealises the army as a homogenous and just institution and ends with the arrest and punishment of a *black* suspect, Pete (Denzel Washington). This surprise twist at the end of the narrative, which sacrifices one more black man in order to show that justice exists, fails to satisfy the expectation, on the part of the black spectator, to find the Klan or a white soldier

*The Birth of a Nation* (1915). Silas Lynch (George Siegmann), the mulatto protege of her father, proposes marriage to a horrified Elsie Stoneman (Lillian Gish). "What is at issue in . . . *The Birth of a Nation* is the contradiction between the rhetorical force of the story—the dominant reading compels the black spectator to identify with the racist inscription of the black character—and the resistance, on the part of Afro-American spectators, to this version of US history, on account of its Manichean dualism" (DIAWARA, page 894).

responsible for the crime. The plot of *Soldier's Story*, with its predominantly black cast, suggests a liberal reading of race in the American South; but by implicitly transferring villainy from the Klan to the blacks, it denies the pleasure of resolution to the Afro-American spectator.

If we return to the sequence from *The Birth of a Nation* it is possible to see the interaction of race and gender in two narrative situations which position the black spectator in a similarly problematic relation to the film's ideological standpoint. The first is voyeuristic: Gus watches Little Sister as she innocently plays with a squirrel. Knowing that Gus has been following her, the spectator begins to fear for her safety. As the opening intertitle states, her brother warned her about the danger of being alone in the woods. Being watched unawares here connotes not the lures of voyeurism and exhibitionism, but danger, and equates Gus, intertextually, with the unseen danger that stalks the innocent in many thrillers and horror movies. The other situation concerns the chase itself. As Gus begins pursuing Little Sister, the parallel montage accelerates, encouraging the spectator to identify with the helpless condition of Little Sister. Only when Little Colonel appears does the spectator feel a moment of release, as she or he is repositioned to identify with the rescue of Little Sister. The long take of Little Colonel slowly raising his sister in his arms, and its sub-

Reggie Hammond (Eddie Murphy) and Jack Cates (Nick Nolte) in *48HRS* (1982). "The two male protagonists are presented as antagonistic, but in the eyes of the black/resisting spectator it is clear that [Murphy] is only there to complement the white character as an authority figure. ... Reggie Hammond transgresses the boundaries of the law established by Jack Cates as the representative of white authority" (DIAWARA, page 896).

sequent repetition, is organised to make the spectator feel grief and desire vengeance against Gus. As I have argued, the black spectator is placed in an impossible position—drawn by the narrative to identify with the white woman, yet resisting the racist reading of the black man as a dangerous threat. It seems to me that a parallel dilemma is created in some scenes from *The Color Purple*, especially where Mister (Danny Glover) chases Netti (Akosua Busia) on her way to school. This chase scenario is similar to that of the 'Gus chase' sequence in many respects.

Both take place in the woods, outside 'civilisation' and, in each case, a tall, menacing black man chases an innocent girl with the intention of raping her. In each the girl epitomises innocence while the black male connotes evil. The girls' activities—Little Sister playing with a squirrel, Nettie on her way to school to get a much needed education—encourage the sympathy of the spectator, while Gus and Mister symbolise a danger and brutality that solicits only antipathy on the part of the viewer. In *The Birth of a Nation*, evil and lust are attributed to the black man and the black woman alike, but in *The Color Purple* they are attributed to the black male alone. Close-ups of Gus' nose and eyes appear to make him deformed and telephoto lenses are used in *The Color Purple* to exaggerate Mister's features, as if to emphasise his inhumanity or bestial nature. Both films use parallel montage and fast rhythm to encourage the spectator to identify with the victims of the danger represented by Gus/Mister, and to desire lynching for Gus and punishment by death for Mister.

The pairing of these two 'chase' sequences suggests another reading of the rhetoric of punishment. When Netti hits Mister in the genitals her action can be seen as castrating, signifying the removal of the penis from an undeserving man; but in terms of narrative structure this can be read as a replay of the Gus chase sequence. The Manichean figuration of Mister as evil (with its implicit judgement of black males in general) is the main reason why some spectators—and black men in particular—have resisted the dominant reading of *The Color Purple*. Its simplistic portrayal of the black man as quintessentially evil prevents the film from dealing adequately with such complex issues as black female and black male relationships, white racism, sex and religion that Alice Walker's original text addressed.

The treatment of the two shaving scenes also illustrates the film's denigration of the black male. Here Celie replaces Little Colonel as the punishing agent or the father figure, just as Nettie does in the scene of the chase. Must the spectator adopt the dominant reading of these scenes, and be implicated thereby in the vengeance of black women against black men, or should this reading be resisted because it attempts to ally black women with the symbolic white father in the castration of black men? While the former reading is obvious in the first shaving scene, the latter reading is made possible through the montage of the second scene and the ideological positions of race and gender which it narrativises. Because the first scene is preceded by a heart-rending separation of the sisters imposed by Mister's cruelty, Celie's wish to kill him may be seen as a justified end to black male tyranny and the liberation of the black woman. But in repeating the same scene (note that *The Birth of a Nation* also repeats the vengeance-denoting shot of Little Colonel holding his sister), its message is unmistakable. The black man's place of origin, Africa, it is implied, is the source of his essential evil and cruelty. By intercutting violent shots of ritualistic scarring and other initiation ceremonies with shots of Celie and Mister, the film might be read

as suggesting that sexism is fundamental to black male and female relationships and that its locus is Africa. For the resisting spectator, the problem with this interpretation is that such juxtapositions might equally be read by a white male spectator as not only exonerating 'the white man' from sexism, but more importantly, calling for the punishment of the black man as the inevitable resolution to the conflict.

Throughout this article I have argued for an analysis of resistant spectatorship, but the question of how some black spectators identify with the representation of blacks in dominant cinema—through an act of disavowal?—remains to be explored. On a more positive note, however, resisting spectators are transforming the problem of passive identification into active criticism which both informs and interrelates with contemporary oppositional film-making. The development of black independent productions has sharpened the Afro-American spectator's critical attitude towards Hollywood films. Black directors such as Charles Burnett, Billie Woodberry and Warington Hudlin practice a 'cinema of the real' in which there is no manipulation of the look to bring the spectator to a passive state of uncritical identification. The films show a world which does not position the spectator for cathartic purposes, but one which constructs a critical position for him or her in relation to the 'real' and its representation. Other directors such as Larry Clarke, Julie Dash, Haile Gerima and Alile Sharon Larkin use a mixed form of fiction and documentary in which the documentary element serves to deconstruct the illusion created by the fiction and makes the spectator question the representation of 'reality' through the different modes. Clyde Taylor describes Clarke's *Passing Through* (1977) as an attempt to 'subvert the Hollywood action genre, riffing its search, confrontation, chase and vengeance formulas with unruly notes from the underground'.[8] Women film-makers like Larkin and Dash practice the mixed form, to counter dominant sexist and racist perceptions of black women.

As more audiences discover such independent black films, spectatorial resistance to Hollywood's figuration of blacks will become increasingly focused and sharpened. In the influential 'Third Cinema' film, *The Hour of the Furnaces* (1968), Frantz Fanon is quoted as saying that 'every spectator is a coward or traitor', a comment which resonates in independent film practices that question the passive role of the spectator in the dominant film culture. One of the roles of black independent cinema, therefore, must be to increase spectator awareness of the impossibility of an uncritical acceptance of Hollywood products.

1988

---

[8]Clyde Taylor, 'The L A Rebellion: New Spirit in American Film', *Black Film Review* vol 2 no 2, 1986, p 11.

# JOHN BELTON
# DIGITAL CINEMA: A FALSE REVOLUTION

André Bazin was intrigued by the "delay" in the invention of the cinema. Noting that the *idea* of the cinema—the duplication of external reality in sound, color, and relief—had existed for centuries, he was amazed at the slow pace at which technology was developed to make that idea a reality. What is interesting about Bazin's theory of technological development is not entirely his notion of "an integral realism" toward which the cinema teleologically evolves, but his acknowledgment of a counterforce, an "obstinate resistance" that is innate to the cinema and that steadfastly thwarts its development. Bazin's theory is both idealist and materialist, though his focus is ultimately idealist—on the drive toward what he called "total cinema." I want to explore the implications of the materialist thrust of Bazin's argument, to look at the significance of certain delays in technological development. (I shall be using the terms "invention, innovation, and diffusion," introduced to film studies by Douglas Gomery. "Invention" refers to the phase in which the necessary technology is developed; "innovation" to the manufacturing and marketing of the technology; "diffusion" to its widespread adoption by the industry.)

During the period of the cinema's actual invention—the two decades prior to 1900—motion pictures were made in sound, color, and widescreen (and even in 3-D). But, of course, sound wasn't successfully innovated and diffused until the late 1920s and it was not until the mid-1950s that widescreen cinema became the norm. Though color was more or less continuously being innovated and more or less successfully marketed in the mid-1930s in the form of Technicolor, it was not until 1965, when an ancillary market for color features opened up on network television, that Hollywood had an economic incentive to make most films in color.

Clearly, the diffusion of new technology depends upon a variety of factors. No one technology takes quite the same path to full diffusion as another. Nor do they necessarily ever achieve full diffusion. In our attempts to understand this uneven develop-

ment of new technologies, it has become clearer to me over the years that we cannot look to the path taken by one technology to explain or understand that of another. That is because the conditions within which technological change takes place are continually changing. This is why contemporary comparisons of the advent of digital cinema to the coming of sound in the late 1920s are not only misleading but wrong.

The latest so-called technological revolution is the digital revolution, which, it would seem, is taking place in quite distinct phases—not all at once, as was the case for earlier technologies. For audiences, it began in the realm of special effects—a field that is now dominated by computer-generated imagery. Then there was digital sound. Now we are seeing a very slow movement toward digital production using digital cameras and digital projection. Within the history of digital sound, there has not yet been full diffusion of the technology. The number of theaters worldwide that have digital sound readers is under 50 percent. Moreover, every print carrying a digital sound track continues to rely on a back-up track of analog sound, usually Dolby SVA.

The digital revolution is more clearly being driven by home theater and home entertainment software and hardware technologies, and by corporate interests in marketing, than it is by any desire—as in the past—to revolutionize the *theatrical* moviegoing experience. In short, the digital revolution is part of a new corporate synergy within Hollywood, driven by the lucrative home entertainment market.

The first stage of this revolution within the cinema was the digitization of special effects. Digital technology has transformed the photographic image into a truly "plastic" object that can be molded and remolded into whatever shape is desired. As Lev Manovich has argued, digital technology has made the cinema a subset of animation. It is a world inhabited by the liquid-metal man, as in *Terminator 2* (1991) or multiple Eddie Murphys interacting with one another in *The Klumps* (2000). Computer-generated graphics have enabled filmmakers to realize fantasy in a way that was only dreamed of a few years ago.

Digital special effects led the way, but digital sound was not far behind. With the commercial popularity of the compact disc, film sound went digital. Audiences expected it; analog was dead. As one motion-picture exhibitor put it, "digital means progress and customers want it." The digital revolution was and is all about economics—all about marketing new digital consumer products to a new generation of consumers—all about the home electronics industry using the cinema to establish a product line with identifiable brand names for home entertainment systems.

Among digital motion picture technologies, sound was most driven by consumer demand. In a marketplace in which the word "digital" sells consumer products, it is digital sound that marks, for consumers, the entry of motion pictures into the digital era.

Digital sound was introduced in 1990 with the release of *Dick Tracy,* then with *Edward Scissorhands* (1990), *The Doors* (1991), and *Terminator 2*. Because of the compact disc, the public increasingly associated digital sound with state-of-the-art sound. The marketability of digital sound drove its development and the advent of Cinema Digital Sound (CDS) clearly prompted Dolby and others within the industry to accelerate work on their own digital systems. At the same time, the sudden shift in

1990 to digital from analog in the development of a High Definition Television standard undoubtedly encouraged Dolby and others to try to dominate this potential market as well. Indeed, with the shift from analog to digital HDTV, Dolby's status in the highly profitable home electronics industry was suddenly in jeopardy. By 1992, Dolby had perfected a digital track that could be placed alongside an analog Dolby Stereo track. It was introduced with the premiere of *Batman Returns.* Digital Theatre Systems (DTS) introduced a different digital system in 1993 with the release of *Jurassic Park.* DTS is owned, in part, by Steven Spielberg and Universal/MCA and has been used on all Universal and Amblin Entertainment pictures. DTS is a double-system format in which a standard, stereo optical print is distributed with a special time code on it that is synched up with a compact disc.

Dolby began working on a digital sound format in 1987. Perfected in 1992 and introduced with the release of *Batman Returns,* Dolby digital, known as Dolby SRD, combined a conventional Dolby SR track in the standard sound track area alongside the image with a digital track that was located between the sprocket holes at the edge of the film. This permitted a single print inventory for distributors and provided immediate backup, via the analog track, in case of system failure. Although *Jurassic Park* provided a big send-off for the DTS system, DTS made a number of crucial mistakes in promoting the system. DTS encouraged theaters to play back the sound louder than they had with Dolby SR, in large part because DTS (and other digital systems) claimed to have greater headroom. The additional volume strained the amplifiers and loudspeakers, resulting in amplifier clipping, general system shock, and tweeter failure. The result was a harsh, metallic playback of the dialogue. DTS moved fairly quickly to control this potential disaster. And by 1994, DTS had secured an exclusive contract with MGM/UA and had contracted to do a series of films for New Line Cinema. DTS was owned, in part, by MCA, at that time a property of the Japanese electronics giant, Matsushita, which manufactured Panasonic equipment. Matsushita's chief rival was Sony. The emergence of digital sound in the theater served as a lightning rod to galvanize the electronics industry—especially the Japanese electronics industry—which was struggling to retain its dominance in the home entertainment market. In fact, as Paul Rayton has suggested, it is possible to view experiments with digital sound in the theater as the preliminary battle for the potentially much more lucrative market of digital sound in the home. It was a battle that took place on the level of both hardware and software. If MCA (or Sony) could produce enough box-office hits in DTS (or SDDS), it could effectively market playback hardware and film software to home consumers.

By the end of 1994, most studios were releasing exclusively in one format or another. However, during the summer of 1995, more and more studios began releasing their films in multiple digital formats in an attempt to take advantage of the different systems in the majority of digitally equipped theaters. Each of the three systems uses different areas of the release print to encode information. Digital sound has evolved into a three-system standard. As long as most digital theaters can get most big films in digital, the multistandard is likely to continue. Dolby's strategy of overseas domination guarantees its survival in a market dominated by software giants such as Universal, Columbia, and Tri-Star. The bulk of a studio's profits come from overseas distribution; domestic rentals are considered strong if they earn back nega-

tive, print, and distribution cost. Dolby is thus uniquely positioned. In order to reap these overseas profits, studios will ultimately need to make overseas prints available in Dolby. About 25,000 theaters worldwide are equipped to play Dolby Stereo. Since Dolby's analog optical track continues to be placed on most digital prints, theaters will undoubtedly resist digital and continue to rely on four-channel Dolby systems. The fact that all digital systems retain a stereo analog track means that all theaters can run these films without converting to 5.1 digital.

What has emerged is thus a marketplace in which all three systems exist alongside one another. The coming of digital sound is consequently quite unlike other, previous "revolutions" in motion picture technology. The initial transition to sound (1926–1929) led to a single standard—sound on film—that was met by a handful of proprietary technologies (Movietone, RCA Photophone, generic Western Electric). Digital sound is a technology of the new era of Macintosh and IBM; two standards can coexist in the digital marketplace. Consumers have adjusted/adapted to multiple standards; so long as they can run their computer programs or play back their home entertainment programs, they will tolerate multiple standards.

The history of digital sound suggests a need to rethink traditional models of technological determinism. In this particular instance, consumer demand for novelty drove the expansion of the technology. Technology did not determine the demand in the traditional linear, cause/effect pattern. Rather, there was an overlapping of technologies (computers, CDs) and an overlapping of demands (for commodifying/marketing information, for consumer entertainment). These overlapping technologies and demands mutually determined one another in a process of back-and-forth negotiation.

One of the legacies of digital sound has been the death of 70mm as an exhibition format. Digital sound was, of course, not necessarily any better than Dolby's six-track stereo magnetic sound. But it was cheaper. It cost over $12,000 to strike and stripe a 70mm print from a 35mm negative; 35mm six-track digital prints cost almost the same as standard 35mm prints—about $2,000. This particular phase of the digital technological revolution was more of a cost-saving effort on the part of the studios than anything else, although undoubtedly, the upgrade in 35mm sound from four to six tracks and the quality of digital sound did constitute significant improvements over standard 35mm Dolby SVA in the audience's theatrical experience. Even so, all it offered was what we already had in 70mm, Dolby Stereo presentations. And the projected image was far inferior to that of a 70mm print.

At the end of 1999, with the celebration of the faux-millennium, came the advent of a new, "revolutionary" technology—digital projection. Spearheaded by George Lucas, whose *Star Wars: The Phantom Menace* was projected digitally in four theaters in the U.S. in June 1999, digital projection was heralded as the newest technological revolution—a revolution that would change the face of the industry. Admittedly, the production and postproduction of many Hollywood blockbusters had grown more and more dependent on digital technology, and most films—even those without digital imaging—were currently being edited on computer. But this reliance on the digital domain was relatively invisible to the average moviegoer. The potential for a totally digital cinema—digital production, postproduction, distribution, and exhibition—caught the attention and imagination of the media. At the supposed turn of the

millennium, the one-hundred-plus reign of celluloid was over; film was dead; digital was It. The *New York Times, Wall Street Journal, Los Angeles Times,* and several national news magazines heralded the dawning of the new digital age, proclaiming that it was no longer a matter of *whether* it would happen but *when.* One writer noted that the age of Edison was over—the phonograph had been replaced by the compact disc, and film by digital signals; all that remained was Edison's lightbulb. Strategically, it was the perfect moment to introduce the new technology, since the popular media was looking for symbolic events to mark the advent of the new millennium.

George Lucas quickly emerged as digital cinema's poster boy. Lucas wrote that "In the twentieth century, cinema was celluloid; the cinema of the twenty-first century will be digital. . . . Film is going to be photographed and projected digitally. The recorded image will go automatically into a computer and most postproduction will take place in a computer. . . . We made it through the silent era to the sound era and from the black-and-white era to the color era, and I'm sure we'll make it through to the digital era. . . . The creator's palette has been continually widened." Like others, Lucas compared the digital revolution to earlier revolutions in motion picture technology.

Sound designer Walter Murch, who did the sound for Lucas's *American Graffiti* (1973) and Coppola's *The Conversation* (1974) and *Apocalypse Now* (1979), had won an editing and sound-mixing Oscar for *The English Patient* (1996). He now joined in the millennial hype. For Murch, the digital revolution, which had already swept the fields of film editing and film sound, was perfectly positioned to overthrow "the two last holdouts of film's nineteenth-century, analog-mechanical legacy"—projection and original photography.

Theaters showing *The Phantom Menace* digitally displayed banners linking it with other technological revolutions in the cinema—with the projection of the first motion picture, the introduction of sound, color film, CinemaScope widescreen, and digital audio. Interestingly, Cinerama was absent from this list, replaced by the development of CinemaScope, which was erroneously dated as 1955, the year that the Todd-AO Process was premiered. Rick McCallum, one of the producers of *Phantom Menace,* referred to the premiere as "a milestone in cinematic history" and said that "like the introduction of sound and color, these digital screenings represent the beginning of a new era in film presentation." Russell Wintner of CineComm Digital Cinema likened the premiere to that of *The Jazz Singer* in 1927 and the excitement generated by the coming of sound.

If the digital revolution begun in Hollywood's special-effects laboratories was completed in the digitization of projection, then it was hardly a technological revolution on the order of those to which it has been compared. It is really not quite clear in what way it *is* a technological revolution. It does indeed threaten to overthrow the dominance of 35mm film, which has been the chief format of the motion-picture industry for over one hundred years. But it is not revolutionary in the way that these other technological revolutions were. Digital projection as it exists today does not, in any way, transform the nature of the motion-picture experience. Audiences viewing digital projection will not experience the cinema differently, as those who heard sound, saw color, or experienced widescreen and stereo sound for the first time did. Cinerama, for example, did transform the theatrical experience, producing a dramatic sense of audience participation. It was as if the audience, surrounded with image and

sound, had entered the space of the picture. This sense of participation was exploited in Cinerama publicity photos that depicted spectators, sitting in their theater seats, going over Niagara Falls, water skiing, or sitting in Milan's La Scala opera house.

Digital projection is not a new experience for the audience. What is being offered to us is simply something that is potentially equivalent to the projection of traditional 35mm film. This, in fact, is what Steven Morley, vice-president of technology at Qualcomm, which has perfected techniques for delivering digitized motion pictures from studios to theaters via on-site servers or satellite, says was Qualcomm's mission. He writes that the goal of Digital Cinema is "to provide the image quality of a first run motion picture on 35mm film stock projected on opening night at a premier theater." The advantages of "digital"—whatever they may be—are not being exploited in the theater. Current digital projection technology is not interactive. It does not enable audiences to relate to the cinema in ways similar to those provided by the computer or the Internet. It may be digital for George Lucas and Walter Murch at their end of the film chain, but it might just as well be analog for us, since it does not give the audience the empowerment of digital. For it to be truly digital, it must be digital for the audience as well. There would have to be a computer mouse or a virtual reality glove at every seat in the theater. All that the proponents of digital projection are claiming is that it is comparable to 35mm. That does not sound like a revolutionary technology. As far as I can see, the only transformation of the motion picture experience for audiences that has taken place in the last forty years or so has been the development of stadium seating!

If this is not a real revolution, what exactly is it? What is going on? *The Phantom Menace* had "nearly 2,200 digitally generated shots, making up 90 percent of the movie." Lucas is currently filming the next episode of *Star Wars* entirely in digital, using a Sony, twenty-four-frame progressive-scan electronic camera. For George Lucas, digital cinema is clearly the realization of *his* dreams, a revolution in *filmmaking*. His commitment to sci-fi demands that he find new ways of realizing fantasy. In the wake of *Star Wars* (1977), *Close Encounters of the Third Kind* (1977), *E.T. the Extra-Terrestrial* (1982), the *Terminator* films (1984–) and others, sci-fi has emerged as a major Hollywood genre. Sci-fi and special-effects blockbusters from *Star Wars* to *Titanic* (1997) have transformed the motion-picture industry. Big budget blockbusters have driven up negative cost so that it currently hovers at around $55 million. They have spawned saturation ad campaigns and saturation booking, so that these films now regularly open in as many as 3,500 theaters or more on the same day. This saturation marketing strategy has driven up advertising and prints costs to an average of over $27 million per film. Sci-fi and special effects action films have become the dogs that wag Hollywood's tail. But it is not the only dog in Hollywood; there are still other genres. Other filmmakers rely less upon special effects and fantasy; there are scores of directors like Woody Allen, Martin Scorsese, Robert Altman, Stephen Frears, John Sayles, Paul Schrader, and Mike Leigh, who make films about more or less realistically conceived characters in more or less realistic settings. There is no reason for the digital fantasies of sci-fi to drive an industry that, since the sci-fi blockbusters of the late 1970s and early '80s, has become increasingly diverse in terms of narrative content. Indeed, the danger is that an all-digital cinema might very well lead to an all-fantasy cinema— to essentially one genre. Of course, filmmakers do not have to use digital technology

as Lucas does, but if they want to "be digital" and demonstrate what digital cinema can do, then they will surely be tempted to follow in Lucas's footsteps.

To be fair, digital cinema has not necessarily become the sole property of Lucas, James Cameron, and big-budget, commercial Hollywood. It has spawned a counter-cinema of sorts. The relative cheapness of the technology has brought new opportunities for making independent films to a variety of filmmakers. *Timecode* (2000), which cost only $4 million, not only takes advantage of digital video to present events in a continuous way that outdoes Alfred Hitchcock's *Rope* (1948) by a factor of three, but it foregrounds the new technology in its script. The character played by Kyle MacLachlan introduces his client, a filmmaker named Ana, in apocalyptic terms: "Armed with nothing more than a digital camera and an incredible vision . . . Ana is prepared to drag us kicking and screaming into the new millennium." His remarks are suitably punctuated by one of the film's several earthquakes.

Francis Ford Coppola's Zoetrope Studios have gone digital, and he encourages independent filmmakers to work in that format. Next Wave Films, a subsidiary of the Independent Film Channel that furnishes finishing funds to independent filmmakers, has seen a dramatic increase in digital submissions for funding; roughly 51 percent of the films submitted are shot digitally. Sundance, Vancouver, and other independent film festivals have also seen a rise in the number of digital films—and have begun to project these films digitally as well. The question is what the ultimate effect of the "democratization" of the means of production will have—whether independent films will, as they did in the 1990s, evolve by becoming more and more like commercial Hollywood films, or whether they will be able to use the new technology for a different kind of film practice.

The pattern of acquisitions and mergers that has characterized Hollywood in the 1980s and 1990s may explain the fervor for digitization. As the major players in the industry divested themselves of companies that had little or no relation to the emerging media industry, they sought "synergy." Hardware producers of VCRs such as Sony and Matsushita bought software producers such as Columbia and Universal. Publishers, such as the *Time* organization, merged with studios (Warner) and cable companies (Turner) to create vertically integrated entertainment providers. The buzz word in the past few years has shifted slightly from "synergy" to "convergence." "Convergence" refers to "the union of audio, video and data communications into a single source, received on a single device, delivered by a single connection." Convergence looks back to economic structures of yore, such as the vertical integration of the motion-picture industry in the 1920s–1940s. Convergence consists of "three subsidiary convergences: content (audio, video and data); platforms (PC, TV, Internet appliance, and game machine); and distribution (how the content gets to your platform)." The recent $100 billion merger of Time Warner with AOL is an example of both synergy and "convergence." The content provider *Time* and its publishing affiliates can distribute its material on film via Warner, on cable via Turner, and on-line via AOL. In this Age of Information, Hollywood has begun to redefine itself as an information provider and is currently building systems for the delivery of that information, expanding from television and cable to satellites and the internet. Indeed, AOL Time Warner has stated its long-range intentions that studios use AOL's digital networks to distribute movies to theaters. "Convergence" depends upon the development of broadband wired or wire-

less transmission. With the exception of satellite transmission or fiber optic cable, broadband transmission seems fairly far off.

As the motion-picture industry digitizes, it explores new markets that have arisen around digital technology. Most new films are being digitized for release on DVD. More and more of the studio's profits derive from ancillary markets such as video, cable, and broadcast television release. Indeed, 70 percent of the revenues generated by a film now come from these non-theatrical, ancillary markets. Profits from video retail in 2000 were $20 billion, while box-office receipts from theaters totalled only $7.7 billion. Digital projection finds the studios and digital projection companies situating themselves for a new marketplace in which the theater may well become an expendable casualty.

Currently, theaters play a crucial role in providing an initial platform for films, generating public interest in them and providing "buzz" that creates a mass market for future sales. But the role of theatrical release could slowly disappear; the economics of synergy and convergence could lead studios to release films directly to the home, relying upon existing techniques of saturation ad campaigns to bypass the theaters.

In short, digital cinema is a revolutionary technological innovation for filmmakers like Lucas and for the interests of corporate synergy that currently drive Hollywood. As we shall see, it is also a potential boon—in the form of cost saving—for film distributors. But it is not yet clear that it can do anything for motion picture audiences aside from eliminating jitter, weave, dirt, and scratches from the projected image. Even if we concede that these improvements result in better projection, they are not significant enough for them to be declared "revolutionary" in terms of the audience's experience of motion pictures.

On June 18, 1999, *Star Wars: The Phantom Menace* was projected digitally in four theaters in the United States using two different projection systems. CineComm Digital Cinema and its Hughes/JVC projector ran the film at Pacific's Winnetka Theater in Chatsworth near Los Angeles and at Loews' Route 4 Theater in Paramus, New Jersey. A Texas Instruments projector was used at AMC's Burbank 14 Multiplex and at Loews' Meadows 6 in Secaucus, New Jersey. Critical response to the Hughes/JVC system was fairly damning. *Variety* critic Todd McCarthy noted that "the imprecision of the system was woefully apparent the moment the *Star Wars* scene-setting backstory scrolled up the screen—pixilation was readily visible in the letters, which weren't well defined. In the film proper, the darker areas of the frames were murky, colors were flat, there were noticeable blurs in some movements and a general softness was prevalent in the images. Overall effect was akin to a so-so color photocopy." In a special edition of *Widegauge,* Scott Marshall reviewed both systems and noted that the Hughes system "looked like very good video projection" but was "not like film at all. Color registration seemed perfect all the way to the corners, but there was a 'ringing' in the video that added sharp artificial contours to vertical edges, contributing to the 'video look'. . . . There was a faint flickering of horizontal lines in the closing credit scroll, a giveaway that the image was interlaced and not progressive scan."

The Texas Instruments Digital Light Processing cinema projector emerged as the clear winner in the digital cinema projector wars. McCarthy noted that DLP projection was "exceedingly sharp" and "bright." The "process has a cool, clear, hard-edged look." Scott Marshall, who subtitled his review of the DLP "A 70mm for the next

Generation?", attended the screening skeptical of claims that had been circulating that digital was as good as 35mm. When the previews of coming attractions began, he noted that he "was immediately astonished by the spectacularly bright image that also seemed very sharp and with excellent contrast and deeply saturated colors. . . . The picture was absolutely stunning, with deep reds, yellows, and oranges, convincing flesh tones, and sharp, steady superimposed titles. The picture had no dust, dirt, jitter, weave, scratches, or flicker. It was something like a beautifully exposed, new Kodachrome slide, only in motion. It gave me the same feeling in my gut that I get when I watch a perfect 70mm print of a 65mm film." Marshall was a bit less blown away by *The Phantom Menace*—mostly because of flaws in the original photographic style of the film itself.

The Texas Instruments DLP projector is essentially a picture head that is mounted on an existing theater projection lamphouse. This head is twenty inches wide and weighs seventy-four pounds; the projection lens weighs another five to ten pounds. The current method of data delivery to the theater projector is through optical disks. The film is stored on a server, consisting of as many as twenty or more eighteen gigabyte hard drives. The digital sound track is separate and was, for the *Phantom Menace,* played back on a Tascam MMR-8 eight-channel digital tape deck. Since the sound does not need to be digitally encoded on the film, it is not compressed and resembles, in quality, the track heard by the sound engineer in the film's final mix. Steve Morley notes that "it's possible to send sound tracks of six, eight, or more channels of full bandwidth audio, such as 24-bit, 48kHz sampled tracks directly compatible with the formats used by postproduction sound mixing facilities."

Digital information from the Texas Instruments server is decompressed and decrypted and then sent to the projector. The heart of the projector is a digital light processing chip—actually three chips in the cinema projector—known as the Digital Micromirror Device or DMD. A formatter board translates the digital signal into a pure digital bit stream. The chip functions as a digital light switch. Each chip has over 1.3 million tiny aluminum mirrors sixteen by sixteen micrometers square. Each mirror is mounted on a pair of hinges that tilt the mirror plus or minus ten degrees in response to binary code. Each mirror can switch on or off more than 5,000 times per second, depending upon the signal its gets. Amazingly, there have been no mirror or hinge failures to date, and Texas Instruments analysts put the life of these chips at twenty years of more or less continuous use.

Light from the lamphouse hits the mirror; if the mirror is in one position, the light is reflected through the lens and onto the screen. If it is in another position, the light is deflected and absorbed by the interior of the DMD; no light reaches the screen; the result is the projection of a black pixel on the screen. Texas Instruments has recently developed a new, so-called "dark chip." This chip is better than earlier chips in absorbing light. As a result, it can generate blacker blacks on the screen and improve contrast ratio. The function of the chip is to convert a digital electronic input into digital light, which is then projected on the screen. The spectator's eye performs the digital to analog conversion. In other words, what gets to the screen is digital light, not an electronic video image.

Over the past few years, a number of other companies have begun research and development on digital projection. Several of these display their wares regularly at

ShoWest, the annual gathering of movie exhibitors. Several big-name movie compa-
nies have become involved in digital projection. IMAX, for example, has purchased
Digital Projection International. Through this subsidiary, IMAX will build and mar-
ket digital projectors using the TI chips. Technicolor has also become involved in the
development of digital projection technology using the DLP chips. Teaming up with
Qualcomm, Technicolor is offering to distribute digital films for studios and to pay
for the installation of digital projection in theaters for a small fee. Technicolor is also
interested in offering alternative programming—such as rock concerts and sporting
events—to theaters using digital transmission and projection. Texas Instruments,
which brings its DLP projector to ShoWest each year and which has taken a com-
manding lead in the field, has campaigned to get the industry to establish standards
for digital compression, encryption, and projection, possibly hoping that its domi-
nance in the field will result in the adoption of standards compatible with its system.
A SMPTE task force is currently working on establishing industry-wide standards.
However, no standards currently exist, and this lack of standards is one of the chief
roadblocks to the innovation and diffusion of digital projection technology.

Digital cinema is still very much a question mark on the cinema horizon. Although
its proponents claim that within five or ten or twenty years it will have replaced film,
this seems unlikely. The compelling reasons for digital cinema lie in the financial
benefits it can provide to motion picture distributors and in the creative flexibility it
can offer to a handful of very important Hollywood filmmakers like Lucas, Cameron,
and others. Of course, the filmmakers who desire it already have the digital advan-
tage in production and postproduction. It would appear to be the film distributors who
would benefit the most from digital distribution and exhibition. The cost of 35mm
prints—$2,000 each—multiplied by the number of prints currently used on today's
saturation market—3,000 to 5,000 (7,000 prints were struck for *Godzilla*)—add up
to $6 to $10 million per title. Qualcomm's Steve Morley calculates that the cost to
supply 100 or 10,000 theaters is roughly the same with digital cinema—approxi-
mately "$450 per screen per year, compared to the previously computed film cost
exceeding $22,000 per screen per year." The chief selling point of Qualcomm and
others is cost-saving for distributors.

But it is not clear, however, that exhibitors are willing to go along with this. The-
aters are not necessarily reluctant to go digital. To some extent the idea appeals to
them. John Fithian notes that the core of moviegoers is in the twelve to twenty-four-
year-old range. They account for 39 percent of all tickets sold. He points out that the
kids today are the children of the baby-boom generation and that their numbers will
crest in 2010, producing more teenagers in the United States than at any other time
in history. He believes that this population will have considerable influence over what
happens in the theater. "Their life is digitized," he says. The fact that this new gener-
ation of "moviegoers" has grown accustomed to watching film on TV monitors and
has probably never seen films at their optimum—projected on a big screen in 70mm
with six-track Dolby stereo sound—means that they will have nothing to compare
digital projection to but standard 35mm, third-generation release prints, which can be
fairly poor, especially if they were printed on today's high-speed printers that run at
the rate of 2,000 feet per minute.

The question is not one of exhibitors wanting digital. The fact is that they simply cannot afford it. The boom in theater construction that has seen the number of screens climb to around 37,000 has left many theater chains in massive debt. Nine of the largest theater chains in the country have filed for Chapter Eleven bankruptcy protection over the past few years. According to John Fithian, the new president of NATO, the only way digital projection will get into the theater is if "those who are making the savings pay for it." That means the studios and distributors will have to foot the bill. At a cost of $100,000 per screen that comes to $3.7 billion. Recent cost estimates for projectors run from $150,000 to $180,000 each, which would increase that estimate from $3.7 to $5.6 billion. And potential costs do not stop there. Hollywood just barely breaks even on domestic rentals. Profits—more than 50 percent of a film's total revenues—come from exhibition overseas, where there are an additional 22,000 screens in Europe and the UK alone. Distributors will need to foot the bill for digital projection in these and other theaters around the world as well.

Over the past year, Boeing aircraft began negotiations with several theaters to fund the installation of digital projection equipment in the expectation that these theaters would use Boeing's satellite-based delivery system as a distributor. Boeing did participate in the successful satellite delivery of *Bounce* to the AMC 25 theater in Times Square in November 2000 and of Miramax's *Spy Kids* to a recent ShoWest convention in March 2001.

And since digital technology changes every year—how many computer upgrades have we had to make in the last ten years?—these costs are not one-time costs, but will involve continual re-negotiation. Fithian also insists that before theaters even think of converting to digital, industry-wide compression, encryption, and delivery standards need to be established. In this matter, NATO and the MPAA are surely in agreement. At the same time, he argues that the delivery of digital cinema to the theater must be competitively structured. There can be no single gatekeeper; there must be multiple suppliers, if the film industry is to avoid the mistakes of the past associated with the Bell Telephone monopoly. Fithian also fears that exhibitors might lose control of the "show" and that the operations of their theaters might be under remote control of the studios.

Theaters have played a pivotal role in the innovation of revolutionary film technologies, but theaters have generally been dragged to the revolution against the exhibitors' will. Neither the major studios nor their theaters wanted the coming of sound, but when Warner Bros. and Fox forced the issue, the studios found that they had no choice. And, since most of the theaters were then owned by the studios, exhibitors made the transition as well. Color cost exhibitors nothing in terms of technological upgrade, though rental rates were more than for black-and-white films. But it was not until the 1950s that the resistance of exhibitors to costly new technology became a significant negative factor in the innovation of that technology. By this time, U.S. studios were no longer permitted to own theaters, and exhibitors were often cast in the role of adversaries to producers and distributors. The majority of exhibitors capitulated to the widescreen revolution, but they revolted en masse against the costly conversion to stereo magnetic sound that was packaged together with these new widescreen images. In the 1970s, the relatively inexpensive equipment required to

provide Dolby Stereo made an upgrade in theater sound affordable for most theaters. The most recent wave of digital sound technology, which, like Dolby Stereo, is relatively inexpensive, has found a place in many American theaters. However, even six or seven years after this revolution, only about 25 percent of European theaters have converted to digital sound. If theaters have to pay for it, they will not convert to digital projection.

Digital equipment manufacturers try to sell theaters on digital by reviving the dream of theater television and the new revenue streams it was always predicted to provide. Digital theaters could provide big-screen presentations of sporting events, such as prizefights, World Cup matches, or rock concerts, and other Pay-Per-View cable fare. But theater television has never become a viable entertainment format in the past. This was due in part to technological obstacles that digital projection has solved. But it is also due to the difficulty in marketing these events to a public that increasingly expects to see them at home on television either for free or for a modest Pay-Per-View charge.

One of the major threats facing digital cinema is film piracy. Several years ago, Jack Valenti noted that "unless we find suitable technological armor to protect the digital movie, we will soon be standing in the ruins of a once-great enterprise." The studios lose close to $2.5 billion a year in piracy. Qualcomm boasts that it can put "watermarks" into its digital projection that can be used to identify when and where the copy was made. This might help track down the pirates. Encryption of the digital original is designed to protect it on its path from the studio to the theater. According to Dan Sweeney, Qualcomm has an expertise in "military-level encryption" for satellite delivery. It relies on a 128-bit key length and has a "a provision for changing keys during transmission several thousands of times." Each key, it is said, would take weeks to crack on a mainframe. But does encryption work? In the fall of 1999, the encryption code for the Digital Video Disc system was broken by a Norwegian teenager, who was a member of a radical group known as MoRE (Masters of Reverse Engineering). He then distributed the algorithms of the code on the Internet. Having been assured that DVDs could not be copied, Hollywood was traumatized by the event, realizing that millions of perfect copies of popular films could now flood the market.

Given the industry's concern about piracy, it is extremely unlikely that it will embrace satellite delivery of digital cinema, even though it is the cheapest and most efficient way of delivering digital films to the theater. For the present, it would seem that the physical delivery of disks to the theater—and high security storage of them there—or sending them on secure fiber optic lines would be the only viable means of getting digital films to the theater. (Fiber optics were used to deliver *Titan A.E.* [2000] from Hollywood to a theater in Atlanta.)

At present, the digital projection revolution is stalled, lacking product and theaters to show it in. Only thirty-eight screens in the country (two at the AMC 25 in New York City) are equipped with digital projectors, and only thirty-two major motion pictures have been made available for digital projection, including—in addition to those already mentioned—*Tarzan, Toy Story 2, The Perfect Storm, Dinosaur, Fantasia 2000, 102 Dalmatians, Mission to Mars, Vertical Limit, Shrek, Jurassic Park III, Final Fantasy: The Spirits Within, Planet of the Apes,* and *Monsters, Inc.*

Film critic Roger Ebert, who saw a demonstration of digital projection at the May 1999 Cannes Film Festival, is one of the few people speaking out against digital cinema. Ebert's chief objection is that digital projection cannot duplicate the *experience* of 35mm film. In this respect, his argument is much subtler than my own in that all I am saying is that digital projection does not offer audiences a *new experience* in the theater.

Perhaps the most important concern about the digitization of the cinema is its implications for film preservation. At the moment, polyester safety film is the ideal medium for long-term storage of motion-picture images and sound tracks. Its longevity is estimated at about one hundred years—longer if it is placed in cold storage facilities. Digital data has been stored, for the most part, on magnetic tape or disc—a format that has an effective media life of five to ten years and an estimated time until obsolescence of only five years. Studios would be crazy to use digital formats for archiving their holdings. Films made digitally could be stored in that format, but they would have to be converted to a new format every five years. It would make more sense for them to be transferred to celluloid and stored as films. Given the rapid obsolescence of various past digital formats, is it not clear that digital information can be retrieved in the future.

One obvious problem with digital cinema is that it has no novelty value, at least not for film audiences. This being the case, what will drive its future development? Meanwhile, predictions by Lucas, Murch, and others of an all-digital cinema tend to ignore the often conflicting material forces of the marketplace that regularly reshape and even reject new technology. Nor do they take into account the inevitable development of other, nonfilm technologies that might impact upon the evolution of film, altering its ultimate form. Their predictions are idealist, not materialist. They take no note of what Bazin did factor into his quasi-idealist notions of technological development—the obstinate resistance of matter.

2002

# ANNE FRIEDBERG
# THE END OF CINEMA: MULTIMEDIA AND TECHNOLOGICAL CHANGE

As this millennium draws to an end, the cinema—a popular form of entertainment for almost a century—has been dramatically transformed. It has become embedded in—or perhaps lost in—the new technologies that surround it. One thing is clear: we can note it in the symptomatic discourse, inflected with the atomic terms of 'media fusion' or 'convergence' or the pluralist inclusiveness of 'multimedia'—the differences between the media of movies, television, and computers are rapidly diminishing. This is true both for technologies of production (that is, film is commonly edited on video; video is transferred to film; computer graphics and computer-generated animation are used routinely in both film and television production) and for technologies of reception and display (that is, we can watch movies in digitized formats on our computer screens or in video formats on our television screens.) The movie screen, the home television screen, and the computer screen retain their separate locations, yet the types of images you see on each of them are losing their medium-based specificity.

When Marshall McLuhan proclaimed 'the medium is the message' in 1964, this sound-bite aphorism drew attention not only to the *media*tion that the media incurred but also to the specificity of each separate medium. McLuhan inveighed against content-based studies: 'The "content" of any medium,' McLuhan wrote, 'blinds us to the characteristics of the medium.' Instead, he prescribed an account of the effects—'the change of scale or pace or pattern'—that each particular medium might produce. McLuhan analysed the interrelatedness of media in an evolutionary scheme ('The content of any medium is always another medium'), and he insisted that each new medium would 'institute new ratios, not only among our private senses, but among themselves, when they interact among themselves' (McLuhan, 1964: 8–9, 53). In the new media environment of the 1990s, the media of radio, telephone, television,

movies, computer not only interact among themselves, but their cross-purposed inter-actions pose new questions about their technological specificities. German media the-orist Friedrich Kittler anticipated this convergence of media when he wrote: 'The general digitalization of information and channels erases the difference between indi-vidual media' (1986: 102). Yet Kittler predicted that the installation of fiber-optic cable was the technology that would turn film, music and phone-calls into a 'single medium'. We must now ask: how have the material differences between cinematic, televisual, and computer media been altered as *digital* technologies transform them?

Nicholas Negroponte answers this question with a counter-polemical aphorism, turning McLuhan's 'the medium is the message' on its head. 'The medium is not the message in the digital world,' declares Negroponte, 'It is an embodiment of it. A mes-sage might have several embodiments automatically derivable from the same data' (1995: 71). Digital imaging, delivery, and display effectively erase the 'messages' implicit in the source 'medium'. The digitized *Metropolis* illustrates how almost all of our assumptions about the cinema have changed: its image is digital, not photo-graphically-based, its screen format is small and not projection-based, its implied interactivity turns the spectator into a 'user'.

The first part of this essay examines a number of technologies introduced in the 1970s and 1980s which began to erode the historical differences between television and film. The video cassette recorder, the television remote control, and the growth of cable television significantly altered the terms of both televisual and cinematic viewing. As I will argue, these technologies led to a convergence of film and televi-sion technology that began without fiber-optic cable, occurred before the digitaliza-tion of imagery, and preceded the advent of the home computer.

Secondly, as a result of these initial reconfigurations and as our visual field has been transformed by newer technologies, the field of 'film studies' finds itself at a transitional moment. We must add computer screens (and digital technologies), tele-vision screens (and interactive video formats) to our conceptualization (both histori-cal and theoretical) of the cinema and its screens. *Screens* are now 'display and deliv-ery' formats—variable in versions of projection screen, television screen, computer screen, or headset device. *Film* is a 'storage' medium—variable in versions of video, computer disks, compact discs (CDs), high-density compact video-disc players (DVDs), databanks, on-line servers. *Spectators* are 'users' with an 'interface'—vari-able in versions of remotes, mice, keyboards, touch screens, joysticks, goggles and gloves and body suits. Just as the chemically-based 'analog' images of photography have been displaced by computer-enhanced digital images; the apparatus we came to know as 'the cinema' is being displaced by systems of circulation and transmission which abolish the projection screen and begin to link the video screens of the com-puter and television with the dialogic interactivity of the telephone. Multimedia home stations combining telephone, television, and computer (what will we call these: tele-puters? image-phones?) will further reduce the technical differentiation of film, tele-vision, and the computer.

It now seems that a singular history of 'the film' without its dovetailing conspira-tors—the telephone, the radio, the television, the computer—provides a too-narrowly constructed geneology. Once thought to be the province of 'information science' and

not part of the study of 'visual culture', histories of the telephone and the computer become significant tributaries in the converging multimedia stream.[1] In this way, perhaps, Charles Babbage's 1832 'analytical engine' could be measured as significant in the contemporary remaking of visual imagery as Joseph Plateau's 1832 phenakistiscope. Babbage's 'analytical engine'—a mechanical precursor to modern digital computing—could store a number, retrieve it, modify it, and then store it in another location. Plateau's phenakistiscope—an optical toy now considered a key pre-cinematic apparatus—demonstrated how movements analyzed into their static components could be perceived as moving images when perceived through the slits of a spinning disc. The 'analytical engine' turned information into discrete, manipulable units; the phenakistiscope turned images into discrete and manipulable units. The historical coincidence between these two devices only emerges as significant in light of recent technologies of digital imaging and display.

## THE NEW MEDIA ENVIRONMENT

But there were a number of pre-digital technologies that significantly changed our concept of film-going and television-viewing before the digital 'revolution'. The video cassette recorder (VCR), cable television, and the television remote control have prepared us for the advent of computer screens with wired (Internet) connections—for interactive 'usage' instead of passive spectatorship—and continue to produce profound changes to our sense of temporality.[2] If television's innate 'liveness'— its ability to collapse the time of an event with the time of its transmission—was one of its key apparatical distinctions from the movies, the VCR collapsed these separations. Television's mode of absolute presence, as Jane Feuer has eloquently argued, became a key determinant of televisual aesthetics (1983: 12–22). The VCR demolished the aura of live television and the broadcast event, freeing the television screen from its servitude to the metaphysics of presence. Whereas the cinematic apparatus had the potential for re-seeing a film built into its means of mechanical reproduction, television had to await the advent of videotape recording and playback features of the VCR. The VCR introduced the potential to 'time-shift' (to view what you want, when you want), to 'zip' (to fast-forward and/or reverse the video cassette, effectively skipping portions of the taped program (with televised programming, this usually meant commercials)), and also made it easier to re-see a film or program over (and over) again. With the VCR, both the cinematic and the televisual past became more easily accessible and interminably recyclable.

Cable television not only changed the quality of and criteria for television reception, but expanded its offerings with increased channel choice, effectively breaking the monopolies of network broadcasting. In turn, the television remote control

---

[1]In the United States, the 1995 Telecommunications Bill introduced pro-competitive deregulatory policies which encouraged the merging of technology industries, thus erasing many of the historical bases for their separation.

[2]These three technologies fit as examples of Raymond Williams's tripartite typology of communication technologies as: *amplificatory* (distributing messages), *durative* (storing messages), and *alternative* (altering the form of messages) (Williams, 1980). In this way, the VCR is 'durative', cable television is 'amplificatory', and the television remote is 'alternative'.

allowed the viewer instantaneously to change televised channels (to 'zap'), to fast-forward and/or reverse the video cassette (to 'zip'), to switch between live and taped programming, and to eliminate the lure or distraction of television's sound (to 'mute'). As a result of these technologies, the premises of cinema spectatorship and televisual viewing changed radically.[3]

# THE VCR

## *The Time-Shift Machine*

As the VCR became widely available in the mid-1980s, the number of VCR house-holds grew in a parallel 'penetration' of the American home to the growth of television in the 1950s. In 1952 fewer than 250,000 sets were owned by American households; by 1960, 80 per cent of American homes had television; by 1993 there were 93.1 million television households, with a near total saturation, in the high 90 per cent. The marketing of the VCR followed this curve. While there were a variety of video cassette systems marketed in the 1970s, it was not until the early 1980s that the VCR became a common household appliance. In 1985, only 20 per cent of American households had VCRs; in 1989 the figure was 65.5 per cent. But by 1993 the total reached 80 per cent and by 1997, 88 per cent of American homes had VCRs (Lipton, 1991; Nielsen, 1996).

A videotape machine with the capacity for recording and playback on video cassettes, the VCR not only solved broadcast television's reception difficulties, but also freed the television viewer from its programming limitations and rigid timetable. In 1970, there were six competing 'cassette TV' systems in development, set for target marketing dates in mid-1971 or early 1972. [Five of these—Avco, Sony, Ampex, Magnavox, Norelco—relied on videotape. CBS' EVR—Electronic Video Recording—used a photographic film which was scanned and converted to a television signal (Kern, 1970: 46–55).] The Sony Betamax, introduced in 1975, used 1/2 inch videotape in a cassette format that could record for an hour; and a competing 1/2 inch format VHS (Video Home System) was introduced in 1976. The VHS format initially had the advantage of recording for up to two hours. Since cassette recorders were first used primarily for recording broadcast feature films, the two-hour cassette made a difference in the competitive market (Lardner, 1987).

VCRs were first used for recording off the air, but through the 1980s as more and more pre-recorded video cassettes became available, a rental market (an entirely new industry) developed for movies, exercise videos, educational, and self-help material. Hence, the VCR—originally intended by its marketers to be used as a recording and 'time-shifting' device—became essentially a playback device. Both formats—Betamax and VHS—quickly adopted 1) pause buttons so that the viewer could eliminate commercials while recording; 2) timers that allowed the viewer to record while not at home; 3) devices that allowed the viewer to view one program while taping another; and 4) still frame and variable-speed playback features. The sales of VCRs soared

---

[3] Hence, the schoolyard epithet: 'Your folks are so old, they get up to change the channels'. More recently, as 'picture in picture' television sets allow for the simultaneous viewing of multiple channels, the sequential tide of television 'flow' no longer applies.

beyond expectations.[4] As the major film studios sold video rights to their archives, slowly, through the 1980s, most films—even foreign—were transferred to video.

There was only a small cloud over the steamrolling success of the VCR in the marketplace: the issue of copyright. In 1976, Universal and Disney sued the Sony Corporation claiming that any machine that could record, hence 'copy', copyrighted material was in violation of basic copyright laws and should not be manufactured. In 1979, a federal judge sided with Sony, declaring that recording and viewing television program material in the home were 'fair use'. An appeals court reversed this decision, and it was not until a 1984 Supreme Court decision ruled that home taping does not violate copyright laws that the machine itself was in the clear.[5]

As the VCR became a fixture in American living rooms, its penetration of the global market also proceeded apace. A 1983 study showed that VCR penetration of the Third World exceeded television growth. VCRs were used for viewing videotapes, especially of banned material: Indian films in Pakistan and Bangladesh, Western films in Eastern Europe, pornography everywhere. VCRs became an easy 'open door' for cultural contraband—material kept out of cinemas and off television but available for viewing on this playback box. Video cassettes and VCRs also penetrated countries bereft of television; offering uncensored mass entertainment by supplying the immediacy of television without its political impediments. [Statistics from 1982 demonstrated some interesting things about cross-cultural usage: 92 per cent of television homes in Kuwait had VCRs; 82 per cent in Panama, 70 per cent in Oman, 43 per cent in Bahrain, whereas in 1984, in France the figure was 10 per cent, Japan 26 per cent, Singapore 62 per cent, United Arab Emirates 75 per cent, UK 30 per cent (Ganley and Ganley, 1987).]

Despite the initial fear of theater owners and film producers that VCRs would detract from their box-office receipts, the statistical evidence from the 1980s did not support this fear: movie-goers attended in record numbers and still rented videos. While 40 per cent of feature-film viewing is done on VCRs, movie attendance is still strong; as if the use of VCRs actually stimulates movie-orientated activity. Nielsen reports that movie rentals cut into only a small percentage of total television use (Nielsen, 1996). So, if the statisticians have it right, television use has not decreased, movie attendance has not decreased while VCR usage has increased. This would lead us to conclude that in the past 15 years we have spent more time watching television and films and videotapes of both.

## A New Temporality: When Will Then Be Now? Soon!

Now that 'time' is so easily electronically 'deferred' or 'shifted' one can ask: has the VCR produced a new temporality, one that has dramatically affected our concept

---

[4]The VCR became a basic household appliance, but the puzzle of programming a VCR became a running national gag. President George Bush joked at a commencement speech at Caltech in 1991: 'The seventh goal of education should be that by the turn of the century, Americans must be able to get their VCRs to stop flashing 12:00' (Ferguson, 1993: 72).

[5]Soon after Sony won the copyright battle it lost the format battle. Betamax was a format that—although it offered better picture quality—lost its market share as the majority of new VCR buyers bought VHS.

of history and our access to the past? The VCR treats films or videotapes as objects of knowledge to be explored, investigated, deconstructed as if they were events of the past to be studied.[6] The 1987 film *Spaceballs* (Mel Brooks, 1987) parodies some of the changes in movie reception produced by the VCR and the rental marketing of video cassettes. In the film, Dark Helmet (Rick Moranis) and his commander, Colonel Sanders, chase an intergalactic 'winnebago' driven by a space-bum-for-hire Lone Star (Bill Pullman) and his canine sidekick, Barf (John Candy). Dark Helmet and Colonel Sanders stand by the spaceship's video scanner screen when Sanders introduces a 'new breakthrough in video marketing—instant cassettes'. The riff between Helmet and Sanders toys with the new temporality produced by the video cassette: 'Prepare to fast forward . . . go past this part . . . the part on ridiculous speed'. When they suddenly stop the tape at a frame that matches the moment they are in, they do a double take between the screen and each other:

'When does this happen? Then?'
'Now.'
'When will then be now?'
'Soon!'

The jumbled tenses of present and past here form a parody on the very paradoxes of televisual presence ('Now') and the VCR's deeper challenges to time and memory ('When will then be now? Soon!').

Paul Virilio has described the new temporality made possible by the VCR:

The machine, the VCR, allows man [*sic*] to organize a time which is not his own, *a deferred time,* a time which is somewhere else—and to capture it. . . . The VCR . . . creates two days: a reserve day which can replace the ordinary day, the lived day. (1988)

For Virilio, the VCR produces a time that is shifted, borrowed, made asynchronous. The VCR is like an electronic melatonin, resetting the viewer's internal clock to a chosen moment from the past.

While these new attributes of televisual time often lead to liberatory rhetoric about the VCR—freeing its viewers from the tyranny of standard time and broadcast choices with button-pushing empowerment—there remain limits to the choices available. Richard Dienst forecloses any emancipatory potential of this new temporality, reminding us that the privilege of individual prerogative ultimately profits 'paranational . . . conglomerates':

VCRS do nothing but extend the range of still and automatic time, offering an additional loop of flexibility in the circulation of images, bringing new speeds and greater

---

[6]The Mia Farrow character, Cecilia, in *Purple Rose of Cairo* (Woody Allen, 1985) was a pre-VCR viewer who had a viewing repetition compulsion made possible by the cinematic potential to for re-seeing/re-experiencing the identical film over and over.

There seems to be little statistical evidence on how often films were re-viewed by the same viewer, or how often the same viewer re-viewed a film over time—in its original release and then again in its re-release, or its release in repertory. Television viewing was always thought of as more transient. The pleasures of re-viewing television programs, once only available on the cycle of summer re-runs, have been more fully discovered since cable networks become repertories for revisiting the televisual past and since the VCR has made it technologically possible to capture and replay them on videotape. In this regard, it is worth considering how we commonly listen to an audio recording repeatedly, while visual media are thought to be more disposable and, in fact, is often constructed as such.

turnover. . . . video allows people to operate another series of switches, a privilege bought with more time, money and subjective attachment. . . . who profits from this new and immense expansion in the volume of overall televisual time? . . . paranational electronic manufacturers and entertainment conglomerates. (1994: 165–6)

And now that the VCR has become a well-entrenched consumer durable, electronics companies are trying to supplant it with laser disc technology, hoping that the DVD player will become the next VCR, just as audio CD machines have supplanted record players in the past decade (Bauman and Harmon, 1994). DVD technology offers some advantages: as with the larger laser disc formats, one can access a different section of the disc in a near instant; there is no fast-forwarding or rewinding required. But owing to more sophisticated image compression algorithms, a DVD, unlike larger laser discs and CD-ROM technology, can hold an entire feature film on a single disc. CD-ROM technology promised to bring 'movies' to your computer, with new playback possibilities, but the DVD may be the format that succeeds in doing so.

## CABLE TELEVISION

Cable television is almost as old as commercial broadcast television. Because broadcast television required a clear 'line of sight' between the transmitter and the receiving set for adequate 'reception', cable television developed in areas where broadcast television was not easily received, where antennae could not 'see' each other, and where alternative methods were needed for transmitting broadcast signals. But cable television also offered some additional advantages: because it delivered television signals on coaxial cable it could carry more than one channel on the coaxial cable and import distant signals which were received by one master antenna (or, later, by one master satellite dish) and retransmit them.

In 1975—the year that began the Betamax/VHS format wars—a dramatic change in cable programming occurred: Home Box Office (HBO) began distributing special events (beginning with the Ali-Frazier 'Thriller in Manila' fight) and movies via satellite. Shortly after HBO launched its service, Viacom launched a competing pay television service (Showtime) in 1976, and Warner Communication followed with The Movie Channel (which showed movies 24 hours a day) in 1979. These 'pay' or 'premium' cable channels relied heavily on the programming of feature films.

And not long after HBO began using satellite transmission, the owner of a low-rated UHF station in Atlanta put his station's signal on satellite to be seen nationwide. This station, WTBS, owned by Ted Turner, became known as a 'superstation' because of its national availability. Turner's 'superstation' was a 'cable network' which made economic sense both to subscribers and to local cable companies. Cable subscribers were not charged for an extra station, the local cable company was only charged a dime a month per subscriber, and the extra service increased subscribers. And even though the revenues from the local cable companies did not cover the superstation's costs, the superstation could charge higher advertisement fees because it could boast a bigger audience. The core programming on WTBS consisted of Hollywood's movie past. [In 1986 Turner bought MGM and its film library; in 1987 Turner bought rights to an additional 800 RKO films (Gomery, 1992: 263–75).]

In the late 1970s and early 1980s cable television grew phenomenally. Most of what we know now as 'basic cable'—CNN, MTV, Nickelodeon, C-Span, the superstations TBS, WOR, USA Network—were born within a timespan of a few years. In 1993, 64 per cent of television owners subscribed to cable; by 1996, the figure was 68.5 per cent (Nielsen, 1996). While studies on the movie-going habits of basic and pay cable subscribers have shown mixed results, indicating both a decrease and increase in movie-going (Austin, 1986: 93–4), one thing is certain: the increase in VCR users and cable subscribers meant that the cinematic spectator became a televisual viewer.

## The Television Remote Control

A third technology that transformed televisual viewing (and exacerbated its differences from film spectatorship) is the television remote control. The television remote control penetrated the American household as rapidly as VCRs and cable: in 1976, 9.5 per cent of televisions were sold with remote controls; by 1990, 90 per cent of them were (Napoli, 1999); in 1985, only 29 per cent of households had remote controls, in 1996, 90 per cent of US household had at least one (Nielsen, 1996). Versions of the television 'remote' control device were marketed in the 1950s—first tethered to a wire and later as a wireless light-sensor remote—but these offered fewer options to the couch-bound viewer of 1950s' broadcast television than the same device did for the later VCR or cable subscriber. With a television remote control, the viewer becomes a *montagiste,* editing at will with the punch of a fingertip, 'zipping', 'zapping', and 'muting'. Television programmers have noted that to capture the armchair channel-surfer requires more and more 'visual' programming—relying less on plot and characterization and more on fast rhythmic editing. Some studies have shown that this form of viewing even changes the ability to follow linear arguments (Meyerowitz, 1985). And, as if to demonstrate its teleological relation to computer usage, the television remote control is now—retronymically—referred to as an 'air mouse'.

## The Film Screen, the Television Screen, the Computer Screen

Certainly, much of the early competition between film and television centered around screen size and format; the television providing a 10–12 inch screen tailored to the domestic scale of the home, the movie screen differentiating its offerings with color, three-dimensional, and wider screen formats, compensating for what the black-and-white flat screens of television could not supply. Television 'viewing' altered some of the protocols of cinema 'spectatorship': unlike the cinema spectator, the television viewer watches a light-emanating cathode ray box in a partially darkened room. The optics of television do not rely on persistence of vision and projection but on scanning and transmission. [Our eyes have grown accustomed to NTSC 525 lines per image at 30 frames per second; or phase alteration line (PAL) at 624 lines at 25 frames per second; high definition television (HDTV) has 1125 lines per image.] And, as television scholars are quick to note, the placement of televisions in the home significantly alters the function of such spectatorship. Lynn Spigel, for example, likens

the television's screen—a form of 'home theater'—to the 1950s' architectural use of the picture window, a 'window-wall' designed to bring the outside in (1992: 102).

Although both the content and the form of television competed with the film industry for viewers, television also became a delivery system for motion pictures—first in broadcast and syndicated format and later in basic and premium cable movie channels (Gomery, 1992: 247–75). As films were shown on television, changes in cinema screen aspect ratios meant that films were either panned and scanned or—more appropriately—'letterboxed' to fit in the 4:3 rectangular format of the television screen. The television 'viewer' could now view films in a space that was, as Roland Barthes described it, 'familiar, organized, tamed' (Barthes, 1975). In 1974, Raymond Williams predicted: 'The major development of the late seventies may well be the large screen receiver: first the screen of four by six feet which is already in development; then the flat-wall receiver' (Williams, 1974: 136). As HDTV flat screen technology improves and screens replace real windows with a kind of 'inhabited television', a 'windows environment' may come to mean a virtual 'window-wall'.

The scale and domestic place of the television have prepared us for the screens of the 'personal' computer. Computer 'users' are not spectators, not viewers. Immobile with focused attention on a cathode ray screen, the computer 'user' interacts directly with the framed image on a small flat screen, 'using' a device—keyboard, mouse, or, in the case of touch screens, the finger—to manipulate what is contained within the parameter of the screen.[7] While computers have been designed to 'interface' with humans in ways that emulate the associative patterns of human thought (Bush, 1945), to become dyadic partners in a metaphysical relationship (Turkle, 1995), complaints about the awkwardness of this relationship are surfacing. As one critic has proclaimed: 'Using computers is like going to the movie theater and having to watch the projector instead of the film' (Kline, 1997).

## REINVENTING 'FILM STUDIES'

As the field of 'film studies' has been redefining itself, both revising its internal historical accounts and opening up its field to the emerging multiplicities of 'cultural studies' and 'visual studies', much of this work has been coincident with the campaign for the academic legitimacy of film studies as a republic separate from its former disciplinary overlords. But as new technologies trouble the futures of cinematic production and reception, 'film' as a discrete object becomes more and more of an endangered species, itself in need of asserting its own historicity. In the past decade

---

[7]When Microsoft trademarked its second-generation software as Windows™ they emphasized the metaphoric nature of much of our computer usage—'mice' which scurry under our fingers at the fluid command of wrist and palm; 'desktops' which defy gravity and transform the horizontal desk into a vertical surface with an array of possible colors and digital textures. The computer 'window' is only a portion of the computer screen, scalable in size. Windows can overlap, stack, or abut each other. The windows 'environment' makes the screen smaller and allows for simultaneous applications. As an 'interface', Windows™ extends screen space by overlapping screens of various sizes; each 'window' can run a different application; you can scroll through a text within a 'window', arrange windows on your screen in stacked or overlapping formations, decorate your windows (with wallpapers, textured patterns). A paradox begins to emerge: the more the image becomes digital, the more the interface tries to compensate for its departure from reality-based representation by adopting the metaphors of familiar objects in space.

or so, first with the VCR and more recently with on-line and digital technologies, the methods and source material for film and television scholarship have been radically transformed.[8]

Here it seems necessary to describe the following historiographical conundrum: David Bordwell and Kristin Thompson, arbiters of film history-as-text (and as text-book) have marked the history of film as a field of academic research 'no more than thirty years old' (1994: xxvi). Yet in the past several decades, while film scholars have been reworking the histories of cinema's past—adjusting or refuting its teleologies, challenging its grand narratives—our concept of and access to not just the cinema's past but to the past itself have also radically been transformed and this due in no small part to the cinema. Hence, there is a troubling paradox in the way in which the ascendency of film historical discourse in the past several decades may have worked to mask the very *loss* of history that the film itself inflicted. What I am invoking here are a familiar set of historiographic questions about the ways in which we can know the past, the truth claims of histories, and the nature of historical knowledge. As the field of 'film history' has flourished in its vitality, the concomitant changes to our concept of the past produce a reflexive problematic. Cinema spectatorship, as one of its essential features, has always produced experiences that are not temporally fixed, has freed the spectator to engage in the fluid temporalities of cinematic construction—flash-backs, ellipses, achronologies—or to engage in other time frames (other than the spectator's moment in historical time, whether watching the diegetic fiction of a period drama or simply a film from an earlier period).

Without the discourse of film history, films would lose their historical identity, would slip into the fog of uncertain temporality. (As an exercise in my undergraduate film history classes, I ask them to turn on TNT in the middle of the night, without their television guides in hand, and to try to identify a rough production date for the films they are watching.) But even with the discourse of film history, films continue to reconstitute our sense of historical past. Recent films which have digitally 'revised' film footage from the 1960s—*Nixon, JFK, Forrest Gump*—illustrate the compelling urge to reprogram popular memory. And as the past is dissolved as a real referent and reconstituted by cinematic images which displace it, Charles Baudelaire's 1859 cynical prophesy about photography's 'loathing for history'[9] meets Fredric Jameson's (1983) dystopic symptomology of history's 'disappearance'.[10]

---

[8]For example: as part of an on-line collection deemed 'American Memory' the Library of Congress has made films in their 'Early Motion Picture Collection' available for downloading off the World Wide Web along with hyperlinked texts detailing the historical context of 'America at the turn of the century', complete with a selected bibliography. (Although conclusions drawn from these films have to take into account that in their digitized format, 5–10 per cent of the original film frames are lost in the transfer.)

[9]In 1859, Charles Baudelaire indicted photography as being a 'cheap method of disseminating a loathing for history'. Baudelaire was an early declaimer of the dangerous transformations of history and memory that the photographic image would produce. Despite photography's 'loathing for history', Baudelaire also recognized it as a technique that could preserve 'precious things whose form is dissolving and which demand a place in the archives of our memory' (1862: 153).

[10]In a 1983 essay, Fredric Jameson, one of the key diagnosticians of postmodernity, catalogued some of its symptoms as "*the disappearance of history*, the way in which our entire contemporary social system has little by little begun to *lose its capacity to retain its own past*, has begun to live in a perpetual present and in a perpetual change that obliterates traditions" (1983: 125, emphasis added).

And just as soon as film scholars have undone the set of teleologies which read film history backward from the classical Hollywood model, a newly constructed teleology seems to be in the making. If a 1995 *New York Times* front-page story, 'If the medium is the message, the message is the Web', is any indication, a new *telos* is beginning to appear. In a feature-spread headlined, 'How the earlier media achieved critical mass', separate articles on the printing press, the motion picture, radio, and television were juxtaposed, suggesting a synergy of the mythic moments that have transformed each medium from one with technological potential into one with 'critical mass', that is, into a medium of mass reception. In this article, Molly Haskell's account of 'the defining moment for motion pictures as a mass medium' formulaically replays *Birth of a Nation*'s New York premiere as the event 'that catapulted the medium from its 19thc peep-show origins into its status as the great new popular art form of the 20th century' (1995: C5). While *The New York Times* did not directly assert the World Wide Web as *the* heir to the cultural centrality of the motion pictures and television ('there will be no certainty that this medium will achieve the critical mass that capitalism demands of its mass media'), the Web was positioned as a challenging successor which, unlike 'each previous mass medium ... does not require its audience to be merely passive recipients of information'. Certainly, as the World Wide Web has become the *modem* (*modus*) *operandi* of everyday life, media savants have had to change their predictions about the electronic future of the 500-channel information highway and adjust for a much more computer-based key to the electronic future (Levy, 1995).

And now as the cynical futurologists prophesy the future of each new technology, it is worth recalling that in 1895, Louis Lumière boasted 'the cinema is an invention with no future'. While we have some indications of where new technologies might take us, we still have no clear sense of what will be a 'sustainable' technology in market terms. Even the current storage and display media—CD-ROMs and video cassettes—may be seen as transitional technologies as films and other visual material move on-line. And yet it is more than apparent that with the speed of such rapid and radical transformations, our technological environments cannot be conclusively theorized.

The history of 'film studies' in its own way parallels the history of film itself, with a lag of perhaps 40 years. In what has been called the 'classical' Hollywood period of film history there was a consensus not only as to what constituted narrative 'content' but also as to the size, shape, color, and scope of the screen. Similarly, during the 'classical' period of film studies there has been a general agreement as to what constitutes the size, shape, and scope of the discipline's objects. Now, a variety of screens—long and wide and square, large and small, composed of grains, composed of pixels—compete for our attention without any arguments about hegemony. Not only does our concept of 'film history' need to be reconceptualized in light of these changes in technology, but our assumptions about 'spectatorship' have lost their theoretical pinions as screens have changed, as have our relations to them.

# REFERENCES

Roland Barthes 1975: En Sortant du cinéma. *Communications* 23, translated by Bertrand Augst and Susan White, in *Apparatus,* edited by Theresa Hak Kyung Cha. New York: Tanam Press, 1980, 1–4.

Charles Baudelaire 1962: The salon of 1859. In *Art in Paris 1845–1862: salons and other exhibitions*, translated and edited by Jonathan Mayne. Oxford: Phaidon Press, 1965, 144–216.

Adam S. Bauman and Amy Harmon 1994: Rival systems of VCR 'Replacement' could spark standards war. *Los Angeles Times* 14 September 1, D1, D4.

Robert V. Bellamy, Jr and James R. Walker 1996: *Television and the remote control: grazing on a vast wasteland.* New York: Guilford Press.

David Bordwell and Kristin Thompson 1994: *Film history: an introduction.* New York: McGraw-Hill, xxvi.

Vannevar Bush 1945: As we may think. *Atlantic Monthly,* July.

Sean Cubitt 1991: *Time shift: on video culture.* New York: Routledge.

Richard Dienst 1994: *Still life in real time: theory after television.* Durham, NC: Duke University Press, 165–6.

Andrew Ferguson 1993: Charge of the couch brigade. *National Review* 45 (19) 4 October.

Jane Feuer 1983: The concept of live television: ontology as ideology. In E. Ann Kaplan, ed., *Regarding television.* Los Angeles, CA: American Film Institute Monographs, 12–22.

Gladys D. Ganley and Oswald H. Ganley 1987: *Global political fallout: the VCR's first decade.* Cambridge, MA: Program on Information and Resourses Policy, Harvard University.

Douglas Gomery 1992: *Shared pleasures: a history of movie presentation in the United States.* Madison, WI: University of Wisconsin Press.

Molly Haskell 1995: 'The Birth of a Nation', the birth of serious film. *The New York Times* 20 November: C5.

Frederic Jameson 1983: Postmodernism and consumer society. In Hal Foster, ed., *The anti-aesthetic.* Port Townsend, WA: Bay Press, 111–25.

Edward Kern 1970: Cassette TV: the good revolution. *Life* 69 (16) (16 October) 46–55.

Friedrich Kittler 1986: *Grammophon, film, typewriter.* Berlin: Brinkmann and Bose. Translated by Dorthea Von Mücke with the assistance of Philippe L. Similon, as 'Gramophone, film, typewriter', *October* 41: 101–18.

David Kline 1997: The embedded Internet. *Wired Magazine* 5:2, February.

James Lardner 1987: *Fast forward: Hollywood, the Japanese, and the VCR wars.* New York: New American Library.

Steven Levy 1995: *The New York Times,* 24 September.

Lauren Lipton 1991: VCR: very cool revolt. *Los Angeles Times,* TV Times cover story, 'How we tape', 4 August.

Marshall McLuhan 1964: *Understanding media.* Cambridge, MA: MIT Press, 1994.

Joshua Meyerowitz 1985: *No sense of place: the impact of electronic media on social behavior.* New York: Oxford University Press.

Lisa Napoli 1999: A gadget that taught a nation to surf: the TV remote control. *The New York Times* 11 February: D10.

Nicolas Negroponte 1995: *Being digital.* New York: Alfred Knopf.

A.C. Nielsen 1996: *The home technology report.* A.C. Nielsen Company, July.

Lynn Spigel 1992: *Make room for TV: television and the family ideal in postwar America.* Chicago, IL: University of Chicago Press.

Sherry Turkle 1995: *Life on the screen: identity in the age of the Internet.* New York: Simon and Schuster.

Paul Virilio 1988: The third window: an interview with Paul Virilio. *Cahiers du Cinéma,* translated by Yvonne Shafir, in *Global Television,* edited by Cynthia Schneider and Brian Wallis. Cambridge, MA: MIT Press: 185–97.

Raymond Williams 1974: *Television: technology as cultural form.* New York: Schocken.

Raymond Williams 1980: Means of communication as means of production. In *Problems of materialism and culture*. London: New Left Books.

*The New York Times,* 1995: If the medium is the message, the message is the Web: 20 November, pp. A1, C5.

# INDEX

We have designed this index to help the reader find discussions of directors, individual films, film critics, and theorists that cut across the otherwise topical organization of *Film Theory and Criticism*. However, those references are indexed only when they are multiple or when there is an extended discussion. Single references within only one article are therefore, for the most part, not included unless they are otherwise significant. Any essays included by a given author are listed by page number under that author's name, along with any references to his or her work in other essays. Films are listed under the heading of their director and in their most commonly used title. When authors have cited slightly different film titles (for reasons of translation or British versus American spelling), and when they have transliterated names with slight differences (Vertov/Vertoff, Gorki/Gorky), we have not altered their texts but grouped the references in the index under the most familiar spelling.

927